The Russian Far East

A REFERENCE GUIDE FOR CONSERVATION AND DEVELOPMENT

SECOND EDITION

Josh Newell

Daniel & Daniel, Publishers, Inc.
McKinleyville, California

In association with Friends of the Earth–Japan

2004

Copyright © 2004 by Josh Newell
First edition 1996
Printed in the United States of America
Edited and indexed by Frances Bowles
Proofread by Sharon Vonasch
Designed by Dennis Martin

Daniel & Daniel, Publishers, Inc.
Post Office Box 2790
McKinleyville, CA 95519
www.danielpublishing.com

The review of fishing in chapter 1 of this publication appeared in a slightly different
form in *Russia's Far East: A Region at Risk*, copyright © 2002 The National Bureau of
Asian Research. Reprinted by permission of the University of Washington Press.

Library of Congress Cataloging-in-Publication Data

Newell, Josh.
 The Russian Far East : a reference guide for conservation and development /
Josh Newell — 2nd ed.
 p. cm.
Includes bibliographical references and index.
 ISBN 1-880284-76-6 (cloth: alk. paper)
 ISBN 1-880284-75-8 (pbk.: alk. paper)
 1. Conservation of natural resources — Russia — Russian Far East. 2. Nature
conservation — Russia — Russian Far East. 3. Natural resources — Russia — Russian
Far East — Management. 4. Sustainable development — Russia — Russian Far East.
I. Title.
S934.R9N48 2004
333.72′0957′7 — dc22 2003021552

The paper used in this publication is acid-free.

Front cover: Satellite photograph of the Russian Far East giving a perspective from the
Arctic in the north looking south down to Japan. Courtesy of Face of the Earth™, ARC
Science Simulations, copyright © 2000.

Back cover: Glistening water, courtesy of Mikhail Skopets; Walrus, courtesy of Nikita
Ovsyanikov; Tiger, courtesy of Yuri Shibnev; and Drying Fish, Reindeer, and Man,
courtesy of Natalie Fobes, www.fobesphoto.com.

Contents

List of figures, maps, tables, and appendixes

Appendixes

Preface

When a group of colleagues and I decided in 1997 to produce a new edition of *The Russian Far East: Forests, Biodiversity Hotspots, and Industrial Developments*, we foresaw only a moderate revision. "We will have a new edition by 2000," I boldly pronounced. Then we began adding new sections, doubling the length of each chapter, and encouraging our Russian regional coordinators to commission contributions from as many specialists as possible. The first edition had eighteen contributing authors; this edition has more than ninety.

I found myself overwhelmed by the amount of material we had to translate and edit. These tasks were made more difficult by my desire—almost obsession—to add information (a tidbit about diamond mining here, about nuclear power there) in the chapters to ensure even coverage and to give the book the unified tone necessary for a reference guide, but without silencing the voices of the original writers.

Despite these changes and additions, the structure of this new edition remains fundamentally the same as that of the first one. This book, too, is divided into chapters by political division (e.g., *krai, oblast*) and not by ecological boundary (e.g., temperate climate, forest, tundra), although the ecological elements constitute discrete sections within the chapters. Russian environmentalists, politicians, and the corporate sector—although scientists perhaps less so—clearly identify more closely with the political divisions. For instance, on environmental issues Anatoly Lebedev, my good friend and colleague, rarely strays outside the borders of Primorsky Krai and Dima Lisitsyn focuses solely on Sakhalin Oblast.

As did the first edition, this tries to reach out to as many audiences as possible; I like to think of the book as a kind of travel guide for the Russian Far East development community or, as my former colleague, Lisa Tracy, put it, "a hybrid book." My intention was to make the text as useful for the businessperson or World Bank official as it is for the scientist or environmentalist; to bring all those involved in the Russian Far East together into some kind of dialogue; to provide so much useful information that the business community would have to have the book and, while scanning the various sections for data on natural resources, find themselves absorbed by Dale Miquelle's review of the plight of the Siberian tiger or by Geoffrey York's account of the untrammeled poaching that is devastating the salmon rivers of Kamchatka.

I had initially planned to subtitle the book "a reference guide for sustainable development" rather than "conservation and development"—hoping that it would be a blueprint. But,

as the project developed, it became clear that this material provides only a starting point: It describes problems incurred by some industrial activities, it catalogues the biodiversity "hotspots," and it documents the plight of protected-area systems. In hopes of fostering the discussions about how to achieve an ecologically sustainable economy in the region, we added the section Toward Sustainable Development. In it, many contributors question the current development trajectory and suggest some alternatives. Nevertheless, the RFE desperately needs more model development projects, more insight from the environmental community about what sustainable development should look like, and more willingness in the World Bank and other development agencies to look beyond fossil-fuel development and mining. The rather artificial chapter subdivisions in the book, Ecology and Economy, symbolize how far we have to go.

The reader may ask, "Why all the fuss about the RFE?" Quite simply because the RFE is the most biologically diverse region of the largest country on Earth. Its preservation is crucial not only for the plants and animals that depend on healthy ecosystems, but for ourselves, who do likewise! The region is a vital storehouse of natural resources that will inevitably be tapped, particularly as globalization and foreign investment further integrate its economy into the larger North Pacific economy. We depend on RFE fisheries for food, RFE forests to absorb our carbon dioxide, RFE natural gas and coal to supply our power plants, and RFE timber to build our houses. With this growing influence (and interdependence) comes, not only the responsibility for the international community to work with Russians to ensure sustainable development, but also the responsibility to protect what should remain intact. As I wrote in the preface to the first edition:

> Rafting down the Bikin River in the summer of 1993 was my introduction to the Russian Far East. One evening we hiked up from the village of Ulunga at the headwaters of the river to a lookout to watch the sunset. Korean pine and fir forests extended as far as the eye could see; no roads and no towns, only that small village of fifty families. Sitting up there in the mountains, seeing the river, the sky, and the trees, I understood why we need wilderness preserved.

Josh Newell
Seattle, Washington

Acknowledgments

I am tempted to thank people chronologically, since the first edition of *The Russian Far East* began as an idea hatched with colleagues in Tokyo restaurant in the fall of 1993. Because there are, however, so many to acknowledge and because so many have helped me in stretches throughout this period, it is better to thank them by subject.

Project genesis

Andrei Laletin, Randy Helten, Emma Wilson, and Alexander Dobrynin were instrumental in developing the original 1995 Hotspot Study and J. P. Myers, Charly Moore, and others at the W. Alton Jones Foundation made the study a reality. Emma and I developed the outline for the 1996 *Russian Far East*, with help from Rick Fox. In 1998, Emma, Rick, and I met for a two-day work session with Zbig Karpowicz at the IUCN offices in Cambridge, England, where we developed the basic structure for the book. Eiichiro Noguchi provided useful ideas throughout the development process.

Writing

This text would have been impossible without contributions from the more than ninety authors who wrote sections, almost always for meager financial reward. I thank them all for their writing, and for their patience in waiting for publication. I would also like to thank the University of Washington Press and the National Bureau of Asian Research for allowing me to publish a condensed version of Tony Allison's contribution on the fishing industry.

Translation

The daunting task of translating the contributions from the Russian authors fell to a number of talented individuals. Serge Glushkoff and his father Kirill Glushkoff translated most of the Russian contributions to the regional chapters; the Biodiversity Hotspots sections were translated by Rick Fox. Other sections were translated by Misha Blinnikov, Vladimir Dinets, Alexander King, Patricia Ormsby, Oleg Svistunov, and Emma Wilson.

Mapping

Mike Beltz played a large role in the developmental stages of the map making. We had initially thought to develop a database and so had the twelve Russian coordinators prepare a number of thematic maps of protected areas, biodiversity hotspots, industries, indigenous peoples' areas, and so on. Mike,

Rankin Holmes, and others at The Ecology Center, Inc, with help from Oleg Svistunov (FoE–J), digitized the data on protected areas and hotspots and prepared an initial design for maps 1.7–1.16. Matthew McKinzie at the Natural Resources Defense Council and Rory Newell (FoE–J) digitized the others. Guirong Zhou helped me prepare most of the maps themselves and Dennis Martin advised on their final design. Dana Morawitz helped with the regional reference maps and with a number of the forestry maps; Joe Miller helped with the oil and gas maps. Phil Hurvitz, Luke Rogers, and Bill Haskins provide helpful technical support.

Figures

Frank Deserio developed and drafted the initial figures, and Dennis Martin and I worked together to produce the final design.

Photography

Thanks to all the photographers (listed on p. 449) who provided images for this book.

Editing

Frances Bowles, the copy editor, has been an absolute blessing to work with. I appreciate her insightful editorial queries, some of which led me to rearrange or cut entire sections, and her understanding as I chronically broke deadlines. Jeremy Tasch, Alexander King, Melinda Herrold, Devin Joshi, and Emma Wilson had the difficult task of both writing and editing chapters. A small army of editors also helped out: Annie Belt, Vladimir Dinets, Ian Duncan, David Gordon, Jessica Graybill, Randy Helten, Christina Kincaid, Susan Newell, Gloria Pan, Marta Steele, Maggie Suzuki. Sharon Vonasch proofread the entire book.

Reviews

I would like to thank the following for their helpful reviews: Michael Bradshaw, Patricia Gray, Jessica Graybill, Anatoly Lebedev, John Marzluff, Peter Newell, Doug Norlen, Timothy Nyerges, Jonathan Oldfield, Judith Thornton, and Craig ZumBrunnen.

Design

Thanks to Dennis Martin for his typographic and design skill and his patience when dealing with an author (me) who perpetually changed his mind.

General support

Thanks to all who provided support in one form or another: Dmitry Aksenov, Marina Alberti, Ken Allen, Xan Augerot, Magnus Bartlett, Michael Biggins, Sergei Chebetov, Terry Choate, Rory Cox, Lucy Craft, Sue Daniels, Maxim Dubinin, Justin Ferrari, Megan Finaly, Paige Fisher, Jim Ford, Richard Forrest, Dan Gotham, Robert Hathaway, Krista Jensen, Hiroaki Kakizawa, Naomi Kanzaki, Basia Kieska, Shane Krause, Jonathan Lang, Dave Martin, Ikuko Matsumoto, Bente Molenaar, Vladimir Moshkalo, Dylan Myers, Sangmin Nam, Anna Newell, Damon Newell, Daniel Newell, Nicholas Newell, Susan Newell, Keita Nishimura, Yutaka Okamoto, Tokiharu Okazaki, Yuri Onodera, Patricia Ormsby, Len Ottow, Alexander Perepecheko, Jorli Perine, Dave Poritzky, Claes Lykke Ragner, Peter Riggs, Lin Robinson, Tina Rohila, Chris Rusay, Peter Schlesinger, Dmitry Sharkov, Greg Shelton, Eric Shulenberger, Michael Steppler, Tom Stone, Jirou Sugiyama, Yukiko Tomishima, Lisa Tracy, Nathaniel Trumbull, Masanobu Yamane, and Andrei Zakharenkov.

Then, at some remove from the production, were those who know the project only as The Book, demanding all my attention and riding roughshod over relationships—my good friends from Brown, my friends from Tokyo and Seattle, my brothers and sister, my parents, and other loved ones—all of whom I must thank for their forbearance.

Funding

This project would have been impossible without financial support from the W. Alton Jones Foundation between 1993 and 1998, the Pro-Natura Foundation (Hiroshi Okamoto and Kiyoshi Okutomi), the Natural Resources Defense Council (Christopher Paine and Matthew McKinzie), Bob and Ladorna Eichenberg, and Howard and Elinor Smith. A special thanks also goes out to the Urban Ecology program and the Department of Geography, both at the University of Washington, which provided the facilities (office space, computers, printers, scanners, supplies) necessary to write and produce the book.

Contributors

Initials following names are those used in the text to identify otherwise anonymous contributions.

Authors

Sergei E. Abramov, Former Deputy Chairman, Koryakia Committee of Environmental Protection

Dmitry Aksenov, Specialist, Biodiversity Conservation Center (NGO)

Tony Allison, Former Managing Director, Marine Resources Company International

Alexander L. Antonov, Zoologist, Institute of Water and Ecological Problems

Vladimir V. Aramilev, Director, Institute of Sustainable Use of Nature (NGO)

A. Baranov, Former Chief Specialist, Koryak Committee on Environmental Protection

A. N. Belkovsky, Staff, Komandorsky Zapovednik

Yuri I. Bersenev, Protected Areas Specialist, Primorsky Krai Duma

Olga A. Chernyagina, Biologist, Kamchatka Institute of Ecology and Nature Use, Far Eastern Branch of the Russian Academy of Sciences

Yuri A. Darman, Director, World Wildlife Fund–RFE (NGO)

Irina D. Debelaya, Geologist, Institute of Water and Ecological Problems

Roman V. Desyatkin, Researcher, Institute of Biological Problems of the Permafrost Zone

Vladimir Dinets, Freelance Zoologist, Photographer, and Writer

Alexander P. Dobrynin, Forest Ecologist, Botanical Gardens, Far Eastern Branch of the Russian Academy of Sciences

Lyudmila P. Egorova, Staff, Public Ecological Center of Sakha (NGO)

E. V. Ezvekova, Former Staff, Kamchatka Committee on Environmental Protection

Vadim V. Fedorchuk, Head of the Ethnology Department, Sakhalin Regional Museum

Vladimir D. Fedorchuk, Senior Researcher, Sakhalin Museum of Natural History

Nikolai Gerasimov, Ornithologist, Kamchatka Institute of Ecology and Nature Use

David Gordon (DG), Associate Director, Pacific Environment (NGO)

Vasily V. Gorobeiko, Director, Bastak Ecological Initiative Center (NGO)

Vitaly K. Gorokhov, Correspondent Member, International Academy of Environmental Sciences and Life Safety; Expert, EcoJuris Institute

Jessica Graybill, Graduate Fellow in Geography, University of Washington

Melinda Herrold (MH), Graduate Fellow in Environmental Studies, University of California at Berkeley

Gennady V. Illarionov, Former Consultant, Amur Committee on Environmental Protection

Alexander P. Isaev, Head of Forest Ecology Department, Institute of Biological Problems of the Permafrost Zone, Siberian Branch of the Russian Academy of Sciences

E. A. Ivanyushina, Researcher, Kamchatka Institute of Ecology and Nature Use

Lucy Jones, Journalist, Vladivostok News

Misha Jones (MJ), Independent Consultant

Devin Joshi, Graduate Fellow in Political Science, University of Washington

Vladimir P. Karakin, Geographer, Pacific Institute of Geography

Mikhail Karpachevsky, Coordinator of Forests Program, Biodiversity Conservation Center

Alexander King (AK), Lecturer in Anthropology, University of Aberdeen

Andrei K. Klitin, Researcher, Sakhalin Research Institute of Fisheries and Oceanography

Nina G. Klochkova, Researcher, Kamchatka Institute of Ecology and Nature Use

Alexander V. Kondratev, Ornithologist, Institute of Biological Problems of the North

A. Korchmit, Independent Consultant

Vladimir A. Korchmit, Director, Zakrytoe aktsionernoye obshchestvo Vozrozhdenie

Svetlana V. Kramnaya, Botanist, Institute of Water and Ecological Problems

Mikhail A. Krechmar, Biologist, Institute of Biological Problems of the North, Far Eastern Branch of the Russian Academy of Sciences

Maria V. Kryukova, Botanist, Institute of Water and Ecological Problems

Gennady Lazarev, Director, Kamchatka Experimental Forestry Station

Anatoly V. Lebedev, Director, Bureau for Regional Outreach Campaigns (NGO)

Dima Lisitsyn, Director, Sakhalin Environment Watch (NGO)

Maxim Litovka, Researcher, Kaira Club (NGO)

Sergei S. Makeev, Scientist, Sakhalin Fisheries Directorate

Olga Manzhos, Independent Consultant

Sergei V. Maximov, Kamchatka Program Coordinator, Wild Salmon Center (NGO)

Dale G. Miquelle, Wildlife Biologist, Wildlife Conservation Society (NGO), Russian Far East Program

Zoya G. Mirzekhanova, Geologist, Institute of Water and Ecological Problems

Robert S. Moisseev, Director, Kamchatka Institute of Ecology and Nature Use

Vladimir I. Mosolov, Deputy Director of Scientific Research, Kronotsky Zapovednik

Olga A. Murashko, Anthropologist, Institute of Anthropology, Moscow State University

Dmitry Naumkin, Researcher, Kaira Klub (NGO)

E. F. Ogulia, Chief Expert, Kamchatka Forest Service

N. P. Pavlov, Staff, Committee to Save the Vilyui River Basin (NGO)

Dmitry G. Pikunov, Biologist, Pacific Institute of Geography, Far Eastern Branch of the Russian Academy of Sciences

Nikolai G. Pirogov, Senior Researcher, Poronaisky Zapovednik

V. F. Popov, Chief Lecturer, Yakutsk State University

Lyudmila I. Rassokhina, Staff, Kronotsky Zapovednik

T. Reshetenko, Independent Consultant

Bruce Rich, Senior Attorney, Environmental Defense Fund (NGO)

V. S. Rivkin, Center for Monitoring Environmental Pollution, Kamchatka Territorial Directorate on Hydrometeorology and Environmental Monitoring

Sergei A. Rostomov, Independent Consultant

Renat N. Sabirov, Forest Ecologist, Institute of Marine Geology and Geophysics, Far Eastern Branch of the Russian Academy of Sciences

Nadezhda D. Sabirova, Biologist, Institute of Marine Geology and Geophysics, Far Eastern Branch of the Russian Academy of Sciences

Vladimir M. Sapaev, Zoologist, Institute of Water and Ecological Problems, Far Eastern Branch of the Russian Academy of Sciences

Tatiana G. Sapozhnikova, Botanist, Sustainable Ecosystems Institute (NGO)

Nikolai D. Sedelnik, Deputy Head, Department of Forestry of the Republic of Sakha

Olga N. Selivanova, Researcher, Kamchatka Institute of Ecology and Nature Use

Evgeny I. Shirkov, Head of the Laboratory of Ecological and Economic Studies, Kamchatka Institute of Ecology and Nature Use

Svetlana D. Shlotgauer, Botanist, Institute of Water and Ecological Problems

Lyudmila E. Shmatkova, Deputy Minister on Nature Protection, Sakha Ministry of Environmental Protection

Inna F. Shurduk, Senior Researcher, Institute of Biological Problems of the Permafrost Zone, Siberian Branch of the Russian Academy of Sciences

Gennady Smirnov, Chairman, Kaira Club (NGO)

Robert A. Spira, Director, Chapman Spira & Carson LLC

Oleg Svistunov, Former Staff, Friends of the Earth–Japan

Alexander A. Taran, Researcher, Sakhalin Botanical Gardens, Far Eastern Branch of the Russian Academy of Sciences

Jeremy Tasch (JT), Independent Consultant

N. A. Tatarenkova, Researcher, Komandorsky Zapovednik

Peter A. Timofeev, Professor of Permafrost Forestry and Silviculture, Yakutsk State University

Nathaniel Trumbull (NT), Co-Director, Transboundary Environmental Information Agency (NGO)

Sergei I. Vakhrin, Chief Editor, *Severnaya Patsifika* magazine

Boris A. Voronov, Director, Institute of Water and Ecological Problems

Gennady A. Voronov, Biologist, Institute of Marine Geology and Geophysics, Far Eastern Branch of the Russian Academy of Sciences

Emma Wilson (EW), Independent Consultant

Tamara I. Yezhelya, Senior Deputy Prosecutor, Regional Nature Protection Office of the Public Prosecutor

Geoffrey York, Journalist, Toronto Globe and Mail

Mikhail N. Zamosch, Chief of the Laboratory of Disturbed Landscapes, Eastern Scientific Research Institute on Gold and Rare Metals

Vladimir Zykov, Director, Southern Kamchatka Nature Park

Maps

Mike Beltz
Rankin Holmes
Matthew McKinzie
Joe Miller

Dana Morawitz
Josh Newell
Rory Newell
Guirong Zhou

Photography

Hisao Aoki
Mark Brazil
Vladimir Dinets
Natalie B. Fobes
Alexander (A. D.) King
Dima Lisitsyn
Dima Mezentsev
Konstantin Mikhailov
Josh Newell
Eiichiro Noguchi

Yasushi Noguchi
Nikita Ovsyanikov
Alexander Panichev
Jorli Perine
Vladimir Sapaev
Yuri Shibnev
Mikhail Skopets
Hiroki Sugaya
Yukiko Tomishima
Emma Wilson

Translators

Misha Blinnikov
Vladimir Dinets
Herrick Fox
Kirill G. Glushkoff
Serge Glushkoff

Alexander King
Patricia Ormsby
Oleg Svistunov
Emma Wilson

Illustrations

Frank Deserio
Dennis Martin

Josh Newell

Useful terms

Siberia. The name supposedly stems from the Tartar word *sibir*, or sleeping land. To foreigners, the name usually refers to the vast expanse of Russia stretching from the Ural Mountains in the west to the Pacific seacoast in the east. Russians, however, generally consider Siberia's eastern edge to be a series of mountain ranges stretching from western Chita Oblast northward through western Sakha to the Arctic Ocean. Beyond that lies what Russians call *Dalny vostok,* the Far East.

Russian Far East. Geographers disagree on the boundaries of the Russian Far East. Some limit the region to those areas affected by the monsoon climate and Pacific Ocean, i.e., Primorsky, Khabarovsk, JAO, Amur, Magadan, Chukotka, Koryakia, Kamchatka, and Sakhalin. Others define the RFE by its economic ties with the Pacific Rim and include the Republic of Sakha; we have chosen the latter definition herein. The Far East and Zabaikalye Association, a nongovernmental economic group that coordinates interregional programs, also includes the Republic of Buryatia and Chita Oblast.

Basic structure of the Russian government

Russia is a federal state with a republican form of government.[1] With the formation of the Russian Federation in 1991, a loose federation of eighty-nine administrative divisions (see Republic, *Krai, Oblast,* and *Okrug,* below) replaced Russia's formerly unitary structure. In December 1993 a new constitution was adopted by a national vote. The constitution created a two-chamber national legislature: the lower house, or Duma, consists of 450 deputies elected on a territorial basis; the upper house, or Federation Council, consists of 178 deputies, two from each of Russia's eighty-nine administrative regions. Two-thirds of the Duma candidates are elected in a simple majority vote; the remaining third are elected from political party lists (requiring at least 5 percent of the total vote). State officials appoint representatives to the Federation Council. The people elect the president of Russia every five years. The president's role is to establish and maintain the political, legislative, and economic stability of the country. In addition, the president chairs the Security Council, which is responsible for preserving state security and political stability as well as for defending the human rights and liberties of Russia's citizens.

The new constitution gives the president a large amount of direct power. Boris Yeltsin introduced the Presidential Decree in 1992 in order to pass economic and political reforms quickly. Unless used judiciously, this decree can undermine the very institutions that give legitimacy to the state as a democracy. Strangely, the deputies in the Duma authorized the decree, which has served to weaken their power as legislators as well as the power of those in the judicial branch.

The president and his staff are responsible for the functioning of the executive branch, which consists of the Federal Executive Government (formerly the Council of Ministers) and is chaired by the prime minister. Members are from the ministries, the state committees, and other government agencies and commissions. The president nominates the prime minister and the heads of all executive bodies. The legislature (Duma and Federation Council) can approve nominees and demand the resignation of cabinet members; the president has the power to dissolve the legislature and call for new elections. The prime minister oversees the sizeable Executive Administration of the Prime Minister; of his staff, eight deputy prime ministers require legislative and presidential approval. The Executive Administration develops and implements economic reforms and administers programs for each industry.

The Kremlin, the seat of Russia's national government since 1917, sits at the center of Moscow and houses the executive branch, several ministry offices, and the president's primary residence. Russian tsars began building the massive structure—literally a walled fortress encompassing not only government buildings but also Russian Orthodox churches—in the fourteenth century.

Republic, *Krai, Oblast, Okrug*. Administrative divisions (or regions) of the Russian Federation, similar to provinces in Canada. The Russian Federation has twenty-one republics, six *krais,* fifty *oblast*s (one autonomous), ten autonomous *okrug*s, and two federal cities, Moscow and St. Petersburg. Each republic, *krai, oblast,* and *okrug* has its own legislative and executive branch. The local legislature, which consists of an elected body, headed by a chairman, drafts and adopts local laws and regulations. Generally, the governor appoints officials to lead executive agencies, commissions, and committees, although sometimes the local legislature may also do so. In some republics (such as in the Republic of Sakha), an elected president, rather than a governor, governs a council

of ministers, ministries, and agencies that form the executive branch.

Generally, these administrative divisions have less autonomy from the federal government than do the states in the United States. A republic, however, has greater autonomy from Moscow—with, for example, a greater leeway in paying taxes and fees to the capital—than does a *krai*, *oblast*, or *okrug*, and is usually established in a region with a significant non-Russian indigenous population. Furthermore, while all *krai*s and *oblast*s technically have the same status with respect to the federal government, in practice some have more autonomy from Moscow than others, usually because of differences in their historical development. Primorsky and Khabarovsk, for example, maintain strong economic ties with the Pacific Rim; these ties, coupled with their great geographical distance from Moscow, have at times led these administrative regions to behave independently of, or even contrary to, federal directives. Some governors act autonomously, passing laws that do not comply with federal legislation or misallocating federal funds. During the Soviet period, some *krai*s included autonomous *oblast*s created for ethnic minorities. During *perestroika*, most *oblast*s in central Russia became independent from their *krai*s, and many became republics. Specifically established for indigenous peoples, an *okrug* is an administrative subdivision most often under the jurisdiction of an *oblast*; some, however, are relatively free of this jurisdiction. Chukotka Autonomous Okrug, for example, is developing economic ties with Alaska (importing fuel, food, and other essential supplies) and becoming less influenced politically and economically by Magadan Oblast. This is partially because of Chukotka's great geographical distance from the regional capital.

Raion. An administrative subregion of a republic, *krai*, *oblast*, or *okrug*. *Raion* is often translated as *district* and less often as *county*. In this book, *raion* is left untranslated. There are about twenty-five *raion*s in Primorsky Krai, fewer in other regions. Most *raion*s are similar in size to counties in the United States. Large cities may encompass several *raion*s.

This decentralization of power has disadvantages and advantages. The proliferation of new regional and federal legislation leads to laws that often conflict. Similarly, the jurisdictions of city and regional offices are often vague, overlapping, and even contradictory. In addition, some regional officials are both inexperienced and poorly trained, most administrations are operating with inadequate budgets, and corruption within regional administrations remains an intimidating problem. On the other hand, regional administrations have unprecedented power over local governance, resource use and allocation, and future development. Citizens are now able to participate in decision making at the community level.

President Vladimir Putin is trying to increase the centralization of power, an effort strongly resisted by regional officials. He has carved the country into seven federal districts, each headed by a superboss who oversees the governors; the RFE comprises one such district. In addition, Putin wants to give the federal government the right to dissolve regional Dumas (parliaments) if federal rules are broken. The federal and regional power struggle will continue to hinder effective governance.

Ministries, state committees, and agencies

The following list, by no means complete, briefly describes, in alphabetical order, most of the major ministries, committees, councils, and agencies relevant to this book.

Authority on Hydrometeorology and Monitoring of the Environment (Rosgydromet). Rosgydromet collects information on radiation and chemical contamination of the environment to distribute to relevant federal authorities, various branches of industry, defense organizations, and the public.[2] The authority works closely with the Ministry of Internal Affairs and the Russian Space Agency. It is also active in international policy and coordinates with international institutions on such issues as climate change, ozone depletion, environmental pollution, the Arctic, and the global ocean.

Committee on Land Resources and Land Management (Goskomzem). This committee, replaced by the Land Cadastre Service of Russia (Roskomcadaster), was responsible for land reform and developing land taxation. It helped oversee two laws adopted in 1999, On land reform and On farm, that paved the way for Russian citizens to own land. Roskomcadaster has assumed its basic functions and a number of important land-use planning and monitoring responsibilities.[3]

Far Eastern Scientific-Industrial Council. Composed of fishing industry representatives, regional government officials, and members of TINRO (Pacific Institute of Fisheries and Oceanography), Glavrybvod, and the Federal Fisheries Committee, this council meets twice yearly, either in Moscow or in the RFE. The council is essentially a forum for hammering out regional policies and negotiating quota allocations. Because of sharply different positions among administrative regions over quota allocations, this council has lost some status as a unified regional voice for the industry.

Federal Committee on Mining and Industry (Gostekhnadzor). This committee oversees some facets (e.g., occupational safety) of mining, oil, gas, and other hazardous industries.[4] Gostekhnadzor also issues required licenses and permits for all phases of industrial projects, from design to operation.

Federal Energy Commission (FEC). The FEC regulates some components of the energy sector, including electric utilities

and thermal energy (oil, petrochemicals, natural gas) transport and transportation services (e.g., pipelines).[5] The FEC also determines the operating budgets for nuclear plants and Russia's utilities monopoly, United Energy System. Finally, the FEC reviews proposed programs for the developing power sector, and resolves disputes between regional energy commissions, wholesale market customers, and suppliers.

Federal Fisheries Committee. The Fisheries Committee is similar to the U.S. National Marine Fisheries service. The committee develops and implements fisheries policy, coordinates scientific research, grants licenses to fishing fleets, and determines fishing seasons, fishing zones, and fishing grounds. Within the committee administrative structure, but quite independent, is the Federal Research Institute of Fisheries and Oceanography (VNIRO). VNIRO coordinates biological assessments, helps determine fishery quotas, and oversees most scientific research related to fisheries.

Federal Security Service (Federalnaya Sluzhba Bezopasnosti or FSB). Created in 1993 as one of the successors to the KGB, the FSB is Russia's internal intelligence service. Like other similar agencies, the Foreign Intelligence Service (Sluzhba Vneshney Razvedki or SVR) and the Federal Border Service (Federalnaya Pogranichnaya Sluzhba or FBS), the FSB is subordinate only to the Russian president. Like the FSB, the FBS conducts counterintelligence operations, and also battles smuggling, enforces customs regulations, and the illegal harvest and export of natural resources. There are three FBS district headquarters in the RFE, in Khabarovsk (Far East), Vladivostok (Pacific), and Petropavlovsk-Kamchatsky (Northeast). The FBS has recently become an important agency in the battle against illegal fishing. The Northeast FBS, for example, operates about twenty-five ships and forty aircraft, mainly around Petropavlovsk, Provideniya, and Magadan.[6] The ships usually carry an inspector from one of the rybvods (see explanation of Glavrybvod) and make between fifty and one hundred boardings during each patrol. Illegal catches are usually confiscated and then sold. Revenue from fines and confiscated cargo goes to the Federal Fisheries Committee, with a small percentage going to the FBS.

Ministry of Agriculture and Food. This ministry coordinates the agriculture and food processing industries and develops harvest regulations and agrarian and land reforms.[7] The Hunting Administration, a division within the ministry, oversees most of the country's *zakazniks* (wildlife refuges, see below) as well as the hunting industry.

Ministry of Atomic Energy (Minatom). Minatom absorbed all the functions, staff, and assets of its predecessor—the Ministry of Atomic Power and Industry (MAPI), also known as the Nuclear Energy Industry Ministry (1986–1992).[8] Its duties include developing nuclear armaments, overseeing the country's nuclear facilities, and converting military facilities to civilian use.

Ministry of the Economy (Minekonomii). The Ministry of the Economy coordinates state policy to attract foreign investment and coordinates the activities of federal and regional executive bodies in regard to foreign investors. It also organizes international tenders, prepares concession and production-sharing agreements, and organizes credits from international financial organizations (e.g., World Bank, International Monetary Fund).[9]

Ministry of Finance (Minfin). Minfin is responsible for the federal budget, foreign and inherited (from the USSR) external debts, and establishing, regulating, and collecting taxes.[10] Minfin also has jurisdiction over numerous state committees. One such committee is the powerful State Fund for Precious Metals (Gokhran)—formerly the Russian Committee for Precious Metals and Stones (Roskomdragmet)—which oversees the selling and trade of precious metals and gemstones, namely diamonds, platinum, palladium, and gold. Gokhran closely tracks trade in precious metals and gems within Russia, requiring that a percentage of each be offered for sale to Gokhran before being sold domestically or internationally. Another committee is the State Customs Committee (GTK), which advises Minfin on import and export tariffs, and customs regulations.

Ministry of Foreign Economic Relations and Trade. This ministry coordinates and regulates Russian foreign trade and military and technical cooperation with other countries. It works with other federal agencies to pursue a unified trade policy.[11] The ministry has branches in most of Russia's administrative regions. The State Inspectorate on Trade, Product Quality, and Consumer Protection (Gostorginspektsiya) also falls under its jurisdiction.

Ministry of Fuel and Energy (Mintopenergo). One of Russia's most powerful ministries, Mintopenergo manages all facets of federal energy policy (oil, natural gas, coal, and electric). Mintopenergo's responsibilities include: 1) satisfying domestic fuel and energy demands, 2) ensuring foreign economic commitments are honored, 3) balancing federal and regional interests, 4) maintaining existing production and technological relationships, 5) increasing efficient use of natural resources, and 6) helping to create large vertically integrated companies that link upstream and downstream activities.[12] Mintopenergo also represents the federal government's interest in private companies, allowing the government to act as both shareholder and regulator—a clear conflict of interest. The ministry controls energy companies through a variety of means, such as restricting oil export quotas for certain companies.

Ministry of Industry (Minprom). This ministry guides and manages federal policy for science and technology, which includes coordinating the activities of related federal executive agencies.[13] The responsibilities of Minprom include: defining the direction of research and development in Russia, preserving and promoting this scientific and technical potential, adapting science and technology to market economy conditions, guiding federal support for scientific and technological innovation, and marketing high-tech products and services.

Ministry of Internal Affairs (MVD). MVD has had a long, often infamous history in the Soviet Union and in post-Soviet Russia.[14] Its predecessor, the NKVD, operated Stalin's gulags. The NKVD underwent a series of organizational and name changes until 1954, when it became the MVD, and the security police (KGB) were finally separated from the street police. The well-armed MVD has recently been criticized worldwide for its military operations inside Russia, notably in Chechnya. Today, MVD operates Russia's correctional labor institutions, pretrial detention facilities, and prisons. Surprisingly, MVD has increased in size during the post-Soviet era. Officially, MVD has 264,000 staff, but some reports set the figure as high as 800,000. A range of decrees, orders, and instructions—often marked "Secret," and unpublished or publicly unavailable—regulate MVD actions.

Ministry of Natural Resources. On May 17, 2000, Presidential Decree 867 abolished the Russian Federal Forest Service (Rosleskhoz) and the State Committee on Environmental Protection (or Goskomekologia), folding their responsibilities into the Ministry of Natural Resources.[15] Both the forest service and the committee retain regional offices throughout the RFE, which are now under the jurisdiction of the ministry. These offices are referred to in this book with the region's name first, e.g., Khabarovsk Forest Service and Khabarovsk Committee on Environmental Protection. Once Russia's primary regulatory agencies, the forest service and state committee may become less effective in managing resource use under the ministry's jurisdiction. The ministry also actively promotes industrial development and issues licenses to natural resource users. Of particular concern is the effect that the new configuration may have on Russia's environmental impact assessment process, which includes *expertiza* (State Environmental Review or SER) and *ovos* (Assessments of Environmental Impacts).[16] The powerful *expertiza*, mandated by the 1991 Law on Environmental Protection and the 1995 Federal Environmental Review Act, assesses whether a proposed project meets Russian environmental regulations and standards. The *ovos*, created by the former Ministry of Environment, seeks to establish the process for identifying environmental impacts and to obtain different views on the degree of these impacts.

The abolition of the Committee on Environmental Protection continued a decade-old trend in Russia of degrading the status of environmental protection. In 1996, the Yeltsin Administration demoted the Ministry of Environmental Protection to a committee and abolished the Department of Environmental Protection and Use of Natural Resources. Funding has been stripped from most federally targeted environmental programs and, since 1998, there have been two attempts to abolish two other government bodies charged with protecting the environment: the State Committee for Land Policy and the State Committee for the Affairs of the North (see pp. 103–6, for a summary).

Ministry of Transportation (Mintrans). Mintrans is responsible for all facets of Russia's transportation infrastructure (sea, river, air, car, and city—including trolleybuses, buses, trams, and subways).[17] The ministry also works on international transportation issues, such as attracting cargo transit into Russia and developing international transportation corridors.

National Administration of Fishery Enforcement, Resources Restoration, and Fishing Regulation (Glavrybvod). Established in late 1993, Glavrybvod is part of the Federal Fisheries Committee. It regulates the industrial harvest of fish and other marine mammals and plants in Russia's internal waters, on the continental shelf, and in the two-hundred-mile exclusive economic zone. There are six branches of Glavrybvod in the RFE, each responsible for regulating a particular region: Sakhalinrybvod, Primorrybvod, Amurrybvod, Okhotskrybvod, Kamchatrybvod, and Chukotrybvod. Okhotskrybvod, however, lacks the resources to monitor part of its region (the northwestern Bering Sea), so Kamchatrybvod does the monitoring for it and provides some financing and equipment. Primorrybvod, the lead branch, collects information from the other *rybvod*s and relays it to Moscow. Glavrybvod has been widely criticized for failing to regulate exports and punish fishing violations; in 1998 most of the Glavrybvod's enforcement duties were transferred to the FBS, which subsequently hired many Glavrybvod personnel.

Pacific Institute of Fisheries and Oceanography (TINRO). Although TINRO's functions are very similar to those of VNIRO, their relationship is unclear. Officially, TINRO is directly responsible to the Federal Fisheries Committee, not to VNIRO. TINRO's headquarters are in Vladivostok, with closely aligned centers in Khabarovsk (KhFTINRO), Magadan (MagINRO), and Chukotka (ChFTINRO). Two other institutes, SakhNIRO (Sakhalin) and KamchatNIRO (Kamchatka), are also similar in name and function to TINRO, but are essentially independent from it. TINRO operates a research fleet in Vladivostok that has been known, somewhat notoriously, to fish with scientific quotas and then sell the catch for profit.

***Putina* Enforcement Operations.** A joint FBS-Rybvod-Spetsmorinspektsia effort, some of the *Putina* (fishing season) enforcement operations have been quite effective not only

in catching poachers, but also in bringing together the three main enforcement agencies.

Russian Academy of Sciences (RAS). Peter the Great established the Russian Academy of Sciences in St. Petersburg in 1724. The academy confers the highest level of education in Russia and has scientific institutes throughout Russia. The academy has approximately five hundred members and publishes journals in all academic fields (humanities, social sciences, and natural sciences). In the RFE, the Far Eastern Branch of the Russian Academy of Sciences (FEBRAS) includes institutes throughout the region.[18]

Russian Central Bank. The Central Bank of the Russian Federation (Bank of Russia), which is independent of federal, regional, and local government structures, carries out functions set by the Constitution of the Russian Federation (article 75) and the Law on the Central Bank of the Russian Federation (Bank of Russia) (article 22).[19]

Special Marine Inspectorate (Spetsmorinspektsia). Part of the now-defunct Committee on Environmental Protection, Spetsmorinspektsia may no longer be functional. Even when operational, Spetsmorinspektsia is relatively weak, with few vessels and limited staff and funds.

State Committee for Development of the North (Goskomsever). This committee designs and coordinates programs for the vast, resource-rich Russian North and its indigenous peoples. Goskomsever's goals frequently conflict with those of Russia's natural resource commissions and committees.[20]

State Committee for Statistics (Goskomstat). Russia's statistics agency, Goskomstat collects data on topics ranging from industrial production to employment (federal, regional, district, and city) and distributes it to industries, government agencies, and the public.[21] Goskomstat has eighty-nine regional committees and more than twenty-two hundred district (*raion*) departments.

Territorial Fishing Industry Committees. Within each administrative region (*krai, oblast*), these committees coordinate and distribute quota allocations to firms, scientific institutions, and other groups.

Ecological terms

Alas. A geographical phenomenon caused by melting permafrost. Prevalent in central and southern Sakha, *alas* are believed to be remnant vegetation that covered most of Northeast Asia during the last Ice Age. Isolated populations of rooks (*Corvus frugileus*) and other animals common to grasslands live in *alas* ecosystems. *Alas* allowed the Yakut

people to breed horses after migrating from Transbaikalia to present-day Sakha. If disturbed, *alas* often turn into arid barrens or shrublands.

Annual Allowable Cut (AAC). The amount of forest that can be cut in a region without overlogging; determined by each region's Forest Inventory Agency.

Bonitet. An aspect of forest productivity measured on a scale of I through V (I being the highest); *bonitet* is measured by the height that trees reach after a specific number of years. Only an estimate, *bonitet* figures can be manipulated easily to suit bureaucratic needs or policy priorities.

Broadleaved. Deciduous (also called "nemoral" in Europe and "hardwood" in the United States) forests of various tree species, usually characterized by high biodiversity. In the RFE, broadleaved forests occur in the warmest climates, such as southern Primorsky Krai. These forests often look surprisingly similar to the hardwood forests of the Great Smoky Mountains; the two areas share many of the same genera of plants and animals. An unusual type of broadleaved forest is that of the Mongolian oak (*Quercus mongolicus*), which is formed by a dominant tree species and tends to grow in dry areas between forest and grassland zones. The Mongolian oak country of the Amur Basin is not unlike the tallgrass prairies of eastern Kansas.

Eastern Siberian (Angarian), Okhotsk-Kamchatkan, Manchurian, and Dahurian floral and fauna regions. Russian biologists usually track a species to its supposed origin—Eastern Siberian (Angarian), Okhotsk-Kamchatkan, Manchurian, or Dahurian—and classify it accordingly. Grassland species are usually referred to as Dahurian, whereas species common to the RFE's southern broadleaved forests are usually referred to as Manchurian. A wide array of species common to the coastal ecosystem—tallgrass meadows, stone birch, and Ayan spruce forests, for example—are said to form Okhotsk-Kamchatkan flora and fauna. Species of the boreal forests and alpine regions of Eastern Siberia are called Eastern Siberian or Angarian flora and fauna. Although used widely in Russian literature, this classification method is often imprecise. Eastern Siberian fauna, for example, includes species with origins ranging from East Asia (musk deer) to America (Siberian chipmunk) to Central Asia (Siberian ibex) to the Himalayas (rosy finch) and elsewhere.

Forest classification. The Russian Forest Service classifies forests by ecological importance, using three categories to indicate their allowable land use: Group I (highest), Group II, and Group III.

Lesistost. The percentage of a given territory covered by forest. Definitions of *forest* differ slightly between regions:

for example, thickets of dwarf Japanese stone pine may be included or not.

National park (*natsionalnyi park*). A federally protected territory in which small-scale educational, recreational, and cultural activity, as well as scientific research is allowed. These parks are usually split into zones: strictly protected for scientific research, recreational, agricultural, and so on. In actuality, some are actually large suburban recreation areas. Many national parks are adjacent to or near *zapovednik*s.

Natural monument (*pamyatnik prirody*). Usually covering between 100 and 500 ha, this designation protects particular landscape features, such as caves, forests, lakes, waterfalls, and so on. Commercial activity on these territories is prohibited by law. Most administrative regions have dozens of natural monuments, but obtaining a complete list is usually difficult.

Ramsar site. A wetland of international significance, as determined by specific criteria established by the member states of the Ramsar Convention.

Russian *Red Data Book*. The Russian variant of the World Conservation Union (IUCN) listings, the *Red Data Book* lists rare and endangered species of flora and fauna. Russia publishes national and regional *Red Data Book*s; the criteria are similar to those used for compiling the IUCN books. Unlike in the United States, the listing of a species in the *Red Data Book* offers the species no legal protection; however, this listing can be influential in determining where to create a protected area or to limit development.

Small-leaved birch (*Betula*) and aspen (*Populus tremulae, P. davidiana*) forests. These forests are usually secondary and tend to be gradually replaced by other types of forest, most commonly by conifer forests. A notable exception is the park-like forest of stone birch (*B. ermanni*), widespread in areas with a maritime climate. Birches and aspens might also grow in broadleaved forests, but never in pure stands, although they do form isolated groves in the grasslands of the Amur region, which greatly resemble the Canadian prairies.

Territory of traditional nature use (TTP, from the Russian *territoriya traditsionnogo prirodopolzovaniya*). Territories set aside for the traditional subsistence activities of indigenous peoples. The term is often a euphemism for reserves created for indigenous peoples, or even for rural populations in general.

Thermokarst. Erosion due to permafrost. Its surface manifestations (sinkholes, round-shaped lakes) often resemble limestone *karst* formations. Thermokarst occurs naturally in almost all permafrost areas and creates some very unusual landscapes, particularly in places with no forest cover and a markedly continental climate, such as Northern Sakha. If the forest is logged or a settlement built on permafrost, thermokarst erosion may rapidly become catastrophic, with the widespread destruction of soil cover, river pollution from increased runoff, and the collapse of man-made structures. Some Southern Sakha towns look as though they were used for bombing practice, with craters caused by thermokarst erosion marking the streets and plazas.

World Heritage site. A natural or cultural site, these areas are considered to have outstanding physical, biological, or geological features. Threatened plant or animal habitats, scientifically or aesthetically valued areas, and areas set aside simply for conservation can all be nominated as potential World Heritage sites by government members. Nominated sites must be submitted to the World Heritage Center.

Zakaznik. An area set aside for the preservation of smaller ecosystems or individual species. *Zakaznik*s may be protected federally or regionally. Restrictions on commercial activities are sometimes limited to certain seasons. Categories of *zakaznik*s include zoological, botanical, landscape, geological, and others. Many *zakaznik*s have been established in order to regulate commercial hunting so that viable wildlife populations may be maintained.

Zapovednik. A strictly protected federal nature reserve. *Zapovednik*s are established to protect representative areas of a particular landscape or bioregion. In theory, all forms of commercial activity are prohibited; human activity is restricted to scientific research and monitoring. Some *zapovednik*s, however, have small recreational zones; drastic budget cuts have forced many *zapovednik* directors to open the reserves to tourism.

Useful Russian terminology

Russians often use contractions when referring to agencies, companies, or other entities with cumbersome names. Here are some frequently encountered Russian abbreviations and their English equivalents:

- *Dal* — Far Eastern
- *Gos* — State
- *Khoz* — Ownership
- *Kom* — Committee
- *Les* — Forest, timber
- *Min* — Ministry
- *Nedr* — Mining, mineral resources
- *Prom* — Industry, industrial
- *Ryb* — Fish, fishing

Dallesprom. Far Eastern Forestry Department; now a private company.

Goslesfund. State Forest Fund, originally an analogue of the U.S. Bureau of Land Management (BLM).

Gospromkhoz. (GPX) State Enterprise; could be operating in hunting, fishing, logging, or all of the above.

Kolkhoz. The collective farm (*kollektivnoye khozyaistvo*); once the vision of socialist agriculture, in which peasants pooled their land and resources to create large, efficient, cooperative farms. The harvest was requisitioned by the state, which in turn provided the *kolkhoz* with modern agricultural machinery. The *kolkhoz* system remains largely intact in many regions of post-Soviet Russia, despite government efforts since 1992 to aid privatization. The transition to private farming is slow: local officials oppose the disbanding of collective farms and the general populace is wary of change and poorly informed about their rights of land ownership. Similarly, the Soviet farm (*sovkhoz*) is a state-owned farm, still in existence, which operates much like the *kolkhoz*.

Leskhoz. Originally differed from a *lespromkhoz* in that it was responsible for forest management, now many are logging businesses.

Lesnichestvo. Forest Service station, often also the territory serviced by such a station.

Lespromkhoz (LPX). Collective Forestry Enterprise, now usually a private company.

Russians also commonly use abbreviations when writing about the numerous forms of companies allowed under the Russian government. Here are some that frequently appear in this book and their approximate English equivalents:

AO (*aktsionernoye obshchestvo*). A joint-stock (publicly owned) company.

GOK (*gorno-obogatitelniy kombinat*). An ore-enriching combine, generally in charge of individual mining operations, but subject to control from Moscow. This structure is in contrast to the *artel*, an independent mining operation without state support.[22]

JV (*sovmestnoe predpriyatie*). A joint-venture company with international partners.

OAO (*otkrytoe AO*). An open joint-stock company; it is allowed to sell stock publicly and must regularly provide financial data.

OOO (*obshchestvo s ogranichennoi otvetstvennostiyu*). Similar to a U.S. limited liability company: owners have title to a portion of the property, but hold no stock; they become owners by paying into a common fund.[23]

TOO (*tovarishchestvo s ogranichennoi otvetstvennostiyu*). A limited liability company; now defunct.

ZAO (*zakrytoe AO*). A closed joint-stock company; it distributes stock to select shareholders, and shares may be sold only after being offered to current shareholders.

Weights, measures, and currency

The metric system has been used throughout this study.

1 hectare (ha) = 2.5 acres

1 kilometer (km) = 0.6 mile

1 square kilometer (sq. km) = 0.4 square mile

1 cubic meter (cu. m) = 1.3 cubic yards; in the timber industry, approximately 200 board feet

1 kilogram (kg) = 2.2 pounds

1 ton (metric ton) = 1,000 kg or 2,204 pounds

1 centner (Russian) = 100 kg

U.S. $1 = 30.4 rubles (June 16, 2003)

The structure of this book

As this book is a reference guide, information is structured so that readers may go directly to topics of interest, rather than reading straight through. Inevitably there is some repetition of information, particularly in the initial summary pages of each chapter.

The book is divided into eleven chapters. The first chapter, Overview of the Russian Far East, consists of background information on the entire region. Each of the remaining ten chapters deals with an administrative region within the Russian Far East (RFE): Primorsky Krai, Khabarovsk Krai, Jewish Autonomous Oblast, Amur Oblast, Republic of Sakha, Magadan Oblast, Chukotsky Autonomous Okrug (Chukotka), Koryak Autonomous Okrug (Koryakia), Kamchatka Oblast, and Sakhalin Oblast.

All of the chapters are divided into identical sections to simplify comparisons among the regions. These sections are:

Summary pages
Primarily written by non-Russian contributors, these summaries cover the key features of each administrative region and include a reference map. The key features are: location, size, climate, geography and ecology, flora and fauna, key issues and projects, largest cities, population, political status, natural resources, main industries, infrastructure, foreign trade, economic importance in the RFE, and general outlook.

Ecology
In most cases written by Russian specialists, this section is broadly divided into three subsections:
- Basic ecological features (e.g., flora and fauna, forests, wetlands) and prominent environmental stresses.
- Protected area system—a review of the system and brief descriptions of their components: *zapovednik*s (strict nature reserves), *zakaznik*s (wildlife refuges), nature parks, and natural monuments.
- Biodiversity hotspots—background information on the ecological importance of the hotspots, present and future threats, and recommendations for future action.

The color maps 1.7–1.17 (see pp. 13–21) in chapter 1 illustrate the main ecosystems, forests, protected areas, biodiversity hotspots, and basic hydrological features of each of the regions.

Economy
Usually written by Russians specialists, this section outlines the basic economic structure and then focuses on the major industries. Industries of economic importance in the RFE include: fishing, mining, timber, energy, and agriculture. For many of the industries, maps are also provided and, in chapter 1, there are overview maps for most of them.

Toward sustainable development
Russians wrote this section for eight of the eleven chapters. Across the chapters these sections vary in content, as contributors had considerable leeway. Some, for example, see little progress toward sustainable development and their entries are brief, others focus on potential—in chapter 5 Gennady Illarionov outlines different energy development scenarios for Amur Oblast; in chapter 2 Vladimir Aramiliev takes an industry-by-industry approach, weighing each in terms of its development impact, for better or worse.

Indigenous peoples
Largely written by Russians, this section outlines a history of indigenous peoples in the RFE and describes the groups that currently inhabit the various regions, the primary threats to their livelihood, and the responses being made by indigenous associations and collectives in the post-Soviet era. Maps roughly portraying the land of or the land use by the indigenous peoples are provided for most of the chapters.

Legal issues
Russians wrote this section for eight of the eleven chapters. As with that on sustainable development, this section is wide ranging in content. Some contributors deal with current laws and regulations, government environmental management, and natural resource use; others focus on those government institutions responsible for resource management; and still others track trends in government policy on the environment.

Perspective
This section provides offbeat analysis and interest pieces. In chapter 4, for instance, Lucy Jones describes the history of Jewish settlement in the region.

A list of abbreviations, ten appendix tables and lists, and a note on transliteration methodology used for the text are included at the back of the book.

The Russian Far East

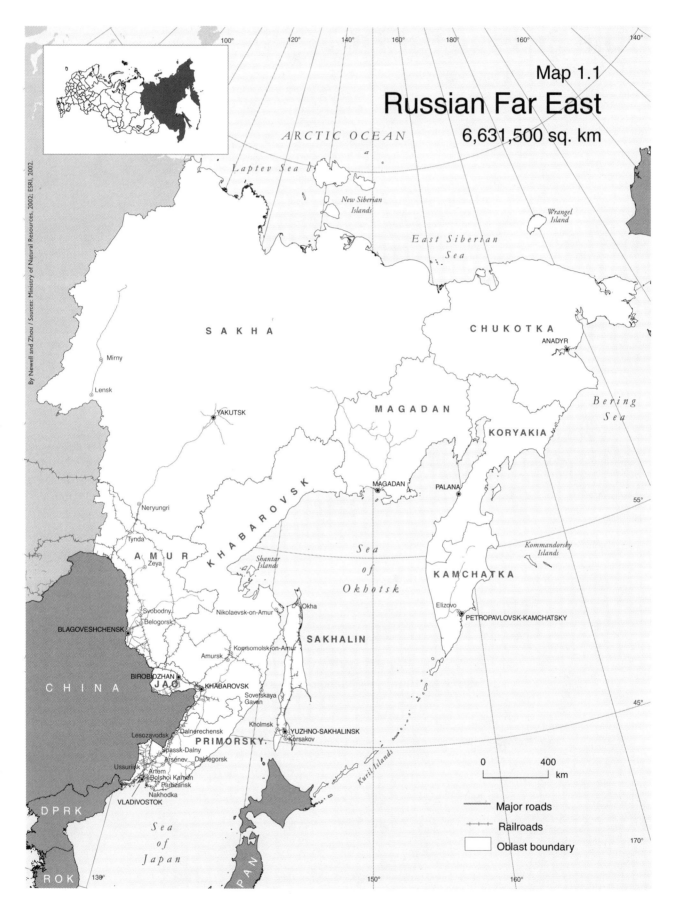

Map 1.1
Russian Far East
6,631,500 sq. km

ARCTIC OCEAN

Laptev Sea

New Siberian Islands

Wrangel Island

East Siberian Sea

SAKHA

CHUKOTKA

ANADYR

Mirny

Lensk

YAKUTSK

MAGADAN

Bering Sea

KORYAKIA

Neryungri

PALANA

MAGADAN

Tynda

Shantar Islands

Sea

Kommandorsky Islands

AMUR

Zeya

KHABAROVSK

of

KAMCHATKA

Svobodny

Belogorsk

Nikolaevsk-on-Amur

Okha

Okhotsk

Elizovo

PETROPAVLOVSK-KAMCHATSKY

BLAGOVESHCHENSK

Amursk

Komsomolsk-on-Amur

SAKHALIN

CHINA

BIROBIDZHAN

JAO

KHABAROVSK

Sovetskaya Gavan

Lesozavodsk

Dalnerechensk

Kholmsk

YUZHNO-SAKHALINSK

Korsakov

Spassk-Dalny

PRIMORSKY

Arsenev

Dalnegorsk

Ussuriisk

Artem

Bolshoi Kamen

Partizansk

Nakhodka

VLADIVOSTOK

DPRK

Sea

of

Japan

JAPAN

Kuril Islands

0 400
km

ROK

— Major roads

+++ Railroads

☐ Oblast boundary

By Newell and Zhou / Sources: Ministry of Natural Resources, 2002; ESRI, 2002.

CHAPTER 1

Overview

Location

The Russian Far East (RFE) comprises the eastern third of the Russian Federation (see map 1.1) and is bordered by China to the south and North Korea to the southeast (see map 1.2, Geographic regions, p. 13). The RFE's Sakhalin Island and Primorsky Krai are less than 50 and 200 km from Japan, respectively. In the far northeast, the narrow Bering Strait separates Chukotka from Alaska. Together, China (north of Shanghai), North and South Korea, Japan, and the RFE form Northeast Asia. Vladivostok, the largest city on the eastern seaboard of the RFE, is more than 9,000 km and seven time zones away from Moscow.

Size

More than two-thirds the size of the United States, the RFE covers 6.63 million sq. km, or 40 percent of the Russian Federation. The Republic of Sakha alone is twice the size of Alaska.

Climate

With frigid winters in northeastern Sakha, the coldest point in the northern hemisphere (−71°C), and sweltering summers along the Amur and Ussuri River basins in the south (40°C), climate zones in the RFE range from arctic to nearly subtropical. Mountain ranges break up these zones into irregular flows as temperate conditions reach far north along the Pacific coast, while subarctic conditions persist on high mountain ridges in the south. The Pacific Ocean and the Sea of Japan bring a monsoon climate to the southern RFE (Primorsky and Khabarovsk Krais, Amur Basin, and southern Sakhalin). Summer is humid in these regions, as monsoon storms blow in from the south. Autumn is dry and warm, with occasional heavy rainfall from typhoons, particularly in Primorsky Krai. Winter is cold and dry because strong air masses flow east from Siberia. Spring is long and cool.

A Siberian, or continental, climate defines the interior of Magadan Oblast and western Amur Oblast, and the entire Republic of Sakha. Summer is short but warm. Winter is long, dry, and very cold. The mountains along the Pacific coastline prohibit the maritime climate from warming the interior. Almost 75 percent of the RFE is dominated by permafrost, or eternally frozen ground, which melts on the surface in summer, providing moisture, but allows for little cultivation of land.

Geography and ecology

Plateaus, mountain ranges, and peaks from about 1,000 to 3,000 m high cover approximately 75 percent of the RFE. The great volcanoes of Kamchatka are still higher with Klyuchevskoi Volcano rising to 4,750 m. Plains cover the remaining 25 percent of the region;

3

the most fertile are located along the Amur River and its main tributaries—the Zeya, Bureya, and Ussuri Rivers. Because these plains are most suitable for growing crops, most people have settled here.

The Arctic Ocean extends along the northern coast to the Bering Strait, which separates the RFE from Alaska. The Pacific Ocean borders the eastern coast down to the Kuril Islands. Tucked away like a pocket, the Sea of Okhotsk, perhaps the richest fishery in the world, is enclosed by the Kuril Islands, northern Japan, and the eastern RFE. The Sea of Japan brings warm ocean currents to the shores of Primorsky Krai and southern Sakhalin.

The vegetation cover follows the same irregular horizontal flows as do the climate zones. Temperate forests reach far into the north, and subarctic vegetation extends south along mountain ridges. Broadly speaking, there are four main vegetation belts:

▨ **Arctic tundra** (patches of moss, sedge, and various grasses) grows in a thin belt along the Arctic Ocean coastline in the far northern regions of Sakha and Chukotka.

▨ **Tundra** grows further south, forming a thin belt in Sakha, but covering most of Chukotka and northern Kamchatka, portions of Magadan Oblast, and mountains farther south. In winter, this region is barren, frigid, and desert-dry. In summer, a dense carpet of gray lichen covers the tundra landscape, forming the food base for animals and migratory birds. In southern tundra zones, dwarf Japanese stone pines (*Pinus pumila*) and Dahurian larch (*Larix gmelini*) grow in unusual horizontal formations, stunted by the wind, shallow soil, and cold, dry climate. Some large trees, mostly larch, grow along the major rivers and are interspersed with poplars (*Populus*), chosenia (*Chosenia arbutifolia*), and willows (*Salix*).

Key issues and projects

Protect wild places

This book describes fifty-eight biodiversity hotspots identified by Russian specialists that should be either protected or developed with ecosystem sustainability as a top concern. Increasing demand for resources and looming land privatization will make such protection more difficult. Russian and international groups need to continue their support of Russia's protected area system and bolster those government agencies responsible for environmental management (see pp. 39–45).

Increase regulatory control over resources

The failure of impoverished and often corrupt government agencies to regulate resource use has led to widespread poaching, destruction of stocks, and disruption of the ecological balance in many areas of the RFE.[1] Illegal trade in endangered species reached peak levels in the 1990s and continues largely unabated.[2]

Increase manufacturing capacity

Exporting raw materials (timber, fish, metals, oil, and gas) to Japan, China, and South Korea, at the expense of developing a manufacturing base, is neither economically nor environmentally sustainable. Increasing the amount of value-added processing would increase revenue both to the regional and federal government and to Russian manufacturers. It would also create more jobs and could reduce pressure to open new areas for resource extraction.

Ensure resource development protects the environment, benefits society, and diversifies the economy

The massive oil-and-gas projects planned (offshore Sakhalin, Siberia-China Yukos pipeline, Siberia-RFE-China Transneft pipeline) will lead to large-scale investment, but benefits to local communities are in no way ensured and, some argue, unlikely. By prioritizing export markets and neglecting domestic markets, while also ignoring the need to convert polluting coal-thermal stations to cleaner natural gas ones, these projects may only exacerbate the RFE's energy crises. Gold-mining projects in Magadan create revenue for government coffers, but they also have a short life span, damage sensitive areas, and may not reduce poverty.

- **Taiga**, the large mass of boreal forest that forms the heart of the RFE, extends as a broad belt between 70 and 50 degrees latitude. Farther south, the forest composition gradually becomes more complex, although tundra can still be found along the mountain ranges. The north is dominated by Dahurian larch forests that grow well on permafrost. In central and southern regions, spruces (*Picea obovata, P. ajanensis*), Korean pine (*Pinus koraensis*), firs (*Abies*), and Scots pine (*P. silvestris*) begin to appear.

- **Conifer-broadleaved** forests grow below the taiga zone along the Sikhote-Alin Mountain Range, which extends along most of Primorsky Krai and into southern Khabarovsk Krai. Russians call these forests the Ussuri Taiga, named after the Ussuri River, which flows northwest from the Sikhote-Alin Mountains and drains into the Amur River. Conifer-broadleaved forests also grow south of the Sikhote-Alin range, just east of the North Korean and Chinese borders. Escaping the last glacial period, the forests in these regions have evolved to become one of the most diverse assemblages of plant and animal species in temperate forests anywhere on the planet.[3] Tree species of the boreal forest thrive here together with temperate and subtropical species such as Korean pine, varieties of maple (*Acer*), birch (*Betula*), fir, and lime (*Tulia*). Southern vines and medicinal plants, such as the famed ginseng (*Panax ginseng*) and eleutherococcus (*Eleutherococcus senticosus*), combine to form an intricate mix of flora. These forests also support the majority of the RFE's rare and endangered species. Similar forests once covered areas of China, Korea, and Japan, but they have largely been destroyed.

Similar mixed forests, composed of a different set of tree species, exist on southernmost Sakhalin Island, Moneron Island, and the Kuril Islands. Farther inland, the southernmost portions of the RFE are covered with broadleaved forests of Mongolian oak (*Quercus mongolicus*), chernozem ('black earth') prairies, and steppes of the Amur Valley. See appendix A for listings of the major topological features in the Russian Far East.

Flora and fauna

The Arctic regions provide habitat for the snowy owl (*Nyctea scandiaca*), arctic fox (*Alopex lagopus*), numerous sandpipers (*Calidris*), eiders (*Somateria*), lemmings (*Lemmus, Dicrostonyx*), reindeer (*Rangifer tarandus*), and many other fauna. Wrangel and Herald Islands in Chukotka boast the highest denning population of polar bears (*Ursus maritimus*), as well as the largest concentrations of walrus (*Odobaenus rosmarus*) and snow geese (*Anser caeruleus*) in the world. Most of the world's population (fifty thousand) of Ross's gulls (*Larus roseus*) nest in the northern RFE. The Republic of Sakha is a major nesting site for the two thousand remaining Siberian cranes (*Grus leucogeranus*).

Kamchatka Peninsula supports the world's largest population of brown bears (*U. arctos*), estimated at 7,500. In its rivers and along its shores are the world's most abundant salmon stocks (including king salmon, which can reach almost 2 m in length), and it is the only place with all six species of Pacific salmon: king (*Onorcynchus tshawytscha*), sockeye (*O. nerka*), coho (*O. kisutch*), pink (*O. gorbuscha*), chum (*O. keta*), and masu (*O. masu*).[4] Scientists estimate that almost half of the wild Pacific salmon can be found in the RFE.[5] Huge populations of northern fur seal (*Callorhinus ursinus*), Steller's sea lion (*Eumetopias jubatus*), and sea otter (*Enhydra lutris*) congregate along the Sea of Okhotsk and Kamchatka coastlines. More than two-thirds of the total seabird population of the former USSR, an

estimated 4.5 million pairs (which includes all remaining Steller's sea eagles [*Haliaeetus pelagicaus*]), breed along the Bering Sea and Sea of Okhotsk coastlines. The taiga forests teem with brown bears, wolves (*Canis lupus*), sable (*Martes zibellina*), squirrels (*Sciurus vulgaris*), lynxes (*Felis lynx*), moose (*Alces alces, A. americanus*), Manchurian wapiti (*Cervus elaphus*), wild boars (*Sus scrofa*), wolverines (*Gulo gulo*), and hundreds of species of birds.

The Amur and Ussuri River basins provide habitat for four of the world's species of cranes. The Ussuri Taiga is home to the

Parides alcinoi *is one of the rarest butterflies in the RFE. Its larvae feed on an endangered plant; adult butterflies have almost been wiped out by commercial collectors.*

Yuri Shibnev

estimated 250–400 remaining Amur, or Siberian, tigers (*Panthera tigris altaica*), the largest cats in the world (see pp. 106–9). Other endangered species sharing this ecosystem include the Himalayan bear (*Ursus thibetanus*), goral (*Nemorhaedus caudatus*), Blackiston's fish-owl (*Ketupa blackistoni*), yellow-throated marten (*Martes flavigula*), Amur cat (*Felis euptilura*), scaly-breasted merganser (*Mergus squamatus*), sika deer (*Cervus nippon*), Mandarin duck (*Aix galericulata*), and endemic Siberian grouse (*Falcipennis falcipennis*). Far Eastern leopards (*Panthera pardus orientalis*), with a population of only about 30, inhabit the Manchurian fir (*Abies holophylla*) forests in the far south of Primorsky Krai. In all, there are more than 2,500 species of vascular plants, almost 100 mammalian species, 400 species of birds, and more than 200 species of butterflies in Primorsky Krai alone.

Largest cities

Vladivostok (pop. 613,100)
Khabarovsk (pop. 617,800)
Komsomolsk-on-Amur (pop. 309,400)
Petropavlovsk-Kamchatsky (pop. 256,000)
Blagoveshchensk (pop. 225,200)
Yakutsk (pop. 194,000)
Nakhodka (pop. 159,800)
Yuzhno-Sakhalinsk (pop. 180,000)
Ussuriisk (pop. 158,400)
Magadan (pop. 115,000)

Population

There are just over 7 million people living in the RFE. Between 1928 and 1959, with the influx of prisoners to the local labor camps, the population grew from about 1.5 million to almost 5 million. Today, with about 1.1 inhabitants per sq. km, it is still one of the world's least populated regions per capita, and much lower than the Russian national average of

Table 1.1
Population of the RFE, 2000

	Total	Persons per sq. km	Percentage living in rural areas	Percentage living in urban areas
Russian Far East	7,098,200	1.1	24%	76%
Primorsky Krai	2,157,700	13.1	22%	78%
Khabarovsk Krai	1,506,700	1.9	19%	81%
Amur Oblast	997,500	2.7	35%	65%
Republic of Sakha	973,800	0.3	36%	64%
Sakhalin Oblast	590,600	6.8	23%	77%
Kamchatka Oblast	378,300	5.3	19%	81%
Magadan Oblast	227,200	0.5	7%	93%
Jewish Autonomous Oblast	197,500	5.5	32%	68%
Chukotka Autonomous Okrug	68,900	0.3	32%	68%
Koryak Autonomous Okrug	28,500	0.1	74%	26%

Note: De facto population figures are used for this table, but in some of the regional chapters de jure figures are used.

Source: Goskomstat, 2001.

8.7 inhabitants per sq. km. As table 1.1 shows, most of the population lives in the southern part of the RFE, particularly Primorsky Krai (2,157,700), Khabarovsk Krai (1,506,700), and Amur Oblast (997,500), where the climate is warmer and the land is more suitable for agriculture. For the last ten years, the population of the RFE has steadily declined partly due to declining birth rates throughout Russia but also to migration back to European Russia, stemming from economic crisis. Population decline has been particularly marked in the northern regions, such as Magadan Oblast and Chukotka. About 76 percent of the RFE's total population is urban. Koryakia, however, remains primarily rural; large settlements of indigenous peoples remain. According to a census done in 1989, there are about 90,000 indigenous peoples in the RFE, and most live in rural areas (see p. 101 for complete statistics).

Political status

Perestroika brought with it a strong movement for greater regional autonomy, in that the Yeltsin administration encouraged decentralization. During this period, the Russian government raised the political status of some RFE regions. Chukotka, Koryakia, and the Jewish Autonomous Oblast (JAO), for example, are no longer parts of other *oblast*s or *krai*s, but are equal members of the Russian Federation. The Republic of Sakha now enjoys more political autonomy than Chechnya ever asked for. Since the dissolution of the USSR, the priorities and character of individual areas within the RFE have become much more diverse, even though the region is often thought of as a unified whole.[6]

In search of greater power, some local governors have routinely blamed Moscow for their problems, eventually creating strong anti-Moscow and even periodic separatist sentiment among the local populace. Primorsky's former governor Evgeny Nazdratenko, for example, defined his political career by defying Moscow's authority and launching allegations of a sellout of the *krai*'s land and resources to the Chinese (see p. 143). Other local governors enjoy much better working relations with Moscow. President Vladimir Putin has tried to reverse the trend toward decentralization.

The RFE currently includes five *oblast*s (one autonomous), two *krai*s, two autonomous *okrug*s, and one republic. Despite different designations, their status is more or less equal, with the exception of the Republic of Sakha. Their degree of autonomy is roughly equivalent to that of the Canadian provinces, with Sakha being comparable to Quebec, or, more accurately, Nunavut.

Natural resources

Decades of large-scale, wasteful extraction, combined with raw materials export reliance, have diminished the RFE's accessible minerals, timber, and other materials.[7] According to forest service estimates, there are over 21 billion cu. m of timber reserves in the RFE, but over half of these are in Sakha, where the trees are primarily larch and too thin to be commercially viable (see appendix B for a listing of the forest resources of the RFE). About forty percent of RFE forests remain inaccessible due to mountainous landscapes and lack of infrastructure; forests near railroads and population centers, however, are heavily overlogged. In addition, forest distribution is uneven, with most timber production in the southern RFE (Khabarovsk and Primorsky Krais, Amur and Sakhalin Oblasts). These southern forests also have many important nontimber forest products (NTFPs) such as mushrooms, pine nuts, ferns, ginseng, and other medicinal plants.

There may be as much as 19 billion tons of coal in RFE reserves (mostly in Sakha). Oil and gas are found mainly on Sakhalin Island and in Sakha, and offshore along most of the RFE coastline. Wind, solar, and geothermal energy reserves also have strong potential. Gold and silver reserves are found mainly in the Magadan, Sakha, Chukotka, Khabarovsk, Amur, and Kamchatka regions. Sakha boasts the world's second largest reserve of diamonds. Most of the RFE's confirmed 4.4 billion tons of iron ore deposits are found in southern Sakha. Koryakia and Khabarovsk regions are emerging as major suppliers of platinum and palladium. Other important metals located in the RFE include tin, antimony, tungsten, mercury, lead, and zinc.[8]

Marine resources are arguably the RFE's greatest resource asset, with fish stocks estimated at 29 million tons. Crab, pollock, and salmon are the most commercially lucrative species. Other important species include herring (*Clupea pallasi*), flatfishes, shrimp, scallops, sea cucumbers, seaweed, and sea urchins (mostly *Strongylocentrotus*). These resources are distributed in the Sea of Okhotsk, in the coastal waters around the northern Kurils, in the Sea of Japan, the Bering Sea, and along the eastern shores of Kamchatka.

Figure 1.1
Industrial production and trade in the RFE

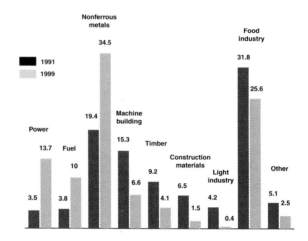

Changes in industrial output
1991 and 1999, by percentage

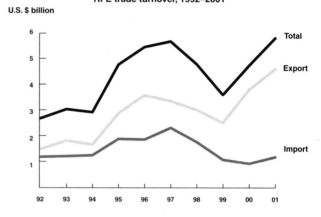

RFE trade turnover, 1992–2001

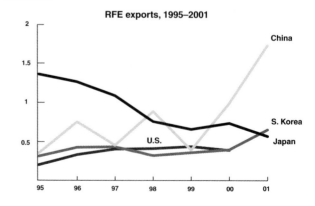

RFE exports, 1995–2001

Sources: Production data from Kontorovich, 2001; Trade data from the Far East and Zabaikalye Association, 2002.

Main industries

Soviet planners developed industries in the RFE primarily to manufacture military equipment and supply raw materials, constructing entire cities (with names such as *Uglegorsk* [coal town] or *Neftegorsk* [oil town]) around the extraction of one or a few resources. During the Soviet era, about half of the RFE's industrial output was related to defense.[9] No longer propped up by federal subsidies and a state-controlled economy, production levels in all of the RFE industries plummeted between 1989 and 1999 before beginning to rebound in 2000. Manufacturing capacity, however, remains at pre-1980 levels.[10] Figure 1.1 shows the increased reliance of the economy on resource extraction and export. In 1991 the major manufacturing sectors (machine building, light industry, etc.) formed a much larger percentage of total industrial production than they do now. Machine building was closely connected to military production. The sharp drop in orders for battleships, Black Shark attack helicopters, and Sukhoi fighter planes has transformed many of the region's thirty-two defense plants into museums of rusting cranes, assembly hangars, and Soviet-era trucks.

Mining (nonferrous metallurgy), food (especially fishing), and power generation are now the RFE's largest industries. Three of the RFE's ten administrative regions (Sakha, Khabarovsk, and Primorsky) combine to produce about two-thirds of the region's Gross Regional Product (GRP).[11]

Infrastructure

Mountainous terrain, severe weather, and low levels of federal capital investment have largely limited infrastructure to the southern RFE, where the two major railroads—the Trans-Siberian and the Baikal-Amur Mainline (BAM)—run parallel to each other in an east-west direction. Most industries have developed along these lines. Spurs connect the two railroads in Amur Oblast and Khabarovsk Krai, and a spur from the BAM reaches southern Sakha, but not as far as the capital, Yakutsk. Sakhalin's railroad, which extends to the island's center, was built by the Japanese when they controlled the island's southern half; this railroad connects to the mainland (through Vanino port) by regular ferry line.

The northern regions have no railroads and few paved roads because permafrost makes construction difficult and expensive. When traveling long distances, people from Sakha, Magadan, and Kamchatka usually travel by air. Rivers are also important for passenger transportation and shipping goods in summer and are used as roads when they freeze over in winter. The major international airports are in Vladivostok and Khabarovsk. Airports in Kamchatka and Sakhalin are expanding. The largest ports in the RFE are Vostochny, Nakhodka, and Vladivostok in Primorsky Krai; Vanino and Sovetskaya-Gavan (Soviet Haven) in Khabarovsk Krai; Kholmsk on Sakhalin Island; and Petropavlovsk-Kamchatsky in Kamchatka.

Existing infrastructure is old, and the Russian government generally lacks funds to maintain it. Many foreign investors, particularly Japanese, believe infrastructure to be the greatest obstacle to more investment. Driven by resource demand in Asia and faced with a growing scarcity of accessible resources, new infrastructure projects are under way throughout the RFE. A federally funded highway under construction from Chita to Nakhodka is opening up Sikhote-Alin forests for logging. The Khabarovsk government and timber companies want to build a road east from the village of Sukpai to the port town of Nelma on the Sea of Japan to reduce the cost of exporting logs to Japan.

Russian policymakers and international associations are promoting the East-West Corridor project to attract financing to upgrade and expand RFE rail, port, and road infrastructure and streamline customs procedures. These upgrades would facilitate resource extraction and enhance the region's role as a transit point for goods from China and Europe. Oil and gas development will spark infrastructure expansion on Sakhalin Island over the next decade as companies expand ports and construct pipelines, plants, and maintenance roads. Oil and gas pipelines (and roads to build and service them) may be built through Khabarovsk, from central Sakha to China, and from Eastern Siberia (Angarsk) across the RFE to Primorsky Krai.

Building the infrastructure required to access fuel and timber resources and transport them to consumers comes with environmental costs. Sakhalin ecologists are concerned oil and gas pipelines and roads will impact salmon rivers and open up new areas of wilderness. The Nelma-Sukpai logging road would bisect the Samarga watershed, a biodiversity hotspot and one of the largest pristine watersheds left in the southern part of the RFE. Biologist Dale Miquelle has documented the negative impacts of road infrastructure on tigers in this region.[12]

Foreign trade

The RFE economy today essentially relies on the export of four primary natural resources: precious metals and gems (gold, silver, platinum, diamonds), marine products (especially king crab, pollock, salmon), raw logs, and fuel (high-quality coking coal and crude oil). These four categories account for about 80 percent of all export earnings.[13] The RFE also exports a limited quantity of manufactured items (machinery, equipment, processed wood products), such as Khabarovsk-built jet fighters to China. Four countries—China, Japan, South Korea, and the United States—together account for about 60 percent of all RFE foreign trade. Trade has more than doubled since 1992 and totaled about U.S.$6 billion in 2001 (see fig. 1.1).

Exports have risen sharply but imports have not, remaining at 1992 levels (U.S.$1 billion). Imports are primarily manufactured goods, because of the RFE's limited manufacturing capacity. An underdeveloped wood-processing industry, for example, makes it necessary to import furniture from places as distant as Finland. The RFE used to rely heavily on imported packaged foods, such as butter from Australia, but Russian food products (many of which are made in European Russia) now line most shelves.

In just the past few years, China has overtaken Japan as the most important trading partner for the RFE. Chinese demand for Russian logs is booming, with 2002 imports more than double Japan's annual log import.[14] But Japan remains the key market for the region's most lucrative export: marine products (although Chinese imports of that resource are climbing rapidly). South Korea, Japan, and China are the primary markets, so far, for tanker shipments of Sakhalin oil. Of the U.S.$578 million in products exported from the RFE to South Korea in 2000, almost 60 percent was crude oil.

Trade statistics underestimate actual trade. Russian customs officials confirm that as much as U.S.$2.5 billion of fish products are exported illegally each year (see p. 58). Official figures of log exports are also dubious, with illegal trade prevalent across the shared, porous border between Russia and China. Much of the Russian-Chinese trade is by barter, which further complicates the export picture. Taking into account unreported fish and timber products, annual RFE exports are closer to $8–9 billion than $6 billion (official figures).

See appendix C for foreign trade by RFE region, and see appendix D for total trade turnover.

Economic importance in the Russian Federation

Although the RFE produces only about 5 percent of Russia's total industrial output, it has a number of resources critical to Russia's economy, including:

- About 75 percent of Russia's fish and marine products
- Virtually all of Russia's diamonds and tin
- About 50 percent of the country's gold
- About 10 percent of all timber production and 30 percent of log exports
- About 25 percent of Russian platinum
- About 14 percent of coal production and 40 percent of the country's total reserves
- Almost 50 percent of all lead
- More than 90 percent of fluorspar
- A growing percentage of Russia's oil and gas exports

General outlook

Despite more than a decade of sweeping privatization and radical political restructuring, the aging and inefficient military-industrial complex built by the Soviets remains largely intact.[15] High energy and transport costs combined with lack of investment have crippled manufacturing and devastated local communities dependent on the industry for jobs and revenue. An erratic energy supply also hinders steady factory production and leaves many people without heat in their homes.

A few areas in the RFE, such as Sakha (with its strategic diamond industry) and Magadan (with its gold industry), retain close economic ties with Moscow, but most of the region survives by supplying raw materials to resource-poor countries in Northeast Asia. The Chinese, Japanese, and South Korean markets now eclipse the region's economic ties to European Russia.[16] Pipelines are being planned to transport crude oil and natural gas across Sakhalin to refineries in Japan and South Korea. Roads are being built to carry Korean pine, larch, and ash logs to sawmills in China and Japan. Coal deposits are being mined to export coking coal to steel factories in Japan. Foreign-built trawlers and drift-netters and refitted U.S. crabbers now ply the seas to harvest pollock, salmon, and king crab to sell to canneries in China, Japan, and the United States. Once a resource colony for the Soviets, today the RFE is essentially a resource colony for the northern Pacific Rim. China, with its rapidly growing natural-resource deficits, is the region's largest trading partner and will have a huge impact on the development patterns of the RFE in the coming decades.

The RFE's present economic reliance on natural resource exports is not the path to sustainable development. Indeed, the region supplies evidence that economies based on extractive industries grow more slowly, fail to employ a significant portion of the population, and may exacerbate poverty.[17] Both the International Monetary Fund (IMF) and the World Bank have urged Russia to diversify its economy by developing domestic manufacturing and noncommodity sectors.[18] Manufacturing would create jobs for the region's unemployed, many of whom resort to poaching and illegal harvesting to secure income.

Investment in manufacturing is unlikely to come from Moscow, which has drastically reduced funding to the region. Government planners and industry representatives in the

RFE continue to hope foreign investors will bring the necessary capital, technology, and know-how. To date, however, foreign direct investment (FDI) in the region has not increased manufacturing. Instead it has increased industry's capacity to extract and export raw materials. Ironically, most foreign investment projects are subsidized and facilitated by international financial institutions such as the World Bank that counsel against such overdependence.

The Russian government meanwhile continues to combat what is perhaps the RFE's most intractable problem: illegal resource harvest. The inability of regulatory agencies to control this problem threatens to wipe out species (such as Korean pine, ash [*Fraxinus*], crab, pollock [*Theragra*], and ginseng) in high demand by Asian markets. This inability also reduces government revenue, discourages domestic and foreign investment, drives down resource prices (making it harder for honest firms to compete), and hinders efforts to certify environmentally responsible firms. Combating illegality has proven particularly formidable because of federal budget constraints, the decentralization of government environmental agencies, and the proliferation of small firms in need of regulation. The greatest obstacle to reform, however, may be corruption in the regulatory agencies themselves. For corrupt officials, bribes and illicit business enterprises are highly lucrative.

Importers and government agencies from China, Japan, and South Korea could assist Russian regulators by requiring chain-of-custody documentation for resources. This would allow certification for businesses practicing legal and sustainable harvesting and export methods. Consumers, in turn, could then demand imports from certified Russian firms. But consumer countries will also have to curb wasteful resource consumption, which may pose the greatest long-term threat to the natural ecosystems of the RFE.

The 1990s witnessed remarkable social change in Russia, with the emergence of nongovernmental organizations (NGOs) and independent media championing causes ranging from human rights to nuclear pollution, and the collaboration of these groups with organizations and individuals across the globe. Indigenous peoples also formed associations to claim legal right to their traditional lands, efforts which have often been resisted by industry and regional governments fearing the loss of access to natural resources. One of the great successes coming out of the 1990s was the creation of new protected areas in many parts of the RFE (the percentage of protected land in the RFE, however, remains low). But the Putin Administration's recent harassment of certain media outlets and NGO leaders in the RFE serves as a reminder that these civil liberties are by no means assured and must be continually championed.

—*Josh Newell*

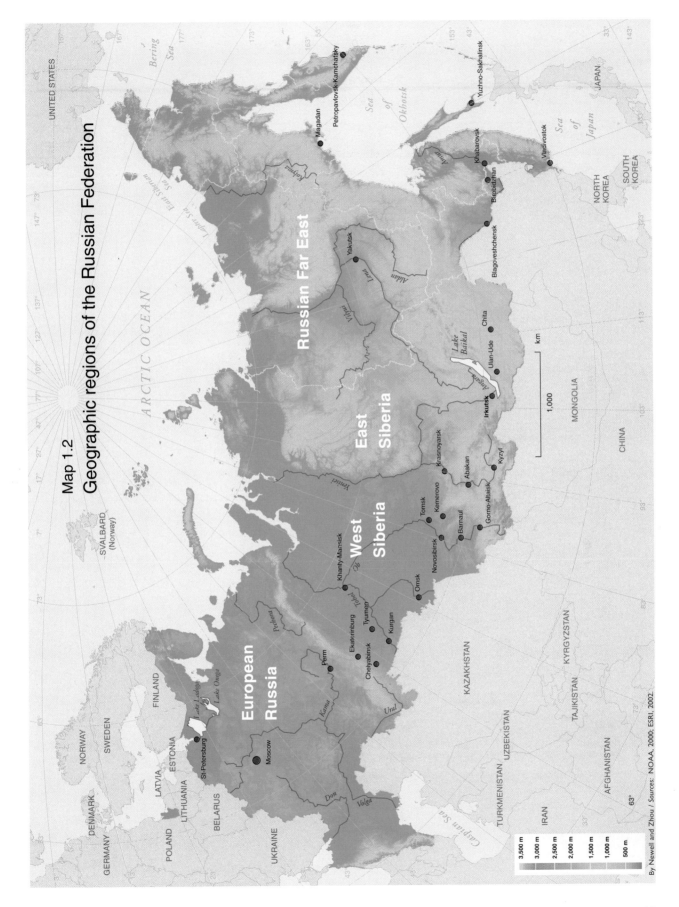

Map 1.2
Geographic regions of the Russian Federation

European Russia

West Siberia

East Siberia

Russian Far East

By Newell and Zhou / *Sources:* NOAA, 2000; ESRI, 2002.

3,500 m
3,000 m
2,500 m
2,000 m
1,500 m
1,000 m
500 m

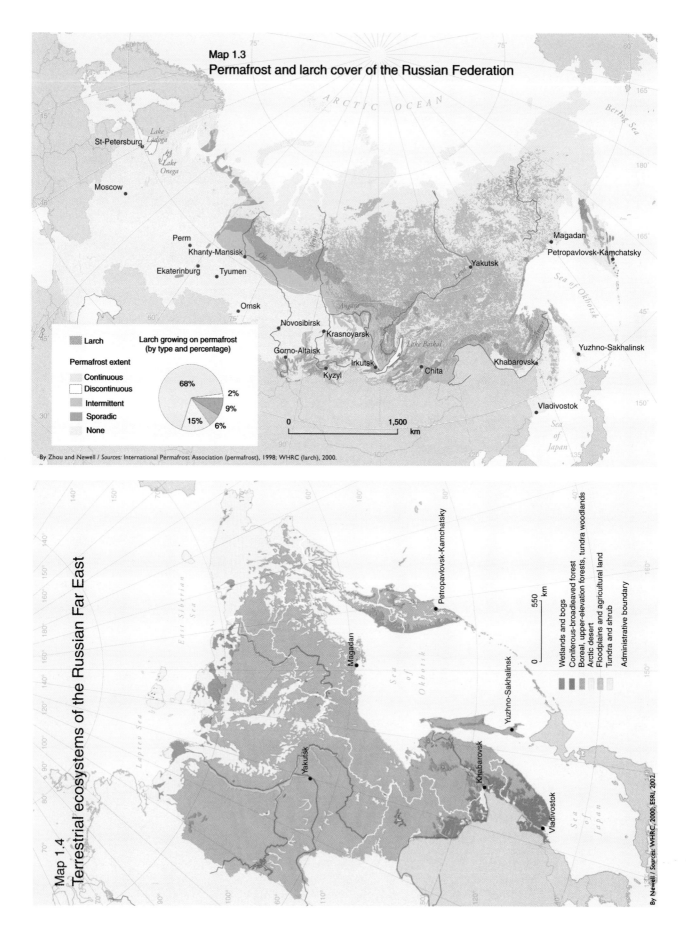

Map 1.3
Permafrost and larch cover of the Russian Federation

Larch

Larch growing on permafrost (by type and percentage)

Permafrost extent

Continuous
Discontinuous
Intermittent
Sporadic
None

68%
2%
9%
6%
15%

By Zhou and Newell / *Sources:* International Permafrost Association (permafrost), 1998; WHRC (larch), 2000.

Map 1.4
Terrestrial ecosystems of the Russian Far East

Wetlands and bogs
Coniferous-broadleaved forest
Boreal, upper-elevation forests, tundra woodlands
Arctic desert
Floodplains and agricultural land
Tundra and shrub

Administrative boundary

By Newell / *Sources:* WHRC, 2000; ESRI, 2002.

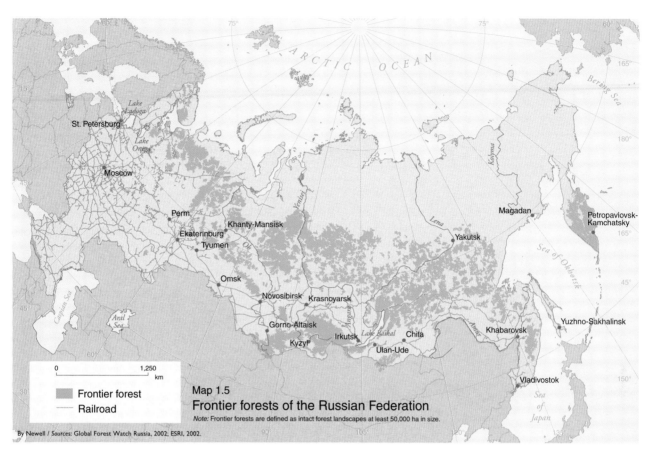

Map 1.5
Frontier forests of the Russian Federation

Note: Frontier forests are defined as intact forest landscapes at least 50,000 ha in size.

By Newell / *Sources:* Global Forest Watch Russia, 2002; ESRI, 2002.

0 1,250
km

◾ Frontier forest
— Railroad

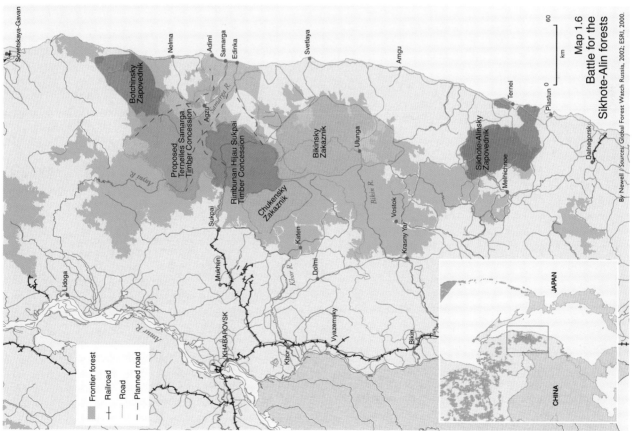

Map 1.6
Battle for the Sikhote-Alin forests

By Newell / *Sources:* Global Forest Watch Russia, 2002; ESRI, 2000.

0 60
km

◾ Frontier forest
† Railroad
— Road
-- Planned road

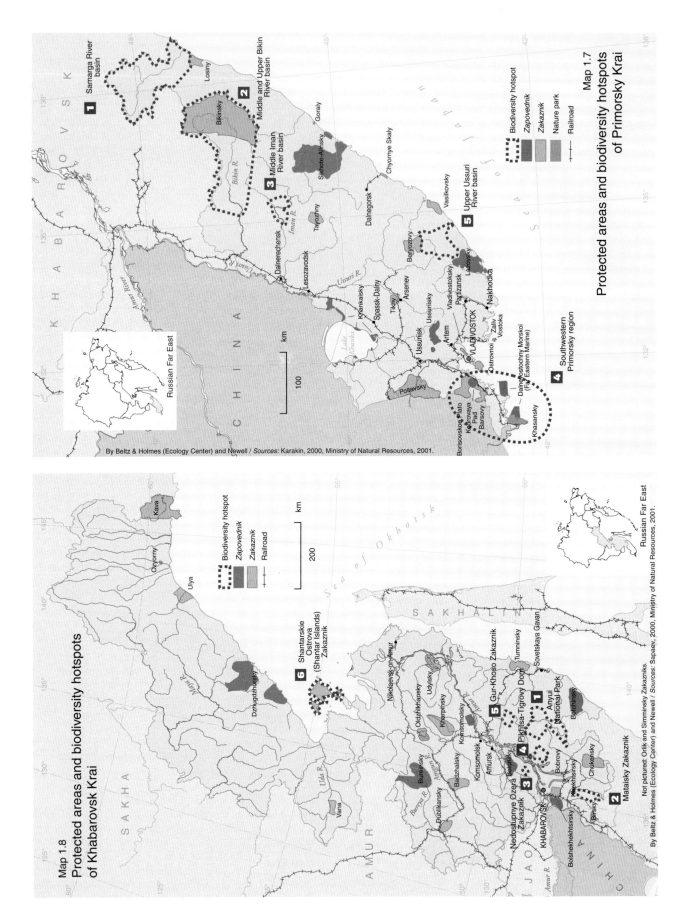

Map 1.7

Protected areas and biodiversity hotspots
of Primorsky Krai

1 Samarga River basin

2 Middle and Upper Bikin River basin

3 Middle Iman River basin

5 Upper Ussuri River basin

4 Southwestern Primorsky region

Biodiversity hotspot
Zapovednik
Zakaznik
Nature park
Railroad

Bikinsky

Losiny

Goraly

Sikhote-Alinsky

Chyornye Skaly

Vasilkovsky

Dalnegorsk

Beryozovy

Lazovsky

Partizansk

Vladivostoksky

Nakhodka

Zaliv Vostoka

Dalnevostochny Morskoi (Far Eastern Marine)

Ostrovnoi

VLADIVOSTOK

Artem

Ussurisk

Ussuriisk

Tikhy

Arsenev

Spassk-Dalny

Khankaisky

Tayozhny

Dalnerechensk

Lesozavodsk

Ussuri R.

Iman R.

Bikin R.

Lake Khanka

Poltavsky

Borisovskoe Plato

Kedrovaya Pad

Barsovy

Khasansky

CHINA

K H A B A R O V S K

Amur River

Russian Far East

km

100

By Beltz & Holmes (Ecology Center) and Newell / *Sources:* Karakin, 2000, Ministry of Natural Resources, 2001.

Map 1.8

Protected areas and biodiversity hotspots
of Khabarovsk Krai

Biodiversity hotspot
Zapovednik
Zakaznik
Railroad

Kava

Ulya

Ozyorny

Dzhugdzhursky

6 Shantarskie Ostrova (Shantar Islands) Zakaznik

Maya R.

Uda R.

Bureinsky

Dubikansky

Vana

Badzhalsky

Bureya R.

Komsomolsky

Amursk

Komsomolsk

Kharpinsky

Oldzhikansky

Udylsky

Nikolaevsk-on-Amur

Amur R.

5 Gur-Khoso Zakaznik

Tumninsky

Sovetskaya Gavan

Anyui National Park

1 Pikhtsa-Tigrovy Dom

Botchinsky

Chukensky

Boytsy

4

Bolonsky

3 Nedostupnye Ozyera Zakaznik

Bobrovy

Nekhtsisirsky

KHABAROVSK

Birsky

2 Mataisky Zakaznik

Bolshekhtsirsky

SAKHALIN

Sea of Okhotsk

Russian Far East

km

200

S A K H A

A M U R

C H I N A

Not pictured: Oriik and Simminsky Zakazniks.
By Beltz & Holmes (Ecology Center) and Newell / *Sources:* Sapaev, 2000, Ministry of Natural Resources, 2001.

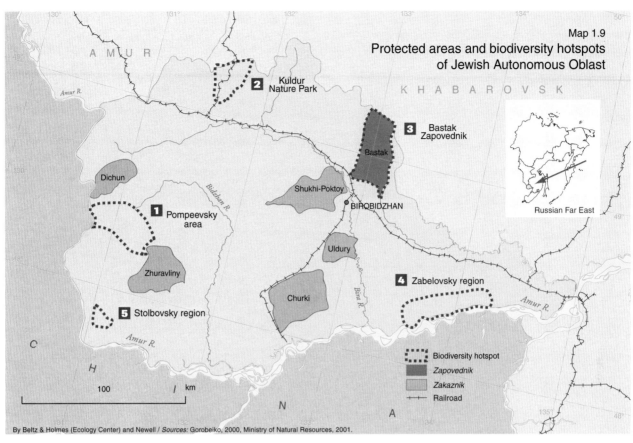

Map 1.9

Protected areas and biodiversity hotspots of Jewish Autonomous Oblast

Russian Far East

Biodiversity hotspot
Zapovednik
Zakaznik
Railroad

By Beltz & Holmes (Ecology Center) and Newell / *Sources:* Gorobeiko, 2000, Ministry of Natural Resources, 2001.

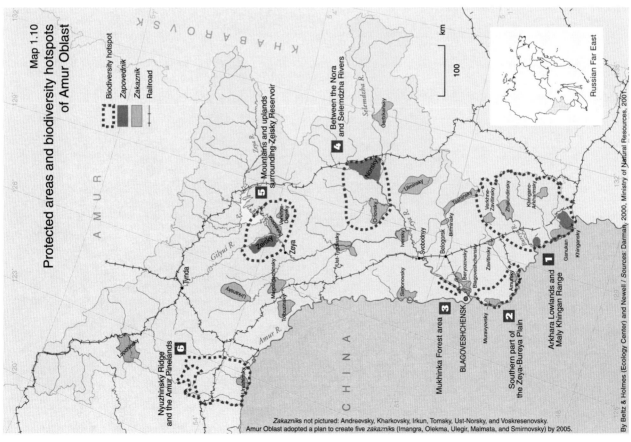

Map 1.10

Protected areas and biodiversity hotspots of Amur Oblast

Russian Far East

Biodiversity hotspot
Zapovednik
Zakaznik
Railroad

*Zakaznik*s not pictured: Andreevsky, Kharkovsky, Irkun, Tomsky, Ust-Norsky, and Voskresenovsky.
Amur Oblast adopted a plan to create five *zakaznik*s (Imangra, Olekma, Ulegir, Malmata, and Smirnovsky) by 2005.

By Beltz & Holmes (Ecology Center) and Newell / *Sources:* Darman, 2000, Ministry of Natural Resources, 2001.

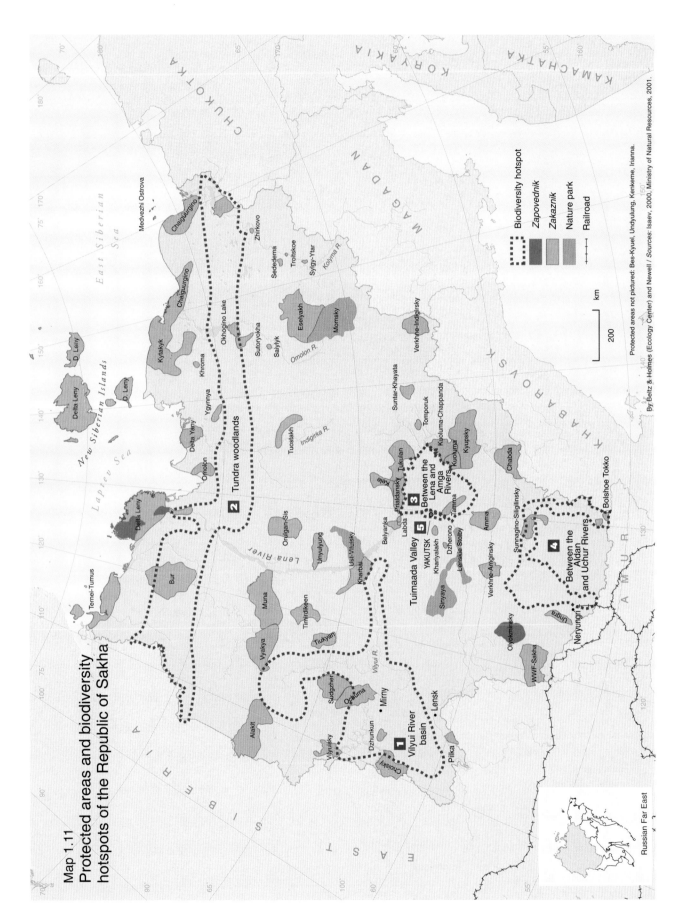

Map 1.11
Protected areas and biodiversity
hotspots of the Republic of Sakha

Legend:
- Biodiversity hotspot
- Zapovednik
- Zakaznik
- Nature park
- Railroad

Protected areas not pictured: Bes-Kyuel, Undyulung, Kenkeme, Iranna. / Sources: Isaev, 2000, Ministry of Natural Resources, 2001.

By Beltz & Holmes (Ecology Center) and Newell

km
200

2 Tundra woodlands

3 Between the Lena and Amga Rivers

5 Tuimaada Valley

4 Between the Aldan and Uchur Rivers

1 Vilyui River basin

Russian Far East

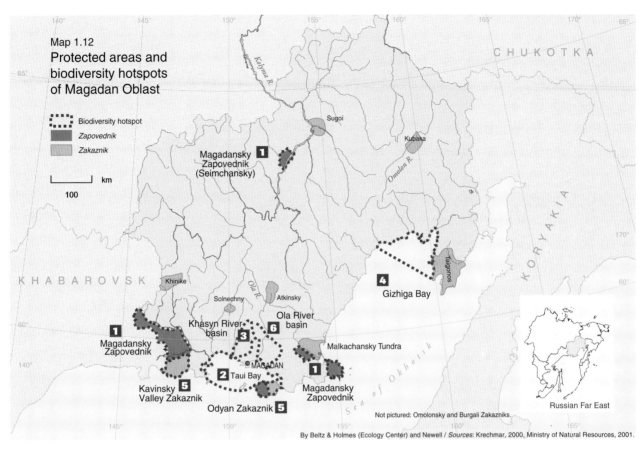

Map 1.12

Protected areas and biodiversity hotspots of Magadan Oblast

Biodiversity hotspot
Zapovednik
Zakaznik

100 km

Magadansky Zapovednik (Seimchansky) **1**

Sugoi

Kubaka

4 Gizhiga Bay

Targonos

KHABAROVSK

Khinike

Solnechny

Atkinsky

Ola R.

1 Magadansky Zapovednik

Khasyn River basin

3 **6** Ola River basin

Malkachansky Tundra

2 Taui Bay • MAGADAN

1 Magadansky Zapovednik

5 Kavinsky Valley Zakaznik

Odyan Zakaznik **5**

Sea of Okhotsk

Not pictured: Omolonsky and Burgali Zakazniks.

Russian Far East

By Beltz & Holmes (Ecology Center) and Newell / *Sources*: Krechmar, 2000, Ministry of Natural Resources, 2001.

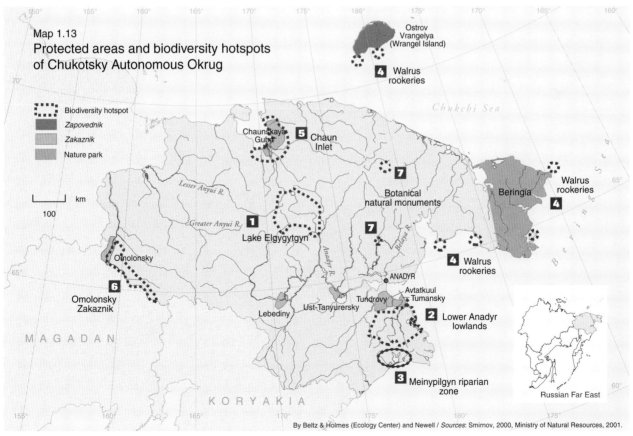

Map 1.13

Protected areas and biodiversity hotspots of Chukotsky Autonomous Okrug

Biodiversity hotspot
Zapovednik
Zakaznik
Nature park

100 km

Ostrov Vrangelya (Wrangel Island)

4 Walrus rookeries

Chukchi Sea

Chaunskaya Guba **5** Chaun Inlet

7

Lesser Anyui R.

Greater Anyui R.

1 Lake Elgygytgyn

Botanical natural monuments

Beringia

Walrus rookeries **4**

Bering Sea

7

Anadyr R.

Belaya R.

4 Walrus rookeries

Omolonsky

6 Omolonsky Zakaznik

ANADYR

Avtatkuul Tumansky

Tundrovy

Lebediny

Ust-Tanyurersky

2 Lower Anadyr lowlands

MAGADAN

3 Meinypilgyn riparian zone

Russian Far East

KORYAKIA

By Beltz & Holmes (Ecology Center) and Newell / *Sources*: Smirnov, 2000, Ministry of Natural Resources, 2001.

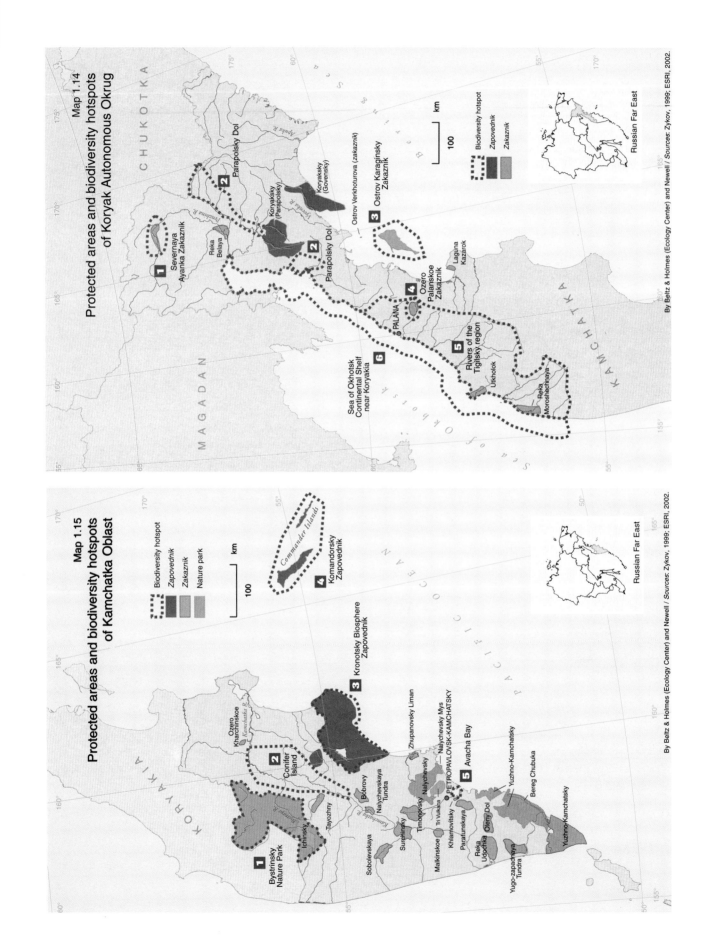

Map 1.14

Protected areas and biodiversity hotspots
of Koryak Autonomous Okrug

Map 1.15

Protected areas and biodiversity hotspots
of Kamchatka Oblast

By Beltz & Holmes (Ecology Center) and Newell / *Sources:* Zykov, 1999; ESRI, 2002.

By Beltz & Holmes (Ecology Center) and Newell / *Sources:* Zykov, 1999; ESRI, 2002.

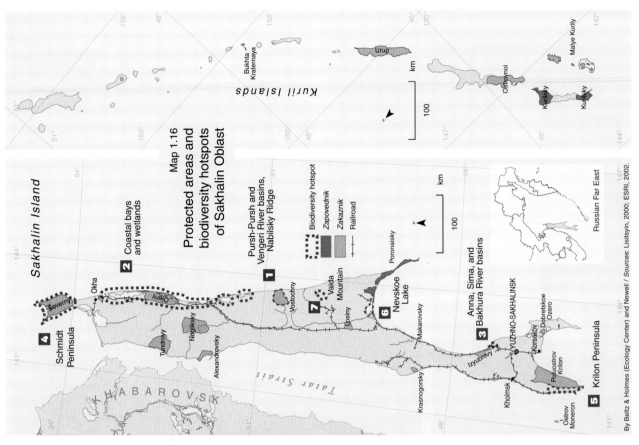

Map 1.16

Protected areas and biodiversity hotspots of Sakhalin Oblast

Sakhalin Island

Kuril Islands

	Biodiversity hotspot
	Zapovednik
	Zakaznik
	Railroad

2 Coastal bays and wetlands

1 Pursh-Pursh and Vengeri River basins, Nabilsky Ridge

3 Anna, Sima, and Bakhura River basins

4 Schmidt Peninsula

5 Krilon Peninsula

6 Nevskoe Lake

7 Vaida Mountain

Russian Far East

By Beltz & Holmes (Ecology Center) and Newell / Sources: Lisitsyin, 2000; ESRI, 2002.

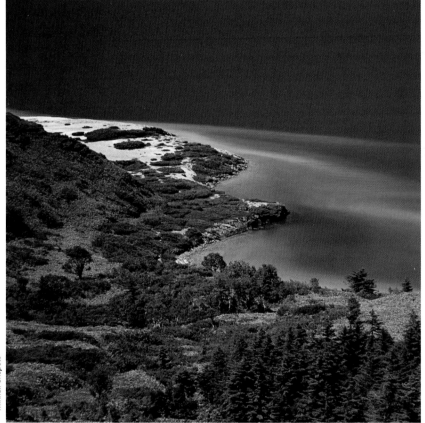

Mikhail Skopets

Natalie B. Fobes

Left: Waters glisten along the coastline of Kunashir, an island in the Kuril chain.

Above: A tram takes people up one of the steep hills surrounding Golden Horn Bay in Vladivostok.

Yasushi Noguchi

Eiichiro Noguchi

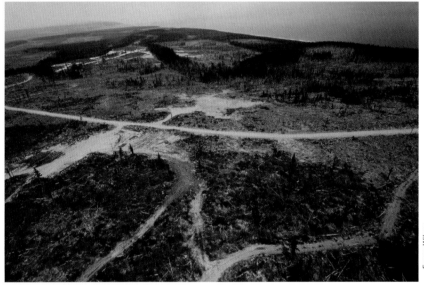

Emma Wilson

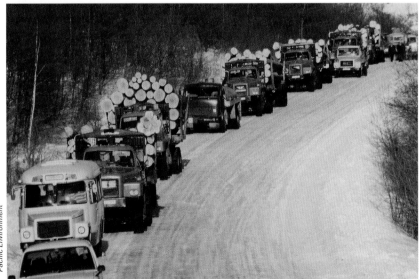

Pacific Environment

Top left: The Bikin River meanders through some of Russia's most biologically diverse forests.

Top right: Russian logs wait for loading trucks in the Japanese port of Niigata.

Middle left: A logging road into Sakhalin's forests.

Above: A clear-cut forest on Sakhalin Island.

Left: Logging trucks line up to unload logs at a port in Primorsky Krai.

Konstantin Mikhailov

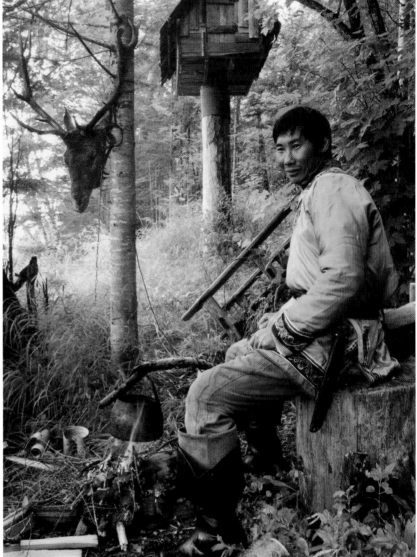

Alexander Panichev

Yuri Shibnev

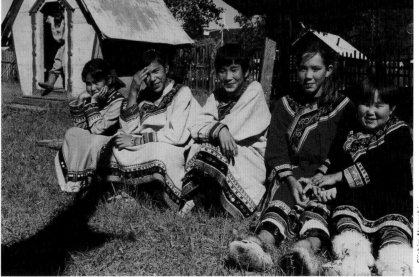

Eiichiro Noguchi

Top left: A lynx cub (Felis lynx) in the forests of Primorsky Krai waits for its mother's return.

Top right: An Udege hunter brews tea at his camp along the bank of the Samarga River. The Udege of northern Primorsky are a community of forest-dwelling hunters and fishers.

Above: The famous Asian ginseng (Panax ginseng), once a common forest plant in the Amur basin, Manchuria, and the Koreas, is on the verge of extinction after centuries of overcollecting.

Right: Udege children dress up in their traditional outfits for a festival in Agzu village in Primorsky's Samarga River basin.

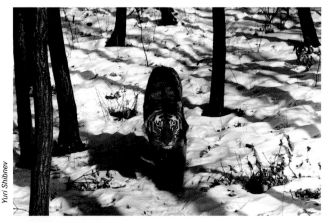

Yuri Shibnev

Yuri Shibnev

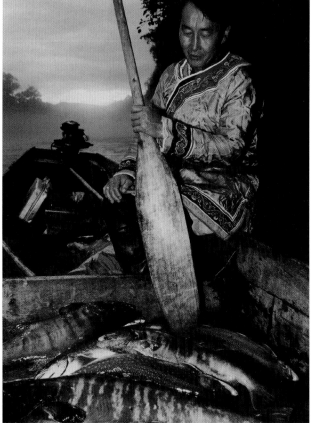

Alexander Panichev

Yuri Shibnev

Yuri Shibnev

Top left: The world's largest cat, the Amur (Siberian) tiger (Panthera tigris altaica) walks a well-trodden path in the snow.

Top right: An Udege fisherman on the Samarga River in Primorsky shows off his salmon catch.

Middle left: The Eastern firebelly toad (Bombina orientalis) is one of many species of flora and fauna threatened since the borders of the former USSR opened.

Above: A Far Eastern Leopard (Panthera pardus orientalis) rests in the Kedrovaya Pad Zapovednik (nature reserve) in Primorsky.

Left: Siberian polecat (Mustela eversmanni). Historians tie conquest of the RFE to the insatiable demand for pelts.

Right: Larch forests in the fall along the Lena River in the Republic of Sakha.

Middle right: The endangered Shlippenbach's Rhododendron (Rhododendron schlippenbachii) grows along the hills just north of the Tumen wetlands in southern Primorsky Krai.

Below: This rare lily (Lilium dahuricum) grows amid the grasses of Sakhalin's Krilon Peninsula.

Bottom right: Among the endangered eco-systems of the RFE are alases, meadows with steppe-like vegetation where flowers such as the Pulsatilla sibirica (pictured) grow in southern Sakha. These relicts of the Ice Age are threatened by agriculture and logging.

Konstantin Mikhailov

Vladimir Dinets

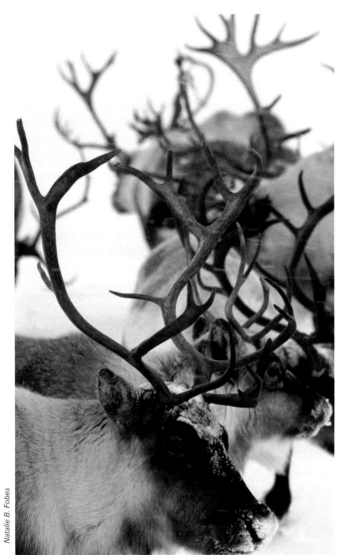

Natalie B. Fobes

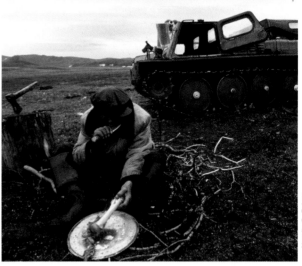

Natalie B. Fobes

Natalie B. Fobes

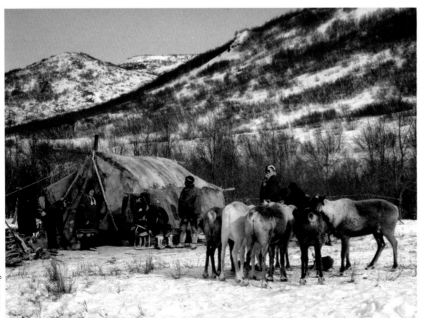

A. D. King

Top left: Reindeer raised by Chukchi herders. The animals are used for food and clothing.

Top right: Chukchi reindeer herders eat boiled reindeer meat on the tundra of the Chukotka Peninsula. Their all-terrain vehicle waits behind them.

Above: A child stays close to his father at a Chukchi reindeer herding camp on the Chukotka Peninsula.

Left: Reindeer herding and meat production minimally impact the environment, but these activities have not attracted the support needed to remain economically viable.

Right: A private fisherman reaches for a small dried fish hanging in his tent at his camp near Magadan.

Below: A Russian fisherman takes time out for a cigarette while off-loading salmon in Poronaisk, Sakhalin.

Middle right: People poach salmon by hand in the Ochepukha River, Sakhalin.

Bottom right: Children play in a Sakhalin Island courtyard littered with waste. Insulation falls from the pipes.

Natalie B. Fobes

Natalie B. Fobes

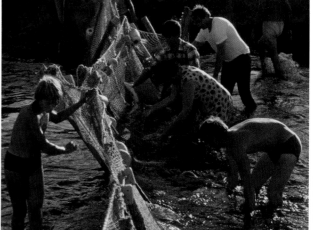

Natalie B. Fobes

Natalie B. Fobes

Mark Brazil

Dima Lisitsyn

Yukiko Tomishima

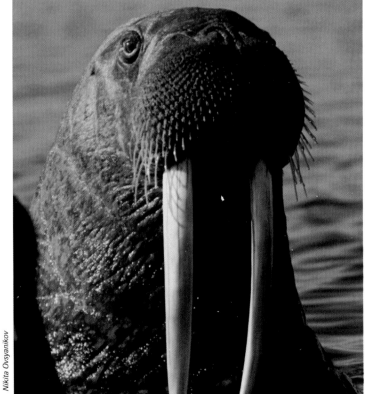

Nikita Ovsyanikov

Top left: The Steller's sea eagle (Haliaeetus pelagicus) *breeds on Kamchatka and along the Sea of Okhotsk coastline; winters are spent mostly in Japan, Primorsky, and Korea. The survival of this majestic raptor depends on the health of salmon stocks.*

Top right: Sakhalin Environment Watch and Greenpeace protest the Sakhalin II project in front of the Molikpaq oil platform.

Above: Vendors sell Kamchatka king crab (Paralithodes kamchatica), *Russia's most lucrative marine export, at a Hokkaido fish market.*

Left: Walruses use their long tusks to anchor themselves to ice floes.

Ecology

Josh Newell and Vladimir Dinets

Researchers and scholars have written extensively on the environmental destruction that occurred under the Soviet Union. Western readers are now familiar with Russia's environmental blights: Chernobyl, oil and gas spills, radioactive waste. While the focus has been on nuclear, air, and water pollution and, somewhat less, on the wanton waste of resources caused by inefficient production, scholars have largely ignored what may be the most significant environmental legacy from the Soviet era, and what is Russia's greatest legacy to the planet: wilderness.[19]

The sheer inefficiency of the Soviet command economy, which caused horrendous destruction and pollution in accessible areas, left vast areas of wilderness intact.[20] The Soviet state lacked both the technology and the capital to build the infrastructure necessary to extract much of its natural resources. Intensive development in the RFE has been limited to urban centers, isolated pockets near strategic mineral and petroleum deposits, and areas along and near railroads.

Russia, more specifically the RFE and Siberia, contains some of the most extensive wild areas remaining on the planet: more than 20 percent of the remaining forests, untouched wetlands, tigers and leopards, pristine beaches, and 20 percent of the world's freshwater in Lake Baikal alone. This wilderness plays a crucial role in mitigating climate change, protecting biological diversity, and generally ensuring ecosystem function, particularly of the polar arctic. The international community and large institutions such as the World Bank have rightfully taken a keen interest in Russian forests not only because of their global importance to the timber supply, but also because of their global environmental significance (see p. 32).

Scientists believe terrestrial ecosystems act as reservoirs for methane gas and carbon dioxide, the atmospheric overabundance of which contributes to global warming. Boreal forests may hold more carbon than other land ecosystems, according to the Intergovernmental Panel on Climate Change (see table 1.2). Oregon State University professors Tatiana Kolchugina and Ted Vinson have estimated that Russia's forests may provide as much as one-seventh of the world's land-based carbon storage.[21]

The health of Russia's northern ecosystems, therefore, has obvious importance for the global climate. Permafrost, or perpetually frozen ground, covers 75 percent of the vast RFE. In some areas permafrost reaches several meters deep in winter. In the dry summer months, the top few meters of permafrost thaw, supplying water and nutrients to trees and vegetation. When winter returns, the top layer freezes again, storing water until the next year. Scientists fear that rising temperatures will melt this permafrost. Normally, plants do not decompose, but rather accumulate, on permafrost. When permafrost becomes swampy, however, organic matter quickly decomposes, releasing trapped methane and CO_2 from the plant matter and soil. Methane is a powerful greenhouse gas with a warming effect ten to twenty times higher than that of CO_2. Logging, mining, and other industrial activity can also disturb this freeze-thaw cycle, either by exposing permafrost to direct sunlight or by melting it during construction or the use of heavy machinery.

In addition to melting permafrost, logging, in particular clear-cutting (where all trees on a given plot are felled), can also release large amounts of CO_2 by transforming carbon-loaded temperate and boreal forests into relatively carbon-poor secondary forests and shrubs.[22] More than 90 percent of logged forests in the RFE are clear-cut, although in the southern RFE they are usually logged selectively. Contrary to popular belief, reforestation does not always put carbon back into storage; managed forest plantations generally hold an estimated one-third to one-half as much carbon as an undisturbed forest.[23] Deforestation is recognized as the second largest emitter of CO_2 after fossil fuel combustion.

Ensuring that mining and logging are environmentally sustainable and setting aside large tracts of Russian forests would help retain CO_2 in the permafrost soil and forests, while simultaneously providing habitat corridors for animals migrating in response to climate changes. Russia, however, seeks to capitalize on its forests by modernizing and expanding its logging industry and exporting its resources abroad.

Table 1.2

Global carbon stocks in vegetation and top 1 m of soils

Biome	Area (10⁶ sq. km)	Carbon stocks (Gigatonnes carbon, 10⁹ tons) Vegetation	Soil	Total
Boreal forests	13.7	88	471	559
Tropical forests	17.6	212	216	428
Tropical savannas	22.5	66	264	330
Temperate grasslands	12.5	9	295	304
Wetlands	3.5	15	225	240
Temperate forests	10.4	59	100	159
Deserts and semideserts	45.5	8	191	199
Croplands	16.0	3	128	131
Tundra	9.5	6	121	127
Total	**151.2**	**466**	**2,011**	**2,477**

Note: Data are derived by the IPCC from the German Advisory Council on Global Change (WBGU), 1998.

Source: Intergovernmental Panel on Climate Change (IPCC), 2000.

Table 1.3
Major environmental issues and problem areas

Region	Issues	Notable problem areas
RFE	Wasteful mining, logging, and fishing methods; outdated equipment; raw material export reliance; absence of waste management and recycling; air and water pollution; fires; reliance on low-grade coal, inadequate energy development; poaching endangered species; illegality in protected areas; lack of government regulation; corruption; melting of permafrost	Industrial belts along major infrastructure lines; areas accessible by road or rail; major river valleys; Sea of Okhotsk, coastal regions along Sea of Japan and Bering Sea; regions along the southern edge of the permafrost zone.
Primorsky	Illegal logging (esp. along river systems) and fishing; poaching endangered species; dumping nuclear waste into the sea; flooding; pesticide use; road construction	Northern Primorsky (logging, gold mining); Primorsky coast (poaching marine species, pollution); Southern Primorsky (poaching, pesticides)
Khabarovsk	Illegal logging and fishing; forest fires; poaching endangered species; river pollution.	Sukpai River basin; Amur valley; Baikal-Amur Mainline (BAM) railroad corridor
JAO	Loss of forest cover; placer gold mining; natural resource export to China	Bira, Sutara, and Pompei Rivers (logging, mining)
Amur	Hydropower development; timber export to China, opening up protected areas to resource exploitation; placer gold mining along river systems; logging Siberian pine, agricultural fires; open-cast coal mining; overfishing and water pollution	Bureya River; Arkharinskaya wetlands; Zeya River basin; Amur River
Sakha	Flooding; forest fires; pollution from diamond and gold mining; logging for local use; planned oil and gas development; melting permafrost	Vilyui River basin; Tuimaada Valley; Yana-Indigirka region; southern Sakha; Lena and Amga River basins; northern subtundra region
Magadan	Gold mining; illegal logging for local use; melting permafrost; planned offshore oil development	Kolyma River basin (mining); Tauy and Gizhinsk Bays (fishing)
Chukotka	Planned floating nuclear power plant; radioactive waste; future oil and gas development; melting of Bering Sea ice; all-terrain vehicles on fragile tundra	Bilibino and Pevek towns; offshore Chukotka; Ichuveyem River basin
Koryakia	Platinum and gold mining; illegal fishing; illegal export of brown bear bladders; sport hunting	Northwestern Sea of Okhotsk shelf (fishing)
Kamchatka	Logging remaining forest stands; possible gold mining; uncontrolled tourism and sport hunting; poaching of brown bears, king crab, and salmon; irrational energy development.	"Conifer Island" (logging, fires); Mutnovsky and Sobolevo regions (energy); protected areas (tourism, hunting, mining); Kamchatka River (poaching, pollution from logged areas)
Sakhalin	Onshore and offshore oil and gas development; wasteful fisheries practices; logging of remaining old-growth forests	Northeastern Sakhalin (oil and gas); Schmidt Peninsula (logging); pockets of forest wilderness (logging)

Sources: Information was summarized by Josh Newell from the regional chapters.

While much of the Russian boreal forest today remains roadless and unlogged largely because of a lack of infrastructure, there is a rising demand from the Japanese plywood industry. Plywood manufacturers are promoting Russian larch as a green alternative to tropical luan timber and have been steadily increasing import levels over the past decade. As map 1.3 (p. 14) shows, however, 98 percent of all Russian larch grows on some form of permafrost (continuous, discontinuous, intermittent, or sporadic), making large-scale logging of the species an unwise proposition.

This review describes the wilderness of the RFE and the measures being taken to protect it. "Ecosystems" describes the region's major ecosystems—tundra, forests, grasslands, wetlands, and marine—and documents those areas that are damaged or newly threatened as a result of economic transition. Map 1.4 (see p. 14) shows the geographic distribution of these terrestrial ecosystems. The section "Protected area system" details Russia's system for protecting wilderness, finding that lack of funds, unclear management structures, and low public awareness threaten reserve management and protection. Despite significant additions to the reserve system in the 1990s, it remains far too small to protect Russia's biodiversity and needs further expansion.

The section "Economy" focuses on the environmental impacts of economic and political transition. Finally, table 1.3 lists major environmental challenges facing the RFE and its ten administrative regions. The regional chapters analyze these challenges in detail.

Ecosystems

Spanning almost 40° latitude, the RFE has hundreds of vegetation types, many unique. Habitat and biological diversity is greater along the coast than inland, where relatively uniform landscapes dominate. The larch forest of the Republic of Sakha, for example, bounded by land on all sides, is the world's largest single-species-dominant plant community.

Upland and mountain tundra. Tundra areas of the RFE, particularly Eastern Chukotka and Wrangel Island, are the world's most diverse arctic ecosystems. Overgrazing by domesticated reindeer, due to mismanaged Soviet-era collective farms and large-scale mining, has degraded large areas of Chukotka tundra. During the 1990s poaching increased, decimating many populations of stone sheep (*Ovis nivicola*), brown bear, and Kamchatkan marmot (*Marmota kamtschatica*). The ecological situation is generally improving, but some areas need urgent protection, such as the coastal tundra of Magadan and Primorsky's mountaintops, home to unique communities of endemic plants, such as Russia's only endemic conifer, microbiota (*Microbiota decussata*).

Forests. The forests of the Russian Federation—the world's largest—comprise 22 percent of the Earth's total forest cover

and more than 57 percent of its coniferous forest cover.[24] In economic terms, this represents 21 percent (82 billion cu. m) of the world's standing timber volume, with a quarter of that total (20.4 billion cu. m) in the RFE alone (see appendixes E and F for data on timber stock).[25] The UN Food and Agricultural Organization (FAO) reports that Russia's forests are actually increasing in area—at a rate of 135,000 ha per year for the 1990–2000 period—and in timber volume. While technically true, the report is misleading; numerous studies show that forest *quality* is declining.[26] Second-growth deciduous forests (aspen [*Populus tremula*], birch [*Betula* spp.], etc.) are replacing mature conifers (spruces [*Picea* spp.], pine [*Pinus* spp.], firs [*Abies* spp.], larch [*Larix* spp.]) in the total forest cover in the RFE, for example, at a rate of about 0.8 percent per year, according to a study by Alexander Sheingauz.[27] A 2001 assessment by the International Institute of Applied Systems Analysis (IIASA) found the stock of "mature and over-mature" forests (essentially conifers) in the RFE decreased from 7.1 billion cu. m in 1961 to just 5.5 billion in 2000 (see fig. 1.2).[28]

In another study aimed at quantifying forest quality, in 2002, a consortium of Russian and international nongovernmental organizations (NGOs), including the World Resources Institute (WRI), published a nationwide assessment (using remote sensing followed by ground-truthing) of Russia's frontier or intact forests—defined as "forests which are relatively undisturbed and big enough to maintain all of their biodiversity, including viable populations of the wide-ranging species associated with each forest type." The study revealed Russia has considerably less frontier forest than that estimated in 1997 (see table 1.4), revising the figure down from 355 million

Figure 1.2
Growing stock of mature and overmature forests in the RFE, 1961–2000

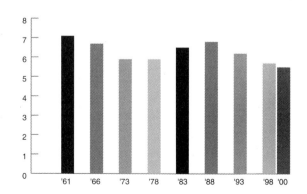

Note: Data are for major species and in exploitable areas (roughly half of the total area).
Source: Nilsson, International Institute of Applied Systems Analysis (IIASA), 2001.

Table 1.4

Countries with the world's remaining frontier forest

Global rank	Country	Frontier forest (000 sq. km)	Share of the world's frontier forest
1	Russia	3,448	26%
2	Canada	3,429	25%
3	Brazil	2,284	17%
4	Peru	540	4%
5	Indonesia	530	4%
6	Venezuela	391	3%
7	Colombia	348	3%
8	United States	307	2%
9	Zaire	292	2%
10	Bolivia	255	2%
11	Papua New Guinea	172	1%
12	Chile	162	1%
The twelve countries as percentage of global total			90%

Note: See text p. 31 for definition of frontier forest.

Source: World Resources Institute (WRI), 1997.

ha to 296.8 million ha, or about 26 percent of Russia's forests (see fig. 1.2).[29] Map 1.5 (see p. 15) shows the extent of Russia's frontier forest. Eastern Siberia and the RFE retained the most frontier forest (112.9 million ha or 39 percent of total forest cover, and 93.7 million ha or 38 percent of total forest cover, respectively), followed by Western Siberia (58.4 million ha, 25 percent of total forest cover), and then European Russia (31.8 million ha, 9 percent of total forest cover). In general, Russia's northern forests were less fragmented than the more commercially valuable (larger trees and denser forests) and more heavily roaded forests in the south.[30] Despite the lower figures, Russia's frontier forests are still among the world's largest and, with the exception of those in Canada, dwarf those found in other northern countries. Logging has reduced old-growth forests in Sweden and Finland to 1–2 percent of their original size, and in Western Europe only about 1 percent of the original forests remain.[31]

There are many underlying causes for the loss of forest quality in Russia: logging, fires, mining, road construction, oil and gas development, clearing for agriculture. The 2002 WRI study identified logging, followed by mineral resource extraction, infrastructure development, and human-induced fires as the major causes. In the RFE, Russian scientists consider logging and fire to be the primary causes. Some studies intertwine these two: attributing waste at logging sites, sparks

from logging machinery, and the carelessness of loggers as the major reasons for fires (see text box on p. 81).

Russia's declining forest quality is of global concern not only for its impact on the planet's long-term timber supply, but also for the crucial role these forests play in mitigating climate change, preserving biological diversity, and maintaining indigenous livelihoods. Awareness of the need for sustainable use of Russia's forests is growing among NGOs, foundations, media, and international financial institutions such as the World Bank, whose 1997 Russian Forest Sector Review succinctly sums up this global issue:

The sheer size of the Siberian and RFE forests and the diversity of their plant and animal life and habitats make these forests a tremendously important environmental factor to Russia and the world. Loss of habitat, mostly from harvesting, fire, disease and inappropriate management is the most serious threat to the unique biodiversity of climax forests. The survival of endangered species, such as the Siberian tiger (*Panthera tigris altaica*), depends on the maintenance of large undisturbed forest areas. Fragile permafrost areas must be recognized as environmentally critical and the forests' large contribution to carbon sequestration must not be jeopardized. Such environmental considerations are currently inadequately incorporated in the planning process or not properly addressed in forest management and harvesting activities. As a general requirement for attending to these environmental concerns, large forested areas must remain undisturbed and forests outside protected areas need appropriate and complementary management.

The unique species assemblages in the Greater Caucasus and the RFE surpass the diversity and endemism found in other more temperate forests. The Amur-Sakhalin Bioregion is particularly significant because much of the region escaped the most recent glaciation period. Consequently, this area became a climatic refuge for many species and communities and has a high amount of plant and invertebrate endemism.

In terms of biological diversity, the Ussuri taiga forests growing along the Sikhote-Alin Mountain Range (Primorsky and Khabarovsk Krais in the southern RFE) are considered the richest in Russia (see map 1.6, p. 15). The World Bank includes these forests, along with the lower Amur River basin and Sakhalin Island, under the term, Amur-Sakhalin Bioregion. Ussuri forests are among the most heavily logged because of their proximity to export markets and the presence of large, commercially valuable trees. Other important forests include:

■ Central Kamchatka conifer forests. Central Kamchatka's larch and spruce forests protect rivers containing among

the world's largest salmon runs, which feed thousands of Kamchatka brown bears. The easternmost taiga forests on the Eurasian continent are on Kamchatka, and locals call the area Conifer Island. In the past thirty years, logging and fires have destroyed more than half of these forests; Conifer Island is one of three identified forest hotspots on Kamchatka (see p. 352). Although logging has declined, the economic crisis paralyzes fire-fighting services and fires are now the main cause of forest destruction.

A hardy plant, stone birch (Betula ermanii) *grows widely in the grass fields of Kamchatka, the Kuril Islands, and along the coast of the Sea of Okhotsk.*

■ Sakhalin Island forests. Heavily logged in the past, patches of Sakhalin old-growth forests remain on this mountainous, biologically diverse island. Brown bears, sable, river otters (*Lutra lutra*), Sakhalin musk deer (*Moschus mosciferus sakhalinensis*), and Siberian grouse all depend on these forests, which also help preserve Sakhalin's salmon rivers.

■ Boreal and subtundra forests of the Republic of Sakha. Conserving Sakha's massive boreal forests is crucial to mitigating climate change. The subarctic forests also prevent tundra from expanding southward, a phenomenon similar to desertification.

■ Amur River basin forests. Heavily logged in the past, the Amur and Jewish Autonomous regions still have valuable pine, larch, and birch forest ecosystems that require protection.

■ Larch forests of Magadan. Magadan larch forests protect soils and regulate the hydrology of the ecosystem. These functions are especially important where forests meet tundra, as the ecosystem in this transition area is particularly fragile. Mining and fires are the primary deforestation threats. Magadansky Zapovednik, which protects large portions of these forests, is a forest hotspot (see pp. 267–68 for an explanation of hotspots)

Grasslands. Grasslands occupy a relatively small area in the RFE. Some are planted, such as those in southern Primorsky, but others are natural and need protection:

■ Small patches of steppe in Amur Oblast support rare plants and isolated subspecies of animals normally occurring further southwest. Some of these animals are now globally endangered, such as the Amur mountain weasel (*Mustela altaica raddei*), Amur polecat (*M. eversmanni amurensis*), Manchurian partridge (*Perdix dauurica shishkini*), and Manchurian bustard (*Otis tarda dybowskii*). These steppes are rapidly being converted for agricultural use.

■ The *alas* meadows of central Sakha are relict patches of steppe-like vegetation supported by melting permafrost. They are fragile and sensitive to microclimate changes.

■ Among the world's most unusual and spectacular grasslands are tallgrass meadows, which exist in particularly humid parts of the RFE. Composed of various grasses reaching 5 m in height, these grasslands provide habitat for brown bears and songbirds. Still widespread on Kamchatka and the Kuril Islands, they are becoming increasingly localized on the Sakhalin and mainland coasts.

Wetlands and freshwater. The RFE has the most important waterfowl and shorebird breeding grounds in Northeast Asia. Habitat destruction and overhunting on wintering grounds are the most pressing threats. A number of lakes and rivers are also polluted and overfished. Dam construction has impacted other areas. To help protect wetlands, the RFE now has nine Ramsar sites, although Russian scientists would like to see more established (see table 1.5). Some of the most important wetlands regions include:

■ Wetland prairies and reed beds of the Amur Basin, including the Ussuri River valley and Lake Khanka. Historically preserved because of their proximity to the Chinese border, these areas are now open to exploitation. These wetlands are crucial for the survival of globally endangered or threatened bird species: red-crowned crane (*Grus japonensis*), white-naped crane (*G. vipio*), swan goose (*Anser cygnoides*), Baer's porchard (*Aythia baeri*), Oriental stork (*Ciconia boyciana*), and reed parrotbill (*Paradoxornis heudei*). Birds breeding further north, such as Siberian crane (*G. leucogeranus*) and hooded crane (*G. monachus*), use these wetlands as migratory stopovers.

Table 1.5
Ramsar sites in the RFE, March 2002

Name	Established	Region	Size (ha)	Location
Parapolsky Dol	1994	Koryakia	1,200,000	62°00'N 166°30'E
Lake Khanka	1976	Primorsky	310,000	44°53'N 132°30'E
Utkholok	1994	Koryakia	220,000	57°40'N 157°11'E
Moroshechnaya River	1994	Koryakia	219,000	56°21'N 156°15'E
Khingano-Arkharinskaya Lowland	1994	Amur	~200,000	49°10'N 130°00'E
Karaginsky Island, Bering Sea	1994	Koryakia	193,597	58°50'N 163°52'E
Lake Udyl and mouths of the Bichi, Bitki, and Pilda Rivers	1994	Khabarovsk	57,600	52°09'N 139°51'E
Lake Bolon and mouths of the Selgon and Simmi Rivers	1994	Khabarovsk	53,800	49°35'N 136°05'E
Zeya-Bureya Plains	1994	Amur	31,600	49°55'N 127°39'E

Source: "List of Wetlands of International Importance," Ramsar Convention Bureau, 2002.

The health of fish populations in the Amur and Ussuri Rivers, including those of rapidly declining species, depends on these wetlands. These rivers also contain endemic freshwater clams and support populations of rare mammals, such as the Amur cat and endemic Evoron vole (*Microtus evoronensis*).

■ The Amur River itself is an ecosystem in peril (see pp. 154–55). It is heavily polluted downstream of major cities, such as Khabarovsk and those in Manchuria. This pollution, combined with overfishing by Russian and Chinese fishermen, has led to population decline of many of the river's 150 fish species. The collapse of salmon runs has impacted communities dependent on this resource. All three of the river's sturgeon species are in catastrophic decline. A large hydroelectric dam and accompanying reservoir has

turned the Zeya River, one of Amur's major tributaries, into a dying river. Another series of dams is being built on the Bureya River (Amur Oblast).

■ Coastal lagoons and lowland tundra of Chukotka, Koryakia, and the coast of the Sea of Okhotsk are prime breeding areas for dozens of bird species, including the endemic spoonbill sandpiper (*Calidris pygmaeus*) and Nordmann's greenshank (*Tringa guttifer*), the world's largest populations of eiders, various geese, the ivory-billed loon (*Gavia adamsii*), the Aleutian tern (*Sterna kamtschatica*), and numerous waders. Particularly important sites include the coast of Chukotka Peninsula, the northeastern wetlands of Sakhalin, and Koryakia's Parapolsky Dol.

■ The Kamchatka River, one of the world's most important salmon spawning areas, is routinely overfished. Large areas of its basin have been logged.

■ The small rivers of Primorsky Krai are critical to the survival of surrounding forests, rare birds nesting alongside them, and endemic mollusks and other aquatic invertebrates. Logging, pesticides from rice fields, and other industrial activities threaten these rivers, in particular Razdolnaya River.

■ Some ancient lakes, particularly Lake Elgygytgyn on Chukotka, have endemic fauna in need of protection.

■ Hot springs are scattered throughout the RFE. Endemic species of microorganisms, algae, plants, and animals live by them—including species not yet documented. Wintering birds use larger hot springs, such as Uzon Caldera in Kamchatka, but they must compete with growing tourism and the tapping of the springs for energy, both of which can damage these fragile ecosystems. A few hot springs are protected as natural monuments.

Marine. Despite decades of overfishing and wasteful, environmentally damaging fishing methods such as the use of driftnets and trawling, the RFE has some of the most biologically productive waters on the planet. Large fisheries remain in the Sea of Okhotsk, the Bering Sea, and around the Kuril Islands. Seabirds and marine mammals depend on these resources. The seas surrounding Chukotka are in the best condition and support the world's largest populations of walrus, polar bear, and other mammals, and provide summer feeding areas for gray and bowhead whales. Major problems facing marine ecosystems of the RFE include:

■ Overexploitation of marine invertebrates and seaweed beds in the Sea of Japan and southern Sea of Okhotsk. The demand for sea urchin eggs, crab, sea cucumbers, shrimp, scallops, mollusks, and other marine products from Japanese and other Asian markets has led to overharvesting. During the 1990s, the populations of numerous species crashed, including the once plentiful populations of sea urchins and sea cucumbers in Primorsky and Southern Sakhalin.

- Protection measures in recent decades have helped restore populations of some marine mammal species, but not all. Scientists do not know why populations of northern right and gray whales in the Sea of Okhotsk are not increasing; illegal whaling in their wintering grounds off Korea and Japan, oil drilling off Sakhalin, and overfishing are possible explanations. Rapid decline of Steller's sea lions has been tied to overfishing of pollock.
- Proposed oil drilling offshore of Sakhalin, Magadan, Kamchatka, and Chukotka poses a threat to arctic coastlines, which are among the world's most fragile ecosystems.

Protected area system

The roots of Russia's protected-area system can be traced back to prerevolutionary nobility, whose members set aside land for hunting reserves. These reserves set temporary restrictions on land use or hunting during breeding season in order to protect important game populations. After the revolution, beginning in 1919, nature reserves (*zapovedniks*) were established, and Vladimir Lenin established a formal statute for *zapovedniks* on September 16, 1921. The *zapovedniks* grew rapidly, particularly in European Russia, and by 1951 more than 128 of these reserves protected over 12 million ha of land. Stalin, however, warped the initial aim of the reserves, changing their purpose from protection and scientific study to providing an "area in which scientists would learn to master and transform nature to serve the needs of the economy." In 1952, citing economic need, Stalin's government dissolved more than 70 percent of the reserves, shrinking their total land area to 1.5 million ha. Over time, many reserves were

reestablished, but not before many were logged, mined, or otherwise degraded. Only in the mid-1980s did the figure again reach 12 million ha, as in 1951.

There are numerous forms of protected areas, each with a different purpose. *Zakazniks* (wildlife refuges) protect more area in Russia than *zapovedniks*, but suffer the reputation of being "paper parks" because of inadequate protection. National parks, first established in 1985, are becoming an important tool in protecting Russia's biodiversity. Other forms of protected areas include natural monuments, regional nature parks, and Territories of Traditional Nature Use (TTPs).

Zapovedniks. *Zapovedniks* were primarily created to protect samples of a particular ecosystem or landscape (steppe, central taiga) and, less frequently, to protect a particular species' breeding or wintering grounds. The most important type of protected area in Russia, *zapovedniks* fall under World Conservation Union (IUCN) Category Ia, the strictest designation possible under this system.

Since the 1970s, a few *zapovedniks* have been designated as World Biosphere Reserves, an initiative set up by the United Nation's Man and the Biosphere program, which aims to establish a worldwide network of biosphere reserves. Such a title usually means greater protection in Russia, and there are two in the RFE: Kronotsky Zapovednik in Kamchatka and Sikhote-Alinsky Zapovednik in Primorsky Krai. Ust-Lensky Zapovednik in the Republic of Sakha is also actively pursuing this status.

Many but not all *zapovedniks* have a permanent scientific research station. Economic activity is strictly forbidden, but due to declining budgets, some *zapovedniks* have opened up to small-scale tourism. Reports of logging, grazing, and other industrial activity on *zapovednik* lands have increased since the disintegration of the Soviet Union. Most *zapovedniks* have a 2 km buffer zone controlled by the regional administration. Hunting and fishing is usually permitted in these areas, but not clear-cut logging or other forms of large-scale natural resource extraction.

Formerly part of the State Committee on Environmental Protection (Goskomekologia), the Nature Reserve Management Division managed most *zapovedniks*, but now they are under the jurisdiction of the State Service for Environmental Protection (part of the Ministry of Natural Resources). There are twenty-three *zapovedniks* in the RFE; three in Primorsky Krai are managed by the Russian Academy of Sciences: Kedrovaya Pad, Ussuriisk, and the Far Eastern Marine.

Konstantin Mikhailov

The endangered Japanese red pine (Pinus densiflora) *grows along the coast of Tilyakovsky Cove, part of Dalnevostochny Morskoi (Far Eastern Marine) Zapovednik in Primorsky Krai.*

The Nature Reserve Management Division was perpetually understaffed and ill equipped to provide a comprehensive management program for the *zapovedniks*. Directors of individual *zapovedniks*, therefore, have incurred increased managerial responsibility and many actively seek international contacts, organize ecotours, and pursue other avenues to secure funding to pay staff and continue research. Usually staffed by forty to eighty people, *zapovedniks* are commonly run by one director and two deputy directors who oversee scientific research and law enforcement.

As of 2001, 101 *zapovedniks* protected 340,000 sq. km, including 65,000 sq. km of marine area. Six of these *zapovedniks*, totalling 41,124 sq. km, including 630 km of marine area, are managed by the Russian Academy of Sciences. The total land area protected under the *zapovednik* system is 1.6 percent of the Russian Federation.[32] These *zapovedniks* are a potent legacy, as they comprise more than 40 percent of the world's strict scientific nature reserves (IUCN Category Ia).

Zapovedniks in some areas are becoming harder to establish, leading government bodies and NGOs to create other, more flexible forms of protected areas.

Zakazniks. *Zakazniks* are created to limit, temporarily or permanently, some forms of economic activity to protect ecosystems or particular species. Restrictions on economic activities are often limited to certain seasons; most *zakazniks* have been established to regulate commercial hunting to preserve wildlife. Categories of *zakazniks* include zoological, botanical, landscape, and geological.

Both federal and regional governments can establish *zakazniks*. There are far more regional *zakazniks* than federal ones, and they form the core of the regional protected-area network. Russia has more than 1,000 regional *zakazniks* that, in principle, protect about 44 million ha. The 69 federal *zakazniks* total 11.5 million ha. About 70 percent of the *zakazniks* protect fauna; 12 percent protect flora.

The two main bodies leasing *zakaznik* land to users are the Ministry of Natural Resources (timber allocations) and the Hunting Administration (hunting licenses). Federal *zakazniks* usually staff rangers to ensure that land users obey restrictions. Unlike *zapovedniks*, *zakazniks* must be renewed every five years; this is problematic for long-term conservation because some are not renewed, or other protected areas are established in their place, effectively transferring administrative duties to an entirely new government agency—a process that can disrupt conservation efforts. They fall under IUCN Category IV.

Natural monuments. Natural monuments (*Pamyatniki prirody*) protect interesting or unique natural or man-made objects. These include lakes, a unique tree or a group of them, waterfalls, caves, bird rookeries, and scenic landscapes. Natural monuments protect small areas, usually between 100 and 500 ha, and therefore cannot protect entire ecosystems.

Some are combined to create a larger protected area such as a *zakaznik* or *zapovednik*, making natural monuments an important conservation tool. They are easier to establish than other protected areas because of their small sizes. As with *zakazniks*, land users are legally responsible for protecting natural monuments. The Ministry of Natural Resources now manages the monuments, but lack of funding often leaves natural monuments without local staff to protect them or even signs to indicate their location. They fall under IUCN Category III.

National parks. Created to protect natural ecosystems and cultural heritage sites, national parks allow for controlled educational, recreational, scientific, and cultural activities. *Zapovedniks* are not designed for tourism—national parks are expected to fill this role. Usually, national parks are divided into zones allowing tourism, some commercial activity, and a core zone forbidding such activities, similar to the national park structure in the United States. Unlike their U.S. counterparts, however, most national parks in Russia do not systematically protect unique geological features or beautiful landscapes, but instead protect representative ecosystems within a bioregion, similar to *zapovedniks*. Most national parks are large and thus important in preserving sizable tracts of land from large-scale industrial activity. Introduced in 1983, national parks are a relatively new form of protection in Russia. Park staffs average about 120 people.

As of 2000, there were 35 national parks in Russia, totalling an area of 7 million ha, or 0.6 percent of Russian territory. No national parks exist in the RFE yet, but there are several plans; the most advanced are for parks in the Primorsky Krai. Most national parks were run by the Federal Forest Service and are now under the jurisdiction of the Ministry of Natural Resources. They fall under IUCN Category II.

Territories of traditional nature use. Territories of traditional nature use (*territorii traditsionnogo prirodopolzovaniya* or TTPs) were created in 1991 to protect the traditional lands of indigenous peoples. There are still no comprehensive rules for such areas in Russia, but regional governments are creating such lands and their importance will increase in the future. TTPs fall under IUCN Category VII.

Nature parks. In March 1995, the government passed a federal law decreeing nature parks (*prirodniye parky*) a new form of protected territory designed to provide recreational areas and protect ecosystems. Unlike national parks, these are regional designations. There are more than thirty such parks in Russia (see p. 123).

Private nature reserves. Russia's first private reserve, Muravyovsky Nature Park, was created in Amur Oblast in 1993. A joint effort between the International Crane Foundation, the Wild Bird Society of Japan, and the Amur branch of

the Socio-Ecological Union (SEU), this 5,000 -ha reserve was leased from the local government after agreement was reached with various land users. It is currently managed by the SEU, a Moscow-based NGO. The park is a Russian model for sustainable development. Rather than prohibit land use, the park gives power to the local community to protect the environment while simultaneously encouraging ecologically benign industry in the region (recreation, ecological tourism, sustainable agriculture).

Restricted forests. Some specialists consider Russia's restricted forests part of the protected area system. The system is divided into three groups (I, II, and III). Group I forests are strictly protected to preserve essential environmental, cultural, scientific, and recreational values. Forests that serve as greenbelts for cities, help mitigate erosion, protect spawning grounds, serve as buffer zones for rivers or other water bodies, or are important seed banks are often classified as Group I forests. Commercial logging is forbidden, but sanitary logging (logging of diseased forests or to reduce fire danger) is often permitted and widely abused by both the Forest Service and timber companies. Group II forests serve both protected and limited industrial functions. Most have already been heavily logged, are usually near major industrial centers, and need to be restored for environmental or industrial reasons. Group III, the largest category, represents those forests theoretically available for commercial logging (see table 1.6).

Table 1.6
Group I, II, and III forests in the RFE

Region	I (%)	II (%)	III (%)
RFE	12.8	1.4	85.8
Kamchatka	29.0	3.2	67.8
Primorsky	26.3	8.4	65.3
Sakhalin	18.8	13.4	67.8
JAO	17.6	17.9	64.5
Khabarovsk	12.5	1.5	86.0
Sakha	12.2	–	87.8
Amur	8.2	6.1	85.7
Magadan	5.1	–	94.9
Chukotka	4.0	–	96.0

Note: Group I – Exploitation largely prohibited
Group II – Limited exploitation permitted
Group III – Commercial logging permitted
Source: Institute of Economic Research, 1998.

International designations. The RFE has two UNESCO World Heritage sites. The first, the Volcanoes of Kamchatka, created in 1996 and expanded in 2001, encompasses more than 4 million ha. The second, Central Sikhote-Alin, was created in 2001 and includes the Sikhote-Alinsky Zapovednik (including a buffer) and Goraly Zakaznik, a total of about 406,000 ha. World Wildlife Fund (WWF) is planning to submit proposals for two more sites, Commander Islands and Kuril Islands. The RFE also has a number of Ramsar sites, mentioned previously. While these designations do not offer legal protection, they do draw attention to the region, bringing in tourists and encouraging the Russian government to ensure continued protection at federal and local levels.

Weaknesses in the system. Budget cuts for all forms of protected areas pose the greatest threat to Russia's reserve system—the world's largest—and to the ecosystems and wildlife it protects. A 1996 study by the World Bank estimated that, in real (constant price) terms, financial support for the reserve system has dropped to less than 20 percent of 1985 levels—leaving at least half of the zapovedniks and one-third of the national parks in a critical state.[33] A 1998 study found that funding for all forms of protected areas dropped by 60–80 percent from 1992 levels.[34]

Many *zakaznik*s have no full-time staff and lack basic infrastructure: some locals living along their edges do not realize they are protected areas. *Zapovednik*s generally have full-time staff, but some have crumbling facilities, no funds for scientific research, and inadequate equipment and fuel to patrol the reserve. Lack of law enforcement, coupled with extreme poverty and the current disregard for laws and regulations in Russia, has led to an escalation of illegal logging, poaching, and mining within reserve boundaries.

Both anecdotal evidence and studies confirm this sad state of affairs. Analysis by scientists at the Institute of Water and Ecological Problems (Khabarovsk) found that Botchinsky Zapovednik, a critical old-growth forest ecosystem for the endangered Siberian tiger, has "no scientific workers, an incomplete ranger staff, and insufficient finances." Further north in Dzhugdzhursky Zapovednik, a huge reserve protecting boreal forest, "there are no staff, scientists, or funds to construct an office or living quarters." The situation is no better in the nearby Jewish Autonomous Oblast, where due to lack of funds and mounting pressure from poaching, the *zakaznik*s no longer function effectively. According to ecologist Gennady Smirnov in Chukotka, "All the protected areas suffer from chronic lack of water and land transport, spare parts, track-lubricating materials, communication equipment, field gear, etc. In effect, the most valuable spots of the Chukotka preserves have been left defenseless."[35]

According to Mikhail Bibikov, former head of Primorsky's now-defunct Committee on Environmental Protection (which was responsible for two of the territory's *zapovednik*s), "Each *zapovednik* in Russia only receives about U.S.$10,000

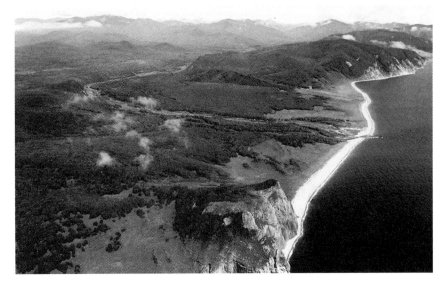

Expansive wilderness near the Samarga River mouth, Primorsky Krai.

annually; this came from the federal budget and the Committee's environmental fund. However, the budget requirements for each *zapovednik* are estimated at $130,000. Most reserve directors can only pay salaries to keep their staff with enough food. Many *zapovednik* directors are raising money on their own, via international fund agencies, scientific exchanges, and from NGO support. The most urgent needs, in my mind, are radios, computers, fire prevention equipment, gas, electricity, [and] salaries for rangers."[36]

Lack of funds has led to squabbling between Moscow and regional governments: the latter complain that money earmarked for the region never arrives, while Moscow complains that money delivered to the regions is not spent properly. Conflicts also arise over whether a proposed reserve should be protected on a federal or regional level, particularly when the area generates revenue or is a magnet for international funding. A primary obstacle to creating the Middle-Ussuri (Sredne-Ussurisky) National Park in Primorsky is resistance from the local *raion* governor, who wants tax revenue generated from future ecotourism to remain in the region. A similar debate rages in Kamchatka where the Forest Service wants to shift jurisdiction of the newly created nature parks from the regional to the federal level. This jockeying between Moscow and the regions complicates the successful administration of protected areas.

A secondary problem facing the reserve system is the conflicting priorities of the government bodies involved in their management; this problem hinders the development of a unified management structure and biodiversity conservation plan. There is generally poor communication between these government bodies. The Russian Academy of Sciences and the Ministry of Natural Resources administer *zapovedniks* and generally prioritize ecosystem conservation and research. The Forest Service manages most of the national parks and allows logging to secure revenue. The Hunting Administra-

tion (part of the Ministry of Agriculture) and Forest Service control most of the federal *zakazniks* and have the legal right to issue hunting permits and logging licenses, respectively. Regional bodies (*krai-* or *raion-*level administrations) usually manage the nature parks. To address this problem, several administrations in the RFE are trying to increase cohesion among the park departments. In the Jewish Autonomous Oblast, for example, the administration adopted a new law, On Specially Protected Nature Territories, and set up an interdepartmental commission to improve management and development.

The protected area system remains poorly understood by the Russian public. In Soviet times, *zapovedniks* were for scientific research, not tourism. Many citizens still consider them reserves for the scientific elite and resent the loss of land for commercial use. There was no form of protected area allowing recreational use until the Soviet government created the national park system in 1983. The park system, however, has been slow to expand (there are still no national parks in the RFE). To broaden support, the government and NGOs are developing new forms of protected areas: TTPs for indigenous people, private parks, and regional national parks. The public, however, generally resists the concept of a designated area for activities such as relaxing, picking mushrooms, and fishing: Most Russians see the taiga as a common resource.

Inadequate coverage. A rapidly growing number of scientists and conservationists realize the current reserve system fails to adequately protect Russia's biodiversity and ecosystems. A World Bank study called for large-scale expansion: "If Russia's protected area network is to provide adequate protection for biodiversity, the system will require significant additions. Effective action must be taken in the next few years to conserve large, unprotected wilderness areas that are not yet sufficiently represented in the protected area network."[37] A global study of protected forests by the World Conservation Monitoring Centre (WCMC) in 1997 found that Russia's forests were the least protected, with just 1.9 percent of the country's forests protected. This contrasts with the protection of 18.8 percent of the forests in North America, where many forests are similar to those in Russia. But calculations for Russia appear to exclude regional *zakazniks* and nature parks, which would have raised the percentage of protected forests considerably. Nonetheless, the percentage of protected forests would still be lower than the current global average of 8 percent and too low to protect Russia's biological diversity. The WCMC highlighted the need to conserve Russia's boreal forests

because of the huge areas of forest necessary to "support viable populations of the large carnivores found there."[38] Much of the boreal forest is indeed intact, with portions inaccessible to industrial development due to the lack of infrastructure. The Russian government, therefore, has a fleeting opportunity to protect these natural resources before development pressures increase.

Reaching a target percentage, however, does not guarantee an effective protected area system. An impressive 20 percent of Kamchatka is protected, for example, but much of that area—the upper elevations of the peninsula's volcanoes—consists of rocks and ice. Kamchatka's most important conifer forests, essential to flood control and ensuring healthy salmon runs, on the other hand, remain largely unprotected. Although the protected area system covers 9 percent of the Jewish Autonomous Oblast, researchers found that two ecosystems within the *oblast*, the Amur lowlands and Dahurian steppe, are virtually unprotected.

Scientists at the Institute of Water and Ecological Problems took a species rather than an ecosystem approach to assess the effectiveness of Khabarovsk Krai's protected area system. Although the reserve system covers about 6 percent of Khabarovsk, within the boundaries of these protected areas, 55 percent of the 212 rare species of vascular plants (IUCN categories I–III) and 36 percent of the 50 species of vertebrate land animals listed in the *Red Data Book*s of the IUCN, USSR, and Russian Federation were left completely unprotected (see p. 155). An effective protection system depends not only on the amount of area covered or the ecosystems represented, but also on the species represented.

Conclusion. Despite inadequate funding and structural flaws, the Russian reserve system expanded remarkably in the 1990s. Driven by fear that land would be privatized, this expansion is often seen as one of the environmental successes of that decade. New forms of protected areas have been developed, particularly on the regional level, giving both governments and NGOs the flexibility necessary to further expand the system. International NGOs, charitable foundations, UN agencies, and agencies of foreign governments have played a key role in providing financing and equipment for several of the most important existing reserves and for the creation of new ones. Nonetheless, the biggest obstacle to the system's effectiveness remains lack of financing: Funds are not sufficient to pay reserve rangers properly, to purchase and fix transport equipment, or to purchase gasoline. Due to their inability to patrol reserve boundaries, illegal logging, mining, and poaching proliferate. Scientific research and monitoring programs continue to be curtailed. Meanwhile, conflicting priorities among government agencies managing the reserves continue to prevent a unified and strong protection system. Resolving these problems is critical not only to protect existing reserves, but also to provide the foundation necessary for continued expansion of Russia's protected area system.

Biodiversity hotspots

Josh Newell

Concern that key wilderness areas in the RFE were both unprotected and largely unknown to decision makers both in Russia and in the international community led Friends of the Earth–Japan (FoE–J) to initiate the RFE Biodiversity Hotspot Study in Spring 1994. Russian scientists, government officials, and NGOs from all ten administrative regions were brought together to identify threatened areas in the forest, wetland, tundra, and arctic ecosystems, thereby establishing hotspots: areas of great ecological importance requiring urgent support. The first conference, assisted by the Botanical Gardens of the Russian Academy of Sciences, was organized in January 1995 in Vladivostok. Consulting with Russian scientists and planners, FoE–J identified scientific criteria and developed a stakeholder-based process to select these hotspots (see text box below).

In total, fifty-two hotspots were identified and described at the 1995 Vladivostok Conference. Since that first conference, FoE–J has worked steadily with Russian NGOs and the government to create new protected territories such as Vostochny Zakaznik in Sakhalin and the Shufan Plateau Zakzaznik in Primorsky.

In 1997, FoE–J joined forces with the World Conservation Union (IUCN) to complete another Biodiversity Hotspot Study. This second study was a larger endeavor and the procedure for identifying the hotspots was refined. Using the same criteria, regional roundtables in each of the ten administrative regions of the RFE were held over a twelve-month period in 1997–1998. At these roundtables, representatives from regional administrations, nature protection agencies, scientific institutes, industry, and NGOs identified and agreed on five to seven priority territories (hotspots) for biodiversity conservation in each region.

Criteria to determine the biodiversity hotspots

1. Presence of rare and endangered or endemic plant and animal species.

2. Existing and projected threats from industrial development.

3. Level of ecosystem fragility.

4. Importance for traditional land use by indigenous peoples.

5. Poorly studied areas meeting criteria 1, 2, 3, or 4.

The procedure for reaching consensus at these roundtables began with presentations by invited specialists, who described and supported the inclusion of one or more territories on the list. Then specialists nominated five areas they felt best suited the criteria. Finally, selections were tallied and the five to seven hotspots receiving the most votes were put forth for final approval by roundtable participants.

In many cases, the recommendations from these hotspot roundtables were integrated into regional government's protected-area development plans. In Amur Oblast, for example, roundtable coordinators Dr. Yuri Darman and A. T. Koval, then-chairman of the Amur Committee on Environmental Protection, used the roundtable results to write Resolution 139, which was signed by the governor on April 1, 1998, and now guides protected-area development in the region. In Khabarovsk Krai, the Commission on Protected Areas organized and held the region's hotspot roundtable.

While the hotspot process uses scientific criteria to identify priority territories, the roundtables also provide a political process geared to build consensus and support among decision makers—an essential step toward creating new reserves. In many cases, sufficient scientific research to determine the importance of protecting a forest or wetland ecosystem has already been conducted. The mixture of scientific and political input blends the expertise of Russian scientists with the political will and the financial resources required to protect these hotspots.

Fifty-eight territories are identified in the FoE–J/IUCN Hotspot List, almost half of which are existing protected areas. Recognizing that sustainable economic practices must be developed to protect biodiversity, a call for sustainable development programs in these regions is among the recommended actions for several hotspots. For example, there is a call to develop ecotourism and a sustainable nontimber forest product industry within 800,000 ha in the Samarga River region (Primorsky Krai, home to the Udege people). This could provide a local economic base and simultaneously protect the ecosystem. The hotspot concept is an evolving tool for establishing new protected areas, supporting existing protected areas, and developing sustainable economic models.

These hotspots are briefly described in the following pages and mapped on pp. 16–21. Most descriptions, environmental threats, and recommendations for these hotspots have been updated for this publication (see regional chapters for this information). Appendix G is a complete list of the Russian government officials, scientists, industry representatives, and NGOs involved in the hotspot selection process.

Primorsky Krai (see map 1.7, p. 16)

1. Samarga River basin (forest). Sparsely settled and largely spared from commercial logging, Samarga remains a nearly roadless wilderness in the heart of the Ussuri Taiga. Udege peoples live in Agzu, a hunting and salmon fishing outpost.

Threats: In 2001, Terneiles (Primorsky's largest timber corporation) won rights to log the basin. After widespread resistance from locals and environmentalists, Terneiles announced a two-year logging moratorium, effective October 2001.

2. Middle and Upper Bikin River basin (forest). The Bikin watershed, habitat for the Amur tiger and traditional homeland of the Udege and Nanai peoples, contains the largest intact, western-slope forests along the Sikhote-Alin and the largest remaining Korean pine stands.

Threats: Hyundai Corporation planned to log the upper basin in 1992, but permission was denied. The Chita-Nakhodka road opens the lower-middle section of the Bikin to logging, poaching, and illegal pine-nut harvest.

3. Middle Iman River basin; proposed Sredne-Ussursky National Park (forest). Clean alpine rivers, rocky cliffs, and magnificent vegetation make the region especially picturesque. The Iman Udege fish and hunt here.

Threats: Logging.

4. Southwestern Primorsky region (forest and wetland). Most Russian ecologists consider the lands along the Chinese border, from the Tumen River to the Razdolnaya River, Primorsky's most important area for biodiversity conservation outside the Sikhote-Alin. The Borisovskoe Plateau provides the largest remaining habitat for the RFE's leopards and an isolated Amur tiger population. The Tumen Delta includes a 40,000-ha wetland with more than thirty freshwater lakes and brackish lagoons.

Threats: Proximity to major population centers (Vladivostok, Nakhodka, and Ussuriysk) has led to widespread hunting, poaching, and uncontrolled tourism; the value of the area's timber stands poses a future logging threat.

5. Upper Ussuri River basin; proposed Verkhne-Ussuriysky National Park (forest). The park would protect the headwaters of the Ussuri River, one of the largest and most important rivers in the RFE. The Amur tiger inhabits the region, surviving their great population decline in the 1930s and 1940s.

Threats: Logging and poaching.

Khabarovsk Krai (see map 1.8, p. 16)

1. Anyui National Park (forest). This proposed 882,000-ha park would include much of the middle and upper Anyui River.

Threats: The Gassinsky Model Forest Project logs the lower basin; the 1996 fishing ban is not enforced.

2. Mataisky Zakaznik (forest). This *zakaznik* protects 121,300 ha of forests, breeding ground for ungulates and the Amur tiger. The Matai basin is an ecological corridor between the

northern Sikhote-Alin range and the Bikin River basin to the south.

Threats: The Chita-Nakhodka road has increased logging and poaching, reducing the number of ungulates.

3. Nedostupnye Lakes Zakaznik (forest and wetland). Located along the middle Amur lowlands, this *zakaznik* would protect meadows, wetlands, the relict Nedostupnye Lakes, and the hilly forests of the Khakhadyan. The region lies on one of the main bird migration routes in East Asia.

Threats: Hunting, fishing, and frequent forest fires have degraded habitat, resulting in a 40–50 percent loss of biodiversity.

4. Pikhtsa-Tigrovy Dom Zakaznik (forest and wetland). This *zakaznik* protects the northernmost habitat of the Far Eastern tortoise and one of the few remaining spawning grounds of the autumnal Siberian salmon.

Threats: Logging and fires have degraded about 30 percent of the territory; uncontrolled hunting and fishing occur. The Gassinsky Model Forest Project has rights to the eastern part of the territory, the Pikhtsa River basin.

5. Gur-Khoso Zakaznik (forest and riverine). Many species, including several very rare *Red Data Book* species, are found here at their northern distribution limit and thus are particularly sensitive to disturbance.

Threats: Logging, large-scale forest fires, and poaching. In the northwest, clear-cuts and burns cover 20 percent of this lowland terrain.

6. Shantar Islands Zakaznik (island ecology). A group of fifteen mountainous islands, this archipelago in the Sea of Okhotsk has unusually complex plant communities, larch forests, and mountain tundra. The islands support more than thirty mammal species, including some rare marine mammals.

Threats: Oil and gas development on the northern Sakhalin shelf. Unregulated hunting tourism impacts bear populations.

Jewish Autonomous Oblast (see map 1.9, p. 17)

1. Pompeevsky area (forest and wetland). The headwaters of the Pompeevka River protect endemic species and form the westernmost spawning grounds for the autumn chum salmon. Scaly-breasted mergansers, mandarin ducks, eagle owls (*Bubo bubo*), ospreys (*Pandion haliaeetus*), and golden eagles (*Aquila chrysaetos*) nest in the floodplain.

Threats: Future foreign and local attempts to log these forests. Small *artels* are mining the estimated 200-kg gold deposits.

2. Kuldur Nature Park (forest). This park has species from four biogeographic zones: boreal, Angarian, Okhotsk-Kamchatkan, and Manchurian.

Threats: Mining, forest fires, poaching, and industrial waste.

Recommendations: Develop ecotourism to reduce incentives to mine and log the region.

3. Bastak Zapovednik (forest). Mammals living in the area include wild boar, musk deer, and Himalayan bear. Hooded cranes nest in the river valleys, the Oriental white stork nests in the Glinyanka River basin, and the Blakiston's fish-owl may still nest in the Bastak River basin. The preserve also plays an important role in protecting water and soil.

Threats: Lack of proper equipment and sufficient staff to control and prevent fires, poaching, and the widespread illegal gathering of rare plants.

4. Zabelovsky region (wetland). The region protects waterfowl, shorebirds, and a number of rare fish species. The famous Komarov's lotus (*Nelumbo nucifera komarovii*) grows here.

Threats: Phenol pollution from the Amur River has affected local rivers and lakes. Bird and fish poaching is increasing. Grass is burned each spring and fall to prepare for crops, creating fires that often burn out of control.

5. Stolbovsky region (wetland). Predominantly steppe and wetlands, the region also has Mongolian oak, Daurian birch (*Betula davurica*), elm (*Ulmus*), and hawthorn (*Crataegus*) forests with some rare plants.

Threats: Hay harvesting, overgrazing, and uncontrolled grass-burning threaten nesting birds and habitat.

Amur Oblast (see map 1.10, p. 17)

1. Arkhara Lowlands and Maly Khingan Range (forest and wetland). These wetlands are home to three hundred bird species, fifty mammal species, and a thousand vascular plant species, including the Komarov lotus. The lowlands include nesting grounds for storks and cranes.

Threats: Agricultural fires in late spring and autumn, unregulated firewood collection, and salvage logging. Opencast coal and gold mining creates wastelands and threatens spawning grounds in the Urin, Uril, and Birya Rivers.

2. Southern part of the Zeya-Bureya Plain (wetland). This relatively untouched floodplain has marshes, abundant lakes, and wetlands, as well as fertile agricultural and pasture lands. It is an important stopover point for migratory birds and a home to nesting cranes and storks, dense populations of snow deer (*Capreolus pygargus*), raccoon dogs (*Nyctereutes procyonoides*), and other fur-bearing animals.

Threats: Inadequate protection by the regional hunting administration, firewood logging, dacha garden expansion,

and agricultural fires. The Sino-Russian Free Economic Zone threatens important wetlands.

3. Mukhinka forest area (forest). These natural pine forests north of Blagoveshchensk are home to many species of Manchurian flora. Mineral and thermal springs attract tourists.

Threats: Poorly controlled construction, unregulated recreational activity, and untreated sewage.

4. Between the Nora and Selemdzha Rivers (forest and wetland). Three hundred vertebrate species live within this corridor, a varied mixture of ecosystems. Migratory species include moose, hooded cranes, whooper swans (*Cygnus cygnus*), and the world's largest migratory population of snow deer.

Threats: Placer gold mining, open-pit mining, and their resulting river pollution. Also poaching of fish by electrocution, and animal poaching (the deer population has been halved).

5. Mountains surrounding Zeisky Reservoir (forest). These mountain forests and river basins form an important north-south migration route. They are home to more than two hundred bird species, including golden eagles, white-tailed sea eagles (*Haliaeetus albicilla*), ospreys, and Siberian grouse.

Threats: The Gilyui Hydroelectric Station, if completed, will create a reservoir that will flood vast forests and clog rivers with silt. Gold mining, clear-cutting of forests.

6. Nyuzhinsky Ridge and the Amur Pinelands (forest). These pinelands contain many Mongol-Daurian species, including the Altaian onion (*Alnus altaicus)* and Japanese stone pine shrub communities, musk deer, Manchurian wapiti, ospreys, and white-tailed eagles. There are therapeutic mineral springs in the region.

Threats: Clear-cutting, selective logging, gold mining.

Republic of Sakha (see map 1.11, p. 18)

1. Vilyui River basin (forest and wetland). Larch forests cover this basin of rolling hills and valley landscapes. River fisheries have been severely affected by industrial activity, but portions of the river basin remain pristine, particularly in the north.

Threats: Diamond, gold, and coal mining; oil and gas exploration; hydroelectric power projects. Between 3 and 8 million cu. m of timberland were flooded to create power station reservoirs.

2. Tundra woodlands (forest and tundra). These fragile tree-line forests grow entirely on permafrost and extend in a 100-km-wide belt across the northern part of the republic. Rare birds, such as the Siberian crane and lesser white-fronted goose (*Anser erythropus*), nest in the region. Indigenous people herd reindeer here. The region is poorly studied,

but scientists fear that permafrost melting could damage the ecosystem and cause a global climate shift.

Threats: Logging, tin, gold mining, and diamond exploration.

3. Between the Lena and Amga Rivers (forest and wetland). A unique *alas*-taiga region composed of lake-marsh, meadow, meadow-steppe, and taiga ecosystems. Rare plants endemic to the area grow amid birch forests between the two rivers.

Threats: Forests cleared for agriculture, logging for firewood, road construction, intensive cattle grazing, and gas reserve exploitation.

4. Between the Aldan and Uchur Rivers (arctic and forest). The Far Eastern and Eastern Siberian biogeographical regions converge here, resulting in high biodiversity, particularly in Sakha. There are more than 850 species of vascular plants, including many rare and endemic species. Of particular note is the Bolshoe Tokko Lake region: comprising only 3 percent of Sakha's total area, it contains one-third of all plant species in the region. Indigenous Evenki rely on the region.

Threats: Coal and gold mining, a new railroad, construction of the Uchursky hydroelectric station, and development of the Elginsky coal reserves.

5. Tuimaada Valley (forest and wetland). Only about 9 percent of the forest cover remains, as early settlers cleared and burned the forests to raise livestock. Sakha's capital, Yakutsk, is located here. There are also meadows, steppes, and swamps.

Threats: Logging, and urban and industrial sprawl destroy unique steppe ecosystems.

Magadan Oblast (see map 1.12, p. 19)

1. Magadansky Zapovednik (wetland, forest, and marine). This *zapovednik* protects the largest marine bird colonies in the northern Pacific. Endangered fauna includes osprey, Blackiston's fish-owl, peregrine falcon, Steller's sea eagle (forty-eight pairs), and a variety of marine mammals.

Threats: Proposed coalfield development on the Burgagylkan River (which feeds into one of the primary rivers in the reserve) and a gold mine near the Olsky region. Illegal crab and halibut fishing along with bear and snow sheep poaching continue unabated in the zapovednik.

2. Taui Bay (marine and wetland). Forty-five percent of all fish, 84 percent of all birds, and 75 percent of all mammals on the rare and endangered species list of the Russian northeast permanently inhabit or migrate to this region. Thirty percent of all rare plants in the region grow on nearby islands. The bay is one of the most plentiful areas in the Sea of Okhotsk for commercially valuable fish, mollusks, and crabs.

Threats: High population density, intensive transport routes, and heavy exploitation of biological resources have affected ecosystems. The polluted waters of Nagaeva and Gertnera Bays are harmful to residents. Potential oil and gas extraction is a future threat.

3. Khasyn River basin (wetland). This basin represents a unique natural and economic community unparalleled in northeastern Asia. Khasyn Basin rivers are spawning grounds for Pacific salmon.

Threats: Industrial pressure (logging, hunting, and coal mining) on the ecosystems in the middle and upper basin, where there is a railroad and a highway. Only two of the seven towns and villages in the basin have sanitary sewage facilities.

4. Gizhiga Bay (wetland and marine). Gizhiga Bay, one of the most biologically productive and diverse territories of the Sea of Okhotsk, has huge populations of herring, salmon, crab, and other marine resources, making this a prime commercial fishing area.

Threats: A coal mine on the shores of the bay pollutes nearby waters. Commercial fishing and hunting often conflict with the needs of indigenous peoples.

5. Odyan and Kavinsky Valley Zakazniks (forest and wetland). Both *zakazniks* are linchpins of Magadan's protected area system. Odyan (72,000 ha) was created to protect brown bears: more than a hundred live within the refuge's boundaries (2.5 individuals per 10 sq. km); only southeastern Kamchatka and southwestern Alaska have higher brown bear densities. Kavinsky Valley (320,000 ha) includes nesting grounds of the whooper swan, greater white-fronted goose (*Anser albifrons*), and bean goose (*A. fabalis*), as well as endangered osprey, golden eagle, and white-tailed and Steller's sea eagles.

Threats: There are attempts to mine within Odyan's borders.

6. Ola River basin (forest). Just east of Magadan city, the larch forests of the Ola River basin protect natural salmon spawning grounds.

Threats: Poorly designed industrial development has degraded huge areas beyond restoration. Severe localized pollution is forcing indigenous people to move from their ancestral lands. Overfishing, industrial mining.

Chukotsky Autonomous Okrug (Chukotka)
(see map 1.13, p. 19)

1. Lake Elgygytgyn (arctic and wetland). Relic and endemic species of alpine plant grow around this beautiful, nearly round lake, which hosts three endemic char species. Wild reindeer and snow sheep breed near the lake. Rare bird species include peregrine falcon (*Falco peregrinus*), gyrfalcon, golden eagle, and ivory-billed loon.

Threats: Although the area is remote, overfishing, uncontrolled mining, illegal archeological excavations, and waste dumping affect salmon and wild reindeer populations.

2. Lower Anadyr lowlands (arctic and wetland). The vast wetlands here are critical for nesting and migratory birds; Avtatkuul Zakaznik is one of the largest remaining goose breeding grounds in the RFE. The rivers are important for migrating calico salmon, *nelma*, other whitefishes, and smelt.

Threats: Future oil development may lead to road construction, and land and water pollution. Overfishing.

3. Meinypilgyn riparian zone (arctic and wetland). Brown bear, moose, ermine (*Mustela erminea*), snow sheep, and Kamchatkan marmots frequent the area. The fisheries include one of the largest stocks of chum salmon in Northeast Asia. Seals, killer whales (*Orcinus orca*), and migrating gray whales (*Eschrichtius gibbosus*) visit to feed on the salmon. Indigenous peoples rely on the area.

Threats: Largely pristine; the primary problem is garbage around settlements; locals are starting to collect eggs illegally.

4. Walrus rookeries (arctic and marine). In some years, more than half of the world's walrus population visits these six rookeries, staying for up to six months.

Threats: Polar and brown bear attacks, poaching of walrus for their tusks, and uncontrolled tourism, particularly illegal low-elevation plane and helicopter flights.

5. Chaun Inlet (marine and wetland). Geese and shorebirds nest in coastal hills and plains and wetlands. Other birds include Bewick's swans (*Cygnus bewickii*), arctic terns (*Sterna paradisaea*), and Ross's gulls. The rivers have commercially valuable stocks of humpback salmon and dolly varden (*Salveninus malma*).

Threats: Mining, fishing, and localized reindeer grazing. Oil and gas development.

6. Omolonsky Zakaznik (arctic and forest). Tundra and taiga valleys support white-tailed sea eagle, gyrfalcon (*Falco rusticolus*), wild reindeer, brown bear, and wolverine. Moose reach record population densities here.

Threats: Upstream and downstream gold mining, including the Kubaka project in adjacent Magadan Oblast. Sable and wolverine poaching.

7. Botanical natural monuments (forest and wetland). Chosenia and poplar groves, reaching 18 m in height, are refuges for rare arctic plants and serve as reindeer calving sites.

Threats: Uncontrolled logging for firewood and reindeer grazing.

Koryak Autonomous Okrug (Koryakia)
(see map 1.14, p. 20)

1. Severnaya Ayanka Zakaznik (wetland and arctic). Protects the largest Kayander larch forests in Northeast Asia, and includes lichen cover and important winter pasture for reindeer.

Threats: Forest fires and logging cause disastrous floods on the Penzhina River and affect fish populations. Wood is cut for fuel.

2. Parapolsky Dol (valley) (wetland and arctic). Sedge-covered hilly tundra and grassy swamps dominate the area, drained by many small rivers and dotted with numerous glacial and thermokarst lakes. This highly productive reindeer pasture is also important for nesting and migratory birds.

Threats: Population growth, geological surveys, poaching. Future gold mining may lead to increased pollution and poaching, particularly along the route of the proposed Ametistovo-Manily road. The hydropower plant proposed for the Belaya River, irrigation projects and the consequent drainage of thermokarst lakes.

3. Ostrov Karaginsky Zakaznik (marine). Created to protect marine bird colonies, marine mammal rookeries, white fox populations, and other rare but unprotected flora and fauna. Salmon spawn in almost all streams. The shallow waters of the shelf contain commercially valuable species, such as Kamchatka king crab (*Paralithodes kamchatica*).

Threats: Increased poaching by locals; a proposal to make the island an area of traditional nature use without a full appraisal of its biological resources; potential offshore oil and gas development, mining.

4. Ozero Palanskoe Zakaznik (wetland). Notable fauna include snow sheep, wild reindeer, bear, Kamchatkan marmot, and migratory birds. Salmon are important for the subsistence of indigenous peoples. An unusual thermal ecosystem has formed around nearby hot springs, which includes the northernmost habitat for Okhotsk fimbristilis (*Fimbristilis okhotensis*), a *Red Data Book* plant.

Threats: Increased salmon roe poaching and overfishing; pollution from sewage and untreated waste.

5. Rivers of the Tigilsky region (wetland and forest). Nesting and feeding grounds for migratory birds, the lower basins of the Moroshechnaya and Utkholok Rivers are now *zakaznik*s. Salmon and other commercial and rare fish species spawn in the rivers.

Threats: Intensified commercial and illegal fishing, pollution from sewage and industrial wastewater, possible offshore oil and gas development, coal mining.

6. Sea of Okhotsk Continental Shelf near Koryakia (marine). Fish and marine mammals are the primary food sources for local indigenous peoples here. Upwelling ocean currents pro-vide a major reproduction area for Kamchatka king crab and other species, including halibut, herring, gray whales, beluga whales (*Delphinapterus leucas*), and seals.

Threats: Commercial fishing, proposed oil and gas development.

Kamchatka Oblast (see map 1.15, p. 20)

1. Bystrinsky Nature Park (forest). Indigenous Evens, Itelmens, and Koryaks—as well as non-Native residents—practice subsistence activities in this park, which is a part of the Volcanoes of Kamchatka World Heritage site. It is home to brown bear, snow sheep, sable, rare wild reindeer, Kamchatkan marmot, and all Pacific salmon species.

Threats: Development of the Aginskoe gold deposit and the Shanuch River nickel and copper deposit, forest fires, and the negative effects of largely unregulated tourism, particularly hunting.

2. Conifer Island (forest). Vitally important for regulating water levels in the Kamchatka River basin and protecting valuable salmon spawning grounds, the Conifer Island forests are almost the only tall stands of coniferous forest (Ayan spruce and Dahurian larch) on Kamchatka. Inaccessible forests have been preserved.

Threats: Commercial logging (these forests are almost the only source of timber on the peninsula and are widely logged), frequent forest fires, poor forest regeneration.

3. Kronotsky Biosphere Zapovednik (volcanic, forest, and wetland). The most important protected area within the Volcanoes of Kamchatka World Heritage site, the reserve boasts the world-famous Valley of the Geysers, Uzon Caldera, and other unique phenomena such as the Valley of Death. It also includes large areas of wetlands, forests (including part of Conifer Island), glacial alpine landscapes, a coastal marine zone, a dense network of rivers and creeks, and the huge Lake Kronotskoe, home to endemic char and freshwater sockeye salmon.

Threats: Poaching and poorly planned tourism, mainly in the Valley of the Geysers, but starting to affect other areas such as Uzon Caldera.

4. Komandorsky Zapovednik (marine). The reserve includes most of the Commander Islands and surrounding waters. The indigenous Aleuts, struggling to preserve their traditional lifestyle, suffer extreme economic hardship. It provides important habitat and migratory stopover areas for both American and Eurasian bird species; *Red Data Book* species include the gyrfalcon, peregrine falcon, and red-legged kittiwake (*Larus tridactylus*). All northern Pacific marine fauna are found here.

Threats: Poaching of fish, mammals, and birds; driftnet fishing; local economic crises.

5. Avacha Bay (wetland and marine). A world-renowned natural harbor, Avacha Bay is surrounded by Kamchatka's main population centers, as well as by picturesque volcanic mountain ranges. It is an important bay for recreation and transportation and is home to all southeast Kamchatkan marine and coastal flora and fauna.

Threats: Industrial, household, and agricultural pollution; possible radiation leakage from aging nuclear submarines anchored at the military base.

Sakhalin Oblast (see map 1.16, p. 21)

1. Pursh-Pursh and Vengeri River basins (forest). Supporting one of Sakhalin's last large frontier forests, this region is an important nesting area for sea eagles, a rutting and calving ground for wild reindeer, and a spawning ground for salmon. In addition, the picturesque mountainous area is popular with tourists.

Threats: Logging. A local timber company has leased part of the territory and is building roads and loading sites, with additional plans to log by helicopter.

Update: Vostochny Zakaznik (65,386 ha) was established in 1999 through the joint efforts of the Sakhalin Institute of Marine Geology and Geophysics, the Sakhalin Committee on Environmental Protection, Sakhalin Environment Watch, Friends of the Earth–Japan, and the Pro-Natura Foundation (Japan).

2. Coastal bays and wetlands of Northeastern Sakhalin (wetland and marine). An important migratory stopover point for waterfowl and a nesting site for sea eagles, ospreys, and the endangered Nordmann's greenshank. The bays support eight salmon species, the rivers are home to the *Red Data Book* taimen (*Hucho sakhalinensis*), and endangered gray whales summer in the coastal waters. Indigenous Nivkhi live and fish on the bays in summer; Uilta and Evenki herd reindeer on summer pastures here.

Threats: Seismic testing, drilling, tanker transportation, pipeline and infrastructure construction related to offshore oil and gas projects; pollution from existing oil industry and other sources; overfishing in the Sea of Okhotsk.

3. Anna, Sima, and Bakhura River basins (forest). Old-growth fir and spruce forests, preserved in the absence of forest fires, logging, and access. Scenery varies from cliffs and waterfalls to East Asian vegetation. Home to Sakhalin musk deer, peregrine falcon, whooper swan, and mandarin duck. All rivers are important salmon-spawning grounds. Increasingly popular for recreation and tourism.

Threats: Logging and intensified human access by a road that crosses all three rivers; increased fishing, hunting, poaching, collection of nontimber forest products, and recreational use.

4. Schmidt Peninsula (forest). Sakhalin's northernmost peninsula has a warm microclimate and an unusual forest ecosystem, including Yeddo spruce (*Picea glehni*), normally found much further south. Fauna includes brown bear, sable, ermine, wild reindeer, sea eagle, and Siberian grouse. The rivers and bays have pink salmon, green sturgeon (*Acipenser medirostris*), and kaluga sturgeon (*Huso dahuricus*).

Threats: With declining timber reserves elsewhere, timber enterprises want to log the spruce. Other threats include road construction, planned mining, unregulated tourism, poaching, and attempts to bury toxic chemicals.

5. Krilon Peninsula (forest). The southwestern peninsula, the warmest part of Sakhalin, is a distinct geographical and botanical subzone. Fragments of old fir and coniferous-broadleaved forests remain after the Japanese logging of 1920–1940. Species diversity is high: five hundred vascular plant species and twenty *Red Data Book* bird species, including osprey and white-tailed sea eagle.

Threats: Erosion after logging has silted rivers and climatic changes have affected flora and reduced animal populations. Logging is planned in the Uryum Basin, forest fires are a threat with the increasing number of visitors, and the fishing industry is irresponsible.

6. Nevskoe Lake (wetland). A large, shallow, brackish lagoon filled with fish, this is an important stopover point for migrating ducks, waders, and gulls. Muskrats (*Ondatra zibethica*), red foxes, river otters, brown bears, and raccoon dogs feed near the shores. The eastern part of the lake is included in the buffer zone of Poronaisky Zapovednik.

Threats: Spreading swampland, increasingly shallow waters, and inadequate food sources for fish, primarily because the railroad dike has cut off the natural channel between the lake and the sea. Logging near the lake's tributaries has reduced water levels and increased sedimentation. Year-round poaching.

7. Vaida Mountain (forest). Sakhalin's largest rift formation, Vaida Mountain, has unique caves with stalactites and petroglyphs. Alpine flora grows at mid-elevations and shelters many rare insects. The rare endemic East Sakhalin poppy (*Papaver valpoli*) grows near Lake Perevalnoe to the south.

Threats: Breaching natural monument regulations, the local administration has approved logging and mining. Uncontrolled hunting, encouraged by a road constructed in the 1980s, has destroyed wild reindeer populations.

Economy

Josh Newell

Since the era of the tsar Peter the Great (who ruled from 1682 to 1725), the RFE has been a military outpost and supplier of raw materials for the rest of Russia. Until recently, planners in Moscow, not regional administrators, dictated the region's development.[39] Soviet industry, like that which came before, exploited the region's precious metals, minerals, fisheries, and timber supplies and exported these raw materials to the rest of the Soviet Union. Large federal subsidies to state-owned enterprises ensured steady production and export. To increase production, economic ministries in Moscow set quotas for specific enterprises under a series of five-year plans. Although production costs were generally higher than in other parts of Russia, the RFE had become the country's largest producer of raw materials by the mid-1980s. The Soviet centralized economy, however, resulted in tremendous inefficiency and high levels of waste in all industries. Some manufacturing also occurred—notably the production of milled lumber, canned fish, and military equipment—but not nearly enough to satisfy local needs. The RFE has always been highly dependent on processed goods imported from European Russia or abroad. Today more than half of the RFE's energy, foodstuffs, and consumer products are made outside the region.[40]

With the devolution of decision-making that came with *perestroika*, however, entrepreneurs and government officials in the RFE hoped to strengthen the regional economy—using their newfound control over local resources, unprecedented opportunity to export to the Pacific Rim, and the chance to attract foreign investment to retool industries. But shrinking federal subsidies, combined with high fuel costs, declining domestic demand, and lack of competitiveness on both domestic and international markets (due to outdated technology and inefficient production), crippled the RFE economy in the 1990s, reducing production in all sectors. High transportation costs effectively isolated the region from the rest of Russia, severing the interdependent economic bonds of the former Soviet command economy. The breakdown of old economic bonds combined with the lure of hard currency shifted the region's economic ties to Northeast Asia.

Since 1999, overall industrial production has increased, but manufacturing capacity has not.[41] Existing equipment for machine building and timber and fish processing is obsolete due to lack of reinvestment by industry and lower government investment because of budget constraints.[42] The decline of processing in the timber and fishing industries has strongly affected the economies of many RFE regions, where entire villages were founded on logging, hunting, coastal fishing, and boat repair. Foreign investors—who could provide technology, management and marketing expertise, and capital to build a competitive manufacturing base—have

chosen instead to develop natural resource extraction projects (see pp. 86–99).

Corruption, privatization, and weak government regulation. The Russian tax regime, recognized as "one of the most complicated, burdensome, and unpredictable in the world," has impeded foreign investment and, more critically, fueled corruption and capital flight.[43] The practice of concealing revenue to avoid taxation is widespread. The World Bank estimates between 40 and 50 percent of the Russian economy operates in the shadow and is controlled by illegal capital.[44] Sakhalin Governor Igor Farkhutdinov estimates illegal businesses export half of the fish caught in Russian waters. Capital flight totalled a staggering U.S.$1 billion to $2 billion a month during the 1990s, with Russian capital in offshore accounts and real estate amounting to about U.S.$150 billion by the year 2000.[45]

Some argue that privatization helped set the stage for corruption and capital flight. The World Bank, economist Joseph Stiglitz, and others often refer to Russia's early privatization efforts as "spontaneous" since institutional and legal frameworks were not in place to prevent opportunists from stripping formerly public assets and initiating schemes to gain personal control over them.[46] Some managers, seeking short-term personal enrichment, sold off assets of state-run enterprises under their charge rather than continuing to run the businesses. Others appropriated equipment from newly privatized firms to create completely new firms. These activities, together with trade deregulation, led to a flurry of new small firms in many sectors, especially fishing, forestry, and mining. In 1990 for example, 306 fishing and fish-processing companies were registered in the RFE; by 2001, this figure swelled to 1,600, according to the Federal Fisheries Committee.[47]

But regulatory agencies have chronically lacked sufficient funds to effectively monitor the rising number of businesses. To supplement their budgets, some agencies have resorted to commercial activity. Local branches of the forest service (*leskhoz*es), for example, now spend less time regulating timber operators and more time harvesting timber themselves, disguising their illegal harvesting as salvage logging. TINRO (Pacific Institute of Fisheries and Oceanography), the primary fisheries research institute, sells the fish quotas it receives for determining sustainable fish-harvesting levels to fishing companies. Some unscrupulous officials within these agencies also use their positions to enrich themselves, augmenting their meager salaries.

Government regulation has also been weakened by jockeying for power between federal and regional governments, which muddies lines of jurisdiction over resource use and allocation. A number of federal decrees on privatization, land use, and forest management, aimed at empowering regional governments, are marred by jurisdictional inconsistencies. President Putin has tried to reduce this confusion by gradu-

ally recentralizing federal control. He appointed presidential representatives, or "super-governors," to oversee seven federal districts for Russia. The presidential representative for the RFE federal district is the former military general Konstantin Pulikovsky, who helped orchestrate the removal of Evgeny Nazdratenko, then governor of Primorsky Krai who was an official widely accused of corruption.

Some regional laws and responsibilities are clear — officials simply lack the expertise or will to enforce and fulfill them. Russia's traditionally low regard for written law and preference for "situational" law, which is more open to interpretation, is part of the problem. After living in the RFE for years, lawyer Kevin Block found Russia was governed by "lawlessness law: … Who you knew was more important than what the rules said, and … most rules were not really rules at all, but guidelines for action, subject to endless variation when applied in practice."[48] Existing laws are also poorly enforced because there is no independent judiciary. In Soviet times, judges were appointed or removed at the whim of Communist Party leaders. Laws that conflicted with government priorities were often ignored, a practice that continues today.

Effects of economic transition on the environment. Academics, research institutes, and financial institutions such as the World Bank and IMF have analyzed at length such post-Soviet economic and political trends as lower industrial production, decline of manufacturing, types of foreign investment, corruption, capital flight, federal-regional power dynamics, poor government regulation, and weak rule of law. More than ten years of transition in Russia have provided researchers with a wealth of data both to debate the effects of privatization and liberalization and to consider future policies and measures to move Russia toward stable political, social, and economic development. But far too few have considered the effects of this transition on the natural environment. Those that have, essentially focus on two lines of inquiry: (1) how the Soviet industrial legacy affects environmental conditions today, and (2) whether the transition to a market economy is positively or negatively affecting pollution levels and energy use. Reports by the European Bank for Reconstruction and Development (EBRD) typify both approaches. EBRD's 2001 publication, *Environments in Transition*, for instance, focuses on continued inefficiency in industry including the use of obsolete equipment, lack of pollution abatement equipment, and wasteful energy and material use.[49] The report concludes: "[M]any of the region's industrial plants continue to use energy and materials very inefficiently and pollute the atmosphere, land, and water resources. By investing in projects that reduce wastage and pollution, the EBRD can make a real difference in improving the environment." The EBRD then offers a prescription of increased foreign investment, reduction of subsidies, and continued deregulation. The few academics to consider post-Soviet environmental issues have focused on similar lines of inquiry. D. J. Peterson,

for instance, explores why the Russian economy has become more pollution-intensive (pollution levels have dropped less than industrial output) and concludes that reduced economic efficiency and falling investment in environmental infrastructure, such as pollution abatement equipment, are to blame.[50] Although useful and necessary, the narrow focus of these studies risks restricting the consideration of complex environmental problems to the study of pollution levels and industrial efficiency. There are other equally important angles to explore.

How, for instance, has the RFE's drop in manufacturing and rise in raw materials exports to Asian markets affected the natural environment?[51] Asian markets now largely dictate what resources are extracted, where, and at what rate. This pattern intensifies and localizes the harvest of certain natural resources — a process harmful to many plant and animal species and the natural systems upon which they depend. Commercial fishing, for instance, targets only species in demand by export markets, namely crab, pollock, sea urchin, and salmon. This has decimated stocks of some species, leading to temporary closures of fishing areas and severe harvest restrictions. In the timber industry, Asian demand for larch may lead to large-scale logging of northern permafrost forests and subsequently threaten the global climate. The geography of new markets and rising transport costs (largely due to loss of subsidies) are also increasing logging pressure on forests in the southern RFE, Russia's most biologically diverse region (see pp. 69–70). Weak government regulation and corruption encourages such overharvest and allows illegal methods to flourish. Illegal harvesting of king crab, Russia's most lucrative marine export, has forced the Russian government to close crab beds and greatly reduce quotas. Illegal logging targets protected species, such as Korean pine, yew (*Taxus cuspidata*), and Amur cork tree (*Phellodendron amurense*), and quota-restricted species, such as ash. Such logging does occur along protected river systems and affects water levels, which can lead to flooding. The opening of borders for export and poor domestic economic conditions have led to a flourishing trade in endangered species and their by-products, particularly affecting the Siberian (Amur) tiger, musk deer, black and brown bears, and ginseng.[52]

Another subject requiring study is the effect of federal and regional power dynamics on resource use and management. The breakup of the former Soviet Union gave regional governments unprecedented responsibility for economic and environmental decisions. Environmentalists in the RFE heralded the change, thinking regional residents would be better stewards of local resources than Muscovites. The results, however, have been mixed. Some regional governments have set aside large tracts of land as protected areas, particularly in Amur and Kamchatka Oblasts. But these governments have also developed close ties with timber, mining, and fishing interests seeking to gain land-use rights, avoid environmental regulations, and hide profits. Collusion between corrupt

Building the Trans-Siberian Railroad

Industrial development in the RFE began just 150 years ago, spurred by fur traders who gradually moved east in search of new resources. Prior to 1850, native peoples inhabited the region. The great government effort to industrialize Siberia and the Far East really began with the building of the Trans-Siberian Railroad between 1891 and 1905, which today spans more than 9,000 km from Moscow to Vladivostok. The railroad was built to facilitate colonization, to allow transfer of troops and supplies to protect Russia's eastern shores from the growing military powers of Japan and China, and to develop industrial centers to extract raw materials for domestic use and export. Developing the Amur River basin was of primary importance, as it was the richest basin in the entire RFE. As early as 1857, the American millionaire Perry McDonough Collins saw the Amur's potential and proposed a railroad to connect the western headwaters of the Amur to the Pacific Ocean. To Collins, the Amur River was "the destined channel by which commercial enterprise was to penetrate the obscure depths of Northern Asia, and open a new world to trade and civilization."[53]

Convicts built the railroad, and the first leg between Vladivostok and Blagoveshchensk in Amur Oblast was completed in 1897. Vladivostok (which translates as Lord of the East) quickly grew into a bustling military and trading port with a population of about thirty thousand by the turn of the century. Industrial centers developed along the railroad, and by 1910, British gold-mining companies were financing ventures and International Harvester Company was supplying all types of agricultural equipment to the Far East.[54]

The Rise of the Red

The Bolshevik Revolution brought an abrupt halt to foreign investment, as communist leaders brought all industries under state control and broke ties with the Asian-Pacific community. State control of industry gained momentum under Stalin, who came to power in 1924. Through a series of five-year plans, Stalin sought to catch up to the West by transforming Siberia from a primarily agrarian economy into a huge industrial complex. "Industrialization was the new faith. Factories were its cathedrals, its priests were the elite workers who smashed production targets and led the way to the future."[55] To fuel this massive drive, Stalin perfected the tsarist gulag system to provide slave labor. No Russian citizen was safe as people were rounded up for petty "crimes against the State." Three types of camp developed: (1) factory and agricultural colonies, (2) camps for logging and mining, and (3) punitive compounds for those who disobeyed at the other camps. Camps were built throughout the Far East — Khabarovsk, Vladivostok, Sakhalin, Kamchatka, and in the gold-rich Kolyma River basin in

Magadan Oblast. Camp laborers built the cities of Magadan and Komsomolsk-on-Amur. At its peak in the 1930s, the gulag Archipelago held more than 21 million prisoners. Stalin had created an economy almost completely dependent on slave labor; in 1937, the year of Great Terror, an estimated 7 million citizens were exiled to keep the camps full — as the death rate was 25 percent a year. Of the estimated 12 to 15 million killed by labor camps, the Kolyma Basin camp claimed about one-fifth.[56]

Stalin's death in 1953 brought the release of many prisoners, but the Kolyma-Magadan camp still held more than one million so-called political prisoners in 1956. Faced with an ailing economy and increasing dissent, President Nikita Krushchev revived a smaller version of the gulag system in 1961 by stipulating that "anyone who had not had a proper job for more than a month could be exiled for two to five years to one of the traditional Russian places of exile."[57] The prison camp system persisted even under President Mikhail Gorbachev, but it never reached the horrific scale of the Stalinist gulag system.

After Stalin, the Soviet empire returned largely to ostensibly free labor, using the ex-gulag resource extraction cities as industrial centers. Many large-scale development projects initiated by Stalin continued — although some were abandoned, such as the half-built railroad tunnel under the Tatar Stait to Sakhalin — and huge hydroelectric dams became the order of the day. "Dams symbolize Russian might, just as troops and rockets. They embody man's conquest over nature and they are the article of the Communist faith."[58] However, as dams flooded millions of hectares of forests, displaced local and indigenous peoples, and destroyed fishing grounds, not all Russians embraced them.

In addition to dams, Soviet planners dreamed of a new railroad, the Baikal-Amur Mainline, which would run north of and parallel to the Trans-Siberian, before terminating in Khabarovsk Krai, and would open up vast mineral deposits and forests for exploitation. It was also supposed to be less vulnerable to possible Chinese invasion than the Trans-Siberian, which hugs the border in many places. Stalin began the project, but with the onset of World War II, the government, in desperate need of iron for the war in European Russia, ripped up the track. In 1974, the project began again and U.S.$25 billion later was finished in 1989. The railroad has been an economic disaster, as Moscow ran out of money before building the originally planned logging and mining cities along the line. The scorched earth from massive fires caused by the line's construction is a painful reminder of the project's ecological costs.

— JN

regional officials and businessmen is evident in frequent rigging or avoidance of the *expertiza* process. Mandated by the 1992 Law on the Environment, the *expertiza* process is a scaled-down version of U.S.-style environmental impact assessments and is required for all proposed development projects in the RFE. Stronger federal control may help to reduce corruption and illegal resource use, but reconsolidation of power might instead further weaken environmental oversight of industrial enterprises. President Putin's recent consolidation of the Committee on Environmental Protection and the Forest Service into the Ministry of Natural Resources, which is in charge of natural resource extraction, effectively eliminated the two major federal bodies responsible for environmental management and control (see pp. 103–6).

This economic overview of the RFE is a backdrop. Environmental and economic developments in the fishing, energy, timber, mining, and agriculture industries are discussed in greater detail below. Basic economic and resource data for each industry are provided. The sections on fishing and timber are longer than those on mining, energy, and agriculture because the latter are discussed more extensively in the regional chapters. The roles of international development banks, NGOs, and foreign investment in the development of the RFE are evaluated in "Toward sustainable development."

Fishing

T. ALLISON — Fishing, which includes fish processing, storage, transport, and related activities, is probably the RFE's largest industrial sector. It is the only significant form of economic activity in many areas, such as Kamchatka and Koryakia.[59] Fish and fish products may account for roughly one-half of all RFE export revenues, if estimated unrecorded high-seas shipments are included.[60]

The RFE fishing industry was privatized and commercialized during the 1990s, spurring widespread fleet modernization. Fishing shifted from lower-value species, bound mostly for the Soviet domestic market, to higher-value products sold internationally. Fleet modernization, financed and often supervised by foreign interests, has led to harvest overcapacity; combined with illegal fishing, this has depleted the stock in key fisheries. Many RFE fishing enterprises already struggling with rising input costs, international market competition, and the end of government subsidies, face economic disaster if this stock continues to dwindle.

Ineffective fishery management and a fishing quota allocation system that lacks transparency have further undermined the economic health of the fishing industry and its communities. The current decreasing fish quotas are accompanied by unprecedented public conflicts between the *krais* and *oblasts* over rights to this shrinking resource and by growing hostility toward foreign involvement in the industry. Capital flight and bribes for fishing quotas have led to the loss of substantial revenue from this valuable national resource. In sum,

bureaucratic infighting, lack of funding, and corruption have plagued the key fishery management tasks of gathering data, setting biologically sustainable fishing limits, and allocating quotas within those limits to domestic and foreign operators. Meanwhile, the burdensome tax and regulatory regime in Russia for vessel operators has driven much of the industry's activities abroad, where Russian vessels call in foreign ports for repairs, supplies, and cargo transshipments. RFE ports, formerly hubs of Soviet fishing fleet activity, are increasingly inactive and dilapidated.

These trends constitute a widely proclaimed crisis in the RFE fishing industry. The Putin Administration has responded with a controversial quota auction system for the most valuable species. This system is supervised by the Ministry of Economic Development rather than the industry's traditional administrator, the Federal Fisheries Committee. The former Primorsky Governor Evgeny Nazdratenko was appointed the new head of the Fisheries Committee in March 2001 and widely opposes the auction system, as does industry.[61] These developments raise crucial questions. Why did privatization compromise the fishing industry's long-term health? How has the widespread involvement of foreign interests over the last decade contributed to the crisis? How have institutional arrangements in the industry evolved since the collapse of the USSR and how have they facilitated large-scale overfishing and capital flight? Finally, how is the Putin Administration reforming the industry, so crucial to the well being of the RFE, and what are the prospects for success? What other measures and management models might be considered? To explore these questions, we examine the current impasse within the RFE fishing industry.

Heritage of the Soviet fishing industry. The economic reasons for the fishing industry crisis evolved in the 1990s, but its roots lay in the Soviet period. The fishing industry under the Soviet Union was managed by a highly centralized, hierarchical structure designed to procure an inexpensive and stable protein supply for the population. Beginning in the mid-1950s, the USSR began a massive shipbuilding program, deploying fishing vessels throughout the world's oceans. Polish, German, and later Ukrainian shipyards first constructed the large autonomous catcher-processors, while Russian yards built hundreds of smaller oceangoing vessels (ships 50 m or less long). Annual Soviet marine harvest grew from less than a million tons in 1950 to more than 6 million tons in 1970. Annual volumes peaked at a level of almost 10 million tons at the end of the 1980s, with roughly 65 percent caught in the Pacific Ocean.[62] By this time, the USSR had the world's largest fishing fleet and was second in marine harvest only to Japan.[63] Per capita seafood consumption in the USSR grew to more than 20 kg, three times higher than U.S. levels.[64] However, the economic efficiency of these vessels, based on vessel tonnage per unit of output, appears to have been well below that of other fishing nations.[65] Although some

high-value products were exported, such as salmon, pollock, roe, and crab, most seafood was not highly valued internationally: almost all of it (over 90 percent by tonnage) was sold to domestic consumers.[66]

This enormous buildup of fishing power paralleled the growth of other Soviet industrial sectors: the industrial system reflected an emphasis on volume rather than efficiency, and the quality of output, acceptable domestically, lagged behind international standards. Fuel and capital were highly subsidized and product prices were set within the range of consumer purchasing power. An important social consequence of Soviet policies was that large numbers of employees entered enterprises that, when exposed to lower subsidies and open markets, had to quickly transform—a painful process often involving layoffs or nonpayment of wages—or perish. Unfortunately for many employees and their families, most of these fishing enterprises were located in remote areas where the enterprise was the largest employer and the most important provider of social services during the Soviet era. In the case of the RFE fishing industry, the Soviet economic system created artificially successful enterprises, communities, and towns, whose fates are now highly uncertain. The process of determining quotas was controversial and influenced both regionally and in Moscow, because the output of each enterprise and region ultimately depended (and still depends) on fishing allocations. However, throughout the Soviet era, unlike today, most RFE and accessible foreign fishery stock was underutilized, and thus available to fishing companies with harvest capacity. Also, the entrenched centralized Soviet allocation system was relatively resistant to influence by regional leaders and individual enterprises, and thus largely capable of enforcing harvest limits. Anecdotal evidence from long-term participants suggests that corruption in the form of personal gain by regulatory officials played almost no role in establishing and allocating quotas and only a marginal role in the activities of enforcement agencies. Disputes between regions and the center over control of the allocation process were not allowed to develop, and Moscow's all-encompassing administrative power resolved complaints between or from the regions. However, the scope of the government's power and its involvement in the fishing industry, like the structure of the industry itself, changed quickly and drastically when the Soviet system ceased to exist.

The changing role of government. The end of the USSR's command economy led to the abrupt decline of powerful state industrial structures such as the Ministry of Fisheries. In 1991, the ministry became the Russian Committee of Fisheries, and staff was cut from 1,200 to 400 employees.[67] The ministry's authority was also reduced to management of fisheries stock instead of exploitation. Reduced authority was accompanied by frequent changes of the Committee's chairman: six have held the post since 1991.

The all-important function of setting and allocating overall harvest levels has remained chiefly with the Moscow committee, which licenses vessels and fishing companies (see map 1.17). Other government bodies, however, have gradually eroded the committee's authority; by the late 1990s the committee was forced to coordinate the quota allocation system with other government bodies, introducing serious delays and uncertainty into issuance. Observers point to a variety of motives for inserting additional controls into the quota system, including an effort to curb corruption and the eagerness of other bureaucratic agencies to obtain control over an industry with substantial hard-currency earnings.[68]

Formally, the steps in determining quota allocations are similar to those of Soviet times: TINRO, located in Vladivostok, collects scientific data from its regional branches and then makes recommendations to the Russian Federal Research Institute of Fisheries and Oceanography (VNIRO) in Moscow. The various regional-level institutes, however, now conduct local scientific work more independently from TINRO than before. Concerns have been raised about the veracity of the data on which quota decisions are based, because of the drastic decline in federal funding for scientific research at every level.

In an increasingly politicized process, the Fisheries Committee then allocates quotas to each respective administrative region (*oblast, krai*). Instead of having the final word, the committee's recommendations are first sent to a government Commission of Experts, mainly ichthyologists from various national institutes appointed by the Ministry of Natural Resources, and second to the Ministry of Natural Resources. Once any questions or objections are resolved, the prime minister must approve this entire set of harvest recommendations.

The *oblast-krai* administrations then distribute the quotas between companies, sometimes through an intermediary industry association. This distribution of long-awaited quotas, and the subsequent issuance of fishing tickets to specific vessels, is based on the type of vessel owned or operated by each company as well as historical catch levels. Additional criteria explicitly considered by *oblast* and *krai* governments are the vessel operator's record in tax and wage payments, their importance as an employer and social service provider

Walleye or Alaskan pollock (Theragra chalcogramma).

to the *krai* or *oblast*, and any record of fisheries violations. Less formal criteria, according to industry observers, range from family ties to political leanings to outright bribery. Special quotas of considerable value are also periodically awarded from Moscow to individual firms, including firms without vessels.[69]

Different types of quotas also complicate the allocation system. Prior to the introduction of auctions in late 2000, there were four basic types for domestic users:

- The industrial quota, constituting the majority of all quotas; usually free of charge.
- The control-catch quota, typically located in biologically sensitive areas generally closed to fishing, requiring a scientist on board to monitor and analyze the catch.
- The scientific quota: fishing according to a program devised by scientists to systematically explore an area and certain species to establish an industrial quota.
- Paid (commercial) quotas, sold through designated agencies (usually in Moscow). The fees ostensibly support fisheries science, enforcement, search-and-rescue, and other functions needed by the industry.

In addition, separate quotas are set aside for bilateral fisheries agreements allowing foreign vessels to fish in Russian waters. These quotas are provided to foreign governments in exchange for payment in cash or kind (for example, salmon hatcheries or scientific vessels) or, less frequently in recent years, in exchange for reciprocal fishing rights. These quotas were reduced as pressure on Russian stock has grown from Russia's own fleet.

The possibility of moving allocations between quota categories or even creating new special quotas, and the subjective use of the criteria and rules for each category, have led to heavy lobbying in the allocation process. Thus, it is not surprising that the top executives of fishing enterprises and the heads of *oblast* and *krai* fishing departments spend several months each year in Moscow trying to protect and enhance their interests. Local conflicts of interest also occur when *oblast* and *krai* administrations divide quotas between companies based on the changing mix of objective and subjective criteria described above. In 2001, the Russian government began to auction off many of the most valuable quotas to the highest bidder in an effort to increase taxation revenue and reduce illegal harvest, as discussed in the sidebar; see appendix H for a listing of the quotas for major species in 2001.

Weak enforcement. Monitoring and enforcement of quotas for fisheries is weak. Underpaid (or unpaid) scientists and enforcement officers are often offered cash, alcohol, or valuable seafood products in return for falsifying records, easing the rigor of scientific fishing programs, or simply ignoring violations. Although seagoing fisheries scientists and enforcement officers in every country may encounter such hazards,

Moscow auctions fish quotas

In December 2000, Moscow adopted decree No. 1010, a guideline for the quota auction, whereby Russian and foreign firms bid for quotas of select species.[70] By requiring initial payment from firms for quotas, the Russian government guarantees itself revenue. The federal government maintains the system will also increase industry accountability. The decision to auction quotas was met with uniform resistance from RFE governors, fishing associations, and companies, who fear a loss of control over, and revenue from, the resource.

The auction system seems destined to replace government-to-government quotas. In 2001, the government auctioned off 5–10 percent of all quotas, primarily for the highest demand species: crab, shrimp, and pollock.[71] Russia reduced the Chinese quota for pollock from 17,000 tons in 2000 to 9,500 metric tons; only twelve Chinese ships will be allowed to fish versus seventeen in 2000.[72] Russia also lowered Japan's quota for fishing salmon in its economic zone from 16,000 in 2000 to 12,000 tons in 2001. These reductions for countries are expected to continue while quotas for individual foreign companies increase; foreign companies increased their share of quotas in 2001 to 241,000 tons, 20 percent higher than the previous year. Russian companies meanwhile held nearly 9 percent less, at 260,000 tons.[73] Reports have surfaced that some Russian firms are buying quotas with loans from foreign backers, with repayments then made at foreign ports, where the catch (much of it illegal) is unloaded.[74]

Scientific and research quotas may be reduced under the new auction system; in 2002, the government cut these quota allocations significantly. These quotas, given to agencies and institutions to research stock levels and determine the following year's quotas, are widely abused. The quotas are often sold to commercial firms or used by the scientific body simply to fish and export product. Many monitoring and enforcement agencies also receive scientific quotas, from which they earn revenue. This poses an obvious conflict of interest. Scientific quotas are unusually high for some species, particularly king crab, sea urchin, and sea cucumber. For red (*Paralithodes kamtschaticus*), blue (*P. platypus*), and golden (*P. brevipes*) king crab alone, the scientific quota allocation in 2001 was almost 6,500 metric tons, 15 percent of the total allocation for king crab in other quota categories.

Without vigilant monitoring and enforcement, the auctions are unlikely to protect fisheries.[75]

– JN

the Russian citizens' sense of being abandoned by the government, along with the widely held view of Russian fishermen and their employers that success can only be achieved by violating the formal rules, makes this a particularly serious problem.

Similar to the Committee in Moscow, the traditional enforcement agency, Glavrybvod has faced growing criticism during the 1990s for unregulated exports and unpunished fishing violations. Another organization, the Special Marine Inspectorate (Spetsmorinspektsia), a division of the now-defunct Committee on Environmental Protection (Goskomekologia), began to patrol and pursue violators alongside Glavrybvod. The two organizations began to compete for capture of violators, leading to confusion. In 1998, Glavrybvod's enforcement functions were transferred to the Federal Border Service further impinging on the power of the Fisheries Committee and one of several cases of an outside entity receiving decisive authority over an activity with which it was only generally familiar. The border guards' inexperience seems to have been recognized, however, and many Glavrybvod personnel have been integrated into the Border Service units involved in fisheries enforcement. Issues of competence and motivation still remain, and anecdotal evidence suggests corruption has not eased significantly. Indeed, some industry participants have portrayed the takeover as an effort to find a source of unofficial revenue in the form of bribes to appease the Border Service, whose troops are usually asked to serve in difficult and remote areas of the Russian borderlands with little recompense.

Central topics at sessions of the biannual Far Eastern Scientific-Industrial Council include quotas, the status of the resource, and the enforcement of fishing rules. Councils are made up of government and industry representatives from each *oblast* and *krai*. Previously, council meetings were often marked by common positions and actions by RFE *oblast*s and *krai*s in support of regional industry. More recently, however, regional meetings are marked by conflicts over fishing rights between fishing companies in different regions. These constituents now openly and aggressively compete with each other for markets, financing sources, vessels and, above all, quotas.

The emergence and struggles of private industry. The number of independent firms in the fishing industry exploded in the 1990s. Not only did former state enterprises and fishing *kolk-*

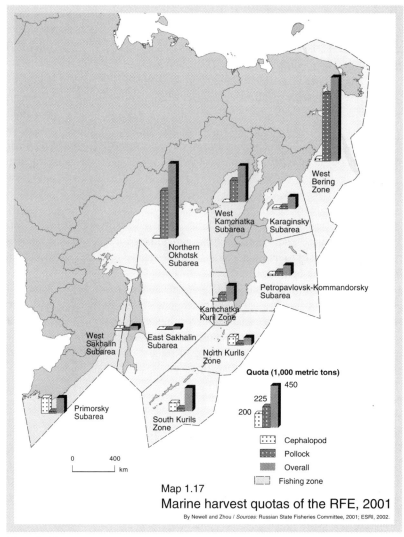

Quota (1,000 metric tons)

Cephalopod
Pollock
Overall
Fishing zone

Map 1.17

Marine harvest quotas of the RFE, 2001

By Newell and Zhou / *Sources:* Russian State Fisheries Committee, 2001; ESRI, 2002.

*hoz*es break free from their controlling umbrella associations, but a myriad of new ventures appeared. One source cites an "incomplete assessment" that found more than one thousand firms active in the RFE fishing industry in 1996.[76] Official data from 1999 indicate that in Sakhalin Oblast alone some 598 enterprises were active, a tenfold increase since 1990.[77] Cut loose from subsidies as well as from central administrative control, RFE industry participants formed new companies and transformed old ones. In either case, they were forced to adopt new products, production techniques, and markets in order to survive. The formation and transformation of so many enterprises, many of them at least temporarily successful, is credited to several factors:

- Key moveable assets (vessels), either imported or easily appropriated from state concerns and quickly modernized for high-value production.
- Economic activity mostly on the high seas, with shipments to foreign ports sheltering the enterprise from problems plaguing other Russian businesses, such as infrastructure weakness.

- Cadres of experienced fishermen and executives with at least passing knowledge of international production methods and markets.
- Foreign financing for an industry that could deliver, with limited infusions of capital and expertise, high-quality seafood products to international markets.

Although every maritime RFE *oblast* and *krai* has seen a proliferation of small new companies in the industry, large former state enterprises and large *kolkhoz* organizations dominated the industry in the 1990s in Primorsky and Kamchatka. On Sakhalin, however, newly formed companies emerged as industry leaders at an early stage, often with foreign participation, alongside *kolkhoz*es. Given the upheaval and change in the industry, it is ironic that CEOs of the largest companies in Primorsky and Kamchatka—the leading regions for seafood production—were almost all the same at the close of the decade as at the beginning.

The large former state enterprises held certain advantages over their smaller new competitors. The influence of these enterprises and their executives was likely to be higher among Moscow bureaucrats and especially among regional officials. Quotas were easier to obtain, particularly because these companies typically had a long history of receiving quotas for their huge outmoded fleets—a major criteria for quota allocation. Additional arguments for receiving quotas under favorable terms were the social infrastructure, large workforce, and broad tax base typically connected to former state enterprises. Finally, the familiarity, visibility, and size of these firms were often advantageous in attracting foreign credit, at least in the first years of reform.

However, new firms were free from the financial burden and distraction of supporting a social infrastructure. They also could hire the most talented managers from older firms, offering better compensation and greater independence, and could tailor their workforce to their firm's developing needs. Lower company profiles also helped avoid Russian regulatory and tax attention, as well as attention from the criminal world. Previously well-known industry executives with useful local, federal, and foreign connections have headed up most of the successful new companies.

It is difficult to measure the advantages and disadvantages of maintaining large former state fishing enterprises for an *oblast* or *krai*. Kamchatka, the *oblast* most heavily dependent on the fishing industry, has shown more stability and less open conflict in allocating regional quotas. Primorsky has the highest degree of violence, shareholder disputes, and scandal over vessel ownership and charters. The largest Primorsky companies, VBTRF and Dalmoreproduct, became snarled in scandal and have either been divided into smaller firms or paralyzed by legal actions and lack of quotas. One large former state enterprise in Primorsky, NBAMR, remains intact, fully active, and relatively free of legal conflicts. On Sakhalin, home to several successful new companies, many large fishing

*kolkhoz*es have defaulted on debts and declared bankruptcy, unhappily affecting local fishing communities. Illegal fishing, mostly by small operators secretly delivering crab to Japan, is apparently more ubiquitous in Sakhalin than in any other region in the RFE.

Figure 1.3

Pollock as a component of total RFE catch, 1985–1999

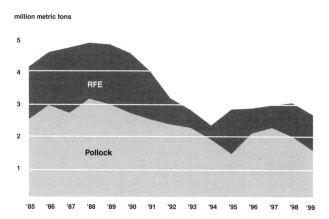

Source: FAOSTAT, State Committee of Fisheries, Goskomstat.

Figure 1.4

RFE red/blue king crab harvest, U.S. and Russia, 1970–1999

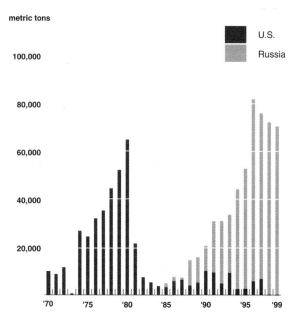

Note: Volumes for Russian harvest in 1992, 1993 extrapolated from partial data.
Sources: Dalryba, Japan; U.S. import data; National Marine Fisheries Service.

A global resource

The world's seventh largest fishing nation, Russia catches 60 to 70 percent of its annual harvest in the major seas of the RFE: the Sea of Okhotsk, Bering Sea, and Sea of Japan.[78] Despite extensive exploitation, the northern Pacific region,[79] which encompasses these seas as well as the South China, East China, and Yellow Seas, remains the world's most productive fishery. The other major fishing nations of Japan, China, South Korea, and the United States fish heavily in these waters. Russian fishing companies now supply high-demand species for export rather than species traditionally harvested for the Soviet market, such as saira (*Cololabis saira*) and sardines (*Sardina, Sardinops*), resulting in the overharvest of pollock, crab, salmon, and a variety of roe (sturgeon, pollock, salmon). Demand is high also for *trepang*, or Japanese sea cucumber (*Apostichopus japonicus*), football sea cucumber (*Cucumaria japonica*), and other endangered sea delicacies popular in China, Korea, and Japan. The diversity and multitude of marine species in these seas is evident in the allocation of scientific quotas for species.

The government continues to reduce the quota for Walleye pollock—by total tonnage the lifeblood not only of the Sea of Okhotsk and Bering Sea fisheries, but also of the fishing industry as a whole. Figure 1.3 shows the pollock catch in terms of overall RFE catch from 1985 to 1999. King crab are faring no better; populations have fallen so dramatically that experts in TINRO compare the situation with the 1950s, when catches throughout the Kamchatka-Kuril subzone were prohibited.[80] Each year, Russia exports almost the entire King crab harvest (both legal and illegal) to Japan and the United States.

Data for salmon harvest indicate relatively stable populations. The 1999 salmon harvest was 244,076 metric tons, about the same as in 1997 and 1998, and higher than in 1996 (185,374 metric tons). Pink salmon account for about 75 percent of the total salmon catch, with chum, sockeye, coho, and king making up the remainder. Both foreign and domestic driftnet fishing operations focus on sockeye, coho, chum, and king. In 2000, Japan imported 16,354 metric tons of sockeye, virtually the entire RFE harvest for the year. This same pattern, to a lesser degree, is true for coho, chum, and king salmon harvests. Russia harvests primarily wild salmon, accounting for roughly 25 percent of all wild salmon caught worldwide.[81] Hatchery salmon represents a small percentage of total harvest. Widespread poaching, especially for roe, remains a huge problem, and fisheries specialists believe this will lead to stock declines. See chapter 11, pp. 368–69, for an exposé of salmon poaching.

Both Alaskan pollock and salmon migrate to and from Russian, Japanese, and U.S. waters, making the sustainable use of fisheries resources of global ecological and economic concern. Gray whales, which breed and feed throughout the Sea of Okhotsk and Bering Sea, depend on the fisheries, as do a host of smaller whales, sea lions, and sea birds. Northern Pacific countries must assist Russia in protecting these seas and work to curtail their own illegal activities.

Map 1.17 (p. 52) shows pollock and cephalopod quotas by fishing zone for 2001 in the Russian portion of the northern Pacific region. The largest overall quotas are for the northern Sea of Okhotsk and the western Bering Sea. Map 1.18 (p. 57) shows the 2001 crab quota for the same fishing zones.

–JN

Declining harvest levels. During the 1990s, the chaotic transformation and growing crisis in the fishing sector was reflected in declining harvest levels. The RFE catch plummeted from 4.6 million tons in 1990 to 2.3 million tons in 1994 (see fig. 1.3). This decline resulted partially from the collapse of Soviet demand and the need to reorient the fleet to new products, but also from the combined effects of an aging fleet and lack of capital. After recovering to a catch of almost 3 million tons annually during the next 4 years with the help of chartered European ships and modernized Russian vessels, the catch dropped again by about 350,000 tons in 1999 and continued to fall in 2000 and 2001.[82] The initial catch reduction in the early 1990s was temporary and correctable with foreign capital and redirected operations. The latest trend reflects an increasingly severe resource constraint, especially for the most abundant commercial species, Walleye pollock (*Theragra chalcogramma*). Meanwhile, the annual harvest of the other major commercial species, king crab, peaked in 1996 (see fig. 1.4) and saw a steep decline in 2002, which is expected to continue.

With the exception of imported or refit pollock and crab vessels, most of the RFE fleet has continued to age and deteriorate. In Primorsky, the area with the largest concentration of vessels, more than 65 percent of the fishing ships were more than 17 years old in 1999.[83] The situation is similar in other areas of the RFE.

A sharply declining overall catch, overfished pollock and crab stocks, and an aging and decrepit fleet are only the most blatant signs of trouble. Production by shoreside plants declined even more precipitously than fleet production—by almost 60 percent between 1990 and 1994.[84] According to materials from a Fisheries Committee–sponsored conference in mid-1999, shoreside plants and ship-repair facilities are operating at only 20–30 percent of capacity. Fishing ports,

formerly bustling centers for repair, supply, and transshipment, have seen ship turnover curtailed by a factor of three.[85]

As a result, the RFE fishing industry lost roughly 30 percent of its workforce between 1990 and 1996.[86] This decline, however, must be seen against a backdrop of an 8 percent fall in the RFE population and a roughly 26 percent decrease in the number of employees in all RFE industries between 1990 and 1996.[87] Considering this, the percentage of workers employed by the fishing industry has remained large and fairly constant throughout the maritime areas of the RFE. In the second half of the 1990s, for example, roughly 18 percent of the population in Primorsky was employed by the fishing industry, as was 28 percent in Sakhalin, and 50 percent in Kamchatka.[88]

The economic significance of the fishing industry's transformation in the 1990s to local communities and regional governments is difficult to quantify. Much of the industry's activity, including substantial amounts of compensation to seamen, has taken place offshore or is otherwise hidden from scrutiny. Unofficial payments to regulators and tax collectors grossly distort measures of financial flows to government, as well as the industry's burden. Besides employing many local residents, the only obvious physical evidence of the industry's transformation is the fishing firms' luxurious offices and expensive foreign cars and, much less often, new or refurbished shore plants, and powerful newer vessels.

Reliable data on company profits during the 1990s is also difficult to obtain, given the ubiquitous underreporting of catches, revenues, and profits. The fragile state of the industry's finances, however, has been dramatized by frequent and well-publicized cases of tax arrears, vessel arrests by unpaid creditors, and bankruptcies. Although anecdotal evidence suggests that some entrepreneurs who participated in the crab and pollock boom years of the early and mid-1990s managed to accumulate substantial wealth in overseas banks, this represents a small fraction of the industry. Most importantly, the lack of capital investment in the industry (outside of crab and pollock vessels, many of which were chartered or heavily mortgaged) has contributed to the downward spiral of undercapitalization, underutilized assets, increased reliance on foreign financing, and additional scrutiny and bureaucratic interference in attempts to stem capital flight.

In summary, during the 1990s the industry faced a range of fundamental problems: lack of domestic capital, a confiscatory tax system, outdated technology (this applies especially to shore plants), and, by the late 1990s, lack of adequate quotas for some key species, especially pollock and crab. Additional difficulties have included the underfunding of fisheries science and the confusing, inefficient, and sometimes corrupt system of quota allocations and fisheries enforcement discussed earlier. Many government and industry leaders have also pointed to the allegedly harmful role played by foreign interests, and this has become one of the most controversial elements in the fishing industry crisis.

> The experience of recent years has shown that foreign investors enter the Russian fishing industry with one goal: to get access to Russia's marine biological resources and supply seafood products to the international market. In doing this foreigners are not in the least interested in the preservation of our resources, or in the life of our villages, and less so in Russia's food security. And although we continue to work with foreign investors, trying to find mutually profitable alternatives, basically we rely on our own capabilities.
>
> — *Evgeny Nazdratenko, then Governor of Primorsky Krai, speaking at a government hearing on fisheries, December 9, 1999. Nazdratenko was appointed head of the Federal Fisheries Committee in March 2001. (Digest of Fishermen's News and Regional Press, December 1999–January 2000.)*

The role of foreign interests. Foreign companies and governments, especially from Japan, Korea, China, and the United States, were more active in the fishing industry in the 1990s than any other sector of the RFE economy.[89] This activity has ranged from fishing with foreign fleets in Russian waters to joint ventures, seafood trading, fleet modernization, and supply of provisions for vessel operations. Japan's seafood import market, the largest in the world, has been dependent on RFE output for several decades. China and Korea serve as centers for reprocessing and transit of Russian seafood, and as end markets. Crab, salmon, pollock, scallops, and bottomfish from the RFE are familiar to importers throughout Asia, North America, and Europe.

Foreign interests have been key in transforming the RFE fishing industry, especially its most valued asset, fishing vessels. Enormous modern trawling fleets, built in the shipyards of Norway, Spain, and Germany, and financed through long-term bareboat charters, have appeared in RFE waters. State-of-the-art crab catcher-processors have been bought from the United States, where crab stock has sharply declined, by Russian shipowners. Dozens of Russian-built vessels have been refitted in Korea, China, and the United States for crabbing, shrimping, and long-lining operations. In most cases, these new and refitted vessels are much more efficient than those of the Soviet fleet. The removal of subsidies, however, coupled with the vessels' higher operating costs and debt loads has meant they must be operated effectively and use large volumes of quotas to be economically viable.

The Russian fleet, both old and new, has come to rely on foreign ports for repairs, crew changes, and even transshipment of products; thus, Russian ports are inactive and decaying. Numerous shoreside plants, which operated throughout the RFE in Soviet times, have deteriorated, and work has virtually ceased at many. Russian financial sources for the industry are almost nonexistent, resulting in widespread reliance on foreign credit. For numerous reasons, much of

the profit during the boom years of crab and pollock fishing in the 1990s ended up offshore. The proliferation of new fishing firms in the early 1990s was accompanied by a radical reorientation toward foreign markets, foreign financing, and foreign technology. Although other industrial sectors saw similar change, the fishing industry's move into the international market was particularly abrupt and widespread due to factors peculiar to the industry:

■ Close international contacts, especially with Japan and the United States, forged during joint fishing operations and other business conducted in the past.

■ Insulation, particularly for export activities, from the barriers inhibiting foreign involvement in other industries.

■ The established value of many RFE seafood products on international markets.

■ The decline of productive fisheries and access to fisheries throughout much of the world, including those countries comprising the RFE fishing industry's major potential foreign partners: Korea, Japan, Europe, and the United States.

■ Foreign businesses affected by the decline of productive fisheries and therefore particularly eager for new buyers of their ships, or particularly enthusiastic to send vessels to Russian waters, and international seafood marketers particularly hungry for new product sources.

Foreign-built vessels brought the greatest foreign involvement. In the first half of the 1990s, approximately fifty new pollock supertrawlers were delivered under bareboat charter from Norwegian, Spanish, and German shipyards—the largest infusion of foreign capital the industry had ever seen. A fleet of twelve new longliner vessels arrived from Norway under similar conditions. Approximately fifteen large crab catcher-processors, with capacities roughly three times greater than their Russian counterparts, entered RFE fisheries between 1990 and 1996 from the United States. Likewise, Japan and Korea sold or chartered a large number of smaller used vessels of various types to RFE fishing companies.

These foreign vessels typically fly the Russian flag, and Russian companies based in the RFE effectively own and operate them. Arrangements, however, commonly include some operational management and marketing by a foreign company. Foreign specialists typically occupy key positions on the vessel, and foreign entities retain financial control through chartering or mortgage obligations. Operational control has tended to revert to the Russian side as financial obligations are satisfied and as the Russian fishermen gain experience with the new vessels and their technology. Although many of these new and chartered vessels have operated successfully in RFE waters, their combined impact has depleted resources. Payments of loans and charter fees have often been problematic and led to conflicts with foreign entities and between Russian operators over the terms of these transactions.

High taxes and duties, along with burdensome regulations and inefficient port procedures, have led many Russian operators to keep foreign-built vessels out of RFE ports. Even crew changes have often been done at sea or in foreign locations. Russian-built vessels are more likely to call in Russian ports between voyages, but almost uniformly ship their export seafood products directly from the high seas to foreign ports. Russian-flag vessels or those delivering their product then stock up with provisions from these foreign ports to be delivered directly to the Russian fleet at sea. During the 1990s, Pusan, Korea, nearby and with good service capabilities, has come to resemble an offshore Russian port city: the dry docks are full of Russian vessels, business hotels host delegations of Russian fishing industry entrepreneurs, and one entire area of town near "*ulitsa* (street) Texas" caters to Russian fishermen and shuttle traders and resembles a Korean version of Brighton Beach's commercial strip.

Foreign financing of vessel acquisition, refits, repairs, and provisioning has been closely connected with obtaining marketing rights to fish products. These rights confer some control over cash flow, and therefore increase security for the financing entity in an environment where mortgages and other legal instruments lack sufficient power. Marketing rights also help the financing entity to make a profit through margins or commissions on the sale of product. This approach to profitability usually substitutes for a more traditional equity stake, which carries the vagaries of shareholder rights in Russia and the dangers of Russian taxes. For the aspiring Russian seafood executive, initially inexperienced in international markets, assigning rights-of-sale to a foreign partner is a way to learn about these markets firsthand before entering them directly, and also to check on the sales of other foreign partners. This arrangement also offers, through transfer pricing and other methods, a mechanism to accumulate funds not subject to harsh Russian taxes and currency controls.

The dramatic shift of RFE seafood producers toward foreign markets after the collapse of the USSR did not represent a calculated preference for higher returns: Russian producers simply had no alternative since the domestic market was no longer viable. The steep decline in the purchasing power of Russian consumers was accompanied by a breakdown of old Soviet marketing channels. Producers lacked the financing to offer the extended terms of sale required by most Russian buyers. The business environment made the collection of sales proceeds difficult. Fortunately, Pacific Rim markets were close at hand. Unfortunately, these markets have been widely accessed through illegal, as well as legal, exports of RFE seafood.

Legal and illegal export: pollock and king crab. It is difficult to measure the true quantities of seafood exports from the RFE in the 1990s because of the extent of unrecorded and under-reported export shipments. Official figures, however, clearly indicate the trends: revenues from export shipments roughly

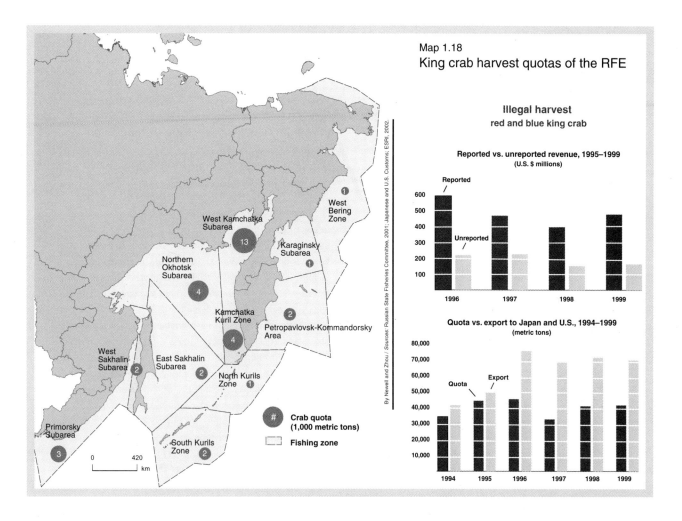

Map 1.18
King crab harvest quotas of the RFE

Illegal harvest
red and blue king crab

Reported vs. unreported revenue, 1995–1999
(U.S. $ millions)

Quota vs. export to Japan and U.S., 1994–1999
(metric tons)

By Newell and Zhou / *Sources: Russian State Fisheries Committee, 2001; Japanese and U.S. Customs; ESRI, 2002.*

doubled from the late 1980s to 1992, and then doubled again by 1996.[90] This should be viewed in the context of a roughly 40 percent decrease in harvest volumes during the first period, and another 10 percent drop during the second. The sharp rise in export revenues in the face of large harvest declines was achieved in part by terminating or decreasing fishing of low-value species, a significant part of the Soviet catch.

Russian vessels' pollock catch has also fallen by about 50 percent since 1988, but this drop has been offset by a rise in the value of pollock, the most abundant RFE species. The arrival of the European supertrawlers, along with the refitting of several large Russian trawlers, which primarily produce blocks of frozen fillets, has made Russia a major international supplier of relatively high-value pollock fillet blocks. By processing the frozen fillets onboard, and thereby adding value to their product, the Russian trawlers are potentially providing a higher return to the vessel owner.

King crab is the other major RFE seafood contributing to export sales, and the one most associated with unrecorded shipments, illegal fishing, and underreported revenues. Prior to 1990, the few RFE companies fishing for king crab used small Japanese-style conical pots. Most of this catch was canned for European markets. With the arrival of U.S. crabbers and large rectangular pots in the early 1990s, alongside

the deterioration of Russian monitoring and enforcement, legal and illegal catches quickly increased. The catch rose from about 15,000 metric tons per year in the late 1980s to more than 70,000 metric tons per year in the late 1990s (see fig. 1.4). Using a relatively small boat, king crab can be delivered live, chilled, or frozen and is potentially very lucrative compared to operations involving pollock and other species; thus incentive for illegal fishing and unrecorded exports has been very high.

As a result, informed observers estimate Russian king crab harvest levels by extrapolating from the import data of Japan and the United States, the two major importing countries, rather than from the official catch and export data.[91] This data shows that about 43 percent of the actual catch of the most abundant and lucrative crab species (red and blue king crab) caught in the RFE between 1996 and 2000 represents overharvest and illegal fishing. Based on these estimates, the implied value of illegal shipments of red and blue king crab from 1996 to 2000 is about U.S.$180 million per year (see map 1.18). This figure represents overharvesting only; it does not account for the underreporting of revenue through transfer pricing, misidentification of species, or other techniques used to avoid income reporting or quota limitations. This estimate for red and blue king crab may represent the most

Illegal fishing and export

Admiral Innokenty Naletov, commander of the Federal Border Service's marine forces, estimates Russian losses from illegal fishing in its exclusive economic zone annually top U.S.$2.5 billion.[92] Evgeny Nazdratenko, chairman of the Fisheries Committee, estimates U.S.$500 million in unrecorded fish exports to Japan alone. Bureaucratic red tape leading to high harbor dues and long clearance times in Russian ports is a major reason for illegal export, which usually takes place with the fish illegally traded on the open sea.[93] Despite well-crafted Russian efforts to blame foreign firms, according to Vyacheslav Serzhanin, first deputy chief of the marine protection department of the Federal Border Service, 95 percent of those who violate the country's antipoaching rules are Russians.[94] Russian trawlers often operate without a license, ignore quotas and tax regulations, and sell their illegal catch from Russian territorial waters in Japan and South Korea. In 2000, Russian border guards shot and sank a Russian trawler suspected of poaching in the northern Kuril region.[95]

These operations appear well-organized: journalists, researchers, and officials increasingly refer to a "fish mafia" composed of established firms that use complex embezzling schemes, sophisticated document forgeries, and even violence. This "mafia" is believed responsible for the assassination in May 2002 of Vitaly Gamov, head of the Federal Border Service directorate in Yuzhno-Sakhalinsk, the capital of Sakhalin and a region claiming one of the most corrupt fishing industries in Russia. In a series of investigative articles, the Russian daily *Izvestia* named individuals in the industry suspected of corruption, including Dalmoreprodukt President

Yury Didenko, who allegedly gave a U.S.$1 million bribe to a "group of people" in the government and Federal Fisheries Committee to help him "resolve some problems."[96] Dalmoreprodukt is one of the RFE's largest fishing firms, raising speculation that corruption has reached the highest levels.

Illegal fishing is not limited to Russian companies: Japanese, Chinese, Korean, and U.S. firms have also been caught. In May 2000, a large South Korean fishing firm agreed to pay U.S.$2.5 million for poaching in the Sea of Okhotsk after the captains of three ships admitted to concealing harvest volumes that were much larger than permitted.[97] In June 2000 alone, Japanese fishermen were fined an estimated U.S.$2 million for illegal fishing and seven Japanese fishing vessels had their salmon licenses revoked for poaching. Charter and boat lease arrangements between the United States and Russia have paved the way for unusual, sometimes illicit, trade arrangements.

The Russian government has tried to address the problem, but lacks both money and manpower and faces corruption within enforcement agencies. As State Duma Audit Chamber Chairman Sergei Stepashin cynically put it, "the more bureaucrats there are, the more sources of corruption there are."[98] There have also been limited efforts to address the problem bilaterally. A memorandum of cooperation on antipoaching efforts between the Federal Border Service and Japan's Department for Security at Sea, for example, has resulted in increased vigilance by Japanese customs officials inspecting export documents. Some arrests have been made.[99]

– JN

significant illegal seafood exports from the RFE. A similar situation exists with other crab species, but on a smaller scale. Japan's northern ports, processing plants, and entrepreneurs have benefited greatly in the short term from illegal live crab exports from Russia. Such overharvesting, however, represents a serious threat to one of the RFE's most valuable resources and to all who rely on it.

Developments in the king crab and pollock fisheries reflect the complex and sometimes paradoxical role of foreign interests in RFE fisheries generally. New fishing and processing technology—financed, installed, and often temporarily operated by foreigners—has sharply raised harvest efficiency and greatly improved quality. But harvest efficiency, combined with ineffective monitoring, has pushed pollock and crab stock into decline. Furthermore, the financial obligations of Russian firms have led to many cases of substantial foreign control of operations, especially of marketing channels. But international transactions, including unreported product de-

liveries to foreign ports, have allowed Russian entrepreneurs to hide income, accumulate personal and corporate wealth abroad, and reduce Russian government rents. Undoubtedly far greater rents, both public and private, have been lost to the RFE through the wholesale shift of industry support activities (shipbuilding, repair, provisioning, transshipment, crew rest, and recreation) to foreign ports. Unlike the shift to exports, this shift is not stimulated by the logic of geography and markets. It is largely the result of Russian taxes, customs, and regulatory practices, along with deteriorating RFE port facilities. It is no surprise that Russian proposals for improving the RFE fishing industry often involve recasting the role of foreign interests and fundamentally reforming the management of fisheries resources.

Industry reform. As Russia grapples with its fisheries crisis, lessons from the region's neighbors are important to consider. The United States, Japan, and Korea have all seen major

declines in seafood harvests, bitter conflicts between resource users, and arguments over the role of foreign interests. None of these countries, however, have had to address these problems all at once while simultaneously confronting dramatic national, political, and economic change.

The key ecological and economic question for RFE fisheries is how to ensure long-term sustainable harvests. Over the past decade, pollock and king crab have delivered most of the revenue earned from the region's fisheries, if illegal fishing and unrecorded exports are included.[100] The status of these species, therefore, will largely determine the future health and viability of the RFE fishing industry. In the U.S. Pacific region, where pollock and king crab have held a similar economic importance, dramatic changes in the abundance of these species have caused ferocious debate as to the cause. Political battles over the fishing quotas for these species continue regionally and in Washington, D.C. In recent years, the United States has significantly resuscitated pollock populations and increased the value of pollock products produced at sea through management measures, including limited entry, cooperative fishing, vessel buy-back programs, and transferable quotas. Meanwhile, Russia's pollock stocks continue to decline, with Chairman Nazdratenko and others calling for a moratorium on pollock fishing in the Sea of Okhotsk.[101] Adopting successful management techniques from the United States may benefit Russian stocks, but will have no lasting impact unless the government reigns in uncontrolled fishing in RFE waters by Russian and foreign operators.

Alaska's once enormous king crab population declined sharply in the early 1980s, and remains at a fraction of its former level. The part that overfishing, environmental change, and other factors play in this dramatic and enduring downturn are still under debate. Just such an irrevocable lesson may be the essential one for the RFE: once king crab stock is driven below a certain level, its recovery may be weak even while fishing is tightly controlled, as in Alaska. The Russian catch peaked in 1996, declining slightly in annual metric tonnage through 2000, but with a significant drop in the average size of crabs caught, according to industry observers. In response, the government reduced quotas for king crab by more than 40 percent in 2001, with another cut (especially sharp in the key area of western Kamchatka) in 2002.

Although stock assessment and fisheries management are inexact sciences, most experts maintain environmental change and fishing pressure interact; thus, climate change may affect a stressed stock more readily than a healthy one. This is one reason why the unreported catches allowed by weak monitoring and enforcement are so troubling for the future of Russia's fisheries.

The Putin Administration is explicitly committed to establishing the rule of law and taking action on illegal activities, especially those that harm Russia's national interest. The fishing industry appears to be a good candidate for these efforts, but such attempts could further burden an already harsh and complex regulatory regime without actually reducing illegal fishing or corruption. Largely through top officials in the Fisheries Committee, the Putin Administration has consistently advocated certain fisheries policies, which can be summarized as follows:

- Increase open-ocean fishing and fishing in zones of other countries to offset current resource shortages in the RFE.
- Encourage inshore, small-boat fisheries development, thus increasing employment and other benefits to local economies, and reward, through quotas, those firms establishing or delivering to shoreside facilities or otherwise selling to the domestic market as opposed to the export market.
- Reform tax and customs law to draw the Russian fleet back to Russian ports for repairs and other services. Streamline other regulations to avoid costly delays for vessels in RFE ports.
- Stimulate Russian shipbuilding by offering guaranteed quotas to those companies buying fishing vessels from Russian shipyards.
- Reform the quota system by tying each allocation to a specific vessel capable of fishing for it, and by rewarding companies not in tax arrears and companies that directly benefit the Russian economy, through the delivery of product to the Russian market or by ordering vessels from Russian shipyards, with quotas. Indeed, certain quotas are available only to shipowners agreeing to deliver their product to the Russian market. The government also began pursuing its goal of transparency in 2001 through open auctions of many valuable quotas, obligating the buyer to pay for quotas in full prior to fishing.
- Crack down on illegal fishing and illegal exports. The government has introduced a system based in Petropavlovsk-Kamchatsky and Murmansk to track catches and ship locations; vessels are required to install and operate approved electronic transmitting systems. Mandatory port clearance may be introduced for all vessels carrying product for export, especially crab.

Some of these policies have not been—indeed cannot be—implemented, and thus have done little to ameliorate the problems they were designed to address. This ineffectiveness stems from a combination of unrealistic and ill-informed policy measures and the deep, recalcitrant nature of many of the political and economic problems facing the industry and the region. Following is a short critique of the proposed policies:

- Although some Moscow and regional officials advocate returning to open-ocean and foreign-zone fishing, as in Soviet times, experienced industry participants say such operations are unprofitable for shipowners without subsidies and are even potentially disastrous, given current input costs (such as fuel). In any case, the access system

in foreign zones has changed dramatically and would no longer be open to Russia on an acceptable basis.[102] This policy proposal seems to be based more on nostalgia for the Soviet's worldwide fishing presence, and in desperation about the state of the RFE's stock, than on a sober and realistic strategy.

■ The RFE would suffer if government policy ignored the advantages of international trade and insisted that seafood products be delivered to the Russian market or to Russian shoreplants. Widespread development of inshore fisheries and related shoreside plants remains unlikely since the already large domestic fishing fleet, which processes products on board, lacks sufficient quotas. In addition, any shoreside operation will encounter the same regulatory and infrastructure problems that the offshore fleet has attempted to avoid by basing many operations overseas. For these reasons, most attempts to attract foreign or domestic investment in shoreside development projects in the RFE have failed in the past decade.

■ As for reforming regulations to attract the fleet back to Russian ports, there appears to be little meaningful progress in this area. Putin's efforts to strengthen governmental control in all economic sectors may work against his goal of streamlining port procedures. Chairman Nazdratenko complained recently that about seventeen separate agencies harass fishermen in their attempts to earn a livelihood, and that to receive the proper licenses and permits for fishing operations requires 102 separate signatures.[103] To date, several foreign ports remain centers of offshore Russian fleet activity.

■ Attempts to stimulate shipbuilding in Russian yards through quotas are doomed to fail as long as those yards cannot turn out competitive vessels. At present, Russian shipyards generally produce inferior, inconsistent products at high prices. Far fewer vessels are entering the RFE fisheries today than previously, and those that do are typically older, foreign-built hulls with lower fixed and operating costs and higher productivity than new Russian-built ships. For the federal government to force Russian operators to purchase Russian-built ships in order to procure quotas would undermine the industry's chances of achieving economic viability.

■ Introducing auctions for the most valuable quotas is the most tangible change enacted by the Putin Administration. It is still premature to assess the overall impact of auctions, but they do seem to be relatively open and transparent compared to the traditional opaque quota system. The purchase of auctioned quotas, however, depends on financial wherewithal (whether from foreign credits, "mafia" money, or other sources) and the possession of requisite vessels. Many established firms do not have the required funds or are tempted to overpay in order to continue operations and retain employees. Since no company can reliably estimate what its fishing quotas will

be until the auctions are held, auctions also complicate the planning and financing of efficient fleet maintenance and fishing operations. Perhaps more challenging still, many industry observers are convinced that some companies have bought small quotas at high prices with the intention of illegally harvesting greater volumes than those purchased. Finally, even top officials question the financial benefits to the government: Chairman Nazdratenko said auctions have not brought more money to the Russian treasury, but in fact have "brought Russia only losses," which he assesses at U.S.$33 million (the auctions contributed some U.S.$190 million in total to the Russian budget in 2001).[104] Despite several highly publicized arrests of foreign and Russian vessels for violating fishery rules and despite discussions between Russian and Japanese officials about illegal seafood deliveries to Japan, the essential problem of enforcement remains unsettled as of late 2002. The total amount of illegally caught live red and blue king crab shipped to Japan was virtually the same in 2000 as in 1999. Since the total volume of this crab caught in the RFE was lower because of resource depletion, illegal crab actually comprised a larger percentage of the catch in 2000 than in 1999. The data for 2001 are similar, and informed speculation about the role of auctions in stimulating illegal fishing continues. Meanwhile, as enforcement agencies try to fulfill their mandate to end illegal fishing, they take little note of their increasingly costly disruptions to legitimate operators. In the end, successful, cost-effective enforcement depends not only on public campaigns and more officers, but also on providing management that offers stability and opportunity for operators to make a profit without illegal fishing. It remains for Russia's neighbors, particularly Japan, to assist in controlling illegal fishing and export by tightening controls and exchanging information about RFE seafood imports, especially live crab.

Expanding the domestic activity of Russia's fishing industry will require fundamental reform of taxes, duties, and regulatory procedures to attract the fleet back to Russian ports. Ironically, the RFE fishing industry attracted large amounts of foreign and domestic capital (mostly in the form of vessels) to the RFE in the 1990s, and has succeeded so well that fishing power has outstripped the resource base upon which it depends. The implications are deeply troubling for fishermen and their families, shoreside communities, and the region's tax base and overall economic well-being. Given the recent clashes between *oblast*s and *krai*s over fishing rights and Russia's problematic fisheries management and enforcement, it is difficult to envision how public allocations of this shrinking resource will alleviate problems. In addition to managerial and enforcement improvements, measures to reduce fishing capacity must be implemented. The alternative may be the destruction of the RFE's most important industry.

Energy

J. NEWELL—Russia holds the world's largest natural gas reserves, second largest coal deposits, and eighth largest oil reserves.[105] A considerable portion of these resources are located in the RFE. With energy-poor Northeast Asia next door, some promote oil, gas, and coal export as the region's greatest economic hope.[106]

The region already exports large quantities of coal and some oil from Sakhalin. The largest coal producer, Sakha-based Yakutugol, exports about 60 percent of its annual production to Japan and other Asian-Pacific countries. Companies in Primorsky and Sakhalin also export coal.[107] The Sakha government, together with domestic and Japanese energy companies, dreams of a power bridge from Sakha through Sakhalin ending in Hokkaido, Japan—generated by hydroelectric power stations on the Uchur (3700 MW) and Timpton Rivers (1300 MW), with a third station on the Sakhalin River (2000 MW).[108] There are also plans to export hydroelectric power from plants in Amur to China.

Despite these export plans, the region continually struggles with energy shortages. Residents are often without heat or power due to an inadequate and erratic supply; in 2001 a number of people froze to death for lack of heat. To survive such shortages, energy suppliers import coal from western Siberia to fuel coal-driven generators, which provide more than three-quarters of the RFE's heat and power.[109] The region also imports petroleum products because of inadequate refining capabilities. Sakhalin, for example, uses profits from crude oil exports to purchase oil products from abroad, such as diesel fuel from the United States. Even the RFE's largest producer of refined oil, Khabarovsk Krai, imports fuel products.

The origins of the current energy morass are complex, extending beyond the scope of this summary, but they relate to how the Soviets built the region's energy system.[110] The RFE's mountainous topography made constructing an integrated system in the northern RFE unfeasible.[111] Soviet planners instead designed a series of systems (see map 1.19) to supply power to dispersed settlements, essentially military outposts and mining and fishing towns. But the World Bank estimates five thousand villages in Russia are not connected to the electricity grid.[112] This system often requires ship-ping coal from surrounding regions. The smallest settlements largely rely on diesel generators and their fuel, since it must be trucked, shipped, or flown in, is expensive (up to U.S.$0.21 per kWh).[113]

In the south, the Soviets built an electricity grid, but again, in many regions coal must be imported to fuel thermal power stations. Khabarovsk Krai, for example, has imported up to 85 percent of its fuel in some years.[114]

Shipping coal to the north is costly, partly due to the short navigation season (the Sea of Okhotsk and the Siberian seas are frozen most of the year) and poor infrastructure (railroads through the southern RFE travel primarily west to east and roads become increasingly scarce farther north). Lower federal subsidies and high transport costs make these shipments even more costly, leading to a spotty supply. The energy crisis has become acute in remote villages and in the mountainous northern region. Many of these villages, even those in the south, have power only a few hours a day.

High cost is only one reason for the erratic energy supply. Coal industry restructuring closed many mines, greatly reducing production. Some operating mines lack the capital to modernize and increase production.[115] Coal mines near Vladivostok, for example, often cannot produce because fuel transportation is too costly and workers have not been paid. This causes power cuts and blackouts in Vladivostok—the banking and trading center of the RFE. Many industrial enterprises unable to pay for coal are forced to halt production or close. In towns where a single industrial enterprise may employ most residents, lack of coal delivery can essentially shut down the town as the enterprise may also supply the area's electricity and heating. To keep energy flowing, these

Nikita Ovsyanikov

A power station belches coal soot in the arctic town of Pevek, Chukotka Peninsula.

enterprises require subsidies, which further impoverishes municipal and regional budgets.

Increased energy efficiency would help ameliorate the RFE's energy crises. As one of the world's most energy-inefficient countries, Russia has a high rate of energy intensity (energy per unit GDP). There are four reasons for this, according to William Chandler, an energy specialist on the former Soviet Union: (1) energy-hungry heavy industry dominated Stalinist economies, (2) energy conservation was not a priority because production costs were rarely important, (3) Soviet energy prices rarely reflected actual cost, and (4) technological development was stifled. Throughout the former Soviet Union, Chandler found "energy use in factories, apartments,

Figure 1.5
Energy surplus and deficit for selected countries, 1965–2020

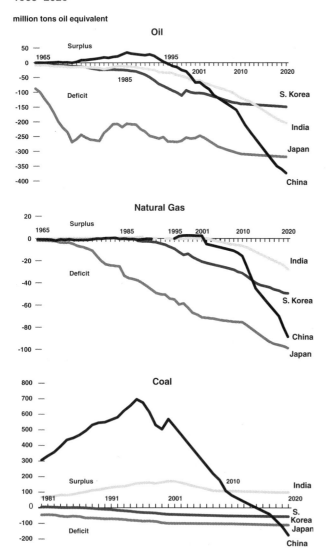

Source: Adapted from data in the *BP Statistical Review of World Energy*, 2002.

Pipeline geopolitics in Northeast Asia

Faced with rising energy use, energy-poor Northeast Asia sees Russia as a future supplier of coal, oil, and natural gas. Natural gas is attractive to Asia as a low-emission fuel, and Russian oil is attractive as a means to reduce dependence on Middle Eastern oil. Figure 1.5 shows past and projected energy deficits for Japan, South Korea, China, and India (included because of India's 20 percent share in the Sakhalin I oil and gas project), using U.S Energy Information Agency medium economic growth scenarios. Already the world's largest importer of oil and liquefied natural gas, Japan has imported RFE coking coal for decades and now imports oil from the Sakhalin II project. South Korea, which received the first shipment of oil from Sakhalin II, may become a major buyer of Sakhalin liquefied natural gas (LNG) and forms a potential primary market for Sakha natural gas. China is a potential market for both oil and gas and, although long a coal exporter, may face a deficit of this resource in just fifteen years (see fig. 1.5).

Sakhalin-based companies are planning or already building the infrastructure necessary to bring oil and gas to these markets. Sakhalin Energy (Sakhalin II) plans to build oil and gas export pipelines across Sakhalin Island to Prigorodnoe, close to the ice-free port of Korsakov and future site of the world's largest LNG terminal. But Sakhalin Energy has not secured a long-term contract for gas; plans will not proceed until this occurs. Exxon-Mobil, operator of Sakhalin I, may also build a gas pipeline across the island and undersea to Hokkaido (Japan), exporting natural gas to Japan by 2008. ExxonMobil is also negotiating with potential buyers in China.[116] To deliver its oil by 2005, the company wants to build another undersea pipeline – this one across the Tatar Strait to an existing tanker terminal in the town of De-Kastri on the eastern shore of Khabarovsk.[117] In late 2002, Russian oil giants Yukos and Transneft announced competing pipeline plans to export oil to Asia. Yukos, with the state-owned Chinese National Petroleum Company, wants to build a U.S.$1.7 billion, 1,700 km pipeline from Angarsk (Eastern Siberia) to Datsin, China. Transneft envisions a U.S.$5 billion, 3,800 km pipeline from Angarsk to a small bay near Vladivostok. From there, it would ship oil by tanker.[118]

These projects come with environmental costs. The pipelines for Sakhalin II will cross salmon-spawning rivers (see p. 400), and environmentalists have similar concerns about the Kamchatka gas pipeline (see p. 362).

—JN

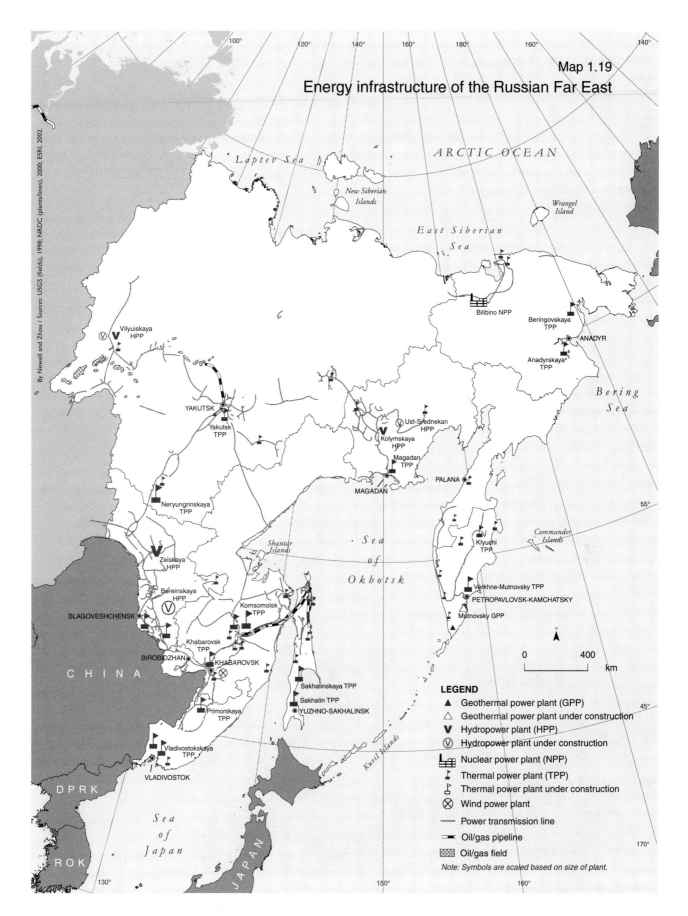

Map 1.19
Energy infrastructure of the Russian Far East

By Newell and Zhou / *Sources:* USGS (fields), 1998; NRDC (plants/lines), 2000; ESRI, 2002.

ARCTIC OCEAN

Laptev Sea

New Siberian Islands

Wrangel Island

East Siberian Sea

Bilibino NPP

Beringovskaya TPP

ANADYR

Anadyrskaya TPP

Bering Sea

Vilyuiskaya HPP

YAKUTSK

Yakutsk TPP

Ust-Srednekan HPP

Kolymskaya HPP

Magadan TPP

MAGADAN

PALANA

Neryungrinskaya TPP

Commander Islands

Shantar Islands

Sea of Okhotsk

Klyuchi TPP

Zeiskaya HPP

Bureinskaya HPP

Komsomolsk TPP

Verkhne-Mutnovsky TPP

PETROPAVLOVSK-KAMCHATSKY

BLAGOVESHCHENSK

Khabarovsk TPP

Mutnovsky GPP

BIROBIDZHAN

KHABAROVSK

CHINA

Sakhalinskaya TPP

Sakhalin TPP

YUZHNO-SAKHALINSK

Primorskaya TPP

0 400
km

N

Vladivostokskaya TPP

VLADIVOSTOK

DPRK

ROK

Sea of Japan

Kuril Islands

JAPAN

LEGEND

▲ Geothermal power plant (GPP)
△ Geothermal power plant under construction
V Hydropower plant (HPP)
Ⓥ Hydropower plant under construction
▙ Nuclear power plant (NPP)
▐ Thermal power plant (TPP)
▙ Thermal power plant under construction
⊗ Wind power plant
— Power transmission line
▬ Oil/gas pipeline
▨ Oil/gas field

Note: Symbols are scaled based on size of plant.

and cars from Warsaw to Vladivostok conformed to a striking wastefulness."[119] Some former Soviet states managed to reduce their energy intensity in the 1990s, but in Russia it actually increased. Chandler concluded that Russia could reduce energy intensity by one-quarter to one-half by implementing a number of efficiency measures.[120]

To reach energy self-sufficiency and reduce environmental costs associated with burning coal and diesel fuel, some RFE regions want to increase use of natural gas.[121] Chukotka wants to convert the Anadyr power plant from coal to gas—extracted from the nearby Zapadno Ozernoe gas field—but lacks investment to do so. For decades, Sakhalin's government has seen development of its offshore gas reserves as a means to make conversion possible. The Khabarovsk government would also like to increase its use of natural gas and has been lobbying ExxonMobil, operator of the Sakhalin I project, to build a gas pipeline through its territory for export to Northeast Asia. Khabarovsk has also secured federal funding to help renovate and extend the existing oil and gas pipeline running from Sakhalin to Komsomolsk-on-Amur (Khabarovsk). But ultimately the success of this effort depends on Sakhalin I's commitment to develop this pipeline route. And gas production from either Sakhalin I or II may not begin anytime soon, as the companies need to secure the long-term contracts to make gas extraction viable.

For companies developing the Sakhalin projects, the economic viability of supplying oil or gas to the domestic market is questionable. RFE consumers are unlikely to pay world gas prices (U.S.$90–$110 per metric ton) unless government subsidizes the cost. The Russian market is also comparatively small, and oil and gas infrastructure costs are high.[122]

Southern Kamchatka may be one of the few RFE regions to receive gas, thanks to a pipeline being built from onshore gas fields across the southern peninsula to the region's capital, Petropavlovsk-Kamchatsky, and nearby cities. But the gas will only meet Kamchatka's short-term needs, as the fields are projected to hold only a twelve- to sixteen-year supply. Fishing industry associations and the public oppose the project, as do environmentalists, who fear the pipeline is the first stage of a larger plan to open up greater oil and gas reserves offshore.

Given the remote location of many settlements, the lack of a unified grid system, and good potential for wind, solar, and other renewables, parts of the RFE are ideal for the aggressive development of renewable energy. Unfortunately, investment in this sector has been low, partly because the major international financial institutions active in the region—European Bank for Reconstruction and Development (EBRD), the U.S. Overseas Private Investment Corporation (OPIC), and the Japan Bank for International Cooperation (JBIC)—primarily finance oil and gas (see p. 87).

Oil. Onshore production is limited to northern Sakhalin (about 90 percent of RFE production) and central Sakha (10 percent of production). Oil is piped from both production areas to industrial centers: The Sakhalin pipeline goes under the Tatar Strait to a refinery in Komsomolsk-on-Amur, and the Sakha pipeline connects the Talakan oil field with the diamond-mining region near Mirny. After decades of speculation, surveying, and development, Sakhalin's offshore reserves finally produced oil in 1999 (1.7 million metric tons by Sakhalin II in 2000). Oil companies have ambitious plans to survey and tap more offshore oil and gas reserves near Sakhalin, Magadan, Kamchatka, Chukotka, and Khabarovsk (see map 1.20). The Far East and Zabaikalye Association estimates RFE oil reserves to be 8.9 billion metric tons, although this figure is rough because the exact size of the offshore reserves (which contain 60 to 75 percent of the estimated reserves) is not known.[123]

Oil refining is limited to two technologically outdated refineries in Khabarovsk Krai (Khabarovsk and Komsomolsk) and one small refinery on Sakhalin. Together, they produce less than half the oil consumed in the RFE; the rest is imported from other parts of Russia and from the United States.

An oil flare at onshore oil operations near Nogliki, Sakhalin Island.

Emma Wilson

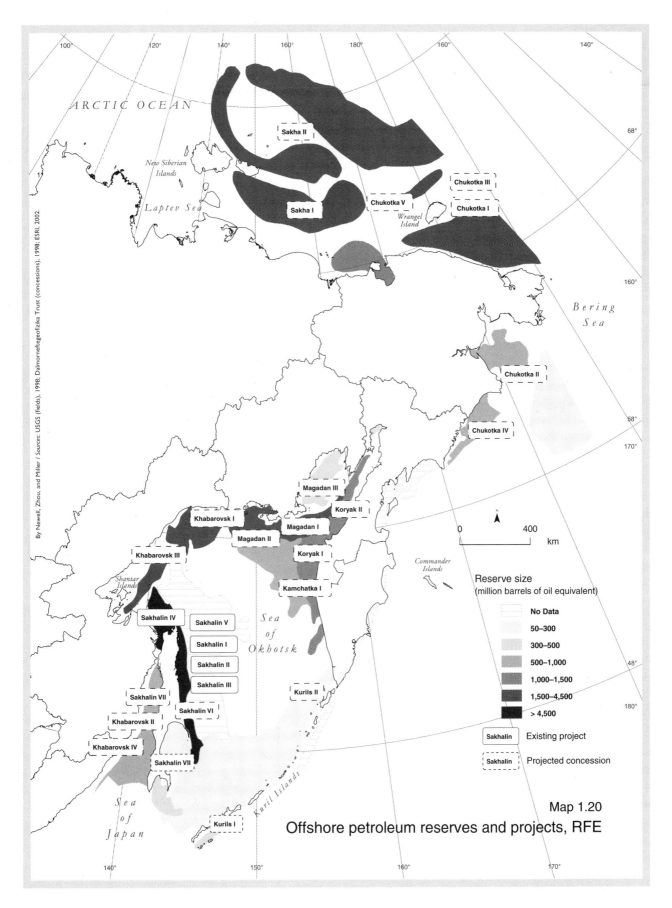

ARCTIC OCEAN

New Siberian
Islands

Laptev Sea

Sakha II

Sakha I

Chukotka V

Wrangel
Island

Chukotka III

Chukotka I

Bering
Sea

Chukotka II

Chukotka IV

Magadan III

Koryak II

Khabarovsk I

Magadan II

Magadan I

Khabarovsk III

Koryak I

Shantar
Islands

Kamchatka I

Sea
of
Okhotsk

Commander
Islands

0 400

km

Reserve size
(million barrels of oil equivalent)

Sakhalin IV

Sakhalin V

Sakhalin I

Sakhalin II

Sakhalin III

Sakhalin VII

Sakhalin VI

Khabarovsk II

Khabarovsk IV

Sakhalin VII

Kurils II

No Data

50–300

300–500

500–1,000

1,000–1,500

1,500–4,500

> 4,500

Sakhalin Existing project

Sakhalin Projected concession

Sea
of
Japan

Kurils I

Kuril Islands

Map 1.20

Offshore petroleum reserves and projects, RFE

By Newell, Zhou, and Miller / Sources: USGS (fields), 1998; Dalmorneftegeofizika Trust (concessions), 1998; ESRI, 2002.

NASA

Taken from a NASA space shuttle, this photograph captures the frozen wetlands and seas along the northeastern coast of Sakhalin.

Oil-producing areas in Sakha and Sakhalin are heavily polluted, and extraction methods are wasteful, as in other parts of Russia. Oil companies lose an estimated 3 to 7 percent (10–20 million metric tons) of Russia's annual crude oil to leakage.[124] The 1995 Neftegorsk earthquake fractured Sakhalin's oil pipelines, resulting in numerous small leaks that polluted wetlands and streams in northern Sakhalin.

Natural gas. With more than one-third of the world's natural gas reserves, Russia is the world's largest exporter. Western Siberia holds Russia's largest gas fields, but the RFE also has significant reserves, mostly in Sakha, Sakhalin, and other offshore areas. The Far East and Zabaikalye Association confirmed RFE gas reserves of 1.6 trillion cu. m, with 60 percent in Sakha and the remainder near Sakhalin. Reserves may be as high as 24 trillion cu. m.[125] Both regions produce about 3.5 million cu. m of gas yearly, but production is not commensurate with reserve size. A pipeline connects Yakutsk to gas fields near Vilyui. Another gas pipeline follows the same route as the Northern Sakhalin-Komsomolsk oil pipeline. Large-scale gas reserve development will likely occur first off Sakhalin, with the development of Sakha's fields dependent on securing foreign investment.

Coal. Coal, the most important energy source throughout the RFE with the exception of Kamchatka Oblast, accounts for about 90 percent of Primorsky Krai's and more than 80 percent of Sakha's total energy production.[126] In the early 1990s, RFE coal production declined more precipitously than that of other industries, but it has remained steady since 1998. The RFE produced 28.2 million metric tons of coal in 2001 (about 10 percent of Russian production) from mining in four

regions: Sakha (9.7 million), Primorsky (9 million), Sakhalin (3.3 million), and Amur (2.7 million).[127] The government hopes to revitalize the industry by mining large untapped deposits, the most important being the Elginskoe deposit in Sakha, the Solntsevskoe deposit in Sakhalin, several deposits in Primorsky and Khabarovsk Krais, and a series of smaller open-pit mines throughout the RFE. The RFE has an estimated 19 billion metric tons of coal, with more than half in Sakha. About 55 percent of RFE coal is lignite; the remainder is bituminous coal.[128]

Coal is largely extracted with opencast mining, which is more destructive though less costly than shaft mining. Opencast mining transforms landscapes and pollutes rivers.

Nuclear. The RFE's only nuclear power plant is an aging reactor in Bilibino, Chukotka. The Ministry of Atomic Energy (Minatom) would like to build floating nuclear power plants in Pevek, Chukotka (see p. 304) and has tried to build stationary plants in other RFE regions. The most recent serious effort was in 1995 when Minatom proposed building a reactor near Lake Evoron in Khabarovsk. Widespread public opposition, concerns about seismicity, and environmental impact and building costs led to the plan's demise. Minatom has since resurrected a 1980s plan to build a 1,200 MW plant in Primorsky Krai, possibly in Dalnerenchensky Raion or Yakovlevsky Raion.[129]

Due to the 1986 Chernobyl accident, Russia's poor nuclear safety record is infamous worldwide. Nuclear accidents have occurred in the RFE as well. Between 1965 and 1994, the Vladivostok-based Pacific Fleet recorded 60 accidents on its nuclear-powered submarines, including 9 fires, 8 nuclear-power generation incidents, 20 collisions, and 4 groundings. In all, 107 people were killed and an estimated 1,300 suffered radiation exposure.[130] In 1993, the Japanese government, acutely aware that Russia was dumping nuclear waste in the Sea of Japan, provided about U.S.$29 million to build a floating filtration plant to store liquid radioactive wastes generated by the Zvezda Far Eastern Shipyard in Bolshoi Kamen. After numerous delays and complaints that contractors were dragging out the work to raise construction costs, the *Landysh* facility began operating in October 2000.[131]

Russian environmentalists are resisting government plans to import spent nuclear fuel. In July 2000, Putin signed a controversial law allowing such imports, which could bring a total of 20,000 metric tons into Russia, generating an estimated U.S.$21 billion in revenue over a 10-year period.[132] Russian environmental groups collected 2.5 million signatures to have a national referendum, but the Central Election Commission, saying that some of the signatures had been falsified, rejected the initiative (see p. 104).[133] The government has tentative plans to build processing facilities for spent nuclear fuel in the RFE, including one on Simushir, a small island in the Kuril Island chain. Use of existing facilities in Siberia is more likely, but this will require transporting nuclear fuel

from Asian countries through RFE ports, such as Vladivostok and Vanino. Transport raises concerns about the potential for accidents or theft along the route.

Hydroelectric. The rivers of the RFE can potentially generate 1008 billion kW-hours of electricity, 68 percent of which is commercially feasible and only 2.8 percent of which is currently exploited.[134] The largest hydroelectric station is the Zeysky plant in Amur Oblast. While hydroelectric power is often promoted as environmentally benign, scientists noted that construction of the Zeysky plant permanently altered ecosystems, replaced taiga landscapes, and obstructed migration patterns of roe deer and moose. The 2000 MW Bureinskaya Hydroelectric Power Station, also in the Amur region, is under construction (see p. 221), and there are plans to build the Gilyuisky Hydroelectric Power plant, which will flood part of a *zapovednik* when constructed (see pp. 209–10).

Geothermal. Geothermal reserves lie primarily in Kamchatka, where the Mutnovsky Geothermal Power Plant was built (see p. 362). The plant, built in part with a U.S.$99.9 million loan from the EBRD, began operating in December 2001.

Wind, solar, and other energy sources. With ongoing energy crises, some regional governments are showing growing interest in renewable energy including microhydroelectric power stations, wind-power stations, and solar energy devices. In Chukotka, a 250 kW capacity wind-power station was installed to take advantage of strong winds off the Bering and Chukchi Seas.[135] A Japanese philanthropist recently installed a wind-power turbine in Agzu, an indigenous village in Primorsky Krai.[136] These model projects, unfortunately, are rare.

Timber

J. NEWELL—Although the timber industry has traditionally accounted for between 5 and 10 percent of the RFE's total industrial production, its importance to the economic and social fabric of village life in some regions is far greater. In the timber-rich southern RFE, especially Khabarovsk and Primorsky Krais, log exports contribute a large portion of hard-currency revenue. For many other towns and villages, the closure of wood-processing enterprises, a trend that began after *perestroika*, has been devastating, causing a loss of jobs, tax revenue, and basic services such as a stable energy supply (the boilers used in timber mills often provide centralized heating for communities).

Official timber production figures for the RFE indicate a dramatic decline in harvest, with 2000 production registering just a third of 1985 levels. This would suggest that accessible forests have had some respite from decades of overlogging, including wasteful and destructive practices such as clear-cutting, where all trees in a given plot are logged. (Clear-cutting has contributed to the steady replacement of mature conifer forests with second-growth deciduous forests at a rate of about 0.8 percent a year [see p. 31].)

In fact, these practices may have become even more prevalent than during the Soviet era. Higher energy and transport costs have combined with a market shift from states of the former Soviet Union to China, Japan, and South Korea to increase overlogging in forests accessible to these markets. Biologically diverse forests in the southern region (Primorsky and southern Khabarovsk Krai) have been particularly hard hit. The collapse of processing, caused by decreased domestic demand, has meant that woodchips, branches, and smaller logs used to make sawnwood, plywood, and pulp and paper, are left at logging sites—increasing the already enormously wasteful operations and providing fuel for potential future fires (see "Forest Fires of 1998," p. 81).

These Asian markets are radically changing the type of species logged and the type of wood product produced (logs rather than sawnwood, plywood, etc.) as timber companies from the RFE and Eastern Siberia compete to meet demand. The increase in high-grade logging, whereby only large-diameter, commercially valuable trees are felled, is one result. Chinese and Japanese demand for ash logs, prized for housing construction, has led to another: logging along protected river basins (Group I forests) that are crucial for regulating water levels. And the continued high demand for harvest-restricted Korean pine logs has led to overharvest of that species, significantly reducing an important food source (pine nuts) for many animal species in the Ussuri Taiga.

Official production figures are considerably clouded because many logging companies, particularly smaller ones, operate illegally. Numerous small firms emerged as the industry was privatized, and the government has been unable to regulate them. According to a study by World Wildlife Fund–Russia (WWF–Russia), 50 percent of total timber harvest in Primorsky Krai in 1999 was illegal. In addition, *leskhoz*es, the regulatory bodies responsible for forest protection, abuse salvage logging policies and regulations to augment their budget shortfalls; unscrupulous *leskhoz* officials also sometimes seek to enrich themselves. This corruption has fostered widespread indifference among timber companies toward logging regulations, creating a "frontier mentality" in the RFE. It is now difficult if not impossible to enforce timber harvest regulations and collect stumpage and licensing fees. Honest timber companies struggle to compete with illegal loggers.

The greatest long-term threat to the region's forests, however, is rising wood consumption in Northeast Asia. Russia has emerged as the largest log supplier for China, Japan, and South Korea. Massive flooding in China in 1998—attributed to the widespread deforestation of upper river watersheds—forced the central government to strictly limit timber harvests to protect the few remaining natural forests and to prevent further soil erosion. This policy shift led to a tripling of Russian log imports to China in just four years (1999–2002). By 2025, China may face a deficit of 200 million cu. m of wood

per year, or 15 times the total reported yearly harvest in the RFE (see p. 74).

Regional governments have continually called for investment in wood processing, recognizing the advantages of providing such products to these booming markets: larger, more sustainable revenues, more jobs in local communities, and a slowing of timber harvest by increasing the use of secondary products (woodchips, branches). The latter advantage would in turn reduce pressure to continually open up "frontier forests" for exploitation. But such investment has not been forthcoming, primarily due to illegal logging, capital flight, and corruption.

The Russian government has taken measures to reform and better regulate the industry; President Putin himself branded the industry "uncivilized."[137] But efforts so far have been largely unsuccessful because the same government agencies responsible for forest protection are among the violators (see pp. 73–74).

The future health of the RFE forests depends upon effective Russian government regulation of the industry, substantial cuts in Chinese and Japanese timber imports, and the development of a competitive processing industry.

The collapse of wood processing. Since the late 1980s, the production of sawnwood, plywood, paper, and other processed products in the RFE has plummeted. Causes for the collapse are many, including outdated machinery, lack of reinvestment by Russian firms (capital flight), reduction of domestic demand, loss of government subsidies, and continued tariffs on processed wood products by primary consumer countries.[138] The region's timber industry now exports about

70 percent of all production, mostly in the form of logs, to three countries: China, Japan, and South Korea.

In 1989, the industry was more balanced. Almost half of all timber production was used regionally, while 25 percent was sent to other regions of the former Soviet Union, and 30 percent was exported abroad.[139] Processed timber (lumber and panel products) accounted for 20 percent of the region's total timber production, and the Sakhalin and Khabarovsk pulp and paper mills still operated. By 1998, processed timber accounted for just 5 percent of total production, producing only about 485,000 cu. m (see table 1.7).

The collapse of the wood-processing industry negatively affected the region's economy in numerous ways. Aside from quick profits and subsistence incomes for a select few, the export of raw materials provides few benefits. An investigation in February 1999 by two NGOs, Sakhalin Environment Watch and Pacific Environment, revealed the miserable working conditions of Russian loggers. During a visit to a logging site in southern Sakhalin Island, the organizations determined the logging brigade, composed of eight people, earned only about 75 cents per cu. m logged.[140] Thus, each brigade member received an average of less than 10 cents per cu. m logged. The truck driver transporting the logs 40 km to a port received about 25 cents per cu. m. The wood itself was then sold to Japan for ($70 to $100) per cu. m. Loggers work for such low wages because no other job opportunities exist. Unfortunately, many Russian entrepreneurs invest their final profits abroad—part of Russia's capital flight—rather than reinvesting in necessary items for the industry, such as wood-processing equipment.

Logging methods. The collapse of processing has exacerbated the wasteful use of forest resources that plagued the region throughout the Soviet industrial period, from 1940 to 1988. During this period, the timber industry wasted an estimated 40 to 60 percent of all cut timber during the production process, a figure four times higher than in Western timber-producing countries.[141] At the felling stage, loggers chose the best logs and left all others at the logging site. During the transportation stage, the amount of timber cut often exceeded transportation capabilities. Logs left lying for long periods of time often rotted or were infested by insects. Transportation of timber along rivers led to further loss as logs sank, destroying spawning grounds, and releasing resinous tar and other harmful substances into the water. Timber brigades would simply abandon an area after depleting it and move on to new stands of trees.

Russian foresters now report even higher levels of waste at logging sites than in Soviet times due to a lack of demand for woodchips, branches, and smaller diameter trees (which are harvested when a site is clear-cut). These secondary products are traditionally used in the processing industry. There are, of course, other reasons for this waste. Costs to transport and ship to the industry's primary markets—China, Japan, and

Table 1.7
Output of the RFE forest sector, 1985–1998

Product	1985	1990	1995	1998
Timber (000,000 cu. m)	34.5	29.6	10.5	9.8
Lumber (000 cu. m)	6,179.0	5,414.0	973.0	476.0
Plywood (000 cu. m)	35.9	25.3	1.0	–
Particle board (000 cu. m)	117.1	189.4	22.1	5.1
Fiberboard (000,000 sq. m)	23.0	23.8	5.6	2.6
Cellulose (000 tons)	418.3	539.9	60.0	2.2
Paper (000 tons)	228.3	215.4	14.1	0.2
Cardboard (000 tons)	192.0	240.6	13.1	6.1

Note: Timber production includes total wood cutting, but not logging waste.

Sources: Institute of Economic Research, 1999, and the regional chapters in this book.

Table 1.8

Reported RFE timber production, 1995–2000 (cu. m)

Region	1995	1996	1997	1998	1999	2000
RFE	10,508,000	9,500,000	10,930,300	9,854,600	10,615,400	12–15,000,000 (est.)
Khabarovsk	4,600,000	4,400,000	4,662,400	5,618,000	5,016,000	6,393,000
Primorsky	1,830,000	1,450,000	2,761,000	2,200,000	2,672,000	3,309,000
Amur	1,715,000	1,542,000	1,531,000	848,000	1,306,000	–
Sakhalin	1,440,000	1,448,000	1,070,000	461,100	869,400	–
Sakha	868,000	623,000	742,700	561,800	586,200	–
Kamchatka	–	–	136,300	149,200	135,800	–
JAO	55,000	37,000	26,900	16,500	30,000 (est.)	–

Sources: Data, compiled by Newell and the authors of the regional chapters in this book, are from Khabarovsk Forest Service, Sakhalin Forest Service, Amur Forest Service, Institute of Economic Research, and Russian Federal Customs.

South Korea—make it unfeasible to export smaller logs. And inefficient Soviet harvesting and transport equipment is still widely in use.

Perhaps most important, for a variety of reasons (illegal logging, weak regulation, Soviet-era managers still in control of many firms), sustainable forest management and logging techniques have failed to gain a foothold. Clear-cutting remains the preferred practice over much of the RFE's boreal and northern temperate regions. Clear-cuts cause soil erosion, clog river systems, and erode topsoil necessary for regrowth. Clear-cuts also dry out the soil, hinder seedling growth, and create canopy breaks in forests, making forests more susceptible to wind and fire damage. Large-scale clear-cutting also simplifies forest structure, reducing the forest's ability to support a wide range of plant and animal species. Many clear-cut forests never fully recover.

The diversity of species as well as the topography of Sikhote-Alin's forests makes them uneconomical to clear-cut, so selective high grading remains the area's most cost-efficient logging method. The practice of high grading, or taking only the best trees, slowly degrades the forest's genetic diversity and can affect water quality.

Logging shifts to the southern RFE. Timber harvest is gradually shifting from the north to the south. Both Primorsky Krai and Khabarovsk Krai have become growing timber centers, accounting for 72 percent of the RFE's total production in 1999 (see table 1.8), up from 55 percent in 1992. The relative importance of northern regions (Sakha and Kamchatka) to overall production in the RFE, meanwhile, has declined due to high energy costs and comparatively higher transport costs to export logs to Northeast Asian markets.

Given its location in the southern RFE, Amur Oblast's timber production might have been expected to remain stable during the 1990s, but production dropped from 20 percent in 1992 to 10 percent in 1999. This may be due to heavy overlogging of accessible timber stands during the 1970s and 1980s. In Chapter 5, Yuri Darman and Gennady Illarionov also point to the region's remoteness—although it borders China, exporting timber requires rail transport to Eastern Siberia or through Primorsky Krai. Darman and Illarionov also note the comparatively lower quality of most of the timber (see pp. 213–14). Sakhalin Oblast is a puzzle as well: timber production fluctuated greatly, ranging from 12 percent of the RFE's total production in 1992, to 16 percent in 1995, and down to 9 percent in 1999. The closure of most of the island's pulp and paper plants, which were large timber consumers, is likely a major reason (see pp. 402–4).

This geographic shift is significant economically because timber-dependent communities in areas distant from export markets will be less able to compete with their counterparts in more strategically located southern regions. Alternative economic strategies for communities in northern regions must be developed.

For Primorsky Krai and Khabarovsk Krai, by contrast, logging pressures will increase. The two regions contain Russia's most biodiverse forests (the Ussuri Taiga), raising concern that this geographic shift will lead to large-scale logging in these forests. Virtually all foreign logging operations, which account for a growing percentage of timber produced in the RFE, operate in the Ussuri Taiga and nearby coastal forests, particularly in southern Khabarovsk Krai. These ventures may dramatically increase the volume of timber logged in these forests because foreign firms have the capital to build roads and the technology to access timber on previously inaccessible steep slopes. In December 1997, Rimbunan Hijau, a Malaysian company, received a 48-year lease on 365,454 ha in the Sukpai watershed in Khabarovsk Krai. Logging these

Table 1.9
Top fifteen timber producers in the RFE

Firm (Region)	Country	Annual production (cu. m)
Terneiles (Primorsky)	Russia	393,000
Amurlesprom (Amur)	Russia	382,000
Forest Starma (Khabarovsk)	U.S.A.	370,000
Tyndales (Amur)	Russia	267,000
Rimbunan Hijau DV (Khabarovsk)	Malaysia	264,000
Everonsky LPX (Khabarovsk)	Russia	249,000
De-Kastriles (Khabarovsk)	Russia	223,000
Shelekhovsky LPX (Khabarovsk)	Russia	188,000
Gorinsky LPX (Khabarovsk)	Russia	161,000
Luchegorskles (Primorsky)	Russia	139,000
Roschinsky LPX (Primorsky)	Russia	129,000
JV Arkaim (Khabarovsk)	Japan	127,000
Vega (Khabarovsk)	Russia	126,000
Kavelerovsky LPX (Primorsky)	Russia	119,000
Amgu (Primorsky)	Russia	114,000

Source: Compiled by Josh Newell using data from regional chapters of this book. Data for Amur companies are for 1997; the rest are for 2000.

forests may lead to fragmentation of wilderness throughout the northern Sikhote-Alin Mountains because new logging roads will provide forest access outside the leased area (see pp. 175–77). On a positive note, enforcing regulations on large foreign operations is easier than on Russian ventures because historically the government, press, and NGOs have scrutinized international ventures more conscientiously. Rimbunan's logging operation is now one of the largest in the RFE (see table 1.9).

Illegal logging. As noted earlier, official statistics for the RFE indicate a sharp decline in timber harvest throughout the 1990s: Production was between 12 and 15 million cu. m in 2000, down from 29.6 million in 1990 and from 34.5 million in 1985, but up from a post-Soviet low of 9.1 million in 1996 (see tables 1.7 and 1.8). These figures, however, do not reflect actual harvest levels. According to numerous RFE timber sector studies, actual production may be twice as high as the official figures owing to underreporting to avoid taxation and, more importantly, to widespread illegal logging.[142]

The actual definition of "illegal logging" is open to debate: once defined, we can begin to determine actual harvest levels. Defining "illegal logging" would require extensive fieldwork and developing a sampling method to allow for

averaging illegal logging levels across the huge region. Forestry economist Alexander Sheingauz argues, if all forestry regulations were taken into account, virtually every logging operation in the RFE would be illegal.[143] WWF–Russia adopted a more narrow definition, limiting illegal logging to harvesting more than permitted volumes, harvesting outside the permitted area, logging banned species or those not allowed for logging in a given area, commercial logging under the guise of sanitary or salvage logging, and logging without a license or with forged papers. They exclude basic logging violations, such as failing to clean up a site after logging or using inappropriate harvest methods, which Sheingauz undoubtedly includes.[144] Using this definition as a benchmark, WWF–Russia estimated that in 1999 about 1.5 million cu. m of timber (50 percent of total production) in Primorsky Krai alone were illegally logged; this represents about U.S. $450 million in unreported revenue.[145] The Russian government, eager to dispel claims of unbridled illegal logging, maintains only 24,000 cu. m were illegally logged in Primorsky for 1999. Greenpeace-Russia puts the figure at 600,000 cu. m.[146]

Rather than try to supply a monetary figure or to estimate illegal harvest levels in the RFE (since available figures are so variable), this study instead documents some of the more egregious forms of illegal activity. Logging methods and locations, not overall harvest levels, are the primary cause of forest degradation in the RFE. The following sections explore why illegality has flourished in the post-Soviet era, what forms it takes, and why it is so detrimental.

Multiple logging companies, exporters, and export points. Radical privatization led to the conversion of state-controlled *lespromkhoze*s to joint-stock companies. Today, Russian-owned medium and large joint-stock companies produce most of the RFE's reported timber product—from 75 to 85 percent. Privatization, however, forced many large, formerly state-owned logging and wood-processing companies to cut back on production and lay off workers, contributing to an economic crisis. Some unemployed workers started their own logging firms using equipment and materials appropriated from *lespromkhoze*s, leading to a proliferation in the number of firms. By 2000, over 450 logging firms were registered in Khabarovsk Krai alone.[147] Most of these smaller operations log illegally and accordingly their production goes unreported. They often operate for only a few years and then disappear before authorities catch them. Sometimes this is done to avoid taxation, a common practice in post-Soviet Russia. Penalties stipulated in both criminal and civil legal codes are too weak to be effective deterrents: fines for breaking environmental regulations are so low that companies can actually profit more by paying fines for logging and exporting illegally than by operating legally. Criminal timber dealers do worry about confiscation of their timber by the government, but bribes can usually resolve this problem. Larger firms also log illegally, but their less mobile operations are easier to inspect.

According to government documents and testimony from officials and industry representatives, Chinese timber brokers are aggressively moving into the RFE, many illegally. In a letter to then-Primorsky Krai Governor Nazdratenko, the Russian Federal Immigration Service wrote: "After inspection, we found that in the Lesozavodsky and Dalnerechensky Raions, seventy-one Chinese residents are dealing in timber wholesale and export to China. They come to Russia with the S-series business passport, arrange expert assessment of timber quality and value and accompany the timber back to China. All of this goes on, even though they have no rights to work in Russia."[148]

The strong reaction from Russian officials is partially attributed to phobias about Chinese residence and commercial activity on Russian soil, but also reflects the increasing involvement of Chinese firms in the RFE timber industry. Many Chinese operators control wholesale timber yards in the Primorsky cities of Luchegorsk, Dalnerechensk, Lesozavodsk, Ussuriisk, Nakhodka, and Dalnegorsk. Some Chinese export firms are listed under false names or aliases, which allow them to hide cash operations. Growing evidence also indicates Chinese money funds numerous small Russian timber firms and exporters, many of which operate illegally, according to Anatoly Lebedev, director of the Bureau for Regional Outreach Campaigns, a Vladivostok-based NGO.[149]

In spring 1999, the Department for Fighting Organized Crime (DFOC) of the Primorsky regional police uncovered a Chinese organized crime group in the forest-rich Krasnoarmeisky Raion, with a timber storage area and headquarters in nearby Dalnerechensk. Illegal ash and oak stockpiles, purchased from loggers and legalized with fake documents, were being exported to Japan. A police search revealed numerous blank transport certificates, a forest service document required for customs clearance.

In the mid-1990s, reforms dismantled the Soviet system strictly limiting the number of exporters and export points, resulting in an explosion of both. By 2001, Khabarovsk Krai alone had 294 exporters registered.[150] Export points today are so numerous they are virtually impossible for government authorities to regulate. The Primorsky government estimates there are more than ninety-seven export points in Primorsky Krai alone.[151] According to an estimate by Nakhodkales Director Nikolai Pozdnyakov, almost one hundred private piers and moorings that can be used for wood export exist in Nahkhoda port. Newspaper articles throughout the 1990s reported corruption and export of illegally

harvested ash and Korean pine through Primorsky's smaller, more remote ports.[152] On Sakhalin, several companies take advantage of leased forest plots near the shore to helicopter wood from forest plots to ships offshore. Uncontrolled export points also exist upriver from Khabarovsk along the Amur River, where timber is delivered across the river into China. Timber flows are increasing across the Amur River to Tong Jiang (near Khabarovsk) and Hei He (across the river from Blagoveshchensk).

The rising number of export sites has made it increasingly difficult for the Forest Service and Customs to track the origin of timber and assure its legality. Nonetheless, some regional governments do attempt to control the situation. The Khabarovsk government, for example, now mandates that a new state firm, KhabGlavLes, export 20 percent of the region's timber. But this may be an attempt by the government to increase profits rather than to regulate illegal export. In Primorsky, the governor signed a decree in 1997 to ban ash log export and reduce the number of possible export points. Many exporters have ignored the decree, however, and continue to sell timber to other wholesalers and exporters, such as Primorsklesprom or Chinese private companies. In addition, illegally harvested timber is extremely difficult to track through Customs due to the widespread use of forged documents.

"Purchasing" documents. To market illegal timber, companies must provide documentation. They use fraudulent shipment declarations, which list inaccurate prices, grades, species, and timber volumes. Similarly, transport regularly involves forged logging and export licenses, fake transport certificates, and double contracts (one official and one secret).

Josh Newell

Anatoly Lebedev films Russian militia officers inspecting a logging truck at a checkpoint in Krasnoarmeisky Raion (Primorsky Krai).

Such licenses and certificates are widely available on the black market in Primorsky and Khabarovsk Krais. In Roshchino village in Primorsky Krai, field research revealed that logging and transport certificates, complete with the embossed seal of the Forest Service, could be bought for U.S.$300.[153] These documents include dates for logging, logging site data, tree species, allowable logging volume, truck license numbers, drivers' names, and a logging license number. With such certificates, militia and customs checkpoints are easily manipulated.

"We have a steady but mediocre salary," reported Yuri, a truck driver for an undisclosed logging company in Primorsky. "Our officials give me blank certificates to fill in information about the timber that I take on my truck from a logging site. So I write in whatever I want to sell officially; the difference that I hide for a private cash sale is up to me. We negotiate the extra logs' price, and I simply give them to the port manager for cash. Everything is always negotiable, both documents and timber to be exported."[154]

There are other loopholes: Logging without a license also occurs; militia are then bribed at the checkpoint, and the timber is sold to a wholesaler who then forges customs documents. According to Alexander Kichigin, director of the firm Belogorka in Roshchino, "Any consignment can get through the militia point for two to three hundred dollars."[155] The timber is then taken to a wholesale timber yard for sale and export. Pavel Soldatov, former chairman of the Committee on Environmental Protection in Krasnoarmeisky Raion (Primorsky Krai), agrees: "Depending on the quality of fake documents, the amount of ash timber, and the number of people involved, two to five hundred dollars will get you through the militia point. One typical procedure for dealing with the militia is to send a scout ahead of the log trucks to bribe the militia officer, and then the truck can proceed."[156] This is a common strategy in the city of Dalnerechensk: illegally logged timber passes the militia checkpoint and is transferred to a large timber holding area, now a wholesale point controlled by Chinese exporters.[157]

Mislabeling species and quality. Russian exporters and Japanese importers label high-quality timber as pulp logs to reduce the official contract price. This illegal export strategy hides company profit on the Russian side, thereby reducing taxes paid to the government. RFE customs officials and border guards either look the other way or fail to catch this because they are poorly trained in species identification. Japanese importers, after sorting and sizing logs, sell it as commercial-quality timber. In the first six months of 1997, Japan reported 120,000 cu. m of softwood pulp log imports from Russia, North America, and Australia. Russian statistics for the same period show that Russia alone exported 163,000 cu. m of softwood pulp logs to Japan. This practice appears more prevalent in the export of more valuable hardwood ash and oak logs. Japanese customs statistics for 1997 show that

Russian hardwood log imports totaled 363,000 cu. m. Of this total, high-quality logs made up 150,000 cu. m, while the remaining 213,000 cu. m (an unlikely figure) were reported as pulp logs.[158]

Logging of rare and protected species. Large amounts of high-quality Korean pine logs can be seen in the port of Plastun, ready for export to Japan, even though Russian regulations forbid commercial logging of the species. The species may be logged, however, under certain circumstances, to build roads, for example, or during salvage logging. This timber may then be exported legally. Melnichny Timber Company reported exporting 1,200 cu. m of Korean pine from the port of Plastun to Japan in 1998, as well as exporting about 25,000 cu. m of "coniferous" raw logs. A review of the company's logging sites, however, revealed the company's permits pertained primarily to Korean pine forests.[159] The Forest Service participates by issuing bogus logging licenses, granting permission to build roads through Korean pine stands, and agreeing to expand the size of leased plots to include Korean pine areas—all of which facilitate the commercial logging of the species.

Demand for large, high-quality ash logs is increasing in both Japan and China, where the housing industry covets this hardwood. Thus, intense logging targets riparian areas in southern Khabarovsk and Primorsky Krais, where the largest ash trees grow and where they are vital for regulating water levels and controlling erosion. These riparian areas are protected Group 1 forests and hence closed to commercial logging but open to salvage logging. Local customs data show that 640,000 cu. m of hardwood timber (ash and oak) from Primorsky Krai and 150,000 cu. m from Khabarovsk Krai was exported to China in 1998—a total of 790,000 cu. m. In contrast, federal customs data report only about 520,000 cu. m of hardwood timber was exported to China from Russia in 1998. Assuming the reliability of local statistics, federal statistics underestimated the volume of trade by at least 35 percent, not considering hardwood exports to China from regions outside Primorsky and Khabarovsk.

According to Vsyacheslav Balandin, former head of Primorsky's logging industry department, estimated over-logging of hardwoods increased four- to fivefold between 1995 and 1999. The Primorsky and Khabarovsk governments have repeatedly tried to restrict hardwood exports, especially ash, but with little success. On May 25, 1999, Vladimir Stegni, former Director of Foreign Economic Relations for Primorsky Krai, asked the Russian Ministry of Economy in Moscow to include strict quantity limitations on export licenses. He wrote: "Timber hardwood export volumes from Primorsky region to Japan and China are constantly increasing and are much greater than the legal allowable cut volume.... Providing export licenses without quantity limitations yields no results. From February 15 through May 20, 1999, licenses were issued for hardwood logs exported at

a volume of 930,900 cu. m (both Primorsky and Khabarovsk Krais), while the legal quota in Primorsky region for these species for [all of] 1999 is 260,000 cu. m."

Other forms of illegality. Illegality in the industry does not stop here. Myriad other complex schemes and frauds thrive. Many of these involve, ironically, the active cooperation or tacit agreement of the Russian Federal Forest Service, the primary government agency responsible for regulating forest use. *Leskhoz*es regularly harvest export-quality timber themselves under the guise of salvage or sanitary logging.

The Forest Service: oversight agency or logging company?
Prior to 2001, the Federal Forest Service and the State Committee on Environmental Protection managed and controlled the forests. The Forest Service managed eighty-one regional departments, each of which managed a respective region (*krai, oblast*) or republic. Under the jurisdiction of these departments, forest service districts (*leskhozes)* oversaw forest use, management, and protection of a particular administrative district. Although Putin's decrees abolished the Forest Service, *leskhoz*es still function and are administered by the Ministry of Natural Resources. There are 1,740 *leskhoz*es in Russia, with over 40 in Khabarovsk Krai alone.

Years of declining federal funding left many forest service departments and *leskhoz*es without sufficient funds to manage and protect forests. The 1997 forest service budget in Primorsky Krai, containing Russia's most ecologically diverse forests, was 67 million rubles (U.S.$2.7 million), which paid 2,500 staff salaries for 123 forest service stations scattered among 31 *leskhoz*es. Only 18 million rubles came from the federal budget; additional funding sources were varied. The regional government provided 3 million rubles for reforestation, generated by leasing payments and stumpage fees; penalties and fines provided 2.5 million rubles. The U.S. Forest Service donated 1 million rubles to fight the gypsy moth. The remaining 42.5 million rubles, or 64 percent of the total budget, were generated from salvage logging conducted by the Forest Service and small firms.

By Russian definition, "salvage," "sanitary," or "maintenance" logging is intended to remove old and ill trees and trees posing fire threats. This kind of logging, allowed within protected territories, is exempt from lease payments and stumpage fees. *Leskhoz*es and local companies illegally exploit salvage logging rules to raid high-grade forests for commercially valuable species, such as Korean pine and ash.

Before it was abolished, the inspection division of the Khabarovsk Committee on Environmental Protection addressed the abuse of salvage logging. Concerned about forest health, particularly the survival of ash forests, the inspection division and local police reviewed 380 logging sites licensed by the Khorsky, Oborsky, Mukhensky, and Sukpaisky *leskhoz*es during 1996–1999 and published the findings in the report "Status of Group I forests in riparian protection zones of the rivers and creeks in Lazo Raion, Khabarovsk Krai."[160] According to the report, *leskhoz*es routinely: (1) logged in violation of the Forest Service's mission to log ill trees and reduce fire threats, not to generate profits; (2) undergraded the value of logged timber; (3) removed under- and oversized trees; and(4) logged in prohibited areas, such as steep slopes, river banks, and key watershed areas. "Based on many inspection trips," the study's authors wrote, "*leskhoz*es have been logging rich, commercially valuable timber of key species (ash, Korean pine, and spruce) in sensitive riparian protection zones and along spawning rivers under the guise of 'salvage logging'; this is absolutely prohibited." The study then listed the species violations by *leskhoz*es operating in the area. For example:

> On forest plot #192 (Sukpaisky department of Sukpaisky Leskhoz), license #38 dated July 27, 1996 delivered rights for so-called "Renewal logging" in the riparian protection zone of the highest category spawning region of the Khor River. Using this license, 698 cu. m of high quality timber were logged, including 560 cu. m of top-grade export timber. Eighty-two percent of this timber was A-1 quality ash. This area, upon inspection, did not need "maintenance" or "renewal."

> On forest plot #85 (Gorny department of Sukpaisky Leskhoz), license #17 of February 14, 1996, delivered rights for so-called "passage logging"; 516 cu. m of

It is no secret that we ourselves, *leskhoz*es in RFE administrative districts, are some of the most serious violators of forestry rules and regulations. Even though logging may be our only means to survive as we receive almost no financing from the local administration and from the government, we have no right, I suppose, to log commercially under the label of "salvage logging."

— *Viktor Kozachko, Director of Melnichny Leskhoz, Krasnoarmeisky Raion, Primorsky Krai*

Our main worry in forest protection is that salvage logging, conducted by *leskhoz*es in forests where no maintenance is actually necessary, leads to a large amount of healthy timber cut for export. We [need] … to introduce a regional law to ban logging by *leskhoz*es completely, even so-called "salvage" logging.

— *Sergei Krylov, Head of Administration, Olginsky Raion, Primorsky Krai*

high-quality timber were logged, including 447 cu. m of commercial quality ash—this site did not need maintenance.

On the set of forest plots administered by the Katensky Leskhoz on the riparian protection zone of the first fisheries category of the Katen River, there were a series of so-called "rejuvenation logging" operations in 1996–1997. These operations delivered more than 2,000 cu. m of first quality ash to the market, although licenses provided for logging of primarily old yellow birch trees.

The report also documented increased water levels of 100 to 115 cm due to selective logging along the Khor River watershed.[161] The report concluded 82 percent of the logs harvested under salvage logging licenses were in fact commercial-grade timber, and sales of this timber generated revenue for the Khabarovsk Forest Service and *leskhozes*.

According to Greenpeace-Russia, by 1998 the Forest Service had become Russia's biggest timber producer, providing 10 million cu. m of commercial timber. During that year, Primorsky Krai's Forestry Service alone allowed 377,000 cu. m to be cut under salvage logging loopholes.[162] The Forest Service's violations of Russian salvage logging regulations prove they are unable, unwilling, or cannot be trusted to regulate the industry.

Timber exports to Northeast Asia. With weak regulation, antiquated processing equipment, and illegal logging and export, the RFE is poorly prepared to face what is the greatest long-term threat to the region's forests: growing wood consumption in Northeast Asia. Russia has already emerged as the primary source of logs for China, Japan, and South Korea, a major shift in just ten years (see fig. 1.6). In 2001, about 15 million cu. m of timber from the southern RFE (Khabarovsk, Primorsky, Sakhalin, and Amur) and Eastern Siberia (Irkutsk, Buryatia) flowed through Siberian and RFE land and seaports to these countries (see appendixes I and J for detailed statistics). Logs comprised about 90 percent of this total.

China. Chinese consumption of timber is growing rapidly; by 1995, China was already the second largest consumer of wood in the world after the United States.[163] As early as 1986, Richardson predicted that under a middle-growth scenario, China's annual consumption could reach 1.163 billion cu. m by 2040, almost 10 times the 1995 level.[164] The Chinese government has developed programs to increase self-sufficiency in timber production through massive plantation efforts and by increasing harvesting efficiency. Despite these efforts, the future is clear: China will become the world's largest importer of timber in the near future, overtaking Japan. Richardson estimates China will face an annual deficit of 225 million cu. m by 2025. The Center for International Trade in Forest Products (CINTRAFOR), an influential U.S.-based think tank, predicts a similar figure (200 million cu. m) by 2025

under a low-growth scenario. The Finnish consulting firm Jaako Poyry predicts a deficit of 110 million cu. m, including a log deficit of 30 million cu. m, by 2010.

Two specialists in Russia's forest economy, Thomas Waggener and Charles Backman, point out that outside of Eastern Siberia and the RFE, few other regions in the world can supply such massive amounts of timber.[165] Russia has already emerged as China's primary source of logs. In 2000, Russian logs accounted for almost 44 percent (5.9 million cu. m) of China's total log imports, a rise from just 11 percent (.39 million cu. m) in 1993. This trend shows no signs of shifting. Chinese imports of Russian logs for the first nine months of 2002 was 11.32 million cu. m—roughly double 2000 figures and double Japan's average annual import level (see fig. 1.6).

Virtually all Russian logs exported to China come from either Eastern Siberia (about two-thirds) or the RFE (one-third). China imports Siberian pine (*Pinus sibirica*) and larch logs from Eastern Siberia, and ash, larch, fir, Korean pine, and spruce from the southern RFE. Some logs travel by the Russian-built Chinese Eastern Railroad, which cuts through Manchuria from the Eastern Siberian border of Zabaikalsk, runs southeast of Lake Baikal to Manzhouli in China and then on to Harbin, a Russian-built city and the current capital of China's Heilongjiang Province (see map 1.21). Others travel by railroad from Naushki, just south of Lake Baikal in the Republic of Buryatia, to the Mongolian town of Erlianhot, on to Ulaanbaatar, and finally to Beijing. Illegally logged

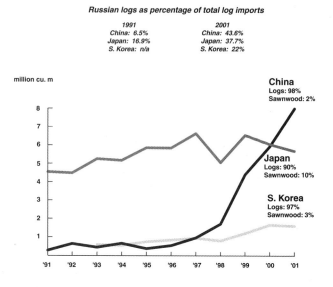

Figure 1.6
Russian timber exports to Northeast Asia, 1991–2001

Russian logs as percentage of total log imports

1991
China: 6.5%
Japan: 16.9%
S. Korea: n/a

2001
China: 43.6%
Japan: 37.7%
S. Korea: 22%

million cu. m

China
Logs: 98%
Sawnwood: 2%

Japan
Logs: 90%
Sawnwood: 10%

S. Korea
Logs: 97%
Sawnwood: 3%

Note: 2001 figures for China are estimated based on first three quarters. Log and sawnwood statistics are for 1999 (China) and 2001 (Japan, South Korea).
Sources: Japan Lumber Importers Association; Japan Ministry of Finance, 2002.

pine from Northern Mongolia is mixed with Russian timber shipments bound for China on the Russian-Mongolian rail route, according to one Chinese forestry expert.[166]

The southern RFE supplies the rest of the timber via the third major route, from Primorsky Krai's Gorodekova (Pogranich-noe) to the Chinese city of Suifenhe, located just 100 km from Russia's Us-suriisk, a city of 250,000 and a center for the expanding Russian-Chinese trade.[167] These three routes (Zabaikalsk-Manzhou-li, Gorodekova-Suifenhe, and Naushki-Erlianhot) account for about 95 percent of all timber exported to China (see fig. 1.6), providing hope that illegal export can be combated with more stringent regulation of the routes. In 2000, about 2 million cu. m was exported via both Manzhouli and Suifenhe, and about 1.5 million via Erli-anhot. All three routes have transported increased amounts of timber exports in the past five years (see appendix J).

Timber is also shipped across a number of points on the Amur River, the larg-est of which is Blagoveschensk in Amur Oblast. Other methods for transporting timber include trucking across numerous small roads and river crossings along the 2,000-km Russian-Chinese border; many of these small export points are beyond the control of customs officials. Previously, a significant percentage of timber exported to China was shipped by sea (almost 40 percent in some years), but it has dropped to about 2 percent with increased Russian-Chinese railroad trade.

Japan. Despite a decade of decline in housing starts (the number of residential construction projects begun in a given year), figure 1.6 shows that log exports to Japan steadily increased from 1991 (4.3 million cu. m) to 1997 (6.1 million cu. m). Although log exports fell in 1998 (4.7 million) as a result of the Asian financial crises and the ruble devaluation, they rose again to the 5 to 6 million cu. m range in 1999, 2000, and 2001. Eastern Siberian timber accounts for roughly one-third of total annual export (2 million cu. m) to Japan, with timber from the RFE making up the remaining two-thirds (4 million cu. m). These wood sources are replacing more

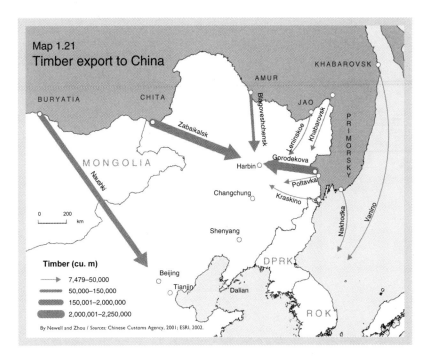

Map 1.21
Timber export to China

Timber (cu. m)
- 7,479–50,000
- 50,000–150,000
- 150,001–2,000,000
- 2,000,001–2,250,000

By Newell and Zhou / Sources: Chinese Customs Agency, 2001; ESRI, 2002.

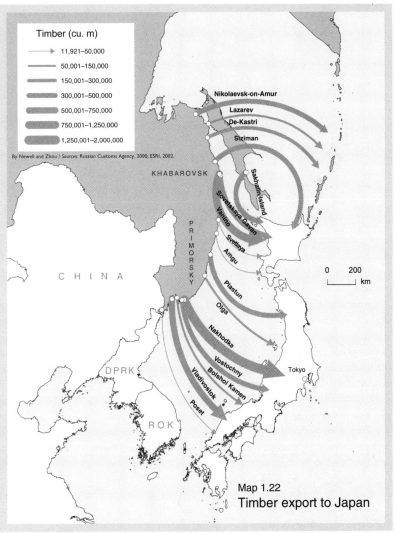

Timber (cu. m)
- 11,921–50,000
- 50,001–150,000
- 150,001–300,000
- 300,001–500,000
- 500,001–750,000
- 750,001–1,250,000
- 1,250,001–2,000,000

By Newell and Zhou / Sources: Russian Customs Agency, 2000; ESRI, 2002.

Map 1.22
Timber export to Japan

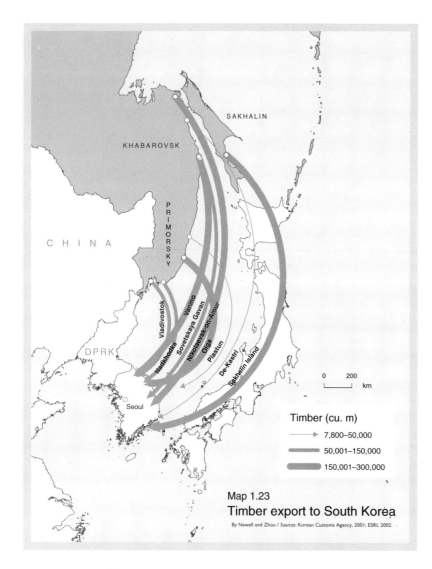

Map 1.23
Timber export to South Korea

By Newell and Zhou / Sources: Korean Customs Agency, 2001; ESRI, 2002.

Timber (cu. m)

→ 7,800–50,000

50,001–150,000

150,001–300,000

In addition to these larger ports, there are a number of smaller coastal ports in the Khabarovsk, Sakhalin, and Primorsky regions, which almost exclusively export timber logged from nearby forests. Among the largest in Khabarovsk are Nikolaevsk-on-Amur (300,000 to 400,000 cu. m annually) and De-Kastri (250,000 to 300,000 cu. m) and in Primorsky are Plastun (400,000 to 500,000 cu. m) and Olga (100,000 cu. m). Sakhalin ports, including Korsakov, Poronaisk, and Kholmsk, export a total of 400,000 to 500,000 cu. m per year.

South Korea and North Korea (DPRK). South Korea, whose forests were devastated during the Japanese Occupation, World War II, and the Korean War, imports about 90 percent of its timber products, including about 8 to 9 million cu. m of logs each year. New Zealand remains South Korea's largest log supplier, but Russia has become a major source, ranking third after New Zealand and Chile. In 2001, South Korea imported about 1.55 million cu. m of Russian logs, thereby tripling its 1994 imports (see appendix I). Russia ships logs from ports in the RFE to the South Korean ports of Pusan and Inchon. South Korean imports will likely increase, since Russian old-growth timber is higher quality than New Zealand or Chilean plantation timber but costs about the same. Unlike their Japanese counterparts, Korean timber importers place a premium on price rather than quality. Demand for medium- and pulp-grade logs, therefore, is high; Korean manufacturers often convert larch pulp logs into sawn timber, for example.

In 2000, about 830,000 cu. m of timber was exported to South Korea via Vanino, Sovetskaya Gavan, Nikolaevsk-on-Amur, and De-Kastri (see map 1.23). Much of this timber was logged in Khabarovsk Krai. About 10 to 15 percent of Russia's annual exports to South Korea was shipped from Sakhalin ports, perhaps reflecting the close business relationship between South Korean companies and the large local Korean community in Sakhalin.

North Korea imports RFE timber from North Korean–managed timber concessions in Chegdomyn (Khabarovsk Krai) and Tynda (Amur Oblast). The Soviet and North Korean federal governments first signed the Chegdomyn and Tynda logging agreements decades ago, and regional officials seeking timber revenues have since extended them. North Korean loggers have badly damaged the forests in these concession areas.

traditional log sources, such as Southeast Asia and North America. As with China, Russia has emerged as Japan's largest supplier of logs. Barring significant environmental restrictions or a Japanese housing market collapse, Russian log imports will remain steady at about 5 to 7 million cu. m per year.

Exporters ship wood to Japan from numerous locations in the southern RFE, including large ports such as Nakhodka, Vanino, Sovetskaya Gavan, Vladivostok, and Vostochny (see map 1.22). Nakhodka alone handles about one-third of the trade, exporting 1.5 to 2.5 million cu. m annually. Most timber exported through Nakhodka is Siberian pine from the Irkutsk region near Lake Baikal in Eastern Siberia, and to a lesser degree from Amur Oblast. The remainder comes from throughout the southern RFE. The ports of Vladivostok and Vostochny (in southern Primorsky) annually export from 600,000 to 700,000 cu. m and from 400,000 to 500,000 cu. m, respectively. Half of this timber comes from Eastern Siberia and half from the southern RFE. Timber exported from Vanino (700,000 to 1,000,000 cu. m) comes mainly from Khabarovsk Krai and Amur Oblast.

One major export route to North Korea runs via the Tumen River railroad crossing near Khasan. Timber is also shipped from Vladivostok and Poset to the commercial ports of Rajin and Chajin. Statistics show that Russia exported 26,000 cu. m to North Korea in 1999, yet local observers claim the volume of timber logged in North Korean concession areas that year was far greater. North Korea may also be exporting some of its portion of the concession timber to China. In 1999, North Korea exported an estimated 163,406 cu. m in logs to China, a high figure considering the country's depleted forests.[168]

Conclusions and next steps. Interconnected, simultaneous events—the privatization of the Russian timber industry, the opening of Asian markets, the collapse of processing, and the disintegration and corruption of the Federal Forest Service's regulatory functions—triggered a flurry of illegal logging and export operations throughout the RFE. This has included logging of protected forests and species, such as Group 1 forests and Korean pine. The shift toward Asian markets continues to dictate where and what type of timber is cut. In the long term, rising wood consumption in Northeast Asia, particularly in China, poses the greatest threat to the region's forests.

Obstacles to reducing illegality. The Russian government has a vested interest in eliminating illegality. Illegal logging floods the market with cheap timber, which drives down prices, and the government loses stumpage fees and other tax revenues generated by legitimate logging operations. Still, success has been limited for a litany of reasons, including:

▨ Inadequate funding for inspecting agencies, resulting in understaffed departments with poorly trained, poorly equipped, and poorly paid staff.
▨ Dependence of inspecting agencies on fines and payments from timber companies.
▨ Poor collaboration between federal bodies (Customs, the Forest Service, the Ministry of Foreign Trade) and regional administrations.
▨ Lack of power among agencies controlling the timber sector and consequent overruling by more powerful government agencies.
▨ Poor inspections of log export shipments and poor enforcement of regulations by customs officials.
▨ High costs associated with tracking the chain of custody from logging to export.
▨ Poor government policies for reinvesting revenues in the forestry sector to ensure responsible forest management and trade controls.
▨ Lack of incentives to promote processed wood exports.
▨ Lack of checks and balances for government agencies responsible for the forest sector, and consequent corruption.
▨ Failure to release information on trade and export contract prices in the timber industry to the public.

▨ Incomplete export contracts that fail to specify where the timber is cut.
▨ Too many timber export points.
▨ Byzantine tax system, prompting companies to work illegally to avoid taxation.
▨ Negligible fines and punishments for logging and trade violations.
▨ Cutting and export bans passed without commensurate increases in enforcement resources.
▨ Failure of importing countries to accurately check species and grade of timber.

A basic problem underlying many of these obstacles is the prevailing disregard for laws and regulations. Poverty and high unemployment fuel this disregard, pushing people to break the law to make a living, including loggers, traders, police, forestry service officials, customs officials, even government officials in Moscow. This fundamental socioeconomic reality, manifest in government corruption, is the biggest obstacle to industry reform.

Federal and regional governments have developed concrete policies to combat illegal logging, only to find them compromised by internal corruption. Although forest service personnel and police confiscate illegally logged or exported timber, officials in both camps have been caught reselling the timber to the same firms they confiscated it from. Primorsky Krai instituted a system of transport certificates to track the chain of custody for timber, making it theoretically possible to check the timber source and ensure that it was legally logged.[169] Primorsky regional agencies maintain roadblocks at strategic points to check these certificates; these can succeed because there are just a few major roads along which timber is transported. Unfortunately, the local police who run the roadblocks are susceptible to bribes and forged documents. Officials from Krasnoameisky Raion (Primorsky) were actually able to establish a relatively corruption-free roadblock, mainly due to vigilant staff from the Committee on Environmental Protection (Goskomekologia). Timber interests, however, managed to pressure government officials to reduce the year-round inspections to seasonal ones, diminishing their effectiveness.

Still, if roadblocks could be successfully maintained and if the documents required could be difficult to forge or purchase, illegal logging and export could be curtailed. Grigory Markov, a deputy in the logging department of the Khabarovsk administration, suggests a ten-day holding period for timber export, allowing time for the government to research the consignment's chain of custody. Industry has criticized the measure, however, citing the already considerable delays from transport bottlenecks and inadequate staffing at customs export points.

The main regulatory agencies (divisions with the Ministry of Natural Resources, the Forest Service, and the Hunting Administration) also need the right to arrest loggers

Josh Newell

The railroad town Gorodekova is one of three major timber export points into China.

and carry firearms. The Ministry of Internal Affairs, whose officials have this right, has established special task forces targeting illegal logging and trade; these task forces, however, so far have struggled to work effectively with other regulatory agencies.

NGOs have formed brigades with regulatory agencies to patrol forests. The Tiger Task Force, established within the Primorsky Committee on Environmental Protection but essentially run with NGO funding and aided by NGO staff, slowed poaching of Siberian tigers in the early and mid-1990s. This government-NGO model is now being applied to timber task forces, also in Primorsky Krai. The scale of these activities cannot match the scale of the problem, however. Tens of millions of dollars would be needed each year to create and maintain the necessary number of task forces to reform the industry in the RFE—a level of financing NGOs do not have.

Rejuvenating processing. A number of regional governments recognize the benefits of reviving processing, an industry that collapsed in the 1990s. The Khabarovsk government has issued directives requiring at least 20 percent of the *krai*'s timber harvest be processed locally, although enforcement of this regulation has proved virtually impossible; for example, some foreign companies promise to process timber simply to access forest resources. The Malaysian logging firm Rimbunan Hijau, which logs the Sukpai River watershed in southern Khabarovsk, agreed to process 20 percent of its cut timber but hasn't done so and continues to export Sukpai logs to Japan and China. Some processing ventures, however, have established themselves in the RFE. Several Japanese-Russian joint ventures process timber. STS Technowood, a joint venture between the Russian firm Terneiles and Sumi-

tomo Corporation, is the largest of the ventures and produces about 30,000 to 50,000 cu. m of lumber for export to Japan.

But recent developments in China are likely to hinder Russian efforts to modernize its processing industry. Chinese limits on domestic logging forced the timber industry in Manchuria, China's main timber-producing region, to search for new log sources. At least 300 sawmills operate in Manchuria and process about 4 million cu. m of timber annually. [170] These mills already use Russian timber and may be exporting sawnwood made from Russian logs to Japan, Taiwan, and elsewhere. Since 1996, Chinese sawnwood exports to Japan have grown dramatically.

If China is indeed modernizing and expanding this industry to capitalize on growing demand for processed timber, firms in the RFE would have to compete with Chinese suppliers for the Japanese and South Korean markets. Chinese suppliers and Japanese investors, however, are more likely to invest in Chinese processing mills due to cheaper labor and greater economic and political stability. In Manchuria, many small sawmills have been established with Taiwanese investment, some as joint ventures and others as Taiwan-owned companies. Despite declining harvests in China, there are new timber-processing enterprises springing up in Heilongjiang Province. The Chinese timber companies Nacha Wood, Lancian Wood, Mudanjiang Forest Wood, San Gan Ling, and Xin Yang Wood together have the capacity to process more than 600,000 cu. m annually; this indicates an already sizeable processing industry is in place.

The Russian government is aware of this threat: stipulations regarding processing are prominent in recent Russian-Chinese timber harvest agreements. In March 2002, for example, the Hebei Forestry Bureau, a division of the Forest Industry Bureau in China's Heilongjiang Province, agreed with the Russian government to log 200,000 cu. m and produce 50,000 cu. m of sawnwood in the Jewish Autonomous Oblast. Plans to develop similar logging and processing ventures in Primorsky and Khabarovsk Krais and Amur Oblast exist, but may not reach fruition because they require large-scale investment and acceptance of political and economic risks.

Khabarovsk Governor Viktor Ishaev has issued an ambitious decree calling for raw logs exports to cease by the end of

2003, with only processed wood products allowed for export thereafter (see p. 171). According to the U.S. and Foreign Commercial Service, a division of the U.S. Department of Commerce, this would not only create new jobs but also increase profits three- to fifteenfold.[171] Such a radical transformation, however, would require massive investment, which is unrealistic to expect as continued corruption discourages Russian and foreign timber companies from the long-term investments needed to develop processing. These companies would rather keep their profits abroad than reinvest. The effort to ban raw log exports also faces stiff resistance from certain ministries in Moscow that are preparing the country for entry into the World Trade Organization (WTO), which is likely to consider such a measure protectionist. Finally, some within the timber industry, fearing the loss of the Asian log market, would resist the ban as they did when the Primorsky administration passed a decree in 1998 banning the export of ash logs. The regional prosecutor overturned the 1998 ban after complaints from certain individuals within the industry.

Timber certification. Corruption will also hinder efforts to establish forest certification, which NGOs such as the Forest Certification Center in Khabarovsk promote as a tool to ensure sustainable forest use and management. The most progressive of the major certifying agencies is the Forest Stewardship Council, an NGO that defines certification as "the process by which the performance of on-the-ground forest operations are assessed against a predetermined set of environmentally sound standards."[172]

Even if such a system were in place for some timber operations, monitoring to ensure that companies follow the standards would be as problematic as setting up roadblocks. Illegally logged timber would find its way into shipments of certified timber; this happens in Indonesia, where forest certification is expanding rapidly.[173] In addition, certification will be slow in the RFE because unlike Western European and U.S. consumers, Japanese and Chinese buyers have shown little interest in certified timber.

Addressing corruption. Addressing illegal logging, rejuvenating processing, and introducing forest certification all hit the same roadblock: corruption. For successful industry reform, government at the highest levels must first flush out corrupt forest agency workers, and customs, militia, and other government agency officials. Then, relevant agencies need to enforce strict regulations for all forms of illegal logging and trade, and large fines and incarceration must be imposed. This effort will require sustained commitment and funding by the government, both of which are in short supply.

International responses. The Chinese, Japanese, and South Korean governments could work with the Russian government to slow the flood of illegal timber. Such cooperation should be multilateral, but bilateral cooperation would be a start. Russia has attempted to control illegal exports through its intelligence and security agencies, including divisions of the Ministry of Internal Affairs and the Federal Security

Another short-lived house in Tokyo.

Hiroki Sugaya

Service (FSB), as well as through inspection units in the Ministry of Natural Resources. Companion agencies in China, Japan, and South Korea need to be given a mandate to work with these agencies and divisions.

A centerpiece of cooperation must be to tighten key export points by, for example, stringently checking for harvest-restricted timber species such as Korean pine and by thoroughly inspecting all documents. Unlike marine products— which are difficult to regulate because they are often traded on the open sea—timber goes through a limited number of land checkpoints and seaports. Real progress could be made in Chinese-Russian trade as the timber is exported essentially from three points: Zabaikalsk, Gorodekova, and Manzhouli.

China, Japan, and South Korea must also enact policies to reduce overconsumption of wood products. In the short term, doing so in China is a complicated proposition. First, civil society in China remains far too weak to press the Chinese government to enact policies aimed at reducing consumption (this might be more fruitfully done through international agencies such as the World Bank and the Asian Development Bank). Second, Chinese wood consumption per capita is much lower than in other industrialized countries; it would be difficult for international NGOs, foreign government agencies, and international institutions to call for reductions when the United States, Japan, and Europe remain so wasteful. Third, Russian timber is not only for domestic use in China, a good portion of it is processed and exported abroad as sawnwood, plywood, and furniture. Chinese imports of Russian hardwoods, for example, supply one of China's fastest growing export industries: furniture. To effectively address Chinese overconsumption of Russian logs, one must therefore also address consumption in those industrialized countries that import Chinese wood products. Despite these

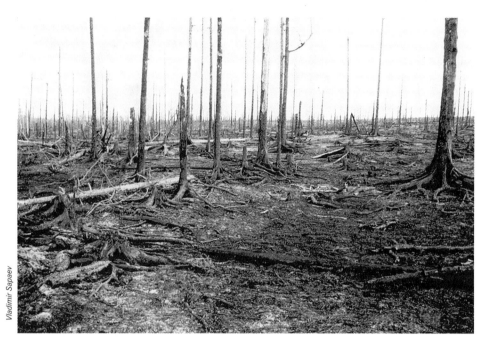

Vladimir Sapaev

Charred remains from the fires of 1998, southern Khabarovsk Krai.

by government, finance, and insurance sectors. One writer described this system as a "constant turnover of housing destruction and construction."[175] To reduce wasteful timber use, NGOs suggest revising building codes to encourage use of nontraditional materials, dissolving loan policies and regulations mandating limited life spans for houses, and decentralizing housing construction.[176] But with government reformers focused on the Japanese economy, housing reform remains a low priority. Nevertheless, unless changes are made, Japan's impact on Russian (and the world's) forests will continue to be detrimental.

Two NGO reports, *Plundering Russia's Far East Taiga* and *Illegal Logging in the Southern Part of the Russian Far East*, provide more detailed information on the steps needed to address illegal logging and overconsumption in China, Japan, and South Korea.[177] More research addressing South Korea's overconsumption of timber is strongly needed.

difficulties, it will be crucial to address Chinese consumption of wood products as China will become the world's largest importer of timber.

Addressing overconsumption in Japan is less equivocal. As the world's largest importer—and a major consumer of Chinese wood products—the Japanese government and industry are no strangers to criticism of their wasteful wood use. In the early 1980s, NGOs and scholars, both internationally and within Japan, called attention to Japan's use of tropical timber from Malaysian, Indonesian, and Philippine rain forests to build houses. The most notorious such use was to make *kompane*, a plywood sheet used to build forms in which to pour concrete.[174] *Kompane* is usually used twice and then discarded or burned. After enduring years of criticism, the Japanese timber industry began to shift from tropical log sources to temperate ones. To make plywood, the industry is gradually replacing tropical luan wood with larch. Plywood associations now promote Russian larch as a "green" alternative to luan and have steadily increased import levels over the past decade.

Unfortunately, simply shifting to new supply sources will only create new environmental problems. Increased use of larch could have major long-term implications for Russian forests and potentially the global climate. As map 1.3 (see p. 14) shows, 98 percent of all Russian larch grows on some form of permafrost; unsound logging could melt this frozen ground, thereby releasing methane gas and CO_2 and reducing the capacity of Russian forests to serve as a "carbon sink."

In Japan, about 75 percent of Russian timber is used to build houses, primarily as nonstructural timber and plywood (including *kompane*). Houses last thirty to thirty-five years, due to a "scrap-and-build" housing policy supported

Figure 1.7
Causes of forest fires in the RFE, 1987–1997

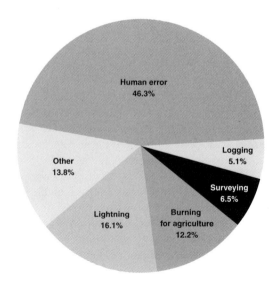

Human error 46.3%

Logging 5.1%

Surveying 6.5%

Burning for agriculture 12.2%

Lightning 16.1%

Other 13.8%

Source: Economic Research Institute, 1998.

The forest fires of 1998

Fires in the RFE are common: Khabarovsk Krai experiences 700 to 800 fires annually. But the scale of the 1998 fires was unprecedented. Over the preceding 20 years (1977–1997), fires in Khabarovsk burned 2.3 million ha, or an average of 115,000 ha per year; in 1998, more than 1.5 million ha of forestland were burned in 1,262 fires.[178] According to the Khabarovsk Forest Service, about 154 million cu. m of timber stock, worth an estimated 4.6 billion rubles (U.S.$460 million) was destroyed. On Sakhalin, fires in 1998 burned 100,000 ha, mostly in Tymovskoe Raion, where half the forests were destroyed. Sakhalin forest service officials estimated the cost of fire fighting and the loss of timber and equipment at 670 million rubles (U.S.$67 million).[179] The Sakhalin Committee on Environmental Protection estimated 50 percent of the area's ground-nesting birds (including game birds), and 10 to 20 percent of the area's mammals were killed in the fires. Nesting areas for three *Red Data Book* species, including two eagle species, were severely damaged. Wildlife biologists in Khabarovsk are still researching the impacts of the fire on large carnivores, such as the Siberian tiger, wild boar, and bear, which all require large habitat areas. Khabarovsk authorities estimated 100 million ha of forest suffered negative impacts on biological processes, leading to reduced carbon-fixing potential. Indeed, sources from the Federal Forest Service reported 900,000 ha of forest completely lost this capacity, and as a direct result of the fires, around 30 million metric tons of carbon were released into the atmosphere over a short period of time. Other environmental impacts include forced early and changed bird migration patterns, river pollution and its effect on salmon-breeding streams, loss of vegetation cover on mountainous terrain leading to soil erosion, and an overall reduction in biological diversity leading to the recolonization of opportunistic species at the expense of other species.[180]

One of the most badly damaged areas was Khabarovsk's Nanaisky Raion, where indigenous peoples compose 17 percent of the population and rely on fishing and hunting. Throughout the krai, choking haze and smoke affected one million people, including those in the city of Khabarovsk. Regional sanitation and epidemiological authorities reported carbon monoxide levels three to thirteen times the maximum permissible concentration (MPC) over a period of weeks, with levels periodically reaching twenty-four times the MPC.[181]

The fires also reduced available regional timber. Some areas may never recover, particularly areas burned previously; the Khabarovsk Forest Service reported 300,000 ha that burned in 1976 are still not regenerating properly. The 1998 fires destroyed some of the most valuable forest stands, forcing the timber industry to expand into new areas. At least 15 million cu. m of export-grade timber burned, an amount equal to almost three years of reported timber production in Khabarovsk.[182]

Although natural fires are an important succession process in virgin boreal forests, the Forest Service estimates humans are responsible for 70 to 85 percent of the fires in the RFE; this finding is supported in a study by Alexander Sheingauz, who calculated the causes of forest fires in Khabarovsk from 1988 to 1997 (see fig. 1.7). A United Nations Disaster and Assessment Coordination (UNDAC) mission to Khabarovsk found no evidence the 1998 fires were started deliberately, but pointed to difficult economic conditions that "drove many more people to use the forest margins for hunting and fishing; mushroom, berry, and fruit picking," and speculated that "nonexperienced hunters may have started some fires through careless cigarette disposal, using broken glass to concentrate solar rays, cooking fires getting out of control, etc." The year was also unnaturally dry: the monsoon summer season provided only 15 to 20 percent of normal rainfall levels, and September and October were without precipitation.[183]

The areas hardest hit were also those most heavily logged (Komsomolsky, Solnechny, Ulchsky, Nikolaevsky, and Nanaisky Raions), drawing speculation as to the connection between logging and fires. In addition to dry weather, Sheingauz pointed to logging waste (branches, logs, and stumps) as a contributing factor to the severity of the fires. Lack of funding impedes the Forest Service from enforcing rules obliging logging companies to clean up such debris. Sheingauz also found forest fires began to increase in the 1930s, when logging operations became mechanized. This process brought in "machines with their flames and sparks … people with campfires," and new logging roads that allowed unprecedented numbers of hunters, poachers, and mushroom gatherers into the forest. A study by the Wildlife Foundation (an NGO) on forest fires and protected areas in Khabarovsk Krai concluded most protected areas were spared from the 1998 fires. They found fewer roads and human activities such as logging and hunting, coupled with the better fire-fighting capabilities of the reserve staff, were the primary reasons for this.

Forest service officials believe the 1998 fires could have been contained to a much smaller area with adequate funding and equipment; in 1988, the Forest Service had four times as many resources at their disposal and lost only about 300,000 ha in similar conditions. The Forest Service also lacks adequate early-warning systems and surveillance patrols.

— *JN*

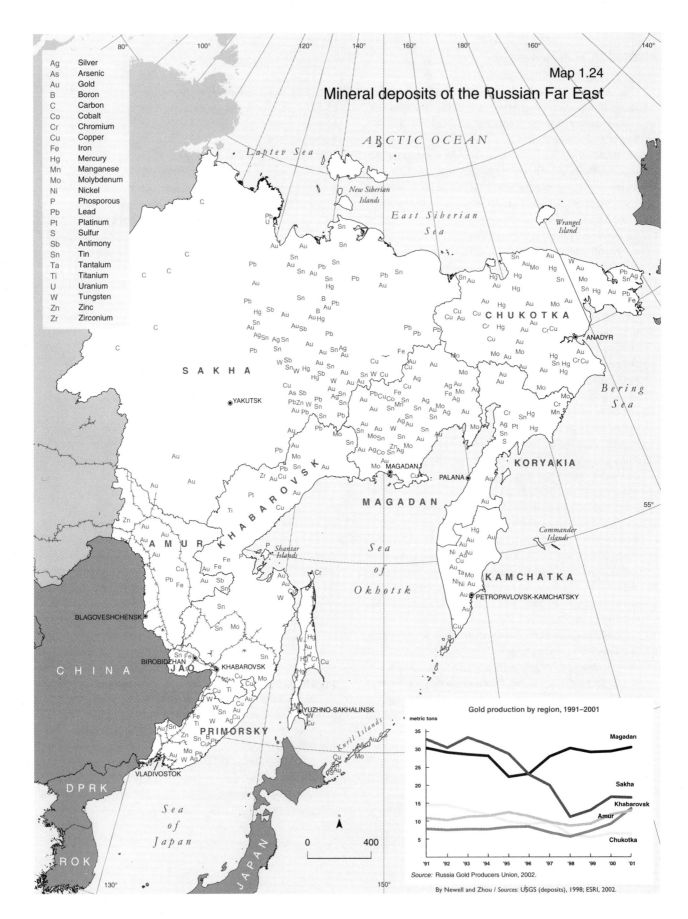

Map 1.24

Mineral deposits of the Russian Far East

Ag	Silver
As	Arsenic
Au	Gold
B	Boron
C	Carbon
Co	Cobalt
Cr	Chromium
Cu	Copper
Fe	Iron
Hg	Mercury
Mn	Manganese
Mo	Molybdenum
Ni	Nickel
P	Phosporous
Pb	Lead
Pt	Platinum
S	Sulfur
Sb	Antimony
Sn	Tin
Ta	Tantalum
Ti	Titanium
U	Uranium
W	Tungsten
Zn	Zinc
Zr	Zirconium

ARCTIC OCEAN

Laptev Sea

New Siberian Islands

East Siberian Sea

Wrangel Island

CHUKOTKA

ANADYR

Bering Sea

SAKHA

YAKUTSK

KHABAROVSK

MAGADAN

PALANA

KORYAKIA

55°

AMUR

Shantar Islands

Sea of Okhotsk

Commander Islands

KAMCHATKA

PETROPAVLOVSK-KAMCHATSKY

BLAGOVESHCHENSK

CHINA

BIROBIDZHAN JAO

KHABAROVSK

YUZHNO-SAKHALINSK

PRIMORSKY

Kuril Islands

VLADIVOSTOK

DPRK

Sea of Japan

JAPAN

ROK

Gold production by region, 1991–2001

metric tons

Magadan

Sakha

Khabarovsk

Amur

Chukotka

'91 '92 '93 '94 '95 '96 '97 '98 '99 '00 '01

Source: Russia Gold Producers Union, 2002.

By Newell and Zhou / Sources: USGS (deposits), 1998; ESRI, 2002.

N

0 400

130° 150°

Mining

J. NEWELL, D. GORDON—Mines in the RFE are integral to Russia's mining industry, producing rare and lucrative metals and precious stones, as well as more common commodities such as antimony, tin, iron, boron, lead, and zinc. Western Sakha's diamond pipes produce 99 percent of Russia's diamonds, and platinum and palladium deposits in Koryakia and Khabarovsk produce a significant portion of one of Russia's most lucrative exports. About 60 percent of Russia's annual gold production comes from the RFE. Locations of mineral deposits are shown in map 1.24, and a rough picture (reliable data for gems, minerals, and metals are scanty) of mining resources in the RFE and their importance to Russia and international markets is provided in table 1.10.

Mining production declined throughout the 1990s, partly due to lower demand for ferrous and nonferrous minerals from the industry's major buyer, the RFE's military-industrial complex. But high energy and transport costs also make it unfeasible to ship to traditional processing sites in the former Soviet states and other parts of Russia. The RFE mining industry today produces and exports only the most valuable products (diamonds, gold, platinum). These are shipped to Moscow, as required by federal regulation, instead of being exported. There are some exceptions, however; Sakha recently received rights to export a percentage of its diamonds, and Magadan companies export small quantities of gold.

Like other RFE extractive industries, mining wastes enormous amounts of raw material—during extraction at least 20 percent of the minerals mined are wasted. During the enrichment process, losses average 50 percent.[184] This waste accelerates the depletion of deposits at existing mines, and developing new ones may not bring profit: Between 30 to 70 percent of all nonferrous metal ore deposits are unprofitable to develop due to wasteful mining methods and outdated technology.[185] And small mining firms generally lack funds to modernize. (As with the timber industry, the privatization of mining resulted in the fragmentation of large state-owned mining enterprises and the development of numerous smaller ones. In the case of mining, many small independent mining teams, or *artels*, were created.) Determining the size of untapped reserves also requires expensive geological surveys. To increase production, the industry hopes to attract foreign companies, and their western technology and capital. Industry representatives are pressing the Russian government to reform burdensome mining laws and regulations (especially production sharing agreement legislation) and to streamline the taxation structure.[186] President Putin, however, wants to reestablish federal control over the mining industry through legal reforms, with particular attention to the Law on Mineral Deposits.[187]

Despite such obstacles, foreign joint ventures (mostly for gold and silver mining) have emerged in almost every region of the RFE. Low production costs (about 60 percent of average costs elsewhere) continue to draw investors.[188] Some ventures mine existing reserves, such as the Dukat silver mine, but most are developing new deposits. Many of the new deposits are located in wilderness areas, often where other land-use interests compete. The proposed Aginskoe gold deposit in Kamchatka is a case in point. Canada's Kinross Gold Corporation established a joint venture to mine this deposit, located in Ichinsky Zakaznik, a protected area that later became the Bystrinsky Nature Park. The governor, who had originally approved the refuge, quickly altered the park border to exclude the mine site and accommodate Kinross Gold. The project did not go through however; international financial institutions withheld their support as it was inside the Volcanoes of Kamchatka World Heritage Site (see p. 361), and because of pressure from NGOs.

Rather than developing places like Aginskoe, environmentalists and some within the Russian mining industry are asking foreign firms to invest in existing mines.[189] Environmentalists fear foreign firms may shirk precautions and procedures to cut costs. They cite the Kubaka mine in Magadan Oblast as an example. The Kubaka project, made possible by financing from EBRD and OPIC, was launched without a reclamation plan. Project operators rectified that oversight but changed the building plan for the mine after the environmental impact assessment (OVOS) and state environmental review (*expertiza*) were approved, without consulting the public or resubmitting documents for a new *expertiza*. Problems arose soon after production in the toxic form of cyanide leaks from the mine's tailings dam (see p. 278–80).

Environmental impact. From the standpoint of the environment and public health, regulation of mining in the RFE has always been weak. Mining operations have left rock piles and toxic tailings throughout the RFE. Recultivation of mined areas is rare: Disturbed areas remain disturbed. Damage is particularly evident in the north, where the extreme cold slows recovery of fragile northern ecosystems.

Placer mining (hydraulic washing or dredging of gravel or sand) accounts for two-thirds of RFE mining and causes numerous environmental problems, including increasing suspended particle loads in rivers, altering riverbeds, and preventing salmon from reaching spawning grounds. Mining contaminants pollute rivers and streams for long distances (extending environmental damage beyond the mine area by a factor of 7 to 20). During extraction, water temperatures rise in settling basins and dissolved oxygen levels decrease, further impacting fish productivity.[190] In addition to reducing fish populations and polluting rivers, Russian ecologists have documented areas where mining has decreased forest cover, caused erosion, impacted a wide variety of fauna, altered hydrological regimes of rivers and underground streams, and changed the microclimate.[191]

Most gold mines release large quantities of tailings relative to the amount of gold produced. Each year in the southern RFE alone, mining operations produce more than 30 million

Table 1.10
Resource base and production of strategic metals and minerals

Resource	Regions	RFE's importance for Russia (% of total) (2000 unless noted)	Russia's importance globally (% of total or global ranking) (2000 unless noted)	Production (2000 unless noted)
Diamonds[1]	Sakha	Reserves: 82% Production: 99%	Reserves: 34–50% Production: 26%	RFE: Gems, 10.5 million carats; industrial stones, 10.5 million carats
Gold[2]	Magadan, Sakha, Khabarovsk, Chukotka, Amur	Production: 60%	Reserves: 3rd Production: 6th	RFE: approx. 80 tons Russia: 140 tons
Silver[3]	Magadan, Sakha, Primorsky, Chukotka	Reserves: +90%		Russia: 375,000 kilograms (1999)
Platinum[4]	Khabarovsk, Koryakia		Reserves: 40% Production: 24%	Russia: 1,020,000 ounces (including Khabarovsk 129,000 ounces, Koryakia 129,000–193,000 ounces)
Coal[5]	Sakha, Primorsky, Amur, Khabarovsk	Reserves: 9% Production: 12%	Reserves: 16% Production: 6%	RFE: 30 million tons (1999)
Antimony[6]	Sakha (100%)	Reserves: 100% Production: 100%	Production: 4th	RFE: 2,000 tons (1999); 6,000 tons (1991)
Mercury	Sakha, Magadan, Kamchatka	Reserves: 50%		RFE: 50 tons (1999)
Iron[7]	Sakha, Amur, JAO		Reserves: 27% Production: 4th (1999)	Russia: 214 million tons
Tin[8]	Sakha, Khabarovsk, Magadan, Primorsky	Reserves: 95%	Reserves: 1st Production: 8th (1999)	
Lead[9]	Primorsky	Reserves: 8% Production: 49%	Reserves: 1st Production: 0.6%	Russia: 43,000 tons (1999)
Zinc[9]	Primorsky, Khabarovsk, Sakha, Chukotka	Reserves: 4% Production: 14% (1993)	Reserves: 1st Production: 1.5%	Russia: 114,000 tons (1998)
Fluorite	Primorsky (43%)		Reserves: 11% Production: 6–8%	Russia: 331,000 tons (1999)
Fluorspar	JAO, Primorsky	Reserves: 41% Production: 91% (1993)		
Boron	Primorsky	Reserves: 90%		
Tungsten[10]	Magadan, Khabarovsk, Primorsky, Sakha	Reserves: 24% Production: 37% (1993)	Production: 2nd (1999)	Russia: 3,500 tons (1999)

Notes: [1]Russia exported U.S.$877.4 million, out of total production revenue of $1.5 billion, in 2000. [2]Russia exports 70–80 tons annually. [3]Dukat mine (Magadan) holds about 90% of Russia's silver reserves. [4]RFE exported $192 million (at U.S.$600/ounce) of platinum in 2000. [5]RFE has 13–18 billion tons of coal; possible reserves fifteen times higher. [6]The RFE has an estimated 238,000 tons. [7]RFE has 3 billion tons of proven iron reserves. Russia exports 15 million tons annually. [8]Tin reserves total about 140,000 tons. Major RFE producers are Deputatsky (Sakha) and Solnechny (Khabarovsk) mines. [9]Dalpolimetal is primary RFE producer of lead and zinc. [10]Mined with tin and exported to Northern Caucasus for processing.

Sources: Compiled from: the regional chapters in this book; James Dorian, *Minerals and Mining in the Russian Far East* (1997); Richard Levine, *The Mineral Industry of Russia* (1999); *BP Statistical Review of World Energy* (2002).

cu. m of tailings.[192] The use of heavy and toxic metals pollutes soil, water, and air—especially the continued use of mercury to separate gold, despite regulations passed in 1988 outlawing its use. Mercury-contaminated wastepiles line the banks of mined riverbeds. Preliminary studies in Amur Oblast have documented mercury groundwater contamination near mined areas. People in these areas continue to garden, fish, raise cattle, and drink the water. Scientists have also documented high mercury concentrations near gold mining sites in Sakha.

Hard-rock mines, such as in Magadan, have also polluted the environment. Their abandoned mine pits leak acid waste into drinking water and wildlife habitat. Often built with only a berm to contain waste, tailing ponds lack clay or synthetic liners to prevent water pollution.

Government agencies lack funds to clean up abandoned mines. Holding enterprises responsible for abandoned mines is virtually impossible as many have gone bankrupt or

changed ownership, and joint ventures are unwilling to accept responsibility for cleanup at existing sites. Some propose a special tax on mineral production to clean up abandoned mines. Others propose funding reclamation by reprocessing oil found in tailings.

To ensure new mines are properly developed, environmental groups are calling for mining companies to adhere to the highest international environmental standards: detailed reclamation plans, prevention of groundwater pollution, installment of reliable and safe tailings impoundment systems, and financial assurance for all environmental measures, including toxic spill prevention, reclamation, and mine closure. In case of accidents, emergency response plans (and the medical ability to respond) for both the local government and the public need to be in place.

Gold. The RFE produces about 60 to 70 percent of Russia's gold (see appendix K). Magadan and Sakha traditionally

Foreign corporations in RFE mining

Foreign investment in the industry is volatile; companies frequently sell or transfer rights to other foreign corporations. Canadian Western Pinnacle, Ltd., once one of the largest players in RFE gold and silver mining, changed its name to WPN Resources, abruptly divested most of its RFE holdings, and is now involved in international oil and gas speculation, but not in Russia.[193] Despite WPN's divestiture, Canadian companies remain the largest foreign investors in the industry.

Kinross Gold Corporation. Based in Toronto, Kinross Gold is the largest gold producer in North America. Kinross has a controlling interest (54.7 percent) in the RFE's largest gold mine, Kubaka. From 1995 through 1997, EBRD and OPIC provided U.S.$130 million in debt financing to build the mine. Associated with Kubaka is the Birkachan gold and silver deposit, of which Kinross also owns a controlling stake. In late 2002, Kinross sold its 25 percent interest in the undeveloped Aginskoe deposit (Kamchatka) to the platinum mining firm Koryakgeolodobycha. In June 2002, Kinross announced plans to combine operations with Echo Bay Mines, Ltd., which had an interest in the Kuranakh deposit (Sakha), reportedly Russia's second largest gold deposit.[194] The company also plans to merge with TVX Gold Inc. (Toronto), 50 percent owner of a joint venture (Trevozhnaya) that holds rights to develop some deposits in Kamchatka.

Bema Gold Corporation. This Canadian company, a producer of gold and other precious metals in Latin America (Refugio gold mine in Chile) and the western United States, owns 79.5 percent of the Julietta gold mine and 50.5 percent of the Atagan, Makinskaya, and Ivaninskaya projects in the RFE.[195] Commercial production at Julietta began in December 2001. The International Finance Corporation (IFC) has invested U.S.$10 million in the Julietta mine (see p. 280).

Pan American Silver Corporation. Pan American Silver Corporation formerly had a controlling interest in the Dukat silver mine, but after several struggles with Russian partners and the Magadan government, now holds just a 20 percent stake (see pp. 280–81).

WPN Resources Ltd. WPN sold its 85 percent interest in the Russian firm Geometall Plus in June 2001. This eliminated WPN's investment in most Russian deposits, including Dukat, Kubaka, Chai Yuria, Orotukan, and Nyavengla. WPN's sole investment in the RFE appears to be its 50 percent stake in the Kyuchus gold deposit in the Republic of Sakha (see p. 249).

Big Blackfoot Resources Ltd. During 1999 and 2000, this Canadian firm acquired a 74 percent stake in the Magadan gold mining company Zolotaya Kolyma, which has begun exploration and survey of the Dubach gold deposit.[196]

Nevada Manhattan Mining, Inc. Based in Sherman Oaks, California, this company harvests and exports logs and lumber from Brazilian rain forests and mines precious metals in Nevada and Indonesia. In 1999, Nevada Manhattan Mining bought twenty-five-year rights to develop the Glukhoe gold deposit (Primorsky), and the Primorskoe and Salut gold and silver deposits (Primorsky).[197]

– JN

have produced the most gold, and Khabarovsk Krai is starting to expand production (see map 1.24). Economic turmoil led to sharp production declines in Sakha, but production in Magadan, Amur, and Khabarovsk remained fairly stable throughout the 1990s. Nationwide, gold-mining production declined less than many other industries. The Kubaka mine is now the second largest gold producer in Russia.[198] Kubaka produces about 12 to 15 metric tons a year, or almost 20 percent of RFE production. Other major producing mines are Mnogovershinnoe (Khabarovsk Krai, 2–3 metric tons) and Pokrovka (Amur Oblast, 2.8 metric tons in 2001).[199]

In 2001, Russia produced about 154 metric tons, making the country one of the world's largest gold producers.[200] Of this total, Russia exported about 90 metric tons: jewelers and other manufacturers used between 15 and 20 metric tons, and Gokhran, the state repository for gold and precious metals, bought the remainder. About 14 percent of companies involved in gold mining (78 companies) produce about 74 percent of Russia's gold. *Artels* produce about half of all RFE gold.

Continued gold industry growth depends on developing lode deposits as companies are depleting the placer mines. Unlike placer operations, lode mines can operate year-round, an attractive feature for foreign investors.

Agriculture

J. NEWELL—Arable land is limited to fertile plains in and around the Amur and Ussuri River basins in the southern RFE. Amur Oblast claims almost 60 percent of all arable land in the RFE, about 1.76 million ha.[201] Primary crops include soybeans, oats, wheat, and potatoes; meat, dairy products, and honey are also produced. Despite this diversity, the region will probably never be self-sufficient in foodstuffs.

Three types of agricultural producers have emerged since privatization began in 1991.[202] First, large Soviet-type collective farms remain. Although they use most of the available agricultural land, many of these enterprises are going bankrupt due to a lack of proper equipment and stable energy supply. Second, smaller agricultural enterprises now use roughly 6 percent of the total useable land and are facing similar problems. Third, there are now individual household plots, often dacha gardens (suburban plots owned by city dwellers), which tend to be the most efficient. Although comprising only 3 percent of all agricultural land in Russia, they contribute up to 50 percent of all food consumed in Russia.[203] In Khabarovsk, household plots use 10 percent of the cultivated land but produce an estimated 50–80 percent of the major food staples.[204]

Despite privatization, most land remains under the control of the regional government through land redistribution funds. More than half of all arable land in Amur Oblast is controlled by the regional government, which leases it to large agricultural enterprises.

The agricultural industry is in dire need of new equipment and access to a stable energy supply. At the annual U.S. West Coast–Russian Far East Ad Hoc Working Group in 2001, the Agriculture working group reiterated their need for new equipment and recommended the international community create an equipment-leasing program to be supported by the U.S.-Russian Investment Fund (TUSRIF) and the EBRD. The RFE produces almost three-quarters of the country's soybeans, giving agricultural companies in Amur, Primorsky, and the JAO reason to hope foreign firms will invest in production. New equipment would supplement such investment. Potential export markets include China and Japan, both major consumers of soybean products.

Toward sustainable development

Josh Newell

Throughout the RFE, NGOs, progressive government officials, and emerging private companies held high hopes that the fall of the Soviet Union would usher in reforms to transform an economy reliant on resource extraction into one based on manufacturing. Blessed with low labor costs and rich mineral, energy, timber, and fishery resources, many believed the region could manufacture value-added products from these resources for domestic and international markets. Reconstructing the energy infrastructure would also eventually ensure a reliable supply for RFE residents; this would involve developing natural gas reserves and renewable energy sources (such as wind and solar) to reduce dependence on polluting coal and diesel fuel. Revenue and jobs would increase, the economy would become more diversified, and natural resources would be used more efficiently. If this transformation occurred with environmental controls in place, the RFE would make great strides toward sustainable development—broadly defined as meeting present and future economic and social needs without compromising ecological systems.[205]

Ten years later, this scenario seems naïve. Sawnwood and plywood production, fish processing, machine building, and light industry are at unprecedented lows. The region is even more reliant on raw material export. Unemployment is high. Wasteful resource use and inefficient production persist. Energy intensity in Russia has increased, and coal (when available) remains the only option for most power plants (see p. 66).

Why have more than ten years of economic and political transition brought with them so little progress toward these goals? Low levels of government investment are part of the

problem. Economist Nadezhda Mikheeva estimates that by 1998 federal investment in the RFE had plummeted to just 15 percent of 1990 levels.[206] The federal government lacks funding to activate numerous National Action Plans and Federal Target Programs designed to increase manufacturing and environmental controls.[207] More cynical observers maintain the government lacks the will to activate these programs in the RFE, pointing out that expanded manufacturing capability might make the region more self-sufficient and more independent from Moscow at a time when President Putin is trying to recentralize control. Economists argue manufacturing decline is the result of market forces: Soviet economists and planners supported inefficient manufacturing industries that could not compete without large federal subsidies for energy and transport. Some blame capital flight for the decline: Russian firms continue to protect their profits in foreign accounts rather than reinvest them in domestic infrastructure and technology, which is needed to make manufacturing competitive. Still others cite resistance to reform from those in the RFE who benefit most from exporting precious raw materials.[208]

Lack of federal funding, lack of federal will, lack of competitiveness, capital flight, and greed: These are all factors impeding structural change. But what of the role of foreign

Foreign direct investment (FDI) in the RFE

Foreign direct investment levels in the RFE have been relatively low, given the natural resources and major consumer markets of China, Japan, and South Korea. Instability in Russia continues to deter investors: tax laws and regulations are too fluid, the legal system is weak and capricious, power relations between the regions and the center continue to shift muddling jurisdiction, and corruption and black markets remain prevalent. Using Goskomstat regional (*krai* and *oblast*) statistical sources, the Far East and Zabaikale Association estimates that official RFE FDI—a significant percentage goes unreported to avoid taxation and extortion by criminal organizations—totaled U.S.$4.2 billion for the period 1995–2001 (see table 1.11). Investment in Sakhalin, with its oil and gas projects, makes up about half of this total ($2.13 billion), and the region is annually one of Russia's top recipients (first in 2000).[209]

This indicates a clear pattern: FDI is primarily going into resource extraction and export projects in oil and gas and mining, followed by timber and fishing.[210] FDI in mining has primarily gone into developing gold and silver deposits in Magadan Oblast. Foreign companies exert great influence on mining in Magadan: Kinross Corporation (Canada) controls and operates Kubaka, one of Russia's largest gold mines; Bema Gold Corporation (Canada) controls and operates the huge Julietta gold and silver mine; and Pan American Silver Corporation has a large stake in one of the world's largest silver mines, Dukat.

Foreign companies have long been interested in RFE forest resources, but corruption in the industry and a series of failed ventures in the early 1990s—Hyundai (1991) and Weyerhauser (1993–1994)—have limited the widespread investment originally predicted. Nevertheless, a handful of foreign companies operate in the Primorsky and Khabarovsk Krais, supplying the Northeast Asian log market. Rimbunan Hijau, a Malaysian timber conglomerate with a reputation for poor harvest practices, has the largest operations: The company secured two forty-nine-year leases in 1998 to log more than one million ha of forestland in Khabarovsk Krai. Rimbunan has emerged as one of the RFE's largest loggers and exporters. Pioneer Corporation (part of the Pioneer Investment group based in Boston) was once a major timber producer and exporter until it shut down operations in April 2002. Pioneer operated out of Siziman Bay, on the northeastern coast of Khabarovsk Krai, where it had effectively created a timber camp and private port—heavily guarded and cut off from nearby villages. Chinese investors, meanwhile, have funded small-scale logging and export operations near the Russian-Chinese border. Few foreign companies have invested in manufacturing (sawnwood, plywood, furniture), with STS Technowood being a major exception. A joint venture between the Japanese firm Sumitomo and the Russian firm Terneiles, Technowood is one of the few and definitely the most successful timber-processing venture with foreign investment in the RFE.

Unreported investment and complex charter arrangements make tracking FDI in the fishing industry difficult. Throughout the 1990s, foreign companies chartered fishing trawlers and vessels to Russian firms or developed joint ventures. U.S. firms, for example, set up such arrangements to harvest crab: Common arrangements included either refitting Russian-built vessels in the United States for crabbing or supplying U.S. crabbers, with payment from Russian operators in product.

Table 1.12 inventories the largest FDI projects, with public finance (international financial institutions and export credit agencies) where involved noted. The table also includes infrastructure projects because their expansion and modernization expedite resource extraction and export.

—JN

Table 1.11

Foreign investment in the RFE, 1995–2001 (U.S. $ million)

	1995	1996	1997	1998	1999	2000	2001
RFE	198	408	271	554	1,438	577	764
Sakhalin	52	45	53	136	1,207	251	389
Primorsky	53	97	94	85	54	78	108
Sakha	12	8	14	198	86	160	144
Magadan	14	149	63	52	30	28	26
Kamchatka[a]	24	24	34	43	26	29	78
Khabarovsk	42	79	12	40	33	27	19
JAO	0	0	0	–	–	–	–
Amur	1	6	1	–	2	4	–
Chukotka	–	–	–	–	–	–	–

Note: a. Includes Koryak Autonomous Okrug.

Source: Interregional Association of Economic Cooperation for the Far East and Zabaikalye, 2002.

direct investment (FDI)? Theoretically, FDI, in the form of joint ventures, equity investment, and wholly owned foreign ventures, can provide capital, management expertise, and technology to retool industries, develop manufacturing capability, and reduce resource waste and pollution. Less FDI has flowed into the RFE than many economists expected—about U.S.$4.2 billion from 1995 to 2001—suggesting that more FDI is needed for the region to achieve real progress (see tables 1.11 and 1.12 and text box). But FDI may be part of the problem: FDI has flowed almost exclusively to resource extraction projects, first in offshore oil and gas development (Sakhalin) and gold mining (especially Magadan), then in logging and fishing. A brief review of the RFE generally supports the view that regions reliant on extractive industries—namely oil, gas, and mining of minerals and metals—have low levels of economic growth and fail to distribute revenue evenly. FDI appears to be perpetuating this unsustainable development and is having unexpected negative environmental impacts. Meanwhile, the potential benefits of western technology—modernizing manufacturing and light industry in the RFE—have yet to materialize.

This becomes problematic for international financial institutions (IFIs) using public monies to invest in these industries: Foreign-controlled energy and mining projects dominate the RFE investment portfolios of these institutions (see table 1.12 and text box on p. 92), yet IFIs are mandated to support projects fostering "environmentally sound and sustainable development" (in the case of the European Bank for Reconstruction and Development) as well as projects alleviating poverty through sustainable development (World Bank).

If these institutions instead shifted their lending priorities to support FDI in manufacturing, renewable energy production, progressive environmental practices, and underdeveloped sectors such as ecotourism and nontimber forest-product businesses, then progress toward sustainable development in the RFE would indeed begin to take place. These efforts would be enhanced with more effective NGO and foreign-aid-agency programs, such as the United States Agency for International Development (USAID). Working with grants rather than loans, these groups could develop nascent industries that would not be immediately profitable.

The extractive industry debate

Can a region primarily rely on extractive industries to achieve long-term economic growth? Traditional economic wisdom says yes. In the 1940s, economists began promulgating the idea that countries rich in oil and minerals would prosper through attracting foreign capital to export their resources in unprocessed or semi-processed form.[211] Domestic profits would then be directed toward social needs, such as education and infrastructure, and reinvested in manufacturing industries and services. FDIs would also introduce technology to harvest resources more efficiently and improve production methods, both of which would minimize environmental impacts.

This economic model guides the policies of today's publicly funded international institutions, which are charged with financing development projects and economic programs throughout the industrializing world. Although there are considerable policy differences among these institutions, they

can be divided into three groups: (1) IFIs, such as the World Bank Group, the International Monetary Fund (IMF), and EBRD, all of which are funded by member governments; (2) Export Credit Agencies (ECAs), or bilateral agencies, such as the U.S. government's Overseas Private Investment Corporation (OPIC), a provider of low-interest loans and political-risk insurance to U.S. companies, and the numerous export-import banks such as the Export-Import Bank of the United States and Japan Bank for International Cooperation (JBIC); and (3) bilateral aid agencies, which primarily provide grants and technical assistance, such as USAID and Canadian International Development Agency (CIDA), and various United Nation agencies, such as United Nations Development Programme (UNDP) and United Nations Industrial Development Organization (UNIDO).

Critics, such as Hans Singer, an economist during the 1950s, have long challenged the tenets of this economic development model. Over the past two decades numerous studies have reinforced the critics' arguments. One such study by then-Harvard economists Jeffrey Sachs and Andrew Warner found that, between 1970 and 1990, economies of resource-rich countries grew more slowly than those without natural resource wealth—even after controlling for factors such as labor productivity, trade and investment policies, political risk issues, and other growth handicaps.[212] The difference between the two types of countries was dramatic: If all countries had started at the same level in 1970, by 1990 the least resource-intensive economy would have a per capita GDP roughly 2.5 times larger than the most resource-intensive economy.[213]

This phenomenon has become popularly known as the "resource curse" or the "paradox of plenty." And researchers have come up with numerous explanations for why it occurs. For one, extracting and exporting raw materials provides less revenue and creates far fewer jobs than does processing the materials and producing finished goods.[214] This is in part because prices for raw materials have fallen relative to those for manufactured goods.[215] Prices for raw materials are also volatile, prone to booms and busts. During price booms, governments often fail to reinvest revenue, quickly overspending their surplus, or worse, corrupt government officials appropriate or misuse them.[216] Alan Gelb, in *Oil Windfalls: Blessing or Curse,* documents how oil-dependent economies, in addition to failing to save, neglected to reinvest in other sectors (particularly manufacturing and agriculture).[217] In economic literature, this is often referred to as "Dutch Disease," whereby investment in natural resource extraction draws labor and capital away from other sectors such as agriculture and manufacturing, stunting their development and making them less competitive.

Perhaps more damning have been studies correlating resource dependence with increased poverty and inequality, particularly in countries dependent on mining. UCLA political scientist Michael Ross found oil and gas and mineral sectors to be enclave industries separate from the local economy, creating jobs for a small number of skilled workers. Industry representatives counter that they indirectly create jobs, by expanding upstream to businesses supplying the extractive industries and downstream to businesses that process and add value to raw materials. Ross found this linkage weak, however, especially for downstream businesses, because governments fail to reinvest in manufacturing and because industrialized countries tend to protect their own processing industries through tariffs or subsidies.[218] Although highly profitable for "oil and mining firms, for well-placed politicians and bureaucrats, and for the World Bank itself," Ross concludes mineral-dependent economies are "disastrous for the poor."[219]

Criticism of this development model extends beyond academic circles. NGOs have long accused the World Bank of funding mining and oil projects that fail to provide equitable socioeconomic benefits and pollute the environment, noting that financing such projects contradicts the Bank's mandate. Where such projects involve FDI, NGOs have been particularly vocal about environmental impact, accusing foreign companies of moving their resource-extraction and pollution-intensive operations to countries with weak environmental regulations ("pollution havens") to cut costs or of pressuring regulatory agencies within these countries to lower environmental standards ("race to the bottom") or change land use plans as a prerequisite for investment.

On behalf of a large NGO coalition, Friends of the Earth–International Chairman Ricardo Navarro in September 2000 called upon the World Bank to cease financing oil and gas and mining projects altogether.[220] Bank president James Wolfensohn responded by creating the Extractive Industries Review (EIR) in October 2001 to consider whether the Bank's role in these industries is compatible with its mission. NGOs have commended the Bank's initiative, although many are skeptical because the Bank selected its own review team and because recommendations from a similar but better-financed review (World Commission on Dams) were never implemented.[221]

If recommendations from a critical EIR review were implemented, however, it would have a broad impact on Bank activity in extractive-based countries, including loans, structural adjustment programs, and FDI-promotion programs. This would spill over into EBRD and ECA operations—these institutions often incorporate Bank findings in their lending guidelines.

These policy changes would also alter development of the RFE—a region where these institutions heavily fund FDI projects in energy and mining. Let's explore the "resource curse" thesis as it pertains to the RFE by considering extractive industries in the region generally and then focusing on the Sakhalin II oil and gas development project specifically.

Table 1.12

Foreign direct investment and public finance in resource extraction projects in the RFE

ENERGY

Sakhalin I
■ Resource: Oil and gas
■ Region: Sakhalin
■ Estimated cost: $12 billion
■ Foreign ownership: ExxonMobil (30%), Sodeco (Japan) (30%), ONGC Videsh Ltd. (India) (20%)
■ Bank: EBRD, $56.4 million (2001)
■ Estimated resources: Oil, 325 million tons; gas, 425 billion cu. m
■ Loan provided to Russian partner, Rosneft Sakhalinmorneftegas; production sharing agreement (1995)

Sakhalin II
■ Resource: Oil and gas
■ Region: Sakhalin
■ Estimated cost: $10 billion
■ Foreign ownership: Royal Dutch Shell (55%), Mitsui (25%), Mitsubishi (20%)
■ Bank: EBRD, $131 million (1998); OPIC, $116 million (1998); JBIC, $116 million (1998)
■ Estimated resources: Oil, 140 million tons; gas, 494 billion cu. m
■ Annual production: Oil, 2 million tons (2001)
■ First Sakhalin project to start production (1999); production sharing agreement (1994)

Sakhalin III
■ Resource: Oil and gas
■ Region: Sakhalin
■ Foreign ownership:
 · Kirinsky Block—ExxonMobil (33.3%); ChevronTexaco (33.3%)
 · Ayashkinsky and E. Odoptinsky Blocks—ExxonMobil (66.6%)
■ Estimated resources: Oil, 801 million tons; gas, 1.386 trillion cu. m
■ No production sharing agreement

Sakhalin IV
■ Resource: Oil and gas
■ Region: Sakhalin
■ Foreign ownership: BP (UK)(49%)
■ Estimated resources: Oil, 123 million tons; gas, 540 billion cu. m
■ Production sharing agreement

Sakhalin V
■ Resource: Oil and gas
■ Region: Sakhalin
■ Foreign ownership: BP (UK) (49%)
■ Estimated resources: Oil, 154 million tons; gas, 450 billion cu. m
■ No production sharing agreement

Sakha–China gas pipeline
■ Resource: Oil and gas
■ Region: Sakha
■ Foreign ownership: China National Oil Corporation
■ Estimated resources: Oil, 235 million tons; gas, 13 trillion cu. m (Sakha total)

Sakha–South Korea gas development and pipeline
■ Resource: Oil and gas
■ Region: Sakha
■ Estimated cost: $17–23.5 billion
■ Foreign ownership: Fifteen South Korean companies
■ Expects 34 – 44 billion cu. m of gas yearly

Gas development
■ Resource: Gas
■ Region: Sakha
■ Foreign ownership: Eurogas, Pan Asia Mining

Mutnovsky Geothermal Power Plant
■ Resource: Geothermal
■ Region: Kamchatka
■ Estimated cost: $169.7 million
■ Bank: EBRD, $112.8 million (1998)

MINING

Kubaka
■ Resource: Gold and silver
■ Region: Magadan
■ Foreign ownership: Kinross Gold Corp. (Canada)
■ Bank: OPIC, EBRD, $35.8 million (1998), $16.5 million (2001)
■ Estimated resources: Gold, 1.627 million ounces (high); 514,000 ounces (lower); silver, 2.2 million ounces
■ Kinross total project revenue in 2001 was $67.8 million

Julietta
■ Resource: Gold and silver
■ Region: Magadan
■ Estimated cost: $76.5 million
■ Foreign ownership: Bema Gold Corp. (Canada) (79%)
■ Bank: IFC, $10 million (2000), $1 million (2001); MIGA, $27.4 million (2000)
■ Estimated resources: Gold and silver, 866,000 ounces
■ Estimated annual production: gold, 400,000 ounces; silver, 6 million ounces

Dukat
■ Resource: Silver
■ Region: Magadan
■ Estimated cost: $105 million
■ Foreign ownership: Pan American Silver Corp. (20%)
■ Bank: IFC, $13.9 million (2000), $17.5 million (2000)
■ Estimated resources: Silver, 10.55 million tons (provable)
■ World's third-largest known silver reserve; expected annual production, 16.8 million ounces (silver); 34,000 ounces (gold)

Gold preproduction financing facility
- Resource: Gold
- Region: Chukotka
- Estimated cost: $9.5 million
- Bank: EBRD: $2 million (2000)

Berezovskaya (Dubach)
- Resource: Gold
- Region: Magadan
- Foreign ownership: Big Blackfoot Resources (unknown %)

Kuranakh
- Resource: Gold
- Region: Sakha
- Estimated cost: $450 million
- Estimated resources: Gold, 450 tons
- Annual production: 3.7 tons (1996)
- Expected annual production of 14 tons

Kyuchus
- Resource: Gold
- Region: Sakha
- Foreign ownership: WPN Resources (50%)
- Estimated resources: Gold, 150 tons
- Expected annual production of 7 tons

Nezhdaninskoe
- Resource: Gold
- Region: Sakha
- Estimated cost: $300 million
- Foreign ownership: Celtic Resources Holdings (50%)
- Estimated resources: Gold, 335–480 tons
- Expected annual production of 3 tons

Pokrovka
- Resource: Gold
- Region: Amur
- Foreign ownership: Zoloto Mining (UK) (75%)
- Bank: IFC support dropped
- Project was dropped by IFC; annual production of 3–4 tons by 2003

Tas-Yuriakh
- Resource: Gold
- Region: Khabarovsk
- Foreign ownership: The Pioneer Group, Inc. (94%)
- Estimated resources: Gold, 34 tons

Nyurba and Botuobinskaya deposits
- Resource: Diamonds
- Region: Sakha
- Foreign ownership: Caterpillar
- Region: U.S Ex-Im, $62 million (1997), $80 million (2000)
- Annual production: $1.5 billion (2000)
- World's second-largest diamond producer, 26% of global production

FORESTRY

Rimbunan Hijau Ltd. (Sukpai River)
- Resource: Logs
- Region: Khabarovsk
- Foreign ownership: Rimbunan Hijau International (Malaysia) (100%)
- Estimated resources: 500,000 cu. m per year
- Annual production: 300,000 cu. m (2000)

Rimbunan Hijau Ltd. (Bitchi River)
- Resource: Logs
- Region: Khabarovsk
- Foreign ownership: Rimbunan Hijau International (Malaysia) (100%)
- Estimated resources: 500,000 cu. m per year

Arkhaim
- Resource: Logs
- Region: Khabarovsk
- Foreign ownership: Unknown Japanese firm

Technowood
- Resource: Sawnwood
- Region: Primorsky
- Foreign ownership: Sumitomo (Japan)

INFRASTRUCTURE

Chita-Nakhodka road project
- Region: RFE
- Bank: World Bank and EBRD (level of financing unknown)

RFE air navigation modernization project
- Region: RFE
- Estimated cost: $80.6 million
- Bank: EBRD: $25 million (2000)

Far Eastern Shipping Company (FESCO)
- Region: RFE
- Bank: EBRD: $18.5 million (1994)

Sakhalin Shipping Company
- Region: Sakhalin
- Estimated cost: $25.7 million
- Bank: EBRD: $25 million (1996)

Note: EBRD = European Bank for Reconstruction and Development; IFC = International Finance Corporation (World Bank); JBIC = Japan Bank for International Cooperation; MIGA = Multilateral Investment Guarantee Agency (World Bank); OPIC = Overseas Private Investment Corp. (U.S.); U.S. Ex-Im = United States Export-Import Bank

Sources: Compiled from regional chapters; EBRD Investment Profile, 2001

Development banks in the RFE

In dollar terms, loans for foreign-controlled energy and mining projects dominate the RFE investment portfolios of the two multilateral development banks or International Financial Institutions that focus on private-sector lending—EBRD and the International Finance Corporation, the private sector arm of the World Bank Group—and the bilateral Export Credit Agencies active in the region. This summary provides explanation to Table 1.12.

International Financial Institutions (IFIs). To date, the Sakhalin II project (U.S.$131 million loan) is EBRD's largest, followed by the Mutnovsky Geothermal Power Plant in Kamchatka, and then a number of gold and silver mining projects (Kubaka, Julietta, Dukat) in Magadan.[222] The Mutnovsky project is technically Russian—the loan is made to the Russian firm Geoterm, with the Russian government as an intermediary—although Germany's Siemens Corporation has done much of the contract work.

IFC's portfolio is essentially two mining projects: Dukat (U.S.$13.9 million equity investment and U.S.$17.5 million loan) and Julietta (U.S.$10 million loan). Meanwhile, the World Bank's provider of political risk insurance and guarantees, the Multilateral Investment Guarantee Agency (MIGA), is insuring Julietta for $27.4 million. The World Bank's third major arm, the International Bank of Reconstruction and Development (IBRD), has a role somewhat different from that of IFC or MIGA. IBRD focuses on institutional and policy changes to specific industrial sectors of the Russian economy and makes loans accordingly. IBRD, for example, has provided two large loans designed to restructure Russia's coal industry.[223] IBRD has also provided a U.S.$400 million Highway Rehabilitation and Maintenance loan earmarked to rebuild Russian roads and build new ones, including the controversial Chita-Nakhodka road that is being built through previously inaccessible forests in the Sikhote-Alin Mountain Range (Primorsky and Khabarovk Krais) and will expedite logging and timber export. As with IFC and MIGA, promoting FDI as the primary vehicle to achieve sustainable development remains the underlying philosophy of IBRD.

All three institutions (EBRD, IFC, and IBRD) have made limited attempts to finance Russian firms and to encourage processing (see pp. 95–96).

Export Credit Agencies (ECAs). The other major source of international finance, the ECAs, meanwhile exist solely to support foreign corporate interests, either through loans directly to these firms or through financing to Russian companies purchasing foreign equipment and services. The U.S. government's Overseas Private Investment Corporation (OPIC) financed Sakhalin II (U.S.$116 million) and Kubaka (amount unknown), and created a Private Equity Fund for Russia designed to encourage direct foreign investment generally.[224] The U.S. Export Import Bank (Ex-Im), which provides financing to Russian companies that want to purchase U.S. equipment and services, had authorized more than U.S.$2 billion in loans, guarantees, and insurance for projects in Russia (as of October 2002). Ex-Im has developed framework agreements on oil and gas (1993) and forestry (1996) to encourage U.S. exports of equipment and services to these sectors. The Trade and Development Agency (TDA) provides grants for U.S. firms to carry out feasibility studies and other planning services needed to garner future financing for major projects. In the RFE, TDA recently provided $600,000 for new fishing vessels equipped with U.S. engines and financed a study to explore the export of Alaskan coal to Magadan.

Lending by the Japan Bank for International Cooperation (JBIC)—Japan's primary lending agency and one of the world's largest financial institutions—has been largely limited to the Sakhalin II project, although its predecessor, the Export-Import Bank of Japan, supported resource development projects throughout the Soviet era and was instrumental in building the industrial structure that persists in the RFE today (see text box, A history of Japanese investment in the RFE, p. 99).

– JN

The RFE: A resource-cursed region?

The RFE is by no means an integrated economic unit—industries and their methods of operation vary considerably by administrative region. But all regions rely on resource extraction and export and have a weak manufacturing capacity. Mining defines the economies of three northern regions: Sakha (diamond, gold, tin, and coal), Magadan (gold and silver), and Chukotka (gold and tin). Fishing is dominant in Kamchatka and Koryakia, although the latter has a growing platinum mining industry, and gold mining is being considered on Kamchatka. Sakhalin relies primarily on fishing, followed by oil and gas, and then timber and coal mining. Oil and gas will become major contributors to the Sakhalin economy in years to come, perhaps eclipsing fishing. Other southern regions (Primorsky, Khabarovsk, Amur, and Jewish Autonomous Oblast) have more diversified economies, although mining is a major component in each.

Unfortunately, few researchers have weighed the pros and cons of extractive industries for Russia, let alone the RFE. There is evidence of the state "squandering" windfall profits from oil and gas export in the late-Soviet period, and failing to reinvest in manufacturing and social services.[225] Post-

Foreign investment of selected countries

Japan. Japanese investment in the 1990s has decreased. The main investments include the Sakhalin I and II gas projects (Mitsubishi, Mitsui, Sodeco), two timber-processing joint ventures, STS Technowood and STS Hardwood (Sumitomo) in Primorsky Krai, one major logging joint venture (Arkhaim), and ventures in fishing, communications, car repairs, and hotels.[226] The Japanese government and numerous Japanese companies have also invested in the expansion of Zarubino port, in the Tumen River Delta region, to facilitate trade with Manchuria (northeast China).[227]

China. Chinese investment has been largely small-scale and focused on trade and logging, particularly in the southern RFE. The Chinese government is interested in possible investment in the Sakha oil and gas projects.

South Korea. South Korean companies invested U.S.$69 million in fifty-five projects in the RFE in the 1990s. Hyundai Corporation has been the most significant with the failed Svetlaya joint venture (see p. 133) and the Hotel Hyundai in Vladivostok. The South Korean government and South Korean companies are interested in the Sakha and Sakhalin oil and gas projects.

United States. U.S. energy companies are prominent in several Sakhalin projects: ExxonMobil (Sakhalin I, Sakhalin III, and Sakhalin IV) and ChevronTexaco (Sakhalin III). U.S. firms in the timber sector (Weyerhauser, Pioneer Corporation, and Global Forest Management Group) have had less success. Several U.S. companies supply equipment to the fishing, timber, and especially the mining industries.

Others. Canadian companies have the most investment in the mining sector—located almost exclusively in the Magadan Oblast. Rimbunan Hijau, the Malaysian logging company, has two large long-term leases in Khabarovsk Krai.

—*JN*

is sufficient to provide either economic recovery or sustained economic growth. The geographers cite numerous other constraints to basing the RFE economy on resource extraction: aging equipment, legal and environmental constraints, and large-scale depletion of accessible resources.[230]

Vladimir Kontorovich, an economist at Haverford College, has studied labor demand and the generation of rents (excess payments or profits generated by natural resources) in RFE industries. He found extractive industries in the RFE now employ far fewer people than did manufacturing during the Soviet era and that substantial production increases in these sectors would not make up for the job shortfall.[231] Alexander Sheingauz and others at the Institute of Economic Research in Khabarovsk support this assessment in a separate study.[232] Kontorovich contends foreign investment in extractive sectors will bring labor-efficient western technology, leading to further employment declines.

Kontorovich finds little evidence rents generated from these sectors can subsidize other more labor-intensive industries such as service, manufacturing, and agriculture. Only the Republic of Sakha's diamond industry achieves this, he maintains, and only for a portion of the Sakha economy. High extraction and transportation costs make rent from Sakhalin oil and gas projects only "marginal." The profit margin for mining is even slimmer than for oil and gas, and may be reduced even further given the short life span—sometimes only two or three years—of many mining projects. A significant price increase for resources could increase the rent, but Kontorovich doubts this will occur anytime soon, particularly for minerals.

The Sakhalin II oil and gas project

Another way to weigh in on the extractive industry debate, and the approach favored by the Extractive Industries Review, is to look at specific projects. The RFE's keynote project is the Sakhalin II oil and gas project. It contains all the elements central to the debate: large-scale resource development (oil and gas), FDI, and public money in the form of loans from EBRD, OPIC, and JBIC.

Sakhalin II project operator Sakhalin Energy Investment Corporation (SEIC) claims the economic and social benefits will be "overwhelmingly positive" largely due to the "increase in employment, both indirect and direct" and the generation of large revenues for federal and regional governments (taxes, royalties, and other payments).[233] Kontorovich's research refutes this, as does a report by the Auditing Chamber of the Russian Federation. The report contends that, despite producing oil since 1997, as of February 2000 the project had contributed no economic benefits to Russia's budget. Provisions in the project's Production Sharing Agreement (PSA) allow SEIC to pay U.S.$19 billion less in taxes than they would have otherwise, over the life of the project.[234] SEIC calculates benefits to the Russian government totalled

Soviet research indicates resource-rich regions in Russia have, in the short-term, fared better economically than regions without resource wealth.[228] But British geographers Michael Bradshaw and Nicholas Lynn speculate long-term economic growth of resource-rich regions may be compromised because they have been slowest to adopt necessary reform.[229]

Bradshaw and Lynn also question the size of the RFE natural resource base. Higher energy and transport costs make extracting remote resources such as mineral deposits in the north economically unfeasible, leaving only the most accessible resources viable for exploitation. If the region remains extractive-industry dependent, they doubt whether this base

U.S.$233.8 million through the end of 2001. This includes a onetime contribution of U.S.$100 million to the Sakhalin Development Fund, some of which is tagged to develop infrastructure that would greatly benefit oil companies: New roads and port upgrades are crucial to the project.[235]

Both sides are likely overstating the case. More worrisome is how this revenue will be distributed. Emma Wilson's fieldwork in the communities of northern Sakhalin led her to conclude that any local benefits from the project will go to a select few (see p. 408), primarily those in Sakhalin's capital, Yuzhno-Sakhalinsk, and not to the northern communities (many of which are indigenous) whose traditional livelihoods are threatened by the project and who will bear most of the ecological risk. Wilson blames the PSA system and the fact that the oil and gas reserves are in federal waters, which means Nogliksky Raion (situated just west of the project) has "no claim to any payments for the use of resources although an oil spill would devastate the local fishing economy." The only bonus payments to the *raion* (required by the PSAs) so far have been for a gas-fired power station near Nogliki that was built primarily to supply gas to southern Sakhalin. The power station uses gas from the onshore reserves. While the project could bring revenue to local services, shops, and restaurants, Wilson notes ExxonMobil (Sakhalin I) and SEIC have built a self-sufficient compound with strictly limited access for security purposes outside Nogliki; and the *raion* receives no revenue from the camp because both companies are registered in Yuzhno-Sakhalinsk.

Environmental impacts. It appears Sakhalin II will not deliver a solution to the island's energy problems anytime soon, a benefit that residents had expected. Residents had hoped the project would process gas locally and then use it to convert the island's unstable, polluting coal-thermal power stations. But SEIC is pursuing an "oil first" strategy: exporting crude and planning to build a pipeline and liquefied natural gas (LNG) terminal to export gas to Asian markets.

Environmentalists maintain companies such as Royal Dutch Shell, the largest shareholder in Sakhalin II, and ExxonMobil, the largest shareholder in Sakhalin I, are operating in Russia and other so-called pollution havens in part because environmental regulations are weaker (or in Russia's case more malleable) and labor standards are lower than in wealthier countries. This debate occurs when foreign companies apply for IFI or ECA financing: NGOs see their participation as an opportunity to ensure projects adhere to high environmental standards.[236] Indeed, decades of NGO campaigning have led to significant improvement in the World Bank's environmental and social guidelines, and the EBRD's guidelines have also steadily improved since its creation in 1991, although many still consider both institutions' improvements inadequate. The guidelines of OPIC, JBIC, and other ECAs are much weaker, but they too have improved over the past five years due to NGO pressure.[237]

Improving these guidelines, however, does not ensure companies will use the "best available standards" (those usually required for projects in the United States and Western Europe). A coalition of NGOs, led by Sakhalin Environment Watch (Russia) and Pacific Environment (United States), claims Sakhalin II uses "far weaker environmental standards than those used internationally and in the U.S." This claim was strengthened by a September 2002 exposé in the *Wall Street Journal* documenting the disparity between the environmental standards for Sakhalin I and II and those for similar projects in Alaska:

[The oil and gas companies] already at work aren't following many of the protective measures that would be standard in the U.S. … The consortium [Sakhalin I, ExxonMobil] plans to transport oil year-round through Russia's ice-clogged Tatar Straits. Alaska, by contrast, has limited oil operations during periods of heavy ice floes in the Arctic Ocean because the industry flunked tests on cleaning up spills from drilling in those conditions.

The Shell-led group [Sakhalin II] has discharged toxic mud drillings into the shallow ocean waters off Sakhalin after an industry-sponsored study persuaded the Russian government to change its rules to allow the practice. To protect marine life, such dumping is prohibited in much of coastal Alaska.

For oil spills, Shell's closest cleanup equipment and manpower is about 50 miles from the oilfields, too far to meet requirements in most developed nations. ExxonMobil's plans rely on the same spill response setup. Neither group has so far offered any plans to protect the salmon from pipeline discharges, as would be required in the U.S.[238]

The *Wall Street Journal* exposé essentially accuses Sakhalin II of watering down Russian environmental regulations to allow the discharge of drilling muds directly into the sea and to bypass the more costly reinjection method common in Alaska. The questionable regulatory change was recommended in a study by the Sakhalin branch of TINRO (SakhNIRO), funded by Sakhalin II companies. The change also required that the Fisheries Committee downgrade the protection status for fisheries in the project's primary drilling area. A number of Russian scientists and government officials question the study's validity, noting its failure to consider migratory fish, such as salmon, and its analysis of only those fisheries "directly located over oil deposits, ignoring the rest of the coastal ecosystem."[239] Pacific Environment, meanwhile, maintains SEIC has already damaged nearby fisheries by dumping drilling muds and cuttings directly into the sea. This not only concerns the northern communities who rely on these resources, but also potentially all residents, as fishing is the island's largest employer.

Environmental standards for Sakhalin II are important not only because the project is geographically dispersed and will affect forests, marine areas, and a variety of other habitats, but also because the project's standards will set the benchmark for future oil and gas projects in the RFE. One of the stated missions of EBRD and other development banks is to improve private projects such as Sakhalin II. But if these institutions cannot require SEIC to use the same standards as those widely required of oil and gas projects in wealthier countries, then their ability to improve the environmental performance of such projects is questionable. See Chapter 11 for more detail on Sakhalin II and other oil and gas projects.

There are other instances of regional governments in the RFE loosening regulations to attract or retain FDI. To entice the Malaysian timber conglomerate Rimbunan Hijau to log the Sukpai, for example, the government of Khabarovsk Krai overturned federally approved plans to create a *zapovednik* (nature reserve) in the upper Sukpai River basin. The *krai* government even went so far as to ask regional scientists to prepare the necessary papers (see pp. 175–76).

The case for the environmental benefits of FDI

IFIs and foreign government agencies maintain FDI benefits the environment. Indeed, FDI is a centerpiece of the U.S. government's strategy for promoting environmental stewardship and sustainable development worldwide, a strategy expedited by U.S. lending agencies such as OPIC and the Ex-Im Bank. This vision was articulated most recently in their flagship publication for the 2002 UN Summit in Johannesburg, *Working for a Sustainable World: U.S. Government Initiatives to Promote Sustainable Development:* "The private sector can help manage and conserve natural resources and the environment by using environmentally sound production methods. Production that limits pollution, and conserves water, soil, land, and fuels, protects natural resources for the future."[240]

The use of lower standards to produce oil, as with Sakhalin II, undermines this claim. The argument also hinges on the theory that FDI brings resource-efficient and environmentally benign technology. Foreign companies either sell equipment directly to domestic firms or introduce it via joint- or wholly owned ventures. This equipment protects the environment, if used properly. It generally harvests resources more efficiently, and some design features reduce environmental impact. But this more mobile and powerful equipment can do significant albeit unintended environmental damage in places like the RFE, where government regulation is weak.

A few examples make this clear. In the timber industry, Finnish, Japanese, Korean, and American timber harvesters, skidders, and loaders dominate the market.[241] Most of these harvesters have features such as rubber tires designed to minimize damage to soil and undergrowth. But they are also more mobile, enabling companies to log forested slopes inaccessible to heavier Russian equipment. Russian regulations prohibit

timber harvest on slopes greater than 20° but introducing this equipment has facilitated illegal logging of the slopes. A similar phenomenon is apparent in the fishing industry. The introduction of European trawling fleets in the 1990s improved harvest efficiency, according to fishing specialist Tony Allison, while simultaneously leading to the harvest of unsustainable (and illegal) quantities of pollock to pay for the trawlers' high operating costs (see pp. 55–56). Introducing large U.S. crabbers similarly affected king crab stocks.

Western technology and production methods could increase yields and reduce environmental damage in existing gold mines and onshore oil and gas production areas. But to date, foreign investors have used their technological expertise and capital to open up wilderness: the Kubaka gold-mining project in Magadan, the Sakhalin offshore deposits in the fragile Sea of Okhotsk, and the Rimbunan Hijau Sukpai logging venture. Given that most RFE mining and logging companies lack capital and equipment, it is unlikely these areas would be developed without foreign investment.

Finally, foreign technology has not significantly reduced resource waste because most of the equipment introduced thus far has been for extraction, not processing, where the real benefits of this technology accrue. Western equipment, for example, could modernize the plywood, pulp and paper, and sawnwood industries. A processing industry, in turn, would create demand for smaller logs, woodchips, and branches, which are often left at the logging site.

Prospects for a sustainable economy

Given the questionable benefits of extractive industries, the questionable economic viability of the RFE's natural resource base, and the questionable effectiveness of FDI in minimizing environmental impact, a different development strategy is needed—one that diversifies the economy by expanding manufacturing and developing new industries. Bradshaw and Lynn have little hope this will occur because the supply of domestic capital is low, and the region's firms tend to focus on short-term profits rather than on long-term development.[242] Kontorovich is similarly pessimistic, arguing the RFE holds little attraction for manufacture because it is remote, sparsely populated, and lacks infrastructure.[243]

Nonetheless, there is progress. Small and medium-sized businesses in food, trade, and services are being established, albeit slowly. The timber business, with the help of FDI, could produce competitive value-added products.[244] Some regional governments have tried to increase timber processing by placing conditions on FDI, and the federal government recently adopted an ambitious plan to increase processing fourfold by 2010.[245]

International financial institutions. The World Bank's International Bank of Reconstruction and Development (IBRD) has made some effort to advance manufacturing, certainly more

than have the EBRD or International Finance Corporation (IFC). The U.S.$60 million IBRD loan to the Sustainable Forestry Pilot Project, for instance, requires promoting foreign investment in wood processing (see p. 172). The loan was finalized, however, at the same time the Russian government abolished the Forest Service—the project's main beneficiary. Environmentalists failed to persuade the World Bank to freeze the loan until the Forest Service was revived, but the loan was stalled until institutional arrangements consistent with World Bank environmental policies could be agreed upon. The project's original goals may yet be twisted to suit the more industrially minded interests of the new implementing agency, the Ministry of Natural Resources.

In September 2000, the World Bank also announced the creation of a Coal and Forestry Sector Guarantee Facility (worth U.S.$200 million) in Russia to encourage FDI by "protect[ing] private investors from political risks." The facility ostensibly would encourage value-added processing in the forestry industry, but the proposed mechanisms to ensure this are not clearly stated.

Ramping up lending to Russian-owned small and medium-sized enterprises (SMEs), which often provide goods to the domestic market, would expand manufacturing. The World Bank's 2002 *Country Assistance Strategy* (CAS) for Russia certainly promoted the importance of such loans: "The poverty-reducing impact of growth with each region and across regions would be strengthened further if growth were based on a more diversified economy with a rapidly developing SME sector, instead of the current highly concentrated industrial structure dominated by natural resource exporters."[246] But currently, SMEs receive a small percentage of IFC and EBRD financing for the RFE.[247] Increased lending to SMEs would require lending agencies to shift their focus from foreign-owned corporations to Russian-owned firms, a shift Russian officials endorse.[248]

The EBRD has financed Russian firms in the RFE, mainly through its Regional Venture Fund for the Far East and Siberia. Administered by Daiwa Corporation (Japan), the Venture Fund primarily buys equity in Russian companies with a strong domestic market.[249] To date the fund has invested U.S.$1.2 million in the Nakhodka meat plant and U.S.$3.1 million in Amur Pivo, one of the RFE's major brewing companies. But the scale of the Venture Fund's investment so far, U.S.$10 million, has been disappointing. The IFC's efforts to finance similar firms have also been less than expected; it loaned U.S.$10 million to Delta Leasing and U.S.$20 million to Delta Credit Bank, both of which in turn provide financing and lease equipment to Russian SMEs and are administered by the private U.S.–Russia Investment Fund (TUSRIF), which is primarily financed by the U.S. government.[250]

IFI performance has been weakest in the renewable-energy and energy-efficiency sectors. Most of the EBRD and World Bank Group investments in energy concern fossil fuels rather than renewables, and the EBRD's investments in energy-efficient projects in the RFE are negligible.[251] In the post-Soviet RFE, rising energy and transport costs have led to serious disruptions in the supply of diesel and coal, especially to remote villages and the northern regions. Many of these areas are well suited for small-scale renewable energy systems such as wind power, solar, small-scale hydropower, and low-emission generators as evidenced by contributors to this book. Scientist Gennady Illarionov documents the solar power potential in Amur Oblast (see pp. 220–23). NGO leader Gennady Smirnov estimates wind energy resources in Chukotka alone can generate 1.5 trillion kW annually, or more than 14 percent of Russia's wind energy resources (see p. 305). Sergei Abramov notes the Sea of Okhotsk, with some of the world's largest tide shifts, would be a good location for tidal generators (see p. 331).

Unfortunately, the IFIs have inadequate mechanisms in place to encourage such projects. As its own environment department admits, the EBRD needs "additional financial vehicles" to promote renewables and energy-efficiency projects and to encourage "sponsors of environmental projects to approach the Bank."[252]

Nongovernmental organizations. Most Russian and international NGOs operating in the RFE fall into two groups: (1) industry and government watchdogs that track, protest, and reform destructive practices among logging, mining, oil and gas, fishery, and dam construction projects, and (2) biodiversity conservators that establish or support protected areas, fund and conduct anti-poaching efforts, or research and support the protection of endangered species. A few have attempted to chart underlying socioeconomic causes of widespread illegal resource use, overreliance on raw material export, and energy shortages. Still fewer have developed projects to ameliorate these problems.

The Sustainable Land Use and Allocation Program for the Ussuri (Wusuli) River Watershed was such a project. The Ussuri River, a major tributary of the Amur River, delineates the Russian-Chinese border. The Ussuri River basin is a major industrial area and on the Russian side provides habitat for a large percentage of endangered animals in the RFE, such as the Far Eastern leopard, Siberian tiger, oriental white stork, and white-tailed eagle. Established in the early 1990s by Ecologically Sustainable Development (a now-defunct land use planning NGO from the United States), the project brought together government officials, scientists, and NGO representatives from China, Russia, and the United States to develop a comprehensive cross-boundary plan to conserve biological diversity and ensure economic development. Absent funds or the political will to implement it, however, the plan remains a paper project. Such projects need long-term commitments from local, regional, and federal governments and support from the residents of affected communities, in addition to funding. To expect revenue-starved local and regional governments to finance such projects is unrealistic.

Given their ability to work in the field with minimal overhead, NGOs with relevant technical expertise are well positioned to develop such model projects. But only a few philanthropic foundations (Rockefeller Brothers Fund, Pro-Natura Foundation, Japan Fund for the Global Environment, Turner Foundation—primary funders for many NGOs) are inclined to fund projects in the RFE. As a result, few NGOs operating in the region have adequate financial, legal, and staff resources. Even the World Wildlife Fund (WWF), the region's largest NGO, has been restricted in its efforts, focusing on programs to conserve biological diversity such as the creation of protected areas, antipoaching campaigns, and forest certification programs. For years, Friends of the Earth–Japan has tried to develop community-based projects in the Samarga River basin, including a project to provide wind power to villagers. But Friends of the Earth–Japan has had minimal success due to lack of funds, staff, and difficult social conditions produced by rampant alcoholism and the area's remoteness.

The Global Environment Facility. One emerging source of financing is the United Nation's Global Environment Facility (GEF). GEF-funded projects hold promise if (1) funds allocated to western consultants and administrative expenses can be kept to a minimum, and (2) projects focus on implementation rather than information gathering.[253] Unfortunately the primary project implementers—United Nations Development Programme (UNDP), World Bank, and United Nations Environment Programme (UNEP)—do not work that way.

GEF projects are limited to five focal areas: biodiversity, climate change, international waters, ozone depletion, and land degradation. GEF projects must grind through a time-consuming "project scoping phase"—where information is relentlessly collected to generate long reports—before concrete action takes place. The broad focal areas do not lend themselves to community-development projects, although some project designers try to adapt them. Demonstrating Sustainable Conservation of Biological Diversity in Four Protected Areas on Russia's Kamchatka Peninsula (a U.S.$2.3 million GEF-funded and UNDP-implemented project), for instance, proposes financing "sustainable livelihood support" and calls for ecotourism and a "more sustainable path of development"—vague wording that indicates either naïveté or cynicism. Unfortunately, many project planners either have little understanding of the time, money, and knowledge required to translate these ideas into project success in Russia or simply do not intend to commit the necessary resources.

After navigating GEF and other implementing agencies' complex operational policies, proposal development procedures, and eligibility criteria, several NGOs now work directly with various federal and regional Russian government agencies to develop fundable projects. These have potential. The Wild Salmon Center, a Portland, Oregon–based NGO—in partnership with UNDP and a number of government

agencies—is seeking U.S.$3.3 million in GEF support for the Kamchatka-based project Conservation and Sustainable Use of Wild Salmonid Biodiversity. This project seeks to diversify the economic base of local communities and thereby target the root causes of threats to salmon.[254]

Responding to criticism that its application procedures are too time-consuming for many NGOs, GEF has also established funding for medium-sized projects (up to U.S.$1 million). The Wildlife Foundation, a Russian NGO, has received U.S.$750,000 for such a project, Strengthening the Protected Areas Network for Sikhote-Alin Mountain Forest Ecosystems Conservation in Khabarovsk Krai, which is aimed at conserving diversity.

Foreign government aid agencies. Of the foreign government aid agencies, USAID has been the most active.[255] In 1995, USAID announced U.S.$20 million in funding to create the Russian Far East Sustainable Natural Resources Project, or the Environmental Policy and Technology Project (EPT). USAID-funded subcontractors, including NGOs, were selected to implement its ambitious objectives, which include biodiversity conservation, ecotourism, obtaining Russian NGO support, nontimber forest product development, policy analysis, and forest-code revision in the Sikhote-Alin Mountain Range. The project included a comprehensive land use plan, which integrated resource harvest, community and business development, and biodiversity conservation plans for Chuguevsky Raion, a large, timber-dependent region in Primorsky Krai. Like its predecessor, the Ussuri project, this project was ultimately a planning exercise: EPT's time frame was too short and funding too limited to move beyond the planning stage.

EPT succeeded, however, in financing and providing equipment for protected areas, funding scientific research on endangered animals, and providing small-scale financing for antipoaching teams. EPT also funded a small grants program for Russian NGOs, which is administered by the ISAR, a U.S. NGO. EPT made timid forays into packaging and marketing nontimber forest products, but had few sales and failed to establish stable operations for drying, harvest, and packaging. Some Russians complained EPT made little effort to inform local stakeholders or the general public of the specifics of the project and failed to spend most of its funds to benefit local communities. Instead, a seemingly endless stream of seminars, workshops, exchanges, and western consultants bogged down the project. Significantly, no community-development projects initiated by EPT, such as the nontimber forest product businesses and components of the Chuguevsky project, have succeeded.

In 2000, USAID announced funding for a similarly ambitious project, FOREST, based in Khabarovsk, with the NGO Winrock International managing most of the project (see p. 172). To date, the five-year initiative has placed a priority on increasing valued-added timber processing in Khabarovsk,

Primorsky, and Sakhalin—as well as in Eastern Siberia (Krasnoyarsk and Irkutsk), with the aim of supplying products for the export market.[256]

USAID also established EcoLinks to "promote market-based solutions to environmental problems."[257] EcoLinks stations "tech reps" in Russia to facilitate public and private sector partnerships with U.S. businesses that possess environmental technologies. A handful of sustainable energy projects in the RFE have been funded under EcoLink's Challenge Grants program (up to U.S.$50,000 per project).[258] The EcoLink program is quite small, however.

Other promising sectors. In addition to the energy sector, contributors to this book have consistently identified two other sectors where such projects are crucial but to date poorly developed: ecotourism and nontimber forest products.

Ecotourism. Ecotourism shows potential in numerous RFE regions. While the Russian people are wonderful, colorful hosts to visitors, facilities such as cabins and transport vehicles are lacking. Some of the most interesting areas are remote and can be visited only by chartered helicopter, which is cost-prohibitive for many. In addition, the visiting season is short, but the wilderness in many parts of the RFE is spectacular and much of it remains wild.

USAID-funded efforts to promote ecotourism are unsuccessful largely because they have been directed at the United States, and Alaska Airlines no longer flies to the RFE. Ecotourism efforts focusing the Korean, Chinese, and Japanese markets would be more effective.

A steady increase of tourists has visited Kamchatka since the early 1990s, but this has benefited only a few and, in some instances, threatens the ecosystem (see pp. 372–73). Nevertheless, with proper regulations, ecotourism could become a viable source of income—especially for small communities in photogenic areas of the RFE that currently depend on one resource (usually logging, mining, or fishing) for most of their income.

Nontimber forest products. The development of nontimber forest products (NTFPs) has strong potential along the Sikhote-Alin Mountain Range (Primorsky and Khabarovsk Krais). The products include medicinal plants such as ginseng, Devil's walking sticks (*Aralia mandshuria, A. elata*), wild rosemary (*Ledum palustre*), Amur cork tree, yew (yew needles contain taxol, an effective cancer medicine), and *Astragalus membranaceus*, pine nuts, Manchurian walnuts (*Juglans manchurica*), and a number of berries (blueberries, raspberries, cranberries, and foxberries). Wild mushrooms and edible ferns, among them *Pleridium aguilinum* and Japanese cinnamon fern (*Osmunda japonica*), are also plentiful.

The Udege people, who live in the Bikin, Khor, and Samarga River basins in the Sikhote-Alin Range, view these products as viable economic alternatives to commercial forestry. They can provide a significant financial return and represent a sustainable form of forest use. Incorporated

in 1996, the Far Eastern Association of Nontimber Forest Products Processors is a clearinghouse for information on harvesting, processing, marketing, and pricing, and facilitates cooperation between harvesters and processors. Representing over fifty companies, the association is the first contact for Russian and international concerns interested in purchasing nontimber products. The World Conservation Union's (IUCN) program, Building Partnerships for Forest Conservation and Management in Russia, is a new project operating in Kamchatka and Sakhalin that supports the development of small NTFP businesses with local indigenous groups. Though hampered by excessive bureaucracy, this program may become effective.

To develop, the industry needs experience in packaging and marketing products domestically and abroad and tax incentives to encourage production and export. Foreign investment is also crucial as Russian producers believe international markets hold the most promise.

Conclusion

A brief review of research suggests the RFE cannot base its future development on extractive industries, but the region faces obstacles to the alternative—manufacturing and nontraditional industries. Reasons for this are varied and complex, having much to do with how Soviet planners developed the region as a raw materials base. Segments of the Russian government and public who benefit from this resource-based export economy are happy to see it continue. But others have tried to channel FDI into manufacturing through tax credits, tariffs, and other forms of subsidy. It is hard to imagine a transition to a manufacturing economy in the RFE without this type of government support, but then again, it is hard to imagine any country or region making such a transition without some kind of government support despite the arguments of free trade pundits. Nevertheless, Russia's intention to join the World Trade Organization (WTO) may force manufacturing supporters to cleverly mask or scale-down their efforts: The WTO may consider as protectionist any conditions placed on FDI or any tariffs and taxation intended to discourage raw materials export.

Whether international capital plays a positive role in this economic transition remains to be seen. Its importance for the region will continue to grow as the RFE gradually blends into the northeast Asian economy. But current FDI trajectories indicate little interest in manufacturing. The keys to change therefore are held by the international financial institutions, which are grappling about whether, how, and where they should support extractive industries. But their ability to conduct this clear-sighted review is perhaps clouded by the fact that the foreign corporations who control oil, gas, and mining projects in the RFE are among their most profitable clients. For the RFE, an in-depth independent evaluation of the costs and benefits of bank-financed gold- and silver-

A history of Japanese investment in the RFE

Trade and investment in the RFE date back to the first decade of the twentieth century, but large-scale investment didn't begin until the late 1960s when the Japanese government and some of Japan's largest corporations orchestrated a series of long-term agreements with the Soviet government that provided Japanese technology and low-interest government loans in exchange for raw materials.[259] These agreements helped the Soviets develop large-scale regional production complexes in the RFE and Siberia along with the export infrastructure needed to take advantage of the Japanese market.[260] Although they are no longer negotiated between the two governments, the agreements paved the way for similar arrangements between the Russian and Japanese private sectors and were instrumental in developing the industries that dominate the economy today.

The first government-arranged agreement was the KS Sangyo Project, designed to exploit the region's vast forests. Signed in 1968, KS Sangyo (named after the consortium of Japanese companies it represented) called for the export of more than 8 million cu. m of raw logs to Japan in exchange for bulldozers, logging machinery, steel pipes, and other equipment over a five-year period. The Japanese government would also provide soft, low-interest loans that the Soviets could pay back in resources. This powerful agreement catalyzed Japanese-Russian trade; by 1970, 63 percent of all Japanese machinery and metal goods exported to the USSR was connected to the project, and Japan had emerged as the USSR's largest trading partner.[261] Two more KS Sangyo projects followed, and together they provided for the export of more than 32 million cu. m of timber to Japan.[262] More importantly, the agreements gave the RFE a continuous supply of timber-cutting, hauling, and road-building machinery for the duration of the three projects (1969–1985).[263] Missing in these agreements, however, was a significant percentage of Japanese wood-processing equipment.

Similar agreements were made to develop other resources, such as the Neryungri coalfields in Sakha. The Soviet Union agreed to ship 100 million metric tons of high-quality coking coal in exchange for 126 billion yen worth of mining machinery, equipment, and credits.[264] Throughout the 1980s, Sakha's coal monopoly, Yakutugol, shipped about 5.5 million metric tons annually. Though this agreement has expired, Yakutugol continues to export million of metric tons of coal to Japan each year. In the 1970s, the two countries also forged an agreement to develop Sakhalin's offshore oil and gas reserves; Japan gave U.S.$170 million (mostly government funds) in credits and created the Sakhalin Oil Development Corporation (Sodeco), a quasi-governmental Japanese agency, to round up additional project financing and expertise. This initial investment later developed into the U.S.$12 billion Sakhalin I oil project, of which Sodeco holds a 30 percent share. In the 1970s, Japanese capital also financed construction of Vostochny Port in Primorsky Krai, which has the largest coal and timber container terminals in the RFE.

Although beneficial for Moscow and Japan and selected firms, these long-term agreements have reinforced the extractive orientation of industries by facilitating the export of raw materials rather than manufactured goods. In the process, the agreements have restricted opportunities for the RFE to make structural economic changes.[265] The KS projects are a prime example: Russia exports raw logs in exchange for logging machinery, very little processing equipment, and to pay back loans. Japan, meanwhile, uses the raw logs to create value-added products that can be sold for ten times the cost of the timber.

— JN

mining projects in the region and the Sakhalin II project is strongly needed to shed further light on this extractive industry debate.

One measure could be taken while the debate broils: Multinational companies, to encourage good governance, should be required to report all payments to governments as a condition for IFI loans.[266] Even if IFIs reduced loans to extractive industries and increased loans to manufacturing, renewable energy, and other industries, the benefits could be dissipated by corruption. Transparency International's 2002 *Corruption Perceptions Index* ranked Russia among the world's most corrupt countries (71st out of 102 countries), and Russian companies were ranked most likely to pay bribes to win business.[267]

Given the unlikelihood the Extractive Industries Review will lead to dramatic reform of IFI lending policies, perhaps the greatest hope for encouraging sustainable development in the RFE lies with the foreign aid agencies and NGOs. These smaller institutions do not have the resources to finance large-scale projects, but they can fund and implement projects that do not yield immediate revenue. Support in the early phases is crucial to render profitable some of the RFE's labor-intensive, environmentally sound, community-based industries (nontimber forest products businesses, ecotourism, small-scale fish processing, or village-level sustainable energy systems). These institutions need to work more effectively with those segments in Russian government that support such value-added projects.

Indigenous peoples

Josh Newell and Jeremy Tasch

Paleo-Siberians are believed to be the first indigenous peoples to inhabit the RFE. This ethnic assemblage includes the Chukchi, Yukagir, Koryak, Kerek, Asiatic Eskimos, and Kamchadal tribes, who mainly lived in the north, and the Nivkhi tribes, who mostly lived on Sakhalin. The Ainu, an isolated group of unknown origin, inhabited Southern Sakhalin, the Kuril Islands, and probably Southern Kamchatka. By the third century A.D., the Manchu-Tungus and Turkish tribes began settling the territory. The Manchu-Tungus group, which includes the Evenks, Udege, Uilta, Evens, and Nanai, settled widely throughout the region. Turkish tribes were represented by Yakuts, who settled most of present-day Sakha, with large settlements along the Lena, Vilyui, Indigirka, and Kolyma Rivers.[268]

By the fifteenth century, Russian traders began to impose a government-enforced fur tribute, or *yasak,* upon the tribes to secure a steady supply of sable and fox pelts. The *yasak* system formed the basis of Russian colonial strategy: The "early evolution of the colonial administration, its allocation of resources, military strategy and disposition of troops were all fundamentally governed by this end. This policy left its mark on Siberian society long after the fur trade had ceased to dominate its economic life."[269] Advancing eastward, Russian traders would take over a village, assemble the elders, and then take the tribal leaders hostage, forcing them to adopt the *yasak* system. The government would then enforce the system for a 10 percent return on all fur, fish, and animal takes in every village. "Far from being alarmed at finding a large native population in a given area, the Russians rejoiced, because of the great fur tax their subjugation would produce."[270]

To supply the tremendous demand for furs, traders forced tribes to overhunt, which destroyed fox, otter, and bear (sable, black, and polar) populations. This destruction was then compounded by trade with the Russians, who introduced new items, such as tools and arrowheads, to the native peoples. No longer content to hunt only for need, many native tribes hunted recklessly to stockpile skins. This encouraged fighting between different tribes as they competed for hunting grounds. The competition divided the tribes, hastening their decline.

In 1858, the Governor-General of Eastern Siberia, Nikolai Muravyov, annexed the Amur-Ussuri region in the name of the Russian Empire. Annexation brought Slavic settlers to the RFE from the North and the West en masse, pushing some of the indigenous peoples southward. In the south, however, Chinese groups were establishing themselves in the Ussuri and Sikhote-Alin regions, pushing northward into the Amur Valley. Many of the indigenous people, therefore, found themselves surrounded by recent arrivals with different cultures and lifestyles. Many indigenes entered into deceitful and exploitative debtor contracts with the recent emigrants, sometimes mortgaging the following season's fish catch in advance. These circumstances entangled indigenes in a new cultural system that eventually forced many to abandon their traditional lifestyles and succumb to a form of pseudo-serfdom. By the beginning of the twentieth century, many indigenous groups, particularly those in the southern RFE, were unable to preserve an independent culture and way of life.[271]

Under communism, beginning in the 1920s, the state appropriated tribal land and began to industrialize the RFE to profit from its natural resources. "Any parcel of land could be taken from the native people by a stroke of the pen."[272] State farms blocked rivers with fishing nets, and violated the seasonal fishing periods, thus depriving the indigenous people of their traditional food resource.[273]

Under Stalin's rule, collectivization and forced labor intensified and indigenous groups were forced to abandon their native tongue for Russian. Larger sedentary villages were created by collectivization policies as the state dissolved so-called unprofitable smaller villages and herded the tribes together. In place of small self-sufficient communities, indigenous peoples found themselves in much larger villages with an insufficient food base to support the population. The collectivization of the Nivkhi on Sakhalin is a tragic but common example. The population was forced to live in the cities of Nogliki and Nekrasovka without suitable land to fish and hunt; alcoholism, unemployment, and other social problems soon followed. The expansion of timber, mining, and oil-drilling enterprises, particularly after World War II, have also led some native groups away from their traditional lifestyles, with younger indigenes lured by the possibility of employment in these enterprises.

According to the 1989 census there are about 89,000 indigenous peoples in the RFE; the largest populations are in Sakha, Khabarovsk, and Chukotka (see table 1.13). These figures, however, are misleading, as Russians have acculturated into most of the indigenous communities through marriage.

Despite their tragic history, some indigenous groups continue to maintain their traditions, particularly in the far north, with its small population base and the vast undeveloped spaces. Others are attempting to regain lost traditions. Expressions of cultural awakenings are found in literature and art, and political and economic activities. And as the RFE opens to international influences, many far eastern ethnic groups are finding new hope in the emergent present.

Native peoples have formed associations to protect their rights. In 1991, in the landmark First Congress of Northern Minorities held in Moscow, these groups adopted some important resolutions, including the need to return to an administrative system of tribal soviets and councils of elders, a system that prevailed in the early years of communism and that theoretically gave indigenous peoples administrative control over their land and villages.[274] The call for more

Table 1.13
Populations of indigenous peoples in the RFE

Region and ethnic group	Population	% living in rural areas	Region and ethnic group	Population	% living in rural areas	Region and ethnic group	Population	% living in rural areas
Sakha	24,817		Chukotka	14,690		Magadan	4,903	
Evenk	14,428	83.3	Chukchi	11,914	91.9	Even	2,433	65.4
Even	8,668	78.0	Inuit	1,452	85.6	Koryak	918	88.3
Yukagir	697	72.0	Chuvan	944	52.8	Chukchi	649	14.5
Chukchi	473	78.0	Yukagir	160	73.1	Itelmen	492	47.4
Dolgans	408	91.4	Others	220	61.4	Others	411	24.1
Others	143	27.3	Kamchatka	11,800		Sakhalin	2,869	
Khabarovsk	23,484		Koryak	7,190	74.0	Nivkhi	2,008	44.4
Nanai	10,582	63.8	Chukchi	1,530	94.4	Orochi	212	53.8
Evenk	3,691	83.0	Even	1,489	90.4	Evenk	188	75.5
Ulchi	2,733	80.0	Itelmen	1,441	75.2	Nanai	173	15.0
Nivkhi	2,386	55.7	Others	150	19.3	Orok	129	14.7
Even	1,919	77.0	Primorsky	5,213		Others	159	32.7
Udege	697	71.6	Udege	766	84.7	Amur	1,817	
Negidal	502	67.0	Nanai	425	69.4	Evenk	1,617	87.4
Orochi	499	59.1	Evenk	112	13.4	Others	200	34.0
Others	475	27.4	Others	3,910	33.6			

Source: Census of Indigenous Peoples, 1989.

control over their traditional land has also led to a new form of protected territory, the Territory of Traditional Nature Use (*territoriya traditsionnogo prirodopolzovaniya* or TTP), which provides the legal framework for the transfer of land use rights to indigenous groups. Regional associations of indigenous peoples have been instrumental in calling for this new form of land use. For example, the Khabarovsk Krai government has set aside more than forty territories for traditional use and in Primorsky Krai, regional representatives of the Russian Association of Indigenous Peoples of the North (RAIPON) have been trying to establish TTPs in the Bikin and Samarga River basins to protect the land of the Udege. Laws and regulations implementing the TTPs are weak, particularly those concerning industrial development by indigenous groups within TTPs. Funds allocated by regional governments to indigenous groups to develop TTPs are also insufficient.

Other important issues for indigenous peoples include increasing federal aid to specific regions for native peoples' programs and creating solid federal and regional laws to protect their land and their rights to resource use.

Legal issues

Nathaniel Trumbull

The development of state environmental protection in Russia since the collapse of the Soviet Union has paralleled the emergence, growth, and consolidation of Russian democratization. State environmental protection received increased attention during the *glasnost* period from the mid- to late 1980s. This state protection was strengthened during the early 1990s, but the mid-1990s brought a devolution toward regional environmental protection along with a further consolidation of state environmental protection under Putin's policy of "strengthening of vertical power" (*ukreplenie vlastnoi vertikali*). While significant evolution and change mark state environmental protection, some continuity remains: After more than a decade of reform, state environmental protection now resembles the former Soviet exploitation of the natural environment more closely than ever since the collapse. The following timeline traces the development (and subsequent

near dismantling) of state environmental protection in Russia from *glasnost* to the present.

Soviet inheritance

The 1960s witnessed academic discussions of environmental issues, and the late Soviet period defined several precursors to state environmental protection in the 1990s.[275] Detailed reporting of environmental conditions and violations was required by numerous agencies and by elaborate environmental laws, but these laws existed largely on paper rather than in practice.[276] Legislation such as the 1960 Law on Air Protection and the 1972 Water Code established strict norms, in some cases stricter than in the West, but those norms were not widely enforced. Soviet factory managers, for example, often misreported water effluent and air pollution data, and officially published environmental statistics have proved to be inaccurate.[277] In the late Soviet period, a time of relative détente and unprecedented exchange between Soviet and Western scientists, acquaintance with environmental issues was minimal, as they were considered specialized knowledge; thus, scientific understanding of such environmental issues as adverse health effects and the extent of environmental degradation was largely inaccessible to the Soviet public. Soviet officials remained silent on this topic, not wishing to alarm the public with information they were unprepared to comprehend.

Nevertheless, many environmental degradation cases were highly visible in the second half of the 1980s as press censorship was lifted. The cause célèbre became Lake Baikal:

The threat to the lake's unique biological species could not be outweighed by Soviet plans for industrialization of the region.[278] The number of paper-processing projects planned for the region, especially on the northern shore where the Baikal-Amur Mainline (BAM) railroad passes, was eventually lowered, and a ban was imposed on the movement of logs on the lake itself.[279] Additionally, construction of a flood barrier in Leningrad captured national attention, and the proposed reversal of Siberian rivers to flow southward to arid Central Asia was debated.[280] The infamous 1986 Chernobyl tragedy reinforced the notion that the Soviet government placed industrial development before public and environmental health. Indeed, some argue that environmental degradation and its accompanying health consequences played an important role in discrediting the legitimacy of the Soviet state in the eyes of its citizens.[281]

1988–1992 Emerging focus on the environment

The public's lack of response to environmental degradation until the last years of the Soviet Union resulted from a paucity of information. As one environmental specialist noted, "The seventy-three year history [of the Soviet Union] is a history of systematic misinformation on the environmental situation in Russia."[282] This came to light when the Soviet regime's cavalier exploitation of the natural environment was gradually revealed to the public and the larger international community. Heated debate and criticism in the Congresses of Peoples' Deputies in 1988 and 1989 focused on environmental degradation and its health consequences, and public opinion polls showed that the environment ranked second or third among the problems concerning citizens.[283]

Because of the growing focus on environmental degradation, a January 1988 government decree established Goskompriroda, which was responsible for natural resource protection and replaced its weaker predecessor, which bore the same name. Beginning in 1989, annual reports providing the first official accounts of environmental conditions and protection efforts "promote[d] the dissemination of verified environmental information, the mobilization of society's efforts to improve the environment, and rational use of natural

Members of the NGO Sakhalin Environment Watch call for the establishment of Vostochny Zakaznik (wildlife refuge) in front of the Sakhalin Forest Service.

Dima Lisitsyin

resources, as well as the adopting of effective management decisions in this sphere."[284] The annual report, a synthesis of work done by many environmental agencies and specialists, has become an invaluable government document.

Promulgated under Mikhail Gorbachev, the 1991 Law on Environmental Protection specified the following: (1) the citizen's right to a healthy and safe environment, (2) the citizen's right to form environmental associations, to obtain information, and to seek legal redress for environmental change, (3) environmental responsibilities at federal and governmental levels, (4) environmental obligations of enterprises, (5) the state ecological examination system, (6) environmental liability, and (7) the creation of an environmental funds system.[285] Earlier laws, such as the 1982 Law on Air Protection, remained in force, and contradictions between new and existing laws remained a hallmark of the reform period. Gorbachev appointed a presidential advisor to work specifically on environmental issues, and the biologist Alexei Yablokov served as a highly visible presidential advisor into the beginning of the Yeltsin presidency.

Press reports carried revealing details about environmental degradation during the Soviet period. A translation of Murray Feshbach's *Ecocide in the USSR* reached a wide audience in Russia; the author's apocalyptic visions for the future of Russia's environment were criticized by some Russian specialists, but viewed as accurate by others.[286] Environmental NGO and citizen activity increased significantly during this period, and such influential NGOs as the Socio-Ecological Union and the Institute for Soviet-American Relations (ISAR, later renamed Initiative for Social Action and Renewal in Eurasia) entered the country by the end of 1992.

1993–1996 Experiment with pollution charges

Reinforcing the importance and necessity of government environmental protection, the 1993 Constitution of the Russian Federation states in article 9: "land and other natural resources are used and protected in the Russian Federation as the basis of the life and activity of the population inhabiting the corresponding territory."[287] Article 42 of the Constitution states: "everyone has the right to a healthy environment, accurate information about its conditions, and compensation for damage to health or property as a result of violation of environmental law."[288] Although funds were allocated to state environmental protection, approved projects were unlikely to reach fruition because of inflation and recurring nonpayment of transactions.

Under increasingly difficult economic conditions, the newly created Ministry of Environmental Protection and the Ministry of Finance implemented an innovative market-based approach to environmental protection: a pollution-charge system.[289] The basic principles of this program were outlined in the 1994 document *State Strategy of the Russian Federation on Environmental Protection and Sustainable Development.* In addition, the biennial *Government Action Plan for Environmental Protection for 1994 and 1995* also listed about one hundred priority environmental measures.[290] The Ministry of Natural Resources was created in 1996, replacing the Committee of Geology and Natural Resource Use.[291] A "polluter pays" principle was established: all sources emitting pollutants above a certain threshold were charged.[292] Additionally, the resulting revenues were allocated to the Federal Ecological Fund and earmarked for environmental protection. The Ecological Fund's main revenue source, the monies were allocated at both the federal (10 percent) and regional and local (90 percent) levels; the total revenue from 1992 to 1997 was about U.S.$2.2 billion.[293]

The sharp decline in the industrial economy in the mid-1990s actually improved drinking water and air quality. Some improvements resulted from new air filter and water purification treatment plants and from the replacement of water pipes and delivery systems, but economic decline was by far the largest factor in lower industrial pollution levels. Indeed, energy intensity (the amount of energy used per unit of economic output) levels increased in the 1990s. As industrial production declined, however, only modest savings in energy expenditure were gained. Elsewhere, environmental regulation compliance was often the first practice abandoned by financially strapped enterprises.[294] An in-depth assessment of Moscow's current environmental conditions concludes that many expected environmental quality improvements have not occurred.[295]

1997–2000 Goskomekologia and devolution of state environmental protection

On May 26, 1997, decree 643 replaced the Ministry of Environmental Protection with the State Committee on Environmental Protection (Goskomekologia), resulting in a lower status for the environmental protection agency and reflecting the state's interest in natural resource exploitation at the expense of environmental protection.[296] Goskomekologia's tasks were to: (1) implement and coordinate environmental policies, (2) develop environmental policy, (3) implement state *expertiza* and inspections, (4) manage nature conservation, (5) establish and supervise environmental norms and standards, (6) report on the state of the environment and provide technical advice, and (7) manage the Federal Ecological Fund.[297] Goskomekologia was also responsible for international environmental cooperation.[298]

Goskomekologia held offices at the republic, *oblast*, and *krai* levels and was largely independent at the republic and *oblast* level, often siding with local needs rather than federal preferences. In St. Petersburg, for example, Goskomekologia was often at odds with the city environmental protection administration concerning the distribution of the regional Environmental Fund.[299] Several other federal bodies also had jurisdiction over environmental protection issues: the

Ministry of Public Health, the Ministry of Emergency Situations, the State Committee for Land Policy, the Fisheries Committee, the Federal Forest Service, and the Federal Service for Hydrometeorology.[300] Continuity between the former Goskompriroda and Goskomekologia was maintained by the appointment of bureaucrats like Victor Ivanovich Danilov-Danilyan, the former minister of Goskompriroda, as chairman of the new Goskomekologia until its dissolution in April 2000.

Goskomekologia's record was mixed, and its success rate for protecting the environment largely depends on the local perspective. Reasonably well-trained inspectors emerged by the end of the 1990s, and although bribery of inspectors or other Goskomekologia officials undoubtedly occurred, it appears to have been the exception rather than the rule. Goskomekologia communicated relatively openly and regularly with the environmental NGO community, and large environmental projects progressed in the late 1990s (after the 1998 financial crisis). Goskomekologia provided World Wide Web–based environmental information resources (April 2000 UNEP/GRID conference, Moscow) and the devolution of power within Goskomekologia from the federal to the regional and local levels offered creative solutions to local environmental issues. Abuse of this regional power and violations of laws also occurred, however. In Bashkiria, for example, a dam was under construction in an area considered part of a national park,[301] and de facto decentralization elsewhere meant that local decision-making was an unguided process.[302] In sum, Goskomekologia was both supported and criticized, but the looming prospect of dismantling the agency appalled even the most vocal critics.

Dissolution of Goskomekologia and transfer of power

Vladimir Putin's presidency, first as acting president on December 31, 1999, and by an overwhelming electoral win three months later, largely reversed state environmental protection in Russia. Putin's self-proclaimed ideology, "strengthening of vertical power," reined in the regional independence that emerged in the 1990s.[303] Within two months, Putin issued decree 867, liquidating Goskomekologia and transferring its responsibilities to the Ministry of Natural Resources. The May 17, 2000, decree also abolished the Federal Forest Service, again transferring its responsibilities to the Ministry of Natural Resources; the two-hundred-year-old Forest Service previously employed about one hundred thousand people.[304]

Putin's decision appeared to respond to several events, namely the devolution from centralized to decentralized management within Goskomekologia; the August 1998 devaluation of the ruble, from which Russia's economy slowly recovered; and renewed state support for the unencumbered exploitation of Russia's natural resources to revive Russia's economy. The fallout from decree No. 867 was almost im-

mediate among Russia's nascent but increasingly coordinated environmental NGO community. In disbelief, several NGO representatives doubted Putin had approved the decision and expected its annulment. The large-scale elimination of a federal environmental protection agency is unprecedented for any industrialized country at the beginning of the twenty-first century, and despite publicly expressed reservations by some NGO representatives on Goskomekologia's prior achievements, this now-defunct agency found an unlikely source of support.

The Socio-Ecological Union, the largest environmental NGO umbrella organization, collected the requisite number of citizen signatures (2 million) to officially sanction a national referendum on three environmental questions, two of which directly related to decree 867. The questions were: (1) Do you agree with the decision to abolish Goskomekologia?, (2) Do you support the import of spent nuclear fuel from abroad (a common practice during the Soviet period that was outlawed in the early 1990s)?, and (3) Do you support the abolition of the Federal Forest Agency? The second question, although not directly related to decree No. 867, was strategically included in the signature drive, because the environmental NGO community anticipated an unambiguously negative public response.

From May through September 2000, more than one hundred environmental NGO representatives in more than fifty Russian cities tirelessly publicized the signature drive. By the end of September, almost 600,000 more signatures than the requisite 2 million were collected, but upon review of the signatures locally and by the Central Election Committee in Moscow, many signatures were eliminated for technical reasons.

On November 29, 2000, the Central Election Committee, on the basis of numerous minor technical points such as incorrectly abbreviated addresses, ruled that an insufficient number of signatures had been collected (i.e., less than 2 million) for a national referendum to reinstate Goskomekologia. An official court appeal by the Socio-Ecological Union resulted in an official reaffirmation that 600,000 votes were missing. In a further blow, President Putin signed a decree in June 2001 permitting spent nuclear fuel import for reprocessing. The Ministry of Atomic Energy argued that the revenue from such imports would be used to clean up existing nuclear waste sites in Russia, a conclusion that is considered spurious among environmental specialists in Russia and the West.[305]

In the fall of 2001 at the highly publicized Civic Forum, the government's attempt to find common ground with the environmental NGO community, Putin himself pledged support for the NGO's work. It appears, however, that his support was either only partially genuine or simply fleeting, as no follow-up activities have occurred since the forum. Some note that "the state is in no shape to support public movements, and moreover it has little interest in encouraging them."[306]

The "strengthening of vertical power" within the Ministry of Natural Resources

The most recent period has widely been seen as the "de-greening" (*de-ekologizatsiia*) of the Russian state.[307] Hope that the newly recreated Ministry of Natural Resources will retain any substantial state environmental protection appears slim. Goskomekologia's previous inspectors, significantly reduced in number, are now subordinate within the Ministry of Natural Resources, and the loss of expertise from Goskomekologia will likely be long-lasting. One NGO representative concludes: "We have witnessed a sudden and nearly complete collapse [of state environmental protection], marked by a mass exodus of staff, problems with document circulation, and silence in response to official inquiries."[308] Furthermore, some suggest the new Ministry of Natural Resources was designed to orchestrate the future privatization of forests, to benefit specific oligarchs.

In a few cases, municipal environmental protection administrations have been retained. In St. Petersburg, for example, the municipal environmental agency (recently renamed the Administration for Environmental Safety and Natural Resource Use) appears to have fully retained its environmental protection responsibilities. This, however, is an exception to the rule, and further attempts to keep a federal environmental protection agency have failed. Instead, state-sponsored environmentally sensitive initiatives, such as the recently completed Baltic Pipeline System or oil extraction development on Sakhalin, have met with little or no resistance from the Ministry of Natural Resources. As one Russian commentator observed, "There simply is no environmental policy in Russia—the existing policy could actually be construed as intending to destroy environmental policy."[309]

Positive developments in state environmental protection since April 2000 include improved access to basic environmental information within the Ministry of Natural Resources. While Goskomekologia's annual reports had very small pressruns, the annual *Status of the Environment* reports are available online from the Ministry, and other official environmental publications are increasingly available on *oblast*-level websites. Environmental issues are covered in the ministry-funded *Prirodno-resursnye Vedomosti* and *Ekologicheskaia Gazeta Spasenie*, although each newspaper has an admittedly government rather than activist perspective. A few public officials remain optimistic that the better-financed Ministry of Natural Resources will provide more opportunities for environmental infrastructure investment, such as wastewater and purification plants, than did Goskomekologia.

Current developments seemingly prevent the reemergence or strengthening of future federal environmental protection: The Ministry of Natural Resources, for example, is mandated to resolve any environmentally controversial question in favor of increased natural resource extraction and profitability. It is difficult, therefore, to envision the Ministry halting a government-sponsored project on environmental grounds. The Ministry's overall goal of economic development is unambiguous.

Conclusions

The strengthening and subsequent weakening of Russia's federal environmental protection during the 1990s did leave behind a positive legacy. In the face of opposition, the Russian environmental community emerged as a stronger entity and with a clearly identified opponent. As a result, the environmental community's efforts will likely be more effectively targeted and deployed. The experience of the summer 2000 signature drive forever changed the Russian environmental community by proving that a nationwide event could be coordinated. In addition, environmental NGOs recently recruited some former Goskomekologia environmental specialists, whose expertise can only help to bolster the image of NGO representatives as informed and well trained.[310]

The first land reform bill, a volatile issue under Putin's government, was passed by the Duma in December 2001 without opposition. The government's intention for land reform is to move quickly and decisively, and the first step will privatize about 1.5 percent of Russia's land. Any land reform, however, is commonly seen as simply legalizing preexisting conditions that emerged from the chaos of the 1990s (when most of Russia's land was de facto privatized). Environmental NGOs response to current land reform has been largely muted: Putin's actions demonstrate he will advance land reform measures without public discussion (not unlike the Stolypin Reforms at the beginning of the twentieth century).[311]

Human rights remain a critical issue for Russian environmental activists, as in the cases of Grigory Pasko, a naval journalist accused of revealing naval secrets regarding nuclear waste dumping in the Sea of Japan; and Igor Sutyagin, accused of spying and transferring state secrets to Western government representatives even though he demonstrated that his sources were public records. The acquittal of Alexander Nikitin after more than five years in court and a one-year jail term is an exception, probably made as a result of international pressure. One difficulty is that Russian courts do not have a strong record of independence,[312] and incidents such as firings at nuclear power plants and other environmentally sensitive sites occur regularly as whistleblowers attempt to reveal environmental risks to the public. Attacks continue on the environmental NGOs' reliance on foreign financial assistance, especially with their active opposition to many current government policies; this support, however, is one of the best possible peace investments for Western governments.

Recent dismantling of state environmental protection may limit possible international environmental cooperation, as Russia is the cosigner of several international initiatives and bilateral and multilateral environmental programs.[313] Indeed, Alexei Yablokov, now head of the Center for Envi-

ronmental Politics, has called on the U.S. government to actively assist in blocking the future import of spent nuclear fuel into Russia since the United States controls the majority of this fuel worldwide.[314] Alexander Nikitin recently solicited support from foreign NGOs in drawing attention to human rights abuses in Russia. His work exemplifies the continuing confrontation between the environmental NGO community and the Russian government, as well as the NGO community's continuing dependence on the outside world for both financial and moral support.

Environmental whistleblowers in Russia

Alexander Nikitin, a former Naval officer based in Murmansk, drew the wrath of the Russian military establishment by cowriting a report for the Norwegian NGO Bellona on nuclear hazards from the Soviet and Russian navy in the Barents Sea. Nikitin was arrested in February 1996, held in solitary confinement for fourteen weeks, and, after more than a year in prison for alleged spying and the release of state secrets to a foreign government, was released. The case drew international attention to human rights abuses in Russia. Nikitin was later fully absolved, but only after two years of highly public trials that revealed the extent to which some authorities would go to conceal environmental information if considered even remotely related to militarily sensitive information and activities. The Russian Supreme Court eventually heard his case, as Nikitin's prison conviction outraged both international and Russian environmental NGOs. Nikitin's lawyers, engaged by Bellona, played a critical role in his acquittal.

The fate of another Russian whistleblower, Grigory Pasko, an investigative journalist for the Russian Pacific Fleet's newspaper, *Boyevaya Vakhta*, has been less fortunate. Pasko also focused on nuclear safety issues and was arrested by the Federal Security Service (FSB) — the Russian security police, formerly KGB — in November 1997, accused of committing treason through espionage with Japanese journalists. The Court of the Pacific Fleet acquitted Pasko of the treason charges in July 1999 and released him under a general amnesty, but the Military Collegium of the Russian Supreme Court reversed the verdict in November 2000 and sent the case back to the Pacific Fleet Court for retrial. In December 2001, Pasko was sentenced to four years in prison. Both the Nikitin and Pasko cases have been highly publicized in Russia and are indicators of the general intolerance of environmental whistleblowers by the Russian government.

—NT

Serious challenges face Russia in terms of continuing environmental degradation. Russia must not only work to repair damage caused during the particularly destructive recent past, but also to address new environmental challenges.[315] While a sustained economic upturn might lead to state environmental policy reform in the future, current protection remains only marginally better than that of the Soviet period. Despite significant state intervention in the 1990s to improve the environment, genuine concern for it appears to have passed; one environmental NGO representative has called the performance of the Ministry of Natural Resources in 2002 "reminiscent of the 1930s–1950s" in terms of its Stalinist-style leadership.[316] As Russians come to appreciate their well-being (material wealth, health of their children, recreational opportunities in an unpolluted environment), the Russian state will be obliged to return to the measures begun in the 1990s for environmental protection. Until this occurs, however, Russia's future leaders will likely consider strengthening state environmental protection a luxury.

Perspective

Dale G. Miquelle, Dmitry G. Pikunov

Status of the Amur tiger and Far Eastern leopard in Northeast Asia

Large predators that sit atop the trophic pyramid and are dependent upon large tracts of land are particularly sensitive to environmental changes, including anthropogenic impacts. The Amur tiger (*Panthera tigris altaica*) and the Far Eastern leopard (*Panthera pardus orientalis*) are two such large, mammalian carnivores whose survival in the RFE, as well as in the rest of Northeast Asia, will be largely dependent on how this region develops and what steps are taken in the near future to secure key habitat and linkages across international boundaries.

Amur tiger. At the end of the nineteenth century, tigers were considered a commercially harvestable wildlife species in the southern RFE, and between 120 and 150 tigers were shot annually. Intense commercial exploitation and the simultaneous reduction and degradation of tiger habitat by logging and forest fires reduced the number of wild tigers to between twenty and thirty individuals by the end of the 1930s, bringing the wild population to the edge of extinction in Russia.[317] A ban on tiger hunting was imposed in 1947, followed by a partial (1956), and then a full (1960) ban on capturing cubs, which were supplied to the world's zoos. With these restrictions, the tiger population began to recover. At the beginning of the 1970s, there were approximately 150 tigers in the RFE; by the end of that decade, the tiger population had grown to

about 200, and by the end of the 1980s, had increased to 250.[318] According to the last tiger survey, conducted in the winter of 1995–1996, the total number of wild tigers in Russia was estimated to be 415–476, 330–371 of which were adults and subadults, with the remainder representing young.[319] According to the survey, approximately 95 percent of the tigers in the RFE belong to an unfragmented population in the Sikhote-Alin Mountain ecosystem in Primorsky and southern Khabarovsk Krais, but there were two smaller, fragmented

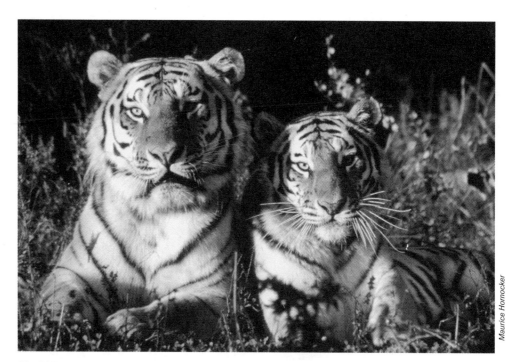

The Sikhote-Alinsky Zapovednik provides some protection for Siberian tigers (Panthera tigris altaica).

Maurice Hornocker

subpopulations in Pogranichny Raion (westernmost tip of Primorsky), southwestern Primorsky, and northwestern Primorsky (tigers have since disappeared from Pogranichny Raion). Tiger migration between Russia, the northeastern provinces of China, and North Korea is possible only in three locations, two of which are in regions providing habitat for the fragmented populations just mentioned: southwestern Primorsky Krai, Pogranichny Raion, and along the crests of the Strelnikov Range along the border of Primorsky and Khabarovsk Krais opposite the Wandashan Mountains in Heilongjiang Province, China (fig. 1.8).[320] The Strelnikov Range, therefore, represents an important ecological corridor —the only location where tigers from the large Sikhote-Alin population can potentially move across international boundaries.

The status of tigers is considerably worse in northeastern China than in Russia. Based on two surveys conducted by an international team of specialists in 1998 and 1999, only about four to six tigers remain in the eastern portions of Jilin Province, and only about four to seven tigers remain in Heilongjiang Province (fig. 1.8).[321] Most of these animals were located along the Russian border, although the presence of tigers was reported as far away as the Zhangguancailing Mountain Range in central Heilongjiang. Despite confirmation of their presence in northeastern China, there has been no evidence of breeding females for at least five years in either province, and most individuals appear to be transient dispersers with no fixed home range. It is likely that tigers dispersing from Russia are the single source of animals for China and that these cross-border movements are responsible for preventing the extinction of tigers in northeastern China.

The situation on the Korean Peninsula is less clear. Military personnel reported photographing a tiger in the Demilitarized Zone (DMZ) as recently as the early 1990s. Recent journalistic reports of tigers in South Korea have not been confirmed. A 1998 scientific report from the Institute of Geography in Pyongyang suggested that tigers still remain in the Paektusan area of North Korea, but reviews of photographs provided in the report suggest that at least some tracks were misidentified.[322] There has been no evidence of tigers on the Chinese side of the border (ChangBaiShan Reserve) since the early 1990s. Until reliable ground surveys are conducted in North Korea, the status of tigers on the Korean Peninsula will remain unclear.

A monitoring program to determine trends in the population of tigers in Russia was initiated in 1997 and has been conducted yearly. Results of this program indicate that, although there are local changes within the monitoring sites, overall, the tiger population across the region has remained stable over the observation period.[323]

Far Eastern leopard. At the beginning of the 1900s, the habitat of the Far Eastern leopard covered an extensive area of northeastern China, extending to Beijing and including the Korean Peninsula as well as portions of the RFE. At the beginning of the 1900s, V. K. Arseniev reported that the northern boundary for the leopard in Russia paralleled Lake Khanka (fig. 1.9). By the mid-1900s, distribution of the Far Eastern leopard had decreased dramatically.

The first Russian survey of the Far Eastern leopard in the winter of 1972–73 confirmed the existence of thirty-eight to forty-six individuals in three fragmented populations in southern Sikhote-Alin, Pogranichny Raion, and southwestern

Figure 1.8
Distribution of tigers in the Russian Far East and four locations where tiger occur along the international boundary with China

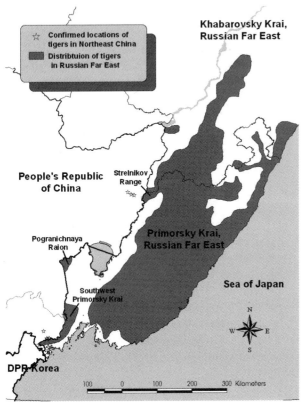

Note: Some Russian place names spelled differently than in other sections of this book.
Source: Reproduced by Dale Miquelle from Matyushkin et al., 1996.

Figure 1.9
Present distribution of leopards in southwest Primorsky Krai, based on four surveys conducted between 1997–2000

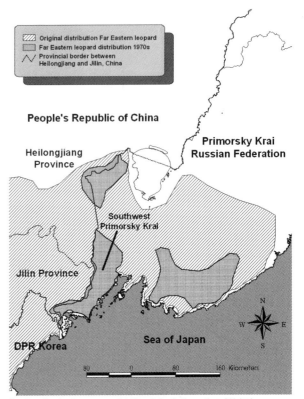

Note: Some Russian place names spelled differently than in other sections of this book.
Source: Reproduced by Dale Miquelle from Murzin and Miquelle, 2000.

Primorsky Krai (fig. 1.9).[324] A second Russian survey in 1983–1984 was unable to confirm the presence of leopards in the southern Sikhote-Alin or the northwestern Pogranichnaya areas.[325] Consequently, the total number of leopards has decreased to between twenty-five and thirty individuals due to the apparent loss of two of the three populations, and despite evidence suggesting that there may have been some leopard migration from the northern portions of DPR Korea (North Korea). In the past decade, full-scale leopard surveys were conducted in 1990–1991, 1997, 1998, and 2000.[326] Data from these surveys suggest that during this period the leopard population in southwestern Primorsky Krai has remained relatively stable, but interpretation of the data by different scientists suggests that actual leopard numbers range between twenty-five and forty-two individuals.

The most recent survey in Jilin Province, China, suggested there might be four to seven leopards located mostly along the border with southwestern Primorsky (2002 surveys confirmed the presence of at least two leopards in the newly created Hunchun Tiger Leopard Reserve).[327] Although no direct evidence was found in Heilongjiang, information from interviews suggests that three to five leopards may still exist in this province.[328] Information for the Korean peninsula is less reliable, but leopards may still survive in South Korea. We can only speculate on the status of leopards in DPR Korea, but leopards likely exist in remote areas of this country. As with the tiger, intensive ground surveys will be necessary to accurately determine the status of this animal across the Korean peninsula. At present, conservation efforts must be focused on the last known remaining population in Southwest Primorsky Krai.

Conservation of leopards and tigers. This brief review indicates how rapidly both of these large felids have declined in northeastern Asia over the past century and clearly demonstrates that the last remnant population of Far Eastern leopards, which occurs only in the Tumen River area, is on the verge of extinction. This continuing threat to leopards was the primary motivation for creating Barsovy Zakaznik in 1979 and Borisovskoe Plateau Zakaznik in 1995. Additional conservation measures have included full and partial bans on ungulate hunting in the early 1980s. Despite these actions, the loss of habitat has continued, and in 1997, the

total area of habitat was almost half that reported in 1972. Presently, leopards inhabit 2.2 to 2.6 million ha of habitat in southwestern Primorsky Krai (fig. 1.9).[329] Some evidence suggests the reproduction rate of this population may be declining.[330] Whether or not this is the case, the population appears incapable of increasing in number, most likely due to a combination of the lack of suitable habitat in which to expand, the effects of genetic impoverishment, and natural and human-induced mortality rates that exceed reproduction rates.[331] A national strategy for leopard conservation has been devised in Russia, but there has been no coordinated effort to implement this conservation program to date. The creation of Hunchun Tiger Leopard Reserve in November 2001 in Jilin Province, China, offers hope that the amount of suitable habitat for leopards can be increased in the near future, but the creation of a second population via a reintroduction program will be critical to ensure the survival of this subspecies in the wild.

The tiger population is in better condition, but continued poaching, an increasing number of roads, threats to their prey populations, and a decreasing amount of quality habitat are all realities indicating that this species is still highly endangered. A national conservation strategy has been developed in Russia, some components of which have been implemented. Priority actions to conserve this tiger subspecies include the following:

- Improve control over illegal tiger poaching and the demand for tiger products.
- Fulfill existing plans for protected-areas network for Khabarovsk and Primorsky Krais.
- Establish specially managed zones in suitable habitat outside protected areas with multiple-use management regimes compatible with large carnivore conservation, including reduction in poaching of ungulates, closely managed hunting regimes, better control of road access, and increasing prey populations.
- Create a transboundary network of protected territories to preserve key habitat and retain a core population with the capacity for transboundary migration.[332]
- Improve awareness of local people via environmental education and awareness programs.

Protecting and expanding tiger and leopard populations is possible, but efforts to reach this goal are essential to their long-term survival in Northeast Asia. For the leopard, the creation of a second population and an increase in total available habitat are critical to increasing total population numbers and ensuring the long-term survival of this rare and endangered subspecies. International cooperation will be essential to allow transboundary management plans to ensure conservation of these large carnivores in the region.

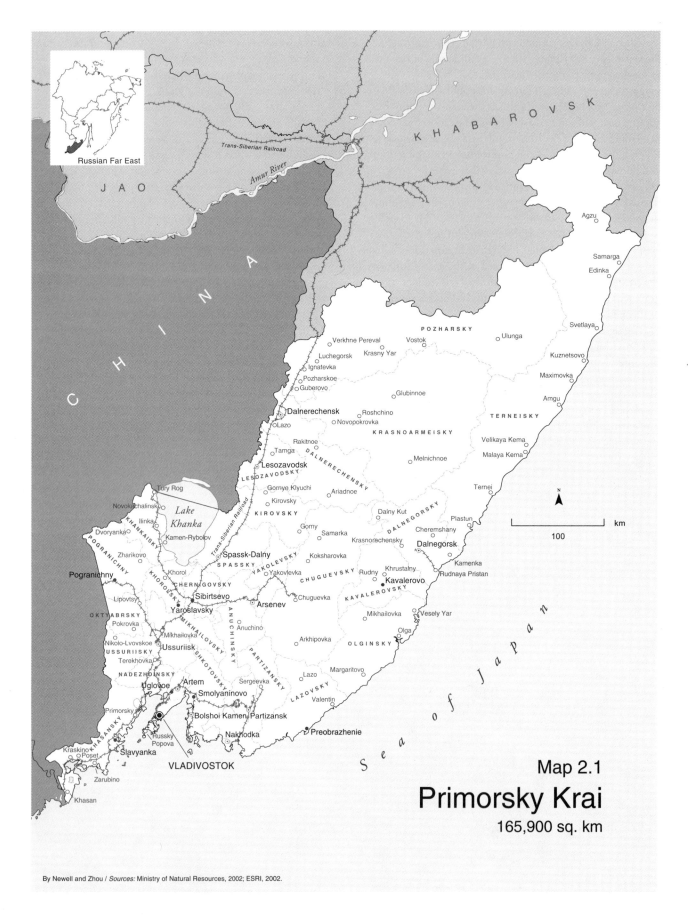

Russian Far East

K H A B A R O V S K

J A O

Trans-Siberian Railroad

Amur River

C H I N A

Agzu

Samarga

Edinka

P O Z H A R S K Y

Svetlaya

Verkhne Pereval Vostok Ulunga

Luchegorsk Krasny Yar Kuznetsovo

Ignatevka Maximovka

Pozharskoe Amgu

Guberovo Glubinnoe

Dalnerechensk Roshchino

OLazo Novopokrovka T E R N E I S K Y

K R A S N O A R M E I S K Y

Rakitnoe Velikaya Kema

Tamga Malaya Kema

Lesozavodsk D A L N E R E C H E N S K Y Melnichnoe

L E S O Z A V O D S K Y

Gornye Klyuchi Ariadnoe Ternei

Kirovsky

K I R O V S K Y Dalny Kut Plastun

Tury Rog D A L N E G O R S K Y

Novokachalinsk Lake Gorny Samarka Cheremshany

Ilinka Khanka Krasnorechensky

Dvoryanka Kamen-Rybolov Dalnegorsk

K H A N K A I S K Y Kamenka

Zharikovo Spassk-Dalny Koksharovka Rudny Khrustalny Rudnaya Pristan

P O G R A N I C H N Y S P A S S K Y Y A K O L E V S K Y Kavalerovo

Khorol Yakovlevka C H U G U E V S K Y K A V A L E R O V S K Y

Pogranichny C H E R N I G O V S K Y

K H O R O L S K Y Chuguevka

Lipovtsy Sibirtsevo Arsenev Vesely Yar

O K T Y A B R S K Y Yaroslavsky Mikhailovka

Pokrovka M I K H A I L O V S K Y Anuchino Olga

Nikolo-Lvovskoe Mikhailovka A N U C H I N S K Y Arkhipovka O L G I N S K Y

U S S U R I I S K Y S H K O T O V S K Y P A R T I Z A N S K Y

Terekhovka Ussuriisk Lazo Margaritovo

N A D E Z H D I N S K Y Sergeevka L A Z O V S K Y

Uglovoe Artem Smolyaninovo Valentin

Primorsky Bolshoi Kamen Partizansk

Russky Nakhodka Preobrazhenie

Popova

VLADIVOSTOK

Kraskino

Poset Slavyanka

Zarubino

Khasan

S e a o f J a p a n

N

km

100

Map 2.1

Primorsky Krai

165,900 sq. km

By Newell and Zhou / *Sources:* Ministry of Natural Resources, 2002; ESRI, 2002.

CHAPTER 2

Primorsky Krai

Location

Situated along the southeastern border of the RFE, Primorsky Krai, or Primorie, shares a common border with China in the west and Khabarovsk Krai in the north. To the east lies the Sea of Japan, which separates Primorsky from Japan by only 400 km. In the far south of the *krai*, Russia, China, and North Korea share a border on the Tumen River Delta. The region's coast, which extends 1,350 km, is washed by the Sea of Japan.

Size

Primorsky Krai covers 165,900 sq. km, approximately 2.67 percent of the RFE, and is larger than the entire Korean Peninsula.

Climate

In winter, cold Siberian air blows east creating consistently dry and sunny weather with little precipitation. January temperatures average −10°C in the south and −30°C in the north, and reach −45°C in the mountains. Winter snows begin to thaw in the middle of March in the south and toward the middle of April in the north and in the mountains. In summer, masses of humid air flow up from the south across the Sea of Japan creating hot, rainy weather, especially along the coast. Flooding is a yearly event. July, with an average temperature of 22°C, is the warmest time in the inland regions. August brings the warmest temperatures (averaging 20°C) to the coastal regions. Residents consider fall, or *zolotaya osen*, the best season, with clear dry weather lasting from mid-September to late November, when snow begins to fall.

Geography and ecology

The Sikhote-Alin Mountain Range covers much of the territory, stretching from the southwest to the northeast, parallel to the coastline. The mountains rise to a height of 1,855 m (Mount Oblachnaya) and average about 1,000 m. The northern part of this range extends into Khabarovsk Krai.

Rivers on the western side of these mountains flow into the Ussuri River, a major tributary of the Amur River, which runs south to north and forms the Russian-Chinese border. One of these rivers, the Bikin, runs through the largest intact stands of Korean pine (*Pinus koraiensis*) and broadleaved forests remaining in the *krai*. Short swift rivers flow from the southeastern slopes of the Sikhote-Alin Mountains into the Sea of Japan. Generally no longer than 50 to 100 km, these rivers often flood after the intense summer rains. Agriculture and logging over the past seventy to eighty years have increased the size and frequency of floods. Almost all of Primorsky's rivers, especially those flowing east, are spawning

grounds for migratory fish, including many species of salmon. The Sea of Japan reaches the eastern coast, which has estuaries and lagoons, beautiful beaches, and a diversity of marine and shoreline wildlife.

In the southwest, rare Manchurian fir (*Abies holophylla*) and broadleaved forests of the East Manchurian Mountains, which extend into North Korea and China, provide the last habitat for the endangered Far Eastern leopard (*Panthera pardus orientalis*), a subspecies on the brink of extinction. The few marshes in the *krai* are mostly in the Khanka-Ussuri Plain, which borders Lake Khanka in the south and east and stretches north along the Ussuri River. The very shallow Lake Khanka (10 m at its average depth and covering about 4,000 sq. km) is the largest body of freshwater in the RFE. The lake's wetlands, extremely valuable for migratory birds, have been degraded by agriculture. The Tumen River Delta in the far south and forming a border with China and North Korea also provides wetland habitat for migratory birds, marine mammals, and reptiles.

Forest covers 80 percent of the *krai*. In the north and at higher elevations, Ayan spruce (*Picea ajanensis*), East Siberian fir (*Abies nefrolepis*), and Dahurian larch (*Larix gmelini*) dominate. Further south, and in the river valleys, northern and southern tree species intermix to create unique forests that Russian ecologists call the Ussuri Taiga. The biological diversity of these forests, the wetlands, and the rich coastal waters is higher than it is almost anywhere else in Russia and rivals that of any temperate ecosystem in the world.

Key issues and projects

Logging in the Samarga River basin

In the spring of 2001, the Primorsky administration announced that the Russian logging firm Terneiles had won rights to log almost all of the roadless forests in the Samarga River basin. The local community was not involved in the decision-making process, and studies show that other economic measures will be more beneficial to those living in the region (see p. 126).

Illegal harvest and export of natural resources

The region is one of the most corrupt in Russia.

Conservation of rare and endangered species

The conservation of habitat for the tigers and leopards remains a priority for the Russians and the international community.

Infrastructure expansion

The building of roads and expanding of ports is localizing and intensifying pressure on Primorsky's largely unlogged northern forests (see p. 132).

Flora and fauna

Primorsky has about two thousand species of flora, many of which are endemic. There are more rare and endangered species and subspecies here than in any other region in the RFE. Critically endangered species include the Far Eastern leopard, the most northern subgroup of leopards, of which only about sixty remain in the wild (between thirty and thirty-six in southern Primorsky, fifteen in Jilin Province, China, and perhaps five or ten in North Korea).[1] Most of the estimated four hundred Siberian tigers (*Panthera tigris altaica*) roam Primorsky's forests. This subspecies of tiger is found only in the forests of Primorsky and southern Khabarovsk, China, and possibly North Korea. Rail lines and highway roads connecting Vladivostok and Khabarovsk, and the development of Razdolnaya and Ussuri River basins, have prevented genetic exchange among large predators and hoofed animals between populations living in the Sikhote-Alin Mountains and the southwestern part of Primorsky.

Rare cranes, including the red-crowned crane (*Grus japonensis*, world population approximately 1,800) and the white-naped crane (*G. vipio*, world population estimated at 5,500), migrate to Lake Khanka, the Tumen River Delta, and the Ussuri River, as well as

to other wetland regions of Mongolia, China, the Korean Peninsula, and Japan. Other rare and endangered species include Amur cat (*Felis euptilura*), dhole (*Cuon alpinus*), Sika deer (*Cervus nippon hortulorum*), Steller's sea eagle (*Haliaeetus pelagicus*), golden eagle (*Aquila chrysaetos*), Oriental white stork (*Ciconia boyciana*), Chinese egret (*Egretta eulophotes*), scaly-sided merganser (*Mergus squamatus*, world population approximately 1,200 pairs), Himalayan bear (*Ursus thibetanus*), mandarin duck (*Aix galericulata*), Blakiston's fish-owl (*Ketupa blakistoni*, fewer than five hundred pairs exist), and Amur goral (*Nemorhaedus caudatus amurensis*). Over seven hundred fish species inhabit the coastal waters of the Sea of Japan. Now practically extinct in China and North Korea, Asian ginseng (*Panax ginseng*) is found in two main concentrations in the southern part of the Sikhote-Alin Mountains of Primorsky and in the East Manchurian Mountains along the Primorsky and Jilin border. Some of Primorsky's other rare flora include the Manchurian apricot (*Prunus mandshurica*), Siberian kiwi (*Actinidia arguta*), Komarov's lotus (*Nelumbo nucifera var. komarovii*), Japanese yew (*Taxus cuspidata*), and Shlippenbach's rhododendron (*Rhododendron schlippenbachii*).

Largest cities

Primorsky has 11 cities, 30 towns, 47 "company towns," 221 villages, and 619 minor settlements. Vladivostok ("Lord of the East") (pop. 613,100, founded 1860) is the administrative center and has commercial and military ports. Most of the RFE's premier universities and research centers are located in Vladivostok. It is also the eastern terminus of the Trans-Siberian Railroad (9,302 km from its start in Moscow). Nakhodka (pop. 159,800, officially designated a city in 1950) is Russia's most southeastern city, one of the RFE's major timber and coal ports, and the site of a much-discussed Free Economic Zone. One of Russia's largest fish canneries is also located here. Ussuriisk (pop. 158,400, founded 1866) is a center for agriculture and food processing, and serves as a regional transport hub. Known as an industrial center, in addition to producing electrical equipment and washing machines, Arsenev (pop. 67,100, founded 1885) produces military aircraft, particularly helicopters. Spassk-Dalny (pop. 57,800, founded 1885) is the center of the building and cement industry.

Population

The *krai*, with 2,157,700 residents as of 2001, is home to about 30 percent of the RFE's population.[2] Most live in the cities and towns in the lowlands and along the coast of southern Primorsky. The population, as in other parts of the RFE, has declined steadily since the collapse of the Soviet Union, with a loss of about 100,000 residents between 1994 and 2000. Predominantly Russian, Primorsky is home to Ukrainians, Belarussians, Germans, Tatars, Koreans, Kazakhs, Tajiks, Georgians, and Azeris. Indigenous peoples number about 2,000 and include Nanai, Udege, Oroki, Orochi, and Taz.

Political status

Primorsky Krai was formed as an individual administrative territory on September 20, 1938. The *krai*'s ties with Moscow have been frequently strained, particularly when the former governor Evgeny Nazdratenko ruled the region as his personal fiefdom for most of the 1990s. A controversial leader, Nazdratenko was widely accused of political favoritism, mismanagement of the region's resources for uncertain aims, and antipathy toward foreign

investors. Primorsky governments have traditionally viewed neighboring China and the many Chinese visitors with circumspection, causing friction particularly on territorial issues between the two countries.

Natural resources

Primorsky has abundant natural resources, including more than 2 billion tons of coal (11 percent is coking coal and approximately 89 percent is lower quality brown coal or lignite) and 1.7 billion cu. m of timber (including the RFE's largest stocks of Korean pine and ash). The forests in Primorsky, due to the warmer and wetter climate, are denser and grow more quickly than in any other region of the RFE. The *krai* holds 14 percent of the RFE's tin resources, 40 percent of its known tungsten deposits, 79 percent of its zinc, 81 percent of its lead reserves, and large deposits of copper, silver, and bismuth. Gold can be found along the northern river basins. There are deposits of datolite and boron and large supplies of fluorite, graphite, and both therapeutic and potable mineral waters. Diamonds were discovered recently.[3] About 10 percent of Primorsky is arable, making the region an important agricultural area. Marine species fished include salmon, cod, flounder, herring, king crab (*Paralithodes kamtschatica*), shrimp, and mollusks. In Peter the Great Bay alone there are about 194 species of fish, and in the 200-mile strip along the northern Primorsky coast there are more than 160 species. According to data acquired during benthic

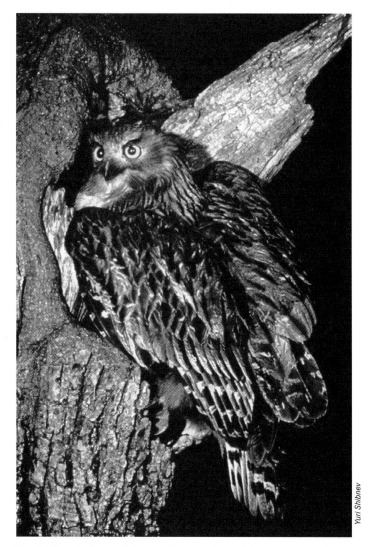

Yuri Shibnev

The Blakiston's fish-owl (Ketupa blakistoni), *a globally endangered species, depends on old-growth valley forests, like those along the Bikin River, for survival.*

trawl surveys made between 1984 and 1989, the total biomass of fish on the shelf and the upper section of the slope in Peter the Great Bay is between 65,000 and 93,000 tons (6.5 tons per sq. km); northern Primorsky is estimated to have between 101,000 and 378,000 tons (3.1 tons per sq. km). The main varieties of benthic fish resources include flounder (36 percent), cod (26 percent), goby (17 percent), and two species of sea trout (13 percent). Salmon stocks, best preserved in the northern rivers of the eastern Sikhote-Alin Mountain slopes (Samarga, Kabanya, Edinka, and Venyukovka), are important for the local economies and for export; the annual catch of pink salmon (*Oncorhynchus gorbuscha*), the most common species, is about 35 tons in those regions.

Main industries

After a steady decline since 1989, industrial production began to increase again in 1999 and 2000. The fishing industry is the most important sector of Primorsky's economy, representing about 38 percent of total production. Primorsky is by far Russia's largest producer

of fish and fish products, harvesting approximately 1.5 million tons of fish and sea products a year in the Russian Exclusive Economic Zone (EEZ) and outer Pacific Ocean waters. Another critical industry is transportation, by rail and sea. Eighty percent of the RFE's ocean transport services and more than 40 percent of the RFE's international trade are through Primorsky. The *krai* produces between 3 and 4 million cu. m of timber annually, and most of it is exported. Actual figures for both the fishing and timber industries are not publicly known, owing to the widespread corruption within the industry. Primorsky—a crucial region with China, the Koreas, and Japan so close—serves as the center for the Far East military. Some sectors of the economy are growing, among them tourism (mainly from China), mining, and textiles.

Infrastructure

Infrastructure is fairly well developed, with the Trans-Siberian Railroad running along the western part of the *krai* and single-track railroads to China and North Korea. A railroad line recently built from Hunchun, China, to Kraskino, Russia, will open a new China-Japan trade route. Khasansky Commercial Port at Zarubino and Poset Port are modernizing so as to accommodate all types of cargo. A military road from Chita (which is to end in Nakhodka) is being built through previously roadless wilderness in Primorsky and has reached about halfway through the *krai*. A logging road from Nelma to Sukpai in Khabarovsk Krai may be built across the Samarga River basin to expedite logging and shipment of logs to Japan. Several other logging roads are being built or planned in the northern region of the *krai*. Vladivostok has a number of ports, together capable of handling millions of tons of cargo, but the Vostochny-Nakhodka port complex, with its large container, coal, and timber terminals, has overtaken Vladivostok in importance and continues to expand. Bolshoi Kamen was recently transformed from a military to a commercial port and now handles numerous types of cargo. Other smaller coastal ports such as Olga, Plastun, and Ternei are also being modernized and reoriented toward timber and fish export.

Foreign trade

In 2000, Primorsky officially exported almost U.S. $1 billion in products, mostly marine products ($462 million), timber ($157 million) and Korean pine nuts ($13 million), metal scrap ($44 million), textiles ($40 million), and coal (N/A).[4] The major export markets are China (mainly timber and pine nuts), the United States (mainly fish products), South Korea (fish products, some timber, and metal scrap), and Japan (timber and fish products) (see fig. 2.1). The official figures for 2000, which are probably much higher when unofficial trade is factored in, are noticeably higher than the 1999 figure of $864 million. Primorsky imported goods totaling U.S. $375 million in 2000. Primorsky buys almost one-third of its total

Figure 2.1
Foreign trade with Primorsky Krai, 2000

Export – U.S.$993 million

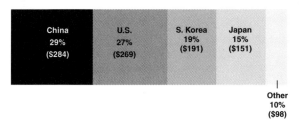

| China 29% ($284) | U.S. 27% ($269) | S. Korea 19% ($191) | Japan 15% ($151) |

Other
10%
($98)

Import – U.S.$375 million

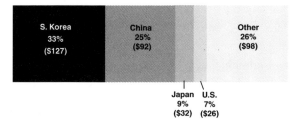

| S. Korea 33% ($127) | China 25% ($92) | | Other 26% ($98) |

Japan
9%
($32)

U.S.
7%
($26)

Source: Primorsky Administration, 2001.

imports, primarily fuel, consumer electronics, and food products, from South Korea. China exports food and consumer products to Primorsky; the United States exports primarily fuel. Given Primorsky's wealth of natural resources and importance as the major economic region in the RFE, it seems surprising that foreign investment remains so low. South Korea is the leading investor in the *krai*'s economy, followed by Japan, and then the United States. Japanese foreign investment, once the largest in the region, fell to only $38 million in 2000. About one-third of all joint ventures are with Chinese firms, the rest with companies from the United States (11 percent), South Korea (11 percent), and Japan (7 percent).

Economic importance in the RFE

Of all the regions in the RFE, Primorsky has:

- The largest and most balanced economy.
- Thirty percent of the total industrial output (and 1.5 percent of overall Russian output).
- Thirty percent of the total energy production.
- Twenty percent of the agricultural production.
- Second-highest timber production after Khabarovsk.
- About 15 percent of the total investment.
- Russia's largest fishing industry, providing about one-third of the nation's annual catch.
- The transportation center of the RFE with the ice-free ports of Vladivostok and Vostochny-Nakhodka.

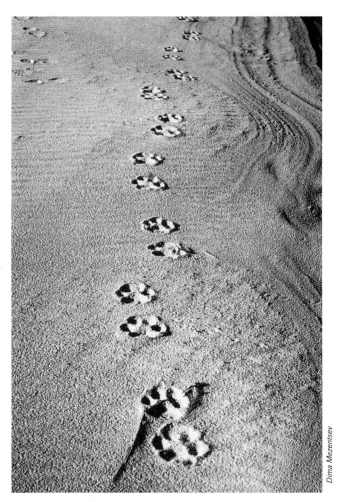

Dima Mezentsev

Primorsky's beaches are a popular hunting ground for tigers as deer make regular migrations to the shore to lick the sodium from seaweed.

General outlook

Primorsky, with its many ports, has long been Russia's gateway to the Pacific. With a regional economy increasingly reliant on trade with the Pacific Rim, the region is the economic and social center of the RFE. Structural reform of the Primorsky economy toward sustainable patterns of production and consumption and the development and implementation of sound environmental policies are essential if the RFE in general is to adopt sustainable development. Unfortunately, rather than serving as a model for the other regions, Primorsky has the dubious reputation of being one of Russia's most corrupt.[5] The illegal harvest of natural resources is widespread throughout the RFE, but Primorsky's situation is worse because much of the trade in endangered and protected species relies on poaching. Sea urchins, protected on paper, have almost been eradicated. Nets strung across protected river mouths catch endangered species of salmon. The roe is prized for export to Japan; the rest of the fish is usually discarded. Intensive logging of ash trees for export to China is taking place along river systems that are protected to control flooding in the densely populated lowlands. Trade in parts from endangered animals such as tiger, goral, and leopard supplies the vast demand in China. The illegal

harvest of ginseng and Korean pine nuts has generated multimillion-dollar businesses. This resource poaching continues to degrade the region's ecology, considered by scientists to be the most diverse in all of Russia.

The search for new supplies of natural resources continues to increase pressure on the gem of the Russian Far Eastern forests—the northern Ussuri Taiga. Russian logging companies are punching new roads into the pristine forests to secure raw logs to supply the Japanese, Chinese, and Korean markets. Much of the land belongs to the Udege, an indigenous peoples, but the regional administration and the timber interests continue to find ways to deny the Udege control over this land. The current battle is in the Samarga River basin, where a logging company secured rights to log Udege land without the consent of the local villagers.

The regional government has been either unable or unwilling to regulate effectively. Tragically, the corruption has scared away foreign and Russian investors alike and has helped build an economy reliant on quick profits through export of raw materials, with little reinvestment in industry. Such practices have done little to benefit local communities, instead enriching only a select minority involved in the trade. This is particularly true of Primorsky's remote communities, the timber, fishing, and mining villages that were built around such activities. Coastal fishing villages that once relied on processing and boat repair, and timber towns that relied on producing sawnwood, have, in large part, collapsed, leaving many of the local residents unemployed and destitute.

Assistance from the international community has so far focused primarily on environmental conservation measures—mainly efforts to establish new protected areas and combat poaching. In part because of pervasive corruption, there have been far fewer attempts to develop small-scale business opportunities for local communities. But saving Primorsky's natural environment will depend on innovative, effective business models that use nontimber forest products properly, establish sustainable fish and timber processing facilities, and provide clean, stable energy sources for the region.

— *Josh Newell*

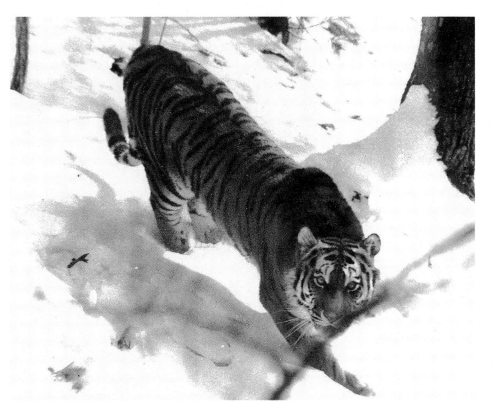

Dima Mezentsev caught this female tiger on film while sitting in a tree.

Ecology

Vladimir Karakin and Anatoly Lebedev

Primorsky Krai lies on the border of the vast Eurasian continental and oceanic plates, in the ancient volcanic zone of the Pacific Ring of Fire. This geographical position combined with a monsoon climate, which can cause catastrophic floods, typhoons, soil erosion, and landslides, also helps define the region's unusual ecology. Most of the landscape is mountainous. Low-lying valleys and river basins suited for agriculture cover only one-fifth of the region. Primorsky's global value is due to its wealth of flora and fauna, varied climates, ancient natural communities, high biological productivity, and diverse forests. Unusual ecosystems found specific to Primorsky include:

- Manchurian fir and broadleaved forests in and around Kedrovaya Pad Zapovednik.
- Forests along the Sikhote-Alin Mountain Range.
- Oak and sparse forest-steppes of the Pogranichny and Khasansky Raions.
- Estuaries and lagoons along the Sea of Japan coast.
- Lake Khanka's wetlands.
- Salmon rivers.

The *krai* can be subdivided into three terrestrial ecoregions: the Sikhote-Alin Range, the Khanka-Ussuri Valley, and southwestern Primorsky. Each region differs in its environmental characteristics, natural resources potential, and resource management requirements. Most environmental studies and projects have been focused on the Sikhote-Alin, thereby largely ignoring the other two ecoregions.

The extensive Sikhote-Alin Range covers about 75 percent of Primorsky. With its high elevation, significant diversity of climate and soil conditions, and location at the junction of different Asian ecozones, this region has the greatest biodiversity and largest number of ecosystem types in all of Russia. These ecosystem types include, among others, Manchurian, Okhotsk-Kamchatkan, Angarian, and Dauro-Mongolian. Forests of Korean pine, Ayan spruce, fir, larch, Manchurian ash (*Fraxinus mandshurica*), valley elm (*Ulmus japonica*), and Mongolian oak (*Quercus mongolicus*) cover most of the Sikhote-Alin. The range of Siberian tiger is almost exclusively limited to these forests. They provide habitat for brown bear and its southern relative, the Himalayan black bear. There are also Eurasian lynx (*Lynx lynx*), Amur goral, Sika deer, yellow-throated marten (*Martes flavigula*), Manchurian hare (*Lepus brachyurus*), and other rare and endangered species.

The Khanka-Ussuri Valley, composed of wetlands, mixed grassland, and forests, and which includes the narrow strip of the Ussuri River basin that possesses a similar wetland ecology, accounts for about 20 percent of Primorsky's territory. The Russian portion of the Lake Khanka Basin is about 1.5 million ha (about 10 percent of the *krai*'s territory), and as a haven for migrating birds is critical for the protection of biodiversity. Part of the basin is recognized as a Ramsar wetlands site. It is also an important agricultural and industrial area. Nearly half of the *krai*'s plowed fields and the largest proportion of drained wetlands are located here.

Although comprising only about 5 percent of the *krai*'s total area, southwestern Primorsky includes part of the East Manchurian Mountains and unusual coastal landscapes, with a shallow continental shelf, both of which boast some of the highest biodiversity levels in the RFE. This area includes Khasansky Raion (435,000 ha) and the western parts of Nadezhdinsky and Ussuriisky Raions, forming a narrow strip of land south of Vladivostok along the Russian-Chinese border up to the Russian–North Korean border. Protected areas and recreational territories make up 38 percent of the region. The harbors of Poset Bay were declared natural monuments in the 1970s for the crucial conservation role they play.

The closure of deer and animal farms has left people unemployed, and coupled with the opening of Chinese markets, an illegal trade in trepang (*Apostychopus japonicus*), a species of sea cucumber, has skyrocketed, destroying a number of

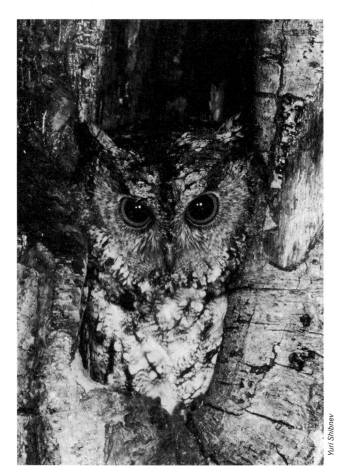

The collared scops-owl (Otis bakkamoena) *needs large trees for nesting.*

Yuri Shibnev

rich and diverse sea communities in the waters of the Dalnevostochny Morskoi (Far Eastern Marine) Zapovednik. Attempts to get trepang listed in the Convention on International Trade in Endangered Species (CITES) have failed in the absence of consistent cooperation between the Federal Fisheries Committee and the now-defunct Committee on Environmental Protection. The Far Eastern leopard is the most endangered large mammal in Russia, despite having been listed in the IUCN *Red Data Book* since 1966. Subsequent surveys in 1973, 1983–1984, and 1990–1991 have recorded continual declines in numbers. Today, this leopard is almost extinct, confined to isolated portions of southwest Primorsky.

Despite the continued attention of international nature conservation organizations, such as World Wildlife Fund (WWF), to the problem of protecting Primorsky's biodiversity, little progress has been made to develop sustainable communities living within these ecosystems. This deficiency needs to be resolved if people are to be permanently dissuaded from poaching endangered species and illegally harvesting the region's natural resources.

Forests

A. DOBRYNIN—Primorsky is one of the more densely forested regions of Russia and, according to state forest statistics, has a total of 12.46 million ha of forested territory (including *zapovednik*s and other protected territories), with an estimated timber supply of 1.72 billion cu. m. Approximately 90 percent of the forests are owned by the state. Agricultural enterprises and other departments own the remaining 10 percent.

Forests are distributed unequally across the *krai*. The average *lesistost* (area covered by forest) is 77 percent, the highest in the RFE, although this figure is gradually decreasing due to poor logging practices. Considerable stretches in the far southwest and on the Khanka-Ussuri Valley have few forests, the average *lesistost* there is lower than 25 percent. In the northern and central regions, the *lesistost* reaches 95 percent. The total area of Group I forests is 3.1 million ha, almost one-quarter of Primorsky's forests.

Alpine tundra covers the highest mountains of the Sikhote-Alin Range. At timberline is a belt of rocky tundra with Japanese stone pine (*Pinus pumila*) and various bushes, such as microbiota (*Microbiota decussata*), the only genus of conifers endemic to Russia. Forests in the north are mainly Ayan spruce and east Siberian fir; Dahurian larch dominates on the upper mountain slopes. At lower elevations, stone birch (*Betula ermani*) in the fir and spruce forests is replaced with yellow birch (*B. lutea*), and there are significant stands of Korean pine.

Toward the south of the *krai*, there is a gradual change to conifer-broadleaved forests, mainly Korean pine. A significant role is played by Mongolian oak, Amur linden (*Tilia amurensis*), and Manchurian ash. Maple, elm, walnut, giant poplar (*Populus maximovichii*), and Amur cork

(*Phellodendron amurense*) trees are also common. On one hectare of forest, there might be up to twenty timber species. The upper forests of these southern regions are stone birch and Ayan spruce forests, with some stands of East Siberian fir and Korean spruce (*Picea koraensis*). In the far south, Manchurian fir is found, and in the river basins that flow into Peter the Great Bay, it sometimes replaces Korean pine as the dominant forest species. On the western coast of the bay, there are sparse groves of the rare daimyo oak (*Quercus dentata*). Forests on coastal rocky outcrops and in the valleys of the Ussuri, Razdolnaya, and other rivers are dominated by Mongolian oak, with Dahurian birch (*Betula davurica*) and other broadleaved varieties. Large areas of the region have been developed agriculturally. The lowest plains are marshy. As the elevation increases, the marshes are replaced by sedge and grassy meadows.

Many of the species and forms of vegetation of Primorsky are not found elsewhere in Russia. Some of these are ancient, originating in the Tertiary Period. Ancient species include Japanese yew, endemic willow species, Amur cork tree, aralias, Asian ginseng, magnolia vine (*Schisandra schinensis*), castoraralias (*Kalopanax*), and various species of fern. The Komarov maple (*Acer komarovi*) and microbiota are endemic to Primorsky. In Khasansky Raion in the far south, there are up to one hundred species of rare and endangered plants. These include Manchurian apricot, kiwis (*Actinidia*), Japanese jack-in-the-pulpit (*Arizema japonica*), several species of lady's slipper orchids (*Cypripedium*), Asian ginseng, Komarov's lotus, rhododendrons, and Japanese yew.

Given the region's intense summer rains, forest cover is very important in protecting the land against erosion and flooding, especially in forests that grow on slopes of more than 30 degrees, those that grow on the upper limits of their habitat, in the valleys of spawning rivers, in areas of the Khanka lowlands that have been exploited for agriculture, along the coast, and around large population centers.

Along the river valleys, stands of elm, chosenia, willow, alder, and poplar protect the riverbanks from erosion. Spruce and fir forests with grasses and moss have an important water regulatory function. Dry Korean pine and oak forests on steep slopes have an important protective role to play, as do the associated forests of Japanese stone pine. Destroying these forests leads to increased erosion, stony scree, and the deterioration of the river's hydrology. In winter, the forests retain snow and help regulate the moisture content of the soils. In spring, the forests are especially important when the snow melts. Beneath the forests the soil does not freeze as much as it does in the plains. If forest density decreases, river flow changes, increasing the likelihood of flooding.

Natural forests make up 94.5 percent of the total forest stock. Plantation forests cover only 43,000 ha. The largest areas are covered with fir and spruce forests (27.2 percent) and forests dominated by Korean pine (19.5 percent). Less area is taken up with oak forests (17.3 percent), birch forests,

Ginseng

Primorsky Krai is the only region in Russia where Asian ginseng, a globally endangered medicinal plant, grows. Historically, it could be found in other portions of RFE, the Korean peninsula, and northern China. Heavy exploitation at the beginning of the twentieth century that was controlled by a state monopoly on ginseng gave way to a thriving black market that has severely damaged wild populations of the plant and brought it close to extinction. It has disappeared in the wild in Korea, is very rare in China, and only three wild populations remain in Primorsky Krai: in Chuguevsky, Spassky, and Khasansky. In 1997 Governor Nazdratenko signed an executive order (No. 550), the Primorsky Krai Target Program to Restore (Reintroduce) the Primorsky Population of Ginseng in the Period Prior to 2005, a program to protect ginseng habitat, to cultivate the plant in special reintroduction centers, and to implement legal measures against the illegal trade. Owing to revenue shortfalls, this program has remained a paper project.

— MJ

including stone birch (14.9 percent), and larch forests (10.7 percent). As a result of intensive logging, mining, and agriculture, conifer forests are being replaced by deciduous varieties. Forests categorized as "mature and overmature" take up about 41.9 percent of the territory. For conifer forests, this figure reaches 42.5 percent, for hardleaved varieties (e.g., oak, ash, elm), 43.1 percent, and for softleaved varieties (e.g., aspen, lime, poplar), 38.2 percent. The overall supply of mature timber is 838.74 million cu. m, of which 547.43 million cu. m are conifer species (including Japanese stone pine). The average yield for one hectare is between 180 and 200 cu. m, the average annual growth on one hectare is 1.5 cu. m. The overall average yearly growth is 17.17 million cu. m.

Protected area system

Y. BERSENEV—As conserving Primorsky's biodiversity is of global significance, the establishment of an adequate nature preservation system is essential. One way to do so is to expand the network of protected areas, and this has occurred in the *krai* over the past few decades. The protected-area network still, however, contains only about 6.3 percent of the *krai*'s total area (see table 2.1) and fails to protect the region's biodiversity adequately because many boundaries have been established without proper consideration of the habitat range necessary to protect endangered species. Possible solutions include creating more protected areas, broadening the existing ones, improving protection regimes, and creating more (and bigger) buffer zones around the *zapovedniks*. The Primorsky

Ecological Program (1991) outlines a comprehensive vision for expanding the protected area system. *Krai* and federal government decrees, such as Chernomyrdin decree No. 572-r (April 23, 1994), have outlined the need for a series of new national parks and Territories of Traditional Nature Use (TTPS). In 1994–1995, twenty-five-year licenses were granted to log forest regions in the *krai*. Areas slated for protection have been temporarily excluded from the licensing process. Establishing a reserve requires completing an *obosnovanie* (an ecological-economic justification). With the licensing process continuing apace, *obosnovanie*s should be completed quickly for territories in urgent need of protection.

Zapovedniks. There are six *zapovednik*s in Primorsky, more than in any other region of Russia. However, the overall area is fairly small (679,423 ha, including 65,900 ha of marine areas and 5,690 ha of Lake Khanka), encompassing only 4.1 percent of the *krai*'s territory, a protected area seven times smaller than in Kamchatka, and 2.5 times smaller than in Magadan or Khabarovsk. Three *zapovednik*s (Sikhote-Alinsky, Lazovsky, and Khankaisky) used to be administered by the Federal Committee on Environmental Protection, now part of the Ministry of Natural Resources; the other three are administered by the Russian Academy of Sciences (RAS). Over the past few years *zapovednik* directors have been making great strides to secure funding from international donors, but the overall situation within the reserves has been deteriorating because of Russia's continuing economic crisis. The number of people who depend on marine and forest resources for their survival has increased, making it difficult to protect all endangered species even within the *zapovednik*s. Scientific research has also been drastically curtailed.

Kedrovaya Pad. Kedrovaya Pad—the first *zapovednik* in the RFE—was established in 1916, even though World War I was in progress. Located in the south of Primorsky (Khasansky Raion) and centered around a valley and small mountain ridge (692 m), Kedrovaya Pad has an extremely high index of biodiversity. Small enough to be more like a botanical garden, the reserve, administered by the RAS, provides habitat for sixty species of mammals including Far Eastern leopard, Siberian tiger, Himalayan bear, Amur cat, and Sika deer, as well as for 380 species of birds, some of them rare. Approximately 860 species of vascular plants grow on the territory, and insect diversity is the highest in the RFE, with some species endemic to the area. Other notable features of the *zapovednik* include some of the largest remnant stands of Manchurian fir and giant yew trees.

Ussuriisky. Established in 1932, together with a mountain-taiga research station under its aegis, Ussuriisky Zapovednik is also administered by the RAS. There are no high mountains or large rivers in the area. The most valuable ecosystem is the liana-conifer-broadleaved forest, which has miraculously escaped fires and logging. Forests cover over 95 percent of the territory. It protects many rare and endangered species, such

Table 2.1
Protected areas in Primorsky Krai

Type and name	Size (ha)	Raion	Established
Zapovedniks			
Sikhote-Alinsky	390,184	Terneisky, Krasnoarmeisky	1935
Lazovsky	120,024	Lazovsky	1935
Dalnevostochny Morskoi	63,000	(aquatoria)	1978
Ussuriisky	40,432	Ussuriisky	1932
Khankaisky	37,980	Khankaisky, Spassky	1990
Kedrovaya Pad	17,890	Khasansky	1916
Nature Park			
Khasansky	35,000	Khasansky	1997
Federal Zakaznik			
Barsovy (Leopard)	106,000	Khasansky	1979
Regional Zakazniks			
Zaliv Vostoka (Vostok Bay)	182,000	(aquatoria)	1989
Poltavsky	119,000	Pogranichny, Oktyabrsky	1996
Borisovskoe Plato (Plateau)	63,429		1996
Beryozovy (Birch)	60,000	Chuguevsky	1963
Vasilkovsky	34,000	Olginsky	1973
Tayozhny (Taiga)	29,000	Krasnoarmeisky	1978
Losiny (Moose)	26,000		1986
Tikhy	23,000		1957
Vladivostoksky	16,500	Vladivostok city	1967
Chyornye Skaly (Black Rocks)	12,400	Dalnegorsky	1984
Ostrovnoi (Island)	9,000		1956
Goraly	4,749	Terneisky	1976

Source: Primorsky Committee on Environmental Protection, 2000.

as the Siberian tiger, Himalayan bear, Amur forest cat, Sika deer, black stork (*Ciconia nigra*), rare shrews, bats, and raptors. There are 868 species of vascular plants including 15 rare and endangered species, 62 land mammal species, 160 bird species, 6 amphibian species, 7 reptile species, 12 fish species, and thousands of insect species. The Primorsky Ecological Program proposes expanding the borders of this *zapovednik* by 6,900 ha at its northwestern border and by 17,600 ha along its southwestern border.

Sikhote-Alinsky. Established in 1935, Sikhote-Alinsky Zapovednik, at 1,800,000 ha, was at the time the largest in Russia and one of the largest in the world. But in 1951, the area of the reserve was reduced almost sixfold. In 1995 a marine aquatoria of 2,900 ha was added. Located in northern Primorsky (Terneisky and Krasnoarmeisky Raions), the *zapovednik* is controlled by the Ministry of Natural Resources and has the status of a biosphere *zapovednik*, which arguably affords it greater protection. Three types of forest on the territory are Korean pine, broadleaved, and fir-spruce forests. The endangered species protected here include the Siberian tiger (21 to 29 individuals), goral (150), Sika deer (100 to 120), and mountain hawk-eagle (*Spizaetus nipalensis*). There are 1,100 species of vascular plants (including twenty rare and endangered species), 63 species of land mammals, 375 species of birds, 7 species of amphibians, 5 species of reptiles, and 32 species of fish.

Lazovsky. Lazovsky Zapovednik, located in southeastern Primorsky (Lazovsky Raion), was also established in 1935 and was a branch of the Sikhote-Alinsky Zapovednik until 1940. The original area of the reserve was 339,000 ha, but it was dissolved in 1951. In 1957, it was reestablished but covered only an area of 173,932 ha. In 1960 the area was reduced again (to 139,891 ha) and it is now 120,024 ha. It is also controlled by the Ministry of Natural Resources. Forests of many types can be found in the *zapovednik*. Most of the forests were, however, logged at one time. The reserve protects Siberian tiger (20 individuals), goral (210 to 220 individuals), and Sika deer (730). There are 1,212 vascular plant species, including 44 rare and endangered species. The reserve provides habitat for 56 land mammal species and 317 bird species.

Dalnevostochny Morskoi (Far Eastern Marine). This *zapovednik* is controlled by the RAS and was created in 1978 to protect the marine shelf ecosystems and bird colonies. An unusual feature of this area is that it protects the regions where the cold Primorskoe and warm Tsusimskoe Currents meet. Therefore, arctic, subarctic and even tropical organisms can be found in the waters of the *zapovednik*. There are 556 vascular plant species, about 50 land mammal species, 1 resident marine mammal species, 306 bird species (of which at least 80 species nest on the territory), and more than 2,000 species of marine invertebrates. Birds nesting in the reserve include the globally endangered Chinese egret (*Egretta eulophotes*)

and Japanese murrelet (*Syntliborhamphus wumizusumae*), as well as rare Japanese cormorant (*Phalacrocorax capillatus*), hill pigeon (*Columba rupestris*), and Pleske's grasshopper-warbler (*Locustella ochotensis pleskei*). Some insect species are endemic to the *zapovednik*.

Lake Khanka. After a long struggle, Khankaisky (Lake Khanka) Zapovednik was finally established in 1990, under the control of the Committee on Environmental Protection. The *zapovednik*, divided into five isolated areas located in Khankaisky, Khorolsky, Chernigovsky, Spassky, and Kirovsky Raions, protects birds and their valuable wetland habitat. Endangered species include red-crowned crane (80 to 90 individuals), reed parrotbill (*Paradoxornis heudei*, 350 to 400 wintering birds and 230 nesting pairs), Oriental white stork (15 nesting pairs), Eurasian spoonbill (*Platalea leucorodia*, 3 individuals), white-tailed sea eagle (*Haliaeetus pelagicus*, 2 individuals), swan goose (*Anser cygnoides*, no statistics), and white-naped crane (*Grus vipio*, 50 individuals). There are 617 vascular plant species, including 49 rare and endangered species, and 523 algae species. The reserve is home to 48 mammal species, 333 bird species, 6 amphibian species, 7 reptile species (including the rare Mongolian racer [*Coluber spinalis*]), 60 fish species (including the endangered Chinese perch [*Siniperca chuatsi*] and other rare fishes), and some rare and endangered insect species. To fulfil its obligations under the Ramsar Convention (Lake Khanka Zapovednik is part of the Khanka Ramsar site), Russia would have to include more crucial wetlands into the *zapovednik*, because two-thirds of the populations of key species such as cranes and Oriental white stork are currently unprotected. One major problem for the *zapovednik* is a 16,000-ha aviation testing ground located near the reserve where yearlong bombing exercises created noise and cause grass fires, disturbing nesting and migrating birds. There is a protected area on the Chinese side of the lake but it differs greatly from its counterpart on the Russian side in terms of protection. In 1996, both governments agreed to establish an international reserve, but the exact borders and protection regulations remain to be agreed upon.

Zakazniks. There are thirteen *zakazniks* (with an overall area of 298,700 ha; 1.8 percent of Primorsky's territory), but only Barsovy is a federal-level *zakaznik*, the rest being regional-level reserves. The Primorsky Hunting Service administers most of them. Depending on the Ministry of Agriculture for its financing, the service lacks funds to protect the reserves properly. Many have no rangers on staff to deter poaching.

Barsovy. Barsovy protects lowland river valleys, a good forest type for fauna. Secondary growth broadleaved forests are the most common, although some virgin forests remain. The major protected species is the Far Eastern leopard. Many rare and endangered vascular plants can be found in the area as well as over 150 breeding bird species. In terms of protecting biodiversity, this *zakaznik* is as important as Kedrovaya Pad Zapovednik. Hunting, commercial fishing and logging,

ploughing for agriculture, and use of agricultural chemicals are all forbidden. It is however difficult to carry out such extensive protection as several villages are located near the *zakaznik*, including a 40,000-ha military testing ground in Barabash Village.

Losiny (Moose). Losiny protects moose and other rare game animals. Prohibited activities include hunting, ploughing for agriculture, use of agricultural chemicals, and tourism. Geological exploration, natural resources development, and scientific research are limited. The *zakaznik* protects the lower Venyukovka River basin, but should be expanded to include the entire basin. The Ecological Program proposes expanding Losiny by 43,000 ha.

Tayozhny (Taiga). Located in northern Primorsky (Krasnoarmeisky Raion), Tayozhny, which has never been commercially logged, covers the entire upper portion of the Perevalnaya River basin. Spruce and Korean pine broadleaved forests cover most of the territory. Seventeen rare and endangered plant species, some rare insect species, ninety breeding bird species, and mammals such as the Siberian tiger, sable (*Martes zibellina*), and wild boar (*Sus scrofa*) can be found. Deer hunting, ploughing, agricultural chemical use, tourism, recreation, and noncommercial fishing are prohibited. There are limits placed on geological exploration and natural resource development. Scientific research that does not comply with the purpose of the *zakaznik* is forbidden. But it is hard to protect the area because it is easily accessible by road.

Tikhy (formerly Daubikhinsky). Created to protect ducks, particularly mandarin duck (*Aix galericulata*), other birds, and their wetland habitat, this reserve, with over fifteen natural lakes, is in central Primorsky in an irrigation valley between the Sinegorka and Arsenevka Rivers, close to the town of Arsenev.

Poltavsky. Situated in western Primorsky, the reserve was reduced in size in 1996, leaving a sliver of unprotected area between its border and that of Borisovskoe Plateau Zakaznik. The reserve protects large feeding areas for a variety of birds. All types of hunting are forbidden.

Beryozovy (Birch). Located in central Primorsky (Chuguevsky Raion), the reserve protects a number of species, including Siberian tiger and Himalayan bear. All types of hunting as well as land ploughing, tourism, and recreational activities are forbidden.

Chyornye Skaly (Black Rocks). Located in eastern Primorsky (Dalnegorsky Raion), the reserve stretches along the Sea of Japan coast, protecting habitat for Sika deer. All types of hunting, commercial logging, chemical use, automobile parking, and tourism are forbidden. Scientific research not compliant with the goals of the *zakaznik* is also forbidden.

Vasilkovsky. Also stretching along the coast of the Sea of Japan, this *zakaznik* is located in southeastern Primorsky (Olginsky Raion). Twenty-eight rare and endangered vascular plant species grow here. The *zakaznik* protects a great number of Sika deer and, as a result, a great number of tiger.

Gorals live in the rocks along the coast. There are also Himalayan bears there. Over one hundred bird species nest in the area, sixteen of them rare and endangered. Fishing, commercial logging, commercial gathering of plants, tourism, recreational activities, and house construction are prohibited. The Ecological Program proposes expanding Vasilkovsky by 58,100 ha.

Borisovskoe Plato (Plateau). Located in southwestern Primorsky, stretching along the Chinese-Russian border, this important reserve with larch, Schmidt birch (*Betula schmidtii*), and Korean pine forests, protects in particular the Far Eastern leopard, its prey, and its habitat. All types of hunting, tourism, and automobile parking are prohibited, as is scientific research conflicting with the goals of the *zakaznik* and agriculture.

Ostrovnoi (Island). This *zakaznik* was established to protect birds and animals on a number of islands (Russky, Popov, Reineke, Rikorda, and Askol) in Peter the Great Bay. Its status has expired, and no decision has been made whether to dissolve it or extend it.

Goraly. Administered by staff of the Sikhote-Alinsky Zapovednik, this *zakaznik* includes a coastal area along the Sea of Japan, including 1 km of aquatoria. The reserve is designed to protect the goral. All forms of industrial activity that disturb the natural environment are forbidden. The presence of people and boats is also restricted.

Zaliv Vostok (Vostok Bay). Created to protect biota of the bay for scientific research and to establish plantations of disappearing marine species. Dumping pollutants and developing natural resources is prohibited here.

Vladivostoksky. This *zakaknik*, a forested park in the Vladivostok suburbs, was created to protect the natural ecosystem.

Khankaisky. This *zakaznik*, created to protect species of duck, was dissolved in 1997.

Other protected areas. The *krai* has the following:

National parks. No national parks in Primorsky exist as of March 2002, but three are planned: the Verkhne-Ussuriisky (Upper Ussuri), Sredne-Ussuriisky (Middle Ussuri), and Kema-Amginsky National Parks. This plan is in accordance with the Russian Federation decree No. 572-r, commonly referred to as the Chernomyrdin decree. Kema-Amginsky (268,000 ha) National Park, located on the eastern slope of Sikhote-Alin, mainly in Terneisky Raion with a small portion in Krasnoarmeisky Raion, would protect most of the Kema River basin, the upper part of the Amgu River basin, which has the highest waterfalls in the *krai*, a part of the Maximovka River valley, Mount Kurortnaya, the Ozyornoe Plateau, and Amginsky mineral water pool. (For descriptions of the Verkhne-Ussuriisky and Sredne-Ussuriisky National Parks, see Hotspots #3 and #5).

Nature parks. There is only one nature park in Primorsky, but there are plans to create the Yuzhno-Primorsky (Southern Primorsky) and Vladivostoksky Nature Parks. Yuzhno-Primorsky Park would consist of two unconnected parts. The northern part (22,700 ha), located in Partizansky and Lazovsky Raions, would include the upper part of the Alexeevka River basin, Mount Olkhovaya, on top of which there are two lakes, and the northern part of the Partizansky Range including Lysaya Mountain. This area has many endemic plant species. The southern part (38,600 ha), in Partizansky and Shkotovsky Raions, would include the cities of Partizansk and Bolshoi Kamen.

Khasansky Park, created in 1997, protects part of the vast Tumen wetlands along the southeastern border of the *krai*. Forty-seven species of birds and four species of mammals here are rare and in need of protection; some species of insects are endemic to the area. The park is subject to the conditions of three international conventions on the protection of migrating birds.

Natural monuments. Currently, there are 214 approved natural monuments, all of which have regional status and 9 of which have been recommended for federal-level protection. In the Chernomyrdin decree mentioned earlier, there are plans to create 94 more monuments. Primorsky's largest monument, the Kedrovniki (Korean Pine Forests) in Krasnoarmeisky Raion, protects 4,929 ha of forest. There are also three spa regions with a total area of 121,000 ha and other protected zones such as Group I forests.[6]

Biodiversity hotspots

Vladimir Karakin and Anatoly Lebedev

1. Samarga River basin (forest)

The Samarga River, located along the eastern slope of the Sikhote-Alin Mountains in the northernmost part of Primorsky, is often referred to as the political peninsula. Khabarovsk Krai, except for a narrow corridor in the south, surrounds the Samarga on all sides, and logging companies in Khabarovsk continually try to get access to these rich forests. To the west lies the Nelma River basin, to the north the Anyui River basin, and to the east the heavily logged Khor River basin.

As in most of the central Sikhote-Alin region, subarctic and subtropical climate zones converge in the Samarga basin. Human-caused fire, however, has marred some of the forests in the area.

Of the 630,000 ha of forest administered by the Svetlaya Leskhoz (forest service unit), 45 percent consists of spruce and fir stands, with between 1 and 2 percent intermixed with Korean pine. Larch forests comprise 40 percent of the total; birch, aspen, Japanese stone pine, and burnt forests make up the remainder.

The Samarga River and its tributaries are pristine spawning grounds for many species of fish, the most valuable being salmon. For this reason, the regional government prohibits commercial fishing entirely in these rivers and limits fishing at the Samarga River mouth along the seacoast. The government does allocate an annual 200-kg quota to each family of indigenous peoples.

There are only three settlements in the region: the village of Samarga at the river mouth, the ten-family former Old Believers' village of Unty in the river's lower reaches, and the predominantly Udege village of Agzu, which is isolated from other regions because there is no road. River and winter trails provide the only land access in and out of the village. Agzu has a total population of 205, of which 145 are native Udege. In 1992, the Primorsky regional legislature passed a decree calling for the creation of what is called an ethnic territory to protect the Udege and their traditional economy of fishing and hunting. This designation is intended as a temporary measure until permanent protection status as a TTP or similar designation can be conferred. For at least a thousand years, the Udege have been living in an ecologically sustainable manner in the Samarga.

The entire territory is divided into twenty-three hunting leases, which are granted to Udege families, as well as to Russians and Ukrainians living in the area. The trading company Troika and some small merchants from Khabarovsk purchase the furs and other wild animal products. Locals complain that one of the Khabarovsk firms, Vostok-Pushnina, has a bad reputation in the Samarga area because the company treats the Udege hunters rudely and pays very badly.

Threats. Large timber companies have long eyed the Samarga forests, primarily because of the region's proximity to the coast and, therefore, accessibility to the Japanese timber market. In the 1980s, local authorities were able to avert a timber lease to a Cuban firm that had clear-cut large areas in the neighboring Sukpai basin in Khabarovsk Krai. In December 1997, Rimbunan Hijau, a large Malaysian firm, won an international tender to cut 500,000 cu. m in the Sukpai over a forty-nine-year period. In the economic planning documents submitted for the tender competition, Rimbunan indicated that the timber logged in the Sukpai would be transported along a road to be cut through the Samarga basin to the port of Nelma on the coast. This plan has not yet been realized, but it or an alternative one, such as the reconstruction of an old railway spur from Sukpai to Obor in Khabarvosk Krai, will have disastrous consequences for the Samarga forests. For years, Russian companies have wanted to build the Nelma-Sukpai road, but have not had the capital to do so. However, in 1997, when Rimbunan executives approached the local administration in Ternei about getting logging rights in the Samarga basin, they discussed the road in great detail. Rimbunan officials even lobbied Agzu villagers to gain their support, but the villagers opposed the idea. Since then, almost

the entire Samarga watershed has been leased to Terneiles, a large timber company based in Primorsky.

Horrendous social conditions in the Samarga basin, combined with the lack of export routes for furs and fish products, mean that logging companies and regional governmental officials may be able to persuade local residents to accept the Nelma-Sukpai road. With this very real possibility and the current uncontrolled poaching of animals and fish by nearby timber companies, the Samarga basin ecosystem is critically threatened. If Terneiles begins harvesting operations in the Samarga, the logging will obviously affect the forests and wildlife. The only ecologically and socially viable solution for the Samarga is to develop an ecologically balanced land-use program for the natural resources of the basin; this program must focus on small- to medium-sized businesses, ecotourism, and adequately controlled hunting and tourism.

Existing protection measures. The idea of establishing some sort of protected area in the Samarga first surfaced in 1990 at a meeting of the USSR State Forest Committee, when participants, after pressure from Udege representatives, agreed to withdraw the territory from the jurisdiction of the state-run Samarga Lespromkhoz. When the Primorsky Ecological Program appeared in 1991, the Samarga watershed was included as a region to be protected as a Territory of Traditional Nature Use. However, efforts by Russian and international NGOs and some officials within the now-defunct Committee on Environmental Protection to implement the program have so far been unsuccessful.

The Non-Timber Forest Products Association in Khabarovsk, in cooperation with Agzu community leaders and Friends of the Earth–Japan, began the first phase of a development program in 1997. The program seeks to assist the Udege in using their traditional harvesting methods and selling their forest products on the commercial market. Troika trading company, based in the nearby town of Edinka, may also assist in this effort. Troika company executives distinguish themselves from most of their competition by paying attention not only to economic priorities but also to the importance of resource conservation and nature protection. However, since 1999, progress to develop sustainable economic alternatives in the Samarga has been limited.

Recommendations. To promote a sustainable development plan and to promote traditional resource-based economies, it is necessary to:
- Revoke the Terneiles tender for the Samarga.
- Develop a business plan for resource use.
- Improve the marketing and sale of local forest products in Japan, Primorsky Krai, and Khabarovsk.
- Help the Udege acquire equipment for small-scale timber harvesting and nontimber forest products and fish processing.

The Samarga River basin has rich salmon runs.

- Establish tax exemptions and related benefits for Udege commercial enterprises.
- Encourage international and domestic tourism in the region.

2. Middle and Upper Bikin River basin (forest)

Located in northern Primorsky along the western slope of the Sikhote-Alin Mountains, between the Iman and Khor Rivers, the Bikin River basin comprises more than 700,000 ha of roadless coniferous and broadleaved forest. The forests consist in nearly equal proportions of spruce and fir (28 percent), Korean pine and broadleaved species (32 percent), and larch (21 percent). Topography, including exposure, grade, and humidity, plays an important role in this species distribution. The Bikin basin, the largest intact ecosystem in the Sikhote-Alin Range, provides year-round habitat for fifty-two mammal species; another eight species migrate in and out of the region. Thirty of those species, including Siberian tiger and Himalayan and brown (*Ursus arctos*) bears, live exclusively in the Bikin's rich Korean pine and broadleaved

Russian timber giant wins tender to log the Samarga watershed

In spring 2001, Terneiles, one of the largest timber companies in the RFE, received a twenty-five-year license to log virtually the entire Samarga watershed. The proposed annual cut for the region, according to tender documents, is an astounding 800,000 cu. m per year or almost twice what Terneiles is presently logging in all of its harvest sites. Reportedly, the tender process was done without participation or even knowledge of the peoples living in the Samarga region's main village of Agzu. Most of the residents of the village are Udege and use the entire region to hunt and fish. According to Ecodal, a non-profit Russian environmental law firm based in Khabarovsk, since the local community was not involved in the process, the Primorsky Krai administration acted illegally, and so Ecodal plans to sue. It does appear that the community is against the project. In September 2001, half (102) of the Agzu residents sent a letter to Primorsky Krai administration asking it to rescind the tender immediately. Most of the local community is against any large-scale logging in the river basin. Instead they would like to see support of their fishing and hunting enterprises, as well as investment in ecotourism and nontimber forest product harvesting and processing. There is evidence that such an approach would be economically viable. In October 1999 a team of consultants worked in the watershed and concluded that well-organized local hunting and fishing, together with access to markets and modern processing and storage technology, can provide employment to the local population and stable revenue to the district and regional budgets without destruction of natural forests.

In late September 2001, under pressure to make some gesture of goodwill, Terneiles announced a two-year moratorium on all logging in the Samarga. Skeptics, however, point out that the company needs time to do a feasibility study to plan initial harvest areas and necessary road and logging infrastructure. When asked if Terneiles would cease all activities related to the Samarga concession, a vice president of the firm, Sergei Naumkin, replied no.

Terneiles is positioning itself as a "green" timber company, particularly for the Japanese market. Since 1999, it has been working with the Far Eastern Forest Certification Center, an NGO, to obtain Forest Stewardship Council (FSC) timber certification for its logging site near the Sikhote-Alinsky Zapovednik. Reportedly, this effort is in response to Sumitomo Forestry's interest in working with a Russian timber company that has some sort of certification. Sumitomo Forestry and Terneiles have a long working relationship and together they run one of the few successful wood-processing operations in the entire RFE. The joint venture produces primarily sawn wood for the housing market in Japan. So far Terneiles is noncommittal about whether it will also seek FSC certification for any logging operations, if they occur, in the Samarga basin. Some environmentalists see Terneiles's attempts to obtain FSC certification as merely a marketing ploy to appease Sumitomo Forestry and the larger Japanese market; they point out that only a small portion of Terneiles's holdings would actually be certified. Environmentalists point to Terneiles's dubious actions in the past; the company, for example, spearheaded an unsuccessful attempt in March 1999 to repeal a 1989 Soviet ban on the cutting of Korean pine and has been widely accused of shipping the protected species under the guise of another label from its port of Plastun for years.

A conglomeration of several state-run *lespromzhoz*es during Soviet times, Terneiles in the mid-1990s became an independent joint-stock company. Since that time, the company has grown to become one of the most powerful timber companies in the RFE. Closely aligned to Terneiles are two other major logging companies, Melnichnoe and Roshchinsky Lespromkhozes, which primarily supply the company with logs. With this alliance, coupled with its own holdings, Terneiles now controls much of the prime forestland in northern Primorsky.

— *JN*

forests. Seventy percent of the 240 bird species that live in the region nest in the Bikin, the remainder are seasonal. Thirty-five of those species are rare and require protection, including hooded crane (*Grus monacha*), osprey (*Pandion haliaetus*), Blakiston's fish-owl, scaly-sided merganser, and Siberian grouse (*Falcipennis falcipennis*). Seven species of amphibians and ten species of reptiles also inhabit the Bikin, as do fifty-one species of fish. Twenty-seven of the region's insect species are listed in the Russian *Red Data Book*.

Historically, geographically, and economically the basin has been divided into three land-use zones. Intensive land use, primarily logging, hunting, and open-pit coal mining has taken place along the lower portion, from the river mouth upstream to the confluence of the Alchan and Takhalo Rivers. Most of the population of Pozharsky Raion lives in this region. The middle portion, around the village of Ulunga, is predominantly used for gathering Korean pine nuts and for the traditional economic activities of the Udege peoples. In 1992, the regional government reserved the upper Bikin and its headwaters as a potential TTP but, in October 1998, this status was changed to that of a *krai*-level landscape *zakaznik*.

Threats. Originally, there was a plan to make the entire 1.35-million-ha middle and upper Bikin basin a TTP that would be administered by the Udege for the Udege. However, to date, it has not been possible to include the uppermost 700,000 ha in this area because of the Russian and South Korean timber joint venture, Svetlaya, which claimed rights to a substantial portion of the area. Logging never took place, but this dispute has effectively kept the rich forests of the upper Bikin from being protected as a TTP or as a protected Group I forest. A logging road that runs from the logging town and port of Svetlaya toward the upper Bikin also poses a threat to the region. Russian companies continually lobby the regional government and the Primorsky Krai forest service for permission to log the upper Bikin; this road would be the major access point. This threat, as well as the current uncontrolled poaching by residents of Vostok and others where unemployment has reached very high levels, will continue to plague the region as long as the TTP remains unestablished.

Perhaps the greatest immediate threat is, however, the newly constructed Chita-Nakhodka road that cuts directly across the Bikin near the Udege village of Krasny Yar. This road has opened up the lower-middle portion of the Bikin to logging, poaching, and illegal harvest of pine nuts. In particular, there have been regular reports of illegal logging of ash and Korean pine near this road.

Existing protection measures. In addition to efforts to establish a TTP, over the past two years there have been significant attempts to make the entire central Sikhote-Alin region a UNESCO World Heritage site. Greenpeace-Russia and the Bureau for Regional Outreach Campaigns, a local nongovernmental organization based in Vladivostok, lobbied the regional government to create the Verkhne-Bikinsky Zakaznik, rather than the more ethnically focused TTP, on the territory. The governor signed a decree establishing the *zakaznik* in October 1998. Staff and facilities to monitor and protect the *zakaznik* are still not in place. Nonetheless, the creation of the Verkhne-Bikinsky Zakaznik and nearby Chukensky Zakaznik to the north and efforts to develop a sustainable land-use plan for the Samarga basin to the east do create an opportunity to achieve sustainable resource use and nature protection along the entire central Sikhote-Alin.

Recommendations. The following actions should be taken:
- Hire staff and complete zoning; otherwise the newly created refuge will remain a paper park.
- Fund the building of facilities for the park.
- Support the local business, particularly nontimber forest products processing equipment, of the Udege peoples living along the Bikin.
- Promote ecotourism.

3. Middle Iman River basin (forest)

The proposed Sredne-Ussuriisky National Park covers 1,090 sq. km along the western slope of the central Sikhote-Alin near the middle reaches of the Iman River, which flows into the Ussuri River. Of the species in the region thirty-one vascular plants, twelve lichens, twenty-eight insects, nine birds, and two mammals are endangered. Clean alpine rivers, rocky cliffs, magnificent vegetation, and beautiful landscapes make the region especially picturesque. The area is one of three remaining traditional territories for the native Udege; 122 of them live in the region. The proposed park would help protect Udege culture and their traditional land-use practices; the Iman Udege peoples fish and hunt in the region. One of the key objectives of park development strategy is to revive the traditional culture of land use by the Iman Udege, who have recently established the public organization Iman Tribal Community.

The area's network of rivers includes the Iman, its tributaries (Armu and Perevalnaya), and a number of smaller creeks. The swift, clean Iman and Armu Rivers are ideal for rafting, boating, and sportfishing.

Korean pine and broadleaved forests grow in the region, with elm and ash prevalent in the valleys and occasional stands of willow, cottonwood, and poplar. Scattered larch forests grow along the fringes of the marshes, and second-growth oak forests are found on steep, south-facing slopes near the Dersu and Dalny Kut villages. Spruce and fir forests grow at elevations above about 800 m.

Threats. In recent years, logging has fragmented some of the forests nearby and is a threat to the forests within the borders of the proposed park.

Existing protection measures. Both the federal- and the *krai*-level protected area programs call for the creation of Sredne-Ussuriisky Park; to date, lack of funds has made this unachievable. Until the 1950s, the proposed park was part of nearby Sikhote-Alinsky Zapovednik. The Krasnoarmeisky Raion government supports the halting of logging in Korean pine forests, has created Peace Zones on the Armu River banks, and, to limit illegal logging, has called for a permit process for transporting timber. Regional authorities also promote ecotourism, regulate hunting, and work to preserve rare species.

The *raion* government approved the creation of Sredne-Ussuriisky in 1997 and, in 1998, Greenpeace-Russia and the Federal Committee on Environmental Protection prepared the documents necessary to include the park within a proposed UNESCO World Heritage Site for the central Sikhote-Alin. In 2001, however, UNESCO announced World Heritage Site status for Sikhote-Alinsky Zapovednik, but no other protected areas in Primorsky.

Recommendations. The following actions should be taken:
- Once established, the park should be supported: patrols organized, an Udege cultural center created in the village of Ostrovnoi, and a variety of trails and programs developed to attract ecotourism.
- Combat illegal timber harvesting and animal poaching, both within and on the borders of the park.
- Protect rare species such as ginseng and Siberian tiger.
- Develop environmental education programs.
- Acquire communications equipment and vehicles for the park.

4. Southwestern Primorsky region (forest and wetland)

Most Russian ecologists consider the lands along the Chinese border from the Tumen River to the Razdolnaya River to be Primorsky's most important area, outside the Sikhote-Alin, for biodiversity conservation. The region includes portions of four *raions*: Khasansky, Nadezhdinsky (western portion), Ussuriisky (western portion), and Oktyabrsky (southern portion). Existing protected areas in the region include the Khasansky Nature Park, Barsovy Zakaznik, Borisovskoe Plateau (Shufan) Zakaznik, and Kedrovaya Pad Zapovednik.

Threats. The Shufan plateau is the largest remaining habitat for the remaining wild Far Eastern leopards and is also habitat for an isolated Siberian tiger population. Manchurian fir and broadleaved forests cover this region of great animal and plant biodiversity. Other rare and endangered species in the region include the Himalayan black bear, dhole, Amur cat, spotted bush warbler (*Bradypterus thoracicus*), and Kruper's nuthatch (*Sitta kruperi*).

Within and near Shufan plateau, there are many hunters and thus a lot of poaching. Intensive selective logging is

already threatening the forest ecosystems, particularly the ash forests that grow along the river valleys. The proximity of the plateau to the *krai*'s major population centers (Vladivostok, Nakhodka, and Ussuriisk) increases the threat to the territory from hunting, poaching, and uncontrolled tourism, and the value of its timber stands makes it a future target for timber companies.

The region is known for a number of wetlands of international importance that have been proposed as Ramsar sites, and for vulnerable lagoons and estuaries. The Tumen Delta includes a 40,000-ha wetland complex with over thirty freshwater lakes and brackish lagoons. About two hundred species of birds nest or stop over the territory during migration, forty-seven are rare species and include red-crowned, Siberian (*Grus leucogeranus*), and white-naped cranes, white-tailed sea eagle, scaly-sided merganser, and Chinese egret. Currently, poaching and forest fires are major problems.

Threats to the Tumen wetlands include a number of planned international development projects, including the Tumangan Project by the United Nations Development Programme, a proposal to develop infrastructure for large-scale recreation and biotechnology in lands presently used for deer farming. This project could have severe consequences for the region's marine ecosystems.

Existing protection measures. Several protected areas exist in southwest Primorsky, including two *zapovedniks* (Dalnevostochny Morskoi and Kedrovaya Pad), two hunting *zakazniks* (Barsovy and Borisovskoe Plateau), and Khasansky Nature Park. An international (Russian-Chinese) nature reserve was just created to help give the Far Eastern leopard the habitat necessary for a chance to survive.

Recommendations. Because of an extensive network of hunting lands and the planned economic projects, there needs to be land-use zoning in southwestern Primorsky Krai to increase coordination among the many competing land-use interests in the region. This zoning plan should include a well-developed and interlinked network of protected areas, zones of limited economic activity, and areas for more intensive use. This plan will require the use of a Geographic Information System (GIS). Special emphasis must be placed on protecting leopard habitats and marine resources.

A plan to establish sufficient ecological corridors to link existing leopard habitat in southwestern Primorsky with potential habitats in the Sikhote-Alin also needs to be carried through. The development and maintenance of the protected area network must take into account the present habitat of rare and endangered species and the level of protection offered by existing protected areas. Ultimately, the regional government needs to establish a single, unified protected area based on existing areas, such as Kedrovaya Pad Zapovednik, and possibly Khasansky Nature Park and the Borisovskoe Plateau and Barsovy Zakazniks.

5. Upper Ussuri River basin (forest)

Three mountains, Sestra (1,671 m), Oblachnaya (1,854 m), and Snezhnaya (1,682 m), form the watershed of the Ussuri, Milogradovka, and Margaritovka Rivers. Russian ecologists call this region the upper Ussuri River basin. The federal government will likely create the proposed Verkhne-Ussuriisky National Park because doing so would meet a number of important conservation priorities, including the provision of an ecological corridor connecting Lazovsky and Sikhote-Alinsky Zapovedniks. Locals support the park because it will be a base for ecotourism and thus will bring in revenue and create jobs. The area has been a popular recreation destination since the 1930s; the dome-shaped Oblachnaya (Cloudy) Mountain, the highest in Primorsky, is a favorite among climbers. The proposed park would also protect the headwaters of the Ussuri River, one of the largest and most important rivers in the RFE.

The flora and fauna is typical of southern Primorsky. Korean pine and broadleaved forests predominate at elevations less than 800 m, spruce and fir forests are more common at 1,000 m and above. Above 1,500 m the forest is mainly stone birch and Japanese stone pine, and alpine tundra grows above 1,600 m. The diverse elevations found within close proximity of one another have created floral mixtures that scientists have found nowhere else.

The park will strengthen protection for 132 species of vascular plants, 9 of which are rare. The park will also protect two paleoendemic species: microbiota and *Saussurea sovietica*—a tundra herb. Siberian tiger, Himalayan black bear, wild boar, Manchurian wapiti (*Cervus elaphus xanthopygus*), Sika deer, Manchurian snow deer (*Capreolus pygargus bedfordi*), goral, and musk deer (*Moschus moschiferus*) live within the proposed park. The Siberian tiger is a constant inhabitant, living here even during the great decline in its populations in the 1930s and 1940s.

Existing protection measures. Three different variations for the park's area, ranging from 100,000 to 180,000 ha, have been proposed. In 1996, the Primorsky Committee on Environmental Protection coordinated an ecological-economic justification (*obosnovanie*) to create Verkhne-Ussuriisky Park. Since then the Primorsky Committee on Environmental Protection has been working to achieve consensus among the main land users (the regional forest service and hunting authorities) on boundaries and jurisdiction issues. It has also been working on procedures to enable federal and regional agencies to work together to create and manage the federal-level park.

Recommendations. The following actions should be taken:

- Establish the legal status of the park.
- Fund staff, transport, and communications.

Economy

Vladimir Karakin, Anatoly Lebedev, Josh Newell

Intensive settlement of Primorsky corresponds with large-scale industrial development that began in the early nineteenth century, as the federal government encouraged settlement of the RFE by offering incentives, usually land grants, to settlers. Most settlements were established by the 1860s, with Russians, Ukrainians, Belorussians, Moldavians, Estonians, and Finns streaming in. They were allocated land, often areas heavily cultivated by seasonal workers from China and Korea, who were working there under a number of international agreements. The settlements that developed were of mixed nationality, and so the cultures were a mixture of European and Asian elements. In some areas indigenous peoples mixed with permanent Chinese settlers. Development of the coastal, forest, and agricultural settlements continued throughout the Soviet period and right up until recent times, enriching the ethnic picture still further.

Despite representing only a small percentage of Russia's total population and comprising less than 1 percent of the federation's total area, Primorsky Krai is crucially important to the country for several strategic raw materials, including lead, boron, fluorite, coal, commercial timber, and most importantly, fish and marine products. Primorsky has Russia's largest fishing, fish-processing, and transportation fleet. Local supplies of regular commercial fish make up a large percentage of the total RFE catch. The huge ports in Vladivostok, Vostochny, and Nakhodka make Primorsky Russia's Asian gateway for trade throughout the Pacific Rim. Commercial hunting and collecting of nontimber forest products takes place near settlements and in areas accessible by existing infrastructure. The Ussuri Taiga still retains vast natural resources in inaccessible regions. The local agrarian economy is based on meat, dairy products, poultry, rice, fruit, potato, and berry production. Although more developed than are other regions in the RFE, the *krai* still does not provide enough food for the local population. Mink breeding, Sika deer herding, and rice, soybean, and ginseng production are also important.

Uneven industrial development. The region is largely mountainous, so industrial development has been concentrated in limited areas. Economic activity and natural resource use is heavily concentrated in the southern and western portions of the *krai*; the northern and eastern areas are less developed, but even there pockets of intense industrial activity have created ecological problems. Analysis of *raion* agricultural and industrial data suggests a tripartite zonal division of Primorsky into subregions with distinct patterns of development. These subregions are similar to the ecoregions described in the section "Ecology." The Prikhankayskaya

Valley, including the wetlands of Lake Khanka, and the plains along the Ussuri River, has the largest share of the *krai*'s economic activities, especially as an area for agriculture. Almost 80 percent of the *krai*'s plowed fields (600,000 ha), 49 percent of the hay fields, and 52 percent of pasturelands are concentrated in this western section. Agroindustry, mining, and raw material processing all occur here, as well as in the western foothills of the Sikhote-Alin. This area has the most favorable natural conditions for human settlement. Not surprisingly, anthropogenic disturbance is quite high. There are, however, relatively undisturbed sites, particularly in the protected areas in Lesozavodsky, Kirovsky, Spassky, Khankaisky, Khorolsky, Chernigovsky, Pogranichny, Oktyabrsky, Mikhailovsky, and Ussuriisky Raions.

The second subregion covers most of the Sikhote-Alin Range (excluding the northeastern part), 50 percent of the *krai*'s territory. This includes relatively developed mountainous and taiga areas as well as the southern coastal *raions*. The *krai*'s timber and mining industries are concentrated here. There is limited agricultural production, mostly small plots, geared toward meeting the area's needs. This region, encompassing western Pozharsky, Dalnerechensky, western Krasnoarmeisky, Chuguevsky, Yakovlevsky, Anuchinsky, Partizansky, Shkotovsky, and Nadezhdinsky Raions, has managed to maintain a more or less stable level of industrial activity (including logging, hunting, mining, and fishing) with a concurrently stable level of environmental impact. The third area, 30 percent of the *krai*'s territory, includes poorly- and undeveloped regions of Primorsky, where about 3 percent of the *krai*'s plowed fields are located. These territories include the eastern and northeastern regions of the Sikhote-Alin and the eastern Pozharsky, Terneisky, Dalnegorsky, eastern Krasnoarmeisky, Kavalerovsky, Olginsky, and Lazovsky Raions, together with the geographically distant southwestern Khasansky Raion. Economic activity in these territories continues to decline with sharp increases in airfares, reduced demand for fur, the disruption of seasonal investment in forest development, and fewer mining and exploration operations.

Environmental impact. Environmental degradation is prevalent in many areas. State rice farms have degraded many of the richest wetlands of Lake Khanka. Destructive logging methods have fragmented forests growing on the Sikhote-Alin Mountain Range. Uncontrolled use of toxic chemicals has polluted rivers, lakes, and bays. Lack of control over land allocation to industries has led to rapid and wasteful use of resources. Overfishing has led to serious reductions of fish populations in many of the rivers. The only undisturbed salmon-spawning grounds are now in the northern and sparsely populated Samarga, Edinka, Venyukovka, Peya, and Avakumovka River basins. Indigenous peoples have also come under threat, particularly by logging and mining com-

Table 2.2
Timber industry employment in Primorsky Krai

Year employed	Total	Percentage compared with 1991	Percentage of total industry
1991	24,768	100	8.7
1992	24,021	97	9.0
1993	21,226	86	8.9
1994	19,499	79	9.7
1995	19,767	80	9.5
1999	12,067	49	6.7

Source: Primorsky Krai Administration, 2001.

panies who want their land. Despite declines in industrial production, due to continued reliance on outmoded technology, unstable economic conditions, and poor enforcement of existing policies, the environment continues to be affected.

The port and ship-repair base and ports and ship traffic create all kinds of oil pollution, vast amounts of uncontrolled liquid waste are dumped into the water, and municipal and other waste is discharged untreated into coastal ecosystems, which are extremely productive and valuable for recreation. Poor control over military and naval activities has left areas contaminated by military waste. Recently, the international community has become aware of the dumping of nuclear waste into the Sea of Japan and the rusting nuclear submarines in Bolshoi Kamen. A facility has been built to store the nuclear waste.

Timber

In Primorsky before 1917, logging took place on a narrow strip along the Trans-Siberian Railroad and in some of the river basins the railway crossed. Sawmills were established at the crossings. Industrial forestry began in the 1930s. The timber industry today accounts for about 7 percent of the *krai*'s industrial production by volume and employs about thirteen thousand workers. The industry used to employ more, as indicated in table 2.2, but the figure is decreasing since the collapse of timber processing. Now the industry focuses primarily on supplying the export markets of Japan, China, and South Korea with raw logs of fir, spruce, larch, Korean pine, oak, and ash. There is some processing underway, more than in any other region of the RFE, notably by the Terneiles-Sumitomo joint venture in the coastal town of Plastun. However, exports of processed timber have been stagnant at about 10 percent of total exports for years. Domestic demand for processed timber is at an all-time low.

Recognizing the great importance of Primorsky's rich forests, the government has taken some steps to protect them. Commercial logging of Korean pine, heavily cut after World War II, is forbidden except to build access roads and loading sites. However, because of the foreign demand, illegal cutting and export of the species is high. Terneiles's main port of Plastun is consistently stocked with high-quality Korean pine logs. Decentralization of the industry and the dramatic increase in the number of logging operations has made it extremely difficult for the poorly funded government agencies to regulate logging effectively in the region, and violations of forest policy have increased sharply. Local forestry authorities have insufficient resources to mitigate the effects of disastrous natural and anthropogenic threats such as forest fires, floods, and pest outbreaks, including the Siberian and gypsy moth, both of which threaten vast territories of spruce forests.

Logging volumes peaked at about 6.4 million cu. m in 1988. According to Forest Service statistics, in 2000, harvest levels were 3.3 million cu. m, higher than the 2.2 million cu. m of 1998 and 2.67 million of 1999. Figure 2.2 shows harvest levels in the *krai* from 1959 to 2000. In the statistics for 2000, what is notable is the large amount of "noncommercial or one-time use" logging, which totaled 977,000 cu. m (see table 2.3) This logging is often salvage or sanitary logging and is a major loophole in the forestry regulations that allows both the forest service and commercial firms to log commercially under the guise of noncommercial use. This is done to avoid taxes and to supplement the Forest Service's budget.

Figure 2.2
Timber harvest in Primorsky Krai, 1959–2000

million cu. m

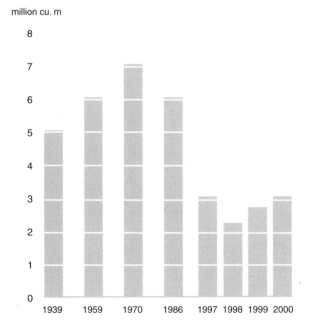

Source: Primorsky Forest Service, 2001.

Table 2.3
Timber production in Primorsky Krai, 1998–2000

Company	Leased area (ha)	1998 (000 cu. m)	1999 (000 cu. m)	2000 (000 cu. m)
Terneiles	619,000	333	387	393
Luchegorskles	159,000	100	100	139
Roshchinsky LPX	400,000	124	119	129
Kavalerovsky LPX	162,000	79	114	119
Amgu	198,000	101	141	114
Melnichnoe	184,000	88	115	111
Sergeevsky LPX	110,000	92	95	109
Primorlesprom	109,000	52	67	78
Terneilesstroi	74,000	71	82	76
Vyazemsky LPX (Khabarovsk Krai)	85,000	90	71	74
Dalnerechenskles	149,000	–	48	61
Vostok	15,000	–	36	57
Prestizh	78,000	–	24	46
Koksharovka	104,000	13	36	44
Primorsky DOK	88,000	69	42	35
Ussuriisky DOK	65,000	38	34	28
Izmailikha	67,000	17	53	27
Bikin	22,000	29	–	24
Aralia	68,000	–	11	23
Military Loggers	54,000	24	15	23
Vostochny	29,000	–	20	23
Kemales	–	8	–	20
Pavlovskoe	23,000	–	17	19
Primsnabcontract	22,000	–	18	19
Transpi	32,000	–	11	17
Pozhiga	99,000	–	17	15
Kirovskles	65,000	13	12	13
Sikhote-Alin	15,000	14	13	12
Energia	56,000	–	16	11
Limonniki	31,000	15	8	11
Yappi	33,000	–	15	7
Germes	64,000	46	15	6
LuTEK	40,000	–	15	4
Dalnerechensky LK	28,000	16	18	–
Anuchinsky LPX	73,000	8	–	–
Subtotal	3,420,000	1,440	1,785	1,887
Others	1,200,000	282	442	455
Total	**4,620,000**	**1,722**	**2,227**	**2,342**
One-time/noncommercial logging		415	445	977
Total		**2,137**	**2,672**	**3,319**

Source: Primorsky Forest Service, 2001.

Small enterprises, under the pretext of sanitary cutting, export unprocessed logs to China. Actual harvest levels in the *krai* are much higher due to such illegal logging.

Export. Much of this production, as mentioned, is for export. One study by the Bureau for Regional Outreach Campaigns puts Primorsky's exports in 1999 at 1.78 million cu. m.[7] Determining an exact figure is difficult because timber from other regions of Russia flows through Primorsky's rail and sea ports, and often this timber is mixed with locally cut timber. Regardless of the exact figure, the industry is extremely reliant on the export markets of Japan and China and thus susceptible to price and demand fluctuations in those markets. In 1997, during the Asian economic crisis, timber prices fell by 30 percent due to oversupply. Logging companies operating on the eastern slopes of the Sikhote-Alin, who have entered into longer-term contracts with Japanese customers,

are somewhat more insulated against short-tern economic declines and have maintained relatively constant extraction rates. But enterprises along the western part of the region have to rely on a new and highly unpredictable Chinese market in which cash transactions are favored and long-term investment is not encouraged. Small timber agents who tend to engage in illegal or semilegal procurement in the most accessible and valuable floodplain areas dominate this market.

In 2000, the *krai*'s logging companies officially received about U.S. $114 million for their timber exports. Between the two leading exporters, Terneiles shipped out more timber than did Primorlesprom. Closer inspection of the composition of Terneiles's exports reveals a high volume of Korean pine, mislabeled as pulpwood. The practice of buying illegally logged timber and exporting it with falsified documents and contracts is widespread (see pp. 70–74 for a fuller discussion).

Development of specialized coastal ports and construction of logging roads

With the RFE reorienting its economy toward the export markets of Japan, China, and South Korea, a major priority for Primorsky exporters over the past ten years has been to expand, upgrade, and even create new ports along the coast. Olga, Plastun, Svetlaya, and Amgu are four coastal ports that have become major export centers for forest and marine resources. Timber exporters have been converting former military ports at Bolshoi Kamen and Sovetskaya Gavan in Khabarovsk Krai. Terneiles has plans to build a shipping terminal in the coastal village of Adimi, at the mouth of a salmon-spawning river, to export timber from the Samarga and Edinka watersheds. Meanwhile, Primorlesprom, another major timber corporation in the region, appears to be focusing on expanding capacity at Svetlaya, a port that has the potential to serve as the major timber export point for all of northern Primorsky. Most of the wood exported out of the coastal ports is going to Japan.

These coastal ports are being developed for a number of reasons. First, limited road infrastructure in the northern regions of Primorsky makes it cost prohibitive to use the large, multiuse ports of Nakhodka, Vostochny, and Vladivostok. Second, cities such as Olga and Plastun are timber towns; it is much easier for timber companies to "control" these ports than the larger ones. It is, therefore, easier to ship endangered tree species such as Korean pine from these smaller ports. Bribery is facilitated by the tremendous latitude in the interpretation of customs rules and regulations, and the fact that the rules are always changing. Pavel Buzytsky (Talbot Com-

pany), whose firm hosted Vostochny customs officials, puts it this way: "Because the customs codes are so complicated it is almost impossible for these regulations to be interpreted accurately by the consignees. You need to have the customs official interpret each regulation for you to fully understand it and this is where bribery can come into play."[8] Environmentalists see proper enforcement at these smaller ports as essential to reduce illegal timber and precious metal export flows.

Coordinated with the port development has been construction of logging roads. The biggest limiting factor to increased log exports has been the lack of road infrastructure, particularly in the northern part of the *krai*. This is changing, however, as timber companies have ambitious plans to build a series of roads. The plan to build a road from Sukpai to Nelma on the eastern coast of Khabarovsk Krai will open up a million hectares of roadless wilderness and fir, spruce, and larch forests in the Samarga and Sukpai River basins and, in the process, could destroy traditional hunting grounds of the Samarga Udege and damage a key range in the northern habitat of the Siberian tiger. Just north of Nelma, along the Khabarovsk coast, is the Botchinsky Zapovednik, which may also be threatened by the road. A road currently under construction is the federally funded interstate from Chita (Eastern Siberia) to Nakhodka, which, when finished, will effectively slice the previously unroaded central and northern Sikhote-Alin forest in half. There are also plans underway to build a series of logging roads from Svetlaya and other coastal ports.

— JN

Whatever happened to Hyundai's logging operation in Svetlaya?

Perhaps no joint venture in the RFE has received more attention from the international community than Svetlaya Timber Joint Venture. In 1991, Hyundai Corporation (South Korea) and two Primorsky regional timber enterprises (Primorlesprom and Terneiles) signed a 30-year agreement with the Primorsky Krai government. In 1992, the Hyundai joint venture tried to get access to log the Upper Bikin basin. The Bikin River is the largest old-growth watershed in Primorsky Krai. Despite protests from the Udege and environmentalists, then Primorsky Krai Governor Kuznetsov gave rights for Hyundai to log 500,000 cu. m annually.[9] The Udege protested and won; the Primorsky Krai Duma passed a law overturning the governor's decision. Svetlaya appealed the decision to Primorsky's Regional Court, which favorably sided with the international joint venture. The case continued to the Russian Supreme Court, where the lower court's decision was overturned in favor of the Udege. The Supreme Court made a unilateral ruling based on a Presidential Decree, passed in 1992, giving indigenous groups the right of formal consent for any encroachment onto their traditional lands. As these groups had granted no consent, the Court ruled that the governor had no legal standing for transferal of additional logging rights to Svetlaya.

Despite failing to gain access to the Bikin basin, the joint venture still had considerable forestlands on the Svetlaya plateau, and during the early 1990s, was logging approximately 200,000 cu. m per year and selling the logs, mainly to Japan.[10] However, by 1997, logging was scaled back considerably, and since then the joint venture has gone bankrupt. The reasons behind the failure are unclear. Some point to the failure of the joint venture to gain access to upper Bikin, having clear-cut most of the accessible forests near Svetlaya. Others attribute the bankruptcy to the Russian partners, who sought to "bleed" Hyundai into bankruptcy so they could seize the timber harvesters and other equipment left by the enterprise and use the renovated Svetlaya port facilities for their sole purposes. Still others point to general corruption within Russia as the reason for Hyundai's withdrawal. Regardless of the reasons, the joint venture's failure has clearly cooled foreign investor interest in the timber industry in Primorsky; to date only one major forestry joint venture exists—the Terneiles-Sumitomo venture in Plastun.

Meanwhile, the Upper Bikin basin issue has not been settled. While the Basin was declared a wildlife refuge (zakaznik) in 1998, there are regular attempts by industry to circumvent this designation and log the territory.

— JN

Logging practices. Despite years of intensive industrial logging, 75 percent of the *krai* remains forested. However, the composition has changed and the quality of those forests declined considerably. In the past fifty years, more than half of the Korean pine forests in the RFE have been destroyed and replaced by broadleaved species. Overlogging occurs in many of the ash and spruce forests, most of which are in protected riverine forest zones, largely in the upper mountain belt of the southern Sikhote-Alin. Logging techniques, particularly in the spruce forests, have caused profound long-term ecosystem transformations, frequently causing irrevocable changes in forest cover. Selective logging, usually in the form of high-grading, is the most widely practiced method, conducted on 62 percent of the territory and contributing about half of the total timber harvest. By law, under this logging method, foresters are required to leave intact seedlings up to 10 to 14 cm in diameter, which reportedly allows for a natural regeneration rate of forty to fifty years.

There are signs that the industry lacks accessible timber and is making efforts to secure new, formerly undeveloped forestlands. Terneiles, Primorlesprom, and other major companies are targeting the forest areas in the north of the *krai*, with strong support from a *krai* administration ready

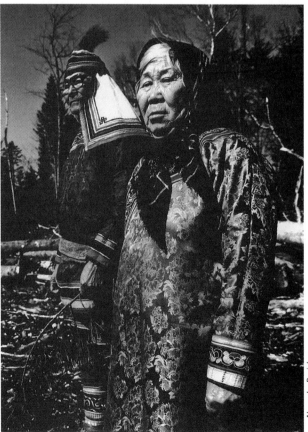

Alexander Panichev

The Udege protested Hyundai Corporation's plans to log the Upper Bikin basin and won.

to overlook established environmental policy. This has been made all the easier since the dissolution of the Federal Committee on Environmental Protection and the Forest Service by presidential decree in March 2000.

Fishing

Until the mid-1950s, Primorsky's fish and invertebrate harvest centered along the coast, mainly using a low-tonnage fleet. But by the late 1950s, the industry had developed a large-tonnage fleet and greatly reduced the variety of species caught, focusing on the most commercially valuable. This led to rising fish harvests and the concentration of processing enterprises in a few large cities, with the subsequent decline of many coastal fishing communities. However, with a declining resource base in the Bering Sea and Sea of Okhotsk, where about 80 percent of Primorsky's companies obtain their catch, a new focus is being put on rejuvenating coastal fishing and on aquaculture. One of the major initiatives within the Committee of Fisheries is to develop a coastal fisheries development plan.

Harvest figures show that during the past fifty years, the average annual catch in the Russian EEZ of the Sea of Japan has been about 180,000 tons. The main varieties included flounder, herring, pollock, and sardines. Primorsky's coastal waters are inhabited by nearly forty varieties of invertebrates that hold promise for future commercial harvest. Primorsky's coastline is nearly 1,200 km long. The coastal aquatic regions are divided into approximately 120 fishing sites, which under current regulation are distributed among eighty companies that are lessees. Lessees can, in addition, catch certain species at other companies' sites. According to estimates made in 1995 by the Pacific Institute of Geography, each kilometer of Primorsky's coastline yielded nearly U.S.$4,500 from mariculture activities and coastal fishing; these estimates include figures for illegal catches and smuggled sea foods. Nevertheless the fishery enterprises of Primorsky pay too little attention to certain potential catch targets located in the coastal zone. As the 1995 data indicate, only 7 percent of the potential catch is actually caught. Fish harvests, as noted, represent slightly more than one-third of the total available catch. Flounder, pollock, and salmon found in Peter the Great Bay and near the northern coast of Primorsky account for the increased number of fish caught. To increase harvest levels further, it will be necessary to revive the use of standing seines, standing nets, and benthic traps in the littoral zone at depths of up to twenty meters. Pacific squid has the greatest potential (300,000 tons) among the resources available. Realizing this potential, however, will require a special resource development program.

Aquaculture. Primorsky's natural and climatic conditions are well suited to the artificial reproduction of different forms of mollusks, algae, and fish on an industrial scale. There are numerous gulfs and bays suitable for mariculture and coastal fishery farms. The most promising species for artificial reproduction are Japanese laminaria (*Laminaria japonica*), Primorsky crest, Pacific mussel (*Mytilus trossulus*), trepang, and salmon. Some of these species have been artificially cultivated for decades. Japanese laminaria (sea cabbage) has been cultivated in the *krai* since 1976. At one stage 5,000 tons were produced a year, with a yield of twenty-six tons per hectare. Today, enterprises lack equipment to produce dry laminaria and, as a result, produce no more than several tons of this highly valuable product. Cultivation of Primorsky crest also began twenty years ago. Two crest farms operated successfully in Minonosok Cove of Poset Bay and in Vladimir Bay. In 1989, 40-ha plantations yielded 180 tons of crest, but production has since declined. However, there is interest in reviving these farms, and within five to seven years, benthic cultivation of crest could produce nearly ten tons. Preliminary estimates show that it may be possible to cultivate four thousand tons of Pacific mussels yearly.

Trepang has become the most prized product of Primorsky's mariculture industry. High demand on foreign markets makes cultivation of this species potentially very lucrative. Substances extracted from trepang are used to treat cardiovascular diseases and to slow the growth of some malignant tumors. The annual production of trepang could rise to between 300 and 500 tons per year and could reduce pressure on stocks, which are being destroyed by poaching. Trepang harvesting has been illegal since 1997 because of the alarming decreases in the catch. The amount of illegal harvest is not well known; some put the figure as high as 400 tons annually. Also, the distribution of scientific quotas of trepang to the Pacific Institute of Fisheries and Oceanography (TINRO) and other research institutes has fueled the harvesting of the species, either by the institutes themselves or by the sale of these quotas to commercial firms. Most of the illegal harvest is exported to China, where one kilogram of dried trepang can command U.S.$60.

There is also interest in establishing salmon hatcheries in the *krai*. In 1994, the Federal Fisheries Committee, TINRO, and the Russian firm SS Lotiko developed and adopted a detailed program entitled "Primorsky's Salmon," which called for the construction of seven fish hatcheries and twelve fish farms. There are two small-scale hatcheries in the Khasan region (Ryazanovka and Barabashevka farms). If these two facilities prove successful, similar ones may be built along the Kievka, Narva, Margaritovka, Avvakumovka, Edinka, and Samarga Rivers and in the town of Ternei. There are also hopes of harvesting two types of char, Dolly Varden (*Salvelinus malma*) and kunja (*Salvelinus kamchatica*). Presently only pink salmon, chum salmon (*Oncorhynchus keta*), and cherry salmon (*O. masu*) are harvested on a commercial scale. The annual catch of pink salmon in the *krai* decreased from 16,000 tons in the early 1940s to 9,000 tons in the 1950s and to 2,500 tons by the late 1980s. Primorsky is the main area for

cherry salmon reproduction. Before World War II, the annual catch in northern Primorsky was 1,200 tons. In the 1920s, about 100 tons of cherry salmon were caught each year in the Samarga, Botchi, and Koppi Rivers. Currently, despite a ban, cherry salmon populations in most of the rivers of Sovgavansky and Terneisky Raions are down.

Mining

The extraction and processing of mineral and fossil fuel resources has played a prominent role in the *krai*'s economy for centuries. Primorsky produces 100 percent of Russia's boric products, 80 percent of its fluorite, 40 percent of its zinc, lead, and tungsten, 20 percent of its tin, and 10 percent of its coal. Major mining centers include the cities of Dalnegorsk (zinc, silver, boron), Vostok (tungsten, copper, sulfur, gold, silver), Yaroslavsky (zinc, fluorspar), and Spassk (cement). Because of the continued energy crisis, outdated equipment, rising energy and transport costs, and export duties of 6.5 percent

on all mined products, the industry struggled throughout the 1990s. Development of Primorsky's mining and metallurgy industry and, many argue, the entire economy, relies on a stable energy supply, of which coal is the major contributor. Production of coal, in addition to difficulties facing the industry as a whole, varies according to swings in the intense local politics and in energy prices. Ironically though, throughout the nineties, mining enterprises faced with outdated equipment have turned to logging to gain quick and, in many instances, illegal profits. The industry is rebounding somewhat; production for 2000 was up by 18 percent from the previous year. Most of this production is now exported to Pacific Rim countries.[11]

Mining of any kind causes environmental problems. Mining of tin and polymetals pollutes surface and underground waters. Underground coal mining changes the hydrological regime, decreases groundwater reserves, and changes the landscape. Open-pit mining degrades lands and decreases soil fertility.

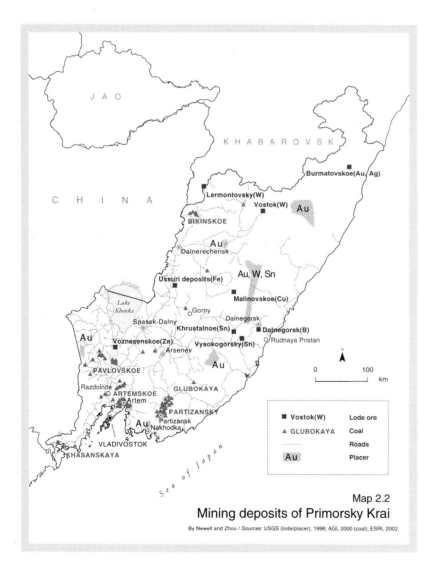

Map 2.2

Mining deposits of Primorsky Krai

By Newell and Zhou / Sources: USGS (lode/placer), 1998; AGI, 2000 (coal); ESRI, 2002.

Coal. Coal mining began at the end of the 1880s with mining of the Suchansky and Suifunsky coal basins. In 1931, mining of the brown coal site near the town of Artem began. Since 1994, underground coal mining has been curtailed in favor of more profitable techniques. From 1994 to 1997, eight underground coal mines with a total annual capacity of well over 600,000 tons (Ozernaya, Primorskaya, Kapitalnaya, Dalnevostochnaya, Khasanskaya, Glubokaya, Predgorodnenskaya, and Lipovetskaya shafts) were closed, and extraction at the Artemovskaya shaft (one million tons) was terminated in 1997.

The brown coal reserves in the Uglovsky, Bikinskoe, Pavlovskoe, Shkotovskoe, Partizansky, and Razdolnensky basins represent much of Primorsky's present coal production. In addition to Primorskugol (part of the Ministry of Fuel and Energy), several new enterprises now have licenses to mine coal, including ZAO (closed joint-stock company) Malye Razrezy, OAO (open joint-stock company) Argillit, ZAO DV PIK Energia Vostoka, ZAO Ussurugol, TOO (limited liability company) Zenit, Karbo, Diorit, Sodruzhestvo, ZAO Adams, and ZAO Lutek. This deregulation was implemented, in part, to avoid erratic coal supplies, but many of these enterprises are now bankrupt or heavily in debt. Those that do function are often

operating at limited capacity and have no funds to implement environmental regulations. Environmental concerns related to the coal industry include permanent land deformation over mined areas, mine gas seepage, and inadequate slag and waste disposal.

Boron. AO (joint-stock company) Bor, Russia's only producer of boric acids and related compounds, operates near the city of Dalnerechensk. Most of the output, estimated at 80,000 tons yearly, is exported worldwide, especially to Japan (via Marubeni Trading) and China. In 1998, the Moscow-based firm Energomashkorporatsia (EMA) gained control over AO Bor.[12]

Fluorite. Primorsky has reportedly the world's largest deposits of fluorite, mainly at the Voznesenskoe and Pogranichnoe reserves. Yaroslavsky Company is the main producer, and resources are estimated to last at least another fifty years at present production rates. In the 1980s, production peaked at 350,000 tons of fluorite concentrate yearly and has since declined, but is stabilizing. The company plans to produce fluorite briquettes and export them internationally.[13]

Tungsten. Primorsky traditionally produced a significant percentage of Russia's tungsten. Production peaked during the Cold War, when demand was high and the resource was harder to obtain. China, which produces 70 percent of the world's total, Kazakhstan, and Russia have flooded the market, and now the price of the mineral is ten times lower than it was in the 1970s.[14] Primorsky Company extracts the ore and processes the concentrate mainly from a huge deposit near the village of Vostok, which was a restricted area until the late 1980s. The company ceased production between 1995 and 1998, but started up again and now exports about 70 percent of its total output, primarily to Japan. A major importer is Marubeni Corporation, which then sells the product to Dowa Mining.[15] The other major producer is Lermontovskaya Mining Company, which mines in northern Primorsky Krai at a deposit that reportedly has one of the highest tungsten concentrations in the world. The company has an annual production capacity of 2,400 tons a year. The ores at these sites are complex and also contain copper, gold, silver, sulfur, and bismuth.

Tin. In recent years tin extraction in the *krai* has accounted for between 20 and 30 percent of Russia's production (averaging 27.6 percent in 1991–1996). Between 1946 and 1997, over 246,000 tons were extracted. Until 1993, tin was produced at the Khrustalnensky mining and processing plant, but between 1993 and 1996, four tin companies received licenses to develop eleven bedrock and one alluvial tin sites. In the 1990s, tin production plummeted. In 1997, for example, production levels were about 62.5 percent of 1989 levels. By 1999 the major tin-producing enterprises, OAO Khrustalnenskaya Company (HOK) and IC Vysokogorsky (Kavalerovsky Raion), had ceased mining operations at most facilities. In 1993, HOK produced 24 percent of Russia's tin concentrate, and because of its position as a strategic supplier, was to receive public financing to construct the third phase of the Yubileiny mine and to explore and develop the Arsenievsky mine, but financing never materialized. By early 1996, seven of Khrustalnenskaya's nine sites were unprofitable. Company executives started a new enterprise, ZAO GRK Khrustalnaya, to continue production at the Iskra mine, with 51 percent of its capital belonging to HOK. After termination of production, HOK failed to protect the mine's facilities. The site was looted, the ceilings of the shafts were destroyed at every mine, and equipment was stolen. IC Vysokogorsky produced 346 tons of tin in 1997 at the Vysokogorsky site, but production was terminated in December of that year. The site has since been flooded, and a number of the entrances and exits are in disrepair and are inaccessible. Reportedly, existing commercially exploitable tin reserves are almost exhausted, and new mines will have to be developed if production is to reach previous levels.[16]

Lead and zinc. Dalpolimetal, the oldest mining company in Primorsky, has five mines and a factory and is the *krai's* primary producer of lead and zinc. Most of the 60,000 to 75,000 tons of zinc and lead concentrate produced annually is exported from the port of Rudnaya Pristan to Japan, South Korea, and Thailand through Glencore International, which has a substantial stake in Dalpolimetal. Refined lead is also exported. The company also produces about 12 tons of silver annually. Dalpolimetal's reported annual revenue in 2000 was U.S.$14 million, but the actual figure is likely much higher. Yaroslavsky Company began to produce zinc concentrate in 2000, and Primorsky Company produces and exports small quantities of lead concentrate to Japan.

Gold. Primorsky has never been a major producer of gold, its production ranging from 450 kg in 1993 to about 100 kg in 1999. Most gold is extracted from alluvial (placer) deposits, with the exception of small-scale extraction of ore deposits by the firm Dalpolimetal. Part of this decline in production was caused by the closure of two of the region's main enterprises, AO Primorsky Priisk (now CSC Imkar) and AO Russia (now TOO Okean), and the closure of twenty smaller ones. Despite this modest production, the *krai* has some rich gold deposits, particularly in the Svetlaya, Samarga, and Bikin River watersheds and those of other northern rivers. In 1999, Aldanzoloto, a huge gold-mining company from the Republic of Sakha, began mining a deposit (with gold density of 24 grams per ton) on Burmatov Creek in northern Terneisky Raion. According to local environmentalists, the work began without any assessment of the impact of the operations on

salmon-spawning grounds. Similar deposits are being offered up for exploitation in other *raion*s of the *krai*, such as Krasnoarmeisky Raion. Planned tenders include placer deposits in the Svetlovodnaya River (Pozharsky Raion). The biggest gold ore deposits are Glukhoe, with about 27.5 tons of reserves, and the Malinovskoe deposit, with at least 26 tons. If full-scale mining of these deposits begins, analysts predict that production will be between 1 and 1.5 tons per year. The main producers for 1999 were OOO (limited liability joint-stock company) Diada (50 kg), ZAO AS Pioneer (20 kg), ZAO Primorsky (20 kg) and OOO Dalnevostochnaya ZDK (5 kg).[17]

Agriculture

Agriculture has a major effect on the region's biodiversity and land-use patterns. As alluded to in the section "Ecology," the intensive farming in the Khanka Lake lowlands and Ussuri River valley has transformed natural landscapes, including wetlands, meadows, and forestlands. These lowlands have suffered gravely from the extremely inefficient and destructive use of fertilizers, herbicides, and pesticides on vast wetland areas, practices that have reduced the number and variety of animals and plants in the region. The Russian economic crisis, coupled with price fluctuations on international and domestic markets, has expedited the demise of the huge rice-producing state farms, allowing parts of the wetlands, lakes, and swamps to restore themselves. Many other industries have virtually disappeared, including large-scale animal husbandry and fur farming (mainly mink breeding), both of which were tied to fishery enterprises, as fish waste had previously been used as a cheap fodder. In other parts of the *krai*, agriculture consists primarily of growing vegetables for local needs, dairy and beef husbandry, and poultry farming. Another unfortunate consequence of economic restructuring and decline has been the loss of interregional cooperation in agriculture in the RFE. During Soviet times, hay harvested from the meadows of southwestern Primorsky was sent to dairy and beef farms in Magadan, Chukotka, and other northern regions. This is no longer economic and has largely ceased, but the unmown meadows remain and are a constant seasonal source of devastating fires in the region.

Hunting

Despite comprising only a small portion of the *krai*'s gross regional product, hunting has a disproportionate effect on the region's forests, as most people living in hunting areas are involved in the industry in some form. In 1998, the *krai*'s total hunting land area amounted to 14,984,140 ha. In that year, six hunting units thoughout the *krai* (all regions except for Terneisky and Pozharsky Raions) issued licenses for hunting on 74 percent (11,136,800 ha) of these lands. Economic crisis,

loss of government support, and changes in the administrative structure of the industry have virtually destroyed the hunting sector. Hunting facilities have closed, administrative agencies lack the resources to function properly, and the system of nontimber forest production has broken down.

Since the dismantling of the Chief Office of the Hunting Industry, formerly a division of the Ministry of Agriculture, there has been a need for a specially authorized body to protect and soundly manage hunting resources and the use of game animals. The 1994 transformation of Primorpromokhota, the industrial association of hunting enterprises, ended the previous practice of combining the functions of game animal use and protection. Primorsky's *gospromhoz*es were transformed into independent units within Primorokhota. With removal of state support and traditional state purchasing of hunting and service products no longer guaranteed, the *krai*'s *gospromhoz*es began to dissolve. Several months after the establishment of Primorokhota, the *gospromhoz*es were transformed into companies with limited liability and partnerships: some went bankrupt, others were sold at auction. In 1996, the state enterprise, Primorokhota, was itself auctioned to a private firm. As a result the *krai* lost hunting enterprises that had been supplying the local population and the entire country with products from the Ussuri Taiga for decades.

Additionally, procedures for leasing hunting sites, a process established in the mid-1990s, remain unresolved, primarily because of an unclear division of powers between federal and *krai* authorities for wildlife management. Severe budget deficits in the late 1990s have led the *krai* administration to withdraw from leasing hunting lands and focus on preserving the management structure of the hunting industry by supporting hunting farms. Amateur hunting is regulated by licensing, and penalties are imposed on unlicensed local hunters, who complain that the necessity to purchase licenses presents a financial hardship. Most problematic is the lack of outside or scientific oversight to provide an accurate census of game animals and effective control of hunters.

Hunting needs to be managed primarily to conserve biodiversity and, in particular, to maintain optimum numbers of Siberian tigers. To control poaching, economic solutions need to be found for those living below the poverty line, as they are the main poachers. Logging on hunting lands needs to be curtailed to ensure sustainable levels of game species. Restricting logging in some forests increases the vegetative cover. This, in turn, provides more fodder for snow deer and other game species. The ban on the industrial logging of Korean pine, enacted in 1988, will, it is hoped, increase the productivity of hunting lands. Other needs include a greater awareness of the rights of local hunters. The industry also needs to establish public hunting organizations in settlements within the forests to help regulate hunting. Finally, more *zakaznik*s need to be established to protect key hunting areas.

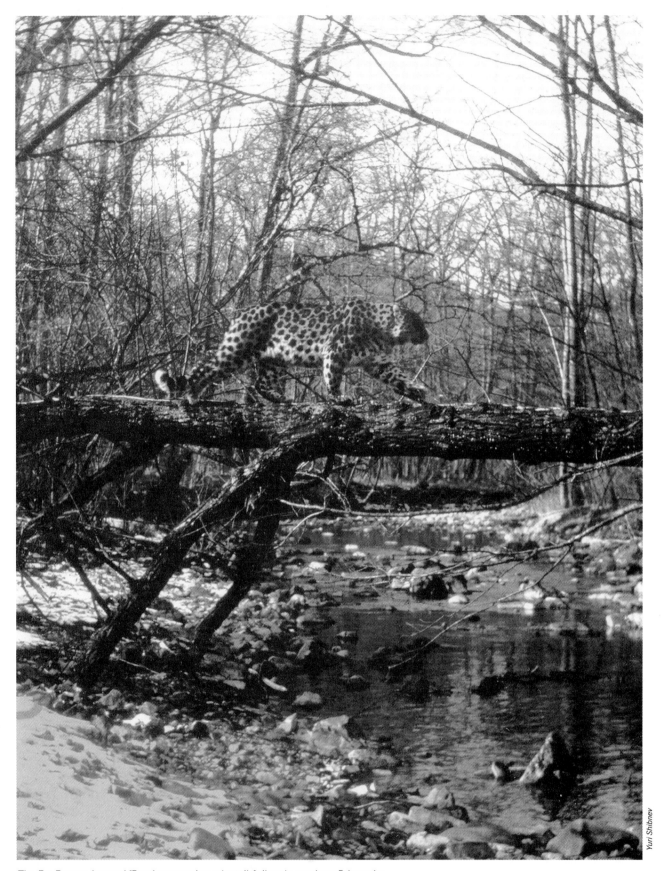

Yuri Shibnev

The Far Eastern leopard (Panthera pardus orientalis) *lives in southern Primorsky.*

Toward sustainable development

Vladimir Aramilev

A remarkable event for Primorsky in particular and the RFE in general was development of the Long-Term Program for Environmental Protection and Sustainable Nature Use in Primorsky Krai in 1991 (also called "The Primorsky Ecological Program"). During the Soviet period, scientists and intellectuals began working together to try to halt environmental destruction in the region, as dozens of scientific institutes began to collect information and research species and natural conditions. In the beginning of the 1990s, specialists decided to create a comprehensive regional program for nature protection and sustainable natural resource use that would be legally recognized by the federal and regional governments. Primorsky's first democratic legislative organ, the Krai Duma (established in 1991), the Committee on Environmental Protection, and the Far Eastern Branch of the Russian Academy of Sciences worked together to create this long-term ecological program. The program had ten components: protected areas, water resources, forestry, hunting industry, fishing (including littoral fishing), agriculture, mining, recreation, sanitary and environmental problems, and environmental priorities in nature use. Existing and future environmental threats were thoroughly considered, and measures to limit damage were recommended. One of the drawbacks of the program was, however, the lack of economic projections necessary to determine the best types of development and the long-term performance of Primorsky's economy. Because of limited funds, the program focused to a large extent on expanding the existing protected area system within the Sikhote-Alin region.

In 1993 and 1994, the U.S. Forest Service funded a project, Biodiversity Conservation and Sustainable Development of the Bikin River Basin, to provide the local people with several possible models of development, all conditional on the conservation of biological diversity. Like the *krai* program, the project resulted only in recommendations, rather than in action. And today only a handful of people actually use the results of this project. The next attempt to establish a regional sustainable-development plan was the Sikhote-Alin Biodiversity Conservation program (1996–1997), drawn up under the auspices of the Environmental Policy and Technology Project, an umbrella project for U.S. Agency for International Development projects in the Russian Federation and Newly Independent States. The project covered all of Primorsky and the southern half of Khabarovsk Krai. Some elements of planning in model regions were introduced, and financial assistance was provided to governmental and nongovernmental institutions that were oriented toward the environment and nature use. The main focus of this program was, how-ever, support for protected areas (*zapovednik*s and *zakaznik*s) and environmental education, the conservation of rare species and biological diversity in general, and support for the development of the nontimber forest product industry.

Since 1996, the environmental NGO Friends of the Earth–Japan has been working on introducing sustainable development in the Samarga River basin, home to a population of indigenous peoples. The book *Samarga: The Past, the Present, and the Future* by Alexander Panichev can be considered the end of the first phase of this work.[18] The project has one important advantage over its predecessors: From the beginning it has not been a compilation of plans and analytical references but has been focused on real development and the support of sustainable nature-use activities.

Other activities have also encouraged the sustainable development of the interregional Sikhote-Alin territory to some degree but they were either not completely finished or tried simply to duplicate activities in other countries and were often not suited to the RFE.

Even though a great deal of criticism is directed toward the Russian and Primorsky governments, one should not forget that the legislative base and timely regulation of the process allow for the existence and development of nature use in Primorsky Krai. There is plenty of information about law infringement in the sphere of nature use but there is also evidence that such activities are being stopped. It would be useful if there were more concrete projects promoting sustainable development supported by both the Russian state and international environmental organizations.

Primorsky needs an overall sustainable development plan for the *krai* as well as sustainable development projects targeting specific industries. Potential development of industry, agriculture, and their infrastructures should be in line with the overall plan. The portion of natural resources available for domestic consumption, processing, and export, respectively, should be identified precisely. One also needs to evaluate prospects for the development of different types of natural resources, including recreational resources. Such projects should not be shaped according to orders from authorities but rather by considerations of long-term economic benefit, sustainable resource use, and maximum profits for the local and Russian economies. Such projects can be realized with the help of foreign investment and joint participation by foreign organizations and companies. Already some positive examples of such cooperation exist.

Timber

New forest management practices need to be implemented throughout Primorsky. *Leskhoz*es should not engage in any form of logging, but should simply monitor logging operations and do reforestation. Ideally, so as to keep their independence, *leskhoz*es should receive their funding only from the federal government. At present, *leskhoz*es also receive

funds from logging leases sold to logging companies who bid for rights to log a particular territory.

Hunting

Government regulation of other industries, such as forestry, mining, and fishing, was more successful in Soviet times as well. New progressive federal and regional laws that regulate relations among different types of land users need to be passed. Hunting organizations need to be financially self-sufficient and branch out into tourism to diversify their financial resources and to limit excessive hunting. Likewise, the practice of logging to finance the hunting industry should be banned.

Fishing

The control of amateur fishing and strict limits on quotas for commercial fishing can help preserve fisheries resources in rivers and lakes, particularly on Lake Khanka and Razdolnaya River. Poaching, by nets, electric fishing rods, explosive substances, or any other method, needs to be eliminated. Sport fishing should be limited in Primorsky's northern rivers, including the Bikin, Iman, Kema, and Maximovka. Sustainable use of fisheries resources in the Sea of Japan requires coordination by all neighboring countries and should include joint calculation of quotas, monitoring and control, and scientific research. To rejuvenate shellfish stocks, aquaculture is necessary.

Mining

Potential development of mineral resources undergoes an environmental impact assessment under the supervision of the Ministry of Natural Resources and Committee on Geology. A usage plan is then established to assess potential damage and compensation. But Primorsky lacks well-developed principles and practices for land recultivation after mining. However, in Primorsky, natural regeneration occurs relatively quickly so it does not always make financial sense to spend funds on, for example, backfilling sandpits. The money could be better spent on improving the welfare of Primorsky's people or on other environmental projects.

Water

A comprehensive project to supply all households and industries with fresh water is necessary. This project is first required for southern and southwestern Primorsky.

Agriculture

Primorsky needs agricultural development consistent with the region's climate and geography. For example, in Primorsky, it is profitable to cultivate rice and buckwheat, because these crops cannot be grown in most other parts of Russia. Locally produced foods should take priority over imported foods. Small-scale farms need to be supported, particularly in the rich soils of the Lake Khanka lowlands and along the valleys of the Ilistaya, Arsenevka, and Partizanskaya Rivers.

Recreation

Primorsky's tourism industry is developing slowly. But environmental, hunting, and fishing tourism are hardly being developed at all. Projects aimed at establishing the required tourism infrastructure could catalyze development of a sustainable tourism industry.

Other industries

Given Primorsky's rich water resources, mink and otter breeding could become a significant industry. Beekeeping was once a large industry and is now being undertaken on a much smaller scale. Ginseng cultivation has almost collapsed but holds great potential for both the domestic and international market. Cattle, sheep, and goat herding are not promising; they can be viable only if located in the suburbs of large cities, where their products can be consumed quickly.

Indigenous peoples

Anatoly Lebedev

Most of the indigenous people, the Udege, Nanai, and Orochi, living in Primorsky belong to the Tungus-Manchurian group. Another small group, the Taz, represent the intermarriage in the middle of the nineteenth century of native women and Chinese men. The Taz live in southeastern Primorsky, in the village of Mikhailovka in Olginsky Raion.

Indigenous peoples in Primorsky number around two thousand. In Pozharsky Raion in the north of the *krai*, about eight hundred indigenous people (Udege, Nanai, and Orochi) live in the Bikin watershed in the villages of Krasny Yar and Verkhne Pereval. To the south of the Bikin watershed, in Krasnoarmeisky Raion, 129 indigenous people live in Dalny Kut, Roshchino, Novopokrovka, and Ostrovnoe. About 250 people live in Terneisky Raion, which stretches along the northeastern coast of the *krai*; the largest concentration is in the town of Agzu in the Samarga River watershed (see map 2.3).

Traditional indigenous economic activities include hunting, fishing, and gathering nontimber forest products. Most of the Iman Udege group (Krasnoarmeisky Raion) are either

unemployed or work part-time at forest enterprises. The Taz and Nanai in Olginsky Raion are employed in agriculture and domestic service.

Krasny Yar and Olon (Pozharsky Raion) and Agzu (Terneisky Raion) carry the title of National Villages because of the high percentage of indigenous peoples living there and because these communities are centers for traditional, cultural, and economic activities of the *krai*'s indigenous peoples.

Logging activities in the Iman watershed (Krasnoarmeisky Raion) forced the dispersal of the Iman Udege group as the land-based resources upon which this group was dependent disappeared. Encroachment by the timber industry in the Bikin and Samarga River watersheds is changing wildlife patterns and is leading to less productive forest ecosystems as individual tree species are being logged and exported. If such tendencies continue into the future, indigenous economic activities in the Bikin and Samarga areas will be severely undermined.

Special protected areas, or Territories of Traditional Nature Use (TTPs), are necessary to protect these traditional lands. Such a system ostensibly would provide indigenous peoples with a direct voice in managing the resources of the lands upon which they are dependent. As early as 1976 the Krai Council designated Pozharsky Gospromkhoz (1,384,000 ha) as a territory designed for economic activities of indigenous peoples. In 1992 by *krai* regulation (No. 165), the area of the central and upper Bikin River basin designated for traditional nature use was reduced to 407,800 ha. The Association of Small Indigenous Populations of Primorsky appealed to the Krai Council and produced a study to justify the restoration of the territory's borders to its previous size. The next year the Lower Council adopted two decisions — the Provisional Regulation on Traditional Nature Use Territories (TNUT) by Small Indigenous Populations and Basic Regulations on the Special Regime and Methods for Using the Goslesfund (Federal Forest Fund) — to establish a 1,250-ha TNUT in the upper and central Bikin River basin.

Since the 1970s industrial logging has been banned in this zone, and only nut collecting has been permitted. However, the decision of the legislative bodies has never been implemented. Only in 1998, under pressure from the international community, was a *zakaznik* giving the indigenous population all the rights for this territory envisaged in the Provisional regulation in 1993 established in the upper part of Bikin River basin. Nevertheless, the territory still lacks the status of a protected area. The Krai Council (of People's Deputies) also adopted a decision (No. 120, November 17, 1992) to protect the Samarga and Bikin ethnic territories.

Map 2.3
Indigenous lands of Primorsky Krai

By Newell and Zhou / *Sources:* Karakin, 2001; ESRI, 2002.

Legal issues

Jeremy Tasch

The period of massive subsidies from the central government to Primorsky Krai came to an end in 1990 — a date that also marked an end to the integration of industrial and technical coordination between Primorsky and the other regions and economic sectors of the RFE.[19] In addition, the regions (*krai*s, republics, *oblast*s) of Russia, through a wave of new legislation, were given more power. Notable laws included the following: On Krai and Oblast

Alexander Panichev

An Udege man returns home after an afternoon along the Bikin River in Primorsky.

to make decisions on issues of local relevance, but their ability to write and pass statutes was severely curtailed.[22]

Between 1995 and 1996, the *krai* Duma passed a number of laws regulating and defining relations between the *krai* and its municipalities, with particular emphasis on the capital city of Vladivostok. The most significant of these laws included On Local Referendums in Primorsky, On Procedures for Registration of Statutes of Municipalities in Primorsky, and On Elections of the Major Municipalities (October 1995). On Local Self-Governance Within the *Krai* followed in December 1995, On Citizenry Assembly in Primorsky in May 1996, and On the Status of Deputies of Representative Organs of Local Self-Gover-

Soviet of People's Deputies, and Krai and Oblast Administrations (1992), and On Local Self-Governance (1995). In the environmental sphere several federal laws were passed to shift environmental management and protection from a tradition of administrative command toward economic regulation.[20]

Both these changes, one promoting economic regulation of the environment and the other promoting decentralized regional administration, were incomplete and rife with legislative contradiction. Much legislation designed to give more power to the regions lacked clear demarcation between executive powers and, in Primorsky, between the *krai* and the municipalities, leading to jurisdictional confusion between Vladivostok's mayor and the *krai*'s governor. Vladivostok's city council and other municipal councils in the *krai* were left to sort out gaps in the legislation, largely without success. In 1993, the *krai* administration, through the draft law On the Status of Primorsky Krai, sought to gain control over much of the *krai*'s important economic assets, particularly the ports and railroads, the military, the use and allocation of natural resources, the issuing of export licenses, and the registering of joint ventures.[21] These efforts supported the early separatist and demagogist tendencies of the powerful former governor, Evgeny Nazdratenko.

Enhancing the *krai*'s power was passage of the law On General Principles of the Organization of Local Self-Governance in the Russian Federation (1995), by the federal Duma, which gave regional organs the power to write normative acts and to allocate funds to local, particularly municipal, entities. These municipal entities were allowed

nance and of Elected Officials of Local Self-Government in Primorsky Krai in October 1996. Through these acts, the *krai* administration effectively defined local self-governance: Local authorities could independently resolve only those questions specifically within their jurisdiction, providing they had the resources for their resolution. According to Article 33 of the *krai* law On Local Self-Governance, municipal powers included: the local budget, off-budget resources, municipal property, municipal lands and their associated natural resources, businesses and organizations, residential and nonresidential properties, educational institutions, public health, cultural, and sport services.

Most municipal properties do not generate income, but rather require spending. Municipalities were given jurisdiction over institutions that required economic support, but few municipal institutions can generate enough tax revenue to function independently. Regional laws perpetuate an excessively centralized *krai* budgetary system and an unfair distribution of state treasury allocations.[23] As cities of special importance to the *krai*, Vladivostok and Nakhodka were singled out by the *krai* to receive 6 and 12.1 percent, respectively, of tax revenues collected on profits. Those two cities, however, contribute a larger percentage of tax to the regional budget than they receive in return. This underscores the more general problem common to practically all *krai* municipalities. With conditions of economic crisis and instability, growing unemployment, a falling tax base, and production declines, almost all the municipalities in the *krai* have been operating with budget deficits and are thus, largely dependent

upon the *krai* and its executive office, regardless of legislation. The result has been political and economic gridlock within Primorsky, between municipal councils and the regional government, and between regional and federal levels of government. The 1990s were marked by extended struggle over resources and jurisdiction within the *krai*, and by attempts of governmental and quasigovernmental institutions to consolidate power with little regard for either the long-term sustainability of Primorsky's energy sector or for the welfare of the *krai*'s citizens.

The limits of gubernatorial and personal power within Primorsky as well as within the Russian Federation were tested by the former governor Evgeny Nazdratenko beginning from his appointment by former President Yeltsin in 1993 and continuing with his resignation strongly encouraged by President Putin in 2001. Like other elected governors throughout the federation, Nazdratenko sought, especially during Yeltsin's second term, to maneuver power away from potentially competitive authorities, both central and local. During the former governor's tenure, sixteen elections failed to create a Vladivostok City Council. Each election was declared invalid by the *krai*-appointed elections commission.[24] Since 1997 Vladivostok's mayor has been a gubernatorial appointee.

During his tenure Nazdratenko had been outspoken about his determination to protect Primorsky against "greedy foreign shareholders and their Russian business allies."[25] His actions may have extended beyond legal norms, but he maintained that this was necessary to protect the best interests of the *krai*. In one bankruptcy case Nazdratenko called police

to a municipal court to prevent the sale of a fishing enterprise "for the price of a second-hand foreign-made car."[26]

Yeltsin failed to unseat Nazdratenko, but Primorsky's governor resigned abruptly in February 2001 (during one of Primorsky's most severe winters and worst energy crises) after a telephone conversation with President Putin. By the end of February, Putin had appointed Nazdratenko as the head of the federal-level State Fisheries Committee, and the Kremlin introduced a bill proposing that the president once again directly appoint regional governors.

Although the reasons behind Nazdratenko's appointment are unclear, there has been speculation that the center lacked sufficient power to oust him completely. According to Andrei Ryabov, a political analyst with the Moscow Carnegie Center, the "Kremlin just did not have sufficient resources to oppose Nazdratenko should he have decided to run in the early elections," which were held in 2001.[27] The bill on presidential appointments introduced during the same month as Nazdratenko's resignation would have, had it passed, amended the current law on executive powers, sanctioning the direct executive appointment of regional governors rather than the current practice of popular election.[28] The bill represents Putin's strategic plans for strengthening the vertical flow of power from the center to the regions. President Putin's influence over Nazdratenko's resignation, combined with the efforts to appoint governors, shows that the Kremlin is aware of how much power governors managed to appropriate during the latter half of Yeltsin's presidency and is perhaps, in consequence, promoting political and economic recentralization.

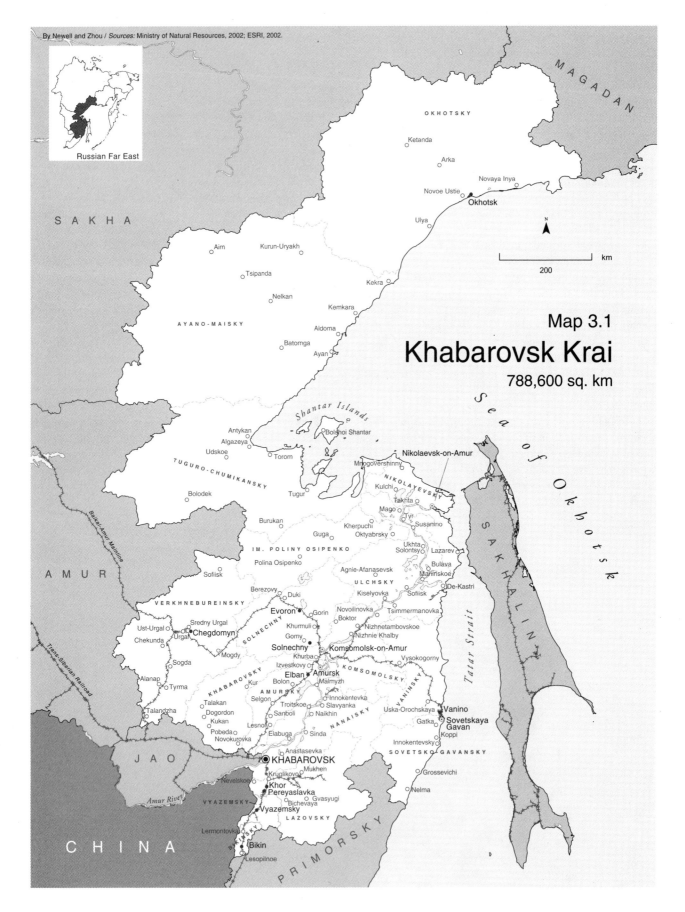

By Newell and Zhou / *Sources:* Ministry of Natural Resources, 2002; ESRI, 2002.

Russian Far East

MAGADAN

OKHOTSKY

Ketanda

Arka

Novaya Inya

Novoe Ustie

Okhotsk

Ulya

SAKHA

N

km
200

Aim Kurun-Uryakh

Tsipanda

Kekra

Nelkan

Kemkara

AYANO-MAISKY

Aldoma

Batomga

Ayan

Map 3.1
Khabarovsk Krai
788,600 sq. km

Shantar Islands

Bolshoi Shantar

Antykan Nikolaevsk-on-Amur
Algazeya Mnogovershinny
Udskoe Torom NIKOLAYEVSKY
TUGURO-CHUMIKANSKY Kulchi
 Takhta
Bolodek Tugur Mago Tyr
 Susanino
 Burukan Kherpuchi Ukhta
 Guga Oktyabrsky Solontsy Lazarev
 Bulava
 IM. POLINY OSIPENKO Mariinskoe
 Polina Osipenko Agnie-Afanasevsk
 ULCHSKY De-Kastri
Sofiisk Kiselyovka Sofiisk
 Berezovy Duki Timmermanovka
 Gorin Novoilinovka
 Evoron Boktor
VERKHNEBUREINSKY Khurmuli Nizhnetambovskoe
Sredny Urgal Gorny Nizhnie Khalby
Ust-Urgal Urgal Vysokogorny
Chekunda Chegdomyn Khurba Komsomolsk-on-Amur
 Mogdy Solnechny KOMSOMOLSKY
Sogda Izvestkovy VANINSKY
Alanap KHABAROVSKY Elban Amursk
 Tyrma Kur Bolon Malmyzh Vanino
 AMURSKY Innokentevka Uska-Orochskaya Sovetskaya
Talakan Selgon Troitskoe Slavyanka Gatka Gavan
Dogordon Sanboli Naikhin Koppi
Kukan Lesnoi NANAISKY Innokentevsky
Pobeda Elabuga Sinda SOVETSKO-GAVANSKY
Novokurovka Grossevichi

JAO KHABAROVSK
 Mukhen
 Kruglikovo
Nevelskoe Khor Nelma
 Pereyaslavka
Amur River Bichevaya Gvasyugi
VYAZEMSKY Vyazemsky
 LAZOVSKY

Lermontovka
CHINA Bikin
 Lesopilnoe PRIMORSKY

AMUR

Baikal-Amur Mainline

Trans-Siberian Railroad

SAKHALIN

Sea of Okhotsk

Tatar Strait

Khabarovsk Krai

Location

Khabarovsk Krai, the second largest administrative region of the Russian Far East (RFE), stretches 1,800 km from north to south along the Tatar Strait and the Sea of Okhotsk. Its northern zone extends to within 430 km of the Arctic Circle, and its southernmost tip is approximately on the same latitude as Seattle in the northwestern United States (47° N).

Size

788,600 sq. km; approximately 4.6 percent of the entire Russian Federation, one and a half times larger than France, and equal to the combined area of the states of Oregon, Washington, the western third of the province of British Columbia, and the Alaskan panhandle.

Climate

Winters are cold and dry. January temperatures average −23°C in the south and between −36°C to −40°C in the north. Summers are warm and humid, with July temperatures in the south approximately 21°C and in the north about 15°C. The southern portion of the region has approximately 130−150 frost-free days per year; in the north-central region and at higher elevations, the number of frost-free days drops to 90−130.

Geography and ecology

Because Khabarovsk Krai extends a great distance north to south, it has a wide diversity of plant and animal species. Mountains in the northern part of the *krai* are covered with tundra and fields of lichen-covered rock called *goltsi*. Further south one finds sparse Dahurian larch (*Larix gmelini*) forests interspersed with Japanese stone pine (*Pinus pumila*) on mountain slopes, and then denser Dahurian larch forests (which cover 15 percent of the north) with grass, small marshes, and meadows. Most of the region lacks roads and is therefore largely inaccessible. The towns are along the coast. Population density is low. The central part of the *krai* includes the lower part of the Amur River valley, one of the world's largest river basins. The headwaters of the Amur are in Chita Oblast and China. Here, in the broad Amur Valley, the region and its forests are influenced by the monsoon climate. East Siberian fir (*Abies nephrolepis*) and Ayan spruce (*Picea ajanensis*) forests gradually mix in with the Dahurian larch. Usually spruce and fir are dominant on the wetter eastern slopes, while larch grows on western slopes. Birch (*Betula*) and aspen (*Populus tremulae*) grow back first after logging or fire. The Baikal-Amur Mainline (BAM) and adjacent rail spurs have greatly increased access. Population density is higher here than in the northern regions of the *krai*.

The southern part of the *krai*, which includes part of the Ussuri River basin and the southeastern sea coast from around the town of Vanino, is strongly influenced by the monsoon and has warm, humid summers. It escaped glaciation during the last Ice Age and has high levels of biodiversity. The Ussuri Taiga, named after the Ussuri River, is one of the most unusual and species-rich temperate forests in the world.

Flora and fauna

There are about 2,000 species of vascular plant (terrestrial and nonterrestrial) and 650 vertebrates (including freshwater fishes) in the *krai*, including many rare and endangered species. There are approximately two hundred different types of woody plant species and a large diversity of forest cover, including: deciduous (broadleaved) and mixed forests, forests of Mongolian oak (*Quercus mongolicus*), forests of Korean pine (*Pinus koraensis*), secondary aspen and birch forests, thickets of Japanese stone pine, regions of stone birch (*Betula ermani*), poplars (*Populus*), chosenia (*Chosenia arbutifolia*), elms (*Ulmus*), and ash (*Fraxinus*) forests, spruce and fir forests, peat bogs with sparse larch trees, complex forests with Ayan spruce dominant and birch, alder (*Alnus*), and mountain ash (*Sorbus*). Key species include the Siberian tiger (*Panthera tigris altaica*), Oriental white stork (*Ciconia boyciana*), and Steller's sea eagle (*Haliaeetus pelagicus*). Other mammals include the Himalayan bear (*Ursus thibetanus*), brown bear (*Ursus arctos*), and wild boar (*Sus scrofa*), as well as many smaller mammals such as river otter (*Lutra lutra*), American mink (*Mustela vison*), yellow-throated marten (*Martes flavigula*), sable (*M. zibellina*), wolverine (*Gulo gulo*), red fox (*Vulpes vulpes*), raccoon dog (*Nyctereutes procyonoides*), Eurasian lynx (*Felis lynx*), Eurasian squirrel (*Sciurus vulgaris*), and variable hare (*Lepus timidus*). Numerous whale species feed in the rich waters around the Shantar Islands. In the *krai*'s estimated 120,000 rivers and 50,000 lakes, there are over 200 species of fish.[1]

Largest cities

Approximately 85 percent of the *krai*'s population is urban, distributed among the seven major industrial centers.[2] The administrative center is Khabarovsk, the largest territorially (400 sq. km) and in terms of population (pop. 617,800). Khabarovsk is also a center for petroleum refining, meat, dairy, and fish processing,

Key issues and projects

Pollution of the Amur River
The Amur River is one of the world's ten largest rivers. It is also among the former Soviet Union's most polluted (see pp. 154–55).

Logging by multinational corporations
Of all the regions in the RFE, Khabarovsk has attracted the most multinational logging companies. The giant Malaysian company Rimbunan Hijau recently secured over 1 million ha of prime forestland and has begun logging (see pp. 175–77).

Increased road building
Rapid road construction in the southern Khabarovsk, much of it federally funded, continues to fragment the critically important forests there, opening up new areas to logging.

Forest fires
Forest fires, most caused by humans, plague Khabarovsk. Fires in 1998 were particularly destructive with millions of hectares burned throughout the *krai*.

Foreign investment in the timber industry
As Khabarovsk is the largest timber-producing region in the RFE, the World Bank, USAID, the Canadian International Development Agency (CIDA), and others are funding projects (see pp. 171–72).

Indigenous land rights
Even though the Khabarovsk government began determining borders of Territories of Traditional Nature Use (TTPs) in 1992, indigenous peoples still do not hold title to or own their own territory and do not have the right to allocate resources from their traditional territories (see pp. 173–74).

Khabarovsk Forest Service

The 1998 fires devastated huge areas of Khabarovsk.

and light industry. Particular industries are associated with each urban area, for example: Komsomolsk-on-Amur (pop. 309,400) is a center for petroleum refining, ferrous metallurgy, meat, dairy, and flour production, fish processing, and chemical production; nonferrous metallurgy is associated with the town of Solnechny; gold, silver, and platinum refining are centralized in Mnogovershinny; Okhotsk, with a 245,000-ton handling capacity, is a center for fishing and seafood processing. Amursk (pop. 57,900) is a center of the *krai*'s defense industry. Nikolaevsk-on-Amur (pop. 35,600), Vanino (pop. 22,000) and Sovetskaya Gavan (pop. 34,400) are the *krai*'s three major port cities.

Population

As of 2001 the population was 1,506,700, almost 25 percent of the RFE total.[3] Eighty percent of the population is Russian, approximately 8 percent Ukrainian, 2 percent Jewish, and, very approximately, 2 percent a combination of Nanai, Nivkhi, Ulchi, Evens, and Negidal ethnic groups. Density varies from the sparsely populated northern regions (approximately 1 person per 10 sq. km) to the warmer and more industrialized south (approximately 10 to 30 people per sq. km). Most people (1,223,700; about 80.6 percent of the *krai*'s total) live in cities; the rest in villages. The population is, however, decreasing; the local death rate exceeds the birth rate by 1.9 times. Approximately 50.6 percent of the *krai*'s population is considered of employable age. Of this population, 86.9 percent was employed (663,000 people), with the remainder, according to the International Labor Organization, unemployed. Officially, 25,100 people, 3.3 percent of the total potential labor force, were registered as unemployed.

Political status

Through the influence of the governor, Viktor Ishaev, Khabarovsk enjoys a much better working relationship with Moscow than does Primorsky Krai. Critics point to Ishaev's control over all facets of economic and social development in the *krai* as a major reason for this close relationship.

Natural resources

One of the richest RFE regions in terms of quantity and diversity, Khabarovsk is perhaps best known for its timber and mineral resources. There are approximately two thousand known deposits of one hundred different commercial minerals, including gold, silver, platinum, molybdenum, tungsten, copper, lead, zinc, bismuth, arsenic, antimony, mercury, and rare metals.[4] The world's largest zirconium deposit is in the Ayano-Maisky region — a region well known for large gold, silver, and platinum deposits.[5] Khabarovsk has one of the largest reserves of tin in Russia. Figures for total timber reserves vary widely, as inventories are often based on outdated Soviet data. The Federal Forest Service estimates that the *krai* has about 1.75 billion cu. m of commercial timber (70 percent coniferous, with the following reserves by species (million cu. m): spruce (515), pine (505), and oak (185). Much of the commercially valuable timber is in the southern half of the *krai*, and accessible areas have been heavily exploited and exposed to fire. Commercial reserves of black and brown coal total about 1 billion tons, with coking coal reserves at 4 billion tons. Agricultural lands total 695,500 ha, about 0.9 percent of the total land area. Preliminary estimates of oil and gas reserves, mainly offshore around the Shantar Islands, put the figure at about 500 million tons.[6]

Main industries

Power and fuel production account for about 50 percent of the total industrial production, as reported in state statistics, but these sectors are heavily subsidized and do not generate significant revenue, aside from federal government support (see fig. 3.1). The backbone of the economy consists of exports of aircraft equipment, refined oil and oil extraction equipment, timber (mostly raw logs), precious metals (gold, silver, and platinum), and fish. In 1999, gold and platinum yielded 97 percent of the mining industry's output.[7] The Solnechny Mining complex, one of the largest in Russia, used to produce over 35 percent of the country's tin and copper concentrates. Most output, however, is sent to other regions in Russia for processing. Today, the shaft mine at Urgal, one of the largest in the Far East, produces more than 1 million tons annually. Despite this production and large coal reserves elsewhere, Khabarovsk annually imports about 6 million tons of coal each year from other regions of Russia, much of

Josh Newell

While Khabarovsk would like to increase exports of sawnwood, outdated machinery poses a huge obstacle.

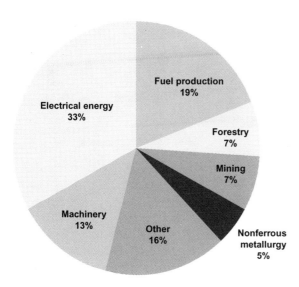

Figure 3.1
Industrial production in Khabarovsk Krai, 1999

Fuel production
19%

Electrical energy
33%

Forestry
7%

Mining
7%

Machinery
13%

Other
16%

Nonferrous
metallurgy
5%

Source: Khabarovsk Administration, 2000.

that coming from the Republic of Sakha's huge Neryungri coal deposit.[8]

The Khabarovsk timber industry is the RFE's largest, with about 5 to 10 million cu. m of timber produced yearly. In recent years and particularly the past few, almost all production has been exported as raw logs. With the size of the forests, their geographically strategic location for export markets, and a relatively well-developed rail, road, and port infrastructure, the timber industry is attracting foreign investment and international aid projects. The *krai* also has the largest machinery and metalworking plants in the RFE, again in Khabarovsk and Komsomolsk-on-Amur, and a large ship-building facility in Amursk, the Amur Shipbuilding Yard. This yard, along with the Amursteel Company, has received a number of contracts to build portions of the oil platforms for the Sakhalin projects. These contracts have helped to retool the industry. Khabarovsk also has the two biggest, and really only significant, petroleum refineries in the RFE, with enterprises in Komsomolsk-on-Amur and Khabarovsk. The Komsomolsk Refinery, in dire need of modernization, is looking to Japanese investment to achieve this, and hopes to receive a steady supply of oil and ultimately gas from Sakhalin offshore oil and gas projects via an existing oil pipeline connecting oil extraction facilities in Sakhalin with the refinery.

Infrastructure

Two railroads, the Trans-Siberian and the Baikal-Amur Mainline (BAM) cross the *krai* and are linked by two connecting trunk lines. Construction of the federally funded Chita-Nakhodka road has opened up large areas of forestland in the southern part of the *krai*; this road included construction of a bridge across the Amur to the nearby Jewish Autonomous Oblast (JAO). The eastern terminus of the BAM is in Vanino, the port that handles most of the region's timber exports to the Pacific and runs a ferry between Khabarovsk and Sakhalin Island. Vanino handles approximately 10 million tons of shipments a year, 20 percent of which is export. Five thousand freighters, 50 percent oceangoing, visit the port annually. Until quite recently, 65 percent of the freight destined for Sakhalin from the Russian mainland passed through Vanino. Sovetskaya Gavan, a port city just to the south and a part of Primorsky Krai until 1948, and the port city of Nikolaevsk-on-Amur to the north are both rapidly growing in importance as timber and fish export points. Cargo volumes and turnover have been increasing, and as of March 2000, were up 116 percent and 106 percent, respectively, over 1999 levels. Railroad transport accounted for 70 percent of total regional cargo volumes. According to various specialists, with the prospective construction of a second rail line, Sovetskaya Gavan would be capable of handling more than 1.5 million tons of freight annually.[9] Khabarovsk's international airport and Vladivostok's newly expanded international airport compete for designation as the Russian Far East's largest. The northern part of the *krai* has few roads, no railroads, and is accessible largely by helicopter.

Foreign trade

Japan and China are the *krai*'s largest trading partners (see fig. 3.2).[10] Reported exports totaled U.S.$1.3 billion in 2000, and imports totaled U.S.$141 million; this is about double the 1999 trade turnover (exports—U.S.$596 million; imports—$157 million).[11] This increase was largely from the sale of military aircraft and equipment to China, which accounted for about $524 million in exports from the *krai*. The largest exporters were the Komsomolsk Aircraft Manufacturing plant ($444 million), the Komsomolsk ($260.5 million) and Khabarovsk ($113.7 million) oil refineries, the heavy industry manufacturers, Amurmetal ($44.8 million) and Vostok Metall ($12.8 million), and the timber exporters, Flora ($31.1 million), Dallesprom ($12.9 million), and Forest Starma ($11.5 million). Khabarovsk supplies approximately 4 percent of Russia's total wood exports and is the RFE's leading exporter. In 1999, Khabarovsk exported about 4 million cu. m, including 3,937,000 cu. m in raw logs. There were over 220 timber exporters active in the trade, but 45 firms control about 90 percent of total exports.[12] Export of fish and sea products amounted to 21,300 tons during the first quarter of 2000, an increase of 3.2–3.4 times over January–March 1999. Most were sold directly to foreign countries, including the United States (40 percent), Cyprus (29 percent), Japan (25 percent), Poland, South Korea, and Peru. Imports are primarily of machinery and equipment, food products, and electronics from Japan, China, the United States, and South Korea.

Although the *krai* receives U.S.$300 million in investment each year, more than 90 percent comes from within Russia. Between 1994 and 2000, about $105 million, or 40 percent of all foreign investment during the period, went into the timber sector, with mining receiving about $38 million.[13] Corporations from Japan, Malaysia, and the United States are the largest investors.

Economic importance in the RFE

- RFE's third largest industrial producer after the Republic of Sakha and Primorsky Krai and contributes about 1.2 percent to Russia's gross domestic product.
- Provides more than one-third of the RFE's annual timber production.[14]
- Second highest number of operating companies and enterprises: as of 1999, Primorsky officially had 38,867 registered enterprises, Khabarovsk had 26,314.
- The regional leader in oil and gas refining (not diesel) and the wholesale petroleum trade; the fourth-largest coal reserves in the RFE.
- Fourteen percent of gold reserves in the RFE and, in 2000, Russia's third-largest gold producer.
- Vanino and Sovetskaya Gavan ports are key export and import centers not only for the *krai*, but also for the entire RFE.

Figure 3.2
Foreign trade with Khabarovsk Krai, 2000

Export – U.S.$1.3 billion

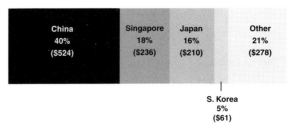

| China 40% ($524) | Singapore 18% ($236) | Japan 16% ($210) | Other 21% ($278) |

S. Korea 5% ($61)

Import – U.S.$141 million

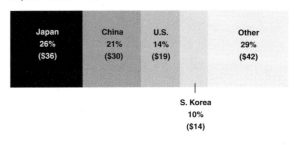

| Japan 26% ($36) | China 21% ($30) | U.S. 14% ($19) | Other 29% ($42) |

S. Korea 10% ($14)

Source: Khabarovsk Administration, 2001.

■ Currently the only producer of metal-cutting machinery in the RFE and, with Primorsky, one of only two regions in the RFE that produces wood-processing machinery.

General outlook

In the past ten years, the *krai*, especially the southern part, has suffered severe deforestation, forest fires, and water pollution, all caused by destructive logging, mining, agricultural, and industrial practices. Open-cast and placer mining have impaired riverine fisheries and polluted important groundwater reservoirs, such as those near the villages of Solnechny and Gorny. The huge forest fires in 1998, largely brought on by poor logging methods and inadequate forest conservation efforts, burned about 3 million ha of forestland and, in the process, created a public health crisis. Unfortunately, policy makers in the *krai* have not yet heeded this warning and have failed to act decisively to protect forests in the region. Inappropriate logging has historically led to losses in forest cover, to inadequate forest restoration and soil erosion, and to the destruction of salmon spawning grounds. The Khabarovsk government has had little success in controlling illegal logging or the illegal export of raw logs. Rather, Khabarovsk is known internationally as a center of the so-called Russian timber mafia—elites within the timber industry who manipulate forest-management decisions to their benefit. The region was the first to receive large-scale foreign investment in the timber industry, but environmental groups are concerned about the tactics used to attract this investment and the real possibility that foreign companies will have a major influence on the management of Khabarovsk's forests. The Khabarovsk government is also interested in attracting Chinese companies and workers to develop logging concessions. If this trend continues, it is unlikely that forest management in the *krai* will benefit local communities and residents. Control by foreign companies may make it more difficult to ensure enforcement of environmental regulations, although at this stage this is not clear; Russian firms are currently the main violators.

Khabarovsk policy makers have made some effort toward the sustainable management of forests. In 1999, for example, the regional Duma passed a regional forest law. However, even proponents of the law admit that Khabarovsk Forest Service employees have failed to implement it. Khabarovsk's governor recently issued a decree calling for the gradual abolishment of raw log exports. The decree is laudable, but only time will tell whether it will be implemented, given the Japanese and Chinese desire for raw logs rather than processed timber and the hopelessly outdated wood-processing equipment. The region, of all of those in the RFE, has proceeded most quickly to certify some of its forest operations according to Forest Stewardship Council (FSC) standards, but these remain small in size and largely unsuccessful as they are competing with operations that largely ignore forestry practices codes.

Protecting the remaining old-growth forests in the southern part of the *krai* is critical, as these forests support the highest biodiversity and are the most productive in the region. If protected, they will form a core wilderness complex with neighboring areas in Primorsky Krai to protect the heart of the Sikhote-Alin Mountain Range.

Khabarovsk has gained political clout in major decisions affecting the RFE in recent years and its governor, Viktor Ishaev, is in high favor with President Putin. He sits on the influential Federation Council in Moscow and has persuaded Konstantin Pulikovsky, Putin's presidential representative, or super governor, to the RFE, to set up his offices in the

city of Khabarovsk. However, Governor Ishaev has come under criticism for his authoritarian, heavy-handed style. Khabarovsk is known as one of the least friendly regions in the RFE to civil society and nongovernmental organizations.

Several other serious environmental and land-use issues are likely to become more prominent in the coming years. Chronic pollution of the Amur River continues to degrade fisheries stocks and damage the health of local residents. So far, scientists in Khabarovsk have been unable to explain significant occurrence of pollution, such as the presence of high phenol levels in fish. As conditions in the Amur worsen, Khabarovsk will need to focus significant attention on restoring this vital watershed.

The Khabarovsk government is also lobbying for the construction of a new pipeline from Sakhalin Island to Komsomolsk-on-Amur to transport oil and gas from the Sakhalin I and II offshore oil and gas projects. Khabarovsk hopes to process the oil in Komsomolsk and reexport the oil and gas to China, and would also like to provide natural gas as an energy source to its own residents. The latter, however, is unlikely because of the significant investment required to modernize Khabarovsk energy systems and the inability of Russian consumers to pay world prices for the oil and gas. The Sakhalin government is opposed to the pipeline proposal and is threatening to stop the oil project outright. The existing pipeline from Sakhalin to Komsomolsk-on-Amur—which transports oil from onshore projects in Sakhalin—is in disrepair and requires extensive upgrading. There are also plans to open up the Shantar Islands and the eastern portion of the *krai* near northern Sakhalin to oil and gas development.

Issues of indigenous land rights are likely to become significant over the next several years. On paper, the Khabarovsk government has approved forty-one Territories of Traditional Nature Use where indigenous peoples are guaranteed participation in land-management decisions. Local officials have, however, never truly provided equal participation. Indigenous peoples in the *krai*, and especially along the lower reaches of the Amur River, have started to organize in order to assert the due process granted under the law.

— *Josh Newell, Jeremy Tasch, David Gordon*

Ecology

Boris Voronov, Vladimir Sapaev, Jeremy Tasch

The *krai*, extending almost 1,800 km north to south, is exceptionally diverse in both topography and biogeography. Tundra grows along the northern borders of the region, and broadleaved forests, with unusual subtropical flora and fauna, grow in the south. Mountains cover nearly three-quarters of the *krai*. The largest, and most geographically complex mountain ranges include Sikhote-Alin, Suntar, Dzhugdzhur, Bureya, and Stanovoi. Separating the ranges are large freshwater lakes and alluvial plains, including those of the Tuguro-Evoron, Udil-Kizin, and the Middle Amur. The territory contains approximately one hundred and twenty thousand streams and rivers and close to fifty-five thousand lakes.[15] The largest rivers are the Ussuri, Amgun, Bureya, Uda, Maya, Uchur, Anyui, Khor, and Okhota. Most of the rivers are located within the basin of the Amur, one of the ten largest rivers of the world. Its annual discharge is 227 sq. km, 90 percent of that in the summer.

Much of the *krai* north and west of the Amur River is taiga dominated by Dahurian larch. Dahurian larch, east Siberian fir, and Ayan spruce forests cover the Lower Amur basin. South of the Amur and along the Khabarovsk portion of the Sikhote-Alin Range are rich Korean pine and mixed broadleaved forests. These forests, home to more than 260 species of terrestrial vertebrates and more than 1,400 vascular plants, hold the greatest biodiversity in the *krai*. The Sikhote-Alin Range, in particular, stands out for its biodiversity and endemism. There are close to 1,600 vascular plant and about 290 vertebrate species here. Biotopic diversity is also great, with almost all of the *krai*'s vegetation types represented here. Rivers contain more than thirty-five species of fish. Many plant and animal species are not seen in such quantities anywhere else in Russia.

In total, there are about 2,000 species of vascular plant (terrestrial and aquatorial) and 650 species of vertebrate (including freshwater fish) in the *krai*. Unfortunately, due to years of intensive logging, the forest structure has been damaged and many ecosystems are now degraded.

Ecological imbalance. In the 1950s it became apparent that human depredations were outpacing the land's ability to replenish itself. Despite this, development has continued. In the northern regions, the pace of gold mining and tin ore extraction is increasing. Forests are being logged at an unsustainable rate. Korean pine forests have decreased drastically, and dozens of animals and plant species are threatened with extinction. Poor logging practices have altered the hydrology and temperature of rivers and streams. This, and overfishing in the 1960s and 1970s, has greatly reduced fish populations throughout the Amur basin. Massive timber harvests

have reduced populations of brown bear, Siberian tiger, wild boar, Eurasian lynx (*Felix lynx*), Siberian grouse (*Falcipennis falcipennis*), and many others. In the ten years following construction of the BAM, lynx populations have shrunk by twenty times in most areas, and in some locations the animal has disappeared completely

Unfortunately, government planners have not created a suitable strategic plan for land use. The biological importance of many regions in the *krai* remains poorly studied. Environmental policy still does not properly regulate how the environment will be used. There are no long-term plans for development in regions that will soon lose their importance as a source of raw materials. One hundred and ten settlements and thousands of roads have been abandoned as intensive logging has exhausted the forests. As present-day land-use policies suggest, these territories have no future until the forests around them regenerate themselves. Considering the ten- to fifteen-year cycle of ecological catastrophes in such areas and the weakened regenerative potential of the forests, it could be many generations before forests reach a stage of regrowth sufficient to justify logging again. Meanwhile, the fabric of the region's ecology is destroyed. In recent years, many serious ecological changes have hit the *krai*.

Ecological disaster areas are constantly developing and broadening, especially around the cities of Komsomolsk-on-Amur and Amursk, in the Lake Evoron region, along the BAM, and around the towns of Urgal, Chegdomyn, and others. Destructive logging, mining, and agricultural practices have damaged the areas adjacent to the Chegdomyn-Uralsky and Badzhalsky industrial complexes, and those around

The rare spotted lady's slipper (Cypripedium maculatum) *grows in Khabarovsk.*

Nikolaevsk, Polina Osipenko, and Lazo. Specific environmental problems include forest fires, watershed pollution by sedimentation and heavy metals, untreated industrial effluents and agricultural wastewater, the destruction of riverine spawning grounds, and an overall degradation of ecosystems to the extent that they are loosing their resource-forming qualities. Of special concern is the worsening water quality in the Amur and its main tributaries—the Sungari (in China), Ussuri, Zeya, and others. The construction of new water-treatment facilities in Khabarovsk and Komsomolsk has stopped and existing plants are outdated and insufficient.

The fragility of the *krai*'s northern ecosystems makes them extremely sensitive to even minor disturbances. Present environmental problems in these areas are tied to mining, frequent forest fires, and destruction of fish habitat. But, being relatively inaccessible, parts of these far northern regions and some higher-elevation areas have avoided environmental degradation.

Russia's ongoing economic crisis has had mixed effects on the *krai*'s environment. Pollution emissions have declined with the reduction and even complete collapse of some industries. In many cases those emissions have been replaced by other forms of pollutant. For example, the region has seen a rapid increase in the number of automobile emissions. Large and long-lasting forest fires in 1998 dramatically affected air quality in most *raion*s. The increase in carbon dioxide in Komsomolsky, Amursky, Solnechny and other *raion*s continually exceeded 20 million parts per centimeter during this period. The government lacks funding to combat forest fires and oil spills and to introduce new environmentally sensitive industrial equipment and machinery.

Water and air pollution—the Amur River. Ecologically, historically, and geographically the Amur has been a vital life-sustaining and transport artery in the *krai* as well as the wider RFE. Few rivers in the northern hemisphere are as important for biodiversity. According to Russian scientist Vladimir Belyaev, 104 species and 7 subspecies of fish, 18 of which are endemic, inhabit the river, and a diverse array of plants and animals (including several rare species) are found within its floodplains in Russia, China, and Mongolia.[16] Historically, the lives of several indigenous peoples, including the Ulchi, Negidals, and Orochi, have been closely tied to the currents of *Batyuska Amur* (Father Amur). Geographically, the Amur extends 4,400 km and connects the RFE territorially, economically, and strategically with China and Mongolia.

Parts of the river rival other waterways of the former Soviet Union for the unfortunate distinction of being the most polluted.[17] The highest pollution levels are found downstream of the city of Khabarovsk, a result of a combination of household and industrial discharges, agricultural runoff, and landscape disruption in several parts of the vast watershed. Contaminants include organic and bacterial substances and heavy metals. Primary discharge in combination with other substances forms secondary pollution. Although anyone who consumes fish, especially from the river's lower reaches, is at risk, that risk is particularly acute for the local indigenous peoples who traditionally rely heavily on fish from the Amur.

Surprisingly, the *krai*'s industries are not responsible for the bulk of the river's industrial contaminants. Although Russia's economic troubles have impaired many aspects of life across the federation, some regional environments have benefited. Despite reductions, and in many cases the cessation, of industrial production throughout the RFE and the effects of stricter environmental legislation, the condition of Amur has not improved. Russia currently lacks an adequate monitoring system, but from proxy data it appears that the main sources of pollution are located in China.

After pollution levels dropped by 4.2 percent in 1998, they rose, possibly because of increased industrial activity in the Chinese portion of the Amur and Surgyan River basins. Four million Russians live along the Amur; 70 million Chinese live on the other side. Better monitoring and documentation are necessary but not currently possible financially. More collaboration with Chinese researchers and governmental authorities is needed.

As the river delineates 2,900 km of a shared border, a small portion of which is still in dispute, politics, security, economics, and sovereignty are all intertwined in a complex international network of historical biases, contemporary priorities, and ethnic identities, as well as environmental policy. Cooperative ecological programs could permit the other areas of joint concern to be addressed and perhaps encourage economic and cultural ties that would forestall political or security conflicts.

Vladimir Sapaev

The Kaluga sturgeon (Huso dauricus) *is the largest, and one of the most endangered, fish species in the Amur River.*

Industrial pollution in the Komsomolsky, Solnechny, and Amursky regions, and in the city of Khabarovsk and its suburbs, is excessive. Atmospheric pollution has been increasing for decades, with large quantities of methyl mercaptan in Amursk, formaldehyde, sulfur dioxide, phenols, lead, and benzopyrene in Khabarovsk and Komsomolsk-on-Amur, and dust prevalent in Solnechny, Urgal, Chegdomyn, Komsomolsk-on-Amur, and Khabarovsk.

Between 1990 and 1999, industries in Komsomolsky and Amursky Raions were the worst polluters of the Amur River. High concentrations of heavy metals, copper (38–49 MPC), zinc (22 MPC), and chloroprene (2 MPC) were found. Industrial and agricultural facilities that treat 40 percent or less of their wastewater (some treat none) create a water deficit for people and industry, despite the seeming abundance of water. The problem is exacerbated because of:

- Pollution and low water levels in smaller rivers, particularly near industrial centers (e.g., Solnechny and the Silinka River, where heavy metal levels exceed 130 MPC).
- A loss of soil fertility.
- Fires and logging, which impair the forests.
- Intensive development and quarrying of mineral resources, primarily construction materials.
- A lack of or inadequate buffer zones.

Protected area system

S. SHLOTGAUER, A. ANTONOV, M. KRYUKOVA, S. KRAMNAYA, B. VORONOV, V. SAPAEV—Protected areas (PAs) in Khabarovsk Krai are distributed quite unevenly. In the most developed southern half there is a well-developed network; in the northern part, where ecosystems are extremely fragile and sensitive to disturbance, PA coverage is inadequate. This is particularly true in the remote Okhotsky and Ayano-Maisky Raions. The *krai*'s protected areas, as of January 1, 1999, are listed in table 3.1. The *krai* has also ratified fifty-two *krai*-status natural monuments. The overall portion of protected lands in the *krai* should reach 9.4 percent by 2005, up from the present 5.8 percent. But the work of organizing, operating, and forming protected areas needs to be accelerated because important ecosystems continue to be destroyed at an alarming rate. Current environmental protection efforts to ensure full or even partial conservation of valuable territorial systems are inadequate.

Biodiversity indicators and the presence of typical zonal and regional communities were considered when most of the existing preserves were established, ensuring a fairly good representation at the species level. Nonetheless, 55 percent of the 212 rare species of vascular plants (IUCN categories I, II, and III) are not included in the existing PA system. Of fifty species of vertebrate land animals listed in the IUCN, USSR, and Russian *Red Data Books*, only thirty-two are included in the protected areas of the *krai*, although some of the remaining eighteen species (or 36 percent) can be found

Table 3.1
Protected areas in Khabarovsk Krai

Type and name	Size (ha)	Raion	Established
Zapovedniks			
Dzhugdzhursky	860,000	Ayano-Maysky	1990
Bureinsky	359,000	Verkhne-Bureinsky	1987
Botchinsky	267,400	Sovetsko-Gavansky	1994
Bolonsky	103,600	Amursky, Nanaisky	1997
Komsomolsky	61,200	Komsomolsky	1963
Bolshekhekhtsirsky	44,900	Khabarovsky	1963
Federal Zakazniks			
Badzhalsky	275,000	Solnechny	1973
Oldzhikhansky	159,700	Poliny Osipenko	1969
Tumninsky	143,100	Vaninsky	1967
Udylsky	100,400	Ulchsky	1988
Khekhtsirsky	56,000	Khabarovsky	1959
Regional Zakazniks			
Kava	566,000	Okhotsky	1988
Shantarsky	515,500	Tuguro-Chumikansky	1997
Kharpinsky	326,700	Solnechny	1979
Ulya	240,000	Okhotsky	1986
Dublikansky	131,500	Verkhne-Bureinsky	1984
Vana	105,000	Tuguro-Chumikansky	1989
Bobrovy	89,000		1969
Simminsky	80,000	Amursky, Nanaisky	1976
Birsky	53,600	Vyazemsky	1981
Ozyorny	37,500	Okhotsky	1988
Orlik	3,800	Nikolaevsky	1974

Source: Khabarovsk Committee on Environmental Protection, 1999.

occasionally. Most of these populations are at the peripheries of their ranges and are seldom in their optimal habitat. One can conclude, therefore, that the existing regional PAs do not ensure the preservation of the entire gene pool of rare species.

Many of the existing PAs have been poorly planned. Several lack buffer zones, ecological corridors, and water-protection zones that would link them together to provide long-term ecological viability. For example, Botchinsky Zapovednik on the coast of the Tatar Strait has no outlet to the sea. The small size of the *zapovedniks* and the proximity

of some of them to large industrial centers make them particularly vulnerable to fires, poaching, and pollution. The practice of residual financing, which had gained a foothold during the economic crisis, has resulted in the absence of staff scientists and enforcement services in some of the reserves (Dzhugdzhursky, Botchinsky, Bolonsky). This has also led to the breakdown in ecosystem monitoring.

Zapovedniks. There are six *zapovedniks* (strict nature reserves) in the *krai*, four of which are described here.

Bolonsky. This *zapovednik*, situated in the lower reaches of the Kharpi, Selgon, and Simmi Rivers in the Bolon Lake basin, is on the boundary of two administrative *raions*, the Amur and the Nanai. The reserve also includes the southwestern part of the lake. The preserve is remarkable because it includes Bolon Lake, which has the largest concentration of marsh and meadow habitat in the Amur region. This habitat provides extensive nesting grounds for aquatic and wetland birds and feeding grounds for fish of the Amur ichthyological complex. In summer, Amur moose (*Alces alces cameloides*) and Manchurian wapiti (*Cervus elaphus xanthopygus*) frequent the area. Because the lake is on a major flyway, the diversity of bird species is very high.

The most promising scientific research activity in the preserve is the study of wetland ecosystems, the adaptation of animals and plants to the environmental conditions, and the anthropogenic effects on the natural complexes. Rare and endangered species of plants and animals should be monitored and strategic measures developed to protect them. Specific endangered species to be studied and protected include plants such as Japanese snake-mouth orchid (*Pogonia japonica*), tall devil's club (*Oplopanax elatus*), species of iris (*Iris*), water chestnut (*Trapa natans*), and various nesting birds, such as Oriental white stork, black stork (*Ciconia nigra*), whooper swan (*Cygnus cygnus*), mandarin duck (*Aix galericulata*), osprey (*Pandion haliaeetus*), Oriental honey-buzzard (*Pernis ptilorhynchus*), golden eagle (*Aquila chrysaetos*), peregrine falcon (*Falco peregrinus*), red-crowned crane (*Grus japonensis*), and hooded crane (*G. monacha*). The success of the *zapovednik* depends primarily on establishing an ornithological station to research this still poorly explored territory. At present, staffing is inadequate, and scientific studies so far are on hold.

Botchinsky. This *zapovednik*, situated on the very southeastern tip of the *krai*, protects the Botchi River and the diverse ecosystems of surrounding plains and mountains. Fires have affected both the coast and the watersheds of the Botchi and the Dzhaus Rivers. The forested mountainous taiga zone and the subalpine zone form two easily discernible elevation belts within the *zapovednik*. Fur-bearing animals within the *zapovednik* include river otter, American mink, yellow-throated marten, sable, wolverine, red fox, raccoon dog, Eurasian lynx, Eurasian squirrel, and variable hare. The area contains some of the highest populations of river otter,

wolverine, and Eurasian lynx in the Sikhote-Alin region. With its preserved ecosystems of spruce-fir forests and mixed forests with Korean pine and broadleaved species, and a large variety of animal and plant species sporadically distributed and living on the fringes of their habitat, this territory is biogeographically interesting. The area is susceptible to fires, so the most important immediate objectives should include a fire prevention and response system and continuous monitoring of the ecosystems. The insufficient staff, absence of scientific researchers, and inadequate financing make these goals unattainable at present.

Bureinsky. This *zapovednik* has 479 species of vascular plants, many of them rare. Among rare animals are the goral (*Nemorhaedus goral*) and peregrine falcon. In existence for more than a decade, Bureinsky Zapovednik has fully justified its creation and has proven the validity of its selection. Situated in a bend formed by the Ezop, Dusse-Alin, and Bureinsky ranges, the reserve incorporates ecological characteristics of each, uniting them territorially and highlighting their genetic commonality. The *zapovednik* acts as a landscape-ecological nucleus, linking the Selemdzha, Amgun, and Bureya River basins while preserving its own natural characteristics. From a biogeographical viewpoint, the *zapovednik* protects corridors that permit gene flow among the animal populations. The territory ought to be recommended as a biosphere preserve. The *zapovednik* is currently staffed with enforcement personnel and a minimal number of scientific employees.

Dzhugdzhursky. There are more than four hundred species of vascular plants in this *zapovednik*, of which twenty are rare or endangered and have been listed in *Red Data Books* at various levels. Biodiversity is high because of the highly diverse climate and complex relief. Before the reserve was established, the area was mined, hunted on, fished, and logged so the entire region was damaged and the ecosystem disrupted because of the extreme fragility of the landscape. The natural structure and function of the territory, and its genetic interconnections and integrity have been altered. To a great extent, the old-growth forests have been destroyed. The *zapovednik* has no staff, no scientists, and no funds to construct an office or living quarters. Currently the reserve cannot ensure the preservation of the gene pool of the locally rare species of plants and animals.

Protected area needs. Protected areas in Khabarovsk Krai should be established:
- To preserve the biodiversity.
- To preserve stable populations of protected species in accordance with the Convention on Biodiversity and legislative acts of the Russian Federation.
- To achieve equilibrium between natural ecosystems that are relatively unaltered and those that have been dramatically disrupted.
- To ensure representation of typical and endemic ecosystems under threat of destruction.

- To preserve region-specific resources (forests, fur-bearing mammals, fish).
- To ensure the stability of climatic parameters needed for human habitation.
- To manage the territory for the economic and recreational needs of the population.

It appears reasonable to assume that preserving 70 percent of the protected species can ensure the integrity of the flora and fauna. The basic principle in organizing the protected territories involves the selection of key ecosystems, distinctive nuclei that function to maintain balance within the ecological framework of *krai* territory. Such nuclei, for example, are the unique ecosystems of the broadleaved and mixed forests. Within the region they form a zone with high diversity of both animals and plants. Clearly noticeable in that context are the Khor, Anyui, and Gur River ecosystems and the coastal area of the Tatar Strait from the delta of the Tumnin River to Nelis Bay.

The proposed system of PAs in the *krai* should comprise an array of ecosystems of various stages, from successional to climax. Within the grouping of the Bikin-Khor-Anyui sections, the segregation of an absolutely protected zone is mandatory for several reasons. This region would act as the nucleus of the entire system of protected nature territories, ensuring favorable conditions for the flora and fauna gene pool and for supplying adjacent territories.

The nucleus will act as a functional structure only if it, together with the supporting territories, is part of an integrated system. Thus, the Birsky, Chukensky, and Khekhtsirsky Zakazniks and the Bolshekhekhtsirsky Zapovednik would, with the help of ecological corridors, provide the necessary connection with the Bikin River watershed on one side and through the Tigrovy Dom [Tiger's home] Zakaznik and the Gassinsky Model Forest to the Anyui and the Gur River basins.

The coast of the Tatar Strait is home to a unique assortment of littoral plants and animals of the Pacific Ocean, most of which are relict species. Botchinsky Zapovednik does not provide access to the shoreline and does not include coastal ecosystems. This is an enormous drawback. The Tumninsky Zakaznik, to some degree, contributes to animal preservation.

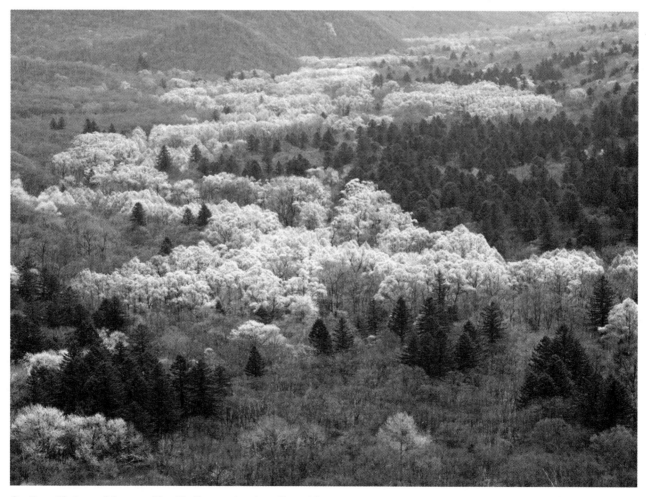

Southern Khabarovsk has considerable Korean pine–broadleaved forests.

Proposed zapovedniks. The *krai* should create the following two proposed *zapovednik*s as soon as possible.

Anyuisky (see Hotspot no. 1, pp. 158–59). Location: Upper Anyui River basin, Nanaisky Raion.

Badzhalsky. Size: 250,000 ha. Location: Upper Badzhal River, Central Badzhal Ridge, Verkhnebureinsky, and Solnechny Raions. The reserve would protect indigenous spruce, larch, and mixed forests in combination with high-mountain tundra communities. Unique to this region are the endemic Voroshilov's aster (*Aster woroschilowii*) and talus groundsel (*Senecio schistosus*). Rare birds include Siberian grouse and peregrine falcon. The *zapovednik* may be recommended for biosphere status because the territory serves vital ecological functions within the upper section of the Amgun River.

Proposed zakazniks. The *krai* should create the following nine proposed *zakaznik*s as soon as possible:

Gur-Khoso (see Hotspot no. 5, pp. 161–62). Size: 179,480 ha. Location: Basins of the Khoso and Yuli Rivers, and the left bank of the lower and middle sections of Dzhaur River, all tributaries of the Gur River, Komsomolsky Raion.

Ulike. Size: 65,490 ha. Location: Ulike River basin, Vaninsky Raion. The refuge would protect salmon breeding grounds on the Ulike River and its tributaries, which are currently under considerable anthropogenic stress. Also in need of protection are plant and animal systems of the coastal and upland landscapes, and areas of seasonal concentration of animals and migratory birds. The Ulike Zakaznik and the existing Tumninsky Zakaznik would constitute a single nature-protection zone.

Pikhtsa-Tigrovy Dom (see Hotspot no. 4, p. 161). Size: 124,850 ha. Location: Basins of the Pikhtsa (a tributary of the Amur River) and Nelta (the right tributary of the Mukhen River) Rivers, Nanaisky Raion.

Dzhevdukha. Size: 100,000 ha. Location: Lake Dzhevdukha. The refuge would protect marshes and wetlands of Lake Dzhevdukha and a system of lakes and the channel in the area of the confluence of the Amur and Amgun Rivers, a key area of the lower Amur in terms of plant and animal species. Also to be protected are water and marsh ornithofauna, both nesting and migrating species.

Torom. Size: 100,000 ha. Location: Byuko Range. The refuge would protect the Byuko Range, a key ecological zone in the basin of the Torom River. The protected area will include a key section of boreal taiga containing a typical Beringian complex of plants and animals.

Koppi. Size: 124,980 ha. Location: Basin of the upper Koppi River, Sovetsko-Gavansky Raion. The refuge would protect mountain-valley nature systems that include elements of mountain tundra, Japanese stone pine growths, and open woodland at high elevations, Dahurian larch stands, and spruce-fir valley forests.

Nelma. Size: 80,360 ha. Location: Nelma River basin, Sovetsko-Gavansky Raion. The refuge would protect spruce-fir forests as yet unaffected by logging or forest fires, areas where ungulates congregate during seasonal migrations, spawning beds of salmon, and habitats of scaly-sided merganser (*Mergus squamatus*).

Shaman-Yai. Size: 37,650 ha. Location: Basin of the Yai River (the Lake Kizi basin), Ulchsky Raion. The refuge would protect Shaman Mountain, the habitats of wild ungulates, and the salmon spawning beds. A part of the territory has already been designated a local natural monument.

Khalkhadyan. Size: 120,000 ha. Location: Central-Amur plain, Nanaisky Raion. The area includes floodplains, marshes, a group of oxbow lakes, the Nedostupnye Lakes, and the hilly forest tract of Khalkhadyan. The refuge would protect breeding areas of rare animal species, such as white-tailed sea eagle (*Haliaeetus albicilla*), osprey, Oriental white stork, black stork, mandarin duck, peregrine falcon, whooping swan, and a number of endangered plant species including water chestnut (*Trapa natans*), water-shield (*Brasenia schreberi*), and various orchids.

Biodiversity hotspots

Svetlana Shlotgauer, Boris Voronov, Vladimir Sapaev

1. Anyui National Park (forest)

This proposed protected territory of 882,000 ha occupies the basin of the upper and middle reaches of the Anyui River (a right-hand tributary of the Amur). On the western slopes of the Sikhote-Alin Mountains in the *krai*'s Nanaisky Raion, where altitudes range between 400 and 1,000 m, with a maximum of 2,090 m (the highest point of the Sikhote-Alin range). The climate is monsoon-continental, with average temperatures of –24.4°C in January and 16°C in July. The Anyui River, a typical alpine river along its entire extent, flows for 393 km before emptying into the Amur; the average annual water flow is 225 cu. m per second.[18]

Forests cover over 90 percent of the region, about half of that being rich spruce and fir forests. There are also ecidu-ous forests (19.8 percent), Korean pine forests (0.8 percent), broadleaved forests (1.5 percent), secondary forests of aspen and birch (19.8 percent), thickets of Japanese stone pine (0.5 percent), regions of stone birch and sparse forest (6.0 percent), and alpine tundra (1.1 percent). Poplar, chosenia, elm, and ash forests (1.1 percent) grow mostly in the floodplains. Burnt forests and clear-cuts cover 4.25 percent of the territory.

In the Anyui basin (including the lower part, where there are also plans to create a protected territory), several types of fauna are represented: Boreal, Okhotsk-Kamchatkan, Angarian, and Manchurian. Animals include Siberian tiger, Hima-

layan bear, Eurasian badger (*Meles meles*), yellow-throated marten, raccoon dog, wild boar, Manchurian wapiti, snow deer (*Capreolus pygargus*), scaly-sided merganser, Blakiston's fish-owl (*Ketupa blakistoni*), mandarin duck, brown bear, wolverine, sable, reindeer (*Rangifer tarandus*), Siberian grouse, and black capercaillie (*Tetrao parvirostris*). The vast brush regions are particularly important for ungulates such as wild boar and snow deer, which are primary food for the Siberian tiger.

The Anyui is the northernmost large salmon river along the Amur in the Korean pine and broadleaved forest zone. In addition, the Anyui is the uppermost tributary of the Amur for summer spawning of pink salmon (*Oncorhynchus gorbuscha*) and chum salmon (*O. keta*). The salmon support a great number of invertebrate species, fish (Amur grayling [*Thymallus amurensis*] and char [*Salvelinus malma*]), and several mammals (river otter, American mink and raccoon dog).

In the Anyui River basin, there are at least 292 vertebrate species (35 fish, 7 amphibian, 6 reptile, 200 bird, and 50 mammal). More than thirty of these are endangered, including Siberian tiger (according to data compiled in 1996, only eighteen tigers were counted in the Anyui basin) Himalayan bear, scaly-sided merganser, mandarin duck, golden eagle, white-tailed sea eagle, osprey, Blakiston's fish-owl, black stork, Oriental white stork, and Siberian grouse. The upper reaches of the Anyui clearly have the highest population densities of rare species of freshwater fish-eating birds, especially ospreys (0.93 per 10 km of river channel in 1996), in the *krai*. In 1996, grayling with different dorsal fins from those of Amur grayling were found in the Anyui. This endemic subspecies is definitely found only in this region. Also, in 1996, in the Moad River valley, a tributary of the Anyui, a population of Far Eastern toad (*Bufo raddei*) was found, living 300 km north of the nearest known distribution of the species. The richness of the fauna in the Anyui rivals that of the more southern Bikin River basin, which is world famous for its biodiversity. The Bikin has a few more species of Manchurian fauna, but the salmon runs of the Anyui are much bigger.

The Udege and Nanai peoples use almost the entire basin for traditional activities, including hunting, fishing, and gathering forest products. The area is also noted for its historic and aesthetic value. The famous Russian explorer Vladimir Arsenev wrote of the Anyui's picturesque mountains, cliffs, and swift rivers. The Anyui remains the most pristine and least settled large salmon river in the entire Sikhote-Alin region.

The entire Anyui basin, together with the basins of the Bikin, Samarga, and part of the Khor River, forms a huge, connected, and relatively intact ecosystem that most ecologists consider to be the heart of the Sikhote-Alin Mountains. About one thousand and two hundred people, in three settlements, live permanently in the basin, and along either side of the river run two forestry roads, which have already reached

the Podya (on the left bank) and Gobilla (on the right bank) tributaries. Between 20 and 25 percent of the territory has already been disturbed by logging and fires. Other threats include the newly constructed highway from Lidoga to Vanino, hunting, fishing (hundreds of fishermen come to the Anyui every year from Khabarovsk), uncontrolled tourism, and fires.

No integrated zoological research has even been conducted. Some knowledge can be gained from Arsenev's *Anyuisky Raion* (1949), on his expedition in 1926, in which he brought up the question of creating a nature reserve. The Far Eastern Branch of Russian Academy of Sciences (FEBRAS) has some data on game, and the Amur branch of the Pacific Institute of Fisheries and Oceanography has information on salmon. We have collected material on the flora and fauna and have published a few reports.

Existing protection measures. The basin is currently unprotected. The Gassinsky Model Forest Project operates along the left bank in the lower part of the basin. Since 1996, fishing has been forbidden, but this regulation is not enforced.

Recommendations. The following actions should be taken:

- New areas must not be leased to logging companies.
- All road entry points need to be monitored.
- Create a large national park on the Anyui, beginning with a *zapovednik* to protect the middle portion of the basin.
- Permit some commercial activities, such as ecotourism and permit-only sport fishing in the upper portion, where there is a proposal to create a national park.
- Forbid all forms of industrial activity.
- Permit limited fur trapping and small-scale fishing during the autumn and winter. During the rest of the year, permit sport-fishing, limited hunting for hooved animals and brown bear, collecting of wild plants, and tourism in some places.
- Conduct detailed ecological planning of the territory and more comprehensive zoological, botanical, and geomorphologic research; this work may be done by a group of seven or eight people over the course of two or three years.

2. Mataisky Zakaznik (forest)

Mataisky Zakaznik (121,300 ha) protects the 110-km long Matai River, a tributary of the Khor River. Its southern border lies along the mountain watershed between Alchan (Bikin River basin); the western border lies along Pravy Podkhoryonok River; the eastern border runs along the watershed of the Kafen River (Khor River basin). The region has relatively low mountains ranging from 300 m to 1,038 m. The moderately continental climate still experiences the monsoon summers that characterize much of the Sikhote-Alin Mountain region; flooding occurs periodically during July and August.

The river basin has 800 species of vascular plant, 120 species of moss, 75 species of lichens, and more than 420 species of fungae. The plant life is of particular interest because of relict families such as Araliacea in the Korean pine and broadleaved forests.

In the 1940s and 1950s scientists studied the botany and zoology of the region extensively. This research reveals that, with its rich Korean pine, Mongolian oak, Manchurian walnut (*Juglans manchurica*), and hazel (*Corylus*) forests and good climatic conditions, the region was prime habitat for Manchurian wapiti, wild boar, and consequently, Siberian tiger. In addition, musk deer (*Moschus moschiferus*), sable, Eurasian eagle owl (*Bubo bubo*), osprey, and Steller's sea eagle can be found. However, with advancing logging and road construction, the region has lost some of its diverse animal life. Wild ungulates, for example, have decreased three to five times, an effect of increased hunting: The Chita-Nakhodka road now provides increased access for hunters and loggers. Key ecological corridors in the Takhalo—Matai, Podkhoryonok—Khima regions, as well as Matai-Alchan, face destruction. To protect these territories, it is essential to change the Matai's protected area status. Continued fragmentation of these forests will disrupt centuries-old migratory corridors and reduce genetic diversity.

The Matai has particular importance for the tiger as a breeding ground but is becoming less suitable because of habitat fragmentation and the declining number of ungulates. There used to be ten to twelve tigers in the region; now only three or four live there permanently. At present there are no females or cubs living in the region. Himalayan bear also used to live throughout the area (forty to sixty individuals per 100 km) but its numbers have declined. Dhole (*Cuon alpinus*) and Amur cat (*Felis euptilura*) that were found in the area in the late seventies no longer live in the Matai.

Even though logging has fragmented some of the rich Korean pine and broadleaved forests, the forests here have the highest level of biodiversity in Khabarovsk Krai. The Matai is the only place in the *krai* where Asian ginseng (*Panax ginseng*) still grows. The territory, if protected, is still healthy enough to support large numbers of Manchurian wapiti, sable, musk deer, snow deer, and wild boar. It can be the most important reproduction area in the south of the *krai*.

Existing protection measures. A *zakaznik* totalling 121,300 ha was established in late 1999. The *zakaznik* does not include the hunting grounds of the military hunting bases, which lie north of the Matai. The *zakaznik* also includes Yuzhny Village.

Recommendations. It is critical to implement a number of measures to protect the tiger:
- Promote natural regeneration of Korean pine and broadleaved forests, which are the food base for wild boar and Manchurian deer.
- Preserve the ecological migration corridors in the *zakaznik*.
- Prohibit logging along the Matai, Katen, and upper Bikin Rivers to preserve their role as migration and breeding areas for tigers.
- Zone the territory to limit industrial development in the *zakaznik*.

3. Nedostupnye Ozera (Inaccessible Lakes) Zakaznik (forest and wetland)

Located along the middle Amur lowlands, the Nedostupnye Ozera Zakaznik would protect meadows, wetlands, the relict swampy Nedostupnye Lakes, and the hilly forests of the Khalkhadyan. The interconnectedness of wetland and forest ecosystems creates a high level of biodiversity, and all three regional floras and faunas thrive here. The region is particularly important for large mammal species and birds. The Nedostupnye Lakes, which represent a larger ancient water body, are famous for water-shield, a relict plant found at the northern edge of this region. Four hundred species of vascular plants and 157 resident vertebrates inhabit the region. If migrating birds and occasional visiting mammals are counted, the number of vertebrate species exceeds 220.

Threats. The protection of the region is essential for the following reasons:
- Threat of extensive biodiversity loss in the middle Amur lowland.
- Obvious anthropogenic damage to the existing flora and fauna.
- Overall degradation of the territory and decrease in protective functions of the lakes and the forested Khalkhadyan area.
- Need to protect key habitats of rare species of wildlife and plants, especially those listed in *Red Data Books*, e.g., white-tailed sea eagle, osprey, Oriental white stork, hooded crane, possibly red-crowned crane, mandarin duck, peregrine falcon, whooper swan, water-shield, water chestnut, and some orchids.
- Need to protect forests and expand the network of protected areas in the middle Amur lowlands.
- Need to protect one of the main bird flyways in East Asia.

Hunting and fishing are also threats. Frequent fires coming from the Amur floodplain have replaced old-growth forests with less diverse and less productive second-growth forests. In the low-lying areas forests have disappeared entirely. Between 40 and 50 percent of the original floral diversity has been lost, primarily as a result of habitat destruction. Habitat diversity has also decreased, which has in turn, affected animal populations. The region's ecosystems are under stress. There are, however, no current plans to develop the area economically.

No significant research on the region's biodiversity has been conducted. The general responses of the local ecosystems to human pressure and ideas about local geomorphology and soil cover can be obtained from other regional studies. For example, a monograph *Territory: Problems of Ecological Stability (Amursky Raion in Light of the Geographical Assessment)* was published in Khabarovsk in 1998.

4. Pikhtsa-Tigrovy Dom Zakaznik (forest and wetland)

This proposed protected area (125,000 ha) is located in Nanaisky Raion in the basin of the Pikhtsa River, a tributary of the Amur, and the Nelta River, a right-side tributary of the Mukhen River. Low mountains, with altitudes up to 900 m, define the topography in the south and include unusual cliffs in the headwaters of the Nelta River and on Tigrovy Dom (Tiger's house) Mountain. The northern portion of the territory, the middle Amur lowlands, is a plain with elevations from 30 to 60 m and numerous lakes. Lake Gassi is shallow and its hydrological regime depends almost completely on the Amur; during the winter, there is almost no water in it.

About 70 percent of the territory is forested and consists of Korean pine–broadleaved forests with some old-growth (27.2 percent), spruce and fir forests (21.8 percent), broadleaved forests (20.2 percent), birch and aspen forests (12.8 percent), peat, moss, and bog forests (11.5 percent), larch forests (5.8 percent), and fragments of mature shrubs and meadows.

The variety of species in the territory has not been accurately established; there may be between 350 and 400 species of vascular plants, 50 lichens, and 75 mosses. Rare species include Japanese yew (*Taxus cuspidata*), Japanese barbet, tall gastrodia (*Gastrodia alta*), and Japanese wild yam (*Dioscorea nipponica*). About 250 species of vertebrates may live here. Of greatest importance may be the pristine Korean pine forests in the basin of the Pikhtsa River. The mouth of this river and Lake Gassi are currently the northernmost habitat of the Chinese softshell turtle (*Trionyx sinensis*). The Pikhtsa and Nelta Rivers are two of the few remaining spawning grounds of the autumnal chum salmon. The Tigrovy Dom cliffs at the headwaters of the Nelta River and the headwaters of the Pikhtsa and Mukhen Rivers were, in the opinion of Vladimir Arsenev, "the most tiger- and game-filled places in the entire Ussuri Taiga in the 1920s."

Species characteristic of Korean pine and broadleaved forests (including tiger, two species of bears, wild boar, Manchurian wapiti, snow deer, Eurasian badger, raccoon dog, yellow-throated marten, mandarin duck, and scaly-sided merganser) thrive here. There are unconfirmed reports of sightings of dhole and Amur cat in this region. The cliffs of Tigrovy Dom are a site of religious worship by the Udege—a practice that Arsenev wrote about in his work *Skvoz Taigu* (Through the Taiga).

The zoology, botany, and geomorphology of the area are practically unstudied. The Far Eastern Forest Research Institute has funded some research. In November 1997, initial research of the Tigrovy Dom region revealed that tigers, both bear species, Manchurian wapiti, wild boar, musk deer, and Eurasian lynx were regular residents and white-tailed sea eagles could also be encountered. Chum salmon come to the Nelta River annually to spawn.

Threats. Logging and fires have damaged about 30 percent of the territory. Logging and uncontrolled hunting and fishing continue to threaten the biodiversity. The Gassinsky Model Forest Project recently received rights to the eastern part of the territory, the Pikhtsa River basin.

Recommendations. The following actions should be taken:
- Upgrade the area of Tigrovy Dom to the status of regional natural park.
- Develop ecotourism to control access to the picturesque cliffs, a driveable road, and the nearby Mukhen mineral springs.
- Conduct basic zoological, botanical, and geomorphologic research; five or six people can complete this over two years.

5. Gur-Khoso Zakaznik (forest and riverine)

In the Komsomolsk region of Khabarovsk Krai, the proposed 179,480 ha Gur-Khoso Zakaznik lies on the lower and middle reaches of the Gur River and the Khoso and Yuli tributaries. Gorbilya Mountain (1,221 m) looms over the region to the north and the gently sloping Khoso-Chermal watershed is in the south.

The Gur River basin is an important biogeographical boundary. To the north, Angarian flora and fauna is dominant and Manchurian types less prevalent. To the south, the influence of Manchurian flora and fauna is stronger, and Okhotsk-Kamchatkan flora and fauna are significant. Together, these three communities create a rich and diverse array of life. Pine and larch forests grow along the mountainous southeastern portion. Fir and spruce forests cover 57 percent of the territory, deciduous forests cover 16 percent, Korean pine covers slightly more than 5 percent, larch forests cover 5 percent, and sparse forests cover about 0.4 percent. There are an estimated 250 species of land vertebrates, 30 fish species, and 1,000 plant species. In the Gur, Khoso, and Yuli Rivers and their tributaries, autumn and summer chum salmon and pink salmon spawn.

This territory is poorly studied, despite the extensive industrial activity here. There have been no significant integrated studies of the natural resources, forest cover, and animal life. Only a few, old publications have scattered data about the region. Ecologists from the Institute of Water and Ecological Problems (IVEP) visited the region twice, going in June 1975 to the lower reaches of the Khoso and Yuli Rivers and in June 1976 to the Dzhaur River basin. Since then,

hunters, game specialists, foresters, and loggers have provided some information and IVEP ecologists flew over the region in June 1994 and 1995.

Threats. Logging, large-scale forest fires, and poaching have affected the region; in the northwest, clear-cuts and burns cover 20 percent of this lowland terrain. Many species found here are at the northern limit of their distribution and thus particularly sensitive to disturbance. Magnolia vine (*Schisandra schinensis*) and Amur grape (*Vitis amurensis*) are becoming rare and encounters with Amur cat have practically ceased. Siberian tigers have become very rare, as have scaly-sided merganser and Blakiston's fish-owl. Wild boar, black capercaillie, and Siberian grouse populations have fallen sharply. Nevertheless, the territory proposed for protection is still valuable and needs to be preserved.

The main threat comes from the timber industry. Clear-cut logging has taken its toll and these clear-cuts are much more susceptible to fire, which then spreads to nearby uncut forests. This was the case with the catastrophic fires of 1976 when more than 1 million hectares were burned and tens of thousands of hectares of forest were destroyed along the lower reaches of the Chermal, Khoso, and Yuli Rivers. The threat of catastrophic fires remains.

Recommendations. The following actions should be taken:
■ Study the area in greater detail both on the ground and from the air. An interdisciplinary team of specialists should identify the state of ecosystem health, delineate ecosystem boundaries, determine the level of anthropogenic disturbance, determine the level and activity appropriate for the region, and determine needed measures to regenerate degraded ecosystems.
■ Inventory animal and plant life to identify rare species and those particularly sensitive to disturbance.
■ Establish a number of natural monuments.
■ Concentrate on the areas where the tiger live and on the current state of the prey base. Studies show that the tiger comes here less often; this may be a result of declining populations of wild boar and Manchurian deer.

6. Shantarskie Ostrova (Shantar Islands) Zakaznik (island ecology)

The Shantar Island archipelago in the Sea of Okhotsk consists of fifteen large and small islands, including Bolshoi Shantar (1,790 sq. km), Feklistova (393 sq. km), Maly Shantar (112 sq. km), and Belichy (70 sq. km). The climate on these mountainous islands is more severe than that along the coastline of the Sea of Okhotsk because of the close proximity of the Republic of Sakha. Cold winds blow east in the winter, the sea freezes over, and fog and storms are frequent.

The plant communities on the islands are unusually complex, with Okhotsk-Kamchatkan forests (Ayan spruce

forests, woolly birch [*Betula lanata*], alder, and mountain ash) combined with larch forests and mountain tundra. There are 480 species of plants, many of them rare. Of the 241 bird species observed on the islands, 141 are breeding, 57 are migratory, and 3 are wintering; 9 are found only occasionally. Twenty-five species (10.4 percent of the total) are listed in the IUCN, USSR, and Russian *Red Data Book*s. Two reptiles and three amphibians are found on the islands: viviparous lizard (*Lacerta vivipara*), common viper (*Vipera berus*), Far Eastern frog (*Rana dybovskii*), Siberian frog (*Rana amurensis*), and Siberian salamander (*Salamandrella keyserlingii*). About thirty-five fish species are found around the islands, more than one-half being marine species that enter Bolshoe Solyonoe (Big Salt) Lake, Yakshina Bay, etc. Among thirty mammal species there are river otter, sable, brown bear, ermine (*Mustela erminea*), red fox, and reindeer. There are also several breeding pinnipeds, and an increasing number of whales, which have almost disappeared elsewhere in the Sea of Okhotsk.

Abundant salmon spawn in the rivers. Sole (*Solea*), Pacific herring (*Clupea pallasi*), saffron cod (*Eleginus gracilis*), and Kamchatka crab (*Paralithodes kamtschatica*) breed in the shelf waters. Along the entire coast of the Sea of Okhotsk, steelhead (*Oncorhynchus mykiss mykiss*) are found only in the Srednyaya River.

Researchers have had an interest in the islands since Shishkin and Dulkeit began scientific assessments in the 1920s. However, the bird life on the islands was not systematically documented until the 1970s, when Roslyakov and Yakhontov worked in the region. Members of the Institute of Marine Biology of the FEBRAS in Vladivostok have studied the tidal zone and marine habitat and, in the 1980s, members of the Institute of Biology and Soil Sciences (also in Vladivostok) studied the spruce forests. In 1986, the Amur Geographical Society researched both the vegetation and wildlife and published the results in the monograph "Shantar Archipelago"

The ringed seal (Phoca hispida) *is one of many marine mammals living on the Shantar Islands.*

in 1990. In the 1930s, Dulkeit suggested that the islands become a *zapovednik* and, in 1980 and 1982, the magazines *Young Naturalist* and *Hunting and Game Management* raised the issue again. Since then, the All-Union Research Institute of Game Management and Captive Breeding, the Institute of Marine Biology, IVEP, the Amur Geographical Society, the Khabarovsk Committee on Environmental Protection, the Khabarovskpromokhota Game Union, the *Pacific Star* and *Khabarovsk Press* newspapers, and regional radio and television stations have all supported the idea of creating the protected area.

Threats. Oil and gas development on the northern Sakhalin shelf threatens the ecological health of the islands. Due to the extreme climatic conditions, the ecosystems are fragile. For example, in 1991, a small oil spill off Bolshoi Shantar killed a large number of seabirds and damaged the marine biology and wildlife. Imminent development of Tuguro-Chumikansky Raion, the Sea of Okhotsk coast, and the Sakhalin shelf for petroleum will definitely exacerbate the situation.

Unregulated tourism is also having an effect. According to data from IVEP, between 1978 and 1992, more than twenty tour groups, ranging from between three and seventeen people, each visited the islands. Many of these groups are on hunting expeditions seeking bears and pinnipeds. Brown bears, prized for their skins and gall bladders, are the most common target.

Existing protection measures. Five natural monuments on the islands protect rocks, caves, unique semiprecious stone deposits, and unique biological communities. On August 1, 1986, the Glavokhota (Game Department) of the Russian Federation issued order No. 309 proposing that Shantarsky Zapovednik be created. On July 23, 1989, the Federal Committee on Environmental Protection submitted a letter to the Khabarovsk Committee on Environmental Protection, proposing officially that a *zapovednik* encompassing 300,000 ha be officially created.

In 1993, the All-Union Research Institute of Game Management and Captive Breeding suggested that a national park be created instead of a *zapovednik*, a suggestion that was eventually approved by the *Raion* administration. When the plans for the park were finished, opposition arose at the federal level (from the federal Forest Service and the Ministry of Finance) and at regional and local levels. After some deliberation, the stakeholders decided to create a *zakaznik* instead. A working group was formed, and the Russian program office of the World Wildlife Fund provided a grant to do the work. The current project director is Alexander Kulikov, the chairman of the Wildlife Foundation.

Recommendations. The following actions should be taken:
- Protect and restore the island's ecosystems; protected natural area must be created to conserve the Shantars.

Regulated ecotourism will help provide income to develop and maintain this park.
- Support scientific research and environmental education, including international programs, within the range of use appropriate for the *zakaznik*.

Economy

Boris Voronov, Zoya Mirzekhanova, Jeremy Tasch

Leading up to and after the founding of Yakutsk (Republic of Sakha) in 1632, every Russian military governor serving east of the Yenisei River in the 1600s was concerned with securing stable supplies of food. Finding the boreal forest and tundra inadequate for growing crops, officials directed their attention further southeast from Moscow, toward the Pacific. The Stanovoi Mountains in present-day Khabarovsk Krai were a natural boundary separating the Eastern Siberian taiga from fertile floodplains of the Amur River and its tributaries. Russia's occupation of the Amur River Territories, initiated by expeditions led by Vasily Poyarkov (1643–1646) and Erofei Khabarov (1649–1653), was punctuated by 165 years of often brutal treatment of the region's indigenous peoples as well as cultural hostility and border conflict with China.[19]

In 1858, the governor-general of Eastern Siberia, Nikolai Muravyov, approached the Chinese at Aigun with two Russian gunboats. There he presented the case for Russia's acquisition of the entire left bank of the Amur, from the Argun to the Pacific. In return he expressed Russia's willingness to leave the right bank of the Amur up to the Ussuri River under Chinese control. The remaining portion of the right bank would be considered common property until a delineated border could be determined. Continuing along the Amur to its convergence with the Ussuri, Muravyov founded Khabarovka, later the regional capital, Khabarovsk. Immediately following Russia's annexation of the left bank of the Amur, a special Amur Cossack regiment was formed, groups of exiles were relocated, and thousands of peasants were offered state land, government loans, and tax and draft exemptions as incentive for settling in the so-called unpopulated lands along the Amur.

Russian settlers introduced mining, forestry, commercial transport, construction, agriculture, technical production, artillery manufacturing, and shipbuilding (including both seagoing vessels and riverboats) to the *krai*. In 1914 more than 380 steamships and 340 barges plied the Amur basin, from which 55,000 tons of fish were harvested that year in the Russian portion alone. Fur and gold, however, were mainstays of Khabarovsk's initial economy and in the early years of the twentieth century, annual gold yields reached as high as 12 tons. Completion of the Ussuri and Amur railroads (1897

and 1916 respectively) spurred economic development by providing Khabarovsk with access to the Sea of Japan and the Trans-Siberian Railroad.

In 1922 the Far Eastern Krai was created, with the administrative center relocated from Chita to Khabarovsk. To strengthen its international borders and presence in the RFE, the Soviet government throughout the 1930s made heavy capital investments into the regional economy. The government reorganized present Khabarovsk Krai's industrial, agricultural, and transport sectors, and by 1937 the gross industrial output of the *krai* had increased by fourteenfold compared to pre–World War I levels. Large-scale coal mining began in Khabarovsk in the 1940s in the Urgal deposit. Intensive industrialization of the region continued from the 1930s to the 1980s, with focus on the machine-tool industry and metallurgy, mining and metals enrichment, forestry and paper production, fish processing, and oil refining. The mining industry began processing some of its ore rather than just sending it to Moscow or abroad. Rail spurs extended from the Tran-Siberian Railroad to Komsomolsk-on-Amur, Bereyozovy (on the Amgun River), Sovetskaya Gavan, and Chegdomyn.

The 1980s were characterized by economic stagnation and decline, in both resource extraction and manufacturing. Between 1992 and 1996, however, the *krai* reinvented itself macroeconomically, with the share of manufacturing in regional gross domestic product (GDP) dropping as the share of services rose.

Economic reform. As with the RFE more generally, economic development of the *krai* had traditionally been subsidy driven, where average regional consumption was greater than production and the trade balance between regions was negative. During the years of economic reform between 1990 and 1996, the situation became increasingly unbalanced, with declines in production in the RFE most pronounced in Khabarovsk.[20]

By 1992 the *krai*'s current industrial structure was largely consolidated, and included machine tool and metal processing, forestry and forest products, mining, food processing (including fish), construction materials production, light industry, electric power, ferrous and nonferrous metallurgy, fuels, and chemicals (including petrochemicals).

By 1994 the production of goods and services had an approximately equal share in the GDP of the *krai* (47 percent and 49.3 percent respectively). Two years later, services had grown to 69.2 percent and manufacturing dropped by 3 percent. This trend is reflected nationally and highlights the disproportionate tendencies of value formation and the comparative rate of decline within different branches of industry.[21]

The legacy of the Soviet organization of the regional economy explains, given the relatively well-developed machine-building, forestry, and metallurgical industries, the difficulties of this period for the *krai*. As a whole, the region's

economy was focused on the output of military goods. After 1991 the single largest consumer of the *krai*'s output, the state was unable to pay consistently. Military orders from the government declined sharply as did financial compensation. Consumer goods appropriate for civilian consumers could not compete with imported goods.

All sectors of the economy declined, but the sharpest decreases were in sectors oriented toward the output of finished goods. In 1996, machine building was just 16.5 percent of 1990 levels, light industry and food processing were both below 35 percent, and chemical and petrochemical industries were just 2 percent of 1990 levels.[22] Sharp and rapid increases in transport and energy prices, coupled with a higher cost of labor compared with other regions, combined to make the *krai*'s industrial output more expensive and consequently less in demand. The current situation remains uncertain, as there are signs of recovery among declining production trends.

Current structure. The diverse natural resources of the *krai* and the geopolitical interests of the Russian state established the historical industrial structure that underlies the *krai*'s present development trajectory. Industry is the mainstay and receives more than 40 percent of primary investments.

Khabarovsk Krai's machine-tool industry is unique in its diversity and consists of transport machinery (shipbuilding and ship repair and aviation equipment production), energy and electrical machinery production, machine-tool manufacturing, and radioelectric and electrical apparatus manufacturing. Within the timber industry, manufacture of wood fiber and wood chip tiles, furniture, and trim moldings used to be significant but is no longer. The chemical industry consists of specialized production by enterprises that deal with basic chemistry, pharmaceutical products, and synthetic cleaners. Light industry includes sewing, knitting, decorative ceramics, and native crafts. The food industry consists of two large sectors: household foods and fish processing.

The energy sector includes coal mining and production, and oil refining. The basis of the *krai* energy comes from city TETs (thermal electric generating stations) that together form three electricity grids (Khabarovsk, Komsomolsk, and Nikolaevsk) connecting the *krai*'s economically developed areas with low-energy power lines. The *krai*'s agricultural production is currently not able to meet demand and needs capital investment. Some analysts see great potential for agriculture as a source of high investment return.

Resource potential, natural constraints on development, and labor availability have caused uneven development across the *krai* and among the six primary industrial production centers of Khabarovsk, Komsomolsk-on-Amur, Solnechny-Gorny, Birobidzhan, Urgal-Chegdomyn, and Sovetskaya Gavan. In total, these industrial centers comprise about 10 percent of the *krai*'s territory. The remaining 90 percent is comparatively undeveloped and dominated by single resource use, such as hunting, reindeer herding and fishing, and

mining. Mining is found in almost all of the administrative *raion*s. In the center and south, forestry and agriculture are of primary importance.

Mining

I. DEBELAYA, J. NEWELL—The *krai*'s mountainous regions supply commercial quantities of rare and precious metals, as well as nonmetallic mineral resources, construction materials, and fresh and mineral waters. Out of 118 known minerals in the *krai*, there are only 34 with notable reserves, of which 24 are being mined.[23] Almost all of these notable mineral resources could feasibly be exported to countries of the Pacific Rim. These include hard and brown coal, gold, zinc, platinum, tin, iron-ore concentrates, alumina, peat, zeolites, vitreous and mold sands, cement, rocks for facing applications, gravel, sand, and various kinds of mineral water. The as yet unexploited deposits of molybdenum in the Okhotsky and Ayano-Maisky Raions, of tungsten in the pristine Sikhote-Alin and Badzhal ranges (near the Sea of Okhotsk coast), and of antimony and mercury, are potential sites for mining. Rare and rare earth elements found in the ores of a number of deposits in the Solnechny Raion, on the Aldan shield, and the large deposit of zirconium discovered on the Siberian platform also present potential expansion of mining activities. Initial exploration and assessment has been made of large reserves of titaniferous resources: compound titan-phosphate (apatite-titanic iron ore) ores that are of no lesser quality than the ores of the finest deposits in the United States and Canada, which are characterized by high titanium levels that are accessible through technologically simple means. The ores contain large quantities of apatite, and it is possible to extract not only high-quality titanic iron ore but also phosphoric concentrations that are essential for agriculture.[24] Practically all types of raw materials for agricultural chemical are to be found here: apatites, phosphorites, alunites, limestone, zeolite, and peat.

Current economic conditions make gasification of the hard-coal basins near Khabarovsk unprofitable, but this could change if the price of crude oil continues to rise. Oil and gas have been confirmed at the Bureya deposit, the Middle Amur valley, the eastern part of the Siberian platform, and in the Tatar Strait.[25] Some of these deposits also include molybdenum, tungsten, copper, lead, zinc, gold, silver, bismuth, arsenic, antimony, mercury, and rare metals. Aluminiferous materials are found in deposits of alunite, anorthosite, and bauxite in the Lower Amur. There is a proposal to develop a large aluminum processing plant that would produce alumina, metallic aluminum, aluminum sulfate, chlorine-free potassium fertilizers, sulfuric acid, and other compounds.[26] Of great importance to the entire Far East region are deposits of vitreous sands, cement limestone, building rock, clays, and sand-and-gravel mixtures. The huge deposits at Nilan could eventually support a facility

producing cement, slate, asbestos-cement pipes, materials used in land reclamation, decorative gravel, calcium carbide, and other products. The deposits of quartz sand are a source of raw material for industries producing sheet and bottle glass and glass for metallurgical casting molds.

The mining industry has been and will continue to be a backbone of the economy, and there is a strong resource base for expanding production of gold, tin, and other traditionally mined materials and of minerals that have not been exploited on a large scale. The few geological surveys so far conducted (particularly in the *krai*'s northern regions) leave open the potential for undiscovered reserves. The industry, in general, needs investment for geological surveys, to develop new deposits, and to modernize technologies.[27] The largest mining facility is in Solnechny where tin, lead-zinc, tungsten, and copper concentrations are mined.

Throughout the *krai*, the mining industry is characterized by the following considerations.[28]

- Uneven resource development. Mines in Komsomolsky, Solnechny, and Osipenko Raions are the most developed; the least developed are in the Okhotsky, Ayano-Maisky, and Tuguro-Chumikansky Raions.
- Potential for export of minerals. If new deposits are developed, the krai could become a major player in domestic and international mineral markets.
- Limited geological surveying. Exact figures of some mineral deposits remain unknown, particularly in the northern regions. Survey costs are high, primarily due to inadequate infrastructure and equipment and the remoteness of the sites.
- Wasteful mining practices. Losses range from 6 to 11 percent and 27 to 43 percent during alluvial dredging for gold, 9 percent for platinoid alloy, about 16.4 percent for tin, 28.2 percent for tungsten, 25.7 percent for copper, 45.1 percent for lead, and 29.2 percent for zinc.
- Lack of value-added processing of raw concentrates. The krai needs to increase processing of raw materials.
- Declining overall production. Lack of investment and modern technologies limits production.
- Large impact on the environment. Mining occurs in wilderness areas. Environmental assessment is necessary to optimize management practices and levy fines.

Environmental impact. Destructive open-cast and placer mining has damaged riverine fisheries and polluted important groundwater reservoirs, such as those near the villages of Solnechny and Gorny.[29] The most pressing problems related to mining center around the Solnechny mining complex. The ores are rich with compounds and, in addition to tin, contain more than ten chemical elements including arsenic, antimony, and cadmium. Almost all of these materials end up in tailing ponds, which often erode, and the toxic compounds are transported by water and air. Comparable problems occur in the large-scale underground coal mining operation in

Urgal, Verkhne-Bureinsky Raion. The harsh environment, including limited air circulation due to valley-mountain topography, and forest fires, intensifies these problems. Catastrophic exogenous processes have developed, such as the settling and slumping of topsoil. Destructive open-pit quarrying for construction materials (construction stones, clays, sand, and gravel) occurs primarily near most populated areas. Areas affected are found in all of the *raions* of the *krai*, but particularly in the cities of Khabarovsk, Komsomolsk, Nikolaevsk, and Vyazemsky.

Research done during explosions at the Korfovsky stone quarry has documented the formation of huge dust clouds, reaching 1.6 km in height and extending for up to 15 km, and with pollution levels often exceeding those permissible by 900–1000 times.[30] The dust has affected the health of nearby workers and residents, causing respiratory illnesses such as silicosis and chronic bronchitis. Air, surface waters, and groundwater carry solid, liquid, and gaseous toxins from open pits and strip mines.

Companies mine sand and gravel aggregates from the bed of the Amur River, and surface water carries sediment filled with suspended particles and petroleum-based pollutants. The aggregates are extracted by floating scoop devices. The turbidity of the water poured back into the channel is 40–50 times greater than that during flood stage.[31] This practice leads to development of deep depressions in the riverbed, which affects river flow and exacerbates erosion in river valleys. Although environmental protection agencies prohibit gravel mining during the downstream migration of salmonid juveniles and during the fall salmonid runs, sedimentation is nonetheless affecting spawning beds.

Gold. Nikolai Anosov, a mining engineer, is credited with being the first to discover alluvial gold deposits and thus the founder of the gold industry in the region. By official accounts, extraction began in 1871 on the Amgun River, 100 km from Nikolaevsk, when the Nizhneamursk Gold Company was formed.[32] Gold was mined in Kerbinsk, Amgun, Udil-Limuriysk, Lower Amur, Belaya Gora, Tumninsk, and Okhotsk. Much of the yield was controlled by the larger companies, including the Eltsov and Levashov Company, the Amgun Gold Company, the Okhotsk Gold Company, the G.I. Genrikhsen Enterprise, and the Novo-Udilsk Gold Association. These enterprises used technology and equipment characteristic of the time: dredges (steam- and electric-powered), excavators, gold-washing machines, steam-powered trains, and hydraulic mining.[33] As had California's early gold strikes fifty years before, Khabarovsk's gold rush attracted emigration to a largely unpopulated region, despite government efforts to prevent peasants from abandoning their land. The governor, Nikolai Muravyov, issued a decree in 1864 that prohibited peasants from working at the mines. This prohibition was renewed in 1903 and remained in effect until 1907.[34] With labor in short supply, the companies used a high proportion of Chinese and Korean labor. Gold yields grew, and for the eight years between 1899 and 1906, annual yields reached between 10 and 12 tons, after which output began to decline. These are official data; actual yields may in fact have been two to three times greater.[35]

There are important gold and silver deposits at the Mnogovershinnoe and Khabarovskkandzhinsk sites. The Yurev and Tas-Yurakh deposits are now ready

By Newell and Zhou / Sources: USGS (lode/placer), 1998; AGI, 2000 (coal); ESRI, 2002.

Map 3.2
Mining deposits of Khabarovsk Krai

SAKHA

Au

Khakandzha(Au, Ag)
Yurev(Au, Ag)
Au
MARIKANSKOE
Okhotsk

Au

Sea of Okhotsk

Au
Konder(Pt)
Au PGE

■ Konder(Pt)	Lode ore
▲ URGALSKY	Coal
– – –	Roads
Au	Placer

Shantar Islands

Au

0 200
km
N

Mnogovershinnoe(Au, Ag)
Au
Belaya Gora(Au, Ag)
Nikolaevsk-on-Amur

Au

Au

AMUR

Au
Au

Au

SAKHALIN

Tatar Strait

Urgal
Gorny KHURMULINSKY
URGALSKY Solnechny
Solnechnoe(Sn)
Komsomolsk-on-Amur

Au

Au

Vanino

JAO

KHABAROVSK
Korfovsky
Vyazemsky

CHINA

for gold ore extraction. Though Mnogovershinnoe GOK (Mining-enrichment combine) has begun processing gold ore deposits, the main volume of yield is still from alluvial deposits. About 70 percent of known reserves are ore, with the remainder being alluvial placer deposits.

In 1999 gold production reached 7 tons in Khabarovsk, 28 percent higher than 1998, largely due to resumption of production in Mnogovershinnoe. And in 2000, the *krai's* gold production reportedly doubled to 14 tons (see fig. 3.3). The firm, Mnogovershinnoe, which was established with investment of Neftyanaya Finansovaya Company, a subsidiary of Sibneft, produced about 1.2 tons of gold in 1999, even though it operated for only the last six months of the year. Further development of this facility will bring annual production to between 3 and 6 tons a year. The *artel* AS Amur, which mines both placer and ore gold and is one of Russia's biggest producers of platinum, began prospecting at the Ryabinovoe gold deposit and expects to produce a few tons of gold per year. Staratelely currently produces about 1 ton of gold per year and more than 10 percent of all Russian platinum. Development of the Tas-Yurakh deposit was again delayed; the license for this deposit is held by SP Tas-Yuryakh, a joint venture with the U.S. firm Pioneer Corporation and Delplast. Expected investment is about U.S.$27 million, with Pioneer supplying American equipment and technology. The deposit, if developed, is expected to produce about 2 tons a year. Development of the Khakandzha gold and silver deposit was also delayed; Okhotskaya Gorno-Geologicheskaya Company,

Table 3.2
Production of major gold mining companies in Khabarovsk Krai, 1999

Firm	Amount (kg)
OOO Mnogovershinnoe	1,150
AS Amur	825
AS ZAO Sever	650
OOO Ros-DB	600
OAO AS ZDK Primorye	450
ZAO Dalnevostochnye Resursy	450
AS PK Pribrezhnaya	350
AS Progress	350
OAO Primorzoloto	350
OOO AS Zarya	350

Source: Gorny Zhurnal, 2000.

a subsidiary organization of Polimetal, had plans to invest U.S.$21 million dollars by the end of 1999. The company expects an annual production of 4 tons of gold and 81 tons of silver.[36]

Placer mining in the *krai,* as in many other regions of the RFE, is undertaken by companies that have erratic production levels, with output varying considerably from year to year. The sharpest growth in the production of placer gold was by a company called Ros-DV, which in 1999 produced more than 600 kg of gold and has plans to increase production aggressively. Other major firms or *artel*s producing gold include Primorie, Pribrezhnaya, and Progress, each with outputs totalling about 350 kg in 1999. AS Amur plans to develop the Ryabinovoe deposit in Ayano-Maisky Raion, which would allow the company to at least double its annual gold production.[37] Table 3.2 shows the *krai's* major gold producers.

Platinum. Since 1986, AS Amur has been extracting platinum from a deposit at Konder, Russia's second largest in terms of yield and reserves. Particularly valuable are the reserves in the upper part of the site. Nuggets weighing 3.5 kg, the world's largest, have been found. Amur mines about 3 tons of platinum yearly.[38]

Coal. In 1932, V. Z. Skorokhod discovered the *krai's* largest hard-coal basin, the Urgalsky, located in the present-day Verkhne-Bureinsky Raion, and sixteen years later mining began via shafts, tunnels, and open pits. Intensive development of the deposits began in conjunction with construction

Figure 3.3
Gold production in Khabarovsk Krai, 1991–2000

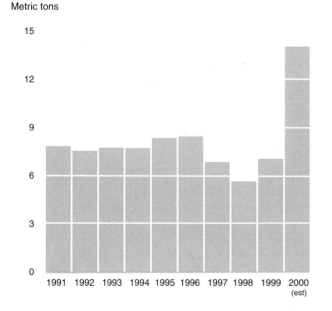

Metric tons

Sources: Gorny Zhurnal, 2000, and Vasenyov, 2001.

of the Baikal-Amur Mainline (BAM). Today, the shaft mine at Urgal, mined by AO (joint-stock company) Urgalugol, produces more than 1 million tons annually, one of the largest mines in terms of production in the RFE and the largest in the *krai*. Sands, gravel, construction stone, and brick clays are also mined at the site. The Tokinsk coal basin (coking coal) and the Liansk lignite deposits represent additional prospective sites. The government would like to expand production to increase coal exports, mainly to Japan. This is controversial because the *krai* annually has to import about 6 million tons of coal to feed its power plants from other regions of the RFE, mainly Sakha. Other major producers include Okhotskoe and Marikanskoe coal mining companies, which annually produce about 100,000 tons each. In 1997, the U.S. firm Quaker invested U.S.$2.2 million to develop the Khurmulinsky brown coal deposit near Solnechny, about 40 km west of city of Komsomolsk, but the coal was not suitable for power plants. By end of 1997, this plant was producing only about 100,000 tons, rather than the 500,000 tons originally planned.[39]

Tin. Mined primarily in the Solnechny Raion, tin is often extracted with concentrations of copper, silver, tungsten, and other metals. The Solnechny operation is Russia's largest tin-producing combine. Duran Impex, a Russian firm, recently took control of the company's stock. The company has three mines and the capacity to produce 14 tons of tin annually.

Table 3.3
Forest cover in Khabarovsk Krai

Dominant tree species	Coverage (000 ha)	Wood stock (million cu. m)
Total forest cover	52,503	5,265
Korean Pine	542	114
Spruce	7,958	1,329
Fir	573	72
Larch	29,079	2834
Pine	1,105	N/A
Ash	97	12
Yellow pine	849	100
White pine	4,109	218
Aspen	708	53
Open canopy, intended for forest cultivation	3,171	N/A
Nonforested land cover	15,823	N/A

Source: Goskomstat, 1998.

Reportedly the company is operating at about 65 percent capacity.[40] Most of the tin concentrate is either shipped to Novosibirsk for processing or exported abroad.

Timber

J. TASCH, J. NEWELL—Boreal forest growing on varying depths of permafrost typifies most of the *krai*'s forests. Larch forests dominate the landscape north and west of the Amur; to the southwest of the great river the forests are a mixture of larch and spruce. Korean pine and mixed broadleaved forests grow along the southern tributaries of the river. Table 3.3 shows the distribution, in terms of coverage and wood stock.

Production in the *krai* has fallen steadily since 1986.[41] In the meantime, however, the harvesting industry has switched its sights to the export markets of the Pacific Rim, initially shipping roundwood to Japan and South Korea, but increasingly trucking raw logs over the border to China.

By 1999, about 80 percent of all timber produced in Khabarovsk Krai was exported (4 million cu. m). Table 3.4 and map 3.3 show timber production for 2000, both by *raion* and by logging company. The major timber exporters in the *krai* in 1999 were Dallesprom, Forest Starma, Flora, and Smena Trading.

Both the quality and extent of forest cover have declined considerably in the *krai* over the past twenty years. Accessible forests have been heavily overcut. Regrowth after clear-cut logging has been marginal in many areas, with bushes still being dominant in many areas and hardwoods tending to come in before the commercial softwoods can return. Forest fires, almost entirely human-caused, have devastated huge areas. In the past fifty years, Khabarovsk has experienced approximately thirty thousand fires, and in 1998 alone, lost about 2.5 million ha of forest.

As the region is vast, it is useful to think of the *krai* as being divided into forest zones, as was done for a study by the Khabarovsk Forest Service. The six zones were based on several factors including climate and topography, forest type and use, forest regeneration issues, infrastructure, forest economy, and administrative responsibilities.[42]

Sikhote-Alin zone. Forests of the southernmost zone, the northern Sikhote-Alin Mountain Range, are the richest in terms of floral and faunal biodiversity. A number of existing and proposed protected areas are in this zone: Bolonsky Zapovednik, Mataisky Zakaznik (Hotspot no. 2), the proposed Anyui National Park (Hotspot no. 1), the Pikhtsa-Tigrovy Dom Zakaznik (Hotspot no. 4), and Khalkhadyan Zakaznik. Spruce and mixed spruce-larch forests cover the eastern part of the zone. The western section, technically classified as being a mixed deciduous and coniferous forest with oak, ash, walnut, yellow and white birch, aspen, poplar, Korean pine, spruce, and larch, has, after more than forty years of extensive logging, lost most of the coniferous overstory and the Korean

Table 3.4

Timber production in Khabarovsk Krai, 2000

Raion and Company . . . Amount (000 cu. m)

Solnechny Raion1,148	Vodolei88	Yasen50	Nikolaevsky Raion302
	Kato85	Ulikansky LPX42	Lazarevskoe94
Ulchsky Raion726	Arkaim68	Kaskad40	Nikolaevskles53
Evoronsky LPX249	Extrales63	Skimen-les34	Liman41
De-Kastriles223	Vaninolesexport61	Ves Mir21	Nord25
Gorinsky LPX161	Sovgavanles50	Magdusa18	Flox21
Rimbunan Hijau150	Ros-DV47		Nikolaevsky DOK20
Sredne-Amgunsky LPX 141	Tis45	Sovetsko-Gavansky	
Takhtinskoe67	Khorles43	Raion452	Nanaisky Raion263
Taiga66	Tumnin-les 238	SAR101	Sindinskoe LP61
Tzimmermanovskoe65	Chistovodnoe35	Nelma99	Gassinsky Model Forest . 23
Krona60	Vanino Marine Port35	Lazarevskoe72	Spektr20
Amgun59	Dallesstroy28	Fart55	Altai9
De-Kastrinsky	Mukhenskoe22	Lestransservice34	
Torgovy Dom43	Ost19	Business Center Anchor 29	Vyazemsky Raion 117
Klyuchevoi39	Progress11	Germes28	Vyazemsky LPX92
Monolit38	Modul8	Mezhdureche28	
Ves Mir38		Gector12	Poliny Osipenko Raion . . . 115
Harpin26	Komsomolsky Raion799		Cheatyn53
Mariinskles26		Verkhne-bureinsky	Amgun23
Flan18	Khabarovsky Raion93	Raion348	
	Shelekhovsky LPX188	Suluk122	Amursky Raion59
Vaninsky Raion1,211	Komsomolsky LPX135	Badzhalsky LPX 118	Yasen38
	JV Arkaim127	Skidder52	Snezhnoe37
Lazovsky Raion432	Vizir65	Dallestroi35	Kaskad32
JV Forest Starma370	Snezhnoe61	Mercury28	Litovsky LPX23
Vega126	Magma58	Urgal8	
Rimbunan Hijau114			Bikinsky Raion37

Total harvest6,393

Note: Only major logging companies are listed. Companies are listed in the *raion* where they are based, but some harvest timber in multiple *raions*. Company timber harvest totals reflect this.

Source: Khabarovsk Forest Service, 2001.

pine is now a *Red Data Book* species. The *krai*'s forest service estimates that during the past two decades the Korean pine forests in southern Khabarovsk have been reduced by half. Despite a relatively long history of logging within the zone, some of the world's most diverse temperate forests remain here. Nontimber forest products were harvested here long before commercial logging began, historically by indigenous peoples such as the Nanai and the Udege, and later by Chinese and Slavic peoples.

Many of the *krai*'s logging companies and leased logging sites are found here—the logging roads in the zone are extensive, and population density is relatively high. Construction of the planned roads from several communities within this zone to the seaports of Vanino and Sovetskaya Gavan will open up prime forests to increase logging and the harvesting

of nontimber forest products and the subsequent export of these products.

Komsomolsk zone. Moving north, the most boreal examples of the mixed Korean pine forests are found in this zone. The proposed Gur-Khoso Zakaznik (Hotspot no. 5) is located here, and the planned Dzhevdukha Zakaznik borders this zone and the Lower Amur zone. Badzhalsky Zapovednik overlaps this zone and the Upper Bureya zone. Bisected by the Amur River and located within its basin, the zone contains three main forest types. In addition to the mixed Korean pine forest, the northern section (as well as the zone's higher elevations) has forests of mixed larch and spruce, which grow on permafrost. The transition region contains examples of both.

The area has a long history of intensive logging, road construction, recreation, and subsistence use. With the closure of a pulp mill near Komsomolsk-on-Amur, local demand for roundwood has decreased. Sixty percent of the *krai*'s forest fires occur in this zone, and it is prevalence of forest fires combined with the industrial pollutants generated in and near Komsomolsk-on-Amur that prompted the Russian government to designate the area a disaster zone. The zone contains 700,000 ha of once-forested land, but much of the area has been transformed into grassland by fire and heavy logging.

Upper Bureya zone. Separated from the rest of the *krai* by the Bureinsky and Badzhalsky Mountains and bordering the Amur Oblast to the west is the Upper Bureya zone. The forests are mainly larch, with some areas of spruce. Permafrost is prevalent throughout much of the region. For several years a special logging agreement with the North Korean govern-

ment has permitted North Korean laborers to log near the town of Chegdomyn and give 60 percent of the roundwood cut back to the *krai* as compensation. The main industry within the zone is coal mining, and the Baikal-Amur and Trans-Siberian railroads cut through the region. Northern logging roads are few and far between, so helicopters provide access to hunting and gold mining camps in the more isolated regions.

Lower Amur zone. This zone hugs the eastern border of the *krai*, and includes the Tatar Strait and the delta region of the Amur, marshes and wetlands, and varied lowland and highland regions. The proposed Shaman-Yai Zakaznik is in this zone and the planned Dzhevdukha Zakaznik is located both here and in the Komsomolsk zone. Forests are of mixed larch and spruce. *Raion*s within this zone receive much of their revenues from logging, especially the port settlements on either side of the Amur and along the Strait.

With the exception of the town of Nikolaevsk-on-Amur, other industrial areas are remote. The region is connected to the *krai*'s capital, Khabarovsk, by road in the winter; the rest of the year the Amur River is the only route. Portions of the zone continue to be disturbed as a result of gold mining.

Coastal zone. Extending further south along the Sea of Japan is the coastal zone, bordered to the south by the northeastern portion of Primorsky Krai. Several proposed *zakaznik*s are located within this zone, including the Ulike, the Koppi, and the Nelma, as well as the recently created Botchinsky Zapovednik. Forests here are mixed spruce and larch, with more instances of spruce in prevalence; broadleaf species are common in the understory. The zone's two major towns, Vanino and Sovetskaya Gavan (both large seaports), have year-round access to the *krai*'s industrial centers via air, rail, and road. These port centers have facilitated extensive access to the zone's forests and have made it one of the *krai*'s most active logging regions. Although infrastructure to support logging is quite developed, timber extraction has been decreasing. The forests here also support salmon fishing, hunting and trapping, and commercial cranberry harvesting. Fresh timber stands are increasingly distant from coastal transport centers, and building infrastructure to

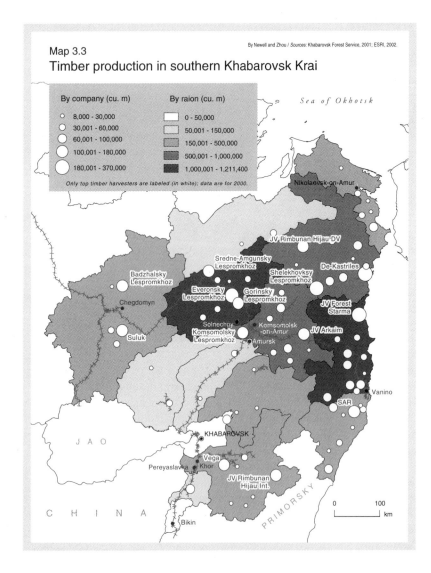

Map 3.3
Timber production in southern Khabarovsk Krai

An end to raw log exports?

An ambitious decree in spring 2000 by Governor Ishaev suggests official efforts to reorient the industry away from raw log exports. By 2003 all of Khabarovsk's timber-producing companies will export only processed and structural lumber.

According to the *krai* administration, this plan is feasible because the region's major timber enterprises have generated enough profits to allow reinvestment in facilities modernization. The administration has developed a number of proposals for investment focused on complete processing. The proposed projects include paper production at the Khor Biochemical plant and cellulose at Amurmash.

The administration suggests that the investment projects will increase profits by 10 to 15 times as well as create new jobs. To make this plan a reality, however, investments in the timber industry must be made by international concerns, and the *krai* is largely relying on investments from American manufacturers of timber equipment.[43]

By the end of the 2002, however, international investment in the industry had largely been for harvest and export infrastructure, rather than for wood processing and value-added manufacturing. Without such investments, foreign or otherwise, it is unlikely that the industry can develop the capacity and production standards to hold its own in the international markets for lumber.

– JN

access these stands is costly. Development of the coastal port of Nelma would, however, make it feasible to extract nearby stands for export to Japan.

Northern zone. This northernmost zone is mountainous, remote from industrial centers, virtually inaccessible by either rail or road, and has an extremely low population density (approximately 1 person per 10 sq. km). Dzhugdzhursky Zapovednik and the proposed Toromsky Zakaznik are located here. The region's forests are primarily larch with scrubby pine, and due to its northern latitude, forest productivity and harvest volumes per hectare are the lowest in the *krai*. Very little logging takes place in this zone, with small-scale operations confined to the southern portion and along a few river valleys. Large expanses of the region are used by local inhabitants for reindeer pasture, and snow sheep (*Ovis nivicola*) and brown bear feed a small demand for sport hunting.

Toward sustainable development

Josh Newell, Jeremy Tasch

Since 1994, several projects aimed at ecologically sustainable development have been implemented in the *krai*, with varying degrees of success. These projects have been funded by international organizations including the World Bank, U.S. Agency for International Development, the Canadian government, international NGOs, and others. Some overlap or are a component of the larger initiatives described in more detail in "Toward sustainable development," chapter 1.

Khabarovsk Krai forest law

At the beginning of 1999, in a collaborative project initiated by Khabarovsk Forest Service and involving regional and international NGOs, scholars, and local, national, and international forest service representatives, the *krai* drafted and passed Russia's first regional forest law. This law and the process by which it was created stand out as locally directed, regionally specific, and internationally important movements toward sustainable development. The law includes articles specifying regionally specific requirements for public auction and public review, forest lands leasing, nontimber resource development, and so forth. The process used for the forest law's development, which included public participation, input, and review in open meetings, as well as the law itself, is currently being used as a model in other regions of Russia. This law is an example of movement toward legislation that is regionally specific, encourages and incorporates public participation, and refines legislation that has been passed centrally and often devalues local ecological considerations. Even proponents of the law acknowledge, however, that, although it may be well written, forest service officials and the regional administration have not moved to implement it.

Gassinsky Model Forest Project

This project includes about 270,000 ha of forest and is part of Canada's International Model Forest program. Funding (C$3 million) for the four-year project, 1994–1998, was provided by the Green Plan for International Partnerships Fund, administered by the Canadian Department of Foreign Affairs and International Trade. The project focuses on "model forest values and the need to develop local solutions," and has conducted an extensive ecological survey of the forest territory. In 1999, the project was extended to integrate economic development efforts in the forested territory of the indigenous Nanaisky Raion. Ecologists and advocates for indigenous people express concern, however, that Canadian

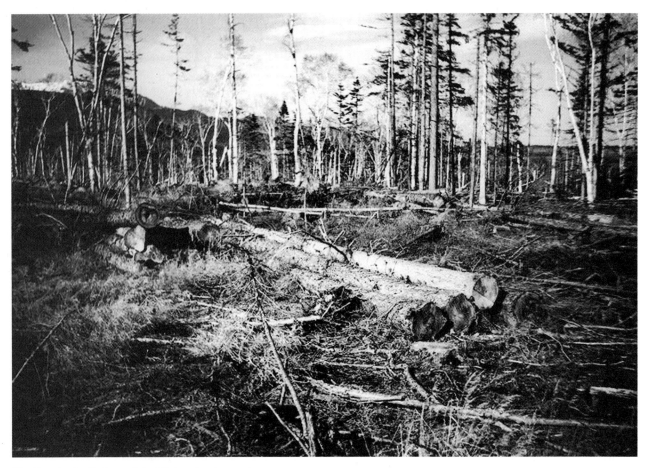

Most logging in Khabarovsk is still done by clear-cuts.

investment will strengthen the local timber industry at the expense of local Nanai who depend on the forests. Others have suggested that the model forest is being used to help Canadian timber companies get a foothold in the RFE timber market.

World Bank Forestry Pilot Project

The World Bank initiated a U.S.$60 million Sustainable Forestry Pilot Project in 1999, with Khabarovsk Krai as one of three pilot regions. The other two are Leningrad Oblast in the northwest region of European Russia and Krasnoyarsk Krai in central Siberia. The project has three main components. The first aims to support sustainable forest management through policy reforms, forest land-use planning and information management, improved forest protection, and regeneration. The second supports regional administrations in restructuring forest industrial enterprises, offering training programs in improved forest harvesting and processing technologies, management and business practices, and the improved use of nontimber wood products. The third supports public management and project coordination, including technical assistance on implementation, financial management, and monitoring.

USAID-funded forestry project

In July 2000 USAID launched a five-year, $20 million Forest Resources and Technologies Project, working in the Russian Far East, Siberia, and Moscow. The project's major objectives are to reduce the threat of global climate change and to preserve biodiversity by promoting sustainable forestry management and preserving Russian forests as a globally important carbon sink and critical habitat for rare and endangered species. There are four primary components to the project: forest fire prevention, pest management, the development of nontimber forest products and secondary wood processing, and the development of renewable energy alternatives, including biomass generation. Also included are forest policy and legal reform, applied forestry research, and a forestry grant and loan program. The project, still in planning stages, has been criticized by some Russian government officials for not providing necessary financial support to the agencies and bodies responsible for forest management.

Indigenous peoples

Boris Voronov, David Gordon

Eight ethnic groups inhabit Khabarovsk Krai (see map 3.4). The largest of these, the Nanai, number about 10,000 and live primarily in the lower Amur basin. In Chursky Raion, there are about 2,500 Ulchi. In the lower reaches of the Amur River, about 2,500 Nivkhi make their home. This area and the Amgun River valley are also home to 500 Negidals. In the Khor and Anyui River basins, there are about 1,000 Udege; in Vaninsky Raion along the Tumnin River there are several hundred Orochi. There are more than 3,500 Evenks and about 1,500 Evens in the northern part of Primorsky and Khabarovsk Krais. Some Yakut families also live in the northern regions of the *krai*, although they are not considered native to the region. At present about forty traditional land-use territories, an area of 30 million ha, are set aside throughout the *krai* for indigenous peoples; their interests are represented by the Association of Indigenous Peoples of the North, which has offices in the city of Khabarovsk.

Land rights

In 1992, after a decree from the governor, the *krai* administration started to determine the borders of Territories of Traditional Nature Use (TTPs) and to develop a set of regulations for them. Eight years later the government is still searching for an effective mechanism for interaction between native peoples and the timber industry, even though much of the TTPs are covered by forest.

Indigenous peoples do not hold title to or own their own territory and do not have the right to allocate resources from their traditional territories. Regional governments have those rights. Regional legislation allows some natural resource comanagement, and there is a provision in the federal law for native self-management. Indigenous peoples are trying to gain title to at least some of a properly defined traditional-use area and an effort is being made to map and inventory traditional-use areas. The *krai* has forty TTPs, which include pristine forests and forests designated for commercial timber harvest. It is clear that government management and industrial use of these lands is often not in the best interests of local people.

Even though TTPs are officially recognized and formalized on paper, government bureaucrats have always ignored them when making natural resource allocations. Logging operations are violating these rights and laws throughout the region in such *raion*s as Verkhne-Bureinsky, Vaninsky, Sovgavansky, Solnechny, Ulchsky, and Lazovsky.

Given government guarantees of public participation, some indigenous peoples attend meetings and are becoming involved in a debate with policy makers and legislators over forest management. Many indigenous peoples in Khabarovsk region and, indeed, throughout the RFE, do not.

Russia's difficult economic conditions make indigenous peoples especially vulnerable. In the villages, native peoples are fighting not only for ethnic survival, but also for physical survival. To protect traditional lifestyles, it is necessary to protect the landscape—the forests that are the basis for life for native peoples.

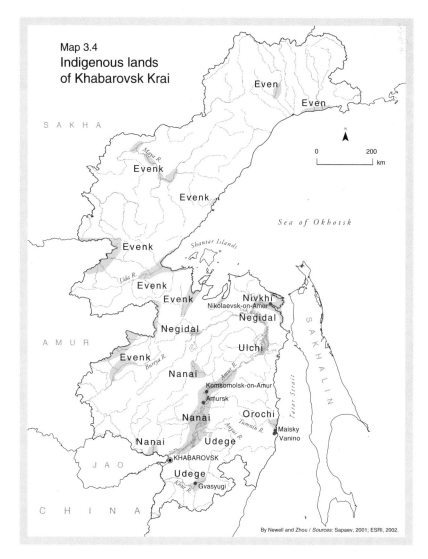

Map 3.4
Indigenous lands of Khabarovsk Krai

By Newell and Zhou / *Sources:* Sapaev, 2001; ESRI, 2002.

The Khutu, the Butu, and Arkaim

The Khabarovsk Regional Association of Indigenous Peoples of the North (Khabarovsk RAIPON) is using the small taiga river Khutu to get the government to produce an environmental impact assessment to determine what effect timber harvest will have on the forest, the wildlife, and the fish before that government issues a license to harvest in the watershed. The headwaters of the Khutu River, in Vaninsky Raion, contain a *zakaznik*. Salmon, including endangered cherry salmon (*Oncorhynchus masu*), enter the Khutu and its tributary, the Butu, to spawn. The watershed's coastal range has fur-bearing animals and deer. The people indigenous to this region are the Orochi.

In February 2000 the joint venture Arkaim started to pressure the *krai* administration to allow it to develop the region's forests. At the same time, P. Slobodchikov, chairman of the local Committee on Environmental Protection, asked Khabarovsk RAIPON to help defend the TTP in the Khutu watershed from Arkaim. In response to a letter from Khabarovsk RAIPON, the administration said that it was not going to give the forests of the Khutu watershed to Arkaim. Yet in June 2000, after the Committee on Environmental Protection was liquidated, Arkaim again asked for permission to log forests in the Khutu.

This request provoked representatives from Khabarovsk RAIPON, including Galina Volkova, the director, and Irina Bogdan, an environmental lawyer and chair of Khabarovsk RAIPON's advisory board, to go to the Khutu to talk with local people and to meet with Arkaim representatives. At a public meeting it became clear that the local people had not been consulted before the license was approved. Indeed, they had not even been informed that the concession was under consideration. Arkaim was not able to report on the potential effects of logging on the Khutu watershed because no government environmental expert review (*expertiza*) had been conducted. The meeting concluded with a demand for an *expertiza* before any license is issued.

According to the Khabarovsk law on Territories of Traditional Nature Use for Indigenous Peoples of the North, economic and all other issues must be resolved in the "interests of assuring a traditional way of life for these peoples." The Russian Federation and Khabarovsk are allowed to annex land in indigenous peoples' traditional-use areas only in specific cases. In the Khutu, the Orochi's traditional way of life is hunting and fishing; irrational or unwise logging will damage these resources.

Russian forests are federal property, and article 36 of the Federal Law on the Protection of the Environment requires an *expertiza* for government actions that pose a direct threat to the environment. In article 91 of the Khabarovsk Forest Code, a commercial timber tender must be preceded by a report on the environmental impact. All estimates of timber harvest fees and compensation payments are subject to the same *expertiza* process. No *expertiza* has been conducted on the commercial timber tender or the logging plans for the Khutu.

As a result of Khabarovsk RAIPON's advocacy, the administration agreed to negotiate with the association. Together, they zoned the territory. The administration agreed to protect a fisheries refuge, an ecological corridor, key hunting grounds, and places with endangered plant or animal species from logging. Khabarovsk RAIPON was also allowed to make suggestions for conditions under which the concession would be awarded. The association is now working with regional and federal authorities to make sure that this environmental assessment is completed.

Alexander Panichev

The Udege live in southern Khabarovsk.

Legal issues

Tamara Yezhelya

Adoption of the Khabarovsk Krai law *Ob osobo okhran-yaiemikh prirodnikh territoriyakh* (On Specially Protected Territories) must not be delayed. This law, though regionally enacted, will function at the federal level and would regulate the protected territories. Nor should there be a delay in publishing the planning document that will define the process of designating land for protected areas in the future. The efforts of scientists of Khabarovsk and Primorsky Krais, with international cooperation, have resulted in a conceptual strategy for biodiversity conservation. It outlines the creation of an ecological framework for the RFE and a system of consequent practical activities. Economic, legal, and organizational support for this work is essential in order to fulfill the responsibilities assumed by Russia in the Convention on Biodiversity.

Perspective

Josh Newell, Dmitry Aksenov, Mikhail Karpachevsky, David Gordon

Rimbunan Hijau moves in to log Khabarovsk's forests

In 1998, the Malaysian multinational logging corporation Rimbunan Hijau secured two forty-eight-year logging leases in Khabarovsk Krai, one (550,00 cu. m per year) in the Sukpai River basin about 150 km from the city of Khabarovsk and the other (485,000 cu. m) in the Bitchi River basin in Ulchsky Raion in the north. Rimbunan began logging in 1999, and in 2000 emerged as the second-largest timber producer in the *krai*, producing 150,000 cu. m from the Bitchi concession and 114,000 cu. m from the Sukpai concession. Despite a formal agreement in the lease to develop timber-processing capabilities, both ventures thus far have produced logs only for the region's main export markets—Japan, China, and South Korea. In 2000, Rimbunan exported 73,000 cu. m to those countries from the Bitchi site and 58,000 cu. m from the Sukpai site. Environmentalists from the region point out that the company has no intention of ever processing timber for export.[44]

Viktor Ishaev, the governor of Khabarovsk, personally courted Rimbunan, and thus the company enjoys strong political support in a region controlled by a few key political figures and industrialists. Pointing out that the deal with Rimbunan was made at the same time as the Malaysian government purchased jet fighters that were built at a defense factory in Komsomolsk-on-Amur, environmentalists suspect that the logging concession was not awarded to Rimbunan on entirely fair terms.

NGOs and Russian scientists are most concerned about the Sukpai lease (361,454 ha), as the Sukpai River is a major tributary of the Khor River and part of the western slope of the biodiverse Sikhote-Alin Mountain Range. The forests of the Sukpai are spruce-fir (66 percent), with the remainder larch and birch dominant. Logging and timber processing did not arrive in the Sukpai region until the beginning of the 1970s, when a small settlement of the same name was established at the river mouth. Until now, logging has taken place only in the lower part of the basin. The Sukpai region is well known for its ecological values; little is known about more inaccessible Ulchsky Raion, where the Bitchi concession is held.

The company has been very secretive about its operations, avoiding engaging with NGOs and even the media in Khabarovsk. In meetings with Rimbunan and government officials in Khabarovsk, NGOs, despite extensive efforts, were unable to obtain the business plan, prefeasibility study, or even the lease agreement.[45] The general public and even the local communities to be affected are largely unaware of Rimbunan's plans or the financial arrangements made between the company and the local administration. Many regional government officials oppose the project. "I have always been against the Rimbunan tender and their coming to our area," maintains Viktor Surkhov, former head of the Interdistrict Committee on Environmental Protection of the southern territories of Khabarovsk Krai. Surkhov has pointed out repeatedly that the region cannot sustain the logging volumes that Rimbunan has plans for:

> The forest is not that valuable in terms in economic value, but is more important for environmental reasons. Generally, the region is mountainous; there are numerous slopes over 30 degrees (where logging is forbidden) and a large number of protected rivers and streams. As a result there is not that much forest for logging and definitely not enough for forty-eight years. There is enough timber for five to ten years at Rimbunan's annual projected cut of 550,000 cu. m. It is better to stop Rimbunan today than have them leave in ten years after infrastructure has been developed and communities are dependent on them.[46]

The Russian government originally designated the Sukpai River basin as a future protected area. In response to this governmental decree, in 1994, researchers from IVEP in Khabarovsk prepared an ecological-economic justification for creation of the Verkhne-Sukpaisky Zapovednik to protect the upper and middle portions of the watershed. This proposed *zapovednik*, after gaining support from the Khabarovsk Committee on Environmental Protection, was listed in Chernomyrdin decree No. 572-r, which outlined a comprehensive plan for creation of *zapovednik*s and national parks to be created between 1994 and 2005. The Khabarovsk

Hunting remains an important economic component of village communities in the RFE.

and enhancing the economic benefit of the Rimbunan venture needs to take place.

The public, NGOs, and local administrations need more information about Rimbunan's plans. This can occur only if documents are made publicly available and NGOs, local government and communities, and media regularly consulted. Opening up this consultation to public scrutiny will also minimize collusion and corruption among Khabarovsk's government officials. Russian NGOs need to be financially supported if they are to monitor both of Rimbunan's logging operations regularly.

Essential questions about the operations still remain unanswered:

How will the venture improve the economic and social conditions of Sukpai and nearby communities? Clearly Sukpai settlement and those small communities along the Borskaya railroad, which links the region with the Trans-Siberian Railroad, need economic development but, if Rimbunan plans only to log in the region for five to ten years as rumoured, will the benefits be long lasting? Will Rimbunan commit itself to processing timber to provide more income and jobs for the local community? Will Rimbunan and the government resurrect the Borskaya railroad or will they seek to open up new forests in the Samarga and Nelma River basins? Has there been a study proving the long-term benefits of the venture? Is the local community sufficiently aware of how Rimbunan operates in other countries, such as Papua New Guinea? It appears the Khabarovsk government did not explore other options for the Sukpai region to diversify a regional economy already largely dependent on logging. It also appears that the tender was issued through a closed process, and other bids were not received. NGOs would rather see other smaller forestry companies, with a much better logging record than Rimbunan, develop the region as an alternative to the large-scale logging planned by Rimbunan. Local hunters and fishers in the area fear that large-scale logging will damage their resource base, and although Rimbunan will provide jobs for some Sukpai residents, the number of jobs is not well known.

How will the timber be transported out of Sukpai? There are conflicting reports of Rimbunan's long-term plans to export the timber. From the Sukpai site, most of the timber is exported by railroad and road to the Trans-Siberian Railroad and then out of the port of Nakhodka in Primorsky Krai.

government did not, however, have either the financial means or the political will to follow through on the decree. Such transfer of land slated for conservation to industrial logging (or any other intensive land use for that matter) sets a dangerous precedent in Russia. Part of the justification for this land transfer was that, due to fires and logging, the Sukpai had minimal ecological value. However, an analysis completed in 2002 by Greenpeace-Russia and the remote sensing firm ScanEx (Moscow) revealed that significant frontier forest habitat remains in the area once proposed as a *zapovednik*. Russian NGOs would still like to see the area protected, perhaps not as a *zapovednik* but as a *zakaznik*, which would permit traditional use of nontimber forest products but would prohibit large-scale logging, mining, and road development. Given that logging has already begun and economic conditions in the town of Sukpai and nearby settlements are dire, a more realistic approach to limiting the environmental impact

According to Grigory Markov of the Khabarovsk logging department, Rimbunan is developing plans to extend the Sukpai road across the Samarga to the port of Nelma. This would open up the unroaded Samarga River basin, which is home to the Udege peoples, to logging and would allow Khabarovsk to receive port transfer duties and export taxes, which the *krai* would not have access to if the timber were exported via Nakhodka. Environmentalists strongly resist this road because it would effectively divide the northern Sikhote-Alin from the central Sikhote-Alin, fragmenting previously unroaded habitat and wildlife corridors. Field research in August 2000 confirmed suspicions that Rimbunan is building the Nelma-Sukpai road: Construction from the Sukpai side had reached the Primorsky Krai administrative boundary.

However, the Primorsky-based logging giant, Terneiles, recently won a twenty-five-year tender to log the Samarga River and, according unconfirmed reports, does not want RH exporting timber through the region. Terneiles has plans to expand port capacity at Adimi, a small port in Primorsky region, as the company and the Primorsky government want to control exports from the Samarga, rather than exporting Samarga timber through Khabarovsk-based Nelma port. Yet another possible scenario currently under consideration by Khabarovsk officials is to build a road from the Sukpai to intersect the west-east paved Lidoga-Vanino road.

Time and influence from various interest groups will determine which timber export route is chosen. All the potentially affected communities, however, need to be involved in the decision. Rimbunan's secretive political dealings shut them out. The Nelma-Sukpai road would permanently change the lives of the Udege in the Samarga, open the region up to large-scale logging, cripple the small towns, including the Sukpai, along the Borskaya railroad, and effectively fragment northern Sikhote-Alin old-growth forests.

What will be the ecological effects of large-scale logging on the watershed? As very few documents have been made public, it is difficult to assess the future effect on the ecology of the region. According to Viktor Surkov, much of the forest lies along steep slopes of more than 30 degrees and, due to extensive river systems, a significant percentage is Group I forest. Therefore, Surkov estimates the watershed will be commercially logged out in no more than ten years. This raises serious questions about the allowed annual cut, the type of logging to be conducted, and the long-term commitment of Rimbunan in the Sukpai region. Also troubling is the virtual absence of ecological data in the initial leasing tender documents, prepared by the Khabarovsk Forest Inventory Department, which found "no evidence of the presence of Russian *Red Data Book*–listed plants and animals in the area."

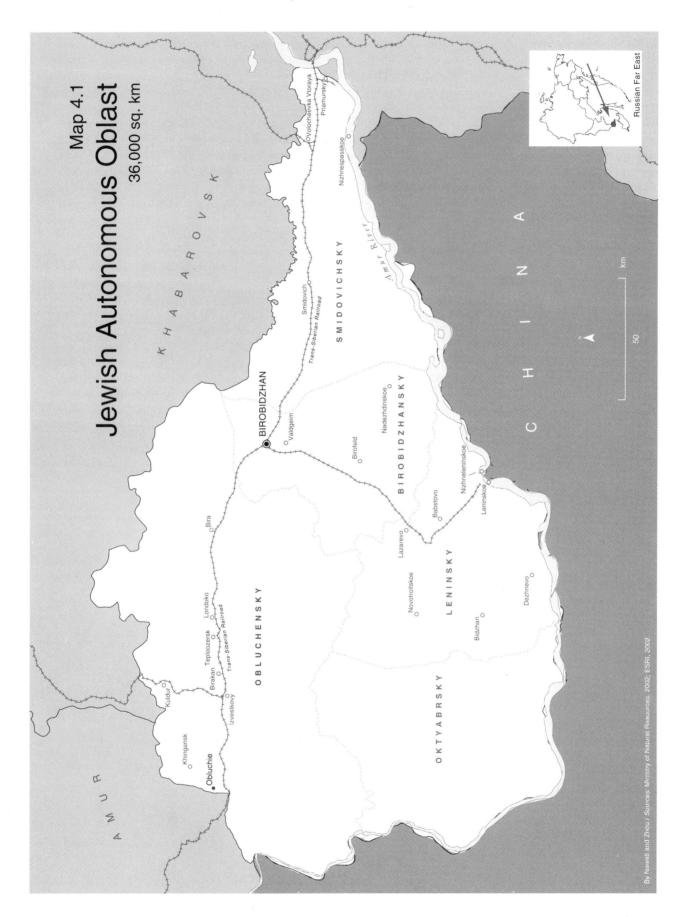

Map 4.1

Jewish Autonomous Oblast
36,000 sq. km

Russian Far East

JAO

KHABAROVSK

Ovolochaevka Vtoraya
Priamursky
Nizhnespasskoe

Amur River

SMIDOVICHSKY

Smidovich
Trans-Siberian Railroad

BIROBIDZHAN
Valdgeim
Nadezhdinskoe
Birofeld

BIROBIDZHANSKY

CHINA

Nizhneleninskoe
Babstovo
Leninskoe

Bira

Lazarevo

LENINSKY

Novotroitskoe
Dezhnevo

Bidzhan

Londoko
Teploozersk

OBLUCHENSKY

Birakan
Trans-Siberian Railroad

OKTYABRSKY

Kuldur
Izvestikovy

Khingansk

A M U R

Obluchie

N

km

50

By Nawest and Zhou / Sources: Ministry of Natural Resources, 2002; ESRI, 2002.

CHAPTER 4

Jewish Autonomous Oblast

Location

330 km from west to east and 200 km from north to south, the tiny Jewish Autonomous Oblast (JAO) borders the Amur Oblast to the west, Khabarovsk Krai to the north, and China to the south across the Amur River.

Size

36,000 sq. km; slightly larger than the Netherlands.

Climate

JAO's relatively mild climate is similar to that of neighboring Amur Oblast, and thus more suited to agriculture than most other parts of the RFE. Winter temperatures range from –5°C to –40°C.[1] Annual precipitation in the plains is between 400 and 450 mm, with 75 percent occurring during summer.

Geography and ecology

The JAO is divided into two main geographical regions: mountains and plains. The Khingan-Bureya range runs along the western and northwestern part of the *oblast*. Other major mountain ranges include the Maly-Khingan, Sutara, Pompeevsky, and Shuki-Poktoi. The middle Amur plains cover the eastern and southeastern portions, which are blessed with four distinct ecosystems: Amur or Manchurian mixed and deciduous forests, Okhotsk-Kamchatka spruce-fir taiga forests, East-Siberian or Angara light conifer taiga forests, and Dahurian-Mongol steppe. The Bira and Bidzhan Rivers both begin in the mountains in the western part of JAO and flow south before emptying into the great Amur River, which forms the western and southern border of the *oblast*. The region's other major river, the Tunguska, flows through marshy plains and wetlands and also drains into the Amur. The average yearly water flow totals 226.4 cu. km. The rich *blackzem* soils of the lowlands in the south and southeastern parts of the JAO provide excellent agricultural land, which totals about 15 percent of the *oblast*'s land area.

Forests carpet 44 percent of the JAO, 17 percent (395,000 ha) of which are Group I forests. About 85 percent (5,579,000 ha) of these forests are coniferous, mainly Scots pine (*Pinus silvestris*), Ayan spruce (*Picea ajanensis*), Siberian spruce (*P. obovata*), and Dahurian larch (*Larix gmelini*). Broadleaved hardwoods make up the remainder and include Mongolian oak (*Quercus mongolicus*, 60 percent of the total). Uncontrolled clear-cut logging has destroyed vast areas of forests, particularly the valuable Siberian forests growing in the Birobidzhansky, Leninsky, and Oktyabrsky Raions. Today, most of these once-rich forests are secondary, relatively species-poor deciduous forests. Over 125,000 ha

of previously forested areas are now barren. Some of the forests have regenerated naturally. However, in the central and southern parts of the JAO, natural regeneration is slow, mainly because of past and present logging, land conversion for agriculture, and forest fires. Scientists estimate about 25 percent of old-growth forests remain in the region.

Flora and fauna

In the JAO four ecosystem types come together to create a rich diversity of flora and fauna, including 60 species of mammals, 280 species of birds, 7 species of reptiles, and 73 species of fish. The JAO, despite its small size, has over twelve hundred species of plants, including 178 rare and endangered species. Notable species include the Himalayan bear (*Ursus thibetanus*), Komarov's lotus (*Nelumbo nucifera* var. *komarovii*), and numerous endangered birds and fish.

Largest city

Birobidzhan (pop. 87,000).

Population

205,000. About 4 percent of the population is Jewish.[2] A third of the population still lives in agricultural villages. There are no indigenous peoples living in the JAO.

Political status

Established in the 1920s by Stalin for Jews who were persecuted or unwanted in western Russia and to attract wealthy Jews from overseas, the region has served as a buffer between Russia and China. Prior to their arrival, except for a few Cossacks and Koreans, the region, part of Khabarovsk Krai, was uninhabited.[3] In 1934 the Jewish population peaked at 20 percent. In 1991, as the Jewish Autonomous Oblast, the region became independent.

Natural resources

The JAO is rich in mineral resources, particularly for a region so small. Tin deposits of around 17,233 tons are found primarily in the Khinganskoe and Karadubskoe regions. Copper, zinc, silver, molybdenum, gold, and other mineral deposits are found in combination with the tin. Manganese and iron deposits are primarily in two large deposits at Bidzhanskoe and Yuzhno-Khinganskoe. Placer gold deposits (in estimated reserves of 1,570 kg) are found mainly in the Sutara River. The world's second largest deposits of brushite, with commercial deposits totaling 4.38 million tons, are also found in this region; much of the production comes from Brusitovy Quarry.[4] The region's Sounenskoe graphite deposit is also one of the world's largest.[5] There are seven deposits of brown coal, including a particularly large one near Birobidzhan. Initial geological surveys reveal considerable oil and

Key issues and projects

Loss of forest cover

Because of logging and fires, the forests are shrinking by about 1 percent every four years. Heavy logging at higher elevations has disrupted the water balance of the Bira River, affecting the lower, marshy regions that are productive for agriculture (see p. 192).

Placer gold mining

To diversify the economy, the JAO government is again opening up the region, in particular to placer mining, and hopes to expand production to 500 kg yearly. Of particular concern is the opening up of the Sutara and Pompeevka Rivers to mining (see p. 193).

Rising interest in China

Chinese firms have interests in the region's timber, coal, and mineral resources.

Emigration

Since *perestroika*, thousands of the Jewish residents of the *oblast* have emigrated to Israel (see pp. 194–95).

Figure 4.1
Industrial production in the Jewish Autonomous Oblast, 1999

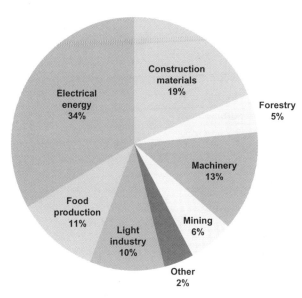

- Electrical energy 34%
- Construction materials 19%
- Forestry 5%
- Machinery 13%
- Mining 6%
- Other 2%
- Light industry 10%
- Food production 11%

Source: Goskomstat, 2000.

gas deposits; reserves may amount to as much as 100 million tons of oil and 5 billion cu. m of gas.[6] Numerous gravel and sand reserves are used to make concrete and road construction materials. Large clay deposits are also used for a variety of construction purposes.

The region has fertile agricultural land primarily in the floodplains of the Amur, Bidzhan, and Bira Rivers. Arable land totals 161,000 ha.[7] Its close proximity to China makes the *oblast*'s shrinking forest resources attractive for logging and export. The Kuldur hot springs, famous throughout Russia, represent a considerable recreational resource.

Main industries

Energy generation, food production, and light industry, particularly the garment sector, have traditionally been the mainstays of the economy (see fig. 4.1). In Soviet times, the region also produced agricultural machinery. Analysts doubt that the machinery and light industries will revive due to competition from neighboring China, which can produce such goods more cheaply. The JAO government wants to expand gold, coal, and iron mining to diversify the economy. The *oblast* is also devoting financial resources to expanding the logging industry. Exports of raw logs to China are a major source of hard currency revenue.

Infrastructure

The Trans-Siberian Railroad and the Amur River system are two major means of transport for both freight and people. There is also a well-developed 1,900 km road infrastructure. A road across the Amur River has just been built, making it possible to drive from Birobidzhan to Khabarovsk in just two hours. The three border crossings (Nizhneleninskoe, Amurzet, and Pashkovo) with China, through which cargo and passengers travel, provide links with the Chinese cities of Tuntzian, Minshyan, and Syain, respectively. The airport connects Birobidzhan with other cities, and there are plans to modernize it and open a route with Tsyamushi in China.

Foreign trade

International trade does not play a large role in the economy, but trade with China is growing. In 1998, the official international trade turnover was under U.S. $10 million.[8] The other

Yuri Shibnev

A blue-and-white flycatcher (Cyanoptila cyanomelana) *feeds her young.*

major trading partner is South Korea. Major exports are garments and timber. In 1998, small logging companies exported about 50,000 cu. m of raw logs to China. The governor, Nikolai Volkov, has a reputation for aggressively seeking foreign trade and investment.[9]

Economic importance in the RFE

The JAO is important as a breadbasket for the RFE, where agricultural land is limited. During Soviet times, the region supplied grain, potatoes, meat, and milk to Khabarovsk Krai and northern regions of the RFE. The *oblast* also has large supplies of some scarce minerals, including brushite. Close proximity to China has given the *oblast* a new economic importance.

General outlook

Few realize how important the forests growing in the west along the Maly-Khingan and Sutara Mountain Ranges are in regulating water flow and maintaining water quality for the lower marshy plains in the east that are so essential for agriculture, the lifeblood of the region's economy. Forests used to carpet between 65 and 70 percent of the *oblast*, but the figure is down to 44 percent, and the forests are going at a rate of 1 percent every four years. Loss of forest cover has reduced the productivity of agricultural land by reducing the quality of the soil and threatens endangered species by reducing and fragmenting their habitat. Logging is a major reason for the declining forest cover, but conversion of forest land for agriculture is also a major contributor. An influx of Chinese capital to the timber industry has occurred since 1999 as Chinese firms hope to exploit the forests. Logging needs to be strictly controlled and limited to protect the remaining forests and help ensure that agricultural land remains productive. Reduced agricultural productivity will lead to increased wetland reclamation, particularly in the poorly protected Central Amur lowlands, which are, among other things, prime habitat for a host of endangered migratory birds.

With similar resources and geographies, the problems and prospects of the region resemble those of the neighboring Amur Oblast. Like Amur, the Jewish Autonomous region is faced with a declining agricultural production and the government response has been to subsidize the placer gold mining industry to diversify the economy (see table 4.1).

The regional government plans to continue to open up the central Khinganskoe belt, which is rich not only in gold but also in coal and tin. In 1999, the regional government spent nineteen million rubles, half on geological surveys of the region, half on exploration for gold. Gold mining began in earnest in the 1930s, when placer mines were developed along the Sutara River; this continued until mining ceased in the mid-1960s. The government hopes to raise gold production to half a ton—a significant increase from 1998 when only 90 kg were mined.[10] Ecologists worry that salmon

Table 4.1
Employment by industry within JAO, 1999

Industry	N
Education	8,542
Industry	6,417
Health and welfare	5,714
Administration	5,227
Transport	5,055
Agriculture	3,314
Construction	3,101
Culture and art	1,663
Communications	1,243
Credit and finance	803
Forestry	534
Science	342
Insurance	120
Total	*42,075*

Source: Goskomstat, 1999.

Small forest rivers are critical habitat for mandarin ducks (Aix galericulata), *scaly-sided mergansers* (Mergus squamatus), *Blakiston's fish-owls* (Ketupa blackistoni), *and many endangered species of freshwater clams.*

spawning tributaries of the Sutara and Pompeyevka Rivers will be opened up; fish populations have declined in many lower reaches of the region's major rivers and scientists point to destructive gold mining as a major cause.

As in Amur, regional administrators are trying to retool the economy to serve the import needs of China. In addition to exporting raw logs, both regions hope to capitalize on China's expected booming demand for other raw materials such as coal, tin, and iron ore.

Always in search of an identity to distinguish itself, the region should consider stepping away from traditional methods of economic recovery, such as subsidies for the mining industry, and market itself again as a center for processing. In Soviet times, the region had thriving garment, food production, and agricultural machinery industries. It has been pointed out, however, that the region will have trouble competing with nearby China, which can produce such goods more cheaply. Some foreign investment or increased commitment from Moscow will be necessary for these industries to develop. The Kuldur hot springs remain a largely underdeveloped resource; with responsible development they could be a major tourist attraction both for Russians and those coming from abroad.

— *Josh Newell*

Ecology

Vasily Gorobeiko

See pp. 179–80 for an overview of the region's ecology.

Protected area system

The protected area system includes Bastak Zapovednik and five regional *zakaznik*s (see table 4.2). There are also eighteen natural monuments. Although 9.8 percent of the *oblast*'s total land area is under some form of protection, one cannot say that there is a system of protected areas in the *oblast*. First, there is no hierarchical structure of protected areas. Second, those natural landscapes currently protected are similar to one another. Only four natural monuments are located in the Central Amur lowlands; all of the other protected areas are on the spurs of the Maly-Khingan range. Third, numerous natural monuments do not correspond to criteria outlined in federal protected area law. The creation of an integrated system is essential to preserving biological diversity and the unique natural systems in the *oblast*.

Given today's economic crisis and the mounting pressure from poaching, the *zakaznik*s are in an extremely difficult situation and incapable of fulfilling their function of protecting nature. Moreover, despite the impressive size of these *zakaznik*s, they are all situated on the peripheral mountain massifs of the Maly-Khingan whereas territories that should be preserved, such as the central areas of the Khingan mountain massif, wetlands, and marshes, are being actively exploited.

The Amur Valley is one of the last places on Earth where large areas of tallgrass prairies are still relatively intact.

Vladimir Dinets

Of the eighteen natural monuments established in the JAO, only five are under the jurisdiction of the *oblast*. The others, in violation of existing laws, are under the jurisdiction of the Khabarovsk Krai and the *raion*. According to article 26 of the law On Specially Protected Nature Territories of the Russian Federation, when a natural object is declared a natural monument, it must be placed under protection, custodial obligation papers must be placed, other documents stipulated by the legislature of the Russian Federation must be prepared and certified, and the regulations of the federal Ministry of Natural Resources complied with. This procedure has been followed in only two new natural monuments, those established on November 6, 1994, by decree No. 326 by the head of the JAO administration. A number of previously declared natural monuments have now lost their nature-protection value, and no less than fifty natural and cultural areas currently unprotected need to be given natural monument status.

The protected area system in the JAO is not a single unified system, does not protect the region's biodiversity or unique cultural areas adequately, and fails to provide suitable recreational opportunities for residents and visitors. Therefore, in 1996, the JAO Committee on Environmental Protection, together with the *oblast*'s economic administration and the Comprehensive Analysis Institute for Regional Problems, a

Table 4.2
Protected areas in the Jewish Autonomous Oblast

Type and name	Size (ha)	Raion	Established
Zapovednik			
Bastak	91,121	Birobidzhansky	1997
*Zakaznik*s			
Churki	85,000	Birobidzhansky & Leninsky	1982
Shukhi-Poktoy	60,000	Birobidzhansky & Obluchensky	1963
Dichun	49,500	Obluchensky	1998
Zhuravliny	40,500	Oktyabrsky	1988
Uldury	28,000	Birobidzhansky	1963

Source: JAO Committee on Environmental Protection, 2000.

division of the Russian Academy of Sciences (RAS), developed a plan to strengthen the system.

In 1998, the protective service for Bastak Zapovednik was developed, the forest *zakaznik*, Dichun, was established, and large tracts of rich mixed forests were protected. An ecological-economic justification (*obosnovanie*) for creating Kuldur Nature Park was completed, and certification of eight new natural monuments is being prepared. In 1999, work began on the effort to establish Zabelovsky Zakaznik. State protection will be extended to the Central Amur lowlands, the most important region in terms of biodiversity preservation, and to numerous Amur River tributaries valuable to local fisheries.

Between 2003 and 2005, efforts will be made to establish a protected area to help preserve the Pompeevka River basin. There will also be efforts to modify the boundaries of Zhuravliny Zakaznik to include the remnants of the undisturbed portions of Dahurian steppe. Further plans to improve the system include expanding the network of the natural monuments and establishing protected areas where rare and disappearing plant species are concentrated.

The primary limits to an expansion of the protected area system are lack of funds (more than 50 percent of the *oblast*'s budget is subsidized by the federal government) and the lack of administrative cohesion among the nature-protecting agencies. Currently, the *zapovednik* is under the jurisdiction of the Ministry of Natural Resources, while the JAO Hunting Service administers four of the *zakazniks*. Another *zakaznik* and the dendrological park are under the control of the Forest Service, and, as mentioned above, the

administrative responsibility for most of the natural monuments is unclear.

At present, the *oblast* administration is taking some steps to overcome this lack of cohesion. A new law On Specially Protected Nature Territories was adopted in February 1999 establishing an interdepartmental commission to improve the protected area system and an operational group to protect the biological diversity of the JAO. In accordance with the law, 5 percent of the proceeds received by the *oblast* for mining will be directed toward financing these territories. However, actually protecting these territories will be impossible without assistance from foreign organizations, foundations, and governments.

Zapovedniks. There is one *zapovednik* (strict nature reserve), Bastak Zapovednik (91,121 ha), in the *oblast*. See p. 188 for a description

Zakazniks. Within the JAO, there are four *oblast*-level nature *zakazniks* and one *oblast*-level forest reserve. In total, these reserves cover 263,000 ha, which represents about 7 percent of the JAO's territory. The integrated *zakazniks* are administered and funded by the JAO Hunting Service. Regulations stipulate that a minimum staff of ten rangers, two per reserve, is necessary, but in 1998, only eight rangers were employed for all of the *zakazniks*, and in two of them, Uldury and Churki, there were no vehicles.

Salvage logging, hay harvesting, and cattle grazing are conducted inside the reserves. There are more than twenty apiaries, some of which have been privatized, on these

People often associate the JAO with wetlands, but the mountainous western and northwestern regions have significant forests.

Yuri Shibnev

reserves. These activities all lead to depletion of flora and damage to the foraging base of wildlife. A division of the Forest Service, the Obluchensky Leskhoz, administers the recently established Dichun Zakaznik.

Natural monuments. Eighteen sites of scientific, historical, aesthetic, environmental, and cultural significance have been designated as natural monuments (see table 4.3) Khabarovsk Kraiispolkom (Regional Executive Committee) resolutions No. 208 and No. 472, dated March 26, 1996, and August 27, 1980, respectively, established eight of them. Three were established by resolutions of the Oktyabrsky and Obluchensky Raion executive committees and therefore do not have a definite status on the territory of the *oblast.*

Nature parks. In accordance with the program for the Development of a System of Specially Protected Nature Territories of the Jewish Autonomous Oblast up to 2005, a draft was prepared to establish the Kuldur Nature Park (see pp. 187–88).

Biodiversity hotspots

1. Pompeevsky area (forest and wetland)

The Pompeevka River Basin (40,000 ha) includes the southwestern foothills (73 to 912 m) of the Maly-Khingan range. The 71-km Pompeevka River, a tributary of the Amur River, descends from these hills and broadens to a 3-km-wide marshy delta at the river mouth. Various forest types cover the basin, including Ayan spruce and East Siberian fir (*Abies nephrolepis*) interspersed with Korean pine (*Pinus koraensis*), Dahurian larch, and linden (*Tilia amurensis*) in the head-waters, Korean pine and broadleaved forests in the middle reaches, and Mongolian oak and Dahurian birch (*Betula davurica*) stands in the lower reaches. Birakansky Lespromkhoz (LPX) logged these forests until the enterprise went bankrupt in 1996, but not before cutting most of the Mongolian oak, Korean pine, and broadleaved trees. Overlogging fragmented the forest habitat for the local Siberian tiger (*Panthera tigris altaica*) and goral (*Nemorhaedus goral*) populations and, by

Table 4.3
Natural monuments in the Jewish Autonomous Oblast

No.	Name	Type	Established	Size (ha)	Raion
1.	Duck Lake	Botanical	1994	1,825.0	Oktyabrsky
2.	Relictual pine stand	Botanical	1982	108.0	Obluchensky
3.	Cherepashy Bay	Zoological	1994	61.0	Leninsky
4.	Peshchera Bannaya	Geological	1985	12.5	Obluchensky
5.	Peshchera Glubokaya	Geological	1980	12.5	Obluchensky
6.	Peshchera Kabanya Lovushka	Geological	1985	12.5	Oktyabrsky
7.	Peshchera Kordornaya	Geological	1980	12.5	Oktyabrsky
8.	Peshchera Ledyunaya	Geological	1979	12.5	Oktyabrsky
9.	Peshchera Peschanaya	Geological	1980	12.5	Obluchensky
10.	Peshchera Sankina	Geological	1985	12.5	Obluchensky
11.	Peshchera Spartak	Geological	1985	12.5	Obluchensky
12.	Peshchera Stary Medved	Geological	1980	12.5	Obluchensky
13.	Verkhnetulovchikhinsky	Mineral Spring	1979	N/A	Oktyabrsky
14.	Nizhnetulovchikhinsky	Mineral Spring	1979	N/A	Oktyabrsky
15.	Starikovsky	Mineral Spring	1979	N/A	Oktyabrsky
16.	Lotus Bed	Botanical	1966	N/A	Birobidzhansky
17.	Lotus Lake	Botanical	1982	N/A	Smidovichsky
18.	Rose Bush	Botanical	1983	N/A	Obluchensky

Source: JAO Committee on Environmental Protection, 2000.

the 1970s, these animals had become extinct in the region.

Threats. Forests in the headwaters remain relatively intact, but local ecologists expect that both foreign and local companies will attempt to log these forests. There are also placer gold deposits, estimated at 200 kg. Placer mining is already underway in the Berezovaya River basin, which flows into the Amur 7 km downstream from the Pompeevka River mouth.

Although the tiger and goral have disappeared, the biodiversity value of the Pompeevka River basin remains considerable. The headwaters host a number of endemic species and form the westernmost spawning grounds for the autumn chum salmon (*Oncorhynchus keta*). Scaly-sided mergansers (*Mergus squamatus*), mandarin ducks (*Aix galericulata*), eagle owls (*Bubo bubo*), ospreys (*Pandion haliaeetus*), and golden eagles (*Aquila chrysaetos*) nest in the river's floodplain, which is also a feeding ground and resting area for numerous migratory waterfowl.

Existing protection measures. No significant measures have been taken to protect this area, nor have in-depth studies been conducted. In the 1970s, a group of ornithologists from Moscow State University and under the direction of Dr. Sergei Smirensky studied the area's waterfowl. Unfortunately, material from this research and from a botanical study, done in 1986 by Dr. V. A. Nedoluzhko, remain unpublished. The most recent forest inventory was conducted in 1986.

Recommendations. The following actions should be taken:
- Create a federal *zakaznik* to protect the Pompeyevka basin; recommendation made June 1996 at a scientific conference on the development of a system of protected areas in the JAO.
- Determine the most appropriate boundaries and protection regime for this *zakaznik*.

2. Kuldur Nature Park (forest)

Kuldur Nature Park (36,700 ha) is located in the northwest part of the *oblast* on the southern slope of the Maly-Khingan range, with mountains and hills ranging in elevation from 280 to 1,001 m. The territory includes the upper Kuldur River basin down to its confluence with the Karadub and Karagai Rivers. The town of Kuldur, located within the park's boundaries, includes five resort complexes, a metal beam factory, and a railway station.

Vladimir Dinets

The Amur Basin forms a border between boreal and Manchurian forests. Here, two closely related butterfly species feed together. Arachnia levana *is a widespread boreal insect, while* A. bureana *is endemic to the broadleaved forests of the Far East.*

The park has diverse forests, including Korean pine, Ayan spruce, East Siberian fir, Dahurian larch, birches, aspen (*Populus tremulae*), willows (*Salix*), and shrubs, together with grassy meadows and mossy swamps. The approximate border between boreal and East Asian biomes is near Kuldur, so the diversity of species is high and includes Japanese wild yam (*Dioscorea nipponica*), irises (*Iris*), Daurian lily (*Lilium dahurica*), Siberian ginseng (*Eleutherococcus maximus*), Chinese cinquefoil (*Potentilla chinensis*), and twenty other rare and endangered species.

The park's fauna is also diverse, a result of the intermingling of four geographical zones—boreal, Angarian, Okhotsk-Kamchatkan, and Manchurian—but the numbers of individuals of any one species are rather low. Boreal species include brown bear (*Ursus arctos*), Bohemian waxwing (*Bombycilla garrulus*), three-toed woodpecker (*Picoides trydactilys*), viviparous lizard (*Lacerta vivipara*), Siberian salamander (*Salamandrella keyserlingii*), and burbot (*Lota lota*). Angarian species live in the mountains. These include the mountain weasel (*Mustela altaica*), red vole (*Clethrionomys rutilus*), Siberian jay (*Perisoreus infaustus*), and willow tit (*Parus montanus*). Also in the mountains are Okhotsk-Kamchatkan species such as musk deer, spotted nutcracker (*Nucifraga caryocatactes*), and pine bunting (*Emberhiza leucocephalus*). Manchurian fauna can be found in the broadleaved forests of the valley and include Himalayan bear, yellow-throated marten (*Martes flavigula*), Ussurian wild boar (*Sus scrofa ussuriensis*), Manchurian wapiti (*Cervus elaphus xanthopygus*), Manchurian hare (*Lepus brachyurus*), raccoon dog (*Nyctereutes procyonoides*), azure-winged magpie (*Cyanopica cyana*), Shrenk's rat snake (*Elaphe schrenkii*), and Amur grayling (*Thymallus amurensis*).

Vladimir Dinets

Populations of the Schrenk's racer (Coluber schrenkii) *and other snakes of the RFE are crashing in many areas, as Chinese immigrants collect large numbers for food and for their skins.*

Threats. Mining, forest fires, poaching, and industrial waste pose a huge threat to the forests and affect fisheries and wildlife. Several studies have been made of the area's mineral resources, but few of the ecosystems. The staff of the Birobidzhan Botanical Gardens, an institute affiliated with the RAS, has done some preliminary research in the watershed.

Existing protection measures. Numerous organizations are trying to protect the area as a nature park. A May 1998 governor's decree allocated land for the park.

Recommendations. Develop well-organized tourism, which will not only improve the regional economy, but also reduce the need to mine and log the region.

3. Bastak Zapovednik (forest)
Bastak is the first and only *zapovednik* in the JAO and protects 5,190 ha of Group I and 85,931 ha of Group III pine forests in the Birobidzhan Leskhoz. The *zapovednik* also protects spruce, fir, and birch forests in the north; birch and deciduous savannas and bush chaparral grow in the southeast. The southeastern slopes of the Bureya Range (1,200 m) form the northern border of the *zapovednik*. Because the headwaters of the Bastak, Sorenak, Kirga, and Ikura Rivers are located here, the reserve is essential for water and soil conservation. Nine hundred vascular plant species grow in the reserve, including the endangered little pond lily (*Nymphar pumila*), Amur peony (*Paeonia obovata*), tall devil's club (*Oplopanax elatus*), and pink lady's slipper (*Cypripedium macranthon*). Many ecologists consider this region the oxygen supply for Birobidzhan.

Mammals living within the reserve include musk deer (*Moschus mosciferus*), Manchurian wapiti, snow deer (*Capreolus pygargus*), moose (*Alces alces cameloides*), Eurasian lynx (*Felis lynx*), American mink (*Mustela vison*), sable (*Martes zibellina*), badger (*Meles meles*), brown and Himalayan bear, red fox (*Vulpes vulpes*), and raccoon dog. The most valuable species are the hooded crane (*Grus monachus*), which nests in the Kirga and Glinyanka River valleys, and Blackiston's fish-owl (*Ketupa blakistoni*), which lives in the Bastak River basin.

Seven people work at the *zapovednik*, and their tasks include protecting the territory, conducting scientific research, and developing ecological and educational activities. Dry weather each fall and spring increases the chance of forest fires. Because the authorities lack proper equipment and enough staff, uncontrollable fires have already destroyed portions of the reserve. The illegal gathering of rare plants and poaching of animals plague the reserve because there are no funds to protect the area.

Existing protection measures. The government of the JAO spent 35,000 rubles (U.S.$5,000) to suppress two fires in the reserve in spring 1998, in addition to the annual 50,000 rubles ($7,143) already allocated for such a purpose. Two *zapovednik* inspectors have begun regular patrols of the reserve boundaries.

Recommendations. The following actions should be taken:
- Create and post signs.
- Purchase uniforms and firearms.
- Develop the land ownership certificate.
- Complete research of the territory.
- Purchase two vehicles, a snowmobile, and maintenance equipment.
- Create an ecological center for children.

4. Zabelovsky region (wetland)
Primarily a wetland along the Amur floodplain above Novospasskoe Village, the Zabelovsky region (20,000 ha) also has a number of important rivers and lakes including the Zabelovka River and the Zabelovskoe, Umayuvskoe, and Liman Lakes. Willow and deciduous forests line the rivers. Virtually pristine, the region protects waterfowl, shorebirds, and a number of rare fish species. Migratory birds

include brant (*Branta nigricans*), graylag (*Anser anser*), lesser white-fronted (*A. erythropus*), bean (*A. fabalis*), and swan (*A. cygnoides*) geese, as well as whooper (*Cygnus cygnus*) and Bewick's (*C. bewickii*) swans, Baikal teal (*Anas formosa*), and broad-billed (*Calidris falcinellus*) and marsh sandpipers (*Tringa stagnatilis*). Eurasian spoonbills (*Platalea leucorrhodia*), Oriental white storks (*Ciconia boyciana*), and ospreys nest here. Fish species within the Zabelovsky region include the black carp (*Mylopharyngodon piceus*), smallscale yellowfin (*Plagiognathops microlepis*), yellowcheek (*Elopichthys bambusa*), and Chinese perch (*Siniperca chuatsi*). The famous Komarov's lotus also grows here.

Threats. Phenol discharges into the Amur River are polluting local rivers and lakes. Poaching of birds and fish is continuously on the rise. Seasonal fires are a continual danger; people burn grass each spring and fall to grow crops, and these fires often burn out of control.

Recommendations. The following actions should be taken:
- The government of the JAO would like to establish a federal-level *zakaznik*, but lacks the funds to do so.
- A bird-monitoring center also needs to be created.

5. Stolbovsky region (wetland)

The Stolbovsky region (15,000 ha) covers the middle Samara River basin, near Stolbovoe Village. Predominantly steppe and wetlands, there are also some Mongolian oak, Dahurian birch (*Betula davurica*), big-fruit elm (*Ulmus macrocarpa*), and Chinese hawthorn (*Crathaegus chinensis*) forests. Shrub species include hazelnut (*Corylus*), two-flowered lespedecia (*Lespedezia biflora*), Dahurian rhododendron (*Rhododendron dahuricum*), and Oriental sekurinega (*Sekurinega orientalis*). Other floral species include the *Arundintilla anomalica*, Chinese cinquefoil (*Potentilla chinensis*), Eastern edelweiss (*Leontopodium blagoveshczenskyi*), Baikal skullcap (*Scutellaria baicalensis*), Baikal feather grass (*Stipa baicalensis*), *Tromsdorviya ciliata*, Chinese prairie-smoke (*Geum chinensis*), yellow sophora (*Sophora lutea*), and Chinese fenugreek (*Trigonella sinensis*). This is one of the most diverse steppe communities in the RFE.

Threats. The fauna of this region remain poorly studied. Scientists have sighted the Dahurian partridge (*Perdix dahurica*), which is extremely rare in the JAO. During the 1960s, most of the steppe was used for agriculture. Hay harvesting and overgrazing are impacting the region now. Another danger is uncontrolled grass burning, which threatens nesting birds. Currently, there is no research of meadow steppes underway in the JAO. Therefore, knowledge of the region's biodiversity remains sketchy. In summer 1997, V. A. Nedoluzhko studied the region, but his findings remain unpublished.

Recommendations. The following actions should be taken:
- Multidisciplinary research of the regions.
- Implementation of measures to decrease human impact on the most vulnerable species.

Economy

Vasily Gorobeiko

The pillar of the economy is agriculture and, to a lesser degree, mining, the production of construction materials and machinery, light industry, food production, and until recently, forestry. The JAO was made an autonomous region because of its large tracts of arable land; development thereafter was focused on producing food for the cities of Khabarovsk, Komsomolsk-on-Amur, and the northern regions of Khabarovsk Krai.

Almost all agricultural enterprises produce grain, soybeans, and vegetables. Farmers are increasing production of buckwheat, corn, and melons and are maintaining the already sizable potato crop. Crops account for more than half of the agricultural volume of the *oblast*. In addition to tracts of land suitable for plowing, the natural grazing offers favorable conditions for developing animal husbandry, particularly of cattle.

The machinery industry consists of making equipment for farming (soil and crop cultivation), general construction, and road building. The mining industry consists of tin ore extraction and enrichment, mining alluvial gold deposits, and the extraction of materials used in construction. Coal mining also takes place, and the development of the Ushumunsk brown coal deposits is under way. The timber industry consists of timber harvesting and processing, and the production of mill wood, construction lumber, and furniture. The centers for timber harvest are located in the forests of Birakan, and the centers for wood processing are located in Birobidzhan and Nikolaevka.

Light industry in Birobidzhan consists of five large enterprises producing sewn and knitted items, socks, felt, and footwear. Other smaller companies also produce these types of goods. The food industry, located in urban centers, produces meats, sausages, and other products, such as baked goods, confectionery, pasta, milk products, alcohol, canned vegetables, and others. A network of small businesses processing agricultural goods, food products, and other consumer goods has developed in the *oblast*.

The JAO is home to two of the oldest fish hatcheries in the RFE, the Teplovka and Bidzhan hatcheries, which produce fall-run chum salmon and have a combined annual capacity of 65 million fry. Since 1988, however, they have steadily been incubating far fewer fish eggs, a result, in part, of active

license fishing downstream, increasing poaching along the migration route, unlimited fishing in the Amur River by Chinese fishermen, and violations of environmental laws by gold mining enterprises that mine on the headwaters of spawning rivers.

Each of these industries is in a deep crisis. It is doubtful that machinery and light industries will rebound to their former state, partly because of delays in receiving the necessary materials from the western parts of Russia. Competition from China and the Pacific Rim countries will also make it difficult for such industries to develop a market niche. The future for the agricultural industry is brighter, provided governmental and regional policies support it. The relatively large mineral resource base and favorable geographic position of the *oblast* makes mining another possible growth industry.

Changes in the *oblast*'s economy over recent years have had a dual effect on ecosystems. On the one hand, the drop in industrial production has decreased the release of harmful discharges. On the other hand, however, businesses lack the financial resources to not only initiate new pollution-control technologies, but also maintain existing ones. As a result, the accumulation of toxins in rivers and lakes has not decreased, but has even increased in many regions; nearly all the watercourses in the JAO that have monitoring stations

show decreases in dissolved oxygen and increases in phenols, petroleum products, steel, DDT, and other harmful substances. In addition, because of high shipping and fuel (coal) costs, people have responded by using firewood to heat their houses and apartments. This wood is illegally logged from protected forest lands, as well as from the sparse natural forests near inhabited areas.

The timber sector, although historically a minor industry, has had a significant impact on the region's ecosystems and upset the water balance of the Bira River. Recent battles with forest fires, pests, and pathogens relate to the timber industry. Once every seven to ten years, fires reach catastrophic proportions, causing tremendous economic and ecological harm to the forests. Preventative measures are virtually nonexistent due to lack of funds. Unfortunately, forests are not being regularly monitored, leaving them more susceptible to pests and diseases.

Agriculture, largely in the central and southern parts of the *oblast*, takes place primarily on reclaimed land and has also harmed the water balance. The topsoil is being eroded by both wind and water, and 15 percent of all agricultural land suffers from erosion. This has led to increased alkalinity of the soil, making it less productive. Soil nitrate levels average between 7.5 and 45 mg/DM3.

Vladimir Dinets

Edible berries and mushrooms, such as this king boletus (Boletus edulis), are an important food source not only for wildlife and native peoples, but also for city dwellers. In late summer and early fall, thousands of people flock to the countryside to gather them.

Timber

Birobidzhan Lespromkhoz, established on April 1, 1964, as the May 1 Cooperative, was the first company to harvest timber on a commercial scale and logged primarily in Obluchensky and Oktyabrsky Raions until production ceased in 1995. Between 1985 and 1995, the timber harvest by the *lespromkhoz* decreased from 341,000 cu. m to 53,000 cu. m. In the final years of operation, the *lespromkhoz* logged forests on Pompeevsky Ridge, a region of great importance in protecting the water quality of the Bidzhan River basin, which supports agricultural regions in its central and lower reaches.

In 1999, however, Chinese capital flowed into the forestry sector making the situation more complex. In January, six logging leases were issued to small timber companies with annual harvesting capacities of up to 20,000 cu. m each. Five of these companies are either partly Chinese or have significant amounts of Chinese capital and use Chinese labor. These enterprises received five-year agreements, which indicates their aspiration to log as much as possible in the shortest time. Unfortunately, after five years, during which timber harvest yields never exceeded 7 percent of the annual allowable cut, *leskhoz*es

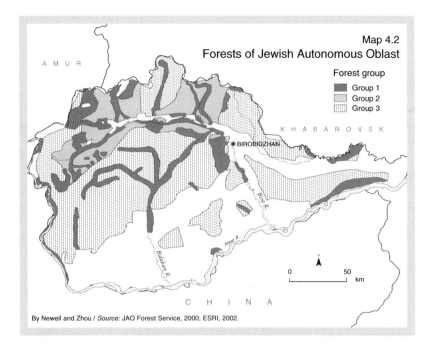

Map 4.2
Forests of Jewish Autonomous Oblast

Forest group
■ Group 1
▨ Group 2
▦ Group 3

AMUR

KHABAROVSK

● BIROBIDZHAN

Bira R.

Bidzhan R.

Amur R.

0 50
km

N

CHINA

By Newell and Zhou / *Source:* JAO Forest Service, 2000; ESRI, 2002.

are eagerly offering such leases. Our information indicates that some of these companies have already started logging, although none of the timber-harvest plans have been submitted for governmental or environmental assessment.

According to a state survey, there are 21,393 sq. km of forests in the JAO, including 3,771 sq. km of Group I forests, 3,813 sq. km of Group II forests, and 13,809 sq. km of Group III forests. The overall forest area totals 2,292,700 ha, including 395,600 ha (17.3 percent) of Group I forests. The Annual Allowable Cut (AAC) is 1,281,200 cu. m yearly, including 326,400 cu. m of coniferous species. In 1991, the forestry sector employed 6,000 people, or 4.6 percent of the eco-

nomically active population but this figure declined to 2,700 people by 1995.

The rapid commercial use of the Maly-Khingan region for logging dictates the need to create a network of protected territories to reduce anthropogenic impacts and preserve forest biodiversity. In conjunction with the Program for Development of the Network of Specially Protected Territories of the JAO for 1996–2005, several measures have been defined to protect the region. To promote habitat formation, protected forests include valley forests, forests near the Kuldur mineral springs, forest belts of special significance, and greenbelt forests near inhabited areas. The baseline territory includes Bastak Zapovednik. To protect resources, *zakaznik*s, among them Shukhi-Poktoi, Dichun, and Pompeevsky, reserve forest plantings, among them a plantation of Korean pine in the Birsky Leskhoz near the 30-km road from Birobidzhan to Obluchie, and nut production zones, among them Korean pine in the broadleaved forests of the Sutara and Pompeyevsky ridges, and natural monuments, among them a Korean pine grove in the Mikhailikha River headwaters have been included. A dendrological garden on the eastern border of the Shukhi-Poktoi ridge, and the Kuldur Nature Park, are included to protect recreational sites.

Agriculture

From the time of the first settlers, agriculture has been the main activity in the *oblast*. Clearing of lands was widespread, and reclamation was prevalent during the 1950s and 1960s. Until 1991, when the region became independent of Khabarovsk Krai, the *oblast* produced almost 80 percent of the krai's grain, more than half of its soy beans, and almost half of its potatoes, meat, and milk. About one-third of the *oblast* residents live in agricultural villages. Agricultural lands total about 390,000 ha, of which 136,100 ha are plowed.

The transition to a market economy has led to radical changes in the agricultural sector. *Kolkhoz*es and *sovkhoz*es have been reorganized and various enterprises (collective, cooperative, public) with differing types of private ownership have been created in the villages. These enterprises now use 257,500 ha of agricultural land, or about 70 percent of the total area, including about 78 percent of all plowed land. The farming sector consists of about four hundred holdings, on which almost 20,000 ha of agricultural land is located. This land yields about 20 percent of the overall volume of agricultural production. There has been a significant decrease in the number of cattle, swine, and poultry. Yield figures for milk per cow, as well as gross milk production, were lower in 1999 than they had been for many years.

Chinese investment in JAO

The JAO's largest trading partner, China has shown increasing interest in the region. In July 1998, the JAO and the Chinese province of Heilongjiang signed an agreement on long-term trade and economic and scientific cooperation.[11] China is particularly interested in timber resources that can be easily shipped on the Trans-Siberian railroad and exported by boat or truck to China. In 1998, small businesses in the *oblast* exported 50,000 cu. m in logs to China.[12] In 1999, logging leases were issued to five companies that were either partly Chinese or have significant Chinese capital. Chinese investors have also shown an interest in iron ore deposits in the Obluchensky Raion.

– *JN*

The agricultural regions belong to the "mostly warm/humid," "warm/excessively humid," and "moderately warm" agroclimatic regions. The most favorable conditions are close to the Amur River and its tributaries, the Bidzhan and the Bira Rivers. These are, however, also subject to heavy, localized flooding. Heat resources greatly determine what types of crops are planted. In the JAO, typical crops are corn, soybeans, early vegetables, and grain.

The *oblast* is primarily a forested territory. These forests are central to making the landscape stable and the lower, marshy reaches productive for agriculture. Forests used to carpet between 65 and 70 percent of the area, but now cover only 44 percent of the area. Every four years the forest cover is reduced by an average of 1 percent, principally the result of conversion for agriculture. Today, deforestation in some of the regions is catastrophic. Decreased forest cover has affected water levels and the climate. Between 85 and 90 percent of the forests essential in containing the snowpack has been lost; this has affected soil productivity in the plains and lower reaches of the rivers. Loss of the tree cover has also led to an increase in frequency of the *sukhovei*, the hot, dry wind of the Far East. According to scholar Y. Zarkhina, a loss of between 20 and 25 percent of the snow cover causes the temperature to drop by 1°C, which in turn leads to a loss of between 2.5 to 3.0 centers per ha of soybean crops.[13] In ten to fifteen years, the soil will lose up to a third of its humus content and soil productivity will drop by a factor of one or two. This process most markedly affects the structurally weaker soils of the Oktyabrsky and Leninsky Raions, where, after five or ten years, the productive soil layer has been blown away, and wind erosion has formed areas of denuded land, in the form of basins. These basins also form on cultivated peat soils. Loss of forest cover also disrupts water flows and levels, causing localized floods during heavy rains. This, in turn, causes an increase in surface and wind erosion of the soil. Erosion rates have ranged between 40–50 and 100–130 tons/ha.

A systematic analysis of agriculture of the region, conducted in 1993, allows us to reach some important conclusions:

- Biota and soil cover are the first to be affected by the large-scale industrial use of land that results in rapid degradation, with reduced forest cover, loss of wetlands to reclamation, and the pollution of waterways. The effects of crop cultivation on biota and soil cover could be minimized if management decisions were made with more environmental awareness.

- The continued decline of the environmental health of the region has made agricultural techniques less effective and productivity has declined.

- Measures to protect biota and soil should include, foremost, a reassessment of the structure of land management and ownership. This includes the adoption of regulations for particularly valuable ecological resources. Such regulations should include buffer zones near river systems and lakes and restrictions on land use where there are large numbers of rare plant and animal species, in areas susceptible to erosion, and in popular recreation sites.

Mining

Mining in the region began in the period between 1857 and 1886, when the geologists F. B. Schmidt and P. P. Anosov discovered alluvial gold deposits in the Sutara River basin. The first claims to mine the placer deposits were made in 1880, and mining began in 1889. Until 1960, gold was mined at twenty-nine fields, the largest being Kazansky, Lyubavinsky, Frolovsky, Mikhailovsky, and Viktorovsky. After the Russian revolution and until 1928, only small cooperatives extracted gold. In 1928, the state began managing placer prospecting and exploitation. The first major enterprise was Soyuzzoloto Trust, and later, after 1932, Primorzoloto was the major mining company. The gold was mined mostly by hydraulic and dredging methods. In 1964, gold mining in the *oblast* ceased, and it did not begin again until the 1990s, when small private cooperatives began mining again. According to estimates by the geologist V. Buryak, the total amount of gold extracted in the *oblast*, since mining began has been about 20 tons.[14] As a result of this placer mining, more than 40,000,000 tons of tailings

Map 4.3
Mining deposits of Jewish Autonomous Oblast

By Newell and Zhou / *Sources:* USGS (lode/placer), 1998; AGI, 2000 (coal); ESRI, 2002.

Opening up the region to mining

Gold mining ceased in the JAO in 1964, but in the mid-1990s, small *artels* of gold miners began operating. The *oblast* administration plans to expand gold mining from the current annual production of 100 kg to more than 500 kg per year. *Artels* currently mine all of the gold. Mostly placer deposits, gold reserves are estimated at 20 tons.[15] Geologists have been focusing on the placer reserves located along two river systems in the mountainous northwestern region of the *oblast*, the Sutara and Pompeyevka Rivers. The Pompeevka River lies within one of the *oblast*'s biodiversity hotspots and has valuable Korean pine forests, and the upper reaches are spawning grounds for autumn chum salmon. Gold mining is already under way in the nearby Berezovaya River, which lies just 7 km to the south. The Sutara River basin has been heavily mined for decades and millions of tons of tailings have been dumped in the river, which feeds directly into the Bira River, one of the largest in the JAO and of primary importance for agriculture. The main gold mining *artel* is Arktika, and another gold mining company, Zolotaya Sutara, recently won a tender to exploit twenty gold placers with proven reserves of more than 2 tons. In the summer of 1998, twenty-eight placer gold deposits and one ore deposit, all in the Obluchensky Raion where the Sutara River is located, were tendered.

Geologists also expect to find another 42 million tons of brown coal at the region's only major coal deposit, Ushuman, which has confirmed reserves of 104 million.[16] This reserve is conveniently located on a rail spur just south of Birobidzhan. A strip mine, Sebtrany, is being built, and administration officials hope that they can eventually produce 1.5 million tons of coal. Initsiativ, a joint-stock company, plans to do the mining.

The *oblast* is also looking for foreign investment to develop its considerable iron ore deposits in Obluchensky Raion, in the northwestern part, near the Sutara River. There are three large deposits: Kimkanskoe (with probable reserves of 200 million tons of ore), Sutarskoe (probable reserves of 600 million tons), and Kostenogeskoe (probable reserves of 200 million tons of ore).[17] All the reserves are located close to the Trans-Siberian Railroad, making shipment convenient. In the 1960s, the Soviet government planned to build a processing facility in neighboring Amur Oblast and the iron ore would have come from the JAO, but this plan was shelved after the huge Amurstal works were built in Komsomolsk-on-Amur, Khabarovsk Krai.

— JN

were dumped in the Sutara region, destroying the original landscape.

The Maly-Khingan region also has tin ore deposits. The AO (joint-stock company) Khinganolovo extracts industrial tin at the main deposit, Khinganskoe. Tin was discovered in 1944 and on May 25, 1945, the State Defense Committee decided to build an ore-enrichment plant. Mining ceased during World War II, but resumed after the war. The plant was known to have the highest efficiency rate of tin concentrate extraction from ore in the Soviet Union, which allowed it to produce the cheapest tin in the country. Extraction was done by open-cast mining, but now shaft mining is the dominant method. Accompanying indium and sometimes fluorite were also extracted. The current goal is to extract other components of tin ore, including lead, zinc, copper, and silver. In total, more than 45,000 tons of tin concentrate have been extracted.

Brusitovy Quarry, which has been operating since 1980, is one of only three brushite mining quarries in the world. The brushite is transported to the Sverdlovsk Oblast to be processed for magnesium. There is enough brushite to greatly increase production, as there are large, unexploited, high-quality surface deposits. Only high-grade ore is being extracted. Materials for the construction industry, including limestone, dolomite, clay, and quartz sand, are also mined, usually by open-cast methods. Open-cast coal mining takes place at the Ushunmunsk deposit.

In 1993, the Committee on Environmental Protection analyzed the social and economic condition of Obluchensky Raion and, to improve the economy, recommended the *raion* create an industrial mining complex. Our analysis showed that the stable development of such a complex would be possible only if recreational territories are enlarged to allow the ecosystems to function naturally. To some degree, the Kuldur Nature Park could perform this task.

The industry poses a threat to the environment because of the open-cast methods used; they alter landscapes and leave large amounts of tailings in mine dumps. These gold dredge tailings contain large amounts of mercury, which was widely used in Soviet times.

Most present mining enterprises are unprofitable; the industry needs to be completely restructured. Mining experts estimate that 5 percent of the employed population works in the industry, which supports entire communities, such as the mining towns of Khingansk, Teplozersk, Londoko, and Priamursky. Decline of the industry has had drastic social implications; these areas have the highest unemployment levels and the lowest life expectancy of any region in the *oblast*. Due to the territory's rich mineral resources, the regional government hopes to attract foreign investment to this industry to revitalize the region's economy.

Toward sustainable development

Vasily Gorobeiko

The JAO needs to develop a program for stable long-term development that takes into account the needs of all social, economic, and political groups and movements. Some factors do exist that would support the creation of such a plan. They include:

- Rich natural resources. The region has mineral, energy, soil, biological, and recreational resources.
- Advantageous geographical location. The region is close to border and transit routes, and is well connected with the interior of Russia and the countries of the Pacific Rim.
- Stability. The social and political atmosphere is relatively stable.
- Flora and fauna. Large numbers of plant and animal species found within the *oblast* are rare and endangered; also the area is graced by unique and diverse landscapes
- Climate. The climate of the JAO is better than it is in many other parts of the country.

The most important requirement for future development must be to restructure industry. This should include:

- Making interagency structural changes that promote sectors which create consumer products.
- Minimizing wasteful use of energy and natural resources
- Using ecologically safe technologies.
- Minimizing transportation expenses.
- Creating industrial structures that can adapt to the new market economy.

Restructuring would improve the quality of life, conserve ecosystems, improve the condition of the environment, develop a more highly educated workforce, and increase employment opportunities. Limiting the transience of residents must be an essential element to sustainable development of any RFE region, as economic and social stability is impossible without a long-term resident population.

Taking into account the JAO's economically inefficient objectives and the necessity to produce goods and materials more cheaply, it would be appropriate to close some enterprises. Declining industrial production has led to emigration from the region, but preventing emigration by maintaining old industrial structures creates parasitic tendencies, decreases the quality of labor, and lowers the morale of workers. Also, a declining population is harmful for the defense and the strategic goal of increasing the presence of the Russian state in this region, which borders China. What is happening today in the JAO's economy? The system continues to deteriorate with no signs of abating. There are no elements of a new system in place that might reverse the industrial collapse and reduce state support for inefficient industries. Because of the rich natural resources of the *oblast* and its current economic and social situation, the region must improve its social and labor resources, which requires increasing social expenditures to spur consumer activity and to encourage the production of consumer goods. This, it is to be hoped, will lead to increased investment and restructuring of the economy. This expenditure must be supported with minimal investment expenses, just enough to maintain the viability of industrial sectors vital for population growth and production, to create financial resources for consumer demand, and to support the production of goods for the general public.

Legal issues

Vasily Gorobeiko

Prompted by ecological organizations and the public, some basic laws have been adopted, including laws on special protected natural areas, forest use, hunting and the hunting industry, and trade and exchange in plant and animal resources. Two more *oblast* laws are being created, one on public inspectors for nature protection and another on land reserves. In 1994, an *oblast* Commission of Rare and Endangered Animal, Plant, and Fungi Species was created. Lists of rare and endangered vertebrates and vascular plants were compiled and included in the *Red Data Book*. In 1998, the first volume of the *Red Data Book* was published. Still, many aspects are not currently regulated by local laws. The rights and duties of public inspectors of nature protection and of resource-using enterprises have not yet been legally determined. The export of resources from the Russian Federation is not legally controlled, and there are problems with collaboration between agencies. For example, the protection of the Amur River must be determined on the international level, yet there are differences between laws among the neighboring regions of Russia. Most legal problems can be solved only on a federal level.

Perspective

Lucy Jones

A Jewish homeland focuses on its people

As the train draws into the station of the Far Eastern Russian city of Birobidzhan, two things seem distinctly unfamiliar: the presence of bright lights and noncyrillic lettering. Blazing

on top of the recently renovated station, the city's name is lit up in Hebrew, signposting Birobidzhan's status as capital of the Jewish Autonomous Republic, declared as such by Stalin in 1934. There are more clues: the out-of-town synagogue, a Jewish Sunday school and secondary school, Russia's only Yiddish newspaper, and a busy Israeli repatriation agency.

But many of the Jews here, who recreated these traditions post *perestroika*, have left for Israel. Of the region's 20,000 Jews, the Jewish Agency of Russia estimates that 70 percent have left, and most of those are young. The Jewish Theater has since moved to Moscow, and the social club for young Jews has closed. "We want to leave because Israel is our homeland; it's as simple as that. We've had to live in an anti-Semitic country all our lives, facing discrimination and intimidation, and now we have a chance to leave, so why stay?" said Slava Sherman, head of the Jewish Agency of Russia. The agency helps Birobidzhan residents leave for Israel by giving them information and help with plane tickets.

For many people, the choice of whether to stay or go is economic, tinged with hope of a more lively existence; Birobidzhan has little entertainment with the exception of a Jewish theater and a popular microbrewery restaurant. Factories have been closed, and in those that remain, the pay is low and irregular. Boris Vassilyev works in a television factory and has not been paid for six months. "At least if I go to Israel, I'll be guaranteed a pension, even work; it's more than I'll get here," he said while in line to see the repatriation representative.

But in 1927, when the Jewish professor Boris Brook arrived in the swampy area between the Bira and Bidzhan Rivers, there was a genuine belief among Jews that a homeland could be created. After the Soviets opened the area for settlement, in part to populate an area vulnerable to Japanese expansion, more than three hundred Jewish families arrived from Argentina, Venezuela, America, Germany, Switzerland, Byelorussia, and Poland, as well as from across Russia.

Some were communists, like Iya Beyekherman, 92, one of the fifty Argentinians who came to the area. Beyekherman lives in Birobidzhan still. "We arrived by train on the 20th of March. We had absolutely nothing but the wish to rejuvenate our culture and create a homeland. We built communes; life in the commune still remains a ray of light in my life. It was a very pleasant life; we ate fish we caught from the river and drank milk from the cows we kept. We all dreamed we would create a great industrial and agricultural city; life was very peaceful," he said. Beyekherman recalls the commune's football, volleyball and basketball teams, the library, and the Spanish-language radio station.

But after 1930, repression eclipsed the ideals of the fledgling homeland. First there were provocations; the secret services burned down the houses of prominent Jews. Then many of the Jewish families from abroad were declared spies

and forced to leave; the director of the commune was shipped off to a concentration camp, where he spent fifteen years. The twenty-six Jewish schools, the synagogue and the library were closed, and the Hebrew and Yiddish languages were banned. "It was a black and tragic period for the region and one of the reasons why so few people today speak Yiddish," said Inna Dmitrienko, editor of the *Birobidzhan Stern*, published in Yiddish and Hebrew and circulated in Ukraine, Byelorussia, America, and Israel.

"Many of our writers and poets were arrested, and some of them did not survive. Our tradition was destroyed. When the region was established, people only spoke Yiddish; today very few people know Yiddish," she added. At the state-operated Jewish School, which is in its fifth academic year, efforts are being made to teach the children Yiddish and Hebrew. Of the 130 pupils, whose number is continually diminished by families leaving for Israel, 40 percent are Jewish. Pupils attend lessons in Hebrew, Yiddish, Jewish tradition, Jewish dancing and music, and take part in Jewish festivals.

But the school feels more support could be given by Israel. "They promise books, but they never arrive. My feeling is that they (the Jewish government) do not like the idea of any other Jewish state than Israel," said Anna Piskovets, Deputy Head of the Jewish School. A representative from the Israeli embassy in Moscow visits Birobidzhan every month, but support is more moral than financial. "It's very important to help them learn more about their history, about their tradition because they know very little about it, almost nothing," said Aliza Shennar, the Israeli ambassador to Russia on her first visit to Birobidzhan.

"But many people are talking about Jewish autonomy and I don't know the meaning of it. It's very hard to see why they want to learn Yiddish in schools instead of Hebrew because the common language is Hebrew. The Bible was written in Hebrew. Of course, we dream of seeing all the Jews come to Israel. However, we understand that some of them are going to stay here, and Israel is going to support them in many ways." The regional government tacitly supports the new attempts to resurrect Jewish culture in the region, while at the same time fearing Jewish nationalism.

Victor Bolotnov, mayor of Birobidzhan, said, "The Jewish element gives the region identity and puts the place on the map." However, he hastened to add he was not Jewish but fully Russian. In the local government's glossy guide to the region, there is no mention of the region's Jewish culture and population. In the suburbs of Birobidzhan, next to a Baptist church, is the synagogue, partly funded by an American organization headed by Boris Kaufman. "The Holocaust has overshadowed the persecution of Jews in Russia," Kaufman observed. "But Jews in Russia have suffered immensely. Now is our opportunity to recreate the Russian Jew, but whether it will happen, I don't know."[18]

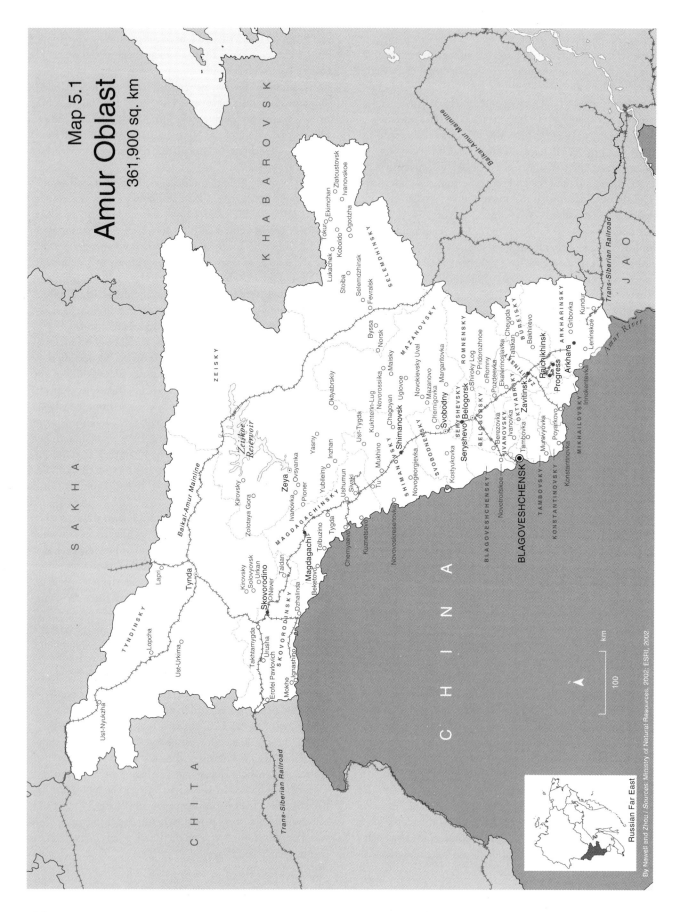

Map 5.1

Amur Oblast
361,900 sq. km

AMUR

S A K H A

K H A B A R O V S K

Z E I S K Y

Baikal-Amur Mainline

Zeiskoe
Reservoir

Ust-Nyukzha

Lapri

Lopcha

Ust-Urkima

TYNDINSKY

Tynda

Takhtamygda

Mokhe
Erofei Pavlovich
Urusha
Ignashino
Dzhalinda

Kirovsky
Solovyovsk
Neverⓞ Urkan
Taldan

Beketovo
Tolbuzino

Kirovsky
Zolotaya Gora

Zeya

Ivanovka
Ovsyanka
Pioner
Yublileiny
Ushtumun
Sivaki

Yasny

Inzhan

Mukhino
Tu

Tygda

Chernyaevo

Kuznetsovo

Novovoskresenovka

C H I N A

MAGDAGACHINSKY

SKOVORODINSKY

Magdagachi
Skovorodino

Ust-Tygda

Chagoyan

Novogeorgievka

Kostyukovka

SHIMANOVSKY

SVOBODNENSKY

S E L E M D H I N S K Y

Lukachek
Stoiba
Selemdzhinsk
Fevralsk

Tokur
Koboldo
Ogodzha

Ekimchan
Zlatoustovsk
Ivanovskoe

Byssa

Norsk

Oktyabrsky

Kukhterin-Lug
Novorossiika

Malsky

Uglovoe

M A Z A N O V S K Y

Novokievsky Uval
Mazanovo
Chernigovka

Margaritovka

SERYSHEVSKY

ROMNENSKY

Shimanovsk

Svobodny

Seryshevo Belogorsk

BELOGORSKY

Shiroky Log
Pozdeevka
Romny

Pridorozhnoe

Berezovka
Ekaterinoslavka
Ivanovka

Cheugda
Talakan

IVANOVSKY
Tambovka

OKTYABRSKY

Muravyovka
Poyarkovo
Konstantinovka

TAMBOVSKY

KONSTANTINOVSKY

Bakhirevo

BUREISKY

Raichikhinsk
Progress
Arkhara

ARKHARINSKY

Kundur
Gribovka
Leninskoe

Innokentevka

J A O

Trans-Siberian Railroad

Amur River

Baikal-Amur Mainline

BLAGOVESHCHENSKY

Novotroitskoe

BLAGOVESHCHENSK

MIKHAILOVSKY

ZAVITINSKY
Zavitinsk

MAGDAGACHINSKY

C H I T A

Trans-Siberian Railroad

km

100

Russian Far East

By Newell and Zhou / Sources: Ministry of Natural Resources 2002; ESRI 2002.

CHAPTER 5

Amur Oblast

Location

Amur Oblast, in the upper and middle Amur River basin, is 8,000 km east of Moscow by rail (or 6,500 km by air). The Amur River (Black Dragon or Hei Long Jiang in Chinese) provides a natural border with China to the south. The *oblast* borders the Republic of Sakha in the north, Chita Oblast in the west, and the Jewish Autonomous Oblast and Khabarovsk Krai in the east.

Size

361,900 sq. km or approximately the size of Poland or the state of California.

Climate

Amur Oblast has a severe continental climate. It has both continental winds and monsoon streams, a combination that does not occur anywhere else in the world at the same latitude. Average temperatures are 19°C in July and 28°C in January,[1] but can reach highs of 42°C in the summer and lows of −58°C in the winter. Spring is dry and clear. Summer is hot, short, and moist—resulting in rapid vegetation growth. Fall is clear and warm. Winter is dry and cold, with little snow. The growing season in the southeastern Zeya-Bureya region, the best farming land in the Russian Far East (RFE), averages four and a half months. Precipitation in the mountainous eastern region can reach up to 800 mm per year. The western region is comparatively drier.

Geography and ecology

The Stanovoi Mountains form the dividing line between Sakha and Amur Oblast and spread across the entire northern border of the territory. Japanese stone pine (*Pinus pumila*) and alpine tundra cover higher elevations on these mountains. Larch forests with small stands of monarch birch (*Betula middendorfii*) and Dahurian birch (*B. davurica*) grow at lower elevations. Scots pine (*Pinus sylvestris*) forests grow along the river plains. The Zeya River begins in these mountains in the northeast. The middle reaches of this great river were dammed to create the huge Zeiskoe Reservoir, a project that caused much environmental destruction and now sprawls over 2,500 sq. km between the Stanovoi Mountains and a parallel southern range running across the center of the *oblast*. The lowlands between the two mountain ranges make up the Upper Zeya plain, which is primarily marshland with Dahurian larch (*Larix gmelini*) and pine forests. South of the second ridge is the vast Amur River plain, which covers 40 percent of the *oblast*.

Along the eastern border of Amur Oblast is another series of mountain ridges separating Amur from Khabarovsk Krai. These ridges of larch and fir-spruce forests form the

watershed of the Selemdzha River, which flows south into the Zeya, continues to the city of Blagoveshchensk, and then empties into the Amur River. Southeast of the Selemdzha are the Bureya and Arkhara Rivers, which have the richest forests left in the *oblast* with Korean pine (*Pinus koraensis*), magnolia vine (*Schisandra chinensis*), Mongolian oak (*Quercus mongolicus*), and other Manchurian flora. The Zeya, Amur, and Bureya Rivers form a cradle for the highest biodiversity in Amur Oblast, the Zeya-Bureya Plain. Much of this plain has been ploughed up or burned for agriculture, but large patches of forest remain intact. It is a nesting place for red-crowned crane (*Grus japonensis*), white-naped crane (*G. vipio*), Oriental white stork (*Ciconia boyciana*), and many other rare birds.

Flora and fauna

Amur Oblast has four distinct habitat zones, each with different types of fauna: boreal (e.g., brown bear [*Ursus arctos*], hazel grouse [*Bonaza bonaza*], sable [*Martes zibellina*], moose [*Alces alces cameloides*], gray wolf [*Canis lupus*]); Manchurian (e.g., Oriental white stork, red-crowned crane, raccoon dog [*Nyctereutes procyonoides*]); Dahuro-Mongolian (e.g., white-naped crane, Manchurian mole rat [*Myospalax psilurus*]); and alpine (snow sheep [*Ovis nivicola*]). Manchurian wapiti (*Cervus elaphus xanthopygus*) and snow deer (*Capreolus pygargus*) live in the mixed conifer-broadleaved forests. Many rodents, including various voles and Manchurian mole rat, inhabit the forest-steppe zone. Rivers and lakes are home to many waterfowl. There are 326 species of birds, 67 species of mammals, 64 species of fish, 7 species of amphibians, and 10 species of reptiles in the *oblast*. Rare and endangered species include a number of crane species, Himalayan bear (*Ursus thibetanus*), goral (*Nemorhaedus goral*), Baer's pochard (*Aythia baeri*), Oriental white stork, black stork (*Ciconia nigra*), mandarin duck (*Aix galericulata*), and osprey (*Pandion haliaeetus*).

Largest cities

Blagoveshchensk (pop. 225,200), situated on the Amur River across from the rapidly developing Chinese city of Heihe, is the administrative capital and industrial and commercial center. It is also the major transportation hub in the *oblast*, with an airport, railroad junction, and river port. Svobodny (pop. 70,400), situated on the Zeya River and located on the Trans-Siberian Railroad, is the second most important industrial center. Belogorsk (pop. 74,300), 109 km northeast of Blagoveshchensk, is

Key issues and projects

Timber exports to China

The Amur timber industry is poised to undergo major developments in the next ten years as a result of widespread changes in forestry practices and policies in the People's Republic of China. When China imposed a moratorium on most domestic logging,[2] the timber harvest in Amur increased by almost 40 percent.[3] This occurred after a decade of decreasing timber harvests (see p. 215).

Threats to protected areas

More forests in protected areas may be opened up to timber harvests (partially in response to demand in China). Recently, practically all of the forest resources in one protected area, Urkansky Zakaznik, have been slated for clear cutting[4] (see p. 215).

Expansion of hydroenergy

With a huge hydroenergy potential in the *oblast,* expect the construction of more hydroelectric power stations—not only to supply regional needs, but also to sell to the burgeoning Chinese cities and towns just across the border. The Bureinskaya hydroelectric power station, begun in 1976, will be the largest in the RFE when it is completed[5] (see p. 221).

Quest for foreign investment

If foreign investment is secured and the political environment favorable, the gold mining industry is likely to expand. Amur officials have offered tax benefits for foreign investors and lessees (see p. 217.

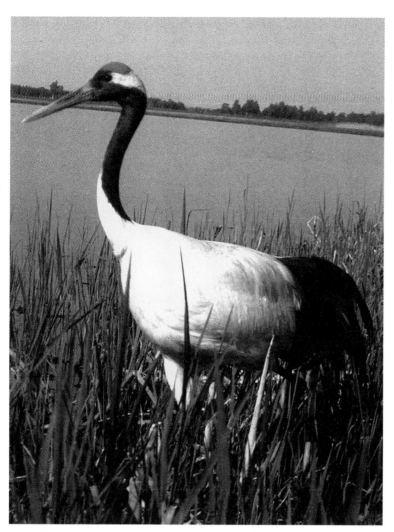

Four endangered species of cranes, including the red-crowned crane (Grus japonensis), breed in or migrate through the Amur Valley.

a railroad junction on the Trans-Siberian Railroad. Food processing is the major industry. Tynda (pop. 45,600), located on the Baikal-Amur Mainline, has suffered tremendously during the post-Soviet period. Population increased rapidly during the heyday of railroad construction and timber extraction. In recent years, however, the population has decreased by more than 25 percent as people have emigrated to other areas of the *oblast*.[6]

Population

As of January 1, 2001, the total population of Amur Oblast was 997,500.[7] The population has declined by more than 60,000 since 1990. Approximately 65 percent of the population is considered urban; 35 percent is rural. Today, there are only about 1,360 Evenks, an indigenous group, in the *oblast*.[8]

Political status

The population is mostly composed of ethnic Russians, Ukrainians, and Belorussians whose ancestors migrated to the RFE at various times during the past century and a half.[9] During the 1990s, the *oblast* went through a series of changes in its executive leadership. Between 1991 and 1997, there were six different governors of Amur Oblast, practically a new governor each year. A certain amount of stability was achieved when Anatoly Belonogov, formerly a chairman of the Amur Oblispolkom (Regional Executive Committee) during the Soviet period, became governor in 1997.[10]

Natural resources

Mineral reserves have been estimated at $400 billion.[11] These abundant resources include coal, iron ore, gold flakes, timber, water, and various nonferrous metals. There are over 71 billion tons of brown and bituminous coal in more than 90 deposits and close to 4 billion tons of iron deposits. Major deposits include Raichikhinsk, Arkhara-Boguchan, Yerkovtsy, Ogodzha, and Garinsk. Building materials such as clay, sand, gravel, quartz, and limestone are also plentiful. Estimates for nonferrous mineral concentrations in tons are as follows: silver (3,000), iron (2,000), copper (10 million), titanium (40 million), platinum (100), zinc (400,000), apatite (30 million), zeolite (100 million), kaolin (100 million).[12] Reported annual gold extraction is about twelve metric tons. There are also 20 million ha of forests containing an estimated 2 billion cu. m of timber, largely larch but also other coniferous timber (spruce, pine, fir) and deciduous timber (Mongolian oak, iron birch

[*Betula ermani*], Dahurian birch, aspen [*Populus tremulae*], poplars, and lime [*Tilia amurensis*]). The region has a number of large rivers that the Russian government would like to harness to provide hydroelectricity. There are also numerous clean underground springs and hot springs valuable for medicinal purposes and tourism. The rich *blackzem* soils of the *oblast* make up more than half of the RFE's arable land and produce a third of the RFE's gross agricultural product.

Main industries

Resource-based industries, such as electricity generation, fuel, nonferrous metallurgy, and forestry, are fundamental to Amur's economy, comprising more than 70 percent of the total industrial output for the region (see fig. 5.1). Electricity generation (much from hydroelectricity) is one of the cornerstones; in 2000, the fuel and electricity industries accounted for almost 40 percent of total industrial output. Major sources of electricity are the Zeiskaya Power Station, small coal-power stations, and generators used by mining and logging operations to supply their own electricity.

The mining industry also plays a major role in the *oblast*'s economy. Ferrous and nonferrous metallurgy represents about one-third of the total industrial output.[13] Coal is the most abundant resource; this industry is controlled by the Dalvostokugol AO (joint-stock company). Gold mining is the fastest growing industry, and given the large reserves, will likely expand in the future. Some estimate that the placer gold deposits in Amur are the largest in Russia and third largest in the world.[14]

In 2000, the timber industry accounted for 7 percent of total industrial output. Amur Oblast has almost 2 billion cu. m of timber over an area of nearly 23 million ha.[15] Amurlesprom and Tyndales are the main logging ventures (see table 5.8) and clear-cutting is the main logging method. Food processing, flour milling, and feed production comprise about 17 percent of total industrial output.[16] This industry benefited from the devaluation of the ruble, which made imported food products more expensive.

Infrastructure

Amur Oblast has two major railroads, which traverse the territory from west to east: the Baikal-Amur Mainline (BAM) (1,525 km) in the north and the Zabaikal section of the Trans-Siberian Railroad (1,411 km) in the south. The two lines are connected by a 180-km north-south railroad between Tynda and Skovorodino. The railways carry the vast majority of cargo, 70 percent of the total.[17] There are close to six thousand miles of public roads, about half of which are paved.[18] Road conditions outside the cities are unpredictable, especially in winter. The construction of the 1,017-km Trans-Siberian Highway, from Chita to Nakhodka,[19] will increase trade between Amur and neighboring provinces and will likely open up new areas to mining and logging.

Amur also has 2,100 km of navigable waterways.[20] The main ports of Blagoveshchensk, Poyarkovo,

Figure 5.1
Industrial production in Amur Oblast, 2000

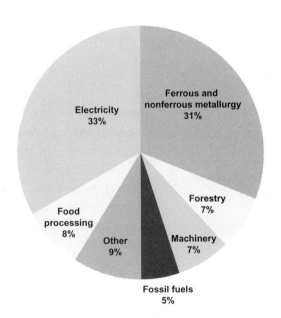

Source: Goskomstat, 2001.

Figure 5.2
Exports from Amur Oblast, 2000

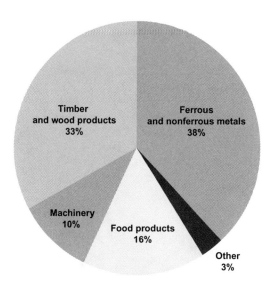

- Timber and wood products 33%
- Ferrous and nonferrous metals 38%
- Machinery 10%
- Food products 16%
- Other 3%

Source: Amur Oblast Committee of State Statistics, 2001.

Svobodny, and Zeya are in operation for six months of the year.[21] River shipping is used throughout the entire length of the Amur River, along the Zeya River and the Zeiskoe Reservoir (to Bomnak), the Selemdzha River (to Norsk), and the Bureya River (to Cheugda). The airport in Blagoveshchensk has flights to towns in Amur, to a few RFE and Siberian cities, and to Moscow. Presently there are no bridges over the Amur River although one, just below the confluence of the Amur and Zeya Rivers, connecting Blagoveshchensk with the Chinese city of Heihe, has been planned. Telecommunications exist but remain fairly undeveloped: Only 10 percent of rural residents and 14 percent of urban dwellers have telephones.

Foreign trade

In 2001, Amur's total international trade was officially valued at U.S.$87.2 million. The value of trade has declined by nearly 40 percent since 1995.[22] Much of this decline in dollar value is probably the result of the devaluation of the ruble in August 1998. In 1999, following the collapse of the ruble, imports to Amur declined by 60 percent and exports increased by 17 percent.[23] Most of Amur's exports are raw materials, especially timber and metals (see fig. 5.2). The trade in services, valued at about U.S.$5.5 million annually, accounts for a small fraction (7.5 percent) of total trade.[24] Some analysts point to the growing illegal, and thus unreported, trade with China and maintain that actual trade figures are much higher.

Amur's main trading partner is China, and its share has increased tremendously in the past decade. In 1995, China accounted for 39 percent of Amur's international trade; in 1998, 53 percent, and by 2001, about 82 percent of the trade in goods and 99 percent of the trade in services. In 2000, exports to China were valued at U.S.$46.9 million.[25] A much smaller share, less than 15 percent, of Amur's exports go to Japan and South Korea. In 2000, exports to Japan were valued at U.S.$6.8 million.[26]

In winter, the border points of Blagoveshchensk, Poyarkovo, and Dzhalinda host a shuttle trade (which accounts for two-thirds of Amur's foreign trade) across the frozen Amur River. In exchange for Amur's raw materials and machinery, canned foods, cheap clothing, shoes, and other products are imported from China. Imports in demand include sugar, rice, tea, fruit, canned food and meat products as well as construction, woodworking, and logging equipment from firms such as Caterpillar (U.S.) and Sumitomo (Japan).[27] To expand trade with China, the government plans to establish a Sino-Russian Free Economic Zone between Blagoveshchensk and Heihe in an area encompassing a total of one thousand ha on both sides of the border.[28]

Economic importance in RFE

As the RFE's largest producer of soybeans, grain, and milk and its second largest producer of potatoes and meat, Amur is the major agricultural producer in the region, accounting for more than 50 percent of all grain, 28 percent of all meat, and 30 percent of all milk

produced in the RFE.[29] However, the value of Amur's industrial production lags far behind that of most other regions of the RFE, ranking seventh out of the ten regions,[30] with an industrial output that accounts for only 4.3 percent of the RFE's total.[31] For comparison, the value of Amur's industrial production is approximately one-eighth of Sakha's, one-fifth of Primorsky Krai's, and less than one-third of Khabarovsk Krai's.[32] Recent estimates have placed gross annual production in the *oblast* at between three and four hundred million dollars, however, as with all statistics from the RFE, estimates tend to be coarse. For example, to avoid fees, taxes, and duties, the timber industry is fraught with illegal logging and exports.[33]

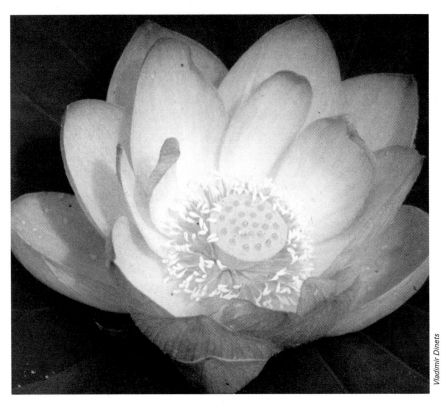

Vladimir Dinets

The endangered Komarov's lotus (Nelumbo nucifera var. komarovii) *grows primarily in the Amur basin.*

General outlook

The region appears to be tying its future to its huge neighbor just cross the Amur: The People's Republic of China. Logging could increase dramatically if the timber trade with China continues to expand. Forests in Amur region are not as rich as they are in some other regions, but the *oblast*'s geographic proximity to major export markets and extensive rail infrastructure makes its raw log export industry competitive with other regions of the RFE and eastern Siberia. The Amur government, traditionally one of the most progressive in the RFE in creating new protected areas, appears eager to help fill China's growing need for imported timber. It has proposed allowing logging in Urkansky Zakaznik. The proposed Blagoveshchensk-Heihe Bridge spanning the Amur River would help increase trade with China but could also threaten its forests. Japanese logging companies have been expressing a growing interest in RFE larch trees, a species of which Amur region has considerable resources, as the Japanese plywood industry shifts away from logging in Southeast Asia. The forests, which have already been devastated by excessive clear-cutting, primarily on permafrost soil, will continue to be degraded, and erosion and flooding problems will continue unless logging practices change.

Government and industry are eyeing the export of energy, mainly from hydroelectric power stations, to China. While the government justifies construction of these huge power stations as necessary for supplying local energy needs, studies show that the *oblast* does not need such massive amounts of energy and is well suited for alternative energy sources such as solar power. With the exception of eastern Siberia, no other region of Russia has as many sunny days as does Amur Oblast. Nevertheless, the Bureinskaya Dam, when completed, will flood large tracts of forest and will permanently alter the hydrological balance

in wetlands downstream. Japanese corporations have shown interest in providing turbines and other equipment to expand the energy production of this dam.[34] The Gilyuiskaya hydroelectric station, for which technical documentation has been completed, and several small power stations will likely follow the completion of the Bureya project, despite warnings from ecologists that vast tracts of forests will be flooded to build the reservoirs and silt will pollute the rivers.

The government would also like to expand mining of the region's considerable gold deposits. Currently, gold extraction is dominated by placer mining, which is cheap and environmentally destructive. In the northern part of the *oblast*, gold mining from alluvial deposits has damaged river ecosystems. Coal mining has replaced fertile agricultural land with sterile moonscapes. Reforming these environmentally degrading practices is frustrated by the complete lack of financial resources for doing so. Additionally, the enterprises that carry out these activities are major social forces in their communities. Because they are often the predominant employer in an area and among the essential providers of social services, local people often strongly support their ventures.

The region, heavily dependent on the exploitation of natural resources, lacks the processing facilities to add value to these products. Only a tiny fraction of Amur's raw materials is processed locally. Exports are primarily unprocessed raw materials. Officially, unprocessed wood products accounted for 45 percent of the volume of exports in 1999.[35] Agriculture products are also exported unprocessed. Currently, most processing of the *oblast*'s rich soy bean harvest occurs outside its borders in Irkutsk and Primorsky regions and China. Investment in the processing of raw materials could be of great benefit to both the population and the environment. The processing of wood, for example, would generate jobs and increase revenue and might slow down logging as conceivably less timber would need to be exported to secure enough revenue to keep the industry alive. Other value-added projects being promoted by the government and industry include: a timber-processing complex in Tynda, a soy bean processing plant and a jewel factory in Blagoveshchensk, and a mechanical plant in Zeya.[36]

Above all, the government needs to protect the shrinking pine forests and wetlands, particularly in the Zeya-Bureya Plain, as both ecosystems preserve much of the region's plant and animal biodiversity and are key routes for migratory birds and vertebrates, including a number of globally endangered cranes.

— *Melinda Herrold, Josh Newell*

Ecology

Yuri Darman, Gennady Illarionov

Consisting of a variety of ecosystems, ranging from mountainous tundra to Far Eastern mixed forests and East Asian prairies, the Amur region contains a very high level of biodiversity. Vegetation in the area includes elements of Eastern Siberian, Okhotsky-Kamchatsky, Manchurian, and Dahurian flora totaling around two thousand species of vascular plants. In the southern region of the *oblast*, which was never covered by glaciers, numerous ancient species including the Komarov's lotus (*Nelumbo nucifera* var. *komarovii*) and water shield (*Brasenia schreberi*) have been preserved. At last count, 212 species of rare and endangered plants in Amur had been listed as requiring special protection.[37] A significant number of species are endangered (see table 5.1), including many not yet listed in *Red Data Books*.

Table 5.1

Animal species of Amur Oblast

	Total species	Russian Red Data Book species	Species needing Red Data Book listing
Birds	326	37	8
Mammals	67	4	6
Fish	64	2	2
Reptiles	10	1	2
Amphibians	7	0	3

Source: Darman, 2000.

The *oblast's* three most crucial biodiversity hotspots are:
1. The wetlands of Arkhara Lowlands in the southeast.
2. A small patch of broadleaved forest in the southeast, where Siberian tigers (*Panthera tigris*) were seen as late as 1972.
3. The Zeya-Bureya Plain, which contains rich *blackzem* soils and unique flora and fauna.

These ecosystems have been damaged by human activities, and restoration will require maximal effort. In particular, the ecosystems that lie at the southern edge of the permafrost zone require special methods of assessment. The forests of Amur, which cover 22.9 million ha (an area larger than the entire forest cover of a densely forested country such as Finland), play an important role in maintaining the global climate.

Forests

Amur Oblast forests are primarily Dahurian larch (60 percent), together with broadleaved deciduous species such as birch and aspen (22.3 percent), Japanese stone pine (5.7 percent), Scots pine (3.2 percent), Siberian spruce (*Picea obovata*) and East Siberian fir (*Abies nephrolepis*) (2.3 percent), and other broadleaved species (2.1 percent). Larch, pine, and birch forests have the greatest commercial value. Larch forests grow throughout the region, excluding the unforested areas of the Zeya-Bureya Plain. Mountain larch usually occurs in pure stands, occasionally interspersed with small stands of Japanese stone pine. Larch forests in the foothills and valleys grow with smaller bushes such as rhododendron (*Rhododendron*), foxberry (*Vaccinium vitis-idaea*), and Labrador tea (*Ledum*), or grow as *mari* (sparse larch forest and marshland). Broadleaved species grow in mountain valleys. Silver birch and aspen regenerate on land burned by forest fires or after logging. Fir and spruce forests have a very limited distribution (only in the subalpine vegetation band) and grow with moss, sedge, and foxberry. Japanese stone pine, mountain mosses, and lichen tundra (*goltsi*) cover the highest mountain slopes.

Vladimir Dinets

The Siberian chipmunk (Tamias sibiricus), *valued for its fur in Soviet times, is no longer hunted.*

AMUR

Table 5.2
Protected areas in Amur Oblast

Type and name	Size (ha)	Raion	Established
Zapovedniks			
Norsky	211,200	Selemdzhinsky	1998
Zeisky	99,400	Zeisky	1963
Khingansky	97,800	Arkharinsky	1963
Federal Zakazniks			
Orlovsky	121,500	Mazanovsky	1999
Khingano-Arkharinsky	48,800	Arkharinsky	1958
Regional Zakazniks			
Ulminsky	162,000	Mazanovsky	1981
Verkhne-Depsky	156,800	Zeisky	1976
Lopchinsky	142,400	Tyndinsky	1976
Urkansky	141,000	Tyndinsky	1967
Bekeldeul	104,700	Zeisky	1995
Birminsky	101,500	Mazanovsky	1999
Tashinsky	90,800	Romnensky	1967
Gerbikansky	87,600	Selemdzhinsky	1995
Tolbuzinsky	80,100	Magdagachinsky	1959
Simonovsky	77,800	Shimanovsky	1963
Ust-Tygdinsky	67,500	Shimanovsky	1963
Magdagachinsky	67,200	Magdagachinsky	1963
Zhelundinsky	67,200	Bureinsky	1967
Ganukan	64,000	Arkharinsky	1985
Andreevsky	60,000	Arkharinsky	2000
Iversky	50,000	Svobodnensky	1963
Blagoveshchensky	48,000	Blagoveshchensky	1974
Urushinsky	36,800	Skovorodinsky	1995
Verkhne-Zavitinsky	36,100	Zavitinsky	1998
Zavitinsky	35,200	Zavitinsky	1963
Muravyovsky	34,000	Tambovsky	1967
Voskresenovsky	16,800	Seryshevsky	1968
Amursky	16,500	Konstantinovsky	1967
Kharkovsky	15,000	Oktyabrsky	1995
Beryozovsky	11,300	Ivanovsky	1974
Irkun	7,200	Bureisky	2000
Ust-Norsky	2,700	Mazanovsky	1981
Tomsky	–	Romnensky	1976

Note: Urushinsky Zakaznik is defunct.

Source: Darman, 2000.

Intensive clear-cutting is shrinking the intact pine forests. They must be protected, and any cutting must be sustainable. Pine forests grow in the western part of the *oblast* (west of the Selemdzha River and the lower reaches of the Zeya River). On the eastern boundary, patches of pine can be found in the Byssa, Tomya, Bureya, and Arkhara River valleys. Floodplain pine forests, which grow alongside poplar, larch, and willows (*Salix*), are the most productive. Intensive agriculture and logging have destroyed large portions of the forest-steppe zone in the Zeya-Bureya Plain. However, some of the conifer and mixed forests here still remain and are rich in plant species. Deciduous oak, linden, elm (*Ulmus*), and ash (*Fraxinus*) thrive together with the conifer varieties. There are also fragments of Mongolian oak and black birch (*Betula reofila*) forest.

Protected area system

The only realistic way to conserve the region's biodiversity is to develop a more comprehensive system of protected areas. Protected areas in Amur Oblast today cover 2.36 million ha, or 6.5 percent of the *oblast*'s total area. There are three *zapovedniks*, of which the most recently created is Norsky Zapovednik. The total area covered by Norsky and the older Khingansky and Zeisky Zapovedniks is 408,400 ha, or 1.11 percent of the *oblast*'s total area. This is the smallest percentage of strictly protected land among all of the RFE's ten regions. Also in existence are 25 zoological *zakazniks* for game species conservation, an ichthyological *zakaznik* preserving a spawning ground, 2 botanical *zakazniks* protecting medicinal plants, 2 *zakazniks* with comprehensive protection regimes and 128 natural monuments (see table 5.2).

In 1991, various federal and regional government agencies developed a program to create a protected-areas network for Amur Oblast. This program included the creation of a minimum of four new *zapovedniks* and two national parks. Because the entire program cannot be fulfilled under current economic conditions, it is necessary to focus attention on those territories that are most important for biodiversity conservation, and, at the same time, most threatened by anthropogenic disturbances—hotspots.

Five hotspots were identified at the first conference on hotspots held in Vladivostok in January 1995. In accordance with its recommendations, two new protected areas were created within the two subsequent years: Norsky Zapovednik and Bekeldeul Zakaznik; a third—Ganukan Zakaznik—was expanded. In February 1998, in connection with the second hotspots conference, specialists gathered at a regional roundtable discussion to identify new priorities for biodiversity conservation. Since that time, four additional *zakazniks* have been created to protect these hotspots.

Biodiversity hotspots

Yuri Darman, Gennady Illarionov

1. Arkhara Lowlands and Maly Khingan Range (forest and wetland)

The Arkhara Lowlands and adjacent foothills of the Maly Khingan range (varying in elevation from 100 to 600 m) have the most diverse natural ecosystems found in Amur Oblast. The forests, ranging from East Asian prairie and mixed Korean pine and broadleaved forests to Ayan spruce and northern larch, boast a surprising level of biodiversity. This region is the only place in the *oblast* where pine and broadleaved forests mix with Mongolian oak, Siberian ginseng (*Eleutherococcus senticosus*), Amur grape, and wild kiwi (*Actinidia colomicta*).

Broad expanses of wetlands (covering about 250,000 ha) provide nesting grounds for eighteen to twenty pairs of red-crowned cranes and ten to eleven pairs of white-naped cranes. The Arkhara Lowlands host the world's largest nesting population of Oriental white storks—in 1994 there were thirty-four nests, and in better years there are up to fifty nests or over two hundred birds. A thousand species of vascular plants have been found, many of which are rare or endangered, including Komarov's lotus and water shield. Avifauna totals three hundred species. There are about fifty species of mammal, including snow deer, wild boar (*Sus scrofa*), Manchurian wapiti, brown bear, Himalayan bear, Eurasian lynx (*Felis lynx*), gray wolf, and river otter (*Lutra lutra*). There have also been occasional sightings of Amur cat (*Felis euptilura*) and yellow-throated marten (*Martes flavigula*).

Industrial development of this region has, so far, been limited to a narrow strip on either side of the Trans-Siberian Railroad. The vast marshes of the lowlands have not been drained for agriculture because they are regularly flooded when the Amur rises after heavy rains. The steep slopes of the Maly Khingan foothills and a ban on the commercial harvest of Korean pine have spared the valuable old-growth forests from industrial logging. Selective logging earlier in the twentieth century did not significantly degrade these forests. Rivers, including the entire Arkhara basin, remain largely free of pollution because there is little human settlement in the watersheds. Given the high biodiversity and absence of environmental degradation, this territory is considered the first priority among the hotspots identified for Amur Oblast.

Threats. Despite the decline in economic activity over the past few years, threats remain. Every year, agricultural fires reach the *zapovednik*, destroying the nests of cranes, storks, and many other bird species. Fires in late spring and autumn threaten forests. Firewood collection by local residents is completely unregulated. Salvage logging in the remaining large coniferous forest is increasing. In the region around Boguchan Village, open-cast coal mining is gradually creating a wasteland. Gold mining threatens the upper Urin, Uril, and Birya Rivers, which are important spawning grounds. When completed, the Bureinskaya Hydroelectric Power Station will create an enormous reservoir flooding large tracts of valuable forest and destroying a number of migratory routes for large mammals. There are plans for logging along the riverbank below the dam that will increase the frequency and volume of floods and will affect downstream wetlands in the floodplains of the Bureya and Amur Rivers.

Red-crowned cranes (Gros japonensis) *nest in Zeya-Bureya Plain.*

Existing protection measures. In 1958, the Khingano-Arkharinsky Federal Zakaznik (48,800 ha) was established between the Urina and Dydy Rivers to protect the last remaining Korean pine forests from logging. In 1963, the federal government created Khingansky Zapovednik between the Uril and Khingan Rivers. In 1978, its area was expanded to 97,800 ha to include more wetlands and riparian birch and oak forests.

Khingansky Zapovednik is well studied; the studies of the Oriental white stork, red-crowned crane, and white-naped crane there are particularly valuable. Within the *zapovednik*, a station has been established to reintroduce these birds and other rare species; this is the only facility of its kind in the RFE. At the station, an international program is under way to increase red-crowned and white-naped crane populations. In 1985, a landscape *zakaznik*, Ganukan (64,000 ha), was established to protect the last remaining unprotected crane nesting sites in the Arkhara Lowlands and is now under control of Khingansky Zapovednik. In 1994 the Arkhara Lowlands within the *zapovednik* and the *zakaznik* were given Ramsar status. In 1997, the site was included in an international network of key crane habitats of northeast Asia.

The Zhelundinsky Zakaznik (67,200 ha) has protected Manchurian broadleaved forests on the left bank of the Bureya River since 1967. The importance of this protected area will increase in coming years, as the reservoir created by the planned Bureinskaya station will affect this territory. The dam also threatens ten natural monuments. The Tatakan River (which is a natural monument), for example, preserves one of the westernmost salmon hatcheries in the Amur Basin. The protected-area network of this region conserves 15 percent of the lands in this *raion*, the highest percentage of any *raion* in Amur Oblast.

Recommendations. The following actions should be taken:
- Finalize documents within the Ramsar Convention Bureau for the Arkhara Lowlands.
- Improve protection of the floodplain forests in Ganukan Zakaznik.
- Establish a natural monument, under the jurisdiction of Khingansky Zapovednik, on the shores of Lake Krivoe, to preserve the *oblast*'s only population of the Komarov lotus.[38]
- Establish a science station near Lake Dolgoe, administered by Khingansky Zapovednik.
- Increase financial support for Khingansky Zapovednik and the Rare Birds Reintroduction Station there.[39]
- Create a biosphere *zapovednik* that encompasses the combined territories of the existing Khingansky Zapovednik, the Ganukan Zakaznik, and the Khingano-Arkharinsky Zakaznik.
- Forbid logging within Khingano-Arkharinsky Zakaznik.
- Continue ecological surveys in the region.
- Improve protection for the Zhelundinsky Zakaznik, particularly in light of the planned Bureinskaya station.

To avoid repeating the tragic mistakes of the Zeiskaya Hydroelectric Power Station, funding must be found to conduct monitoring as the reservoir forms behind the dam on the Bureya.
- Create a 36,000-ha regional biological *zakaznik* to protect migratory routes along the right banks of the Bureya, Verkhnyaya, and Zavitinskaya Rivers. The Amur government has included this planned protected area in a number of decrees on expanding the protected-area network.[40]

2. Southern part of the Zeya-Bureya Plain (wetland)

This territory, with abundant lakes, marshes, and wetlands interspersed with agricultural and pasture lands, is the last relatively untouched floodplain in the middle reaches of the Amur River. Due to their proximity to the Chinese border, strict restrictions have been placed on these lands. The ecology of this region is similar that of the Arkhara Lowlands. Along the smaller tributaries of the Amur (the Alim, Gilchin, Dim, Zavitaya, and Chesnokovka), there are marshes and meadows with rich *blackzem* soil.

Red-crowned cranes, white-naped cranes, and Oriental white storks nest here. In earlier times there were also swan geese (*Anser cygnoides*), Manchurian bustards (*Otis tarda dybovskii*), and Dahurian partridges (*Perdix dauurica*). During the spring migration, massive flocks of geese stop over here. During the autumn migration more than three hundred hooded cranes (*Grus monachus*) stop here to refuel. The floodplain forests and marshes sustain many mammal species; there are dense populations of snow deer, raccoon dog, and red fox (*Vulpes vulpes*).

The area has been well studied; bird censuses by air and land take place frequently. Since 1981, scientists at Muravyovsky Zakaznik have regularly conducted field studies of animals. Strict border zone regulations have complicated scientific studies along the Amur. Since 1992, many international organizations have promoted the protection of the wetlands and rare birds and have provided funds for numerous projects.

Threats. Protected solely by the regional hunting administration, which has jurisdiction only to prevent poaching and does not have adequate resources, the territory is threatened by increasing agricultural activity, land drainage, and frequent changes in land ownership among small landowners. Every year fires destroy crane and stork nests. Fuel shortages in settlements leads to logging for firewood in the forests unscathed by fire. Unfortunately, the Federal Forest Service has no specialized unit to manage timber use in this region. The gradual expansion of *dacha* gardens is also disturbing crane and stork nests. The planned construction of a bridge across the Amur and the establishment of a Sino-Russian Free Economic Zone may completely destroy wetlands near Kani-Kurgan Village.

Existing protection measures. In 1967, the 31,600-ha Muravyovsky Zakaznik was established (and expanded to 34,000 ha in 1995) to protect wetlands in the basin of the Arguzkikha River, which feeds into the Amur River 30 km downstream from the Zeya Delta. Hunting, agricultural burning, chemical fertilizer and pesticide use, land reclamation, and new construction are all prohibited in the territory. Also in 1967, the Amursky Zakaznik (12,200 ha) was established on the lower Dim River, and later expanded to 16,500 ha in 1995. In 1993, the Socio-Ecological Union, a Russian nongovernmental organization (NGO), set up the private Muravyovka Park for sustainable land use. The park leases 5,206 ha of marshland and meadows. In 1994, a section of the Zeya-Bureya Plain within Muravyovsky Zakaznik was included in the Ramsar Convention's List of Wetlands of International Importance, according to a government order (No. 1050, signed September 13, 1994). Regional land users and the Amur government have agreed to this designation. Along the Amur basin between the Zeya and Bureya River deltas there are eight regional natural monuments.

Recommendations. Creating new protected areas will not completely protect the region's biodiversity. It will be necessary to create and implement programs that balance economic and ecological needs.

- Increase financial support to control fires and protect nesting sites in Muravyovka Park. In 1997, scientists found Oriental white stork, red-crowned crane, and white-naped crane nests along the lower reaches of the Kupriyanovka River; the government should establish a nature *zakaznik* with seasonal protection in this region.
- Study the small remaining marshland systems that host isolated nesting sites of rare birds, and create natural monuments in these locations.
- Preserve the uncommonly rich soils of the Zeya-Bureya Plain. Some of these *blackzem* pasture lands must not be used, so that the East Asian prairie ecosystems can regenerate. Agricultural plots abandoned by farmers should be leased and protected, with some of them incorporated into the Muravyovsky and Amursky Zakazniks. This requires funding for rangers and passing of legal regulations allowing such a plan.

3. Mukhinka forest area

Mukhinka is on the right bank of the Zeya River, 30 km north of Blagoveshchensk. The region has a landscape and microclimate unique in Amur Oblast. The eastern and southern slopes of the hills there are protected from the prevailing cold northwesterly winds that hit other nearby areas. As a result, winter in Mukhinka is mild, with only small fluctuations in temperature, and its rich mineral and thermal springs do not freeze over, even on the coldest days.

Mukhinka has the last remaining natural pine forests near Blagoveshchensk, an eastern flank of what was once a band of continuous pine forest on the Amur-Zeya plateau. It also serves as the eastern border for many species typical of Manchurian flora such as Mongolian oak, Manchurian walnut (*Juglans manchurica*), Amur maackia (*Maackia amurensis*), magnolia vine, Amur grape, and others. This juxtaposition of communities within a rather small area presents excellent possibilities for a botanical garden for scientific and educational purposes. In addition to the pine forests, the wide Zeya floodplain extending between 2 and 3 km from the foothills and the marshlands dotted with numerous lakes are areas of ecological importance.

Threats. Basin lakes and natural hot springs make this area very attractive for tourists from Blagoveshchensk. Horseback riding and river rafting are popular. In the 1970s, high-ranking bureaucrats began to construct large sanatoria and tourist complexes. Five years ago this activity was halted, but not before the poorly controlled construction had taken its toll on Mukhinka's forests and slopes. Unregulated recreational activity is degrading vegetation, causing erosion, and creating ravines and gullies. Lake Galyanie is polluted by untreated sewage.

Existing protection measures. For years, ecologists have tried to protect Mukhinka. In 1975, activists managed to establish the Blagoveshchensky Zakaznik encompassing part of the Mukhinka area. A portion is designated as a natural monument and administered by the Amur Forest Service. Scientists from the Russian Academy of Sciences and the Blagoveshchensk State Pedagogical Institute mobilized governmental support to establish a botanical garden here in the late 1980s, but only in 1994 were 300 ha of pine and floodplain forests officially set aside for this purpose. In 1997, the design of the gardens was completed and the first of three sites were protected; now efforts are under way to transfer control of the hotel and offices from the sanatorium to the botanical gardens.

Recommendations. The following actions should be taken:
- Find funding to create recreation areas and tourist trails, hire rangers, and implement a public-awareness campaign.
- Increase funding for the botanical garden, which could serve as a nucleus for the proposed Mukhinka Nature Park. The proposal to create this 35,000-ha park, which will be a single nature-protection institute and facilitate measures to control tourism, has been included in the *oblast*'s work plan and is supported by the Amur Forest Service and the Blagoveshchensk administration.

4. Between the Nora and Selemdzha Rivers (forest and wetland)

Permafrost, which covers this region, affects the vegetation and landscape. Larch forests grow throughout the area. Of the 481 species of vascular plants (about 25 percent of all the species in the *oblast*) that grow here, most are Manchurian species growing on the northern reaches of their habitat: elms, Siberian ginseng, Mongolian oak, Dahurian birch, Manchurian ash (*Fraxinus manchuricus*), Asian parilla (Menispermum dahuricum), and Sargent's hawthorn (*Crataegus sargentii*).

The Nora and Selemdzha River valleys serve as corridors through which southern species migrate northward; this creates a rich mixture of ecosystems. Boreal, Dahuro-Mongolian, Manchurian, and Okhotsk-Kamchatkan fauna all thrive here. Birds are primarily of the latter two types; most of the mammals are the boreal type. There are three hundred vertebrate species, including 70 percent of the birds and about 50 percent of the mammals found in the *oblast*. Rare birds such as the Oriental white stork (between four and six nests), black stork (three nests), white-tailed sea eagle (three nests), and osprey (at least six pairs) nest here. There are also about seven pairs of hooded cranes, which is a significant proportion of the total hooded crane population in the Amur River basin. There are more whooper swans (*Cygnus cygnus*), estimated to be as many as eighty individuals, than anywhere else in the *oblast*.

But the region is perhaps most famous for the world's largest migrating population of snow deer (about seven thousand individuals); in the summer the population density approaches between forty and fifty head per 1,000 ha. In the winter, the deer migrate to the Orlovka-Gramatukha valley, where between 250 and 300 moose migrating down from the nearby ridges also settle in. These wintering grounds play a critical role in maintaining herd populations of both species.

Threats. Construction of the Baikal-Amur Mainline (BAM) railroad and settlements along it opened up huge areas of pristine forest to logging. Placer gold mining along snow deer migratory routes has destroyed valuable habitat and led to increased animal poaching, which here and throughout the *oblast* has reduced the number of deer by half. The exploration and extraction of precious metals from mineral springs within the basin and open-pit mining for semiprecious stones such as chalcedony have polluted the Nora River. This pollution and increased fish poaching, often done by electrocution, has destroyed fish stocks. The construction of the proposed Dagmarsky hydroelectric station, with a reservoir that would flood most of the low-lying Nora-Selemdzha basin, will cause further damage.

Existing protection measures. In 1968, the Norsky Zakaznik (40,000 ha) was established. In 1984, because of concern about the construction of the BAM railroad, the area was increased to 211,200 ha and the preserve became a federal *zakaznik*. Then, after five years of lobbying, it was upgraded to a *zapovednik*. The Mamynsky and Maisky Hunting Zakazniks, established in 1959 and 1978, respectively, to protect snow deer, were merged to form the Orlovsky Zakaznik (121,500 ha). Ust-Norsky Zakaznik and five natural monuments are also located in the Nora-Selemdzha basin.

Recommendations. The following actions should be taken:
- Increase funding to purchase equipment and hire staff for Norsky Zapovednik.[41]
- Establish the biological research station of Norsky Zapovednik on the nearby Sorokaverstka Island.
- Establish a buffer zone, which limits some kinds of economic activities, around the *zapovednik*.
- Make the Nora-Selemdzha wetlands a Ramsar site.
- Upgrade Orlovsky Zakaznik to federal status to protect the snow deer populations.[42]

5. Mountains surrounding Zeisky Reservoir (forest)

The Tukuringra-Soktakhan-Dzhagdy Mountain Range divides the southern taiga from the middle taiga forests. Manchurian and Dahuro-Mongolian ecosystems flourish on the southern slopes, and boreal flora and fauna may be found on the river plain. The Zeya Valley and Ogoron Lake depression river basins are the primary northern migratory path for these southern species. The first of these paths was destroyed by the Zeiskaya hydroelectric station in the early eighties, when the reservoir flooded more than 240,000 ha of forest and river plains. Zeiskoe Reservoir, as it is now called, serves as a classic case for the study of human impact on nature in the Amur basin. Construction of the BAM railroad degraded the second migratory pathway, the Ogoron Lake depression basin. This entire ecosystem has become unstable and is, therefore, a constant concern for ecologists.

Nevertheless, large areas of old-growth forest remain intact. Zeisky Zapovednik, next to the reservoir, protects the mountain forests of central Amur Oblast, including 637 vascular plant, 230 bird, and 52 mammal species. Notable bird species include golden eagle (*Aquila chrysaetos*), white-tailed sea eagle (*Haliaeetus albicilla*), osprey, and Siberian grouse (*Falcipennis falcipennis*).

Threats. Staff and scientists of the Zeisky Zapovednik had been studying the effects of the reservoir on the flora and fauna of Tukuringra Ridge. Due to the lack of funds, research has been discontinued. Water quality in the reservoir is declining, fish stocks have been reduced by 90 percent, and water levels are not regulated with ecological needs in mind. The construction of Gilyuiskaya Hydroelectric Power Station, which may be built where the reservoir narrows to

become the Gilyui River, will cause siltation behind the new dam. Gold mining, which is underway in the Gilyui basin, is exacerbating the situation. Timber companies have clear-cut most of the forests growing along the foothills of these ridges and are now moving to the river headwaters to log. The last fir-spruce forests remaining in Verkhne-Depsky Zakaznik are being logged. Logging and placer gold mining, which occur along all the tributaries of the right bank of the Dep River, have left a landscape of barren hills and mining waste and polluted the nearby Lake Ogoron and its surrounding marshes.

Existing protection measures. Established in 1963 and enlarged to 99,400 ha in 1986, the Zeisky Zapovednik protects most of Tukuringa Ridge. A new national park planned for the uplands around the reservoir may become a reality. Also, in response to the first Hotspots Conference, *oblast* authorities established Bekeldeul Zakaznik (104,700 ha); logging is prohibited within the reserve. This *zakaznik* was initially supposed to be added to Zeisky Zapovednik, but lack of funds has prevented the transfer.

In 1976, Verkhne-Depsky Zakaznik (156,800 ha) was organized to protect the Dep River and Lake Ogoron. Unfortunately, 5,000 ha of forest have been commercially logged, and placer mining has degraded another 15,000 ha. These activities have led to a decline in key animal species, and the Ogoron basin has lost its value as a migration route for moose and snow deer.

In addition to the *zapovednik*s and *zakaznik*s, there are thirteen regional natural monuments.

Recommendations. The following actions should be taken:
- Provide financial and technical support for Zeisky Zapovednik, principally to monitor the ecological effects of Zeiskoe Reservoir.
- Enlarge the *zapovednik* northern portion to include the watersheds along the left bank of the Gilyui River.
- Find funding to incorporate Bekeldeul Zakaznik into the *zapovednik*.
- Designate forests along the mountainous shores of the reservoir for recreational use.
- Create a national park on the entire upland area, with Zeisky Zapovednik serving as the core area.

6. Nyuzhinsky Ridge and the Amur Pinelands (forest)

Pine forests, which are similar to those found in the Baikal region, serve as indicators for ecosystem health. Many plant species of Dahuro-Mongolian origin manage to penetrate this primarily Siberian region. Flora in the floodplains along this part of the Amur are found nowhere else in the *oblast* and include the rare Altaian onion (*Alnus altaicus*). The flora of Nyuzhinsky Ridge, where there is a transition from alpine pine forests to shrub communities of Japanese stone pine, is also noteworthy.

Most of the region's fauna is poorly studied. Like the flora, the fauna shows Dahuro-Mongolian influence, the only part of the *oblast* where this is the case. Musk deer (*Moschus moschiferus*) live among the cliffs along the Amur. This population is isolated from the primary habitat of the species, which is 100 km away. The forested valleys support a number of other ungulates, including Manchurian wapiti, as well as osprey and white-tailed eagle. Therapeutic mineral springs (Ignashinsky and Urushinsky) are also found here.

Threats. Because it is adjacent to the Trans-Siberian Railroad, part of the region has been heavily industrialized. Clear-cutting and selective logging have taken place in 80 percent of the area's pine forests, and the remaining forests are now being logged. New logging roads have been constructed in the headwaters of the Urka and Urusha Rivers. Intensive gold mining has taken place over the past decade and exploratory work at the Snezhinka site in the Urka headwaters is complete. Several other significant deposits have been discovered and mining is underway in the Oldoi and Khaikta River basins. Urushinsky Hunting Zakaznik was dissolved to allow for gold mining. The Chita-Nakhodka road, when complete, will open up new areas for development. Complete plans exist for two new hydroelectric stations on the Amur (Dzhalindinskaya and Amazarskaya); the Russian and Chinese governments will finance construction.

Existing protection measures. At present there is only one regional zoological *zakaznik*, which covers an area of 36,800 ha, to serve as a replacement for the now-defunct Urushinsky Zakaznik. The area surrounding Ignashinsky mineral springs has been designated as a recreational zone. There are four natural monuments in the region, mostly preserving the scenic cliffs along the Amur—the most famous being those at Cherpelskie Krivuny.

Recommendations. The following actions should be taken:
- Create Urkinsky Zapovednik, as called for in the federal Program for New Protected Areas, to conserve the headwaters of the Urka, Urusha, and Omutnaya Rivers. This *zapovednik* would protect transbaikalian alpine forests and help compensate for the damage being done by gold mining in the nearby Khaikta River basin. Residents support the creation of this reserve; more than five hundred signatures were collected for a petition in favor of the initiative. This support led to the prohibition of logging by the Erofeevsky Lespromkhoz in the Urka headwaters.
- Create a similar protected area in the region encompassing the Urka, Omutnaya, and Nyukzha headwaters, as included in the *oblast*'s own program for new protected areas.

- Establish the second *zapovednik*, Verkhne-Amursky, as proposed in the federal program, to protect the typical pine forests growing along the Upper Amur. A variant proposal called for creating the *zapovednik* along the Kutamanda River basin, but that idea was scrapped because the forests in the area have already been clear-cut. As an alternative, establish a federal botanical *zakaznik* in the pine forests in the border zone near Cherpelskie Krivuny.
- Establish a regionally administered protected area to conserve flora near the village of Ignashino and the floodplains at the confluence of the Amuzara and Amur Rivers.
- Protect the pine forests along the Gerbelik River, near the village of Chernyaevo. A plan to create a national park in this region has been included in the *oblast*'s program for new protected areas.

Economy

Yuri Darman, Gennady Illarionov

The standard of living, as elsewhere in Russia, has declined dramatically since Soviet times. Currently 45.6 percent of the population has a per-capita income below the poverty line.[43] The structure of industrial production has not only changed substantially (see table 5.3), but also has declined by more than 60 percent since 1992.[44] Much manufacturing has disappeared, and light industry has practically collapsed. In comparing figure 5.3 with figure 5.1 (see p. 200), one can see how drastically industrial structure has changed. The energy

Figure 5.3
Soviet-era industry in Amur Oblast

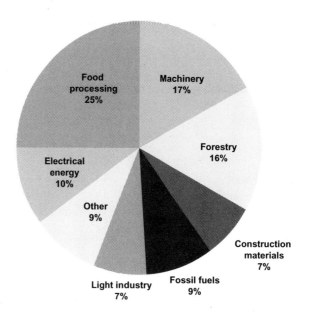

Source: Goskomstat, 2000.

generation and fuel industries have been the most stable during the transitional period.[45]

In 2000, approximately 17 percent of the Gross Internal Product (GIP) came from industrial production. Transportation accounted for 25 percent, agriculture 15 percent, construction 4 percent, and commerce nearly 16 percent of the GIP.[46]

Electricity production and nonferrous metallurgy

Table 5.3
Structure of industry in Amur Oblast, 1992–1999

	1992 (%)	1993 (%)	1994 (%)	1995 (%)	1996 (%)	1997 (%)	1998 (%)	1999 (%)
Electricity	13.8	19.2	29.9	35.5	42.2	45.7	45.1	36.1
Nonferrous metallurgy	17.4	23.0	17.6	13.7	9.8	11.0	13.1	25.9
Food processing	13.1	17.6	13.7	13.2	13.3	10.8	10.8	12.1
Forestry	12.7	8.9	6.7	8.3	5.8	4.2	4.6	6.0
Fossil fuels	7.1	8.0	10.2	8.5	9.7	13.4	11.2	5.8
Machinery	8.2	7.8	6.6	6.1	6.4	5.2	4.7	4.7
Flour-milling, oats, fodder processing	8.7	5.6	5.8	4.9	4.3	3.8	2.9	4.7
Construction materials	5.9	6.8	7.0	6.6	6.0	4.5	6.0	3.3
Light industry	2.1	1.9	0.9	0.9	0.3	0.1	0.1	0.1
Other	11.0	1.2	1.6	2.3	2.2	1.3	1.5	1.3

Source: Amur Oblast Committee of State Statistics, 2000.

Table 5.4
Employment in Amur Oblast, 1999

Sector	Percentage
Commerce	16.9
Industry, including mining	16.0
Transportation and communication	14.6
Agriculture	11.3
Education, culture, and the arts	10.7
Construction	9.3
Public health and social security	7.2
Government, judiciary, and police	4.8
Public housing management	3.8
Banking and insurance	0.9
Forestry	0.4
Science and scientific services	0.4
Other	3.7

Source: Amur Oblast Committee of State Statistics, 2000.

dominate industry, accounting for 64 percent of all industrial production.[47]

The coal industry (which supplies heat and power) includes coal-mining facilities at the Raichikhinsky, Arkharo-Boguchansky, and Ogodzhinsky deposits, and at several smaller sites. Some preparatory work had also been performed for opening a mine at the Yerkovetsky coal deposit. Electric power is supplied by three thermal power stations (the Raichikhinsky, the Blagoveshchensky, and the Ogodzhinsky) and the Zeiskaya Hydroelectric Power Station.

Agriculture has always played an important role in the economy of the region, with 58 percent of the total arable land area of the RFE concentrated there. The main agricultural products are summer wheat and soy beans, with Amur Oblast being the leading producer of soy beans in Russia. Next in importance is animal husbandry, followed by hunting, reindeer breeding (mainly in the north), and beekeeping. Horticulture remains largely undeveloped. All significant agricultural and animal-breeding enterprises are located in the central and southern parts of the *oblast*.

The distribution of the population by sector has changed considerably since 1992. The number of workers employed in construction has declined by more than 40 percent. The number of those employed in the industrial sector has declined by 27 percent and that in agriculture has decreased by 26 percent. Concurrently, the number of workers engaged in commerce has nearly doubled.[48] See table 5.4 for a summary of the distribution of the local population in the various sectors of the Amur economy in 1999.

Timber

The total area of timber resource lands covers 30,746,500 ha, of which 22,578,800 ha (1999) are forested. Commercial timber reserves amount to 1,175.14 million cu. m, including 735.65 million cu. m of coniferous species. A 1993 survey of timber resources revealed declining trends. Predominately coniferous forests decreased by 1,896,000 ha, and the total area of timberlands not covered by forests increased to 2,797,200 ha. It should be noted that the stated forest areas do not include forests in the forest-steppe zone of the Zeya-Bureya Plain, which are being rapidly depleted through uncontrolled cutting for firewood and by constant agricultural burns. At the same time, the forest area subject to insect damage and disease is expanding, primarily because there are no funds for prevention (see table 5.5). Figure 5.4 shows these nonforested lands, including burned areas and those destroyed by logging.

The total reserve of timber in the *oblast*'s forests is estimated at 1,943,000 cu. m. Mature and overmature timber represents more than half of this figure. The quantities of timber cut in the period from 1985 to 1999, for primary use lumber, are listed in table 5.6.

Clearly the harvest is steadily declining, reaching only 10 or 11 percent of the intended amount in recent years. The primary tree species used for construction are larch, pine, fir, and birch. Timber resources are listed in table 5.7. The main timber-producing species in Amur Oblast include the Dahurian larch, Scotch pine, white birch, and Amur philodendron.

Korean pine is predominant on 7,900 ha or 0.04 percent of the *oblast*'s forests. These forests require special care as

Figure 5.4
Nonforested lands in Amur Oblast (2,797,200 ha)

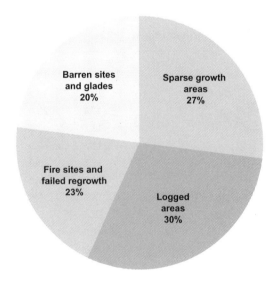

Source: Goskomstat, 2000.

Table 5.5

Degraded forest lands in Amur Oblast

	1997 (ha)	1998 (ha)	1999 (ha)	2002 (forecast)
Weakened forests	279,000	274,000	269,000	262,000
Pest outbreaks	136,900	121,900	20,700	1,700
Diseased	5,000	5,000	5,000	5,000
Imminent desiccation	3,600	5,000	5,000	7,000

Source: Amur Forest Service, 1999.

Table 5.6

Timber production in Amur Oblast, 1985–1999

Year	Actual harvest (million cu. m)	Planned
1985	5.70	—
1986	5.87	—
1987	6.57	—
1988	6.32	—
1989	6.54	—
1990	6.06	10.92
1991	5.12	10.92
1992	3.95	12.42
1993	3.16	15.84
1994	1.82	15.84
1995	1.72	15.84
1996	1.54	15.84
1997	1.53	16.04
1998	0.85	16.04
1999	1.31	16.04

Source: Amur Forest Service, 1999.

Table 5.7

Forest cover in Amur Oblast, 1999

Dominant tree species	Coverage (000 ha)	Wood stock (million cu. m)
Larch	13,477,200	1439.86
Birch	4,980,000	320.04
Pine	685,800	54.32
Spruce, fir	495,200	80.96
Oak	432,300	17.04
Aspen	166,600	16.61
Korean pine	7,900	1.44

Source: Amur Forest Service, 2000.

Table 5.8

Main timber producers in Amur Oblast, 1997

Company	Harvest (cu. m)
AOOT Amurlesprom*	382,000
AO Tyndales	267,000
AOOT Taldansky LPK	54,000
TOO Agalan	41,000
TOO Tayozhny	29,000
Others	758,000
Total	*1,531,000*

* Zeisky Lespromkhoz produced 278,000 cu. m of the total.
Source: Amur Forest Service, 1997.

monuments of nature and as a reserve for possible reproduction in the long term.

Over the past several years the timber industry comprised between 6 and 7 percent of the total industrial production of the *oblast*. The industry is now almost exclusively limited to the production and transport of commercial timber (see table 5.8). There are very few milling enterprises. The only wood-processing enterprise is a new one, Shakhtaum, which was organized in 1997. In 1998, the firm started to manufacture wood fiberboard,[49] and by 1999, production had more than doubled from the 73,000 cu. m produced in 1998.[50]

Demand from Japan, China, and North and South Korea led to an increase in timber production in 1999.[51] In that year forest products represented almost 45 percent of all exports from the *oblast* and were valued at about u.s. $22 million.[52] The current markets for these products are China, Japan, the Koreas, and other regions of Russia. Exports accounted for up to 40 percent of the total timber production, almost all of it commercial timber. Export share has recently increased even more, not only because of production increases, but also because of the nearly complete collapse of home markets and the reduction of lumber exports to other regions of Russia and countries belonging to the Commonwealth of Independent States (CIS).

Individual timber enterprises have been attempting to revive the industry. In February 1999, a new enterprise, Export-AmurLes, touted as being well connected to take advantage of export markets, was created. This enterprise intends to undertake logging operations in areas that are difficult to access.[53] Another is AO Tyndales (in the town of Tynda), which, over a period of years, has been exerting considerable efforts to create a wood-processing industry by attracting the capital and technology of foreign partners (Bison Corporation, Germany). Nevertheless, the timber industry of the *oblast* remains in a very difficult position for three main reasons:

1. The remoteness of the area from potential customers of commercial timber and absence of seaports from which timber could be exported.
2. The comparatively low quality of most of the timber produced in the region (larch, the primary species, is inferior to pine produced in eastern Siberia).
3. The almost total absence of factories that manufacture finished wood products.

The *oblast*'s forestry sector is, therefore, less attractive to potential foreign or even Russian investors than that of the neighboring eastern Siberian and Far Eastern coastal regions. Moreover, as the traditional emphasis of regional authorities has been on the development of agriculture, mining, and power generation, less attention is focused on the forest industry. Thus, there are no prospects for foreign investment in the forestry sector in the near future.

Nonetheless, in recent years, the forest resources of the region have been exploited intensively. The pine forests along the Trans-Siberian Railroad (Skovorodino, Magdagachi, Shimanovsk, Svobodny, and Blagoveshchensk sectors) have been almost completely logged, and replaced by biologically less productive and commercially less valuable species. Regrowth is poor in large areas. In spite of a marked decline in timber production over the past decade, there are many problems associated with production that continue to threaten the ecosystems of the forests. Major damage has been inflicted by commons logging in the northern sections of the *oblast*, where clear-cutting of trees in the permafrost zone has lead to erosion, thawing, and waterlogging of the fragile topsoil.

Rules for commons logging are constantly violated; for example, new growth and saplings are not preserved. According to expert estimates, some 10,000 ha of the 22,000 ha logged annually lose their ability for self-restoration. Instead they turn into barren sites and bogs and become an irretrievable loss for the *oblast*'s timber resources.

Problems likewise arise from the failure to complete harvesting plans. Every year there are increasing numbers of overly mature stands that are prone to fires. Forest fires annually destroy tens, and sometimes hundreds of thousands, of ha (384,000 ha in 1996). Another serious problem in recent years has been the increasingly frequent conversion of forestry areas to other uses, primarily mining. The *oblast* has lost more than one million ha of forest in this way. At the same time, reforestation measures have been reduced over the past two years because of budget cuts.

The head of the *oblast* administration authorizes short-range programs for forest protection and restoration under Amur Oblast Reforestation Program for the 1993–2005 period. In 1997, within the framework of a federal program for the protection, restoration, and rational utilization of forests, a regional program for Amur was proposed and accepted. It encompasses a series of measures to protect the forests of the *oblast*. In November 1998, a regional law for a Special-Purpose Fund for the Restoration of Forests was passed, which guarantees that 50 percent of forest revenues will be used for forest restoration work.

Because many populated centers depend upon the forest industry for their existence, its social significance is very high. For many years timber production was one of the leading

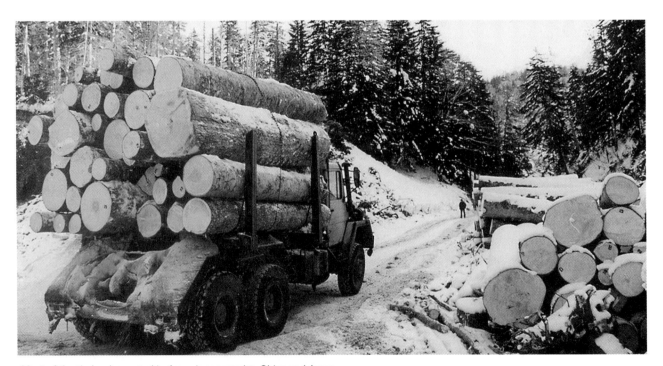

Most of the timber harvested in Amur is exported to China and Japan.

Timber trade with China

Chinese imports of Russian timber have increased four-fold since 1995.[54] After the 1998 catastrophic floods in China, unrestricted logging in the nation's most important watersheds was blamed for the devastation. The central government subsequently passed sweeping legislation to restrict logging severely. As its timber demands continue to grow unabated, China, now without a plentiful domestic supply, has turned to other countries to meet its needs.[55] Amur Oblast is one of the regions that has increased timber exports to help make up the shortfall. According to David Gordon, an expert on Siberian and Far Eastern forests at Pacific Environment, Amur business interests are pushing to open up more areas for logging in response to demand from China.[56] The Amur government, in an enthusiastic report about the opportunities of increased timber exports to China, has stated: "The greatest possibilities for our timber industry have come from the moratorium in the northern provinces of China on timber harvest. And the demand in China for wood products is great. It is necessary to make use of this chance to the greatest extent for our *oblast*'s economy."[57] The combination of China's immense timber needs, a bridge to facilitate timber export, inadequate forest protection, and Amur's desperate need for revenues, makes the forestry situation critical.

– MH

Timber lease in Urkansky Zakaznik

Environmentalists in the *oblast* were shocked to learn that in late 1999 a concession of 100,000 ha of forested land in the 141,000-ha Urkansky Zakaznik was handed over to a company called AO Most to harvest timber. This *zakaznik*, located in Tyndinsky Raion in northern Amur, protects a unique boreal forest system that is home to rare musk deer, Siberian grouse, black grouse (*Tetrao tetrix*), black capercaillie (*Tetrao parvirostris*), and other species.[58] No environmental impact assessment was conducted and local environmental groups are pushing to have one done.[59] Currently there is little information on the status of this deal.

According to the Amur Branch of the Socio-Ecological Union (a Russian conservation NGO), a major problem is that an *oblast* law passed in 1999 that permits economic activities in some protected areas contradicts a federal law, passed in 1995, that prohibits the destruction of wildlife and wildlife habitat in *zakaznik*s and other protected areas.[60] Accordingly, in many *zakaznik*s, logging and mining are under way. These activities have already destroyed Urushinsky Zakaznik, have brought Tolbuzinsky and Verkhne-Depsky Zakazniks to the brink of destruction, and damaged Iversky and Simonovsky Zakazniks.[61]

– MH

industries in the region, and employees of timber-related enterprises were some of the highest-paid workers in the area. In addition, the plants required the services of personnel in many other fields including construction, power generation, maintenance, transportation, commerce, and social work. The recent decline of this industry has, however, left many forestry and lumber specialists without work. Timber processing plants have closed down, leaving other tradespeople out of work as well. It would be advantageous for the *oblast* to remedy this situation with sustainable forest-management techniques.

Mining

The *oblast* is a rich source of raw materials including numerous placers of gold (considered to be the largest deposit in Russia's estimated reserves) as well as gold veins, iron, titanium, tungsten, molybdenum, mercury, antimony, zinc, copper, lead, platinum, diamonds, brown and anthracite coal, minerals such as graphite, talcum, apatites, and phosphorites, kaolin, alunites, precious and semiprecious stones, other stones suitable for lapidary work, and rare-earth and radioactive elements (see table 5.9).

Environmental impact. Gold mined at placer deposits poses a threat to aquatic ecosystems of rivers and swamps and the forest ecosystems of the adjoining river valleys. Thus far, placer mining has destroyed some 150 small rivers (up to 200 km in length) with a total watershed area of some 12,000 sq. km. Consequently, some valuable floodplain ecosystems have been lost. Water runoff is impeded by the destruction of wetlands that play a crucial role in the hydrologic system. Mining sites currently occupy a total area approaching 36,000 ha with an additional 1,500 ha being destroyed every year in preparation of new sites. Only 30 percent of the needed restoration takes place, and the situation is aggravated by the northern ecosystem's extremely low level of resistance to damage. Over the past several years some gold mining enterprises have advocated the cessation of soil restoration attempts altogether, holding that, because current technology fails to extract all of the gold from the alluvial placers, these same areas will be revisited a few years hence with newer and better extraction techniques. Simplistic logic of this sort presents a serious danger to the *oblast*'s environment, especially in view of plans to expand placer mining.

A related problem is the contamination of soil by mercury. The concentration of mercury on former mining sites is three

Table 5.9
Mineral resources in Amur Oblast

Ore	Millions of tons
Brown coal	3,000
Iron	2,000
Anthracite	1,000
Kaolin	100
Graphite	50
Titanium	40
Copper	10

Source: The Amur Oblast: A Guidebook for Businessmen, 1998.

times higher than permissible levels, so high that one could literally label the areas as manufactured mercury deposits. No cleanup efforts have been mounted in these inhabited areas. Similarly, open-pit mining has lead to the contamination of rivers with suspended particles. Both active and abandoned sites interfere with the ecosystem's rivers and dry riverbeds. The dumping of contaminants and the modification of microclimates damage downstream portions of rivers. By now, the volume of washed ore amounts to 50 million cu. m per year and uses up 1.5 billion cu. m of river water. Rivers are rendered lifeless by suspended mineral particle concentrations reaching 15 g/liter. Similarly, peat dumping also has long-range detrimental effects on the river ecosystems: downstream concentrations of phenols, nitrates, and hydrocarbons are fifteen to twenty times higher than the maximum permissible levels.

In the south of the *oblast*, active mining of brown coal deposits has significantly modified soils. The primary threat here is not to wilderness but to the fertile soils that support the farming economy. In the southeastern territories adjacent to the Raichikhinskoe and Arkharo-Boguchanskoe deposits, biodiversity is high and wildlife habitats have been preserved. However, in the course of most coal deposit development, so-called lunar landscapes are formed. The total surface of such areas today exceeds 12,000 ha, less than 5 percent of which is cultivated annually.

Gold. Today, gold mining is the primary industry in the *oblast*, constituting 17 percent of the total industrial output. Predicted reserves amount to 2,640 tons (900 tons of placer gold and 1,740 tons of ore gold) and the production forecast for 2003 calls for 24 tons of gold (20 tons from placer deposits and 4 tons from ore deposits). It is the fifth largest source of tax revenue for the *oblast* budget, after commerce, transportation, construction, and power generation. Four *raions* (Zeisky, Tyndinsky, Selemdzhinsky, and Mazanovsky) base their budgets on tax revenues from gold production. In the eight administrative *raions* where gold is mined there are over one hundred gold mining enterprises, which employ 18 percent of the industrial work force.

More than fifty gold-bearing deposits have been found, representing an area equivalent to 42.6 percent of the *oblast*'s territory. At present gold is being mined from about two hundred placer deposits. More than 80 percent of the placer

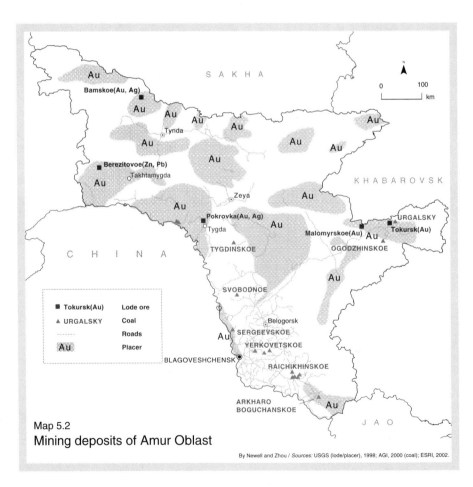

Map 5.2
Mining deposits of Amur Oblast

By Newell and Zhou / *Sources:* USGS (lode/placer), 1998; AGI, 2000 (coal); ESRI, 2002.

deposits are estimated to contain modest amounts of gold (up to 700 kg). Opencast methods account for more than 60 percent of the gold obtained in the region; the dredge method for a little over 25 percent. The total area used for conducting open casting for placer deposits has been increasing every year, with a subsequent increase in the number of ecosystems being disrupted.

Given current levels of placer gold production (some ten metric tons per year), the *oblast* has enough placer gold reserves for the next fourteen years. Gold mining areas include Tokursk mine in Selemdzhinsky Raion, Pokrovka ore deposit in Magdagachinsky Raion, and the Berezity gold and polymetal deposits and the Bamskoe ore deposits in Tyndinsky Raion. Additional gold ore mines are planned for Borgulikansky (Zeisky Raion) and Malomyrsky (Selemdzhinsky Raion) as well as dozens of other promising sites. Presently, the overall resource potential of gold ore in the *oblast* is twice that of potential placer gold, and experts predict that by 2005, between thirty and thirty-five tons of gold will be mined annually, primarily from gold ore deposits. From an environmental perspective, gold ore mining is less damaging than placer mining, but it, too, causes ecological problems.

The development of the Pokrovka gold lode has attracted foreign capital in the form of credits from the International Financial Corporation (IFC) and investments procured through a financial intermediary from private foreign companies. In autumn 1999, production at Pokrovka began and the enterprise produced about 200 kg; it produced about 1.52 tons in 2000.[62] By 2002, the Pokrovka operation plans to produce between three and four tons of gold annually.[63] Gold-producing enterprises licensed to prospect for and mine gold deposits at Berezitovoe and Bamskoe also seek foreign investment. In 1999, Apsakan, which holds the license, began exploiting at the Bamskoe deposit. As at Pokrovka, the deposit will initially be exploited using concentrated leaching methods and factory operations will follow.[64] After certain Moscow banks were granted licenses for working with gold, they began to show interest in the *oblast*'s gold mining industry. Several are prepared to provide preliminary credits to mining enterprises. Various international financial institutions (the IFC and the World Bank) and private gold mining companies (primarily from the United States and Canada) are ready to fund specific extraction projects.

The *oblast*'s largest gold mining company, in terms of production, is Solovyovsky Priisk, which is also one of the oldest gold mining enterprises in all of Russia, having mined placer gold for more than 130 years.[65] In 2000, Solovyovsky produced 1.8 tons. Other major producers were *artels*, among them Maya, Zarya-1, Zeya, Rassvet, and Khergu. On the whole, conditions for gold mining companies are now favorable in the Amur region, thanks to strong support from the *oblast* administration and greater interest from Russian banks.

Gold ore mines to watch

As emphasis shifts away from gold placer mining and toward gold ore mining, foreign investment has been sought to help underwrite capital-intensive extraction projects. Regional authorities are committed to developing gold production, primarily through mining, and private companies will soon be given rights to exploit new deposits. Amur officials have offered tax benefits for foreign investors and lessees. The standard package includes a 50 percent reduction of the *oblast* profit tax on leasing for the first two years of the lease and on collateral that has been created or purchased. In addition, the Golden Fund (gold reserves promised to foreign investors in the event that an investment project goes sour) has been established as a guarantee for investments in the *oblast*.[66] These projects seek to develop the *oblast*'s economy, but environmental negligence and destruction may prove their long-term value to be more harmful than beneficial. The following sites are of particular concern:

Berezitovoe deposit. Located 60 km southwest of Takhtamygda train station, this deposit includes 42.3 tons of gold, 225 tons of silver, 142,000 tons of zinc, and 85,000 tons of lead.

Malomyrskoe deposit. A 75-sq.-km deposit in the northwest corner of Selemdzhinsky Raion containing around 170 tons of gold, this site has been selected for open-pit excavation at a depth of 600 m. Construction will take three years and cost U.S.$115 million. Foreign investment of $25 million is sought with an expected return on investment time of seven years.

Bamskoe deposit. Located in northern Tynda, 60 km from the train station. Geologists have found gold ore, silver, tungsten, and copper in bore holes between 300 and 350 m deep. A project, to cost U.S.$60 million, seeks to extract 46 tons of gold. Cyanide will likely be the primary extraction method. Cyanide leaching into local soils and polluting the groundwater has been a serious problem in some areas of the *oblast*.

Pokrovka deposit. Located in the Magdagachinsky Raion, 14 km from Tygda in the northeastern part of the *oblast*, this mine is expected to operate for eighteen years to excavate a total of 12.5 million tons of ore and produce 90,000 gold ounces per year. The project is a joint venture in which the British Zoloto Mining Corporation owns 75 percent, the Pokrovka AO about 25 percent, and Russian authorities a small portion.

— *DJ*

Coal. Coal mining is another significant industry in the *oblast*. Currently three deposits of brown coal (Raichikhinskoe, Arkharo-Boguchanskoe, and Yerkovetskoe) and one deposit of anthracite (Ogodzhinskoe) are being mined. Reduced yields from the Raichikhinskoe deposit have led to precipitous declines in overall production. Currently, only 9.2 percent of the total coal reserves are being mined. Other coal resources are located at the explored reserve deposits (in Svobodnoe, Sergeevskoe, Tygdinskoe, and the eastern section of Yerkovetskoe) in addition to sectors adjacent to the active cuts. The reserves of the active coal mining sections are estimated to last for between seven and forty years. The working sections of the brown-coal deposits at Raichikhinskoe, Arkharo-Boguchanskoe, and Yerkovetskoe are in the southern part of the *oblast*. Mining of these sites decreases agricultural production by destroying land containing the most fertile soils in the RFE. Planned recultivation of the soil has thus far not been carried out, and the debt of the coal mining concerns for this activity exceeds 50 percent of the total area of affected soil. Moreover, in recent years many small, easily accessible areas have been exploited by small private enterprises that frequently lack both environmental specialists and surveyors.

Other mineral resources. Abundant raw materials in the region, including iron ore and peat, have been largely ignored. About six hundred peat fields have been located. Most are in the north and many of them are located on top of gold placer deposits. However, despite the fact that large amounts of peat are excavated in the process of uncovering gold placers, very little of it is used. The *oblast* also contains a large untapped iron-ore deposit in Garinskoe and several untapped deposits of titanium-magnetite-ilmenite ores in Bolshoi Seim and Kurany. Records document over a hundred additional deposits of minerals and building materials including deposits of kaolin, zeolite, graphite, vermiculite, talcum, apatite, and phosphorites. Currently, only forty-five (37 percent) of these deposits are being exploited. In addition

to mineral deposits, thirteen fresh groundwater reserves and two mineral groundwater sites have been recorded by scientific survey.

Agriculture

Agriculture, accounting for 15 percent of Gross Internal Product (GIP) in 2000, is one of the economic mainstays of the *oblast*, traditionally considered the granary of the Russian Far East.[67] The rich soils, particularly those in the Zeya-Bureya Plain, are ideal for growing soy beans, grains, potatoes, and vegetables (see table 5.10) and for raising livestock for meat and dairy products. Nevertheless, farmers, both private and cooperative, are struggling to break even. In spite of the fertile land, the prices for inputs such as fuel, fertilizers, machines, and parts are very high in comparison with the prices received for farm products. Farmers receive little or no support from the state. Currently, farmers have very little access to credit. Much of what they produce is bartered for fuel and fertilizers.

Policies that keep farm product prices low to promote cheap urban food have also hurt farmers. Humanitarian aid from the United States to Russia in 1999 and 2000 left some farmers without markets for their products. Soy bean farmers had to accept reduced prices from processors who were glutted with beans from abroad. Meat prices were also reduced. This may be of benefit to urban consumers, but it made raising livestock unprofitable. Local government policies that temporarily restricted meat exports to other regions of Russia and soy bean exports to China further reduced prices when farmers had nowhere else to sell their products.[68] Additionally, a lack of economic incentives for farmers to increase production has resulted from a situation in which "all the profit goes to the processor, rather than to the farmer."[69]

The total land area used for farming declined in the 1990s by almost 50 percent.[70] Since the end of the Soviet period the production of grain and soy beans, which are produced primarily by agricultural enterprises such as cooperative and state farms, and are the most important commercial crops in Amur Oblast, has plummeted. Even allowing for the over-reporting of harvests in Soviet statistics, grain production is probably one-third and soy bean production two-thirds of what it was in the 1980s. However, the production of subsistence rather than commercial crops (e.g., potatoes and vegetables) has actually increased.[71] Local people, both rural and urban, produce primarily these crops on small family plots. Altogether, agricultural land constitutes 7.42 percent of the total area of the *oblast*. Categories of agricultural land use in 1996 are shown in table 5.11.

Plans and programs undertaken in recent years by national authorities to develop local farming industries have always been unstructured and have aimed at the short-term support of the farmers. It is unsurprising that no fundamental economic improvements have resulted. Regionally, agriculturally

Vladimir Dinets

Abandoned logging and mining roads, which now serve as access routes for poachers, crisscross many parts of the Amur basin.

Table 5.10

Agricultural production in Amur Oblast, 1980–1999

Year	Grain		Soy beans		Potatoes		Vegetables	
	Harvest (000 tons)	Yield (100 kg/ha)	Harvest (000 tons)	Yield (100 kg/ha)	Harvest (000 tons)	Yield (100 kg/ha)	Harvest (000 tons)	Yield (100 kg/ha)
1980	601.4	8.2	292.5	6.1	244.0	85	71.6	83
1990	1,030.6	14.2	468.6	11.0	266.8	102	73.3	99
1995	258.8	6.5	170.4	5.8	338.0	117	97.7	152
1996	315.0	8.1	156.2	5.6	316.7	114	83.1	136
1997	318.4	8.8	169.5	7.3	358.8	126	79.6	129
1998	304.8	9.1	161.5	7.6	347.8	125	102.3	162
1999	211.3	6.6	182.6	8.4	444.4	126	95.1	148

Source: Amur Oblast Committee of State Statistics, 2000.

Table 5.11

Agricultural land use in Amur Oblast, 1996

Land use	Area (000 ha)	Percentage of total land area
Arable land	1,783.7	4.93
Grazing land	479.5	1.33
Hayfields	407.8	1.13
Fallow land	10.7	0.03
Long-term planting	0.5	0.001
Total	*2,682.2*	*7.42*

Source: Amur Oblast Committee of State Statistics, 2000.

Table 5.12

Degraded agricultural lands in Amur Oblast, 1996

Indicator	Ha
Reduction in humus	1,752,200
Pesticide contamination	1,125,000
Waterlogging	755,000
Water and wind erosion	132,100
Contamination by toxic substances	6,800
Landfills and dumps	4,200
Total	*3,775,300*

Source: The State Report on the Environment of Amur Oblast, 1997.

oriented legislation (On Land Reclamation, On Pedigree Animal Husbandry) has been purely for show, with no mechanism for actual implementation. The share of agriculture in the *oblast*'s GIP has declined substantially since Soviet times. In 1990, agricultural production constituted almost a third of GIP for the region; by 1999, it was only one-tenth of the total and few agricultural enterprises are profitable.[72]

Foreign technology and capital are being introduced on a very limited basis by enterprises processing farming products and manufacturing food products. Plans and hopes for attracting foreign investment in soy bean production remain far from realization. The Socio-Ecological Union, a Russian NGO, is implementing a small-scale project in sustainable agriculture on the territory of the Muravyovka Park—the first nongovernmental territory under special protection in Russia

Long-term observations reveal a progressive degradation of the soil. The loss of humus amounts to between 0.4 and 0.6 tons/ha annually, and more than 132,000 ha are subject to erosion (see table 5.12). The primary causes are the plowing of light soils on slopes without using measures to keep the soil in place, and the absence of windbreaks. Erosion leads to the loss of fertile soils and degradation of the watersheds that receive the organic runoff and gives rise to dust storms. The proportion of humus in the soil is reduced, and other indicators of damage increase.

Agricultural production has significantly altered the natural appearance of the southern section of the *oblast* and transformed the coniferous and mixed forests of the plains into agricultural landscapes. Farming activity constantly threatens the few remaining wilderness areas in the south. Fires caused mostly by spring burns pose the greatest threat, destroying the last natural habitats of wildlife that has adapted to life near human settlements, e.g., the nesting areas of rare bird species, such as the white-naped crane, the red-crowned crane, and the Oriental white stork.

Toward sustainable development

Gennady Illarionov

The position Amur Oblast inherited from the Soviet period was that of a peripheral resource base for the Soviet economy. Its other function was that of an agricultural supplement to the rest of the economy in the RFE. Because Amur is located between Baikal and the Far Eastern coastal region of Russia, it received little attention from politicians in Moscow regardless of their political orientation.

At first glance, this situation may not look promising in terms of Amur's development prospects. There are, however, other regions that are more heavily industrialized and even more damaged. Healthy development in Amur is still possible. Despite all the environmental problems mentioned in this chapter, Amur Oblast has sufficient natural reserves to follow a course of sustainable development. One may suggest two possible development scenarios.

The ideal scenario. The first priority in the economic development of the region would be given to principles and technologies that would incur minimal damage to the environment. All technological processes would imitate natural processes, and the rate at which renewable resources are used would not exceed the natural reproductive capacity of the environment.

In particular, forest resources would be used mainly to produce nontimber forest products, to increase recreational activities, and, most importantly, to maintain the balance between carbon dioxide and oxygen levels on the planet. Amur will need to downsize its timber industry everywhere and place a special emphasis on reforestation. In this scenario, wood extraction would be limited to supplying only local industries and needs. Water would be used in a multilevel closed-cycle system. This would entail supplying water for drinking and sanitary purposes, household use, industry, and agriculture separately. Water from natural sources is supplied only for the first level of the system—for drinking and sanitary purposes. The used water from the first level is then supplied to the level below, and eventually, to industry and agriculture. Used water from the second and third levels would be purified and reenter the system.

In order to generate electricity, hydroelectric stations would be built to make use only of free water flow without blocking rivers with dams. The Evenk indigenous people would use wildlife resources in traditional ways while the recreation industry would use wildlife in ways that do not reduce populations.

Mining of nonrenewable natural resources in the region would be excluded from industrial activities. Instead, recycling and reusing worn-out metal products would satisfy the economic demand for metals. Demand for chemical agricul-

tural products would be satisfied by natural organic material, and demand for electricity met by alternative energy sources. In particular, with the number of sunny days in Amur Oblast being one of the highest in Russia, the use of solar panels is highly recommended. Fossil fuels such as peat would be used only as a resource base for the construction industry and organic fertilizer. In general, the government should impose strict quotas on mining operations using these resources.

Damage sustained by the environment will be assessed based on the damage caused in the previous years—natural environments altered by or converted into agricultural lands and populated areas, or occupied by industry, transportation, and communications. Agriculture would be reorganized to make it more suitable to the climactic conditions in the area along the banks of the Amur River to minimize the environmental impact. Further expansion of all existing anthropologically altered areas would be banned. In so doing, further industrial and social development would result from the more efficient use of the space already taken out of the natural environment. The transition to mature sustainability will require cooperation, patience, and a dedication toward the long term.

Scenario for partial sustainability. In the near future, it is possible to make the transition to partial sustainability in Amur. This will require the development of new natural resources and the adjustment of the existing resource-use system to reduce human impact on the environment and increase the efficiency of local resource extraction and processing. The essential feature of this scenario is that the regional policy on resource use would be changed to improve both the environment and the economy.

As previously mentioned, gold mining is one of the most important industries in the region, and it poses a major threat to the environment. Therefore, one of the key regional issues is finding ways to restructure the industry to increase efficiency and environmental safety. Nearly all specialists (economists, geologists, gold miners, and environmentalists) agree that, in order to improve the situation, it is necessary to direct the industry from placer mining toward the development of gold ore deposits, which will create jobs for those who live permanently in the region. Ore deposit mining is more complicated technologically and requires more complicated production methods, a requirement that will improve the skills and qualifications of the employees. Furthermore, it is possible to extract and use not only gold, but also all the other valuable components of the ore, including silver, copper, lead, zinc, and tungsten. The tailings can be used in the construction industry if they comply with the relevant sanitary norms.

Gold ore mining is, however, tied to a set of unavoidable problems, but these will be easier to resolve than will those related to placer mining. Restoring the environment after mining can be assured, to a certain degree, by requiring insurance bond deposits prior to mining. This system is

Table 5.13

Major power stations in Amur Oblast

	Current capacity (KW/hour)	Projected capacity (KW/hour)
Zeiskaya Hydroelectric Power Station	1,330	4,900
Blagoveschenskaya Thermal Electric Power Station	280	1,550
Raichikhinskaya Thermal Electric Power Station	230	1,100
Ogodzhinskaya Thermal Electric Power Station	22	50
Bureinskaya Hydroelectric Power Station[a]	0	2,000–7,100
Total	1,862	—

a. Under construction.

Source: The Concept of Socio-Economic Development of Amur Oblast for 1998–2000.

successful in many foreign countries. Unlike placer mining, environmental insurance deposit funds are well suited for ore deposit mining, which involves significant investment and operations planned many years ahead. In the case of a mining enterprise bankruptcy, money in the fund can be used to recultivate the land.

Also important is the energy sector, which centers upon four main power sources, with a fifth under production, that produce 7,600 million kW hours of electricity annually (see table 5.13). Besides these plants, electricity is produced by numerous small enterprises, mainly boiler-houses, but their contribution to the region's energy supply is insignificant.

Also included in the energy sector are coal mining enterprises that supply thermal energy. The largest enterprises producing electricity in the region are part of the United Energy System of Russia. Amur Oblast, with a positive balance of electricity production and consumption, exports energy to other regions of Russia and to the neighboring People's Republic of China. The region also has approximately 80 percent of the entire hydro-energy potential in the RFE. Therefore, federal plans for development of the region include construction of several more hydropower plants.

The combined environmental damage associated with these enterprises is significant. The quality of the air, soils, and water reservoirs decreases because of electricity production and coal mining. Enormous environmental damage results from construction of hydropower plant facilities. Hence, for the partial sustainability scenario, it is imperative, considering the number of energy resources in the region, to adjust the energy policy of the region. The energy sector should become the most important element of the regional economy, so we must use energy sources that have the lowest-environmental impact.

Hydroelectric power stations

If the history of Zeiskaya Hydroelectric Power Station is any indication, one must expect the current and planned projects to damage the environment. The Zeiskaya Station and the Zeiskoe Reservoir, in controlling the flow of the Zeya River, damaged the aquatic and riparian ecosystems by changing the temperature cycle and the hydrochemical characteristics of the river. The subsequent alteration of the microclimate adjacent to the reservoir has also led to the flooding of riparian habitats, the modification of reservoir banks, and the replacement of taiga landscapes with coastal landscapes. The reservoir obstructed migration routes of snow deer and moose and isolated some animal populations.[73] Increased recreational activities at the reservoir have meant greater access to protected areas and increased poaching.[74]

Fifteen percent of the 2,000-MW (six 335-MW units) Bureinskaya Hydroelectric Power Station on the Amur River has already been built, and the first stage is expected to be completed in 2003. The project was first launched in 1976, but has been delayed several times for lack of funds. The total cost of the project has been estimated at U.S.$1.4 billion. The project is supervised by AO Amurenergo and reportedly includes investment from Japanese and Chinese companies. The Russian federal government has put a high priority on the project, earmarking U.S.$123 million in federal funds for fiscal 2001, more than double what was disbursed in 2000.[75] In 2001, the Amur government signed a U.S.$1 million contract with China to cut timber at the plant construction site.

Two of the stated aims of the project are to reduce carbon dioxide emissions and to generate income from the sale of electric energy to China. This project requires substantial deforestation: 2 million cu. m of forest land still remain to be cleared.[76] Citizens living along the Amur River, which is already heavily polluted and unfit for drinking, have criticized the government for unilaterally choosing to build a technologically outdated electricity generating solution in a region well suited to cleaner and more efficient energy-producing alternatives. A large number of residents have spoken out against the construction of the 140-m high concrete dam and the cascade of seven hydrostations that will interrupt the natural cycle of fish swimming into tributaries to spawn.

Another hydroelectric project has been proposed for the Gilyui River, upstream from the Zeiskoe Reservoir. If this power station is constructed, part of Zeisky Zapovednik will be flooded. Migration routes of snow deer and moose will again be disrupted.[77]

– MH, DJ

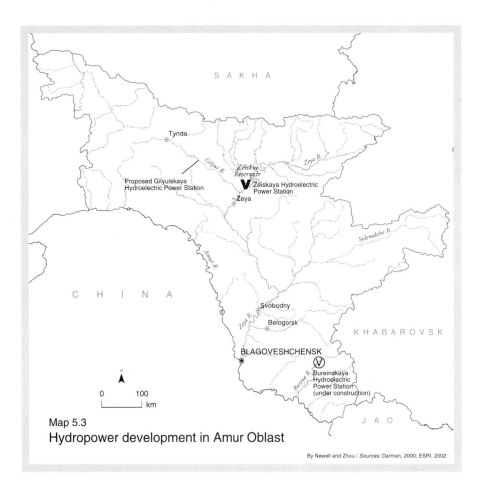

Map 5.3
Hydropower development in Amur Oblast

By Newell and Zhou / *Sources:* Darman, 2000; ESRI, 2002.

Alternative energy

The region holds large reserves for clean energy, particularly in solar and hydro-energy generated on small electric power plants without the use of dams. Several alternative energy possibilities for the region have been studied. Proposals to implement some concrete projects have been prepared, but at the federal level, large traditional projects still have more support even though they present a clear threat to the surrounding ecosystems. At the level of private enterprises, no action is being taken due to a lack of investment.

Solar. The potential for solar energy generation is justified by the favorable mode of the solar radiation. The yearly cycle of solar radiation has two peaks—March and June. The spring peak is characterized by the absence of clouds and the growing day-length; the summer peak corresponds to the longest day. Winter solar conditions, too, are favorable, which can be explained by the absence of clouds during a stable anticyclone over the region. Owing to the transparency of the air, the solar radiation, compared with that in other regions at the same latitude, is intense. In most regions solar radiation decreases drastically in winter because of the shorter solar day and increased cloud formation; the drop in Amur Oblast is insignificant. Simply put, the sun shines a great deal in Amur. With the exception of eastern Siberia, no other region of Russia has as many sunny days as does Amur Oblast.[78]

The possibility for solar power generation here is more than hypothetical. Solar panels have been successfully installed in Muravyovka Nature Park to generate electricity for the park's Visitors' Center and living quarters. The power generation there is on a small scale, but this project does demonstrate the viability of solar power for meeting some energy needs.[79]

Wind. With the exception of a few well-populated, favorable locations, the prospects for wind energy pale in comparison to the potential for solar energy. Conditions are relatively good in the city of Blagoveshchensk, which benefits from winds over the Amur River: The average annual wind velocity at the height of 50 m exceeds 8 m per second. Hurricanes never occur and wind less periods are rare. Another favorable populated area is Magdagachinsky Raion, where the average annual wind velocity at the height of 50 m is 16 m per second. Wind-power stations cannot yet serve as completely autonomous energy sources. Nevertheless, they can be used as additional sources of energy in remote locations where sufficient electricity is not available.

Biogas. A relatively simple, inexpensive, and efficient source of energy in agriculture is biogas and fertilizers made from organic waste. To produce biogas, thermophilic bacteria process organic waste from crop production and animal husbandry in a special ferment-reactor. The process produces a gas without unpleasant odor and with a high concentration of methane, whose burning heat is 5,500 kcal. The process also produces a high-quality fertilizer, the by-product being a protein and vitamin concentrate. Introduction of this technology would not only contribute to energy generation, but also save money that could be allocated to environmental protection, to reduce heating costs on farms, and to increase agricultural productivity by using the high-quality fertilizer.

Preliminary calculations in the early 1990s suggested that if 100 percent of the available biological waste were used to produce biogas, Amur Oblast could economize on 27,000 tons of conventional fuel equivalent. It has since become clear that by the end of the 1990s the situation in agriculture had greatly changed, and such savings become unachievable.

Nevertheless, some energy reserves do exist in this area. There is also some energy potential in hard-waste burning, which is done at incinerators in large cities. It is worth mentioning however, that air emissions produced by burning the waste creates social and environmental problems.

Hydroelectric. As has been noted earlier, the hydro-energy potential in the region is high. Plans for construction of traditional hydropower plants (HPP) with dams are slowly being realized. Zeiskaya HPP is already functioning, Bureinskaya HPP is being finished, and the Ministry of Energy has plans for constructing HPPs on the Lower Bureya and Gilyui. In the long term, the construction of HPPs on Nyukzha and Olyokma Rivers and a group of small HPPs, which do not use dams on the Zeya River, is being planned. In the meantime, the region holds enormous possibilities for small HPPs that, without blocking rivers, use only the power of uninterrupted flows. Aside from the obvious environmental advantage that no damage is caused, such HPPs also provide a number of economic benefits: production and consumption of energy in the same location. This is perfectly suited to Amur Oblast where population density is low. Such local developments also eliminate large energy transportation expenses and the energy losses incurred during transportation. Therefore, for every small town and village in Amur region that is located on a river, free-flow HPPs are a promising prospect for energy supply.

Conservation

The biggest potential for preserving traditional energy resources and the surrounding environment arises from energy conservation measures, which currently are deplorable. To conserve energy one should not only apply new technologies but also employ economic and financial measures to ensure compliance. In some cases, even the often-criticized administrative measures may work, but that would be the subject of a separate report.

Some prospects for Amur Oblast are related to its geographical location which, to date, has not been used to its advantage. Its position as a provincial gap between the Baikal region and the Pacific coast, which previously had led to deep social and economic problems, could, in the future, be turned into a great advantage. Amur Oblast, both in the geopolitical and geoeconomic senses, could find itself, in the twenty-first century, as a crossroads between Siberia and East Asia and between the Arctic (Republic of Sakha) and Central Asia (China). This position may entail significant economic dividends for the region as well as higher environmental costs. Consequently, it is necessary to prepare for this prospect now. The first steps in this direction have already been taken: A bridge across the Amur River is planned, the Chita-Nakhodka Road is being built across the *oblast*, and the construction of an international airport in Blagoveshchensk

Amur bridge construction

The proposed bridge across the Amur River linking the Chinese city of Heihe with Blagoveshchensk has been on the agenda for the past decade. Finding funding for such a venture, however, has been problematic. The estimated cost of the 3-km bridge has continued to rise from U.S.$50 million to more recent estimates of U.S.$250 million.[80] Although the two cities would share the costs of building the bridge, this still represents a considerable sum for Amur Oblast. It appears that the solution to the financial problem will be the trading of rights to natural resources for bridge construction. Currently, two companies, AO Most and Genstroi, have agreed to undertake construction in exchange for the rights to sell titanium and 150 million cu. m of timber.[81] The bridge will not only require the exploitation and export of unprocessed natural resources, but also will facilitate their continued exploitation and export once it has been completed. The *Russian Far East Update* quotes the president of Genstroi, Ingo Skulason, making the revealing statement that bridge construction is likely to become a reality because "Governor Belonogov is willing to appropriate the region's physical assets."[82]

– MH

has begun. It is necessary that environmentalists consider the prospect and implications of such deep changes in the status of the region before it actually becomes a reality.

Indigenous peoples

Yuri Darman, Gennady Illarionov

The territory of Amur Oblast is home to the Evenk peoples. In the past five years they have numbered fewer than fifteen hundred. Most of them are registered as residents of five village administrations in the three northern *raion*s: the Pervomaiskoe, Ust-Urkima and Ust-Nyukzha in Tyndinsky, Bomnak in Zeisky, and Ivanovskoe in Selemdzhinsky. A small group of Evenks (fewer than forty in number) live in the settlement of Maisky in the Mazanovsky Raion.

Traditionally, the Evenks lived across a huge territory stretching from the Yenisei basin in the central part of eastern Siberia to the shores of the Sea of Okhotsk on the Pacific Coast. They were primarily nomadic reindeer breeders and, to a lesser degree, hunters. Their traditional way of life was dependent mainly on northern larch taiga and transitional upland zones that were rich with lichen—the best feeding

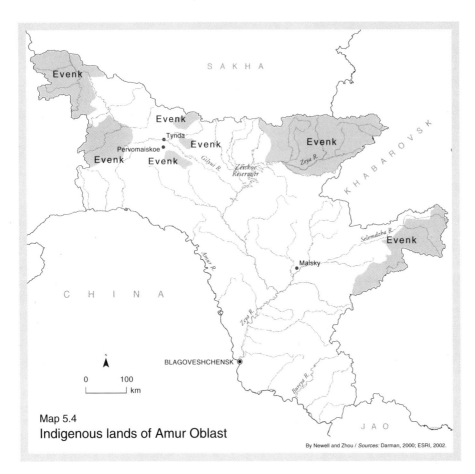

Map 5.4
Indigenous lands of Amur Oblast

By Newell and Zhou / *Sources:* Darman, 2000; ESRI, 2002.

and gold mining in traditional Evenk territories have destroyed the natural cycle's components that are the life-support system of the Evenks. The territory available for traditional herding is continually dwindling, and hunting has also been affected as Evenks are now forced to compete with hunters of other nationalities and are limited in the areas where they can hunt.

Most (about 60 percent), but not all, Evenks today are involved exclusively in traditional occupations (reindeer herding, hunting, animal husbandry, and the production of native crafts). Among the hunters and reindeer herders, they are the dominant group, representing 73 percent and 98 percent, respectively. Reindeer herding employs about 22 percent of working Evenks. It is a form of resource use well suited to the northern taiga and the ways of the Evenks, allowing a maximal exchange of production for relatively minimal inputs of labor and resources. Nevertheless both the number of herders and the size of the herds has fallen rapidly in recent years.

Hunting accounts for about 30 percent of the employment of working Evenks. This activity is losing its significance, as the fur harvest has declined dramatically since the late 1980s. Furthermore, hunting on Evenk territory often occurs illegally and without regulations, and is conducted by both Evenks and people of other nationalities. During the Soviet period, the Evenks were allowed to develop captive breeding enterprises. An animal farm was established in Pervomaiskoe in the Tyndinsky Raion. This was a sensible form of compromise between traditional and modern economies, but today fewer than 5 percent of Evenks are involved in it. Only 5.5 percent of Evenks engage in production of traditional wares—leather goods from reindeer and other species, clothing and footwear using bearskin, and souvenirs.

Like many other indigenous peoples, Evenks have little understanding of the concept of property. As a result, the process of entering a market economy, where the notion of property is fundamental, was doubly difficult. In the past decade, there have been attempts to secure legal rights to land and resource use in territories traditionally occupied by native groups. Most federal acts in this realm have been devoted to financial and organizational measures related to socioeconomic and cultural development of indigenous peoples.

grounds for small reindeer herds. The system of reindeer herding of the Evenks was a classic example of sustainable resource use: Feeding sites were left to regenerate themselves after being grazed, and herds were moved to adjacent areas. Subsequently they could return in later years to repeat the cycle. The population growth of the Evenks was closely related to the reindeer population, which in turn was dependent on the natural succession of the grazing pastures that could occur only under specific conditions. For centuries a balance was maintained between the Evenk economy and the resource parameters of the northern ecosystem.

This pattern of self-sufficient resource use obviously required delicate balance and was susceptible to outside disturbance. The Evenks were practically a part of the ecosystem, having adjusted to its natural limiting factors. They created their own culture and language, which was oriented to their habitat (there are, for example, more than twenty terms in Evenk for various forms of snow).

The situation deteriorated significantly with the arrival of settlers from the west and with the subsequent integration of Amur's resources and Evenk territories into the outside economy. Evenks of Amur Oblast encountered the same sorts of problems that other nations have experienced through contact with the technogenic European civilizations. Their situation was particularly affected by their heavy dependence upon the slim resources of the northern ecosystems. Forestry

A law has been drafted to establish a special regime of traditional resource use in areas inhabited by native peoples. Rights have also been granted for traditional resource use on some lands that are otherwise protected natural territories. The Russian Federation law, On Payment for Land, creates some advantages for native peoples purchasing land on which they have traditionally lived. The presidential decree On Necessary Measures for the Protection of Habitation and Economic Activity Areas of the Small-Population People of the North acknowledges that TTPs are the inalienable possession of these peoples. In the current forestry code, special forest-harvest rights are granted to native peoples in order to preserve conditions for traditional resource use.

Significant rights are also granted to native peoples by the federal law On Animals. This is the first time that legislation has recognized the Evenks' way of life. The law grants them special rights to use animal resources, both as a collective group and as individual members of a nation. Native peoples are given first rights to resource use on their traditional territories. Unfortunately, the current law of the federation about mineral rights has almost no special provisions for native peoples on their territories. A single law dictates that payment for use of mineral resources in areas inhabited by native peoples must be directed toward these peoples' socioeconomic development. In practice, these payments are seldom properly used because *raion* administrators rather than representatives of the native peoples handle the distribution.

Federal legislation still lacks special provisions to regulate questions of native people's status, property rights, and other rights on their territories of traditional resource use. The federal Duma is currently preparing similar laws. In Amur, the law On Territories of Traditional Resource Use of Small-Population Peoples is being prepared. It is intended to address the problems of land management and natural resources on the traditional territories of the Evenks. Also, the *oblast* law On the Protected Nature Fund is in the process of being written, and will oversee the creation of ethno-ecological territories to preserve areas of traditional Evenk habitation and wildlife.

Unfortunately, there are still no positive examples of Evenk development of natural resources on their territories. The best that the Evenks can hope for are single payments from gold mining enterprises for solutions to specific socio-economic problems. The securing of legal protections for Evenk natural resource rights on their territories may become the first step in the resolution of the problems described here.

Legal issues

Yuri Darman, Gennady Illarionov

A basic problem stems from the fact that each of the *oblast*'s agencies involved in environmental protection and resource use is the regional branch of a federal department and thus prioritizes its own department's interests. The agencies are often interested solely in the organization and protection of their natural resource, at the expense of protecting other natural elements. It is advisable for the coordination of resource agencies to function at the *oblast* level to develop a comprehensive system of resource use. Work is proceeding on the development of an *oblast*-level form of agency coordination to integrate the planning of resource use and the protection of biodiversity.

An *oblast* law On the Nature-Zapovednik Fund, which had been prepared and submitted to the Amur Oblast Council, forms a legal basis for the protection for special territories and biota (including both *oblast* and federal *Red Data Book* species). This law creates many new legal categories of protection to complement the existing federal law On Specially Protected Natural Territories. The law On Overall Principles of Nature Use in Amur Oblast is being prepared to legally strengthen the comprehensive planning of regional nature use by prioritizing comprehensive regional management. If this law is adopted, all resource users will be obliged to pay for all of the resources used in their enterprise, regardless of whether or not they obtain any direct income from that usage. For example, strip-mining enterprises will have to pay for the "use" of locally affected plant, animal, water, and soil resources.

These two legal efforts are essential for the successful regulation of resource use. The first law serves to preserve the natural environment; the second one requires ecosystem users to pay for all the effects of resource use and development.

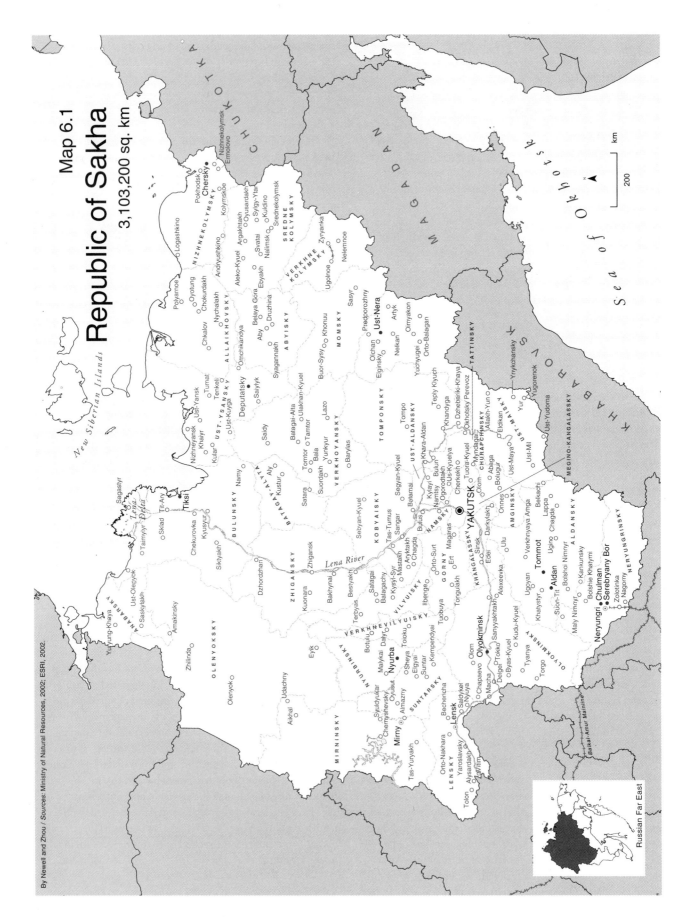

Map 6.1

Republic of Sakha

3,103,200 sq. km

Sea of Okhotsk

km
200

Russian Far East

SAKHA

By Newell and Zhou / Sources: Ministry of Natural Resources, 2002; ESRI, 2002.

Republic of Sakha

Location

The Republic of Sakha (Yakutia) in northeastern Siberia stretches to Henrietta Island (77°N) in the far north and is washed by the Arctic Ocean (Laptev and Eastern Siberian Seas). These are the coldest seas in the northern hemisphere, and are covered in ice for nine or ten months of the year. Chukotka and Magadan form Sakha's mountainous eastern border, Amur and Khabarovsk its southern border, and Eastern Siberia its western border. The name of this republic has changed several times in recent years, and in Russia, the names Sakha and Yakutia are used interchangeably. To be consistent, Sakha is used in this text.

Size

Sakha accounts for almost one-fourth of the territory of the Russian Federation (3,103,200 sq. km) and is larger than the combined areas of France, Austria, Germany, Italy, Sweden, England, Greece, and Finland, or, five times the size of Texas. It stretches 2,000 km north to south and 2,500 km east to west.

Climate

Winter is prolonged and severe, with average January temperatures of about −40°C. Summer is short but warm; the average temperature in July is 13°C, and temperatures have reached 39°C in Yakutsk. In the northeast, the town of Verkhoyansk reaches −70°C (−83°F) and is considered the coldest inhabited place on Earth. There is little precipitation, ranging from 150 mm in central Sakha to 500 mm in the mountains of eastern and southern Sakha.[1]

Geography and ecology

Forty percent of Sakha lies within the Arctic Circle, and all of it is covered by permafrost (permanently frozen ground), which limits forests mainly to the south. Sakha can be divided into five great vegetation belts that merge very gradually into one another. The islands are mostly covered with snow for up to eleven months each year and are considered arctic desert, although scattered patches of tundra vegetation grow there in the spring and summer. Arctic tundra grows along the mainland coast, and subarctic tundra defines most of northern Sakha, where lichen and moss grow into great green carpets, favored pastures for reindeer (*Rangifer tarandus*).

Tundra woodlands with scattered Dahurian larch (*Larix gmelini*) trees separate tundra from boreal forests further south. They are also the most widespread vegetation type in the intermontane valleys of northeastern Sakha. Relict patches of steppe grasslands are found

on southern slopes in this zone. Boreal forests define the fifth vegetation belt. Dahurian larch dominates—about 90 percent of the forest cover is larch,[2] though stands of fir (*Abies*), spruce (*Picea*), and Scots pine (*Pinus silvestris*) begin to appear in the south.

Isolated stands of Siberian spruce (*P. obovata*) also grow along the western border and in sheltered canyons of Verkhoyansk Range in the northeast. An unusual feature of the lowland forests in central Sakha is that they grow in an arid climate and depend on permafrost for moisture. Large meadows, locally called *alas*, also grow in this area.

The great Lena River watershed begins in the steep mountains that border the western shores of Lake Baikal. The river then meanders northeast and is joined by the Vitim River, followed by the Olyokma, Aldan, Amga, and Vilyui Rivers, before flowing through a wide delta into the Arctic Ocean. It spreads through Sakha like a huge pitchfork and, with its tributaries, forms the great river network that supports this immense region's ecology. The Lena River is over 4,000 km long, and the entire basin covers 2.5 million sq. km.

Mountains, highlands, and plateaus cover 70 percent of the republic. Sakha's longest mountain range, the Verkhoyansk, runs parallel to and east of the Lena, forming a great arc that begins not far from the Sea of Okhotsk and ends in the Arctic Ocean (Laptev Sea). This great range gives rise to the hundreds of small tributaries that feed the Lena. The Chersky Range runs east of the Verkhoyansk and has the highest peak in Sakha, Mount Pobeda (3,147 m), as well as one active and many extinct volcanos. Between these two ranges lies the Yana-Oimyakon Plateau. Even further east are the spurs of gold-rich Kolyma Mountains, which stretch all the way to Chukotka, but enter Sakha only on the eastern fringes. All three major ranges are connected by the Suntar-Khayata (Misty Mountains) Range. The edge of the great central Siberian plateau is found in the west. In the remote northwestern part of Sakha lies the Popigai Meteor Crater, which is 70 km in diameter and surrounded by a circular mountain ridge. The Arctic coast and islands are flat, with hundreds of thousands of lakes. The volcanic De Long Islands in the extreme northeast are covered with ice shields. One of them, Bennet Island, which recently erupted, is the northernmost active volcano on Earth.

Geologically, mainland Sakha is very old, and its complex and diverse geological structures are rich in minerals. In the western part of the republic is one of the most ancient portions of the Earth's crust, the source of its massive diamond reserves. Sakha is well known throughout Russia for its mineral wealth. Besides diamonds, it has gold, tin, natural gas, and oil. The full extent of its mineral resources is not completely known.

Key issues and projects

Sakha's diamond industry
Alrosa Corporation and government agencies are all angling to capitalize on Sakha's immense diamond reserves, estimated to be the world's second largest (see p. 244).

Natural gas exports
Japan, China, and South Korea are all potential consumers of the region's oil and natural gas, which would be transported by pipeline (see pp. 253–54).

Japanese investment in coal mining
Russia and Japan, with government financing and support, began joint coal-development projects in 1974 in the Neryungri region (see pp. 251–52).

Foreign investment in gold mining
Canadian and Irish mining companies are investing millions of dollars to exploit gold reserves (see p. 249).

SAKHA

Flora and fauna

The fauna includes 64 species of mammals, 285 species of birds, 4 species of amphibians, 2 species of reptiles, 43 species of freshwater fish, and some 4,000 species of insects. Polar bears (*Ursus maritimus*) den and hunt in Arctic regions. Each year over thirty thousand geese migrate to the wetlands between the Yana and Kolyma Rivers, and between two and three hundred thousand ducks migrate to the region between the Kolyma and Alazeya Rivers.[3] Siberian cranes (*Grus leucogeranus*), sandhill cranes (*G. canadensis*), Ross's gulls (*Larus roseus*), geese, and other waterfowl nest on the left bank of the Khroma River and along the lower Indigirka and Alazeya Rivers. The Siberian crane is the unofficial national symbol of Sakha (the official symbol is the horse). The population in Sakha is one of just two isolated nesting populations; the other is in the lowlands of the Ob River and is almost extinct.[4] Sakha's *Red Data Book* contains sixteen species of mammals and fifty species of birds. Between 70,000 and 80,000 moose (*Alces canadensis*), 50,000 snow sheep (*Ovis nivicola*), and 250,000 wild reindeer live in Sakha. Sakha's flora includes 1,831 species of vascular plant, 526 species of moss, more than 550 species of lichen, and more than 510 species of mushroom. Many plants are rare or endangered. Among them are 67 endemics and subendemics, including some that grow in very limited areas.

Largest cities

Yakutsk (pop. 194,000), the capital and industrial center, was founded in 1632. Built entirely on permafrost, it has developed some manufacturing and food industries. Neryungri (pop. 76,000) in the south is the center for coal mining and has a large thermal power plant. Mirny (pop. 29,000) is the center for Sakha's diamond industry. Aldan (pop. 26,400) is in the gold mining region. Lensk (pop. 31,200) is a major river port located on Sakha's northern coast.

Population

The population of Sakha is 976,400.[5] The main ethnic groups are Russian, Yakut, and Ukrainian. Native people include Evenks, Evens, Dolgans, Chukchi, and Yukagirs. In 1920, indigenous people made up 90 percent of the total population, but rapid expansion of the mining industry brought many Russians and Ukrainians to the territory. By the late 1980s, indigenous people's share had shrunk to about 33 percent of the population, but with a decline in industry, they now comprise 40 percent.[6]

Political status

Sakha is one of the Russian Federation's twenty republics. Each republic has a president, council of ministers, and a two-tiered parliament. Alrosa President Vyacheslav Shtyrov, endorsed by the Kremlin, was elected president in late 2001, replacing Mikhail Nikolaev, who had been president since 1989. As a republic, Sakha has more autonomy than do other *krai*s and *oblast*s of the RFE. The Republic of Sakha is divided into thirty-five districts and two municipalities. Because Sakha is a republic and not a *krai*, *oblast*, or *okrug*, its administrative districts are called *ulus*es rather than *raion*s.

Natural resources

Sakha is blessed with tremendous deposits of precious metals, oil and natural gas reserves, and vast forests.[7] It has 84 percent of Russia's diamond reserves, as well as the largest tin

reserves in Russia. It also has the largest coal reserves in Russia, between 4.4 billion and 15 billion tons, with the most extensive reserves in and around Neryungri.[8] There are 4.4 billion tons of iron ore, mostly located in the southwest (Aldan region), as well as the only phosphate deposit in the Russian Far East (RFE). After Brazil, Sakha has the world's second-largest niobium reserves (in Tomtor), as well as many other important minerals, including zeolite, bismuth, mercury, and antimony. Gold reserves are estimated to be the third largest in Russia, although exact figures are unknown. About half of the territory has oil and gas potential, oil and natural gas reserves totaling about 253 million tons and 13 trillion cu. m, respectively.[9]

About half of all the rivers in East Siberia and the Far East that are viable as commercial sources of hydroelectric power are in Sakha. Water resources include over seven thousand rivers with a combined length of 1.5 million km. The Lena, 4,400-km long, is one of the ten longest rivers in the world, with 844 billion cu. m of runoff yearly. Groundwater reserves are estimated at 7.43 billion cu. m. Commercially feasible hydro-energy resources amount to 300 billion kW per hour annually, or about 60 million kW of power.

There are about nine billion cu. m of timber, although much of this is small-sized larch. There are also large amounts of commercial furs.

Main industries

Sakha is a natural resource colony; the processing industry is underdeveloped. Large federal subsidies keep the republic afloat. In 1999, it received about 5 percent of all Russian federal subsidies, the third largest subsidy among all Russian republics.[10] Sakha is important to Moscow primarily because of its diamond industry, which produces 98 percent of Russia's diamonds and is the second-largest producer in the world.[11] The industry, controlled by the state-owned monopoly Almazy Rossii-Sakha, known as Alrosa, produced about U.S. $1.5 billion in diamonds in 2000, up 32 percent from 1993.[12] Gold mining is another major industry but, since the early 1990s, loss of federal subsidies, an unstable energy supply, and high transport costs, as well as a declining resource and limited foreign investment have hit the gold industry hard. Tin is mined from the Deputatsky region in the north, which used to provide about half of Russia's annual production. Almost all the antimony used in Russia comes from Sakha. Indigirzoloto shipped its first consignment of 1,000 tons of antimony concentrate through Magadan in spring 2000.[13] Indigirzoloto mining company used to supply the huge Kadamzhay Antimony Combine in Kyrgystan with 70 percent of its antimony concentrate.[14]

Sakha produces about 10 million tons of coal annually, 75 percent of which comes from the huge Neryungri strip mine in the south. About 142,000 tons of oil are produced annually in Sakha, and the government plans to increase production to 300,000 tons. Alrosa consumes almost half of all oil production. Electricity generation is one of the region's secondary industries. The Vilyuiskaya (hydroelectric), Yakutskaya (gas-fired), and Neryungri (coal-fired) power stations supply most of the electricity and are based in the major mining centers. The main forms of energy are coal (mined in the Neryungri, Kangalasskoe, Sangarskoe, Dzhebariki-Khaya, and Zyryanskoe reserves), gas (from the Vilyui basin), imported oil products, and firewood.

Sakha has over 44 percent of the RFE's total timber stock. The volume of wood logged has decreased steadily from between 4.5 and 5 million cu. m of timber per year in the 1980s to less than 2 million cu. m by the late 1990s. Most logging occurs near the main

Sakha was the first region of the RFE colonized by Russians. This ostrog *(fort) in Yakutsk is probably the oldest Russian-built structure in the RFE.*

transport routes and along the Lena River and nearby settlements. Farming in Sakha, mainly animal husbandry, includes raising reindeer and fur animals, as well as cattle and horses. Grain, potatoes, and vegetables are grown. Pig and chicken farming are slowly developing. Sakha is an important hunting region, mainly for fur. There is also some light industry.

Infrastructure

The infrastructure is unbalanced and underdeveloped. Sakha relies heavily on the Lena River and its tributaries to transport goods and people. Most transport is seasonal; traffic is shipped along the rivers during the short summers and driven along their frozen surfaces in winter. Shipping cargo is costly, particularly to remote villages and small cities, forcing the Sakha government to stockpile food and other supplies.[15] In summer, goods are often shipped through the Arctic Ocean and up the mouths of the Yana, Indigirka, and Kolyma Rivers. This is reportedly the cheapest way to import supplies from the United States. Raw material exports out of Sakha are limited by the lack of links between its capital, Yakutsk, and the Baikal-Amur Mainline (BAM) and Trans-Siberian Railroad. The only permanent rail link runs from the BAM to the town of Tommot, about one-half of the way to Yakutsk. All roads leading out of Yakutsk remain unpaved. The road network totals 25,000 km, but paved roads account for only about 11 percent. Small quantities of cargo travel by way of a winter road to Magadan. Airplanes are necessary to cover large distances within the republic, but service is spotty. Air travel to and from the republic is more regular, with frequent service to Moscow and a weekly flight to Vladivostok. Helicopters are being used increasingly to reach remote settlements.

Foreign trade

In 2001, exports totaled about u.s. $1.3 billion, most of which was diamonds. Coal and timber are exported by rail or ship primarily to Japan. Logs used to be sent to Japan via the Lena River and then transported from Tiksi, on the Arctic Ocean, to Nakhodka (Primorsky Krai) by ship. Since the 1970s, Japan has traded coal extraction and transportation machinery for Sakha's high-quality coking coal. Major imports include consumer goods,

foodstuffs, mining and construction equipment, and oil products. Due to a constant fuel shortage, oil products worth about u.s.$200 million are imported into Sakha annually. There are more than thirty companies operating in Sakha with foreign capital. The region saw about u.s.$140 million in foreign investment in 2001. Leading investment sectors are gold mining and oil and gas development. French-based companies invested u.s.$100 million of the total investment.[16]

Economic importance in the RFE

With the largest economy in the RFE, Sakha supplies 27 percent of the total GNP, 98 percent of Russia's diamonds (in 2001), and 23 percent of Russia's gold production. Vilyuiskaya is the largest power station in the RFE. The republic, which occupies 49 percent of the total land area of the RFE, has:

- 42 percent of all coal reserves.
- 43 percent of all tin reserves.
- 79 percent of all iron reserves.
- 62 percent of all natural gas reserves.
- 31 percent of all oil reserves.

General outlook

The republic has the largest economy in the region, contributing about 27 percent of the RFE's gross regional product. About 75 percent of Sakha's annual revenue comes from its diamond industry.[17] Alrosa plans to increase revenues to u.s.$2 billion by 2005, mostly through expanding the diamond cutting industry.[18] The move to expand the production of semifinished diamonds is supported by the Sakha government, which sees the development of a diamond processing industry as a key to stabilizing the economy. According to an agreement with the Russian Federation, the republic retains 20 percent of the jewelry-grade diamonds and 11.5 percent of the gold produced, and so the Sakha government would like to process these resources within the region. In 2001, Rus-Almaz, based in St. Petersburg, and the Sakha government opened a new diamond cutting plant, Aurora Diamond, in Yakutsk. The new plant has the capacity to process 84,000 carats of diamonds per year.[19]

To diversify the economy, the Sakha government has heavily subsidized the gold mining industry and is providing incentives to attract foreign investment. The government reportedly wrote off 126 million rubles in taxes due from gold mining companies in 1999 on the condition that they upgrade capacity and close down unprofitable operations. As a result, production increased in 1999 to 15.2 tons, up from 12.7 tons in 1997.[20] Expecting the start-up of the Nezhdaninskoe gold mine and expanded production from the Kuranakh gold mine, the government hopes to increase gold production to 20 tons.[21] Both of these ventures involve foreign companies. The government also plans to issue more licenses to groups of small prospectors (*artels*), which are major producers with an increasing market share. Major gold producing companies in Sakha include Indigirzoloto and Aldanzoloto. To increase production, new technologies, but not necessarily environmentally friendly ones, are being introduced. The government also has ambitious plans to export some of Sakha's vast natural gas resources to Korea or China by pipeline. This project, however, will need massive infusions of foreign capital, possibly as much as u.s.$23 billion, and so far investment has been limited to feasibility studies. Yakutugol, Sakha's coal monopoly,

operates all of the mines but is on the verge of bankruptcy. So the Sakha government has offered shares of Yakutugol to Japanese companies and is looking for foreign investment to develop the vast Denisovskoe, Chulmikanskoe, and Bolshoe Tokko coal deposits.

With a harsh climate and lack of arable land, Sakha is highly dependent on other regions in Russia and abroad for basic foodstuffs and consumer goods and will probably never be self-sufficient. However, timber, gold, oil, and diamond processing industries could slow down the rapacious resource exploitation that now occurs and stabilize the economy by providing jobs. If Sakha, like other regions in the RFE, continues simply to extract raw materials, the rivers will continue to be poisoned and fragile forests will continue to be overlogged. If the railway from Amur Oblast to Yakutsk is ever completed, raw materials will be exported even more rapidly.

In the extremely cold, dry climate, the forests grow slowly and trees are small, so large areas must be logged to obtain timber. Unable to import timber because of high transport costs, small logging ventures are cutting Group I protected forests along the northern river basins (particularly along the Indigirka and Kolyma Rivers) for building materials and firewood. Despite their relatively moderate scale, logging ventures are significantly damaging because of the destructive clear-cutting and heavy logging near settlements and transportation routes. Recent studies have highlighted the importance of boreal forests in mitigating climate change, and the preservation and sustainable use of the forests in Sakha should be an issue of global concern.

The government, one of the few in the RFE to develop a comprehensive ecological program, has ambitious plans to ultimately protect 25 percent of Sakha (an area about the size of France). The international community should support these efforts. A major step would be the preservation of Sakha's biodiversity hotspots, in particular the protection of Bolshoe (Greater) Tokko Lake, which is threatened by plans to mine coal for export.

— *Josh Newell*

Vladimir Dinets

Verkhoyansk, Sakha — considered the coldest inhabited place on earth.

SAKHA

Ecology

Alexander Isaev

Permafrost covers all of Sakha and leaves its imprint on the region. Depths of this permanently frozen soil vary from between 30 and 50 m in southern Sakha to 500 m and more (the world's deepest) in central and northern Sakha. Because permafrost soil temperature at a depth of between 5 and 10 m remains constant at −10°C and lower, it has a cooling effect on the ecosystem. Depending on climatic and soil conditions and vegetation type, the upper layer of soil thaws in summer to a depth of between 0.4 and 2.0 m. In summer, the vegetation above ground, such as trees and brush, has elevated temperatures, while the underground roots remain at temperatures that are low, but still above zero.

Sakha consists of five natural zones: arctic desert, arctic tundra, subarctic tundra, subarctic tundra woodlands, and boreal forests, locally called taiga. Forests cover 47.4 percent (257 million ha) of the territory, but the extent of forest cover varies by region: 32 percent in the northeastern region, 78 percent in the northwestern region, 77 percent in the central region, and up to 93 percent in the southern region. Total forest area is almost 260 million ha, including 150 million ha of unbroken, or old-growth, forest. Timber reserves total more than 9 billion cu. m, including 6 billion cu. m of mature and overmature timber reserves. Conifers make up 97 percent of total wood resources. Dahurian larch accounts for 79 percent of the forests, with the remainder primarily Scots pine, Siberian spruce, East Siberian fir (*Abies nephrolepis*), birch (*Betula*), and aspen (*Populus tremulae*). Siberian pine (*Pinus sibirica*) and Siberian fir (*Abies sibirica*) grow in the southwest, while Ayan spruce (*Picea ayanensis*) and stone birch (*Betula ermanii*) grow in the mountainous southern regions. In river valleys, aromatic poplar (*Populus suaveolens*), chosenia (*Chosenia arbutifolia*), and willows (*Salix*) grow. There are significant areas of Japanese stone pine (*Pinus pumila*), primarily in the mountainous regions. In the southern part of the tundra belt, scattered stands of Japanese stone pine and Dahurian larch grow along the rivers.

In the north, the forests are mainly found along river valleys, sometimes almost all the way to the coast. High in plant and animal diversity compared with the surrounding regions, the northern river valley forests of the Indigirka and Kolyma River basins and adjacent tributaries are very productive, considering their northern latitude. The main threat is logging. Almost all of these forests grow in protected Group I zones along rivers. Lack of firewood and timber for building in the cold northern regions has forced locals to log these protected forests. In the past, wood was imported from other regions, but the high cost of fuel and transport has made this practice prohibitively expensive. Other important forest zones include:

- Larch forests of the Olenyok region.
- The mountain larch forests of the northern taiga region near the Yana and Kolyma Rivers.
- The pine and larch forests of the Lena-Baikal region.
- The central taiga of the Aldan region.

Forest fires are increasingly frequent, especially in the hot, dry summers. Between 1978 and 1987, 131,000 ha of forest were burned. However, between 1988 and 1998, as many as 8,500 fires have burned an estimated 2.5 million ha, resulting in the loss of almost 40 million cu. m of timber. Between 800 and 1,000 forest fires are recorded annually, burning an average of more than 250 ha each. In the record year of 1996, fires raged over an area of more than 500,000 ha. About half of the fires are caused by lightning and one-third by human error; about one-tenth are planned burns.

Edible and medicinal plants abound in Sakha's forests. Some of the most familiar types include berries (two arboreal species, ten bushes, five small shrubs, and five grasses), nut-bearing plants (two species of pine), twenty species of leafy grasses, and two species of birch. There are also more than one hundred species of edible mushrooms. In addition, more than twenty species of plants were known to our ancestors as "famine" foods. Medicinal plants include seven species of trees, twenty-six species of bushes and shrubs, more than fifty species of grasses, six species of mushrooms, and ten species of lichens. Of these, more than thirty species are presently used to make medicine.

Large numbers of waterfowl, such as several species of swans, geese, and ducks, as well as cranes and shorebirds, nest here. Over half of the Bewick's swans (*Cygnus bewickii*) in Sakha, as well as sandhill cranes, eiders (*Somateria*) and other waterfowl, nest between the Kolyma and Konkovaya Rivers. Little curlews (*Numenius minutus*), Siberian white cranes, hooded cranes (*Grus monachus*), and black storks (*Ciconia nigra*) nest between the Lena and Kolyma Rivers.

Protected area system

L. SHMATKOVA—The government established the Olyokminsky and Delta Leny Zapovedniks in 1984 and 1996, respectively, and a number of *zakazniks*, but these territories occupy less than 2 percent of Sakha's total area, and thus have not adequately protected the region's ecosystems and biodiversity. Decades of destructive diamond and gold mining have destroyed over 25,000 ha of land, and today these areas are still devastated. The Sakha government, however, recognizes the necessity to protect ecosystems for biodiversity conservation and use by indigenous peoples, as well as to encourage sustainable development. In 1994, the government decreed that 25 percent of Sakha would be protected to preserve pristine areas and to ensure that some natural resources remain untapped for future generations.[22] This decree has served as

a predecessor and, in some cases, a catalyst for the creation of similar networks of protected areas in other regions of Russia. It appeared considerably ahead of the Pan-European Biological and Landscape Diversity Strategy, which was adopted by the European Union in October 1995. This strategy is considered to be the main European contribution toward fulfilling the goals of the UN-sponsored Agenda 21, which has become the cornerstone of sustainable development efforts in many regions worldwide.

To establish a network of protected areas, the republic first created the legal foundations for such territories.[23] For the first time in the Russian Federation, protected areas were given names in the Yakut language: *Ayan ayilgy* (national nature parks), *Erkeyi sirder* (national resource reserves), *Uluu tuolbeler* (protected landscapes), and *Ayilba meneler* (natural monuments). In addition to new laws, standard guidelines were developed to clarify the functions of the reserves.

As a result, the republic's present protected area system (*Yityk kere sirder*) combines federal-level protected areas (*zapovedniks*), republic-level areas (national nature parks, resource reserves, and *zakazniks*), and an array of district-level (*ulus*) and municipal territories into one system. The system includes two *zapovedniks* (Olyokminsky and Delta Leny), four national nature parks (Lenskie Stolby, Sinyaya, Momsky, and Ust-Vilyuisky), forty resource reserves, forty-three reserved territories, a few protected landscapes, a few dozen natural monuments, and twenty-six lakes of unique national significance (see table 6.1.) This network protects 587,000 sq. km, or about 18.9 percent, of the republic. The protected territories conserve habitat for some 17 species of mammals, 54 species of birds, and 311 species of vascular plants, all of which are listed in the Sakha *Red Data Book*. In most cases, ecological corridors, such as buffer zones along the river, connect these protected areas.

The Sakha Ministry of Environmental Protection is responsible for the overall administration of the network. Individual protected areas are administered by the protected-area department within the ministry, by district-level committees, and by directorates for each *zapovednik* and national park.

Zapovedniks. As in other areas of Russia, *zapovedniks* are administered by the federal government. In Sakha, indigenous groups have a number of problems with the *zapovednik* system, as it contradicts their traditional notions of land use. Whenever proposals for new *zapovedniks* arise, indigenous peoples are some of the strongest opponents.

Olyokminsky. This *zapovednik* lies on the western Aldan highlands and protects part of the Olyokma River and its tributaries.[24] The area encompasses low-elevation mountains, with the highest reaching 1,166 m. The *zapovednik* protects taiga forests composed of Dahurian larch (53 percent), Scots pine (25 percent), Siberian pine (14.5 percent), and other species (7.5 percent). The mountaintops are rocky, with moss and lichen vegetation. This region has both Yakutian and Transbaikalian floras. Of 650 species of vascular plants, 67 are endemic or rare. Notable plant species include *Rhododendron adamsii*, *Anomonastrum calvum*, and *Rosa jacutica*. There are 40 mammal species, 2 reptile species, 2 amphibian species, 180 bird species, and 18 fish species. Moose, musk deer (*Moschus mosciferus*), reindeer, sable (*Martes zibellina*), and Siberian weasel (*Mustela sibirica*) are commonly seen; Eurasian lynx (*Felis lynx*) and wolverine (*Gulo gulo*) are less common. Rare birds

Dahurian larch (Larix gmelini) *is the dominant tree of Sakha forests.*

Table 6.1

Protected areas in the Republic of Sakha

Region and type and name	Size (ha)	Established	Region and type and name	Size (ha)	Established
Lena River basin			Indigirka River basin		
Zapovedniks			*National nature park*		
Delta Leny (Lena Delta)	1,433,000	1996	Momsky	2,175,600	1996
Olyokminsky	847,102	1984	*Zakazniks*		
National parks			Saiylyk	700,000	1980
Momsky	2,175,600	1996	Verkhne-Indigirsky	700,000	1992
Sinyaya	1,467,517	1996	Khroma	523,000	1992
Ust-Viluisky	1,016,000	1997	*Resource reserves*		
Lenskie Stolby (Lena Pillars)	868,000	1995	Kytakyk	1,607,900	—
Zakazniks			Suntar-Khayata	631,000	1996
Ochuma	615,000	1982	Eselyakh	500,000	—
Timirdikeen	520,000	1995	Sutoryokha	500,000	—
Undyulyung	500,000	—	Okhogino Lake	214,250	—
Verkhne-Amginsky	500,000	1975			
Tomporuk	285,600	1983	Kolyma River basin		
Khariyalakh	280,000	1969	*Resource reserves*		
Bolshoe Tokko	265,800	1983	Sededema	65,000	1995
Pilka	216,000	—	Sylgy-Ytar	14,000	1984
Dzhunkun	200,000	1987	Zhirkovo	11,000	1971
Ungra	200,000	1979	Troitskoe	5,100	1975
Tamma	177,200	1995			
Dzherono	60,000	1969	Yana River basin		
Beloozyorsky	35,800	1974	*Resource reserves*		
Resource reserves			Tuostakh	500,000	1997
Delta Leny (Lena Delta)	5,932,000	1996	Omolon	332,500	1996
WWF-Sakha (Charuoda)	1,372,000	1997	Irianna	185,000	1974
Belyanka	262,400	1997			
Bes-Kyuel	108,000	1996	Alazeya River basin		
Kenkeme	93,632	1995	*Resource reserve*		
Prialdansky	46,000	1997	Chaiguurgino	2,375,600	1982
Kharbai	32,600	1996			
Kele	30,000	1996	Anabar River basin		
			Resource reserve		
			Ternei-Tumus	1,112,000	1997

Note: Not all resource reserves are listed.

Source: Sakha Ministry of Environmental Protection, 2000.

include Siberian crane, hooded crane, osprey (*Pandion hali-aeetus*), golden eagle (*Aquila chrysaetos*), and peregrine falcon (*Falco peregrinus*).

Delta Leny. This *zapovednik* protects the Lena Delta and has two major sections: Deltovy (1,300,000 ha) in the central part of the delta, and Sokol (133,000 ha) in the Kharau-lakhsky Mountains. Channels, bays, and lakes cover over half of the area. The vegetation is primarily tundra, with thickets of willow along the riverbanks. There are about four hundred vascular plant species, including twenty rare species such as *Androsace gorodkovii*, *Corydalis gorodkovi*, and *Saxifraga lactea*. The thirty mammal species found here include reindeer, snow sheep, arctic fox (*Alopex lagopus*), and Kamchatka marmot (*Marmota kamchatica*). There are about seventy bird species, including Bewick's swan and Ross's gull. Important fish species include various whitefish (*Coregonus, Prosopium, Stenodus*) and sturgeon (*Acipenser sibiricus*). The *zapovednik* is working with World Wildlife Fund (wwf)–Russia to create a biosphere *zapovednik* to strengthen the protection of the entire Lena Delta. Activities of the *zapovednik* include monitoring the water quality of the Lena River and the Laptev Sea, tracking fish populations, studying effects of the diamond industry along the lower Lena, and studying soil composition of the New Siberian Islands.

National nature parks (*Ayan ayilgy*). Administered by the Sakha Ministry of Environmental Protection, nature parks

are intended for nature conservation, and educational, scientific, cultural, and recreational use. The development of natural resources within the parks is allowed in some areas, provided it is compatible with the overriding purposes and the resource use is compatible with the principles of traditional nature use. Different types of zoning are allowed within the parks, including:

- Protected zones (*Tyytyylybat sirder*)—all industrial, agricultural, and recreational use is prohibited.
- Sacred areas (*Yityk sirder*)—places of traditional spirituality and worship.
- Limited and active recreation zones.
- Traditional nature-use zones (*Torut sirder*).
- Enclosures and captive breeding zones for endangered wildlife.
- Protected historical or archeological zones.

The use of land, mineral, and biological resources is prohibited except in zones of traditional nature use. Each park has its own directorate. Regulations vary for each park and determine particular zoning and protection regimes.

National resource reserves (*Erkeyi sirder*). These reserves are created to protect land, water, mineral, and biological resources, as well as the land of indigenous peoples, and to allow for environmental education and ecotourism. There is a variety of different zoning regimes, including protected zones, sacred lands, licensed resource-use zones, seasonal protection of biological resources, and traditional nature use, determined by the regulations for each reserve. Interaction between landowners and users in each reserve is regulated by negotiated agreements. Tourism and recreation are regulated on a project-by-project basis and licensed.

Protected landscapes (*Uluu tuolbeler*). These areas preserve unique landscapes. Recreation, tourism, and other limited activities are allowed. To establish a protected landscape, it is not necessary to take over the land or to prohibit current users from enjoying the resources. Regulations for each landscape vary, and they determine the protection regime.

Natural monuments (*Ayilba meneler*). Standard regulations adopted by the republic determine the creation and protection of natural monuments.

Reserved territories. Reserved territories protect, sustain, and restore natural habitats. Limited traditional natural resource use is allowed, but no industrial mining development.

Tour Agency of the Republic of Sakha

Polar bears (Ursus maritimus) *den along Sakha's northern coast.*

Biodiversity hotspots

1. Vilyui River basin (forest and wetland)

L. EGOROVA, N. PAVLOV—In western Sakha, the rolling hills and valleys of the Vilyui River basin are covered with larch and sparse forests. The northern part of the basin, where the terrain is more rugged, with elevations of up to 800 m, includes the Markoka, Markha, Tiung, and Tiukyan Rivers. The southern part of the basin includes tributaries of the Vilyui (Chona, Botuobuya, Ulakhan, Ochchugui-Botuobuya, and others) and the Lena (Nuya, Dzherba, Biryuk, Blue, and others). In January, the temperature drops to −55°C or −60°C; in July, temperatures reach 35°C. Winds from the west bring moisture, and the climate is somewhat milder than that of central Sakha.

Threats. Diamond mining, oil and gas prospecting, gold and coal mining, cattle grazing, and reindeer breeding are degrading this vast river basin, all of which lies on sensitive permafrost soil. Diamond mining has had the most serious impact, as highly mineralized waters, containing harmful levels of strontium, bromine, lithium, and boron salts accumulated during the processing of kimberlite pipes, were stored in cesspools. Subsequent floods washed this waste into rivers, including the Vilyui and Markha. Water quality studies by scientists at the Institute of Applied Ecology of the North revealed that the thallium concentration in waters around diamond mining ventures was two to three times higher than acceptable. Geochemical studies have shown that there are unacceptable levels of thallium concentrations throughout most of the region. Water pollution by the diamond mining venture, Russian-Sakha Diamonds, continues.

Vilyuiskaya Hydroelectric Power Stations No. 1 and No. 2 were built to meet the energy demands of the diamond industry. The world's first power station on permafrost was constructed without consideration of the ecological impact. Forests in the water reservoir were not logged, but flooded; an estimated 3 to 8 million cu. m remain underwater. This has caused tremendous phenol pollution, twenty-five times above acceptable levels in some years. Vilyuiskaya Hydroelectric Power Station No. 3 is under construction, and the reservoir basin will be cleared by burning the forests, which will pollute the river. In general, power station construction has damaged glacial, thermal, and hydrological regimes.

Since 1974, underground nuclear tests have been conducted in the region. Accidents occurred during two of the tests: Kristall (1.7 kilotons) and Kraton-3 (19 kilotons). Research revealed that their radioactive pollution totaled 239 isotopes and 240 isotopes, respectively. Until 1996, rocket fuselages launched from Baikonur in Kazakhstan regularly fell into the northern part of the region. This no longer takes place, but the environmental consequences of this practice remain. In 1997, an area between the Lena and Vilyui Rivers was designated as a location in which dumped fuselages would be acceptable. However, the public is demanding an end to this practice, because conditions of this agreement have been regularly violated.

Large oil and gas fields have been explored in the Lena and Vilyui lowlands. Some of these, such as the Maastakhskoe, Urelyakhskoe, and Talakanskoe fields, are being commercially developed. Oil spills due to extraction and exploration have polluted large areas, and many wells have been abandoned. One of the most serious ecological problems in the region has been caused by the development of Talakanskoe oil field, for which a temporary oil pipeline from Talakan to Vitim was built along the bank of the Lena River. Built without the required environmental impact review, the pipeline is not capable of withstanding natural disasters. For example, it has no fire prevention system, the fire suppression lane parallel to the pipeline is not wide enough, and the pipeline area is filled with garbage.

Forest fires, logging, unsustainable agriculture, and uncontrolled hunting and fishing have created additional environmental problems. Since 1989, the Yakut Institute of Applied Ecology has monitored public health and environmental conditions in the Vilyui watershed. Results show that public health and the environment are in poor condition.

Existing protection measures. A portion of the Vilyui River basin remains pristine; the northern territories in particular are not well explored. In 1991, the Yakutia Council of Ministers declared the republic a nuclear-free zone. Yakutia banned all nuclear testing, the use and storage of nuclear weapons or radioactive waste, and the construction of nuclear power plants. Thanks to the Vilyui Committee and other nongovernmental organizations, in 1992, the Yakutia Supreme Soviet and government adopted a resolution calling for the ecological restoration of the Vilyui River. In 1997, the government created a committee to eliminate the effects of nuclear tests. This committee is developing projects to reclaim territories affected by the underground nuclear tests, Kraton-3 and Kristall. Although the republic launched a government program and identified sources of financial support, funds have not yet been provided in full.

Federal authorities are developing programs to improve public health and the state of the environment. The government is also developing a research program to study the environmental impact of fuselages from rockets that have crashed in the Nyurbinsky and Gorny Uluses.

Recommendations. The following actions should be taken:
- Reclaim areas disturbed by diamond mining and oil and gas development.
- Conduct an independent environmental impact review of oil and gas exploration and development.
- Conduct multidisciplinary research on the effects of fuselage refuse on the environment and on public health.

SAKHA

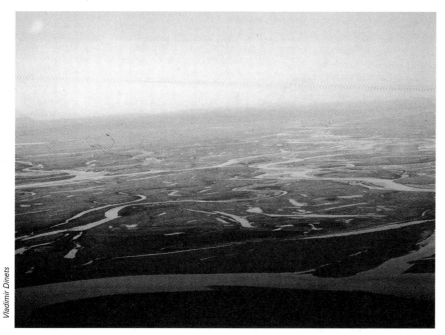

Lowland tundra – immense labyrinths of lakes, small rivers, and permafrost that are important breeding grounds for the Siberian crane (Grus leucogeranus), *Ross's gull* (Larus roseus), *Bewick's swan* (Cygnus bewickii), *and many other birds.*

2. Tundra woodlands of Northern Sakha (forest and tundra)

N. SEDELNIK—Forests growing on permafrost total an estimated 860 million ha, 480 million of which are inhabited. In many of these permafrost forests, industrial activity should be forbidden and, in other areas, only limited types of activity should be allowed. Logging on sensitive permafrost forests leads to collapsing thermokarsts, landslides, erosion, and other undesirable results. Once this happens, it is too late to restore the forests. There is a growing movement to conserve the northern forests, and in particular, the tundra woodlands. These woodlands form a 100-km broad belt, encompassing about 19,716,000 ha across the northern part of Sakha. They also dominate the northeastern part of the republic. These forests represent one of the most important virgin forest territories on Earth, and are one of the world's few remaining regions that have not been disturbed since the Ice Age. Along this broad belt of tundra and taiga, logging should not take place, as these forests fulfill critical ecological functions that far outweigh the economic benefits gained from logging. Unfortunately, in addition to logging, diamond, gold, tin, and polymetal mining degrades these forests.

Rare animals and plants inhabit this fragile taiga and tundra ecosystem. Nesting birds include Siberian crane, gyrfalcon (*Falco rusticolus*), and Ross's gull. Indigenous people herd reindeer in this region. The poorly studied territory remains largely pristine, and scientists fear that the damage to the ecosystem may have a multitude of unseen consequences, such as causing shifts in the global climate with melting of the permafrost. What is becoming well known about the region is its critical role in regulating the water flow of the northern rivers and circulation processing of the atmosphere.

Threats. Several mining companies operate within the region, including large tin and gold mining companies (Deputatsky and its subdivisions, the Kularzoloto gold mines). Diamond mines are being developed (Ebelyakh mine), and deposits of niobium have been discovered and partially prospected (Tomtor mine). In strip mining, large tracts of forest are destroyed, primarily in the river valleys, where the most productive forests grow. Little effort is made to recultivate the land after mining, and the areas often become lunar landscapes.

The forests have no real commercial export value, but local communities are logging them for firewood. In some cases, entire river valleys have been logged for this purpose. Due to rising transport costs, it has become much more difficult to bring in fuel supplies. Fires, although less frequent than in regions further south, also continue to destroy vast tracts of these fragile forests; some areas burned between 100 and 150 years ago still have not recovered. Similarly, many forests have not recovered after logging.

Research has focused primarily on the impact of industrial development in the Yano-Indigirka region, and particularly some of the impact from gold and tin mining companies. The Siberian white crane, which lives in this region, has also been studied to some degree.

Existing protection measures. To regulate use and conserve the forests of this subtundra zone, the Sakha government established a protected 100-km strip on January 1, 1960. Within this strip, some protected areas have been, or are in the process of being, created. It is unclear, however, what is actually prohibited in this protected strip.

Recommendations. The following actions should be taken:
- Conduct ecological monitoring to support conservation and rational use of these forests; databases compiled by the Sakha Forest Service could be a good starting point.
- Study the impact of industrial activity on this region and the globally important role played by these forests.
- Recultivate all lands destroyed by gold and tin mining.
- Do not develop new mines.
- Use alternative sources of fuel, other than timber, whenever possible.

3. Between the Lena and Amga Rivers
(forest and wetland)

P. TIMOFEEV, R. DESYATKIN—The region, which covers 9.5 million ha, includes the Amgin, Megino-Kangalass, Ust-Aldan, and Churalchin regions. Part of the central Yakutsk Plain, the area has a continental climate and receives little precipitation (between 200 and 800 mm yearly), 80 percent of it in summer and fall. Forests cover 72 percent of the region, or 7.64 million ha. The total wood supply is estimated at 780 million cu. m. Larch covers 87.4 percent of the forested area, with pine forests making up 3.7 percent. Other forest types include primary birch forests (3.2 percent), and dwarf forests and birch shrub (5.6 percent). Within the ecologically diverse birch forests (local and different from secondary forests of birch and aspen) grow a community of steppe plants known as *charan*s; these communities only grow between the Lena and Amga Rivers. Spruce, aspen, willow, and poplar forests are rare and more likely to be found on the left bank of the Aldan River. Twenty-eight percent of the area consists of *alas*es—a unique complex of wetland, meadow, and forest-steppe vegetation.

Threats. Intensive agriculture and cattle grazing are degrading the region. Forests are being converted into pasture and plowed fields. In two decades, the soil will become so poor that it will be virtually unusable. Animal waste, mineral fertilizers, pesticides, and herbicides have polluted many lake and river systems. Also, because it is one of the most populated regions of Sakha, tourism has had a negative impact. Like most ecosystems in Sakha, this region is fragile, and even limited disturbances can cause a thermokarst phenomenon, which frequently leads to major changes in the landscape. The *alas*es are communal, ancestral places for the indigenous Yakut peoples and are considered sacred.

Other major causes of damage are forest fires and logging, either for firewood or for the construction of industrial facilities. Each year, at least 10,000 ha of forest are cut for firewood. Regeneration can take up to three hundred years. Construction for road and water transportation is fragmenting this taiga region, limiting the proper regulation of water levels. Some experts speculate that, as a result, there have been changes in the local climate, causing the region to become more prone to drought.

Due to forest destruction, water birds, squirrels, and weasels are becoming rare. Bears and deer have virtually disappeared. Ecologists fear that further damage will be disastrous for wildlife and will increase desertification in an already hard-hit region. There are already extensive areas of sandy, barren deserts in the central Lena basin.

Recommendations. The following actions should be taken:
- Strictly limit logging for firewood and construction to conserve the remaining pristine forests.
- Replant forests on a massive scale where the land is not regenerating itself naturally.
- Monitor all the *alas*es of the Lena-Amga region regularly.

4. Between the Aldan and Uchur Rivers
(arctic and forest)

L. SHMATKOVA—The region between the Aldan and Uchur Rivers occupies a sizable area in the mountainous part of southern Sakha. Administered by the Neryungri and Aldan regional governments, these subalpine forested lands have altitudes ranging between 650 and 2,200 m. The forests are primarily larch and Scots pine, with some Siberian pine, spruce, and fir, interspersed with birch, aspen, and, less commonly, poplar. The area has a high biodiversity, particularly for Sakha, as this is where the Far Eastern and Eastern Siberian geographical regions meet. There are more than 850 species of vascular plants in the region, including a number of endemics and species that are listed in the *Red Data Book* (lycopodiums, orchids, dryases, saxifrages, thyme, and so on). There are several species of carnivores and ungulates in the area.

Threats. The indigenous Evenks, although few in number, inhabit this region. Some have settled in the village of Khatystyr; others remain nomadic. In the Aldan River valley, gold and coal mining, along with the construction of the industrial towns of Neryungri, Timpton, Berkakit, and Kanku and the construction of a railroad, has affected the ecosystems.

There are currently plans to construct the Uchur hydroelectric station and to mine the Elginsky coal deposit, which is located next to the protected Bolshoe Tokko Lake, considered by most ecologists to be one of the natural gems of Sakha. If this area is developed, the high biodiversity will suffer as some species will be exterminated, the unique and scenic lake will be affected, and widespread destruction of these permafrost lands can be expected.

Existing protection measures. Part of the region has been protected as a series of republic-level natural resource reserves, among them the Ulakhan-Tary, Ungra, Tynym, Dzhanda, Gonam, Bolshoe Tokko, Timpton Cascade, and Synnagino-Silinsky reserves.

Recommendations. The following actions should be taken:
- Recultivate areas already affected by gold and coal mining.
- Develop a comprehensive program, on a regional level, for sustainable development of the south Yakutsk industrial region, incorporating better technologies for developing the natural resources, guidelines on limiting development, and programs for restoring degraded forests.
- Conduct an environmental impact assessment of the planned Elginsky coal mining and Uchurskaya hydroelectric station projects.

5. Tuimaada Valley (forest and wetland)

I. SHURDUK, V. POPOV—Tuimaada Valley, which extends from north to south for 65 km and is 12-km across at its widest point, is situated on the left bank of the Lena River. North and south of the valley are the Kangalass and Tabagin cliffs, respectively, both of which are composed of Jurassic-era sandstone. To the west are mountains built up from ancient alluvial deposits. Covered entirely by permafrost, this land ranges in altitude from 25 to 50 m in the valleys and to 400 m in the mountains. The rich alluvial soil has allowed pine, larch, and spruce forests to grow here, creating a relatively rich region suitable for cultivation. The first inhabitants of this area herded livestock, and to do so, they cleared forests and set fires. Only about 9 percent of the forest cover remains today. Sakha's capital, Yakutsk, is located here.

The rich valley has a diverse variety of ecosystems (forests, shrub, meadow, steppe, forest-steppe, and swamp) for such a small region. Some of the areas in need of protection include the Tulagino-Kildyam lake-steppe complex, with spruce groves that are unique to the Tuimaada Valley, the Zhataisk forest-steppe complex with combinations of *charan*s and fragments of steppe and halophytic vegetation, the Vladimir and Shestakovka forest massifs, with bearberry (*Arctostaphylos uva-ursi*) and diverse pine, birch, whortleberry (*Vaccinium myrtillis*), and larch forests, and natural monuments, including Sergelyakh, Prigorodny, Kyutyur-Kal, and others.

Threats. The steppes, in particular, are in need of protection, as numerous rare species of flora grow here, many endemic to Sakha. Urban and industrial sprawl is the major cause of the destruction of these steppes. The ecosystems are fragile and unstable, and industrial growth and deforestation have rendered them incapable, in many cases, of protecting the permafrost ground from erosion and collapse. This degradation is becoming visible in the city of Yakutsk. As the valley was settled, the heat flow in the soil increased, and the protective frost-preserving ability of the land decreased.

Existing protection measures. The importance of measures for conserving the ecosystem of the valley has been supported by a resolution of the Sakha administration. This resolution points to the need for emergency measures to be taken to address the problem of permafrost melting in and around the city of Yakutsk.

Recommendations. The following actions should be taken:
■ Regenerate the forests of Tuimaada Valley. This program should include the establishment of protective forests belts in the valleys of the Markhinka, Maganka, and Shestakovka Rivers, as well as around all lakes in the Tuimaada Valley. Forest vegetation around lakes regulates and filters outflow and may help desalinate the water.

Economy

Alexander Isaev, Josh Newell

Industry, primarily power generation (25 percent) and mining for diamonds, gold, coal, and tin (70 percent), accounts for almost 65 percent of total economic output. Other main industries include production of building materials, food, light manufacturing, and logging.

Sakha includes the following industrial centers:
■ Western and northwestern regions. Diamond industry, hydroelectric power generation, natural gas and oil industry.
■ Southwest. Timber.
South and southeast. Mining for gold, black coal, and other minerals, power generation, and building industry.
■ Central. Building industry, power generation, coal mining, and local industry.
■ Yana-Indigirka industrial region. Mining for gold, tin, and other minerals.

Sakha's economy is in crisis. Sweeping political and economic changes first affected heavy industries, notably mining. In 1992, mining operations began to shut down because of a lack of domestic demand for the mineral resources. Only diamond and coal mining have remained viable, and they (along with subsidies from the federal government) are the main sources of revenue for the republic. The budget has shrunk steadily since 1996, and its overall debt continues to increase. Failure to pay wages and other problems in many industrial sectors, particularly the farming sector, have led to increased social tension and crime.

However, the fundamental structure of the Soviet-era state-operated economy remains, hampering further industrial development. Dependence on imports for basic raw materials, an increasing need for capital investment and credit, an underdeveloped and costly infrastructure, and the absence of an established internal market all combine to make the economy vulnerable to external influences. The resulting economic instability has led to increased unemployment and a decline in social services. Many mining and energy enterprises are bankrupt or on the brink of bankruptcy.

In converting to a market economy, the objectives of mining enterprises have fundamentally changed. Many were created to ensure that the former USSR was self-sufficient in all necessary mineral resources, in accordance with strategic industrial development plans for the Far North. Economic viability was often of secondary importance, and mining enterprises were supported by government credits and price controls. With the introduction of a market economy, many of these enterprises became unprofitable.

Environmental impact. Assaults on Sakha's environment come from all sides, industry and development, agriculture, the economy, and government policies. These include:

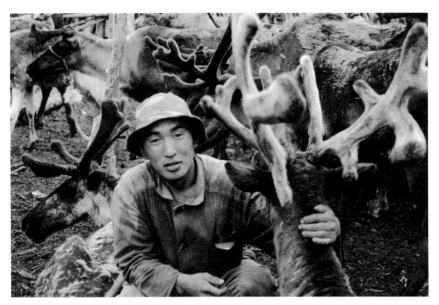

A Yakut man tends to his reindeer.

- Diamond, coal, gold, and tin mining.
- Oil and gas development.
- Hydroelectric power, including the Vilyui and Kolyma power station chains and some under construction.
- Forest fires.
- Excessive agricultural use of ecologically fragile areas, especially in the area between the Lena and Amga Rivers and in the Tuimaada Valley.
- Uneven growth of the infrastructure.
- Intensive logging in the mid-Lena River region and the valleys of northern rivers.
- Industrial development without adequate environmental safeguards.
- Inadequate education about the ecology.[25]
- Continuing radiation from sites of underground atomic explosions, including the disastrous Kraton-3 and Kristall explosions.

Closing industrial enterprises does not always reduce pressure on the environment. Although many mining operations have closed down, huge devastated territories remain, and the possibility that these areas will be reclaimed is slight. Similarly, even though annual timber production has shrunk from 5 million cu. m to less than 2 million cu. m, this has not necessarily reduced the stress on forests. With logging companies facing financial difficulties, and operating and transport costs rising, the distance over which timber is transported has diminished drastically, increasing logging pressure on forests near populated areas and transport arteries. Logging has intensified in accessible areas that, under optimal conditions, might not be considered appropriate because the trees are small or are growing along riverbanks.

Sakha's mining industry has damaged the structure and function of both marine and terrestrial ecosystems, decreas-ing their productivity and impoverishing their biological diversity. Of particular concern are (1) the Vilyui River basin, with its extensive diamond and gas extraction industry, (2) the Yana-Indigirka industrial region, where there is intensive gold and tin mining, and (3) southern Sakha, which is a center for coal, gold, and other minerals. Inefficient utilization of agricultural lands has led to a decline in the lichen that naturally grows on northern tundra and destroyed the many *alas* lake ecosystems in central Sakha. Because Sakha occupies a significant portion of northeastern Russia and has a great variety of ecosystems including arctic deserts, tundra, taiga, mountain systems, steppes, river basins, and numerous lakes, the territory is of vital significance for the ecological balance in Eurasia.

Sources of radioactive pollution in Sakha are numerous and varied. These include underground nuclear explosions, the dumping of radioactive waste generated during exploratory drilling and mining, and airborne radionuclides from nuclear weapons testing in nearby regions during the 1950s. In addition, so-called peaceful underground nuclear explosions were set off in Sakha, two of which (Kraton-3 and Kristall) released radionuclides into the atmosphere and onto the ground. The Sakha Ministry of Environmental Protection classified these incidents as environmental disasters.[26] Rockets also pass over Sakha and often release toxic fuel. Waste dumping from other regions occurs continually, notably from the Norilsky mining complex.

Although there are hundreds of thousands of rivers and lakes in Sakha, some regions (primarily the area between the Lena and Amga Rivers) lack water. The quality of river water has not deteriorated over the past few years, but many rivers remain polluted. Concentrations of phenols, oil byproducts, copper, and zinc exceeded permissible levels in many instances. Water is being redirected from the Lena River to the overexploited agricultural region between the Lena and Amga Rivers.

The Kolymskaya Hydroelectric Power Station, on the border of Magadan and Sakha, will affect the Kolyma River, which begins in Magadan Oblast and runs through Sakha to the Arctic Sea. It will destroy rivers, wetlands, and rich fisheries. The Chernyshevskaya Hydroelectric Power Station (Viluisky Ulus) was built in the 1960s to provide energy for the huge diamond mining center near Mirny, and it is the first station of its kind to have been built on permafrost. Vast areas of taiga forest were flooded by the reservoir; this is now a major problem, as rotting trees in the reservoir and

massive waste from nearby diamond mines are poisoning the water.

Since 1987, the release of harmful substances into the atmosphere has been declining. However, with the continuing economic crisis, this has changed recently. The figures for chemical releases in 1996 were almost 9,000 tons higher than in 1995. Recycling of waste is insignificant. Among the most critical unsolved problems are the disposal, utilization, and detoxification of hazardous wastes, of which, by the most conservative estimates, some 90,000 tons have accumulated.

Timber

The timber industry logs in the Lensky and Olyokminsky Uluses, primarily near the Lena River and the settlements alongside it. Forest composition, and structure in the permafrost zone in general, is relatively simple, and productivity is low. The forests, even those between 140 and 200 years old, seldom exceed 200 cu. m per ha, although productivity increases toward the south. The forests of the southwest Prilensky Ulus, the most productive in the republic, form the nucleus of Sakha's great central taiga region. Due to poor infrastructure, logging is localized near settled regions. Intact forests are shrinking due to logging and frequent, unnatural forest fires. Despite their relatively moderate scale, logging operations have a great impact on the environment owing to

destructive clear-cutting and heavy logging near settlements and transportation routes. To obtain 100 cu. m of acceptable quality construction lumber, it is often necessary to clear-cut up to 5 or 6 ha of forest. In some areas, such as the central reaches of the Aldan and Lena Rivers, forests have been badly degraded due to logging. Logging and fires also disrupt fragile transition zones between forest and tundra, which often do not regenerate themselves well.

Hunting and fishing

Hunting is another major industry. More than 500,000 muskrat (*Ondatra zibethica*) pelts, 250,000 Eurasian squirrel (*Sciurus vulgaris*) pelts, some 50,000 sable and ermine (*Mustela erminea*) pelts, more than 10,000 arctic fox pelts, and 500,000 variable hare (*Lepus timidus*) pelts are obtained yearly. Sakha is Russia's largest producer of pelts. Forty thousand wild reindeer are killed annually. Fishing annually yields about 8,000 tons, mainly in the lower reaches of the Lena, Yana, Indigirka, and Kolyma Rivers.

Agriculture

Since 1997, with dissolution of the *sovkhoz* system, 49 state enterprises, 166 collective limited partnerships, 4 horse-breeding farms, 5 agricultural farms, and 16 privately owned stockholding companies have sprung up in its place. There are also 2 poultry companies, 130 family-owned communal enterprises, and 3,769 family-operated farms. The overall structure of agricultural production is changing. However, despite farm production reform and the transfer to a market economy, productivity has declined. Field-grown fodder is in decline, and the area under grain has decreased almost fourfold. Animal husbandry, which represents more than 85 percent of the total agricultural production, includes reindeer breeding and raising fur animals in cages. In central Sakha, cattle and horse breeding is often combined with the production of grain, potatoes, and vegetables. Pig and poultry farming is also under way.

Mining

There are more than nine hundred potential mining sites in Sakha. Open-pit mining, the most common method, has degraded ecosystems in southern and eastern Sakha. Some vegetation has grown back on these degraded lands, but most remain barren.

Map 6.2
Mining deposits of Sakha

By Newell and Zhou / Sources: USGS (lode/placer), 1998; AGI, 2000 (coal); ESRI, 2002.

Key players in the diamond industry

Almazy Rossii–Sakha (Alrosa)

Alrosa mines all of Sakha's diamonds. Founded in 1992, Alrosa is owned by the Sakha and Russian governments (32 percent each), company employees (23 percent), administrations of Sakha *uluse*s in which the company carries out its activities (8 percent), and the Fund for the Social Guarantees of Servicemen under the Russian government (5 percent). The company employs about thirty-seven thousand people, has interests in Angola and Namibia, and has offices in London, New York, Antwerp, and Moscow. In 2000, Alrosa sold about U.S.$725 million worth of diamonds to De Beers, with the other $725 million sold to Russian manufacturers and the Russian government.[27]

Between 2001 and 2005, Alrosa plans to invest U.S.$2.8 billion in production development, with $2.2 billion coming from its own funds and $600 million from loans, including $90 million from the U.S. Export-Import (Ex-Im) Bank and $60 million from the South African Export Agency.[28] Funds from the two banks will go toward construction of the Nyurbinsky Ore Mining and Processing facility.[29]

Roskomdragmet

This powerful committee determines industry policies and oversees all Russian firms that extract and process diamonds. The committee also controls all of Russia's gold, diamond, and precious metal reserves.

De Beers Corporation

De Beers, the largest diamond mining company in the world, has been losing world market share, partly because large quantities of Russian diamonds are flooding the international market. In 2000, the corporation announced that it would focus on marketing jewelry and high-quality diamonds rather than trying to act as the sole supplier of uncut diamonds. But De Beers is by no means relinquishing the latter role, as the corporation's Diamond Trading Company will continue to be the world's principal supplier of uncut diamonds.

Sakha Government

The government is pushing to increase production in an attempt to secure more revenue for the republic, as well as trying to develop a polishing and cutting industry to generate value-added products. In 1991, the government established the joint-stock company Tuimaada Diamond (Alrosa controls most of its stock) to develop a processing industry. The Sakha cutting industry has thirty-three enterprises, sixteen of which are owned by Tuimaada Diamond. They can produce up to 100,000 carats of cut diamonds, which are worth approximately U.S.$150 million annually.[30] However, the processing industry in Sakha, thus far, has languished.

– JN

Diamonds. Sakha produces 98 percent of the Russian Federation's diamonds and is the second-largest diamond producer in the world (26 percent of world production) after Botswana and South Africa combined. Experts estimate that Sakha has the resources to increase its overall share of world production to between 30 and 35 percent. Annual production ranges between 18 and 30 million carats. Russian diamonds account for between 20 and 26 percent of De Beers Corporation's worldwide sales. The industry is based in Mirninsky Ulus, in the western Sakha. Diamonds are extracted from both bedrock veins and placers, and 95 percent of them come from five mines: Udachny, Aikhal, Mir, Internatsionalny, and Sytykansk. The remaining 5 percent come from alluvial deposits, usually placer deposits, but there are some alluvial-talus and talus deposits. The Udachny mining complex produces four-fifths of Sakha's diamonds, and the No. 12 Concentration Factory is the world's largest diamond mine.[31] Two diamond pipes, Botuobuya and Nyurbin, were recently discovered in Nyurbinsky Ulus. Sakha has modern diamond mining technology with a well-developed infra-structure for sorting, assaying, and implementing diamond production. It also has the equipment necessary to process diamonds, and thus should participate in the diamond trade rather than simply supply raw diamonds. Sakha now has the world's largest modern complex for commercial diamond mining, built over a period of four decades.

In 1994, Sakha began creating new diamond enterprises, including the Yubileiny mine, and some new individual shafts in the Internatsionalny mine, and attempted to convert the Mir mine from open-pit to shaft mining. Further growth of the diamond industry depends on developing new mining sources, including new mines at Yubileiny, Zarnitsa (open-pit), and Anabar (placer), as well as new facilities at the Internatsionalny mine, development of the Botuobuya pipe, and, starting in 2007, an underground mine at Mir. The diamond industry has recently expanded operations to the Anabar River, where forests are also being cut. Prospecting shows that some previously unexplored areas along the middle reaches of the Vilyui River appear promising for development.

All of Russia's rough diamond exports were under Mos-

cow's control during the Soviet period, but since *perestroika*, Sakha has managed to gain control over 20 percent of all mined diamonds. Moscow retains control over the other 80 percent. At the end of 2001, the Russian government and De Beers Corporation signed a five-year trade agreement regarding the sale of Sakha's diamonds. As stipulated in the agreement, De Beers committed to buy up to u.s. $800 million worth of diamonds per year from Russia. Russia is free to use the other diamonds it produces as it sees fit. Twenty percent of the mined diamonds produced can remain in the republic, provided they are processed. The Alrosa Corporation controls the diamond industry on the Russian side. De Beers has been purchasing diamonds from Russia since the 1950s.

Tour Agency of the Republic of Sakha

Local fishermen enjoy a successful day along a tributary of Sakha's largest river, the Lena.

Unlike other sectors of the mining industry in Sakha, the diamond industry is fairly robust. In addition to 20 percent of the mined diamonds, Sakha has started to receive 45 percent of revenue from diamond sales. Alrosa almost completely subsidizes some farming areas. It may start mining promising sites in southern Sakha and will fund geologists to continue exploration of these deposits.

Both Moscow and the Sakha government used to channel almost all diamond exports through the De Beers Corporation. However, De Beers's new strategy to market jewelry rather than concentrate on purchasing uncut diamonds is having a major impact on the Russian diamond industry; the industry is greatly expanding its own manufacturing capabilities.

History. Locals found diamonds in northwestern Sakha in the 1920s. On August 7, 1949, a team of geologists found diamond deposits on the Vilyui River, and by 1954, dozens of diamond deposits had been found and prospected in this river basin. Other alluvial deposits were found along tributaries of the Lena River and in the Anabar River basin. In late 1954, geologists found the first kimberlite pipe, the Zarnitsa (Distant Lightning) deposit near the Daldyn River, a tributary of the Vilyui River. On June 13, 1955, the Mir pipe was found in the upper reaches of Irelyakh River, a tributary of the Lesser Botuobuya River. Later that year, a huge pipe, the Udachny (The Lucky One) was discovered. During 1955 and 1956, the Vilyui basin yielded numerous other kimberlite pipes, which provide the material basis for the industry today. In 1957, the predecessor to Alrosa, Yakutalmaz trust, was created, and a settlement (present-day Mirny) sprang up near the Mir pipe. In 1959, the Rudnik mine was created and included a pit, two enrichment plants, a laboratory, and a mine with an experimental enrichment facility. Construction of Plant No. 3 began in 1962 and was completed in 1966. In 1960, the Aykhal diamond pipe was discovered, Plant No. 8 was built, and operation of the second diamond site in western Sakha began. The third, and now largest, center of the diamond-mining industry was the town of Udachny, near the Udachny pipe.

Environmental and social impacts. The diamond industry alone is not responsible for the large-scale environmental destruction in the Vilyui River basin. Pollution from jettisoned rocket boosters, underground nuclear explosions, hydroelectric development on the Vilyui River, airborne pollution from the Norilsky complex, radioactive fallout from military

nuclear testing on Novaya Zemlya Island to the north, and small-scale agriculture all contribute. For the past thirty years, the industry has, however, played the leading role in disrupting the basin's ecological balance. It has polluted the environment, retarded the ability of the ecosystem to regenerate itself naturally, and damaged the health of all living things in the region. Mining inevitably leads to localized pollution and disruption of natural landscapes and ecosystems, particularly when precautions are not taken. Diamond mining, which processes a massive amount of raw material to obtain the final product, accumulates waste at both the mining and the enrichment stages. One-sixth of the nonagricultural area of Sakha is concentrated in the Mirninsky Ulus, and the diamond industry makes up one-sixth of this area.

During mining, rocks with harmful chemical components are brought to the surface and stored in waste dumps, which contain geochemical anomalies and leak hydrocarbon ions, calcium ions, and trace elements into the environment. Highly mineralized drainage water from open pits often leaks into the river systems. In the past, diamond mining factories have used contaminating reagents and toxic substances during the enrichment stage and these tailings were dumped into the environment.

In 1994, concerns about these environmental and social effects were voiced at the Vilyui region's first environmental seminar. Soon afterward, the Community Ecology Center of Sakha and the Vilyui Committee, which was established shortly after the seminar, organized the first public, nongovernmental expeditions to investigate regions affected. Consultation and discussions between land users, citizens, and specialists were organized. The concerns expressed in these meetings resonated strongly with the general public, and attracted the attention of administrative, governmental, and scientific agencies, organizations, and institutes. In an attempt to find solutions to pollution problems, a comprehensive scientific analysis and evaluation of the ecological situation in the Vilyui River basin was conducted. Specialists from the Yakut Science Center of the Russian Academy of Sciences (RAS), the Academy of Sciences of Sakha, the Yakut State University, and others conducted research from 1989 to 1994 to obtain objective and credible data about the significant changes that had occurred in the environment and in the situation of those living in the basin. The findings of this study bear out concerns for the environment.

Effects on the water resources and river ecosystems. Suspicions about river pollution turned out to be well founded. The primary source of pollution was the dumping of industrial and open-pit mining effluents into the rivers. Even though the industry ceased dumping waste into rivers by the early 1990s, high concentrations of harmful chemicals remain in the river bottoms of the Markha, Botuobuya, and Vilyui Rivers, as well as their tributaries. This residue is not only a store of toxins and carcinogens, but may also contaminate the water. A state of environmental emergency was declared

in Mirninsky Ulus due to large concentrations of hazardous chemicals, where substances exceeded the maximum permissible level by five to ten times. Waste dumping by enrichment plants drastically reduced concentrations of zooplankton in some rivers. Reserves of commercially valuable fish have also sharply declined. In sum, the ecosystems of the Vilyui River and its tributaries (Irelyakh, Botuobuya, Daldyn, and Markha Rivers) were declared environmental disaster zones. These rivers have always been the only source of potable water for residents. Pollution of this water supply has had a severe impact on the health of the local human population.

Medical and biological studies revealed that incidents of malignant tumors and developmental anomalies were the highest when by-products from submerged, decayed forests and highly mineralized wastewater had entered the Vilyui River watershed. Studies have shown that mortality rates in this region are significantly higher than in Sakha as a whole. Fifty percent of those examined had a weakened immune system. Studies have also shown that those living close to diamond mining plants and the Vilyuisky Reservoir demonstrate higher rates of immunological homeostasis. Evidence of contamination-induced damage to the genetic structure of those living near the Vilyui River basin indicates that future generations will also be harmed.

Ecosystems of the Vilyui River basin are quite varied, with differing capabilities for regeneration and levels of biodiversity. Before industrialization, the basin supported 882 species of flora, including 662 flowering species, in 69 families. Since then, indigenous plant life has been drastically affected. Studies of rodents and fur-bearing species show that mammals have also been strongly affected. About 11,000 ha of land in the region have been declared an environmental disaster zone. Northern taiga and highland forests in the Aikhala-Udachny industrial center have been harmed, and the taiga forests in the Mirninsky industrial zone, which includes the Vilyuisky Reservoir, have been destroyed. Burnt forests that fail to develop new growth after ten years are declared environmental disaster areas. Heavy metal contamination caused by diamond mining is present in Mirninsky Ulus as well as the Vilyui and Markha Rivers and their tributaries.

Over the past decade, Alrosa has devoted between 8 and 10 percent of its total capital investment to environmental protection and cleanup. Many projects now planned by Yakutniproalmaz, the planning arm of Alrosa, abide by federal and republic-level environmental legislation. All projects must include an environmental impact assessment, which is coordinated with the Sakha Ministry of Environmental Protection. Every large industrial plant has environmental controls and industrial sanitation laboratories. Approval by the Ministry of Environmental Protection is required before a plant can begin operating. The financial group, Sakhaalmazprovinvest, which was set up by Alrosa, transfers 2 percent of its profits to the Vilyuisky group of *ulus*es as compensation for past damages to their infrastructure and environment. In

addition, the company provides regular financial assistance to the Nature Protection Committees of those *uluses*.

Alrosa has developed some technological measures to reduce environmental impact and clean up degraded areas, and water quality in the river watersheds has improved considerably. Alrosa has stopped dumping mineralized wastewater into river systems. All the water used in the Mir and Udachny open-pit mines is now disposed of underground. Construction of an antipercolation tamponage barrier in the Mir mine, which will reduce the inflow of water into the working area of the mine, is complete. Dumping of industrial wastewater has ceased at Plants No. 3, No. 8, and No. 12, and from Dredges No. 201 and No. 202. The Yubileny and Anabar Mine sites are being equipped with watertight reservoirs for tailings and hydraulic systems that maximize the use of recycled industrial water, which has increased to 95 percent of total water used. Almost all the agricultural and household sewage in Lensk, Mirny, Aikhala, Udachny, and Ebelyakh is now being treated. To improve air quality, Alrosa restricts the use of heating oil, no longer burns coal, and is converting boiler rooms to gas. Vehicles are being equipped with catalytic converters, and vehicle exhaust emissions are now being monitored. Soil is now regularly recultivated.

Gold. Long a pillar of the Sakha economy, residents of gold mining regions and the republic's budget alike depend on the industry. However, production of gold has declined sharply in recent years (see fig. 6.1). Reasons for this decline include:

- Prices for goods, commodities, fuels, and energy have increased dramatically.
- Loans carry high interest rates.
- Currency exchange rates are unstable.
- Taxation between 1992 and 1995 was high.
- Costs for social infrastructure, particularly housing and utilities are rising.
- The raw material base is declining.
- Relations between industries and republics have been disrupted, leading to decentralization and a decline in the quality of service and maintenance.
- There is no significant foreign investment.

Despite this crisis, Sakha remains the second-largest gold producer in the RFE and in 1999 produced slightly more than 15 tons. Gold is mined primarily in the southern Yakutsk, Verkhne-Indigirkinskoe, Allakh-Yun, and Kularskoe gold fields (see fig. 6.2).

The average gold content has decreased, the location of reserves is less favorable, and engineering conditions have become more difficult. Several gold mining enterprises, including a number in the Kularsky, Verkhne-Indigirsky, Aldansky, and Dzhugdzhursky Uluses, have gone bankrupt. Many smaller open-pit sites, and even large enterprises such as Lebedinsky Gold Mining Company, AO (joint-stock

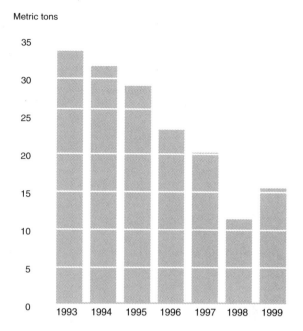

Figure 6.1
Gold production in Sakha, 1993–1999

Metric tons

Source: Gorny Zhurnal, 2000.

company) Nezhdaninskoe Zoloto, and AO Kularzolotohas, have also closed. Numerous sites have been turned over to independent associations of prospectors (*artel*s). Entire gold mining settlements are now in shambles.

The structure of Sakha's gold mining industry is like that of the rest of the Far East: two-thirds placer mining and one-third vein mining. However, the proportions of the actual deposits are closer to two-thirds ore and one-third alluvial, and herein lies part of the problem for the industry. Exploration for new ore deposits has been drastically curtailed due to a lack of capital and the uncertainty of financial return resulting from high extraction costs. (To extract 1 ton of gold from ore, an initial investment of U.S.$3–5 million is needed.) The prospects for expanding open-pit mining are limited. Funds and effort, therefore, should be redirected toward the mining of gold ore veins. Government subsidies are needed to shift the industry toward exploiting large gold ore deposits using advanced mining and enrichment technologies. To do so, the government is promoting joint ventures with foreign companies and capital. Plans are also under way to establish gold refining and jewelry production.

Sakha has the third largest gold reserves in Russia. Forty-three percent of these gold reserves are confirmed; the remainder are estimated resources. About 70 percent of confirmed reserves are gold ore, primarily in the Yuzhno and Allakh-Yunsky Uluses (see fig. 6.2). These reserves are located in large sites, including Nezhdaninsk, Kuranakh, and Kyuchyus, which together account for about 90 percent

Figure 6.2

Gold reserves and production in Sakha, by region

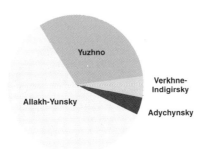

Ore deposits

Alluvial deposits

Production

Source: Isaev, 2001.

Table 6.2

Major gold mining companies and associations in Sakha

Company	Established	Notes
AK Aldanzoloto	1992	Joint-stock company
AK Indigirzoloto	1992	Joint-stock company
AO Nezhdaninskoe zoloto	1992	Joint-stock company
AO Zoloto Dzhugdzhura	1992	Joint-stock company
OAO FPK Sakhazoloto	1995	Holding company; controls Sakha government's holdings in the four companies listed above
AK Zoloto Neryungri	1995	51 percent owned by Sakha government
AK Zoloto Yakutiy	–	Coordinates prospecting teams
Association Zolotoi Soyuz	1995	Supports prospectors and resolves technical and procurement issues
AO Kuranakh Gold Mining Co	–	Joint-venture company
AO Zoloto Kuchusa	1996	Joint-venture company

Source: Isaev, 2000.

of all known ore reserves.[32] Most estimated alluvial reserves are in the Yuzhno-Yakutsk and Verkhne-Indigirsky Uluses. There are also gold resources in gold and silver mixtures, as well as in ancient greenstone bands of the nevadite type. Remaining confirmed reserves are valued at U.S.$10 billion, and estimated reserves at U.S.$30 billion. All the reserves are located in some 700 sites, including between 30 and 50 underground sites and more than 650 alluvial deposit sites, which account for 52.8 percent and 47.2 percent of industrial reserves, respectively.[33] About 62 percent (around 500 sites) of gold deposits are exploited by open-pit mining, 26.9 percent (about 20 sites) by dredging, and 1.4 percent (more than 130 sites) by underground shafts. Seventy additional placer mines with undetermined reserves are also being worked by private ventures.

Yakutzoloto used to control all the gold mining, but its subsidiaries, encouraged by the Sakha government, split off in the early 1990s. Today, Yakutzoloto (now Sakhazoloto) is one of several joint-stock companies producing gold.[34] The government holds 51 percent of the company's shares. By the end of 1997, Sakhazoloto consisted of five operating enterprises, which produced 37.4 percent of that year's total. *Artels* increased their share of total production from 40.8 percent in 1990 and 1994 to 61.6 percent in 1997. In 1996, the state began to monitor and control the artels, and made it easier for Sakhazoloto to form joint ventures (see table 6.2).

History. The first, but somewhat unreliable, accounts of gold discovery date back to 1782. In those days, panners would sell several dozens of kilograms of gold per season to middlemen, who then shipped the gold to Japan or China. In 1843, alluvial deposits were discovered in the upper Olyokma River and its tributary, the Tungir. In the 1860s, gold was discovered on the tributaries of the Vilyui River, and from 1908 to 1916, prospectors from the Lensk Gold Mining Association and the Verkhneamurskaya Corporation explored these areas.

Foreign investment in gold mining

The Sakha government has ambitious plans to introduce foreign investment and technology to the industry. Currently there are four major projects operating with foreign investment (see map 6.2).

Kuranakh gold ore deposit
◾ Location: Kuranakh River, 20 km south of Aldan in southern Sakha. The placer deposit stretches for 23 km.
◾ Estimated development cost: U.S.$450 million.
◾ Estimated reserves: 450 tons, consisting primarily of nuggets, but also some alluvial gold. These epithermal deposits have a high gold content, but as they have been heavily mined for the past forty years, many of the large deposits now have only lower quality ore left.
◾ Current production: The twelve confirmed gold deposits yielded 3.7 tons of gold in 1996.
◾ Estimated production: New leaching equipment for lower quality ore is expected to increase gold output to between 7.7 and 14 tons per year.
◾ Foreign involvement: Canada's Echo Bay Mines holds 50 percent of Kuranakh Gold Mining Company. The Russian firms Aldanzoloto (30 percent) and Sakhazoloto (20 percent) control the remainder. Reportedly, the U.S. firm Newmont Gold is in the process of purchasing shares from Echo Bay.

Aldanzoloto is a joint-stock company that owns the Kuranakh mill. This mill can currently handle 2.5 million tons of ore annually, and there are plans to upgrade so that it can process 5 million tons of ore annually. Full projected capacity of the project is 15 million tons of ore annually. The project plans to use standard gravitation technology. The field is currently being developed with two deep dredgers (up to 15 m) and a single rotor excavator with an annual capacity of 400 kg of gold per year. As of 2000, Echo Bay Mines was attempting to obtain U.S.$150 million in credits from foreign banks.[35] As of December 2001, the companies still had not worked out the details of the Production Sharing Agreement (PSA).

Kyuchyus hardrock gold deposit
◾ Location: Kyuchyus River valley, 4 km from the Yana River and 100 km from the town of Severny in Ust-Yansky Ulus. The deposit extends for about 3,500 m.
◾ Estimated development cost: U.S.$120 million.
◾ Estimated reserves: 150 metric tons.
◾ Estimated production: Up to 7 tons per year.
◾ Foreign involvement: WPN Resources Ltd. (Vancouver, Canada) and Sakhazoloto are equal partners in the venture, Zoloto Kyuchyus, which will explore and develop the deposit.

H. S. Simons and A. C. A. Howe International, Ltd. (Toronto and London, respectively) did initial studies of this site. Although discovered in the 1970s, the deposit has never been mined. The project plans to use bio-oxidation technology.[36]

Nezhdaninsk gold and silver deposit
◾ Location: Aldan River in the Tomponsk mining region in northeastern Sakha.
◾ Total value: U.S.$5.6 billion (according to the Duma Natural Resources Committee).
◾ Estimated gold reserves: 480 metric tons. Western sources report that 335.9 tons are recoverable. Estimated to be the second-largest gold deposit in Russia.
◾ Silver reserves: 2,000 metric tons.
◾ Current production: None.
◾ Foreign involvement: Celtic Resources Holdings (Ireland) holds 50 percent of the joint-stock company, Nezhdaninskoe Zoloto, which was set up with Sakhazoloto in January 1997. In September 2000, Celtic Resources announced it had secured a U.S.$7 million loan from Zenit Bank of Moscow.

The company plans to build a plant capable of processing 500 tons of ore and yielding 3 tons of gold annually. A feasibility study for the project has been completed. The cyanide method will be used. The deposit, first explored in 1974, was yielding 1 ton of gold annually in the 1980s. Russian geologists say that the gold will be difficult to extract because of its high carbon and arsenic content. The Duma Natural Resources Committee estimates that it will cost up to U.S.$300 million to rehabilitate the mine and to achieve an annual output of 5 tons.[37]

Ust-Kuyga gold deposit
◾ Location: Northern part of Sakha (70° latitude, 135° longitude).
◾ Foreign involvement: No current information is available. As of 2000, Pinnacle Associates, Ltd. (Moscow) owned 50 percent, and Western Pinnacle Mining, Ltd. (Canada) owned the other 50 percent. Ownership of the mine was achieved through acquisition of Sakha Gold Overseas, Ltd. However, Western Pinnacle is now WPN Resources, Ltd. and their investment in the project, as of June 2002, is unknown.

An epithermal gold deposit, the ore includes carbon, antimony, and mercury. Underground and open-pit mining is planned by the fourth year of the development. There are enough resources to last twenty years. Capital costs of the mine are expected to be U.S.$210 million. A feasibility study was completed in 1997.[38]

—JN

In 1889, mining began in earnest with the discovery of rich deposits in the Timpton and Sutam River basins in the south, followed by the subsequent development of these deposits by the Russian Gold Mining Association and the Verkhneamurskaya Corporation. These operations were infamous for destroying the region's ecology. In 1898, volumes 38–40 of the newspaper *Yakutskaya Zhizn* described the operations as follows: "The mine leaves one feeling depressed. Forests near the mine have been burned or cut down, dampness abounds, and there is mud and water everywhere.... Monotonous, hastily slapped together shacks bring to mind the thought that all these structures are temporary, that there will be no regret in abandoning them, and how many have, indeed, already been abandoned! Such is the Timpton region today. What will come next is hard to say at present."

By World War I, depletion of the Sutam and Timpton deposits had begun. Prerevolutionary gold prospecting in the Vilyui and Aldan basins failed to spur development, as these mineral reserves were thought to lack commercially viable quantities of gold.

In 1923, commercially valuable gold reserves were discovered in southern Sakha, near Nezametny. By 1924, the Yakutsk State Gold Mining Trust had been established to mine the Nezametny deposit, site of the present-day city of Aldan. A dredge was brought in from the abandoned Olyokma mine, and with this dredge, the first large gold mining center was born. Geologists discovered three more large gold deposits (Ust-Maya in 1936, Indigir in 1945, and Kular in 1964), which were also developed during the Soviet period. An industrial association, Yakutzoloto was established in 1965, with facilities in the Aldansky, Ust-Maisky, Tomponsky, Oimyakonsky, and Ust-Yansky Uluses. During this period, despite extremely harsh conditions in these remote areas, a powerful industrial base and some of the largest mining enterprises in the USSR were established. State enterprises accounted for up to 80 percent of gold production. Nevertheless, the most profitable enterprises then, and to this day, are associations of individual prospectors. Other gold mining regions developed during the Soviet period include Allakh-Yunsky Ulus (1936), Verkhne-Indigirsky Ulus (1944), and Kularsky Ulus (1963).

The present period has seen a decline in production and a concomitant decline in standards of living throughout Sakha. The current state of production is discussed on pp. 247–49 and of the economy in general on pp. 241–43.

Environmental impact. In the 1990s, the Institute of Applied Ecology[39] in Sakha studied the Aldan mining region and the area between the Seligdar and Yakotit Rivers, where Aldanzoloto operates. It was determined that gold mining in these regions was damaging the ecosystems and harming their potential for future sustainable development. Mining waste dumps and pits occupy 7.2 sq. km, or 0.5 percent, of this area, and dredge sites occupy about 76.8 sq. km, or 4 percent, of the area. Dredging operations have further affected 42 sq. km, or 20 percent, of the area between the Seligdar and Yakotit Rivers. During mining operations here, associated industrial activities have also affected the ecosystem. Fires and logging between the 1950s and 1980s affected two huge chunks of land, 30 sq. km (14 percent of the total area) and 0.92 sq. km (0.5 percent of the total area), between the Seligdar and Yakotit Rivers. In this part of southern Sakha, ecosystems usually regenerate themselves fairly rapidly when compared with more northern ecosystems. Due to the scale of the destruction, however, they have not regenerated themselves well here. In total, 32.5 percent of the interfluvial plain has been completely transformed by industrial development. The ecological balance has been disrupted and is beyond repair in many areas.

Summary of impacts:
- Dredging and prospecting have disrupted valley landscapes.
- Mining facilities have modified interfluvial ecosystems.
- Modification of ecosystems has reduced biodiversity.
- Forest fires and logging have degraded vegetation cover, particularly in areas of mild, intermittent, and insular permafrost. Regeneration in these areas is retarded, and some rare plant species have disappeared entirely.
- Toxic compounds have polluted the ecosystem.

Coal. The coal industry was the first to develop, starting in the prewar Soviet period. In the late 1920s, the territorial administration of the Main Directorate of the Great North Sea Lanes developed the first coal mining operations in the region, starting with the Kangalasskoe (in 1929) and Sangarskoe (in 1930) coal reserves on the Lena River. These reserves were located about 45 km and 300 km, respectively, downstream from Yakutsk. Sangarskoe coal is of higher quality, producing more heat and less ash than Kangalasskoe's brown coal, so mining the Sangarskoe reserves took priority. The Kangalasskoe deposit, because of its large size, favorable geologic position, and convenient location, was mined despite its impurities. In those days, mining was not mechanized, but open-cast, and Sakha's entire production (1,800 tons) came from those two sites. By 1936, production in Sakha had reached 38,000 tons, and soon thereafter, large-scale development of the Sangar reserves began. For decades, Sangar was the largest site, with annual production in the 1960s averaging 250,000 tons.

In 1933, the Kolyma Department of River Shipping, a division of Dalstroi, started exploratory mining of the Zyryansky deposit, as well as an open-pit mine in northeastern Sakha. Commercial mining using open-cast methods began in 1940. Coal mining was the foundation for development of the Zyryan industrial and transportation center, and the site still supplies coal to users throughout the RFE. In 1940, Dalstroi began working the Dzhebariki-Khaya deposits, where the coal was even higher in quality than at Sangarsky. In 1952, the mine produced 112,000 tons and supplied the river shipping industry and enterprises in Yakutsk. By 1964,

production had almost doubled to 220,000 tons. In the late 1980s and early 1990s, the site was producing 1.1 million tons annually. However, production subsequently declined sharply, and 1999 production was down to 500,000 tons. Coal is mined both by open-cast and shaft methods.

Until the late 1970s, Sakha's coal industry served the energy needs of the republic, sent small shipments to Magadan and Irkutsk Oblasts, and supplied ships traveling along the northern sea route. Coal mining in southern Sakha began in the late 1970s with the development of the Neryungri coking coal site, made possible by Japanese investment. Today, the industry has an annual capacity of 17.25 million tons, mined at one underground mine (Dzhebariki-Khaya), three large open-pit mines (Zyryansky, Kangalassky, and Neryungri), and a number of small mines.

Japanese investment. Japan and Russia have a long history of joint coal-development projects in Sakha. In 1974, fifty-one Japanese banks, trading companies, and individual Japanese manufacturing companies formed the South Sakha Coal Development Cooperation Company. Eyeing the proven 7.4 billion tons of coal in the south Yakutian basin, this consortium helped set up the present Neryungri coal mining complex in 1974 to mine its rich coking coal. Sakha began mining the vast reserves in the mid-1980s when the Export-Import Bank of Japan (now the Japan Bank for International Cooperation) provided low-interest loans to fund the project. This allowed Japanese companies to provide credits of 126 billion yen (including 109.5 billion yen for machinery and equipment) in exchange for 5.5 million tons of coal annually over a sixteen-year period. The Soviet-Japanese agreement was one of a series of large-scale resource exploitation projects between the two countries; others include the KS Sangyo forest development agreement, Sakhalin offshore oil development, and numerous fishing agreements. The main Japanese companies benefiting from this arrangement were Komatsu, which provided bulldozers, Kato Works, which sold excavators and truck-mounted cranes, and Banzai Automobile, which provided repair operations. Others who provided practical assistance in establishing the Neryungri facility included Sumitomo Heavy Industries and the Mitsui Mining Company.

Although beneficial for companies in Moscow and Japan, imports of extractive machinery have created a dependence on coal exports in exchange for steel and machinery, which has handicapped Sakha's efforts to develop its own steel-making industry. In addition, open-cast mining has been the main method used to extract the coal, and there has been almost no recultivation of ruined land.

Sakha used to produce about 17 million tons of coal annually, but this total has declined to about 10 million tons. The Neryungri strip mine produces most of the coal, with annual production estimated at 7.5 million tons of coking and energy coal. The other major coal mines are the Dzhebariki-Khaya deep mine (1.1 million tons), Kangalassky

strip mine (520,000 tons), Zyryansky strip mine (300,000 tons), and Sangar deep mine (330,000 tons). Yakutugol, Sakha's coal monopoly, established in 1974, operates all of the mines. In an effort to bail out an unprofitable industry, the Sakha government recently offered shares of Yakutugol to Japanese companies. Yakutugol is Russia's largest coal exporter, and according to some reports, it sells about 40 percent of Neryungri mine's output, mainly high-quality coking coal, to Japanese steel makers such as Nippon Steel Corporation, through Sumitomo, Kanematsu, and Marubeni trading companies.[40] Domestic consumers are the Neryungri and Chulmanskaya power stations, and power stations in the Khabarovsk, Primorsky, and Sakhalin regions.

Open-cast methods are used to mine the rich coking coal, which has been shipped to Japan since commercial operations began. Coal from this site also supplies coal-fired electric power to plants in Sakha. The Neryungri site has the capacity to mine 15 million tons of coal per year, while its enrichment plant can process 9 million tons of coking coal annually. The government wants to increase production of the Neryungri mine to between 12 and 13 million tons. Twenty percent of the coal mined in southern Sakha is used locally within the republic, 40 percent is shipped to other regions of the RFE, and the remaining 40 percent is exported to Japan and South Korea, and to a lesser degree, metallurgical plants in Chelyabinsk and Ekaterinburg Oblasts in European Russia.

About 20 km from Neryungri is the Denisovsky deposit, which has about 300 million tons of coking coal. The Sakha government is also promoting investment in development there, but the price tag is about U.S. $2 billion due to infrastructure costs.[41] In the neighboring Neryungri region, there are an estimated 118 tons of gold, with another 40 tons expected. The Chulmikan bituminous coal deposit has about 700 million tons of coal, but costs to develop these reserves are estimated at U.S. $2.7 billion.[42] There are also two industrial deposits of iron ore near Chulmikan: Tayozhny (1,254.6 million tons) and Desovsky (400.7 million tons). Total costs to develop these reserves are estimated at U.S. $660 million and $580 million, respectively.[43]

In a related development, the government would like to open up the rich Elginsky coal reserves, but lacks funds to do so. These reserves are located in the Bolshoe Tokko Lake region, in the extreme southeast of Sakha. Reserves of high-grade coking coal are estimated at 500 million tons.[44] Some analysts consider these reserves the most promising, in terms of both quantity and quality, in the entire RFE.[45] Ecologists are concerned, however, that mining in this region could destroy one of the most important biodiversity hotspots in Sakha (see p. 240). They point out that new ventures should be put on hold until new technologies can be practically employed to extract and process the coal for local use. Two regional *zakazniks* currently protect some portions of the Bolshoe Tokko Lake region; open-cast coal mining is

planned in areas between these *zakazniks*. To develop the mines, a railroad is also being planned, which will open up forests for exploitation.

Energy

The Soviet and Russian governments have traditionally placed great importance on Sakha's energy production (see table 6.3). In the 1980s, 50 percent of all capital investment for industrial development was allocated to the energy industry, rising to almost 55 percent by 1995. The energy industry (oil, gas, hydroelectric, and coal) now employs about 25 percent of those working in Sakha. In addition to providing Sakha's needs, energy was exported throughout the RFE and abroad. To date, the industry has received virtually no foreign investment. Major companies involved include AO Yakutenergo and AO Sakhaneftegaz, along with branch companies of the latter: AO Yakutgazprom, Lenaneftegaz, Lenagaz, Yakutgeofizika, and Taas-Yuryakh-neft.

In 1928, Sakha's two 300-kW power stations produced only 700,000 kW-h per year, and not until 1937 was construction of a centralized electric power station in Yakutsk completed. By the 1960s, Sakha had more than fifteen hundred small power stations and electrical installations. Primary sources of power included black and brown coal, wood, and imported oil. Ninety percent of these power stations had a capacity of less than 200 kW; a few had capacities of up to 5,000 kW. The largest were the Yakutsk, Chulman, Yakokut, Batagai, and Deputatsky stations. Large mobile power stations were set up in Lensk and the settlements of Pokrovsk and Zhatai. In 1967, the first modules of the Vilyuiskaya Hydroelectric Station, now called the Kaskad Station, were brought on line. To complete the station, a gigantic dam with a huge reservoir was constructed in an area of permafrost. Today, Kaskad, together with the Yakutsk Natural Gas Station in central Sakha and the Neryungri Coal-Fired Station in southern Sakha, provide about 84 percent of the total electrical energy production. In 1997, Sakha's power stations produced 27 percent of the republic's electricity from coal (770,000 tons), 24 percent from gas (704,000 tons), 12 percent from diesel oil (357,000 tons), and 36 percent from hydro sources (1,049,000 tons).

Power generation is a primary polluter. In 1990, just twelve of the Yakutenergo's facilities generated 389,600 tons of harmful substances. More than 5.7 million cu. m of effluent, including 3.2 million cu. m of insufficiently processed waste containing large quantities of suspended particulates, chlorides, sulfates, oil byproducts, and nitrogen, were dumped into the rivers. Producing energy also pollutes the air. The average concentration of dust in Neryungri, the location of a large coal mine and coal-fired power plant, exceeds the maximum permissible level (MPL) by 2.7 times, and occasionally reaches 7 times the MPL. Nitrogen dioxide concentrations exceeding the MPL by four times and instances of benzopyrene pollution have also been recorded. Use of outdated technologies in oil and gas development may have dire effects upon the Lena and Vilyui Rivers. Construction of the reservoir for the Vilyuiskaya station has had an adverse effect upon the health of the local population and ecosystem (see pp. 245–47).

Oil and natural gas. Oil first flowed in Sakha in 1937. The Sredne-Botuobuya field has been producing oil for ten years, and production began recently at the Irelyakh and Talakan fields. The Talakan-Vitim oil pipeline was built on schedule, and a refinery in Vitim is producing diesel fuel. Future plans call for the construction of oil-refining facilities in Lensk and in the settlement of Tas-Yuryakh. In 1997, a total of 152,000 tons of oil were extracted. As in previous years, the primary

Table 6.3
Energy resources in Sakha

Resources	Quantities
Oil and gas	
Hydrocarbons	20.1 billion tons
oil	9.4 billion tons
free gas	9.4 trillion cu. m
gas dissolved in oil	0.7 trillion cu. m
condensate	0.6 billion tons
Extractable resources	
oil	2.4 billion tons
gas	9.4 trillion cu. m
Coal	4.4–15 billion tons (reserves)
Hydropower	
Lena River	144 billion kW-hr
Indigirka River	54 billion kW-hr
Vitim River	51 billion kW-hr
Aldan River	49 billion kW-hr
Kolyma River	46 billion kW-hr
Olyokma River	25 billion kW-hr
Yana River	22 billion kW-hr
Olenyok River	14 billion kW-hr
Anabar River	3 billion kW-hr

Note: There are at least 32 oil and gas deposits in Sakha: Vilyuisk region – 9 (gas, condensed gas); Predverkhoyansky depression – 2 (gas); Nepsko-Botuobinsky region – 18 (gas, gas-oil, oil-gas, oil-condensed gas); Predpatomsky depression – 3 (gas, condensed gas).

Source: Isaev, 2000.

consumer (42.6 percent) was Alrosa. Oil extraction and delivery are carried out by several companies, including Lenaneftegaz (from Talakan and Irelyakh), Yakutgazprom (from Sredne-Botuobuya field), and Irelyakhneft (from Irelyakh). A recent discovery showed that there are over 100 million tons of oil in the Talakan region.[46]

The Ust-Vilyui natural gas deposits were discovered in 1956, and in 1968, a gas pipeline was constructed from the site to Yakutsk. Production facilities have also been developed at other gas fields. Fifteen hundred km of gas pipeline in western Sakha (Tas-Yuryakh, Mirny, and Svetly) and in central Sakha (Kyzyl-Sur, Yakutsk, and Moxogollokh) supply most of the large population centers. A gas-processing plant has been built in Yakutsk. In 1998, in the Kyzyl-Syr settlement, work began on a gas reprocessing facility with a capacity of thirty thousand tons per year. Liquid gas is being supplied to riverside *ulus*es (Aldansky, Neryungriisky, and Gorny), as well as to the settlement of Sangar. Yakutgazprom extracts 70 percent of its gas from Srednevilyui, 14 percent from Maastakh, 15 percent from Sredne-Botuobuya, and 1 percent from Severo-Nelbinsk. Efforts are under way to connect pipelines to wells at the Srednevilyui and Taas-Yuryakh fields.

Exporting Sakha's natural gas? Oil and natural gas reserves in all prospective areas of western Sakha may exceed 20 billion metric tons of hydrocarbons. The U.S. Geological Survey estimates Sakha's hydrocarbon potential at between 70 and 278 trillion cu. ft. of natural gas and between two and fifteen billion barrels of oil. Estimates by the South Korean Ministry for Energy and Resources of the area's natural gas reserves are even higher: 350 trillion cu. ft.[47] More than 65 percent of these reserves are located in the Botuobuya and Vilyui regions. A recent inventory revealed there are over 100 million tons of oil in the Talakan region.[48]

As noted earlier, Sakha's heavy reliance on diamond, gold, and coal mining makes it eager to diversify its industries and develop a stable source of oil products. It is currently looking for foreign investment to do so. Lack of transport facilities and equipment have left much of Sakha's oil untapped, although there are thirty-one oil and gas production sites. Even though it is sitting on vast reserves, Sakha imports most of its oil products—3 million metric tons annually—at very high cost. Sakha is now constructing two oil refineries that will be capable of producing about 300,000 tons of oil yearly. The government has offered up six oil fields for development,

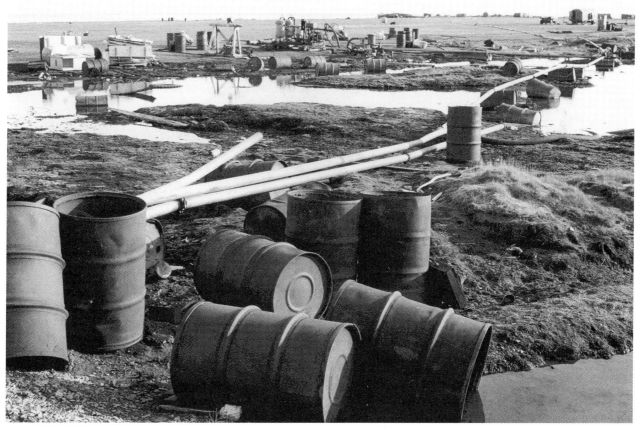

Careless oil and gas development in western Sakha.

primarily in the southwest. The oil and gas industry is controlled by Sakhaneftegaz, which is responsible for the exploration, development, and marketing of new oil and gas resources within Sakha and abroad. Fifteen South Korean companies interested in building a gas pipeline to South Korea spent u.s.$30 million for a general study.

Initially, Sakha's natural gas reserves, rather than oil, were most interesting to investors. Japan's Institute of Energy Economics estimates that demand for Russian natural gas in Japan, South Korea, and China will be 45 billion cu. m/year in 2010 (out of a total demand of 180 billion cu. m/year).[49] Since the late 1960s, the Japanese have had an interest in the Taas-Tumus gas fields in the central Lena Valley, which have an estimated annual capacity of 20 billion cu. m. Japanese participation in the project was secured when an agreement was signed to create the joint venture Yakutia National Gas Exploration Project on January 28, 1975, backed by u.s.$100 million from the Export-Import Bank of Japan. Japanese investors, particularly the project leader Tokyo Gas, considered U.S. participation to be essential, so when the main partner, Occidental Petroleum, was unable to get sufficient financing from the U.S. Export-Import Bank, the project faltered. Initial project plans were to pipe the gas to a liquid natural gas plant near Olga in Primorsky Krai and then ship it to Japan.[50] Japanese companies continue to show interest in Sakha's reserves, but are perhaps more interested in the reserves located off Sakhalin Island.

Given Japan's immediate interest in Sakhalin, perhaps the most likely scenario for Sakha is to build pipelines to South Korea and possibly across the entire Korean Peninsula, or to China. In the initial feasibility study, four different project scenarios for export to Korea were explored, with project costs ranging from between u.s.$17 and $23.5 billion. The first two options would produce 34 billion cu. m of gas a year; the third and fourth options would produce 44 billion cu. m a year. Development of gas production would consume between 40 and 42 percent of investments, or between u.s.$7.2 billion and $9.6 billion, depending on the project chosen. About 55 percent would be spent on construction of a Sakha-Korea pipeline: 85 percent on the Russian segment and 15 percent in Korea. The project would have a profitability of between 15 and 18 percent, and production could peak in 2010, 2015, or 2018.[51]

Sakhaneftegaz recently signed an agreement with the Chinese national oil company to prepare a feasibility study on constructing a gas pipeline from Sakha to China. Gas deliveries would begin after 2005, and the volume would be a maximum of 20 billion cu. m. During President Putin's visit to China in July 2000, both countries signed a Memorandum of Understanding to approve construction of two natural gas pipelines from Russia to China. The understanding also includes approval for a number of companies from South Korea to continue with feasibility projects for the pipelines. Given the massive size of the Irkutsk's Kovykta reserves, a pipeline from this region would likely be built first. But conceivably, the Sakha reserves could then be linked to the Irkutsk-China pipeline.

The environmental impacts of large-scale oil and gas development are well known. However, the location of Sakha's reserves in a permafrost region, the frigid temperatures, and the widely varying pressure of the deposits add to these concerns. An independent environmental impact assessment should be done to determine the expected effects of this proposed development, particularly before large infusions of capital are poured into the project.

Toward sustainable development

Lyudmila Shmatkova

A federal program for the social and economic development of Sakha, adopted in 1994, includes a program for environmental protection that calls for a study to determine where sustainable natural resource management methods historically adapted to the northern environment should be permitted to operate and which territories should be protected from new industrial development. These measures, together with environmental-protection regulations, if enforced, would allow the republic to shift to the most efficient method of operating in a free-market economy.

To preserve the flora and fauna of the unique northern landscapes, the program calls for the expansion of the protected area system from its present 134,000 sq. km to 301,000 sq. km by the year 2005. To stabilize the economic situation, resolve social problems, and restructure the economy, several comprehensive natural resource management programs have been adopted. The most important are:
- Developing lumber processing, furniture making, building material, and food processing industries.
- Improving the environmental situation in the Vilyui River basin.
- Providing for the social and economic development of northern ethnic minorities.
- Supplying natural gas to populated centers in the central, transriver, and the Vilyuisky Ulus.
- Providing a stable water supply for the transriver *ulus*es.

Besides these specific programs, the government has developed several comprehensive environmental policies:
- Gradually converting the entire Sakha economy to environmentally benign modern technologies.

- Establishing a single, unified system of governance and oversight.
- Ensuring a proper balance between industrial and traditional methods of nature management.
- Creating a system to set aside up to 30 percent of the nonrenewable natural resources, and at least 25 percent of Sakha's territory in the specially protected areas, for future generations.

Indigenous peoples

Josh Newell

The Republic of Sakha is the traditional homeland of the Yakut people, who today constitute about one-third of the population. When the Russians arrived at the end of the sixteenth century, the Yakuts were settled in the Lena River valley, with smaller settlements along the headwaters of the Yana, Indigirka, and Kolyma Rivers.[52] Their traditional way of life continues to center around reindeer herding, cattle and horse raising (*Yakut* means "horse people"), hunting, and fishing, but most Yakuts today are urban dwellers and live much like other Russians.

Reindeer herders are nomadic and have no formal hierarchy. Hunters and fishers live either in permanent settlements or wander within a limited territory on a seasonal basis.[53] Other indigenous peoples who live in Sakha include Evens, Evenks, Dolgans, Chukchi, and Yukagirs. Like the Yakuts, they hunt, fish, and herd reindeer. Under Soviet collectivization, nomadic herders were organized into work units so that their reindeer herding followed an official plan.[54] To reach production quotas, communist officials forced herders to have their animals overgraze the land. This led to a rapid decline in the productivity of pastures, which hit the reindeer industry hard. There are still about 400,000 domestic reindeer today, but good grazing land continues to decline.

Horse herding is still a strong tradition. Yakut horses are very hardy and can survive the winters on natural pastures without being fed by humans. One hundred ninety thousand horses still roam the lichen and moss fields. Cattle are also bred, but their numbers are presently at an all-time low. Efforts to regenerate cattle herds are being made on farms in the Even-Bytyntaysky Ulus, as well as in central Sakha.[55] Hunting and fishing are not being done sustainably. Overfishing of rivers and overhunting of snow deer and snow sheep has led to a drastic decline in populations. As with the collectivization of reindeer herds, this decline stems mainly from restructuring and reorientation imposed during the Soviet period.

At least eight major villages in southern Sakha continue to preserve their traditional way of life. These include the Eveni villages of Topolino, Beryozovka, Sebyan-Kyuel, and Oyotung. Between five hundred and seven hundred Evens live in the Algama region, and for years they have been protesting the operations of Yakutugol, the Yakut coal monopoly, which has expanded onto their native territory. Most Evens in this region have retained their own language and culture, continuing to herd reindeer in the traditional manner. Other villages include Iengra (Evenks), Nenemnoe (Yukagirs), Andryushkino (Chukchi), and Yuryung-Khaya (Dolgans). A gold mining venture is planning to expand its operations to the village of Iengra and surrounding land, despite protests from the Evenks.

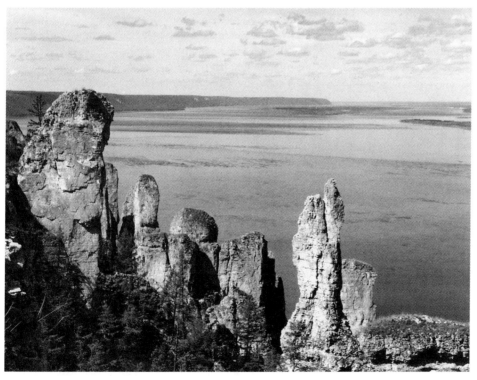

The Republic of Sakha is famous for its stolby *(pillars)*, unique rock formations along the Lena and Sinyay Rivers.

Legal issues

Lyudmila Shmatkova

Laws, decrees issued by the president of Sakha, resolutions and directives from the government of Sakha, and instructions and regulatory reports from the federal ministries govern environmental protection in the republic. Since 1992, financial support for environmental protection has come from a system of taxation on the use of nonrenewable natural resources. These fees are also levied on rights to use natural resources.

Legislation on environmental protection includes:

- General environmental protection.
- The establishment of protected territories and agreements with the Magadan and Irkutsk Oblasts to establish joint protected areas that span more than one territory.
- Use of Forest Resources; these laws are based on the constitutional principle that the forests of Sakha are the inalienable property of its people.
- The use of mineral resources.
- Encouragement of foreign investment, by which several development priorities for attracting more foreign investment were identified:
 - Joint ventures in diamond processing, gold mining, and jewelry manufacture.
 - Export-oriented gas and oil industries and medical and biological industries.
 - Modernization of the energy sector and food production.
 - Modernization of the construction industry.
 - Modernization of the transportation and telecommunications industries.
 - The tourism industry.

International cooperation. Sakha has international and economic connections with many countries, as well as with smaller administrative units within individual countries. It maintains official relations with Latvia, Mongolia, Slovenia, Hungary, Belorussia, China, Switzerland, and others. To foster direct links, the Republic of Sakha also has offices in Latvia, Ukraine, Kazakhstan, and Japan. In a context of favorable geographic and geopolitical circumstances, the republic strives to establish mutually advantageous economic interactions with countries in the Asia-Pacific region. The republic actively participates in the activities of international organizations such as UNESCO, the United Nations Industrial Development Organization (UNIDO), the Northern Forum (a regional organization that unites northern countries and territories), the Organization of Unrepresented Nations and Peoples, and the Russian National Committee for Pacific-Ocean Economic Cooperation. In the nature protection arena, the republic works with numerous international organizations and foreign government agencies, including the World Wildlife Fund (WWF), the World Conservation Union (IUCN), Friends of the Earth–Japan (FoE–Japan), the U.S. Fish and Wildlife Service, the U.S. Department of National Parks in Alaska, and the German Union for Nature Conservation.

Perspective

Robert A. Spira

Moscow's share of diamond wealth falls into corrupt hands

1999: An abortive attempt to liberate the Russian diamond industry from its dependence on De Beers Corporation failed due to corruption of the well-connected, but dishonest, principals.[56] The effort ended up amounting to a mere siphoning off of federal stocks of diamonds and other valuables, and collapsed in a flurry of arrests and fines by American and Russian authorities, though most of the central players remain unscathed.

Evgeny Bychkov, chairman of the Russian Federation's Committee on Precious Metals and Gems at the time, grew up with Boris Yeltsin, and was trusted beyond his actual merits. Bychkov initiated a plan to set up a company to sell Russian diamonds competitively with De Beers Corporation, using federal stocks of diamonds and other valuables held to back up the national currency. De Beers assumed early on that the Russian diamond resources would be ephemeral, an assumption that has not been borne out in reality.

A company with opulent facilities, Golden ADA, was set up in San Francisco, California, and chief executives made concentrated efforts to curry favor with local and national politicians, business leaders, and the people of San Francisco. Gems of the finest quality began to pour into San Francisco, with other valuables also included in the shipments. Golden ADA signed a contract with Unique Premium Metals, a Los Angeles gold distributor, which called for Unique to melt down and sell 5.5 tons of Golden ADA's gold. Meanwhile, Golden ADA offered to sell 22,000 carats of diamonds.

The Russian government officials who had approved this transaction were told that these valuables were being put up as collateral with the Bank of America to fund the new business venture. However, flamboyant purchases indicated that the company's executives were expropriating the fruits of these sales. Expensive U.S. and foreign real estate, cars, yachts, a jet, and museum-quality paintings were purchased by Andrei Kozlenok, one of the chief executives and a protégé of Bychkov, who was also receiving funds that were used inappropriately to set up numbered bank accounts and purchase expensive real estate near Moscow.

It didn't take long for the U.S. Federal Bureau of Investigation to take interest in the new company, and De Beers also mounted a private investigation. They were soon joined in their suspicions by the U.S. Customs Service, Interpol, and the Financial Crimes Division of the Russian Interior Ministry.

Ultimately, a sting operation was put together between the Moscow special police and the FBI. It was found, among other things, that most of the diamonds landing in San Francisco had been shipped on to Golden ADA's office in Antwerp, Belgium, where they were cut, polished, and sold for a total of U.S.$77 million. This money eventually wound up in Swiss bank accounts owned by the conspirators. Bogus certificates of origin were unearthed that purported to show that the diamonds came from Zaire. Payoffs to the people in the diamond industry in Antwerp in exchange for their silence were substantial. Nevertheless, the diamonds continued to pour into San Francisco at an ever-increasing pace, even though the number of employees was insufficient to process such a large number of stones.

After a time, the company began to come apart at the seams. Two of the original three chief executives left, allegedly on the threat of violence. Kozlenok remained for a short time, but eventually left behind a looted operation to be cleaned up by a succession of CEOs, one of whom found an undocumented leak of U.S.$130 million. Threats from the last CEO, Moscow entrepreneur Andrei Cehmukhin, induced Bychkov to flee Russia in September 1995.

The U.S. Internal Revenue Service raided the San Francisco office and served a lien of U.S.$63 million for unpaid taxes. The IRS found large quantities of gold, diamonds, and jewelry, together with automatic weapons, thousands of rounds of ammunition, explosives, mortars, and bulletproof vests, but little of the total wealth that had passed through the company remained. In the end, the Russian government got 65 percent of the U.S.$40 million dollars remaining, the IRS kept 25 percent, and creditors got back 10 percent.

Bychkov was found and arrested for "criminal negligence," as well as other treasonable offenses, facing a minimum sentence of ten years of hard labor in Siberia. Coincidentally, he was up for sentencing on the same day that Russia would be celebrating the fiftieth anniversary of the end of World War II, and President Yeltsin took this very convenient opportunity to pardon him. Today, the resilient Bychkov once again has become a senior officer of one of Russia's largest banks.

The other partners have not fared as well. One has been indicted on tax evasion charges, another is wanted for questioning, and Kozlenok was arrested in Greece for the possession of a phony passport. Russia requested his extradition, but this is being fought on the grounds that his life would be worth not two minutes' purchase in Moscow.

Golden ADA turned out to be only one of a series of similar efforts going on simultaneously that also seemed to be emanating from people in central control. Groups were formed to steal timber and oil, and there was even a competing group selling precious metals. While Golden ADA was only a U.S.$200 million piece of the pie, the others were able to quietly steal over a billion dollars of the Kremlin's choicest property.[62]

An old cemetery in Pokhodsk, a Cossack village on the Kolyma River. Graves of Russians are marked by crosses; graves of Yukagirs, by geese.

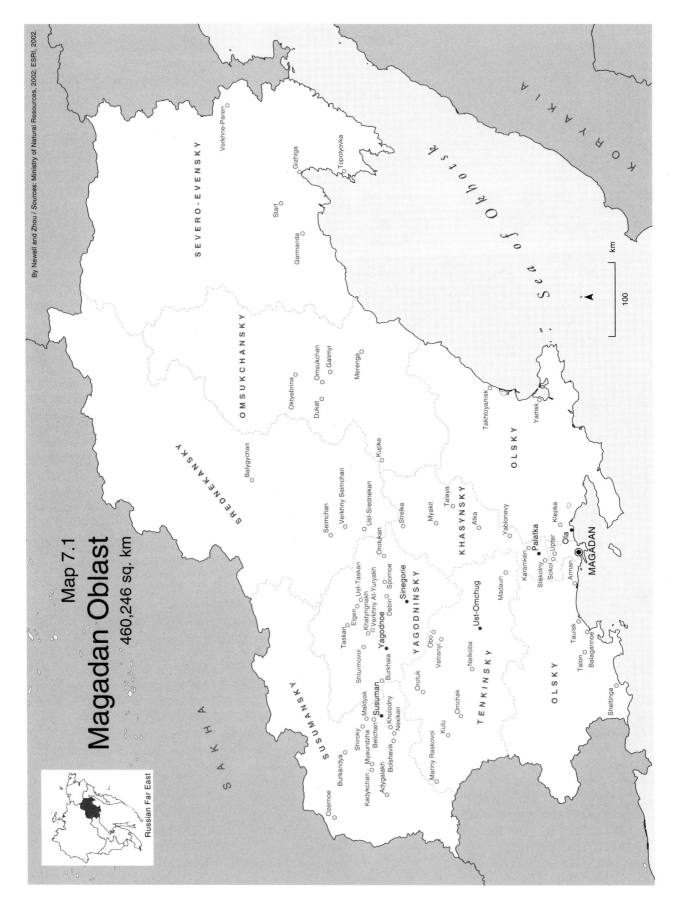

By Newell and Zhou / *Sources:* Ministry of Natural Resources, 2002; ESRI, 2002.

MAGADAN

Map 7.1

Magadan Oblast

460,246 sq. km

K O R Y A K I A

S E V E R O - E V E N S K Y

Verkhne-Paren

Gizhiga
Topolyovka

Start

Garmanda

S e a o f O k h o t s k

O M S U K C H A N S K Y

Omsukchan
Galimyi

Merenga

Oktyabrina

Dukat

km

100

N

Balygychan

S R E D N E K A N S K Y

Kupka

Takhtoyamsk

Yamsk

O L S K Y

Seimchan

Verkhny Seimchan

Ust-Srednekan

Orotukan

Strelka

Myakit

Talaya

Atka

Yablonevy

Madaun

K H A S Y N S K Y

Palatka

Klepka

Karamken

Stekolny
Uptar
Ola

Sokol

MAGADAN

Arman

Elgen
Ust-Taskan

Khatyngnakh
Verkhny At-Yuryakh

Taskan

Debin
Spornoe

Yagodnoe

Sinegorie

Y A G O D N I N S K Y

Obo

Vetrenyi

Nelkoba

Ust-Omchug

Shturmovoi

Burkhala

Orotuk

Omchak

T E N K I N S K Y

O L S K Y

Talon

Tauisk
Balagannoe

Shiroky
Maldyak
Susuman

Myaundzha

Belichan

Kholodny

Nexikan

Kulu

Mariny Raskovoi

Sheltinga

S U S U M A N S K Y

Kadykchan

Adygalakh

Bolshevik

Burkandya

S A K H A

Ozernoe

Russian Far East

Magadan Oblast

Location

Magadan Oblast lies on the northwestern shores of the Sea of Okhotsk. The Chukotsky and Koryak Autonomous Okrugs border on the north; to the south is Khabarovsk Krai, and to the west lies the Republic of Sakha.

Size

460,246 sq. km, or about six percent of the Russian Federation. The total area of cities and villages is 62,700 ha, or less than 0.00014 percent of the *oblast.*

Climate

The arctic and subarctic climate is influenced by the Arctic Ocean to the north, the cold Sea of Okhotsk to the east, and the continental terrain of Sakha to the west. Winter lasts for eight months with temperatures as low as −70°c in Seimchan Gorge. Coastal temperatures are more moderate, with winter lows of about −47°c. Summer temperatures average about 15°c in Kolyma and about 8°c on the Okhotsk coast.

Geography and ecology

Magadan is covered mostly by permafrost and includes northern taiga and tundra woodland ecosystems. The border between the two can be traced by the locations of stands of large tundra shrubs and the limits of riparian chosenia (*Chosenia arbutifolia*) and poplar (*Populus*) forests. Open tundra is limited to scattered areas in the mountains of the Kolyma region and along the Okhotsk coastline. The Kolyma plateau and the Chersky Mountain Range cover almost all the territory of Magadan. Most of the mountains do not exceed 1,500 m, with the highest rising to 2,586 m above sea level. Most of the watersheds drain into the Arctic Ocean via the Kolyma and Omolon River basins. Large areas of tundra grow on the Taigonos Peninsula, at Pyagina, in the Taui lowlands, and on the coast of Shelting Bay. The defining factors of this area are widespread permafrost and lack of sheltered areas, which lead to low biological productivity and diversity. The main part of the region's biomass and attendant biodiversity are concentrated along river valleys and on the coast.

The region has limited forests, mainly Dahurian larch (*Larix gmelini*), which grow and regenerate slowly due to the extreme cold. The most productive forests grow around the city of Magadan and the gold mining regions of the Kolyma River basin. Many of the forests were logged in the 1970s and 1980s. The only remaining forests are in inaccessible areas or are in protected forest zones close to rivers, lakes, and the sea. Larch forests and marshland form the landscape in the south. Japanese stone pine (*Pinus pumila*) grows

along the coast. The most valuable forests (mainly larch, poplar, and willow) grow along river valleys. The vegetation is 2 to 2.5 times denser in river valleys than on neighboring slopes, but plant productivity in the *oblast* as a whole is less than 18 percent of productivity in the riparian zones. These river valley forests are the richest in terms of species diversity, biomass, and productivity, and often have the main gold deposits.

Flora and fauna

The Yamskie Islands, off the Pyagina Peninsula on the southeastern coast, are home to over one million birds. Steller's sea lions (*Eumetopias jubatus*) and Steller's sea eagles (*Haliaeetus pelagicus*) also live on the islands. A population of Kamchatka marmot (*Marmota kamtschatica*), a species virtually extinct in other parts of the region, has found a home in Magadansky Zapovednik. Large mammals include snow sheep (*Ovis nivicola*), brown bear (*Ursus arctos*), moose (*Alces canadensis*), and reindeer (*Rangifer tarandus*). The Okhotsk littoral contains the greatest biodiversity in Magadan. Rivers flowing into the Sea of Okhotsk are the spawning grounds for many species of Pacific salmon (*Oncorhynchus*) and migrating char (*Salvelinus*). The interior rivers flowing north into the Kolyma basin have rich stocks of Arctic grayling (*Thymallus arcticus*), whitefish (*Coregonus*), lenok (*Brachymystax lenok*), and Northern pike (*Esox esox*).

Key issues and projects

The persistent energy crisis
The endemic energy crisis presents a major challenge to environmental quality and the standard of living.

Foreign investment in mining
Magadan is by far Russia's leading gold producing region.[1] Multinational corporations and development banks such as the European Bank for Reconstruction and Development (EBRD) and the World Bank are sinking millions into Magadan to expand mining of the vast gold and silver reserves (see pp. 278–81).

Offshore oil
Preparations for a tender to explore and produce hydrocarbons at the Magadan shelf were completed in Magadan in June 2000.[2]

Illegal fishing and export
According to expert assessments, illegal catches of salmon are up to three times the amount of official quotas (see pp. 275–76).

Largest cities

Founded in 1933 as a way point for prisoners sent to the Kolyma gold fields, Magadan is the *oblast*'s largest city, with about 115,000 people. Two-thirds of all the *oblast*'s enterprises are registered in Magadan, which was recently declared a special economic zone and is exempt from various federal taxes. Susuman (pop. 16,800) is the administrative center for the Kolyma mining area.[3]

Population

As of January 1, 2001, the population was 227,200.[4]

Political status

Magadan City was established in 1933 as part of the "gulag archipelago" and was built by prison labor to serve as a port and processing facility for tin (initially) and gold mines in the area. In 1953, the *oblast* was formed from the northern area of Khabarovsk Krai and western Penzhinsky Raion in Koryakia. The Chukotka Autonomous Okrug was part of Magadan until 1991, when it successfully asserted separate administrative status. In the summer of 1999, the federal government approved Magadan City as a special economic

Figure 7.1
Industrial production in Magadan Oblast, 1999

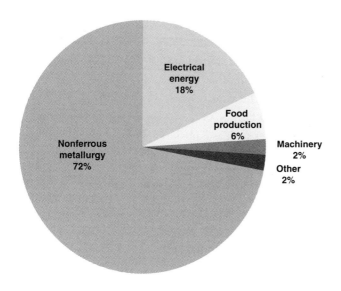

Source: Goskomstat, 2000.

Figure 7.2
Gold production in Magadan Oblast, 1993–2000

Metric tons

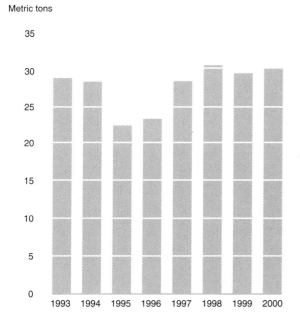

Source: *Gorny Zhurnal*, 2001.

zone. "The zone has brought in an additional 11 million rubles (U.S.$400,000) in registration fees as companies enter the market ... [and] twenty-seven trading companies have signed contracts to do business in Magadan."[5] The law, which will be in effect for the next fifteen years, aims to stimulate development of natural resources and manufacturing by reducing federal taxes and customs duties.

Natural resources

The greatest economic resource of the *oblast* is precious metals, most of which are undeveloped. The Magadan administration plans to tender several appraised and unappraised gold lodes (including Shkolnoe, Lunnoe, Natalka, and Vetrennoe) with estimated reserves of 900 tons.[6] Marine resources are the second most important. Habitat destruction and overfishing are reducing salmon stocks, particularly in the Arman, Ola, and Taui Rivers. Stocks of species such as pollock in the Sea of Okhotsk have been declining precipitously since 1990. Seismic tests done in the 1970s confirmed that the shelf has oil and may contain up to 4.5 million tons of oil. Gas resources are estimated at 1,170 billion cu. m.

Main industries

Gold and silver mining dominates the economy, amounting to more than 70 percent of total output, and other leading sectors are oriented to supporting the needs of the mining industry (see fig. 7.1). Gold production totaled about 30 tons in 2000, a large increase from 1995 when the total was 22.34 tons (see fig. 7.2). Of this total about 17 tons come from ore deposits and the remainder from placers.[7] Mines are located in Susumansky, Yagodninsky, and Tenkinsky Raions, and parts of Omsukchansky, Srednekansky, and Khasynsky Raions. In June 1998, the Kolyma Gold Refinery was completed; it is the seventh-largest gold refinery plant in Russia and has an annual capacity of 30 tons.[8]

Magadan has a small fishing fleet (pollock, herring, and salmon) that focuses on the Sea of Okhotsk and has some limited seafood processing facilities. The total reported fish catch for 1999 was 66,700 tons, about half of which was processed.

Infrastructure

Relatively isolated geographically, Magadan relies heavily on air transportation. Of the seven local aviation companies operating in Magadan City, the largest is Mavial, which serves almost half of all passengers flying in and out of Magadan. Because of higher fuel and other costs, airline tickets are more expensive than they are in other parts of Russia. Almost all airport facilities and services are in need of repair or renovation. Direct air service is available to Moscow, St. Petersburg, Khabarovsk, Vladivostok, and other Russian cities, and there are even biweekly flights to Anchorage, Alaska. Each of the *raion* centers has an airstrip, as have most small villages, which are served by an aging fleet of AN-2 biplanes (built in the 1960s) and AN-28 twin-prop planes. Remote mines such as Kubaka rely on helicopter transport in the summer. Magadan is poorly integrated with the rest of the RFE. For example, the main highway to the Republic of Sakha is in poor condition, even by Russian standards, and since 1998, there have been no direct flights from Magadan to Kamchatka.

The Magadan seaport, with an annual capacity to serve 3.5 million tons of cargo, was opened to foreign vessels in 1995. The port serves Magadan as well as the Chukotka Autonomous Okrug and Sakha, to which cargo is hauled by truck along a 1,500-km highway. The port is ice-free from May till December and remains open year-round with the help of icebreakers. The cargoes it handles, mostly from ships operated by companies in the RFE, mainly consist of coal, ore concentrates, 20-foot containers, and food products. South Korea and U.S. vessels have recently introduced regular service. The port plans to close underused facilities, leaving only two operating docks. Port equipment is outdated; most of the cranes were built in the 1970s.

Because of the extensive mining industry, Magadan has a much more developed road system than neighboring territories. Few of these highways are paved, however, and many are nearly impassable during the spring melt. Only winter roads and air transport serve the most remote areas (e.g., Severo-Evensky Raion). Internet access is limited to the city of Magadan. Most towns have telephone service, but the most remote villages (e.g., Verkhne-Paren) rely on two-way radio contact with nearby towns for emergencies and news of incoming flights.

Foreign trade

The greatest exports in terms of volume and value are gold and silver. Nearly everything else is imported: food, clothing, vehicles, building materials, and fuel. Used cars are imported from Japan. Food is imported primarily from other areas of Russia and the former Soviet Union, but South Korea, Canada, and the United States are also major food exporters

The dilapidated Kolyma Highway is the only overland route between Magadan and the rest of Russia.

Vladimir Dinets

The city of Magadan, typical Soviet construction.

to Magadan. In 2000, Magadan ranked first among destinations for U.S. exports (valued at U.S. $35,710,000) to the RFE. U.S. companies exported mainly food products (supplying 60 percent of the local food market), fuel (aviation fuel, coal, and diesel), and mining and construction equipment. Clothing and other dry goods (typically of the lowest quality) most often come from China and South Korea. Prices in villages are double or triple what they are in the city of Magadan. In 1999, eight enterprises were involved in exporting fish, and 17,000 tons of seafood products (54 percent more than in 1998) were exported abroad, totaling U.S. $20 million, mainly to Japan (57 percent) and the United States (42 percent), with only 1 percent being sent to South Korea.

Economic importance in the RFE

Through its incredible mineral wealth and established mining industry, Magadan attracts millions of dollars of foreign investment every year. Magadan's gold mining industry is the largest in the Russian Federation and now accounts for about 25 percent of Russia's total production.

General outlook

The basis of Magadan's economy is mining precious metals. Many explored deposits remain to be exploited, and new discoveries will undoubtedly establish further mineral reserves. With this in mind, environmental organizations such as the Magadan Center for the Environment (MACE) focus on regulating practices and enforcing environmental quality standards. Foreign investors, backed by loans from the International Finance Corporation (IFC), the European Bank for Reconstruction and Development (EBRD), and the U.S. political risk insurance agency—the Overseas Private Investment Corporation (OPIC)—have effectively taken over control of the majority of gold production by the industry; more than half of all the annual gold yield is from projects operating with foreign capital. Tensions between Russian and foreign partners and Russian government agencies, however, complicate some of the development projects; see the Dukat silver project, pp. 280–81.

The entire Kolyma River basin, the center of the mining industry, has been hit hard by poorly planned and executed mining. Some of the last remaining river valleys in the upper Kolyma River basin may be opened up to gold extraction. Given the low price of gold and complicated investment conditions, development of these reserves is still limited to the richest deposits, but this will change as reports of steady profits from the huge Kubaka gold project are leading to investment in other projects. Foreign investors and international financial institutions maintain that their participation is actually reducing environmental

impact by bringing in more ecologically benign technologies and equipment. Critics, however, counter that the Kubaka mine, which was touted as a model mine that would help green the industry, has a poorly designed tailings dam and that the mine operations in general are not "consistent with good international mining practices."

The great wealth produced by the industry has, unfortunately, benefited only a small percentage of the region's population. In January 2000, a report in *Vremya* (Interfax) rated Magadan as one of the ten worst places to live (ranked seventh worst) in the Russian Federation.[9]

Like most regions in the RFE, Magadan has been unable to develop a stable and environmentally clean energy supply. Low-grade coal and diesel for heating and electricity contribute more pollution, and local people are cutting more trees, as firewood increasingly becomes the main source of home heating in many villages. River valleys can be used to develop small-scale wind and hydroelectric energy projects, reducing energy costs of mining ventures and releasing funds for ecological measures.

Estuarine portions of every salmon run in the Taui and Gizhiga Bays have one or more illegal fishing operations. Joint fishing ventures registered as scientific research are involved in overfishing and illegal fish exports to Japan, which imports most of Magadan's fish exports. Over 75 percent of the region's forests have been logged since the first major settlements were built in the early 1930s. Heavy logging along river valleys, particularly in the northern regions, has caused serious soil erosion, divided riverbeds, and destroyed salmon-spawning grounds. Often in the summer, following clear-cut logging, the permafrost melts, causing entire layers of soil to slip from the hillsides. This clogs rivers and causes flooding in river basins. In winter, these flooded areas become vast ice fields, destroying the most important wintering grounds for moose, ermine (*Mustela erminea*), ptarmigans (*Lagopus*), and hazel grouse (*Bonasa bonasia*).

Oil exploration and extraction might be the greatest future threat to ecosystems in the Sea of Okhotsk. Most specialists believe, however, that oil exploitation will not happen soon as investors will wait to see if the Sakhalin oil projects are successful. Opposition from the Pacific Institute of Fisheries and Oceanography (TINRO), Magadansky Zapovednik officials, and, in particular, MACE has held back the developments. In 1999, the Ministry of Natural Resources suspended the license of Trest Dalmorneftegeofizika [Trust Far East-Sea-Oil-Geophysics], a Sakhalin-based company, to conduct offshore seismic testing for oil in the Sea of Okhotsk by Magadan. MACE charged that Trest Dalmorneftegeofizika failed to conduct an environmental impact assessment before it began the testing. TINRO's economic calculations, meanwhile, emphasize that oil extraction would be less profitable than exploiting marine fish resources. Other officials, however, remain dedicated to developing offshore oil reserves.[10] In November 2000, the Ministry of Natural Resources approved the Magadan offshore oil and gas lease program, making it a federal program.

Magadan's ecology suffers because the population of the region is transient. The economy was built by the Stalinist gulag system of prison labor. In the 1970s and 1980s, workers from European Russia came to work for several years for high wages and then returned home. Historically, many residents have not been tied to the land and, therefore, few have taken care of it.

— *Alexander King, Josh Newell, Mikhail Krechmar*

Ecology

Mikhail Krechmar

The mountainous terrain consists largely of a system of small ridges and highlands. The arctic and subarctic climate is influenced by the northern Arctic Ocean to the north, the cold Sea of Okhotsk to the east, and the continental terrain of Sakha to the west. The most severe climates are in the internal regions of the Kolyma basin, where the conditions are extremely continental. The frozen period occupies eight months of the year, and temperatures of −70°C have been recorded at the Seimchan Gorge. Coastal temperatures are much more moderate, with winter temperatures staying above −47°C. Average summer temperatures in continental Kolyma are between 12° and 18°C, and between 6° and 10°C on the Okhotsk coast.

Magadan contains northern taiga and tundra woodland ecosystems. The border between the two can be traced by the locations of stands of large tundra shrubs and the limits of distribution of strips of intrazonal chosenia and poplar forests. Open tundra is limited to scattered areas in the mountains of the Kolyma region and in strips of southern tundra along the Okhotsk coastline. There are significant areas of tundra on the Taigonos Peninsula, at Pyagina, in the Taui lowlands, and on the coast of Shelting Bay.

Dahurian larch is a dominant forest species. Intrazonal riparian poplar and chosenia forests penetrate deep into the shrub and mountain tundra, and reach their greatest development in the northern taiga zone. Aromatic poplar (*Populus suavolens*) and chosenia are the canopy species here with an understory of various shrubs, providing thick ground cover in local riparian formations.

Formations known as *redkolesie*, or sparse forest, occupy much of the RFE. Larch *redkolesie* occupies a significant portion of the forested area of Magadan. There are relatively few species here, and bioproductivity is low. Plant productivity here is less than 18 percent of that in the riparian zones.

Changes in altitude are analogous to changes in latitude. Lower elevations are forested with Dahurian larch *redkolesie*, except on the coast, where occasional stands of stone birch (*Betula ermanii*) exist. The second belt consists of shrub birches, Japanese stone pine, and dwarf alders (*Alnus*). Above this there is mountainous tundra with mosses and lichens and patches of *goltsi* uplands.

The main plant communities within the direct climatic influence of the coast are thickets of Japanese stone pine on slopes, with stone birch below them. A fairly rich understory is populated with shrubs above a grassy ground cover. The steep coastline rises directly to small (up to 600 m) mountains adjacent to the sea. Long stretches of rocky outcrops and cliffs dominate much of this landscape. These ravines alternate with depressions covered with meadow vegetation, which serve as a food base for large numbers of snow sheep

and brown bear. The depressions are encircled at the upper levels by stone birch, and a belt of Japanese stone pine above that.

The Okhotsk littoral contains the greatest biodiversity in Magadan. Tides vary between 2 and 6.5 m, while the width of the littoral reaches between 2 and 4 km in some bays. Rivers flowing into the Sea of Okhotsk are the spawning grounds for many species of Pacific salmon: pink (*Oncorhynchus gorbuscha*), chum (*O. keta*), coho (*O. kisutch*), and chinook (*O. tschawytscha*). They are also the home for migrating river char: Dolly Varden (*Salvelinus malma*) and East Siberian char (*S. leucomaenis*).

The interior rivers of Magadan flow north into the Kolyma basin, and have fisheries of little commercial value. They are, however, critically important to local subsistence activities. The main species are Arctic grayling, whitefish, *lenok*, and northern pike. The defining factors of this area are widespread permafrost and a lack of sheltered areas, which lead to low biological productivity and diversity. Group I forests are almost completely absent. The main part of the biomass of the region and attendant biodiversity are concentrated along river valleys and on the coast.

Protected area system

Most of the protected areas in Magadan were established between 1968 and 1991. In addition to the *zapovednik* and *zakazniks* listed below, there are thirty regional natural monuments, and one federal natural monument, Ostrov (Island) Talan.

MACE and the Institute of Biological Problems of the North (IBPN) identified areas that need to be protected. But financial difficulties associated with economic decline have led to a lack of funding for existing protected areas, let alone proposed ones. For example, many of the reserves do not have the financial resources to fight forest fires, even those occurring within their own borders.

Zapovedniks. The only federal-level protected territory in the *oblast* is Magadansky Zapovednik.

Magadansky. Established in 1982 in the Olsky and Srednekansky Raions, the *zapovednik* totals 883,817 ha, the third largest in the RFE. Magadansky Zapovednik consists of four separate sections: Kava-Chelomdzhinsky, Olsky, Yamsky, and Seimchan. The reserve's biological richness is closely linked to the Sea of Okhotsk, one of the cleanest and most biologically productive seas in the world. The Magadan Ministry of Natural Resources oversees the administration of the *zapovednik* from its offices in the city of Magadan, centrally located to all of the protected territories. The ministry provides some funds to the *zapovednik* but these are far from sufficient.

Located in the southwest near the border of Khabarovsk Krai, between the slow flowing Kava River and the rushing,

The Pacific eider (Somateria molissima *var.* nigrum) *is the most abundant of four RFE eiders. Its numbers have decreased dramatically in recent decades, but it is still widely hunted, primarily for its down, used to make clothing.*

mountainous Chelomdzha River, the Kava-Chelomdzhinsky section (624,456 ha) protects the typical boreal and flood-plain ecosystems of both plains and mountains and, thus, the nesting and migration stops for waterbirds and spawning grounds. The inland territories have large expanses of larch-dominated taiga (larch covers 52 percent of the *zapovednik* territory), and riparian poplar and willow forests. Alpine tundra plants grow on mountain ridges.

Occupying the western half of Koni Peninsula, the area included in the Olsky section (103,425 ha) is mountainous with an average altitude of 1,000 m, and has picturesque cliffs and valleys. The nearby Sea of Okhotsk greatly affects the climate. Protected elements include coastal ecosystems, populations of brown bear, snow sheep, Kamchatka marmot (a species once nearly extinct in the region), and Steller's sea eagle.

Situated in the north, the Seimchan section (117,839 ha) protects the floodplains and ecosystems of the Kolyma River valleys. Upstream lies the Kolymskaya Hydroelectric Station, which regulates the river's flows. The climate is continental.

Situated in the southwest, the Yamsky section (38,096 ha) consists of three unconnected parts. The largest lies 25 km upstream from Yamsk Village on the floodplains of the Yama River, which have relict stands of east Siberian fir (*Abies nephrolepis*). The second section includes the coast of the Pyagina Peninsula from Cape Yapon to Cape Chyorny, an area of 51 sq. km. The third includes the Yamskie Islands, 20 km offshore of Pyagina Peninsula, which are home to the RFE's largest seabird colony. The islands are also home to Russia's largest colony of Steller's sea lions and large numbers of Steller's sea eagles.

The *zapovednik* includes flora communities typical of the southern Magadan: 638 species of vascular plant grow in the Olsky, Yamsky, and Kava-Chelomdzhinsky sections; the species-poor Seimchan section has only 236 types of plant. Dahurian larch, the most common forest species, covers 62 percent of the *zapovednik*'s total area. Japanese stone pine occupies 34 percent. Ayan spruce (*Picea ajanensis*), a relict species, grows in the Yamsky region. Eighty-three species of rare vascular plant grow in the *zapovednik*. Two rare plant species, Ola magadania (*Magadania olaensis*) and Asian quillwort (*Isoetes asiatica*), occur in the area. There are also two species of amphibian: Siberian sala-mander (*Salamandrella keyserlingii*) and Siberian frog (*Rana amurensis*). Thirty-two species of fish inhabit the lakes and rivers. The most numerous anadromous fish are chum, coho, and pink salmon. Chinook and sockeye salmon are spotted occasionally. Dolly Varden, Arctic grayling, and East Siberian char can be found in large rivers (Chelomdzha, Yama, and Kava). The salmon spawning grounds in the Chelomdzha and Yama Rivers are the largest natural ones remaining on the Okhotsk shore.

One hundred seventy-three bird species, including 150 nesting species, can be found in the *zapovednik*. Marine bird colonies deserve special attention, there being forty-eight mixed and single-species colonies living among the cliffs along the Okhotsk seashore in the Olsky section. The pri-mary species are black-legged kittiwakes (*Larus tridactylus*) and slaty-backed gulls (*L. schistisagus*). Nesting birds include pelagic cormorant (*Phalacrocorax pelagicus*), black guillemot (*Cepphus carbo*), and horned puffin (*Fratercula cornuta*). Three large colonies of tufted puffin (*F. cirrhata*) are located here as well.

Marine bird colonies on the Yamskie Islands are the largest in northern Pacific. They include common and thick-billed murres (*Uria aale, U. lomvia*), crested, parakeet, and least auklets (*Aethya cristatella, A. psittacula, A. pusilla*), black guillemot, tufted and horned puffins, slaty-backed gull, black-legged kittiwake, pelagic cormorant, and North-ern fulmar (*Fulmarus glacialis*). According to bird counts on Matykil, the largest island of the archipelago, there are about 7 million birds. Most numerous are least auklets. Rare species nesting in the *zapovednik* include osprey (*Pandion haliaetus*), Blackiston's fish-owl (*Ketupa blakistoni*), peregrine falcon (*Falco peregrinus*), and Steller's sea eagle (forty-eight pairs). Golden eagle, white-tailed sea eagle, and long-billed murrelet (*Brachyramphus perdix*) are occasionally spotted in

this region. Yellow-billed loon (*Gavia adamsii*) and Bewick's swan (*Cygnus bewickii*) migrate from the Kava-Chelomdzha forestry region. Brant geese reportedly nest near the Koni Peninsula shoreline in the spring.

Forty species of mammals live in the *zapovednik*, including Microtus voles, Siberian chipmunk (*Tamias sibiricus*), northern pika (*Ochotona hyperborea*), variable hare (*Lepus timidus*), brown bear, red fox, sable, ermine, American mink (*Mustela vison*), and moose. Common but less abundant species are Eurasian squirrel (*Sciurus vulgaris*), flying squirrel (*Pteromys volans*), Clethrionomys voles, Siberian weasel (*Mustela sibirica*), and wolverine (*Gulo gulo*). Eurasian lynx (*Felis lynx*) is spotted in all parts of the *zapovednik*. The shorelines of the Olsky and Yamsky sections are the only places where Kamchatkan marmot is found. Other rare species include Amur lemming (*Lemmus amurensis*), muskrat (*Ondatra zibethica*), and wild reindeer.

Three species of seals (bearded [*Erignathus barbatus*], spotted [*Phoca largha*], and ringed [*Ph. hispida*]), Steller's sea lion, and three species of whales (killer whale [*Orcinus orca*], beluga whale [*Delphinapterus leucas*], and gray whale [*Eschrichtus robustus*]) are found in the marine part of the *zapovednik*, that is, the seashore of Koni Peninsula and Pyagina and Yamskie Islands. Harbor porpoise (*Phocaena phocaena*), Dall porpoise (*Phocaenoides dalli*), and ribbon seal (*Phoca fasciata*) are also occasionally found in these waters.

Zakazniks. The Magadan Hunting Service manages the eleven *zakaznik*s, all of which have *oblast*-level status.

Kavinsky Valley (320,000 ha). There is a description of this *zakaznik* on pp. 269–70.

Malkachansky Tundra (45,000 ha). Created in 1967 to protect ecosystems and migratory waterfowl, this *zakaznik* does allow hunting for pelts. In 1993, regional authorities extended the life of this *zakaznik* until 2003. The prevailing landscapes are windswept tundra and valleys with larch. Due to absence of staff, each fall and spring, people hunt the wildlife.

Odyan (72,700 ha). There is a description of this *zakaznik* on pp. 269–70.

Atkinsky (123,000 ha). Established in 1982 to protect bighorn sheep populations, this *zakaznik* had protected status until 2002. Prevailing landscapes are treeless mountains with many cliffs and cirques.

Solnechny (3,700 ha). Created in 1975 to protect migratory waterfowl, the area, characterized by mountainous taiga and Japanese stone pine, is patrolled by only one ranger.

Khinike (370,000 ha). Created in 1986 to protect a variety of animals, this *zakaznik* of mountains and valleys has protected-area status until 2021. Located far enough from transport routes, the region remains free from hunters because there is no access. There are no rangers patrolling the area.

Taigonos (350,000 ha; initially 400,000 ha). This *zakaznik* of mountainous tundra and coastal bluffs was created in 1973 to protect snow sheep. Its status will be discussed again

in 2004. Two rangers patrol the area. In 1995, the size of the *zakaznik* was reduced by 50,000 ha to give more land to indigenous peoples living in the nearby village of Topolyovka.

Burgali (104,500 ha). Created to increase game animal populations, this *zakaznik* was established for a ten-year period in 1993. The highlight of the area is the colorful Burgali River valley, which is rich in flora and fauna, and has large floodplains and mountainous larch taiga. There are no staff.

Omolonsky (159,700 ha). This *zakaznik* was created in 1980 to protect moose and sable. The prevailing landscapes are lowlands with some wetlands and fragments of mountainous taiga including thin larch forests and Japanese stone pine. One ranger patrols the area. One-third of the *zakaznik* lies in neighboring Chukotka.

Kubaka (280,000 ha). Created in 1994 for a period of ten years, this *zakaznik* protects game animals and is located between the Gizhiga and Khivach Rivers, about 80 km north of the village of Evensk. Mountain and valley ecosystems with fauna and flora typical of Magadan define the area. Two rangers patrol the area.

Sugoi (152,700 ha). Created in 1995 for a ten-year period, the *zakaznik* protects sable, river otter (*Lutra lutra*), and American mink. The most biologically productive portion is the Kolyma basin, which has a rich diversity of flora and fauna. One ranger is employed here.

Natural monuments. Talan Island Federal Natural Monument (32 ha) in the Taui Bay is an island with a huge seabird colony. There is no administration or staff.

Biodiversity hotspots

1. Magadansky Zapovednik (wetland, forest, and marine)
See pp. 265–67 for a description of the reserve.

Threats. The hydrological regimes of the Seimchan section located near the Kolymskaya and Ust-Srednekanskaya hydropower plants (the latter still under construction) have been completely altered; scientists predict that within fifty to eighty years the forest vegetation will be completely changed. Barren permafrost areas will increase and the succession in natural communities will change. Another threat is the newly constructed fish farms, which have almost completely wiped out natural salmon stocks in the large rivers. Some companies are lobbying to construct hatcheries near the *zapovednik*'s spawning grounds. Mining has virtually destroyed fish populations in the Kolyma region. Other threats include the proposed development of a coal field on the Burgagylkan River,

which feeds into the *zapovednik's* Chelomdzha River, and a gold mine that is being developed near the Olsky region.

Zapovednik staff are unable to protect the shore and sea because they lack marine transport and fuel. Poaching threatens marine habitats in Yamsky and Olsky. Illegal fishing for crab and halibut within the protective zone of the *zapovednik* continues unabated. Uncontrolled fishing threatens the natural salmon spawning grounds in Kava-Chelomdzhinsky and Yamsky Raions. Illegal hunting of brown bear and snow sheep continues. There is little public support for brown bear conservation. The international sport-hunting industry and trade (especially with South Korea and China) in bear parts, mostly gallbladders and pelts, is lucrative. There is very little biological data about populations. Specialists with IBPN estimate that the Magadan bear population dropped by 20 percent between 1990 and 1996.

Existing protection measures. The *zapovednik* was created in 1982 on practically pristine ecosystems. The zoology of the territory is well studied; soils, landscapes, and fungi and lichens are not fully studied. The *zapovednik* has a science department staffed with three researchers and one laboratory research assistant. The primary scientific activity is long-term ecosystem monitoring as a part of the program Nature Chronicle, but most of the program activities have been cancelled for lack of funds. Other studies include research on fish-eating birds and on marine and terrestrial mammals.

The *zapovednik* actively collaborates with the IBPN (Magadan), researching the dynamics of mammals, monitoring salmon, and describing the flora. Since 1994, the *zapovednik* has collaborated with the Chugach National Forest Service in Alaska to implement the joint Sister Forests program. Research on the white-tailed sea eagle and the summer ecological school are part of this program.

Recommendations. The following actions should be taken:
- Eliminate poaching throughout the *zapovednik*.
- Provide staff with transportation and mobile communication equipment.
- Develop methods to assess the impact of hydroelectric power plants on *zapovednik* ecosystems to find real changes and ways to deal with them.
- Continue long-term studies of *zapovednik* ecosystems as proposed in research programs.

2. Taui Bay (marine and wetland)

A. KONDRATEV—Taui Bay has an immense role in preserving the biodiversity of the Magadan. Forty-five percent of all fish, 84 percent of all birds, and 75 percent of all mammals from the rare and endangered species list for the Russian northeast permanently inhabit or migrate to the region. Thirty percent of the rare plants of the region are found on the nearby islands along the shores of the bay. This is one of the most productive areas in all of the Sea of Okhotsk for commercially valuable fish, mollusks, and crabs. Many spawning rivers in Magadan flow into this bay. The largest settlements are located on the shores of Taui Bay, and more than 50 percent of the population lives here. Indigenous peoples live along these shores, primarily in the settlements of Tauisk, Arman, and Ola, and their physical and cultural survival depends upon the area's ecological vitality.

Threats. The relatively high population density, intensive transport routes, and heavy exploitation of the biological resources have had an impact on the bay's ecosystems. In Nagaeva and Gertnera Bays, which are within Magadan City proper, the environment is so polluted that the waters have become harmful. Oil and gas fields under the shallow waters of the bay should also be mentioned, because future development of these reserves is planned.

Existing protection measures. Environmental conservation efforts in Taui Bay are sporadic. The marine resource potential has been fairly well studied by the Magadan division of TINRO (MagINRO), the administration of the Magadan branch of Glavrybvod (Okhotskrybvod), and the IBPN. Water and atmosphere dynamics are monitored. The conservation committee and special marine patrols conduct inspections of the bay and fight marine pollution.

Recommendations. The first priority is to develop a multidisciplinary conservation program to protect the bay. This includes the following:
- Estimate the region's overall biological diversity and resource potential.
- Map habitats with abundant game species and rare and protected species.
- Identify and map ecological disaster zones.
- Determine regions of traditional land use and develop measures to restore the indigenous culture and economy.
- Make restoration plans for each region.
- Create disturbance-free zones and migratory corridors, and strictly regulate hunting and fishing.
- Develop and implement ecological monitoring programs.
- Develop a network of stationary observation points as well as land and water observation routes.
- Monitor polluted bays, mining areas, and areas with high biological productivity (e.g., mouths of spawning rivers).
- Establish an ecological safety and biodiversity preservation program in Magadan's bays, especially Nagaeva Bay; this program should include the identification of pollution sources and polluted areas, an assessment of the health of plant and animal populations, and maps of the levels and types of pollution of the bay shores and bottoms. This information will make it possible to develop a plan to reduce the ecological danger in bays and shorelines and to decrease industrial and domestic pollution.

- Determine the carrying capacity of these ecosystems for tourism and develop a recreation plan that includes the creation of public parks in Taui Bay.

3. Khasyn River basin (wetland)

M. ZAMOSCH—Khasyn River basin occupies 3000 sq. km and represents a unique natural and economic community with no parallel in the northeastern part of the Asian Pacific. Rivers in the Khasyn basin are spawning grounds for Pacific salmon. Valuable animal species also inhabit this territory. Anthropogenic impact on the territory began in 1930s with the industrial development of Magadan.

Threats. Most of the industrial pressure on the ecosystems occurs in the middle and upper part of the basin where there is a railroad and highway. Coal and volcanic ash fields have been mined, and logging and hunting have taken place. There is also a regional airport, two pipelines that carry petroleum, and several large oil-storage facilities.

In the favorable climatic conditions, agriculture and cattle breeding are well established. In the upper part of the basin, the Karamken gold mine was active from 1978 to 1995. Cyanide-laden waste remains stored in cesspools. With the construction of a precious metal refinery complete, there are plans to develop coal reserves. Of the seven towns and villages in the basin, only two have proper sewage facilities.

Existing protection measures. The present ecological health of the basin and the upper limits of industrial activity have been poorly studied. For lack of funds, research was suspended in the early 1990s, and the hydrological observation station on the Khasyn River was removed. Present monitoring is limited to summertime testing of surface water and groundwater along the Tumanny River, which is near the Karamken mine and is a tributary of Khasyn River.

Recommendations. The following actions should be taken:
- Conduct multidisciplinary research of the current ecological situation, including an assessment of the impacts on biodiversity due to industrial development.
- Develop a permanent monitoring and environmental protection program that should include environmental impact assessments for all new industrial projects and the retrofitting or dismantling of ecologically destructive industrial equipment.

4. Gizhiga Bay (wetland and marine)

A. KONDRATEV—Gizhiga Bay is one of the most biologically productive and diverse parts of the Sea of Okhotsk; huge populations of herring, salmon, crab, and other marine resources make this a productive area for commercial fishing.

Threats. A coal mine on the bay shore pollutes nearby waters. Commercial fishing and hunting often conflict with the needs of local indigenous peoples; Gizhiga Bay is the most important region for indigenous communities in Magadan. Traditional Evens and Orochi settlements are located here.

Existing protection measures. No specific measures are now in place to protect the bay and its nearby shores. Taigonos Zakaznik lies on the bay's northeastern shore, but this protected territory exists more on paper than in reality due to the lack of funding.

Recommendations. The following actions should be taken:
- Rejuvenate traditional forms of economy (reindeer breeding, hunting, and fishing) for the indigenous communities; any land use program should reflect this, not by limiting commercial fishing and hunting, but by ensuring the rights of the native peoples.
- Adopt an ecologically sensitive land-use program that will allow for preservation of the biodiversity of Gizhiga Bay (including the ecosystems of the Tavatum mineral springs, unique marine bird colonies, whale populations, and so on).
- Take measures to protect the flora and fauna, which include snow sheep and Kamchatka marmot, in Taigonos Zakaznik. There are also Steller's sea eagle, peregrine falcon, and gyrfalcon (*Falco rusticolus*) nests in the area.

5. Odyan and Kavinsky Valley Zakazniks (forest and wetland)

These zoological *zakaznik*s are the linchpins of Magadan's protected area system. Odyan boasts diverse flora and fauna; Kavinsky Valley is an important resting stop for migrating birds.

Odyan Zakaznik was created in 1993 to protect brown bear, but may be dissolved in 2003 if it is not legally renewed. More than one hundred bears live within the boundaries of the refuge (2.5 individuals per 10 sq. km). Only southeastern Kamchatka and southwestern Alaska have higher densities of brown bear. The prevailing landscapes are tall, grassy meadows and sloping hills covered with Japanese stone pine. The rivers are filled with salmon. This landscape mix and rich fish resources are the keys to sustaining the bear population. Only in Odyan Zakaznik and Yama River valleys can one find unique, species-rich tall-grass meadows and stone birch groves. In addition to the brown bear, the *zakaznik* protects river otters and nesting grounds for Steller's sea eagles, ospreys, and peregrine falcons.

Nine bird species nest on Umara Island, including pelagic cormorant, slaty-backed gull, black-legged kittiwake, tufted puffin, horned puffin, common and thick-billed murre, parakeet auklet, and black guillemot. In this bird colony, there are

an estimated fourteen thousand birds. The colony serves as a natural indicator of the health of this shallow, but rich bay.

Kavinsky Valley Zakaznik was created in 1961 and renewed in 1993 until 2003 with expanded borders to include the Chutkavarsky Range, which contains snow sheep, brown bear, and Kamchatka marmot—the most threatened mammal species living along the shores of the Sea of Okhotsk. The prevailing landscapes are wetlands with larch *redkolesie*, mountainous cirques, and coastal cliffs of the Chutkavarsky Range. It protects nesting grounds of the whooper swan (*Cygnus cygnus*), greater white-fronted goose (*Anser albifrons*), and bean goose (*A. fabalis*), as well as the osprey, golden eagle, and white-tailed and Steller's sea eagle. Migrating birds rest in the Chukcha, Lesser Chukcha, and Bezymyanka Lakes, all located in the center of the *zakaznik*. A small taiga reindeer herd lives on the Kavinsky Valley lowland. Two rangers regularly patrol the area.

Threats. The Odyan and Kavinsky Valley Zakazniks have to date been spared from large-scale resource exploitation. Fur hunting, however, is allowed, and a potential threat is gold prospecting in Odyan by the Goldtrap enterprise. There is also unregulated bear hunting in the spring, as the area is accessible by boat from the cities of Magadan and Ola. Only one ranger patrols Odyan.

Recommendations. The following actions should be taken:
- Upgrade the *zakazniks* to federal-level status.
- Control poaching and illegal resource harvesting.
- Conduct monitoring and scientific research of the region.

6. Ola River basin (forest)

Just east of Magadan City, the Ola basin has rich larch forests that protect natural salmon grounds frequented by pink, chum, and coho salmon. According to the Magadan Hunting Service, the Ola River basin has the following game species:
- Moose, 100–120 individuals.
- Sable, 800–100 individuals.
- River otter, 20–30 individuals.
- Snow sheep, 40 individuals.
- Brown bear, 40–50 individuals.
- Willow ptarmigan, 4,000–5,000 individuals.

Threats. Indigenous peoples still hunt and fish in the Ola basin, but much of their land has been degraded as a result of poorly designed industrial development. According to ecologists, 60 percent of the pastures in the Khasynsky region cannot be restored. Some indigenous peoples have therefore been forced to relocate with disastrous psychological, cultural, and economic results.

Overfishing has depleted salmon runs, and industrial mining, which has been done without any environmental impact assessment or consultation with indigenous peoples,

has destroyed portions of the basin. One example of this negligent practice is the new Julietta gold mine, which is located on the Lankovaya River, a salmon-spawning ground.

Existing protection measures. Current measures are practically absent.

Recommendations. The following actions should be taken:
- Reduce fishing in the Ola basin and reorient the industry to favor the needs of the indigenous people living in the area.
- Form an ecological committee that will represent all interested parties.
- Conduct multidisciplinary ecological reviews of all industrial development projects.
- Enforce nature protection measures in the basin.

Economy

Mikhail Krechmar

Until the inception of active industrial development, there were five main settlements in the area, with a total population of fewer than 4,000 people. At the time of the Soviet revolution, the population of the area now making up the *oblast* and parts of adjoining territories was between 8,000 and 11,000 people, consisting mainly of indigenous people occupied mostly in fishing in the estuaries and lower reaches of rivers, reindeer herding, hunting (for subsistence and the fur trade), and to a much lesser extent, sea hunting.

The beginnings of modern resource development occurred at the end of the 1920s and early 1930s, and were related to the first expeditions of Soyuzzoloto, the national gold industry organization. The contemporary industrial structure of the region began to take form in 1935, with the mining industry at its forefront. Gold, silver, and, to a lesser extent, coal were the main resources that were exploited by several mining *kombinati* (Gornoobogatitelny kombinat—GOK: "enrichment combine").

Industrial development began in earnest in 1932 when Dalstroi began operations with prison labor on Nogaev Bay, the site of present-day Magadan. Magadan was the base of operations for Dalstroi, which was the commercial organization of Stalin's Far Eastern section of the infamous "gulag archipelago." More than two million prisoners were sent to Magadan during the course of its existence (1932–1957) and were primarily used for intensive labor in gold processing, forestry, and road construction.

Until 1931 there were no roads in Magadan. There was only a winding route from the central areas of Kolyma to the coast of the Okhotsk via the village of Ola. In 1938, prison la-

bor was used to build a graveled highway to link Nagaev harbor with central Kolyma. The main highway was completed in 1958, when it was connected with the Aldan highway.

Initially, the gold industry was based on a network of primitive mines, united by a concentration of prison camps, *lagpunkts* (lit. "camp-points"). In 1944, there were 312 *lagpunkts* in the upper Kolyma watershed, housing 650,000 prisoners. During World War II, prison labor built roads encompassing almost the entire upper basin of the Kolyma River, thereby increasing the environmental degradation of the region. With the closure of Dalstroi, a large part of this network was no longer maintained and subsequently ceased to exist.

In 1968 the mines were consolidated into a more modern industrial system of GOKs. There were seven GOKs in Magadan in 1991; since then several have become bankrupt.

Logging proceeded chaotically. Few forest tracts were large enough to have any commercial value. In the first years of construction of the city of Magadan and the Kolyma road, all the larch forests within a radius of 40 km from the city and within 4 or 5 km from the road were cut. Today, these areas are covered with a second growth, which is between thirty and fifty years old. The creation in 1963 of the Yansk Leskhoz and subsequent growth of the village of forestry workers at Verkhne-Yansk led to the increase of anthropogenic pressure on the forests in the Yana and Chelomdzha River basins. These small forests were quickly harvested by the 1970s and 1980s. In its last years, the Yansk Leskhoz survived on the forests of northern Khabarovsk Krai. In 1996, the Yansk Leskhoz and the Verkhne-Yansk Village were liquidated. There were insignificant attempts to harvest forests in the Sredneakansky area and in the Balygychan and Korkodon regions. These activities have also ceased.

Since the 1930s there have been attempts at agricultural production. The Ola-Taui agricultural region in the south, as well as agriculture (primarily potatoes and cabbage) in the Seimchan region in Srednekansky Raion, were developed to reduce dependency on imported foodstuffs. Domestic reindeer husbandry had existed locally for a long time before it was subjected to Soviet collectivization and reorganization beginning in the 1930s. The *sovkhoz* collective system developed and solidified in the mid-1940s. A large part of the Magadan, including the Upper Kolyma mining region, was crisscrossed by reindeer herds. Today large numbers of reindeer herds have returned into private hands. For several reasons, the size of the overall reindeer population has decreased significantly.

Cities and towns were established from 1939 (with the establishment of Magadan as a city) to 1974 (when the villages of Susuman and Yagodnoe were designated as cities). The permanent population of Magadan, within its current borders, grew in this period from 50,000 to 250,000. Most of this growth (56 percent) was from immigration from other regions in the country. Much of this population does

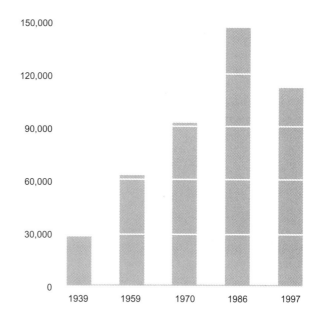

Figure 7.3
Population growth for Magadan City, 1939–1997

Source: Krechmar, 2000.

not consider Magadan to be its home and plans to leave at some point. The majority of the population was concentrated in the cities of Magadan and in the adjacent Olsky Raion. Figure 7.3 shows population growth for the capital.

The decrease, mainly by emigration, in population between 1986 and 1997 is related to the overall economic decline in the *oblast*, and is probably a long-term tendency.

Industrial development. Overall, Magadan and its industrial development can be divided into three areas. The first is the Ola-Taui industrial/agricultural area and includes the green zone of the city of Magadan and parts of Olsky and Khasynsky Raions. Limited forms of agriculture are possible here in the valleys of the Ola, Arman, and Taui Rivers, principally potatoes, cabbages, and carrots. Magadan is the transport center and port terminal, and it used to have repair facilities for boats and mining equipment. Today it is the largest fish-processing center in the *oblast*.

The second area is the upper Kolyma mining region and includes the Susumansky, Yagodninsky, and Tenkinsky Raions, and parts of Omsukchansky, Srednekansky, and Khasynsky Raions. This region has 80 percent of Magadan's gold mining facilities. The western parts of Srednekansky Raion contain agricultural lands.

The third area is the northeast region, which includes all of Severo-Evensky Raion, the eastern part of Olsky Raion, and southeast portions of Srednekansky and Khasynsky Raions. This is a region of traditional natural resource use

for both native and immigrant populations: fishing, hunting, and reindeer herding. In recent times it has become the object of attention of foreign gold mining companies and has become the site of the Kubaka project. The area is not connected by road to other routes in Magadan. The bay at Evensk, its only port, completely freezes over in winter, so that entry is impossible without heavy icebreakers.

The total area of populated territories is 62,700 ha. From 1992 to 1997 this area grew by 7,800 ha, despite the closure of many settlements. The increase was a result of changes in settlement boundaries and the transfer of lands to village administration control.

The further development of industry and Magadan itself depends on regular imports of supplies. The *oblast* is dependent on imports for 95 percent of its food, 87 percent of its coal, and 100 percent of its oil and gas. Foodstuffs cost on average between 30 and 70 percent more in Magadan than in Russia as a whole. Significant emigration to central Russia can largely be attributed to the high cost of living and loss of economic opportunities. The population has declined by thirty thousand people since 1986. The service and maintenance facilities for the mining and fishing sectors have been all but liquidated. The reduction of domestic reindeer is estimated at 75 percent. If these trends continue, and there is no reason to believe that they will not, the population in 2015 will be eighty thousand people. This is made more likely by the fact that a large part of the current population does not view Magadan as a place for permanent residence.

Nezavisimaya gazeta-regiony (January 25, 2000) reported that one-half of the population of the *oblast* earns less than the minimum subsistence wage. This represents a twofold increase since 1998. In 1999 the average monthly salary was nominally 3,006 rubles, but in real terms, the average was only 1,695 rubles per month. In November 1999, eighteen thousand people were officially registered as unemployed (3.9 percent).[11] During 1999, prices increased by 37.2 percent while average monthly incomes increased by only 2.7 percent.[12] Almost half (42.7 percent) of the workforce was owed back pay (averaging 14,100 rubles each) in 1999. One-third of all enterprises and organizations owe five or more months of back pay (15,700 people), and the government sector owes 51 million rubles in back wages as of January 1, 2000 (89 percent of the total for Magadan).[13]

Environmental impact. Environmental degradation of populated areas is being caused by:
- Excessive number of heating plants that are not equipped with gas and dust filtering devices.
- The inadequate condition of waste dumps and landfills containing solid municipal waste and sewage.
- The air-particulate pollution between March and October that is caused by dust from dirt roads.

There are 74,611 ha of degraded lands, of which 16,128 have been recultivated or are awaiting rehabilitation. Restoration is done very slowly, without proper seasonal timing, and

Abandoned Stalin-era labor camps can still be seen near most Kolyma Valley settlements.

at inadequate levels. In 1997, 697 ha were recultivated, and 4,421 ha were returned to the state by local enterprises without recultivation (sites with shrub cover that could facilitate recovery). Restoration work is subject to the vagaries of the enterprises' economic stability and solvency, which occasionally results in bankruptcy and collapse.

Over 75 million tons of liquid waste is generated annually from gold mining, and about 40 million tons of waste from other industries and from towns and cities. Ninety percent of this waste is discharged into rivers and streams. Nearly every water-treatment facility is outdated. Many drinking water sources (including Balakhapchan River) are polluted. Almost all of Magadan's urban waste is discharged, untreated, into the Sea of Okhotsk.

Annual air pollution is about 122,000 tons. Air transport and centralized heating boilerhouses are the main sources of pollution. Gas emissions from slag heaps and liquid waste reservoirs associated with gold extraction plants are not tabulated into the air pollution index, nor is road dust kicked up by automobiles. This road dust, which kills vegetation, is the main source of air pollution in the Kolyma basin and in Magadan. Despite the drop in industrial production, the area of polluted lands and areas covered with debris are increasing rather than decreasing, a result of the closure of villages, collective farms, and other sites that no longer are being used by people.

Mining

The gold and silver industry was the basic force behind the development of Magadan and its highways. Active exploration for gold began on the upper Kolyma River with the expedition led by Yuri Bilibin in 1928. Discovery of the first deposits, named Utinoe, on the Srednekan River, led to the establishment of Dalstroi on November 11, 1931. Dalstroi was under the control of the GPU (State Political Service) and then the NKVD (the predecessor of the KGB) of the USSR. Dalstroi was closed in 1957 at the same time that the NKVD was restructured as the KGB. The territory's gold mining projects then began to be called *sovnarkhoze*s. In 1967 the mining department was reconfigured into the Susuman GOK, and the Severovostokzoloto agency was formed. Gold extraction peaked in the Upper Kolyma region during World War II, rising to 80 tons (the largest quantity ever mined in a single year) in 1940. The decline became precipitous in the 1990s (see fig. 7.4).

At the end of World War II, some alluvial deposits were worked by dredging, but the method was not much used in Magadan primarily because of the high cost of melting permafrost gravel, which consumes up to 30 percent of the total profit from the deposit. Smaller placer deposits were extensively dredged, primarily using panning methods.

Today, about one-third of the 268 registered mineral users in the *oblast* are gold prospecting cooperatives. Since

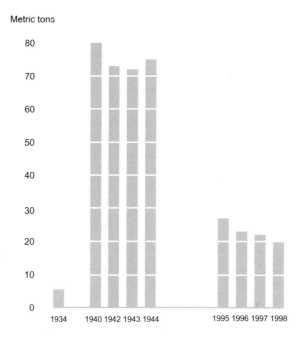

Figure 7.4
Gold extraction from the Upper Kolyma, 1934–1998

Source: Gorny Zhurnal, 2000.

1997 more than half of the annual gold production has been financed with foreign capital and the most significant of these enterprises is the Kubaka ore deposit (see pp. 278–80).

Mining companies in Magadan produced 30 tons of gold in 2000. Of this total, about 12 tons come from placer mining and 17 tons from ore deposits. Almost half of total production is provided by Magadan's largest gold concern, the Omolon Gold Mining Company, which owns and operates the Kubaka field. The Susuman, Berelyokh, and Yagodnoe GOKs are the biggest placer gold producers. Susuman and Berelyokh produced, respectively, 1.7 tons and 1.6 tons of gold. Among the *artels*, or brigades of prospectors, Krivbass produced 510 kg, Kurchatov, 360 kg, Maiskaya, 345 kg, Expeditsionnaya, 320 kg, and Vympel, 300 kg.[14] Overall, nonferrous metal production held steady in 1999, dropping only 3 percent from 1998 levels.[15]

Environmental impact. Gold deposits are often found in the rich river valleys, where most of Magadan's remaining valuable forests grow. The technology presently used in gold mining leads to the destruction of these ecosystems. Every year 250 million cu. m of sediment are produced, most of it during gold mining. Every year, the area of land destroyed due to mining grows by 2,000 to 4,000 ha. Less than six percent of the disturbed land is reclaimed. Exhausted mines in the Kolyma River basin exceed 12,600 ha. By reclaiming land from exhausted mines, Magadan could increase the land available for agriculture by 50 percent. In the far

north, land can be recultivated for reindeer pasture. There are only about 28,000 ha of land suitable for agriculture. Joint research is currently being undertaken by the Zonal Institute of Agriculture, the IBPN, and the Magadan branch of the Far Eastern Hydrological Institute to develop a comprehensive land recultivation program.

Toxic liquid waste from gold extraction plants poses a particular problem. Magadan has to deal with 75 million tons of liquid toxic waste annually. The places where this waste-water is concentrated—around the gold-extraction plants, e.g., the Matrosova plant in the Omchak River valley—should be classified as ecological problem zones. Massive geochemical changes in the Kolyma River basin have been caused by gold mining and, to a lesser degree, agriculture. The water's natural carbonate content is turning to sulfate; this could completely change the biological structure of water communities.

Coal. Magadan contains nine thoroughly explored coal deposits. The Arkagalin coal field, consisting of two separate deposits (Nizhny (Lower) and Verkhny (Upper) Arkagala deposits), lies in the middle of the central industrial region, which provides 80 percent of the *oblast*'s coal. Over the years, miners have extracted over 18 million tons of coal.

At Lower Arkagala, coal deposits total 222 million tons, of which 42 million are accessible and 86 million are estimated reserves. There are also two mine shafts, with estimated reserves of 850,000 tons. At Upper Arkagala, comparable figures are 325 million tons, with 30 million accessible and 20 million tons in reserves. In this region, the Tas-Yuryakh open pit has estimated reserves of 360,000 tons. The coal found in these deposits is of the "D" and "G" categories, with a 20 percent moisture content, 9–15 percent ash content, 0.3–0.4 percent sulfur content, and 33–41 percent yield of volatile substances.

The weakness of the regional energy sector has led *raion* administrations (Olsky, Severo-Evensky, and Srednekansky) to make plans to mine deposits that are very close to the *raion* centers of Lankov, Taigonos, and Omolon.

Agriculture

After gold mining, agricultural fertilizers and pesticides are the greatest river polluters. Over 40 percent of Magadan's river valleys have already been ploughed, drained, or irrigated. Agricultural development has destroyed soil and vegetation cover, and overuse of chemical fertilizers has damaged the soils and rivers. Much of the cultivated land is unproductive. In the past, nitric fertilizers for potatoes were used in amounts far exceeding the soil's capacity to retain nitrogen and the plants' capacity to use it effectively. The decline of the *sovkhoz* (state farm) system and the declining population have actually contributed to environmental degradation through neglect and increased mining activity. Naturally

productive agricultural land has been used for gold mining or flooded to create reservoirs.

Agriculture in Magadan consists of reindeer herding, farming, and animal husbandry. As of January 1, 1998, agricultural lands occupied 22,879,000 ha. Soil productivity is low. Annually, floods cover up to 15 percent of the fields. Without special soil conservation and productivity measures, agricultural lands become waterlogged, soil acidity increases, and erosion processes set in. In January 1998 an analysis of agriculture showed that, since 1992, agricultural lands had decreased by 24,100 ha, ploughed fields by 10,200 ha, and pastures by 4,132,100 ha. The greatest proportion of unused lands is associated with large agricultural organizations (*sovkhoz*es, stock companies, and partnerships).

Reindeer herding is one of the traditional forms of natural resource use practiced by the three main indigenous peoples inhabiting Magadan: Orochi, Evens, and Koryaks.

Kolyma-Okhotsk pastures occupy the upper watershed of the Kolyma River and the northern coast of the Sea of Okhotsk, between the Taui and Penzhina Bays. The watershed consists of close to 46 million ha, of which 43.3 million are pasture. The upper watershed of the Kolyma, open coastal valleys, and plateaus are used as summer pasture. Hollows and smaller valleys of mountain rivers, covered in larch *redkolesie* provide good pasture for the rest of the year. In the 1970s and 1980s, up to 140,000 head of reindeer grazed in this area. According to the specialists at the Zonal Institute of Agriculture, its carrying capacity is above 200,000 head.

Open croplands are found in the Okhotsk coastal regions and central Kolyma region. Cultivated lands had an area of 10,000 ha in the mid-1970s. Potatoes took up 1,300 ha, vegetables (primarily cabbage and onion), 500 ha, and feed crops, 8,000 ha. The average harvest of potatoes was between 80 and 120 metric centners/ha, and of vegetables, between 200 and 260 centners/ha. During this same period, there were 10,000 head of livestock, 8,000 swine, and about 400,000 poultry.

Timber

The forested lands of Magadan comprise 24,619,000 ha, or about one-third of the total area (see table 7.1). The area is categorized as follows: Group I: 7.14 percent (not including *zapovednik* lands); Group II: 92.86 percent. Group II forests are almost nonexistent. The main species—larch—grows on an area of 7,666,600 ha (44.91 percent of forested lands). The equivalent timber reserve is 280 million cubic meters. Dwarf Japanese stone pine occupies second place, 7,096,000 ha (41.57 percent of total forest). Shrub birch covers 1,839,300 ha (10.77 percent), and other species 468,200 ha (2.75 percent).

Most forested tracts consist of low-productivity larch, with a timber density of 45 cu. m per ha, and sphagnum larch forests on waterlogged sites in valleys and on hills, with a timber density of between 20 and 70 cu. m per ha.

Table 7.1

***Leskhozes* (Forest Service Divisions)**

Forest type	Magadansky (000 ha)	Orotukansky (000 ha)	Berelekhsky (000 ha)	Seimchansky (000 ha)	Severo-Evensky (000 ha)	Total (000 ha)
Forested						
Closed	3,384	2,195	1,974	5,377	1,796	14,726
Open	1,275	1,440	1,088	2,145	509	6,457
Burns, logging areas	532	785	438	1,675	6	3,436
Total	*5,191*	*4,420*	*3,500*	*9,197*	*2,311*	*24,619*
Unforested						
Unproductive	4,091	2,392	2,009	5,130	4,007	17,629
Aquatic	41	42	34	114	38	269
Total	*4,132*	*2,434*	*2,043*	*5,244*	*4,045*	*17,898*

Source: Magadan Forest Service, 1999.

Over 75 percent of the region's forests have been logged since the first major settlements were built in the early 1930s. Heavy logging along river valleys, particularly in the northern regions, has caused serious soil erosion, divided riverbeds, and destroyed salmon-spawning grounds. Often in the summer following clear-cut logging the permafrost melts, causing entire layers of soil to slip from the hillsides. This clogs rivers and causes flooding in river basins. In winter, these flooded areas become vast ice fields, destroying the most important wintering grounds for moose, ermine, ptarmigan, and black capercallie (*Tetrao parvirostris*). Almost all of Magadan forests are Group III (commercial) and not protected by federal regulation. The regional forest service and IBPN are trying to get some important forests reclassified.

In 1975, annual timber production was 500,000 cu. m. Since *perestroika*, the amount has dropped to about 300,000 cu. m per year. The main logging ventures in the region (Central Lespromkhoz (LPX), Magadan LPX, and Agroprom) have decreased their activities dramatically. At present, however, there are two major LPX concessions: one in the Korkodon River basin and the other in the Sugoi River valley (Kolyma basin). The local population actively protested logging in Korkodon, but the federal government went ahead with plans anyway.

Since commercial logging in Magadan began, a total of about 60 million cu. m of commercial-grade timber and logs have been produced. The largest volume of cutting was about 3.5 million cu. m annually. In the 1970s between 400,000 and 500,000 cu. m were cut annually, of which 200,000 cu. m were commercial grade. The result of the intensive cutting during the Dalstroi period in the more developed areas

(near cities, inhabited areas, industry, and along the Kolyma highway) was complete deforestation except in protected territories.

Logging was insignificant in the period 1995–2000 and did not exceed 5 percent of the planned timber harvest. Other types of timber cutting (primarily in areas associated with mining operations) were also insignificant, with a total area of 3000 ha; 40,000 cu. m of wood was extracted in this way.

Maintenance logging was done on 2,000 ha, of which 1,020 ha were of Group I forests. There were 155 forest fires in the Goslesfond (Federal Forest Fund) in 1997, covering 925 ha. Of all of the fires, only one was designated in the worst category; all of the others were designated as lower categories. Reforestation efforts in 1997 covered 4,508 ha.

The mining industry also destroys massive areas of Magadan forest. About 77,500 ha of state forest have been given over to long-term mining. The timber industry declined by one-third in 1999 compared to the previous year.

Fishing

Inhabitants of Magadan have relied on fishing since the Neolithic period. Until 1931, 80 percent of the population was concentrated near the mouths of rivers flowing into the Sea of Okhotsk. Aside from isolated fur hunting and government posts, the first economic ventures in the region were fishing cooperatives at the Ola and the Taui River mouths. Fishing consequently became the second specialization in the economy of Magadan. In the 1950s the catch of fish, whales, and marine animals amounted to 20,000 tons annually. In the 1960s, this grew to 60,000 tons, and to 100,000 in the

1970s. In the late 1970s and early 1980s there was a dramatic drop in the population of commercial species, after which there was a drop in the catch.

Five fishing companies were operating in the Magadan region in 1995. The largest, Magadanrybprom, with more than 2,000 employees, was privatized into a stockholding company in 1994 and controls most of the region's fish quotas. The smaller fishing companies primarily catch high-value products, including crab, for export. Magadanrybprom is the leading wholesaler of fresh, frozen, and canned fish.[16]

Magadanrybprom operates thirty fishing vessels, including three trawlers, and a processing plant. In the mid-1990s, the company experienced serious financial difficulties, although some improvement resulted following privatization and new management. The company also expanded its other ventures, which included a hotel, restaurant, and several stores in Magadan City. Magadanrybprom seeks U.S. partners for fishing operations, in particular for bare-boat charters for fishing pollock, salmon, cod, crab, and other species. The company also wishes to upgrade its existing canning facilities and operations.[17]

The regular failure to attain humpback salmon quotas is the result of poor organization of the fishery (too many crews and delays of the opening of the season) and an inadequate processing base. The situation with the Anadyr chum is somewhat different, although quotas are not filled for this species either because of the massive scale of the marine salmon driftnet fishery, which is oriented toward the capture of the most commercially valuable species—Anadyr chum and sockeye.

In 1999, salmon fishing in the rivers of Taui became officially prohibited. Coastal fishing territories do not have clearly marked boundaries because the administrative borders of licensing zones are constantly rearranged. According to local expert assessments, illegal fishing accounts for up to three times the amount of official quotas. In any case, estuarine portions of every salmon run in the Taui and Gizhiga Bays have one or more illegal brigades. The rapacious practice of caviar poaching, in which the rest of the fish is left to rot, is a problem in Magadan, as elsewhere in the RFE.

The three fish hatcheries in Magadan, on the Taui, Ola, and Arman Rivers, are not under the continual attention of numerous regulatory agencies, as is the gold industry. Factors that make abusive practices possible include the flexibility in quota distribution, limits, and areas of catch, as well as the opportunity to manipulate catch quotas (commercial and scientific) with the help of the Magadan branch of TINRO.

According to the marine inspectorate and the IBPN, salmon hatcheries using outdated Japanese technology are ecologically harmful. The newest hatchery is Yamskaya Farm, run by the Russian-Japanese joint venture Magadan-Nikkeirei and built at the end of 1994 by American contractors according to Japanese designs. The projected capacity is 35 million eggs a year. To get such a huge volume of eggs for the hatchery, large numbers of salmon will be taken from the Yama River, which is already being heavily fished commercially. According to experts, the factory's outdated technology will cause the loss of up to 50 percent of the eggs during the incubation period.

Joint fishing ventures registering as scientific ventures are involved in overfishing and illegal fish exports to Japan. These joint ventures rent vessels from Magadanrybprom (the coordinating body of the Magadan fishing industry) and use quotas set by the Federal Fisheries Committee or obtained from TINRO or Magadanrybprom.[18]

Toward sustainable development

Mikhail Krechmar

Magadan has no officially defined programs for sustainable natural resource use. In 1995 the IBPN and the Northeast Comprehensive Scientific Research Institute of the Far Eastern Branch of the Russian Academy of Sciences offered to develop such a program for the administration, but a lack of funds prevented its completion.

Local people collect mushrooms, medicinal plants, Japanese stone pine nuts, and berries, especially raspberries, foxberries, currants, blueberries, and cloudberries. Expanding the nontimber forest product harvest could help diversify Magadan's economy. Despite horrendous energy shortfalls, there has been little inclination by the Russian government or the international community to develop alternative energy sources, such as wind or tidal electric power generators.

Indigenous peoples

Mikhail Krechmar

Five indigenous peoples populate Magadan: Evens, Orochi, Koryaks, Yakuts, and Chukchi. Magadan also recognizes Kamchadals (descendants of early Cossack settlers and indigenous people) as an indigenous people of the North, but their status is sometimes disputed at the federal level. The most populous are the Evens (6,000), followed by the Koryaks (3,000). Most indigenous people live in the northern part of the Olsky and Severo-Evensky Raions. Several towns in Magadan are designated ethnic villages. These are Tauisk, Gadlya, Yamsk, and Takhtoyamsk in Olsky Raion (populated mostly by Evens and Orochi); Topolyovka, Verkhne-

Paren (Koryaks), and Gizhiga (Evens, Koryaks, and Kamchadals) in the Severo-Evensky Raion; and Ust-Balygychan in Srednekansky Raion.

Traditional nature use by the native peoples in contemporary Magadan is fishing, reindeer herding, and hunting and gathering. During the Soviet period, at least two thousand native people were employed through state subsidies for reindeer herding; these subsidies have since disappeared. Today reindeer grazing competes with the mining industry for land in the *oblast*. The herding communities are thinly spread throughout tundra woodlands, and apparently today exact routes are unknown. There has been a de facto reversion to precollectivization conditions, as people are taking up subsistence activities to feed themselves and their families. Coastal fishing areas are much fewer and are associated with traditional fishing sites that have existed for centuries. In addition to providing important economic resources, these sites are connected to the spiritual and cultural well being of indigenous people.

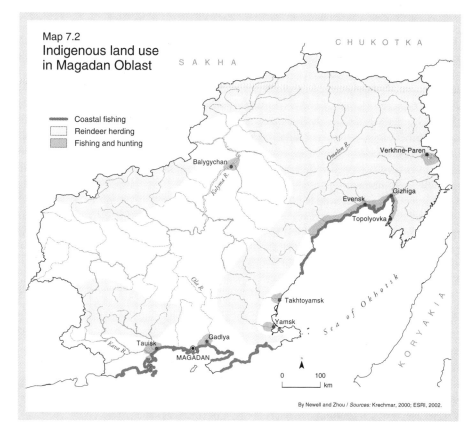

Map 7.2
Indigenous land use in Magadan Oblast

Coastal fishing
Reindeer herding
Fishing and hunting

By Newell and Zhou / *Sources:* Krechmar, 2000; ESRI, 2002.

Legal issues

Mikhail Krechmar

Today both the scale and spectrum of violations of environmental law have grown. They are part of the most common illegal activities of the post-Soviet era. In addition to traditional forms of environmental violation (poaching, forest destruction, water and air pollution), illegal forms of mining and oil development have appeared.

Sixteen federal laws outline the current legal status and relations in the realms of nature protection and resource use. The main defect of regional law is the absence of laws pertaining to environmental bonds or mitigation banking. The latter is based on a fund collected from enterprises, then held in a special bank account. When an environmental violation occurs, the cost is calculated, and the sum is then used for restoration after the closure of the enterprise.

Nature protection agencies face a particularly difficult task in situations where harm is caused and impact needs to

be determined. In cases of oil pollution of forest or mining lands, environmental regulation is invoked only when environmental degradation occurs. But in forests the effects might become evident only after several years. In worsening environmental conditions, sanctions against environmental damage must be severe, practical, and clear. The various administrative organs involved have produced a mélange of laws and documents that often contradict one another, thus undermining the development of a single, unified approach to determining the significance or level of impact.

The implementation of environmental laws is made more difficult by a wealth of declarative laws and an absence of regulatory laws based on practice. Another problem with environmental law is the attempt of various agencies to assume control of resources, under the guise of ecologically based arguments.

Local administrations (city, *raion*, *oblast*) are wary of plans to create protected areas or change the status of existing ones. From their perspective, such designations inevitably lead to the loss of local control of these areas. A visible example is the unwillingness of authorities to give federal-level status to the Odyan or Kavinkskaya Valley Zakazniks for the stated reason that this will turn over control of these reserves to central protection and resource-use agencies. This very reason is the source of continual confrontation between the *oblast* administration and the *zapovednik*. The *zapovednik* is viewed by local authorities as an external structure, and because of this, any proposals to increase its size are resisted from the outset.

Okhotskrybvod. Until recently this was Magadan's largest nature-protection agency and, with almost exclusive control of fishing quota distribution, an economically influential organization. Today, however, a significant number of the staff has been transferred to a newly organized division of the Federal Border Service, which specializes in the protection of marine fisheries. Nevertheless, Okhotskrybvod has its own high-quality fisheries control department, with more than thirty inspectors equipped with jeeps, motorboats, and night surveillance equipment.

However, Okhotskrybvod is subservient to the Federal Fisheries Committee, which many feel has little interest in protecting fisheries. Okhotskrybvod has irregular recruiting practices and has hired people who have been laid off from security agencies and even convicted criminals. Inspectors have been involved in several suspicious homicides. Inspectors are often drunk on the job, and fishermen are routinely physically harassed and beaten. The extent of fish poaching

that now occurs in the Magadan would be impossible if the inspectors carried out their responsibilities.

Magadan Committee on Environmental Protection. Organized in 1988, but now defunct, the committee was made up primarily by officials from the Kolyma Basin Authority on Water Protection, construction engineers, and some staff from Okhotskrybvod. Many members of the staff had no specialized background in environmental protection, in law, or even biology. The scope of the responsibilities of the committee was so broad and there were so few staff members (thirty-five) that implementing their duties was difficult. Nevertheless, the committee was the least corrupt environmental agency in the *oblast*.

Magadan Hunting Service. The department is accountable to both the Agricultural Division of the *oblast* administration and to the Magadan Hunting Service. Many staff members of this agency have expertise (as hunting specialists or lawyers), but resources for protection are practically nonexistent.

Yakuts have only recently moved into the Magadan region, settling primarily in villages along the western border.

Perspective

Alexander King, Josh Newell

Since the early 1990s, multinational mining corporations, with financial assistance from international institutions such as the International Finance Corporation (IFC), the European Bank for Reconstruction and Development (EBRD), and the U.S. Overseas Private Investment Corporation (OPIC), have steadily increased their involvement in and control over gold and silver mining in Magadan. Foreign interests largely control the region's biggest gold producer, the Kubaka mine, and have large stakes in the Dukat and Julietta mines.[19]

Environmentalists, in particular the California-based Pacific Environment, have raised concerns about the environmental and social effects of the Kubaka and Julietta projects. Below we profile the major mining projects in the region, directing attention to the role of foreign investment.

Kubaka. Located in Severo-Evensky Raion, 700 km northeast of Magadan City, the Kubaka project was the first joint venture

to be a given a mineral deposit license in the Russian Federation. In terms of production, the project has been hugely successful; the 13 metric tons of gold produced in 2000 represent almost half of all the gold produced in Magadan.

The Russian-American firm Omolon Gold Mining Company holds the license for the deposit. The American partner was Amax Gold, Inc., which then sold its share to the Canadian Kinross Gold Corporation.[20] Kinross controls 53 percent of Omolon. The Russian partners are AO Geometal Plus (25 percent), Magadan Silver and Gold Company (7 percent), Russian Credit Bank (7 percent), and a local organization of shareholders that includes the Severo-Evensky Raion section of the Russian Association of Indigenous Peoples of the North (RAIPON), which holds 7 percent.

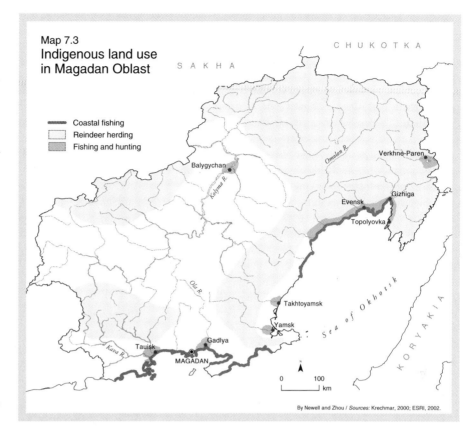

Map 7.3
Indigenous land use in Magadan Oblast

Coastal fishing
Reindeer herding
Fishing and hunting

By Newell and Zhou / *Sources:* Krechmar, 2000; ESRI, 2002.

OPIC and the EBRD provided a total of $130 million in loans and $150 million in insurance for the project.

Kilborn Engineering Pacific, Ltd. (Vancouver, Canada), which in 1993 was contracted to develop technological and economic foundations for constructing the mining facility at Kubaka, estimated gold reserves of 1.627 million ounces at an average grade of 16.08 grams per ton and 2.2 million ounces of silver at 21.67 grams per ton. The deposit is being exploited by open-pit mining and 630,000 tons of ore are extracted each year. Cyanide and water pressure are used to extract the gold ore. The Kubaka mine has a further 16 tons of gold at the Severo-Evensky deposit.[21]

Environmental impact. Some environmental groups claim OPIC and the EBRD are providing financing and political-risk insurance for a poorly designed mine. Pacific Environment, after consulting with the mine's operators and seeing the mine in person, released a report in April 1998 that accused Kubaka project operators of altering the original design of the tailings dam and other structures critical to preventing pollution; these original designs, Pacific Environment pointed out, were used to secure international financing and Russian approval at local and federal levels.[22] Below are several excerpts from Pacific Environment's report:

Unfortunately, based on Pacific Environment's initial analysis of the problems at the Kubaka mine, it believes that it is indeed accurate to call the Kubaka mine a model—a model of a mine that could cause significant

long-term environmental impacts as a result of poor design, improper implementation, and lack of public oversight. Problems include poor disclosure of design modifications, poor baseline data for critical precipitation models, seepage and slope settlement on the critical dam at the tailings impoundment, cyanide-contamination at an inactive tailings site on mine property, and a lack of effective reclamation plans well after the mine is already in operation. The lack of timely response to public requests for information and the response with out-of-date materials sets [sic] a poor standard for this first effort in the RFE.

Many western companies promote themselves as being more environmentally responsible than Russian mining companies. It is true that strong citizens' and governmental oversight in the United States has forced a significant improvement in mining practices in the last twenty years. The early lessons from the Kubaka situation underscore the extreme difficulty of mining in an appropriate manner in Siberia and the RFE and show that even U.S. companies can create significant and potentially long-term environmental problems in the RFE unless there is regular and effective oversight from governmental authorities and the public.

From Pacific Environment's investigation, it is clear that—despite public documents from the EBRD—the practices at the Kubaka mine are not yet "consistent with

good international mining practice." It is incumbent on the company and the international financial institutions—OPIC and EBRD—backing the project to resolve the problems at Kubaka and ensure that the mine does improve its performance to meet strict environmental standards. Pacific Environment suggests that OPIC and EBRD consider withholding any outstanding funds and suspending financial backing until resolution of the above activities and that the banks and company convene an emergency multiparty working group to address the problems at the Kubaka mine.[23]

The Kubaka project unfortunately failed to develop a "zero-discharge" model mine. In late winter 1998, Omolon Gold Mining requested and received permission to release 74,520 cu. m of cyanide-contaminated water from the primary tailings pond. Because of poor design and high rainfall, water levels were critically high after only one year of operation in a pond designed for "zero discharge" over the entire life of the mine. Thus, gradual releases were performed during the spring to avoid a catastrophic spill.[24]

Julietta gold project. The Julietta deposit, discovered during a geological survey in 1989, is in Omsukchansky Raion, 180 km southeast of the town of Omsukchan in the northern part of the Kilgan Mountains and the upper drainage of the right tributary of the Kilgan River. In 1994, AO Dukat-geologia and Omsukchansk Mountain Geology Company (OmGGK) conducted a geological and economic review of the site. In the same year, OmGGK prepared a Declaration of Intent, on the basis of which they were granted land for a road and building site. Preliminary agreement on the site was issued by Administration Proclamation No. 149 of Omsukchansky Raion on June 7, 1994. In 1995, the foreign investor New Arian Resources Limited (Colorado, U.S.A.) joined OmGGK to form a ZAO (closed joint-stock company).

The ZAO has rights, thanks to a license issued on April 21, 1995, to develop the ore deposit and its underground yield, to construct a gold extraction facility, a tailings dump, and employee facilities at the mine shaft. Bema Gold Corporation (Vancouver, Canada) acquired 79 percent of OmGGK in April 1998. In May 1999, a federal law was passed in Russia that recognized the Magadan region as a special economic zone. This allows registered companies, like OmGGK, that are investing in Magadan to benefit from substantial reductions in various federal taxes and import duties. In May 2000, Bema acquired U.S. $10 million in financial backing from the IFC and credits totaling U.S. $25 million from Bayerische Hypo and Vereinsbank of Germany and Standard Bank London of Great Britain.[25] The company expects the project to cost approximately U.S. $75 million.

In August 2000, the other partner in the project, New Arian Resources, secured U.S. $26.2-million worth of political-risk insurance from the Multilateral Investment Guarantee Agency (MIGA), a unit of the World Bank group, to support expanded operations.[26] According to MIGA, the project will increase Russian gold production by 4 percent and create 250 jobs.[27] This financing was secured despite opposition from environmental groups

The Julietta deposit contains initial reserves of 866,000 ounces of gold. The gold extraction facility expects to produce 122,500 tons of ore and 113,000 ounces of gold equivalent annually, at a cost of about U.S. $93 an ounce, over the initial five years of a nine-year mining life. The ore processing at the extraction facility involves the crushing, grinding, and cyaniding of the ore, followed by filtration of tailings and separation of the valuable metals.

In the first quarter of 2002, the Julietta mine produced about 1.5 tons of gold.

Dukat silver project. The Dukat mine, the third-largest known silver deposit in the world, is located 40 km west of the town of Omsukchan. At full production, Dukat is expected to produce about 16.8 million ounces of silver and 34,000 ounces of gold a year. The ore mineralization at Dukat extends over an area covering 2.5 km east to west and 3.5 km north to south. The two mining zones within the area are the Central and Smely (Brave). In 1980, the Dukat GOK started open-pit mining with an annual ore extraction and processing capacity of 400 tons. The ore was processed at the Omsukchan enrichment factory in the town of Omsukchan. Construction of the second phase of the Dukat GOK, which included an enrichment factory and a tailings pit, started in 1985, but was left unfinished after the initial financial crisis.

From 1980 to 1995, Dukat was Russia's largest producer of silver, yielding more than 2 million tons of silver. In 1997, as a result of the economic crisis, the Dukat GOK ceased all mining activity and was declined a license for mineral rights. On November 17, 1997, the company Serebro ("silver") Dukat won a competitive bid for the mineral and mining rights of the Dukat deposit. The founders of Serebro Dukat are the Canadian firm Pan American Silver Corporation and OAO (open joint-stock company) Geometal Plus.

In the spring of 1999, Serebro Dukat arranged financing from the IFC and began construction on the site, which required substantial repairs to the tailings dam, the mill, and other assets. In December 1999, construction work on the Dukat mine was suspended after Kaskol, a Russian company, won an auction to purchase the aboveground assets, including the old mill building, which was being renovated. A feasibility study in January 2000 indicated that the mine would still be profitable with a wholly new mill being constructed closer to the mine itself than the existing one purchased by Kaskol. Serebro Dukat and Pan American Silver tried unsuccessfully to invoke conditions of the lease of aboveground assets to force Kaskol to sell the mill at the price of U.S. $8.3

MAGADAN

million. Pan American Silver has also lost all legal challenges made in local and federal courts, despite clear irregularities in the auction and in Kaskol's demands.[28]

As of February 2002, the Russian firm Polymetal had secured control over 80 percent of the project and was responsible for project financing and management. Pan American Silver holds control over the remaining 20 percent but has declined to invest additional resources in the project.

Vetrensky. This deposit is in the Tenkinsky Raion, 100 km from the raion center of Ust-Omchug and 380 km from Magadan City. The deposit was explored between 1968 and 1972, and now there is a plan for geological surveys on the flanks and in the deeper horizons of the deposit with a goal to increase yield by two and a half or three times.

Natalka (Matrosov). Located 390 km northeast of Magadan in Tenkinsky Raion, this project is still seeking foreign investment. Current production capability is 2 tons of gold per year. A u.s.\$120-million project would increase finished output to 10 tons of concentrated gold per year, according to some analysts.[29] Magadan mining experts say the Natalka deposit is in need of between u.s.\$150 and \$200 million in capital investment. Natalka has 250 metric tons of proven gold reserves and projections show up to a total of 400 metric tons.

The Matrosov complex produced 1.7 metric tons of gold in 1997, slightly lower than the previous year, and 1.22 tons in the first three quarters of 1998.[30] At a shareholder meeting in 1998, shareholders approved a plan to create an open-stock joint-venture company for Matrosov's Natalka deposit. It was proposed that Rudnik Matrosov hold no less than 50 percent of the charter capital in the Natalka joint venture. Placer Dome Exploration (San Jose, California), a subsidiary of Placer Dome (Vancouver, Canada), has expressed an interest in a joint venture for the Natalka deposit.

Orotukan. Orotukan consists of gold in quartz veins along with silver and tin. Portions of the deposit were mined in the 1930s and produced 30 kg of gold. Average values for the surface of the deposit are 6 grams per tons; however some

veins averaging 1 m wide grade up to 150 grams per tons. Gold reserves exceed 300 tons of gold. Geometal Plus used to own all of the mine but as of 2003 their participation is unknown.[31]

Nyavlenga. The project is located in the Olsky Raion. Gold and silver are found in an epithermal deposit. The average ratio of gold to silver is 1:50. Open-pit and underground mining methods are planned. Geometal Plus owns the mine.[32]

Rassokha. Canadian firm Big Blackfoot Resources Ltd., which owns this placer gold property, is seeking foreign investment to restore and develop placer gold operations.

Shkolnoe. The high-grade Shkolnoe gold mine contains steeply dipping veins, and underground reserves are estimated to hold commercially extractable reserves of 10,575 kg gold. In December 1997, a feasibility study of the property was completed. Capital costs to finance the construction and development of the underground mine, processing plant, and surface infrastructure are estimated to be u.s.\$20 million. The processing plant would have a capacity of 250 tons per day, producing an average 51,000 ounces of gold annually. Susuman Gold owns 90.2 percent of the mine, and Canadian firm Galaxy Online, Inc. owns 9.8 percent and an agreement to acquire up to a 50 percent interest through its subsidiary Russgold X. Investment Ltd. (Cyprus).

Berezovskaya (Dubach). The Berezovskaya property covers 95 sq km. Big Blackfoot Resources Ltd. holds a 49 percent interest in the mine through the Russian company Whitefoot Resources Ltd. The majority owner (51 percent) is zao Golden Kolyma.

Chai Yuri. The deposit is located about 20 km from Susuman City and just beneath what was once one of the world's greatest placer gold deposits, which has been successfully mined since 1943 and has produced over 200 tons of gold. Ore deposits are expected to be at least as large as those of the placer deposit. Estimated gold reserves are in the region of 3 million ounces of gold.

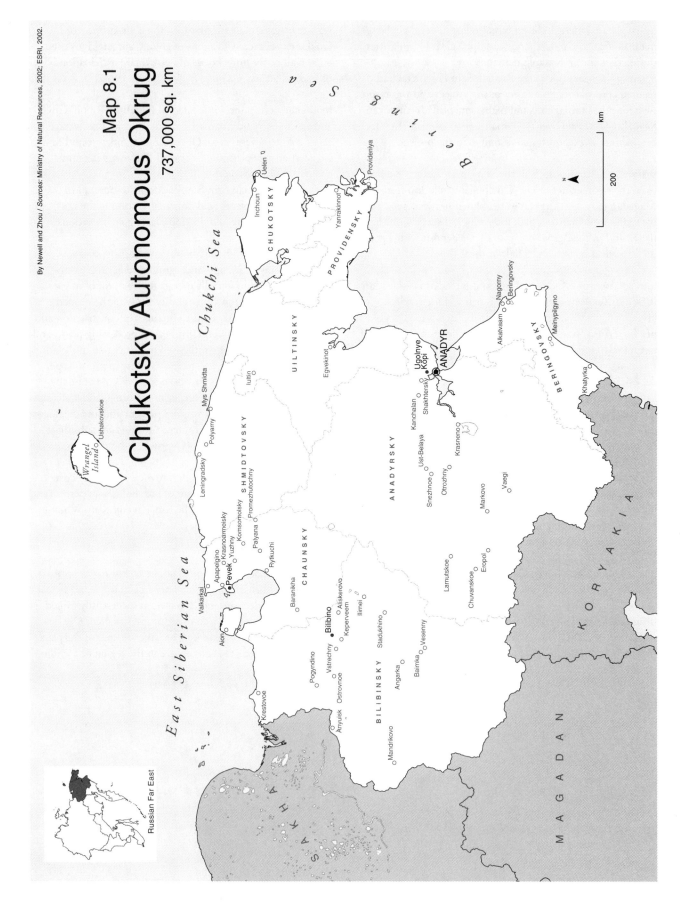

By Newell and Zhou / *Sources:* Ministry of Natural Resources, 2002; ESRI, 2002.

Map 8.1

Chukotsky Autonomous Okrug

737,000 sq. km

Bering Sea

km

200

N

Chukchi Sea

Uelen
Inchoun

CHUKOTSKY

Yanrakinnot

PROVIDENSKY

Provideniya

Nagorny
Beringovsky

Melnypilgyno

Alkatvaam

BERINGOVSKY

Khatyrka

Egvekinot

UILTINSKY

Ugolnye
Kopi
ANADYR
Shakhtersky
Kanchalan

Krasneno

Ust-Belaya

ANADYRSKY

Snezhnoe
Otrozhny

Markovo

Vaegi

Iultin

Mys Shmidta

Polyarny

SHMIDTOVSKY

Leningradsky

Komsomolsky
Krasnoarmeisky
Yuzhny
Promezhutochny
Palyana
Rytkuchi

Apapelgino
Pevek
Valkarkai

Alon

Krestovoe

Baranikha

CHAUNSKY

Bilibino
Aliskerovo
Keperveem
Ilimei
Stadukhino

Vstrechny
Ostrovnoe
Pogyndino

Anyuisk

Mandrikovo

Angarka

Baimka
Vesenny

BILIBINSKY

Lamutskoe

Chuvanskoe

Eropol

KORYAKIA

MAGADAN

S A K H A

Ushakovskoe

*Wrangel
Island*

East Siberian Sea

Russian Far East

282 ■ THE RUSSIAN FAR EAST

Chukotsky Autonomous Okrug
(Chukotka)

Location

At the northeastern tip of Russia, the 85-km Bering Strait separates Chukotsky Autono-mous Okrug (Chukotka) from Alaska. Ratmanov Island (Russia), the bigger of the two Diomede Islands, is less than five kilometers from the other Diomede Island, which belongs to the United States. Magadan Oblast and Koryak Autonomous Okrug border Chukotka to the south, while the Arctic Ocean (East Siberian Sea and Chukchi Sea) and the Pacific Ocean (Bering Sea) wash northern and eastern shores. Chukotka is nine time zones away from Moscow.

Size

About half the size of Alaska: 737,000 sq. km. The sixth largest administrative area of Russia, Chukotka has eight *raion*s.

Climate

Heavily influenced by the two great oceans that surround it, Chukotka's weather is unstable with strong, cold northerly winds that can quickly shift to southerly, wet storms. Cyclones occur frequently. Coastal areas have an average of 150 windy days per year. Precipitation averages between 200 to 400 mm per year. Navarin Cape has the highest incidence of hurricanes and storms in Russia. Ice covers the surrounding seas most of the year. Chukotka averages between 80 to 100 growing days per year.[1] January temper-atures average between −15°C and −35°C, with July temperatures averaging between 5°C and 14°C.

Geography and ecology

The region is mountainous. Chukotka's largest rivers, the Anadyr, Greater Anyui, Lesser Anyui, and Omolon, all flow from the mountainous western part of the peninsula, where peaks reach 1,800 m. The Anadyr River flows east, meandering through lowlands of marshes, plains, and riparian forests before emptying into Anadyr Bay and the Bering Sea. The Lesser and Greater Anyui Rivers flow north, through another lowland of plains and marshes, and cross the border into the Republic of Sakha before merging and emptying into the great Kolyma River. The third major lowland area is just south of Chaun Inlet, where numerous small rivers and streams flow north into this bay. Mountains, though not quite as high as those found in the west, dominate much of central and eastern Chukotka. The largest lakes are Krasnoe and Elgygytgyn.

The Bering Strait provides for the only exchange of water between the Pacific and Arctic Oceans in the northern hemisphere. The ocean current that flows north just

southeast of Navarin Cape to Anadyr Bay and through the western portion of the strait carries rich nutrients that fuel the production of massive amounts of phytoplankton and zooplankton, making the region one of the most productive marine areas in the world.[2]

Chukotka can be divided into four vegetation belts: arctic tundra, subarctic tundra, tundra woodland, and boreal forest. Arctic tundra, heavily influenced by the cold Arctic Ocean, includes Wrangel Island and nearby islands and a strip of coastline between the Kolyma River and Kolyuchinskaya Bay in the east. Vegetation similar to western Alaska, primarily mosses, lichens, and small shrubs, covers about half the region. Wrangel Island has especially diverse flora with many endemic, American, and steppe species. Subarctic tundra, with areas of tall shrubs and lichen grasslands, grows throughout much of Chukotka. It gradually turns into tundra woodland toward the southwest, and includes the extensive riparian forests of Anadyr basin. The tundra can be spectacular: "On this wild northern land neck, light plays in the green expanse of tundra in the summer time and highlights the bonfire of colors in early fall."[3] Tundra woodland, primarily Dahurian larch (*Larix gmelini*), willows (*Salix*), and poplars (*Populus*), grows in the lowlands of western Chukotka. Woodlands also exist in southern Chukotka although these elfin forests reach only 4 to 5 m in height. Tall boreal forests are mostly limited to the Omolon and Greater Anyui valleys in the western Chukotka.

Flora and fauna

Chukotka is part of the ancient Beringia region (land and aquatic ecosystems on both the U.S. and Russian sides of the Bering Strait). The land bridge created unique plant communities in Chukotka; the region was a hotbed for species formation during the glacial and interglacial periods. Now Chukotka has 48 percent of the world's ninety-six endemic vascular plants of the Arctic; the most important regions are Wrangel Island with 17 percent of the total, Beringian Chukotka with 14 percent, and continental Chukotka with 12 percent.[4] In all, Chukotka has more than nine hundred species of vascular plants, about four hundred species of mosses, and four hundred species of lichens.

Fauna is also diverse with 220 bird species and 59 mammal species, 37 of which are terrestrial and the other 22 cetaceans and pinnipeds. Ten whale species frequent the coasts: gray (*Echrichtius robustus*), bowhead (*Eubalaena mysticetus*), humpback (*Megaptera novaeangliae*), fin (*Balaenoptera physalis*), sei (*B. borealis*), minke (*B. acutorostratus*), blue (*B. musculus*), beluga (*Delphinapterus leucas*), killer (*Orcinus orca*), and narwhal (*Monodon monoceros*). Of these, gray, bowhead, and beluga whales are the most regular visitors. Almost 80 percent of the populations of breeding polar bears (*Ursus maritimus*) in the Bering and Chukchi Seas den and give birth on Wrangel and Herald Islands.[5] About half of the world's population of Pacific walruses (*Odobeus rosmarus divergens*) frequent the rookeries along the coast. Fur (*Callorhinus ursinus*), harbor (*Phoca vitulina*), and spotted (*Ph. larga*)

Key issues and projects

Oil and gas development

In 2001, Russian industry giants Sibneft and Yukos began exploratory drilling in Chukotka. Development in this fragile region could affect the most important year-round habitat for polar bears in the circumpolar Arctic (see p. 305).

A floating nuclear power plant for Chukotka?

The government has ambitious plans to install a series of floating nuclear power plants along the coast of Chukotka. Aside from obvious concerns about nuclear waste and accidents, critics maintain that developing wind and solar energy sources would be cheaper and safer (see p. 304).

seals are common in the southern part of the Bering Sea; ribbon (*Ph. fasciata*), ringed (*Ph. hispida*), bearded (*Erignathus barbatus*), and spotted (*Ph. largha*) seals are found in more northern waters.[6] Endangered Steller's sea lions (*Eumetopias jubatus*) also live in the west Bering Sea.

These marine mammals rely on Chukotka's fisheries; the Bering Sea alone has more than 450 fish and shellfish species. Mollusks and crustaceans are commercially important species and include crab, shrimp, and whelks. The Bering Sea boasts five species of Pacific salmon: chinook (*Oncorhynchus tshawytscha*), coho (*O. kisutch*), sockeye (*O. nerka*), chum (*O. keta*), and pink (*O. gorbuscha*). Chukotka also has large river and lake fisheries.

Thousands of migratory birds travel from wintering grounds in the Americas, Asia, and Europe to breed and feed in the region. Seabirds and waterfowl, which form huge bird colonies along the rocky shores, islets, sandy spits, and estuaries, include nearly 3.3 million seabirds on the eastern coast of Chukotka peninsula alone.[7] These include pelagic cormorants (*Phalacrocorax pelagicus*), guillemots (*Cepphus*), murres (*Uria*), auklets (*Aethia*), puffins (*Fratercula*), gulls (*Larus*), various ducks and waders.

Largest cities

Anadyr (pop. 13,000), the capital and largest city, serves as the administrative center. Pevek (pop. 11,000), established in the 1930s, is above the Arctic Circle and the most northern city in Russia. It was once a major seaport. Without the aid of icebreakers, ships can access the city only one hundred days per year; now only two or three ships arrive to bring supplies.[8] Bilibino (11,000), the site of the RFE's only nuclear power plant, is also a gold mining outpost.

Population

Chukotka's population is rapidly dwindling as a result of industrial decline and the loss of federal government subsidies. The population in 2001 was 75,300, down from 113,000 in 1995 and 157,000 in 1989.[9] Seventy-two percent of the residents live in cities. Most are immigrants, who came to the region because of high-paying jobs and other perks offered by the Soviet government. Approximately 17,000 indigenous peoples, primarily Chukchi and Yukagirs, Yupik Eskimos, Koryak, and Evens, make their home here.

Political status

In 1930, the USSR created Chukotka Autonomous Okrug, but for most of its history the *okrug* has been under the control of a neighboring administrative region. It was under jurisdiction of the Kamchatka Oblast administration until 1951, under Khabarovsk Krai from 1951 until 1953, and under Magadan Oblast from 1953 until 1993, when a Russian constitutional court finally allowed it to separate legally. Billionaire oligarch Roman Abramovich was elected governor in 2001.

Natural resources

Chukotka has the second largest gold reserves in Russia and numerous other mineral resources such as tin, mercury, coal, copper, tungsten (14 percent of all RFE reserves), and silver. Maiskoe gold reserve, located 280 km southeast of Pevek, is the largest in Chukotka.[10] Reportedly, the quality of gold deposits in Chukotka is much higher than that in nearby Kolyma reserves (Magadan Oblast).[11] Copper reserves are mainly in the

Peschanka field located 150 km south of Bilibino. Tin reserves are in the Pyrakaiskoe deposit located 80 km east of Pevek. Marine resources, mostly pollock, are also significant, but poor fishing practices have reduced salmon stocks by an estimated 50 to 75 percent of what they were in the 1940s.[12] Onshore and offshore oil and gas reserves have recently been discovered. The reserves include: Anadyr Reserve (onshore: 20 million metric tons; offshore: 110 million metric tons) and Khatyr Reserve (onshore: 25 million metric tons; offshore: 85 million metric tons).[13] Chukotka is the RFE's least forested region, with timber reserves averaging just eighteen cu. m per ha.[14]

An Arctic fox (Alopex lagopus) *stretches amongst the Wrangel Island tundra.*

Nikita Ovsyanikov

Main industries

The mining industry, particularly gold mining, has traditionally been the backbone of the economy, providing 71 percent of Chukotka's total industrial production. Gold mining takes place primarily in Bilibinsky, Schmidtovsky, and Chaunsky Raions, with tin mining in Chaunsky and Iultinsky Raions. In 2000, production was about one ton. During Soviet times, Chukotka accounted for 20 percent of the total USSR tin production, but now production has almost ceased.[15] Other major industries include power and energy (19 percent), primarily the Bilibino nuclear power plant (48 MW) and the Chaunsky power plant. The fuel industry (3 percent) is essentially coal production (1.1 million tons) near Anadyr and in Beringovsky. Oil and gas exploration is under way. Chukotka's ports serve as supply points for the Northern Shipping Route.

Commercial salmon fishing is centered on the mouth of the Anadyr River, where about 1,000 metric tons are caught yearly. Okrug government officials plan to develop the industry, as they receive annual quotas (2,000 tons of pollock and cod) from the federal government. However, they lack modern fishing equipment and sell most of the quota to foreigners. The *okrug* government wants to increase fishing production, particularly in Anadyr Bay. Over 1 million tons of fish are now harvested in the seas north and east of Chukotka.

Indigenous peoples have rights to harvest 169 whales, 10,000 ringed seals, and 3,000 walruses yearly. By-products from these marine mammals are used to feed cultivated pelt-bearing animals such as foxes. Food production is limited due to the harsh climate; most vegetable cultivation is done in greenhouses. Reindeer breeding is in steep decline, with reindeer decreasing from 464,457 in 1985 to just 148,000 in 1998.[16]

In winter, Arctic foxes become nomadic. Some remain in the tundra, others travel for hundreds of miles into the forests or across frozen seas. Their tracks often look like "negatives," as wind blows away the softer snow around them.

Infrastructure

To move resources, goods, and people within, to, and from Chukotka, a complicated system of marine ports, rivers, ice and gravel roads, and airports are used. Chukotka's eight seaports (Anadyr, Beringovsky, Egvekinot, Lavrentia, Zelyony Mys, Provideniya, Mys Shmidta, and Pevek) primarily service the Northern Shipping Route, which goes from Murmansk to the Pacific, to export gold and tin and to bring supplies to mining settlements. Most roads link interior cities and settlements with ports along this shipping route. Bilibino has access to the sea by a 300-km ice road and riverway to Zelyony Mys. Pevek port services the nearby Komsomolsky gold field, the Valkumei tin mine, and the Krasnoarmeisky tin deposits.[17] A road connects the town of Iultin, which produces tin and tungsten, to Egvekinot port. The primarily ice or dirt roads, rather than gravel, limit year-round access. Chukotka has no highways or railways, but does have a number of decaying but functioning airports, including those located in Anadyr, Pevek, Markovo, and Provideniya. During the Soviet period, transport between the large settlements and cities was by air, but now most people travel by ground, mainly on river routes and by *vezdekhod* (passenger tank).

Foreign trade

Chukotka imports most food products, particularly meat and vegetables from Alaska, making the cost of living one of the highest in the RFE. Experts maintain that foreign trade is underreported. The sale of fish quotas and shipments of gold are not registered as trade. One journalist quipped that Chukotka must import everything from "toilet paper to light bulbs" and pay for them with earnings from the raw materials it exports.[18]

Economic importance in the RFE

Since the 1930s, Chukotka has served mainly as a source of tin and gold, as a base port for the Northern Shipping Route, and as a strategic military territory because of its proximity to the United States.

General outlook

Chukotka needs to resolve its persistent energy crisis. Power cuts and blackouts are common. In the winter of 1999, power was shut off for four hours a day.[19] Reduced coal production because of declining federal government financing and rising costs to import coal have led pleas by the *okrug* government for more support from Moscow. The peninsula also relies on the aging Bilibino nuclear plant, which many local residents and ecologists believe to be unsafe. They point to the spent fuel and liquid waste that has accumulated

at the plant, to the high radiation doses noted among plant personnel, and to the plant's inefficient filtering systems. However, the real radioactive waste disaster so far has been the leakage from RITEGs (radioisotopic thermoelectric generators) that power shipping beacons for the Northern Shipping Route. Scientists have classified fifty-seven of these RITEGs as radioactive waste. Reportedly, lack of funds has slowed their removal.

The government plans to build a number of floating nuclear power plants, the first to be installed by 2006 near the town of Pevek. Aside from obvious concerns about an accident, critics maintain that the cost of generating such energy is much higher than the cost of wind or solar power. Scientists estimate that Chukotka can generate 1.5 trillion kW annually, or about 14 percent of all commercially viable wind energy resources in Russia. Rather than promoting outdated forms of power generation, environmentalists would like to see the Chukotka administration and the master planners in Moscow promote renewable sources. Energy development has been tied to mining of the peninsula's mineral resources and thus has focused on supplying power to mining settlements and ports. Moscow has had little interest in developing sustainable, inexpensive energy sources for the citizens of Chukotka, particularly for the numerous small fishing, hunting, and reindeer herding settlements that dot the peninsula's coastline.

To reinvigorate the economy, the government is trying to attract foreign investment in the mining sector, but interest has been limited because of the high operating costs in the region and lack of a stable energy supply. Open-cast mining along the river valleys has destroyed large areas of land including productive reindeer pastures. Portions of the northern coastal region of Chukotka have been destroyed by the Komsomolsky, Peveksky, and Polyarninsky mining ventures. Placer deposit mining, specifically quarry and dredge mining, in the Ichuveem River basin has created artificial floodplains and river terraces. In the river basins that flow straight into the Chukchi Sea, about 60,000 ha of soil and vegetation have been partially or totally destroyed. These rivers are a constant source of pollution in the Arctic Sea, increasing the possibilities of serious destruction of the marine ecosystems.[20] In this extreme environment, effective technology is essential to restore these destroyed lands.

The government also has ambitious plans to increase the harvest of bioresources, particularly coastal fisheries, and is already developing oil and gas reserves. Fisheries resources in the Bering Sea continue to be mismanaged with overfishing, bottom trawling, use of drift nets, and poaching. The government is also pondering the introduction of hatcheries, which could lead to competition with native species and genetic pollution from these nonnative stocks.[21] Environmentalists would rather see support for adventure tourism, the reindeer herding industry, and sustainable but limited fisheries development.

The election of Roman Abramovich in 2001 as governor has led to increased optimism among residents about Chukotka's future. He has made some important gestures, including delivering food supplies, increasing the reindeer stocks, paying back wages, and increasing tax collection. It remains to be seen whether his efforts will have lasting impact. Critics would like to see more emphasis on development of alternative energy sources and small businesses, rather than oil and gas extraction and expansion of gold mining.

Population and industrial decline is leading to lower anthropogenic pressure on ecosystems, but is also leading to increased poaching as a result of unemployment and the lack of an adequate food supply. Therefore, stabilizing the economic situation of Chukotka is critical to ensuring protection of the region's ecosystems.

Sea ice in the Bering Sea has diminished by about 5 percent over the past thirty years.[22] Scientists fear that this diminishing ice cover, caused by global warming, will lead to a decline of microalgae, which live on the underside of or in the ice itself. These algae are the foundation for the Arctic food chain. The reduced ice cover also means reduced habitat for polar bears, seals, and other marine mammals and may disrupt weather patterns, leading to an increase in storms.

The introduction of alien species, such as rats and marine organisms, is also a threat: ships along the Northern Shipping Route transport these species on hulls, in ballast tanks, and on anchors. Other urgent environmental issues to address include limiting the impact of all-terrain vehicles on the fragile tundra, establishing waste-treatment centers in towns and settlements, particularly for petroleum products, and developing international programs to conserve marine mammals and migratory birds. Protected areas cover 8.3 percent of Chukotka's landmass, and funding is needed to support these reserves and to create new ones. Much of Chukotka's rare endemic flora remains unprotected.

—*Josh Newell*

NASA

Arctic pack ice breaks up and rushes southward through the Bering Strait (pictured here slightly above center).

Ecology

Gennady Smirnov, Maxim Litovka, Dmitry Naumkin

Mountainous Chukotka Autonomous Okrug lies in the extreme northeast of the RFE, divided from Alaska by the Bering Strait. Three mountain ranges, reaching 1,800 m in height, dominate the topography:

1. The Kolyma-Chukotka mountainous region, including the Anyui Plateau and the northern part of the Chukotka Plateau, which stretches east toward the Bering Strait.
2. The Okhotsk-Chukotka mountainous region, which includes the Anadyr Plateau and the southern part of the Chukotka Plateau.
3. The Anadyr-Koryak mountainous region, located in the southeast of the *okrug*, which includes the Chukotka section of the Koryak Plateau.

The three geographically separate lowlands areas (Anyui, Chaun, and Anadyr) are primarily plains, marshes, and lakes.

The East Siberian and Chukotka Seas, part of the Arctic Ocean, surround Chukotka to the north and northeast, while the Bering Sea, part of the great Pacific Ocean, lies to the east. The coldest is the East Siberian Sea with depths averaging between 60 and 70 m. The Chukotka Sea is the shallowest, with average depths of between 40 and 60 m. Ice covers them in winter, but melts partially in summer. Because of these ice conditions, shipping is sporadic. The Bering Sea, the warmest of the three seas, is most suitable for shipping, although the northern section also freezes in winter. Ice in Anadyr Bay is thickest in March; it begins to melt by the end of April and is usually gone by July.

Chukotka's seas teem with fish. The Bering Sea alone has more than four hundred fish species from sixty-five families; of these, fifty species from fourteen families are commercially valuable. The most important are walleye pollock (*Theragra chalcogramma*), Pacific cod (*Gadus macrocephalus*), Arctic cod (*Boreogadus saida*), Pacific herring (*Clupea pallasi*), smelts (*Osmerus*), capelin (*Mallotus villosus*), halibuts (*Hipoglossus*), and rockfish (*Sebastes*). Aquatic invertebrates are also plentiful. Mollusks and crustaceans are the most commercially important species and include crabs (*Callinectes, Paralithodes,* and *Cancer*), shrimp, squid, and whelks.

Seabirds and waterfowl form huge colonies along the rocky shores, islets, sandy spits, deltaic formations, and estuaries. Notable species include cormorants, guillemots, auklets, puffins, gulls, ducks, and waders. Twelve cetacean and eight pinniped species live in the Chukotka seas. Pacific walruses form sixteen rookeries during the thaw period. Three species of Phocidae inhabit the coastal zone: bearded, ringed, and spotted seal. The pelagic ribbon seal, usually seen in the sea, is rare here.

Winters are long and summers are short. In northern Chukotka, in January, temperatures reach as low as −28°C; in July they hover between 4°C and 8°C. Annual precipitation, mainly snow, is between 150 and 400 mm. Average wind speeds on the coast are 10 to 15 m per second, and reach 30 to 35 m per second during storms. Snow cover of 600 mm is continuous from the end of September to mid-July. More than 150 days of the year are without true sunlight.

A continental climate dominates the western and central portion of Chukotka. Annual precipitation ranges between 300 and 500 mm. Snow cover is heaviest in the east, averaging 1 m, but declines in the west to as little as .3 m. The Koryak Plateau and the Penzhina-Anadyr lowlands, with an annual average of 300 to 500 mm of precipitation, are in the moderate continental and maritime climate zones. Snow cover ranges between .5 m and 1 m. Winter winds, from the north, have an average speed of 9 m per second. January temperatures reach −36°C in the continental zone and −25°C in the moderate continental zone. July temperatures reach 14°C.

Influenced by a monsoon maritime climate, southeastern coastal Chukotka has the warmest temperatures and heaviest rainfall (700 to 900 mm annually) in the *okrug*. Snow cover reaches 1.5 m in the mountains and in the south. Temperature extremes here are −13°C to 15°C and 8° to 9°C, in January and August, respectively.

Vladimir Dinets

Thamnolia (elongated one on top of photo), Cetraria (all others), Cladonia, and other tundra lichens are the primary food sources of wild and domestic reindeer.

CHUKOTKA

Vegetation

The arctic tundra region, influenced by the cold northern seas, includes Wrangel Island, other nearby islands and a thin strip of coastline between Kolyma River and Kolyuchinskaya Bay. The coarse, acidic, and organically deficient soils support a paucity of vegetation and low basal area coverage (50 to 70 percent.) Plants are primarily chamaephytic, with a prostate habit that allows them to survive the severe winter. Plants include mosses, lichens, some species of grasses, saxifrages (*Saxifraga*), mountain avens (*Dryas*), *Vaccinum* berries, Labrador tea (*Ledum*), bearberry (*Arctostaphylos*), dwarf birches (*Betula*), and dwarf versions of other shrubs. In a few locations, hot springs and thermal vents support associations of other plants that depend on this harsh habitat. Flora is more diverse in river valleys. Wrangel Island has unique flora that developed independently from the paleo-Beringia landmass and is rich in endemics. Vegetation of this arctic tundra is similar to that of western Alaska.

Terrestrial vertebrates living in the arctic tundra include brown (*Lemmus trimucronatus*) and collared (*Dicrostonyx torquatus*) lemmings, arctic fox (*Alopex lagopus*), snowy owls (*Nyctea scandiaca*), rock ptarmigan (*Lagopus mutus*), snow geese (*Anser caeruleus*), all species of eiders (*Somateria*), long-tailed duck (*Clangula hyemalis*), various species of gulls (*Larus*) and sandpipers (*Calidris*), jaegers (*Catharacta*), snow buntings (*Plectrophenax nivalis*), and Lapland longspurs (*Calcarius lapponicus*).

Subarctic tundra. Chukotka's subarctic tundra has more vegetation than the more northern tundra, and the river valleys contain sparse larch stands, willow and poplar forests in riparian areas, and birch. Here plant cover is almost continuous, interrupted only on steep or windswept slopes. Diverse grass beds rich in lichen, prime feeding grounds for reindeer, cover the uplands.

Insect diversity is insignificant. Hymenopterans, Dipterans, Lepidopterans, and Coleopterans are the common groups. A number of species of spiders live in the tundra. Common animals include gray wolf (*Canis lupus*), ermine (*Mustela erminea*), variable hare (*Lepus timidus*), Arctic ground squirrel (*Spermophilus parryi*), brown lemming, forest lemming (*Myopus schisticolor*), voles (*Microtus*), raven (*Corvus corax*), willow ptarmigan (*Lagopus lagopus*), sandhill crane (*Grus canadensis*), greater white-fronted goose (*Anser albifrons*), bean goose (*A. fabalis*), ducks (*Anas*), gulls (*Larus*), dunlin (*Calidris melanotos*), hoary redpoll (*Acanthis hornemanni*), snow bunting, and Lapland longspur.

Tundra woodland and boreal forests. Western Chukotka has scattered areas of woodlands, which are primarily Dahurian larch and Japanese stone pine and, in floodplains, chosenia (*Chosenia arbutifolia*) and poplar. Tundra grows at higher elevations where there is little winter snow cover. River valleys have sphagnum bogs and sedge tussock meadows, while lichen and Japanese stone pines cover the higher elevations. Tall boreal forests are mostly limited to the Omolon and Greater Anyui valleys. Dahurian larch is the canopy species in the larch forests. The upper understory is Japanese stone pine, birch, and alder shrubs. Green mosses and shrubby lichens grow along the ground. Larch forests are important in part because of their relatively fast circulation of biomass. Larch trees drop their needles annually, and the needles are rapidly processed by microorganisms. Stands of Japanese stone pine that fail to grow higher than 2 m form thickets. In southern Chukotka this growth forms elfin forests, with heights up to 5 m. These trees retain their needles for between five and eight years, and a slow detritus cycle prevents undergrowth from developing. Fires are frequent here because of large quantities of easily combustible matter.

Bark-eating beetles, longhorn beetles, and leafcutters live in the larch, Japanese stone pine, and alder trees. Bloodsucking Dipterans, mosquitoes, and midges are the most common insect fauna. The main vertebrate animals are brown bear (*Ursus arctos*), moose (*Alces canadensis*), wolverine (*Gulo gulo*), sable (*Martes zibellina*), variable hare, voles, golden eagle (*Aguila chrysaetos*), Northern goshawk (*Accipiter gentillis*), scoters (*Melanitta*), Eurasian magpie (*Pica pica*), spotted nutcracker (*Nucifraga caryocatactes*), wagtails (*Motacilla*), common redpoll (*Acanthis flammea*), leaf warblers (*Phylloscopus*), pipits (*Anthus*), and bluethroat (*Luscinia svecica*).

Rivers and lakes. Chukotka's larger rivers are the Anadyr, Amguema, Greater Anyui, Lesser Anyui, and Omolon. The rivers freeze over completely, with ice covering them up to eight months a year, and large ice floes at higher elevations do not melt for years. Snowmelt is the primary source of water for these Arctic rivers, with precipitation and groundwater as lesser secondary sources. Groundwater, surface water, and precipitation feed the rivers that flow into the Pacific. The headwaters of Chukotka's rivers have velocities of up to 4 m per second. Riverbeds are rocky with little sediment. The upper reaches of rivers contain little plankton. In the lower reaches, plankton biomass increases and benthic organisms decrease. Aquatic invertebrates include crustaceans that make use of the slower water and silt of the lower reaches and estuaries. The small lakes in the tundra freeze completely and plankton biomass is insignificant even during peak productivity in the summer when the water is warmest. Typical organisms are copepods and water fleas. The only amphibian is Siberian salamander (*Salamandrella kesserlingii*) found in shallow lakes of the south and west.

Forty-four species of fish from ten families live in the rivers and lakes. Salmon and whitefish (*Coregonus, Prosopium,* and *Stenodus*) species are the most important commercially, but the chum fishery in Anadyr Bay is the largest and widely considered the best in the RFE. There are also three species of char (*Salvelinus*), one of them endemic to Lake Elgygytgyn. Other typical ichthyofauna include the Arctic grayling

(*Thymallus arcticus*), burbot (*Lota lota*), sculpins (*Cottidae*), three species of lamprey (*Lampetra*), Northern pike (*Esox esox*), sticklebacks (*Gasterosteidae*), and Alaska blackfish (*Dallia pectoralis*).

Two hundred and twenty species of birds live in Chukotka. There are fifty-five species of mammal, thirty-seven of which are terrestrial (insectivores, rodents, lagomorphs, ungulates, and carnivores.) The remaining eighteen are cetaceans and pinnipeds.

Protected area system

Until 1976, Chukotka's protected area network consisted of five regional-level *zakaznik*s (Tundrovy, Tumansky, and Avtatkuul in the Lower Anadyr lowlands, Ust-Tanyurersky located on a main tributary of Anadyr River, and Teyukuul on the eastern shore of Chaunskaya Inlet) and one federal-level *zakaznik* on Wrangel Island.

The rapid industrialization of Chukotka during the 1970s brought vigorous mining and intensified prospecting for oil and gas. Settlements were erected and new roads were built. Use of heavy-tracked vehicles increased abruptly, scarring formerly pristine tundra areas throughout Chukotka. The wave of migrants from the central regions of the country were mostly interested in the promise of quick and easy earnings.

Vladimir Dinets

There are seven species of lemmings in the RFE. Their numbers peak sharply every few years; this cycle is extremely important for all other inhabitants of the tundra. When abundant, lemmings become bold and sometimes aggressive.

These circumstances drastically increased the threat to the natural ecosystems of Chukotka.

Anticipating this threat, environmentalists raised awareness in media and through scientific publications of the need to establish new protected areas. Of particular concern were population declines, and in some cases disappearance, of rare and endangered species: emperor goose (*Anser canagicus*), lesser white-fronted goose (*A. erythropus*), tundra bean goose (*A. fabalis serrirostris*), black brant (*Branta nigricans*), Steller's sea eagle (*Haliaeetus pelagicus*), and others. With these continued efforts and the signing of Soviet-Japanese and Soviet-American treaties to protect migratory birds and their habitats, the reserve system was expanded. In 1976, the *zakaznik* on Wrangel Island was declared a *zapovednik*.

In 1977, the Chukotka Okrispolkom (*okrug* executive committee) approved a plan to create fifteen new reserves. However, biased Party technocrats, Soviet leaders, and mining and agricultural companies continually opposed implementing this program, and this opposition delayed the process. The first of the planned reserves, Omolonsky, was not created until 1980, and only in 1984 was the federal *zakaznik*, Lebediny, approved.

Perestroika brought social and political reforms that led to an explosion of grassroots environmental activity in Chukotka. Local ecologists and activists managed to prevent construction of Amguema Hydroelectric Power Station, which would have flooded large areas of reindeer grazing grounds and relict poplar stands.

In 1990, then-Presidents Mikhail Gorbachev and George Bush agreed to create an international park, Beringia, to allow collaboration between Russian and American scientists and nature conservation specialists. This plan was discussed regularly during Gore-Chernomyrdin Commission meetings. In 1993, the Chukotka government established Beringia, a regional-level nature-ethnographic park. On August 14, 1994, the Russian prime minister, Viktor Chernomyrdin, instructed the minister of the environment to develop the Russian portion of Beringia Park. However, from the outset, progress was stymied by endless debate within executive and legislative branches of government on all levels. Suddenly, many opposed creating the park. The *okrug* administration was particularly opposed, as exemplified by statements from the former governor, Alexander Nazarov.

In 1994, the Russian government approved an ambitious plan to create a number of new protected areas throughout Russia by 2005. Two were planned for Chukotka: a national park, Tsentralno-Chukotsky (Lake Elgygytgyn

basin region), and a *zapovednik*, Pribrezhny, in the Meinyp-ilgyn lake and river region). The Chukotka Committee on Environmental Protection completed a feasibility study to create the national park, but plans changed to designate it as a regional park. Implementation of this study is indefinitely delayed due to lack of funds. In 1995 environmentalists had great expectations for the presidential decree No. 1032, dated May 10, 1995, which guaranteed financial support to *zapoved-nik*s and national parks through 2005. However, these hopes were quickly dashed when former President Yeltsin annulled the decree.

The *okrug* government has adopted its own document on the expansion of protected areas, which included two *zapovednik*s, five national parks, and twenty-four *zakaznik*s. If the plan is implemented, 15 to 20 percent of Chukotka will be protected. In 1995, responding to demands of the indige-nous village, Rytkuchi, and, at the initiative of the Chaunsky Raion administration, the regional government created the Chaunskaya Guba (Chaun Inlet) Zakaznik to stem further decline of game populations. Game decline can be traced to opening the Bilibino-Pevek highway, which in turn, led to increased poaching. This *zakaznik* is the only regional *zaka-znik* to be created in Chukotka in the post-Soviet era.

The protected area system in Chukotka is not expanding because of political and economic difficulties both in Russia and in Chukotka. The total area protected in some form in Chukotka amounts to 5,533,000 ha (8.3 percent of the *okrug* territory). Ostrov Vrangelya (Wrangel Island) Zapovednik

totals 1.1 percent of the territory, one regional nature park totals 4.2 percent, one federal and six regional *zakaznik*s total 2.8 percent, and twenty natural monuments make up 0.2 percent.

Maintaining the protected area system in Chukotka is becoming increasingly difficult. This is particularly apparent on Wrangel Island, the most inaccessible and geographically isolated of the reserves. This *zapovednik* is also responsible for the welfare of the island's only village, Ushakovskoe. Supply-ing the settlement with adequate food, heating and electricity, communications, and utilities is beyond the reserve's meager budget. Deteriorating social and economic conditions on the island have produced a flood of complaints from the residents; in response, *okrug* authorities decided to return the *zapovednik* to the local jurisdiction of Chukotsky Autono-mous Okrug.

Financing for Lebediny Zakaznik, which has federal status, is also inadequate. It does not even appear as a separate item in the game department's budget. Salaries for the reserve director and the only ranger are repeatedly delayed. Of the six regional reserves, only three (Chaunskaya Guba, Omolonsky, and Ust-Tanyurersky) have any staff (one ranger each) and they receive their salaries sporadically. All the protected areas lack proper transport equipment, spare parts, communication equipment, and field gear. Most, as a result, have been left defenseless to poachers and other forms of illegal activity.

With industrial development and shipping activity down because of the economic decline, there is a general feeling

Table 8.1

Protected areas in Chukotsky Autonomous Okrug

Type and name	Size (ha)	Raion	Established
Zapovednik			
Ostrov Vrangelya (Wrangel Island)	759,650	Ushakovsky	1976
Zakazniks			
Tundrovy (Tundra)	500,000	Anadyrsky	1971
Ust-Tanyurersky	450,000	Anadyrsky	1974
Tumansky	389,000	Anadyrsky	1971
Lebediny (Swans)	250,000	Anadyrsky	1984
Chaunskaya Guba (Chaun Inlet)	210,500	—	1974
Omolonsky	160,000 (32,000 in Chukotka)	Bilibinsky, Magadan Oblast	1980
Avtatkuul	159,700	Beringovsky	1971
Regional Nature-Ethnographic park			
Beringia	3,000,000	Providensky, Chukotsky	1993

Source: Chukotka Committee on Environmental Protection, 2000.

that creating new protected areas is less urgent. However, it is only logical to expect new industrial expansion in Chukotka, particularly the exploitation of land, marine, and oil and gas resources. Preemptive action should be taken, the most important of which is to create new *zapovednik*s, national parks, and *zakaznik*s.

Zapovedniks. Chukotka has just one *zapovednik*, Ostrov Vrangelya. Wrangel Island, 170 km north of the mainland, is divided latitudinally by a 1,100-meter mountain range. North of this range is the tundra and wetland ecosystem known as Akademy Tundra. To the south of the range, the tundra is drier and higher in elevation. Herald Island, 12 sq. km in size, lies 60 km northeast of Wrangel and only has sparse alpine tundra.

Wrangel Island has relict populations of more than seventy species of plants characteristic of ancient Beringia, when the two continents were connected. Plant species of both continents are found on the *zapovednik*; six North American species that do not grow anywhere else in Asia have been found on the island. Arctic endemism, with twenty-five endemic species, is highest on Wrangel Island. In total, the reserve has 380 species of plants.

There are only six terrestrial animals on the islands: polar bear, arctic fox, brown and Vinogradov (*Dicrostonyx vinogradovi*) lemmings, musk ox (*Ovibos moschatus*), and reindeer. According to some sources, gray wolves and wolverines have made periodic visits to the island from the continent. Vinogradov lemming is endemic to the island. There are two hundred musk ox, introduced in 1976, and a herd of domestic reindeer, introduced in the 1930s, on the island. Paleontologists believe that the last woolly mammoths (*Mammothus primigenius*) lived on the island during the Holocene Era (8,000–3,000 years ago). Bones and tusks are still frequently found. Scientists also believe that a population of wild reindeer lived on the island until fairly recently.

About 80 percent of the populations of polar bears in the Bering and Chukchi Seas den and give birth to cubs on Wrangel and Herald Islands. Between three hundred and four hundred polar bear females annually hunker down on Wrangel Island in snow caves on the slopes of low mountains. The highest density of such birthing dens are on five sites of the reserve: 1) Bezymyannye (Nameless) Mountains; 2) Vostochnoe (Eastern) Plateau; 3) Gavai; 4) Medvezhya (Bear) River; and 6) between the Neizvestnaya and Pestsovaya Rivers. During winter the polar bears feed on the large populations of ringed and bearded seals. The world's largest walrus rookeries are found in ice-free years on Cape Blossom and the sandbar, Davydova Kosa. Bowhead, humpback, gray, and beluga whales feed near the islands.

Fifty species of birds nest on the island. Snow geese breed on the island, and several thousand black brant come to Wrangel in late summer from North America. About five hundred thousand seabirds of eight species nest on the islands and feed on the rich fish and marine life. Bird endemism is not significant, but island subspecies of the red knot (*Calidris canutus*) and black guillemot (*Cepphus grylle*) nest here. Nesting colonies of thousands of snow geese and black brants congregate annually on Tundrovaya and Gusinaya Rivers and in the Akademy Tundra. Ross's gull (*Larus roseus*) can also be seen here. Eiders nest in colonies on Cape Zapadny (Western) and Cape Warring.

The *zapovednik* has a marine buffer zone of between 25 and 50 km around the islands. The World Conservation Union (IUCN) has proposed the area as an international biosphere reserve. Threats include a new shipping route planned to go near the island, climate change, ocean debris, and uncontrolled poaching.

Zakazniks. *Zakaznik*s occupy an area of 2.1 million ha and include the following:

Lebediny. The vegetation in this reserve, which is located between the Anadyr and Main Rivers, is tundra woodland with Japanese stone pine, upland marshes, sedge and cotton-grass tundra, thickets of shrub alder, and reeds. The abundant lakes are interconnected by meandering streams and provide prime conditions for nesting, molting, and feeding waterfowl including whooper swan (*Cygnus cygnus*), greater white-fronted goose, bean goose, lesser white-fronted goose, pintail (*Anas acuta*), Northern shoveler (*A. clypeata*), Eurasian wigeon (*A. penelope*), and common teal (*A. crecca*). Moose, wild reindeer, and brown bear are typical land mammals found in the reserve; less commonly sighted are gray wolf and wolverine.

Avtatkuul. This *zazaznik*, consisting of primarily meadows and coastal tundra, has swamps and lakes that provide migratory and nesting places for numerous types of birds including Northern pintail, Eurasian widgeon, four species of geese (greater white-fronted, bean, emperor, and black brant), three species of swan (whistling [*Cygnus columbianus*], Bewick's [*C. bewickii*], and whooper), Sabine's gull (*Larus sabini*), sandhill crane (*Grus canadensis*), and spoonbill sandpiper (*Calidris pygmaeus*).

Tumansky. Typical coastal tundra, the reserve provides habitat for migrating and nesting birds, including large nesting colonies of eiders, black brant, emperor goose, and swans. Sandhill crane, bean goose, lesser white-fronted goose, Northern pintail, and waders are found throughout the reserve.

Tundrovy. The reserve protects migrating and nesting waterfowl, including bean goose, greater white-fronted goose, sandhill crane, swans, spoonbill sandpiper, Eurasian widgeon, and others. Predatory animals include red fox (*Vulpes vulpes*), gray wolf, wolverine, and, in summer, brown bear.

Ust-Tanyurersky. This reserve is located on the transitional zone between tundra woodland and subarctic tundra, with

hilly sedge-cotton grass tundra, cranberry swamps, and abundant lakes. Whooper swans are common, and other birds include ducks, sandpipers, bean goose, greater white-fronted goose, and other migratory birds. Sandhill crane also nest here in large numbers.

Chaunskaya Guba. Situated on the eastern and southeastern shores of Chaun Inlet, the landscape is typical coastal tundra and, like many of the other reserves described, was established to protect waterfowl and shorebirds. The *zakaznik* consists of two parts: one part (200,000 ha) is on the eastern shore of Chaun Inlet near Komsomolsky and Krasnoarmeisky settlements, and the second part (10,500 ha) is on the southern shore of the bay, between the mouths of the Pucheveem and Chaun Rivers.

Omolonsky. This *zakaznik*, the only one to protect boreal forests, was established to protect and restore moose and sable populations. The reserve provides high-quality habitat for wolverine, gray wolf, brown bear, and variable hare. The *zakaznik* also has allowed for the regeneration of valuable fur species including sable, American mink (*Mustela vison*), wolverine, river otter (*Lutra lutra*), and Eurasian lynx (*Felis lynx*). Future plans include expanding the reserve boundaries and redesignating it as a national park. Currently, the *zakaznik* is under the jurisdiction of the Chukotka Hunting Service.

Regional nature park. There is one such park in Chukotka, the Beringia Regional Nature-Ethnographic Park. The purpose of the park is to preserve and enhance the Bering Sea hunting cultures of the Chukchi and Eskimo peoples, protect the biological diversity of the plant and animal life, and preserve the fragile Chukotka landscape. The park is a refuge and habitat for unique communities of animals and plants. Relict and *Red Data Book* flora and fauna species are observable everywhere. Numerous species of rare migratory waterfowl nest here, including sandhill crane, emperor and white-fronted geese, and sandpipers. Huge colonies of nesting birds and rookeries are found on the coast alongside marine mammal breeding grounds and resting places. Notable marine species include walrus, ringed seal, bearded seal, and whales (gray, humpback, beluga [*Delphinapterus leucas*], minke, killer [*Orcinus orca*] and others).

Notable sites:

- Arakamchenchen Island, one of the largest walrus breeding grounds in Chukotka, also has hot thermal springs. Of special archeological significance is Kitovaya Alleya (Whale Lane), an ancient architectural monument built five centuries ago out of bones of bowhead whales.
- The upper basin of the Chegutun River, which protects snow sheep (*Ovis nivicola*), a very rare, *Red Data Book* species.
- Litke and Bennet Islands, Lavrenty Bay, and a number of other areas are slated to receive *zapovednik* status.

Other protected areas. Chukotka has twenty natural monuments with a combined area of 13,700 ha. Most of these protect either poplar stands in river valleys, ancient settlements, rare species and unique animal communities, or relict botanical plant communities. Whether there will be adequate protection of natural monuments is cause for concern. The natural monuments have not been officially protected since Chukotka broke off from Magadan Oblast in 1992 and the Raion Council of the All-Russian Nature Conservation Society broke up; this council once played an active role in protecting the monuments.

Biodiversity hotspots

Gennady Smirnov, Maxim Litovka

1. Lake Elgygytgyn (arctic and wetland)

Located on the northern Anadyr plateau approximately 500 m above sea level, Lake Elgygytgyn, 11 km in diameter, is almost perfectly round. The maximum depth is 169 m. Formed between 3 and 5 million years ago in an impact crater, this lake is the largest freshwater reservoir in northeast Asia. Mountains surround the lake. The tallest peaks are Akademik Obruchev and Ostantsovy, 600 and 1,000 m, respectively. The Enmyvaam River flows from the southern part of the lake and numerous small streams flow into the lake. Three species of char (*Salvelinus*) live in the lake, one of them endemic and one endangered throughout the region. The algae are also remarkable and there are endemic crustaceans and oligochaetes.

The lake is part of a larger basin that has diverse vegetation and 249 vascular plant species. Most of the plants are circumpolar alpine species, and some are relic and endemic species. Wild reindeer and snow sheep breed near the lake, and several rare and endangered bird species live here. Within the lake basin and the headwaters of the Enmyvaam River, many bird species thrive. There are particularly high densities of peregrine falcon (*Falco peregrinus*), gyrfalcon (*F. rusticolus*), golden eagle, and yellow-billed loon (*Gavia adamsii*).

Geological research here began in the 1930s with expeditions by Sergei Obruchev. The area and its geological history are well documented in scientific literature. The basin's biological diversity is not, however, well known. The first studies of diatoms of the lake were made in 1956. Studies of terrestrial fauna began in the late 1970s, and botanical research began in the 1980s.

Threats. The basin is isolated and remote but vulnerable. In 1950, the area was completely pristine, but overfishing,

uncontrolled mining, illegal archeological excavation, and dumping of waste have had an impact, particularly on char and wild reindeer populations. Tourists, fishermen, and hunters frequent the beautiful lake.

Existing protection measures. In 1986, the Magadan branch of Glavrybvod (Okhotskrybvod) banned the commercial and sportfishing of char for five years, and in 1991, the ban was extended for five more years. At that time, three species of lake char were recommended for inclusion in the Russian *Red Data Book.* In 1993, the lake was declared a regional natural monument by the Magadan administration, which had jurisdiction of Chukotka at that time. In 1994, the Chukotka Committee on Environmental Protection began to implement a plan to create the Tsentralno-Chukotsky Zakaznik, as stipulated in the government resolution On the Creation of Protected Areas in the Russian Federation in 1994–2005.

Recommendations. The following actions should be taken:
- Establish the Tsentralno-Chukotsky Zakaznik. The regional governor has approved plans to establish this reserve, but there are no funds, at present, to implement the plan.
- Work toward UNESCO World Heritage site status for this unique lake. However, the *zakaznik* must be established first.

2. Lower Anadyr lowlands (arctic and wetland)

The Anadyr lowlands are primarily glacial and marine ecosystems. Tributaries of the Anadyr River, including the Velikaya, Tumanskaya, and Avtatkuul Rivers, run through the region. There are numerous lakes of thermokarst and oxbow origin, some of which are of significant size. Tundra dominates the landscape, specifically sedge and cotton-grass tundra and moss and grass swamps. In the river valleys, there is shrubby vegetation with some small willow and alder trees.

This territory is valuable primarily because of the wetlands and the nesting and breeding birds that depend on them. The main species include several species of goose: great white-fronted, bean, emperor, and black brant. Snow geese and lesser white-fronted geese migrate here every year. Spoonbill sandpipers and Aleutian terns (*Sterna kamtschatica*) nest along the seashore. According to ornithologists from the Institute of Biological Problems of the North (IBPN), Avtatkuul Zakaznik is the largest remaining goose-breeding ground between the Indigirka River in eastern Sakha and the Bering Strait, supporting a population of approximately five thousand of three different species. In the southwestern edge of the Anadyr River estuary there is a large colony of king eiders (*Somateria spectabilis*). During the molting seasons, there are approximately ten thousand eiders, greater scaups (*Aythia marila*), and scoters (*Melanitta*) in Glubokaya

Lagoon, and geese and their fledglings and male river ducks (*Anas*), two species of shorebirds, and two species of swans are found along the entire shoreline of the Anadyr Estuary. White-tailed sea eagles (*Haliaeetus albicilla*) nest here and peregrine falcon, gyrfalcon, and Steller's sea eagle have also been spotted. Considerable numbers of sandhill cranes nest in the marine tundra of the Anadyr lowlands. Overall, eighteen species of nesting and migrating birds listed in the *Red Data Book* can be seen in this area.

In 1992, after the foundation of the Chukotka research center, several groups from the IBPN conducted multidisciplinary research here. Scientists from the Okhotskrybvod have studied fisheries of the Anadyr, Velikaya, and Tumanskaya basins. Since 1994, researchers from the Laboratory of Anadromous and Freshwater Fish of the Chukotka division of the Pacific Institute of Fisheries and Oceanography (TIN-RO) have done research. Foreign scientists are also working here.

The Anadyr Estuary and lower streams of the Anadyr and Velikaya Rivers also have rich fisheries. The area is a migratory route for chum salmon and serves as an upwelling area for game fish including whitefish and smelt. Salmon fishing is a big commercial business. Oil and gas was found here and in Anadyr Bay in the late 1980s.

Threats. Untreated sewage waste from Anadyr city is dumped directly into the sea. Oil development poses a threat for several reasons: land development and road construction, the inevitable land and water pollution from petroleum products, and human and technical intervention, which increasingly disturb the nesting birds.

Existing protection measures. In 1992, the Chukotka administration established three *zakaznik*s on the Lower Anadyr lowlands: Tundrovy, Avtatkuul, and Tumansky. Several resolutions made by the Soviet of the Ministers of the USSR are designed to protect the fauna of these *zakaznik*s: On Protection Measures of Migrating Birds and Their Habitat after the Soviet-American Convention (No. 195, March 1975, and No. 255, March 19, 1979); On Protection Measures of Migratory Birds and Their Habitat (No. 196, April 11, 1979); and On the Approval of the List of Rivers, Their Tributaries and Other Water Sources Serving as Spawning Grounds for Salmon and Sturgeon Fish Species (No. 554, October 26, 1973).

Recommendations. The following actions should be taken:
- Make both Avtatkuul and Tumansky Zakazniks Ramsar sites. IBPN has already prepared the necessary documents.
- Merge the two *zakaznik*s and give them higher protection status.
- Tightly control all economic activity, particularly in summer.

CHUKOTKA

3. Meinypilgyn riparian zone (arctic and wetland)

The Meinypilgyn lake and river system is located on the Koryak shore of the Bering Sea, in Beringovsky Raion. Primarily a series of large lagoon lakes, Pekulnei and Vaamechgyn interconnect with each other and with the sea by straits and the system of tributaries flowing into them—Vaamechgyn, Vaapveem, Kakanaut, Pekulveem, and others that originate on the southern slopes of the Koryak Range.

Japanese stone pine form tall bushes on the lower mountain slopes; mountain pine tundra grows on the upper slopes. Lichen rock tundra and meadows are prevalent in the mountains. In the lowlands, sparse forests, sedge, and swamps dominate the landscapes. Tall willow and alder groves are common along the rivers.

Common mammals (brown bear, moose, and ermine) and rare mammals (snow sheep and black-capped marmot [*Marmota kamchatica*]) frequent the area. The birds are those that frequent the tundra. There are a number of types of fish, including chum, chinook, and pink salmon, which are fished commercially. The chum salmon is considered the most valuable, and this particular stock is one of the richest in all of northeast Asia. Indigenous people rely on this species, as do seals, killer whales, beluga whales, bowhead, and migrating gray whales, which are regularly spotted.

Threats. The area has seen little industrial development. The primary problem is garbage found around settlements. Due to economic hardship, locals also collect common eider eggs in the Ankave Bay and Pekulnei Lake. Future threats include development of the Khatyrsky oil reserves; 90 percent of this field is located in the Bering Sea. Development of the field could damage marine life, especially the migration routes of Pacific salmon. Oil development may also threaten the remarkable bird colonies on Navarin Cape.

Existing protection measures. Researchers at the Chukotka Scientific Center and the Chukotka branch of TINRO have studied the region. For this review, we have used the field data compiled by E. V. Oschepkova in the 1997 field season. In July 1997, A. V. Kondratev, an IBPN researcher, did a waterfowl census by airplane. The Russian government has formally proposed establishing Pribrezhny Zapovednik to protect this region.

Recommendation. Get formal approval from the federal government to establish the *zapovednik* and then create it.

4. Walrus rookeries (arctic and marine)

This proposed protected territory combines six of the largest walrus rookeries: Blossom Cape, Somnitelnaya Spit, Inchoun Cape, Arakamchenchen Island, Rudder's Spit, and Kosa Meechkyn Island. Adult walruses of all ages stop here once the ice melts. In some years more than half of the world's walrus population rests here. Walruses stay at the rookeries for as long as five or six months, depending on ice-floe formation and the melting period. Walruses need to rest between feeds. Normally, walruses stay on land for between four and six days, then leave for the sea to get food, and return again to rest.

Threats. Storms, attacks by polar bears and brown bears, and various human activities disturb the normal rhythms of walrus communities. Walrus rookeries have always attracted people. For Chukchi and Eskimos, walruses were a primary source of meat supply. Commercial walrus hunting began in earnest in the second half of the nineteenth century, when American whalers exterminated almost all the shore-based walrus colonies in the Bering Sea. Currently, walrus poaching in the rookeries is limited, but there is a growing tendency, which has increased owing to extreme poverty in the area, to poach the animals for the illegal sale of walrus tusks. Hunters often drive walruses to sea to get to the tusks of dead ones. Tourists often disturb the walruses by getting too close, but most harmful are the unsanctioned plane and helicopter flights over the rookeries. Panic among the walrus herd can be extremely destructive. In Somnitelnaya Bay, 102 walruses were killed when the herd panicked at the noise from a low-flying airplane.

Existing protection measures. Insufficient numbers of rangers and lack of transportation and communication equipment have left the rookeries virtually unprotected. These walrus rookeries play a critical role in preserving the endemic Pacific subspecies of walrus. Walrus rookeries, unique natural treasures of Chukotka, symbolize the pristine nature of the territory. Walrus research has decreased significantly over the past ten years. The Okhotskrybvod's monitoring stations for marine mammals have been shut down. The research expeditions of TINRO, its Magadan division (MagINRO), and other scientific institutions have been suspended. Recent research documents steep decline of local walrus populations in the northwestern part of Anadyr Bay due to depletion of the food base. There is no information on seasonal gatherings of walrus on the northern and eastern coasts of Chukotka. Exact counts of Pacific populations are also unknown, which makes it impossible to develop regulations for walrus protection and hunting.

Regional fisheries protection authorities and the staff of Ostrov Vrangelya Zapovednik are in charge of protecting walruses. The Chukotka governor issued the decree On the Protection and Hunting of Walrus in Chukotka Autonomous Okrug on March 10, 1998; this document describes twenty rookeries and lists measures for walrus protection and hunting. The rookeries in Blossom Cape and Somnitelnaya Spit are the best protected because of the efforts of *zapovednik* rangers. Manned protection points have also been set up at the rookeries at Arakamchenchen Island and Rudder's Spit.

The Kaira Club (a Chukotka nongovernmental organization) and the Association of Chukotka Indigenous Peoples studied and reconstructed a model of a traditional walrus economy of the Chukchi and Eskimos in the Meechkyn rookery. Local indigenous groups have already used this model to restrict walrus hunting. The native peoples in Inchoun Village appointed a villager, Alexei Agranaut, as the guardian of the Inchoun rookery.

Recommendation. Find $50,000 to permit the Chukotka division of TINRO to develop a project for the long-term monitoring of walrus rookeries. As part of this project, native people would be hired as permanent observers and guardians of the rookeries. The exchange of information between Russian and American scientists is also proposed to improve the management of the entire Pacific walrus population.

5. Chaun Inlet (marine and wetland)
On the Arctic shore of western Chukotka (Chaunsky Raion), the plain gradually slopes down to Chaun Inlet on the East Siberian Sea. The southeast coast of the bay is somewhat hilly, with rare grasses. In the southern part of the lowland, there are picturesque rocks reaching 700 m. Swamps around the hills are covered with sedges and *Arctophila*. The lowland is traversed by many rivers, which, in their lower reaches, become a mesh of straits and tributaries. The main rivers are the Palyavaam, Chaun, and Pucheveem. The numerous thermokarst lakes occupy approximately 50 percent of the tundra area. Vegetation is typical for Chukotka with sedge and hummocky tundra with willows, dwarf birch, and berry bushes. Areas of large-shrub tundra grow along river valleys on well-drained river terraces. The main species are willow and alder, which grow as high as three meters.

Geese and plovers both nest and migrate here. Other shorebirds include tundra swan, snow goose, lesser white-fronted and bean geese, Arctic loon (*Gavia arctica*), three species of eider, and Ross's gull. Pink salmon, Dolly Varden (*Salvelinus malma*), and whitefish in the rivers of the Chaun lowland are commercially valuable.

Threats. Native peoples rely on reindeer pastures and fishing in the Chaun lowland. The existing *zakaznik* does not protect the lowland's ecosystems from the growing human impact, mainly from mining. The mining industry creates a lot of waste, and the heavy machinery is also destructive. There is no recultivation of mined lands. Additional problems may occur when the Komsolmosky-Bilibino winter road is improved.

Existing protection measures. Chaunskaya Guba Zakaznik was created in 1995. The Chaun lowland is listed as one of the most important national wetlands of the former USSR.

Recommendation. Create a federal-level *zakaznik* in Chaun lowland, taking into account comprehensive work done by a West Siberian hunting research expedition. According to I. A. Chereshnev, anadromous Dolly Varden in local rivers urgently need protection due to heavy overfishing.

6. Omolonsky Zakaznik (arctic and forest)
The Omolon River, the primary tributary in the Kolyma and Omolon basins, is one of the largest ecological gems in subarctic East Asia. The southern part of the river flows through the subalpine landscapes of Kolyma Plateau, the middle reaches run primarily through boreal forests, and the lower part of the river has relic lake ecosystems typical of northeastern Sakha. Mixed forests of chosenia, poplar, birch, and larch are found in the floodplains and valleys.

These tundra and forest valleys are rich with birds and animals. Common bird species include black capercaillie (*Tetrao parvirostris*), hazel grouse (*Bonasa bonasia*), ptarmigans, curlews (*Numenius*), whooper swan, and Northern pintail. Rare species include white-tailed sea eagle, lesser white-fronted goose, eagle owl (*Bubo bubo*), great knot (*Calidris tenuirostris*), little curlew (*Numenius minutus*), and gyrfalcon. Bewick's swan, bean goose, different shorebirds, and Ross's gull migrate through this region. Mammals include Eurasian squirrel (*Sciurus vulgaris*), moose, wild reindeer, brown bear, ermine, and wolverine. Kolyma moose reach record density levels (between 14 and 18 per sq. km) in the Omolon basin. The Omolon Valley is the shortest migratory route between the north shore of the Sea of Okhotsk and the arctic tundra of Sakha. Fish species include Arctic grayling, Northern pike, longnose sucker (*Catostomus catostomus*), and whitefish.

Since the early 1970s, IBPN has had a biological station in the region. Long-term studies of flora, fauna, and landscape structures of the Omolon River basin have resulted in a series of scientific publications. These publications emphasize the high biodiversity, uniqueness, and productivity of the region's ecosystems, including the presence of unusual plant communities, endemic plants and animals, and migration routes of Arctic birds.

Threats. The Chukchi peoples are the original settlers in the Omolon basin. Russian settlements appeared in the 1940s (Scherbakovo) and 1960s (Mandrikovo). Uncontrolled poaching for ungulates and fur-bearing mammals quickly led to a decline of the originally abundant moose, sable, and wolverine populations. The basin was most heavily affected in the 1970s and 1980s, when industrial waste polluted rivers, forest fires occurred frequently, and poaching flourished. Currently, due to the crisis in the mining industry, unemployment, and the closure of some settlements (villages), poaching has reached unprecedented levels as nature-protection agencies are poorly equipped to control the problem.

Gold mining ventures, located both upstream and downstream and, in particular, the Kubaka project in adjacent Magadan Oblast, are constant threats.

Existing protection measures. In 1980, in response to IBPN's proposal to the Magadan Hunting Service, Omolonsky Zakaznik was created in the lower reaches of the Omolon River. This was done primarily to protect the largest habitat of the threatened Kolyma population of moose.

The associations of Indigenous Peoples of Chukotka in the Omolon and Bilibino regions required an ecological-economic justification (*obosnovanie*) for the enlargement of the *zakaznik*. In the future, the *zakaznik* should be granted regional status and later become a national park. With the closure of several gold mines and nearby villages, poaching increased. This led to a complete ban on hunting in the Bilibinsky Raion, which is still in effect. The *okrug* hunting service prepared a decree draft for the governor that would enlarge the *zakaznik* without changing its current status.

Recommendation. Enlarge the Omolonsky Zakaznik and change its status, while allowing some restricted, sustainable land use. IBPN proposes three options to change the borders: minimal, moderate, and maximum. Local protection authorities would like to enlarge the reserves as much as possible. The Chukotka-Magadan border currently runs through the *zakaznik*. Only people in the Bilibinsky Raion use the Omolon floodplain. Rassokhino reindeer herders use the Monakova and Namyndykan River watersheds. Coordinated action between Magadan and Chukotka authorities is needed to enlarge the *zakaznik*. If this occurs, the ambitious enlargement plan calls for protected strips between 30 and 50 km in length along portions of the Omolon's left bank to include the floodplain forests of the Kedon, Aihenny, Namyndykan, and Mangazeika Rivers in the lower reaches.

7. Botanical natural monuments (forest and wetland)

Two natural monuments need urgent protection:

Tnekveemskaya Roshcha (Tnekveem Grove). This grove, located in the northern Anadyr lowland in the floodplain of the eastern tributary of Kanchalan River, is the only large poplar and willow grove, with trees between 16 and 18 m tall. The

The Omolon River Valley has the best forests on Chukotka.

Vladimir Dinets

grove is the heart of a diverse floodplain community of the Tnekveem River forest, which contrasts with the surrounding tundra. A refuge for boreal plants, the grove is a place where reindeer calve, and it is a tree-seed bank. Since July 8, 1983, as a result of Magadan regional government resolution No. 296, the grove has been a regional natural monument.

Professor B. A. Yurtsev of the Botanical Institute of the USSR Academy of Sciences studied the region in the 1960s and 1980s. At present, however, no scientific research is under way.

Threats. The nearby native village of Kanchalan and reindeer grazing routes mean that the grove may be used for firewood. Another potential threat is the Valunisty gold mine.

Recommendations. The following actions should be taken:
- Create a botanical *zakaznik* in the grove to prevent any logging.
- Educate the local population.

Telekaiskaya Roshcha (Telekai Grove). Telekai Grove, the largest and most northern grove of chosenia, is located in the central Chukotka plateau in a deep valley where the two Telekai Rivers converge. Growing on a vast gravel area, the trees reach between 12 and 15 m high. There are isolated trees further up the valley and downstream. Other plants include isolated occurrences of *Salix udensis* and *Poa ursulensis*. Beyond the floodplain there are three species of birch: *Betula cajanderi*, *B. middendorfi*, and *B. extremorientalis*, and common juniper (*Juniperus communis*). The mountain slopes have remnant steppe vegetation.

The northerly location and size of the grove make it particularly interesting. Floral diversity is also high, making it valuable scientifically and aesthetically.

In 1939 a research group led by K. F. Yakovlev documented the grove, but this research was lost. Later A. P. Vaskovsky "rediscovered" the grove by airplane, and Y. P. Kozhevnikov studied it in 1974.

Threats. Grazing reindeer and logging for firewood are the major threats.

Existing protection measures. Since July 8, 1983, the grove has been a regional natural monument, thanks to Magadan regional government resolution No. 296.

Recommendations. The following actions should be taken:

- Create a botanical *zakaznik* to protect the grove.
- Research the area fully.
- Limit grazing and logging.

Economy

Gennady Smirnov, Maxim Litovka, Dmitry Naumkin

Until the seventeenth century, the economy was based on hunting, fishing, and gathering, primarily by indigenous peoples. Small populations of nomadic and settled indigenous tribes lived well on account of tremendous populations of reindeer and walruses, abundant fish in the rivers and seas, and the summer fruit gathered in the tundra. From the thirteenth to the seventeenth century, reindeer-herding practices developed. The first indication of environmental damage caused by human interference was the loss of reindeer feeding areas because of overgrazing.

In the first half of the seventeenth century, Russian explorers reached Chukotka and established trade with the native peoples. In the late-nineteenth century, trade also began with Americans. Desire for wealth led to a search for new walrus breeding grounds and the opening of the Bering Strait in 1648 by Semyon Dezhnev and Fedot Alexeev. Soon after, the huge breeding grounds at the Anadyr estuary mouth were discovered, and within several years, Dezhnev's Cossacks had killed the entire walrus population there. The intensive commercial exploitation of walrus began in earnest, with trade in their tusks bringing fabled riches from the Asian markets. The population of Pacific walruses has been intensively hunted for the past three centuries—at first by Russian whalers and later by American, Norwegian, and British whalers, who collectively killed an estimated 130,000 walruses between 1869 and 1980. The population is now a third of its former size. Foreign whaling ships began hunting bowhead whales in the middle of the nineteenth century; the western Arctic population of this species has still not fully recovered.

The extinction of walrus and whale populations at their traditional hunting grounds rapidly brought hunger, disease, and increased mortality to native Chukchi and Eskimo

peoples. In one of the first conservation efforts by the Russian government, military ships were sent to the Bering and Chukotka Seas to limit the excessive hunting of marine animals.

Industrial development in Chukotka is connected with the gold rush, which penetrated Chukotka from nearby Alaska. The first prospectors arrived in 1890 and began extracting gold from the Zolotoy and Pekulin mountain ridges in 1904. Other geological expeditions to the area soon followed and, by the 1930s, coal was being mined near Ugol (Coal) Bay. The construction of seaports began at present-day Anadyr, and a fish factory and airports were built. Just prior to World War II, geologists discovered large deposits of tin near Pevek and Iultin and began mining them during the war. Continued geological prospecting during this period yielded deposits of gold and other precious metals of commercial significance. Gold has been the leading industry since commercial mining began on the Ichuveem River in 1958. Processing facilities, commercial enterprises, company towns, minefields, and local power stations were built. The population increased rapidly with the inflow of labor from central regions of the Soviet Union, and 90 percent of those living in Chukotka in 1989 were immigrants. Mining reached its peak in the late 1980s and early 1990s.

In the post-Soviet period, restructuring as a result of privatization and other conditions of the market economy is beginning to dictate conditions for the mining industry. No longer profitable, tin and tungsten mining have ceased. Coal mining is also decreasing steadily and even gold mining is becoming unprofitable. Numerous small ventures, that operate for one or two years on the most productive sites, are replacing the large, previously state-owned enterprises. Decline of the mining industry, which for years had been the primary employer in the *okrug*, has led to the massive emigration of workers and closure of a number of settlements. The population of Chukotka has fallen to almost half of what it was in 1989.

All levels of society, from individual prospectors to *okrug* officials, are discussing the plight of the mining industry. Elena Masyuk, a popular television journalist, commented that it is cheaper to buy gold abroad than to mine it in Chukotka. Nevertheless, all *okrug* governmental plans for improving the economy are based on increasing gold and coal production and to a lesser degree other minerals.

Environmental impact. Many of Chukotka's environmental problems are related to mining. Open-pit mining, the most harmful, visibly damages the landscape, eliminates reindeer pastures, ruins wildlife migration routes, causes sedimentation of rivers by run-off, and poisons groundwater. Open-pit mining has damaged more than 75,000 ha. of land in Chukotka. Every year, accidental spills pollute river systems. According to government regulators, sixty-two such spills released 1,417 tons of pollutants in 1995 and 1996. Giant

caterpillar and truck machinery used in mining destroys large tracts of tundra; experts estimate that approximately 80,000 ha have been damaged by this practice.

Oil and mechanical debris in all the major seaports is a major cause of water pollution. In November 1994, the punctured tanker *Kansk* spilled 115 tons of oil near Beringovsky port and caused an estimated 2.55 million rubles ($8,500) in damage. Rapidly rising car use has led to higher air pollution levels in major towns and cities. Around populated areas, tractors and all-terrain vehicles have sliced up the fragile tundra and the unsightliness of metal drums, scrap heaps, and city garbage is matched only by the stench of fires at dump sites.

Research on environmental pollution in Chukotka, conducted in 1991 and 1992 by the Analit Institute, led to the following findings:

1. The main environmental pollutants in populated areas are energy systems (atmospheric deposition, slag piles, coal dumps, dumps from fuel and gas stations); the construction industry (construction platforms, storage of construction materials, construction debris); and vehicles.

2. The soil top layer in many areas has heavy concentrations of Ca, Mg, Ba, Be, Cu, Pb, Zn, Ni, Co, Mo, Cr, Ti, Ga, Ge, Mn, and Zr, caused by microrelief, wind erosion, and the wide distribution of pollutant sources.

3. The peat-gley soils of the tundra tend to salinize and alkalize under anthropogenic influences. Corresponding geochemical barriers and paragenetic associations of elements that concentrate on them are alkalinity (Ba, Zn, Pb, Cu, Ni, Co, Mn), acidity (Mo, Ga, Cr, Ge), gley concentration (Cu, Mo, Cr), and hydrogen sulfide concentration (Zn, Cu, Pb, Ag, Ni, Co).

4. Twenty-five percent of the *okrug* has anomalous quantities of toxic substances. Within these anomalies, there is an excess of allowable concentrations (1–6 mpc of soil) for Cr, Ni, Co, Be, Ba, Pb, Cu, and Zn.

5. Near populated areas, including river watersheds, the natural environment is subjected to dissolved forms of Be, Ba, Pb, and Zn. The natural water around Anadyr has heightened concentrations of Ba, Pb, and Zn.

The main water pollutants come from settlements and the energy and mining industries. The total water discharge in 1996 was 31.81 million cu. m, including 28.95 million cu. m of sewage dumped into the surface water. Discharge of most pollutants has decreased; ammonium nitrate and other nitrate emissions have, however, increased.

Fires, in the 1990s, were especially severe. Five hundred and forty fires burned 927,789 ha of land between 1990 and

With the collapse of many local industries and mining companies, some Chukchi have returned to their traditional lifestyle.

1997. Analysis indicates that humans caused more than half of these fires. Because of a drought in 1993, fires destroyed more 525,000 ha of forests and tundra.

River flooding has increased, and this threatens nearby storage and waste facilities. Seven oil and gas storage terminals with a capacity of 1,600 tons and seven open retention basins that contain suspended sediment and petroleum discharges are within the spring and summer floodplains. Fall storms along the coast have led to sharp rises in sea levels and lowland flooding. Water levels in the Anadyr Estuary reached 722 cm, exceeding the annual average by 3 m. In Anadyr, floods ravaged a reserve electrical substation, two twelve-unit apartment houses, port facilities, a church, and a store. Water and heating pipes were also disrupted. Apartments, factories, coal and fuel depots, food storage warehouses, electrical plants, and boilers and other facilities were also flooded in many communities. Estimated damage was 70 billion rubles ($230,000). The impact of petroleum products that washed into the rivers, lakes, and seas is impossible to assess.

Mining

Chukotka is blessed with large reserves of gold, tin, tungsten, silver, and platinum. Fueled by continuous increases in world gold prices and with strong government backing, gold mining reached its peak in the late 1980s and early 1990s, with annual outputs reaching 30 tons. However, the quality of remaining alluvial deposits has steadily deteriorated, and as mining costs have risen, the gold mining industry has declined. Other factors include industry restructuring and the introduction of new forms of property ownership. Despite this, however, the local administration still views the expansion of the mining industry as a means of achieving rapid economic growth.

In the Soviet era, the mining industry included five mining and enrichment *kombinats* (GOK), geological mining enterprises, commercial enterprises, and prospecting cooperatives. The Bilibino, Polarninsk, and Komsomolsk GOKs and the large Otrozhny mine extracted alluvial gold. The Pevek and Iultin GOKs extracted gold, tin, and tungsten. All these enterprises, which belonged to the government, were part of the large interregional entity known as Severovostokzoloto (Northeastern Gold).

With one mine, several pits, and three large prospecting cooperatives, Polarninsk GOK produced about 40 percent of the *okrug*'s gold. Three rich, closely located alluvial deposits in Schmidtovsky Raion were mined. Centrally located, this profitable GOK primarily mined underground, which minimized the environmental impact. Surface land affected never exceeded 50 ha, about seven times less than land used in the Bilibino or Komsomolsk GOKs.

Bilibino GOK, with five mines and six prospecting cooperatives, mined about 30 percent of the *okrug*'s gold. The resource base of the GOK included about two hundred shallow, small, and low-yielding alluvial deposits scattered throughout Bilibinsky Raion.

Producing about 20 percent of the *okrug*'s gold, Komsomolsk GOK operated the oldest gold mining site (the large alluvial deposits on the Ichuvei and Raucha Rivers) in Chukotka. There were two mines and two large prospecting cooperatives in this GOK. The most profitable area now, with reserves to last until 2005, is near Ichuvei River. Near the village of Komsomolsk is Maiskoe, one of the largest gold deposits in Chukotka. Regional government and industry representatives are attempting to attract foreign investors to this site.

Once Chukotka's largest tin producer, Pevek GOK includes the Valkumei mine. In 1992–1993, the mine ceased producing tin and shifted to gold. Iultin GOK produced tin, tungsten, and gold. The gold division included the Vostochny mine and four prospecting cooperatives.

The Otrozhny mine, based in the city of Anadyr, is essentially two deposits, Otrozhny and Bystry. The GOK included two pit mines and three small prospecting cooperatives, with gold output slightly less than 10 percent of the *okrug* total.

The deposit will continue to provide stable production until about 2005.

In 1992–1993, gold mining was still marginally profitable. However, during privatization, prospecting cooperatives left the GOKs. *Kombinats* were auctioned off or reformed. The production share of gold and other metals by private enterprises has steadily increased. The major gold producers in Chukotka include joint-stock companies of the GOKs (Komsomolsk, Polarninsk, Bilibino), *artel*s Chukotka and Polarnaya, and a host of other firms that mined small amounts (less than 500 kg).

Many industry specialists pin their hopes on the Karalveemskaya mine, which has an annual projected capacity of 100,000 tons, resources projected to last for decades, and net cost and labor requirements that are approximately five times and two times more favorable, respectively, than those of other similar ventures that also mine alluvial gold deposits. In 2000, the mine produced about 30 percent of total production in Chukotka.

Environmental impact. Open-pit mining, widely practiced in Chukotka, is the most harmful type of mining and directly damages the landscape, eliminates reindeer pastures, and ruins seasonal migration routes of wildlife. The most heavily damaged areas are in Bilibinsky, Chaunsky, and Schmidtovsky Raions. Most of the land mined is not restored. Only land believed to be completely spent and some reindeer migration areas are recultivated. Remote sites are often left alone to regenerate naturally, in the belief they will become adequate reindeer habitat in ten or fifteen years.

Fragile tundra is destroyed by heavy machinery. Destruction of underground rock formations during mining alters groundwater flows, leading to a decrease in permafrost depths and changes hydrothermic regimes (water temperatures increase and the relative humidity at and above soils decreases).

Perhaps the most serious effect of mining is the widespread practice of mining along river valleys. Chukotka's terrestrial and marine biodiversity largely depends on the health of the river systems, which are often irreparably damaged by mining. Gold mining in small river channel beds and in surrounding basins moves thousands of tons of gravel; this process causes sediment to leak into river systems and destroys freshwater fauna and flora. Degradation of river systems can be minimized somewhat by sealing off drainage points and using retention basins. Mining companies often accidentally discharge such sediment. Environmental regulations are enforced at only half of the industry sites. Actual pollution levels are higher than those documented by regulators; periodic inspections of process facilities have repeatedly proven this. The Omolon, Lesser Anyui, Greater Anyui, Kanchalan, and Anadyr River basins are at greatest risk.

Cyanide is increasingly used to extract gold. There have been no reported incidents of river contamination, but such cases are numerous across the globe. Some countries, such as

the Czech Republic, have ceased gold mining entirely because of the high risks of cyanide use.

To become more environmentally sustainable, the Chukotka mining industry should:

- Construct permanent (year-round) automobile roads to protect the fragile tundra from caterpillar-track vehicles.
- Develop small, compact but valuable ore deposits rather than alluvial deposits.
- Stop using cyanide. Less harmful technologies can be applied; ore enrichment technology by gravitation only, developed in St. Petersburg, is one example.
- Restore damaged mining lands. Restoration can be profitable, in some instances, if perennial grasses and annual types of feed grasses or fodder (oats, rapeseed, and legumes) are planted. Climatic conditions in the continental areas of Anadyrsky and Bilibinsky Raions are the most suitable sites for restoration.
- Mine previously developed reserves rather than focusing primarily on new ones.
- Promote underground mining operations.
- Develop closed water cycles and build water-treatment facilities.

Energy

Electrical power in Chukotka is supplied by the Bilibino nuclear power plant (BAES) by large coal, diesel, and turbine electrical plants in *raion* centers, by small diesel and coal stations in towns and villages, and by a large powerline (Pevek-Bilibino-Zelyony Mys).

Concerns abound about the safety of the Bilibino plant, which began operating in 1974. Huge amounts of spent fuel and liquid waste have accumulated at the plant. High radiation doses have been noted on plant personnel, and there are indications that the plant's filtering systems are becoming less efficient. Radionuclide contamination around the plant is an obvious indication of the failure of the plant's purification and filtration systems.

Federal and *okrug* authorities link future development of industry with an expansion of nuclear power. Plans to rebuild the nuclear plant and build a second station were completed long ago. The government also wants to build several floating nuclear power plants along the coast, the first to be built near Pevek. The economic crisis and rising public resistance to nuclear power have to date held this project back. There are also plans to convert the Anadyrskaya Power Station, and possibly the Egvekinotskaya Station, from coal to gas, which would be extracted from the Anadyr lowlands.

Coal and diesel fuel, the primary sources of power, become more expensive each year and transporting them is problematic. Planned government countermeasures to resolve the energy crisis are risky. Nuclear power poses a threat not only to Chukotka residents, but also to those living in Sakha, Magadan, Kamchatka, and Alaska. Chukotka must develop

an environmentally safe means of using renewable sources of energy. In this way, we can prevent nuclear pollution, preserve the ecosystems of the Anadyr lowlands, and develop business opportunities through sale of small wind and hydro-power stations to other northern regions. Demand for this type of energy will rise as energy prices from conventional sources, such as oil and coal, increases.

The power requirements [to] support the intensive resource development of Chukotka [have] led to a variety of power projects. It seems that many Western (Moscow) policy decisions on the direction of the development of electrical power systems are being forced upon the Northeast. The Anadyrskaya Power Station is a good example of how large scale development projects can go awry. Anadyr is a city with two satellite towns, the airport/military base and the coal mining town, that lie across Anadyr River. In winter, an ice road connects these suburbs with the regional center of Chukotka. In the summer a half-hour ferry ride will get you from the airport to Anadyr proper. Fall and spring often requires great patience, as the MI-8 helicopters that fly about twenty people at a time are often grounded by fog. Anadyr has a relatively new thermal heat-and-power plant that is engineered to operate at a minimum of five times over the power requirement of the city. While coal is hauled in from the coal mine across the river, no transmission line passes power back over to the mining town and airport/military base, about half the population of the area.[23]

Nuclear. In 1974, one of the first atomic power plants in the USSR was built in Chukotka at Bilibino (BAES). On the one hand, of all the plants in the *okrug* today, BAES, with a capacity of 48 MW and four EGP-6 reactors, may be the most economical. On the other hand, it is also the most costly because fundamental components are outdated and the plant needs to be retrofitted. The plant provides thermal power to Bilibino and electrical energy to villages in Bilibinsky and Chaunsky Raions.

Many specialists believe the plant is unsafe. The following excerpt is from 1995 and 1996 reports by the Chukotka Committee on Environmental Protection: "The plant has accumulated 510 tons of spent fuel and 685 cubic meters of liquid waste. In light of this situation, it is impossible to exclude a possible accident at BAES within the next 10 to 15 years (the time required for construction of the second stage of BAES). Accidents can be radioactive, nonradioactive, or a mixture of both. The highest levels of radionuclides are found in the soils and estuaries downwind from the area adjacent to BAES. A similar picture is observed in drainage water sediment from BAES grounds."

Over the past twenty-five years, no serious accidents or

radiation of personnel have occurred. However, the discovery that several plant personnel have been exposed to excessive dosages, rising repair costs, and maintenance problems worry residents living near the plant. In 1992, Atomenergoproekt Institute developed a safety plan for BAES, but it was not enacted due to lack of funds. The plant must be reconstructed and filtering systems must be improved to comply with safety measures recommended by the Gosatomnadzor (Federal Atomic Energy Committee). Staff of the Chukotka Citizen Safety Committee maintain that an accident could contaminate more than 1,300 sq. km and expose a hundred thousand citizens to radiation. When the slow regeneration of Chukotka's ecosystems is taken into account, a nuclear accident of even moderate size could become a catastrophe.

In 1995, hydrometeorological and environmental protection agencies in Pevek and Kolyma studied radiation levels throughout the *okrug*. Results showed that radiation levels in Chukotka are safe and have not increased. The same year, a scientific research expedition from Saint Petersburg took samples in Chaunsky and Bilibinsky Raions. Although acceptable, levels of cesium 137 and strontium 90 in the plants of Bilibinsky Raion were 2.4 and 2.0 times higher than analogous levels in the Chaunsky Raion. Strontium 90 concentrations are between five and six times higher in the bones of Chukotka's indigenous peoples than in those of the residents of central Russia. The average annual dose of radioactivity for indigenous peoples is 0.5 rem per year; the average for the *okrug* is 0.4. This is explained primarily by the concentration of radioactive particles in the trophic moss-reindeer-human chain, and the poor ability of the human organism to excrete radioactive strontium from the bones.

Nuclear tests on Novaya Zemlya Island conducted in the 1950s and 1960s are the main source of higher radioactivity in Chukotka. Westerly Arctic winds carried the radioactive fallout and contaminated the northern coast with isotopes. Even small amounts of radioactive materials tend to accumulate in soils, especially in tundra lichen. They pose a genetic and a medical threat to people's health through the moss-reindeer-human chain. Radioactive contamination has had the most severe effect on indigenous peoples of Chukotka, who depend on the reindeer.

In Chukotka, radioisotopic thermoelectric generators (RITEGS) pose one of the greatest dangers to the environment. Eighty-five of these generators were built along the coast to power lighthouses and shipping beacons. The total radioactivity of these generators comprises 5.8 million curies, or 99.9 percent of all of the ionizing radiation registered in the *okrug*. As of September of 1996, fifty-seven of the generators were labeled as radioactive waste and slated for removal. Several of them have leaked and continue to do so because the hydrographic service still has not removed them, reportedly because of lack of funds. Unfortunately, both people and animals are exposed to these RITEGS. In Vankarem, a remote Chukchi village, one case of infant leukemia was registered and, although

A floating nuclear power plant

The Russian government plans to build a series of floating nuclear power plants along Chukotka's coast to supply remote ports and mining settlements with energy. The first of those floating plants, to be installed near the city of Pevek, will contain two KLT-40-C-type reactors that are currently used on board icebreakers and will generate about 60 MW.[24] The plants are expected to be in operation for forty years, will cost about U.S.$254 million, and will have about sixty full-time staff. Economic recession and growing environmental concerns have delayed construction of the plant, and it will likely be finished only by 2006.

According to the environmental organization the Bellona Foundation, high construction costs will be twice that of developing the same amount of energy from new wind or solar power sources. In addition to the high costs, critics also maintain that plant construction violates international nuclear nonproliferation treaties as well as the Russian Federal Law on Environmental Expertiza.

The Russian nuclear industry would like to overcome stagnation and expand its export possibilities. Should such desires endanger international security and create new environmental risks? Safety measures listed in official documents are merely references about the past safety histories of other reactors. These data are, however, hard to verify as such information was secret under the Soviet regime. Other risks and costs, such as deconstruction expenses, are not even mentioned in project documents. This leads one to conclude that taxpayers may have to pay for these unseen expenses. A comprehensive report is needed to list all the potential dangers of the project. The obvious ones are:

- Threat of nuclear accidents, which could cause irreparable damage to the fragile Arctic ecosystems
- Threat of nuclear terrorism; spent nuclear fuel from these plants could conceivably be used to manufacture nuclear weapons.

Other serious nuclear waste issues affecting Chukotka include the RITEGs and the Bilibino nuclear power plant.
— OS

scientists have not traced the death of the three-year-old girl to the nearby RITEG, there is widespread speculation that this was the cause.

Since the 1940s uranium ore development sites have remained uncultivated in the villages of Zapadny and Severny (Chaunsky Raion). Radon concentrations in the tailings are hundreds of times higher than background radiation levels.

Despite dangers of nuclear power, *okrug* and federal government officials look at development of the Chukotka energy sector only through the prism of nuclear expansion. In addition to plans to reconstruct the Bilibino plants, the federal government plans to build a number of floating nuclear power plants along the coast of Chukotka, the first one to be in Pevek. This project has been delayed because of the economic crisis and greater environmental awareness among residents. Plans call for installation by 2004, but it is unlikely to be finished before 2006. People keep wondering, when exactly will the station be built? They would like to know so they can leave before it happens.

These grandiose plans by the nuclear industry seem irrational and unfounded compared to potential renewable energy sources, which are virtually untapped. Small, heavily worn wind-power stations at meteorological stations and reindeer herders' camps are the only exceptions. In 1995, basic equipment for a wind-powered station was installed in the village of Nagorny (Beringovsky Raion), but the station was never completed. Wind energy resources alone in Chukotka can generate 1.5 trillion kW annually, more than 14 percent of Russia's wind energy resources. Microhydropower plants would be more suitable than conventional energy in the continental parts of the *okrug,* where the number of windless days is greater than along the coast. The energy crisis in Chukotka is getting progressively more severe. Alternative energy sources are becoming attractive, as the delivery of conventional fuels (coal, oil, and nuclear) becomes more expensive and difficult.

Oil and natural gas. Many low-elevation areas of Chukotka and huge expanses of the continental shelf beneath the Chukotka, East Siberian, and Bering Seas have accessible oil and natural gas deposits. In the 1980s, scientists confirmed these reserves when exploratory drilling in the Anadyr basin led to discovery of the Verkhnetelekaisk oil and gas condensate, the Verkhnechinsk oil, and the Zapadno-Ozernoe gas deposits. These reserves, if developed, would be commercially valuable for between thirty and forty years.

In 1995, the Russian Government opened tender bids for these deposits, which the Chukotka Trading Company won. Prior to the bid contract, however, the Council of Federal Environmental Expertiza tried to stop the project because of its failure to comply with a number of environmental regulations. First, the deposits are within the boundaries of three *zakazniks*, which are habitat for migratory birds. These areas also have some protection under two bilateral migratory bird treaties (one between the USSR and Japan, and the other between USSR and the United States). The Russian Federation legally must abide by these USSR treaties. Displeased with the assessment, the *okrug* government disbanded the council and created a new, more compliant one. Soon after, the Chukotka Trading Company won the contract. Sibneft then purchased the rights in 2001.

Sibneft begins drilling for oil

The Russian firm Sibneft began test drilling for oil in the Mochalivy Island concession (150 km southeast of Anadyr) in late 2001. The company expected to spend about U.S.$50 million on the test well. Sibneft has also teamed up with Russia's second largest company, Yukos, to do seismic studies of Chukotka's offshore fields. Sibneft holds the exploration and production licenses to three oil and gas blocks in the Anadyr basin and another block (Uglovoe) in the Khatyr basin.

Many ecologists based in Magadan consider the proposed oil and gas extraction projects along the Sea of Okhotsk and Bering Sea coasts to be the greatest ecological threat to the region. There is concern about the environmental impacts of construction of drilling platforms, underwater pipelines, tanker terminals, and airports. The natural conditions of this region are particularly hostile, with extremely icy conditions. What measures would protect marine mammals (polar bears, walrus, whales, and seals) who depend on this ocean habitat?

The nature reserve on Wrangel and Herald Islands, together with the surrounding waters, forms the most important year-round habitat for polar bears in the circumpolar Arctic. The polar bears in the Chukchi Sea move freely between Russia and the United States. Polar bear populations would be threatened by an oil spill. According to Dr. Nikita Ovsyanikov, a research scientist affiliated with the Wrangel Island reserve, "some 80 percent of female polar bears in the region come to den on Wrangel and Herald Islands each year. The mother bears are extremely cautious at this time and will often abandon their dens and cubs when disturbed. Together with increased poaching … additional mortality could send polar bear populations plummeting."

– *JN*

Scientists estimate that these are only about 3 to 4 percent of total recoverable reserves of Anadyr basin. Geologists believe that these reserves are the outer edges of much larger shelf deposits, with estimates reaching billions of tons of oil, beneath the Bering, Chukotka, and East Siberian Seas. These deposits have high paraffin concentrations, but several companies want to extract and refine them.

The Khatyrsky basin, located in southern Chukotka in the Meinypilgin network of rivers and lakes, is fairly well explored. During oil exploration, at depths reaching 1,650 m, an accidental underwater oil spill of more than 200 cu. m occurred. The productive wells are on the Bering Sea coast, particularly attractive to industry because of the easy access to nearby export markets.

Oil spills, which can be lethal to marine and terrestrial ecosystems, will be inevitable in offshore and gas oil extraction. The famous example is the *Exxon Valdez* spill in Alaska. Alaskan Inuit remembered this spill when they refused to allow British Petroleum to extract oil in the Beaufort Sea, near Barrow, but nobody bothers to ask the native people of Chukotka for their permission.

Agriculture

Agriculture includes reindeer breeding and the cultivation of some plants, the latter limited by the harsh weather. Agricultural organizations, enterprises, and individuals use about 68 million ha of land; 60 percent (40.7 million ha) of which is used to herd reindeer. The richest pastures are in the Anadyrsky and Bilibinsky Raions, where more than half of Chukotka's reindeer graze. Reindeer herding is the most important agricultural activity, providing jobs, income, and playing a key role in indigenous culture. Agroforestry, mainly hay production, occupies 8,700 ha (0.01 percent) of the land.

Pigs and livestock are an insignificant part of the *okrug* economy, and cattle breeding is declining. Small herds of Yakut horses are kept in the Anadyrsky and Bilibinsky Raions. Raising pigs is generally most successful when done by private owners. Until recently Anadyrsky Raion's farming collective Severny raised fowl, but high costs to transport the feed and high mortality rates led to the closure of the farm.

Until the early nineties, most coastal dwellers on the peninsula raised silver and arctic foxes in animal farms. Despite cheap animal feed, mainly unwanted by-products from marine animal harvesting, caged animal production cost from between three and five rubles for every ruble of profit. Nevertheless, animal farms grew in number as they and the intensive harvest of whales, walruses, and seals were supported by government subsidies. The native peoples sold the whale blubber and ate the seal and walrus meat or fed it to the caged animals. When subsidies ended, most of the farms closed, and the remaining ones will likely close soon. However, hundreds of gray whale skeletons and long rows of collapsing sheds with their fox skeletons will remain for many years to remind us of the senseless sacrifice done for the benefit of an ideological economy.

Hunting and fishing

Native people still largely depend on hunting and fishing of marine resources. The diet of coastal Chukchi and Eskimo depends on the meat of marine mammals and fish, sometimes from marine invertebrates and plants of the tundra. They earn some limited income from minor trade in furs, walrus tusks, and other products derived from hunting and fishing. Hunting wild ungulates and small game is also

important. Low international demand for fur products has hit hunters and trappers hard; the industry was once a major source of income.

Commercial fishing centers around the west Bering Sea (from Cape Rubicon to Cape Dezhnev) and in the rivers. Because of the shortage of boats, the *okrug* government sells a large portion of the annual quota to outside fishing enterprises. A Chukotka fishing company has been formed and will likely increase harvest levels; fish processing may be developed. The main fish processing operation in the region, which is now closed, was in Anadyr and included several factories where fish was processed, cooked, and canned, and caviar was salted. The regional economic collapse closed the facility. A Chukotka trading company recently purchased the assets.

Overfishing, poaching, and pollution of watersheds are the primary environmental problems associated with the industry. Rapacious overfishing in the 1950s and 1960s led to a collapse in fish stocks, and despite years of reduced fishing quotas, there are no indications thus far of a population recovery. Illegal sockeye salmon (*Oncorhynchus nerka*) caviar production conducted in the spawning grounds of the Meinypilgyn network of rivers and lakes threatens this fish population. The fisheries' enforcement agencies are inadequately equipped to stop the rampant poaching.

Light industry is underdeveloped and produces goods only for local markets. This includes a leather factory in Provideniya, a bone-cutting shop in Uelen, and small sewing shops near collective farms and in homes. Animal hides, fur, bones, and tusks are used as raw materials. Despite minimal profits, outdated equipment, and difficulties with product delivery, these enterprises do in fact have some future and the resource base they depend on is fairly large and stable.

In 1993, meat and milk production employed 6 percent of the workforce and generated about 3 percent of national production; almost every *raion* center in Chukotka had meat and milk facilities, and several agricultural and mining enterprises produced food. This industry was always unprofitable and subsidized, but now the high costs of importing materials to produce the food, energy price increases, and production costs have exacerbated this unprofitability. Between 1990 and 1996, the production of sausages fell by 90 percent, milk by 87 percent, and baked goods by 50 percent. Despite these problems, food production has significant possibilities. Enterprises that produce high-quality fish products and reindeer meat, in particular, have good potential.

Until 1990, construction was one of the region's fastest growing industries, employing 2.7 percent of the population and generating 2.9 percent of the industrial production. Primarily in Anadyrsky Raion, this industry included construction materials, sand and gravel mixes, construction sand, clay bricks, and concrete. Loss of state subsidies has led to decline of this industry as well.

Transport

The transport sector employs almost 10 percent of the workforce. Sea shipping moves 90 percent of all cargo. The primary seaports are Pevek, Mys Shmidta, Provideniya, Beringovsky, Anadyr, and Egvekinot. Most goods come from the southern RFE (Vladivostok and Nakhodka), rather than from the west (St. Petersburg, Arkhangelsk, and Murmansk). Airplanes and helicopters move people to and from Chukotka. The largest airports are in Anadyr, Pevek, and Mys Shmidta, with airplanes such as the Ilyushin 62, the Ilyushin 76, the Tupolev 154, and the AN 12 landing there. Travel within the *okrug* is by old MI-8 helicopters. Automobile transport is insignificant. There are 2,400 km of roads, most of which are gravel. Only 700 km of the roads can be used year-round. Heavy use of the roads in winter damages tundra and reindeer pastures.

Toward sustainable development

Gennady Smirnov, Maxim Litovka, Dmitry Naumkin

Increasing use of renewable energy resources is the first thing that comes to mind when pondering alternative forms of economic development for Chukotka. Scarcely used, renewable energy resources have great potential. However, aside from a few small wind-powered generators at meteorological stations and the partial construction of the wind power station in Nagorny Village, little effort has been made. This issue is also urgent because of rising costs to deliver coal and oil to the region, and the great risks of nuclear power. Wind and hydroelectric power stations for individual and community use must be developed. Initially, a demonstration facility should be built in Anadyr. Support from environmental organizations and foundations could help offset the costs of building such a facility.

Learning from indigenous peoples. All forms of traditional nature use follow with the principles of sustainable development. For thousands of years, Chukotka's indigenous peoples have raised reindeer, which can adapt to a range of environmental conditions and thus are able to thrive in the far north. Reindeer meat is of high quality, the skin can be used for a variety of purposes, and the antlers (*panty*) can be used in medicines and liqueurs. Unlike the raising of other domesticated herd animals, a practice alien to traditional Chukotka peoples, reindeer herding requires no transport of feed, and there are no special labor or capital requirements. Currently, as there are enough natural resources to feed reindeer, herding is the most promising industrial enterprise for Chukotka.

Products from marine mammals may also be useful for the pharmaceutical industry. Some experts estimate that the potential value of biologically active substances, enzymes, and endocrine secretions available from marine mammal organs could exceed the revenue from Chukotka's entire gold mining industry. However, the hunting of marine mammals is first and foremost a way of life for the native coastal peoples, with complex principles that may not always be comprehensible to outsiders. These principles must be protected and respected and never sacrificed for other businesses.

Fishing

The fishing industry of Chukotka, if done sustainably, also has a potentially good future. Marine resources are, however, being sold off to foreign fishing companies because Chukotka does not have a commercial fishery fleet and processing is poorly developed.

Hunting

The potential for hunting lies in the harvest of wild reindeer and improvement of meat processing and production facilities in Anadyrsky, Bilibinsky, and Chaunsky Raions. Fur production has some potential, particularly if the *okrug* government supports fur-processing factories in remote areas; this would give native peoples a steady source of income.

Ecotourism

Ecotourism, although fairly well developed on nearby Kamchatka Peninsula, is undeveloped in Chukotka. Tourists who visit Chukotka leave inspired and impressed; few places remain where nature exists on such a grand and pristine scale. The diversity of ecosystems, alternating valley and mountain landscapes, and an unfamiliar intensity of colors matched by the rich wildlife present great possibilities for adventure tourism. Possible tours include sea and river cruises, river rafting, and dog sledding.

Ecological monitoring and assessment

Ecological monitoring is inadequate. An environmental impact assessment system is completely undeveloped. Mining, fishing, and other enterprises are often not inspected. Specialists feel that monitoring and controlling radiation in coastal areas is particularly important (the RITEGS are an obvious example). An independent environmental assessment is urgently needed for the Bilibino nuclear power plant, for the planned floating nuclear power plant in Pevek, and for the proposed onshore and offshore oil and gas projects. Greater regulation of land and water pollution caused by the mining industry is needed. Widening and modernizing the network of meteorological stations is important to predict natural

disasters. Chukotka's unusual geographic position allows for a great scientific opportunity to monitor marine ecosystems in the Bering Strait.

Water quality

Water treatment facilities need to be constructed in all medium and large towns and cities.

Indigenous peoples

Gennady Smirnov, Maxim Litovka, Dmitry Naumkin

Most of Chukotka's ancestral peoples (the Chukchi, Koryaks, Kereks, Eskimos, and Yukagirs) have paleo-Asiatic origins. The exceptions are the Evens, a Tungus-Manchurian group, and the Chuvans, a racially mixed group formed in the seventeenth and eighteenth centuries. Unlike other well-known groups of early settlers with Russian origins such as the Kamchadals and Kolymchans, the Chuvans were recognized as an indigenous group and thus paid regular *yasak* (fur tribute) to the tsar's treasury.

A single ancestral nation of Eskimos and Aleuts are believed to be the oldest inhabitants of northeast Asia and islands in the Bering Sea. Here Eskimos, living on the northeast tip of Asia, developed their marine hunting culture that spread to the northern coasts and Arctic islands of America and Greenland. Ancestors of modern-day Chukchi, Koryaks, and Kereks migrated from southern regions of Eastern Siberia, arriving in Chukotka much later than the Eskimos.

Archeological evidence indicates the Kereks were hunting seabirds and mammals in the region by 1000 B.C. and that an early Koryak group was living in the region as early as 3000 B.C. Evens, primarily reindeer herders and hunters, appeared much later, migrating from northern Khabarovsk Krai and settling part of the Anadyr basin in the nineteenth century. Horseless hunters of the taiga, the Yukagirs (Hodyns, Chuvans, and Anauls) are more difficult to categorize ethnographically. Some scholars place their ancestral roots in the Altai Range (Southern Siberia); others trace their origins to the Kolyma, Omolon, Greater Anyui, and Lesser Anyui River basins in northeastern Russia.

Indigenous peoples live on reindeer herding, hunting, and fishing. For centuries, the Chukchi, Koryaks, and Evens have been reindeer herders in the tundra; Chaplino Eskimos also did a small amount of herding. Before the development of herding, they hunted migrating wild reindeer at river crossings. In the same region, Yukagirs and Chuvans hunted ungulates and traded sable and squirrel pelts. The sable trade expanded greatly in the seventeenth century, as Russian explorers imposed the *yasak* system. Trade expanded with Russian and American traders, who sought other species in addition to sable. The fur trade ensnared all of Chukotka.

Management of large reindeer herds, as practiced today in Chukotka, began in the eighteenth century. Chukchi and Koryaks, who considered herders with fewer than two hundred head to be poor, often had herds of more than one thousand animals. Even herders grazed their smaller herds primarily in boreal forest and southern tundra; the more forested region necessitated smaller herds. The Evens also used dogs to assist in herding, unlike the Chukchi and Koryaks. Evens rode on and carried loads on the reindeer, while Chukchi and Koryaks harnessed theirs to various types of sleds.

Marine mammals, mostly whales and walruses, provided for all the material and spiritual needs of the Eskimos and coastal Chukchi (the Ankalins). Bearded seals were also hunted, as were smaller pinnipeds. Until the appearance of firearms, whales and walrus were hunted with traditional weapons; this required great physical and spiritual stamina, including the mastery of hunting skills and sophisticated esoteric rituals that brought a certain spirituality and gratitude to killing the animals. These practices likely led to formation of secret clans of men, analogous to those described in literature about *Kitovaya Alleya* (Whale's Patch). Chukchi and Eskimo consciousness and culture, as a result, were inextricably linked with sea hunting, nature, and natural spirits.

Contact between native peoples and Russian explorers brought conflict.

Map 8.2
Indigenous lands of
Chukotsky Autonomous Okrug
Note: Chukchi land is dispersed throughout Chukotka

By Newell and Zhou / *Sources:* Smirnov, 2000; ESRI, 2002.

Among many traditional arts and crafts none is as important for seafaring Chukchi and Eskimos as the art of building baidar, *walrus skin boats.*

Written accounts by Semyon Dezhnev, Kurbat Ivanov, and other explorers, describe violent and cruel skirmishes with the natives. Dezhnev and his army of Cossacks destroyed tribes that refused to submit and slaughtered huge walrus populations at their breeding grounds, which had been protected by Eskimo and Chukchi tribes. Yet the natives resisted; their perseverance is evidenced by the fact that three centuries of missionaries were unable to convert either Chukchi or Eskimo to Christianity.

Mid-nineteenth-century expansion of American, Norwegian, and British whaling ships almost destroyed bowhead whale and Pacific walrus populations; the species completely disappeared from some parts of Chukotka. Hunger and death afflicted the native whalers, and many settlements were abandoned during this period.

Soviet control of Chukotka led to *razkulachivanie*, the destruction of the resource-owning class. Owners of large reindeer herds were targeted. Forced collectivization followed, as did the expansion of towns and cities. Reindeer herding, under the iron hand of the government, was reduced to mere meat production. In the late 1960s, Magadan Soviet officials proclaimed that Chukotka must expand the reindeer herd to one million head. Despite obvious lack of grazing land, the government forged ahead. By 1971, the herd peaked at 576,000 and began its inevitable decline. Epizootics increased, as did depleted grazing areas. With the industrialization of Chukotka, the migration of people from other parts of the Soviet Union became a form of governmental politics. By the middle of the 1980s, there were nine times as many immigrants as native residents. Intensive industrialization on the lands of the indigenous peoples, forced acculturation with the European way of life, and the massive immigration permanently disrupted the region. The essential material, social, and spiritual aspects of Arctic civilization and ecology began to disappear, despite the need for balanced development in these fragile polar ecosystems. Many accounts remain of the native people's resistance to incessant Soviet attempts to stamp out their balanced way of life. To a large extent, the truth about this Soviet period is no longer accessible.

The Soviet government eliminated traditional forms of hunting in favor of captive-animal husbandry to provide centralized employment opportunities in growing villages and cities; this increased meat production levels, but the product could not be processed or stored properly. Tractors dragging unused whale skeletons to discard them in the tundra became an increasingly common sight. *Kolkhoz* and *sovkhoz* storage sheds were packed with thousands of untreated seal pelts, which often went unused and were destroyed. In areas around large towns, gigantic dumps of construction material and domestic refuse grew, as did huge whale graveyards. During this era of "developed socialism," Chukotka's native peoples suffered greatly; in particular, most hunters of marine mammals lost their spiritual reverence of the prey that they killed.

After the dissolution of the USSR, reforms brought an end to the regular government subsidies that the villagers depended on. *Sovkhoz* collectives became small farms, which were initially welcomed by native peoples as an opportunity to develop economic independence. However, privatized reindeer herders now find themselves in dire straits because of the collapse of industry, the disruption of economic ties, and high transport costs. Decline in medical services and shortages of basic staples (food and household goods) have become severe. Most reindeer herding farms situated near populated areas have failed and many of the herders and farmers feel they lack true ownership. Reindeer are sold for a fraction of their value, grazing areas are left unprotected, money from sales goes for alcohol, and many of the herders have become *oleneedy* (reindeer eaters). The lack of laws protecting herding lands hastens this degradation of herding culture and the economy. The ancient culture of the herdsman of the tundra is at risk of extinction.

Lacking money, coastal native peoples have again turned to the sea as a source of food, which ironically is bringing them closer to nature. Most now survive exclusively on marine mammal meat, fish, and marine invertebrates. Small surplus quantities of fish and meat, and sewn goods and handicrafts, are sold to tourists, or traded in nearby *raion* centers. Residents are reviving some traditional practices, such as building leather *baidar* (kayaks) or training sled dogs. Some are starting to practice forgotten spiritual traditions, based on exalting the sea hunt and hunter. Hunting at sea is once again becoming a prestigious calling in coastal cultures.

Chukotkan natives and American Inuit are participating in scientific research on bowhead whales. From data collected through this collaboration, the International Whaling Commission (IWC) granted Russia rights to hunt up to five bowhead whales, although in 2002 the IWC revoked this right. Leaders and activists are appearing among the native peoples and are forming nongovernmental organizations (NGOs). The Association of Native Minorities of Chukotka (AMKNCh), with branches in every *raion*, is the first of these new NGOs to develop quickly. The Eskimo Society of Chukotka, a member of the Inuit Circumpolar Conference (ICC,) reindeer herder organizations, such as the Association of Reindeer-Herders of Chukotka, and marine mammal hunters' associations, such as the Union of Marine Mammal Hunters of Chukotka, have been formed. These organizations include in their lists of goals the need to restore traditional forms of resource use and to conserve the environment. Some projects are becoming a reality, thanks to grants from international NGOs and foundations.

The bowhead whale research project began in the early 1990s at the initiative of the North Slope Borough Corporation of Alaska, the national cooperative Naukan, and the Eskimo Society of Chukotka. In addition to research, this project has also helped resolve some social problems of Chukotka indigenous peoples. The project has developed

a creative and committed group of people and a wealth of experience, both valuable assets for future work.

In 1996–1997, Kaira Club and AMKNCh developed the project Meechkyn (Hope of sea hunters of Cross Bay), which studies ecological aspects of the worldviews of sea hunters and the role of the master at the Meechkyn walrus breeding grounds. Also, the group collected extensive information on past and present conditions of traditional resource use; these findings were included in a list of resolutions passed by the Chukotka government concerning the long-term future of the native marine hunting industry. The most significant accomplishment of the project was encouraging citizen activism at Cross Bay, which led to a national movement to protect these important walrus breeding grounds. In this region, Chukchi and Eskimos have already selected people in Inchoun and Yanrakinnot villages to protect these grounds.

Native peoples are beginning to manage marine mammal populations again. In addition to the work on bowhead whales, coastal Chukchi and Eskimos are working on similar projects to study and protect Pacific walruses and polar bears. They are also sharing reindeer herding experiences with counterparts in Finland and Norway.

Effective traditional resource use by native populations in Chukotka, as in the rest of Russia, ultimately depends on resolving issues of land ownership. Much paper has been devoted to prolonged discussion of Territories for Traditional Nature Use (TTP) legislation. This discussion will probably not be decided in favor of the native population as long as allies of industrialization in Chukotka dominate administrative and legal structures. And until the reindeer herder feels himself to be a master of the lands that his ancestors carefully lived on and cared for, reindeer herding as a form of material and spiritual culture will be at risk.

Legal issues

Gennady Smirnov

Despite adequately strong regulations for natural resource use, in practice, poaching levels and other violations remain high. Most of the population does not respect the laws. Many environmental violations and crimes remain hidden because of pressure from *okrug* and *raion* authorities on the regulators. It is difficult to find examples, as such cases are usually not made public. However, through personal contact, we have discovered this to be the case. Attempts to pursue these violators, in defiance of government will, are severely resisted. As mentioned earlier, in 1995, a Chukotka Council for Environmental Expertiza recommended against developing the Anadyrsky oil and gas project, arguing it was a threat to Ostrov Vrangelya Zapovednik. The *okrug* government's immediate response, however, was to disband this disobedient council and appoint a new, more malleable one. One can repeat the common saying in Russia: "Why make new laws, when the old ones aren't followed?"

There has been a gradual departure of the more principled and highly qualified specialists from resource agencies. Lack of professionals in this area is one of the primary problems facing all *okrug* agencies.

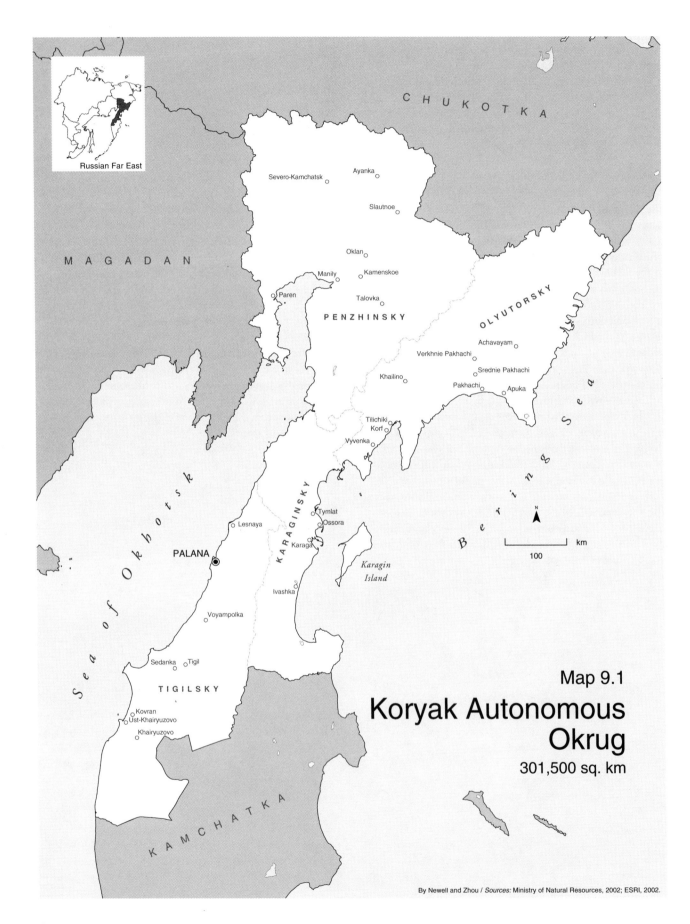

Russian Far East

C H U K O T K A

M A G A D A N

Severo-Kamchatsk Ayanka

Slautnoe

Oklan

Manily Kamenskoe

Paren Talovka

PENZHINSKY

OLYUTORSKY

Achavayam

Verkhnie Pakhachi

Srednie Pakhachi

Khailino Pakhachi Apuka

Tilichiki
Korf

Vyvenka

B e r i n g S e a

S e a o f O k h o t s k

K A R A G I N S K Y

Tymlat
Ossora

Lesnaya Karaga

Karagin
Island

PALANA

Ivashka

Voyampolka

N

100 km

Sedanka Tigil

TIGILSKY

Kovran
Ust-Khairyuzovo

Khairyuzovo

Map 9.1

Koryak Autonomous Okrug

301,500 sq. km

K A M C H A T K A

By Newell and Zhou / *Sources:* Ministry of Natural Resources, 2002; ESRI, 2002.

KORYAKIA

Koryak Autonomous Okrug
(Koryakia)

Location

The Koryak Autonomous Okrug (Koryakia) covers the northern two-thirds of the Kamchatka Peninsula, the adjoining mainland, and several islands, the largest of which is Karaginsky Island. The northern border with Chukotka and Magadan Oblast runs along the tops of ridges, marking Koryakia as a separate watershed from those territories. The southern border with Kamchatka Oblast marks the beginning of Eurasia's most dramatic volcanic landscape.

Size

301,500 sq. km, or about the size of the U.S. state of Arizona.

Climate

Koryakia's subarctic climate is moderated by the Sea of Okhotsk and the North Pacific. January temperatures average about −25°C, and July temperatures average 10°C to 14°C. Average annual precipitation for the region is between 300 and 700 mm. Inland areas in the north have a more continental and drier climate, and areas around the Sea of Okhotsk tend to be cooler in winter and summer than those on the Pacific shore.

Geography and ecology

The *okrug*'s four *raion*s roughly mark four separate drainages: Rivers in Olyutorsky and most of Karaginsky Raion drain into the Bering Sea, while rivers in Penzhinsky and Tigilsky Raions drain into the Sea of Okhotsk. The Central Ridge, including the *okrug*'s tallest peak, Mt. Khuvkhoitun (2,613 m), continues north from Kamchatka Oblast. The ridge declines in average elevation as one proceeds northward to Parapol Valley. Characterized by low, swampy tundra, much of it on permafrost, Penzhinsky Raion is ideal for some of Northeast Asia's largest herds of wild and domestic reindeer (*Rangifer tarandus*). In the northeast, Olyutorsky Raion is more mountainous, with peaks averaging between 1,200 and 2,000 m.

Flora and fauna

Koryakia varies greatly in vegetation, from barren alpine peaks to Dahurian larch (*Larix gmelini*) woodlands, coastal meadows, and riparian forests of chosenia (*Chosenia arbutifolia*) and willows (*Salix*). The most widespread type of vegetation is subarctic tundra, often with groves of Japanese stone pine (*Pinus pumila*) and shrub alders (*Alnus*), and scattered larch trees.

The Okhotsk and Bering littorals are home to many marine mammals, including walrus (*Odobaenus rosmarus*), Steller's sea lion (*Eumetopias jubatus*), Northern fur seal (*Callorhinus ursinus*), and other seals. Gray whale (*Eschrichtius robustus*) largely disappeared from the Sea of Okhotsk in the nineteenth century, but indigenous people still hunt beluga (*Delphinapterus leucas*). The Okhotsk and Pacific shelves are rich fisheries, especially for Kamchatka crab (*Paralithodes kamtschaticus*). The rivers provide spawning grounds for most species of Pacific salmon (*Oncorhynchus*).

Forest and tundra fauna include a range of fur-bearing animals: sable (*Mustela zibellina*), wolverine (*Gulo gulo*), river otter (*Lutra lutra*), Eurasian lynx (*Felis lynx*), red fox (*Vulpes vulpes*), and American mink (*M. vison*). Large predators include gray wolf (*Canis lupus*) and brown bear (*Ursus arctos*), the latter under increasing pressure from poaching for the Chinese gall-bladder market. Indigenous people also depend upon wild and domesticated reindeer, snow sheep (*Ovis nivicola*), and moose (*Alces canadensis*). Many species of rodents are found all over the *okrug*, including lemmings (*Lemmus*) and the rare Kamchatka marmot (*Marmota kamtschatica*). Waterfowl is most abundant in Parapol Valley; other birds common to the region include eagles, owls, falcons, and ravens (*Corvus corax*), a prominent figure in the mythology of native peoples.

Largest cities

The largest town is Ossora (pop. 6,000), the center for Karaginsky Raion, the most populated and economically developed *raion* in Koryakia. Tilichiki and Korf (the site of the main airport, just across a small bay) together total about four thousand people. The capital, Palana, once had a population of over six thousand, but now has closer to four thousand.

Population

As of 2001, there were 29,100 people living in Koryakia, about one-third of those being indigenous to the area (Koryaks, Itelmens, Chukchi, and Evens).[1] This is the first time in over thirty years that the population has been less than thirty thousand, down substantially from the 1991 peak of forty thousand people. The emigration rate has declined in recent years, but so has the birth rate.[2] The population is concentrated in a compact settlement pattern; towns and villages occupy only 37,700 ha, 0.1 percent of the total territory, and human activities seriously affect less than 1 percent of the total area.

Key issues and projects

The persistent energy crisis

The single greatest challenge to the environment and people's standard of living is the energy crisis. Low-grade coal and diesel for heating and electricity contribute to pollution, and local people are cutting more trees, as firewood increasingly becomes the main source of home heating in many villages.

Platinum mining

The main enterprise engaged in mining precious metals in the *okrug* is ZAO (closed joint-stock company) Koryakgeoldobycha, established in 1992. During the first six years of its existence the company became a large enterprise, increasing platinum production from 600 kg to 6 tons annually by 1998. It is the largest alluvial platinum mining enterprise in Russia.

Coal mining

Low-grade brown coal, the deposits are mined for local heating plants.

Poaching

Poaching is a serious threat to salmon stocks. The indigenous and some of the immigrant population sometimes fish illegally, preserving fish for winter and selling the roe for cash. Most seriously, professional caviar pirates are notorious for taking large amounts of roe and leaving the fish to rot on the riverbank. Conservation activity should take into account the subsistence needs of locals and distinguish that from unsustainable poaching.

A. D. King

Chukchi children from the reindeer herding village of Srednie Pakhachi in northeastern Koryakia.

Political status

In 1993, Koryakia was declared an "equal subject of the Russian Federation" in Yeltsin's famous decree, but its political status remains ambiguous. The *okrug* was subordinated to Kamchatka Oblast soon after its establishment in 1930. It has never had a political and economic infrastructure truly autonomous from Kamchatka Oblast. Local political and economic power is mostly in the hands of ethnic Russian and Ukrainian immigrants, and Koryakia's "sovereignty movement" has never been a simple case of indigenous ethnic nationalism. In 1996, Koryakia had the distinction of electing Russia's first female governor, Valentina Bronevich, an ethnic Itelmen. Her administration did not see any marked improvement of the situation among indigenous people (which is certainly hampered by the endemic economic crisis of the past nine years), although in May 1999, the *okrug* and *oblast* administrations did sign an agreement on the terms of the relationship between the two territories.[3]

Natural resources

Koryakia's main resources are precious metals (platinum group metals, gold, and silver) and fishing products: Pacific salmon, whitefish (*Coregonus, Prosopium*), Pacific herring (*Clupea pallasi*), walleye pollock (*Theragra chalcogramma*), Pacific cod (*Gadus macrocephalus*), and various species of crab. Other mineral resources include mercury, antimony, arsenic, sulfur, coal, limestone, and tin. The coal is low grade and suitable only for local consumption. Development of mineral resources has been hampered by high costs associated with rugged, remote locations and almost complete absence of infrastructure. The following deposits of nonferrous metals have been discovered, explored, or partially explored: Snezhnoe, Itchayvayam, Sergeevskoe, Liapganaiskoe, Neptunskoe, Olyutor, Ainavetkinskoe, Khrustalnoe, Ametistovo, and Ozernovsky (see map 9.2). The last two are the largest gold deposits and are being targeted by Russian companies for development with foreign participation. Forest resources are negligible for commercial development. Traditional indigenous activities (reindeer herding, hunting, and fishing) are not commercially viable. Limited oil reserves have been found within Koryakia's territory on the Sea of Okhotsk shelf, but they have not been fully explored and mapped. Oil and gas

regions cover 46.8 sq. km in Koryakia; the most promising are the Vivensky and Voyampolsky regions. The total gas potential is estimated at 87 billion cu. m, but the extraction base has not yet been established due to the lack of foreign investment.

If Koryakia were able to develop a tourist infrastructure, it would be able to capitalize significantly on its latent tourist resources: game hunting, fly fishing, adventure wilderness trips, and ethnographic tourism. Although in an embryonic stage of development, tourism has produced favorable reviews by those few who have visited the region.

Main industries

Accounting for about 70 percent of total annual production, fishing is by far the most important industry in Koryakia and includes subsistence salmon fishing and drying for winter, caviar production (legal and illegal), commercial river fishing, and large-scale, sea-based fishing by local companies, such as Ianin Kutkh, and foreign licensees. After a high of 140,000

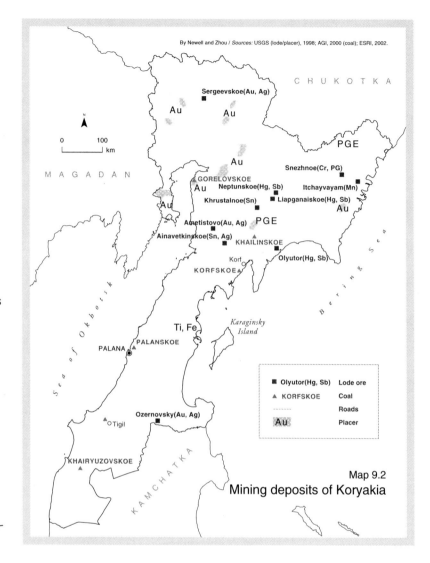

By Newell and Zhou / *Sources:* USGS (lode/placer), 1998; AGI, 2000 (coal); ESRI, 2002.

Map 9.2
Mining deposits of Koryakia

tons of fish caught annually in the 1970s, the official annual fish catch has not exceeded 100,000 tons since. Nonferrous mining is the next most lucrative enterprise, but is poorly organized, save for platinum mining in Karaginsky Raion. Much of the gold is produced by small-scale, semilegal operations in Penzhinsky and Olyutorsky Raions, typically from placer deposits.

Infrastructure

The lack of roads and seaports as well as an aging air fleet characterizes local infrastructure. Koryakia relies upon Petropavlovsk-Kamchatsky as the only major port and airport in the area. None of the towns has port facilities, and ships from the open sea (in Palana) or bays (Ossora, Manily, Korf) are unloaded onto barges. Direct flights from Petropavlovsk are available to Korf, Tilichiki, and Ossora, on Yak-40s, and to Palana on AN-28s. Pakhachi has direct service to Petropavlovsk from May through September. Merchants also make use of commercial helicopter cargo flights from the Kamchatka Oblast towns of Esso and Anavgai, which are connected to Petropavlovsk by highway, to supply the southern part of Koryakia, especially in winter. Helicopter flights to smaller villages are irregular, but are usually available at least once a week. Flights to Magadan and Chukotka

Vladimir Dinets

Of all the RFE regions, Koryakia has the least developed infrastructure. Some coastal settlements have no overland or deepwater access. Visitors to these small villages have to be unloaded by crane to a special barge to get onshore.

were discontinued in the mid-1990s. Soaring fuel costs make air transport very expensive. Chartering an MI-8 helicopter costs about U.S.$200 per hour of flight. A one-way ticket between Petropavlovsk and the capital, Palana, is about U.S.$200.

Winter roads provide more convenient access between many towns and villages, and individuals use snowmobiles, dogsleds, and even reindeer for transport between villages.

The only permanent road in the *okrug* runs from Ossora to the village of Karaga, about 20 km away, and is unpaved. Outboard motorboats are used for local riverine transport. Small, self-powered barges service many of the smaller villages from Palana, Manily, Ossora, and Korf. The Penzhina is the largest navigable river, servicing Kamenskoe, Oklan, Slautnoe, and Ayanka from Manily. However, low water levels in late summer make the last two villages difficult to reach.

Internet access is available through servers in Petropavlovsk. Palana and Tilichiki have direct dial-in numbers to local routers with permanent connections to the Petropavlovsk servers. Internet use is limited to commercial and governmental elite, but is growing. All villages have telephone service except Paren, which relies on two-way radio connections with Manily.

Foreign trade

The greatest exports in terms of volume and value are in fish and marine products and in platinum. There is a growing black market export in bear gall bladder to the People's Republic of China, and poached salmon roe also makes its way to other Russian regions and Japan. Nearly everything else is imported: food, clothing, building materials, and fuel. Used cars are imported from Japan through Petropavlovsk. Food is imported primarily from other areas of Russia and the former Soviet Union, but South Korea, Canada, and the United States are also major suppliers. Clothing and other dry goods (typically of the lowest quality) most often come from China and South Korea. Retail prices in Palana average 1.9 times higher than those in Petropavlovsk.[4] Prices in small villages typically are double what they are in larger towns such as Palana. The administration is actively seeking foreign investment in fishing and fish processing, platinum and gold mining, and attracting foreign hunting and adventure tourism, primarily from Germany and North America.

Hills in an April sunset in northeastern Koryakia.

A. D. King

Economic importance in the RFE

Along with its neighbors Chukotka and Kamchatka, Koryakia was closed as a border zone during Soviet rule. Its biggest contribution to the RFE economy is the sale or lease of fish and crab quotas to Vladivostok or foreign-based companies. Caviar is exported, but Koryakia lacks the ability to process (freeze or can) fish on a large scale.

General outlook

In a word, grim. As is common all over the RFE, Koryakia suffers from a persistent energy crisis. Settlements are widely scattered about and diesel-electric generators and coal-fired centralized heating plants provide for each settlement separately. Skyrocketing transport costs and persistent lack of funds have forced severe cutbacks. All towns experience some kind of electric rationing through periodic outages. Heating plants operate at reduced capacity. Households resort to electric heaters and woodstoves. Many of the smallest and most remote villages (e.g., Paren) rely almost entirely upon woodstoves for heat and candles and oil lamps for light. All of the larger towns and many of the villages are located on the coast, where wind power would be the most economic and reliable source of electric power.[5]

— *Alexander King*

Ecology

Sergei Abramov, Robert Moisseev, Olga Chernyagina

Koryakia lies mainly within the tundra woodland zone. Lowlands are sparsely forested, with Dahurian larch and stone birch (in the south) being the dominant tree species. Tall forests of larch grow in river valleys along the western and southern borders. Upland areas are covered with subarctic tundra, composed of low shrubs, grasses, lichens, and mosses, with large areas of Japanese stone pine, stone birch, and shrub alder thickets. Alpine tundra is widespread at higher elevations. Coastal meadows exist along the eastern seashore, but most coastal areas are covered with wet tundra and peat bogs. Riparian forests, mostly of chosenia, willows, and aromatic poplar (*Populus suaveolens*), line the large rivers.

The ecosystems are mostly pristine because of minimal human impact. The topography of the area is mainly mountainous, though marshy plains cover more than 25 percent of the territory. The Central Mountain Range continues north from the Kamchatka Oblast to Parapol Valley. The rugged Koryak Mountains dominate Olyutorsky Raion. The Ichigem Mountains form the western border with Magadan Oblast and include the headwaters of the Penzhina River. The largest plains are the West Kamchatka lowland (extending north from Kamchatka Oblast territory along the Okhotsk coast) in Tigilsky Raion and Parapol Valley in the north.

The moderate subarctic climate is determined by the high latitude of the area as well as its closeness to the Okhotsk and Bering Seas. The northern, landlocked part of Koryakia has a more continental climate. Marine influences make the weather highly variable. Both the long winters (lasting up to seven months) and the cold summers are punctuated with severe storms. The longest rivers are Penzhina, Vyvenka, Apuka, and Tigil. Characteristically, the water in the rivers is soft and hydrocarbonated. Large areas of the plains are covered with swamps and small lakes, generated by excessive humidity, permafrost, slow surface runoff, and river flooding

Wetlands, mainly moss and grass, cover almost the entire western Kamchatka lowlands and southern part of Parapolsky, and are important for nesting and migratory birds. Trees and bushes growing here include Laddendorf birch (*Betula laddendorfi*) and blue willow (*Salix glauca*). Plants include small cranberry (*Oxycoccus palustris*), cloudberry (*Rubus chamaemorus*), marsh horsetail (*Equisetum palustre*), sedge (*Carex physodes*), wild rosemary (*Ledum palustre*), peat moss (*Sphagnum*), and tall cotton-grass (*Eriophorum angustifolium* spp. *subarcticum*). Meadows carpeting the lowlands along the coast of Karagin Gulf provide habitat for many rodents including the Arctic ground squirrel (*Spermophilus parryi*).

Flora and fauna

The overall forested area of Koryakia is 28,800 ha (35 percent). The dominant tree species are Japanese stone pine (50 percent), stone birch (20 percent), Dahurian larch (19 percent), and aromatic poplar (11 percent). In the southern part, pine trees reach a height of 7 m, but elsewhere they are dwarf. There are four logging areas, which are administered by Kamchatlesprom. The annual cut is approximately 30,000 cu. m, mostly used for firewood. Commercial forestry is practically impossible in the *okrug*.

Considerable areas in the southern part of the *okrug* are occupied by stone birch forests, which cover the lower slopes up to 600 m above sea level and have a grassy undergrowth. Mountain birch forests have underbrush. Lowland forests include false hellebore (*Veratrum*), tasselflower (*Emilia*), wild onion (*Allium*), cow parsnip (*Heracleum*), Arctic blackberry (*Rubus arcticus*), and bluegrass (*Poa radula*). Mountain forests include Japanese stone pine and shrub alder trees, mountain ash (*Sorbus*), with Kamchatka rhododendron (*Rhododendron kamtschatica*) in the undergrowth. Brown bear, sable, wolverine, ermine (*Mustela erminea*), red fox, and variable hare (*Lepus timidus*) live in the stone birch forests. Birds are represented by nuthatches (*Sitta europea*), spotted woodpeckers (*Dendrocopos*), buntings (*Emberiza*), and leaf warblers (*Phylloscopus*).

In the river valleys and on slopes as high as 800 m, Siberian stone pine groves dominate the region. On the lower slopes they form dense thickets; further up they are barely taller than the surrounding vegetation. These hardy dwarf pines, often growing in climates where no other bushes can survive, provide critical habitat for many animals and birds, and protect slopes from erosion. Brown bear, ermine, sable, variable hare, red fox, wolverine, spotted nutcrackers (*Nucifraga caryocatactes*), Eurasian magpies (*Pica pica*), and

Vladimir Dinets

The red-faced cormorant (Phalacrocorax urile) *is an uncommon seabird, nesting locally on remote seashores. Koryakia is the northern limit of its range.*

pipits (*Anthus*) all live here. A host of other shrubs and grassy varieties including windmill-grass (*Chloris sinica*), yellow rhododendron (*Rhododendron xanthostephanum*), blueberry (*Vaccinium uliginosum*), mountain cranberry (*V. vitis-idaea*), crowberry (*Empetrum nigrum*), annual club moss (*Lycopodium*), and northern twinflower (*Linnaea*) also grow in these rich pine forests.

Shrub alder forests (averaging between forty and sixty years old) occupy much smaller areas and grow on the eastern slopes of the Koryak Mountains and on the southern part of the Vetvei Range. Few other plants grow among these leafy alder forests, but there are some species including lady fern (*Athyrium*), twisted stalk (*Streptopuses*), manna grass (*Glyceria*), and false lily-of-the-valley (*Majanthemum*). The fauna is similar to that of the dwarf pine forests.

Valley forests extending as narrow strips along riverbanks include chosenia, aromatic poplar, willows, and aspen (*Populus tremula*). Growing among the underbrush is dog rose (*Rosa canina*), honeysuckle (*Lonicera*), and a variety of herbs. Among the trees are large meadows with thickets of nettle (*Urtica*) and ferns (*Polypodiaceae*), and the increasingly rare northern tiger lily (*Lilium pensylvanicum*), reaching about 2 m in height. The wildlife in these valley forests is rich and includes brown bear, river otter, variable hare, Arctic ground squirrel, ermine, muskrat (*Ondatra zibethica*), Steller's sea eagle (*Haliaeetus pelagicus*), and white-tailed sea eagle (*H. albicilla*). These valley forests are essential in controlling erosion and flooding, and in preserving important spawning grounds.

Dahurian larch forests, often found together with wild rosemary and Japanese stone pine, grow in the Penzhina River valley. Rodents, including voles, Eurasian squirrel (*Sciurus vulgaris*), and Siberian chipmunk (*Tamias sibiricus*), frequent

these forests. Moose inhabit the burned forests and river valleys. Predators include gray wolf, brown bear, wolverine, and Eurasian lynx (*Felis lynx*). In spring, birds such as nuthatches, buntings, leaf warblers, and spotted nutcrackers migrate here, while willow and rock ptarmigans (*Lagopus lagopus, L. mutus*) and hazel grouse (*Bonasia bonasa*) reside year-round.

Lowland tundra, with dwarf pine and lichens, dominates in the northern wetland areas of Parapol Valley, along the northern coast of Penzhina Bay and the river. More than two hundred species of birds have been recorded there. Mammals include variable hare, red fox, wolverine, brown bear, ermine, and river otter.

Subarctic tundra, primarily lichen and brush with mountain avens (*Dryas*), saxifrages (*Saxifragaceae*), Rhododendron, locoweed (*Oxytropis*), alpine bearberry (*Arctostaphylos alpina*), and other bushes and herbs, is found in the Central, Koryak, and Ichigem Mountains. In some places one can see mossy sedge, grassy sedge, and mixed herbs. At lower elevations one can find Japanese stone pine and shrub willows. Some plants growing among mountainous tundra zones are very rare and require protection, including ragwort (*Senecio*), Koryak dandelion (*Taraxacum koryakensis*), and loco (*Oxytropis*). The endangered Kamchatka marmot (*Marmota kamtschatica*), Pechora pipit (*Anthus gustavi*), plovers (*Pluvialis, Charadrius*), wagtails (*Motacilla*), and leaf warblers (*Phylloscopus*) make their home here. Both mountain and lowland tundra are critical for indigenous reindeer herding and are under pressure from various mining activities. The many thermomineral springs of the Central Range shelter unique thermal ecosystems, which remain practically unstudied by scientists.

Koryakia's fauna is typical of subarctic Beringia. About 60 species of mammals and 150 species of birds can be found in the *okrug*. In the coastal areas, almost all pinnipeds of the RFE can be found. Thirteen species of mammals, twenty-four species of birds, and two species of fish are in need of protection.

Wildlife resources are a foundation for traditional nature use by the indigenous peoples. Seventy-five hunting enterprises are registered in the *okrug*. According to the official data, these enterprises, along with individual hunters, annually produce from 2,000 to 3,500 sable pelts, up to 1,000 fox pelts, and from 100 to 200 brown bear and wolverine skins. Moose, river otter, ermine, Eurasian squirrel, Eurasian lynx, and many birds are also hunted. Recently, reduced economic activity has generally resulted in less hunting. In the coastal areas, around eight hundred seals are hunted annually. Seal hunting quotas have not been met for several years.

Alexander Panichev

Most of Koryakia's nonindigenous population are transient and care little about the land. Poaching is widespread.

In rivers and coastal areas, large amounts of salmon, walleye pollock, herring, cod, flounder, and halibut are caught annually. Despite the large catch, experts view the fish quantities as relatively stable. Five species of Pacific salmon spawn in the rivers: pink, chum, sockeye, king, and coho. Rainbow trout (*Oncorhynchus mykiss*) lives in some rivers. The crab population is in trouble. Increased demand for crab has triggered a major population decline in crab populations in the west Kamchatka crab fishing zone.

The Sea of Okhotsk and the Bering Sea are extremely productive and are of great industrial importance. In recent years, issues of oil and gas development have come to the fore. Such enterprises, entailing transportation, construction, and other operations, may cause irreparable damage and drastically reduce the biological productivity of the seas.

Environmental problems. The general environmental situation in Koryakia is much better than it is in the other regions of the RFE. However, pollution is a problem in many areas. Annually, fifteen thousand tons of pollutants are released into the atmosphere. The major pollutants are central heating plants (burning coal) and diesel-powered electric plants. Of forty-six enterprises polluting the environment, only six have exhaust cleansing facilities. Kamchatka and Koryakia are unusual for the quality and quantity of their clean water sources. However, of twenty-four pipeline systems, eleven have sanitary problems. According to test results, about 35 percent of the water is not fit for drinking. Development of gold and platinum deposits in Penzhina and Vyvenka River basins has caused significant damage to the salmon resources.

A less acute environmental issue is the use of city and village lands, which comprise only 37,700 ha (0.1 percent of the territory of the *okrug*). Historically, villages have been located in the water protection zones of rivers. Thus, local agricultural lands are situated in the same areas. The total agricultural area is 45,200 ha. The total reindeer pasture area is 1,631,200 ha. Land used for transportation and other nonagricultural activities, mainly by the mining industry and the military, covers 6,200 ha. Recultivation of the damaged lands is, as a rule, delayed.

Protected area system

The development of protected areas has been successful. Eight *okrug*-level *zakaznik*s have been created. Koryaksky Zapovednik has been established. Four territories (Parapol Valley and three *zakaznik*s: Cape Utkholok, Moroshechnaya River, and Karaginsky Island, with a total area of 2,522,597 ha), have been listed as Ramsar sites (Decree No. 1050 as of September 13, 1994). There are thirty natural monuments in Koryakia.

Protected areas total 992,000 ha, which amounts to 3.3 percent of the territory of the *okrug*. These areas suffer from a catastrophic lack of financing for needed protective measures, including air patrols of the forests, and research, including the maintenance of inventory records. In 1996, a federal program on "Support for establishment of protected areas in Koryak Autonomous Okrug until 2020" was adopted. According to the program, the total protected area in Koryakia should be increased to 7,245,800 ha (24 percent of the territory of the *okrug*). Within the framework of this program, five new *zapovednik*s are planned (South Tigilsky, Karaginsky Marine Biosphere, Ledyanoi, Penzhinsky Littoral, and Upper Penzhina), as well as one national park and six *zakaznik*s of regional significance. Over 5,437,200 ha, or 18 percent of the total area, will be *zapovednik*s. Implementing this program will make it possible to preserve the unique nature of Koryakia. Financing for the program, however, has not been allocated.

Zapovedniks. Koryaksky was established in 1995 with the financial support of the World Wildlife Fund (WWF). The *zapovednik* covers 327,156 ha, of which the Bering Sea makes up 83,000 ha, and consists of two separate sections, Govensky and Parapolsky. Govensky, in Olyutorsky Raion on the Goven Peninsula, incorporates a portion of the Pylgin Range and the upper portion of the Pylgovayam River basin. On the northeastern shore of Penzhina Bay, the Parapolsky section consists of the southern part of the Parapol lowlands and the adjacent spurs of the Penzhina Range and the Koryak highlands. The goal of the *zapovednik* is to prevent disruption of the natural state of the ecology of the Koryak highlands and the Parapol lowlands, which harbor one of the largest nesting concentrations of waterfowl and shorebirds in Asia. There are some 730 varieties of plants, some of which are rare, for example, Drummond's anemone (*Anemone drummondii*), dwarf pond-lily (*Nuphar pumilum*), and Victor's bittercress (*Cardamine victori*).

Of 153 bird species, 97 nest on preserve territory. Particularly numerous are bean goose (*Anser fabalis*), greater white-fronted goose (*Anser albifrons*), greater scaup (*Aythia marila*), northern pintail (*Anas acuta*), Eurasian wigeon (*Anas penelope*), and sandpipers (*Calidris*). Many are rare or endangered, for example, yellow-billed loon (*Gavia adamsii*), black brant (*Branta nigricans*), and spoonbill sandpiper (*Calidris pygmaeus*). There are about thirty colonies of seabirds along the rocky cliffs of Goven Peninsula. Species common to the shores of the Bering Sea are the pelagic cormorant (*Phalacrocorax pelagicus*), slaty-backed gull (*Larus schistisagus*), black-legged kittiwake (*L. tridactylus*), guillemots (*Cepphus*), and puffins (*Fratercula*). Two rare species of falcons (*Falco peregrinus* and *F. gyrfalcon*) nest on the rocky slopes of the river valleys. Their populations in the Koryak highlands are among the largest and most stable in the world. Other rare and endangered bird species that nest here include white-tailed sea eagle and Steller's sea eagle.

There are twenty-eight species of mammals in the reserve, including the brown bear, sable, red fox, ermine, wolverine,

and river otter. The coastal waters of the Goven Peninsula are home to six species of marine mammals. The most common (and a nearly year-round resident) is the spotted seal (*Phoca larga*). Cape Goven hosts one of the largest coastal seal rookeries with a population of between three hundred and twenty-five hundred individuals, both in summer and winter. Korf Bay, especially on Goven coast, is a favorite summer feeding ground for walrus. Sea otters (*Enhydra lutris*) are occasionally seen in Korf Bay, and much of the reserve's shore is otter habitat.

To protect the natural systems from the effects of human economic activity, a buffer zone covering some 676,062 ha was created on the adjacent territory. Within this protective buffer zone, only traditional forms of natural resource use are allowed, (e.g., reindeer breeding and noncommercial hunting and fishing).

Zakazniks. There are eight *zakaznik*s, with an overall area of 6,576,000 ha.

Reka Moroshechnaya (Cloudberry River). This *zakaznik* is located in southern Tigilsky Raion near the delta of the Moroshechnaya River. All 150,000 ha of the *zakaznik* comprises some of the most valuable coastal and wetlands areas of the Okhotsk coast.

Utkholok. In northern Tigilsky Raion, this *zakaznik* encompasses an area of swampy tundra between the Utkholok and Kvachino Rivers and includes a mountainous cape that protrudes into the sea as littoral rocks and islands. This *zakaznik* is significantly smaller in area (49,800 ha) than some others, but its prime task is the same—bird protection. Particular attention is given to protecting molting and breeding areas of bean goose; thousands molt on the *zakaznik*'s lakes. During migratory periods, there are hundreds of thousands of waders, ducks, and other birds.

Laguna Kazarok (Brant Lagoon). This 17,000-ha *zakaznik* is 300 km east of Utkholok Zakaznik, in southern Karaginsky Raion. It encompasses Malamvayam Lagoon and adjacent land, a portion of Ukin Inlet, and Manchzhur Island. Here, too, the principal protected element is the bird population. Laguna Kazarok is one of the most important resting spots during autumn migration of black brant, lesser white-fronted goose (*Anser erythropus*), and greater white-fronted goose. Raptors and waterfowl nest here. During migration, sandpipers may be seen in the tens of thousands.

Ozero Palana (Palana Lake). A description of this *zakaznik* is provided on p. 324.

Ostrov Karaginsky (Karagin Island). A description of this *zakaznik* is provided on pp. 323–24.

Ostrov Verkhoturova (Verkhoturov Island). In the northern part of Karagin Bay is another regional *zakaznik*, Verkhoturov Island. This uninhabited island is situated off Ilpyr Point, within the boundaries of Olyutorsky Raion. The refuge protects the island's population of arctic fox (*Alopex*

lagopus), as well as walrus, Steller's sea lion, and spotted seal.

Reka Belaya (White River). In southern Penzhinsky Raion, the 90,000-ha zoological *zakaznik*, Reka Belaya, was established along the central reaches of the Belaya River. It provides protection for moose, brown bear, raptors, and nesting waterfowl. American mink (*Mustela vison*) is being introduced. Reka Belaya is 40 km from the village of Kamenskoe, the *raion* center, and therefore subject to motorboat traffic on the river in summer and snowmobiles and all-terrain vehicles in winter.

Severnaya Ayanka Listvennichny (North Ayanka Larch). The most northerly of Koryakia's protected areas, Severnaya Ayanka Listvennichny is the only botanical *zakaznik* in the *okrug*. It includes the floodplains of the Penzhina River (where Dahurian larch is found) and its tributaries: Murgal, Topolevka, Khiyuznaya, Kurchugan, and others. This larch forest reserve of 62,000 ha is a part of the only tall forest in Koryakia, and is one of the easternmost boreal forests in Asia. The area of these forests is declining precipitously in many areas. Many typical forest species, such as Siberian chipmunk and Eurasian flying squirrel (*Pteromys volans*), are not found in other parts of Koryakia. The larch forests serve as important habitat for moose. Unfortunately, the territory is practically unstudied; only fragmentary information exists about its biological diversity.

Biodiversity hotspots

1. Severnaya Ayanka Zakaznik (wetland and arctic)

S. ABRAMOV—This 62,000-ha *zakaznik* protects pristine larch valley forests. The trees are between 100 and 150 years old. The lichen cover is good pasture for reindeer in winter.

Threats. The taiga in Penzhinsky Raion is rapidly shrinking. The local population attributes the disastrous floods on the Penzhina River during the past several years to forest fires and logging in the river basin, resulting from the disbanding of the local forest protection aviation unit and the lack of funds necessary to fight forest fires. These changes to the river's hydrological regime also affect fish populations. Locals continue to cut firewood for fuel.

Recommendations. The following actions should be taken:
- Resume operations of the forest protection aviation unit and make funds available for combating forest fires.
- Improve the social and economic condition of villagers in Penzhinsky Raion, providing alternative energy sources.
- Study the biodiversity of the territory.

KORYAKIA

2. Parapolsky Dol (Parapol Valley)
(wetland and arctic)

O. CHERNYAGINA—Parapol Valley is a vast lowland stretching for over 500 km and covering 1,890,000 ha. Sedge-covered hilly tundra and grassy swamps dominate the terrain. In the central part of the area, the hills are between 10 and 30 m high. The river network is well developed, and there are numerous glacial and thermokarst lakes. Moss and lichen grow between the hills, making the tundra a highly productive reindeer pasture.

Parapol Valley serves as a giant refuge for waterfowl from all over northeast Asia. The migration routes of a number of birds congregate in the valley. An endless chain of lakes and swamps serves as a nesting and molting area for geese, swans, and numerous species of duck.

Threats. Since the beginning of the 1960s, the number of waterfowl all over Russia has been declining. This holds true for Parapol Valley, and the indigenous peoples who depend on hunting have been hard hit as a result. Along with the causes originating outside the region (e.g., intensive hunting in areas where the birds are wintering), several local factors are contributing to the decline. These include population growth, geological surveys, poaching, and illegal collection of eggs. This decline has recently slowed down, however, because of decreasing human population, fewer geological surveys, and rising costs of ammunition.

Future threats include the commencement of gold mining in the river basins, the development of the Ametistovo gold deposit (which will lead to poaching as a result of increased access, particularly via the Ametistovo-Manily road that is to go through the region and threatens to fragment Koryaksky Zapovednik), the hydropower plant (with 20 MW capacity) to be constructed on the Belaya River, irrigation projects, and the consequential drainage of thermokarst lakes.

Existing protection measures. Parapol Valley has been proposed as a Ramsar site (by order No. 1050 of the Russian government, September 13, 1994). Since 1987, the Reka Belaya Zakaznik in central Parapol Valley has protected waterfowl and their nesting sites. However, people enter the *zakaznik* by boat in summer and by snowmobile in winter and disturb these sites. The Russian government created Koryaksky Zapovednik to help protect the area.

Recommendations. The following actions should be taken:
- Improve the social and economic situation of villagers in Penzhinsky Raion.
- Develop a sustainable program of natural resource use for the northern *raions* of Koryakia.
- Because it is small, the creation of Koryaksky Zapovednik does not solve the problem of declining bird populations; there needs to be a comprehensive network of protected areas to preserve the stopover and nesting grounds of migratory birds in Parapol Valley.
- Do a thorough land survey of wetlands and wildlife in Parapol Valley.

3. Ostrov Karaginsky Zakaznik (marine)

O. CHERNYAGINA, N. GERASIMOV, N. KLOCHKOVA, S. ABRAMOV—Established in 1974, Ostrov Karaginsky Zakaznik totals 200,000 ha and consists of two parts: the island itself and a 2-km coastal zone in Karagin Bay. The island has no permanent settlements; the nearest populated area is the village of Kostroma on Kamchatka Peninsula. The *zakaznik* provides nesting grounds for up to 400,000 marine birds and thousands of waterfowl. During migration periods, hundreds of thousands of ducks, waders, and gulls visit the area. The reserve is also home to a number of rare species: golden eagle (*Aquila chrysaetos*), Steller's sea eagle, gyrfalcon, peregrine falcon, Aleutian tern, and murrelets (*Brachyramphus*). Seals and other small marine mammals are often encountered in the coastal waters. Salmon spawn in almost all of the streams. In the shallow waters on the shelf there are commercially valuable marine species such as the Kamchatka crab. A herd of reindeer brought to the island now thrives. A few industrial activities are permitted in the *zakaznik* and are regulated by the governor of Koryakia.

The 70-km wide Litke Strait separates the island, with its beautiful coastal landscapes, from Kamchatka. Plains make up the western half of the island, and mountains dominate the eastern part. Ridges stretch from south to north across the island; the peak is Tumannaya (Foggy) Mountain (920 m). There are numerous rivers, and hundreds of lakes.

Island flora consists of forests (stone birch, pine, and shrub alder), widespread grasslands, and tundra in hilltop areas. The tundra near the shoreline is rich in berries and mushrooms. More than 500 species belonging to 205 genera and 64 families grow on the island, including rarities such as Lessing's arnica (*Arnica lessingii*), Victor's bittercress (*Cardamine victori*), Shumshu bluegrass (*Poa shumshuensis*), and Kamchatka crucifer (*Ermania parriiformis*). Along the eastern and southern coasts of the island there are many species of valuable kelp, including laminaria (*Laminaria japonica*).

Today, the reserve is practically unprotected because of the lack of funds. For the same reason it is not possible to monitor migrating birds.

Threats. Because of poor economic conditions, the locals, especially the indigenous peoples, are again using long-forgotten natural resources. For example, birds' eggs have again become an important source of nutrition for the villagers living near the island. Although regulations prohibit hunting and egg gathering, they are not enforced. There is a proposal to make the island an area of traditional nature use. Without first fully assessing the island's biological resources, there is a risk, however, of quickly depleting the natural

resources. Other potential threats include offshore oil and gas development and mining on the island.

Researchers from the Laboratory of Ornithology at Kamchatka Institute for Environment and Nature Use (Russian Academy of Sciences) are doing an inventory of bird colonies along Kamchatka's shore, including Karagin Island. This is under the program Quantity and Food Chain of Seabird Colonies in the Northwestern Pacific. A catalogue of seabird colonies of Beringia is also being prepared.

Existing protection measures. The *zakaznik* has been created. Disturbing seabird habitats is prohibited. All industrial activity is, in theory, strictly regulated. However, the *zakaznik* has no rangers and is, thus, virtually unprotected. Karagin Island has been nominated as a Ramsar site. There is a plan to create the Karaginsky Zapovednik (790,000 ha) with the *zakaznik* forming the core of this new reserve, but there is no funding for this *zapovednik*.

Recommendations. The following actions should be taken:

- Improve the social and economic condition of the villagers in Penzhinsky Raion.
- Research the potential impact of proposed industrial development.
- Develop measures for sustainable use of the island's biological resources.
- Enforce land-use regulations of the *zakaznik*.

4. Ozero Palanskoe Zakaznik (wetland)

S. CHERNYAGINA, S. ABRAMOV—Established in 1980 in Tigilsky Raion, on the western slope of the northern part of Central Ridge, this *zakaznik* covers 88,000 ha. Small and medium mountains reaching 1,300 m dominate the landscape. Palana Lake formed when the Palana River was blocked by lava flows. The lake covers 28,200 ha and is surrounded by forests of stone birch and Japanese stone pine. Important fauna include: Kamchatka marmot, brown bear, snow sheep, wild reindeer, bean goose, and whooper swan (*Cygnus cygnus*). The lake protects spawning grounds for Pacific salmon. The sockeye population in Palana Lake is one of the largest on the Kamchatka Peninsula. The lake and surrounding area are an important natural and spiritual resource for local Koryaks. In the upper Palana River basin, 100 km from Palana Village, there are three hot mineral springs with temperatures reaching 97°C. An unusual thermal ecosystem has formed near the springs. According to available information, this is the northernmost habitat of the endangered plant *Phymbristilis okchotski*.

Threats. Limited industrial activity is permitted in the *zakaznik*, but residents of Palana and Lesnaya are poaching and overfishing, particularly the sockeye salmon in Palana Lake. Sewage and untreated waste are also affecting *nerka* (seal)

populations. Uncontrolled recreational and medicinal exploitation of the mineral springs has damaged the microclimate and thermal ecosystems. Possible offshore oil and gas development threatens coastal resources. Since 1994, the Kamchatka branch of the Pacific Institute of Fisheries and Oceanography (KamchatNIRO) has been conducting a study of the sockeye. Initial results show that populations are declining.

Existing protection measures. The Koryakia Hunting Service controls the *zakaznik*, but there is only one staff ranger who patrols during spring and summer. In the federal program for protected areas in Koryakia, there is a plan to create the Central Koryakia National Park (250,000 ha) with the *zakaznik* serving as the core zone, but the project lacks funding.

Recommendations. The following actions should be taken:

- Protect the *zakaznik* properly.
- Zone the territory to determine which areas need *zapovednik*-level protection of key plant communities, take a biological inventory near Palana hot springs, and use the results of the inventory to develop recommendations for sustainable recreational and medicinal use of the springs.
- Construct water treatment facilities in Palana to eliminate sewage and wastewater discharge into Palana River.
- Improve the social and economic situation of those living in Tigilsky Raion.

5. Rivers of the Tigilsky region (wetland and forest)

S. MAXIMOV, O. CHERNYAGINA, S. ABRAMOV—The lower basins of the Moroshechnaya and Utkholok Rivers, which cover 150 ha and 49 ha, respectively, are now *zakaznik*s. They have also been nominated as Ramsar sites by the Russian government. The rivers of the region originate high in the mountains, on the western slopes of Central Ridge, and are fed by glaciers and areas permanently covered with snow. When the rivers reach west Kamchatka plain, they slow down, forming floodplains, and some flow into the Sea of Okhotsk. The largest rivers are relatively long: Tigil River is 300 km, Khayryuzova is 265 km, Belogolovaya is 226 km, Palana is 141 km, Voyampolka is 167 km, and Shamanka is 109 km. Swamps, lakes, and bays in the lower river basins serve as nesting and feeding grounds for migratory birds.

Five species of Kamchatka salmon of commercial value (coho, pink, sockeye, chinook, and chum) live in these rivers together with abundant populations of char (*Salvelinus malma*) and rainbow trout. In the lower reaches of the rivers, one can catch enormous quantities of smelt (*Hypomesus*). Fishing has been, and continues to be, the main form of subsistence for the indigenous Koryaks and Itelmens. Here, however, salmon fishing is forbidden except for scientific purposes and hatchery construction. Rainbow trout fishing is allowed year-round with few restrictions, although, in the central region of Kamchatka, people avoid trout, considering them

"filthy fish," because voles are often found in their stomachs. By contrast, villagers of Tigilsky Raion value rainbow trout highly especially during winter.

The rainbow trout of Tigilsky Raion are some of the largest remaining wild populations of their species in the world. Since 1994, in a joint Russian-American project involving Moscow State Lomonosov University, the Fishery Department at the University of Washington, and the Wild Salmon Center, researchers have been studying the rainbow trout. The structure of the population is more complicated than previously believed. We now recognize that there are rare and endemic forms of rainbow trout in the rivers of Tigilsky Raion. In 1996, the Kamchatka Institute for Ecology and Nature Use, with support from TACIS European Fund, completed a study on the natural resources of the western coast of Kamchatka: Resource Study and Environmental Potential for Development of Local Economy on Itelmen Indigenous Territories.

Threats. Rainbow trout has never been an abundant species. Because current market price for the fish is much higher than that for Pacific salmon, commercial (and illegal) fishing has intensified. Other dangers include inadequately treated sewage and industrial water discharged into the rivers (in Palana this waste amounts to 250 cu. m per day), sewage leaking into groundwater, possible oil and gas development on the shelf of the Sea of Okhotsk bordering on Tigilsky Raion, and coal mining.

Existing protection measures. In November 1998, the governor of Koryakia issued a decree establishing the first *Tkhsanom* (Territory of Traditional Nature Use) in the region, to be administered by the regional government of the *okrug*, the Koryak Committee on Environmental Protection, and the Council for the Revival of the Itelmens of Kamchatka. Covering more than 2,000,000 ha, this territory includes such rainbow trout spawning rivers as the Utkholok, Sopochnaya, Moroshechnaya, and Saichik.

Recommendations. The following actions should be taken:
- Create alternatives to poaching, and, in the process, improve the social and economic conditions for people living in Tigilsky Raion.
- Strengthen river protection measures.
- Construct water-treatment facilities and improve existing sewage systems.
- Declare a moratorium on oil and gas development on the shelf of the Sea of Okhotsk.
- Use only environmentally sound technologies for other natural resource extraction, and require full compliance with Russian environmental law for all stages of project development.
- Continue to study natural resource use patterns of the indigenous peoples and publish the results.

6. Sea of Okhotsk Continental Shelf near Koryakia (marine)

S. ROSTOMOV, O. CHERNYAGINA—Shelikhova Bay is the largest bay in what is perhaps the world's most productive ocean—the Sea of Okhotsk. The bay borders the western part of Koryakia. The air temperature here is below zero from October until April, producing a steady ice cover after November.

One extremely important and unique area is the northwestern part of the Sea of Okhotsk shelf (at 55° latitude and above), which includes Shelikhova Bay, as well as Gizhigin and Penzhina Bays. A region of upwelling ocean currents, this area has been called the "maternity house" by Russian ecologists, because it is the major reproduction area for Kamchatka crab and other species throughout the Sea of Okhotsk. Halibut fry spend their first two years here, almost all the herring in the Sea of Okhotsk spawn here, and the area is the breeding ground for gray and beluga whales and seals. Fish and marine mammals are the primary sources of food for indigenous peoples here.

Threats. Anthropogenic pressure is now limited to commercial fishing. Institutions in Kamchatka, Koryakia, and Magadan administer and monitor use of the fishing resources. Oil and gas development has been proposed for the area and is a major future threat because it is impossible to avoid polluting the fisheries. Extreme climatic and hydrological conditions in the area, including tides reaching 13 m, huge storms, and difficult ice conditions, increase the chances of accidents and make speedy response more complicated. In addition, the marine ecosystems are continuously poisoned. Projected discharge amounts for just one borehole are between 150 and 400 tons of drilling mud, and between 200 and 1,000 tons of drilling waste, which contain between 120 and 300 tons of oil products. In 1998 in the North Sea, as a result of drilling-waste discharge alone, 22,000 tons of oil, and an additional 100,000 tons of chemicals, went into the sea. Recent studies also show that some water layers contain higher than normal concentrations of natural radioactive elements, such as radium 226 and radium 228.[6]

According to Russian government scientific data, chronic poisoning of the sea reduces the production capacity of plankton and increases the mortality rate of young salmon fry and mollusks by 50 percent. Similar effects have been noted for other fish species. Oil pollution on the sea bottom greatly increases mortality rates for crabs, worms, and mollusks, and bottom-dwelling fish show higher rates of disease. The overall biological mass of bottom-dwelling fish on the west Kamchatka shelf of the Sea of Okhotsk is 602,000 tons (estimated by KamchatNIRO). The fishing capacity of the area may be as much as 22 tons per sq. km, which is one of the highest rates in the world. In the program sponsored by TACIS fund, the potential fishing capacity of Koryakia's shelf and its biodiversity were fully assessed.

Existing protection measures. A federal program, "Support for Establishment of Protected Areas in Koryakia," proposes the creation of the Penzhina Marine Zapovednik (1.1 million ha), which would include a 4-km-long and 1-km-wide coastal area along Penzhina Bay, as well as all the islands in the bay.

In April 1998, a moratorium on oil and gas development on the Sea of Okhotsk shelf was proposed. NGOs from Sakhalin (Sakhalin Environment Watch), Magadan (Magadan Center for the Environment), and Kamchatka (Kamchatka League of Independent Experts and Northern Pacific Fund) started a joint campaign to prevent oil and gas exploration and development on the shelf.

Then, in November 1998, Koryakia's governor issued a decree establishing a *Tkhsanom* Union here. The area is over 2,000,000 ha and includes a 2-mi. aquatoria in the Sea of Okhotsk, stretching from the southern border of Koryakia to Cape Utkholok.

Recommendations. The following actions should be taken:

- Develop a program of rational resource use for the Sea of Okhotsk shelf and Kamchatka Peninsula shelf; this program should include an assessment of the economic benefits from fishing versus oil and gas development.
- Establish a legal foundation to provide international control of the environment and fisheries resources; at a later stage, involve all countries in this process.
- Strengthen control over the environmental conditions of the western Kamchatka shelf.
- Create a system of protected marine areas near the shores of Koryakia.
- Establish Penzhina Marine Zapovednik.
- Find funds for environmental and scientific organizations to study and monitor the use of biological resources of the Sea of Okhotsk

Economy

T. Reshetenko, Sergei Abramov, A. Baranov

The Russian conquest of present-day Koryakia began in 1651, when the Cossack explorer M. Stadukhin landed at the Penzhina River mouth but did not stay to explore the interior. Other Cossack explorers who traveled by sea around the Kamchatka Peninsula soon followed him.[7] V. V. Atlasov's two-year expedition (1697–1698) along the peninsula's western coast marks the beginning of Russian domination and subjugation of the indigenous inhabitants to the tsar's *yasak* (fur) tax.[8] The best early study of Kamchatka was made by S. P. Krasheninnikov, a member of the second Bering expedition to Kamchatka (1737–1741). He meticulously described the flora, fauna, geography, and customs of the indigenous population, made notes of meteorological events, monitored sea currents and tides, and collected artifacts. He made word lists for the Koryak and Itelmen languages and studied archive documents of previous explorers. In 1756, he published his *Description of the Land of Kamchatka*.[9]

During the nineteenth century the territory was virtually forgotten by Russia, primarily because of unfavorable agricultural conditions, which made growing food extremely difficult, and because the region was so remote from other parts of Russia. The fur trade was the only exception because the demand of both domestic and foreign markets was great, and exporting furs from the peninsula was not difficult. Indigenous peoples were deeply engaged in the fur trade and many of the pelts were sold on the open market. By the end of the twentieth century, sable, otter, and fox populations had decreased dramatically.

After the sale of Alaska to the United States, Kamchatka lost its strategic importance and was largely ignored by St. Petersburg. At this time, America, Japan, China, and even Norway increased their presence on the peninsula through the fur trade and fishing. Until the 1920s, the nomadic indigenous peoples bred reindeer for their subsistence; the settled populations fished, traded in furs, and hunted marine mammals. Animal husbandry, tilling fields, and growing vegetables were rarely practiced by indigenous peoples.

The Soviets expelled foreign commercial interests and closed the area in the mid-1920s. During the 1930s, the Soviet government began to develop commercial sea fishing. By 1936, 3,000 tons of fish were caught, and the industry overtook reindeer breeding as the most profitable. The collectivization of the reindeer herds had disastrous results; almost half of the total herds was lost between 1930 and 1934.[10] Mostly immigrant Russians developed fishing and other industries. In the 1960s, the great influx of immigrants attracted by the perquisites for working in the north made indigenous people a small minority in their homelands.

By the end of World War II, there were forty-six collectives, of which thirty-five were fishing enterprises. The volume of fish caught in 1958 was 40,000 tons, mostly herring, cod, and salmon. The 1950s were marked by the active formation of the fishing fleet and the construction of five fish-processing plants. In 1970, the catch reached 146,000 tons. Today the official fish catch does not exceed 100,000 tons a year, although fishing does amount to about 70 percent of the total volume of production.

The mining industry is the only sector increasing production. The first geological surveys in the *okrug* were conducted in the 1930s. By now, deposits of gold, platinum, sulfur, coal, and brown coal as well as other mineral resources have been surveyed. Gold and platinum mines are the main taxpayers to the *okrug*'s budget.

All other sectors of Koryakia's economy are in catastrophic disarray, with heating and energy production most seriously

affected. Electricity is produced separately for each town by small diesel power stations (DPS). Some institutions and industrial enterprises have their own DPS. The aggregate capacity of such stations amounts to 80–85 MW. In recent years, the energy supply problem has become extremely acute. Since 1997, all settlements have had to resort to periodic blackouts to conserve diesel. As this situation worsens, pressures on local forests increase as more trees are cut for firewood.

The economic catastrophe has, however, made local agriculture more efficient. Many collective farms have gone bankrupt as subsidies were eliminated. The most wasteful activities, such as egg and pork production, have been dramatically reduced, casualties of the costs of heating barns and importing feed. The population as a whole, but especially the indigenous population, which is also the poorest, is relying more on subsistence activities (fishing, small-plot gardening, hunting). Before the August 1998 crisis, most food was imported from various Pacific Rim countries, especially the United States, Canada, and South Korea. The following year and a half saw an increase in hunger and malnutrition, and several villages suffered outbreaks of dysentery during the winter of 1999–2000.

The geography and topography of the territory do not allow for large-scale agriculture. Humus-rich soils are located in the floodplains of salmon spawning rivers. Where fields are given over to hay production near these basins, swamps are formed, the surface watershed is enlarged, and the rivers' hydrology changed, making them unsuitable for salmon spawning.

Reindeer herding is one of the few environmentally sustainable economic activities in the region and is closely linked to the cultural and physical well-being of most of the indigenous population. But contemporary reindeer herds have fallen to less than half of their peak numbers in the 1980s. Current herding practices use Soviet methods and operate at a net loss. Reindeer breeding employs about 650 people working in ten collective farms and thirteen private farms. In a number of the collective farms, such as Karaga, Palana, and Polar Star, the herds do not exceed four thousand animals each.

Economic development of the *okrug* is hampered by its poor infrastructure. The main means of transportation are sea (for cargo) and air (for passengers).

The *okrug* maintains close relations with Kamchatka Oblast.

Practically all goods move through the Petropavlovsk seaport. At the same time, the *okrug* does not maintain any sustained economic relations with nearby Magadan Oblast or Chukotsky Autonomous Okrug.

Koryakia maintains foreign economic ties with a number of countries. In 2001, the volume of export amounted to U.S.$21 million. The main export output remains crab, frozen fish, and caviar. The main export companies are Iyanin-Kutkh, Marina-Ich, and Koryakryba.

Ninety-six percent of the *okrug*'s budget comes from Moscow. The economy of the *okrug* does not provide the necessary funds for its social infrastructure.

Environmental impact. The decline in the economy has hurt the environment; decreases in the volume of industrial output have not resulted in correspondent reductions of air and water pollution. Discharge filters and cleaning systems installed at enterprises in the *okrug* operate inefficiently due to excessive wear and poor maintenance. Energy resources imported into the *okrug* are frequently of lower quality than previously, which increases air pollution. Irregular provision of the population with heating and power due to fuel shortages results in unsustainable logging for fuel. Poaching, primarily for salmon caviar and bear gall bladder, has become the only reliable source of cash for many residents. Fishing enterprises are harvesting crab and other valuable sea products at unsustainable levels for short-term profits. The official navigation season (ending October 1 on the west coast, November 1 on

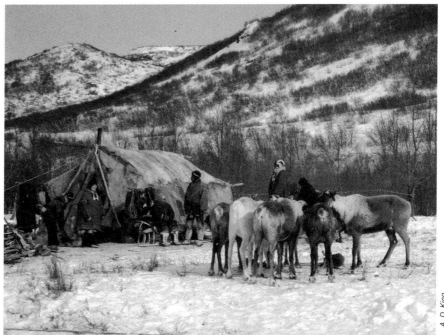

A. D. King

Although everyone agrees that reindeer herding and meat production impacts the environment only minimally, it has not been able to attract the necessary support to remain economically viable.

the east coast) is often violated, resulting in emergencies with the *okrug*'s fuel supply. Diesel fuel, coal, and other cargo must be unloaded in difficult, icy conditions, increasing the probability of fuel spills in waters of the Okhotsk and the Bering Seas.

The areas in Koryakia directly affected by human activities amount to less than 1 percent of the total. The land area under the authority of city, town, and village executive bodies amounts to 34,700 ha, corresponding to just 0.1 percent of the entire territory of the *okrug*. Two towns and thirty villages are located on these lands, and the unbuilt part is used for gardening, haying, and livestock pasture. This highly impacted territory is, however, often located in sensitive areas, along salmon streams, wetlands, and so on.

Industry, transport, and other enterprises not connected with agriculture (mainly mining settlements and military units) occupy 6,200 ha. Precious metal mining is 1,900 ha; 606.7 additional ha are mined illegally. Although the area of direct impact is small, soil and vegetation cover is usually totally destroyed. It should be noted that the biological productivity of tundra and forest-tundra ecosystems is very low; because the biological turnover is slow, adaptation to disturbance is very poor and food chains are short. Therefore, the stress on autotrophic plants and delicate (often permafrost) soils by human-made activities is long-lasting. The destruction of the vegetation cover during mining operations is accompanied by the destruction of permafrost and leads to erosion, flooding, and the destabilization of soil and subsoil organic communities. The vegetation will not regrow for decades, or even hundreds of years. Tundra vegetation in the northern regions will never regrow once destroyed.

Social problems. The standard of living in Koryakia continues to fall. Thirty-six percent of the population falls into the lowest income category and 80 percent of those people are indigenous. This situation is aggravated by regular delays in wage payments. Due to malnutrition people suffer from anemia, impaired vision, impaired immune functions, and other health problems. The rate of tuberculosis in the *okrug* is three times higher than the average figure in Russia, yet medical institutions have no money to buy disinfectants, medicine, or food. Doctors are leaving and not returning.

The drastic deterioration of the social and economic situation has seen a mass outflow of people, aggravating the difficult situation of providing the *okrug* with qualified personnel (teachers, doctors, and scientists). Lesnaya lost its doctor several years ago, and Srednie Pakhachi's doctor returned home to Ukraine in August 1998 with no replacement likely.

Declines in production lead to the liquidation and reorganization of some enterprises and consequently to unemployment. By early 1999, about 8 percent of the *okrug*'s employable population did not have permanent jobs; among the indigenous population unemployment reached 25 percent.

In several indigenous villages (e.g., Lesnaya, Voyampolka, Kovran, and Paren), the unemployment level exceeds 70 percent, and people manage to survive only by fishing, hunting, breeding a small stock of reindeer, and subsistence gathering. The *okrug* constantly faces an increase in the number of troubled families, in which children live in extreme poverty and often do not attend school, yet it is impossible to provide parents with any jobs due to the high unemployment rate.

Social tension manifests itself in strikes and other acts of protest, which from time to time occur in different regions of the *okrug*, but they have yet to result in any actual improvement of the situation due to a lack of organization. Koryakia suffers from a general social, economic, and spiritual malaise, evident in the high levels of drug and alcohol abuse, suicide, theft, and vandalism.

Mining

Koryakia possesses reserves of coal, oil and gas, and gold; there are explored reserves of silver, platinum, mercury, and sulfur; and there are signs of tin, nickel, chromium, plumbum, zinc, and molybdenum. At present, six enterprises operate on seventeen facilities in the *okrug*, including two facilities for platinum, three for coal (up to 50,000 tons a year), and twelve for alluvial gold mining.

Geological surveys of Koryakia began in the 1930s. Regular surveys of the *okrug*'s subsoils started in the 1960s and continue to the present. A recent geological study conducted over an area of more than 250,000 sq. km has helped identify:

- Fourteen metallic zones, within which hundreds of deposits of mercury, antimony, arsenic, polymetals, sulfur, coal, limestone, and other minerals have been found.
- Deposits of mercury and tin in Koryakia and sulfur in northern Kamchatka—new deposits for the RFE.

The mining industry of Koryakia developed irregularly, initially only to meet its own needs; only later did it develop gold and platinum mining. Coal mining began in Korfskoe in 1929 and in Tigil in 1969. Alluvial gold mining began in 1981 and alluvial silver mining in 1998.

About half of the *okrug*'s settlements have coal deposits nearby. There are four main coal-bearing regions: Olyutorsky (Korfskoe and Khailinskoe deposits), Penzhinsky (Gorelovskoe, Chernaya River, and Mametchenskoe), Pustoretsko-Palansky (Podkagernoe, Palana, and Lesnovskoe) and Tigilsky (Tigil and Khairyuzovskoe).

Hydrocarbon resources are concentrated in ten oil and gas regions, a total area of 46.8 sq. km. The most promising are the Vivensky and Voyampolsky regions. The total gas potential of the *okrug* is estimated at 87 billion cu. m. Despite relatively high estimates of the potential, the extraction base

KORYAKIA

has not, however, yet been established because of the lack of detailed surveys.

Gold and platinum. Gold and platinum represent the most promising mining resources. The best-explored gold region is Ichigan-Unneivayamsky, which includes the Ametistovo gold and silver deposits. The hard-rock deposit at Ozernovsky has still not been fully mapped. In recent years, the value of alluvial platinum has sharply increased. The scale of this resource potential indicates the emergence of a new, world-class platinum-bearing province: the Vetvei River basin in Olyutorsky Raion. The territory is being surveyed and mineral fields bearing gold, arsenic, bismuth, silver, tin, copper, polymetals, chromite, and platinoids have been identified.

Starting in 1990, platinum placer deposits were explored and mapped in streams of the Vetvei River basin, which had formed through erosion of the Galmeonsky massif. Kamchatgeology had first discovered these deposits during the Soviet era. Koryakgeoldobycha was established in 1992 and developed the platinum deposits of the Levtyrinyvayam and Ledyanoi Rivers (Vetvei River basin). In 1993 and 1994, when Koryakgeoldobycha was granted the mining license, the company developed the necessary road and civil infrastructure and a mine plant. In partnership with the company Chaibuka Artel, Koryakgeoldobycha operated the mine, having had experience in mining placer gold in Magadan Oblast in the Severo-Evensky Raion, near the Kubaka gold project. During the winter of 1993–1994, Chaibuka Artel transported mining equipment, camp infrastructure, and fuel for nearly 1,500 km (about 930 miles) from various sites in Magadan to the Koryak Highlands near Korfskoe by tractor sledges. Production started in 1994, totaling about 550 kg (16,400 oz) of platinum that year. Production levels rapidly increased until an average annual production of 6 metric tons (186,000 oz) was reached in 1996. By 1998, about 17 tons of platinum had been mined from the streams, eroding Galmeonsky Raion, where the deposits are located.[11]

To mine the platinum placer deposits, the Koryakgeoldobycha-Chaibuka partnership deploys ten D-10 (USA) Caterpillar tractors, four Cat 990 (USA) front-end loaders, several Cat 773B (USA) haul trucks, Ural (Russian) tractors, Kraz-256 (Russian) self-dumping trucks, and Ivanovets (Russian) autocranes. The transport division includes Challenger (USA) and *vezdekhod* (Russian) all-terrain vehicles, and Kamaz and Ural (Russian) trucks that can deliver overland freight regardless of the presence or absence of roads. Most overland transport takes place during winter months. MI-8 helicopters flown by Koryak-Avia in Korfskoe provide much of the air transportation needs of the mining facilities.[12]

There are no foreign companies in the *okrug* mining gold independently. Russian companies, with foreign participation, are mining the two largest deposits of gold ore — Ametistovo and Ozernovsky. Until 1997, the local company Gornorudnaya Compania Koryaki and the Canadian Company Cte-Genevieve Resources Ltd. coordinated plans to develop Ametistovo. Today all the work at Ametistovo has been suspended. A local company, Palamos, and the U.S. Placer Dome Corporation are engaged in geological exploration of Ozernovsky ore field.

Environmental impact. Mining in Koryakia is ecologically catastrophic. Mines completely degrade affected areas. Recultivation is usually delayed and incomplete.

In 1983, a comprehensive inspection conducted by Kamchatrybvod and the *okrug*'s chemical laboratory demonstrated that pollution of the Ushkanya and Kondyreva Rivers (tributaries of the Penzhina) by weighed particles was 170 times higher than the permissible level. Local leaders were directed to take specific measures to prevent further pollution of the rivers. An inspection conducted in 1986 showed that pollution did not decrease, but increased. At a number of sites, it reached 1662 mg/l (the permissible level is 0.25 mg/l).

The workers of the Ametistovo geological group, which operated near the Talovka Lakes, routinely poached resources. For example, to collect 130 kg of whitefish, they caught and discarded more than a ton of Northern pike (*Esox esox*), which can be found in large quantities only in Penzhinsky Raion. Such disregard would have continued were it not for the changes that occurred in the country and the establishment of independent nature conservation services. Penalties for violations of nature conservation legislation have become stricter. The outlook for environmental protection has been changing for the better, but not to such an extent that one can say that all is well in the *okrug*.

In alluvial gold mining areas, vegetation is destroyed and mud sedimentation ponds installed, causing the rise of groundwater and the emergence of new vegetation communities that are atypical for the areas. There is an increased threat of watershed pollution by mechanical admixtures from mud sedimentation ponds, as happened in 1998 at the Ledyanaya site in Olyutorsky Raion after damage to the pond's dike in the spring. Fortunately, the Vetvei River spawning grounds were not polluted.

Mining activities affect wildlife disproportionately to the land area directly involved. Machinery and vehicles frighten animals and disturb migratory and reproductive patterns. Increased accessibility to remote areas leads to increased poaching. Swampy areas cannot support heavy traffic of all-terrain vehicles (ATVs) along makeshift roads. As sections of ATV roads degrade into bogs or ponds, drivers make detours around the sections, thus increasing the damage. Subarctic tundra requires many years to recover from a single pass made by ATVs.

We can expect coal mining to increase, in order to make up for lost fuel subsidies. Precious metals mining will also continue to be attractive to foreign investors in Koryakia.

Energy

The energy industry, consisting of small coal-fired heating plants and small-scale diesel power stations (DPS), was formally established in Koryakia in the 1950s. Active development of the industry began in the 1970s with the emergence of large heating and electric power enterprises, to supply a growing population and increasing industrialization.

In the 1970s, DPS were incorporated into the state company Kamchatskenergo, which served settlements such as Palana, Tigil, Korf, Tilichiki, Ossora, Manily, and Kamenskoe. The power needs of other, smaller villages were organized separately. Power plants annually produce up to 100 million kW per hour. The largest enterprises of the *okrug* that are supplying heating to households and enterprises are in the towns of Ossora, Palana, Manily, and Tilichiki. Heat and power operations normally consume 210,000 tons of coal and brown coal and 45,000 tons of diesel. Diesel used at power stations is imported by sea during the navigation season.

Coal. At present, three coal deposits are being developed: a brown coal deposit in Korfskoe, and coal deposits in Tigilsky and Gorelovskoe. The annual production of the Korfskoe deposit amounts to 40,000 tons of brown coal. Currently, the coal enterprises are working to increase the Korfskoe production levels to 120,000 tons to meet the estimated requirements of Olyutorsky and Karaginsky Raions of 100,000 tons a year. However, the *okrug* administration prefers to buy coal from Sakhalin, Primorsky, and Chukotka.

The Tigilsky deposit produces up to 20,000 tons of coal per annum. Coal from this deposit is used only inside Tigilsky Raion (Tigil and Sedanka), due to prohibitive transportation costs. In Tigil, the heating plant was reequipped to burn fuel in the boiling layer, which allows local coal to be used. Throughout Tigilsky Raion, there is a real opportunity to use only local coal, but this requires retrofitting plants in the other settlements.

In Penzhinsky Raion, the Gorelovsky deposit produces 10,000 tons per annum, mainly in Manily and Kamenskoe. Today, the share of local coal mining is rather low, although there are many explored deposits. Their exploitation could benefit the *okrug*'s economy, since transportation costs increase every year. The wide distribution of coal deposits calls for small-scale open pits to supply local settlements. With sufficient investment in this industry, the *okrug* has the raw materials to meet its own requirements.

Annually, more than 15,000 tons of pollutants, mainly carbon dioxide, nitrogen, and oxide particulates, are discharged into the air. Heating and power plants account for 90 percent of all air pollution (13,000 tons a year).

A. D. King

This sacred rock was dragged from the tundra to the middle of Tilichiki, where the Soviet administration set it up for a World War II memorial. Shortly thereafter, according to local lore, all the men connected with its removal died or suffered tragedies.

KORYAKIA

Environmental impact. The total pollutant levels released may not be excessive, but winter inversions concentrate the particulate buildup in low-lying areas of settlements. Air pollution is worst in Palana, Ossora, and Pakhachi. The lack of funding contributes to equipment failures and poor operations. Pollution levels could be reduced but most sources of pollution are not equipped with gas or dust filtration systems. Where such equipment is installed (six enterprises), it is used inefficiently.

In recent years, the *okrug* has experienced extreme difficulties with meeting its fuel needs. During the Soviet era, fuel was imported according to a centralized program of industrializing the North. Current fuel deliveries are haphazard and insufficient for heating and electric power generation at full capacity. During the winter of 1998–1999, the situation became bleak. The first fuel ships appeared in many of the *okrug*'s ports only at the end of the navigation season. Thus, in January 1999, the region was provided with only half of its coal needs, and only 45 percent of the necessary diesel. Deliveries were even less the following winter (1999–2000). Pollution has, however, not decreased proportionately; the fuel quality is lower and less efficient. Low-grade coal contains impurities that damage the equipment, reducing the normal working life of exhaust fans and chutes. During the 1998 navigation season, several settlements, including the capital city of Palana, received oxidized, powdered, poorly caked coal, which is used at plants operating on sprayers. Because the *okrug*'s boiler plants with fire grates cannot burn this fuel completely, most of the fuel is released as unburned coal dust into the air.

Air pollutants are slowly damaging the surrounding vegetation in the settlements. Sulfur dioxide (SO_2) and nitrogen oxides (NO_x) contribute to acid rain in local areas. In Koryakia, there are no specialized storage facilities, so ash and slag waste is piled near plants on the edge of the settlements. Heavy metals and oxides pollute not only the land and air, but also leach into the groundwater and drain into nearby rivers. There is no organized management plan for the disposal of coal waste.

Air pollution can be ameliorated in the short term using higher quality fuels and equipping plants with gas and dust filtration systems. Real reductions in pollution and waste would be best achieved through alternative energy sources, such as wind and tidal power generation. There are settlements in the *okrug* (e.g., Ilpyr, Apuka, and Slautnoe) where wind-power plants are feasible. In addition, wind power could be used as a supplement at nearly all of the *okrug*'s settlements. Even accounting for windless days, these villages would have electricity more regularly than they do now. Authorities are also considering the possibility of designing and constructing small hydroelectric power plants of capacities up to 20 MW or 50 MW on the Vetrovayam, Kinkil, Rossoshina, and Belaya Rivers.

Toward sustainable development

Sergei Abramov

It will be impossible for the United Nations Development Programme (UNDP) or other institutions to implement environmental protection measures without addressing the severe economic and social conditions. The first priority must be to establish alternative sources of electric power. Wind power is viable in some areas, and the Sea of Okhotsk provides some of the highest tides in the world for tidal generators. The indigenous population should be consulted on environmental protection measures. Traditional subsistence activities (reindeer herding, fishing, hunting, and berry and limited plant harvesting) must be accommodated at reasonable levels. The indigenous population, especially the reindeer herders, are also the most knowledgeable about the details of the landscape, and they should be employed in monitoring and data-collecting functions, which would provide sources of cash for the poorest segment of the *okrug* (see chapter 10, pp. 340–73).

Indigenous peoples

A. Baranov

Koryaks, Chukchi, Itelmens, and Evens live in Koryakia (see map 9.3). The cultural and linguistic groups are more diverse than these four names indicate, but the terms have become institutionalized through long usage by Soviet scholars and in the official ethnic designations inscribed on personal identity cards.

Evens migrated to the region from more southern areas. Now they live in three general areas on Kamchatka Peninsula (one of which is in Kamchatka Oblast). The Even language belongs to the Tungus-Manchurian group of the Altaic language family. Many of their beliefs and traditional practices differ markedly from those of other indigenous groups (riding astride deer, particular rituals, clothing design, and decoration), but there are many similarities as well (cosmology, hunting practices, current social situation).

The terms *Itelmens, Koryaks,* and *Chukchi* are best thought of as referring to segments of a continuum of cultural and/or linguistic difference, running from south (Kamchatka Oblast) to north (Chukotka). Itelmens, who lived off the rich salmon runs and hunted or collected a wide diversity of animals and plants, mostly populated the southern part of Kamchatka. The bear held an auspicious place in Itelmen culture, and bear hunting was associated with many rituals,

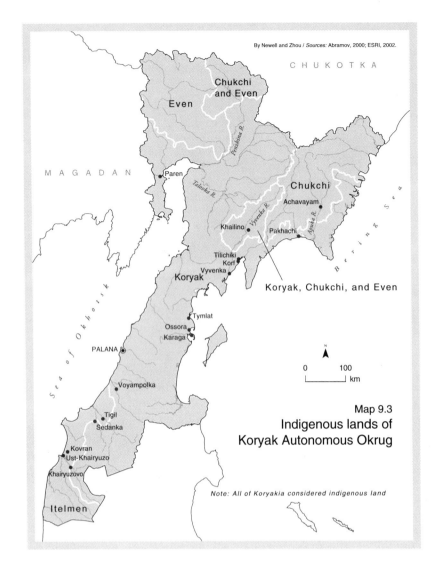

By Newell and Zhou / *Sources:* Abramov, 2000; ESRI, 2002.

CHUKOTKA

Even

Chukchi and Even

MAGADAN

Paren

Talanka R.

Penzhina R.

Vyvenka R.

Chukchi

Achavayam

Apuka R.

Khailino

Pakhachi

Koryak, Chukchi, and Even

Tilichiki
Korf
Vyvenka

Koryak

Bering Sea

Tymlat

Ossora
Karaga

Sea of Okhotsk

PALANA

Voyampolka

Tigil
Sedanka

Kovran
Ust-Khairyuzo
Khairyuzovo

Itelmen

N

0 100
|————————| km

Map 9.3
Indigenous lands of
Koryak Autonomous Okrug

Note: All of Koryakia considered indigenous land

are anthropologically interesting due to their tradition of a mixed economy, which includes reindeer herding, fishing, and hunting.[13] The other indigenous people of northeast Asia were traditionally either reindeer herders or hunters and gatherers, not both. Of course, all of these groups interacted with one another through trade networks, warfare, and even marriage.

The names of territorial groups are the origins of many place-names in Koryakia: Olyutor (*alut-o-el*), Tilichiki, Pakhachi, Vyvenka, Tigil.[14] The indigenous word for river (*wayam* or *weyem*) is also found in the names of towns and rivers: Voyampolka, Achavayam, Unneyvayam, Levtyriny-vayam.

The Nymylan Koryaks of Paren (*Po-itelo* in their language) are famous for their skilled blacksmiths, who were working trade iron from China into knives and spear-points before contact with Europeans, and who refined their technique with the introduction of European hot-forge technology. Nymylans living on the Okhotsk shore hunted gray and beluga whales until commercial whaling eliminated gray whales from the Sea of Okhotsk.[15] To this day, coastal dwellers hunt seals and other marine mammals for food. Boot soles, straps, and other items made from seal skins are superior to those made from synthetic materials and are highly prized by all native peoples in Kamchatka. The ritual life of Nymylans focuses on hunting, most dramatically in the fall thanksgiving ritual *Ololo* or *Khololo*.

The spiritual life of the reindeer-herding Koryaks and Chukchi is organized by the cosmological connections between deer and people. Reindeer herders traditionally lived in a half-dome skin tent (*yaranga*), the frame of which was made of light poles. Many people of the older generation prefer to live in these tents on the edges of Soviet-built villages from May to October, reluctantly residing in heated houses only for the coldest part of the year.

Maritime Chukchi live farther north, in Chukotka. Reindeer-herding Chukchi migrated south into what is now Koryakia, in a pattern of raiding and warfare that began in the nineteenth century and continued until the 1920s. In any case, reindeer and settled people were highly mobile. Whether traveling by dog sled, reindeer sled, or mounted astride reindeer (in the case of Evens), people traveled hundreds of miles in winter to visit friends and relatives, trade goods, find spouses, and "see the world." Koryaks were not great boatmen

culminating in the fall Alkhailailai festival, which has been celebrated annually in Kovran since 1987, after a long hiatus due to Soviet cultural repression. Disease and socioeconomic pressures reduced the Itelmen population, estimated at over eighteen thousand in the eighteenth century, to only twelve hundred people today. Most Itelmens now live in three villages in southern Tigilsky Raion.

The Itelmen language is very different from Koryak and Chukchi, but the latter two languages are similar in many respects. Settled Koryak people (often referred to by the term Nymylan from the Koryak word for town—*nymnym*) lived in towns along rivers and sea coasts from central Kamchatka to Olyutorsky Raion in the east and all around Penzhina Bay in the west, and even as far west as Shelikhova Bay. Nomadic Koryaks (often referred to by the term Chavchuven, derived from *chawchiwaw*, the Koryak word for a rich man [his property in deer]) herded reindeer across large territories in the interior. Farther north are the traditional homelands of reindeer-herding Chukchi and maritime Chukchi, the latter living much as Koryak Nymylans did. The Alutors

and used small skin boats primarily for short-range hunting and fishing trips. People congregated at annual fairs to exchange goods, hold various games and contests, feast, and have a good time. Complex interpersonal networks of trade relationships ("friendships") even allowed for households or individuals to move from one settlement to another, if they became so inclined. Thus, boundaries drawn on maps can mark only the approximate distinctions in Koryak culture among Chukchi, Itelmens, Evens, and so on. Such groupings have never reflected static homogenous populations, but were rather a European simplification of dynamic indigenous communities.

The Russian conquest in the seventeenth and eighteenth centuries incorporated indigenous northeast Asian people into the Russian empire. They were obliged to pay annual taxes in furs (called *yasak*) and engaged in the commercial fur trade for manufactured goods, tea, sugar, flour, and so on. To this day, reindeer herders drink huge amounts of tea, as much as an entire kettle at one sitting. As the Russian fur trade tapered off in the nineteenth century, American traders (mostly whalers provisioning their ships) had a greater influence in Kamchatkan trade.[16]

In the twentieth century, considerable changes occurred in indigenous settlements.[17] In the 1940s and 1950s, Itelmen lived mainly in the villages of Tigilsky Raion: Sopochnoe, Kovran, Napana, Moroshechnoe, Khairyuzovo, Utkholok, and Sedanka. Several families resided in the Koryak villages of Belogolovoye, Sedanka Kochevaya, Ust-Khairyuzovo, and Tigil. Most of these villages were closed during the so-called consolidation in the 1950s and 1960s, and now most Itelmen are found in the villages of Kovran, Khairyuzovo, and Ust-Khairyuzovo. The same happened to Koryak settlements, such as the villages of Mikino, Kultushnoe, Anapka, Vetvei, and Rekinniki, the last of which was closed in 1984.[18]

Indigenous people all across the Soviet Union experienced a cultural revival under *glasnost*, when indigenous languages were once again taught in schools, and religious rituals were practiced openly. Political organization also gathered steam, and indigenous intellectuals in Moscow founded the Soviet (Russian) Association of Indigenous Peoples of the North (RAIPON). Now in operation for ten years, RAIPON has an *okrug*-wide organization with an elected leadership.[19]

Indigenous people are among the hardest hit by the economic crisis, but they are also among the best equipped to adapt to new situations. After twenty years of employment in subsidized state collective farms, Koryaks, Evens, Itelmens, and Chukchis began to rely increasingly on subsistence activities in the 1990s. Now when they catch and dry salmon, they sell the caviar for cash. More people are training and maintaining dog teams now that gasoline for snowmobiles is rare and expensive.

Indigenous cosmology values the landscape as part of a network of personal and sacred relationships. This fosters attitudes of stewardship and a view for the long term that many

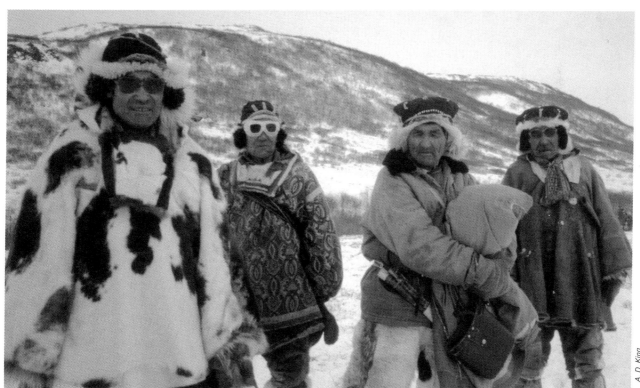

Chukchi and Koryak elders prepare to take their sled deer for a practice run during spring corral festivities.

local Europeans do not have. However, indigenous people are not in a mystical "harmony with nature." They are capable of straining local resources (fish, game, firewood) beyond sustainability. They are hostile toward programs to establish *zapovednik*s or other reserves that would prohibit traditional land use, such as reindeer herding, fishing, berry collecting, and subsistence hunting. Local and foreign environmental activists should engage indigenous people directly in local communities and through official organizations, such as RAIPON, in order to foster sustainable practices and block extractive industries in mining and petroleum. While they want electricity for their refrigerators and VCRs and cash to buy food and clothing, as does the immigrant European population, indigenous people are aware that they have no other home to go to if Kamchatka were to be spoiled. In this way, they are unlike the Russian and Ukrainian immigrants, who are planning to retire back to the mainland. Very few indigenous people are eager to see mining operations expanded in Koryakia.

To protect the area from exploitation, Koryakia adopted measures to reserve zones of traditional use, where industrial and agricultural development would not be permitted.[20]

Several institutions in the *okrug* are working to support such measures, among them: the Okrug Association of the Minority Indigenous Peoples of the North in Palana (Koryakia section of RAIPON), the Council for the Revival of Itelmens of Kamchatka *Tkhsanom* in Kovran, the Association of the Minority Indigenous Peoples of the North of Karaginsky Raion in Ossora (Karaga RAIPON), the Association of the Minority Indigenous Peoples of the North (Nymylan in Tilichiki), and the Gatavkun National Association.

Local projects affecting indigenous peoples

Exploratory and mining work at the Ledyanoi Spring and the Levtyrinyvayam River by Koryakgeoldobycha was monitored by nature conservation agencies. During three years of monitoring, no serious violations were found. Initially, the main adversaries of the mining project were Khailino Village residents, who believed that platinum mining would disrupt reindeer breeding and fishing in the Vyvenka River basin. Then a committee consisting of the director of Korf collective farm, the head of the Khailino administration, a RAIPON representative for Khailino, and a former deputy of Koryakia's Duma visited the mining sites. On December 27, 1996, at a public meeting held in Tilichiki (Olyutorsky Raion center) on the planned development of alluvial platinum deposits at Galmoenan-Seynavsky junction, it was decided that mining in the Vetvei and Levtyrinyvayam River basins using the proposed technology would not have any considerable impact on the environment or the indigenous way of life, and that it was necessary to continue industrial development of alluvial platinum deposits.

A. D. King

Sasha rows his motorboat through shallows on the Paren River on his way downstream to meet his son-in-law, who is returning from the city of Magadan.

KORYAKIA

In July 1998, a dispute arose in Ivashka (Karaginsky Raion) over the allocation of fishing sites between the indigenous and immigrant populations. The head of the Ivashka administration banned fishing by the immigrant population in the region of the northern bay and the Pankara River without taking into account the views of all the villagers and scrutinizing documents on traditional fishing methods. At a community meeting on July 10, 1998, it was decided that the Korzhavin Canal was a place of traditional indigenous fishing in Kamchatka, the northern and southern bays would be places of fishing for all the residents of Ivashka, and the Pankara River basin would be closed to all salmon fishing.

During the 1998 fishing season, eighty-seven residents of Achavayam Village (Olyutorsky Raion) protested in the *okrug* newspaper, *Narodovlastie*, because the right to catch salmon in Apuka River was being granted to outside enterprises. They complained that such enterprises fish unsustainably and span the mouths of the river entirely with nets. The Apuka River is critical to subsistence activities of the residents of Apuka and Achavayam. They have noticed that many fewer fish now enter the Apuka River and most do not reach Achavayam at all.

Russian state policy on indigenous peoples provides them with greater legal and economic independence than before, including a guarantee of state protection of the culture of small ethnic communities (Basic Legislation of the Russian Federation on Culture, article 22). The Land Codex of the Russian Federation (articles 28, 51, 89, 90, 94) guarantees special access to land in places of their traditional residence and use for economic activities, including access to land designated as nature conservation areas, nature reserves, and areas for reindeer pastures, hunting, and other needs. It also guarantees exemption from land tax for enterprises and people engaged in the traditional trades, taking into account their views when allocating plots of land to outsiders.[21]

Russian Federation forest legislation provides for a special regime of forest use in the territories of the minority indigenous peoples, in order to ensure their traditional way of life.[22] This includes exempting indigenous peoples from payment for the use of federal forestlands for their own needs. A portion of the taxes on and fees paid to local administrations (*krais*, *oblasts*, *okrugs*) for subsoil exploitation on the territories of indigenous people shall be used for the social and economic development of those peoples (Law on Subsoils, article 42). Indigenous peoples have preferential rights in acquiring traditional trades and handicraft enterprises at equitable cost (Law on the Privatization of State and Municipal Enterprises, article 20).

Beginning in 1990, information was collected on the possible revival of several villages including Mikino in Penzhinsky Raion; Kultushnoe and Vetvei in Olyutorsky Raion; Rekinniki, Anapka, and Uka in Karaginsky Raion; and Sopochnoe, Nomadic Sedanka, and Moroshechnoe in Tigilsky Raion. Following study, it was recommended to revive Rekinniki, Kultushnoe, and Sopochnoe. Unfortunately, due to the deteriorating economic situation in the *okrug*, all activities aimed to revive those villages were suspended.[23]

Indigenous rights

There are a variety of laws, regulations, and initiatives designed to enhance the rights of indigenous people; some of them are profiled here.

Land reform. To create a land fund for indigenous peoples, national cooperatives, and private reindeer-breeding herders, an inventory of land use was made. The borders of TTPs were to be determined by October 10, 1991.[24]

Tribal lands. The right to own tribal land is granted to citizens, families, and tribal communities permanently residing in territories of traditional habitat and engaged in traditional economic activities. The size of tribal lands is determined by the Council of People's Deputies when allocating them, and use in accordance with local legislation provided without charge for life. Forceful alienation of these lands, or parts thereof, for the state or public needs is prohibited. Special signs are installed on the borders of these lands, showing the type and name of the owner, as well as information on the rules of behavior and peculiarities of the land's legal status. Permission of the owners is required for economic activities of other than traditional nature; access by vehicles, ships, and aircraft; and imports of firearms, dogs, and traps.[25]

Tribal communities. A tribal community may be established, by law, for the revival or preservation of the way of life, culture, and language of indigenous peoples. Members can be Koryaks, Evens, Itelmens, or other indigenous groups and their families who reside permanently in the community and lead the traditional way of life. The General Assembly decides on the original demarcation and changes of land borders, including fishing and hunting sites provided to the community, and the distribution of tribal, family, and individual lands. Land, renewable natural resources, agricultural, hunting, and fishing areas are provided to the community indefinitely and without charge, in one complex or block, as are, with certain exceptions, reindeer pastures, water basins, forests, and hunting areas. Lands transferred to the community cannot, without its consent, be subject to alienation for industrial or other development not connected with the traditional economic activities. To provide their families with food, members of the community are entitled to hunt hoofed animals, game birds, and fish (except those listed in the *Red Data Book*) during the entire year in the hunting areas and water basins (except spawning places) by any means permitted by the legislation.[26]

One of the main principles of community establishment is the presence of an endemic territory of traditional settlement

and economic activity. The traditional economic activities are conducted on the basis of communal property and communal land ownership. Native cooperatives, which are regulated by law, have among their responsibilities the revival of the traditional way of life, indigenous culture, language, customs, and traditional trades. By January 1998, nineteen native cooperatives had been organized in the *okrug*: three in Karaginsky Raion, three in Penzhinsky Raion, one in Olyutorsky Raion, and twelve in Tigilsky Raion.[27]

Territories of traditional nature use (TTP). The legal status of TTPs, provisions for sound management and protection of the rights of the indigenous peoples there, were established in 1997.[28] A TTP can include reindeer pastures, agricultural land, hunting territories, fishing streams, and other areas for comprehensive use. TTPs are established upon the applica-

tion of a tribal cooperative and RAIPON, and regulated by Koryakia's administration or a local self-government body. A TTP cannot be used for industrial or other development without the consent of the indigenous peoples. TTPs are provided for permanent use or on long-term leases of up to forty-nine years, and are exempt from land taxes. TTP lands cannot become personal property, nor can they be privatized, sold, or subleased. Disputes connected with the use of a TTP are settled by administrative order or in court. Quotas for the use of renewable natural resources are preferentially allocated to indigenous peoples.

In a TTP the local residents may:
- Collect wild plants.
- Hunt fur-bearing animals.
- Breed reindeer.
- Hunt and fish for sport.
- Log selectively, for private household needs.
- Hunt sea mammals.

Prohibitions include:
- Trespassing by outsiders.
- Development of mineral resources.
- Commercial logging.
- The application of any chemicals.
- Activities that affect natural complexes, threaten their state, or contradict the aims and objectives of a TTP.

Land transfers. The transfer of historical and cultural heritage landmarks, water resources, TTPs, and burial grounds is forbidden. Indigenous herders wanting to establish reindeer-breeding enterprises are given preference in land allocations, which are made in consultation with local RAIPON officials.[30] The size of such allocations is also regulated and may be based on the holdings of reindeer-breeding teams working under the existing plans of land improvement.[31]

Reindeer breeding. To create conditions for viable economic activities and to preserve the way of life and culture of indigenous peoples residing in Koryakia, the legal, economic, and social foundations of reindeer breeding have been regulated. Taxes are levied only when herd size exceeds the carrying capacities of the pasture. It is necessary to obtain a license to breed reindeer, but state support is envisaged both for the industry and for the protection of natural resources through the provision of subsidies, benefits, and services from the *okrug*'s budget.[32]

Fishing. To protect the economic interests of indigenous enterprises for which fishing is the only way to survive, sport and commercial fishing in rivers and coastal waters are regulated. Indigenous peoples and their legal entities and associations have a preferential right to use fishing resources along with other natural resources. Fishing inside state reservations and preserved areas of national parks is prohibited.[33]

Tkhsanom Territory of Traditional Nature Use (TTP)

Established in Tigilsky Raion, the Tkhsanom TTP covers 2,180,752 ha and includes Utkholok Point (49,800 ha) and Moroshechnaya River (15,000 ha). The Khairyuzovsky coal deposit (3,100 ha) and the municipalities of Kovran, Verkhne Khairyuzovo, and Ust-Khairyuzovo are excluded. TTP Tkhsanom is included in the list of protected natural areas and was jointly administered by the Koryakia Committee on Environmental Protection. The main objective is to ensure the protection of the natural and cultural heritage.[29]

The Khairyuzovsky coal mine, which is in the Tkhsanom TTP, but exempt from its regulation, is becoming a contentious development. Community members complained that the project was planned for an area they used for hunting. The native cooperative Plekhen was concerned about salmon spawning grounds in the Tikhaya River, which runs over the deposit and has asked the World Wildlife Fund for assistance to conduct an environmental review. The *okrug* newspaper, *Narodovlastie*, had published an initial report on the mine on September 25, 1997, but the local residents had not made any formal comments and, on March 17, 1998, license No. PLN N 00196 TE was issued to Kamchatlestopprom for the mine. The concerns expressed are well founded, and only the state or a public review can shed light on this issue. The local community is not, however, united on this issue, as the development of this coal deposit would solve the problems of supply to Kovran, Upper Khairyuzovo, and Ust-Khairyuzovo.

—AK

The salmon fishery is protected by quota. In distributing licenses, the needs of the indigenous residents are met first, and they may take 200 kg of fish annually. The salmon season is established by consensus.[34]

Hunting. The ownership of hunting areas can be transferred to citizens, families, and tribes for whom hunting is either the traditional way of life or the only way to survive. Under free licenses indigenous subsistence hunters are allowed to hunt throughout the year, but may not take species listed in the *Red Data Book*.[35]

National enterprises. By law, a national enterprise must be engaged in a traditional economic activity, and at least 70 percent of the permanent staff must be indigenous.[36] *Raion* administration heads resolve questions on the disputes about the allocation of land for national enterprises.[37] By January 1998, there were fifty-one indigenous enterprises in the *okrug*.

Indigenous cooperatives and enterprises are exempt from taxes on profits from traditional economic activities, which include:

- Reindeer breeding and the sale of reindeer products.
- Fishing, processing, and sale of fishing products (not limited to fish).
- Hunting, processing, and sale of furs and other sea mammal products.
- Collecting, processing, and sale of wild plants.
- Tanning and sale of wild and domestic animal skins, sea mammals, and fish.
- Manufacture and sale of household goods, souvenirs, tools, fur clothing, footwear, and so on.
- Breeding and sale of sled dogs.
- Hunting.

Funding. Fifty percent of the fees paid to the *okrug* for natural resource extraction, payments by enterprises for damage caused to the land and natural resources, special taxes for the right to operate in the territories of traditional settlement, and proceeds of the economic activities of minority indigenous peoples are to be set aside for funding the support and development of the indigenous peoples of the North.

Social services. Indigenous social services are also developing. One such is Aborigenka, a women's organization founded in 1995 and registered by the Department of Justice. Among its activities, the organization obtains apartments, supports public festivals in Ossora, Tymlat, and Karaga, and helps pensioners with financial difficulties (by paying utility bills, providing food, and so on).

Legal issues

Vladimir Korchmit

Environmental protection in Koryakia is handled by the Koryakia Ministry of Natural Resources, the Koryakia Hunting Service, the Koryakia branch of the Special Marine Inspection Service, Kamchatrybvod, the Koryakia Committee on Land Resources, Gostekhnadzor, and the Koryakia Forest Service.

The efficiency of all these authorities leaves much to be desired, partially due to external forces that complicate their work. The nature protection authorities are understaffed because of the lack of necessary professionals in the *okrug*. Koryakia lacks its own laboratories, which makes it impossible to exercise efficient and timely ecological monitoring. All nature protection bodies are ill equipped with means of transportation (snowmobiles, outboard motor boats, seagoing boats), and there are no funds for leasing helicopters. Without helicopters, considering the total lack of land routes, it is impossible to work efficiently. A number of these agencies are described below.

Koryakia Hunting Service. The staff consists of about thirty persons, including five hunting experts, seventeen hunting supervisors, and four state hunting inspectors. Ten voluntary inspectors render some help in animal protection. Resources dedicated to ensuring sustainable management of game animals are insufficient. For example, there is more than one million ha of protected territory per inspector. Financial support for inspection is very weak and, therefore, illegal hunting has flourished in recent years.

The Koryakia Special Marine Inspection Service. The marine area supervised by the Koryakia branch of the Special Marine Inspection Service amounts to 1,148,000 sq. km. Vessels at sea operate within the framework of specialized fishing expeditions: the Sea of Okhotsk theragra and crab expeditions, herring expedition, the Bering Sea theragra expedition, and so on. Usually one or several state inspectors of this branch are included on the staff of each expedition. The staff consists of forty-two inspectors. The agency is seriously underfunded and understaffed. It is extremely difficult, and sometimes even impossible, to prosecute most cases of illegal fishing.

The Koryakia Committee on Land Resources. The land fund of Koryakia amounts to 29,256,300 ha. The Committee on Land Resources conducted 192 inspections, in compliance with the land legislation, on a total area of 647,900 ha.

Gostekhnadzor (emissions inspection service). Two staff are responsible for monitoring pollution emissions, but lack of

KORYAKIA

equipment to control the release of air pollutants by diesel engines limits the effectiveness of this agency.

Koryakia Forest Service. In 1995–2000, financing of aviation for forest protection activities practically ceased. For this reason, forest fire fighting is done only near settlements. In 1997, forest fires did not turn into natural disasters, thanks only to favorable weather conditions. 1998 saw several huge forest fires in Penzhinsky Raion and Magadan Oblast, and smoke from the latter could be sensed in Palana on days with west winds.

This sacred post on the Okhotsk shore near the village of Paren is one example of how Koryaks populate the natural landscape with many kinds of nonhuman entities to create a rich cultural landscape.

Perspective

Olga Murashko

Establishing a territory of traditional nature use

The Itelmens are fishermen and hunters. For them, as for other indigenous peoples, the preservation of their traditional way of living, their culture, and their language are closely related to the protection of the environment and use of traditional natural resources.

The present population of 1,250 Itelmens live in southeast Koryakia. About half live in Kovran Village, where many moved, in 1956, from five villages located in river estuaries that stretched for 200 km along the coast of the Sea of Okhotsk. The rest live together with Koryaks and Russian settlers elsewhere in Tigilsky Raion. When they came in contact with Europeans at the end of the seventeenth century, the Itelmens on Kamchatka numbered between 15,000 and 18,000. They were living in at least 122 villages, situated on 30 rivers. At that time, their population was widely distributed.

The Itelmens only have one river left, which, because of overexploitation during the past forty years, has almost no fish. The Itelmens themselves dream about returning to their old settlements on small rivers, but they have no support to do so.

Support from the MacArthur Foundation enabled Itelmens to reclaim their rights to traditional resources. For several years, discussions were held with Kovran villagers about the resources of the places where they used to live, and negotiations were held with the administration of Koryakia over the return of the historical lands to Itelmen communities. Public opinion polls were also taken among the Russian population.

Historical documents were used to demonstrate land use by the indigenous population in the area for the past three hundred years, and former fishing areas, sacred places, and historical and cultural monuments were mapped.

A. D. King

KORYAKIA

A "union of communities" was established, as indigenous populations in Kovran and adjacent villages still preserve the old system of social organization based on residence in now closed villages. Around one thousand indigenous people joined the union, named *Tkhsanom*, which means "rebirth" in the Itelmen language. *Tkhsanom* members decided to establish environmental posts in the old villages, where they will not only engage in traditional activities on a seasonal basis, but also will protect the environment and, in the future, host tourists for sport hunting, fishing, and dogsled riding.

In the fall of 1997, the union asked the *okrug* administration to give Itelmen lands the status of a Territory of Traditional Nature Use (TTP), then a new type of legal institution. To support the request, the communities and the author of this report prepared a draft agreement with the *okrug* administration. Entitled The Provision for the TTP by the *Tkhsanom* Union, the agreement would establish a nature park on traditional Itelmen and Koryak lands, to be jointly managed by the *Tkhsanom* Union and the Koryakia administration. Under the agreement, the indigenous peoples would protect the resources, and representatives would be trained to do so. In the summer of 1998, development projects for two of the seven communities were prepared.

The agreement was signed on December 2, 1998, and the Koryakia administration allocated 2,100,000 ha to the *Tkhsanom* Union. There are about one thousand indigenous people living on the territory together with two thousand Russians who mainly work at two fish canneries in Ust-Khairyuzovo. There are two federal *zakaznik*s in the area: Cape Utkholok and Moroshechnaya River.

An omission in the agreement with the administration is that indigenous hunting areas near Sedanka Village claimed by the union are not included in the TTP, although about six hundred Itelmens and Koryaks live there. The villagers should be consulted on the issue of annexing their lands to the territory secured by *Tkhsanom*. The Khairyuzovo coal deposit in the center of the TTP and located partly on the indigenous hunting grounds of Khairyuzovo Village also remains outside the scope of the agreement.

The World Wildlife Fund is supporting a project on Utkholok River and has provided funds for purchasing radio stations and other equipment, as well as construction materials for small houses and boats. RAIPON has been well informed about the project, which was deemed promising and recommended to other indigenous communities.[38]

This project should be continued, and expanded to other communities on the Kovran, Khairyuzovo, Moroshechnaya, Sopochnaya, and Belogolovaya Rivers. It is also necessary to discuss the development of self-governance by indigenous people living on the territory, to address, among other things, urgent environmental and legal issues. For example, before *Tkhsanom* secured the territory, a license for coal mining there had been issued. The Okhotsk shelf contains promising oil and gas reserves, which are currently under tender for prospecting and development. This could present a threat to traditional fishing and marine mammal hunting activities.

A common strategy needs to be developed for dealing with such situations. It is imperative to publicize the procedure for securing traditional resources and historical lands for indigenous peoples. If this procedure is widely known, other indigenous communities in the North, Siberia, and the Far East could replicate it. It is also necessary to develop a universal draft agreement between indigenous peoples and regional administrations that could be used by other communities. Work in the state Duma should be continued, especially lobbying for establishment of TTPs.

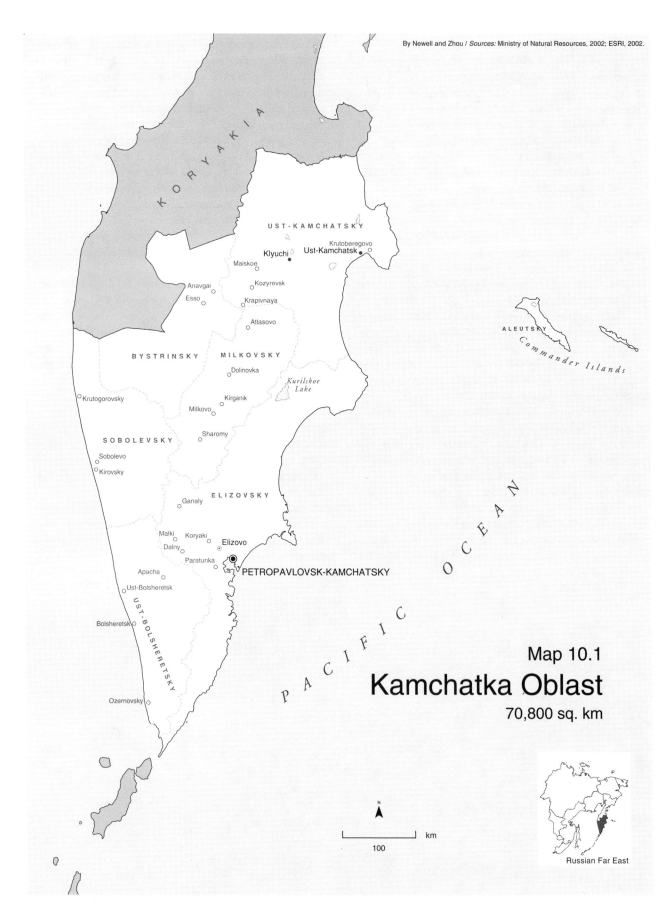

By Newell and Zhou / *Sources:* Ministry of Natural Resources, 2002; ESRI, 2002.

KORYAKIA

UST-KAMCHATSKY

Krutoberegovo
Klyuchi
Ust-Kamchatsk
Maiskoe
Kozyrevsk
Anavgai
Esso
Krapivnaya
Atlasovo

ALEUTSKY
Commander Islands

BYSTRINSKY
MILKOVSKY

Dolinovka
Kurilskoe Lake

Krutogorovsky
Kirganik
Milkovo

Sharomy

SOBOLEVSKY

Sobolevo
Kirovsky

ELIZOVSKY

Ganaly

Malki
Koryaki
Dalny
Elizovo
Apacha
Paratunka
PETROPAVLOVSK-KAMCHATSKY

Ust-Bolsheretsk

UST-BOLSHERETSKY

Bolsheretsk

PACIFIC OCEAN

Ozernovsky

Map 10.1
Kamchatka Oblast
70,800 sq. km

N

km
100

Russian Far East

KAMCHATKA

Kamchatka Oblast

Location

Kamchatka Oblast makes up the southern portion of the Kamchatka peninsula, which is located in northeastern RFE. It is washed by the Pacific Ocean and Bering Strait to the east and the Sea of Okhotsk to the west. To the north, the *oblast* borders the Koryak Autonomous Okrug, which covers the northern section of the peninsula. Kamchatka also includes the Komandorskie (Commander) Islands within its administrative territory.

Size

70,800 sq. km (17.2 million ha).

Climate

The influence of the Pacific Ocean and the Sea of Okhotsk makes Kamchatka's climate milder than continental parts of the RFE. In general, winters are long with heavy snows, and summers are short, cool, and rainy. Heavy fog and sudden changes in atmospheric pressure are common. Annual precipitation is 50–100 cm, with average temperatures ranging from −11°C in February to 14°C in July.[1]

Geography and ecology

Located on the Pacific Rim of Fire, Kamchatka has 29 active volcanoes, 186 geysers, countless boiling mud cauldrons, steam vents, fumaroles, and other forms of volcanic activity. Volcanic eruptions formed the Sredinny (Central) Mountain Range, which stretches down the center of the peninsula. The Valley of the Geysers, in the eastern part of the peninsula and part of Kronotsky Zapovednik, has almost two hundred geysers, making it second in the world to Yellowstone National Park in the United States. Klyuchevskoi Volcano, in the north, rises 4,688 m above sea level. In the heart of the peninsula, between the central and eastern mountain ranges, lies the Kamchatka Valley. Feeding this broad river valley is the peninsula's largest river, the Kamchatka, which stretches 720 km. The water level of its tributaries depends on summer rainfall and melting glacial snow and ice from the Klyuchevskoi-Tolbachinsky group of volcanoes. In summer, these regions suffer from droughts, increasing the risk of forest fires. Vast lowlands define the western coast. The eastern coast is more mountainous, with steep cliffs reaching down to the shoreline in many places.

Influenced by its latitude and long oceanic coastline, wetlands, stony barrens, lava fields, coastal sands, and tundra dominate the landscape. In the north, Japanese stone pine (*Pinus pumila*) and shrub alders (*Alnus fruticosa, A. sinuata*) run down to the shoreline. Sparse stone birch (*Betula ermani*) forests form the typical Kamchatka landscape.

KAMCHATKA

341

Kamchatka's most valuable forests lie in the central Kamchatka River valley. Overall, Kamchatka's natural environment remains one of the most pristine in all of Russia, if not the world.[2]

Flora and fauna

The *oblast* has about one thousand species of vascular plants. The main forest species is stone birch. Willows (*Salix*), aromatic poplar (*Populus suaveolens*), aspen (*P. tremula*), alders, and other trees grow in floodplains along rivers. Dahurian larch (*Larix gmelini*), Ayan spruce (*Picea ayanensis*), and monarch birch (*Betula maximovitschii*) grow in the center of the peninsula. Japanese stone pine and alder shrubs cover mountain ranges and tundra woodlands. Forty rare and endangered species of plants are found around mineral hot springs and fumaroles; four of these species are endemic to Kamchatka.

Forty-three mammal species inhabit the *oblast*, nine of which are marine mammals (excluding migrating whales and dolphins). There are also 240 species of birds, 3 species of bats, and 2 species of amphibians. About 40 birds, 12 cetaceans, and 2 terrestrial mammals are rare or endangered.

Kamchatka has one of the highest populations of brown bear (*Ursus arctos*) in the world, numbering at least 7,650. The peninsula is also one of the world's richest salmon fisheries; the rivers are spawning grounds for all species of Pacific salmon. Up to one quarter of the world's Pacific salmon population spawns in its pristine rivers. Kamchatka crab (*Paralithodes kamchatica*) flourish in the waters off the northeastern coast. Blue whales (*Balaenoptera musculus*), thought to be extinct in the 1970s, have partially recovered and now feed along the shoreline. More than 50 percent of the world's Steller's sea eagles (*Haliaeetus pelagicus*) nest on the peninsula. Other rare and endangered species include Kamchatka snow sheep (*Ovis nivicola nivicola*), gray dolphin (*Grampus griseus*), bowhead (*Eubalaena glacialis*), gray (*Eschrichtius robustus*), blue, and humpback (*Megaptera novaeangliae*) whales, Copper Island arctic fox (*Alopex lagopus mednovi*), Asian harbor

Key issues and projects

Volcanoes of Kamchatka World Heritage Site

This designation offers good possibilities for balanced development on Kamchatka. However, the five protected areas within this site are not being managed properly, jeopardizing future support from international environmental organizations (see pp. 369–70).

Forestry and protected areas

Kamchatka's protected areas should shelter valuable forests from logging, but in practice there is inadequate zoning and in some places no protection at all. Efforts and funds are focused on tourism development rather than on much-needed forest conservation (see pp. 370–72).

Gold mining

Proposed mining activities pose serious threats to the region's ecology and indigenous people's lifestyles. Particularly controversial are the developments at Aginskoe gold mine on the border of Bystrinsky Nature Park. An IUCN resolution halted funding by the U.S. government agency Overseas Private Investment Corporation (OPIC) for this mine (see pp. 361–62).

Tourism

Kamchatka has perhaps the greatest tourist potential of the RFE regions, but the development of tourism has been controversial; intensive use of charismatic places such as the Valley of the Geysers is threatening to destroy fragile ecosystems of global significance (see pp. 372–73).

Rampant fish and wildlife poaching

Illegal fishing costs Kamchatka hundreds of millions of dollars a year in lost revenue. Kamchatka's huge brown bears are regularly killed by poachers to satisfy the Asian market for bear organs (see pp. 368–69).

Energy development

With immense natural energy sources, Kamchatka could become a model of sustainable energy use. Local experts fear that some current and planned energy projects are being developed irrationally (see pp. 362–63).

seal (*Phoca vitulina steinegeri*), whooper swan (*Cygnus cygnus*), Bewick's swan (*C. bewickii*), gyrfalcon (*Falco rusticolus*), peregrine falcon (*F. peregrinus*), Nordmann's greenshank (*Tringa guttifer*), spoon-billed sandpiper (*Calidris pygmaeus*), Aleutian tern (*Sterna kamtschatica*), osprey (*Pandion haliaeetus*), white-tailed eagle (*Haliaeetus albicilla*), and Steller's sea eagle.

Largest cities

Petropavlovsk-Kamchatsky (pop. 256,000) is the administrative center, a hub of the RFE fishing industry, and a nuclear submarine base. Nearby Elizovo (pop. 46,000) is the site of Kamchatka's international airport.[3]

Population

384,200 as of January 1, 2001.[4] The population is steadily decreasing as a result of economic decline; the Russians and Ukrainians who were once encouraged with high-paying jobs and good perks to come to Kamchatka are now returning to European Russia. In 1998, 13,440 people left the *oblast*, resulting in an overall decline of 5,801; in 1999, the decline was about the same, 5,962.[5]

Political status

Kamchatka's current administration has been in place since 1991, developing close ties with local business interests. Kamchatka Oblast and the Koryak Autonomous Okrug were once a single administrative unit. In 1990, they became independent administrative regions, but Petropavlovsk remains the gateway to the entire peninsula. The *okrug* and *oblast* have much in common in terms of economy and ecology; cooperation between their governments could result in mutually beneficial strategies for sustainable development.

Natural resources

Kamchatka has significant deposits of gold, silver, platinum, nickel, copper, and other mineral resources. Coal and brown coal deposits total 273 million tons. There are sixteen natural gas deposits in western Kamchatka with up to 70 billion cu. m of gas reserves. Gas reserves on the Okhotsk shelf adjacent to Kamchatka are estimated at 732 billion cu. m. Oil fields, with confirmed reserves of 360 million tons, were also recently discovered here. The fisheries in Kamchatka's rivers and in surrounding seas are some of the richest in the world.

Main industries

Fishing, particularly for pollock, salmon, and crab, is by far the most important industry. The fish-processing and timber industries are in decline. Development of tourism could become more promising with an improved infrastructure to support it. Kamchatka's substantial geothermal resources are minimally developed. See fig 10.1 for the total industrial production in 1999.

Figure 10.1
Industrial production in Kamchatka Oblast, 1999

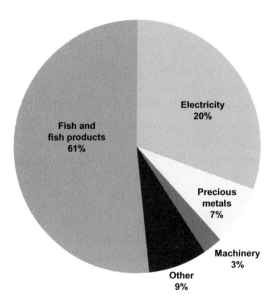

Electricity
20%

Fish and
fish products
61%

Precious
metals
7%

Machinery
3%

Other
9%

Source: Goskomstat, 2000.

Nearby volcanoes provide a dramatic backdrop to the city of Petropavlovsk-Kamchatsky.

Infrastructure

The remote location of the peninsula creates difficulties in supplying regular shipments of fuel, food products, and equipment. Petropavlovsk is the main port. Much of the peninsula is accessible only by air; Kamchatka's only major road goes from Petropavlovsk up the middle of the peninsula, forking and heading out to Ust-Kamchatsk in the northeast and Esso to the central-west (Bystrinsky Raion). International airlines serve the airport in Elizovo, but hotels and services to support tourism are underdeveloped.

Foreign trade

Kamchatka's economy is relying more and more on foreign trade. Reported exported fish products in 1999 amounted to $242.3 million (3.3 percent less than in 1998), of which the United States (27.4 percent), Japan (21.7 percent), and South Korea (21.2 percent) were the largest consumers. Sixty Kamchatka enterprises are involved in the fish product trade. Other exports include machinery (3 percent) and timber (4 percent). Bunker fuel is Kamchatka's primary import, accounting for u.s.$32.2 million in 1999.

Economic importance in the RFE

In 1998, Kamchatka accounted for 6.2 percent of industrial production in the RFE.[6] In past years it produced as much as a third of the RFE's fish catch; in 1997, Kamchatka's portion totaled 782,000 metric tons, or 25 percent of the catch.[7] The peninsula served the former Soviet Union as a strategic military outpost, with Russia's largest nuclear submarine base on the eastern seaboard based in Avacha Bay. Other military bases on the peninsula were used as targets for test missiles launched from other regions of Russia.

General outlook

Kamchatka needs to address its energy crisis first. Currently, it has the highest electricity costs in all of Russia, four times the national average. Fuel shortages have made regular rationing (scheduled blackouts) a daily occurrence for the past few years. Kamchatka has traditionally relied on imported fuel (oil, coal, and diesel) to fire its power stations and is now looking increasingly to domestic sources. Construction of the Mutnovsky geothermal power plant, funded in part by the European Bank for Reconstruction and Development

(EBRD), was recently completed. There are plans to build two hydroelectric power plants and to construct a 414-km gas pipeline from gas fields in western Kamchatka to Petropavlovsk. Construction of this Kamchatgasprom pipeline is proceeding despite concerns about the environmental impact and economic feasibility; environmentalists point to threats posed by its construction and fear that the pipeline could pave the way for future exploitation of the oil and gas reserves on the Okhotsk shelf.

Development of tourism in Kamchatka has helped to bring needed revenue to protected areas. Although many argue that the concept of a *zapovednik* does not include tourist activities, which could adversely affect fragile ecosystems, ecotourism does present the best opportunity for an environmentally sustainable industry employing a broad range of local people. Unlike mining, which requires outside technical experts, tourism requires locals intimately familiar with the landscape. Vladimir Putin, during a visit in the spring of 2000, suggested that tourism be expanded, remarking that he "had never seen anywhere as beautiful as Kamchatka, either in Russia or abroad."[8] Regional experts believe that tourism should be encouraged outside protected areas—on Kamchatka there are plenty of other breathtaking landscapes, hot springs, and other tourist attractions—while areas of particular scientific value remain strictly protected. Given the virtual withdrawal of federal funding for protected areas, these ideals are difficult to uphold.

Local and international groups have strongly resisted efforts by the administration to attract foreign investment for gold mining projects. This resistance, coupled with low global gold prices, has put project development temporarily on hold, but the depressed economic conditions within the *oblast* and recent statements by government officials mean that foreign investment for gold mining will be aggressively sought when prices improve. Although protected areas cover 27 percent of the territory, the perpetual lack of financial support hampers real enforcement of park boundaries and effective monitoring of illegal activities. Despite the large percentage of protected land, important areas, such as the conifer forests in the center of the Peninsula, which are vital to ensure healthy salmon runs and regulate water levels, remain unprotected. The decline of the fish-processing and timber industries, unemployment, and extremely high costs of foodstuffs have left many people in a desperate state, which contributes to the increase in poaching and overall criminal activity.

— *Emma Wilson*

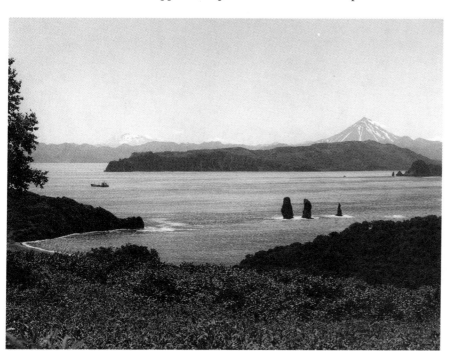

Scenic landscapes of Kamchatka have made it the only part of the RFE with a well-developed tourist industry.

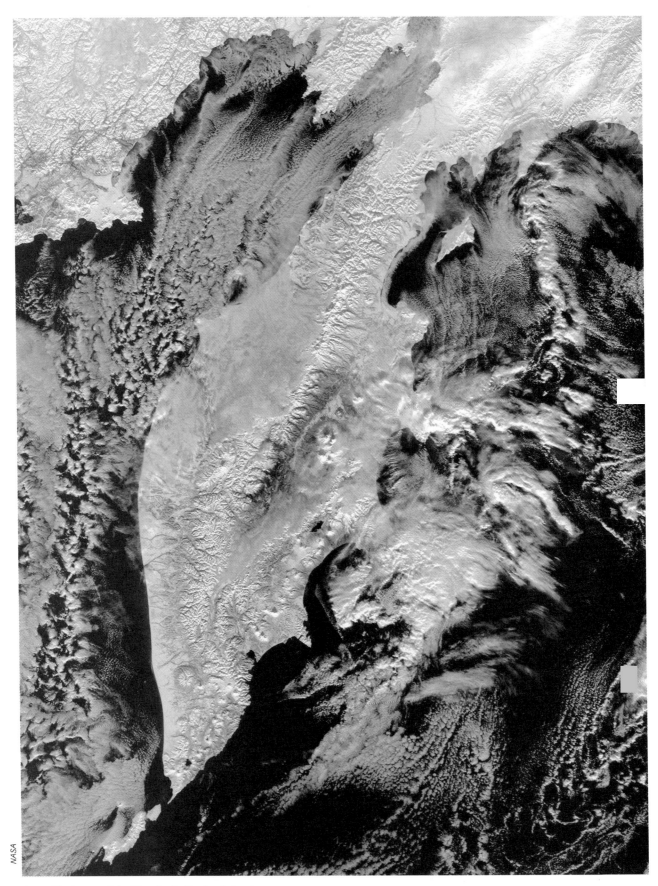

A satellite image of the Kamchatka Peninsula in winter.

NASA

Ecology

Olga Chernyagina, Vladimir Zykov

Despite Kamchatka's relatively pristine nature, extensive land-use practices have taken their toll. This is especially apparent in the vicinity of Petropavlovsk and Elizovo. Excessive air and water pollution, combined with the effects of climate, variability in atmospheric pressure, and the release of chemicals caused by volcanic activity have impaired public health.

In 1992, the economy entered a recession that did improve pollution levels. However, in 1997 a six-hundred-ton increase in airborne particulates (to 50,000 tons) from stationary sources was observed, a result of development of Petropavlovsk's heating grid and a decrease in the quality of fuel oil being used to supply it. Air pollution from mobile sources also increased by 200 tons to 26,700 tons per year.

Water resources are among Kamchatka's most precious natural endowments. The abundance of pure, clear lakes and the variety of mineral waters found in the peninsula's many springs know few equals around the world. Approximately 220 cu. km of runoff empties into the surrounding oceans each year, with a practically inexhaustible water supply in aquifers. The mineralized waters found in many of the peninsula's natural springs have medicinal applications.

In spite of these resources, the supply for household and commercial use is problematic. In some locales, the situation is critical because of difficulties with water treatment and the poor condition of pipelines and drainage systems in settlements with a centralized water supply. Sewage is disposed of primarily via bays and rivers. The worst polluters include the fish-processing, shipbuilding, and energy-production industries, as well as fishing fleets and military bases. Avacha Bay, near Petropavlovsk, the two rivers flowing into it—the Avacha and Paratunka—and the largest river on the peninsula, the Kamchatka River, are degraded primarily by agricultural activity and logging. Several cities and towns on the peninsula lack sewage treatment facilities. None of the settlements of the peninsula has storm drainage collection systems, resulting in large quantities of toxic runoff in nearby river systems.

Almost half of the 280,000 tons of solid waste that were produced in 1997 consists of household waste. Only 10 percent of industrial waste is recycled or reused. More than 100,000 tons of scrap metal litter the peninsula's coastlines, and about the same amount has been disposed of in Avacha Bay. The region's naval installations alone have generated more than 60,000 tons of scrap metal.

The *oblast* administration increasingly wishes to exploit mineral resources to bolster the region's economy. However, at a scientific conference, Problems and Priorities of Mining in Kamchatka Oblast, held in Petropavlovsk in 1997, delegates concluded that any mineral extraction should come within the strictest of environmental regulations because of the unique role that Kamchatka plays in maintaining the

Table 10.1

Forest stock in Kamchatka Oblast by land category, 1995

Category	Area (000 ha)
Group I	3,470.0
Group II	1,424.0
Group III	10,152.3
Total	*15,046.3*

Source: Kamchatka Forest Service, 1996.

ecological stability of the northern Pacific and the productivity of its marine resources.

Public interest groups in Russia and abroad have paid great attention to the problems of nature and resource conservation in Kamchatka. As a result, the Kamchatka administration and related organizations have received substantial support from influential international environmental organizations, particularly for establishing regional nature parks. A number of U.S. environmental NGOs pressured the Overseas Private Investment Corporation (OPIC) to halt its support for developing the Aginskoe gold deposit. As a result, large-scale investment in the mining company's initiative to develop the site was canceled, and continued work on exploiting Aginskoe was averted (see pp. 361–62).

Forests

Kamchatka's forest stock (as of January 1, 1998) amounts to 15,046,300 ha, or 87.8 percent of the total land area (see table 10.1). Of these, 8.95 million ha are actually covered by forest, 3,470,000 ha designated as Group I forests. These include protective strips along spawning rivers (3,448,800 ha) and along roads and green zones around Petropavlovsk and Elizovo. Forests within Group II amount to 1,424,000 ha. To regulate commercial logging and the designation of logging areas, this group was created to include coniferous forest deemed threatened by development, located in the basins of spawning rivers, and in areas that, earlier, had been included in the resources base of Kamchatles, the *oblast*'s main logging enterprise. Group III forests cover the remaining area of the forest fund, 10,152,300 ha.

Kamchatka's estimated timber reserves are 510.0 million cu. m, of which 178 million may be harvested (70.26 million coniferous, 107.74 deciduous). The productivity of the forests is considered low. Stone birch forests are the most widespread and comprise four-fifths of all of Kamchatka's forests. They are dominant in the lowlands and in the middle zone of the mountainous parts of the peninsula. Dahurian larch forests occupy central Kamchatka's lowlands and extend to an

Most of the impact of tourism on Kamchatka is concentrated in Geyser Valley.

mineral hot springs and fumaroles host forty rare and endangered species, four of which are endemic to Kamchatka.

Forty-three mammal species inhabit the *oblast*, 9 of which are marine mammals (excluding migrating whales), and 3 of which have been introduced: American mink (*Mustela vison*), muskrat (*Ondatra zibethica*), and Canadian beaver (*Castor canadensis*). There are also 240 species of birds, 3 species of bats, and 2 species of amphibians. In all, 53 species are listed in the Russian *Red Data Book*: thirty-nine birds, twelve cetaceans, and two terrestrial mammals. Game species include fourteen land animals, fifty-six birds, and six marine mammals. Quotas on sable (*Martes zibellina*), river otter (*Lutra lutra*), brown bear, snow sheep, and reindeer (*Rangifer tarandus*) are strictly limited, but these are typically exceeded, due to poaching.

Sport hunters, including those coming from abroad, focus primarily on the brown bear. In 1995–1996, as part of a World Wildlife Fund program on the sustainable harvest of brown bear in Kamchatka, the Kamchatka Institute of Ecology and Nature Use (KIEP), Kronotsky Zapovednik, and the Kamchatka Committee on Environmental Protection conducted an *oblast*-wide census of the animal. The results showed that there was a minimum of 7,650 individuals, 650 of which live within the territory of Kronotsky Zapovednik. Populations of Kamchatka snow sheep have declined considerably in recent years; the numbers now total three thousand head. Reindeer populations also are declining with each passing year.

All six species of Pacific salmon spawn in Kamchatka's rivers: chum (*Oncorhynchus keta*), pink (*O. gorbuscha*), sockeye (*O. nerka*), chinook (*O. tschawytscha*), coho (*O. kisutch*), and cherry salmon (*O. masu*). Along with the Pacific salmon, there are several other salmonid species: rare rainbow trout (*O. mykiss*) and chars (*Salvelinus*). The spawning grounds offered by Kamchatka's rivers are substantial: 1,852 rivers extending a total of 42,689 km. The entire peninsula acts as a gigantic incubator, where millions of salmon hatch and grow each year. Productivity rates have been declining since the 1950s, but catch quotas (in terms of fish overall) from river basins remain much higher here than in European Russia or Siberia.

The seas surrounding the peninsula are no less rich in fish and seafood resources. In fisheries off Kamchatka's coasts more than two million tons of fish and seafood are caught annually: Pacific salmon, walleye pollock (*Theragra chalcogramma*), Pacific cod (*Gadus macrocephalus*), saffron cod

altitude of 200–300 m in the ranges. The geographic area of larch in the central part of Kamchatka, including Ayan spruce forests, is commonly referred to as Conifer Island. Silver birch forests are also widespread in the central part of the peninsula; aspen forests are much rarer there. Floodplain forests of chosenia (*Chosenia arbutifolia*), willows, and aromatic poplar stretch in narrow strips along the banks of rivers. Dwarf vegetation consisting of Japanese stone pine and shrub alder is also widespread, covering practically all the mountain ranges and forest tundra.

In spite of the low productivity, the *oblast*'s Annual Allowable Cut (AAC) is set at a level more characteristic of regions with high forest productivity. Therefore, many of the less desirable species are ignored altogether, while excessive amounts of more valuable coniferous species are harvested. Of Kamchatka's coniferous forests, only 2.1 percent (350,000 ha) remains undisturbed by logging or fire. Forests in river basins, which are used extensively by salmon for spawning grounds, are most accessible for logging enterprises. In response to dwindling reserves of spruce and larch, the forest services of Kamchatka and Koryak Autonomous Okrug put forward a resolution in 1997 insisting that the AAC for both regions be cut by 30 percent. Meanwhile, as in other regions of the RFE, fires also bring enormous damage to the forests. In 1998 alone, ninety-seven individual fires were recorded, burning 37,700 ha of forest.

Flora and fauna

About one thousand species of vascular plants inhabit the *oblast*. The most widely distributed species are Japanese stone pine, shrub alder, stone birch, and rough bluejoint (*Calamgrostis langsdorfii*). Other species occur quite rarely, often in highly localized habitats. Communities in the vicinity of

Table 10.2

Protected areas in Kamchatka Oblast

Type and name	Size (ha)	Raion	Established
Zapovedniks			
Komandorsky[a]	3,648,679	Aleutsky	1993
Kronotsky Biosphere	1,308,854	Elizovsky, Malkovsky, Milkovsky	1926
Nature Parks			
Bystrinsky	1,333,478	Bystrinsky	1995
Yuzhno-Kamchatsky (Southern Kamchatka)	980,000	Elizovsky	1996
Nalychevsky	285,970	Elizovsky	1996
Federal Zakazniks			
Yuzhno-Kamchatsky (Southern Kamchatka)	225,000	Elizovsky, Ust-Bolsheretsky	1982
Regional Zakazniks			
Ichinsky	183,400	Bystrinsky	1994
Yugo-zapadnaya (Southwestern) Tundra	123,000	Ust-Bolsheretsky	1990
Reka (River) Udochka	99,000	Elizovsky	1983
Timonovsky	72,000	Elizovsky	1994
Oleny Dol (Reindeer Valley)	69,600	Ust-Bolsheretsky	1995
Surchinsky	64,900	Milkovsky	1994
Scientific Research Station Sobolevskaya	55,000	Sobolevsky	1976
Bobrovy (Beaver)	51,000	Milkovsky	1994
Tri Vulkana (Three Volcanoes)	50,000	Elizovsky	1985
Bereg Chubuka (Chubuk's Coast)	49,100	Elizovsky	1994
Tayozhny (Taiga)	41,000	Milkovsky, Bystrinsky	1986
Nalychevskaya Tundra	15,000	Milkovsky	1972
Ozero (Lake) Kharchinskoe	10,000	Ust-Kamchatsky	1978
Nalychevsky Mys (Point)	2,500	Elizovsky	1994
Zhupanovsky Liman (Slough)	2,500	Elizovsky	1994
Total[b]	*8,503,261*		

[a] Includes 185,379 ha of land and 3,463,300 ha of aquatorial area.

[b] Total includes aquatorial area.

Source: Kamchatka Committee on Environmental Protection, 1999.

(*Eleginus gracilis*), flounder and halibut species (*Pleuronectidae*), Pacific herring (*Clupea pallasi*), and hake (*Merluccius productus*). Fishing enterprises focus their efforts on the most profitable species, including certain salmon species, roe-bearing pollock, and crab. These resources are being depleted because quotas and geographical and seasonal limitations are flagrantly disregarded.

Protected area system

E. EZVEKOVA, V. ZYKOV—The first protected areas appeared in Kamchatka in the end of the nineteenth century to protect important sable habitat.[9] The Kronotsky area received special attention in an imperial decree of 1882 to protect sable, snow sheep, and reindeer. Kronotsky Zapovednik was officially designated by a 1926 Dalkraiispolkom (Far Eastern regional executive committee) decree and ratified in 1929 by the Kamchatka Oblast executive committee.[10] Until June 1934, no money was allocated to enforce the protection regime in the area, and no rangers or research staff existed.

Today there are two *zapovedniks* in Kamchatka, one federal *zakaznik*, fifteen regional (*oblast*-level) *zakaznik*s, three regional nature parks, fifty-nine natural monuments, twenty-eight forest reserves, two resort zones (Paratunskaya and Malkinskaya), and the green-belt zones of Petropavlovsk and Elizovo.[11] In all, protected areas occupy 27 percent of the *oblast*'s total land area. In addition, sixty objects have been placed on the register of historical and recreational objects. In 1996, UNESCO designated part of the *oblast*, including the two *zapovednik*s and three nature parks, as a World Heritage site—Volcanoes of Kamchatka.[12]

Zapovedniks. One of Kamchatka's two *zapovednik*s, Kronotsky, is recognized as a biosphere reserve by the Russian government.

　Kronotsky. A complete description of Kronotsky Zapovednik is provided (see pp. 353–55).

　Komandorsky. A complete description of Komandorsky Zapovednik is provided (see pp. 355–56).

Nature Parks. The Kamchatka administration has established three nature parks.

　Bystrinsky. A complete description of Bystrinsky Park is provided (see pp. 351–52) and so is omitted here.

　Nalychevsky. The Zhupanovsky, Koryaksky, Avacha, and Dzenzur volcanoes surround the Nalycheva River valley. A few hundred hydrothermal and cold mineralized springs are concentrated in the upper reaches of the Nalycheva River. Thirty-three mammal species are found in the area. Brown bear is very common in the upper reaches of the river. The volcanic cones and cliffs of Nalycheva Point provide habitat for snow sheep. One hundred and forty-five species of birds frequent the valley. Rare species include black brant (*Branta*

nigricans), Steller's and white-tailed sea eagles, gyrfalcon, peregrine falcon, and golden eagle.[13]

The Nalycheva River provides spawning habitat for five species of Pacific salmon. This park is one of the most frequently visited natural areas in Kamchatka. Hundreds of tourists pass through the valley every year. Tourist cabins are located in the central part of the valley. Due to unstable funding, for the last few years the buildings have not been well maintained. In 1997–1998 the Kamchatka Directorate of Nature Parks used funding from WWF and the Ecological Fund of Kamchatka to build living quarters for four people, the Vladimir Semyonov Ecological Center, and some campground facilities. Funds were also used to improve the bathing areas around hot springs. Six areas for indigenous hunting and one for indigenous fishing have been designated in the park for the local indigenous population.

　Yuzhno-Kamchatsky (Southern Kamchatka). The park's territory encompasses several active and extinct volcanoes, including one of Kamchatka's most active, Mutnovsky, and an abundance of geothermal activity. Fifty-nine mammal species inhabit the park. Snow sheep, brown bear, and sea otter are the most valuable; other animals typical of Kamchatka such as fiery fox (*Vulpes vulpes kamchatica*), sable, river otter, wolverine (*Gulo gulo*), American mink, and Arctic ground squirrel (*Spermophilus parryi*) are also represented here.[14]

The park boasts one of the largest populations of peregrine falcons on the Kamchatka peninsula; it also has at least twenty nesting pairs of Steller's sea eagles, and some ospreys and golden eagles. About two hundred nesting colonies of seabirds can be found on the Pacific shores and on islands near shore. Among these colonies is one of between five thousand and six thousand pairs of long-billed murrelets (*Brachyramphus perdix*), the largest in Russia, and large colonies of slaty-backed gull, murres (*Uria aagle*, *U. lomvia*), tufted puffins (*Fratercula cirrhata*), and pelagic cormorants (*Phalacrocorax pelagicus*).

Eight hunting areas exist in the park. A tourist camp belonging to the aviation-tourism company Krechet operates in the vicinity of Khodutka hot springs. The joint-stock company, Friod, manages an experimental water pumping facility in Russkaya Bay and studies the underground and surface waters here.

Zakazniks. Only the federal zakaznik, Yuzhno-Kamchatsky is described here. See table 10.2 for a list of the regional *zakaznik*s.

　Yuzhno-Kamchatsky (Southern Kamchatka). The gem of this federal *zakaznik* is Kurilskoe Lake, which is surrounded by a group of active volcanoes (Kambalny, Ilinsky, Diky Greben, and Kosheleva). In the fall, the lake shores and the rivers in the area teem with hundreds of brown bears, which feed on the massive salmon runs. Steller's sea eagles nest within the lake watershed, as do hundreds of whooper swans

and many ducks. A sea otter population of 1,500, breeding grounds for hundreds of seals, and a coastal population of snow sheep make this an area of worldwide significance. Rare birds such as yellow-billed loon (*Gavia adamsii*), black brant, lesser white-fronted goose (*Anser erythropus*), osprey, golden eagle, and Aleutian tern are also found here. Poaching, especially of sockeye salmon and brown bear, is a serious threat. The *zakaznik* does not have the necessary funds to deal with this problem. An increase in tourism is also one of the concerns of the staff; *zakaznik* regulations explicitly prohibit recreational activities. Development of tourism is taking place without an adequate impact assessment. Such an assessment is particularly necessary for the tourist hotel already being built in the buffer zone of Kurilskoe Lake (see p. 373).

Vast wetlands of Kamchatka.

Biodiversity hotspots

1. Bystrinsky Nature Park (forest)

Located in the heart of Kamchatka Peninsula, Bystrinsky Nature Park falls within Bystrinsky Raion. Indigenous Evens, Itelmens, and Koryaks live in the park, practicing traditional subsistence activities such as fishing, hunting, gathering of berries and mushrooms, and reindeer herding. Two settlements, Esso and Anavgai, are located within the park. An *oblast*-administered protected area, the park was established by governor's decree in August 1995. In 1996, the park was included in the UNESCO World Heritage site, Volcanoes of Kamchatka. There is also a zoological *zakaznik*, Ichinsky, with a land area of 183,400 ha.

In the park there are several peaks exceeding 2,000 m; the seismically active Ichinsky Volcano, at 3,607 m, is the highest summit of the park. The park's largest river, Bystraya River, serves as the headwaters for the Kamchatka River, the peninsula's longest, and for several important spawning rivers on the western side of the peninsula, including the Tikhaya, Bystraya, Icha, Tigil, and Sopochnaya Rivers. Large wetlands are located in the headwaters of the Rassoshina, Sopochnaya, Yamme, Tkhonma, and Saichik Rivers and in the valleys of the Icha, Tvayan, Ozernaya, and Oblukovina Rivers.

All of the ecosystems found in central Kamchatka are represented in the park in their virgin state and serve as important baselines for analyses of similar regions where anthropogenic effects are more pronounced. The high biodiversity of these ecosystems and the mosaic of ecological communities within them, resulting from the area's volcanic activity and numerous hot springs, add to the park's value for conservation and tourism.[15]

This territory is home to sizable brown bear, snow sheep, and sable populations. The density of introduced muskrat, American mink, and Canadian beaver is unusually high. Three bat species (*Myotis daubentoni*, *M. brandti*, *Eptesicus nilssoni*),

Siberian lemming (*Lemmus sibiricus*), wild reindeer, and Kamchatkan marmot (*Marmota kamtschatica*) are among the rare species that inhabit the park. All species of Pacific salmon can be found in the park's rivers, as well as Arctic grayling (*Thymallus arcticus*) and Dolly Varden (*Salvelinus malma*).

Initial studies of the territory's vascular plants illustrate its distinction: A wide variety of arctic alpine species inhabit the high plateaus and terraces, and relict cryophilic and steppe species are found in insular populations among the jagged cliffs. The park forms the southern extent of many species' geographical distribution. Fifteen are found nowhere else in the *oblast*. Japanese stone pine and shrub alder are the primary vegetation; at elevations below 600 m, stone birch appears. Alpine tundra (shrub species and lichens) dominates the mountain peaks. Tall stands of Ayan spruce and Dahurian larch (part of Kamchatka's Conifer Island) grow on the slopes of the Sredinny Ridge, the park's eastern boundary.

Threats. The boundaries of the park lie almost exactly over one of Kamchatka's richest gold deposits. The administration redrew the park's boundaries to allow extraction at the Aginskoe and Baranyevskoe sites and reduced the size of Ichinsky Zoological Zakaznik to make room for mining at Aginskoe. Along the park's southwestern boundaries the Shanuch River nickel-copper deposit is also pending development, with mining interests lobbying for yet another border modification. At the same time, the park's forests and tundra ecosystems are continually being scorched by fire.

The planned mining activity threatens the park's bioresource potential, which serves as the foundation for the subsistence economies of the native peoples living in the area: Evens, Itelmens, and Koryaks. The land's status as a regionally administered protected area provides only a minimal degree of protection, insufficient to stave off the threat posed by mining interests. At the same time, the territory is an important stabilizing influence for adjacent ecosystems due to the headwaters that rise here.

Another potential hazard is development of uncontrolled tourism. If planning is conducted without a preliminary appraisal of the park's carrying capacity for tourists, including detailed inventories of the flora and fauna inhabiting the park's most unique and attractive ecological communities, the threat posed to the park's biodiversity will increase exponentially. Judging by the growth of tourism in Nalychevsky, another of the *oblast*'s regional nature parks, there is certainly cause for concern.

Existing protection measures. Bystrinsky Nature Park has no financing or staff. A joint program, People and the Park—Social and Ecological Priorities, was conducted by KIEP with Cambridge University. The results of their joint expedition, Project Kamchatka '98, include findings on the administration and regulation of natural resources in the park, prospects for the continued development of the park and its meaning for local residents, an appraisal of local needs and experience in land-use planning, and the conclusions of a study on the biodiversity of the park's flora.[16]

Recommendations. When the park was created, many ideas of and suggestions from several scientific organizations were not taken into account; the territory was initially envisioned as a federally administered protected area rather than one having only regional status. The western slope of Ichinsky Volcano was not included within the park, nor were most of the largest hot springs on the peninsula, along the Kirevna River. Also ignored were alpine Ayan spruce stands. At the same time, a number of areas that had already been significantly altered by human activity were unjustifiably included in the park. Also ignored were recommendations to establish a zoning pattern that takes into account both traditional (native) land use and conservation priorities. Now Bystrinsky Nature Park exists only on paper: Zoning issues remain unresolved, and the local population is unaware of the location of its boundaries. Therefore, the following measures are essential:

- Change park borders to incorporate a number of ecologically valuable areas and acquaint local residents with the new boundaries.
- Resolve the socioeconomic problems of the area. Conditions must be created so that local and native residents can continue to rely on natural resources for subsistence economies. To accomplish this, the natural characteristics and resource base in the park and for Bystrinsky Raion as a whole must be evaluated.

2. Conifer Island (forest)

G. LAZAREV—The only tall coniferous stands found on Kamchatka are located primarily in the Kamchatka River basin in the central part of the peninsula. This region is commonly referred to as "Conifer Island," so named, originally, by a German botanist, Karl Ditmar, who visited this part of Kamchatka in the eighteenth century.

The Kamchatka River basin is wedged between two mountain ridges, Sredinny and Vostochny (Eastern), with maximum elevations exceeding 2,000 m. The northern part of this region is characterized by considerable volcanic activity, and includes the highest active volcano in all of Eurasia-Klyuchevskoi (4,688 m). The climate is continental. A rain shadow area caused by the two mountain ridges results in minimal annual precipitation and relatively small amounts of snow. May and June are the region's driest months.

The Kamchatka River basin has been influenced by volcanic activity for a long time. The soils are volcanic and layered with ash. Soils in coniferous stands are characterized by a lack of podzol [17] and are highly permeable. Ayan spruce and Dahurian larch predominate at the northeastern extents of their geographical distribution. These forests are generally

relict in nature, having been preserved during Pleistocene glaciation. Modern climatic conditions are unfavorable for their natural regeneration.

These forests have a unique value for regulating water levels in Kamchatka's rivers. Because of the region's extended snowmelt, the seasonal permafrost in the soil lasts well into the growing season, which helps to conserve moisture. As the frozen earth thaws, the moisture is released into the area's headwaters at a slow and stable rate. During the dry months of May and June, this slow release of moisture after it has been thoroughly filtered through volcanic soils provides clean water for the Kamchatka River and its tributaries, which are used extensively as salmon spawning grounds.

Many of the coniferous and birch-dominated stands in the Kamchatka River basin are difficult to reach and therefore minimally impacted by human activity. They represent typical ancient forests. They also host a variety of taiga species not found elsewhere on the peninsula.

In general, the forests of Conifer Island are the only source of timber on the peninsula. Commercial harvesting of these resources first began in 1930, with fire a frequent occurrence. Between 1953 and 1993, 3,300 individual fires were recorded, consuming as much timber each year as was logged for commercial use. Because of the natural climate in the region, forests in this part of Kamchatka regenerate very slowly after fire and other disturbances, with no known successful attempts at artificial regeneration. For these reasons there has been a steady decline in the amount of forest cover, a 300-percent reduction from 1.2 million ha sixty years ago to less than 350,000 ha (of which 125,000 ha are protected Group I forests) in 1996.

Threats. The natural complex once evident at Conifer Island no longer exists. The forests that do remain are found either in isolated fragments, in degraded remains of logging areas, or as immature stands on old burn areas and logging sites. At least 200,000 ha of mature coniferous forest are now irrevocably transformed into secondary birch or aspen communities, sometimes peppered with the occasional larch. Roads, fire, logging, and other human depredations have degraded another 200,000 ha. Because of the unfavorable economic climate, commercial logging has declined considerably. Plans are afoot, however, for future widespread commercial logging, exclusively for export. Because of the key role that the area plays in maintaining the hydrological stability of the river, this logging would bring with it irreversible damage to the Kamchatka River basin—and the entire Kamchatka region—in the near future.

Existing protection measures. At present, three portions of Conifer Island are included within protected areas: Bystrinsky Nature Park, Kronotsky Zapovednik, and Tayozhny Zakaznik. Commercial logging is prohibited in these areas. Harvesting is also prohibited within 1 km of spawning rivers in Group I forests, but the Kamchatka administration's Committee on Natural Resources is trying to narrow these water-protection zones.

Recommendations. The following actions should be taken:
- Bolster air patrols to help protect these forests from fire. This must be the top priority; in recent years these patrols have operated with almost no funding.
- Designate the forests of Tayozhny Zakaznik and Bystrinsky Park as Group I forests.
- Establish a series of small, protected areas covering forests representing each type of larch, spruce, and birch community found in the Kamchatka River basin. The remaining ancient forests in the region should be set aside as federally administered *zakazniks* and natural monuments to prevent their being logged.
- Continue to study the forest ecosystems of Kamchatka; this work has been brought to a halt by the closure of the Experimental Forestry Station once operated by the Far Eastern Forest Research Institute.
- Resolve a variety of socioeconomic problems besetting the residents of villages in the Kamchatka River basin, where economic activities in the past focused on timber harvest.

3. Kronotsky Biosphere Zapovednik (volcanic, forest, and wetland)

V. MOSOLOV, L. RASSOKHINA—Kronotsky Zapovednik is located within eastern Kamchatka's volcanic belt, whose influence on the territory's topography, flora, and fauna is readily apparent. Here the full diversity of volcanic activity is found—from twelve active volcanoes, to postcaldera formations and a multitude of thermal springs. The RFE's greatest prevalence of glacial alpine landscapes is here as well; glaciers, including some of the peninsula's largest, cover 14,000 ha of the *zapovednik's* territory. The *zapovednik's* area includes 640,960 ha of forest, 16,847 ha of wetlands, 484,327 ha of open dry range, and 166,720 ha under water, including 31,720 ha under rivers and lakes and 135,000 ha within the three-mile ocean buffer zone.[18] The *zapovednik* has a dense grid of rivers and creeks, about 650 m per 100 ha. All of the rivers drain into the Pacific Ocean. There are numerous small lakes. One of the largest lakes in Kamchatka, Lake Kronotskoe, covers 242 sq. km. All together, there are about eight hundred bodies of water within the reserve.

A number of unique natural objects can be found in the *zapovednik* that have great scientific, recreational, and aesthetic value. The famous Valley of the Geysers is a collection of volcanic phenomena whose scale and localization are rare: twenty large geysers, over two hundred thermal springs, and a multitude of mud pots, thermal vents, and other volcanic formations. The volcanic influence and thermal activity change the vegetative dynamics and affect the seasonal concentrations of brown bears and the bird-nesting sites.

Another uncommon spot in the *zapovednik* is the so-called Valley of Death at the foot of Kikhpinych Volcano. Here, a high concentration of volcanic gases (carbon monoxide, hydrogen sulfide, and carbon dioxide), a lack of wind, and an abundance of naturally occurring heavy metals in the upper layers of the soil cause a variety of insects, birds, and mammals to perish when they enter the vicinity. The massive Uzon Caldera (108 sq. km) is also unique on a global scale for its geological, mineralization, and microbiological processes. Vast thermal vents, hot springs, mud pots, and warm underground watercourses create a variety of highly specialized biological communities.

The *zapovednik*'s Kronotskoe Lake basin hosts a rare stand of tall conifers (part of Kamchatka's Conifer Island). The canopies of these relict forests of Dahurian larch are home to a number of communities more typical of dark coniferous taiga. The lake also serves as habitat to a number of remarkable fish species, including two endemic species of char and land-locked sockeye salmon. Islands in the lake support a number of slaty-backed gull (*Larus schistisagus*) colonies, and large numbers of swans winter in those parts of the Kronotskaya River that do not freeze over.

The *zapovednik*'s flora include 745 vascular plant species representing 303 genera and 86 families, a full representation of the flora found in eastern Kamchatka. Six hundred seventy-nine species grow in pristine habitats, the other 49 are weedy species growing near human dwellings and along trails and roads.[19] Sixteen are endemic to Kamchatka, and one species is found nowhere else on the peninsula. The largest protected population of Steller's sea eagle and one of the largest populations of Aleutian tern live here. Sixty mammalian species inhabit the *zapovednik*, including nine cetaceans.

In recent years, the role of the protected area in preserving many animal species has become much more important. For example, the largest brown bear population of the peninsula (comprising 15 percent of all brown bears in Kamchatka) inhabits Kronotsky; this virtually guarantees the continued health of Kamchatka's bear populations, despite increasing pressures from hunting. Also, thanks to relatively little snow in the winter, alpine tundra areas on volcanic foothills in the *zapovednik* serve as winter pasture for up to 90 percent of the peninsula's wild reindeer population and snow sheep populations remain stable and high despite severe declines elsewhere in Kamchatka. The largest protected population of sable on Kamchatka also inhabits the *zapovednik*.

The climate of the territory is unstable and considered unfavorable for timber production. A large amount of precipitation is characteristic, along with strong winds, frequent fog and cloud cover, and a relatively high average annual temperature. Winters are snowy, spring is cold and dry, summer is short and cool, and autumn is mild. The *zapovednik*'s lands are home to the entire diversity of natural communities typical of the peninsula as a whole: tundra, forest, and coastal meadows and associated flora. Forests are dominated by stone birch, Japanese stone pine, and shrub alder interspersed with large marshes. Isolated patches of conifer forests include Dahurian larch near Lake Kronotskoe and groves of Ayan spruce in the Kamchatka River valley. Kamchatka's only grove of Sakhalin fir (*Abies sachalinensis*) grows near the southern border of the *zapovednik*.

According to the *zapovednik*'s regulations, a few areas are designated for "limited resource use by the staff," where berries and mushrooms can be picked, fuel wood can be collected, and vegetables can be cultivated. Limited licensed fishing of salmon for food is allowed on the Chazhma, Kronotskaya, Bogachyovka, and Olga Rivers and in the Semyachik Estuary.[20]

Threats. Because of exploratory mining from 1940 to 1970 in the center of the *zapovednik*, protected ecosystems have experienced some degradation. The long-lasting presence of military stations in the area also took its toll, and damage caused by tourism since 1976 is visible. Budget cuts have caused a significant decline in patrols and staff, and now the *zapovednik*'s borders are virtually unenforced. Poaching is expected to increase unless the protection of the *zapovednik* is improved. A result of insufficient funding, the monitoring and research system that had been in place since the 1970s is practically gone. Although recreational development is in direct contradiction to the federal regulations and status of a *zapovednik*, ecotourism development was organized in the *zapovednik* to help supplement the budget. There is one helicopter tourist route to the Valley of the Geysers, where a boardwalk trail is maintained. Not more than eighteen hundred people can visit the valley each year. Visits are forbidden from April to May for about one month during the breeding season of bears and other animals. Nonetheless, overuse by tourists, particularly along the well-trod path through the Valley of the Geysers, and the construction of a visitor center along this route without a preliminary environmental impact assessment, threaten this fragile ecosystem. Other threats include logging in the Kamchatka River basin, interbreeding of domesticated reindeer with their wild counterparts, and commercial fishing and the hunting of marine mammals in Kronotsky Bay. In all, careless expansion of human activity threatens the preservation of these unique ecosystems, which, once destroyed, can never be regenerated.

Existing protection measures. Between 1979 and 1982 a full inventory of Kronotsky's vascular plants was conducted, and the *zapovednik*'s mammals and birds were inventoried between 1978 and 1984. From 1982 to 1991, complex research was undertaken on the relationships between predators and ungulates in the *zapovednik*. Over the past ten years, a survey of nesting sites for Steller's sea eagles has been compiled, and monitoring of its population continues. From 1990 to 1994, a geobotanical inventory was conducted, including a full classification of the flora of the territory. The larch forests near

Kronotskoe Lake were evaluated in 1986, and an appraisal of conditions for rare plant species was carried out in 1990. The winter migrations of ungulates have been monitored annually since 1967 and an enormous amount of valuable data accumulated. Because of the multitude of unique natural objects in the *zapovednik* resulting from the area's volcanic activity, Kronotsky Zapovednik was included as part of Kamchatka's World Heritage site.

Recommendations. The following actions should be taken:

- Return the *zapovednik*'s protection regime to its earlier strength by increasing available funding.
- Reconstruct ranger stations.
- Establish airborne patrols.
- Hire new ranger staff.
- Organize an operative team to handle poaching and other illegal activity.
- Provide adequate patrols of the *zapovednik*'s aquatoria.
- Plan and create a buffer zone along the *zapovednik*'s southern and western boundaries.
- Finance monitoring efforts.
- Increase monitoring at the Valley of the Geysers, including careful control of tourist use.
- Finance environmental education to increase awareness and appreciation of the *zapovednik* and its mandate.

4. Komandorsky Zapovednik (marine)

A. BELKOVSKY, O. CHERNYAGINA, E. IVANYUSHINA, N. TATARENKOVA—The Commander Islands are located where the Bering Sea meets the Pacific Ocean between the Asian and North American continents. Geographically the archipelago is a continuation of the Aleutian Island chain. The grouping consists of two large islands, Bering Island and Medny (Copper) Island, two smaller islets, Toporkov (Puffins) and Ary Kamen (Murre's Stone), and a series of reefs and outcroppings spreading about thirty miles into the Pacific Ocean and southern Bering Sea. The islands are volcanic in origin, with their highest point (Mount Steller on Bering Island) reaching 744 m. Bering Island's shoreline consists of flat reefs with steep dropoffs into the sea, intermingled with sand and gravel beaches. Steep cliffs with a very narrow littoral zone form the shores of Medny Island. The climate is maritime, with winters relatively mild and summers short and cool. The average annual temperature on land is 2.5°C. The sea bottom off the shores of the islands varies from shallow lagoons to deep trenches, with the maximum depth exceeding 6,500 m below sea level. Warm, deep-water currents wash the coastline and the oceans remain ice-free almost all year round.

The total area of the reserve includes 185,379 ha of land and 3,463,300 ha of waters in the Bering Sea and the Pacific Ocean.[21] Komandorsky Zapovednik was created to preserve and monitor the natural processes in the pristine conditions

of these islands, the location of which, between the Bering Sea and Pacific Ocean, makes them significant as a bridge between ecosystems. Therefore, the marine and terrestrial ecosystems found here are of great biogeographical importance. Preservation of the traditional lifestyles of the Aleuts living here is also a goal of the *zapovednik*.[22]

About sixty bird species nest in the Commanders; approximately one hundred more use the islands as stopovers on their migratory routes. Of note is the intermingling of American and Eurasian species, and the high overall bird populations. The bird colonies on Medny Island and the southern portion of Bering Island are especially valuable as baselines for research on marine ecosystems of the northern Pacific as they have been minimally affected by anthropogenic influences. Rare species include the Copper Island arctic fox, sea otter (*Enhydra lutris*), gyrfalcon, peregrine falcon, and emperor goose (*Anser canagicus*). The shores teem with about three hundred thousand marine mammals.

Approximately 480 vascular plant species inhabit the archipelago, with a low degree of endemism. Thirty-five of these species have been introduced. Maritime quillwort (*Isoetes maritima*) and pink lady's slipper (*Cypripedium macranthon*) are rare. Mountain tundra covers most of the islands. Some grasslands also occur, but trees or shrubs are sparse.[23] The islands are, however, rich with a variety of species found nowhere else in Russia. The diversity of marine biotopes and the extent of the continental shelf provide habitat for a variety and high productivity of marine microorganisms.[24] Many marine taxa were first discovered in the Commanders, and in many cases, the groupings exist nowhere else on the planet. It is probable that much more needs to be learned about the benthic communities in the archipelago. The fauna of the Commanders include walrus (*Odobaenus rosmarus*), sea otters, two species of eared seals, three species of true seals, and a wide variety of cetaceans—virtually all of the fauna characteristic of the northern Pacific. So many species are found here probably because fishing and hunting have been sharply restricted since the late nineteenth century. At various times there have been prohibitions on the hunting of sea otter, Northern fur seal (*Callorhinus ursinus*), and arctic fox (*Alopex lagopus*) and a variety of other terrestrial and marine protection regimes. A fur seal rookery here has never been seriously hunted, one of only a few such breeding grounds in the world to have mostly been spared exploitation by humans. For this reason the Commanders may harbor the only ecosystems throughout all of the North Pacific that remain in their natural condition.

Threats. The introduction of the red vole (*Clethrionomus rutilus*), Norway rat (*Rattus rattus*), American mink, and reindeer on Bering Island has disturbed the ecological balance on the islands, where previously the arctic fox was the only land mammal. Ticks brought over with domestic and introduced

wild animals probably caused a recent pandemic that nearly killed all of the foxes on Medny Island. Exotic species now comprise 17 percent of the archipelago's bird species and up to 10 percent of its vascular plants.

Currently the *zapovednik* has insufficient financing and materials, which hinders attempts by the staff to protect spawning grounds, bird nesting colonies, and marine mammal breeding grounds. Entire populations of a number of species, including Aleutian Canadian geese (*Branta minima leucopareia*), bald eagle (*Haliaeetus leucocephalus*), Steller's sea eagle, spectacled cormorant (*Phalacrocorax perspicillatus*), and Steller's sea cow (*Hydrodamalus gigas*) have been extirpated by hunting; others, like chum and coho salmon, are newly threatened.

Illegal and semilegal fishing in nearby waters exacerbates the problem, resulting in the removal of hundreds of tons of biomass—in recent years this activity has been particularly focused on such fragile species as halibut and perch. Poaching of both marine and terrestrial fauna in general, all the illegal hunting of rare birds, the pollution of harbors, and cattle grazing are the gravest threats to the islands, even within Komandorsky Zapovednik. Disputes have risen between the *zapovednik* staff and indigenous Aleuts over the regulation of traditional subsistence activities such as hunting of seabirds, gathering of their eggs, and hunting of sea mammals for food.[25]

Ignoring federal laws, Russia recently granted Japan exclusive salmon fishing rights to waters that include the thirty-mile no-trawl zone surrounding the islands. Although prohibited in most parts of the world, the use of drift nets would be allowed and could severely affect the salmon stock and the variety of marine mammals inhabiting the area.[26]

Existing protection measures. *Zapovednik* staff, in cooperation with specialists from the Kamchatka branch of Glavrybvod (Kamchatrybvod), monitor marine mammal rookeries, spawning grounds, bird colonies, and the adjacent waters. They also fulfill the role of environmental inspections in a broader area since the *raion*'s environmental inspectorate was liquidated several years ago. Because of a lack of funding and personnel, the effectiveness of these efforts is far from sufficient.

Recommendations. The following actions should be taken:

- Resolve problems of cooperation between *zapovednik* staff and native Aleuts inhabiting the islands; develop and implement guidelines for subsistence use of the islands' natural resources.
- Provide funding to relocate residents of the town of Nikolskoe (Bering Island) who wish it. According to a recent survey, up to 50 percent of the population is prepared to leave.
- Resolve other socioeconomic problems that have resulted in increased poaching.
- Improve technical provision for the *zapovednik* and other local nature-protection agencies; needs include a seagoing vessel, an all-terrain vehicle, motorboats, radio communications, and other essential items.
- Continue research on the flora and fauna of the Commander Islands and publish existing materials; provide stable funding for the *zapovednik*'s science staff.

5. Avacha Bay
(wetland and marine)

O. CHERNYAGINA, N. KLOCHKOVA, V. RIVKIN, O. SELIVANOVA—Avacha Bay is an inlet of the Pacific Ocean on the southeastern coast of Kamchatka Peninsula, connecting with the ocean through a long but narrow channel. The bay measures 13 km from north to south and 17 km from east to west, totaling 262 sq. km. Two large rivers, the Avacha and the Paratunka, and forty-five streams less than 10 km in length empty into the bay, producing an annual outflow of 6 cu. km into the Pacific, with maximum rates observed in June and minimums in March. In the central portion of the bay, silt composed of coarse sand and gravel has been deposited to a depth of 20 m.

Vladimir Dinets

The Copper Island Arctic fox (Alopex lagopus mednovi) *is one of the most critically endangered mammals in Asia.*

KAMCHATKA

Volcanic mountains ranging in elevation from 400 m to 500 m form the southern, southwestern and eastern shores of the bay; the northwestern shore is a low wetland at the mouths of the Avacha and Paratunka Rivers. Small coves are scattered along the shoreline, some—Rakovaya, Krasheninnikova and Petropavlovskaya—making fine natural harbors. In general, the bay is considered among the world's best because of its size, degree of protection, and navigability. The wetlands in the northwest are an important habitat for waterfowl.

The bay and the rivers that empty into it form an important spawning ground for Pacific salmon migrating on the peninsula's southeastern coast. In past years, high biological productivity and diversity characterized the bay, which is inhabited by practically all the marine and coastal flora and fauna found in southeast Kamchatka.

Threats. The aquatorium of the bay is threatened by degradation because of industrial, household, and agricultural effluent from developments along the shoreline. For some time the bay was able to withstand these influences, but over the years harmful substances have accumulated in the sediment at the bottom. The effects of this on the bay ecosystem are becoming increasingly manifest. The eastern shoreline has been degraded irreversibly, with significant declines in biodiversity and the extirpation of marine biota.

Every year in the summer and autumn, an oxygen deficiency of between 20 and 30 percent is noted in the bottom waters of the bay because of the biochemical oxidation of organic substances and pollutants entering the basin with untreated wastes. Analyses by the Center for Monitoring of Environmental Pollution show a steady decrease in dissolved oxygen over the past five years. In October 1993 a severe shortage of oxygen in the water caused a broad spectrum of bottom-dwelling organisms to perish, and in Krasheninnikov Cove, 3,600 dead Kamchatka crabs were discovered scattered along the coastline.

The amount of petroleum products in Avacha's waters has been shown to be stable for the past several years, totaling on average between two and four times allowable concentrations. The worst pollution occurs along the eastern shore of the bay, where most fishing and commercial ports, as well as naval facilities, are located.

In general, the greatest accumulations of pollutants are found in the seabed at the bay's deepest portions in the center. From time to time, this causes the amount of oxygen in these areas to approach null, with occasional appearances of hydrosulfuric zones. With Petropavlovsk's harbor now handling international shipping, the volume of pollutants and oily bilge in the bay is expected to increase, as will the probability of accidental discharge. But improvements in waste-treatment facilities around the bay are not expected, so the water quality of the bay will decrease in spite of projected declines in industrial output.

Long-term water quality analyses indicate population declines for a number of marine organisms in the bay, including algae, bristleworms (*Polychaetae*), and sea urchins (*Echinoideae*), as well as changes in their geographical distribution and marked deviations in their reproductive cycles. These data represent important indicators of changes in water quality and other factors in the bay's overall environmental health.

Research on chemical accumulations in kelp (*Phaeophyceae*) taken from Avacha Bay, conducted by O. N. Selivanova (KIEP) in 1998, has shown that specimens growing in areas of the bay with higher concentrations of industrial and household pollution can accumulate substantial quantities of toxic substances without showing external damage. Selivanova has strongly recommended a moratorium on seaweed harvesting in the bay because the toxic accumulations substantially exceed acceptable norms.

The largest nuclear submarine base of Russia's eastern seaboard is located on Avacha Bay. Radioactive waste from leaking decommissioned submarines anchored in the bay may also be harming the bay's flora and fauna. Recently the Russian government announced plans for the Ministry of Atomic Energy (Minatom) to "facilitate ecological rehabilitation of hazardous objects in Kamchatka" and other parts of Russia.[27]

Existing protection measures. Hydrochemical observations have been conducted at Avacha Bay since 1961, with eight readings taken each year between April and November. Since 1994 these measurements have been reduced to two or three per year because of shortage of funds. Two meteorological stations conduct visual monitoring for oil slicks on the water's surface. This level of observation is insufficient to make accurate determination of trends in Avacha Bay's water quality. At the initiative of two Japanese organizations (Committee on the Study of Kamchatka and the Japanese Association for Cooperation among Cities and Ports), a compilation of studies describing the dynamics and conditions in Avacha Bay was published in 1999.

Recommendations. The following actions should be taken:
- Increase the capacity of existing treatment facilities and construct new ones.
- Expand sewage and drainage systems.
- Construct an effective system for bilge collection and treatment.
- Implement biorecultivation methods for removing toxins from the bay, including the harvesting and subsequent disposal of kelp as a means of accumulating and disposing of toxic substances.
- Properly dispose of the industrial and agricultural wastes that accumulate on the shoreline.
- Remove oil slicks from the bay's surface using booms and pumps and make these oil wastes available to

Petropavlovsk's central heating and power plants. On smaller slicks, employ oil-dissolving bacteria and micro-organisms.

■ Systematically monitor pollution in Avacha Bay. The estimated cost of sufficient monitoring is approximately U.S.$52,000 per year.

■ Research the Avacha Bay ecosystem and publish the accumulated studies of the bay's biodiversity.

Economy

Evgeny Shirkov

Kamchatka's economic livelihood is based on fishing, which, with its related industries, constitutes 80 percent of the economy. Forestry and food production (except seafood) play a supporting role. Joint ventures are becoming an important component of the economy. Energy production could become a significant industry. Kamchatka's high seismic activity means there are opportunities to tap thermal energy. The most accessible of these sources of underground heat could provide 10,000 gigacalories daily; some are capable of producing 1,400 MW of electric power. The *oblast*'s energy requirements have usually been satisfied by imported fuel, but work has begun to develop the capacity to generate hydroelectric and geothermal power. Only a small proportion of the energy needs are met now by these alternative sources, but their share can be expected to increase in the future. Kamchatka's thermal and mineral waters are also important sources of boron, arsenic, lithium, and cesium. If tapped, these sources would be cost effective even with the expenditure of considerable funds to protect the environment.[28]

Kamchatka's rivers are also a potential source of energy, with flows reaching 172 billion kWh a year. Power stations could be built in Penzhina Bay (in the Koryak Autonomous Okrug), which experiences the highest tides on the peninsula. Wind energy potential makes it possible to produce fifteen million kWh of cheap energy annually, which could supply remote fishing villages and reindeer herding camps.

Kamchatka is geologically rich, with significant deposits of gold, silver, platinum, cobalt, nickel, mercury, and other minerals. Dozens of these deposits are protected within the Federal Resource Fund, and none of the precious metal deposits has been exploited thus far. Placer mining is prohibited in Kamchatka. In recent years, significant foreign investments have been made for the study and exploration of mineral resources.

The shelves of the Okhotsk and Bering Seas are rich in hydrocarbon resources, but have not been well explored. According to the latest data, coal and brown coal deposits in Kamchatka total 273 million tons and estimated reserves

total more than 20 billion tons. There are sixteen natural gas deposits in western Kamchatka, with up to 70 billion cu. m of gas reserves.[29] Gas and gas condensate on the shelf adjacent to Kamchatka are estimated at 732 billion cu. m. Several oil fields with a projected stock of 360 million tons were recently discovered here.[30]

The exploitation of these resources is just beginning and, because of modern extractive technologies, the existing legal base, and the state's inability to monitor resource use, represents the primary threat to Kamchatka's ecology.

Kamchatka is extremely rich in mineral water resources, with over three hundred known springs, many of which are thermal, and is the only part of the Russian Federation where such resources are concentrated. Fresh and mineral waters represent an important export potential and an environmentally sound direction for economic specialization in the interregional and international market. The rivers, lakes, and oceans in and around Kamchatka are rich not only in salmon. More than 60 percent of all the marine biological resources of Russia are concentrated here, including commercially valuable crab, herring, codfish, and flounder.

Kamchatka has been a part of Russia for over three hundred years, but industrial development of the region began only recently. Much of this development has already been destructive and inefficient. The first and most infamous exploitation was the rapacious hunting of the Steller's sea cow that led to its extinction. Local populations of seals, sea otter, walrus, and whales have still not recovered from massive hunting campaigns in the eighteenth century. Dahurian larch growing on Conifer Island in the Kamchatka River valley has practically been destroyed by overlogging.

The modern development of commercial fisheries in Kamchatka follows this same destructive path. The development of mineral and energy resources is under way and may come to mirror the sad experiences of the United States and Japan, where there are virtually no healthy natural populations of Pacific salmon.[31] Salmon fishing has always been important to Kamchatka's economic development, and the future of the region depends on it. Development of the mineral, energy, and recreational industries must be weighed against their potential effect on the fishing industry. The development of agricultural lands, road construction, the lack or insufficient use of purification facilities in commercial enterprises and villages, as well as numerous geological expeditions, have also harmed salmon habitat.

With expanded resource use, the risk of ecological damage increases because of ignorance about proper technologies and prevalence of seismic activity in the region. A proper legal base for resource use and monitoring is currently lacking, in part because of poor leadership in natural resource management. The planned exploitation of raw hydrocarbon materials in the Okhotsk and Bering Seas[32] practically guarantees serious oil pollution in these areas and irreparable harm to their ecosystems.

Other industries such as forestry, energy production, construction, agriculture, and transportation have been developed on a smaller scale, as subordinates to the fishing industry. But they have, nonetheless, contributed substantially to the deterioration of the ecology of the peninsula. Forestry, in particular, has not only undermined the stock of larch in the Kamchatka River valley, but also destroyed a considerable area of salmon spawning grounds in its basin. The total area of coniferous forest unaffected by commercial logging and forest fires amounts to just 350,000: 2.1 percent of the area of the forest fund.[33]

The economic crisis that has resulted in a dramatic decline in production in every branch of Kamchatka's economy has, on the one hand, reduced industrial and agricultural pollution of the environment and, on the other, substantially increased the illegal harvesting of valuable fish and game.

Resource management and environmental protection in such a vast and diversified territory require efficient tools for remote control and monitoring, adequate means for early response, and appropriate tools to permit the evaluation of strategic decisions. Unfortunately, the state of the economy and administration in Russia cannot ensure these requirements. Practical legal, methodological, technical, and financial assistance on the part of international institutions is needed to assist Kamchatka's economy to move toward environmentally safe and sustainable development in the future.

Fishing

S. VAKHRIN—According to experts' estimates, poachers in Kamchatka today catch as much fish as licensed fishermen catch legally. Fish-protection agencies are ill equipped to confront these unlawful activities. The administration of the fishery industry is not particularly concerned about the state of the fish stock: If there are no salmon, we can catch other fish; if not in the rivers, then in the sea.

In the mid-1950s, a new fleet of medium-sized fishing trawlers (with freezers and refrigerators) started to arrive in the RFE. In just two years, they managed to inflict irreparable damage to the fish stocks of Kamchatka's coasts. So the fishing fleet moved to the coasts of America to fish perch and flounder, destroying those stocks as well. The fleet then headed for Hawaii to fish pristipoma and, after destroying that, went to the coasts of Antarctica to catch krill, the main food of whales.

Only after the introduction of the two-hundred-mile economic zone in the late 1970s did the Far East fleet once again return to its own shores. In Kamchatka's waters fishermen discovered gigantic concentrations of pollock, a fish that was previously considered inedible and used only for fertilizer or as an additive to chicken fodder. This fish saved the Russian fishery from disaster, but in gratitude, the industry began overfishing both the Russian roe-bearing pollock in the Sea of Okhotsk and the American nomadic pollock in the Bering Sea. The stock of the latter is now approaching a dangerously low level. Yet another target of the Russian fishing industry is the Kamchatka crab, which is highly valued on the Japanese market and facing wholesale destruction wherever it is found. It is harvested in quantities approximately twice as large as those officially permitted.

The main threats that the fishing industry presents to the environment and ecosystems include:

- The destruction of reserves of such valuable food products as salmon and pollock.
- The reduction of sea mammal population as a result of the depletion of the food that these animals eat; in the past ten years, Steller's sea lion (*Eumetopias jubatus*) populations have decreased tenfold.
- The pollution of the sea by oil products and biological waste.

Currently, hundreds of Russian and foreign companies are harvesting fish and seafood products in Kamchatka's waters. The main companies fishing Kamchatka's salmon (up to 130,000 tons a year) are stock companies, formed as successors to formerly state-run collective fishing enterprises.

Those species most valuable in terms of foreign currency (sockeye salmon, roe-bearing pollock in the Sea of Okhotsk, and Kamchatka crab) are aggressively targeted. The main fishing regions of the RFE—Primorsky, Sakhalin, Kamchatka, and Koryakia—survive in periods of the energy crisis thanks only to their fishing resources.

Deterioration of the fish reserves could have extremely harmful consequences for the economy of Kamchatka and the Koryak Autonomous Okrug. This has already happened once, in the 1950s, and forced the closure of dozens of canneries and collective fishing enterprises and the abandonment of several fishing villages.

The government is doing nothing to preserve stocks of pollock, Kamchatka crab, and salmon. There are limitations on the catch of certain species in particular areas, but these rules are violated each year. Fish protection agencies such as the Federal Fisheries Committee and the Special Marine Inspection Service within the Committee on Environmental Protection, and regional inspections by the Federal Border Service today are unable to counter the threat of destruction of the resources in Kamchatka's waters.

Agriculture

V. ZYKOV—Two types of production represent agriculture in Kamchatka: reindeer breeding, a traditional economic activity of indigenous peoples, and land cultivation and animal husbandry. Reindeer breeding has clearly defined geographic limitations related to the availability of fodder; these areas are mainly found within Bystrinsky Raion, although there are places for pasturing in other *raion*s. Land cultivation and animal husbandry account for 90 percent of the gross

agricultural output. The central region produces 70 percent of the gross output in agriculture, with the main products being potatoes, cabbage, fodder products, milk, eggs, meat, and cultivated mink.[34]

As of 1998, agricultural lands belonging to enterprises, organizations, and citizens amounted to 82,400 ha, of which 57,300 ha included plowed fields, 6,700 ha hay fields, and 18,400 ha pasturage. By comparison, in 1993 these figures stood at 349,000 ha, 64,000 ha, 71,000 ha, and 214,000 ha, respectively.[35] In general, the agricultural value of Kamchatka's lands is low. Most of the land is too wet and too acidic, in need of drainage and liming.

The area of unused land is annually expanding in the *oblast*, primarily because of lack of funds for buying seeds, fertilizers, and lubricants for machinery. The remoteness of some enterprises from the center makes it difficult to sell products owing to high transport costs. Declining animal husbandry output is a result of the industry's dependence on imported fodder, for which prices have drastically increased. Livestock producers cannot find customers at the suggested prices.

Timber

E. OGULIA—The density of Kamchatka's forests is low in comparison to other RFE regions. In mature forests the density is critically low, the result of a quarter century of exploitation, which underscores the need to preserve and restore forests. Larch, spruce, and stone birch forests are most valuable from a commercial standpoint. Kamchatka's forests are not particularly valuable for their timber (except for larch), but they all perform indispensable ecological functions such as regulating the water flow of salmon spawning rivers, preventing soil erosion, and providing protection from wind. The forests in the central part of Kamchatka, in particular, perform these critical ecological functions. However, following intensive logging, erosion, sandstorms, and changes in climatic indicators are occurring.

Kamchatka's forestry industry has never received any loans or investments for its development. Commercial logging in Kamchatka began in 1928, and during World War II, 200,000 cu. m were logged annually, rising to 500,000 cu. m in the 1950s. The coniferous forests near Kamchatka River and its tributaries were the first targets, especially the high-quality larch trees. With resource depletion, loggers often returned to previously logged areas, and consequently, many areas were subjected to two or three rounds of logging. For more than thirty years, the main logging enterprise in Kamchatka was Kamchatles, OAO (open joint-stock company) Kamchatlesholding, which consisted of several *lespromkhozes* (LPXs) and one timber transit base. On average, Kamchatles has logged between 550,000 and 600,000 cu. m annually in coniferous forests. But in the 1970s and 1980s, the company was logging up to 1,000,000 cu. m in these

forests. Prolonged exploitation depleted the forest resources and, consequently, forced the closure of villages dependent on logging activities, such as Kravcha, Shchapino, Bystry, Krapivnaya, and Nizhne-Kamchatsk.

Logging practices have always been poor. Logging enterprises have never used the timber resources fully, passing over small trees, coniferous trees with defects, and the entire stock of larch. The volume of timber abandoned at logging fields is outrageously high, protection of young trees has not been ensured, and there is high danger of forest fires as a result. There have been some changes for the better. Government authorities have outlawed the transporting of timber by river, prohibited logging in Group I forests, ended the use of aggregated logging machinery and introduced selective logging methods, and created factories to process firewood and scrap wood.

The timber stock in Kamchatka's forests has decreased drastically, and in the past twenty years alone, the volume of coniferous trees capable of being exploited has declined by more than 10 percent. While coniferous forests have been the focus of activity, stone birch forests have long been cut to supply firewood for the *oblast*'s internal needs. Kamchatlesprom was the main producer of firewood, but today the company has practically ceased to operate.

Kamchatka's Forest Service, with the support of the *oblast*'s administrative bodies, has on many occasions recommended reducing the volume of logging for internal needs to a maximum of 500,000 cu. m, terminating the export of timber (on the average 100,000 cu. m a year), and ending supply to other *oblasts* (40,000–50,000 cu. m a year go to Chukotka).

Russia's current economic instability has drastically changed the logging practices in the *oblast*. Since 1994, logging volumes have fallen dramatically because of high energy costs, increases in transport costs, and the insurmountable tax burden. The main logging enterprise has practically dissolved. *Lespromkhozes* have become stock companies, but are barely surviving. Actual production of timber in recent years has ranged from 140,000 to 420,000 cu. m, which amounts to 9.7 percent to 22 percent of the AAC. Certain villages such as Kozyrevsk, Atlasovo, and Maiskoe are in an extremely serious situation following collapse of the industry and resulting unemployment. In many settlements, logging remains the only functioning industry that can support the community.

Further development should focus not only on timber extraction. Preservation of forest cover quality should be the main goal throughout the peninsula.

Mining

V. ZYKOV, O. CHERNYAGINA, E. WILSON—Among the riches of Kamchatka are the wealth and diversity of its mineral resources: ore and alluvial gold, silver, platinum, nickel, copper, and tin. In addition, Kamchatka has mineral raw materials

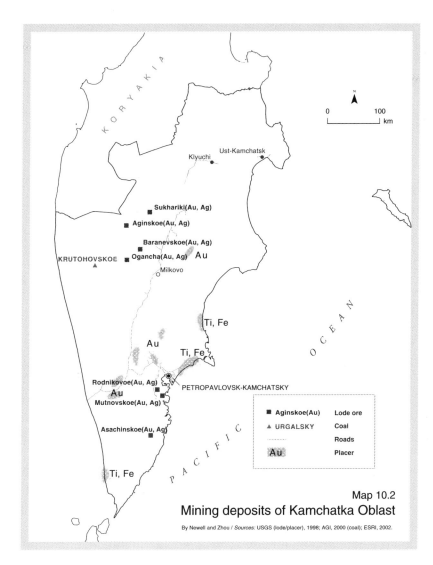

Map 10.2

Mining deposits of Kamchatka Oblast

By Newell and Zhou / *Sources:* USGS (lode/placer), 1998; AGI, 2000 (coal); ESRI, 2002.

a letter to OPIC recommending that it reconsider its decision. An IUCN resolution in 1996 recommended that international financial institutions not invest in any of the Kamchatka gold mines that are close to the World Heritage sites. As a result, OPIC withdrew its support for Aginskoe mine and changed its policy toward World Heritage sites, pledging not to support potentially destructive industrial activities not only within but also adjacent to the sites.

In early 1998, Kinross approached the Canadian Export Development Corporation about export finance for the same project that OPIC had rejected in 1996. The Canadian government asked UNESCO and IUCN for their scientific opinion on whether the proximity of the proposed mine to Bystrinsky Nature Park would pose an environmental risk to the park and was advised that it could. Due to falling gold prices, it seemed as if there would be no further development of the proposal.

However the Ministry of Natural Resources, which Putin has given authority over environmental matters, is now calling for the regional government to shift the park's borders once more, this time about 50 km northward, in order to allow for exploitation of the rich mineral reserves in the south of the park. If the plan goes ahead, Kinross Gold and other mining developers would be allowed to explore within the park's present boundaries. Furthermore, the Ministry of Natural Resources opposes the inclusion of Bystrinsky Park in the UNDP Global Environment Facility (GEF) program for conservation of Kamchatka's biodiversity, claiming that revenues from resource exploitation would be much more than the funds generated by the UNDP project for the local area. The question is where these funds would go.

Today the economic situation in Bystrinsky Raion is so critical that many local people would now welcome gold mining if only because it would provide them with much-needed employment. The head of Bystrinsky Raion administration, Gennady Devyatkin, who is in favor of developing the district's gold reserves, estimates that 220 jobs will be created by opening Aginskoe mine, with priority going to residents of Bystrinsky Raion and neighboring Milkovsky Raion. However, many of these will be jobs for which local residents do not have the necessary skills and which are more likely to be taken up by incoming specialists, e.g., from Magadan. The only road to the mine is directly from Milkovo, and it is expected that jobs for drivers and mechanics will naturally go to residents of Milkovsky Raion. For the same reason, service

that if mined, would develop a local construction materials industry. However, the main plans for Kamchatka's mining industry center around gold mining, particularly developing deposits with high concentrations of gold ore (varying from 10 to 43 g per ton). The development of alluvial gold deposits in Kamchatka is prohibited.

Gold. There are five main gold reserves on Kamchatka: Aginskoe, Balkhachskoe, Baranevskoe, Sukhariki, and Ogancha. Three of these are in Bystrinsky Raion, which is considered a gold province by geologists. The Aginskoe gold mine, close to the southern border of Bystrinsky Nature Park, has been the source of considerable controversy, as the boundaries of both Ichinsky Zakaznik and Bystrinsky Nature Park were changed by gubernatorial decree (in 1994 and 1996, respectively) in order to accommodate the mine. Aginskoe mine was to be exploited by Kinross Gold Corporation (Toronto, Canada), which had shares in the Kamchatka-based joint venture Kamgold, while the U.S. Overseas Private Investment Corporation (OPIC) had agreed to provide political risk insurance. In 1996 international environmental organizations wrote

industries (laundry, cleaning, mechanical servicing, and so on) are more likely to develop in Milkovo.

It is unlikely that even direct "bonus" payments into the local budget will improve the local economy. According to local reports, the last gold bonus received by the Bystrinsky Raion administration was used partly to pay off local "budget" salaries (which should be the government's responsibility), and the rest of the money was invested in a bank that subsequently went bankrupt.

Over one-third of the population of Bystrinsky Raion is of indigenous origins (mostly Evens with some Koryaks and Itelmens), and is currently suffering the effects of the collapse of reindeer herding and the withdrawal of federal subsidies. Gold mining threatens spawning rivers that are vital to the indigenous residents, many of whom have now moved away from their settlements and returned to a traditional lifestyle of fishing and hunting in the forest and tundra. Mining also threatens reindeer pastures used by the last remaining herds and hunting grounds used by native and nonnative hunters alike. Given the acute economic crisis in the *raion*, people are looking more and more to renewable natural resource use—fishing, hunting, gathering of nontimber forest products—simply in order to survive.

Energy

E. WILSON—Kamchatka has traditionally relied heavily on imported fuel (oil, coal, and diesel) to fire its power stations, despite the potential for alternative energy use, including wind, hydro, and geothermal power, that at present makes up only about 2 percent of the region's energy production. With the collapse of central control over fuel distribution, Kamchatka has suffered greatly from the huge costs of importing fuel, and there is an increasingly urgent need to find local solutions to the energy crisis. In the spring of 1999, there were periods where people were receiving only two hours of electricity every forty-eight hours.

With its immense natural energy sources, Kamchatka could become a model of sustainable energy use among Russian regions. Since 1995, the regional government has been implementing its Program for Converting the Kamchatka Regional Electric and Heat Supply System to Non-Conventional Renewable Energy Sources and Local Types of Fuel. However, Kamchatka experts fear that energy projects are being developed irrationally, without proper assessment of their economic feasibility within the overall economic framework of the sector and without due attention to environmental considerations. Instead, it appears that personal and political interests unduly influence projects. The high level of monopolization in the energy sector compounds this, which is a major concern of both the World Bank and the EBRD, both of whom are investing in energy development. Most of Kamchatka's energy production is still controlled by the regional energy monopoly, Kamchatkaenergo.

Natural gas fields have been discovered on Kamchatka's western coast. In 1999, a project to develop two gas-condensate fields (Kshukskoe and Nizhne-Kvachinskoe) where reserves are estimated at 15 billion cu. m of gas and 450,000 tons of condensate was prepared. The project, to cost U.S.$162 million, is to produce 750 million cu. m of gas a year and build a 414-km gas pipeline to Petropavlovsk; the gas would supply the capital for twelve years. The pipeline will cross about 150 rivers that are between 20 and 70 m wide and many smaller rivers. Experts fear that the pipeline construction will irreversibly damage salmon stocks and will degrade the pristine ecosystems on the western part of Kamchatka. The economic feasibility of the project is unproven. There is also concern that the construction of the pipeline is the first step toward the development of gas fields on the shelf of the Sea of Okhotsk, off Kamchatka's coast.[36]

The gas pipeline project was rejected by the EBRD for not satisfying the strict economic and ecological demands of the bank. A federal *expertiza* (environmental expert review) is currently in progress. Local experts completed a public *expertiza*, which will be reviewed as part of the federal *expertiza* process.

Development of Kamchatka's offshore oil and gas fields is favored by Moscow but not by the former Kamchatka governor, Vladimir Biryukov; he recalled the signature of one of his deputies on an interregional document approving offshore exploration. This stance, however, earned him enemies in Moscow. There is growing support locally for oil and gas exploitation.

Kamchatka's other major energy project is the Mutnovskaya Geothermal Power Plant. Mutnovsky is one of four major hydrothermal fields in central and eastern Kamchatka that has been studied with a view to exploitation. The EBRD has approved a U.S.$99.9 million loan to the Russian Federation, to be lent to Geoterm, the project company. The total cost of the project is U.S.$150–176 million, according to the EBRD project summary document. In spring 2000, contracts were signed for construction and bore work at the site. The project is intended to diversify Kamchatka's energy base, reduce the need for imported fuel for power stations, reduce the cost of power generation, decommission environmentally damaging fuel-fired power stations, and develop the first independent power producer in the region.

The World Bank is reported to be proud of the Mutnovsky project as an example of ecologically sound energy development. Local environmentalists also favor the project as being less environmentally destructive than other energy options for the region. Although the landscape around the site itself has already been destroyed beyond repair, environmentalists point out that the Mutnovsky site is mostly tundra and lies beneath several meters of snow for most of the year. The gas pipeline, in contrast, would damage countless spawning rivers, and offshore oil and gas exploitation would

threaten the valuable fisheries and marine ecosystems of the Kamchatka shelf.

Independent international consultants have carried out an environmental study for the Mutnovsky project. The study identifies actions to be taken during project implementation, and these actions form the basis for an Environmental Action Plan that is a legal requirement of the project. Geoterm is obliged to report on the implementation of the plan, and it will be monitored by the EBRD with the assistance of project consultants. It is Geoterm's responsibility to implement and finance environmental measures. However, according to local ecologists, this is not being done adequately. The access road, transmission line, and two blocks of the power station have already been constructed on the Mutnovsky site without completion of baseline research into the flora of the area. This contradicts both Russian law and the EBRD's own strict environmental standards.

Given that the Mutnovsky project apparently does not have enough money for adequate environmental research, ecologists question the granting of tax relief by the federal government to the gas pipeline project and not to the Mutnovsky project, and feel that political interests are being given a higher priority than are economic and ecological considerations.

There are also two projects under way to build hydroelectric power plants on the Tolmachova and Bystraya Rivers. The residents of Bystrinsky Raion, however, already enjoy a relatively consistent supply of electricity and heat for most of the year, thanks to their hydroelectric power and thermal heating systems.

The Kamchatka administration hopes to greatly expand production of geothermal power.

Toward sustainable development

Robert Moisseev

Current resource use is unsustainable. The preservation of the ecology will depend upon limiting economically inefficient and destructive activities. Planned models of sustainable development in Kamchatka have included small-scale projects and larger ones with a considerable impact on the environment, such as the proposed Aginskoe gold mining and processing plant.

Socially and economically, Kamchatka changed dramatically in the 1990s, with the changes in public life, the organization of the state, the system of property, foreign economic relations, demographic tendencies, and so on requiring new principles and approaches to nature use. The fishing, mining, and energy industries should shift, albeit gradually, to sustainable resource use. The most important ecological, economic, and social problems should not be decided independently of one another. This need is well known, but financing and political will have been lacking.

The development of protected areas has become an accepted conservation tool. Almost one-third of the territory of Kamchatka is under some form of protection. Many assume that this policy will make it possible to preserve natural complexes and restore degraded areas. Many also assume that protected areas zoned for recreational use will help restore and develop Kamchatka's economy. But there is a serious lack of infrastructure and recreational facilities for an efficient tourism industry. Efficient management of the protected areas depends on scientific feasibility studies and project designs as well as on strict compliance with ecological requirements.

The idea of diverting Kamchatka's energy industry away from diesel, fuel, and coal to local, cleaner sources of energy is important in the effort to shift the region toward a new model of nature use. These cleaner sources of energy include renewable geothermal energy, wind energy, hydroelectricity generated from small rivers, and to a certain extent, natural gas. Toward these ends,

KAMCHATKA

construction has begun on the Mutnovskaya geothermal station and the Tolmachevsky and Bystrinsky hydroelectric stations and the development of the natural gas fields in Sobolevsky Raion. These sources will allow Kamchatka's energy industry to become sustainable and reduce its dependence on imported fuel.

The lower electricity and heating costs of local sources may also contribute to economic growth and increase the competitiveness of goods and services produced in Kamchatka. Calculations by various institutions, however, are inconsistent and show that not all types of local energy resources can be more economically efficient than those used now. This issue requires additional study.

There is an urgent need for a comprehensive development program that focuses not only on institutional but also on regional economic efficiency and takes into account all positive and negative effects on natural, social, and economic complexes. Then, the energy program could be adopted as a full-scale model for sustainable development.

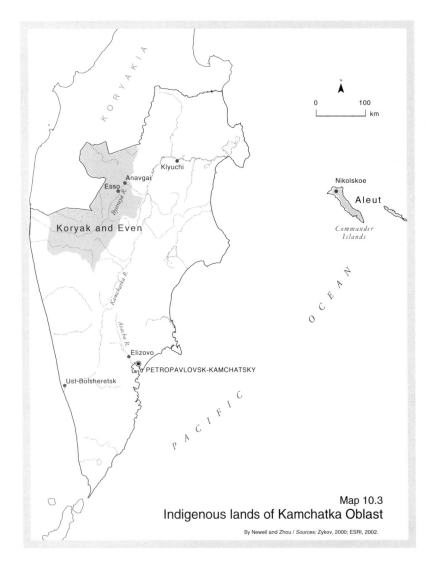

Map 10.3
Indigenous lands of Kamchatka Oblast

By Newell and Zhou / *Sources:* Zykov, 2000; ESRI, 2002.

Indigenous peoples

Robert Moisseev

Archeological evidence shows that people have been living on southern Kamchatka for over ten thousand years. When Russians first arrived at the end of the seventeenth century, indigenous Itelmens and Ainu lived in the far south near Cape Lopatka. For an economy based on hunting and gathering, Kamchatka was rather densely inhabited. Small communities dotted the coasts and river valleys; many of them were not more than a day's walk from one another.

In the first decades of the seventeenth century, the Russian empire pursued a brutal colonial policy in Kamchatka, collecting *yasak* (fur tribute) and violently suppressing uprisings. Kamchatka's indigenous population decreased significantly, and settlements became scattered. By the 1730s, the population in southern Kamchatka had decreased so dramatically, and the volume of *yasak* fallen so drastically, that softer methods of governance began to be used. The Itelmen population stabilized at about 1,500–2,000 people. Periodically, mortality rates increased as Russians inadvertently introduced diseases. Itelmens were often resettled as families left regions ravaged by disease or were moved to new settlements required for the organization of regular transport and communication. By the beginning of the twentieth century, Itelmens and Ainu in the south of Kamchatka had been assimilated into the Russian population, not only through mixed marriages but also through mutual exchange in the social sphere, particularly in economic activities.

The indigenous population learned new types of economic activities from the Russians such as gardening, animal husbandry, and poultry breeding. New types of fishing nets, steel traps, and firearms were used. Other introductions were social; separate huts for nuclear families gradually replaced the large communal homes. This practice of living in separate homes on individual plots of land contributed to social stratification. Descendants of Russian settlers in turn took on a way of life based on fishing and hunting borrowed largely from the indigenous population and developed dog breeding, sledding equipment, and methods of storing food.

Little research has been conducted on these processes of cultural, economic, and linguistic exchange, but it is known that

a particular Kamchadal dialect of Russian developed among this mixed population.[37] Nineteenth-century census data referred simply to a single tribe of Kamchadals, who were in fact, separate Itelmen tribes as well as the new mixed population. Ainu living on the southern tip of Kamchatka were most likely fully assimilated; after 1897 they were rarely mentioned in the census data or other literature.

The Soviet era saw radical changes in the social and economic conditions of indigenous people, who were targeted by special policies. From 1930 to the 1980s, Kamchatka's population increased tenfold, mostly by immigration from European areas of the USSR. The indigenous population increased in absolute terms, but at the end of the twentieth century they comprised only 1 percent of the population overall. The importance of traditional activities for indigenous peoples has decreased dramatically. The Soviets set up state management of the economy and a system of social services based on state subsidies, which eventually led to a decline in traditional pursuits such as hunting and fishing. They also developed a boarding-school educational system that separated children from their families for months at a time. Soviet collectivization consolidated small villages into a few large ones, resulting in the displacement (physically, socially, and psychologically) of almost the entire native population.

Kamchadal chapel in Esso.

Vladimir Dinets

Mobility among all people in the former Soviet Union has led to great ethnic heterogeneity. Kamchatka is home to many different minorities, including people identifying themselves as "indigenous peoples of the Russian North," but only Itelmens, Aleuts, Koryaks, and Evens are considered indigenous to what is now Kamchatka Oblast. Today, some of the natives live in small villages, where they form the majority, and they continue to practice traditional subsistence activities. Others live in cities and towns, but they form a small percentage of the population, are regularly discriminated against, and do not continue traditional ways of life. With the shift to a market economy, the resources for survival have decreased more rapidly among the indigenous peoples in Kamchatka than among the population of the more industrialized regions of the country.[38]

Kamchadals. The politics of ethnic identity among indigenous people of the Russian North are complex. In the 1920s the definition of the term *Kamchadal* as an ethnicity was ambiguous, as illustrated by written material from that time. In 1925, according to the Far East *Oblast* statistical authority, "Kamchadals, who belong to the American group of Paleo-Asians and who number 5,716 in Petropavlovsky Raion, are united into one group with the Russian population since they differ from the latter neither ethnographically nor anthropologically and have long ago assimilated into the Russian population. Currently, the term *Kamchadal* means all persons who were born and have remained for some time in Kamchatka. The term no longer applies to the indigenous population and merely characterizes a resident of Kamchatka as compared to an outsider. The mixed Russian population

of Anadyrsky, Gizhiginsky and Okhotsky Raions also calls itself *Kamchadal* although it has no relation to the ancient Itelmens."[39] The indigenous peoples of Kamchatka and descendants of ancient settlers were, particularly as a result of mixed marriages, practically identical in many ways: Their way of life, dialect, and attitudes toward nature and even some anthropologic features were quite similar. However, both of them differed greatly from the Russian newcomers, and they retained many of these distinctions up to the end of the twentieth century.

By the middle of the twentieth century, the term *Kamchadal* referred to a variously defined and shifting population. Many people in Kamchatka and elsewhere in Russia now regard this term as not referring to indigenous people. This may be one of the reasons why Kamchadals were excluded from the List of the Indigenous Peoples of the North. In the 1980s, Kamchadals residing in Kamchatka gained official inclusion in the List with the provision of corresponding benefits, but in the late 1990s, the *oblast* administration instituted policies to "delete" Kamchadal as an ethnic category in official records.

On March 24, 2000, however, by a decree of the Russian Federation government, the Kamchadals were added once more to the List of Indigenous Minorities (Small-Numbered Peoples) of Russia, together with fourteen others, twelve of which live in Siberia, the Russian North, or the Russian Far East.[40] Difficulties arise with the identification of persons who refer to themselves as Kamchadals, particularly in connection with rights to natural resource use, as Kamchadals today reside mainly in agriculturally and industrially developed areas of Kamchatka.

Other indigenous groups. In 1825, Aleuts from the Aleutian Islands were resettled to the previously uninhabited Commander Islands to expand the Russian fur trade and bolster Russian claims to sovereignty over the islands. Today, 277 Aleuts people live in the only settlement on the Commander Islands, Nikolskoe on Bering Island.[41] The Commander Islands and the thirty-mile marine zone around them were declared a *zapovednik* in 1993. This has not only placed considerable limitations on the Aleuts' capacity for subsistence use of natural resources but also has complicated the development of transportation. The best prospects for the Aleuts lie in implementing projects of nature protection and economic activities that link their interests with those of the *zapovednik*.

In the first half of the nineteenth century, Evens from the Okhotsk region migrated to the Bystraya River basin, where they now continue to fish, hunt, and herd reindeer. Evens are one of the main indigenous groups living in the villages of Anavgai and Esso in Bystrinsky Raion, but they now comprise only 30 percent of the total population in both villages, with fewer in Esso and more in Anavgai. A few families also live in the revived traditional villages of Lauchan, Tvayan,

and Kekuk. In 1998, there were 813 Evens living in Bystrinsky Raion as well as 155 Koryaks and 23 Itelmens. In total the indigenous population of Bystrinsky Raion amounts to 1,009 people, or 37 percent of the *raion*'s population.

Reindeer breeding had been an important economic base for the Even population, but in the 1990s, reindeer herds decreased to fewer than half their previous numbers. Other important resources have also decreased. Unemployment is on the rise. Nearly all of the territory of Bystrinsky Raion was included in Bystrinsky Nature Park when it was established in 1995 and included in Kamchatka's World Heritage Site in 1996, but this has had little impact on the *raion*'s economy and the living conditions of the indigenous population. Planned development of the Aginskoe gold deposit in the mountainous part of Bystrinsky Raion will harm the regions of the traditional nature use of the indigenous peoples and their reindeer breeding, hunting, and fishing. The main problem for Bystrinsky Raion is to find economically sound, socially fair, and ecologically justified possibilities of combining the development of traditional use of nature by indigenous peoples with the new types of economic activities. Conservation activities, tourism, and recreational activities are planned for the nature park. In this regard, public supervision of the ecological and economic feasibility of proposed mining projects and the link between these interests and those of the indigenous peoples and the development of the park require special attention. Most people in Bystrinsky Raion support the planned UNDP project for sustainable development in western and central Kamchatka. The indigenous population has the best knowledge of the landscape and should be included in further development of Bystrinsky Nature Park.[42]

The indigenous peoples of Kamchatka are active in the Russian Association of Indigenous Peoples of the North (RAIPON), and they have established filial organizations in their respective *raion*s and villages. Beside the *Oblast* Association of Indigenous Peoples of the North in Petropavlovsk-Kamchatsky, the following *raion*s have local organizations: Elizovsky, Milkovsky, Aleutsky, Sobolevsky, and Bystrinsky. RAIPON filials are active in the following towns: Elizovo, Ust-Bolsheretsk, Klyuchi, Vilyuchinsk, and Sosnovka. The native commercial enterprises of Pimchakh and Aleskam operate in Elizovsky Raion. In addition, public organizations to advocate for the interests of Kamchatka's indigenous peoples in cultural and public development have been created. Such organizations include "Kamchatka-Ethnos," the Center for Traditional Culture; the Public Compensation Fund for the Peoples of the North; the native's women's organization Aborigenka Kamchatki; the Kamchatka branch of the International Fund for the Development of Minority Peoples and Ethnic Groups; the youth organization Ethno-Initiative; the ethno-ecological club Zavina; and Eyek, the Public Organization of Lawyers and Physicians of the Indigenous Peoples of the North.

Legal issues

Olga Manzhos

Ten regional governmental agencies in Kamchatka are engaged in environmental protection. Their powers include the regulation and protection of the use of natural resources, natural sites, and natural complexes.[43] Regional branches of several federal-level agencies are established in Kamchatka, including the Hunting Service, Committee on Land Resources, Ministry of Natural Resources, Authority on Hydrometeorology and Monitoring of the Environment, and Glavrybvod. Some of these branches address problems specific to Kamchatka.

Glavrybvod. The difficulties that Glavrybvod faces in fulfilling its duties are connected with the inadequacy of the existing legislation, its irrelevance, and its inconsistency. The proof can be seen in the new law entitled On the Exclusive Economic Zone (EEZ), which omitted Kamchatrybvod from the list of protective agencies, although it is included in all other listed legislative acts.[44]

Kamchatka Special Marine Inspection Service. This agency is the Kamchatka branch of the Special Marine Inspection Service, a division of the Ministry of Natural Resources. To increase the efficiency of the Inspection Service's monitoring activities, it is necessary to solve the issue of regular and sufficient financing for leasing vessels and aircraft used to protect the EEZ and shelf, to bring the adopted federal law On the Exclusive Economic Zone of the RF in line with the Constitution and the Water Code, to expedite the consideration and adoption of the new Fishing Rules, and to prohibit issuing of permits for scientific fish quotas to organizations if their programs have not passed an *expertiza*. In practice, scientific programs often mask commercial activities, so it is necessary to create a uniform information system for identifying violations.

The participation of mass media during the annual proceedings of the intergovernmental commissions on fishing should be encouraged. In addition, a division dedicated to monitoring marine pollution should be created. The need for such a division has become acute recently with the increase in the number of owners of small vessels, the fishing industry's reliance on an obsolete fleet, and the consequent increase in the potential threat of environmental pollution by oil products and abandoned vessels, as well as numerous cases of oil spillage and the discovery of abandoned vessels, which require qualified investigation and urgent action. Fines paid for the violations contribute to funding for the activities of the Federal Border Service (FBS).

Regional Inspection of Marine Biological Resources. This agency is a unit of the FBS. It was established in 1998 to pro-

tect, monitor, and regulate the use of marine bioresources and their habitats in the internal marine and territorial waters, the Russian EEZ, and on the continental shelf. Previously, Glavrybvod performed all of the functions of the FBS. The FBS is engaged exclusively in the protection of marine fish resources. Most of the staff moved to the FBS from former divisions of Kamchatrybvod and from Spetsmorinspektsia.[45]

General issues

One of the main legal problems affecting the quality of monitoring and, consequently, protection of natural resources is the lack of coordination among the nature protection laws and an excessively strict division of powers and responsibilities among the agencies.[46] Kamchatka's industry is so dependent on fishing that the activities of the three last-mentioned agencies are especially important. A coordinated legislative system regulating the activities of these bodies is urgently needed.

According to officials from the now-dissolved Kamchatka Committee on Environmental Protection, the main obstacles to environmental protection are the inadequate coordination of activities by the state supervisory services, the lack of a unified and consistent regional policy related to the federal policy on ecology, the lack of coordination between governmental agencies in regions bordering the Okhotsk and Bering Seas and between the nature protection agencies of Kamchatka Oblast and the Koryak Autonomous Okrug, and the insufficient and uncoordinated provision of scientific information.[47]

An efficient legal mechanism of economic and ecological relations between the Russian Federation and Kamchatka must be developed. The law On the EEZ of the Russian Federation serves as a good example of how the center infringes upon the interests of the periphery, in this case, Kamchatka.

Moscow has secured for itself an exclusive right to use all natural resources situated on the continental shelf. This is a direct violation of the constitutional rights of the entire population. There is some danger that the government will ignore the protests of the population and the governor against offshore oil drilling and will begin extraction. This problem could be solved or mitigated by concluding an agreement between the federal executive bodies and Kamchatka Oblast. The provisions of the agreement could specify and complement the norms of federal laws without contradicting them and would temporarily solve the problems of the existing legislation.

It is necessary to specify legal norms establishing procedures for collecting penalties for environmental pollution. It is high time that criminal liability be introduced for rule violations and for the inappropriate use of funds earmarked for nature-protection activities.

Special attention should be paid to the liability of enterprises that avoid conducting an *expertiza* and those that

finance and construct facilities without first obtaining a positive *expertiza*. Because this review process is often ignored on direct instruction of relevant authorities, officials making decisions about the initiation of certain economic activities without conducting the *expertiza* should be held liable.

Kamchatka's economy has always been based on the development and use of biological resources. At present, hundreds of foreign and Russian companies harvest fish and other products in waters adjacent to Kamchatka. There is great pressure on the fish reserves and fishing regulations are violated each year. The protection agencies have no opportunity (under current legislation) to confront this powerful force, and at the governmental level, nothing is done to protect these reserves except to acknowledge the fact that the resources are being depleted.

There are many places in Kamchatka in need of a certain degree of protection. But economic problems are often at the forefront, and environmentally destructive projects that have not passed an *expertiza* are being implemented and financed.

The Tayozhny Zakaznik is a typical example: Its status was not extended in time to protect it from logging. Certain representatives of the *oblast* administration justified the felling of unique trees by citing problems of unemployment, lack of funds in the budget, and so on. The agreement between the Kronotsky Zapovednik and the aviation-tour company Krechet for excursions into the Valley of the Geysers is another notorious example of illegality. This deal contradicts existing legislation, and the agreement should be recognized as null and void in the court.

On September 29, 1997, the administration passed a regulation to the effect that the use of mineral resources and raw materials should be considered one of the main directions of development of the economy and adopted a plan to develop the mining industry in Kamchatka.[48] This is premature. There is no law On the Insurance Deposit for the Use of Mineral Wealth, there are no inspectors to supervise the operations of such enterprises, and there are no sufficiently clean technologies for mining gold in fragile ecological areas.

One of the biggest problems is noncompliance with existing nature-protection legislation. The nature protection prosecutor's office and nature protection organizations do not fulfill their obligations to the full extent. The section of the Penal Code entitled Economic Offenses is not viable and needs improvement. A major step forward would be the adoption of the Ecological Code, which would be a compendium of the entire nature-protection legislation. The law On State Inspectors should be adopted, and the involvement of as many citizens, especially young people, as possible in inspection activities should be encouraged. The level of air pollution is increasing in Elizovo and Petropavlovsk, as road transport develops. The law On Air Protection has been developed but has not been enforced.

Perspective

Geoffrey York

Russian poachers rip roe from salmon

2000: The windswept waters of Kurilskoe Lake are the site of an astonishing annual phenomenon: Asia's biggest salmon spawning run, where 1.7 million salmon fight their way up rivers and creeks, attracting the attention of hundreds of giant brown bears and rare sea eagles as they pass. However, this phenomenon is now attracting a more ruthless predator: organized criminal gangs of knife-wielding poachers, flown in by helicopter and capable of devastating an entire river with just two weeks of illegal slaughter. This summer's spawning season in Russia's Far East has barely begun, and already the poachers are brazenly harvesting their prey. Scattered around creeks are hundreds of dead salmon, their bodies slit open, their roe ripped out. "Not even twenty-four hours after the salmon run began, the poachers were already here," said William Leacock, a researcher from the Wildlife Conservation Society, a New York–based environmental group that is trying to protect the area from poachers. On the first day of the spawning season that began on July 21, he saw hundreds of discarded salmon corpses near the creeks around Kurilskoe Lake, on the southern tip of Russia's remote Kamchatka peninsula. He fears much worse may yet occur. In previous summers, he said, he has seen tens of thousands of salmon killed for their eggs. "It could reach a threshold where the population breaks," Mr. Leacock said.

Poaching is one of the fastest growing threats to the ecological wonderland of Kamchatka, a lush peninsula of wild rivers, forests, erupting volcanoes, hot springs, rare birds, dozens of endangered species, and even a spectacular valley of geysers. About one quarter of the world's Pacific salmon population spawns in its pristine rivers. It is one of the world's greatest unspoiled wildernesses—but its survival could be in peril. Illegal fishing and poaching is believed to cost Kamchatka as much as U.S.$7 billion a year in lost revenue. As many as one hundred fishing companies can be licensed on a single river. Organized gangs harvest the salmon illegally for their red caviar, a delicacy that sells for U.S.$22 a kilogram in Russian shops. Poachers in massive numbers, too, slaughter other animals. Hundreds of Kamchatka's huge brown bears—the same species as the North American grizzly—are killed by poachers every year to satisfy the bear-organ market in Asia, where Chinese and Koreans pay thousands of dollars for the animals' gall bladders for medicinal use. According to some estimates, the bear population in Kamchatka has dropped by 50 percent since the 1960s, the result of excessive hunting and poaching. Nobody knows how many bears still roam the Kamchatka wilderness (estimates range from 6,000 to 25,000), but poachers are killing as many as 2,000 annu-

ally. More than three hundred bears will also be killed legally this year by trophy hunters, including wealthy Americans and Canadians who pay as much as U.S.$13,000 for the privilege of bagging a bear. As many as one thousand bears will be shot legally by local hunters. "There's been a dramatic decline in the size and age of the bears killed," Mr. Leacock said. "If it continues, the population is going to be decimated [sic]." Kamchatka is such a spectacular and unique region that five of its nature reserves have been designated as a UNESCO World Heritage Site. Yet an impoverished Russian government lacks the staff to protect it. Only two federal park wardens, each armed with a shotgun, guard the salmon wealth of Kurilskoe Lake. They live in an isolated compound behind an electrified fence designed to keep out the bears.

A new project to help Kamchatka's nature reserves is being launched by the UNDP, which hopes to raise as much as U.S.$15 million for a plan to strengthen the management of four protected areas, including the Yuzhno-Kamchatsky nature park, where Kurilskoe Lake is located. The Canadian International Development Agency has spent U.S.$100,000 on studies to support the UNDP project, and several Canadians are at the forefront of the planning. "Kamchatka is an amazingly untouched place, but there are so many threats to it," said Paul Grigoriev, an Ottawa-based consultant to the UNDP project. Because of the post-Soviet economic collapse, poaching is often seen as an acceptable means of economic survival. Even local government officials are sympathetic to small-scale efforts. "We can't reproach people for poaching," said Kamchatka's deputy governor, Sergei Timoshenko. "The economic situation here is very difficult. People have to poach to support their families." Large-scale organized poaching, though, is a different story. By blocking rivers with nets, poachers can strip an entire year's salmon run, weakening the diversity of the salmon and reducing their long-term capacity for survival.

"It's a rich resource, but it's under unprecedented pressure now," said Jeffrey Griffin, a UNDP consultant. "The poachers are a real threat to some salmon runs. They're taking away the salmon's ability to reproduce." Gangs of poachers sometimes hire a Russian aboriginal person as a frontman, allowing the exploitation of salmon quotas that are supposed to go to aboriginal people. The illegal poaching brigades have taken on the atmosphere of fear that comes with reputations of power and ruthlessness.

"Poaching is a very big business," said Olga Chernyagina, a leading environmental activist in Kamchatka. "It's easy for them to take a helicopter and fly it to any river. Few people know the details because it's a criminal business. I'm afraid even to talk about it." Russia's federal fishing regulators are almost powerless to combat the poaching. They have only two helicopters to watch Kamchatka's fourteen thousand rivers, and officials say they need a major increase in the number of fishing wardens. With salaries of only U.S.$50 or $60 a month, many wardens are unable to resist the tempta-tion of bribes. "It's hard to fight the poachers," said Vladimir Rezvanov, director of the federal fish-protection department in Kamchatka, Kamchatrybvod. "They have a well-organized system. They come in by helicopter, strip out the caviar and throw away the fish. Sometimes we feel helpless and discouraged when we see we can't improve the situation." The Russian government has admitted the penalties imposed on poachers are too lax. The basic fine for an individual is 83 rubles, less than U.S.$5 an infraction. There can also be a "damage recovery" fine, but this too tends to be small unless the poacher is caught red-handed. In the first half of this year, 972 fishing infractions were recorded in Kamchatka, but only about U.S.$6,300 worth of fines were collected. Likewise, the maximum fine for killing a snow sheep is about U.S.$150, even though a ram's head can fetch up to U.S.$10,000 on the black market. "Clearly, such legislation does not inhibit poaching, but rather inadvertently condones it," a Canadian UNDP consultant concluded.

Perspective

Bruce Rich

World Heritage on Kamchatka

The official designation of five protected areas on Kamchatka by UNESCO in 1996 as the World Heritage site, Volcanoes of Kamchatka, offers greatly enhanced prospects for balanced, environmentally and socially friendly economic development. However, this potential will be realized only if communities and government officials in Kamchatka work together to maximize the opportunities it presents.

The concept of World Heritage originated in 1972 with the promulgation by UNESCO of an international treaty, the Convention Concerning the Protection of the World Cultural and Natural Heritage. Under the treaty, nations agree to identify sites on their territory that are of "outstanding universal value" from a cultural or natural perspective and that will constitute a world heritage "for whose protection it is the duty of the international community as a whole to cooperate." Nearly all the countries of the world (157) are now parties to the convention. Currently there are 721 sites on the UNESCO World Heritage List, of which 554 are cultural, historical sites, 144 are natural sites (such as Kamchatka), and 23 are so-called mixed cultural and natural heritage sites. National governments submit nominations of sites to the UNESCO World Heritage Committee in Paris, which, together with other international organizations and scientific bodies, evaluates the nominations according to their scientific value.

There are four major criteria for selecting World Heritage natural sites. They should:

- Be outstanding examples representing major phases of the earth's history.
- Be exceptional examples representing ongoing ecological and biological processes.
- Contain the most important natural habitats of endangered species of universal value.
- Contain superlative natural phenomena or areas of exceptional natural beauty.

The Volcanoes of Kamchatka site is one of the few that fulfills all of these criteria.

There is great competition among nations and regions to have sites selected for World Heritage designation, because inclusion makes an area an international focus of attention for tourism and, in some cases, attracts financial support from international development and environmental organizations. It also entails a great responsibility and commitment on the part of local and national authorities to conserve the site and to ensure that the economic development that the designation can foster is environmentally and culturally sustainable. If inappropriate development or poor management endangers a site, the UNESCO committee can declare that the site is "in danger," which creates considerable international embarrassment for the government concerned. This occurred in the United States several years ago, when Yellowstone National Park was declared a World Heritage Site in Danger because a proposed gold mine would have posed environmental threats to the park.

Whether tourism and international support materializes depends on whether local communities and authorities can cooperate to effectively manage, protect, and develop the sites. Currently the five protected areas constituting the Kamchatka World Heritage site are not being managed and developed coherently. This has come to the attention of the UNESCO committee and other international and foreign observers. It is widely known that the helicopter company Krechet effectively controls access to the crown jewel of the World Heritage site, Kronotsky Zapovednik. Both the head of the Kronotsky Zapovednik and the former governor of Kamchatka, Vladimir Biryukov, are reported to have close links to Krechet and the company's tourism business. Direct business interests inside any World Heritage site on the part of those responsible for administering it poses an important potential conflict of interest that can undermine international confidence in site management.

Russian law requires an *expertiza* before any infrastructure is developed in protected areas. It appears that construction of tourist infrastructure in Kronotsky Zapovednik, Yuzhno-Kamchatsky Zakaznik, and Nalychevsky Nature Park has occurred without these reviews, i.e., illegally. This suggests that the officials responsible for the construction are not sufficiently concerned with their obligations to preserve and protect the natural environment.

WWF–Germany has raised significant funds for the Kamchatka World Heritage site, but there are questions about how much has actually come to Kamchatka to support real conservation activities. In Nalychevsky Park significant amounts—contributed in part by WWF—have been expended to set up a museum and other facilities, including rather elaborate changing cabins at several hot spring sites, all near the helicopter pad where foreign and elite Russian tourists fly in and out. But other facilities in the park, for example at the overnight resting spot near the pass on the trail that leads back to Petropavlovsk, used more by local hikers, have been allowed to deteriorate to a lamentable condition. There appear to be no investments in management plans or conservation in the two other nature parks, Bystrinsky and the Yuzhno-Kamchatsky Nature Park. The three nature parks were all established according to scientific criteria to protect important watersheds and to develop programs of rational resource use and management. So far it appears that a kind of tourist Potemkin Village has been built in Nalychevsky Park, while a small amount of the money spent there could have been used to clean up other sites in the area that in the summer peak tourist season at times resemble a rural slum.

There are also proposals to create new nature parks on Kamchatka, for example around the Kirinsky and Klyuchevskoy volcanoes. The creation of these parks could in the future be a welcome addition to Kamchatka's system of protected areas, but it would probably be counterproductive to proceed while the existing protected areas lack adequate coordinated management and protection.

Perspective

Emma Wilson

Recommendations for forests and protected areas

Kamchatka's forests are vitally important for preserving the ecological balance of the peninsula and have a special role to play in mitigating floods and protecting salmon spawning grounds. A major concern is to preserve Kamchatka's conifer forests of larch and spruce. These are found only in the center of the peninsula (Conifer Island), make up less than 6 percent of the total forest cover, and have decreased in area by over two-thirds in the past sixty years.

There are varying levels of concern among local experts. According to the head of the protected areas department at the Kamchatka Committee on Environmental Protection, Yuri Nechitailov, the situation is not critical at present given that commercial logging—the main threat to Kamchatka forests—is decreasing every year. However, the economic

situation is so severe that Gennady Lazarev, the director of the Experimental Forestry Station (EFS), believes that people will let their forests be cut at a moment's notice for a quick profit and therefore efforts should be made to provide legal protection for these forests now through creation of protected areas. The head of the Kamchatka Forest Service, Alexei Avramenko, is concerned at the frequency of forest fires and sees an urgent need to provide adequate protection for all forests against the threat of fires (with air patrols, rangers, communications, fire-fighting equipment, and so on).

The timber industry today has collapsed into a number of small private logging ventures. In 1998, they cut 169,000 cu. m over an area of 1,914 ha. (In previous years as much as 1 million cu. m. were logged annually.) Forest regeneration, paid for by a tax on the logging enterprises themselves, covered 5,413 ha in 1998 (over three times the area logged). In recent years only 10–11 percent of the Annual Allowable Cut (AAC) has actually been taken, but experts believe the AAC is too high and should be reassessed. As the more accessible forests have been logged, commercial firms are trying to soften the legal requirements for logging. The water protection zone has been reduced in stages from 5 km to 1 km, and now efforts are being made to reduce it to 500 m. The AO (joint-stock company) Kamchatlesholding (formerly Kamchatles) tried to contract the EFS to provide a scientific justification for logging forests in the water-protection zone. EFS refused the contract. Kamchatlesholding has now practically fallen apart.

Forest specialists agree that export of Kamchatka timber should be banned. The industry should, however, be able to provide sustainable yields for Kamchatka's internal consumption, and should aim for more local processing. Recent plans by Kamchatka industrialists to build a huge wood-processing plant for plywood seemed to be a good idea, but the proposed plant was intending to use 70,000 cu. m of birch wood annually, which would pose a serious threat to Kamchatka's birch forests. The plywood factory failed to pass an *expertiza*, so the threat has been lifted for the present.

Kamchatka's system of protected areas (PAs) has an important role to play in the protection of the forests, though many agree that it is far from fulfilling this role adequately. Today 27 percent of the territory of Kamchatka is set aside in PAs, and the new Klyuchevskoi Nature Park will make it 31 percent. However, ecologists argue that the focus should be not on the number of PAs created, but on the quality of actual protection provided by PA status.

Passions are quickly raised on Kamchatka when the discussion turns to PAs and forest protection. Despite the creation of the Kamchatka Directorate of Nature Parks to control and manage the Kamchatka nature parks, the Kamchatka Forest Service still bears the entire responsibility for protecting all Kamchatka forests, both inside and outside PAs. However, the forest service does not have enough funding to protect the whole region effectively. Meanwhile, funds that are coming into the region for forest protection and PA support, such as the WWF program Protection of the Forests of Kamchatka, are being used almost exclusively to develop tourism infrastructure in the nature parks, notably in Nalychevsky Nature Park, rather than to strengthen the protection regime within the PAs or to increase the capacity of local fire-fighting and fire-prevention services. Specialists suggest that Bystrinsky Park be made into a federal-level national park, so that money would be channeled through the Federal Forest Service and control will officially remain with the Kamchatka Forest Service.

The lack of properly determined park borders or zoning within the parks means that all kinds of activities are permitted as if no PAs existed at all. The head of the Kamchatka Forest Service, Avramenko, exclaims: "They're called protected areas! They don't even provide normal protection, never mind special protection!" The scientific justifications for the zoning and borders were determined long ago for the parks by the KIEP and the Kamchatka Committee on Environmental Protection, but these remain on paper and have not been made legally binding. The parks directorate prefers to put money into tourism than into confirmation of boundaries and zones. Kamchatka ecologists believe it is wrong to place such undue emphasis on tourism within PAs, when there are many equally attractive tourist destinations outside the PA system, and when the priority in PA creation in Russia is the protection of the natural ecosystems.

The legislative framework for forest protection is inadequate. For example, land has still not been officially allocated to Nalychevsky Nature Park for long-term use due to inconsistencies between the law on PAs and the national forest code. The Russian Federation Forest Code was passed on January 22, 1997, but local specialists agree that it cannot possibly embrace local specifics. There is no regional forest code for Kamchatka, although there is such a code for Khabarovsk Krai, Sakhalin Oblast, and Leningrad Oblast.

Despite initial hopes, international intervention has not provided much real support for forest protection on Kamchatka. The Volcanoes of Kamchatka World Heritage nomination has created a focus on protecting "not forests but rocks" in the words of one local ecologist. "Why create a protected area around a volcano? A volcano will not go anywhere. If it erupts, then we will not be able to do anything about it. How can we protect the Klyuchevskaya group of volcanoes? This is not the right way to go about setting up protected areas. We need to determine what are the real priorities for protection."

Recommendations. The following actions should be taken:
- Protect the old-growth conifer forests of Conifer Island that have remained, setting aside these territories as soon as possible so that they are legally protected against future threats from logging companies.

- Create smaller (properly protected) PAs, rather than large PAs that provide no real protection to natural ecosystems.
- Ensure that the existing PAs provide adequate protection, including delineation of boundaries and proper zoning within the PAs as a priority.
- Survey the forests to reassess the AAC, using new methods and technology.
- Break the monopoly on tourism and helicopter transport in PAs.
- Develop tourism outside PAs rather than focusing so heavily on tourism within PAs.
- Direct financial and technical support for forest protection through the Kamchatka Forest Service rather than through the PA structure.
- Reduce the export demand on Kamchatka forests by working with the Japanese and Koreans to reduce their consumption of Kamchatka timber.
- Develop small, sustainable local timber-processing ventures.
- Develop a regional forest code for Kamchatka.

Pespective

Emma Wilson

Tourism and the *zapovednik* — a natural monopoly?

Ecologists in Kamchatka argue that tourism and the concept of a *zapovednik* are incompatible, and there should be no talk of developing tourism in Kronotsky State Biosphere Reserve, one of the oldest *zapovednik*s in Russia.

The Russian system of *zapovednik*s was developed under the Soviets, when, as nowhere else in the world, there was guaranteed state support for science and nature protection. Huge areas of land were set aside for strict protection and regular inventories made of the territories and their natural populations. According to the federal law On Specially Protected Areas, the goal of a *zapovednik* is "the preservation and study of natural processes and occurrences, the gene pool of flora and fauna, specific species and communities of plants and animals, typical and unique ecosystems.[49]

The question today is how such a system can survive in the market economy where there are no comparative models to draw experience from elsewhere in the world. Given the withdrawal of state support for science, where can funds be found to support such a system?

Using Western models for protected areas, tourism seems to be an obvious option. By law, however, tourism is not allowed in *zapovednik*s, nor is any other type of activity that contradicts the goal of the *zapovednik*. According to one scientific researcher, "In order for a *zapovednik* to survive, you can develop mass tourism there, but then you won't be able to call it a *zapovednik* — it will lose its status. It will be on the level of our nature parks where tourism and hunting and everything else is allowed."

Scientific researchers in the *zapovednik* try not to use the word "tourism," preferring instead to talk of "ecological education" or "ecological excursions," which are permitted by law. This generally refers to scientific exchanges, visits from amateur ornithologists, and so on. In theory the ecological education department in Kronotsky Zapovednik could organize this type of activity and ensure that money generated by these activities is used for scientific research and conservation. In practice, the way that tourism (or "ecological education") has been developed in Kronotsky Zapovednik is clearly outside the framework of Russian legislation, and indeed threatens the World Heritage status, which Kamchatka protected areas enjoy.

Kronotsky Zapovednik has sold its soul to the helicopter company Krechet, which has the monopoly on all travel to and from the nature reserve, as well as on virtually all major tourist activities on the peninsula. Relations between the helicopter company and the nature reserve originated at the dawn of *perestroika*. The joint-stock company Sogzhoi (which gave birth to Krechet) was established on the basis of the former State Resource Enterprise (*Gospromkhoz*) in Elizovsky Raion, where the *zapovednik* is situated, and on the personal friendship between the director of Sogzhoi, A. G. Kovalenkov, and the director of the *zapovednik*, S. A. Alexeev. With the helicopter firm's proximity to the *zapovednik*'s headquarters in Elizovo, and special favors that were granted (allowing urgent helicopter trips on credit, and so on), the *zapovednik* became dependent on the firm.

Today the dependency is irreversible. Although S. A. Alexeev has been removed from the director's post, it is said that the new director, Valery Komarov, is a puppet, placed there by Kovalenkov. An agreement has been signed between the *zapovednik* and Krechet that gives the helicopter company "priority rights" (in practice, exclusive rights) to activities within the *zapovednik* for a period of ten years. If any other helicopter company, for example, wants to fly into the famous Valley of the Geysers, it has to obtain the consent of Krechet.

There is considerable controversy about this agreement. The scientific advisory council — a body of scientific researchers from the *zapovednik* and independent scientists that should approve all that happens in the *zapovednik* — amended the draft agreement with the firm, but claims that it was signed without any of their amendments. Alexeev, who was still director at the time, claimed that it was not his signature on the final agreement. The scientific advisory council is concerned that the activities in the *zapovednik* are going ahead without consideration of their recommendations. In 1999, two researchers from the *zapovednik*, one of whom has worked there for twenty years, were removed from the council without being told the reason.

Krechet wants to develop mass tourism in the *zapovednik* and wants to have full control of this very lucrative business. Krechet constructed all the paths and bridges in the Valley of the Geysers. Now the firm has built two houses there, for scientific researchers and forest rangers, as well as a visitors' center, which is leased to Krechet for a period of ten years or so—all without the environmental expert review (*expertiza*) that is required by law. Building materials were apparently just flown into the reserve, and the director, Alexeev, pretended he did not know anything about it. It was no trouble for Kovalenkov to pay the fine for building on land without obtaining an environmental expert review.

Now ecologists are concerned about how excursions into the Valley of the Geysers are being carried out. During the tourist season, there are generally two excursions per day, which is a total of forty people. The helicopter flies in, the tourists walk around the valley, and then they all have lunch. All the food is prepared and cooked there in the valley, then all the dishes, glasses, pans, and flatwares are washed there, and generally the visitors all use the toilets. A pit has been constructed to contain the dirty water, and it is treated, but if that pit were to overflow, all the wastewater would flow down the slopes of the valley into the unique Geyser River. Ecologists are afraid that the ecosystem will not be able to withstand this increased volume of dirty water. Previously, research groups and visitors would fly in, bringing a picnic with them, and then fly out again with all their waste; dirty dishes would be washed at home.

At present, access to the Valley of the Geysers is limited, but Kovalenkov, as head of Krechet, is now talking of abolishing the "quiet month," which is the springtime period when bears mate in the valley and visitors are banned. Last year officials, including the governor, ordered the quiet month to be interrupted as some tickets had already been sold to a foreign tour company for dates within this period.

There is no way to stop people from visiting the Valley of the Geysers now. So far, access is only by helicopter. But there is talk of reopening the foot route. There is also talk of allowing tourism in other places within the *zapovednik*—Burlyashchy Volcano, Uzon Caldera, and Kronotskoe Lake (for licensed fishing.) Krechet is now looking to "develop" Kurilskoe Lake in the south, which is also part of the World Heritage Site. Researchers fear the impact of increased tourism on the fragile ecosystems of these places. Scientists who have worked in Uzon Caldera, for example, believe that it should remain a scientific laboratory, and access should be denied to tourists. There are other equally interesting places on Kamchatka, such as Mutnovsky Volcano. As one researcher commented, "Uzon is unique from a scientific point of view, not so much from a tourism point of view. How can you explain to a tourist just how long it took for that fern to grow that he has just trodden into the ground?" But there are plans to construct seven buildings in Uzon Caldera, including a visitors' center.

What are the alternatives? There are other sources of income apart from tourism. The UNDP GEF biodiversity program is just being developed for Kamchatka, with a protected-area component that includes Kronotsky Zapovednik. There are other international scientific and conservation grant programs, though these are never going to provide a sustainable source of income. There are possibilities for getting money from the regional administration. The federal government also has money—it is just a matter of getting it to spend it in the right way. It has also been suggested that the *zapovednik* develop its own production activities (e.g., small-scale timber processing) away from the territory of the reserve to create an income that would be fed directly into scientific research and conservation.

There is a form of tourism that causes minimal damage to the natural environment: cruises. These are expensive for tourists, but increasingly popular. Small boats bring passengers from the cruise liner to about 300 m from the shore, where they watch birds and other wildlife through binoculars and enjoy the wonderful coastline views, without stepping on land or disturbing the bird colonies.

The *zapovednik* staff complain about their dependency on Krechet, about losing profits from tourism and control over management of the nature reserve, but find it difficult to oppose the agreement. They are, apparently, afraid to act individually for fear of losing their jobs, yet find it impossible to act collectively. The agreement could be changed; the reserve could make a stand against monopolization. Legal experts believe the agreement could be protested on legal grounds. Instead, the *zapovednik* remains stuck in an irrational relationship of dependency, within a nature conservation system that involves a whole network of dependency relationships, including nature protection regulators and the regional administration. In a local newspaper article Kovalenkov is described as "a good business man, a strong boss, whose only problem is that he can't follow the law." And it is this businessman who has a disturbing amount of control over tourism and conservation on Kamchatka.

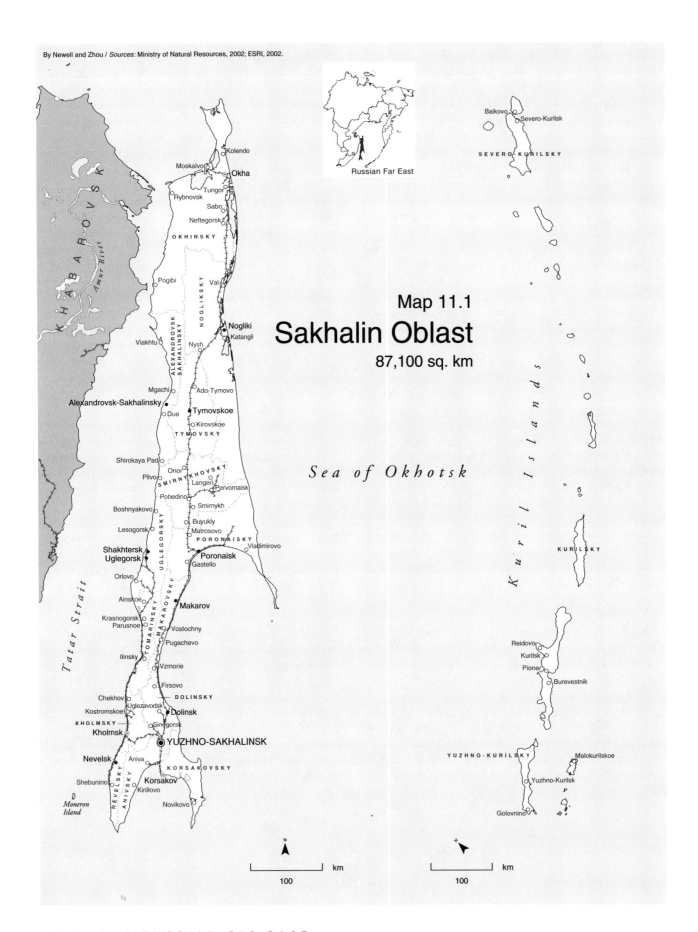

Russian Far East

Map 11.1
Sakhalin Oblast
87,100 sq. km

Sea of Okhotsk

K u r i l I s l a n d s

Tatar Strait

SAKHALIN

Sakhalin Oblast

Location

Sakhalin Island lies east of mainland Khabarovsk Krai, separated by the Nevelsky Strait (7.4 km) and the Amur estuary. It lies 10,417 km east of Moscow, 1,000 km north of Vladivostok, and 40 km north of Hokkaido, Japan. Sakhalin is washed by the Tatar Strait to the west, the Sea of Okhotsk to the north and east, and the Sea of Japan to the southwest. The volcanic Kuril Island archipelago stretches in two ranges (the Greater and the Lesser Kuril Island chains) from Kamchatka Peninsula in the north to Hokkaido in the south, forming a breaker between the Sea of Okhotsk and the Pacific Ocean. Tiny Moneron Island lies in the Sea of Japan to the west of the southern tip of Sakhalin.

Size

Sakhalin Oblast (which includes Sakhalin Island and the Kuril Islands) has a total area of 87,100 sq. km. Sakhalin Island, Russia's largest, is 76,400 sq. km, 948 km long, 160 km at its widest point, and 26 km at its narrowest. The Kuril Island chain (15,600 sq. km) spans 1,200 km and includes over thirty islands as well as many small islets and rocks. The *oblast* has seventeen *raion*s, three of which cover the Kuril Islands.

Climate

Sakhalin's maritime climate is milder and wetter than that of mainland Khabarovsk Krai. Average temperatures range from –30°C in January to 15°C in July. Spring arrives one month earlier in the south than in the north. Summer is cool except in August; June and July are particularly misty and foggy. Fall has typhoons with hurricane-force winds. Snow is heavy from November to March, reaching a maximum depth of 50 cm in the north, 70 cm in the south, and up to 100 cm in the east. The lowlands of the Tym and Poronai Rivers have the most extreme temperature shifts (from –40°C to 38°C). The Kuril Islands are less influenced by monsoons, but do experience swift weather changes. Winters are mild and summers cool. The Sea of Okhotsk is covered by ice for six months of the year, until June or later. The ice reaches a thickness of between 1.5 and 2 m, with pack ice and ice shears in the north. Because of the Sea's influence, the middle part of the Kuril Islands chain has a colder climate than the northern part. There are frequent typhoons, strong winds, constant fog in warmer seasons, and extremely strong currents. Earthquakes can reach 8 on the Richter scale and sometimes cause tsunamis.

Geography and ecology

Mountains cover three-quarters of Sakhalin Island. Two parallel ranges stretch from north to south. The highest peak of the eastern range is Lopatin Mountain (1,609 m); Onor

Mountain (1,330 m) is the highest in the west. A third mountain range, Susunaisky Ridge, lies in the south.

Forests cover about two-thirds of Sakhalin and differ greatly from north to south. Dahurian larch (*Larix gmelini*) forests cover the north. The widest stretches of Ayan spruce (*Picea ayanensis*) and Sakhalin fir (*Abies sakhalinensis*) forests are found in the central regions. The southern half of the island was clear-cut by the ruling Japanese in the first half of the century, and fires have seriously damaged the forests in the south. As a result, large areas are covered with small-leaved forest and stone birch (*Betula ermanii*) forest with bamboo (*Sasa kurilensis*). There are, however, old-growth fir forests along Susunaisky Ridge and some fragments remain on Krilon Peninsula in the southwest. Southern and northern vegetation types grow together in the south. High precipitation, low evaporation, and the mountainous relief have created more than sixteen thousand lakes and sixty-five thousand rivers, most of which are important spawning grounds less than 10 km long. The largest rivers, Tym and Poronai, flow between the two major mountain ranges. The Tym-Poronai lowlands make up central Sakhalin. Wetlands stretch along the northwestern and northeastern coasts, along the shores of Terpeniya Bay, and in the south, near Aniva Bay.

The Kuril Islands are a chain of volcanoes broken by straits; thirty-nine of the volcanoes are active. The highest are Tyatya Volcano (1,819 m) on Kunashir Island and Alaid Volcano (2,339 m) on Atlasova Island. Hydrothermal springs and frequent earthquakes are further testaments to seismic activity; typhoons and tidal waves also strike. Coniferous broadleaved forests cover 55 percent of the southern Kurils. Bamboo is also widespread in the south. Larch forests cover most of Iturup Island, while stone birch forests dominate Urup Island and parts of Shikotan Island. Japanese stone pine (*Pinus pumila*) grows at higher altitudes on all islands except Shikotan. Shrub alders (*Alnus*) are more common in the north, while the middle part of the island chain has mostly tundra and coastal meadows.

Key issues and projects

Offshore oil and gas

Exploration and production for multibillion-dollar offshore oil and gas projects has started on the Sakhalin shelf, with seven planned at a price tag of more than U.S.$100 billion over the next forty years.[1] These projects are a litmus test for further oil and gas development all around the Sea of Okhotsk. Some observers believe that oil development has had some positive effect on the Sakhalin economy; others voice concern about the environmental impact, limited benefits to the local population, and threats to the fishing industry and traditional economic activities.

Wasteful fisheries practices

Sakhalin has lost 30 percent of its natural salmon-spawning grounds because of the logging and oil industries. Herring, pollock, flounder, and smelt populations have declined due to overfishing, illegal fishing (especially for crab), and to a lesser extent, pollution. Russians are concerned about Japanese driftnet fishing, which harms salmon runs in the Sea of Okhotsk.

The Kuril Islands

Kurilsky Zapovednik (65,365 ha) protects the northern and southern portions of Kunashir Island, one of the southern Kurils. Russia has applied to UNESCO to declare the *zapovednik* and a nearby *zakaznik* a World Heritage site. Problems facing the Kurils include gold mining in the buffer zone of the *zapovednik*, illegal driftnet fishing by the Japanese off the Kuril Islands, and plans for a nuclear waste dump on Simushir Island, one of the smaller Kurils.

Flora and fauna

Sakhalin has unique mosaic vegetation due to its geographical position and length, and its proximity to the cold Sea of Okhotsk, the warm Sea of Japan, and the Pacific Ocean. Twenty-seven percent of the former Soviet Union's mammal species, 43 percent of the bird species, and 94 percent of the whale species live in or migrate to the *oblast*.

There are 1,570 species of flora, including 45 endemic and many rare species. Sakhalin has 371 bird species. Whooper swans (*Cygnus cygnus*), scoters (*Melanitta*), mergansers (*Mergus*), sandpipers (*Calidris*), oystercatchers (*Haematopus*), and others migrate to Sakhalin's coastal wetlands. Rare birds include sea eagles (*Haliaeetus*), Nordmann's greenshank (*Tringa guttifer*), a recently discovered endemic subspecies of dunlin (*Calidris alpina actites*), Siberian grouse (*Falcipennis falcipennis*), and Blackiston's fish-owl (*Ketupa blakistoni*). The Kuril Islands have huge seabird colonies with the highest seabird diversity in Asia. Red-crowned cranes (*Grus japonensis*) and other rare species breed on Kunashir and the Lesser Kuril Islands. Kunashir also has more Blakiston's fish-owls than all of Japan.

Sakhalin has ninety-one mammal species, including brown bear (*Ursus arctos*), sable (*Martes zibellina*), river otter (*Lutra lutra*), muskrat (*Ondatra zibethica*), wild reindeer (*Rangifer tarandus*), an endangered subspecies of musk deer (*Moschus mosciferus sakhalinensis*), and eight rare species of cetaceans. It also has the RFE's only endemic reptile, the Sakhalin viper (*Vipera sakhalinensis*). The Kuril Islands have five species of reptiles and a great variety of insects. The waters around Sakhalin are home to hundreds of species of fish. Many marine invertebrates are endemic to the Kurils. Anadromous fish include four species of salmon, the globally endangered green sturgeon (*Acipenser medirostris*), Amur sturgeon (*A. schrenkii*), and kaluga sturgeon (*Huso dauricus*). Dolphins, Steller's sea lions (*Eumetopias jubatus*), seals, and the endangered Okhotsk-Korean population of gray whales (*Eschrichtus robustus*) also inhabit Sakhalin's waters.

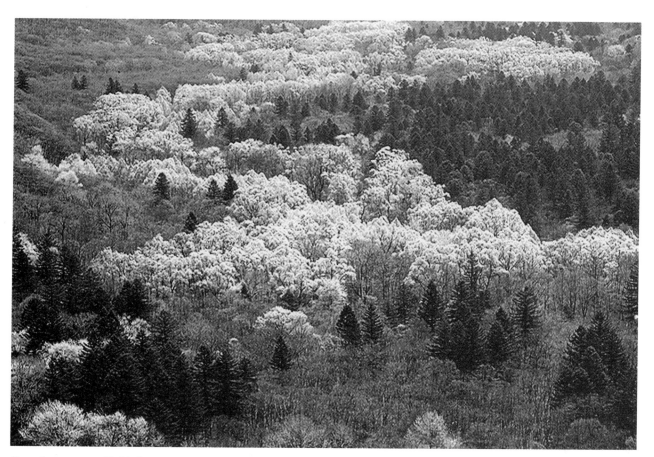

Some forest types of Sakhalin are unique to the island.

Largest cities

More than 85 percent of Sakhalin's population lives in its nineteen towns. Yuzhno-Sakhalinsk (pop. 180,000) was the seat of the Japanese government on Sakhalin between 1905 and 1945. It is now the administrative center of Sakhalin and a base for food production, energy, construction, light industry, finance, science, and tourism. Kholmsk (pop. 51,000) is a major port town with a fishing fleet, fish-processing industry, shipbuilding and repair center, food industry enterprises, and two obsolete pulp and paper plants. Korsakov (pop. 45,000) is a port town, open to international shipping, and is Sakhalin's biggest fishing center; it is likely to increase in importance as the offshore oil projects expand. Dolinsk (pop. 15,900) and Poronaisk (pop. 26,000) are former centers of the declining coal and paper industries. Alexandrovsk-Sakhalinsky (pop. 19,400) is a port, with a shipyard and fish-processing industry.

Okha (pop. 37,000) is the main center for the onshore oil and gas industry and supporting industries (construction and food processing). Nogliki (pop. 14,000) is also a center for onshore oil and gas and will increase in importance as the offshore projects develop. Yuzhno-Kurilsk (pop. 6,500), on Kunashir Island, is a large port, a center for fishing and fish processing, and an emerging tourism center. Kurilsk (pop. 2,700), on Iturup Island, is a center for fishing, fish processing, and fish farming.

Population

As of January 2001, the population was just over 590,000, a decline of nearly 20 percent from 1999.[2] Approximately 20,000 people live on the Kuril Islands. The population of the *oblast* includes Russians (87.7 percent), Ukrainians (6.5 percent), Koreans (4.9 percent; many are now returning to South Korea), indigenous Nivkhi (0.3 percent), Uilta (Oroki, Orochon) (0.04 percent), and others.[3]

Political status

The southern half of Sakhalin was ruled by the Japanese between 1905 and 1945 and the northern part

A forest ecologist hand-measures a large tree on Sakhalin's Schmidt Peninsula.

occupied from 1920 to 1925. In 1947 Sakhalin Oblast became independent of Khabarovsk Krai. The Kuril Islands, ceded to Japan in 1875, were ostensibly liberated by Russia in 1945, but the peace treaty drawn up between Japan and Russia in 1951 remains unsigned and the Kuril Islands remain in dispute, though negotiations have recently resumed. In 1999, Igor Farkhutdinov was voted in as governor and Ivan Zhdakaev, a critic of the offshore oil and gas projects, was voted in as Sakhalin's deputy to the federal parliament (Duma).

Natural resources

Sakhalin's resources include fish, timber, oil, gas, coal, and other minerals. The Kuril Basin and Sea of Okhotsk are some of the richest fisheries in the world. In 1999 the fishing industry had a total catch of 450,000 tons of fish and seafood, of which 330,000 tons were processed. The salmon catch in 1999 was the largest in the past ten years.[4] Kuril Island rivers yield more than 25,000 tons of salmon every year. Offshore reserves of the Sea of Okhotsk shelf are estimated at 1,000 mmt of oil and 3,600 billion cu. m of gas.[5] About 60–70 percent of the onshore oil and gas reserves are depleted.[6] Timber reserves total 616.55 million cu. m, of which 207.47 million cu. m are suitable for commercial logging. There are more than sixty medium-quality coal deposits that can support production for many years, but costs of extraction are high. The Kuril Islands have considerable marine resources and mineral deposits including titanium, sulfur, copper, lead, zinc, and gold.

Main industries

Sakhalin's main industries are fishing and fish processing, oil and gas exploration and production, and forestry (logging, raw log export, small-scale timber processing). Sakhalin's fishing industry is still dominant in the region, providing about one-third of the *oblast*'s industrial output. The oil and gas industry is now becoming increasingly important to the regional economy. Sakhalin has seventy-five onshore oil fields and twenty-five onshore gas fields. The focus is now shifting to the offshore projects currently being developed by some of the world's largest multinational companies. Sakhalin's timber industry is in crisis as a result of years of unsustainable forest exploitation, ineffective regeneration, and a shortage of local processing opportunities. The pulp and paper industry has collapsed, which means that pollution has declined but lower-quality timber is no longer processed. Today the timber industry relies on raw log export, mostly to Japan, and up to 70 percent of the cut timber is left on the logging sites. Despite the huge investment in extracting offshore oil and gas reserves for foreign export, coal is still Sakhalin's major energy source. Much of the coal comes from outside the region, mainly from the Republic of Sakha and Khabarovsk Krai. Industrial production of coal is declining on Sakhalin because of the high transportation costs, loss of federal subsidies, outdated machinery, and intensive resource exploitation. Sakhalin also produces building materials (cement, bricks, and concrete) and food and drink products (flour, confectionery, mineral water, soft drinks, beer, and spirits). Agricultural production (meat and dairy products) is increasing.

Infrastructure

Sakhalin depends heavily on air transportation. There are regular flights from Yuzhno-Sakhalinsk to Khabarovsk, Vladivostok, Moscow, Novosibirsk, and other Russian cities, though connections with Petropavlovsk-Kamchatsky remain problematic. Flights to the Kuril Islands can be unreliable due to the unpredictable weather. There are international

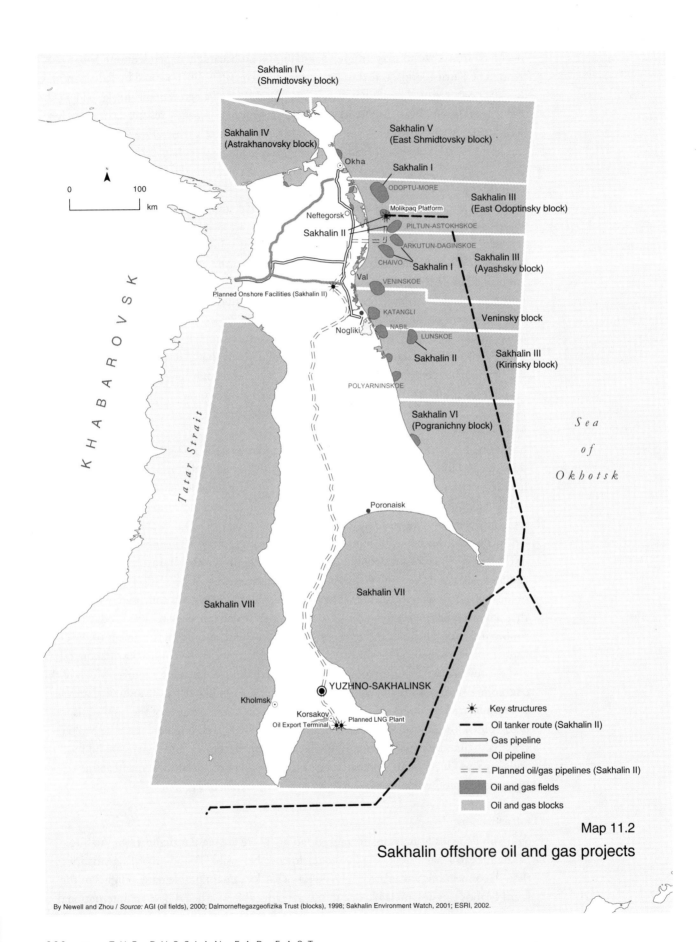

Sakhalin IV
(Shmidtovsky block)

Sakhalin IV
(Astrakhanovsky block)

Sakhalin V
(East Shmidtovsky block)

Okha

Sakhalin I

ODOPTU-MORE

Sakhalin III
(East Odoptinsky block)

Neftegorsk

Molikpaq Platform

PILTUN-ASTOKHSKOE

Sakhalin II

ARKUTUN-DAGINSKOE

CHAIVO

Sakhalin III
(Ayashsky block)

Sakhalin I

Val

VENINSKOE

Planned Onshore Facilities (Sakhalin II)

Veninsky block

KATANGLI

Nogliki

NABIL

LUNSKOE

Sakhalin III
(Kirinsky block)

Sakhalin II

POLYARNINSKOE

Sakhalin VI
(Pogranichny block)

Sea

of

Okhotsk

K H A B A R O V S K

Tatar Strait

Poronaisk

Sakhalin VIII

Sakhalin VII

YUZHNO-SAKHALINSK

Kholmsk

Korsakov
Oil Export Terminal Planned LNG Plant

※ Key structures

▬ ▬ Oil tanker route (Sakhalin II)

▭ Gas pipeline

▬ Oil pipeline

= = = Planned oil/gas pipelines (Sakhalin II)

▓ Oil and gas fields

░ Oil and gas blocks

Map 11.2

Sakhalin offshore oil and gas projects

By Newell and Zhou / *Source:* AGI (oil fields), 2000; Dalmorneftegazgeofizika Trust (blocks), 1998; Sakhalin Environment Watch, 2001; ESRI, 2002.

flights to Hakodate (Hokkaido) and Seoul. There are eight ports, the main ones being Kholmsk and Korsakov. The latter operates a summer ferry to Otaru (Hokkaido). Total port turnover for Sakhalin in 1999 was 3,104 metric tons.[7] A rail ferry built in 1973 runs year-round between Kholmsk and mainland Vanino in Khabarovsk Krai. A Japanese-built railway network runs from Korsakov in the south to Nogliki in the northeast and between Shakhta and Ilinsky in the southwest. An oil pipeline links northern Sakhalin with refineries in Komsomolsk-on-Amur and Khabarovsk. Offshore production is transported by tanker. There are plans to build oil and gas pipelines from the offshore fields to the south for export, a liquified natural gas plant in the south in Prigorodnoe, and a gas pipeline from Sakhalin to Japan. There has also been talk of reviving plans to build a tunnel from Sakhalin to mainland Khabarovsk Krai (8 km) and from southern Sakhalin to Hokkaido, Japan (45 km).

Foreign trade

Sakhalin's foreign trade turnover in 1999 was almost u.s. $700 million, in 2000 well over $1 billion, and about $930 million in 2001. Exports annually account for about 75 percent of this total, with fish and marine products accounting for 20 percent of all exports in 2001.[8] Fuel and energy resources (oil, diesel fuel, and residual fuel oil) accounted for 64.9 percent of exports. The other major export was timber (3.5 percent). Export markets are Japan, South Korea, and Singapore.[9] In 2000, Sakhalin exported about 3.2 million metric tons of oil (u.s. $637.7 million), 133,800 tons of seafood (u.s. $209.7 million), and 80 tons of coal (u.s. $1.34 million).[10] The *oblast* administration expects oil production to reach 13.3 million metric tons (est. u.s. $2 billion) by 2005, much of it to be exported.

More than 70 percent of all goods consumed in the region are imported from other regions of Russia or abroad. Major imports include coal, food, fuels and oils, construction materials, and equipment for the fishing, timber, and oil and gas industries. In 2001, Sakhalin imported these products primarily from the United States (34.8 percent), Japan (28.7 percent), and South Korea (11.7 percent).

In 1999, Sakhalin was second only to Moscow in terms of foreign investment, a result of investment in the offshore oil and gas projects, which totaled u.s. $1 billion in 1999, but dropped to u.s. $251 million in 2000, and then in 2001 rose to about u.s. $389 million. The governor, Igor Farkhutdinov, expected investment to rise again to u.s. $2 billion in 2002.[11] Sakhalin's forestry sector attracted about u.s. $17 million between 1997 and 1999.[12]

Economic importance in the RFE

- Main focus of foreign investment in the RFE.
- About 20 percent of the RFE's foreign trade turnover.
- 16 percent of the RFE's fishing and fish processing industries.

General outlook

Despite huge international investment, Sakhalin is likely to remain on the economic periphery of the Russian Federation if it continues to supply only raw resources. The region is located in a key position for export of timber and hydrocarbons to Pacific Rim markets. The offshore oil and gas will remain a priority for developers. The Sakhalin regional government believes the *oblast* will gain significant revenue from the offshore projects. Critics charge that the Production Sharing Agreements (PSAs) were negotiated

on extremely beneficial terms for the oil companies, without safeguards to guarantee local benefits. A report by the Russian Federation Auditing Chamber identified serious flaws in the Sakhalin PSAs. For the oil companies themselves, the regulatory conflicts between the PSAs and Russia's other normative acts are holding up speedy development of the projects. Local scientists recently issued an appeal to the government criticizing the economic soundness of the projects. Yuzhno-Sakhalinsk is likely to benefit more than the northern communities, whose traditional economies are threatened by the developments and who shoulder the major part of the ecological risk.

Provision of gas to Sakhalin's residents was part of the original tender agreements for the offshore projects. Sakhalin residents are hoping that an increase in local gas-powered energy systems will make up for the failure of timely coal deliveries, which have been at the root of the island's energy crisis. Sakhalin's major gas power project in Nogliki has started its first phase of operation. It is hoped that the current use of gas in local energy systems will be increased from 20 percent to 40 percent when Nogliki is fully operational. Sakhalin has successfully attracted foreign investment for extraction and production, but has not yet been able to attract foreign support to convert its energy system to natural gas.

Governor Farkhutdinov opposes plans to route oil to Khabarovsk Krai, as Sakhalin's budget would be deprived of export revenues. It is likely that oil and gas pipelines will be built down the length of the island. These will be laid mostly along existing road routes, but will nonetheless damage reindeer pastures and spawning grounds. Further infrastructure construction and transportation will cause environmental disturbance in the north and northeast, both onshore and offshore. Plans for the liquid natural gas plant in Prigorodnoe, under the Sakhalin II project, are proceeding. The Japanese are also particularly interested in ensuring that a gas pipeline is constructed between Sakhalin and Japan, perhaps offshore from northern Sakhalin to Hokkaido. Meanwhile, residents of Sakhalin will suffer power outages in winter and severe pollution from coal-fired power plants.

International interest in the offshore oil and gas projects is high, and environmental organizations will continue to monitor the ecological safety of the projects. Local and international environmental organizations are concerned that Sakhalin is poorly prepared for a large-scale environmental disaster such as an oil tanker spill, and a major accident could result in a serious anti-American backlash. Chronic pollution from onshore and offshore oil projects, including the discharge

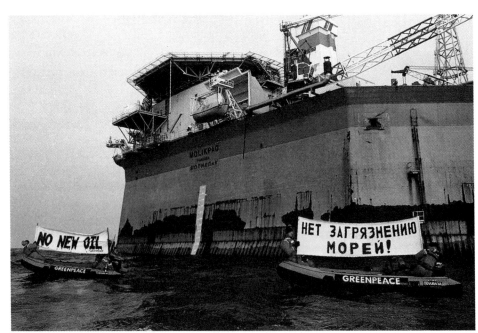

Greenpeace protesting at the Molikpaq oil platform.

of drilling wastes, is likely to continue and, in affecting fisheries, lead to local opposition to the projects. The most recent ecological threat from the projects occurred in summer 2001, when ExxonMobil, operator of the Sakhalin I project, was ordered by the Ministry of Natural Resources to stop all seismic testing because of concerns that the drilling was harming a small population of the endangered Okhotsk-Korean gray whale. ExxonMobil, in response, maintained that it had already finished necessary testing when the order was issued. This order may affect future seismic tests, not only for Sakhalin I, but also for Sakhalin IV and VI.

There is considerable international interest in other sectors of the Sakhalin economy. Many projects are in the early stages of development, but are attracting the attention of international investors. These projects include the upgrading of Uglegorsk and Dolinsk pulp and paper mills, development of Solntsevsky coal pit, construction of the second Nogliki gas power station plant, exploitation of gas deposits in the south, and support for district timber enterprises.[13]

The timber industry is likely to continue exporting raw logs and, unless local timber processing is increased, the excessive wasting of resources. Measures to improve the industry include use of modern technology, including use of Scandinavian machinery with wheels instead of caterpillar treads, hauling timber by helicopter, and small-scale localized timber processing. The timber industry also needs to move toward certification by the Forest Stewardship Council (FSC) to help conserve the island's dwindling forests and participate in the market for FSC-certified wood in Japan. International efforts to conserve Sakhalin's forests, previously focused on creating and supporting the development of protected areas, should now also focus on promoting these changes in the Sakhalin timber industry and working with local communities in conservation and sustainable resource-use projects.

Communities once dependent on the timber, coal, and pulp and paper industries for jobs and social infrastructure remain in a state of crisis; wages have not been paid for months or, in some cases, years. Indigenous livelihoods are declining due to the withdrawal of state support and threats from industrial encroachment. Unemployed reindeer herders, hunters, and fishers cannot find jobs. It is unlikely that the prevalent poaching, drunkenness, theft, and depression will decrease until the deep-rooted socioeconomic problems are resolved in these settlements. Alternative livelihood options include setting up small-scale fishing enterprises, buying and selling food products, collecting and marketing nontimber forest products (NTFPs), or engaging in small-scale tourism.

— *Emma Wilson*

Ecology

A. K. Klitin

Sakhalin Island is located within two geobotanical zones: boreal and mixed forest.[14] The Russian scientist A. I. Tolmachev also distinguishes three geobotanical subzones within the taiga zone: light conifer (with larch dominant); dark conifer (with spruce dominant); dark conifer (with fir dominant). Light-conifer forests grow in the north, with dominant Dahurian larch. Undergrowth often consists of Japanese stone pine and monarch birch (*Betula middendorfii*). Ayan spruce forest grows on mountain slopes (Schmidt Peninsula, Vagis Mountain).

The subzone of dark-conifer forest with dominant Ayan spruce lies in central Sakhalin (the Poyasok Isthmus). The dominant forest is spruce and Sakhalin fir with green moss on the forest floor. Larch forests grow along river valleys with giant poplar (*Populus maximovichi*), elm (*Ulmus*), alder (*Alnus*), willow (*Salix*), and tall grasses. In conifer forests you can also find arrowwood (*Viburnum*), cherry (*Prunus*), Japanese yew (*Taxus cuspidata*), Mongolian oak (*Quercus mongolicus*), wild kiwi (*Actinidia lindleyi*), and magnolia vine (*Schisandra chinensis*). Larch replaces spruce and fir after fires and on mountain slopes.

In the eastern Sakhalin mountain range, dark-conifer forest is replaced by stone birch (*Betula ermanii*) forest above 600 m. Trees are often covered with lichens in this belt. On mountain slopes in western Sakhalin, stone birch forests have dense thickets of bamboo in the undergrowth. Japanese stone pine forms the timberline (above 800 m), while alpine tundra exists at 1,000–1,200 m. Up to 150 species of grasses and bushes have been recorded in this subzone. On coastal terraces with peat soils (Terpeniya Peninsula, around Nevskoe Lake, and northern Schmidt Peninsula), coastal tundra with crowberry (*Empetrum*), peat mosses (*Sphagnum*), and lichens are widespread.

The subzone of dark-conifer forests with dominant fir lies to the south of the Poyasok Isthmus and east of an imaginary line between the Aniva and Tomari Mountains. Spruce and fir forests grow here with bushes, grasses, and ferns. Maple (*Acer*), cherry, aralia (*Aralia*), Siberian ginseng (*Eleutherococcus*), wild kiwi, and magnolia vine are widespread. Elm and ash (*Fraxinus*) dominate in valley forests. There are several species of dwarf bamboo (*Susa*) that grow only in dark-conifer forests on Sakhalin, Hokkaido, and the southern Kurils. The tops of the highest mountains of the Susunaisky, Yuzhno-Kamyshovy, and Shrenka ridges are covered with Japanese stone pine from 800 m up. Mountain tundra is found only at the top of the Chekhov, Ostraya, and Maiorskaya Mountains (Susunaisky Ridge).

The subzone of dark-conifer and broadleaved forest covers southwest Sakhalin, including Krilon Peninsula and the western slopes of Yuzhno-Kamyshovy ridge south of Tomari Mountain. Southern Sakhalin forests have been badly damaged by logging and fires, especially on the slopes of Yuzhno-Kamyshovy, Mitsulsky, and Susunaisky Ridges. As a result, small-leaved forest and stone birch with bamboo thickets cover large areas. Liana vines interweave with the bamboo stems. Tall grasses, often reaching 4 m, are common, especially along rivers and streams. There are 150 tall grass species, with the greatest diversity in the south. They include knotweed (*Polygonum*), angelica (*Angelica*), and various *Umbrelliferae*. Meadow flora is relatively young and represented mostly by forest species and alien plants.

The vegetation of Moneron Island used to be very similar to that of southwest Sakhalin: spruce and fir dominant with broadleaved forest. The original conifer vegetation was logged by the Japanese in the 1920s and 1930s or destroyed by forest fires at the end of the 1960s. Small patches of old spruce forest now cover only 3 to 4 percent of the island, while over half the island is covered with meadows.

The most diverse forests are found on the southern Kuril Islands (Kunashir, Iturup, Urup,

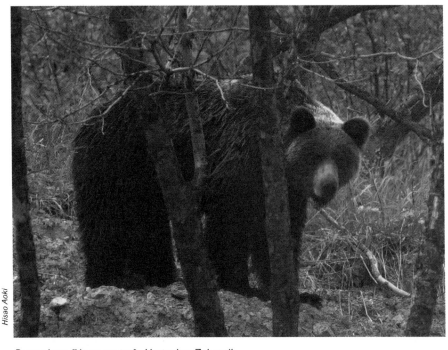

Brown bear (Ursus arctos), *Vostochny Zakaznik.*

and the Lesser Kuril chain)—particularly southern Kunashir with its conifer-broadleaved forests. In the northern Kuril Islands (as far as Rasshua Island), Japanese stone pine and shrub alder (*Alnus kamtschatica*) dominate with mountain ash (*Sorbus*) and willow forming dense thickets. Large areas are covered with meadows and various grass species. The middle part of the Greater Kuril chain is mostly covered with tundra and coastal meadows. Beginning on Ketoi Island, dwarf bamboo, stone birch, Japanese yew, and Kuril cherry (*Cerasus kurilensis*) appear. Stone birch forests cover most of Urup. In the central part of Iturup are larch forests; they resemble the tundra woodlands of northeastern Siberia. Dark-conifer forests grow throughout much of southern Iturup and Kunashir, and include Sakhalin fir, spruces (*Picea microsperma, P. glehni*), and Japanese yew, with broadleaved species such as oak. In southern Kunashir, oak is found with magnolia vine, elm, mulberry (*Morus*), hydrangea (*Hydrangea*), and several species of birch. On Shikotan, spruce and Sakhalin fir now occupy less than 20 percent of the island. Bamboo does not grow very high and juniper (*Juniperus*) replaces Japanese stone pine. Other Lesser Kuril Islands and the southernmost tip of Kunashir are covered with meadows, important breeding grounds for red-crowned cranes.

Flora and fauna

The flora of Sakhalin comprises more than 1,570 species (1,173 of which grow on Sakhalin, 1,143 on Kuril Islands, and 448 on Moneron Island), 45 of them endemic.[15] Many plant and animal species characteristic of mainland RFE are absent from Sakhalin and the Kuril Islands, but others are more common here.

Sakhalin and the Kuril Islands have about four hundred bird species. Among them are short-tailed albatross (*Diomedea albatrus*), Swinhoe's storm-petrel (*Oceanodroma monorhis*), mandarin duck (*Aix galericulata*), osprey (*Pandion haliaeetus*), white-tailed sea eagle (*Haliaeetus albicilla*), Aleutian tern (*Sterna kamchatica*), and Blackiston's fish-owl (*Ketupa blakistoni*).

There are ninety-one mammal species, eleven of which have become introduced to the islands over the past seventy years.[16] Rare species include the Sakhalin musk deer, many marine mammals, and bats. On Sakhalin at least five mammal species have disappeared during the past millennium: walrus (*Odobaenus rosmarus*), snow sheep (*Ovis nivicola*), moose (*Alces alces*), sika deer (*Cervus nippon*), and gray wolf (*Canis lupus*).[17] There are eight reptile species, including two rare skinks (*Eumeces latiscutatus, E. japonica*), and a great variety of insects, including rare butterflies.

There are hundreds of species of fish in Sakhalin's waters, with the most diversity in the Tatar Strait. The marine fauna of Moneron Island is particularly distinctive, its waters being the most northern habitat for black-sea urchin (*Strongylocentrotus nudus*), trepang (*Apostychopus japonicus*), sea star

(*Plazaster borealis*), sea urchin (*Glyptocidaris crenularis*), coastal crab (*Hemigrapsus sanguineus*), and rainbow abalone (*Haliotis iris*). Sakhalin has about sixty-five thousand rivers. Most of these are spawning rivers for valuable species of salmon (pink [*Oncorhynchus gorbuscha*], chum [*O. keta*], coho [*O. kizhuch*], and cherry [*O. simu*]) The total area of the spawning grounds is 22 million sq. m. Sakhalin has forty-one species of freshwater and brackish water fish, including four species of Pacific salmon and the globally endangered green sturgeon.

Protected area system

DIMA LISITSYN—The protected areas (PAs) of Sakhalin[18] cover a total area of almost one million ha (167,035 ha of which have federal status), or about 11 percent of the territory (see table 11.1). But many of the wilderness areas, particularly forests, wetlands, and specific habitats of endangered species, are poorly protected. At present there are two *zapovednik*s, one federal *zakaznik*, one nature park, thirteen *oblast*-level hunting *zakaznik*s, and forty-seven natural monuments.

Lacking funding and adequate equipment, the federal PAs are often unable to combat poaching by Russian and international fishermen. These poachers have been exploiting the marine resources in the waters of the Malye Kurily (Lesser Kurils) Zakaznik for many years. The director of Kurilsky Zapovednik (the reserve has administrative control over the *zakaznik*) has made great efforts to protect the *zakaznik*, but has been unable to be effective due to lack of federal funding to purchase patrol boats and equipment. Japanese fishermen have been granted permission to use driftnets to fish around the Lesser Kuril Island chain. Extensive fishing in this region would affect marine resources and lead to the death of thousands of marine birds and mammals and the disappearance of colonies of marine birds on the islands, as has already happened on neighbouring Hokkaido.

Even though the forest is habitat for many commercially valuable and rare species, the regulations for these *zakaznik*s, as a rule, do not ban any form of logging. This encourages logging companies to exploit the forests. The forest service and the hunting service find it difficult to control logging inside the hunting *zakaznik*s. Commercial timber companies have recently increased pressure on nature protection officials in an effort to obtain permission to log on slopes of more than 20 degrees. They intend to use one of the most destructive technologies, mountain-slope terracing, which at present is forbidden. To drag the timber out bulldozers are used to dig deep terraces across slopes, causing erosion, hindering forest regeneration, and damaging spawning rivers. It is essential to do research in *zakaznik*s and prepare a scientific proposal to recommend changes to the *zakaznik* regulations, specifically regulations that ban commercial and salvage logging.

With the increased development of Sakhalin's onshore and offshore oil and gas fields, coastal ecosystems must be

Table 11.1
Protected areas in Sakhalin Oblast

Type and name	Size (ha)	Raion	Established
Zapovedniks			
Kurilsky	65,365	Yuzhno-Kurilsky	1984
Poronaisky	56,670	—	—
Nature Park			
Ostrov (Island) Moneron	4,200	—	1995
Federal Zakazniks			
Malye Kurily	45,000		
(Lesser Kurils)	(25,200 marine)	Yuzhno-Kurilsky	1982
Regional Zakaznik			
Severny (Northern)	135,000	Okhinsky	1978
Oleny (Deer)	80,000	Nogliksky	1989
Vostochny	67,646		
	(2,260 marine)	Smirnokhovsky	1999
Nogliksky	65,800	Nogliksky	1998
Tundrovy	60,000	Okhinsky	1987
Krilon	52,000	Anivsky	1972
Makarovsky	44,560	Makarovsky	1992
Ostrovnoi	42,000	Kurilsky	1988
Izyubrovy	40,000	Dolinsy	1988
Alexandrovsky	24,600	Alexandrovsk-Sakhalinsky	11980
Dobretskoe Ozero (Lake)	20,000	Korsakovsky	1989
Krasnogorsky	5,700	Tomarinsky	1974
Poluostrov (Peninsula) Bukhta Kraternaya (Crater Cove)	200	Severo-Kurilsky	1987

Source: Sakhalin Committee of Environmental Protection, 2000.

protected. The construction of coastal facilities (pipelines, extraction and processing complexes, electricity cables, roads, and pumping and compressing stations) will destroy these fragile ecosystems. There is no technology yet in the world for the satisfactory restoration of wetlands or for cleaning them up after an oil spill. The coastal areas adjacent to the oil extraction sites are habitat for rare species such as Steller's and white-tailed sea eagles, spotted greenshank, Sakhalin dunlin, and osprey. Those wetlands and bays of northeastern Sakhalin that satisfy international criteria should be designated as a Ramsar site. In 1997, these areas were included in a list of key ornithological territories of Russia. It is essential also to create new PAs to protect the remaining unlogged forests and the habitats of rare and endangered plants.

Zapovedniks. There are two *zapovedniks* (strict nature reserves) in the *oblast*.

Kurilsky. Kurilsky Zapovednik protects three territories—the northern and southern portions of Kunashir Island and Demina and Oskolky Islands in the Lesser Kuril Island chain. Between the northern and southern portions, some commercial activity is limited and there is a one-mile coastal buffer zone around each part. Some forms of tourism, sport fishing and hunting, and use of poisonous chemicals are prohibited in the buffer zone. There are also limits on logging, collecting nontimber forest products, and the use of fertilizers. The *zapovednik* has archaeological and ethnographic monuments (archeological sites and ancient Ainu villages). In total there are 825 species of higher flora, 38 species of fern, 144 species of mushroom, 222 species of lichen, and 218 species of algae. Kuril bamboo, Japanese stone pine, Sakhalin fir, Glehn's spruce (*Picea glehnii*), and stone birch characterize the landscape. Many plants rare elsewhere are common on the islands. About fifty species are endangered. Hundreds of species and many plant families are on the northern limit of their ranges here, such as silver magnolia (*Magnolia obovata*). The birdlife of the islands is rich, with more than 260 species, including sea eagles, osprey, albatross, red-crowned crane, Blackiston's fish-owl, and many species of Japanese birds at the northern limit of their ranges. The species diversity of land vertebrates is limited; the largest mammal is the brown bear. In the forests there are also red fox (*Vulpes vulpes*), sable, and several species of rodents and rare bats. The globally endangered European mink (*Mustela lutreola*) was introduced here in case of its extinction in its natural range. In the coastal waters there are seals, sea otters, and cetaceans. In the freshwater rivers and lakes there are twenty-two species of fish. The invertebrate fauna is rich, unique, and poorly studied. Four hundred and ten species of invertebrate, including 373 insect species, have been recorded, but this is far from a complete list. Scientific research expeditions routinely discover previously unrecorded invertebrate and even vertebrate species.

Notable natural features of the *zapovednik* include Golovina Caldera, a huge volcanic basin with clear Lake Goryachee and milky-white Lake Kipyashchee. Tyatya Volcano (1,891 m) is one of the most beautiful volcanoes in the world. Ptichy (Bird) River is the second largest river on Kunashir and has a series of cascading waterfalls, with water that changes in color from azure to transparent. Locals consider the island's largest waterfall, Ptichy Waterfall (12 m), where the river empties into the sea, the most beautiful natural feature on the island. There are also some unusual golden waterfalls, with water colored by golden algae. The Tyatina, Saratovka, and Nochka Rivers are the heart of salmon spawning on Kunashir and home to brown bears, which have a population density of one or two per sq. km. Broadleaved forests around Alyokhino Village have rare plants, insects, and birds. Virtually all of Kunashir's forest species can be seen in the mixed forests near

the Vodopadnaya and Svetlaya Rivers. This is the only place on Kunashir where the magnolia vine bears fruit. There are also hydrothermal vents and Kunashir's largest fumarole. Endangered mountain hawk-eagles (*Spizaetus nipalensis*) nest near the summit of Mendeleev Volcano. Stolbchaty Point is arguably the most spectacular area of columnar basalt in the world. Relict populations of Kunashir's reptiles inhabit nearby hot springs.

Poronaisky. This *zapovednik* protects landscapes characteristic of central Sakhalin, such as mountain taiga and coastline. The *zapovednik* consists of two unconnected portions, Nevsky and Vladimirovsky, that almost meet along the coast. A much larger reserve was originally planned but it was impossible to reach agreement with logging ventures based in Sobolinoe, a village situated between the sections of the reserve. Animals wander over to the unprotected zone and are hunted. The *zapovednik* protects the remaining intact conifer forests and important wetlands for migratory waterfowl. Protected species include white-tailed and Steller's sea eagles, osprey, Siberian grouse, and Sakhalin musk deer. The *zapovednik* has a buffer zone, where logging, fishing, hunting, use of poisonous chemicals and fertilizers, tourism, and building are all forbidden. This buffer zone includes part of Nevskoe Lake, but protection is inadequate. Efforts to change the reserve boundaries and to bring nearby Tyuleny (Seal) Island under the jurisdiction of the *zapovednik* have so far failed.

Nature parks. The one nature park on Sakhalin, Moneron, encompasses all of Moneron Island, which is about 7 km from north to south and about 4 km from east to west, and a two-mile marine zone around the island. Moneron has an unusual combination of mountain landscapes, alpine meadows, rocky gorges, and shingle beaches with agate and jasper. The clear waters around the island are high in biodiversity, the 30 to 40 m of visibility and warm current creating prime conditions for rare underwater fauna. The island is considered one of the best scuba diving sites in the RFE. Commercial species of invertebrates, such as sea urchin and trepang, need to be protected as their populations are threatened elsewhere due to overharvest. Many marine mammals breed on the island's coastal

reefs, and more visit during spring and autumn migrations. Marine birds nest on the coastal islets around Moneron. On Moneron itself there are colonies of tufted puffins (*Fratercula cirrhata*), rhinocerous auklets (*Cerorhincha monocerata*), black-tailed (*Larus crassirostris*) and slaty-backed gulls (*L. schistisagus*), common murres (*Uria aagle*), and Japanese cormorants (*Phalacrocorax conspicillatus*). Peregrine falcons and white-tailed sea eagles also nest here. Flora includes many rare plants, among them Japanese yew and goldenroot (*Rhodiola rosea*). A third of the island is covered by meadows, where tall grasses reach 3.5 m.

Although the regulations are vague, activities that might harm the landscape, flora, fauna, and objects of cultural and historical interest are forbidden. Park managers organize tours to the island to secure revenue for the park. When the park was created, scientists determined the carrying capacity of the park and are now establishing zones within it to ensure that the tourism is ecologically sustainable.

Zakazniks. There are one federal-level and thirteen *oblast*-level *zakazniks* in the *oblast*.

Malye Kurily. The *zakaznik* was created to protect nesting, migrating, and wintering birds, marine mammals, including endangered whales and dolphins, and important spawning grounds for commercial fish species and marine invertebrates. It has outstanding floral diversity and beautiful coastal landscapes. It also supports a large population of Shikotan vole (*Clethrionomys sikotanensis*), which only lives here and on southwestern Sakhalin. Russia's sole breeding colony of intermediate egret (*Egretta intermedia*) was discovered here in 1989.

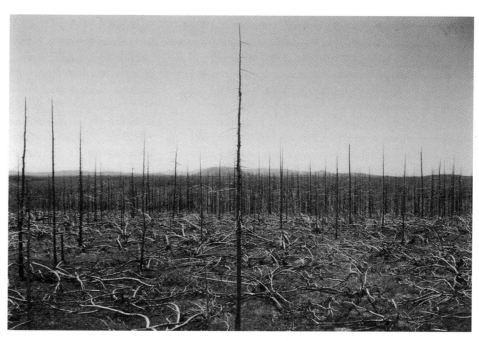

Fires in 1998 destroyed 100,000 ha of Sakhalin's forests.

Notable *oblast*-level *zakaznik*s include Vostochny (Eastern) Zakaznik, which is the first PA to protect Sakhalin's dark-conifer taiga. It protects largely pristine spruce and fir forests in the basins of two large spawning rivers. In contrast with other *zakaznik*s on Sakhalin, commercial logging is completely prohibited. Oleny (Deer) Zakaznik, established in 1989, stretches along the northeastern coastline and protects spring and summer reindeer pastures, valuable wetlands and spawning rivers. The Sakhalin Hunting Service and the Sakhalin Committee on Environmental Protection have attempted to renew its status, but it now appears that it will not be renewed. Oil companies are now likely to lay pipelines across the territory. Nogliksky Zakaznik was established in 1998 in north central Sakhalin (Nogliksky Raion), with assistance from the World Wildlife Fund; it protects reindeer pastures, the Siberian grouse, wild reindeer, and other species. The Dagi-Komsomolsk pipeline and a parallel road cross the northern part of the preserve. Domestic reindeer migrate along this route during winter and summer. The Poluostrov Krilon (Krilon Peninsula) Zakaznik was established in 1972 to protect the game populations of the eastern portion of the peninsula. However, fires and poaching have plagued this reserve. Severny (Northern) Zakaznik protects part of Schmidt Peninsula in the far north of Sakhalin and the region's large massifs of virgin forest, mostly spruce. Hunting and commercial logging are allowed in this *zakaznik*. Regional government officials continue to see this *zakaznik*'s considerable timber resources as suitable for future logging.

Natural monuments. The *oblast* has forty-eight natural monuments, including eight geological, twenty botanical, fourteen complex, three zoological, and three hydrological. In 1997, the Sakhalin Committee on Environmental Protection created the Lunsky Zaliv (Lunsky Bay) Natural Monument (22,110 ha) along the coastline closest to the offshore oil and gas projects to protect the nesting areas of rare and endangered birds—Steller's sea eagle, white-tailed sea eagle, osprey, Siberian grouse—and important stopover points for large numbers of migratory birds. The protection status allows native fishermen and indigenous family enterprises to fish here. Following protests from scientists and because of the legal protection provided by the natural monument, Sakhalin Energy had to reassess its plans to lay a pipeline here.

Vagis Mountain (29,500 ha) was established in 1998 to protect the dark-conifer forests in northwestern Sakhalin, one of the last significant stands of conifer forest on Sakhalin. Anna River, a part of southern Sakhalin that has been spared much anthropological disturbance, was designated a natural monument (3,000 ha) in 1983, but the area is threatened by increased access and logging (see pp. 390–91). Vaida Mountain Natural Monument was established in 1983, but this has not prevented logging and mining (see p. 393).

Several monuments exist only on paper. The fact that those responsible for protection have often been the forest service, schools, and *raion* councils, has not helped. The Society of Hunters and Fishers and other land users and organisations have been restructured or have not been in a position to patrol these protected areas. The Sakhalin Committee on Environmental Protection was doing an inventory of natural monuments to clarify their boundaries and increase protection but, with the abolishment of the Committee, the status of this project is now unclear.

Biodiversity hotspots

1. Pursh-Pursh and Vengeri River basins, Nabilsky Ridge (forest)

R. SABIROV, N. SABIROVA, G. VORONOV—The area encompassing Nabilsky Ridge and its adjacent river basins is one of the last large-scale, intact forest ecosystems on Sakhalin Island. Located in the center of the island, the forests are primarily dark conifer with dominant spruce. Nabilsky Ridge, with its steep, jagged mountains, includes some of Sakhalin's highest peaks, from 1,400 to 1,600 m. The peaks of nearby Tsentralny Ridge are somewhat smaller, between 700 m and 900 m. There are numerous rivers and streams. It is a scenic area popular with tourists.

The headwaters of the Pursh-Pursh and Vengeri Rivers lie on the eastern slope of Nabilsky Ridge and the rivers flow east into the Sea of Okhotsk. Pursh-Pursh River stretches for 30 km; Vengeri is 35 km long. Both rivers are important salmon-spawning grounds. The mountainous topography and the Northern Sakhalin Current in the Sea of Okhotsk influence the region's climate: Winter temperatures average −22°C, with between 70 cm and 80 cm of snowfall yearly. Snow covers the coastal areas for about six and a half months of the year and the mountaintops are snow covered for almost nine months. During August, the warmest month, the cool, misty, and rainy summers prevent average temperatures from exceeding 15°C.

The Pursh-Pursh and Vengeri River basins are well studied, thanks to financial support from Friends of the Earth–Japan, the Japanese Pro-Natura Foundation, and the Sakhalin Committee on Environmental Protection. Of particular value in this region are the large tracts of spruce, fir, and larch forests that have not been disturbed by commercial logging or fire. Stone birch and aspen forests are also found here, along with poplar and willow, white birch, alder, elm, oak, maple, and others. Many species are endemic, particularly among the high mountain flora.

The region's topography and climate, along with the rich mixture of vegetation communities, provide optimal conditions for species diversity. Although the Pursh-Pursh and Vengeri basins comprise only 1 percent of Sakhalin's land area, they are home to about a third of the island's flora species, nearly two-thirds of all terrestrial fauna species, and over half of all bird species. The two river basins are home to 374 vascular plant species, 30 of which are rare and endangered, including Redovsky's rhododendron (*Rhododendron redowskianum*).

The fauna of the region includes thirty terrestrial mammal species, five amphibian and reptile species, and 186 bird species. Fifty-eight species of fauna are rare and endemic, and twenty-eight are listed in the various *Red Data Book*s. Mammals include the Sakhalin roe deer and wild reindeer. The area is particularly important for the latter during rutting and calving. Rare birds include the brant goose, swan goose, whooper swan, mandarin duck, osprey, golden eagle, Siberian grouse, eagle owl, white-tailed sea eagle, Steller's sea eagle, and others. Because of the rich fisheries, abundance of good nesting sites, and absence of humans, large populations of sea eagles nest in the region, and in autumn it is not uncommon to encounter eight or nine in a day. The pristine rivers are productive spawning grounds for pink salmon, chum salmon, cherry salmon, and coho salmon. The scenic landscape draws skiers to the steep slopes for summer skiing; there is a yearly ski camp at Chamginsky Pass.

Threats. Until 1995, with minimal recreational and hunting activity, the region was completely untouched, protected primarily by its inaccessibility—the steep Nabilsky Ridge serves as a formidable barrier. Then the timber company Smirnykhovsky Lespromkhoz (LPX) leased part of the territory and started to build logging infrastructure, with plans to log by helicopter as well.

Existing protection measures. Thanks to the efforts of activists and scientists, again with the support of Friends of the Earth–Japan, Vostochny (Eastern) Zakaznik was created in 1999.

Recommendations. The following actions should be taken:
- End commercial logging.
- Terminate Smirnykhovsky LPX's timber lease on the grounds of repeated violations of logging regulations.
- End road and bridge construction.
- Increase financing for Vostochny Zakaznik.

2. Coastal bays and wetlands of Northeastern Sakhalin (wetland and marine)

D. LISITSYN—The northeastern coast of Sakhalin and the island's shoreline and coastal waters should be regarded as a single ecosystem, essential for preserving the biodiversity of the entire area. The coastline is an important migratory route for waterfowl traveling south to Japan, southeast Asia, and Australia. The coastal waters and the bays also serve as shelter during summer migrations. Population counts taken here between 1989 and 1991 tallied more than sixteen thousand swans, twelve thousand shorebirds, one hundred thousand ducks, and thirty thousand gulls.

The seashore and coastal rivers provide the primary stopover grounds for river ducks (mallards [*Anas platirhynchus*], Northern pintails [*A. acuta*], Eurasian wigeons [*A. penelope*], Northern shovelers [*A. clypeata*], and common teals [*A. crecca*]). Tufted duck (*Aythia fuligula*) and greater scaup (*A. marila*) also nest here, as do mergansers (*Mergus*) and Common goldeneye (*Bucephala clangula*). Large, fish-eating birds of prey nest along the shoreline; these include the endangered Steller's sea eagle (*Haliaeetus pelagicus*), white-tailed sea eagle, and osprey. All the larger bays support mixed colonies of common (*Sterna hirundo*) and Aleutian terns, amounting to a few thousand pairs. Nesting shorebirds include sandpipers (*Calidris*), redshank (*Tringa totanus*), common greenshank (*T. nebularia*), and one of the rarest birds in the world, the Nordmann's greenshank.

These bays are also important fisheries; eight salmon species are found here, including pink salmon, chum salmon, cherry salmon, and coho salmon. Migrating smolts rest in these shallow waters before heading off to the open sea. The northeastern Sakhalin coast is a key feeding place for many populations of Pacific salmon. Young fish spend time in the coastal waters of the Sea of Okhotsk before migrating to the Pacific Ocean. The salmon then return along the same route to spawn. Massive migration begins in the last week of June (cherry and pink salmon) and continues until November (chum and coho). Thus, the rivers that flow into the Sea of Okhotsk on the northeastern Sakhalin coast support their own salmon runs. This fact makes the area crucial for the health of fisheries in the entire Sakhalin region, fisheries being the lifeblood of the Sakhalin economy.

Most nearby rivers also have Dolly Varden (*Salvelinus malma*), taimen (*Hucho taimen*), and whitefish (*Coregonus*). Smelt (*Osmerus*), Pacific cod (*Gadus macrocephalus*), and Pacific herring (*Clupea pallasi*) are abundant in the bays. The endangered gray whale also migrates to the coastal waters.

Threats. The offshore oil and gas projects pose great threats to the area, both on land and off shore.

Existing protection measures. In 1995, the Sakhalin Committee on Environmental Protection proposed to the federal government that the northeastern coastal wetlands be listed as a Wetland of International Importance (Ramsar site). For a variety of reasons, the Federal Committee on Environmental Protection, based in Moscow, continues to hinder this listing process.

Recommendations. The following actions should be taken:

- Declare the coastal bays and wetlands a Ramsar site; this would bring international attention to the importance of the region.
- Require that regional and federal authorities, nature protection agencies, and oil and gas companies comply fully with all existing Russian legislation and regulations during oil and gas development.
- Support the efforts of NGOs, indigenous groups and local citizens on Sakhalin to monitor oil and gas development.
- Permit only the most advanced and least damaging exploration, extraction, and processing methods, including adherence to technological practices such as zero discharge of drilling wastes and the use of double-hulled tankers.

3. Anna, Sima, and Bakhura River basins (forest)

R. SABIROV, N. SABIROVA, G. VORONOV—From their headwaters on the eastern slope of Susunaysky Ridge, the Anna, Sima, and Bakhura Rivers flow east into the Sea of Okhotsk. Dark coniferous forests of predominantly fir and spruce characterize the area. The topography is highlighted by five peaks: Shuya (612 m), Sokolskaya (839 m), Pervomaiskaya (749 m), Bykova (954 m), and Avgustinovicha (1,034 m). Between these peaks are numerous rock slides and steep, narrow valleys.

Sakhalin's southeast coast differs from other areas of the island in that winters are relatively mild. January temperatures average approximately −13°C, falling to −15°C on mountaintops. The warmest month is August, when temperatures average 16 to 17°C. Absolute high temperatures are much higher, however, often exceeding 30°C. Annual precipitation averages between 800 and 1,000 mm, with 130 frost-free days. The area is also one of Sakhalin's snowiest. Because of the heavy snow cover, mild temperatures, and fast currents, the rivers do not freeze over in the winter.

Fir and spruce forests cover 70 percent of the territory. Willow, alder, Japanese stone pine shrubs, and stone birch make up the rest of the forest cover in the Anna River basin. With forest fires rare and logging absent, old-growth forests remain where there are no roads.

Two hundred and seventy-two vascular plant species flourish in the Anna River basin (23 percent of all such species found on Sakhalin Island). Many of Sakhalin's species were first discovered in this area, and twenty are endangered. Numerous species of moss, lichen, and fungus are found here as well.

Fauna include 201 vertebrate species: 162 bird, 35 mammal, 2 amphibian, and 2 reptile, totaling about 40 percent of all Sakhalin's vertebrates. Endangered species include the Sakhalin musk deer, mandarin duck (*Aix galericulata*), whooper swan, eagle owl (*Bubo bubo*), gyrfalcon (*Falco rusticolus*), and peregrine falcon (*Falco peregrinus*).

The ecosystems of the other two basins (Bakhura and Sima) are not as well studied, but they do differ significantly from the Anna River basin. The Sima River basin is characterised particularly by scenic cliffs and waterfalls, and groves of wild Ainu cherry (*Prunus ainensis*).

The watershed of the Bakhura River, totaling 37.7 sq. km, is much larger than those of the other two rivers. The river valley is dominated by large poplar and willow trees, frequently nested in by sea eagles. There are also magnificent stands of oak and other broadleaved species. These add a distinctive, east Asian accent to the otherwise boreal floral communities.

All three rivers are important spawning grounds and, thanks to the dense forest cover along their banks, are the most productive rivers on the southeast coast of Sakhalin. Dolly Varden, steelhead (*Oncorhynchus mykiss*), pink salmon, chum salmon, and cherry salmon are the most common species spawning in these rivers.

Threats. From 1940 to 1990, the territory was not significantly affected by human economic activity. The absence of roads and the alpine topography helped prevent the region from being settled. This has, however, begun to change with the onset of commercial timber harvesting and construction of logging roads nearby. Fishing, hunting, and wild herb gathering (both legal and illegal) have also started to take their toll. One company (Fenix-II), which has a permit to harvest salmon in Anna River, strings a large fishing net across the mouth of the river, with disastrous effects on salmon reproduction. Recreational use is also increasing.

Construction of a gravel road that cuts across all three rivers has destroyed many scenic cliffs and leveled the ground in many places. This road construction required the clearance of a 7 km-long, 20-m- to 50-m-wide strip along the upstream side of the road, and terraces have been built where the cliffs are steep. This road construction is likely to change the hydrological regimes of these rivers. It will certainly cause erosion, and, worse, provide access to previously remote regions, increasing the likelihood of forest fires and poaching.

Existing protection measures. This is one area of southern Sakhalin that has been largely spared the damage of human development. Pristine forests remain in the Anna River basin, 3,000 ha of which were designated a natural monument in 1983. There is also an initiative to create Susunaisky National Park, which would protect the headwaters and basins of all three rivers. This effort, which was supported by the Sakhalin Committee on Environmental Protection, is also included in a federal program for the creation of new protected areas by 2005.

Recommendations. The following actions should be taken:

- Improve protection of the Anna River Natural Monument and raise its status.
- Phase out leases for salmon harvesting in all three rivers.

- Enlarge the Anna River Natural Monument to 50,000 ha; the area is now too small to protect species that require extensive habitat, such as eagles, brown bear, river otter, sable, and American mink.
- Push for the creation of Susunaisky National Park.

4. Schmidt Peninsula (forest)

R. SABIROV, N. SABIROVA, G. VORONOV—Schmidt Peninsula lies at the extreme northern tip of Sakhalin Island. Two hilly ridges (623 m long) run northwest to southeast, and the Pil-Dianovskaya lowlands lie between them. There are picturesque cliffs and waterfalls. Prevailing winds moderate winter temperatures, making the climate somewhat warmer than the rest of central and northern Sakhalin. Winter months are generally 2 to 5 degrees warmer, and temperatures do not fall below −28°C.

The warmer temperatures and hilly topography have created much richer forests than those immediately to the south. Larch forests quickly give way to virgin Ayan spruce forests on Schmidt Peninsula, particularly in well-drained areas on hillsides protected from the winds. Stone birch grows on the windswept slopes, with larch dominating at lower elevations. Willow and alder forests thrive in floodplains. Japanese stone pine shrubs dot the coastline and mountain peaks. Many alpine species, such as *Erysimum pallasi*, grow only on Schmidt Peninsula.

Brown bear, red fox, sable, river otter, ermine (*Mustela erminea*), and reindeer live on the peninsula. Gallinaceous birds are abundant and include the hazel grouse (*Bonasa bonasia*), willow grouse (*Lagopus lagopus*), and Siberian grouse (*Falcipennis falcipennis*). Swan and geese also migrate through the area, and rare coastal birds, such as sea eagles, nest on the coasts. Pink salmon flourish in the clean rivers and the endangered Amur sturgeon (*Acipenser schrencki*) and kaluga sturgeon (*Huso dauricus*) migrate to the bays.

Threats. Because timber reserves are declining elsewhere on the island, the valuable Ayan spruce stands are now a temptation for Sakhalin's timber enterprises. New road construction and existing and planned mining activities compound the logging threat. Increasing unregulated tourism, poaching, and continuing efforts to bury toxic chemicals (especially DDT) are also threats to the peninsula's forests and wildlife.

Existing protection measures. Severny (Northern) Zakaznik (a regional-level game preserve) inadequately protects the peninsula, as hunting and commercial logging are allowed within the *zakaznik* boundaries.

Recommendations. The following actions should be taken:
- Raise the protection status of Severny Zakaznik to that of a comprehensive nature *zakaznik* or *zapovednik*; prepare an scientific justification as a first step.
- Thoroughly research the flora and fauna.
- Halt construction of new roads and mines.

5. Krilon Peninsula (forest)

S. S. MAKEEV, A. A. TARAN—Sakhalin's southwestern tip, Krilon Peninsula, is the warmest part of the island, largely thanks to the warm Tsushimi Current from the south. January temperatures average −10°C in the snowy winter; August temperatures in the warm, humid summers average 17°C. Autumn lasts until mid-November and there are 140 to 160 frost-free days each year.

The peninsula has low mountain ridges, none higher than 500 m, and is crisscrossed by numerous rivers and scenic cliffs. The fragments of uncut fir and coniferous broadleaved forests support some of the highest species diversity on the island. During the 1930s and 1940s, clear-cut logging and repeated fires devastated the southern half of the island.

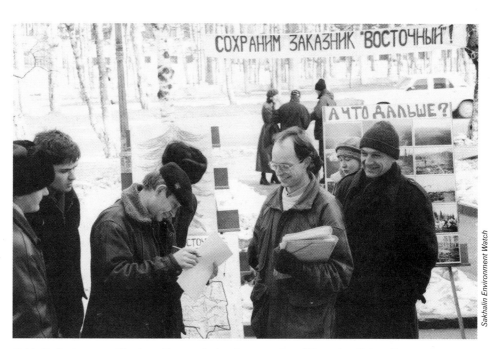

Sakhalin Environment Watch

Sakhalin Environment Watch staff campaigning for protection of Vostochny Zakaznik.

Unfortunately, many of the forests have not grown back, having been replaced by unproductive birch forests and dwarf bamboo. Erosion on the steep, logged slopes has silted up many rivers and streams. These misguided land-use practices have caused microclimatic changes, degrading the unique flora communities of southern Sakhalin. Animal populations have plummeted. Forest cover has fallen by 40 percent and continued logging will lead to irreversible losses of vulnerable plants and animals.

Oak, maple, and the Sakhalin cork tree (*Phellodendron sachalinense*) dominate the coniferous broadleaved forests. Walnut trees (*Juglans*), cherry trees, magnolia vines, and climbing hydrangeas (*Hydrangea petiolaris*) are also present. Equally important are the southern taiga communities dominated by Sakhalin fir, intermingled with Japanese yew and holly (*Ilex*). Stone birch and Middendorf's honeysuckle (*Diervilla middendorfii*) grow at higher elevations.

According to Russian ecologists, the peninsula has global importance for biodiversity conservation because of its five hundred vascular plant species and even greater numbers of moss, lichen, and fungal species. Endangered species include Wright's haw (*Viburnum wrightii*), spurred coral root (*Epipogum aphyllum*), Sakhalin catchfly (*Silene sachalinensis*), and many others.

In addition to brown bear, red fox, and sable, one hundred bird species live on the peninsula, including osprey, white-tailed sea eagle, mandarin duck, peregrine falcon, eagle owl, and Japanese white-eye (*Zosterops japonica*). Ruddy-breasted crake (*Porzana fusca*), a very rare visitor to Russia, nests in the river valleys, as do red-crowned crane and Oriental white stork (*Ciconia boyciana*). The cliffs along the shores host black guillemot (*Cepphus carbo*), ancient murrelet (*Synthliboramphus antiquus*), and tufted puffin (*Fratercula cirrhata*) colonies. Krilon's rivers still have large populations of cherry salmon, pink salmon, chum salmon, green sturgeon, and Sakhalin taimen.

Krilon Peninsula is considered a distinct geographical and botanical subzone, and its ecosystems serve as important baselines for research. Despite damage done to the region, the southernmost parts—particularly in the middle and upper reaches of rivers—have been spared from clear-cutting and retain their natural character. In addition, the low population density and absence of major transportation links, as well as the favorable climate and soil characteristics, facilitate natural regeneration in degraded ecosystems.

Threats. The settlements of Nevelsk, Gornozavodsk, and Shebunino, in the north of the peninsula, are the main areas of economic activity. Proposed plans to log the Uryum River basin would threaten salmon runs and populations of rare animal and plant species. The fishing industry pollutes rivers and streams and fishes irresponsibly. With the increasing number of visitors along the western shores, forest fires are a concern.

Existing protection measures. In 1972, Sakhalin established a 52,000-ha hunting *zakaznik* near Aniva Bay on the eastern portion of the peninsula to protect game populations. The *zakaznik* fails, however, to protect the region from poaching and fires.

Recommendations. The following actions should be taken:
- Reestablish the Yuzhno-Sakhalinsky (Southern Sakhalin) Zapovednik (which functioned until the late 1940s), with northern boundaries marked by the Uryum and Lugovka River basins, a buffer zone no less than 1 km wide, and a 1-km protected marine zone. Incorporate the existing *zakaznik* within the *zapovednik*. Set up a moratorium on logging and strict controls on hunting, fishing, nontimber forest products collecting, and tourism until the *zapovednik* is organized.
- Complete a full inventory of flora and fauna to provide the scientific justification for reestablishing the *zapovednik*.

6. Nevskoe Lake (wetland)

N. PIROGOV, V. V. FEDORCHUK—Located in central Sakhalin north of Terpeniya Bay, Nevskoe Lake is a large (178 sq. km) but shallow brackish lagoon (2 km at its deepest point). Toward the east, the lake gives way to marshlands. Nevsky Spit, a long, narrow strip of land extending west to east, separates the lake from Terpeniya Bay. In many places, small lakes and thick peat deposits bisect the spit. Nevskoe Lake connects to the Bay through two main points, Promyslovka Outlet and Nevsky Strait.

Conifer and broadleaved forests (larch, spruce, birch, and willow) grow on the western shores of Nevsky Spit. These woods are largely inaccessible because the pine bush thickets are so dense. Along the shore at the water's edge are birch stands stunted by frigid, northerly winds and large snow banks. Forests on the eastern shore of Nevsky Spit were destroyed to build the narrow-gauge railroad that connects the city of Poronaisk with the village of Trudovoe.

Preliminary research demonstrates that the Nevskoe Lake area has a high level of biodiversity, in part because of the wealth of food resources (plant and animal). The shallow lake warms up quickly, which stimulates growth of phytoplankton and zooplankton. These plankton serve as the primary food source for fish, including salmon that travel up the Rukutama, Olenya, and Angurovka Rivers to spawn.

The fish support other fauna. A few dozen bird species nest near the lake and, during fall and spring migrations, tens of thousands of birds (ducks, shorebirds, gulls) stop over on the lake. The lake provides shelter from stormy weather, as birds escape Terpeniya Bay. Rare species include Steller's and white-tailed sea eagles, peregrine falcon, osprey, mandarin duck, and the migrating spoonbill sandpiper (*Calidris pygmaeus*). Whooper and Bewick's swans, oystercatchers, broad-billed sandpipers (*Calidris falcinellus*), and reed

bunting (*Emberhiza shoeniculus*), rare in the Far East, are also found. During the summer, the sandy bars and islands of the southern part of the lake provide nesting grounds for the globally endangered Aleutian tern. Red foxes, river otters, muskrats, raccoon, and brown bears feed near the shoreline of the lagoon. Muskrat, which was introduced here in the 1960s, has adapted particularly well to local conditions.

Threats. The lake plays an important role for many species, but except for the eastern part of the lake, the region is poorly protected, and the entire ecosystem is becoming degraded: swampland is spreading, the waters are becoming increasingly shallow, and fish are starving. The main culprit is the dike that provides railroad passage to the town of Trudovoe and has disrupted local groundwater supplies and the circulation of the lake's surface water. Timber cuts around the headwaters of the rivers on the lake's watershed decreased the amount of available water to the lake, and proportionally increased sedimentation of the lake. At present, large amounts of inorganic and organic compounds continue to flow into the lake, silting up the already shallow waters and accelerating bog formation on the lake's margins. This is especially visible along the eastern edge, which lies in the buffer zone of Poronaisky Zapovednik. Weak water circulation promotes the accumulation of organic matter and facilitates the rapid growth of green-blue algae, degrading the quality of water for the fish.

Another major factor is the year-round poaching. The lack of protective measures (except in the buffer zone of the *zapovednik*) and the ineffectiveness of environmental inspectors has resulted in the loss of natural lake fauna. The disturbance of birds during the nesting season is also serious. In 1996, a few colonies of common and Aleutian terns disappeared from an island and near the lakeshore after hay harvesting. A fire in 1997 destroyed an important Japanese stone pine grove near the town of Promyslovoe, which meant the loss of shelter for many species. According to some reports, the endangered Blakiston's fish-owl used to nest in the grove. Some other woods along the shore may still contain this rare species.

Existing protection measures. The only current measure to protect the region is the inclusion of the eastern part of Lake Nevskoe in the buffer zone of Poronaisky Zapovednik.

Recommendations. The following actions should be taken:
- Complete an ecological and archaeological survey of the territory.
- Determine the appropriate protection status (historical-natural park, national park, complex *zakaznik*, etc.).
- Breach the dike and create a suspension bridge to restore the natural water exchange between the lagoon and the sea.
- Establish zones in the territory to locate the most valuable areas requiring maximum protection, and forbid economic activity in such areas.

- Research potential Blakiston's fish-owl nesting sites and protect such sites as *zakaznik*s.

7. Vaida Mountain (forest)

A. KLITIN—Vaida Mountain, once called Okadayama by the Japanese, is the largest ancient rift formation on Sakhalin Island. Located at the headwaters of the Vitintsy River, 12 km southeast of the town of Izvestkovy, the mountain's two peaks (835 m and 947 m) are among the highest points in the Rukutama River watershed, which includes the Vitintsy and Melkaya Rivers. Vaida is notable for its twenty-four karst cavities, which are of great interest to geomorphologists; its environs in general are of geological, archaeological, and zoological importance. The caves on Vaida Mountain, particularly Vaida Cave, Medvezhikh Tragedy ("Bear Tragedy") Cave, and Kaskadnaya Cave, with their distinctive formations, brilliant stalactites, stalagmites, petroglyphs, and variety of animal remains have attracted specialists for decades. The areas around the mountain that remain undisturbed by fire host fine examples of alpine flora, including two species of lady's slipper (*Cyrpipedium*) and a number of rare insects.

Two km to the south of Vaida is the remarkable Lake Perevalnoe. This 6-sq.-km kettle lake was formed by a landslide, and there are multiyear peat formations along its shores. A tiny population of East Sakhalin poppy (*Papaver sakhalinensis*), endemic to these mountains, grows in the watershed above the lake. Between 1986 and 1996, the number of these rare plants increased from about four to about forty.

Threats. Although declared a natural monument in 1983, Vaida Mountain has been hit with logging and mining; the local press has reported a number of these violations. All of these operations were approved by the local *raion* administration, despite the regulations protecting natural monuments. In addition, the construction of a new road in the late 1980s led to the extirpation of reindeer due to uncontrolled hunting. Future threats include possible limestone mining at Vaida once existing deposits elsewhere are depleted; the new road makes Vaida a convenient location for an open-pit quarry.

Existing protection measures. The existence of the road and the ease with which the regulations protecting the natural monument could be repealed at any moment (particularly if there is a demand for the mountain's limestone resources) leave the area highly vulnerable.

Recommendations. The following actions should be taken:
- Raise the status of the natural monument at Vaida Mountain to that of a nature park, strengthening its protection regime.
- Ensure that recreational visits to the mountain's caves are led by experienced guides.

Economy

Emma Wilson

Until the late nineteenth century the main natural resource users on Sakhalin were the indigenous Nivkhi, Ainu, Evenki, and Uilta (Orochon, Oroki). Russians had begun to explore Sakhalin's resource base by the 1850s. From the 1860s there were conflicts between Japan and Russia over fishing rights. Russia established sovereignty over Sakhalin in 1875, and the island became a notorious penal colony. In the 1890s, Russian business magnates, notably Grigory Zotov, set up commercial fishing *artel*s. Zotov also discovered Sakhalin's first oil reserves in 1904, a discovery that attracted considerable interest and capital from England, America, Germany, and China.[19] After the Russo-Japanese War of 1904–1905, Japan gained the southern half of Sakhalin, while Russia, abolishing the convict system, continued the industrial development of the north. The Japanese occupied northern Sakhalin between 1920 and 1925, after which they negotiated coal and oil concessions in the Soviet half of the island; these concessions were annulled in 1944. From 1925, to expand agriculture and exploit Sakhalin's resources, Soviet planners encouraged workers from the western USSR. Fishing and fish processing were further developed. The Russians overtook the Japanese in oil production, and the reserves became essential to the Soviet government, being the only known reserves in eastern Siberia.[20]

The Soviet government imposed collectivization policies from the 1930s, attempting to settle the indigenous people by introducing agricultural activities and setting up reindeer farming and collective fishing enterprises. The politics of amalgamation followed from the 1950s and 1960s: hundreds of native villages were closed and the indigenous people gathered into larger and larger settlements. In the 1950s and 1960s the Soviet government encouraged more and more settlers from European Russia to Sakhalin to work in scientific, industrial, and administrative jobs, and geological prospecting. Settlements developed around a single state-run industry that also provided essential social infrastructure; local communities came to depend entirely on the state. This dependence was even more acute for the indigenous people whose children were placed in state boarding schools (*Internat*) and whose traditional economic activities were reoriented to suit Soviet agricultural policy. They depended on state subsidies for transportation and market access. In the settlements, the indigenous populations were gradually assimilated. The result today on Sakhalin is a mixed population with an overall indigenous representation of 0.3 percent, rising to only 7 percent in the north.

Sakhalin has retained its role as a natural resource colony. Since the collapse of the command economy, the loss of state subsidies and guaranteed markets has hit many sectors of Sakhalin's economy hard, from the indigenous reindeer herding collectives to agriculture to paper production, and the dependent populations are now suffering the consequences. Fishing remains a vitally important economic activity, not only at the regional level, but also increasingly for subsistence users and small-scale entrepreneurs. The timber industry is surviving by focusing on raw log export to Asia. The oil industry is becoming more prominent, representing about one-quarter of total industrial production. The energy crisis on Sakhalin now is highlighting the conflict between satisfying local needs for Sakhalin's resources and political demands for foreign currency profits.

Fishing—lifeblood of Sakhalin

The Sakhalin fishing and fish processing industry constitutes 16 percent of the total RFE industry, making it the third-largest producer of fish and fish products after Primorsky Krai and Kamchatka Oblast. Fishing and fish processing are major sources of revenue and the largest employers in the *oblast*. Fisheries around Sakhalin Island have been heavily exploited for more than a hundred years. Overfishing has been the primary cause of decline, resulting, among others things, in significant fish population variations. In the past decade, illegal fishing around Sakhalin Island has flourished, affecting, especially, valuable marine resources such as crab.

Another significant concern is the Russian-Japanese agreements that allow Japanese boats to use driftnets for taking salmon near the Kuril Islands. This practice, particularly in key, narrow migration routes such as the Kuril Straits, can wipe out entire runs of salmon from a particular river basin.

Another significant issue occurred in June 1999 with the herring kill in Piltun Bay. Dead herring, piled half a meter high and between 1 and 6 m wide, covered a 12-km strip of shoreline in Piltun Bay. Investigators from the Sakhalin-based Institute of Fisheries and Oceanography (SakhNIRO) estimated that the dead fish amounted to between 1,000 and 11,000 tons. According to an investigation by two environmental groups, the kill may have occurred as a result of dumping from the Molikpaq oil-drilling platform, part of the Sakhalin II project. However, the groups claim that government environmental agencies refused to investigate the incident thoroughly, and the project's operator, Sakhalin Energy Investment Company, refused to provide the groups with data that could prove or disprove its responsibility.

– EW

Agriculture

With its mountainous geography and dense network of creeks and rivers, only 2 percent of Sakhalin's territory is suitable for agriculture. The industry consists mainly of vegetable growing, production of animal feed, dairy and meat farming (including reindeer herding), and poultry farming. More than 85 percent of the agricultural land lies in the basins of six rivers, mainly the Tym and Poronai, in central Sakhalin, and in the south. In these areas between 40 percent and 60 percent of the land is cultivated. Present agricultural practices cause loss of topsoil, and agrochemicals poison the land. The hardest hit areas are the wetlands of the Tym River valley and around Aniva Bay, where migratory bird habitats are damaged and salmon now have no access to once-rich spawning rivers. Pastures are overgrazed to about four times their capacity. Agricultural production has declined, so the quantities of mineral fertilizers and poisonous chemicals used on the soil has decreased sharply, reducing the amount of pollution and improving the ecological condition of wide areas of valleys, especially in the basins of the Tym and Poronai Rivers.

Fishing

A. KLITIN — The Japanese were exploiting fishing grounds around Sakhalin long before the Russo-Japanese War. Until the end of the 1890s, Japanese fishing activities in Sakhalin waters were limitless as they controlled four hundred fishing areas.[21] The payments for using these resources were negligible. After the Russo-Japanese War, when Sakhalin was split between Japan and Russia, Japanese fishing (including crab fishing) intensified. The Russian-Japanese Fishing Convention of 1907 did not improve the situation. In the northern (Russian) part of Sakhalin, there were only four Russian border guards to control the activities of Japanese fishermen.

Commercial fishing by Russian fishermen is done by means of seines or sweep nets. Japanese fishermen prefer to use driftnets for salmon fishing and have been doing so near the territorial waters of the RFE since 1927. At the end of the 1980s, an intergovernmental agreement was signed that allowed Japan to engage in driftnet fishing in the economic zone of the Russian Federation. In February 1992, under pressure from the United States, New Zealand, and Canada, Japan signed a convention to ban use of driftnets in open waters, because of the threat to birds, dolphins, and whales.[22] But Japanese driftnet fishing continues today in the Russian economic zone. As a rule, approximately fifty Japanese vessels use driftnets all along the ocean side of the Kuril Islands. The same happens in the southern Sea of Okhotsk. Every vessel puts out and pulls in about eight 4-km-long nets daily.

Fishing operations in Sakhalin are carried out by Nevelsky Trawling Fleet, Korsakovsky Ocean Fishing Base, Severo-Kurilsky (North Kurils) Seiner Fleet, eleven fishing collectives (*kolkhozes*), Alexandrovsk-Sakhalinsky, Kurilsky, and Yuzhno-Sakhalinsky fishing factories, Ostrovnoi and Yuzhno-Kurilsky industrial fishing complexes, Kholmsky Marine Fishing Port, Pilenga-Godo and Sisafiko joint ventures, Svobodnoe TOO (limited liability company), Tunaicha AO (joint-stock company), Kuk ZAO (closed joint-stock company), Vostok Fishery company, Salmo company, Kanif International, and other private firms. At present, 351 commercial fishing areas (between 0.2 and 83 km long) are leased out along the Sakhalin coast. The allocation of quotas according to fishing areas works well with salmon fishing, but makes no sense with marine fish and invertebrates, which migrate widely.

Herring. At the end of the nineteenth century and the beginning of the twentieth century the major commercial fishing species near Sakhalin was Pacific herring (*Clupea pallasi*), found in the northern Sea of Japan. The average annual catch each year between 1900 and 1930 was 720,000 tons and in some years reached one million tons. At that time the quantity of herring in the Tatar Strait was very high, and it could be thrown onto the shore in great numbers. Thousands of tons of herring were used to make mineral fertilizer for rice fields in Japan. In the mid-1930s, the annual catch dropped to between 200,000 and 400,000 tons and remained at that level until the mid-1950s. For the past forty years, the Sakhalin-Hokkaido herring population has been in decline. In the 1970s the herring spawning areas were greatly reduced, due partly to the dumping of untreated waste from pulp and paper factories in the towns of Kholmsk, Chekhov, Tomari, and Uglegorsk. Current Japanese fishing strategy focuses on fishing young herring, so there is nothing left of the populations by the age of maturity (six years).

Salmon. In the 1970s and 1980s, the salmon catch was large and stable (between 30,000 and 80,000 tons) around Sakhalin and the Kuril Islands. The highest catches of salmon (over 100,000 tons) were made in 1989 and 1991, thanks to the high natural reproduction capacity of salmon and the efficiency of salmon hatcheries in the region. At present, over twenty hatcheries are operating on Sakhalin (most of them in the south). The main reproduction areas for pink salmon are the rivers on the southeastern coast of Sakhalin and on Iturup Island. These two areas produce over 70 percent of all salmon. To date, 30 percent of the natural salmon-spawning grounds have been lost as a result of logging and oil industry activities, and 130 rivers have became unsuitable for natural salmon reproduction; other rivers, such as the Tym, Poronai, and Naiba, have been greatly damaged.

Pollock. Pollock fishing began near the eastern coast of Sakhalin in 1975, and the annual catch here has never exceeded 150,000 tons. Pollock migrates here from the northern Sea of Okhotsk and from the Kuril Islands in the south. A marked decrease in the pollock population in the northern Sea of Okhotsk between the 1980s and 1990s resulted in a

significant decrease in the catch near the northeastern coast of Sakhalin (from 140,000 tons in 1986 to 540 tons in 1998). Near the southern Kuril Islands, the pollock catch reached between 300,000 and 400,000 tons in 1976–1982 and 1986–1988. In subsequent years, the annual catch decreased to 200,000 tons. Pollock also migrates to the Tatar Strait from the northern Sea of Japan. In the mid-1980s, the catch in Sakhalin waters of the Tatar Strait fell to 1,000 tons but rose to 16,000 tons by 1992. Nevertheless, with intensive fishing, the pollock population in the northern Sea of Japan has been in decline for the past twenty years. Up to 60 percent of the population is caught annually near the coast of Japan, a practice that severely disrupts the population's reproductive capacity.

Flounder. The main areas of flounder fishing were in the northern Tatar Strait, in the Ilinsk shallows, and in Terpeniya Bay, where the maximum catch was between 11,600 and 16,200 tons in the 1940s and 1950s.[23] Subsequently, the flounder catch decreased due to overfishing and now, in the northern Tatar Strait, does not exceed 2,000 tons; in the Ilinsk shallows the annual catch is 600 tons.

Smelt. According to data from Aniva Marine Fishing Protection Service, in Mordvinova Bay, sports fishermen catch 500 tons of smelt (*Osmerus mordax dentex*) in winter, five times more than the recommended allowable catch for this species. Smelt fishing was banned in Terpeniya Bay between 1986 and 1997. The population decline was caused by untreated industrial effluents dumped from the Poronaisky pulp and paper factory into Poronai River, where the main smelt spawning grounds are.

Crab. As far back as 1909 the Japanese, using floating crab-canning factories, were engaged in crab fishing in Sakhalin waters, mostly for Kamchatka king crab (*Paralithodes camtschatica*). Southeastern Sakhalin was exploited the most, because of the relatively high numbers of crab and the year-round fishing opportunities. Between 1914 and 1944, 109,660 tons of king crab were caught (approximately 3,537 tons per year). The maximum catch in the area (12,350 tons) was in 1917. In that year 117,515 cans of Sakhalin crab were exported to England and the United States. At the end of the 1930s, the numbers of king crab fell because of this overfishing. In the 1950s, the annual king crab catch was estimated at 3,300 tons. In 1953–1956, significant overharvest led to long-term decline of the crab population. Until 1985, the crab catch in the area never exceeded 200 tons. The population began to recover only in the early 1980s when trawlers were replaced with trappers, making fishing more selective. As a result, the allowable catch in the area grew from 200 to 840 tons between 1986 and 1996.

From 1991 to 2002, the Tatar Strait served as a main source for crab exports to Japan, with over sixty vessels fishing near the southwestern coast of Sakhalin. Exporting crab outside of Russian territorial waters (but still in the Russian 200-mile Exclusive Economic Zone) is much easier, so three to four times more crab were caught from 1994 to 1998 than was officially reported. This smuggling scheme is quite simple and safe for the crews. If inspectors from either Sakhalinrybvod (the Sakhalin branch of Glavrybvod) or the Special Marine Inspection Service pay an unexpected visit, the quantity of crab is immediately recorded in the fishing logbook prior to the inspection. The whole operation of legalising the crab catch takes no more than 30 seconds. But nine times out of ten, crab cargoes leave the EEZ without any obstacles. Where crab populations are significantly depleted and catches do not exceed between 100 and 200 kg, fishermen apply a different strategy. It is much more profitable there to "make an agreement" and collect crab from vessels that do not export it to Japan and, as a rule, have no quota allocation for crab fishing. Another popular illegal fishing method is to catch king crab but register it as blue crab.

Due to overharvest, both populations and allowable catch decreased abruptly. But reduced crab quotas failed to improve conditions as crabbers switched to the intensive harvest of female king crabs, severely affecting reproduction patterns. The Japanese, completely aware of the illegal nature of such catches, willingly purchase female crabs at dumping prices.

The long lifespan and other biological and population-related characteristics of the crab predetermined its slow recovery after overharvest. In the South Kuril Strait, for example, in the mid-1930s, the Japanese were catching up to 10,800 tons of king crab; in the mid-1960s, up to 5,700; today a 20-ton catch is difficult to achieve. Populations of other crab species have also declined as a result of intensive fishing, the predominance of Japanese interests in fishing and consumption, and illegal fishing practices.

In 1998 coastal crab fishing was carried out by fourteen enterprises of Sakhalinrybprom (Nevelsky Trawling Fleet, Sakhmoreprodukt AO, Korsakovsky fish-canning factory, Diana joint venture, Tunaicha AO, and others), Korsakov Ocean Fisheries Base, six fishing *kolkhoz*es, twenty-four enterprises of the Fishing Industry Association of Sakhalin, and six enterprises of the coastal fishing industry complex (Kompas, Taranai, Aborigen Sakhalina, and others). Deep-water crab fishing is carried out by Kurilsky Universal Complex, Binom, and fishing *kolkhoz*es of Sakhalin.

Shrimp. Two species of shrimp are caught in the Tatar Strait: northern shrimp (*Pandalus borealis*) and crested shrimp (*P. hypsinotus*). Shrimp fishing is done by Nevelsky Trawling Fleet Base, fishing *kolkhoz*es, Kurilsky Universal Complex, Komandor Company, Preobrazhenie Trawling Fleet Base (Vladivostok), Sako & Co., Baial Company, and others. Between 1979 and 1984, mostly Japanese vessels were engaged in shrimp fishing. In 1984, trapper fishing was started by using vessels of the Nevelsky Trawling Fleet Base. In 1990, the

number of ships increased to thirty-five. By 1995, there were sixty-two shrimp fishing vessels. Prices for small raw northern shrimp in Japanese ports were low, so fishermen began to target only the bigger crested shrimp. This was exacerbated by the indiscriminate system of permits for harvesting any shrimp species. As a result, the quantities of crested shrimp in catches in the early 1990s would reach from 96 to 99 percent. Thus, despite the estimated catch of 680 tons, the actual catch of crested shrimp in 1992 was 2,513 tons. The system was in place until 1996 and led to a drastic decrease in the population size in 1994–1995. Now the catch size of crested shrimp near the western coast of Sakhalin has been reduced to 50 tons. Since 1997, northern shrimp fishing in Tatar Strait has been done with shrimp trawlers, and one vessel may catch up to 20 tons of shrimp per month. In 1997–1998, the use of such trawlers in Aniva Bay resulted in decreasing population numbers of crested shrimp.

Fur seals. In the nineteenth century, fur seals (*Callorhinus ursinus*) numbered up to fifty thousand on nine of the Kuril Islands. Native Ainu people routinely used the noise from large rookeries to help them navigate in foggy weather. They seldom hunted the seals, preferring to use bird skins to make clothes. From 1881 to 1896 fishermen caught twenty-four thousand and five hundred fur seals and in the process destroyed this population.[24] Not until 1955 were small groups of fur seals (totaling about three thousand) discovered on the Dolgaya and Khitraya rocks (Kuril Islands) by the Russian scientist S. K. Klimov. The fur seal populations did not recover to their former size (fifty thousand) until the 1980s.[25] Fur seals also live on tiny Tyuleny (Seal) Island, about 18 km from Terpeniya Cape on Sakhalin Island. By 1896, American and English poachers there helped to reduce the population of two hundred thousand fur seals to only two thousand.[26] According to V. P. Shuntov's estimates, between fifty thousand and sixty thousand fur seals were killed annually at that time on the Kuril Islands and Tyuleny Island.[27] In 1911, a convention was signed between the United States of America, Russia, Japan, and Great Britain restricting fur seal hunting, and populations on Tyuleny Island recovered. However, in 1941, the Japanese resumed hunting, catching up to tens of thousands of fur seals annually and reducing the population to between thirty thousand and thirty-five thousand in five years.[28]

It took forty years for the fur seal population on Tyuleny Island to recover, but by the end of the 1980s it had reached between seventy thousand and eighty thousand. In the 1980s, single male fur seals and four-month-old baby seals were killed periodically by order of the Ministry of Fisheries (Minrybkhoz), to "perfect techniques."[29] The International Convention on the Preservation of Fur Seals in the Northern Pacific Ocean was signed by the Soviet Union, the United States of America, Canada, and Japan in 1957 to the cost of

the Tyuleny Island rookery. Currently, the island is subject to intense sea erosion. Because of the decrease in demand for seal fur, the brigade from the Yuzhno-Sakhalinsk fishing factory left the island in 1994 after thirty years of fur seal hunting. At present, with no guards in place on the island, there have been cases of poaching. Animals also come to the island caught up with remnants of fishing nets, plastic bags, and steel rings.[30]

Seaweed. Fishing for seaweed (*Anfeltia tobuchiensis*) in Izmeny Bay (Kunashir Island) has been carried out since 1937 and most actively between 1964 and 1974, when the harvest reached 14.3 tons.[31] Unsustainable fishing of this fragile seaweed species resulted in reduction of its biomass, the most damage done in Busse Lagoon. By 1970, the seaweed resources in Busse Lagoon were 7.2 percent of the 1916 level, and the harvest was stopped in 1971. Twenty-nine years later the biomass has recovered somewhat, to 20 percent of the 1916 level.

In the 1980s the coastal waters around the Lesser Kuril Islands were famous for their abundance of brown seaweed, especially *Laminaria iaponica*, *L. angustata*, and *L. cichrioides*. After 1987, dredging tools were introduced and severely damaged the resource, reducing the laminaria near Zelyony Island, for example, from 320,000 tons to only 5,000 tons in 1990. The laminaria has now been replaced by less valuable species.

Other marine resources. Commercial fishing for Primorsky sea cucumber (*Patinopecten yessoensis*) in Aniva Bay began in 1961 on a bank near Kirillovo Village. By the following year, the harvest was already at 1,800 tons, which exceeded the recommended catch by 1.5 times. By 1966, the harvest had fallen to 30 tons, and in 1967 sea cucumber harvesting was banned. In 1976, the ban was removed and harvesting resumed until 1984. In 1985 the ban was reintroduced and remains in place. A ban on Primorsky sea cucumber fishing was twice introduced in Terpeniya Bay and near the southern Kuril Islands. It took fifteen years for the sea cucumber population to recover partly. Coastal fishing for gray sea urchin (*Strongulocentrotus intermedius*) began quite recently, without benefit of any scientific research to determine what was sustainable. In 1992 the catch was 600 tons. In 1997, the catch decreased to 70 tons—a sign that the resource has been damaged by overharvesting.

The trepang is harvested in Busse Lagoon, which is adjacent to Aniva Bay. Between 1978 and 1988 the catch reached 155 tons, exceeding the recommended harvest by 20–25 percent. In 1988 harvesting was banned. Currently, the population recovery is hindered by illegal harvesting, estimated at between 10 and 20 tons). Yet more damage was caused by fishing for red *Anphelitsiya* seaweed in Busse Lagoon as immature trepang were caught along with the seaweed.

Mining

Coal is still Sakhalin's major energy source—much of it coming from outside the region, mainly from the Republic of Sakha. Coal production is declining due to high transportation costs, loss of federal subsidies, outdated machinery, and intensive resource exploitation. From January to August 2000, Sakhalin's coal mines produced 1.75 million tons of coal. Coal producers are shifting from shaft to open-cast mining (80 percent of total mining) for the lowered costs and increased export competitiveness. Dolinsk and Poronaisk are the main coal centers, and there is also a large coal factory in Uglegorsk, where 42 percent of the *oblast*'s coal is extracted.[32] There are eleven underground coal mines, built in the 1930s and 1940s, and three open-cast mines: Solntsevsky, in Uglegorsky Raion (221 ha), Novikovsky, in Korsakovsky Raion (221 ha), and Lermontovsky, in Poronaisky Raion (2,796 ha). According to experts of the Vostokgeologiya

(Eastern Geological) Association, the estimated 650 million tons of reserves remain largely undeveloped due to financial difficulties.

Most existing mines are still unprofitable, and maintaining them is a heavy burden on the budget. While old, inefficient mines are being shut down (about seven in ten on Sakhalin), outsiders are coming to Sakhalin to develop new open-cast mines. These owner-operators have proven to be commercially effective, and in 1997 produced 25 percent of Sakhalin's coal output.

Energy

V. GOROKHOV—On January 20, 1925, a convention on cooperation between the USSR and Japan was signed in Peking (Beijing), returning northern Sakhalin to the Soviet Union and marking a new era in natural resource exploitation. The economic priority was to ensure constant growth in production and export of fuel and other resources. Development priorities remain much the same today.

Sakhalin's oil industry was established in 1928 when the Sakhalinneft Trust was set up and oil production began in the north. After only five years, annual output rose to 500,000 tons, peaking in the 1980s at 2.5 million tons. In seventy years, 104.2 million tons of oil have been extracted on northern Sakhalin, yet not one ton has been processed on Sakhalin. All of it was transported to the oil refinery in Komsomolsk-on-Amur or exported abroad.

Onshore oil production increased in the late 1990s to around 1.7 million tons annually, though this is much less than the 2.6 million produced in the 1980s. Rosneft-Sakhlinmornefegaz (SMNG) accounts for about 85 percent of onshore output and is a partner in several of the Sakhalin offshore projects. Most of Sakhalin's oil production is transported by pipeline to refineries in Khabarovsk and Komsomolsk-on-Amur. The small Petrosakh refinery on Sakhalin provides about one-third of Sakhalin's fuel needs. Onshore extraction has declined since the 1980s as known reserves have been depleted. Hopes for future development of the industry rest on the new offshore projects.

Offshore oil and gas. Mineral resources are nonrenewable and mineral development is unsustainable on Sakhalin and never will be sustainable; biological resources, if properly managed, can be developed sustainably. The Sea of Okhotsk has tremendous marine resources and proper development of these resources should take priority over oil and gas development. During the seventy years of oil extraction on Sakhalin, enormous damage has been done to its wildlife, rivers, and biological resources. Even greater damage can be caused by the offshore projects. These resources are now threatened.

The Sakhalin offshore projects commenced on January 28, 1975, when a General Agreement was signed between the Japanese company, Sodeco, and its Russian partner,

Conversion to natural gas?

Coal-fired power stations in Yuzhno-Sakhalinsk and other southern towns such as Vokhrushev are a big environmental concern for citizens. During winter, when black coal dust covers the snow and cloaks the towns, the air is difficult to breathe. Oil companies have advertised that the offshore projects will provide an environmental benefit by allowing the region to convert from coal to gas. But, because Sakhalin has not attracted the necessary investment for conversion to gas, it is unlikely that this will occur. Energy and fuel infrastructure problems result in frequent power cuts. The local authorities claim that a reorganization of coal pits can produce enough coal for power plants but they lack the working capital because the energy producers are not paying the coal mines. Coal deliveries are also hampered by the weather, lack of vehicles to transport the fuel, and payment for spare parts or winter tires.

Sakhalin residents hope that expanding local gas-powered energy systems will offset erratic coal supplies. The Nogliki gas-fired power station is now operating, with four turbines producing 40 MW. Despite the volume of local gas supplies, gas is used much less in local energy systems than on average in Russia (20 percent compared with 63 percent). Local gas is three times cheaper than locally produced coal, and increasing use of gas will save about 400 tons of coal daily. With the second phase of the Nogliki gas-turbine station in operation, gas usage within the power system could increase to between 40 and 45 percent.[33]

—EW

Sakhalinmorneftegaz (SMNG). SMNG received credit to conduct seismic surveys and exploratory drilling, and by 1990 had discovered five oil and gas deposits: Chaivo, Lunskoe, Arkutun-Daginskoe, Piltun-Astokhskoe, and Odoptu-More (see map 11.2, p. 380). The USSR, like the Russian Federation today, lacked both funds and technical expertise to develop the deposits alone, so in 1991 the government requested international bids to develop the Lunskoe gas deposit and the Piltun-Astokhskoe oil field. The main requirements of the Russians were:

- RFE demands for gas should be satisfied first.
- A portion of the gas should be processed on Sakhalin.
- The winner of the tender should use its own finances instead of financial loans.
- Environmental protection should take priority.

On January 27, 1992, a federal commission headed by V. I. Danilov-Danilyan, then head of the Federal Committee on Environmental Protection, analyzed the results of the tender. There were only three Sakhalin representatives in the seventeen-member commission: V. P. Fyodorov (then Governor of Sakhalin Oblast), A. V. Cherny (then Director General of Sakhalinmorneftegaz), and N. V. Solovyov (the indigenous representative). The tender was won by MMM, a consortium of western companies—Marathon, McDermott (both U.S. companies) and Mitsui (Japan). Governor Fyodorov refused to sign the commission's decision, as he and other experts did not trust MMM's promises.

Later, commenting for the newspaper *Sovetskaya Rossiya*, A. V. Cherny wrote:

The Production Sharing Agreement (PSA) allows most environmental issues to be left [in the waters of] foreign countries. It allows for profit making at all stages of the project. Banks provide credits and receive their benefits covered by the investor's portion of production. For the most part new jobs are created at home, but not in the country of operation. The PSA allows companies to establish control over natural resources and expand their influence over world market prices.... Given this terrible situation, it is unbearable to hear Americans … trying to convince people on Sakhalin that the Sakhalin II project will raise the living standards of the local population.[34]

By the end of 1992, MMM consortium had become Sakhalin Energy Investment Company Ltd. (SEIC), registered in Ber-

Eastern Sakhalin coast. The island's shores are a mecca for gray whales, walruses, sea lions, seals, and endangered migratory birds.

muda with assets of just U.S.$100 million dollars. Perhaps for financial reasons, SEIC deviated drastically from the original requirements stipulated by the Russian side and agreed upon by MMM. Gas production was postponed until 2005–2010. Funds are secured as loans from Western banks, with repayment based on revenue from oil and gas sales. Oil production, which began in July 1999, is now a priority.

Oil is being transported in the most environmentally dangerous way, by 90,000-ton tankers at ten- to twelve-day intervals. A similar system was used in Alaska, where in March 1989 the disastrous *Exxon Valdez* accident occurred. As a result of that tragedy, 40,000 tons of oil spilled into the sea, and Exxon had to pay around U.S.$3 billion to deal with the consequences. SEIC has no such funds. Therefore, in its Oil Spill Contingency Plan (January 1999), it claims responsibility only for oil spills in the range of 500 m around the Molikpaq platform. SEIC is not liable for oil transportation or tanker spills.

The results of six environmental expert reviews (*expertiza*) conducted since February 1993 for the Sakhalin I and II projects suggest that oil and gas development in the Sea of Okhotsk may lead to disastrous and irreversible environmental consequences. Comments made in 1993 by experts on the federal environmental expert review committee for Sakhalin II include the following:

- Lack of worldwide experience in design, construction, and operation of offshore extraction facilities in such harsh climatic conditions.
- Threat of irreversible environmental consequences for the fishing industry—Sakhalin's key industry.
- Impossibility of cleaning up spills when the sea is covered with thick ice (at least six months of the year).

- Project documents show lack of consideration of spawning rivers during pipeline construction and lack of concern for ensuring water purity.
- No plan for provision of funds in the event of an accident.

SEIC continues to neglect Sakhalin's natural environment. In 1997, the company submitted a plan of the pipeline route for approval. The pipelines were supposed to be built from Okhinsky Raion in the north to Korsakovsky Raion in the south, and all the pipelines would be placed underground. Sakhalin-rybvod states in response to the plan that "the pipeline routes will cross 463 water streams including the 65 largest spawning rivers, which produce 73 percent of all red salmon caught on Sakhalin.... If this construction plan proceeds, it will lead to water pollution, disruption of spawning grounds, and damage to the fishing industry.... [D]uring pipeline operation, leaks of oil and gas condensate are unavoidable and will damage not only the natural reproduction capacity of salmon but also salmon hatcheries."

The pipeline route also cuts across Group I forests. Permission to use these lands can be given only by the Russian government, after receiving a favorable federal environmental expert review (*expertiza*). The pipeline route would also be crossing lands where indigenous people live. In accordance with the Russian Land Code, the lands can be used only after the issue has been discussed with the local communities and, if required, after a referendum has been held. Such referendums have so far not been conducted in any *raion* of Sakhalin.

The federal expert review for the Sakhalin I project was not favorable. Nevertheless, work continued on the project thanks to the patronage of V. I. Danilov-Danilyan, former head of the Federal Committee on Environmental Protection, and N. I. Onischenko, former head of the Sakhalin

NGOs claim Sakhalin II threatens fish populations and gray whales

Sakhalin Energy (SEIC) has again applied to the European Bank for Reconstruction and Development (EBRD), the Overseas Private Investment Corporation (OPIC), and the Japan Bank of International Cooperation (JBIC), this time for funding the second phase of the Sakhalin II project. However, a consortium of international and Russian NGOs believe both the company and lending institutions have failed to fulfill a number of environmental, social, and economic commitments made during the project's first phase. In a sharply worded letter to EBRD president Jean Lemierre, dated December 10, 2001, NGOs cited a host of problems left unaddressed after the first phase: failure to provide the public with adequate and timely information; failure to reinject 100 percent of drilling waste during operations; almost no revision of an already weak oil spill response plan; unacceptably low levels of economic benefit to the Sakhalin region; and failure to renegotiate the Production Sharing Agreement (PSA) so that it complies with Russian environmental laws.[35]

While these claims are not new, NGOs did raise two new significant concerns: The Sakhalin II project is negatively affecting populations of two fish species (herring and saffron cod) and a globally endangered species, the Okhotsk-Korean gray whale. Local government fisheries inspectors and local fisherman working throughout Northeastern Sakhalin, where the oil company works, found a sharp decrease in saffron cod spawns. However, there has been no analogous decrease in commercial saffron cod harvest in other areas of Sakhalin. In June 1999, there was a herring die-off in Piltun Bay, also where the company operates. Sakhalin Environment Watch (SEW) sent herring samples to a lab for analysis and found the same petroleum products and substances found in the drilling muds from the Sakhalin II Molikpaq platform. Sakhalin Energy, however, refused to provide SEW with an oil sample to confirm the analysis.[36] In 2000, fishermen were only able to catch 40 tons of herring, almost five times lower than both the annual quota and the amount of herring usually caught.

Fewer than one hundred individuals of the Okhotsk-Korean gray whale population remain. They feed primarily off-shore of Northeastern Sakhalin, just 20 km from the Molikpaq platform. In 1999 and 2000, scientists noticed that the whales were displaced to the north of their feeding grounds, likely as a result of the oil drilling. Russian scientist and chair of the Ichtylogical Commission of the Ministry of Natural Resources M. E. Vinogradov has concluded that, "Without designing special measures for gray whale conservation, the continuation of the Sakhalin-II project can lead to extinction of this unique population."[37] In 1997, Sakhalin Energy agreed to develop a Gray Whale Conservation Plan as part of its obligation to its lenders. However, it was not until early 2002 that the company finalized the Conservation Plan, which incidentally only deals with Phase I of the project, not subsequent phases.

SEW filed a formal complaint against the Ministry of Natural Resources demanding that all drilling activity, construction, and seismic testing cease until the Ministry can provide data that the environmental expert review *(expertiza)* for both the Sakhalin I and II projects has been completed. This effort was unsuccessful.

— DG, JN

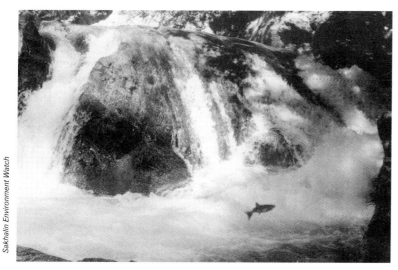

Sakhalin Environment Watch

A salmon makes its way up one of Sakhalin's estimated sixty-five thousand rivers.

Committee on Environmental Protection. In 1997 and 1998, Exxon conducted exploratory drilling, then dumped the waste into the sea. The Sakhalin Special Marine Inspection Service filed a lawsuit, but Danilov-Danilyan responded by disbanding the inspectorate and subordinating it to the Sakhalin Committee on Environmental Protection, under Onischenko, a person more amenable to Western companies. According to the Special Marine Inspection Service, the dumping of drilling waste caused 6 million rubles of damage. Onischenko reduced this figure by thirty-six times. In 1999, the federal *expertiza* committee finally acknowledged how much harm is caused by dumping drilling waste, and did not allow Sakhalin I to drill the Chaivo-6 bore hole (see p. 411).

On January 21, 1999, the state-owned company Dal-morneftegeofizika submitted the Proposed Program of Geological and Geophysical Operations in the Far Eastern and Northeastern Seas of the Russian Federation to the Ministry of Natural Resources. The program was not submitted for a federal environmental expert review nor are the indigenous people of the RFE aware of it.

The Russian government is considering a number of other offshore oil development projects for Sakhalin. If they go ahead, 30 to 40 million tons of oil will be produced annually in the Sea of Okhotsk for the next thirty years. About 0.03 percent of oil is always lost at sea during extraction and transportation, and this figure does not depend on the quality of technology used or qualifications of the personnel. Thus, around 10,000 tons of oil will be spilled into the Sea of Okhotsk annually. Project developers do not analyze or account for this data. The Sea of Okhotsk and Sakhalin could become one great big environmental disaster area. Unless the Russian public, together with indigenous people's groups and local and international environmental and legal organizations get actively involved in monitoring the Sakhalin projects, the situation will not change for the better.

Timber

D. LISITSYN—Sakhalin's forest resources are crucial to the island's industrial development, and their exploitation has received considerable attention—in the tsarist period, during the Japanese occupation of southern Sakhalin, in the Soviet period, and in the era of democratic reform.

Small-scale logging began in the second half of the nineteenth century and was linked to the establishment of the penal colony and the construction of settlements. Later the timber was used to build the coal mines. The only large timber extraction project during the penal colony period was to supply timber for sleepers for the Chinese Eastern Railway in 1896. All other timber export projects initiated by the island's prison administration failed due to stiff competition from nearby Primorsky Krai, Hokkaido (Japan), and Korea. Up to the beginning of the Japanese occupation of southern Sakhalin in 1905, logging was limited, primarily for local use and for the nascent coal industry.

After the occupation, the Japanese government immediately prioritized the extraction and processing of timber in its development plans for Karafuto (the official Japanese name for southern Sakhalin). Timber harvests began to increase rapidly (see fig. 11.1). Timber extraction peaked in 1940 at 7.69 million cu. m. Some was sent to Japan as raw logs, but

Figure 11.1

Japanese timber harvest in Southern Sakhalin, 1912–1935

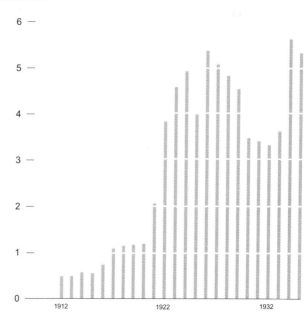

million cu. m

Source: Sakhalin Forest Service, 2000.

Figure 11.2
Forest fires on Karafuto, 1926–1935

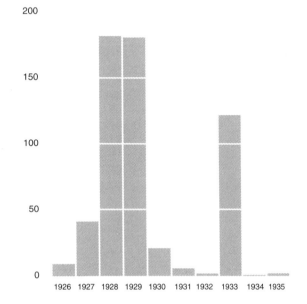

Area burned (000 ha)

Source: Sakhalin Forest Service. 2000.

most was processed on Karafuto at the pulp and paper facto-ries and then exported to Japan. The pulp and paper industry played a key role in the destruction of Sakhalin's dark-conifer (spruce-fir) forests. Between 1914 and 1926 the Japanese erect-ed eight factories in southern Sakhalin to produce cellulose, paper, cardboard, and artificial silk from the island's timber. The ninth mill was built in Sikuka (Poronaisk) in 1935. This was a more northerly location than the others, as logging was shifting to the north with the depletion of timber resources in the south. Between the establishment of the paper industry in 1914 and the arrival of Soviet forces in 1945, Karafuto produced between 50 and 70 percent of Japan's total paper and cellulose. The industry developed rapidly because paper and cellulose were no longer available from Europe at the beginning of World War I, and Sakhalin had vast supplies of spruce and fir, the most suitable timber for the technology that existed then. Only one factory, in what is now Dolinsk, was able to process larch.

The production capacity of all these factories was con-siderably greater than the natural productivity of Sakhalin's forests. According to the first Japanese forest survey in 1908, there were 32,448 sq. km of forest in southern Sakhalin. By 1935 this had been reduced to 16,202 sq. km. In just thirty years of logging, the forests had been reduced virtually by half. Valleys and forests close to settlements and convenient transportation routes (railways and large rivers) were logged first. The effects of logging were compounded by giant fires, the invasion of pests (the Siberian silkworm in 1919–1923 and

the Japanese bark beetle in 1929), and powerful winds that struck the weakened timber stands during typhoons. Fires caused substantial destruction to the forests (see fig. 11.2).

Before the 1920s, forests were mainly clear-cut. Fires on cluttered logging sites left behind barren wastelands. Natu-ral consequences included powerful flash floods, silting up of agricultural land, erosion of the productive soil layer of flood plains, avalanches and snow drifts along transporta-tion routes, and the loss of water supplies to settlements. This forced the Japanese administration to alter the system of timber exploitation. Forest scientists established that selective logging, with the removal of about 30 percent of the trees, was the best way to preserve the ecology and permit regenera-tion. The subsequent use of selective logging meant that the area of forest used for logging had to be greatly increased to allow for growth in the volume of timber logged.

Silviculture was practiced from 1920, and about 160,000 ha of plantations were established before 1944. Most of these were damaged by forest fires between the 1930s and 1950s. Attempts to reproduce forests from seed were completely unsuccessful. The main silviculture species were Ayan spruce and Sakhalin fir. Mining and construction companies planted fast-growing larch for their own use. Municipalities and timber-processing enterprises planted birch for charcoal and plywood blocks.

Logging began in northern Sakhalin after Soviet power was established in 1925. The state forestry monopoly was Sakhalinles. The major trade was in raw logs exported to Ja-pan and to the Russian mainland. Timber was also provided to satisfy the growing demands of the coal, oil, and fishing industries, and for construction. Timber extraction peaked at 450,000 cu. m in 1932. Then production declined and by 1939 had dropped to 138,000 cu. m. Selective cutting was employed everywhere, and only the lower part of the trunk (6–8 m) of the highest quality trees was used.

From the end of the 1940s, after southern Sakhalin was incorporated into the Soviet Union, more and more pristine forests were logged. For a long time volume and productivity levels were low. But with large-scale capital investment in the 1950s and the shift to powerful petrol-driven saws, diesel-powered hauling tractors, and log trucks, timber production almost doubled from 1,453,000 cu. m in 1947 to 3,546,000 cu. m in 1964.

Up to the beginning of the 1990s, eight of the nine Japa-nese-built pulp and paper mills continued production, and dark-conifer timber provided virtually all of the raw mate-rial. For many decades this determined the focus for logging. Spruce and fir stands were logged first, and the best quality timber was traditionally exported to Japan as raw logs. Lower quality timber and pulpwood was sent to the mills. This allowed for a relatively effective use of most of the extractable timber resources. A small percentage of dark-conifer timber was processed into lumber, but poor technology meant this lumber was unsuitable for export, and so it was used locally.

Larch was generally used only for railway sleepers and for pit props in the coal mines.

At the start of the 1960s, changes in timber extraction and transportation technology had a great influence on forest exploitation. Powerful, heavy bulldozers with the capacity to cut deep terraces for hauling logs in steep areas considerably expanded logging on steep slopes, where most of the remaining forests were concentrated. Another important change was the halting of timber transport by river in 1961 (apart from the river Agnevo, where it continued until July 1978). This regulation was enacted because water levels in many rivers had dropped considerably because the forests in the river basins were depleted and because of a growing awareness of the damage caused by log transportation to salmon-spawning grounds. The shift necessitated intensive road construction. In several cases, in outlying timber-rich districts such as Pervomaisk, rail links were specially built. Huge forest areas could now be exploited, both in the already exploited south (on the steep slopes of mountain ridges, in the upper reaches of small rivers) and in the previously distant wilderness areas of central and northern Sakhalin. Production expanded and in 1975 reached its peak with 3,906,000 cu. m, as illustrated in figure 11.3.

Soon after, logging began to drop steadily as the accessible spruce and fir stands were depleted. Forest fires also contributed to deforestation. Huge fires between 1949 and 1954 burned an estimated 1 million cu. m and similar catastrophes occurred in central and northern Sakhalin in 1989 and 1998.

In the early 1980s a logging road was built eastward across Nabilsky Ridge toward the last large valley area of dense spruce stands. To replace entire brigades of loggers, advanced machinery was introduced for cutting and hauling, but even this could not halt the timber decline. The Russian economic crisis in the 1990s has had the most destructive effect on Sakhalin's timber sector. When the planned economy collapsed, there was a sharp decrease in timber production, and the pulp and paper industry collapsed in turn. Since the factories had been constructed by the Japanese and never repaired, they were hopelessly outdated, decaying, and no longer competitive. After privatization and without state support, all the Sakhalin paper mills were closed by 1997, and most will probably never work again. Production has recommenced at Uglegorsk Mill, which is now producing paper for the domestic market and materials for the Korsakov corrugated packaging factory. But the supplies of timber are irregular and production is frequently halted.

The decline in domestic demand for forest products has led to a sharp drop in timber production. The frequent redistribution of property and unsound external economic politics have compounded the collapse. Thousands of people have not received their salaries; some are owed several years of back wages. The pulp and paper mills supported the social infrastructure, and their collapse has left entire towns in disarray. Unlike the coal industry, the timber industry did not have a restructuring program to create alternative jobs or to resettle people. This has led to shock and apathy; many people have lost faith in the possibility of better times. In recent years, due to the stabilization of ownership and distribution of forest resources and because new timber enterprises do not have to provide for social infrastructure, there has been a small but noticeable increase in production. However, locals still remember the unpaid wages and therefore are not

Figure 11.3
Timber production in Sakhalin Oblast, 1940–1999

million cu. m

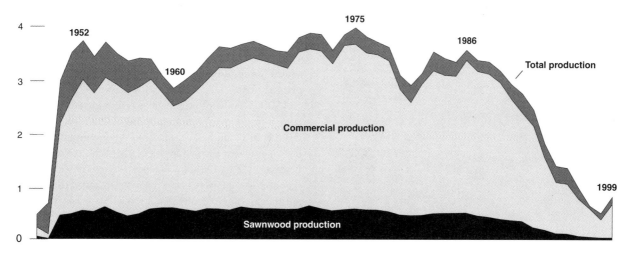

Source: Sakhalin Forest Service, 2000.

too enthusiastic about being employed by these new bosses. Exporting high-quality raw logs is the only economically viable activity in the industry today and leads to an extreme waste of the resource—up to 70 percent of the cut timber remains in the forest. This waste is also exacerbated by high rail transportation tariffs, as it is economical to transfer only the highest quality logs.

Aside from their obvious economic value, the forests on Sakhalin have great ecological significance. The dark-conifer forests here developed as a result of a combination of important factors: the cold moist climate, strong winds, abundant snow, the specific characteristics of the soils, and the infrequency of fires. These forests are extremely vulnerable to both logging and fire. In contrast to most mainland second-growth forests, dark-conifer forests that have been logged or hit by fire are not naturally regenerated. Under good conditions, the territory becomes overgrown with larch, otherwise with small birch trees, or it simply turns into wasteland or marsh. Large areas of mountainous forest in southern Sakhalin have become wasteland, sparse forest, or more frequently, overgrown with dwarf bamboo. In a natural state, the bamboo grows rather minimally in the undergrowth but it grows back quickly after logging or fires and rapidly colonizes the forestland, becoming a thick, impenetrable carpet. This hinders the rejuvenation of other species, particularly spruce and fir. Huge areas of dark-conifer forest have been transformed into bamboo thickets in Anivsky, Nevelsky, Kholmsky, Dolinsky, and Tomarinsky Raions.

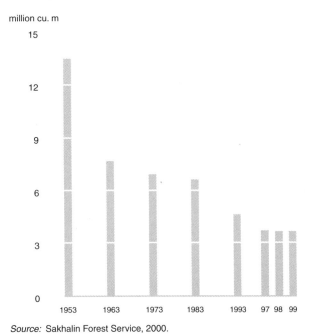

Figure 11.4
Change in the Annual Allowable Cut for Sakhalin Oblast, 1953–1999

million cu. m

Source: Sakhalin Forest Service, 2000.

The present overall supply of timber in Sakhalin's forests is 616.55 million cu. m, including 352.5 million cu. m of dark conifer. Of this, 207.47 million cu. m is mature forest (suitable for commercial logging). Commercially valuable forest comprises about one-third of total forest. In 1972, this supply was 503.84 million cu. m. Thus, mature forests have been reduced by half in just twenty-six years.

Environmental impact. The dynamics of the Annual Allowable Cut (AAC), which is the official indicator of the volume of mature forest that can be cut each year without threatening regeneration, clearly reflect the unsustainability of forest use on Sakhalin and the defects of the AAC, as it is presently calculated. Official statistics state that the AAC was never fully used, but the considerable steady decline in the AAC over time is clearly illustrated in fig. 11.4. Despite reports by the forest service about the underuse of forests throughout the island, in some places, particularly in the south, they were being rapaciously overexploited in Soviet times as now. Forest inventories to determine the AAC, conducted by local forest services (*leskhoz*es), called for sharp reductions. This reveals that the AAC was too high.

The AAC is still far too high: In 1999, the AAC was 3,651,300 cu. m. Most of the valuable remaining forests are scattered as small fragments across a large territory, primarily in the mountains and essentially inaccessible. Many of the accessible, high-quality, mature timber stands are also scattered in small patches and uneconomic to log. All are still included when the AAC is determined.

Logging on Sakhalin has always been accompanied by replanting programs, but on far too small a scale to compensate for the amount of forest logged. Ayan spruce, the most valuable species, grows very slowly when young and needs stable moisture and temperature levels, plenty of shade, and abundant snow cover. Plantations on large clear-cut areas cannot provide such conditions; many seedlings die in the first few years, usually because the soil is too hot or too cold. Attempts to grow pine on barren and burned land are often unsuccessful: The trees go yellow and bushy or break under the weight of snow, or voles eat the roots. It is unlikely that a pine plantation could ever produce commercially valuable timber. In addition, fires destroy a significant number of planted trees.

Until recently, protected areas (PAs), including relatively large forested areas, were created on Sakhalin to protect various species of animal, especially valuable commercial species, but logging was allowed, particularly in the *zakaznik*s. Before Poronaisky Zapovednik was established, so much forest on the proposed territory had already been logged that there is not much point in protecting it today. Kurilsky Zapovednik includes large forested areas, but they are very different from Sakhalin Island forests. The first PA established to protect the representative forests of the Sakhalin subzone of dark-conifer taiga was the *oblast*-level Vostochny Zakaznik.

In Severny Zakaznik commercial logging is threatening the ancient forests (see p. 388). Relatively undamaged forests have been protected in northwestern Sakhalin. These are mostly northern larch forests, which have been damaged to some extent by logging, but much more so by oil industry infrastructure (pipelines, roads, drilling work, and so on). Vagis Mountain in the northwest has significant dark-conifer forests.

The density of rivers and streams on Sakhalin makes the effects of logging unavoidable. Three-quarters of Sakhalin is mountainous, and logging on steep slopes compacts the soil and creates erosion; soil flows into the rivers and clogs salmon-spawning grounds. Logging on steep slopes in northern larch forests causes the fragile, somewhat sandy topsoil to wash away, leaving deep, barren gullies. Loggers transport timber across rivers, often constructing temporary roads along streams. In mountainous areas, timber is hauled along small creeks, which are the sources of larger rivers. Terracing technology is particularly harmful as huge amounts of soil are displaced, often resulting in landslides. Deforestation of the river basins lowers water levels in the rivers and damages the hydrological regime. Logged forests cannot hold the same volume of snow, and in spring the snow melts much more quickly than it would under thick forest cover. As a result, the dry forest undergrowth is more likely to burn and is particularly susceptible to crown fires. During spring thaws, the water flows too quickly into the rivers, often washing away spawning mounds. During the drier months the water level decreases too sharply, as the forest can no longer properly regulate water outflow. The logging of valley forests can cause lowland areas to become marshy, as the water stagnates and forests do not grow back in these areas.

Structural changes in the industry. In the early 1990s, the federal government privatized the region's timber monopoly, Sakahlinlesprom, after a drawn-out battle between various financial-industrial groupings over how its property and resource base would be redistributed. In 1998, Sakhalinlesprom and all its subsidiaries, the *lespromkhoz*es (former state timber companies), went bankrupt, which changed the structure of the shareholding. In early 1998, the main shareholder, previously the Moscow-based Mezhkombank became the foreign holding company ST Far Eastern Timber Limited, which created a new holding company, Sakhinles OAO (open joint-stock company), from the ruins of Sakhalinlesprom and is largely controlled by foreign investors (see fig. 11.5). The First Regional Fund for the Newly Independent States (FRF NIS) is registered in Luxembourg and managed by Baring Vostok Capital Partners, whose largest shareholders are the EBRD and the International Finance Corporation (IFC), an arm of the World Bank Group. The FRF NIS has the controlling share in ST Far Eastern Timber Ltd., which owns 100 percent of OAO Sakhinles.

Figure 11.5

Foreign investment in the timber industry, Sakhalin Oblast

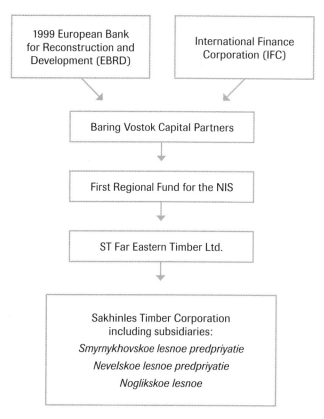

Source: Sakhalin Environment Watch, 2000.

Sakhinles obtained the production assets of its predecessor and created a series of subsidiaries that leased the forest areas given up by the bankrupt *lespromhoz*es and began logging anew. However, Sakhinles found itself in a much more advantageous situation, since the huge debts such as unpaid wages and social infrastructure costs for the forest industry settlements remained with Sakhalinlesprom and the *lespromkhoz*es, which formally remain active and retain their legal status. Thousands of workers of the bankrupt *lespromkhoz*es still have not been paid back wages. Instead, they have been offered jobs with the new enterprises, which even occupy the same buildings; some are controlled by directors of the old *lespromkhoz*es. Knowing this, people are reluctant to work at all and the situation has led to apathy, mistrust, and a general degeneration of the social fabric, with an increase in alcoholism, poaching on spawning rivers, and criminal activity.

In recent years, local branches (*leskhoz*es) of the Federal Forest Service have also become timber producers, as they are legally entitled to sell timber from maintenance and sanitary

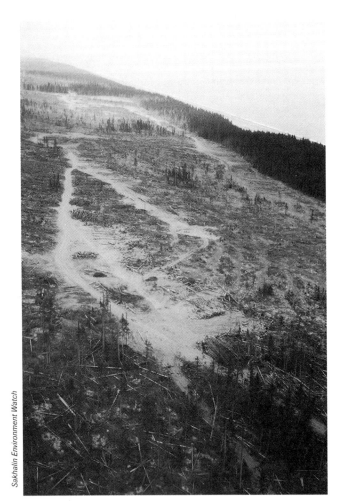

Sakhalin Environment Watch

Industrial forestry on Sakhalin.

Table 11.2
Timber exports and major exporters in Sakhalin Oblast, 1999

	Quantity (cu. m)
Annual Export	
Logs (1st and 2nd grade)	336,800
Logs (3rd grade)	246,500
Pulpwood	39,800
Sawnwood	10,600
Total	633,700
To Japan	
Logs (1st and 2nd grade)	336,800
Logs (3rd grade)	37,600
Pulpwood	3,900
Sawnwood	8,300
To Korea	
Logs (3rd grade)	208,900
Pulpwood	35,900
Sawnwood	2,300
Major Sakhalin Timber Exporters	
Tymovskaya	69,900
Smirnohovskaya	46,100
Hoinsky LPK	43,900
Interpreneur Ivanov	39,800
Agnevo	37,000
Golubye Eli (Blue Spruces)	33,700
Safonov	32,000
Zaab Les (Moscow)	21,900
Interpreneur Boichuk	20,800

Source: Sakhalin Goskomstat, 2000

logging. But the *leskhoz*es use this type of logging to obtain commercially valuable timber. Much of the timber is then exported as high-quality raw logs. Major *leskhoz*es involved include the Alexandrovsky, Anivsky, Makarovsky, Gastellovsky, Krasnogorsky, Kholmsky, and Onorsky Leskhozes.

The main export species is spruce, then fir and larch. Recently there has been an increase in demand for stone birch. High quality fir and spruce (first- and second-class quality) is exported to Japan; lower-quality larch and fir (third class) goes to South Korea. Timber is periodically exported to China, Taiwan, and Indonesia. In 1999, approximately 583,400 cu. m was exported to the two major markets—Japan and South Korea. For export figures and a list of major exporters, see table 11.2.

The timber industry plays a decreasing role in the economy of Sakhalin, particularly with the paralysis of the pulp and paper industry, now accounting for a small percentage of the total industrial production. The introduction of advanced timber-processing equipment would increase the economic competitiveness of the industry, but there is hardly enough forest left to set up large-scale enterprises. The entire industry must be radically reformed.

The Uglegorsk pulp and paper mill is now the only serious timber-processing enterprise and may be able to satisfy demand on the Sakhalin market. But this factory stops production repeatedly due to lack of raw materials and has outdated technology, consumes too much energy, and generates too much waste to be economically efficient. Every mid- to long-term investment program in large-scale timber processing faces the same problem. One viable exception is a small sawmill set up several years ago in Yuzhno-Sakhalinsk by the Japanese company Mitinoku.

As the only market is for raw logs, most timber remains at the logging sites from which only the most valuable logs are taken. The closure of pulp and paper factories has meant

that the lower-quality timber they used now has no market. Workers in lumberyards, sawmills, and pulpmills have lost their jobs. Towns that relied on the pulpmills for the local infrastructure are stranded and thousands of residents unemployed. Most people survive as best they can by poaching salmon, growing vegetables, collecting nontimber forest products, and taking short-term, periodic jobs. For others, coastal fishing and fish processing has become crucial. It is considered more sustainable than logging as the resource base is larger. Some far-sighted timber industrialists realize this and are organizing coastal fishing brigades and small processing plants. The problem of job creation and support for the timber sector could be partially resolved by creating small, highly technical operations to produce lumber. To reduce transportation costs these enterprises should be located in small settlements near remaining timber resources. Some enterprises do transport timber from the logging site to loading area by helicopter, which reduces the impact on rivers, but encourages "high grading" or the selection of only export-quality logs and thus changes the structure of the forest. Helicopter logging is unprofitable if all logging rules are followed. Recently, the timber industry has been aggressively promoting the introduction of foreign harvesters and forwarders. These are light and mobile enough to enable logging on steep slopes, and their wheels reduce the impact on the soil. This technology could definitely reduce the damage to rivers, but will not resolve the problem of watershed deforestation. Also, this type of equipment is so expensive that huge volumes of timber will be necessary to repay the initial investment. As the new machinery replaces between fifteen and twenty loggers, the technology can benefit employment only if the timber is processed locally.

Nontimber forest use (the collection and processing of ferns, mushrooms, berries, wild onion, coltsfoot, the *chaga* fungus, birch sap, medicinal plants) and ecological tourism could improve the economy, but the switch from logging would not be easy.

Toward sustainable development

Emma Wilson

Sakhalin has abundant renewable resources that could provide long-term economic benefit to local communities with minimal impact on the natural environment, but decision-makers are focusing on the offshore oil and gas developments for the development of the economy.[38] The European Bank for Reconstruction and Development (EBRD), which sponsors the Sakhalin II project, has in its founding agreement a pledge to promote "environmentally sound and sustainable development."[39] Oil development generally results in unsustainable "boom and bust" development with high ecological risk. In Russia, the equitable distribution of profits and resources has always been a major problem. The Sakhalin projects are unlikely to guarantee adequate benefits to local communities and threaten local livelihood activities such as subsistence fishing, as well as reindeer herding, which is already under threat of extinction as economic activity and cultural tradition.

Economists argue that the only way for a resource outpost such as Sakhalin to develop is by exporting its raw resources, and point to the proximity to lucrative Pacific Rim markets. However, the profits from these exports need to be invested wisely in development funds, social infrastructure, and processing capacity. Profits in Sakhalin have tended to be directed toward private companies, to Moscow, or to Yuzhno-Sakhalinsk.

Soviet development based on state subsidies, guaranteed markets, and single-industry settlements was unsustainable, as is visible in Sakhalin's declining villages that were formerly dependent on the timber or coal industry. In northern Sakhalin, villages depend on the tax income from the onshore oil and gas industry, but have seen little investment in reindeer herding, forestry, or fishing. If the oil industry were to pull out they would have nothing to fall back on. With depletion of the onshore fields and a shift to offshore production (in federal waters), this could soon be the case. SMNG has already moved its headquarters from Okha in the north to Yuzhno-Sakhalinsk. Fishing and fish processing have traditionally been the dominant industry on Sakhalin, despite the huge annual revenue drain of illegal fishing. There is considerable potential for sustainable development of the fishing industry, but the effects of oil drilling on this industry and on local subsistence fishing could be devastating, not only for Sakhalin, but also for the larger Sea of Okhotsk region.

In a market economy, the state cannot subsidize entire regions as it did in Soviet times. Some state subsidies are, however, important, particularly for some sectors of the economy such as agriculture (as in any western country). Sakhalin's agriculture sector has collapsed. Taxation of and special funds from high-profit, high-disturbance industries should support social infrastructure and traditional resource use, especially if local populations are threatened or disturbed by such industries. Local populations also need federal socioeconomic and cultural programs, foreign grants, and microcredit lending programs. The federal government programs and grants have had some effect on Sakhalin, and microcredit programs are just being introduced.

"Sustainable development" implies equitable access to resources. Russian citizens, and indigenous people in particular, have a growing base of legislation clarifying their rights to natural resources, land, a clean environment, and an equitable distribution of profits from resource use. But there

is often no money in the regional or local budgets to implement the laws, and people at the grassroots level lack the experience to use them.

Sustainable development requires involving all stakeholders in the planning processes, ensuring transparency and public accountability. Public participation in Russia is increasing and may include consultations to accompany environmental impact assessments (EIAS), independent public expert reviews, referendums, village meetings, two- or three-sided agreements between interest groups and the state or industry, representative commissions to assess project development, public monitoring, and litigation. Access to information increases the participation, as do interest groups and NGOs that collect and disseminate information, formulate and promote local interests, and catalyze action. Sakhalin's local groups can rely on considerable international support, though they may be hindered by lack of access to the Internet and an inability to speak English, essential elements in communications between local and international organizations.

The case of Nogliksky Raion in northeastern Sakhalin is instructive. This *raion*, situated alongside the offshore oil and gas fields of the Sakhalin I, II, and III projects and taking on the bulk of the ecological risk of the projects, is unlikely to reap significant long-term economic benefits. The projects threaten the livelihoods of local residents who depend directly on the natural resources of the area.

The *raion*'s budget relies heavily on the onshore oil industry, which has already destroyed large areas of surrounding forest, reindeer pastures, and wetlands by careless exploitation and lack of land regeneration. But onshore production is declining and, with the collapse of the timber industry and withdrawal of federal subsidies for other industries, there are no sectors of the economy able to replace the oil industry.

Initially locals hoped the Sakhalin offshore projects would add to the budget coffers and create jobs. The oil and gas reserves are, however, located in federal waters so Nogliksky Raion has no claim to any payments for the use of resources, although an oil spill would devastate the local fishing economy. The Production Sharing Agreement system, developed in Third World countries and used by the Sakhalin offshore oil and gas projects, has proved incapable of providing local communities with an equitable share of benefits (see pp. 411–12 for a full discussion of the PSAS). Under the PSA, there is a system of bonus payments as the project develops. So far, the only bonus payments Nogliksky Raion has received are earmarked solely for the controversial gas-fired power station close to Nogliki, built mainly to provide energy for southern Sakhalin. Locals have protested this station, because of its proximity to local *dacha*s and the political significance of the project. The old gas pipeline that feeds the power station recently exploded under the extra pressure necessary to transport the additional volumes of gas.

Incoming workers could bring added revenue to local communities by using local services, shops, restaurants, and so on. However, ExxonMobil and SEIC have, for security reasons, built their own self-sufficient compound outside Nogliki. Access to this compound is strictly limited. As the oil companies are registered in Yuzhno-Sakhalinsk, Nogliksky Raion receives no tax revenue from the camp. Local experts feel that the Sakhalin projects have been developed without the interests of the local districts in mind, although the original tender agreements promised significant local benefits (such as gasification of the island, local processing, local jobs, etc.). Local regulatory agencies are not even allowed on board the Molikpaq platform. In November 1997 the mayor of Nogliksky Raion and the head of the *raion* assembly wrote a letter to Governor Farkhutdinov expressing concern that profits from Sakhalin I and II will go primarily to Moscow and Yuzhno-Sakhalinsk, international investors, and multinational corporations. Unfortunately, these local leaders have been unable to negotiate a better deal for their constituencies.

Indigenous peoples

V. D. Fedorchuk

The more than 3,400 indigenous people in Sakhalin, including Nivkhi (pop. 2,400), Oroki (pop. 340, including Uilta and Orochi), Evenki (pop. 240), and Nanai (pop. 180) live primarily in northern Sakhalin in six *raion*s: Alexandrovsk-Sakhalinsky (205 indigenous people), Okhinsky (1,237), Nogliksky (1,018), Smirnykhovsky (45), Tymovsky (226), and Poronaisky (476).[40] Over 220 indigenous people live in Yuzhno-Sakhalinsk.

The Nivkhi and the Ainu (who were still living on Sakhalin and the Kuril Islands fifty years ago) are the region's ancient aboriginals, rooted in the neolithic cultures of the hunters and fishers of the Sea of Okhotsk coast; there are references to both in Chinese geographical tracts dating back two thousand years.[41]

The Sakhalin Nivkhi, always relatively sedentary, now live mostly in northern Sakhalin. Traditional activities rarely practiced today include marine mammal hunting, dog breeding, and making sleds, boats, skis, hunting and fishing equipment, and domestic tools and utensils. Today, their main activities are fishing and gathering of nontimber forest products for personal use. The nomadic reindeer-herding Oroki (Uilta, Orochi) and Evenki came much later to Sakhalin from the mainland. The first references to Oroki can be found in Japanese chronicles from the beginning of the eighteenth century, but they were recorded as an ethnic group much earlier.[42] The Evenki, who moved to northern Sakhalin in the 1860s after a smallpox epidemic on the mainland,[43] still engage in reindeer herding, fishing, hunting, and gathering. The Nanai, who originally came from the lower

Amur, were forced to move to Sakhalin in 1947 after World War II to work in the fishing collective (*kolkhoz*) in Poronaisky Raion. Their main occupation remains fishing.

Fifty to sixty years ago, demographic movement depended on government politics, be it Russian or Japanese. A striking example is the fate of the Sakhalin and Kuril Island Ainu. The Kuril Island Ainu were forced to resettle by the Japanese at the end of the nineteenth century. Most had to move to Shikotan, where all of them died within a few years from malnutrition and disease. The few remaining Ainu were assimilated in the first half of the twentieth century and no longer exist as an ethnic group. The Sakhalin Ainu, as citizens of Japan, migrated from Sakhalin after the end of World War II. Today descendants of the Sakhalin Ainu live on Hokkaido (Japan).

Fires in 1998 destroyed huge areas of land used by the Nivkhi peoples.

If the Ainu were victims of capitalism, the Nivkhi, Oroki, Evenki, and Nanai of northern Sakhalin were the victims of collectivization. The Soviets forced these peoples into collective (*kolkhoz*es) and state (*sovkhoz*es) farms. One of the villages where the Nivkhi were moved to became a collective vegetable farm in the 1930s and was named Chir Unvd (New Life).[44] Today many Nivkhi settlements in northern Sakhalin exist only on the map. The villagers of Nyvrovo, Muzma Viski, Tamlavo, Kaigan, Liugi, Chingai, Tengi, Tyk, Nyivo, Veni, Komrvo, Chamgu, Piltun, Khanduza, and many others were gradually resettled into larger and larger settlements, such as Nogliki, Nekrasovka, Rybnoe, etc.[45] Today the same fate awaits the settlements of the Rybnovsk shoreline in northwestern Sakhalin, where now there are no shops, schools, social infrastructure, energy provision, or transport links.

Cultural revival began in the 1970s and the early 1980s. In 1979 the modern Nivkhi alphabet was updated, and from 1981 the study of the Nivkhi language was introduced in schools.[46] By the end of the 1980s new forms of economic activity were introduced—collective native enterprises and so-called clan enterprises (*rodovye khozyaistva*). Today, there is an emphasis on "clan community" (*rodovaya obschina*), in line with a state program for indigenous revival. The clan community is a voluntary society of people who carry out traditional economic activities on native lands. The aims are to support native subsistence practices, revive and develop native economies, culture, and language, and provide social protection to members of the community. Most of the enterprises are joined in the commercial-agrarian firm Aborigen Sakhalina (The Sakhalin Aboriginal). As of 1997, Aborigen Sakhalina included fifty-three clan enterprises, the clan community Tyi in Poronaisky Raion, the souvenir workshop Tevi in Nogliki, the former state farm Reindeer Herder in Alexandrovsk-Sakhalinsky Raion, and the reindeer-herding enterprise Val in Nogliksky Raion.[47] Although native enterprises are engaged in a range of activities, from hunting and herding to tourism and the creation of traditional craftware using fish skin and animal furs and pelts, the accent today is mostly on fishing, which brings in the bulk of the revenue.

Fishing

For Sakhalin's indigenous people, quotas and fishing ground allocations are particularly controversial. Native enterprises apply to the *raion* administration for allocations. A recommendation is submitted to the *oblast* fisheries department, where it is approved, subject to quotas allocated by the federal government. In 1997, 26 km of commercial fishing grounds were allocated for native enterprises in Poronaisky Raion, 64 km in Okhinsky Raion, 4 km in Alexandrovsk-Sakhalinsky Raion, and in Nogliksky Raion five fishing grounds were allocated on the Chaivo, Nyivo, Piltun, Lunsky, and Nyisky Bays.[48] Many of those grounds are fairly unproductive, and the native enterprises are not a priority for *raion* administrations.

The limit for personal use is 100 kg per year per person of pink and chum salmon. Limits for chum salmon depend on scientific predictions of fish spawning. Usually it is between 40 and 60 kg, or about ten to twelve fish. This is clearly not enough food and certainly not enough to store for winter. Native families naturally use all sorts of ways to get the necessary quantities of fish, which means that they are forced to fish illegally. The size of the fish catch depends not only on the quotas and fishing grounds, but also on the runs of spawning salmon. In recent years, in Alexandrovsk-Sakhalinsky Raion, the clan enterprises have fished only in winter because the summer fishing—pink and chum salmon—has diminished. In Nogliksky and Okhinsky Raions, catches of saffron cod (*Eleginus gracilis*) and smelt have declined, and chum salmon may be fished only for the personal use of indigenous residents.

The worsening ecological situation has affected fisheries in northern Sakhalin. The onshore oil industry in particular has harmed the fish runs, as will offshore projects. In February 1997, the Okha municipal committee for nature protection and land, with help of SMNG, chose a dumping site for offshore drilling waste, a deserted sand quarry near the source of Chyornaya River and several small streams that flow into Baikal Bay, which has already seen declines in fish runs.[49] Residents of the nearby villages of Nekrasovka and Moskalvo have demanded a review of the issue. The problem of storing drilling waste on the shores of Baikal Bay is not resolved.

Reindeer herding and pasturelands

Wild reindeer populations have decreased considerably over the past few years, and domestic reindeer now number only in the dozens, a result of poaching and intensive hunting, industrial encroachment by the oil and logging industries, and forest fires. In 1998, half of the 1,190,678 ha of reindeer pastures allocated to native enterprises were destroyed by forest fires that damaged or destroyed 50 percent of all hunting and herding territories in Nogliksky Raion, 30 percent in Okhinsky Raion, and 100 percent in Tymovsky Raion. The decline is exacerbated by poor policies of regulating reindeer herding, which should include herd censuses, pasture rotation, and quality control. Now, however, all they do is simply shoot the reindeer.

The regional and district administrations and nature protection organs do not have enough money to preserve and restore the natural environment of Sakhalin's indigenous peoples. There have, however, been some signs of improvement, such as the creation of Nogliksky Zakaznik (see p. 388.)

Legal concerns

The legal status of the indigenous peoples of the north was codified on April 30, 1999 (On the Guarantees of the Rights of Indigenous Peoples of the Russian Federation). Most of the other laws are still passing through parliament, which has been dragging out the issue for years. Russian Federation laws in place today contain only general regulations relating to indigenous peoples. Article 12 of the Sakhalin Oblast statutes refers to the protection of ethnic minority rights, their traditional lands, and way of life. Articles 20 and 49 confirm the post of an indigenous peoples representative in the Sakhalin regional assembly (Duma) and the right to initiate legislation. Article 76 is about territories of traditional natural resource use and access to natural resources. Normative acts tend to provide incomplete regulation and be temporary in character. Apart from Okhinsky Raion, where a special amendment has been inserted, at the *raion* level none of the statutes has anything determining the legal status of local indigenous peoples.

Promoting the rights of indigenous peoples

- Create an effective normative and legal base protecting and regulating the socioeconomic development of the indigenous people of Sakhalin.
- Negotiate equitable benefits from the oil, fishing, and logging industries for the indigenous populations. These arrangements should be based on the territories of indigenous peoples, and a legal framework should be established to guarantee this.
- Conduct an ecological expert review of the state of hunting territories, pasturelands, spawning rivers, and coastal waters to determine the damage already done and the potential threat to the environment from industrial activities in areas traditionally inhabited by indigenous people.
- Consider the opinions of the indigenous peoples when exploiting natural resources on the territories where they live.
- Determine the borders of territories of traditional natural resource use; carry out an integrated assessment of the lands with the aim of allocating them to indigenous peoples.
- Ensure proper educational opportunities for indigenous children and adults. This will help develop a body of indigenous specialists – economists, hunting experts, ecologists, and fishing industry specialists.
- Resolve conflicts over fishing limits and fishing grounds. Allocate priority rights to indigenous peoples.
- Encourage indigenous people to take a more active part in defending their own rights.

– EW

Legal issues

Emma Wilson

The use of legislation as a tool to resolve environmental conflict on Sakhalin is increasing, notably in response to development of the offshore oil and gas projects. Local and national NGOs have taken the lead in using legislation to regulate resource developers; such experience has been publicized in the local media and across the Internet. Local populations themselves are, however, more reluctant to use legal tools to assert their rights, despite increasing awareness about the strengthening legislative framework. Russian environmental legislation is noted for its strictness and comprehensiveness. It is the implementation of laws, not the laws themselves, that is less than satisfactory.

Environmental Expert Review (*Expertiza*)

According to the federal law On Environmental Protection (December 19, 1991) any project likely to cause harm to the environment must receive approval in an *expertiza*. This law has been used by Russian regulators as well as by Russian and international environmental organizations. In 1997, international NGOs sent a letter to the EBRD and succeeded in halting financing for the Sakhalin II project until it had passed the federal *expertiza* process. NGOs are also entitled by law to do a public *expertiza*, and there is guidance on how to do this. But this avenue is open only to the few: You need time, money, and access to experts who can carry out the review. Local environmentalists are concerned that Sakhalin Energy is now securing land allocations for its pipeline, but the project has yet to pass the required *expertiza*.

Discharge of drilling waste

When multinationals face legal obstacles in a host country, their initial reaction is to lobby for change to the legislation rather than adapt their own practices, which would often entail a considerable financial cost. An example of this, and probably the most controversial legal issue related to the offshore oil and gas projects, is the disposal of drilling waste at sea. Western oil companies argue that the discharge of drilling waste is permitted in other national waters and so should be legal in Russian waters. Environmentalists counter that zero discharge (reinjecting drilling muds and cuttings) has become a standard for the oil industry worldwide.[50]

According to the Law on the Continental Shelf (October 25, 1995, amended February 10, 1999), the discharge of waste and other materials into continental shelf waters requires a special permit obtained from the Federal Committee on Environmental Protection and given in terms of existing Russian legislation. The two most important pieces of legislation are the state standard, Indicators of the Condition of Fisheries, which categorizes all fisheries into higher, first, and second categories, and the Rules for the Protection of Coastal Waters from Pollution, enacted in 1984, which forbids the discharge of any waste into waters of the highest fisheries category.

In 1999 the Committee on Environmental Protection denied ExxonMobil the environmental permit needed to drill an exploratory well at its Chaivo-6 field (Sakhalin I) after the project failed its *expertiza* because of the plans to discharge drilling waste into the sea. Exxon's threats to withdraw from the project led the then–Prime Minister Sergei Stepashin to pass a decree in 1999 allowing the discharge of drilling waste into the Sea of Okhotsk. A coalition of citizens' organizations, led by Ecojuris, protested the decree in Russia's Supreme Court, which ruled in the citizens' favor and invalidated Stepashin's decree. In 2000, ExxonMobil again threatened to pull out of the Sakhalin I project. The company was eventually granted a license to drill an appraisal well on the Chaivo-6 field after agreeing to reinject the drilling waste back into the well, increasing the cost of the project by U.S.$3 million. This decision signified a triumph for environmental regulation and public pressure.

The controversy over the discharge of drilling waste continues. As Fedorchuk notes earlier in this chapter (p. 410), there are problems with disposing of drilling waste onshore, which SMNG continues to do. SEIC (Sakhalin II project) is still discharging its waste into the sea, even though this violates Russian law, but is apparently planning to change to zero discharge for future drilling.[51] What is more, oil companies are now lobbying to have the fisheries category for the drilling areas in the Sea of Okhotsk reduced from the "highest" category, to the "first" category, which would de facto allow discharge.[52] The State Fisheries Committee apparently ordered SakhNIRO to complete a report providing a justification for such a reduction for waters deeper than 20 meters.[53] Fishing enterprises and environmental groups have united in opposition to this change and are awaiting the decision of the State Fisheries Committee with some apprehension.

Production sharing agreements

The Law on Production Sharing, passed on December 30, 1995, regulates the relationship between the government and investors during the exploration and production of mineral resources in the Russian Federation. The law requires amendments to be made in existing legislation and regulations (amendments were passed in 1998 and 2000) or the adoption of new legislation or regulations, particularly in environmental protection, taxation, accounting, and customs regulations. All agreements between project participants and the Russian Federation made prior to December 30, 1995 (Sakhalin I and II projects) are considered to lie outside the normal Russian legal framework. New Production Sharing Agreements (PSAs) can be made only for reserves included in a special list that is

ratified by the Russian federal Duma, the federal council, and the federal government.

Critics, who include environmentalists, economists, even the Sakhalin representative in the federal Duma, Ivan Zhdakaev, consider the PSA system inadequate in terms of providing benefits to local communities. The PSA for the Sakhalin II project was signed on June 22, 1994, between SEIC and the Russian government and Sakhalin regional administration. According to this agreement, all the production goes first to SEIC until the company has covered its investment costs. Only after the project has started to make a 17.5-percent profit will the Russian side receive its own share of the profits, which will be about 60 percent (split between the federation and Sakhalin region).

The PSAs also free the Sakhalin projects from their federal tax obligations, apart from royalties (only 6 percent) and profit taxes (32 percent, once profit is made). The projects are also exempt from regional and local district taxes. According to the Sakhalin Regional Tax Inspectorate, the estimated loss to the region as a whole will be U.S. $4.16 million for Sakhalin I and U.S. $954 million for Sakhalin II. In theory, the lack of direct benefits is compensated by the bonus payments at strategic points in the project development (total U.S. $45 million) and payments to the Sakhalin Development Fund (total U.S. $100 million). The regional administration and the assembly (Duma) decide how to distribute payment. When the Sakhalin II project celebrated the first oil from Molikpaq in July 1999, Sakhalin received the third payment to the Sakhalin Development Fund (U.S. $20 million) and royalty payments began. In October 1999, SEIC paid the first installment of compensation totaling approximately U.S. $160 million for previous geological exploration work (50 percent to the federal, 50 percent to the regional budget). At the same time the company claimed back U.S. $23 million of value-added tax (VAT) that had been paid previously in contradiction to the PSA. This will be paid back out of the federal and regional royalty payments.[54]

Observers note the bitter irony that in northern *raion*s of Sakhalin, tax holidays have been granted to multinationals such as Shell (SEIC) and ExxonMobil rather than to struggling reindeer herding and fishing enterprises and small farms. Local concerns about the PSAs have been further verified and bolstered by a report by the Russian Federation's Auditing Chamber. This three-hundred-page report details the ways in which the PSAs are not profitable for the Russian government. This report led to a group of Sakhalin scientists criticizing the offshore projects for not providing much-needed benefits to Sakhalin citizens.

Compensation

Compensation for damage to fisheries from the Sakhalin II project was estimated in the project plans at U.S. $1.68 million by the Vladivostok-based Pacific Institute of Fisheries and Oceanography (TINRO), which initially estimated it as U.S. $3 million. SEIC, however, forced this number to be reduced to U.S. $200,000, which will be invested in two fish hatcheries on the Tym River. That river flows out to the southern zone of offshore exploitation; the hatcheries will not be in Nogliksky Raion at all. Environmental groups do not believe that SEIC is paying adequate compensation nor that two hatcheries—with their associated environmental problems—will make up for the damage to fisheries caused by the offshore projects. Compensation paid to local administrations by SMNG for many years of previous damage to reindeer pastures was supposed to regenerate the pastures. The money was, apparently, swallowed by local budgets.

Public consultations

According to Russian legislation, public consultations are an essential part of the Environmental Impact Assessment (EIA) process (*Otsenka vozdeistviya na okruzhayuschuyu sredu*, OVOS) that is mandatory for a project likely to impact the natural environment. SEIC has held two sets of public hearings as part of the EIA for its project (in spring and autumn of 1997). Public consultations for the pipeline are going ahead in 2002 only after the pipeline route has already been agreed upon with regulators and government authorities. ExxonMobil has so far not held any public consultations. Residents of villages in northwestern Sakhalin close to the proposed site of Sakhalin IV are concerned that they were not able to take part in project consultation, which was carried out in private meetings. The results of a public village meeting (expressing categoric opposition) and a collection of over a thousand signatures were ignored. According to Article 28 of the Land Code (1991), the construction of industrial objects (such as a pipeline) on lands inhabited by indigenous peoples has to be discussed in advance with the local residents, even to the point of holding a referendum. No referendums have been held on Sakhalin relating to oil and gas development.

Perspective

Emma Wilson

Sakhalin I oil and gas project

- Project partners: Exxon Neftegas Ltd. (ExxonMobil) (30 percent), Sodeco (Japan) (30 percent), Oil and Natural Gas Corporation Ltd. (India) (30 percent), Rosneft-Sakhalin (11.5 percent), and Sakhalinmorneftegaz-Shelf (Rosneft subsidiary) (8.5 percent).
- Area: Three fields: Arkutun-Dagi, Chaivo, Odoptu.
- Estimated reserves: 325 million tons of oil and condensate; 425 billion cu. m of gas.
- Expected project cost: u.s. $12 billion.

The consortium was formed in June 1995 and signed a Production Sharing Agreement (PSA) in 1996. ExxonMobil is the operator of this project. ExxonMobil missed the 1999 drilling season for Sakhalin I when its plans to dispose of drilling waste at sea failed to receive approval from the state environmental expert review committee. After protracted battles with environmental regulators, ExxonMobil finally agreed to reinject the drilling waste, at an extra cost of u.s. $3 million. ExxonMobil continues to lobby for permission to discharge drilling waste at sea, a move opposed by environmental groups and fishing companies. The appraisal well at Chaivo-6 revealed an oil rim around the gas deposit with an estimated flow rate of 6,000 barrels a day.

In 2002, ExxonMobil was scheduled to begin a $3.5 to 4.5 billion Phase I development (2001–2006), involving early oil extraction from Chaivo using directional drilling from onshore, followed by the erection of an arctic drilling rig, or CIDS (Concrete Island Development System). Drilling at Chaivo, however, depends on obtaining the necessary federal permits. Construction of a u.s. $400-million onshore pipeline is planned to transport oil across the Tatar Strait to De-Kastri Port in Khabarovsk Krai, from where crude would be exported to China, Japan, and South Korea. ExxonMobil has also teamed up with Japanese firms to create Japan Sakhalin Pipeline FC Co. Ltd., which has prepared a feasibility study for an underwater pipeline route to Japan.[55]

Governor Farkhutdinov and the Ministry of Energy strongly oppose these plans, and would prefer Sakhalin I and II to collaborate on joint infrastructure construction. The governor has threatened to suspend the Sakhalin I project. Transporting oil to Khabarovsk Krai would mean that the Sakhalin Oblast budget would get no export revenues from it. The Sakhalin II project north-south pipeline and export terminal will create more jobs for Sakhalin although construction will be more expensive. It is also said that the governor wants to promote Sakhalin Oil Company, which is owned by the *oblast* administration and produces oil and gas

from small fields in the south. The company could use the export pipeline near these fields. The governor is against the construction of two pipelines (north-south and east-west), as according to the terms of the PSA, the government is required to reimburse the cost of both pipelines to investors.[56]

In February 2001, the EBRD gave initial approval to a u.s. $90 million loan to Sakhalinmorneftegaz to upgrade oil collectors, reconstruct oil pipelines to Komsomolsk-on-Amur and Okha, and to drill seven new slant wells at the Odoptu site.[57]

In summer 2001, ExxonMobil again raised the ire of the environmental community when it conducted seismic testing as grey whales were feeding off the northeastern coast of the island. The Ministry of Natural Resources banned the surveys, but Exxon reportedly had already finished the seismic work by that time.[58]

Sakhalin II oil and gas project

- Project partners: Sakhalin Energy Investment Company Ltd. (SEIC) consortium consisting of Royal Dutch Shell (operator) (55 percent), Mitsui Sakhalin Holdings B.V. (25 percent), Diamond Gas Sakhalin B.V. (Mitsubishi) (20 percent).
- Area: Two fields—Piltun-Astokhskoe and Lunskoe.
- Estimated reserves: 140 million tons oil, 494 billion cu. m (18 trillion cu. ft.) of gas (the largest of the proven gas reserves).
- Expected project cost: u.s. $10 billion.

SEIC was established in 1994 and signed its PSA in the same year. Sakhalin II produced the first oil of all the offshore projects in July 1999, with production levels at 20,000 barrels per day. In 2001, Sakhalin II completed its third season of oil production, increasing production to about 2.1 million metric tons for the year. In December 2000, Shell acquired Marathon's 37.5 percent share of SEIC in exchange for other assets, and Mitsubishi bought an additional 7.5 percent share from Shell.

In September 1999, during off-loading from the Molikpaq platform in high winds, about half a ton of crude oil was spilled, and attracted widespread attention, raising international and local concerns about the environmental safety of the offshore projects. Sakhalin II has had several more technical problems since the erection of Molikpaq.

Shell is planning to invest u.s. $5 billion from 2002 to 2006 to develop a 600-km gas-oil pipeline from offshore platforms to a 9.6 million-tons-per-year liquified natural gas (LNG) plant and oil export terminal in the south (Prigorodnoe).[59] So far no ecological expert review has been completed for this pipeline, and agreement on the pipeline route was apparently already reached with land survey officials before the present public consultation process began. In the summer of 2002, the focus was on securing a long-term LNG sales

contract, most likely with a group of companies from Japan. Major construction is expected to begin in fall 2002.

The first phase of development involves ecologically risky tanker transportation from the Molikpaq, which was put in place in 1999. SEIC built a U.S. $60-million housing complex for its expatriat staff and a six-story office building in Yuzhno-Sakhalinsk. In June 2000, SEIC moved its main offices from Moscow to the island.[60] In September 2000, SEIC announced that a U.S.-Russian-Japanese consortium had won the U.S. $10 million tender to develop technical specifications for a feasibility study for the Prigorodnoe LNG plant. In December 2000, approximately U.S. $100 million in major contracts were awarded to, among other companies, the Russian-French joint venture Starstoy for pipeline and terminal design, AMEC Services Ltd. (U.K.) for offshore platform design, and Parsons Engineering (U.S.) for design of onshore infrastructure. Starstroy got the contracts after Russians drew attention to the fact that there were low levels of Russian content in the Sakhalin II project (70 percent is required by the PSA over the lifetime of the project).

Sakhalin III oil and gas project

- Project partners: ExxonMobil (operator), Texaco, Rosneft, Sakhalinmorneftegaz (SMNG) (partners formed the company Pegastar).
- Area: Kirinsky, Ayashsky, and Eastern Odoptinsky blocks.
- Estimated reserves: Kirinsky—687 million tons of oil and condensate and 873 billion cu. m of gas, according to preliminary assessments. Ayashsky and Eastern Odoptinsky—114 million tons of oil and condensate and 513 billion cu. m of gas.

Kirinsky: In 1993 Mobil and Texaco won the tender for the right to explore and develop this block. An agreement was signed between the U.S. and Russian project partners in 1998. The Sakhalin III project has not yet signed a PSA. Delays with the production sharing negotiations mean that exploratory drilling is unlikely before 2003. About U.S. $150 million has been planned to survey the deposit.

Ayashsky and Eastern Odoptinsky: In 1993 ExxonNeftegas Ltd. won the tender for exploration and development rights to these fields. In January 1999, then-Exxon agreed to include Rosneft and SMNG in the consortium to develop the two blocks, to get on the list of projects eligible for a PSA. The PSA has been signed by the consortium together with the Sakhalin and federal governments, and is waiting to be ratified by the Duma. ExxonMobil has committed an estimated $300 million to survey the deposits.

Sakhalin IV oil and gas project

- Project partners: Rosneft, SMNG.
- Area: Astrakhanovsky block, Schmidtovsky block.
- Estimated reserves: 123 million tons of oil and condensate and 540 billion cu. m of gas.

A letter of intent was signed between Rosneft-Sakhalinmorneftegaz and Atlantic Richfield Co. (ARCO) in 1997, and a cooperation agreement signed in 1998, but ARCO withdrew from the project in February 2000. This was apparently due to concern about the lack of a Production Sharing Agreement (PSA), requirements that it would have to reinject drilling waste, and concerns voiced by indigenous peoples about the environmental threats to the northwest region of the island posed by the project. In the summer drilling season SMNG, which has the exploration license and PSA rights to the Astrakhanovsky block, began exploratory drilling independently. The Astrakhanovskoe Sea is estimated to contain 100 billion cu. m of gas deposits. Extracting the gas is estimated to cost U.S. $2.6 billion with expected profits of U.S. $4 billion. SMNG reportedly has started to negotiate with BP about acquiring a share in the project.[61]

Sakhalin V oil and gas project

- Project partners: British Petroleum (BP), Rosneft, SMNG.
- Estimated reserves: 154 million tons of oil and condensate and 450 billion cu. m of gas.

ARCO merged with BP Amoco in January 2000 and the company is now known simply as BP. The local BP office in Yuzhno-Sakhalinsk is being reregistered as BP Exploration Operating Company Sakhalin Inc. BP and Rosneft-SMNG now have an alliance agreement to explore opportunities for developing the Sakhalin V block. Sakhalin V has not yet come up for tender, but it is likely that BP and Rosneft-SMNG will make a joint bid. The block is not yet included in the federal list of fields that can be developed under a PSA.

Sakhalin VI oil and gas project

The Russian firm Petrosakh, owned primarily by Alfa-Eco Group, spent U.S. $13 million on seismic studies in the project area in summer 2000. When completed, there are plans to drill a first well to estimate reserves, which may initially yield 600,000 metric tons of oil each year. In March 2002, Petrosakh and Rosfneft formed a joint-venture to develop the reserves.

Appendix A
Major topological features in the RFE

Seas	Size (000 sq. km)	Maximum depth (m)
Beringovo (Bering Sea)	2,315	5,500
Okhotskoe (Sea of Okhotsk)	1,603	3,521
Yaponskoe (Sea of Japan)	1,602	3,720
Vostochno-Sibirskoe (East Siberian Sea)	913	915
Laptevykh (Laptev Sea)	662	3,385
Chukotskoe (Chukchi Sea)	595	1,256

Rivers and tributaries	Length (km)	Basin size (000 sq. km)
Amur (with Argun)	4,444	1,855
Lena	4,400	2,490
Olenyok	2,270	219
Kolyma	1,870	422
Indigirka	1,726	360
Anadyr	1,150	191
Vilyui (tributary of Lena)	2,650	454
Aldan (tributary of Lena)	2,273	729
Olyokma (tributary of Lena)	1,436	210
Zeya (tributary of Amur)	1,242	233
Markha (tributary of Vilyui)	1,181	99
Omolon (tributary of Kolyma)	1,114	113

Highest peaks	Location	Elevation (m above sea level)
Klyuchevskoi Volcano	Vostochny (Eastern) Range, Kamchatka	4,800
Tolbachik Volcano	Vostochny Range	3,682
Ichinsky Volcano	Sredinny (Central) Range, Kamchatka	3,621
Kronotsky Volcano	Gamchen Range, Kamchatka	3,528
Koryaksky Volcano	Vostochny Range	3,456
Shiveluch Volcano	Vostochny Range	3,283
Pobeda	Cherskogo (Chersky) Range, Sakha	3,147
Bezymyanny Volcano	Vostochny Range	3,085
Kodar	Kodar Range, Sakha	2,999
Mus-Khaya	Suntar-Khayata (Misty) Mountains, Sakha	2,959
Zhupanovsky Volcano	Vostochny Range	2,927
Avacha Volcano	Vostochny Range	2,750
Skalisty Golets	Stanovoi (Backbone) Range, Sakha	2,467
Alaid Volcano	Atlasov I., Kuril Islands	2,339
Mutnovsky Volcano	Vostochny Range	2,323
Tardoki-Yani	Sikhote-Alin Range, Khabarovsk	2,077
Topko	Dzhugdzhur Range, Khabarovsk	1,906
Lopatina	Vostochno-Sakhalinskie (East Sakhalin) Mts.	1,772

Active volcanoes	Location	Elevation (m above sea level)	Last eruption
Kamchatka			
Klyuchevskoi	Vostochny (Eastern) Range	4,800	ongoing
Tolbachik	Vostochny Range	3,682	1976
Ichinsky	Sredinny (Central) Range	3,621	unknown
Kronotsky	Gamchen Ridge	3,528	1923
Koryaksky	Vostochny Range	3,456	1957
Shiveluch	Vostochny Range	3,283	2001
Bezymyanny	Vostochny Range	3,085	1998
Zhupanovsky	Vostochny Range	2,927	1956
Avacha	Vostochny Range	2,750	1991
Mutnovsky	Vostochny Range	2,323	1999
Maly (Lesser) Semlyachik	Vostochny Range	1,560	1952
Karymsky	Vostochny Range	1,486	2001
Kuril Islands			
Alaid	Atlasov I.	2,339	2000
Tyatya	Kunashir I.	1,819	1973
Chikurachki	Paramushir I.	1,816	1995
Fussa	Paramushir I.	1,772	1984
Sarychev	Matua I.	1,446	1976
Krenitsyn	Onekotan I.	1,324	1952
Ivan Grozny (Ivan the Terrible)	Iturup I.	1,159	1973
Severgina	Kharimkotan I.	1,157	1933
Zavaritsky	Simushir I.	625	1957
Sakha			
Balagan-Tas	Cherskogo (Chersky) Range	612	c. 1700

Sources: Atlas of the USSR [Atlas SSSR] (Moscow: Kartografia, 1985); data on volcanic eruptions from Vladimir Dinets.

Appendix B
The forest resources of Russia and the RFE

	Total land area (million sq. km)	Stocked forest land (000 ha)			Growing stock (000 million cu. m)		
		Total forest [c]	Coniferous forest	Deciduous forest	Total forest	Coniferous forest	Deciduous forest
Russia	17,075	705,789	507,708	130,498	73,028	57,677	13,964
European Russia	4,310	136,940	88,420	48,001	16,943	10,968	5,956
West Siberia	2,427	78,760	55,661	22,049	9,519	6,663	2,846
East Siberia	4,123	216,359	166,693	32,293	26,116	22,940	2,915
RFE	6,216	273,730	196,934	28,155	20,450	17,106	2,247
Sakha	3,103	145,268	125,793	2,019	9,229	8,952	84
Khabarovsk	789	47,319	35,440	6,265	4,994	4,272	490
Amur	364	21,853	14,399	5,333	1,954	1,575	327
Primorsky	166	11,240	6,458	4,730	1,769	1,220	546
Kamchatka[a]	472	19,150	1,150	7,233	1,194	132	603
Sakhalin	87	5,358	3,781	1,268	623	533	73
Magadan[b]	461	16,925	7,579	202	423	288	24
JAO	36	1,553	558	994	173	83	90

Notes: a. Includes Koryak Autonomous Okrug.
b. Includes Chukotka Autonomous Okrug.
c. The "total stocked forest land" category is greater than the sum of the "coniferous" and "deciduous" categories because total stocked forest land includes an "other" category consisting of lands with only small volumes of wood per hectare that are not considered a resource supporting the timber industry. Numbers presented for stocked forest land and growing stock exclude those not under direct jurisdiction of the Federal Forest Service.

Source: Compiled by Charles A. Backman and Vadim K. Zausaev from data in *Goskomstat Rossii*, 1995, pp. 3-5; *Goskomstat Rossii*, 1996, pp. 16-21; and *Lesnoi fond Rossii*, 1995, pp. 95-97, 168-69, 180-81, 194-207. Taken from p. 47 of Backman and Zausaev, "The Forest Sector of the Russian Far East." See p. 431, n. 165 for a complete citation.

Appendix C
Foreign trade in the RFE, 1992–2001 (U.S. $ million)

Region	1992	1993	1994	1995	1996	1997	1998	1999	2000	2001
Khabarovsk	449.3	873.2	756.0	977.0	1254.0	983.3	1,301.0	753.0	1,423.0	2,163.2
Export	323.6	515.9	448.0	681.0	993.5	695.7	1,109.0	596.0	1,287.0	2,003.6
Import	125.7	357.3	308.0	296.0	261.0	287.6	192.3	157.0	136.0	159.6
Primorsky	933.0	679.3	965.0	1,615.0	1,956.0	2,019.0	1,447.0	1,231.0	1,371.0	1,781.1
Export	352.0	442.3	432.0	933.0	1,246.0	1,202.0	908.0	864.0	996.0	1,258.9
Import	581.0	237.0	533.0	682.0	710.0	817.0	539.0	367.0	375.0	522.2
Sakhalin	309.9	390.0	263.3	768.5	836.2	1,025.0	977.7	698.0	1,138.0	895.0
Export	206.9	240.0	219.4	475.9	552.2	659.8	486.4	507.6	964.8	709.3
Import	103.0	150.0	43.9	292.6	283.9	364.7	491.3	190.5	172.8	185.7
Sakha	212.6	286.3	287.8	464.9	425.2	404.8	140.3	292.7	176.5	75.0
Export	153.3	157.4	166.0	244.1	227.8	195.7	62.2	153.7	139.5	50.9
Import	59.3	128.9	121.8	220.8	197.4	209.1	78.1	139.0	37.0	24.1
Magadan	141.5	64.9	74.0	175.5	178.3	198.5	160.1	72.4	84.2	100.2
Export	81.1	18.2	14.0	41.0	27.8	28.1	31.1	16.6	16.4	35.9
Import	60.4	46.7	60.0	134.5	150.5	170.4	129.0	55.8	67.8	64.8
Chukotka	–	–	–	–	–	–	–	–	–	14.6
Export	–	–	–	–	–	–	–	–	–	–
Import	–	–	–	–	–	–	–	–	–	14.6
JAO	–	53.4	15.8	13.2	10.2	9.2	7.0	7.6	16.7	13.0
Export	–	30.2	9.7	7.4	5.3	2.8	2.7	3.7	12.0	9.0
Import	–	23.2	6.1	5.8	4.9	6.4	4.3	3.9	4.6	4.0
Amur	428.1	407.6	189.5	140.1	98.6	118.4	96.2	73.1	72.5	87.2
Export	237.6	233.2	91.0	63.8	46.0	51.9	44.9	52.5	55.9	65.5
Import	190.5	174.4	98.2	76.3	52.5	66.6	51.3	20.6	16.6	21.7
Kamchatka	207.0	283.9	373.0	602.9	678.3	901.5	626.4	443.1	441.3	470.6
Export	137.2	185.1	288.0	418.2	473.1	501.2	344.4	295.6	316.9	386.8
Import	69.8	98.8	85.0	184.8	205.2	400.3	282.0	147.5	124.4	83.8
Koryakia	–	–	–	18.7	22.0	20.0	40.0	36.8	23.0	–
Export	–	–	–	18.7	17.9	19.4	31.8	26.8	21.0	–
Import	–	–	–	–	4.1	0.6	8.2	10.1	2.0	–
RFE	2,681.4	3,038.6	2,924.4	4,776.0	5,459.0	5,679.0	4,796.0	3,608.0	4,746.0	5,808.8
Export	1,491.7	1,822.3	1,669.6	2,883.0	3,590.0	3,357.0	3,021.0	2,516.0	3,809.0	4,615.7
Import	1,189.7	1,216.3	1,256.0	1,893.0	1,870.0	2,323.0	1,775.0	1,091.0	936.2	1,193.1

Source: Far East and Zabaikalye Association, 2002.

Appendix D
Foreign trade and full trade turnover, by region, 2000

Region	Annual trade turnover (U.S. $)	Export (U.S. $)	Major exports	Import (U.S. $)	Major imports	Trading partners (% of total)
Khabarovsk	$1.44 billion	$1.287 billion	Timber, military, and energy equipment, fish and shellfish, gold, platinum	$136 million	Machinery, equipment, food, electronics	China 38% Japan 16% Republic of Korea 5% U.S. 2.8%
Primorsky	$1.371 billion	$996 million	Fish and shellfish, timber, coal, pine nuts, metal scrap	$375 million	Fuel, consumer electronics, food, automobiles	China 27.5% Republic of Korea 24.4% U.S. 21.5% Japan 16.5%
Sakhalin	$1.138 billion	$964.8 million	Oil, fish and shellfish, timber, coal	$172.8 million	Coal, food, fuel, equipment	Japan 15% China 8.7% U.S. 7.5% Republic of Korea 6.3%
Kamchatka	$441.3 million	$316.9 million	Fish and shellfish, timber	$124.9 million	Fuel, consumer goods	Republic of Korea 23% Japan 20% U.S. 19% China 5.4%
Sakha	$176.5 million	$139.5 million	Diamonds, gold, coal	$36.96 million	Oil products, consumer goods, heavy equipment	Japan 67% Republic of Korea 12% U.S. 7.6% China 1%
Magadan	$84.18 million	$16.37 million	Gold and other metals, fish and shellfish	$67.81 million	Food, clothing, oil, heavy equipment	U.S. 45% Republic of Korea 18.7% Japan 15.2% China 2.3%
Amur	$72.47 million	$55.85 million	Timber, ferrous and nonferrous metals	$16.5 million	Food, equipment, consumer goods	China 82% Japan 13% U.S. <1% Republic of Korea <1%
Koryakia	$22.99 million	$21 million	Fish and shellfish, platinum	$1.99 million	Food, clothing, building materials, fuel	Republic of Korea 33% U.S. 25% Japan 17% China 13%
JAO	$16.65 million	$12 million	Timber, clothing	$4.65 million	–	China 47% Republic of Korea 29.3% Japan 3.5%
Chukotka	–	–	Gold, fish and shellfish	–	Fuel, equipment, food	–

Note: Export figures especially for marine products are underreported to avoid taxation. Gold, diamonds, and other precious metals do not appear in export figures because most production is shipped to Moscow.

Sources: Trade figures and information on major export partners comes from the Far East and Zabaikalye Association, 2002; information on major export and import products was derived from the regional chapters.

Appendix E
Distribution of RFE timber stock, by dominant species (million cu. m)

Region	Coniferous				Deciduous			Creeping forests and bushes	Total timber stock
	Pine	Spruce and fir	Larch	Total	Oak and ash	Birch	Total		
RFE	1,910	2,550	12,646	17,106	1,488	328	2,268	1,076	20,450
Khabarovsk	239	1,430	2,603	4,272	44	295	490	231	4,993
Amur	59	82	1,434	1,575	287	16	327	51	1,953
Kamchatka[a]	*	38	94	132	—	550	623	440	1,195
Primorsky	465	551	204	1,220	234	194	547	3	1,770
Sakhalin	1	363	169	533	2	61	73	18	624
Magadan	—	—	288	288	—	*	24	111	423
JAO	32	35	16	83	27	35	90	—	173
Chukotka	—	—	50	50	—	*	9	29	88

Notes: Republic of Sakha is not included, but included in RFE totals.
a. Includes Koryakia.
*Less than 500,000 cu. m.

Source: Far Eastern Forestry Inventory Enterprise, 1995. Adapted from the table on p. 8 of "The Forest Sector of the Russian Far East."

Appendix F
Average timber stock in the RFE, by dominant species (cu. m per ha)

Region	Coniferous				Deciduous		
	Pine	Spruce and fir	Larch	Total	Oak and ash	Birch	Total
RFE	126	169	76	87	95	72	78
Primorsky	212	180	169	189	106	116	115
JAO	187	149	107	150	81	80	90
Sakhalin	21	173	105	141	83	56	57
Khabarovsk	144	167	103	121	105	67	78
Kamchatka*	11	182	101	115	-	84	77
Amur	84	165	109	109	37	61	61
Magadan	-	-	38	38	-	34	118
Chukotka	-	-	28	28	-	60	84

Note: * Includes Koryakia. Data for the Republic of Sakha are not included.

Source: Far Eastern Forestry Inventory Enterprise, 1995. Adapted from the table on p. 9 of "The Forest Sector of the Russian Far East."

Appendix G
RFE experts, Hotspot Conference, 1998

The Hotspots were identified at regional roundtables held prior to the joint World Conservation Union (IUCN) –Friends of the Earth–Japan 1998 Conference, Biodiversity Hotspots of the Russian Far East. At each of the roundtables approximately twenty participants from government, NGOs, and academic circles met to discuss and reach consensus on between five and seven priority territories ("Hotspots"). The procedure for reaching consensus began with presentations by all interested specialists, who described and supported the inclusion of one or more territories in the list. Then, on the basis of the criteria outlined in the section "Ecology" (see p. 39), participants nominated and explained their reasons for selecting the five areas that they felt best suited the criteria. These selections were tallied and the five (or seven, in case of ties) Hotspots receiving the most votes were put forth for final approval by the roundtable participants; these participants are listed for each region below. Some of the participants have since taken new jobs, although their respective titles and institutions from 1998 are still listed here.

Primorsky

- A. Lebedev, Director, Bureau of Regional Outreach Campaigns (Regional Co-coordinator)
- V. Karakin, Pacific Institute of Geography (Regional Co-coordinator)
- V. Aramilev, Institute of Sustainable Nature Use
- T. Aramileva, Regional Game Commission
- A. Ashchepkov, Institute of Marine Biology
- Y. Bersenev, Chief Specialist, Primorsky Committee on Environmental Protection
- V. Bocharnikov, Pacific Institute of Geography
- T. Dikun, Pacific Institute of Geography
- V. Dyukarev, Institute of Soil Biology
- P. Fomenko, WWF–Russia, Vladivostok office
- V. Gaponov, Committee on Natural Resources, Primorsky Regional Administration
- L. Kabalik, Zov Taigi Center
- V. Rosenberg, Institute of Soil Biology
- V. Seledets, Institute of Soil Biology
- V. Solkin, Zov Taigi Center
- T. Vorobyeva, Far Eastern State University

Khabarovsk

- A. N. Kulikov, Chairman, Khabarovsk Wildlife Foundation (Regional Co-coordinator)
- B. A. Voronov, Director, Institute of Water and Ecological Problems (Regional Co-coordinator)
- N. M. Balagansky, Director, Regional Game Commission
- N. V. Bolshova, Director, Environmental Information Agency, Khabarovsk Wildlife Foundation
- A. A. Darensky, Director, Far East Branch, All-Russian Scientific Research Institute of Hunting and Animal Husbandry
- N. N. Efimov, Deputy Director, Office of Nature Use Economics and Policy, Department of Natural Resources and Extractive Industries, Khabarovsk Regional Administration
- V. M. Kolomytsev, Deputy Director, Khabarovsk Forest Service
- V. G. Kryukov, Deputy Director, Department of Natural Resources and Extractive Industries, Khabarovsk Regional Administration
- V. M. Sapaev, Senior Researcher, Institute of Water and Ecological Problems
- S. D. Shlotgauer, Head of Laboratory, Institute of Water and Ecological Problems
- V. B. Skachkov, Deputy Chairman, Khabarovsk Committee on Environmental Protection

Jewish Autonomous Oblast

- V. V. Gorobeiko, Director, Bastak Ecological Initiative Center (Regional Coordinator)
- V. A. Akhmadulin, Deputy Director for Science, Regional Institute of Complex Anthropogenic Problems
- N. A. Belonogova, Deputy Chairperson, JAO Committee on Environmental Protection
- A. E. Dementyev, Director, Regional Game Commission
- A. Y. Kalinin, Director, Bastak Zapovednik
- A. A. Kruglenko, Head, Department of Land Management, JAO Committee on Land Resources
- S. A. Mokrov, Chief Inspector, Regional Fisheries Protection Service
- S. M. Mrischuk, Head, Department of Nature Use, Economic Agency, Government of JAO
- A. R. Mukhomedyarova, Chief Specialist, JAO Committee on Environmental Protection
- V. M. Nikitinsky, Head, JAO Forest Service
- V. M. Panevin, Chairman, Hunters' and Fishermen's Society
- T. A. Rubtsova, Chief Lecturer, Blagoveshchensk State Pedagogical Institute
- N. R. Sukhomlinov, Researcher, Laboratory of Social Systems, Regional Institute of Complex Anthropogenic Problems

- V. V. Sukhomlinova, Head, Laboratory of Social Systems, Regional Institute of Complex Anthropogenic Problems
- V. V. Ulanov, Department Head, JAO Committee on Environmental Protection
- S. P. Yakimov, Chairman, JAO Committee on Environmental Protection
- E. M. Yakovleva, Researcher, Laboratory of Bioresources and Ecology, Regional Institute of Complex Anthropogenic Problems

Amur

- Y. A. Darman, Director, Socio-Ecological Union, Amur Branch (Regional Coordinator)
- V. A. Andronov, Director, Khingansky Zapovednik
- V. V. Artyomov, Head, Department of Flora and Fauna Protection, Amur Committee on Environmental Protection
- V. V. Faizulin, Director, Botanical Garden, Amur Research Center
- V. F. Grekhovodov, Director, Zeisky Zapovednik
- G. N. Ivanov, Chairman, Permanent Commission on Agricultural Policy, Nature Use, and Ecology of the Amur Regional Assembly (soviet)
- F. I. Kabatov, Chief Specialist, Committee on Nature Use and Mining Industry, Amur Regional Administration
- A. Y. Koval, Chairman, Amur Committee on Environmental Protection
- V. L. Luzhnov, Deputy Chairman, Amur Committee on Natural Resources
- G. M. Nosovtsev, Head, Department of Environmental Assessment, Control, and Protection of Natural Resources, Committee on Nature Use and Mining Industry, Amur Regional Administration
- I. G. Sakovich, Director, Amur-Batyushka Center for Support of NGOs and Environmental Awareness
- G. V. Shestakov, Deputy Chairman, Amur Committee on Land Resources and Land Management

- B. A. Stamikov, Deputy Director, Regional Game Commission
- A. N. Surovegin, Deputy Head, Amur Regional Administration
- G. S. Veriga, Deputy Director, Amur Forest Service

Republic of Sakha (Yakutia)

- A. P. Isaev, Forestry Group Head, Institute of Biological Problems of the Permafrost Zone (Regional Coordinator)
- R. V. Desyatkin, Laboratory Director, Institute of Biological Problems of the Permafrost Zone
- L. P. Egorova, Ecological Center NGO, Republic of Sakha (Yakutia)
- N. P. Pavlov, Committee to Save the Vilyui River Basin
- V. F. Popov, Chief Lecturer, Yakutsk State University
- N. D. Sedelnik, Chief Forester, Republic of Sakha (Yakutia)
- L. E. Shmatkova, Deputy Minister of Nature Protection of the Republic of Sakha (Yakutia)
- I. F. Shurduk, Senior Staff Researcher, Institute of Biological Problems of the Permafrost Zone
- P. A. Timofeev, Professor, Yakutsk State University

Magadan

- M. A. Krechmar, Institute of Biological Problems of the North (Regional Coordinator)
- N. N. Afanasiev, Director, Magadan Branch, Pacific Fisheries Institute
- V. E. Averyanov, Director, Magadan Forest Service
- V. I. Bekhteev, Director, Magadansky Zapovednik
- B. A. Berdnikov, Chairman, Magadan Committee on Environmental Protection
- D. I. Berman, Institute of Biological Problems of the North
- L. P. Biryukova, Dean, Northern International University
- V. M. Bradesko, Director, Magadan Branch of Okhotsk Fisheries Commission
- F. B. Chernyavsky, Director, Institute of Biological Problems of the North

- G. V. Devyatkin, Deputy Director, Magadansky Zapovednik
- V. A. Dubinin, Institute of Biological Problems of the North
- V. P. Fedortsov, Director, Regional Game Commission
- M. V. Frunza, Deputy Director, Magadan Committee on Environmental Protection
- N. G. Gorobets, Acting Director, All-Russian Scientific Research Institute-1 (Magadan Branch)
- A. K. Khabarova, Chairperson, Regional Association of Native Peoples of the North
- T. G. Klimenko, Deputy Director, Magadan Committee on Environmental Protection
- A. V. Kondratev, Deputy Director, Institute of Biological Problems of the North
- D. P. Koravye, Chief, Department of Indigenous People's Affairs, Magadan Regional Administration
- V. L. Kozlov, Magadan Committee on Environmental Protection
- P. I. Krivulin, Director, State Small Craft Inspection Service
- A. S. Kryuchkov, Okhotsk Fisheries Inspectorate
- N. G. Mikhailov, Director, Arctic Agricultural Research Institute
- V. A. Moskvichev, Chairman, Magadan Committee on Agriculture and Produce
- A. G. Pronin, Director, Northeastern Airborne Forest Protection Base
- N. S. Proskurina, Director, Magadan Center for the Environment
- Y. V. Pruso, Chairman, Magadan Committee on Natural Resources
- A. I. Semkin, Chairman, Magadan Committee on Land Resources
- S. M. Sinopalnikov, Director, Regional Marine Inspectorate
- S. V. Skrylev, Deputy Director, Regional Marine Inspection Service
- V. A. Solovei, Regional Game Commission
- A. S. Tsybulsky, Directors, Department of Education, Magadan Regional Administration
- I. Vedernikov, Assistant to the Committee on Geology, Magadan Regional Duma
- I. A. Vitko, Magadan Committee on Environmental Protection
- M. I. Zamoshch, Chief, Laboratory of Disturbed Landscapes, Eastern Scientific Research Institute on Gold and Rare Metals

Chukotka

- G. P. Smirnov, Chairman, Kaira Club Environmental NGO (Regional Coordinator)
- T. Y. Achirgina, Vice-President, Association of Chukotka Eskimos

- V. I. Ekelkut, Chairperson, Working Group on Environmental Protection, Regional Association of Native Peoples of the North
- A. A. Galanin, Director, Laboratory of Evolution of Biological and Geological Systems of Beringia, Chukotka Research Center
- N. A. Korogod, Deputy Chief Sanitation Physician
- Y. A. Korotaev, Staff Researcher, Pacific Institute of Fisheries and Oceanography
- V. V. Litovka, Executive Director, Kaira Club Environmental NGO
- L. P. Maltseva, Chief Staff Researcher, Chukotka Natural History Museum
- T. A. Melnikova, Chief Specialist on Fisheries, Department of Agriculture, Chukotka Regional Administration
- O. N. Mironenko, Director, State Land Cadaster, Chukotka Committee on Land Resources
- D. V. Naumkin, Staff Researcher, Pacific Institute of Fisheries and Oceanography
- E. V. Ogorodnikova, Consultant, Committee on Natural Resources and Ecology, Regional Duma
- E. V. Oschepkova, Staff Researcher, Pacific Institute of Fisheries and Oceanography
- G. S. Ovcharov, Head, Department of Water Resources, Chukotka Committee on Natural Resources
- E. P. Petrenko, Director, Chukotka Research Center
- I. G. Riga, Staff Researcher, Chukotka Natural History Museum
- B. A. Seifullaev, Deputy Director, Chukotka Committee on Environmental Protection
- E. P. Shevchenko, Chief Inspector, Regional Fisheries Inspectorate
- N. G. Shevchenko, Department Head, Chukotka Committee on Environmental Protection
- Y. B. Tikhomirov, Chief Geologist, Chukotka Committee on Natural Resources
- O. D. Tregubov, Director, Laboratory of Geo-ecology, Chukotka Research Center
- G. A. Tynankergav, Chairperson, Committee on Natural Resources and Ecology, Regional Duma

Koryakia

- O. A. Chernyagina, Staff Researcher, Kamchatka Institute of Ecology and Nature Use (Regional Coordinator)
- S. E. Abramov, Deputy Chairman, Koryak Committee on Environmental Protection
- A. V. Baranov, Chief Specialist, Koryak Committee on Environmental Protection

- A. L. Gridyaev, Chief Specialist, Koryak Committee on Environmental Protection
- V. T. Grigoryev, Acting Chairman, Koryak Committee on Land Resources
- N. K. Grishenev, Committee Chairman, Koryak Regional Duma
- L. F. Gusak, Chief Specialist, Koryak Committee on Environmental Protection
- L. G. Khamidullina, Chief Specialist, Koryak Committee on Land Resources, Representative of Regional Association of Native Peoples of the North
- E. E. Kochnev, Deputy Chairman, Committee on Development of Fuel and Energy Complex
- A. V. Kolpakova, Chief Specialist, Koryak Committee on Environmental Protection
- L. P. Lipatova, Department Head, Koryak Committee on Environmental Protection
- S. E. Malyshev, Deputy Director, Regional Game Commission
- A. B. Meshalkin, Representative of the President of the Russian Federation in the Koryak Autonomous Okrug
- A. P. Morgun, Forester, Tigilsky Forest Service
- Z. P. Pepe, Department Head, Koryak Committee on Land Resources
- M. V. Rogaleva, Head, Koryak Agriculture Department
- A. Smyshlyaev, independent journalist
- I. G. Tsulya, Chairman, Koryak Committee on Environmental Protection

Kamchatka

- O. A. Chernyagina, Staff Researcher, Kamchatka Institute of Ecology and Nature Use (Regional Coordinator)
- A. A. Aliskerov, Kamchatka Regional Administration
- G. P. Avdeiko, Institute of Volcanic Geology and Geochemistry
- V. Berezovskaya, Kamchatka State Fishing Fleet Academy
- V. A. Bondarev, Kamchatka Committee on Environmental Protection
- G. P. Devyatkin, Head, Bystrinsky Local Administration
- V. D. Dmitriev, Kamchatka Representative, Petrovskaya Academy of Arts and Sciences
- N. P. Doronina, Alnei Club, Council Member, All-Russian Society for Nature Protection
- L. G. Ignatenko, Chairperson, ALESKAM Native People Community
- N. S. Karpukhin, Kamchatka Committee on Environmental Protection

- N. V. Kazakov, Kamchatka Committee on Environmental Protection
- V. P. Khvorostov, Koryak Mining Company
- N. G. Klochkova, Kamchatka Institute of Ecology and Nature Use
- G. A. Lazarev, Director, Kamchatka Forest Experimental Station
- E. G. Lobkov, Elizovsky Local Administration
- V. I. Menshikov, Director, Directorate of Nature Parks of Kamchatka Oblast
- V. I. Mosolov, Kronotsky Biosphere Zapovednik
- A. A. Orlov, Kamchatka Regional Administration
- L. N. Skorobogatsko, Director, Garmoniya Public Association
- S. M. Trubitsyn, private farmer and beekeeper
- V. E. Upryamov, Kamchatka Institute of Fisheries and Oceanography
- P. E. Verecheva, Kamchatka Committee on Environmental Protection

Sakhalin

- D. V. Lisitsyn, Chairman, Sakhalin Environment Watch (Regional Coordinator)
- V. D. Fedorchuk, Sakhalin Natural History Museum
- A. K. Klitin, Sakhalin Research Institute of Fisheries and Oceanography
- V. A. Kozlov, Boomerang Tourist Club
- V. S. Labai, Sakhalin Research Institute of Fisheries and Oceanography
- S. S. Makeev, Anivskaya Observation Station, Sakhalin Fisheries Inspectorate
- Z. V. Revyakina, Sakhalin Committee on Environmental Protection
- A. Y. Romanova, Sakhalin Environment Watch
- R. N. Sabirov, Institute of Marine Geology and Geophysics
- O. A. Sankova, Sakhalin Fisheries Inspectorate
- E. V. Semenov, Regional Center for Young Tourists
- V. M. Skalchinsky, Sakhalin Forest Service
- A. V. Solovyev, Institute of Marine Geology and Geophysics
- A. A. Taran, Sakhalin Botanical Garden
- I. G. Zdornov, Sakhalin Zoo

Appendix H
Catch quotas for major species in the RFE basin, 2001 (000 metric tons)

Species	West Bering Sea Zone	East Kamchatka Zone		North Kuril Zone	South Kuril Zone	Sea of Okhotsk Zone				Sea of Japan Zone		Total
		Karaginsky Subarea	Petropavlovsk Kommandorsky Subarea			North Okhotsk Subarea	West Kamchatka Subarea	Kamchatka Kuril Subarea	East Sakhalin Subarea	Primorye Subarea	West Sakhalin Subarea	
Finfish	899.7	132.4	110.1	81.2	250.2	803.0	389.3	165.6	35.2	165.1	46.1	3,077.9
Alaska pollock	722.0	25.0	41.0	21.0	30.0	510.0	230.0	70.0	5.0	20.0	4.0	1,678.0
herring	14.5	77.5	–	–	–	238.0	78.0	–	0.4	0.3	1.7	410.4
flounder	5.0	47.2	19.0	2.5	1.0	0.8	35.8	53.4	5.3	3.3	15.7	189.0
saury	–	–	–	–	100.0	–	–	–	–	50.0	–	150.0
cod	55.0	9.9	26.5	6.1	2.2	3.0	13.1	10.2	0.4	7.4	5.0	138.8
Atka mackerel	–	1.5	20.2	30.2	3.5	–	–	–	–	32.9	0.4	88.7
tuna	–	–	–	–	60.0	–	–	–	–	–	–	60.0
wachna cod	5.0	4.5	–	–	2.0	0.5	17.6	4.4	8.3	1.2	1.4	44.9
halibut	4.8	1.2	0.4	0.6	–	8.6	5.7	4.7	2.8	–	–	28.8
Crab	1.4	0.3	1.4	0.9	0.3	13.9	13.6	6.8	3.2	16.2	1.1	59.1
red king	–	0.1	0.2	0.2	–	1.8	10.2	3.7	0.2	2.0	0.3	18.7
tanner opilio	0.1	–	0.2	–	–	10.4	0.5	–	2.4	0.5	0.4	14.5
red tanner	–	–	–	–	–	–	–	–	–	13.1	0.3	13.4
blue king	1.1	0.1	–	–	–	0.4	2.3	–	0.4	0.5	–	4.8
golden king	–	–	–	0.7	0.3	0.9	0.4	–	0.1	–	–	2.4
hanasaki	–	–	0.1	–	–	0.4	0.3	–	0.1	–	–	0.9
Cephalopods*	25.3	15.7	15.0	88.6	86.7	2.9	0.9	2.1	2.1	116.5	18.0	373.8
squid	25.0	15.0	15.0	85.0	85.8	–	–	–	–	111.0	17.0	353.8
scallops	–	0.4	–	3.6	0.2	–	–	–	0.2	0.2	–	4.6
octopus	–	–	–	–	0.5	–	–	–	–	0.2	0.1	0.8
Echinodermata	–	–	0.3	–	0.1	0.7	–	0.1	0.1	0.4	0.2	2.0
Cucumaria japonica	–	–	–	–	2.0	–	–	3.7	2.1	0.5	0.3	8.6
sea urchin	2.7	0.3	0.4	–	0.1	0.7	0.1	–	0.1	1.6	0.1	6.1
trepang	–	–	–	–	–	–	–	–	–	–	–	0.1
Seaweed	0.1	0.4	0.3	3.0	93.7	0.4	0.2	0.1	2.8	32.0	6.0	139.0

Notes: * Also included but not listed are equipodal, humpback, deepwater, grass, and bear-cub shrimp.
 Figures are rounded up to the first decimal point. A dash indicates quota was less than 0.1.

Source: Russian Fish Report 3, no. 54 (2001), which attributes the data to Russian [Federation] Government Order No. 146-r, February 1, 2001.

Appendix I
Russian timber exports to Northeast Asia, 1991–2001 (000 cu. m)

Country/type	1991	1992	1993	1994	1995	1996	1997	1998	1999	2000	2001
Japan	4,553	4,490	5,260	5,175	5,861	5,846	6,638	5,056	6,544	6,053	5,684
logs	4,303	4,268	4,985	4,847	5,464	5,448	6,134	4,761	6,096	5,512	5,099
sawnwood	250	222	275	328	397	398	504	295	448	541	585
Russian share of total log imports	16.9%	17%	21.9%	22%	25%	25.8%	31.3%	32.4%	38.3%	36.1%	37.7%
China	281	643	444	661	375	540	960	1,711	4,400	–	8,000*
logs	281	625	392	603	358	529	949	1,698	4,305	5,931	
sawnwood	–	18	52	58	17	11	11	13	95	–	–
Russian share of total log imports	6.5%	13%	11%	18%	13.9%	16.6%	21.2%	33%	42.5%	43.6%	–
Republic of Korea	–	–	590	547	747	840	941	796	1,202	1,660	1,600
logs	87	193	572	527	730	823	930	792	1,202	1,636	1,554
sawnwood	–	–	18	20	17	17	11	4	12	24	46
Russian share of total log imports	–	–	–	–	–	–	–	–	18%	24.3%	22%

Notes: * Estimate from *Japan Lumber Journal*. Some numbers do not add up because of pulp and paper exports.

Source: Compiled by author from Japan Lumber Importers Association; Ministry of Finance, Japan; *Chinese Customs Yearbook (1995–1999)*, in Yamane and Chen; Office of Forestry, ROK; Waggener and Backman, 1998.

Appendix J
Chinese imports of Russian logs, 1996–2000, by gateway (cu. m)

Region/gateway type	Customs gateway	1996	1997	1998	1999	2000
Western Manchuria	Manzhouli	149,746	387,540	671,966	1,824,350	2,152,607
Southeastern Manchuria	Suifenhe	276,067	385,027	563,257	1,355,084	2,069,878
Inner Mongolia	Erlianhot	11,778	118,978	261,670	955,947	1,543,103
Small gateways		46,794	27,930	21,725	58,958	102,996
Jilin	Heihe	2,591	208	3,989	106,314	60,462
	Hunchun	626	–	1,404	11,022	8,596
Xinjiang	Alashankou	–	–	269	8,163	7,317
Coastal ports		54,213	40,661	66,206	80,364	94,846
Total		**480,025**	**909,618**	**1,512,494**	**4,235,631**	**5,930,938**

Note: Totals do not add up because some small export points are not included.

Source: Data collected from Chinese customs offices by Yamane and Lu, "Recent Russia-China Timber Trade." See chap. 1, n. 167 on p. 431.

Appendix K
Gold production in Russia and the RFE, 1991–2001 (tons)

Region	1991	1992	1993	1994	1995	1996	1997	1998	1999	2000	2001
Russia	168.1	146.1	149.5	142.6	131.9	123.5	125.6	114.7	126.0	142.7	154.5
Mining companies	133.7	126.0	136.2	131.9	122.8	113.6	116.1	105.8	114.0	137.1	141.2
RFE	96.6	92.2	94.7	91.2	82.7	76.0	74.8	62.7	66.7	74.0	–
Magadan	30.4	29.2	28.6	28.2	22.3	23.2	28.0	30.3	29.2	29.5	30.6
Sakha	32.8	30.5	33.4	31.3	28.8	23.0	20.0	11.1	15.2	16.7	16.6
Khabarovsk	7.8	7.5	7.7	7.7	8.3	8.4	6.8	5.6	7.2	9.2	13.5
Amur	10.8	10.2	11.2	11.4	12.4	11.3	9.7	8.7	9.2	11.8	12.9
Chukotka	14.4	14.4	13.1	11.7	9.8	9.1	9.6	6.2	5.4	6.5	6.4
Primorsky	0.2	0.2	0.5	0.4	0.4	0.3	–	0.1	0.1	0.1	0.1
JAO	–	–	–	–	0.1	0.2	0.1	0.1	0.2	0.2	0.1
Sakhalin	0.2	0.2	0.1	0.2	0.2	0.2	0.2	0.2	0.2	–	–
Koryakia	–	–	0.1	0.3	0.4	0.4	0.4	0.4	–	–	–

Note: Figures are rounded up to the first decimal point. A dash indicates quota was less than 0.1.

Sources: *Gorny Zhurnal*, 2000 (see p. 427 for complete reference); and *Gold Mining Industry in Russia in 2001*, Internet Securities, Inc., 27 June 2002. Available from www.site.securities.com.

List of abbreviations

AAC annual allowable cut

AMNKCh Association of Native Minorities of Chukotka

AO *aktsionernoye obshchestvo*, a joint-stock (publicly owned) company

APHIS Animal Plant Health Inspection Service

ARCO Atlantic Richfield Co.

ATVs all-terrain vehicles

BAES Bilibino nuclear power plant

BAM Baikal-Amur Mainline

BP British Petroleum

CIDA Canadian International Development Agency

CIDS Concrete Island Development System

CINTRAFOR . . Center for International Trade in Forest Products

CIS Commonwealth of Independent States

CITES Convention on International Trade in Endangered Species

CSO Central Selling Organisation (De Beers)

DPS/s diesel power station/s

EBRD European Bank for Reconstruction and Development

EEZ Exclusive Economic Zone

EFS Experimental Forestry Station

EIA Environmental Impact Assessment

EPT Environmental Policy and Technology Project

ERI Economic Research Institute of the Far Eastern Branch of the Russian Academy of Sciences

Ex-Im Bank Export-Import Bank of the United States

FAO U.N. Food and Agricultural Organization

FBS Federal Border Service

FDI foreign direct investment

FEBRAS Far Eastern Branch of the Russian Academy of Sciences

FEC Federal Energy Commission

FoE–J Friends of the Earth–Japan (also FoE–Japan)

FSB Federal Security Service (Bureau)

FSC Forest Stewardship Council

GDP Gross Domestic Product

GEF Global Environment Facility

GIP Gross Internal Product

GIS Geographic Information System

GOK *gorno-obogatitelniy kombinat*, ore-enriching combine

GPP/s geothermal power plant/s

GRP Gross Regional Product

HPP/s hydropower plant/s

IBPN Institute of Biological Problems of the North

IBRD International Bank of Reconstruction and Development

ICC Inuit Circumpolar Conference

IFC International Finance Corporation

IFI International Financial Institution

IMF International Monetary Fund

IUCN World Conservation Union; formerly International Union for Conservation of Nature

IVEP Institute of Water and Ecological Problems

IWC International Whaling Commission

JAO Jewish Autonomous Oblast

JBIC Japan Bank for International Cooperation

JV *sovmestnoe predpriyatie*, a joint-venture company with international partners

KAO Koryak Autonomous Okrug

KamchatNIRO . . Kamchatka Research Institute of Fisheries and Oceanography

KGB former Committee for State Security

KIEP Kamchatka Institute of Ecology and Nature Use

kW kilowatts

kWh kilowatt hour

LNG liquefied natural gas

LPX *lespromkhoz*, collective forestry enterprise, now usually private company

MACE Magadan Center for the Environment

MagINRO Magadan division of TINRO

MIGA Multilateral Investment Guarantee Agency

mmt million metric tons

MPC maximum permissible concentration

MPL maximum permissible level

MW megawatt

NGO/s nongovernmental organization/s

NIS Newly Independent States

NKVD former People's Commissariat of Internal Affairs

NNR natural resources reserve

NPP/s nuclear power plant/s

NTFP/s non-timber forest product/s

OAO *otkrytoe AO*, open joint-stock company

OECD Organization for Economic Cooperation and Development

OmGGK Omsukchansk Mountain Geological Company

OOO *obshchestvo s ogranichennoi otvetstvennostiyu*, similar to a U.S. limited liability company

OPIC Overseas Private Investment Corporation (U.S.A.)

OVOS Assessment of Environmental Impact

PA/s protected area/s

PERC Pacific Environment and Resources Center

pop. population

PSA/s Production Sharing Agreement/s

RAIPON Russian Association of Indigenous Peoples of the North

RAS Russian Academy of Sciences

RFE Russian Far East

RITEGs radioisotopic thermoelectric generators

SakhNIRO Sakhalin Research Institute of Fisheries and Oceanography

SEIC Sakhalin Energy Investment Corporation, Ltd.

SEU Socio-Ecological Union

SEW Sakhalin Environment Watch

SME/s small and medium enterprise/s

SMNG Sakhalinmorneftegaz

SODECO Sakhalin Oil and Development Corporation

TDA Trade and Development Agency

TINRO Pacific Institute of Fisheries and Oceanography

TOO *tovarishchestvo s ogranichennoi otvetstvennostiyu*, a limited liability company; now defunct

TPP/s thermal power plant/s

TTP/s Territory/ies of Traditional Nature Use

UNDAC United Nations Disaster and Assessment Coordination

UNDP United Nations Development Programme

UNEP United Nations Environmental Programme

UNESCO United Nations Educational, Scientific, and Cultural Organization

UNIDO United Nations Industrial Development Organization

USAID United States Agency for International Development

USGS United States Geological Survey

USSR Union of Soviet Socialist Republics; The Soviet Union

VAT value-added tax

VNIRO Russian Federal Research Institute of Fisheries and Oceanography

WCMC World Conservation Monitoring Center

WHRC Woods Hole Research Center

WRI World Resources Institute

WTO World Trade Organization

WWF World Wildlife Fund

ZAO *zakrytoe AO*, a closed joint-stock company

Notes

These endnotes provide bibliographic information for "Useful terms" in the front matter, the chapters, and the figures, maps, and tables. Abbreviations used in the endnotes are listed on pp. 425–26. Works frequently cited have been identified in short form as follows:

East of the Sun
Benson Bobrick, *East of the Sun: The Epic Conquest and Tragic History of Siberia*, 1st Owl Book ed. (New York: Henry Holt and Co., 1993).

Energy and Mineral Resources
Interregional Association of Economic Cooperation Members of the Federation of the Far East and Zabaikalye (Far East and Zabaikalye Association) and Administration of Khabarovsk Krai, *Energy and Mineral Resources of the Far East and Zabaikalye: An Investment Atlas* (Khabarovsk: Far East and Zabaikalye Association, 1997).

Forest Sector of the Russian Far East
Alexander S. Sheingauz, Vladimir P. Karakin, and V. A. Tyukalov, *Forest Sector of the Russian Far East: A Status Report* (Khabarovsk: ERI, 1996).

Gorny Zhurnal
Yu. A. Mamaev and A. P. Van-Van Ye, "Gornodobyvaiushchaia promyshlennost´ Dal´nego Vostoka-nastoiashchee i budushchee" [The mining industry of the Far East—present and future] *Gorny Zhurnal* (2000).

Goskomstat
State Committee for Statistics. Data were accessed online at www.gks.ru or collected from regional statistics agencies.

Russian Far East: A Business Reference Guide
Eliza Miller and Alexander Karp, *The Russian Far East Update: A Business Reference Guide*, 4th ed. (Seattle: Russian Far East Update, 1999).

Russian Far East: An Economic Handbook
P. A. Minakir and Gregory L. Freeze, *The Russian Far East: An Economic Handbook* (Armonk, N.Y.: M. E. Sharpe, 1994).

Front matter — Useful terms

1. Information gleaned from the following websites: www.russia-travel.com/history.htm, www.studyrussian.com/history/history.html, and www.necco.net/category/governments/regional_government.htm [accessed 5 December 2002].

2. See www.fas.org/spp/civil/russia/fsgm.htm for information on this agency.

3. See their website at www.fccland.ru/english/geninfo.htm.

4. See www.bisnis.doc.gov/bisnis/isa/9904cert.htm.

5. See www.fecrf.ru/intl/en/cmden/info/ [accessed 5 December 2002].

6. C. G. Pautzke, *Russian Far East Fisheries Management: Report to Congress* (Anchorage: North Pacific Fishery Management Council, 1997), 52.

7. See the Ministry's website at www.aris.ru.

8. Information from www.fas.org/nuke/guide/russia/agency/minatom.htm [accessed 5 December 2002].

9. See www.fas.org/spp/civil/russia/min_ec.htm and www.oecdmoscow.org/rusweb [accessed 5 December 2002].

10. See www.minfin.ru [accessed 5 December 2002].

11. Information taken from http://projects.sipri.se

12. For background on Minfin, see www.erranet.org/members/russia/ [accessed 5 December 2002].

13. See Minprom's website for more information, www.minprom.ru [accessed 5 December 2002].

14. Information on MVD can be found at www.fas.org/irp/world/russia/mvd.

15. For background on recent developments concerning the abolition of the Committee on Environmental Protection see www.forest.ru/eng/problems, www.earthjustice.org/news, www.americanlands.org/IMF/russia.htm. For information on the Federal Forest Service, see www.forest.ru/eng/problems/control/rosleskhoz.html and www.fire.uni-freiburg.de/media. The ministry's website can be accessed at www.mms.gov.

16. See www.americanlands.org/IMF/russia.htm and www.mms.gov/intermar/russia2.htm [accessed 5 December 2002].

17. See the Ministry's website at www.mintrans.ru.

18. See the RAS website at http://isir.ras.ru/en.

19. Information on the Russian Central Bank can be found at www.cbr.ru/eng and www.russia.net/business/finance/banks.

20. See www.grida.no/pame.

21. See Goskomstat's website, www.gks.ru/eng/about/default.asp.

22. Information taken from www.zrpress.ru and www.tradeport.org/ts/countries/russia [accessed 5 December 2002].

23. See the following web sources, www.emg-russia.com/limited_liability_company.html; www.kpmg.ru/russian; and www.usatrade.gov/website.

Chapter 1 — Overview

1. Korean pine is technically banned for harvest throughout the RFE, but loopholes allow for harvest while building roads, constructing loading areas, and so on. See *Forest Sector of the Russian Far East*.

2. The recent demand for snakes by Chinese restaurants threatens to wipe out snake populations in Primorsky Krai.

3. Vladimir Krever et al., *Conserving Russia's Biodiversity: An Analytical Framework and Initial Investment Portfolio* (Washington, D.C.: WWF, 1994).

4. Masu is commonly referred to as "cherry" salmon.

5. David Gordon, *Protecting the Next Frontier: Recommendations for Stepping across the Bering Strait to Promote Natural Resource Sustainability in Asian Russia* (Oakland: Pacific Environment, 2000).

6. M. J. Bradshaw, "Comments on Chapter 1 from Bradshaw," 15 December 2002, personal e-mail.

7. Scholars now question the accuracy of reported reserves and note that many accessible reserves are depleted. See in particular M. J. Bradshaw and N. J. Lynn, "Resource-Based Development in the Russian Far East: Problems and Prospects," *Geoforum* 29, no. 4 (1998).

8. *Energy and Mineral Resources*.

9. Judith Thornton and Charles E. Ziegler, "The Russian Far East in Perspective," in *Russia's Far East: A Region at Risk*, ed. Judith Thornton and Charles E. Ziegler (Seattle: The National Bureau of Asian Research, University of Washington Press, 2002), 20.

10. Keith Bush, an analyst for the Center for Strategic and International Studies, attributes Russian GDP growth in 1999, 2000, and 2001 to numerous factors, including the remaining impact of import substitution after the 1998 ruble devaluation, high world prices for Russian exports (e.g., oil, gas, metals), Putin's economic restructuring, sound fiscal and monetary policies, and recovery in private consumption and investment. See Keith Bush, *The Russian Economy in June 2002* (Washington, D.C.: Center for Strategic and International Studies, 2002).

11. Nadezhda Mikheeva, "Social and Economic Differentiation in the Russian Far East," in *Russia's Far East: A Region at Risk.*

12. Dale Miquelle, "Effects of Roads and Human Disturbance on Amur Tigers," *Conservation Biology* 16, no. 1 (2002).

13. Most precious metals are exported through Moscow.

14. *Japan Lumber Journal* 44, no. 3 (2003).

15. Brenton Barr and Kathleen Braden's characterization of the RFE's regional economy as "highly truncated[,] … dependent on external sources of capital and equipment, [and] specializing in the production of a limited number of resources, with the bulk of economic activity concentrated in urban settlements in the southern part of the region" remains as true today as when they penned it in 1988. See Brenton M. Barr and Kathleen E. Braden, *The Disappearing Russian Forest: A Dilemma in Soviet Resource Management* (Totowa, N.J.: Rowman & Littlefield, 1988).

16. Thornton and Ziegler, "Russian Far East in Perspective," 3–31.

17. See "Toward sustainable development," pp. 86–99, for more information.

18. For a synopsis of the IMF report, see Victoria Lavrentieva, "IMF Calls Oil the Country's Achilles' Heel," Moscow Times, 15 November 2002. For the World Bank's economic report, see *Russian Economic Report #4* (Moscow: World Bank, 2002).

19. Murray Feshbach has written two of the most popular and influential books on the environmental legacy of the Soviet Union. See Murray Feshbach, *Ecological Disaster: Cleaning Up the Hidden Legacy of the Soviet Regime* (New York: Twentieth Century Fund Press, 1995), and Murray Feshbach and J. R. Alfred Friendly, *Ecocide in the USSR: Health and Nature under Siege* (New York: BasicBooks, 1992).

20. One wonders how much wilderness would be left had the relentlessly efficient U.S. capitalist model been in place in Russia for the last 100 years. Clearly, population and the quantity of land play a role, but would just 3 percent of Russia's frontier forest be left today, as is the case in the United States?

21. Ted S. Vinson and Tatiana P. Kolchugina, *Carbon Cycling in Boreal Forest and Sub Arctic Ecosystems* (Washington, D.C.: United States Environmental Protection Agency [Office of Research and Development], 1993).

22. Kevin Jardine, "The Carbon Bomb: Climate Change and the Fate of the Northern Boreal Forests" (working paper, Stichting Greenpeace Council, Amsterdam, the Netherlands, 1994).

23. George M. Woodwell, "Forests: What in the World Are They For?" in *World Forests for the Future: Their Use and Conservation*, ed. George M. Woodwell and Kilaparti Ramakrishna (New Haven: Yale University Press, 1993).

24. Forest cover figures vary from 22 to 25 percent. For the higher figure, see Armin Rosencranz and Antony Scott, "Siberia's Threatened Forests," *Nature* 355, no. 6358 (1992). For the lower figure, see World Bank, *Project Appraisal Document on a Proposed Loan in the Amount of U.S. $60 Million to the Russian Federation for a Sustainable Forestry Pilot Project: Report No. 20144-RU* (Washington, D.C.: World Bank, 2000).

25. Data are for 1995 and come from the Far Eastern Forestry Inventory Enterprise based in Khabarovsk.

26. FAO, Global Forest Resources Assessment 2000 (Rome: FAO, 2001).

27. *Forest Sector of the Russian Far East*, 13.

28. Sten Nilsson, "Supply Forecasts for Timber from the Russian Far East and Links with the Pacific Rim Market" (paper presented at the conference, Commercial Forestry in the Russian Far East, Yuzhno-Sakhalinsk, Russia, 20 September 2001).

29. Dmitry Aksenov, Maxim Dubinin, and Egorov Alexey, *Atlas of Russia's Intact Forest Landscapes* (Moscow: Global Forest Watch Russia, Greenpeace Russia, Socio-Ecological Union, Biodiversity Conservation Center, 2002).

30. The timber industry assesses forest density by looking at cu. m of timber by ha. Appendix F provides density averages by region; Primorsky Krai forests have the highest densities, followed by forests in the Jewish Autonomous Oblast.

31. Nigel Dudley, Jean-Paul Jeanrenaud, and Francis Sullivan, *Bad Harvest? The Timber Trade and Degradation of the World's Forests* (London: Earthscan Publications, 1995).

32. See Ministry of Natural Resources publications at www.mnr.gov.ru.

33. World Bank, *Russian Federation Forest Policy Review: Promoting Sustainable Sector Development During Transition: Report No. 16222-RU* (Washington, D.C.: World Bank [Agriculture, Industry, and Finance Division], 1996).

34. David M. Ostergen, "System in Peril: A Case Study of Central Siberian Zapovedniki," *International Journal of Wilderness* 4, no. 3 (1998).

35. These quotes come from chapter 3 (p. 156), chapter 4 (p. 186), and an early manuscript version of chapter 8 (see p. 293 for a similar quote), respectively.

36. Josh Newell, *Saving Russia's Far East Taiga: Deforestation, Protected Areas, and Forest Hotspots* (Tokyo: Global Environmental Forum, 1999).

37. World Bank, *Russian Federation Forest Policy Review.*

38. S. Iremonger, C. Ravilious, and T. Quinton, "A Statistical Analysis of Global Forest Conservation," in *A Global Overview of Forest Conservation. Including GIS Files of Forests and Protected Areas, Version 2*, ed. S. Iremonger, C. Ravilious, and T. Quinton (Cambridge, U.K.: Center for International Forestry Research, WCMC, 1997).

39. Bradshaw and Lynn, "Resource-Based Development," 377.

40. Thornton and Ziegler, "Russian Far East in Perspective," 6.

41. Bush, "The Russian Economy."

42. The average age of Russian manufacturing plants and equipment is three times higher than the average for countries belonging to the OECD. See Mikheeva, "Social and Economic Differentiation in the Russian Far East," 106.

43. Arthur Anderson, *Russia Oil and Gas Tax Guide* (Moscow: Arthur Anderson, 1998).

44. Radio Free Europe, "World Bank Says Half the Economy Still in the Shadows" (Radio Free Europe, 12 November 2002 [cited 15 November 2002]); available from www.rferl.org/newsline.

45. M. J. Bradshaw, "The Changing Geography of Foreign Investment in the Russian Federation," *Russian Economic Trends* 11, no. 1 (2002): 34.

46. Joseph E. Stiglitz, *Globalization and Its Discontents* (New York: W. W. Norton & Company, 2002).

47. "Fishing Industry Struggles for Survival," *Russian Journal* 3, no. 173 (2002).

48. Paul Kibel, "Russia's Wild East: Ecological Deterioration and the Rule of Law of Siberia," *Georgetown International Environmental Law Review* 7, no. 1 (1994): 66.

49. EBRD, *Environments in Transition: The Environmental Bulletin of the European Bank for Reconstruction and Development* (London: EBRD, 2002), 2.

50. D. J. Peterson, "Russia's Environment and Natural Resources in Light of Economic Regionalisation," *Post-Soviet Geography* 36, no. 5 (1995). Geographer Jonathan Oldfield reached the same conclusion regarding pollution intensity, but points to different causes. Oldfield argues that economic efficiency had not necessarily decreased, but that pollution discharge (primarily water) from the municipal and agricultural sectors, had remained relatively steady throughout the 1990s despite declining industrial production. See Jonathan D. Oldfield, "Structural Economic Change and the Natural Environment in the Russian Federation," *Post-Communist Economies* 12, no. 1 (2000).

51. Others have written about the "primitization" of the Russian

economy. See Philip Hanson, "Structural Changes in the Russian Economy," *Transition* 2, no. 2 (1996); Philip Hanson, "What Sort of Capitalism Is Developing in Russia?" *Communist Economies and Economic Transformation* 9, no. 1 (1996); and Vladimir Popov, "Will Russia Achieve Fast Economic Growth?" *Communist Economies and Economic Transformation* 10, no. 4 (1998).

52. See Kathleen E. Braden, "Boundary Problems and Wildlife Habitat in Central Asia and Russia" (paper presented at the Third Annual Regional Conference on Russian, East European, and Central Asian Studies, Tacoma, Wash., 26 April 1997), and Kathleen E. Braden, "Endangered Species Protection and Economic Change in the Former USSR" (paper presented at the Conference on the Environment and New Global Economic Order, Austin, Tex., 7 April 1995).

53. Harmon Tupper, *To the Great Ocean: Siberia and the Trans-Siberian Railway* (London: Secker and Warburg, 1965), 44.

54. *East of the Sun*, 273.

55. Ibid., 5, quoted in *Stalin, Part 1: Revolutionary* (WGBH-TV, produced by Jonathon Lewis and Tony Cash, 1990).

56. Tupper, *To the Great Ocean*, 442.

57. Andrei Amalrik, *Involuntary Journey to Siberia*, trans. Max Hayward (New York: Harvest Books, 1971), 14.

58. George St. George, *Siberia: The New Frontier* (New York: Hodder & Stoughton, 1969), 450.

59. Longer versions of this paper were published in Thornton and Ziegler, *Russia's Far East: A Region at Risk*, and *Comparative Economic Studies*, vol. 44, no. 4 (Winter 2002). This shorter version was reprinted with permission. The statement that the fishing industry is the RFE's largest sector is based on industrial output data and sectoral employment from *oblast* and *krai* Goskomstat data for selected years. Also see P. A. Minakir and N. N. Mikheeva, eds., *Dal'nii Vostok: Ekonomicheskii Potentsial* (Vladivostok: Dal'nauka, 1999), 87, for 1995 data showing that the seafood-dominated food industry represented over 25 percent of the region's industrial output, with nonferrous metallurgy and energy both around 20 percent. From 1996 to 1998, while the RFE's industrial output as a whole continued to shrink, the fishing industry maintained its production levels. But in 1999 and 2000, fishing production dropped and industrial production as a whole in the RFE increased. Because a significant part of the fishing industry's production and income goes unreported, the industry's role tends to be heavily understated in official statistics. Discussions with residents and officials in remote coastal areas of the RFE convince most observers of the complete dependence of these areas on fishing.

60. For official data and an estimate of U.S. $1 billion per year of unrecorded seafood exports, see "The RFE: A Survey," *Economist*, September 1999, 6–8. For RFE export data from 1991 to 1996 by sector also see Minakir and Mikheeva, *Dal'nii Vostok: Ekonomicheskii Potentsial*, 213.

61. In April 2003, after Tony Allison wrote this section, Nazdratenko reportedly had been relieved of his duties.

62. FAO, country and area catch data for the USSR and Russia 1950–1997, FAOSTAT Database www.apps.fao.org.

63. Ibid.

64. See Regiony Rossii 1998, vol. 2 (Moscow: Goskomstat, 1998), 136–37, for Russian consumption and *1999 Annual Report on the United States Seafood Industry* (Bellevue, Wash.: H. M. Johnson and Associates, 1998), 90, for U.S. consumption (this study utilizes statistics from the NMFS).

65. Milan Kravanja and Ellen Shapiro, *World Fishing Fleets: An Analysis of Distant-Water Fleet Operations, Past-Present-Future*, vol. 5 of *The Baltic States, the Commonwealth of Independent States, Eastern Europe* (Washington, D.C.: Office of International Affairs, NMFS, U.S. Department of Commerce, 1993), 98–99.

66. FAO, see data for fisheries trade by country and compare catch data to exports, FAOSTAT Database.

67. Kravanja and Shapiro, *World Fishing Fleets*, 108.

68. Such views are frequently voiced in the RFE press. For a good summary about the fishing industry and its bureaucracy, see Viacheslav Zilanov, "Morskoi uzel" [Marine Knot], *Nezavisimaia Gazeta*, 10 October 1999. Zilanov is a former USSR deputy minister of fisheries.

69. A well-publicized instance of this was the large crab quota awarded to the Kamchatka company Ekofim in 1999. For an industry view of the quota allocation system, with reference to the above case, see the interview with Valery Vorobiev, general director of ZAO Akros, one of the largest RFE fishing companies, in "The Misfortune Is That There Is No Unity," *Rybak Kamchatki*, 20 April 2000.

70. Elena Sabirova, "Commercial Update from Sakhalin" (Yuzhno-Sakhalinsk: U.S. FCS & DS, 2000), 1. Most of these reports—cited with U.S. FCS & DS as publisher—are written by staff of the Business Information for Newly Independent States (NBISNIS) and are available online at www.bisnis.doc.gov/bisnis/country/fareast.cfm.

71. Ibid.

72. British Broadcasting Corporation (BBC), "Reduced Fishing Quotas for the Chinese," BBC Wire Services, 5 January 2001.

73. "Fishing Industry Struggles for Survival," *Russian Journal*.

74. Some within the industry argue that the auction system may increase poaching, as firms justify the cost of buying quotas.

75. "Fishing Industry Struggles for Survival," *Russian Journal*.

76. Pavel A. Minakir, *The Russian Far East: An Economic Survey*, trans. Gregory L. Freeze (Khabarovsk: RIOTIP, 1996), 112.

77. Goskomstat fisheries data for Sakhalin, 1999.

78. Between 400,000 and 700,000 tons of seafood are caught in international waters, with the remainder coming from Russian waters in the northwest. See *Russian Fish Report* 3, no. 54 (2001). In 2001, according to the FAO, Russia ranked seventh (3.7 million metric tons) in terms of marine fishery harvest after China (14.7 million tons), Peru (10.6 million), Japan (4.9 million), the United States (4.7 million), Chile (4.3 million), and Indonesia (3.8 million). Data are for fish, crustaceans, and mollusks and exclude aquaculture catch, marine mammals, and aquatic plants.

79. The FAO divides marine fishing regions into Statistical Areas, with the Northwest Pacific considered Statistical Area 61. See FAO, *Fisheries Circular* no. 920, FIRM/C920, for a review of this region.

80. *Russian Fish Report* 3, no. 54 (2001).

81. In 1999, wild salmon represented 43.4 percent (786,200 metric tons) of salmon harvested worldwide, a decline from 47 percent in 1997. Farmed salmon continues to increase, particularly in Europe and South America, which together produce the most farmed salmon. See Bill Atkinson, "Salmon Market," *Bill Atkinson's News Report* 831 (Seattle, 1999).

82. Goskomstat and Federal Fisheries Committee data for selected years.

83. A. P. Latkin, *Na Rubezhe Vekhov* [The fishing industry of Primore between two eras] (Moscow: More, 1999), 46–47.

84. Minakir, *Russian Far East: An Economic Survey*, 112–13.

85. Federal Fisheries Committees materials for industry conference on Sakhalin, 1–2 July 1999.

86. Minakir and Mikheeva, *Dal'nii Vostok: Ekonomicheskii Potentsial*, 123.

87. Ibid., 36–37, 323.

88. Goskomstat fisheries data for Primorsky (contains data on other *oblast-krais*), 2001.

89. This is a difficult measurement to quantify as fisheries activity is diverse and often unrecorded: bilateral and multilateral treaties, direct fishing, commercial and government credits, scientific exchanges, chartered vessels and vessel-management support are all components. Indeed, this statement would doubtfully be disputed by anyone comparing this industry with other RFE industries. However, from the standpoint of foreign financial investment and employment, it is likely that the oil and gas sector on Sakhalin will soon surpass the fishing industry, if it has not already done so.

90. Minakir and Mikheeva, *Dal'nii Vostok: Ekonomicheskii Potentsial*, 126; and Goskomstat, various years.

91. Russian fisheries statistics, especially regarding exports, are notoriously unreliable: lack of funding for responsible agencies, corruption of monitoring bodies, and illegal exports undermine the integrity

of the data. Foreign import statistics and anecdotal information must be used for analysis.

92. A. O. Shubin, "So Who Gets the Quotas after All?" [in Russian], *Rybak Sakhalin*, no. 18 (1998).

93. *Russian Fish Report* 10, no. 49 (2000).

94. Radio Free Europe, "Fish Poachers Overwhelmingly Russian" (Radio Free Europe, 13 November 2000 [cited 15 September 2002]); available from www.rferl.org/newsline.

95. Reuters Wire Services, "Russian Trawler Sunk, Refused Guards Order to Stop," Reuters Wire services, 22 February 2001.

96. Radio Free Europe, "Fight against Corruption Not Going Well" [wire article] (Radio Free Europe, 22 July 2002 [cited 4 September 2002]); available from www.rferl.org/newsline/2002/07/1-rus/rus-220702.asp.

97. Russian News Agency RIA, "South Korean Company Pays Russia Compensation for Damage to Fishing Grounds," quoted in British Broadcasting Company (BBC), 30 May 2000. The prosecutor's office for the Kamchatka Committee on Environmental Protection estimated overall damage at more than U.S.$6 million.

98. Radio Free Europe, "Fight against Corruption Not Going Well."

99. "Fishing Industry Struggles for Survival," *Russian Journal*.

100. Based on the author's estimates using international values and comparisons from the United States.

101. Evgeny Nazdratenko, in an interview titled "Headquarters Takes Responsibility" [in Russian], *Tikhookeansky Vestnik* 41, no. 16 (9 August 2001).

102. Anatoly Kolisnechenko, in an interview titled "We Don't Need the Shores of Chile" [in Russian], *Tikhookeansky Vestnik* 41, no. 16 (9 August 2001).

103. Nazdratenko, "Headquarters Takes Responsibility."

104. "At the Collegium of the State Committee for Fisheries of the R.F." [in Russian], *Tikhookeansky Vestnik* 41, no. 16 (9 August 2001).

105. Richard M. Levine, *The Mineral Industry of Russia: 1999* (Reston: USGS, 2000), 14.

106. Alexander S. Sheingauz et al., "The Russian Far East's Competitive Position in Northeast Asian Markets," in *Russia's Far East: A Region at Risk*.

107. *Energy Sector in the Russian Far East* (U.S. FCS & DS, 2002 [cited 25 June 2002]). Yakutugol, annually among Russia's top fifty exporters, exported U.S.$140.4 million of coal in 2000 and U.S.$130.2 million in 1999. Amur Metal is another major exporter of coal, exporting U.S.$45.4 million in 2000.

108. Ibid.

109. Bradshaw and Lynn, "Resource-Based Development," 385.

110. For a fuller discussion, see M. J. Bradshaw and P. Kirkow, "The Energy Crisis in the Russian Far East: Origins and Possible Solutions," *Europe Asia Studies* 50, no. 6 (1998).

111. Sheingauz et al., "Russian Far East's Competitive Position," 124–25.

112. World Bank, *Russian Federation Energy and Environment Review* (Washington, D.C.: World Bank, 2000), 41.

113. Ibid.

114. Bradshaw and Kirkow, "Energy Crisis in the Russian Far East," 1055.

115. Ibid., 1046.

116. For a study of the Chinese market for both Central Asian and Russian energy resources, see Gaye Christofferson, *China's Intentions for Russian and Central Asian Oil and Gas* (Seattle: The National Bureau of Asian Research, 1998).

117. Energy Information Administration, Russia Country Analysis Brief (Washington, D.C.: Department of Energy, 2002).

118. "Yukos, Transneft Vie for Oil Pipe to Asia," *Zolotoi Rog*, 6 August 2002.

119. William Chandler, *Energy and Environment in the Transition Economies* (Boulder, Colo.: Westview Press, 2000), 7, 15–18.

120. Ibid., 6.

121. Chandler maintains switching from coal to natural gas would cut carbon dioxide emissions in half.

122. Bradshaw and Kirkow, "The Energy Crisis in the Russian Far East," 1057.

123. Bradshaw and Lynn, "Resource-Based Development."

124. Minprom, *On the Impact of the Oil and Gas Industry on the Environment* [in Russian], a report to the Duma, Moscow, 2000, quoted in D. J. Peterson and Eric K. Bielke, "Russia's Industrial Infrastructure: A Risk Assessment," *Post-Soviet Geography and Economics* 43, no. 1 (2002).

125. *Energy and Mineral Resources*.

126. *Russian Far East: An Economic Handbook*, 78.

127. Business Communications Agency, *Russian Coal Industry* (Internet Securities, Inc., 2002 [cited 7 July 2002]); available from www.site.securities.com.

128. *Energy and Mineral Resources*, 27.

129. *Energy Sector in the Russian Far East*.

130. *Russian Far East News* (Anchorage, Alaska: American Russia Center, July 1998)

131. "Landysh Liquid Radioactive Waste Treatment Plant" [electronic report] (Nuclear Threat Initiative, 2002 [cited 29 July 2002]); available from www.nti.org/db/nisprofs/russia/naval/forasst/forasovr.htm.

132. "Russia Edges Closer to Importing of Nuclear Waste," *Space Daily*, 6 March 2002.

133. Judith Ingram, "Russian Environmentalists Vow to Take Fight against Nuclear Waste Reprocessing to Court" (Associated Press, 9 April 2002 [cited August 2002]); available from http://nucnews.net/nucnews.

134. Bradshaw and Kirkow, "Energy Crisis in the Russian Far East," 1045.

135. *Energy Sector in the Russian Far East*.

136. The Tokyo-based Virtual Foundation installed the windmill; see www.virtualfoundation.org.

137. "Russia Losing 30 Billion Dollars a Year from Illegal Logging: WWF" [press release] *Agence France Press* (WWF, 2002 [cited 13 July 2002]); available from www.sites.securities.com.

138. Alexander S. Sheingauz, *Forest Industry of the Russian Far East: A Status Report* (Khabarovsk: ERI, 1999). From 1990 to 1997, according to Sheingauz, railroad tariffs increased in the southern RFE by a factor of 22,107.

139. Ibid.

140. Ruble–U.S. dollar exchange for rates as of May 2000.

141. Sheingauz, *Forest Industry of the Russian Far East*. Others have estimated waste rates from 25 to 75 percent. See Sten Nilsson et al., *The Forest Resources of the Former European USSR* (Lancs, UK: Parthenon Publishing Group; IIASA, 1992), and World Bank, *Russia: Forest Policy During Transition* (Washington, D.C.: World Bank, 1997).

142. Data from Greenpeace-Russia, WWF, Alexander Sheingauz, and other sources.

143. Alexander Sheingauz, interview by the author at the conference, Commercial Forestry in the Russian Far East, Yuzhno-Sakhalinsk, Russia, 20 September 2001.

144. Ibid.

145. WWF–RFE, *Implementation of the WWF Forest Strategy* (Vladivostok: WWF–RFE, 2001).

146. Tamara Rusina from a presentation given at the conference, Commercial Forestry in the Russian Far East, Yuzhno-Sakhalinsk, Russia, 18 September 2001. Presentation available at www.forest-trends.org.

147. Andrei Vasyenov, "Overview of the Forests and Wood Processing Industry of the Khabarovsk Krai, Russian Far East" (Khabarovsk: U.S. FCS & DS, 2002).

148. Federal Immigration Service of Russia, Primorsky Branch, letter to Primorsky Region Governor Nazdratenko, 21 April 1999.

149. Anatoly Lebedev, conversation with author, Vladivostok, 17 September 2001.

150. Vasyenov, "Overview of the Forests and Wood Processing Industry."

151. Lebedev, conversation with author.

152. Journalist Anatoly Lebedev has written extensively on this issue in a number of Russian newspapers, including *Vladivostok* and *Utro Rossii*.

153. "Josh Newell's Notes from the Field: Primorye, Khabarovsk, and Sakhalin" (Tokyo: FoE–J, 1998).

154. Ibid.

155. Ibid.

156. Ibid.

157. Josh Newell and Anatoly Lebedev, *Illegal Ash Timber Flow from Sikhote-Alin Area to China and Japan* (Tokyo: Bureau for Regional Outreach Campaigns, FoE–J, 1998).

158. *Japan Lumber Journal* (1997). See www.jlj.gr.jp.

159. "Josh Newell's Notes from the Field."

160. Committee on Environmental Protection of Khabarovsk Krai, *Analysis of Leszhozes Operating in Southern Khabarovsk Krai* (Peryaslavka: Committee on Environmental Protection of Khabarovsk Krai, 1998).

161. In a separate but related study, the Institute of Water and Ecological Problems, located in Khabarovsk, found that in the Khor River watershed, 50 percent of the trees in riparian protection zones had been logged, thus lowering groundwater levels by 50 cm.

162. Data obtained by author from the Logging Industry Department, Primorsky Krai Administration, 1998.

163. S. D. Richardson, *Cotchell Report* (Hong Kong: Cotchell Pacific Ltd., 1986).

164. Ibid.

165. Charles A. Backman and Vadim K. Zausaev, "The Forest Sector of the Russian Far East," *Post-Soviet Geography and Economics* 39, no. 1 (1998): 45–62

166. Sun Changjin (Chinese Research Center for Environmental and Ecological Economics), conversation with author, Beijing, 10 July 1999. The Mongolian government has instituted high tariffs on timber exports to slow deforestation, but the measure may increase illegal export.

167. Two truck roads operate here at full capacity. Suifenhe officials boast the route handles 55 percent of all international trade between Heilongjiang Province and Russia. For helpful descriptions of major Russian-Chinese timber trade gateways, see Masanobu Yamane and Wenming Lu, "Analytical Overview of the Recent Russia-China Timber Trade," *International Review for Environmental Strategies* 2, no. 2 (2001): 335–47.

168. FAO, *FAO Statistical Forestry Database* (FAO, 2000 [cited 4 September 2002]); available from http://apps.fao.org/default.htm.

169. Tim Cadman, *The Development of an Australian Forestry Standard: An Environmental NGO Perspective* (Native Forest Network, 1999 [cited 5 September 2002]); available from www.nfn.org.au/homef.html.

170. International Tropical Timber Organization (ITTO), "Chinese Industries Relocate" (Yokohama: ITTO, 2002).

171. Vasyenov, "Overview of the Forests and Wood Processing Industry."

172. Forest Stewardship Council (FSC), "What Is Certification?" (FSC, 2002 [cited 15 August 2002]); available from www.fscoax.org/principal.htm.

173. Jessica Lawrence, conversation with author, Washington, D.C., October 2000. Lawrence, of the Rainforest Action Network, is an expert on FSC issues in Indonesia. Also, see a report by the Rainforest Foundation at www.rainforestfoundationuk.org/pub/news/winter%202001.pdf.

174. Two Japanese NGOs, Japan Tropical Rainforest Action Network and the Sarawak Campaign Committee, were the most active on this issue. See http://forests.org/archive/asia/tokyo.htm.

175. See the summary report by the Canadian Institute for Business and the Environment (Montreal & Toronto), accessed on 11 April 2003 from www.fao.org/regional/lamerica/ong/prensa/2000.htm.

176. Since 1994, FoE–J has campaigned to push through some of these measures.

177. For *Plundering*, see www.foejapan.org and for *Illegal Logging*, see www.wwf.ru/eng/.

178. Fires in the RFE (as in other regions in Russia) are frequent, numbering between 12,000 and 30,000 fires yearly, according to the Federal Forest Service. In 1998, other regions in the RFE were not as hard hit; in ecologically rich Primorsky Krai, 556 fires burned 58,000 ha of land. Part of Sikhote-Alinsky Zapovednik (Primorsky) was burned, however, as rangers had trouble procuring fuel and equipment in time to contain the fire.

179. Both ruble estimates are converted at an exchange rate of 10 rubles to 1 U.S. dollar, which was the rate on September 1998, approximately the same time these estimates were made.

180. Unless otherwise noted, all data in this paragraph is from UN-DAC Mission, "Forest Fires on the Island of Sakhalin and Khabarovsk" (Geneva: UN Office for the Coordination of Humanitarian Affairs, 1998).

181. Ibid.

182. Ibid.

183. Alexander S. Sheingauz, *Forest Fires in Primorsky and Khabarovskiy Krais: Their Causes and Consequences* (Kanagawa: Institute of Global Environmental Strategies, 1998).

184. *Russian Far East: An Economic Handbook*, 81.

185. Sheingauz et al., "Russian Far East's Competitive Position," 127.

186. Foreign mining companies complain about the secrecy of geological information in Russia. Due to the strategic nature of mineral resources, the Russian government is often reluctant to share data with foreign mining companies. The secrecy also means companies do not always have full and accurate information about sites to develop environmentally appropriate projects. One clear test of whether a foreign company is willing to meet international standards has been whether the company will provide reclamation and water quality assurance bonds prior to starting mine operations. Regional government officials have expressed interest in seeing mines put up bonds guaranteeing reclamation.

187. "Putin Says Russia's Mineral Resources Mismanaged," *Interfax Russian News*, 31 May 2002.

188. Western Pinnacle Mining, *Business Framework for Gold Mining Operations in Russia* (Moscow: Western Pinnacle Mining, Ltd., 1998), 3.

189. David Gordon, *Mining in the Former Soviet Union: A Report for the International Institute of Environment and Development* (Oakland, Calif.: Pacific Environment, 2000).

190. Yu. A. Mamaev, A. P. Van-Van Ye, and V. V. Litvintsev, "Problems of Mining Gold from Placers of the Far East at the Modern Stage" [in Russian] (paper presented at the Gold Mining: Problems and Perspectives seminar, Khabarovsk, 25–27 November 1997).

191. Ibid.

192. N. I. Trekhnev, "Heavy Metals in the Ecosystems of the Southern Far East" [in Russian] (paper presented at the Gold Mining: Problems and Perspectives seminar, Khabarovsk, 25–27 November 1997).

193. See www.wpnresources.com.

194. Yana Tselikova, "Russia: Gold Mining in the RFE" (Vladivostok: U.S. FCS & DS, 2001), 4.

195. Data cited 28 June 2002; available from www.infomine.com; see also www.bema.com.

196. EBRD, *Russian Federation Investment Profile* (London: EBRD, 2001), 21.

197. "American Gold Mining Firm Wins Primorye License," *Vladivostok News*, 12 November 1999.

198. Business Communications Agency, "Gold Mining Industry in Russia in 2001" (Internet Securities, Inc., 27 June 2002 [cited 13 July 2002]); available from www.site.securities.com.

199. Data on Pokrovka from Russian Information Agency Novosti, "New Gold Mining Plant Put into Operation in Far Eastern Russia" (Russian Information Agency Novosti, 2002 [cited 9 September 2002]); available from http://en.rian.ru/rian/index.cfm.

200. Russia mined approximately 175 tons of gold in 2002.

201. For a discussion of Russian agriculture, see Jennifer Duncan and Michelle Ruetschle, "Agrarian Reform and Agricultural Productivity in the Russian Far East," in *Russia's Far East: A Region at Risk.*

202. Duncan and Ruetschle break down the agricultural sector into these three types of producers; see "Agrarian Reform and Agricultural Productivity," 196–199.

203. Alexei Filatov, "Private Plots Supply over 50 Percent of Food in Russia," ITAR-TASS, 3 April 2000.

204. Duncan and Ruetschle, "Agrarian Reform and Agricultural Productivity," 198.

205. This definition is just one of many for "sustainable development." Two Australian scholars have identified more than eighty definitions of the term; see R. Fowke and D. Prasad, "Sustainable Development, Cities and Local Government," *Australian Planner* 33, no. 2 (1996). For differing Russian conceptions of the term, see Jonathan D. Oldfield, "Russia: Systematic Transformation and the Concept of Sustainable Development," *Environmental Politics* 10, no. 3 (2001).

206. Mikheeva, "Social and Economic Differentiation in the Russian Far East," 106.

207. Oldfield, "Concept of Sustainable Development."

208. Bradshaw and Lynn, "Resource-Based Development."

209. Bradshaw, "Changing Geography of Foreign Investment."

210. A notable large-scale investment in the tourism sector is Hyundai Corporation's (South Korea) construction of Hyundai Hotel in downtown Vladivostok. For a variety of reasons, the role of foreign capital in the Russian banking sector has been limited. See Pavel Minakir, "Influence of Financial Crisis on Economy," in *Russia's Far East: A Region at Risk.*

211. This is often called the "staples theory" of growth; see Michael Ross, *Extractive Sectors and the Poor* (Los Angeles: Oxfam America, 2001), 5–6.

212. Jeffrey D. Sachs and Andrew M. Warner, "The Big Push: Natural Resource Booms and Growth," *Journal of Development Economics* 59 (1999).

213. Graham A. Davis and John E. Tilton, *Should Developing Countries Renounce Mining: A Perspective on the Debate* (Golden, Colo.: Colorado School of Mines, 2002), 18. Accessed on 15 December 2002 at the World Bank's Extractive Industry review site, www.eireview.org/eir.

214. Payal Sampat, "Scrapping Mineral Dependence," in *State of the World 2003* (New York: W. W. Norton & Company, 2003), 121.

215. Ibid.

216. Failure by governments to reinvest surplus revenue is even acknowledged by the IFC. According to an internal paper: "The notion that governments invest incremental rents/returns from extractive industries profitably and for the benefit of poor people is all too often more of an aspiration than a reality." As quoted from Daphne Wysham, "Climate Change," in *Marketing the Earth: The World Bank and Sustainable Development*, ed. FoE and Halifax Initiative (Washington, D.C.: FoE, Halifax Initiative, 2002), 16. In *Extractive Sectors and the Poor*, Ross found oil- and mineral-dependent states had particularly high corruption rates.

217. Bradshaw and Lynn, "Resource-Based Development."

218. Ross, *Extractive Sectors and the Poor.*

219. Ibid.

220. Wysham, "Climate Change," 17.

221. Ibid.

222. EBRD, *Natural Resources* (London: EBRD, 2001), 24, 5. Created in 1991 to assist the transition of central and eastern Europe (including Russia) to a market economy, EBRD has funded projects in Russia totaling U.S.$4.2 billion, or about 20 percent of the bank's total cumulative commitments. (As of 31 December 2001, this figure is converted from euros using the exchange rate on 2 July 2002.) EBRD's investment portfolio reveals that the oil-and-gas sector received the Bank's second highest financing (eleven projects funded as of 31 December 2001 totaling U.S.$573 million), after the Russian finance sector. See www.ebrd.com.

223. For more about the IBRD, see www.worldbank.org. Since 1991, the World Bank has funded an array of projects throughout Russia totaling U.S.$8.9 billion as of February 2002.

224. OPIC, "OPIC to Support $100 Million Russia-Related Investment Fund" (Washington, D.C.: OPIC, 2002).

225. Bradshaw and Lynn, "Resource-Based Development."

226. Kunio Okada, "The Japanese Economic Presence in the Russian Far East," in *Russia's Far East: A Region at Risk*, 426.

227. At present, most goods (especially soybeans) from northern China must be sent by rail south to Dalian and then by ship. Ecologists fear that heavy freighter traffic in the Zarubino area will destroy the bays and capes around Zarubino and threaten Russia's only marine reserve, Dalnevostochny Morskoi Zapovednik, just north and south of the port.

228. Bradshaw and Lynn, "Resource-Based Development," 381.

229. Ibid.

230. Ibid., 389.

231. Vladimir Kontorovich, "Economic Crisis in the Russian Far East: Overdevelopment or Colonial Exploitation," *Post-Soviet Geography and Economics* 42, no. 6 (2001): 406.

232. Thornton and Ziegler, "The Russian Far East in Perspective," 13.

233. Jane Upperton, letter regarding Sakhalin II project [e-mail letter] (Sakhalin Energy Investment Company Ltd. [cited 9 October 2002]); available from www.pacificenvironment.org.

234. Figure taken from Pacific Environment's 4 September 2002 letter to the U.S. OPIC regarding their Sakhalin II loans. Pacific Environment quotes from the report by the Auditing Chamber of the Russian Federation, a division of the Russian Duma.

235. Upperton, letter regarding Sakhalin II project.

236. This debate first came into play in the RFE with the Kubaka gold mine; see pp. 278–80.

237. In terms of ECA standards for projects in Russia, Pacific Environment Policy Director Doug Norlen writes: "In 1996, Pacific Environment successfully sued OPIC under the U.S. Freedom of Information Act to obtain copies of environmental impact assessments of logging and mining projects that OPIC was considering for support in Russia. Soon after, U.S. and Russian NGOs successfully intervened to halt OPIC's support for the proposed Aginskoe gold mine, that was proposed to have been located on the border of what has since become the Volcanoes of Kamchatka World Heritage Site. These efforts combined with those of a small number of other U.S.-based NGOs to persuade OPIC to accept broader policy reforms announced by President Clinton at the United Nations Special Assembly Special Session (so-called Rio Plus Five Summit) in 1997." These efforts were early contributions to a burgeoning international campaign to reform all ECAs, which have collectively become among the largest public finance institutions worldwide (see www.eca-watch.org).

238. Jim Carlton, "In Russia with Fragile Ecology: Stymied in Alaska, Oil Companies Find Russian Rules Aren't as Strict," *Wall Street Journal*, 4 September 2002.

239. Ibid.

240. U.S. Agency for International Development, *Working for a Sustainable World: U.S. Government Initiatives to Promote Sustainable Development* (Washington, D.C.: USAID, 2002), 28.

241. Finnish Timberjack harvesters and forwarders alone are used to produce 35 percent of Khabarovsk Krai's annual timber harvest. See Vasyenov, "Overview of the Forests and Wood Processing Industry," 3.

242. Bradshaw and Lynn, "Resource-Based Development."

243. Kontorovich, "Economic Crisis in the Russian Far East."

244. STS Technowood, the Primorsky-based Russian-Japanese joint venture, is an example, providing sawnwood for the demanding Japanese market.

245. The Khabarovsk government, for example, mandated that the timber company Rimbunan Hijau process—in the form of sawnwood and plywood—a percentage of the timber harvested. Unfortunately, so far the company has failed to meet the agreement; see Vasyenov, "Overview of the Forests and Wood Processing Industry," 3.

246. World Bank, "Memorandum of the President of the Interna-

tional Bank for Reconstruction and Development and the International Finance Corporation to the Executive Directors on a Country Assistance Strategy of the World Bank Group for the Russian Federation" (Washington, D.C.: World Bank, 2002), 5.

247. EBRD, *Environments in Transition*, 40. EBRD does have the Russian Small Business Fund, one of the bank's most successful funds, but activity in the RFE so far has also been limited.

248. "National companies should be financed first [by EBRD], not branches of foreign companies in Russia," complains Deputy Finance Minister Sergei Kolotukhin (Interfax, 2 May 2002).

249. The Regional Venture Fund prefers a minimum investment of U.S.$300,000 and a maximum of U.S.$3 million.

250. These enterprise funds are paid for by U.S. taxpayers but operate as privately managed nonprofit corporations. As a result, it is extremely difficult for the American and Russian public to access their documents and proposals, and to participate in encouraging the funds to make environmentally responsible investments. Since the funds are created with taxpayer dollars and report regularly to U.S. agencies, shouldn't they be subject to the same requirements of public accountability as other U.S. government branches? See www.deltaleaserfe.ru and www.tusrif.ru.

251. The energy-efficiency measures and projects featured in the EBRD portfolio have been applied primarily in the former Soviet states; relatively little has been done in Russia and almost nothing in the RFE. The EBRD did recently create the Dexia-FondElec Energy Efficiency and Emissions Reduction Fund for Russia to encourage private sector investment in this area, but so far they have only invested U.S.$20 million in the fund.

252. EBRD, *Environments in Transition*, 11.

253. In a presentation at the 2001 U.S.-RFE Working Group meeting in Buryatia (Russia), Ecology sector co-chair Valery Gulganov provided a laundry list of examples where internationally funded projects were wasting money, including: (1) instances where Russian partners repeatedly "sold" the same information to Western partners, (2) projects that were poorly designed, e.g., duplicated previous or ongoing efforts, information collection and little else, (3) projects designed to help the regions ended up covering budget shortfalls of government agencies in Moscow, (4) projects that relied too heavily on Western consultants (many of which had little or no knowledge of the regional peculiarities of Russia), and (5) projects that failed to learn from the mistakes of previous ones.

254. GEF has approved funding for other projects in Russia including: Greenhouse Gas Reduction (U.S.$3.2 million); Persistent Toxic Substances, Food Security, and Indigenous Peoples of the Russian North (U.S.$750,000); Support to the National Program of Action for the Protection of the Arctic Marine Environment, Phase I (U.S.$6.1 million); and three ozone depletion projects totaling U.S.$75 million. Regional and global projects that involve Russia include: Development of a Wetland Site and Flyway Network for Conservation of the Siberian Crane and Other Migratory Waterbirds in Asia (U.S.$10.3 million); and Preparation of a Strategic Action Program (SAP) and Transboundary Diagnostic Analysis (TDA) for the Tumen River Area, Its Coastal Regions and Related Northeast Asian Environs (U.S.$5.2 million).

255. In 2001, the U.S. government provided U.S.$1.051 billion in assistance to Russia including U.S.$385.71 million from the Department of Defense, U.S.$335.54 million from the Energy Department (including a small portion for energy-efficiency programs and plans to support wind and biomass energy programs in the RFE), U.S.$60.48 million in food aid from the Department of Agriculture, U.S.$159.43 million in FREEDOM Support Act assistance (including $91 million for USAID), and the remainder to agencies like the Department of Commerce, which has projects in the NIS designed to remove trade barriers. One of these is the RFE Regional Initiative, a cross-sectoral program based in Sakhalin and Khabarovsk that facilitates trade and investment between the United States and the RFE. USAID environmental programs average just U.S.$4–7 million per year and essentially include three major projects: FOREST, EPT, and Replication of Lessons Learned

(ROLL) —which has provided more than two hundred grants totaling U.S.$5.6 million to NGOs throughout Russia. The U.S. Forest Service has worked with the Russian Forest Service in a variety of areas, including reforestation and mitigating forest fires and forest pests. The Chugach National Forest in Alaska has a "sister forest" partnership with Magadansky Zapovednik that focuses on environmental exchanges, ecotourism, and wildlife biology research. The U.S. Fish and Wildlife Service administers small grant programs for Russian nature reserves and conducts joint research on fish, marine mammals, and migratory birds. See the annual report, *U.S. Government Assistance to and Cooperative Activities with Eurasia*, on the State Deparment's Bureau of European and Eurasian affairs website www.state.gov/p/eur/; and USAID, *Annual Report of Government Assistance to the NIS and Former Soviet Union* (Washington, D.C.: USAID, 2001).

The Canadian version of USAID, the Canadian International Development Agency (CIDA), has funded primarily timber-related projects in the RFE. One is a C$3.5 million, seven-year project implemented by the McGregor Model Forest Association and the Khabarovsk Krai administration's Committee on the Economy, a successor to the Gassinsky Model Forest project (see pp. 171–72). CIDA is also funding a C$1.9 million project coordinated by IUCN to promote sustainable use of nontimber forest products in indigenous communities. Technical Assistance for the Commonwealth of Independent States (TACIS), a European Union agency created in 1991 to assist former Soviet and European nations in transition, has traditionally focused its grant-financed technical assistance in western Russia or Russia generally, but is also starting to finance projects directly related to the RFE. For more information on TACIS, see http://europa.eu.int/comm/external_relations/ceeca/tacis/index.htm.

256. *Japan Lumber Journal*, 8.

257. Quote taken from Ecolinks homepage, www.ecolinks.org.

258. For information on Ecolinks grants, see www.ecolinks.org/services/grants.cfm.

259. On the Japanese side, the agreements were negotiated by the Japan-Soviet Economic Committee within the Keidanren (Federation of Japanese Businesses). This committee, renamed the Japan-Russian Economic Committee, continues to function.

260. Kazuo Ogawa, "Economic Relations with Japan," in *Siberia and the Soviet Far East: Strategic Dimensions in Multinational Perspective*, ed. Rodger Swearingen (Stanford, Calif.: Hoover Institution Press, 1987), 158–78.

261. Ibid., 177.

262. Daisuke Gotoh, *Siberian Forests: Japan's Increasing Role* (Tokyo: Japan Environment Exchange, 1993), 31–32.

263. Led by Komatsu Corporation, Japanese companies supplied the regional state-owned forest enterprise Dallesprom with, on average, 1,000 tractors, 650 timber haulers, 250 front-end loaders, 240 bulldozers, autograders, excavators, and other road-building equipment each year for this sixteen-year-period.

264. *Russian Far East: An Economic Handbook*, 176.

265. Ibid., 177.

266. The Publish What You Pay Coalition, a diverse group of eighty NGOs, is pushing "Group of Eight" or "G8" countries (United States, France, Italy, Russia, Japan, Germany, Spain, and Britain) to make this regulatory change. See www.publishwhatyoupay.org.

267. Transparency International, *Global Corruption Report* (Berlin: Transparency International, 2003). For the 2002 Corruption Perceptions index, see p. 264; for the 2002 Bribe Payers index, see p. 266.

268. *East of the Sun*, 81.

269. Ibid.

270. Ibid., 70.

271. For fuller discussions, see A. P. Chekhov, *Polnoe Sobranie Sochineniii I Pisem* (Moscow: Nauka, 1978); J. Forsyth, *A History of the Peoples of Siberia: Russia's North Asian Colony 1581–1990* (Cambridge: Cambridge University Press, 1992); and Bruce Grant, *In the Soviet House of Culture: A Century of Perestroikas* (Princeton: Princeton University Press, 1995).

272. Nikolai Vakhtin, *Native Peoples of the Russian Far North*

(Manchester, England: Minority Rights Group, 1994), 31.

273. Ibid.

274. Ibid., 72.

275. Boris Komarov, *The Geography of Survival: Ecology in the Post-Soviet Era* (Armonk, N.Y.: M.E. Sharpe, 1994).

276. Denis J. B. Shaw, *Russia in the Modern World: A New Geography* (Oxford; Malden, Mass.: Blackwell, 1999), 133.

277. Judith Thornton and Andrea Hagan, "Russian Industry and Air Pollution: What Do the Official Data Show?" *Comparative Economic Studies* 34, no. 2 (1992); Oldfield, "Structural Economic Change and the Natural Environment."

278. Komarov, *Geography of Survival.*

279. James H. Bater, *Russia and the Post-Soviet Scene: A Geographical Perspective* (London: Arnold; New York: John Wiley & Sons, 1996), 316.

280. Loren R. Graham, *The Ghost of the Executed Engineer: Technology and the Fall of the Soviet Union* (Cambridge, Mass.: Harvard University Press, 1993).

281. Peter Rutland, "Sovietology: Who Got It Right and Who Got It Wrong? And Why?" in *Rethinking the Soviet Collapse: Sovietology, the Death of Communism and the New Russia*, ed. Michael Cox (London, New York: Pinter, 1998). Denis J. B. Shaw and Jonathan Oldfield, "The Natural Environment of the CIS in the Transition from Communism," *Post-Soviet Geography and Economics* 34, no. 3 (1998).

282. Tatyana Saiko, *Environmental Crises: Geographical Case Studies in Post-Socialist Eurasia* (Harlow, England; New York: Prentice Hall, 2001).

283. Aleksandr Knorre, "The Rise and Fall of Environmental Protection as a National Security Issue," in *Russia's Fate through Russian Eyes: Voices of the New Generation*, ed. Heyward Ihsam (Boulder, Colo.: Westview, 2001).

284. Goskomekologia, "O Sostoianii Okruzhaiushchei Pridronoi Sredy Rossiiskoi Federatsii" [On the conditions of Nature in the Russian Federation] (Moscow: Goskomekologia, 1999).

285. OECD, *Environmental Performance Reviews, Russian Federation* (Paris: OECD, 1999).

286. Feshbach and Friendly, *Ecocide in the USSR.*

287. OECD, *Environmental Performance Reviews.*

288. Knorre, "Rise and Fall of Environmental Protection."

289. NAPA, *The Environment Goes to Market: The Implementation of Economic Incentives for Pollution Control* (Washington, D.C.: NAPA, 1994), 78.

290. OECD, *Environmental Performance Reviews*, 51.

291. N. D. Sorokin, ed., *Okhrana Okruzhaiushchei Sredy, Pripodopol'zovanie I Obespechenie Ekologicheskoi Bezopasnosti V Sankt-Peterburge Za 1980–2000 Gody* [Protection of nature, natural resource use and ecological threats in St. Petersburg, 1980–2000] (St. Petersburg: Administratsiia Sankt-Peterburga upravlenie po okhrane okruzhaiushchei sredy, 2000), 30.

292. OECD, *Environmental Performance Reviews*, 142.

293. Ibid., 147.

294. Andrew Bond, "Environmental Disruption during Economic Downturn: White Book Report," *Post-Soviet Geography* 14, no. 1 (1993): 75.

295. Jonathan D. Oldfield, "Environmental Impact of Transition: A Case Study of Moscow City," *Geographical Journal* 165, pt. 2 (1999).

296. Sorokin, *Okhrana Okruzhaiushchei Sredy*, 32.

297. OECD, *Environmental Performance Reviews*, 44.

298. D. J. Peterson and Eric K. Bielke, "The Reorganization of Russia's Environmental Bureaucracy: Implications and Prospects," *Post Soviet Geography and Economics* 42, no. 1 (2001).

299. Anatoly Baev, Chairman, St. Petersburg City Administration on Environmental Protection, interviewed by Nathaniel Trumbull, St. Petersburg, 1999.

300. OECD, Environmental Performance Reviews.

301. Knorre, "Rise and Fall of Environmental Protection," 281.

302. Helena I. Glushenkova, "Environmental administrative change in Russia in the 1990s", *Environmental Politics* 8, no 2 (1999): 161.

303. Vladimir Putin, "Vystuplenie Prezidenta Rossiiskoi Federatsii V. V. Putina Na Zasedanii Gosudarstvennogo Soveta Rossiiskoi Federatsii" [Presidential address to the Russian Federation by Vladimir Putin at a government meeting of the Russian Federation] (2000).

304. Peterson and Bielke, "Reorganization of Russia's Environmental Bureaucracy."

305. Alexander Nikitin, "The State of Ecology and Human Rights in Russia" (speech given at the University of Washington, 12 March 2002).

306. Knorre, "Rise and Fall of Environmental Protection."

307. Craig ZumBrunnen and Nathaniel Trumbull, "Obstacles and Opportunities to the Establishment of an Environmental Information Network in Northwest Russia," *Journal of Urban and Regional Development Research* 8, no. 1 (2000).

308. Evgeny Shvarts, "What Is Happening in the Ministry of Natural Resources?" *Russian Conservation News* (Winter 2002).

309. Knorre, "Rise and Fall of Environmental Protection."

310. Shvarts, "What Is Happening?"

311. The Stolypin Reforms were arguably the most important attempt of Tsarism after 1881 to initiate social reform.

312. Shaw, *Russia in the Modern World*, 142.

313. Peterson and Bielke, "Reorganization of Russia's Environmental Bureaucracy."

314. Information gathered by author at a meeting with Yablokov in Washington, D.C., in March 2001.

315. Shaw, *Russia in the Modern World*, 127.

316. Shvarts, "What Is Happening?"

317. L. G. Kaplanov, "Tiger, Deer, Elk" [in Russian] (EZD, MOEP 1948).

318. D. G. Pikunov et al., "Present Area, Numbers and Distribution of Tigers in Primorsky Krai: Rare Mammal Species in the USSR and Their Protection" [in Russian] (paper presented at the Material of the III All-Union Meeting, Moscow, 1983). A. G. Yudakov and I. G. Nikolaev, "The Status of the Amur Tiger Population in Primorsky Krai" [in Russian], *Zoologicheskii Zhurnal* 52, no. 6 (1973).

319. E. N. Matyushkin et al., *Numbers, Distribution, and Habitat Status of the Amur Tiger in the Russian Far East: 'Express-Report'* (Vladivostok: USAID RFE Environmental Policy Project, 1996).

320. D. G. Miquelle and E. Zhang, "A Proposed International System of Protected Areas for Tigers" (paper presented at the Proceedings of the Workshop to Develop a Recovery Plan for the Wild North China Tiger Population; final report to the U.S. Fish and Wildlife Service's Rhinoceros and Tiger Conservation Fund from the Wildlife Conservation Society (WCS), Harbin, China, October 20–23, 2001).

321. See B. Sun et al., "Survey of Amur Tigers and Far Eastern Leopards in Eastern Heilongjiang Province, China and Recommendations for Their Conservation" (New York: Wildlife Conservation Society, 1999); Shihe Yang et al., "A Survey of Tigers and Leopards in Eastern Jilin Province, China, Winter 1998" (UNDP, WCS, 1998).

322. Institute of Geography, *A Survey of Tigers and Prey Resources in the Paektusan Area, Lyangan Province, North Korea, in Winter 1998* (Vladivostok: WCS, 1998).

323. Unpublished data collected by the author.

324. V. K. Abramov and D. G. Pikunov, "The Leopard ('Bars') in the Far East of the USSR and Its Protection" [in Russian], *Bulletin of MOIP, Biology Department* 79, no. 2 (1974).

325. V. K. Pikunov and V. G. Korkishko, "Current Distribution and Numbers of Leopards in the Far East of the USSR" [in Russian], *Zoologicheskii Zhurnal* 64, no. 6 (1985).

326. See V. V. Aramilev, P. Fomenko, and D. G. Miquelle, "A 1998 Survey of Leopards" [in Russian], *Zov Taigi* 4 (Vladivostok, 1999); D. G. Pikunov et al., "Total Count of Far Eastern Leopards and Amur Tigers in Southwest Primorsky Krai" [in Russian] (Vladivostok: n.p., 2000); and D. G. Pikunov et al., "Numbers and Habitat Structure of the Leopard in the Russian Far East" [in Russian], in *Rare Mammal Species of Russia and Adjacent Territories* (Vladivostok: Nauka, 1999).

327. Yang et al., "A Survey of Tigers and Leopards."

328. Sun et al., "Survey of Amur Tigers and Far Eastern Leopards."

329. D. G. Miquelle and A. Murzin, *Spatial Distribution of Far Eastern Leopard in Southwest Primorsky Krai, and Recommendations for Their Conservation* (Vladivostok: Report to Wildlife Conservation Society and WWF, 2001), 45; Pikunov et al., "Numbers and Habitat Structure of the Leopard."

330. Pikunov et al., "Total Count of Far Eastern Leopards and Amur Tigers."

331. O. Uphyrkina et al., "Conservation Genetics of the Far Eastern Leopard (*P. P. Orientalis*)," *J. Heredity* (in press) (2003).

332. Aramilev, Fomenko, and Miquelle, "1998 Survey of Leopards" [in Russian]; Miquelle and Zhang, "A Proposed International System of Protected Areas for Tigers."

Chapter 2 — Primorsky Krai

1. Approximately 196 Far Eastern leopards exist in captivity in about sixty international zoos. Scientists recently determined that one of the Far Eastern leopards used in an international captive breeding program was in fact a Chinese leopard, raising concern about the possibility of using captive-bred animals for future reintroductions.

2. Goskomstat, *Estimation of Number of De-Facto and De-Jure Population on the Subjects of the Russian Federation* [website] (Goskomstat, 2001 [cited 15 January 2001]); available from www.gks.ru/scripts/free. Children under the age of fifteen and retirees constitute 15 percent and 13 percent, respectively, of the *krai* population.

3. Yana Tselikova, "Mining Industry in Primorsky Krai, the Russian Far East" (Vladivostok: U.S. FCS & DS, 2001), 1.

4. Svetlana Kuzmichenko, "Primorsky Krai: Economic Results in 2000" (Vladivostok: U.S. FCS & DS, 2001).

5. The Vladivostok mafia made a fortune in the early 1990s in the illegal import of secondhand Japanese automobiles. Initially, the cars were bartered for natural resources. According to the NGO watchdog Bureau for Regional Outreach Campaigns, Primorsky reportedly has more Toyota Landcruisers per capita than any other place in the world. Ironically, the great increase in the four-wheel vehicles has allowed poachers to invade previously inaccessible forest lands.

6. The author would like to thank the following people who contributed to the report: A. A. Astaf'ev, P. V. Kolmakov, V. G. Korkishko. A. K. Kotlyar, A. A. Laptev, A. I. Myslenkov, V. I. Nesterenko, Y. P. Sushitsky, and S. A. Khokhryakov (all specialists are *zapovednik* employees) and the biologists V. Y. Barkalov, V. V. Bogatov, I. B. Vyshin, V. A. Nedoluzhko, V. A. Nechaev, I. Z. Parpura, D. G. Pikunov, S. Y. Storozhenko, M. P. Tiunov, Y. V. Shibaev, S. S. Kharkevich, and Y. A. Chistyakov.

7. Anatoly Lebedev and Andrei Laletin, *The Wild East: Trees in Transit—the Timber Trade between Siberia, the Russian Far East and China* (London: Forests Monitor, 2001).

8. Elisa B. Miller, "The Russian Far East," *The Russian Far East Update* (Seattle) (November 1994).

9. Elizabeth Wishnik, "The Forest Industry in Russia: Case Study—Primorsky Krai" (unpublished report, 1994).

10. Elisa B. Miller, "The Russian Far East," *The Russian Far East Update* (April 1995).

11. Tselikova, "Mining Industry in Primorsky Krai," 1.

12. Ibid., 3.

13. Ibid., 2.

14. Ibid., 3.

15. Primorsky Company also produces about 5,000 tons of copper annually and exports it to Japan.

16. Tselikova, "Mining Industry in Primorsky Krai," 3.

17. *Gorny Zhurnal* (2000).

18. Alexander Panichev, *Samarga: The Past, the Present and the Future* (Tokyo: FoE–J, 1998).

19. For a discussion of the recent history of reforms in the RFE, see Pavel Minakir, "Dal'nii Vostok Rossii: Istoriia Reformy" [Russian Far East: The history of reforms], *Dal'nii Vostok Rossii: Ekonomika Investitsii Kon'iunktura* 1 (1998): 14–19.

20. Important examples of laws that marked shifts toward economic regulation of the environment include: The Land Code of the Russian Federation (1991), On Payment for Land (1992), On Mineral Resources (1992), On Protection of the Environment (1991, 1992), The Basis for Forest Legislation of the RF (1993), The Water Code of the RF (1995), On the Animal Kingdom (1995), On Ecological Expert Review (1995), On Protection of Special Nature Territories (1995), and The Forest Code (1997) [all in Russian].

21. Peter Kirkow, *Russia's Provinces: Authoritarian Transformation Versus Local Autonomy?* (New York: St. Martin's Press, 1998, 119–40. For actual laws and normative acts, see also updates of S. D. Kniazev and E. N. Khrustalev, *Rossiiskoe Munitsipal'noe Pravo* [Russian municipal law] (Vladivostok: Far Eastern University Press, 1997).

22. A. P. Latkin, *Primorsky Krai: Lessons of Market Reform* (Vladivostok: Far Eastern University Press, 1997), 275.

23. Ibid., 276.

24. S. LaFraniere, "A Crisis of Control in the Russian Far East," *Washington Post Foreign Service*, 2 May 2000, 16.

25. Ibid.

26. Ibid. Nazdratenko went on to comment: "Maybe this decision was not particularly legal on my side, but believe me, in three to four years, life itself will confirm it was correct."

27. Y. Borisova, "Fisheries Choice Raising a Stink," *The Moscow Times*, 27 February 2001, 1–2.

28. E. Larina, "Governor's Bill Rejected," *The Russia Journal* 4, no. 6 (2001): 19.

Chapter 3 — Khabarovsk Krai

1. Alexander Lozikov, ed., *The Land of Khabarovsk* (Khabarovsk: Priamurskiye Vedomosti Publishing House, 1998), 13.

2. For related and more complete data, see Administratsiia Khabarovskovo Kraia, *Khabarovskii Krai: administrativno-territorial'noe delenie na 1 avgusta 1997 goda* [Khabarovsk Krai: Administrative composition] (Khabarovsk: Administration of Khabarovsk Krai, 1997); Goskomstat, *Khabarovskomu Kraiu 60 let: statisticheskii sbornik, iybileinyi vypusk* [Sixty years of Khabarovsk Krai: Statistical overview] (Khabarovsk: Khabarovsk Krai Goskomstat, 1998).

3. A handy analysis of demographic processes at work, especially within the RFE, is Z. E. Sidorkina, *Demograficheskie protsessy i demograficheskaia politika na rossiiskom Dalnem Vostoke* [Demographic tendencies and demographic politics in the Russian Far East] (Vladivostok: Pacific Institute of Geography, FEBRAS, 1997); see also Goskomstat, Khabarovskomu Kraiu 60 let [Sixty years of Khabarovsk Krai].

4. *Energy and Mineral Resources*, 54.

5. Lozikov, *Land of Khabarovsk*, 17.

6. *Energy and Mineral Resources*, 54.

7. Andrei Vasyenov, "The Russian Far East: Mining in Khabarovsk Krai" (Khabarovsk: U.S. FCS & DS, 2000), 4.

8. Ibid., 5.

9. P. V. Vakhnenko, *Morskie porty Iaponomorskovo regiona: ekonomiko-geograficheskaia kharakteristika* [Sea ports of the Sea of Japan region: Economic and geographic description] (Vladivostok: Dal'nauka, 1998).

10. See Goskomstat, *O razvitii vedushikh otraslei ekonomiki Dal'nevostochnovo regiona v khode ekonomicheskikh reform* [Development of leading areas of the economy of the Far Eastern region during the reform period] (Vladivostok: Goskomstat, 1999); Andrei Vasyenov, "Commercial Update from Khabarovsk, Russian Far East" (Khabarovsk: U.S. FCS & DS, 2000).

11. Andrei Vasyenov, "Foreign Trade and Investment in the Khabarovsk Krai in 2000" (Khabarovsk: U.S. FCS & DS, 2001), 1.

12. Vasyenov, "Commercial Update from Khabarovsk."

13. Vasyenov, "Foreign Trade and Investment."

14. O. M. Prokapolo, *Sotsial'no-ekonomicheskii potentsial sub'ektov federatsii na Dal'nem Vostoke Rossii* [Socio-economic potential of the

subjects of Russian Federation of the Russian Far East] (Khabarovsk: Khabarovsk State Technical University, 1999).

15. For various types of overview data for the *krai*, including general ecological characteristics, see Goskomstat, *Khabarovskomu Kraiu 60 Let.*

16. O. M. Prokapolo, *Federal'naia Sluzhba Geodezii i Kartografii Rossii, Khabarovskii Krai-Atlas* [Atlas of Khabarovsk Krai] (Moscow: Federal Geodesy and Cartography Service of Russia, 1995).

17. V. A. Belyaev, "The Fishing Resources of Amur River" [in Russian] (paper presented at the conference, Amur on the Verge of the Two Centuries: Resources, Issues, and Perspectives, Khabarovsk, 1999), 42–44.

18. A. V. Ivanov, "The Model of Penetration and Formation of Concentrations of Hazardous Substances in the Waters of Amur" [in Russian] (paper presented at the conference, Amur on the Verge of the Two Centuries), 45–47.

19. Goskomstat, *Khabarovskomu Kraiu 60 Let,* 124–27.

20. Discussions of the early *krai* can be found in *East of the Sun;* W. B. Lincoln, *Conquest of a Continent* (New York: Random House, 1994); John J. Stephan, *The Russian Far East: A History* (Stanford, Calif.: Stanford University Press, 1994); and Y. Slezkine, *Arctic Mirrors: Russia and the Small Peoples of the North* (Ithaca, N.Y.: Cornell University Press, 1994).

21. Pavel Minakir, *Ekonomika Dal'nego Vostoka: Piat' Let Reformy* (Khabarovsk: FEBRAS, 1998).

22. Ibid.

23. Ibid.

24. V. V. Onikhimovskii and Y. S. Belopomestnykh, *Poleznye iskopaemye Khabarovskogo Kraia* [Mineral resources of Khabarovsk Krai] (Khabarovsk: Priamur'e Geographic Society, 1996).

25. Ibid.

26. A. S. Sheingauz and the Institute of Economic Research, *Prirodopol'zovanie Rossiiskogo Dal'nego Vostoka i severo-vostochnaia Aziia* [Nature use in the Russian Far East and Northeast Asia] (Khabarovsk: RIOTIP, 1997).

27. I. D. Penzin, ed., *Entsiklopediia Khabarovskogo Kraia i Yevreiskoi Avtonomnoi Oblasti* [Encyclopedia of Khabarovsk Krai and Jewish Autonomous Oblast] (Khabarovsk: Priamur'e Geographic Society, 1995).

28. Vasyenov, "Mining in Khabarovsk Krai."

29. V. V. Onikhimovskii, "Problemy ratsional'nogo ispol'zovaniia mineral'nogo syr'ia Priamur'ia" [Problems of rational use of mineral resources in Priamur'e] in *Aktual'nye problemy sotsial'noi ekologii* [Actual problems of social ecology] (Vladivostok: Far Eastern Branch of the Soviet Academy of Sciences, 1989), 142–49.

30. P. V. Ielpat'ievskii et al., *Problemnye ekologicheskie situatsii v zone deistviia gorno-promyshlennogo kompleksa: okhrana okruzhaiushchei sredy i ratsional'noe prirodopol'zovanie* [Difficult ecological situations in the area of operation of the mining-industrial complex: Environmental protection and rational use of natural resources] (Vladivostok: Far Eastern Branch of the Soviet Academy of Sciences, 1988), 51–58.

31. E. V. Shevkun, "Podavleniye pylegazovykh vybrosov pri massovykh vzryvakh na karerakh" [Suppression of dust and gas emissions during mass explosions in open mines]" (paper presented at the All-Russian Conference on Nature Protection, Khabarovsk, 1995), 4–5.

32. Sheingauz and ERI, *Prirodopol'zovanie.*

33. Vladimir Ishaev, *Ekonomicheskaia reforma v regione: tendentsii razvitiia i regulirovania* [Economy reform in the region: Tendencies in development and regulating] (Vladivostok: Dal'nauka, 1998).

34. E. E. Anert, *Bogatstvo nedr Dal'nego Vostoka* (Khabarovsk: Knizhnoe Delo, 1928).

35. Ibid.

36. Ie. Aurilene, *Razvitie promyshlennosti, promyslov i torgovli na Rubezhe XIX–XX vv.-Ocherki Istorii Rodnogo Kraia* [Development of industry, crafts, and trades in late 19th and early 20th centuries—essays on the history of our *krai*] (Khabarovsk: n.p., 93).

37. A. S. Marfunin, *Istoriia zolota* [The history of gold] (Moscow: Nauka, 1987).

38. Vasyenov, "Mining in Khabarovsk Krai."

39. Ibid., 5.

40. Ibid., 6.

41. A. N. Makhinov, V. I. Kim, and A. N. Stepanov, "Ekologicheskie aspekty razrabotki mestorozhdenii peska i graviya v rusle r. Amur: problemy ratsional'nogo osvoeniia mineral'nykh Resursov" (Mel'nikovskie chteniia) [Ecological aspects of extracting sand and gravel deposits in Amur riverbed: Rational use of mineral resources (Melnikov memorial readings)] (paper presented at the All-Russian Conference on Nature Protection, Khabarovsk, 1995), 191–92.

41. See *Forest Sector of the Russian Far East.*

42. Khabarovsk Krai Forest Service, Harvard Institute of International Development, and U.S. Forest Service, *Reforestation in Khabarovsk Krai* (Khabarovsk: Khabarovsk State Technical University, 1998).

43. Vasyenov, "Commercial Update from Khabarovsk."

44. Conversation with Andrei Zhakarenkov, Director, Forest Certification Center, September 2001.

45. Josh Newell, based on discussions with Rimbunan Hijau officials in Khabarovsk City, March 2000.

46. Josh Newell, based on discussions with Victor Surkov in Pereyavslavka City, March 2000.

Chapter 4 — Jewish Autonomous Oblast

1. *Russian Far East: A Business Reference Guide,* 166.

2. "The Jewish Autonomous Oblast: Searching for an Identity," 28 June 1995, U.S. Embassy, Moscow.

3. "Jewish Autonomous Oblast: Searching for an Identity," 2.

4. *Energy and Mineral Resources.* Brushite is used in chemical and glass manufacturing, and its rich color makes it useful as a finishing stone.

5. Ibid. Graphite is used to make fire-resistant materials, brakes, pencils, and batteries.

6. Andrei Vasyenov, "Jewish Autonomous Region—Profile," U.S. FCS & DS, May 2000, 2.

7. *Russian Far East: A Business Reference Guide,* 166.

8. Vasyenov, "Jewish Autonomous Region," 3.

9. Ibid., 7.

10. "Jewish Autonomous Oblast Approves 1999 Exploration Program," *Interfax Mining and Metals Report,* no. 23 (377), 4 June 1999.

11. Vasyenov, "Jewish Autonomous Region," 3.

12. Ibid.

13. Personal communication by the author with Y. S. Zarkhina.

14. Personal communication by the author with V. A. Buryak.

15. Vasyenov, "Jewish Autonomous Region," 3.

16. Ibid.

17. "Chinese Interested in Jewish Autonomous Oblast's Iron Ore Deposits," *Interfax Mining and Metals Report,* no. 28 (333), 10 July 1998.

18. *Vladivostok News,* no. 128, 30 October 1996. Reprinted with permission.

Chapter 5 — Amur Oblast

1. David Gordon, "China's Economy Casts Long Shadow on Russian Forests," *Pacific Environments* 1, no. 2 (spring 1999): 1.

2. Amur Oblast Committee of State Statistics (AOCSS), *Amur Statistical Yearbook* [in Russian] (Blagoveshchensk: Goskomstat, 2000), 26.

3. Svetlana Titova to David Gordon, private e-mail, 16 March 2000.

4. Valerii Smirnov, "Amurskii region na rubezhe stoletii" [The Amur region at the turn of the century] (Khabarovsk: Priamurskie Vedomosti, 2000), 59.

5. AOCSS, *Amur Statistical Yearbook*, 218.

6. Smirnov, "Amurskii region," 148.

7. Ibid., 31–37.

8. Ibid., 30.

9. Ibid., 40–41.

10. *Russian Far East: A Business Reference Guide*, 11.

11. Smirnov, "Amurskii region," 62.

12. Yana Tselikova, "Overview of Amurskaya Oblast (Region)," U.S. FCS & DS, 2000, 6–8.

13. Smirnov, "Amurskii region," 65.

14. Ibid., 67.

15. Ibid., 6.

16. Ibid., 42.

17. Tselikova, "Overview of Amurskaya," 2.

18. AOCSS, *Amur Statistical Yearbook*, 22.

19. Ibid.

20. Smirnov, "Amurskii region," 102.

21. AOCSS, *Amur Statistical Yearbook*, 22.

22. Ibid., 97.

23. Ibid.

24. Ibid., 100–101.

25. Ibid., 99.

26. Ibid., 100.

27. Tselikova, "Overview of Amurskaya," 3–5.

28. *Energy and Mineral Resources*, 63.

29. AOCSS, *Amur Statistical Yearbook*, 332–34.

30. Ibid., 331.

31. L. V. Shnyrova, M. A. Riabchinskaia, G. T. Zhukova, E. Ia. Reshetova, and T. F. Ovsiannikova, "Amur" [in Russian], in *Regions of Russia* (Moscow: Goskomstat, 2000), 11.

32. AOCSS, *Amur Statistical Yearbook*, 331.

33. "Talks on Timber," *The Russian Far East News* (September 1999): 3.

34. At a Russia-Japan Bilateral Economic Committee meeting in 1999, the Japanese delegation selected the Bureinskaya dam as one of the top priorities for investment.

35. AOCSS, *Amur Statistical Yearbook*, 99.

36. Yana Tselikova, "Major Projects in Amurskaya Oblast, Russian Far East," U.S. FCS & DS (2000), 1–4.

37. S. Starchenko, Y. Darman, and D. Shapoval, eds., "Redkie i ischezaiushchie sosudistye rasteniia Amurskogo regiona" [Rare and endangered vascular plants of Amur Region] (Blagoveshchensk: Amur Oblast administration, 1996).

38. On 3 July 2000, the Amur Oblast government established this natural monument.

39. Khingansky Zapovednik has recently received grants from the Global Environment Facility (U.S. $120,000) and the WWF (U.S. $10,000).

40. The Amur Oblast government, one of the few in the RFE to commit itself to creating new protected areas, established the Irkun Botanical Zakaznik on 27 March 2000 and the Andreevsky Landscape Zakaznik on 28 June 2000 to help protect this region.

41. In fiscal year 2000, the Committee of Ecology and WWF committed U.S. $15,000 for the staff of the *zapovednik*.

42. This *zakaznik* was upgraded to federal status on 2 October 1999 and, on 20 October 1999, the government established the Birminsky Regional Zoological Zakaznik to protect wintering grounds of migrating roe deer.

43. Shnyrova et al., "Amur," 143.

44. AOCSS, *Amur Statistical Yearbook*, 19.

45. Ibid., 46.

46. Ibid., 7.

47. Ibid., 20.

48. Ibid., 200.

49. Smirnov, "Amurskii region," 105.

50. AOCSS, *Amur Statistical Yearbook*, 26.

51. Ibid.

52. Ibid., 97–100.

53. Smirnov, "Amurskii region," 105.

54. FoE–J, Bureau for Regional Oriental Campaigns, and Pacific Environment and Resources Center, *Plundering Russia's Far Eastern Taiga: Illegal Logging, Corruption and Trade* (Tokyo, FoE–J, 2000), 10.

55. Gordon, "China's Economy," 1–4.

56. Gordon, personal communication, 6 July 2000.

57. AOCSS, *Amur Statistical Yearbook* (1999), 33.

58. Titova to Gordon, e-mail, 16 March 2000.

59. Idem, 18 March 2000.

60. Idem, 8 April 2000.

61. Amur Branch of the Socio-Ecological Union (SEU) et al., "Open letter to the head of the Administration of Amur Oblast" [in Russian], March 2000.

62. "Mining in the Russian Far East" (Vladivostok: U.S. FCS & DS, 1999), 6.

63. Ibid.

64. Ibid.

65. Ibid.

66. Tselikova, "Major Projects in Amurskaya," 2.

67. AOCSS, *Amur Statistical Yearbook*, 7.

68. Melinda Herrold, forthcoming.

69. "Amur Oblast: Soybeans and timber," U.S. Embassy, 24 July 1995, p. 3.

70. AOCSS, *Amur Statistical Yearbook*, 53.

71. AOCSS, *Amur Statistical Yearbook* (1998), 16; AOCSS, *Amur Statistical Yearbook*, 48.

72. AOCSS, *Amur Statistical Yearbook*, 17.

73. Sergei A. Podolski, "The effects of hydroelectric projects on ecosystems of the Zeya River Valley: Will history repeat itself?" Russian Conservation News (fall 1998): 17.

74. Ibid., 18.

75. Svetlana Kuzmichenko, "Commercial Update—RFE General, Primorsky Krai, Chukotka," U.S. FCS & DS (May 2001), 7.

76. Amur Socio-Ecological Union, "Conservation of Forest Ecosystems in the Russian Far East's Amur Region" (unpublished paper, 1999), 2.

77. Podolski, "Effects of hydroelectric projects," 19.

78. Nikolai K. Schulmann, "Geografiia Amurskoi oblasti" [The geography of Amur Oblast] (Blagoveshchensk: Khabarovskoye knizhnoye izdatelstvo, 1991), 29.

79. Sergei Smirenski, personal communication, May 2000.

80. "Bridge to China to get a sponsor," *Russian Far East Update* (Seattle) (December 1998): 4.

81. Ibid.

82. Ibid.

83. Smirnov, "Amurskii region," 116.

84. For more information, see www.nasawatch.com/russia.1999.html

Chapter 6 — The Republic of Sakha

1. Alexander Isaev, "Ecology and Economy in Yakutia" (paper presented at the FoE–J Hotspot Conference, Vladivostok, 1995), 1.

2. Ibid., 2.

3. Nikita Solomonov, director, Yakutia Institute of Biology, letter to John Turner, chairman, Ramsar Convention Bureau, 1994.

4. The Siberian crane needs more land set aside for it to survive, particularly in eastern China, a major wintering site.

5. Goskomstat, *Estimation of Number of De-Facto and De-Jure Population on the Subjects of the Russian Federation*, see www.gks.ru/scripts/free [accessed 1 July 2000].

6. Ibid.

7. *Russian Far East: An Economic Handbook*, 139; *Energy and Mineral Resources*, 200; *Russian Far East: A Business Reference Guide*, 10.

8. Figures vary widely for coal and other mineral reserves.

The Far East and Zabaikalye Association puts the figure at 14.4 billion (*Energy and Mineral Resources*). Minakir et al. (*The Russian Far East*) put the figure at 4.4 billion. Dr. Alexander Isaev ("Ecology and Economy in Yakutia," 3) puts the figure at 9.3 billion tons of coal, including 6 billion tons for surface mining. The u.s. fcs & ds ("Sakha Republic (Yakutia) Regional Profile") estimates reserves in the south Yakutian basin total 7.4 billion tons, with predicted reserves at 40 billion tons. These widely varying statistics reveal that precise assessments of Sakha's mineral reserves are essentially unknown.

9. *Energy and Mineral Resources*, 44.

10. Gordon Fellers, *Fellers Mining News* [electronic newsletter], www.infomine.com/news/newsletters/websites/feller.html [accessed 1 June 2000].

11. The Diamond Registry, *World Mining Production—Sept. 2000* [Internet report], www.diamondregistry.com/News/world.htm [accessed 21 May 2001].

12. Anne Sudkamp, "Alrosa Figures," *Russia Far East News* (July 2000): 15.

13. The purchaser was the World Trade Corporation.

14. "Interfax Mining and Metals Report," *Interfax Mining and Metals Report* (7 January 1999): 1.

15. Irina Konstantinova, "Sakha Republic (Yakutia) Regional Profile," (Yakutsk: u.s. fcs & ds, 1999), 3.

16. Ibid., 2.

17. Fellers, *Fellers Mining News.*

18. Ibid.

19. "New Cutting Plant Opens in Yakutsk," *Prime-TASS News Wire*, 6 March 2001.

20. "Interfax Mining and Metals Report."

21. Ibid.

22. President, Sakha Republic, decree No. 837: On Measures to Develop Specially Protected Areas, August 1994.

23. Legislature, Sakha Republic, law No. 113-I: Specially Protected Natural Areas, May 6, 1996. This law, based on Article 2 of the federal Russian law No. 33-F3, On Specially Protected Nature Areas, 14 March, 1995, augments law No. 2060-1: On Nature Protection, 19 December, 1991.

24. Center for Russian Nature Conservation, *Olekminsky Zapovednik* [electronic report], www.wildrussia.org/bioregion8/8-olekma.htm [accessed 5 May 2001].

25. Alexander Isaev, internal report, 2000, 5.

26. The Soviet government conducted twelve peaceful underground nuclear explosions (usually to find natural gas or gold) in the 1960s and 1970s. Two of these, Kristall and Kraton-3, caused serious accidents and radioactive isotopes (Cs-137, Se-90, Pu-239, Pu-240, Am-241, Co-60, and Sb-125) leaked into the atmosphere. At the Kristall explosion site, five of the seven analyzed samples showed a plutonium content up to 35,500 times higher than the International Atomic Energy Agency standard. The occurrence of underground nuclear explosions was not revealed to the public until 1985.

27. Sudkamp, "Alrosa Figures."

28. "Alrosa Group to Invest $2.8 Billion in Development," *Prime-TASS Economic News Agency*, 16 February 2001.

29. *Ex-Im Bank Finances Diamond Mining Equipment to Russia* [electronic press release], U.S. Ex-Im, 16 July 1996; www.exim.gov [accessed 16 July 2001]. In its first loan to the Russian diamond industry, the U.S. Ex-Im Bank provided financing totalling u.s.$60 million to Caterpillar and other companies to supply Alrosa with mining equipment. Alrosa and Lazare Kaplan International Ltd., the largest diamond polisher in the United States, will cut and polish rough gem diamonds in Moscow.

30. Russian Regional Report, "De Beers New Strategy Could Change the Face of Russian Diamonds" (New York: EastWest Institute, 2000), 8.

31. Vladimir Teslenko, "The Importance of Russia's Diamond Industry," *Kommersant-Daily*, 28 June 1995, p. 5.

32. Matthew J. Sagers, "Regional Trends in Russian Gold Produc-

tion," *Post-Soviet Geography and Economics* 38, no. 6 (1997): 341.

33. Isaev, "Ecology and Economy in Yakutia," 2.

34. Sagers, "Regional Trends," 339.

35. "Mining in the Russian Far East" (Vladivostok: u.s. fcs & ds, 1999), 5; "Interfax Mining and Metals Report," *Interfax Mining & Metals Report*, 20 November 1998, 2.

36. Ibid; Sagers, "Regional Trends," 339–43.

37. "Mining in the Russian Far East," 5; "Interfax Mining and Metals Report," 20 June 1997; Alaska Center for International Business et al., "rfe Mining News," *Russian Far East News*, September 1998.

38. www.infomine.com [subscription website] [accessed September 2000].

39. A northern branch of the RAS.

40. "Interfax Oil, Gas, and Coal Report," *Interfax Oil, Gas, and Coal Report* 15, no. 328 (1998): 1.

41. *Energy and Mineral Resources*, 139.

42. Yana Tselikova, "Regional Profile: Neryungri, Sakha Republic" (Yakutsk: u.s. fcs & ds, 2000), 3.

43. *Energy and Mineral Resources*, 139.

44. Ibid., 44.

45. Tselikova, "Regional Profile: Neryungri," 5.

46. "Major Oil Deposit Found in Sakha," *Agence France-Press*, 26 November 1997.

47. Eurogas, *Pursuing a Major Opportunity in the Sakha Republic* [electronic press release](Eurogas, 22 December 2000); www.eugs.com [accessed 22 December 2000].

48. "Major Oil Deposit."

49. Andrei Varlamov and Andrei Kirillov, *ITAR-TASS Newswire*, 19 November 1997.

50. Raymond S. Mathieson, *Japan's Role in Soviet Economic Growth: Transfer of Technology since 1965* (New York: Praeger, 1979), 67–79.

51. "Interfax Oil, Gas, and Coal Report," 2.

52. *East of the Sun*, 35 -36.

53. Nikolai Vakhtin, *Native Peoples of the Russian Far North* (Manchester, England: Minority Rights Group, 1994), 31.

54. *East of the Sun*, 455.

55. Emma Wilson, "Yakutia," internal report (Tokyo: FoE–J, 1994), 2.

56. Condensed version of a report entitled "The Gang That Couldn't Shoot Straight." Reprinted with permission. See www.logisticslaw.com.

Chapter 7 — Magadan Oblast

1. Interfax, "Interfax Mining and Metals Report," *Interfax Mining & Metals Report*, 10 July 1998.

2. Interfax, "fsu Oil & Gas Monitor," *FSU Oil & Gas Monitor*, 6 June 2000.

3. *Russian Far East: A Business Reference Guide*, 19.

4. Population figures from Goskomstat. Accessed 1 January 2000. *Nezavisimaya gazeta* reported on 12 May 1999 that the population of Magadan Oblast had dropped by more than 100,000 since the country's economic crisis began in August 1998.

5. Will Englund, "A Glint of Hope in Russia's Gold Rush- Magadan: Once Involved in the Soviet Union's Dreaded Gulag System, a Far East Region Is Returning to Mining to Pull It out of Poverty," *The Baltimore Sun*, 30 December 1999.

6. Svetlana Kuzmichenko, "Magadan Oblast Update" (Vladivostok: u.s. fcs & ds, 1998), 2.

7. *Gorny Zhurnal* 2000, 62–64.

8. Kuzmichenko, "Magadan Oblast Update," 2.

9. From a report on Radio Free Europe/Radio Liberty, Prague, Czech Republic, Russian Federation Report vol. 2, no. 4, 26 January 2000.

10. Kuzmichenko, "Magadan Oblast Update," 3.

11. "Rynok truda" [Labor market], *Regions of Russia: Magadan Chapter* (Moscow: Goskomstat, 2000).

12. "Prices," *Regions of Russia: Magadan Chapter* (Moscow: Goskomstat, 2000).

13. "Monetary Income and Expenditures of the Population," *Regions of Russia: Magadan Chapter* (Moscow: Goskomstat, 2000).

14. Interfax, "Interfax Mining and Metals Report," 10 July 1998.

15. "Rynok truda" [Labor market].

16. Svetlana Osipenko, "U.S. Embassy Report" (Moscow: U.S. FCS & DS, 1998), 3.

17. Ibid.

18. In 1993, such ventures caught 1,729.7 tons of crab, far exceeding the official quota of 474.85 tons. The same year, Magadan GG Godo, a Russian-Japanese fishing joint venture with MaGINRO, illegally sold quotas to Japan that had not been licensed for export.

19. Cascade Investment, a firm controlled by Microsoft founder Bill Gates, has a 10.3 percent interest in Pan American Silver Corp., the company with an interest in the Dukat silver mine in Magadan. See the Alaska Center for International Business et al., "The Russian Far East News," *Russian Far East News* (1992), 4.

20. Kinross Gold Corporation can be contacted c/o Robert Buchan, Chairman and CEO, 57th floor, Scotia, 40 King St. West, Toronto, Ontario M5H342.

21. Western Pinnacle, "Information on the Kubaka Project" (Western Pinnacle Corporation, 2000 [cited July 2000]); available from www.westernpinnacle.com/kubaka.html.

22. Julie Edlund, David Gordon, and William Paul Robinson, *A Model Mine Shows Its Cracks: An Independent Report on Environmental Problems at the Kubaka Gold Mine in the Russian Far East* (Oakland, Calif.: Pacific Environment, 1998), 5.

23. Ibid., 6.

24. "Is Omolon Mining Co. Polluting the Water?" *Magadanskaya pravda*, 11 March 1998.

25. Alaska Center for International Business et al., "Bema Secures Financing," *Russian Far East News* (2000): 1.

26. Bloomberg News, "World Bank Backs Russian Gold Venture over Some Objections," *Bloomberg News*, 1 August 2000.

27. Ibid.

28. Igor Semenenko, "Investors at Loggerheads over Dukat Silver Mine," *The Moscow Times*, 5 May 2000.

29. Osipenko, "U.S. Embassy Report," 3.

30. Interfax, "Interfax Mining and Metals Report."

31. InfoMine, Information on Magadan Database (Robertson Info-Data Inc., 2000 [cited 3 June 2000]); available from www.infomine.com.

32. Ibid.

Chapter 8 — Chukotsky Autonomous Okrug (Chukotka)

1. *Russian Far East: An Economic Handbook*.

2. A. M. Springer, C. P. McRoy, and M. V. Flint, "The Paradox of Pelagic Food Webs in the Northern Bering Sea-III," *Continental Shelf Research* 13: 575–99.

3. Frith Maier, *Trekking in Russia & Central Asia: A Traveler's Guide* (Seattle: The Mountaineers Books, 1994).

4. Conservation of Arctic Flora and Fauna (CAFF), *Atlas of Rare Endemic Vascular Plants of the Arctic*, Technical Report no. 3, p. 59 (Anchorage, Alaska: U.S. Fish and Wildlife Service, 1999).

5. N. Osyanikov, *Polar Bears: Living with the White Bear* (Minnesota: Voyageur Press, 1996).

6. Margaret Williams et al., eds., "Ecoregion-Based Conservation in the Bering Sea: Identifying Important Areas for Biodiversity Conservation" (WWF–U.S., 2000), 13.

7. N. B. Konyukhov, "Seabirds of the Chukotka Peninsula," *Arctic* 51: 315–29.

8. *Russian Far East: A Business Reference Guide*.

9. See Goskomstat website, www.gks.ru.

10. "Chukotka Autonomous Region," 8 October 1998 (U.S. FCS & DS, 1998).

11. Writings of Russian geologist Nikolay Alekseyevich Shilo, taken from John Tichotsky, "Use and Allocation of Natural Resources in the Chukotka Autonomous District" (Alaska Region, United States National Park Service, 1991), 96.

12. Tichotsky, "Use and Allocation of Natural Resources," 96.

13. B. K. Krasnopolsky and A. N. Pilyasov, "Magadan Province: Economic-Geographic Overview," FEBRAS, Magadan 1990, 12. In Tichotsky, "Use and Allocation of Natural Resources."

14. *Russian Far East: An Economic Handbook*, 176.

15. *Russian Far East: A Business Reference Guide*.

16. Chukotka Department of Agriculture, 1998.

17. Tichotsky, "Use and Allocation of Natural Resources," 106.

18. Andrei Ivanov and Judith Perera, "Chukotka Sits on Riches but Lives in Poverty," InterPress Service, November 12, 1998.

19. Ibid.

20. E. Tikhmenev, "Creation of High-Productive Seeding Meadows on Disturbed Arctic Lands," translated by Emma Wilson, MS, 1994.

21. Williams et al., "Ecoregion-Based Conservation," 17.

22. Ibid, 15.

23. Tichotsky, "Use and Allocation of Natural Resources."

24. Bellona Foundation, "Russia's First Floating Nuclear Power Plant," 1997. Data taken from website, www.bellona.org.

Chapter 9 — Koryak Autonomous Okrug (Koryakia)

1. Goskomstat, see website www.gks.ru.

2. "Rossiiskii Statisticheskii Ezhegodnik" [Russian statistics yearly], 1999 (Moscow: Goskomstat, 2000).

3. Untitled article, *Izvestiya*, 6 May 1999.

4. Goskomstat, see website.

5. Alexander King, personal observation, 1997–1998.

6. Information from studies by the Kamchatka Institute of Ecology and Nature Use.

7. V. D. Sergeev, *Istoriia Kamchatki* [The history of Kamchatka] (Petropavlovsk, Kamchatka: Far East Publishing House, 1992).

8. Basil Dmytryshyn and E. A. P. Crownhart-Vaughan, ed. and trans., *Russia's Conquest of Siberia, 1558–1700: A Documentary Record*, vol. 1 (Portland, Ore.: Oregon Historical Society, 1985).

9. Stepan Petrovich Krasheninnikov, *Opisanie zemli Kamchatki* [Description of Kamchatka land], photoreprint of first edition, 1755 (Saint Petersburg: Nauka, 1994). The text is available in English: Stepan Petrovich Krasheninnikov, *Explorations of Kamchatka*, E. A. P. Crownhart-Vaughan, trans. (Portland, Ore.: Oregon Historical Society, 1972).

10. Yuri Slezkine, *Arctic Mirrors* (Ithaca, N.Y.: Cornell University Press, 1984), 212.

11. Thomas K. Bundtzen, "An Update on Platinum Mining Activities in the Russian Far East," *Russian Far East News* (September 1999).

12. Ibid.

13. V. V. Antropova, *Kul'tura i traditsii koriakov* [The culture and traditions of the Koriaks] (Leningrad: Nauka, 1971).

14. Waldemar Jochelson, *The Koryak, in Memoirs of the American Museum of Natural History*, vol. 10, Franz Boas, ed.; and *Publications of the Jesup North Pacific Expedition*, vol. 6; 2 parts (Leiden: E. J. Brill; New York: G. E. Stechert, 1905, 1908); reprinted as Waldemar Jochelson, *The Koryak* (New York: AMS Press, 1975).

15. Antropova, *Kul'tura i traditsii koriakov*.

16. I. I. Ogryzko, *A Brief History of Improved Relations between the Indigenous and the Russian Population of Kamchatka (Late 17th–Early 20th Century)* [in Russian] (Leningrad: Leningrad University, 1973), 191.

17. G. K. Bubnis and S. P. Nefedova, *Sotsial'nye preobrazovaniia v Koriakskom Avtonomnom okruge* [Social transformation in the Koryak Autonomous Okrug] (Moscow: Nauka, 1981).

18. *Istoriia zhizni narodov severo-vostoka RSFSR v 1917–1985 gg.* [The history of the life of the peoples of the North-East of the Russian Federation, 1917–1985] (Petropavlovsk, Kamchatka: Far East Publishing House, 1986).

19. *Malochislennye narody Krainego Severa* (Minority Indigenous Peoples of the North) is a special designation for members of twenty-six officially recognized ethnicities that traditionally reside in Siberia and the Russian Far East. None of the groups numbers more than 50,000 people. Koryak, Itelmen, Even, and Chukchi are all included in this designation. Sometimes the Russian word *malochislennye* is rendered as "small" in English, or "numerically small."

20. Duma, KAO, law: On the Territories of Traditional Nature Use in the Koryak Autonomous Okrug, 23 May 1997.

21. V. A. Korchmit, *Sotsial'no-ekonomicheskie problemy razvitiia Koriakskogo Avtonomnogo okruga* [Social and economic problems of the Koryak Autonomous Okrug development] (Moscow: RAS, 1997).

22. See "The RF Forest Code," articles 107, 124.

23. Board, Council of People's Deputies, KAO, decision No. 11: On the Establishment of [an] Interim Commission to Study the Feasibility of Reopening National Villages.

24. Presidium, Council of People's Deputies, KAO, decision No. 35/42: On the Land Reform in the Koryak Autonomous Okrug, 20 April 1991.

25. Board, Council of People's Deputies, KAO, decision No. 26: The regulation of Tribal Lands in the Koryak Autonomous Okrug, 11 June 1992.

26. Board, Council of People's Deputies, KAO, decision No. 46: Interim Provision on the Legal Status of Tribal Communities of the Minority Peoples of the North [in] the Koryak Autonomous Okrug, 30 April 1993.

27. Duma, KAO, law: On the Status of the Tribal Community of the Minority Indigenous Peoples of the North, 12 November 1997. This law includes definitions of the terms: territories of traditional nature use; minority indigenous peoples of the North; territories of traditional settlement and economic activities; community self-government; communal land ownership; communal property of the minority indigenous peoples of the North; and traditional nature use. See also Korchmit, *Social and Economic Problems*.

28. Duma, KAO, law: On the Territories of Traditional Nature Use.

29. Governor, KAO, regulation No. 317: On the Establishment of the Territory of Traditional Nature Use (TTP) Tkhsanom in Tigil Raion, 2 December 1998. See also V. A. Korchmit and G. P. Yarotsky, eds., "The Prospects of the Koryak Autonomous Okrug Sustainable Development in 1998–2010" [in Russian] (compendium of materials of the first public hearings held at the Conference in Palana, Kamchatskaya Oblast, 13–17 March 1997), 92.

30. Board, Council of People's Deputies, KAO, law No. 22: The Provisional Regulation on the Transfer of Plots of Land for Private Reindeer-breeding Enterprises in the Territory of the Koryak Autonomous Okrug, 6 November 1992. In Russian commercial law and common local usage, private reindeer herds are classed as private farms.

31. Governor, KAO, decree No. 54: On the Maximum Size of Plots of Land Provided for the Establishment of Reindeer Farms in the *Okrug*, 4 March 1992.

32. Duma, KAO, law No. 5003: On Reindeer Breeding in the Koryak Autonomous Okrug, 25 June 1998.

33. Duma, KAO, law: On Fishing in the Koryak Autonomous Okrug, 17 June 1998.

34. Council of People's Deputies, KAO, regulation: On the Procedure of Distribution of Quotas on the Catch of Anadromic Fish in the Territory of the KAO; see also V. A. Korchmit, *Puti stabil"nogo razvitiia rybolovetskogo kompleksa Koriakskogo Avtonomnogo okruga v 1998–2005 gg.* [Means for sustainable development of the fishery complex of the Koryak Autonomous Okrug in 1998–2005] (Moscow: BNIERH, 1998).

35. Governor, KAO, regulation No. 14: The Rules of Hunting in the Territory of the Koryak Autonomous Okrug, 17 January 1992.

36. Council of People's Deputies, KAO, decision: On the Provisional Status of a National Enterprise, 11 June 1992.

37. Administration head, KAO, regulation, 25 February 1992.

38. See *Ethnographical Review* no. 5 (1998) for a description of the "ethical ecological refuge" concept. See *Living Arctic* nos. 9 and 10 (March 1999) for information on the organization of the Tkhsanom Union. See *Kamchatka Aborigine*, 21 June 1999, for a description of a similar union of indigenous communities, called YaYaR, that was established to control and protect traditional nature resources in southern Kamchatka.

Chapter 10 – Kamchatka Oblast

1. *Russian Far East: A Business Reference Guide*, 24.

2. Sergei Solovyov, "Ecology and Economy in Kamchatka," trans. Emma Wilson (paper presented at the FoE–J Hotspot Conference, Vladivostok, January 1995), 2.

3. *Russian Far East: A Business Reference Guide*, 23.

4. Goskomstat; see www. gks.ru [accessed 12 January 2002].

5. Ibid.

6. *Russian Far East: A Business Reference Guide*, 112.

7. Ibid., 114.

8. RFE/RL *Russian Federation Report* 2, no. 27 (26 July 2000); see www.rferl.org/.

9. Kamchatka Regional Committee on Nature Protection, *Doklad o sostoianii okruzhaiushchei sredy Kamchatksoi oblasti 1997 goda* [Report on the environmental conditions of Kamchatka Oblast in 1997] (Petropavlovsk-Kamchatsky, Kamchatka Regional Committee on Nature Protection, 1998).

10. T. N. Gaifulina, ed., *Istoriko-geograficheskii atlas* [Historical-geographical atlas] (Petropavlovsk-Kamchatsky: AO Kamchatkniga, 1994).

11. *O sostoianii okruzhaiushchei prirodnoi sredy v Kamchatskoi oblasti* [State report on the state of the natural environment in Kamchatka Oblast] (Petropavlovsk-Kamchatksy: Kamchatoblkomprirody, 1996).

12. *Khodataistvo pravitel'stva Rossiiskoi federatsii o vkliuchenii Kamchatki v Spisok Vsemirnogo prirodnogo naslediia* [Request of the government of the Russian Federation to include Kamchatka as an object of world natural heritage] (Moscow: Federal Committee on Environmental Protection, 1995).

13. O. A. Cherniagina, ed., "Obosnovaniie dlia priniatiia resheniia o sozdanii prirodnogo parka regional'nogo znacheniia v doline r. Nalychevoi Elizovskogo raiona Kamchatskoi oblasti" [Basis for the adoption of the decision to create a regional nature park in the Nalychevo River valley] (Petropavlovsk-Kamchatsky: Kamchatka Institute of Ecology and Nature Use, 1995).

14. V. Iu. Neshataev, ed., *Proekt organizatsii prirodnogo natsional'nogo parka "Iuzhno-Kamchatskii"* [Proposal for the creation of South-Kamchatksky Nature Park] (St. Petersburg: AO Nord-Vest Eko-servis, 1993).

15. V. I. Kirillov, ed., *Spravochnik turista* (A tourist's guidebook) (Petropavlovsk-Kamchatsky: RUI KOT, 1994).

16. Information about "Project Kamchatka '98" and subsequent expeditions can be found at www.spri.cam.ac.uk/research.

17. Podzol is highly bleached soil, low in iron and lime, formed under moist and cool conditions.

18. A. T. Naumenko, E. G. Lobkov, and A. P. Nikanorov, *Kronotskii Zapovednik* (Moscow: Agropromizdat, 1986).

19. V. V. Iakubov, *Sosudistye rasteniia Kronotskogo biosfernogo zapovednika* (Vascular plants of Kronotsky Biosphere Zapovednik) (Vladivostok: RAS, 1997).

20. Kronotsky Zapovednik regulations are based on the Russian Federation Law, On Strict Nature Reserves (1995), and the Kamchatka Oblast Law, On Strict Nature Reserves (1997 and revised 1999).

21. V. E. Sokolov, ed., *Prirodnye resursy Komandorskikh ostrovov (zapasy, sostoianie, voprosy okhrany i ispol'zovaniia)* [Natural resources of the Commander Islands (status, protection, and use)] (Moscow: Moscow State University Press, 1991).

22. Komandorsky Zapovednik Regulations are based on the same laws as those of Kronotsky (see n. 20).

23. *Ratsional'noe prirodopol"zovanie na Komandorskikh ostrovov* [Rational nature use on the Commander Islands] (Moscow: Moscow State University Press, 1987).

24. A. V. Rzhavsky, ed., *Donnaia flora i fauna shel'fa Komandorskikh ostrovov* [Flora and fauna of the Commander Islands shelf] (Vladivostok: Dal'nauka, 1997).

25. Irina Pokrovskaya, "Editor's Commentary," *Russian Conservation News* (spring 1997), 11.

26. "Japan receives exclusive rights to salmon fishing in Komandorsky Zapovednik" (press release issued by Greenpeace, 11 May 2000; www. news.battery.ru [accessed 5 June 2000].

27. *Rossiiskaia Gazeta*, 15 February 2000, 1.

28. A. S. Revaikin, ed., *Resursnyi potentsial Kamchatki* [Kamchatka's resource potential] (Petropavlovsk-Kamchatsky: AO Kamchatkniga, 1994), 288.

29. "Problemy i napravleniia gorno-promyshlennogo osvoeniia Kamchatksoi oblasti" [Problems of and directions for mining industry development in Kamchatka Oblast] (materials from a workshop) (Petropavlovsk-Kamchatsky: KGARF, 1997), 82.

30. *Kontseptsiia izucheniia i osvoeniia resursov shelfov morei Dal'nego Vostoka* [Concepts for exploration and exploitation of the resources of the shelves of the Far East seas] (Yuzhno-Sakhalinsk: Trest, Dalmorneftegeofizika, 1996).

31. Guido R. Rahr, III, "Kamchatka at the Crossroads," *International Journal of Salmon Conservation* 1, no. 3 (January 1999): 6.

32. *Kontseptsiia izucheniia* (Concepts for exploration).

33. State Committee on Environmental Protection, "O sostoianii okruzhaiushchei prirodnoi sredy Rossiiskoi Federatsii v 1997 g" [The state of the environment in the Russian Federation in 1997], *Green World*, no. 27 (1998).

34. S. P. Bystritskii et al., "Sotsial no-ekonomicheskoe polozhenie" [Social and economic status], in S. P. Bystritskii and A. S. Revaikin, *Resursnyi potentsial Kamchatki* [Kamchatka's resource potential].

35. "Sotsial no-ekonomicheskoye polozheniye Kamchatskoy oblasti za yanvar-sentyabr 1998 goda" [Social and economic conditions in Kamchatka Oblast for January-September 1998], *Vesti*, no. 211 (11 November 1998).

36. Bystritskii et al., "Sotsial no-ekonomicheskoe polozhenie."

37. Nelson Hancock, Columbia University, is studying the ethnohistory of Kamchadals in the Kamchatka River valley.

38. R. S. Moiseev, *Sotsial'no-ekonomicheskie problemy razvitiia narodnostiy Severa* [Social and economic problems of the development of the peoples of the North] (Petropavlovsk-Kamchatskii: Dal"izdat, 1989).

39. *Materialy po statistike Kamchatskoi gubernii. Prilozhenie k Statisticheskomu Biulleteniu No. 13–14 ot 1925 g* [Materials on Kamchatka District statistics, Appendix to the *Statistical Bulletin* no. 14–15 of 1925] (Khabarovsk: Far East Oblast Statistical Office, 1925), 35.

40. Russian Association of Indigenous People of the North (RAIPON), *Severnye narody Rossii na puti v novoe tysiacheletie* [Northern peoples of Russia on the way to the new millenium] (Moscow: IWGIA, 2000), 5.

41. Pavel Suliandziga and David Henry, "Environmental Problems Affecting the Traditional Lifestyles of Indigenous Peoples in the Russian North: A Seminary Report" (Moscow: RAIPON, 1998).

42. Jacques Whitford Environment Ltd., "Demonstrating Sustainable Development and Conversation of Biological Diversity in Four Protected Areas in Russia's Kamchatka Region" (report prepared for GEF, Moscow, May 2000).

43. Postanovlenie Pravitel'stva RF ot 30.12.98 g. No. 1594 "O spetsial"no upolnomochennykh gosudarstvennykh organakh RF v oblasti okhrany okruzhaiushchei sredy" [Regulation of the RF government no. 1594: On specially authorized state bodies of the RF in the protection of the environment, 30 December 1998].

44. Federal'nyi zakon RF "O kontinental'nom shelfe RF ot 25.10. 05 g" [Federal law on the RF continental shelf, 25 October 1995].

45. "Vodnyi Kodeks" (The water code); "Tipovoe Polozhenie o Basseinovom Upravlenii po okhrane i vosproisvodstvu rybnykh zapasov i regulirovaniiu rybolovstva Glavrybvoda Ministerstva rybnogo khoziaistva SSSR" ot 22.06.84 g. No. 45/11 [Model provision on the Basin Office of Fish Reserves Protection and Reproduction and Fishing Regulation of Glavrybvod of the Ministry of Fishery of the USSR, no 45/11, 22 June 1984]; Federal"nyi zakon RF "Ob iskliuchitelnoi ekonomicheskoi zone RF" ot 17.11.98 g [Federal law on the RF exclusive economic zone, 17 November 1998].

46. Postanovlenie ot 23.10.98 g. "O Kamchatskoi regionalnoi inspektsii okhrany morskikh biologicheskikh resursov Federalnoi pogranichnoy sluzhby RF" [Regulation on Kamchatka's regional Inspection of Marine Biological Resources of the RF Federal Border Service, 23 October 1998].

47. B. V. Yerofeev, ed., *Uchebnik Ekologicheskoe pravo* [Manual on ecological law) (Moscow: Novy Yurist, 1998).

48. Postanovlenie administratsii Kamchatskoi oblasti ot 29.09.97 No. 312 "O potentsiale mineral'no-syr'evykh resursov i ikh roli v sotsial'no-ekonomicheskom rasvitii Kamchatskoi oblasti" [Regulation of the Administration of Kamchatka Oblast no. 312: On the potential of the mineral resources and raw materials base and their role in the social and economic development of Kamchatka Oblast, 29 September 1997].

49. "Ob osobo okhranyaemykh prirodnykh territoriiakh" [On Protected Areas], 14 March 1995, article 6.

Chapter 11 — Sakhalin Oblast

1. Elena Sabirova and Michael Allen, "Year End 2000 Update on Sakhalin Oil and Gas Projects" (Yuzhno-Sakhalinsk: U.S. FCS & DS, 2000), 2.

2. Elena Sabirova, "Sakhalin: Economic Performance in 2000" (Yuzhno-Sakhalinsk: U.S. FCS & DS, 2000).

3. M. S. Vysokov, *Sakhalin i Kuril'skie ostrova* [Sakhalin and the Kuril Islands] (Yuzhno-Sakhalinsk: Gidrometeoizdat, 1999).

4. Elena Sabirova, "Commercial Update from Sakhalin" (Yuzhno-Sakhalinsk: U.S. FCS & DS, 2000).

5. Sabirova and Allen, "Year End 2000 Update."

6. Elena Sabirova, "Commercial Update — Sakhalin Region" (Yuzhno-Sakhalinsk: U.S. FCS & DS, 2001).

7. Sabirova, "Sakhalin: Economic Performance in 2000."

8. Ibid.

9. Sabirova, "Commercial Update — Sakhalin Region."

10. Ibid.

11. Sabirova and Allen, "Year End 2000 Update."

12. Sabirova, "Sakhalin: Economic Performance in 2000."

13. Sabirova, "Commercial Update — Sakhalin Region."

14. A. I. Tolmachev, *Geologicheskoe i botanicheskoe zonirovanie ostrova Sakhalin* [Geological and botanical zoning of Sakhalin Island] (Moscow: Academy of Sciences of the USSR, 1995).

15. G. V. Matyushkov, "Endemichnye rasteniia v flore Sakhalina, Monerona i Kuril'skikh ostrovov" [Endemic plants in the flora of Sakhalin, Moneron, and the Kuril Islands], *Lore Bulletin* (1991); E. M. Yegorova, "Kopisaniiu endemichnykh rastenii flory Sakhalina: rasteniia i faktory okruzhayuschei sredy" [On the description of endemic species of Sakhalin flora: Plants and environmental factors] (Yuzhno-Sakhalinsk: Sakhalin Scientific Research Institute of the Academy of Sciences of the USSR, Siberian Department, 1968).

16. V. G. Voronov, *Pozvonochnye Sakhalina i Kuril'skikh ostrovov* [Vertebrates of Sakhalin and the Kuril Islands] (Vladivostok: DVNTS AN SSSR, 1982).

17. Ibid.

18. Data for this section were provided by the Sakhalin Committee of Environmental Protection.

19. John J. Stephan, *Sakhalin: A History* (London and Oxford: Clarendon Press, 1971).

20. Ibid.

21. M. S. Vysokov, "Sakhalin i Kuril'skie ostrova v XX veke" [Sakhalin and the Kuril Islands in the twentieth century], unknown publication, no. 8 (1998).

22. A. O. Shubin, "Tak komu zhe dostaiutsia kvoty?" [So who gets the quotas after all?], *Rybak Sakhalina*, no. 18 (1998).

23. A. E. Kuzin, *Promyslovye vidy ryb, bespozvonchnykh i vodoroslei v vodakh Sakhalina i Kuril'skikh ostrovov* [Commercial fish species, invertebrates, and seaweed in the waters of Sakhalin and the Kuril Islands] (Yuzhno-Sakhalinsk: Far Eastern Publishing Agency, 1993).

24. N. N. Sushkina, *Puteshestvie na ostrov Tiulenii: morskie kotiki i ptich'i bazary* [A trip to Tyuleny Island: Fur seals and bird bazaars] (Moscow: Academy of Sciences of the USSR, 1954).

25. A. E. Kuzin, "Obrazovanie populiatsii morskogo kotika na Kuril'skikh ostrovakh" [Formation of fur-seal populations on the Kuril Islands], in *Issledovaniya po ekologii i faune pozvonochnykh Sakhalina i Kuril'skikh ostrovov* [Environmental and fauna research on several vertebrate on Sakhalin and Kuril Islands] (Vladivostok: DVNTS AN SSSR, 1982).

26. Sushkina, *Puteshestvie na ostrov Tiulenii*.

27. V. P. Shuntov, *Biologicheskie resursy Okhotskogo moria* [Biological resources of the Sea of Okhotsk] (Yuzhno-Sakhalinsk: Agropromizdat, 1985).

28. Ibid.

29. A. Krylov, "SOS s ostrova Tiulenii" [S.O.S. from Tyulenii Island], *Molodaya Gvardiya* (10 February 1989).

30. E. Belovitskiy, "Beskhoznyi ostrov v okeane [Unattended island in the ocean]," *Sovetskii Sakhalin* (23 August 1996); Ya. Safonov, "Tiulenii ostrov mozhet vyzhit' v zapovednike" [Tiulenii Island may survive if annexed to *zapovednik*], *Sovetskii Sakhalin* (19 June 1996).

31. Shuntov, *Biologicheskie resursy*.

32. Sabirova, "Sakhalin: Economic Performance in 2000."

33. Idem, "Commercial Update from Sakhalin."

34. "Kak raz naoborot" [The exact opposite], *Sovetskaia Rossiia* (13 November 1997).

35. Sakhalin Environment Watch et al., "Broken Commitments: Sakhalin II and Ongoing Environmental, Social, and Economic Problems," a letter to EBRD president Jean Lemierre, 10 December 2001.

36. Sakhalin Environment Watch, "Investigation Materials on the Mass Die-Off of Pacific Herring in Piltun Bay, Sakhalin Island" (Yuzhno-Sakhalinsk: Sakhalin Environment Watch, 1999).

37. M. E. Vinogradov, Letter #1-33/49 to the RAS, Ministry of Natural Resources, and the Federal Fisheries Committee, 6 June 2001.

38. Emma Wilson, "Conflict or Compromise? Traditional Natural Resource Use and Oil Exploitation in Sakhalin/Nogliki District" (proceedings from the symposium, Russian Regions: Economic Growth and the Environment, Slavic Research Institute, Hokkaido, 1999). Available online at http://src-h.slav.hokudai.ac.jp/publictn/sympopublic-e.html.

39. EBRD, "Environmental Procedures" (London: EBRD, 1996).

40. N. A. Laigun, "Letter to V. I. Murnaev, Head, Ministry of Emergency Situations" [in Russian] (Yuzhno-Sakhalinsk: 1998).

41. M. S. Vysokov, *Kratkaia istoriia Sakhalina* [A short history of Sakhalin] (Yuzhno-Sakhalinsk: Sakhalin Center for the Documentation of Contemporary History, 1994), 11–12.

42. T. P. Roon, *Ul'chi Sakhalina* [The Ulchi of Sakhalin] (Yuzhno-Sakhalinsk: Sakhalin Regional Museum, 1996), 13–16.

43. A. V. Smoliak, *Etnicheskoe razvitie narodov Nizhnego Amura i Sakhalina* [Ethnic processes of the people of the lower Amur and Sakhalin] (Yuzhno-Sakhalinsk: Nauka, 1975), 66.

44. S. Gal'tsev-Beziuk, *Toponimicheskii slovar' Sakhalinskoi oblasti* [Toponomic dictionary of Sakhalin Oblast] (Yuzhno-Sakhalinsk: 1992), 153.

45. N. A. Laigun, "Nivkhi: Crossroads of Continents. Culture of the Indigenous Peoples of Far Eastern Alaska" (Moscow: Russian Institute of Cultural and Natural Heritage, Smithsonian Institution, 1996), 14–15.

46. Ibid.

47. L. M. Kurmanguzhinova, untitled speech [in Russian] (given at the Third Meeting of Sakhalin's Indigenous Peoples, 1997).

48. V. P. Yagubov, untitled speech [in Russian] (given at the Third Meeting of Sakhalin's Indigenous Peoples, 1997).

49. According to Russian law, drilling waste may not be thrown in offshore waters, so it has to be disposed of onshore.

50. David Gordon, "Time for Oil Companies to Commit to 'Zero Discharge' in Sakhalin," *FSU Oil and Gas Monitor* 3 (2000).

51. Sabirova and Allen, "Year End 2000 Update."

52. Gordon, "Time for Oil Companies to Commit to 'Zero Discharge.'"

53. Sakhalin Environment Watch, personal communication, April 2000.

54. M. Voinilovich, "Kto platit, tot i zakazyvaet muzyku" [Money buys everything], *Sovetskii Sakhalin*, 25 June 1999.

55. Sabirova and Allen, "Year End 2000 Update."

56. Unitled article, Agency APS wire service, 27 December 2000.

57. Sabirova, "Commercial Update — Sakhalin Region."

58. Michael Allen, personal communication, Yuzhno-Sakhalinsk, Sakhalin, September 2001.

59. Sabirova and Allen, "Year End 2000 Update."

60. Ibid.

61. Sabirova, "Commercial Update — Sakhalin Region."

Figures

1.1 Kontorovich, "Economic Crisis in the Russian Far East," 391 (see chap. 1, n. 231); and data collected by Josh Newell from the offices of the Far East and Zabaikalye Association, 2002.

1.2 Nilsson, "Supply Forecasts for Timber," (see chap. 1, n. 28).

1.3 Data gathered by Tony Allison from the FAO, FAOSTAT Database, see www.apps.fao.org; the Federal Fisheries Committee; and Goskomstat.

1.4 Data gathered by Allison from the Japanese fishing association, Dalryba, and the NMFS, see www.nmfs.noaa.gov/.

1.5 Adapted from data in the *BP Statistical Review of World Energy 2002* (London: British Petroleum, 2002). Available online at www.bp.com/centres/energy2002/.

1.6 Compiled using data from the Japan Lumbers Importers Association; Ministry of Finance, Japan, see www.mof.go.jp/english/files.htm; Chinese Customs Yearbook (1995–1999) in Yamane and Lu, "Recent Russia-China Timber Trade" (see chap. 1, n. 167); Office of Forestry, Republic of Korea, see www.foa.go.kr/ext/eng/frame.htm; and Backman and Zausaev, "Forest Sector of the Russian Far East" (see chap. 1, n. 165).

1.7 Sheingauz, *Forest Fires in Primorsky and Khabarovskiy Krais* (see chap. 1, n. 183).

1.8 E. N. Matyushkin et al., *Numbers, Distribution, and Habitat Status of the Amur Tiger* (see chap. 1, n. 319).

1.9 Miquelle and Murzin, *Spatial Distribution of Far Eastern Leopard*, 45 (see chap. 1, n. 329).

2.1 Data were gathered by authors from statistical departments of the respective regional administrations.

2.2 Data were gathered by the authors from the Sakhalin and Primorsky Forest Services, respectively.

3.1, 3.2 Data were gathered by authors from statistical departments of the respective regional administrations.

3.3 *Gorny Zhurnal*, 2000; and Vasyenov, "Overview of the Forests and Wood Processing Industry," 7 (see chap. 1, n. 147).

4.1, 4.2, 5.1–5.4 Data collected by various authors from regional branches of Goskomstat.

6.1 *Gorny Zhurnal*, 2000.

6.2 Data compiled by Alexander Isaev from personal files, 2000.

6.3 *Gorny Zhurnal*, 2000.

7.1 Data collected by various authors from regional branches of Goskomstat.

7.2 *Gorny Zhurnal*, 2000.

7.3 Data compiled by Mikhail Krechmar from personal files, 2000.

7.4 *Gorny Zhurnal*, 2000.

10.1 Data collected by various authors from regional branches of Goskomstat.

11.1–11.4 Data were gathered by the authors from the Sakhalin and Primorsky Forest Services, respectively.

Maps

Data were collected from a wide variety of sources to make these maps. Most use base data (e.g., political boundaries, hydrology, roads, populated places, railroads) from the Digital Chart of the World (DCW), a product by Environmental Systems Research Institute, Inc. (ESRI), which used data from the U.S. Defense Mapping Agency. DCW data can be downloaded for free at Penn State University's Map Room, see www.maproom.psu.edu/dcw. It is common for digital data to derive data from source data, often making it difficult to track the data back to its original sources. If these original sources are known, they are listed below. Otherwise, just the provider of the digital data is cited. As most maps in this book use DCW data (cited as ESRI, 2002), mention of its use in the list below is omitted.

1.1 In addition to ESRI data, these reference maps use digital base data from the Russian Ministry of Natural Resources (2000). Data were provided courtesy of Dima Aksenov and Maxim Dubinin at the Moscow-based NGO the Biodiversity Conservation Center, see www.biodiversity.ru.

1.2 This topographic map uses data derived from the 1-km gridded digital elevation model (DEM) provided by the Global Land One-km Base Elevation (GLOBE) Project coordinated by the U.S. National Oceanic and Atmospheric Administration's (NOAA) National Geophysical Data Center. Download this data at www.ngdc.noaa.gov/seg/topo/globe.shtml.

1.3 The larch forest cover for this map was aggregated from a number of larch forest classes in digital version of the 1:2,500,000 scale map *Forests of the USSR* (1990). These data are available on the CD-ROM *Forests and Land Cover Data of Russia and the Former Soviet Union*, produced by the WHRC, 2000. See www.whrc.org/science/globfor/globfor.htm. Data were originally digitally generated by the World Conservation Monitoring Center, using the paper map. The permafrost data come from the digital version of the Circum-arctic Map of Permafrost and Ground-Ice Conditions, ver. 1.0. In: International Permafrost Association, Data and Information Working Group, comp. 1998. Circumpolar Active-Layer Permafrost System, version 1.0. This working group is coordinated under the auspices of the United Nation Environmental Program's GRID-Arendal project. These data are available on CD-ROM from National Snow and Ice Data Center, University of Colorado at Boulder.

1.4 Ecosystems data come from *Vegetation of the USSR* (1990), a 1:4,000,000 scale map also provided on the WHRC CD-ROM (2000). The data were digitized from paper maps by WHRC and others.

1.5, 1.6 Digital data on Russia's frontier forests provided by Dmitry Aksenov and Maxim Dubinin. For background on the Frontier Forest project, see *Atlas of Russia's Intact Forest Landscapes* (see chap. 1, n. 29) and online at http://forests.wri.org/pubs.

1.7–1.16 In addition to the ESRI data, base data from the Ministry of Natural Resources were used. The data on protected areas and biodiversity hotspots come from paper maps hand drawn by regional coordinators of this book, labeled, e.g., Karakin, 2000. Oleg Svistunov (formerly FoE–J) and Mike Beltz (The Ecology Center, Inc.) digitized these maps to create "layers" for use in ArcGIS.

1.17, 1.18 Fish production, quota, and export data come from the Federal Fisheries Committee, made available by the *Russian Fish Journal*, and data from Japanese and U.S. Customs, 2001. For U.S. data, see the NMFS website, www.nmfs.noaa.gov/.

1.19, 1.20 For digital data on oil and gas fields, see Dr. Thomas Ahlbrandt, F. M. Persits, G. F. Ulmishek, and D. W. Steinshouer, 1998, *Maps Showing Geology, Oil and Gas Fields and Geological Provinces of the Former Soviet Union*, USGS Open-File Report 97-470E. USGS, Denver, Colorado. Digital data on power plants and lines were provided by Matthew McKinzie, NRDC. Original source of data are unknown. Oil and gas block and concession data for the RFE were obtained by digitizing the paper map "Status of Oil and Gas Projects Offshore the Far East of Russia," by the Russian government agency Dalmorneftegazgeofizika Trust, 1998. Data on Sakhalin oil fields come from the CD-ROM *The Natural Resources GIS of Russia*, provided by the American Geological Institute (AGI) in 2000, in cooperation with Minprom, USGS, and ESRI. To purchase the CD-ROM, see http://agisoft.agiweb.org/russiangis. General Sakhalin pipeline route data derived from paper maps drawn by the Russian NGO Sakhalin Environment Watch in 2000.

1.21–1.23 Timber flow maps use data collected by the author from Chinese, Russian, and Korean customs agencies, respectively.

1.24 Lode ore and placer mine data come from Warren J. Nokleberg et al., *Significant Metalliferous and Selected Non-Metalliferous Lode Deposits and Placer Districts for the Russian Far East*, USGS Open-File Report 96-513B. Denver, Colorado: USGS, 1997. Download this digital data at http://wrgis.wr.usgs.gov/open-file/of96-513-b/. Data on coal comes from *The Natural Resources GIS*.

2.1 See note for map 1.1.

2.2 See note for map 1.24.

2.3 This map of indigenous peoples lands, originally produced as a paper map drawn by a regional coordinator (e.g., Karakin, 2001), was scanned and digitized by Matthew McKinzie, NRDC.

3.1 See note for map 1.1.

3.2 See note for map 1.24.

3.3 Data provided by the Khabarovsk Forest Service.

3.4 See note for map 2.3.

4.1 See note for map 1.1.

4.2 See note for map 1.24.

4.3 Data provided by the JAO Forest Service.

5.1 See note for map 1.1.

5.2 See note for map 1.24.

5.3 Data from Matthew McKinzie, NRDC, who digitized a paper map on hydropower development hand drawn by Yuri Darman, 2000.

5.4 See note for map 2.3.

6.1 See note for map 1.1.

6.2 See note for map 1.24.

7.1 See note for map 1.1.

7.2 See note for map 1.24.

7.3 See note for map 2.3.

8.1 See note for map 1.1.

8.2 See note for map 2.3.

9.1 See note for map 1.1.

9.2 See note for map 1.24.

9.3 See note for map 2.3.

10.1 See note for map 1.1.

10.2 See note for map 1.24.

10.3 See note for map 2.3.

11.1 See note for map 1.1.

11.2 See note for map 1.19.

Tables

1.1 Summarized from data tables available on the Goskomstat website, accessed in 2001.

1.2 Watson, Robert T., Ian R. Noble, Bert Bolin, N. H. Ravindranath, David J. Verardo, and David J. Dokken, *Land Use, Land-Use Change, and Forestry: A Special Report of the Intergovernmental Panel on Climate Change* (Cambridge, U.K.: Cambridge University Press, 2000).

1.3 Information gleaned by Josh Newell from Chapters 2–11.

1.4 Bryant, Dirk, Daniel Nielsen, and Laura Tangley. *Last Frontier Forests: Ecosystems and Economies on the Edge* (Washington, D.C.: World Resources Institute, 1997), 42.

1.5 Ramsar Convention Bureau, "List of Wetlands of International Importance" (Gland: Ramsar Convention Bureau, 2002). Available online at www.ramsar.org/key_sitelist.htm.

1.6 Adapted from a table on p. 23 of *Forest Sector of the Russian Far East*. That table attributes data to the Far Eastern Forestry Inventory Enterprise, Khabarovsk, 1995.

1.7 Data compiled from the regional chapters of this book and the *Forest Sector of the Russian Far East* (see table on p. 26 of report).

1.8 Data, compiled by Josh Newell and the authors of the regional chapters in this book, from Khabarovsk Forest Service, Sakhalin Forest Service, Amur Forest Service, ERI, and Russian Federal Customs.

1.9 Compiled by Josh Newell using data from regional chapters of this book. Data for Amur companies are for 1997; the rest are for 2000.

1.10 Compiled from the regional chapters in this book; Dorian, James, "Minerals & Mining in the Russian Far East," in *Politics and Economics in the Russian Far East: Changing Ties with Asia-Pacific*, edited by Tsuneo Akaha, 233. London; New York: Routledge, 1997; Levine, *Mineral Industry of Russia*, 20 (see chap. 1, n. 105); and the *BP Statistical Review of World Energy 2002*.

1.11 Data from the Far East and Zabaikalye Association, 2002.

1.12 Compiled from regional chapters and the EBRD. "Russian Federation Investment Profile" (London: EBRD, 2001), 48.

1.13 *Itogi Vsesoiuznoi perepisi naseleniia 1989 goda* [USSR Census of Indigenous People, 1989] (Minneapolis, Minn.: East View Publications, 1996).

2.1 Data gathered by the authors from the respective regional branches of Committee on Environmental Protection.

2.2, 2.3 Data gathered by the authors from the respective regional branches of the Federal Forest Service.

3.1 Data gathered by the authors from the respective regional branches of Committee on Environmental Protection.

3.2 *Gorny Zhurnal*, 2000.

3.3 Data gathered by the authors from regional branches of Goskomstat.

3.4 Data gathered by the authors from the respective regional branches of the Federal Forest Service.

4.1, 4.2 Data gathered by the authors from the respective regional branches of Committee on Environmental Protection.

5.1 Data compiled by Yuri Darman, 2000. Original source is unknown.

5.2 Data gathered by the authors from the respective regional branches of Committee on Environmental Protection.

5.3, 5.4 Data gathered by the authors from regional branches of Goskomstat.

5.5–5.8 Data gathered by the authors from the respective regional branches of the Federal Forest Service.

5.9 Adapted from the National New Service's *Amur Oblast: A Guidebook for Businessmen*, 1998. Available online at www.nns.ru/gallery/stos/amur.html.

5.10, 5.11 Data gathered by the authors from regional branches of Goskomstat.

5.12, 5.13 Compiled by Melinda Herrold, using data from the Amur Oblast administration's *The State Report on the Environment of Amur Oblast, 1997* and *The Concept of Socio-Economic Development of Amur Oblast for 1998–2000*.

6.1 Data gathered by the authors from the respective regional branches of Committee on Environmental Protection.

6.2, 6.3 Compiled by Alexander Isaev from data in personal files, 2000.

7.1 Data gathered by the authors from the respective regional branches of the Federal Forest Service.

8.1 Data gathered by the authors from the respective regional branches of Committee on Environmental Protection.

10.1 Data gathered by the authors from the respective regional branches of the Federal Forest Service.

10.2, 11.1 Data gathered by the authors from the respective regional branches of Committee on Environmental Protection.

11.2 Data gathered by the authors from regional branches of Goskomstat.

A note on transliteration

In transliterating Russian personal and place names and reference material for this book, we used the systems devised by J. Thomas Shaw and outlined in his manual, *The Transliteration of Modern Russian for English-Language Publications* (Madison: University of Wisconsin Press, 1967). For the text proper and the tables we used System I, as it is most suitable for the general reading public rather than, for example, for a specialist in Slavic linguistics. For many of the source notes, we used System II, which is the Library of Congress system for transliteration of modern Russian. This will assist the reader in locating reference material of interest.

We did, however, at times diverge from System I to enhance the readability for the English-speaking audience and to accommodate the numerous Russian geographic titles and terms that are already anglicized. These exceptions are as follows:

To "sky" or not to "sky"

We dropped such endings when inclusion made the flow of the text cumbersome and distracting for the reader. For example, rather than Khabarovsky Krai and Sakhalinskaya Oblast, we simply used Khabarovsk and Sakhalin. In general, sites for which a translation to English was imperative have had their endings removed. Thus, where a location or geographical name is translated to English — Okhotskoe More, for example, is rendered Sea of Okhotsk — the ending has been removed. Endings were not, however, dropped for the names of oil and gas fields, mineral deposits, mining sites, power stations, and dams, such as Elginsky mining site, because it is not always obvious what the root is, and because these place names are widely used in economics, geology, and other fields. For the same reasons, all *raion*s and untranslated locations were formalized with a "-sky" ending. Most areas with indigenous titles appear without their Russified endings. Areas, especially administrative districts such *raion*s, *zapovednik*s, and *zakaznik*s, retain their Russian endings. Sometimes we did drop the "-sky" to enhance readability. If by removing an ending the location became confusing, the "-sky" was left for clarity.

Russian plural endings

We dropped Russian plural endings, such as *zakazniki, zapovedniki, raioni,* and *leskhozy,* and added anglicized endings, such as *zakaznik*s, *leskhoz*es, etc.

Russian letter й

System I requires that this letter appear as a y after any vowel. Frequently appearing and popularly anglicized words such as *krai* then become the subject of confusion. Therefore, combinations ай, ей, ёй, ий, ой, уй, эй, ый, юй, and яй are transliterated as ai, ei, yoi, ii, oi, ui, ei, yi, yui, and yai, respectively. Only endings -ий and -ый are transliterated as y, in accordance with System I.

Geographic descriptors

When a geographic descriptor was attached to a specific location or territory, it remained untranslated; for instance, Verkhne-Bikinsky Zakaznik rather than Upper-Bikinsky Zakaznik. If, however, the handbook refers to a geographical area, like *Nizhne-Lensky Bassein*, the location was translated: Lower Lena Basin. One of the few exceptions is Maly Khingan Range on the northern side of the Amur River. To avoid confusion with Lesser Khingan Range in China, we did not translate its name. We also did not change some well-known geographic names widely used in English literature, such as Tiksi (should be Tixi according to System I), Novaya Zemlya (New Land), Komsomolsk-on-Amur (Komsomolsk-na-Amure), or Bolshoe Tokko (Greater Tokko Lake).

Russian companies

The names of all Russian companies appear directly transliterated and unaltered, unless they have established names in English.

Use of primes

We took out all primes (′ and ″), including the ones for the Russian letter ъ, except for those in the endnotes.

We hope these circumstantial additions to Shaw's system will create a more accessible and cleaner vocabulary for the reader.

Shaw's systems I and II

Russian	System I	System II
Аа	a	a
Бб	b	b
Вв	v	v
Гг	g	g
Дд	d	d
Ее	e	e
Єє	yo	e
Жж	zh	zh
Зз	z	z
Ии	i	i
Йй	y	i
Кк	y	y
Лл	k	k
Мм	l	l
Нн	m	m
Оо	n	n
Пп	p	p
Рр	r	r
Сс	s	s
Тт	t	t
Уу	u	u
Фф	f	f
Хх	kh	kh
Цц	ts	ts
Чч	ch	ch
Шш	sh	sh
Щщ	shch	shch
Ьь	″	″
Ыы	y	y
Ъъ	´	´
Ээ	e	e
Юю	yu	iu
Яя	ya	ia
-ый	-y	-yi
-ий	-y	-ii
-ия	-ia	-iia
-ье	-ie	-'e
-ьи	-yi	-'i
кс	x	ks

Index

Note: Page numbers in *italics* denote illustrations; page ranges followed by *passim* denote recurring, but not continuous, references.

minerals, 8, 10, *82* (map), *84* (chart)
 in Amur Oblast, 199, *216* (map), *216* (table), 218
 in Chukotsky Autonomous Okrug, 285
 in the JAO, 180, 182
 in Kamchatka Oblast, 343, 358, 360–62
 in Khabarovsk Krai, 148, 165
 in Magadan Oblast, 261, 263
 in Primorsky Krai, 114, 135, 136, 140
 in Sakha, 228, 229, 230
 in Sakhalin Oblast, 379
Minfin. *See* Ministry of Finance
mining, 9, 83–86, 93
 as environmentally damaging, 83, 85, 241–43, 245–47, 250, 267, 279–80, 288, 298, 300–301, 302–03, 329, 354
 foreign investment for, 83, 85, *90–91* (table), 92
 social effects of, 89
 sustainable development and, 140
 in Amur Oblast, 198, 200, 203, 209, 210, 212, 215–18, 220–21
 in Chukotsky Autonomous Okrug, 286, 288, 298, 300, 302–03
 in the JAO, 180, 181, 182, 187, 188, 189, 192–93, *192* (map)
 in Kamchatka Oblast, 342, 347, 360–62, *361* (map)
 in Khabarovsk Krai, 150, 163–64, 165–68, *166* (map)
 in Koryak Autonomous Okrug, 314, 316, *316* (map), 326, 328–29, 334–35
 in Magadan Oblast, 260, 261, *261* (chart), 263–64, 267, 273–74, 275, 278–81, *279 (map)*
 in Primorsky Krai, 115, 135–37, *135* (map)
 in Sakha, 228, 241, 243–52, *243* (map)
 in Sakhalin Oblast, 398
Ministry of Agriculture and Food, xvii, 122
Ministry of Atomic Energy (Minatom), xvii, 66, 357
Ministry of Finance (Minfin), xvii
Ministry of Foreign Economic Relations and Trade, xvii
Ministry of Fuel and Energy (Mintopenergo), xvii
Ministry of Industry (Minprom), xviii
Ministry of Internal Affairs (MVD), xviii
Ministry of Natural Resources, xviii, 36, 38, 49, 50, 73, 77, 79, 96, 103, 105–06
 in the JAO, 184, 185
 in Kamchatka Oblast, 361, 367
 in Koryak Autonomous Okrug, 337
 in Magadan Oblast, 264, 265
 in Primorsky Krai, 120, 121, 140
Ministry of the Economy (Minekonomii), xviii
Ministry of Transportation (Mintrans), xviii
Minprom. *See* Ministry of Industry

Mintopenergo. *See* Ministry of Fuel and Energy
Mintrans. *See* Ministry of Transportation
Miquelle, Dale, 10
 contribution by, 106–09
Mirny, 229
Mirzekhanova, Z. G., contribution by, 163–65
Mitsubishi, Sakhalin oil projects and, 93
 see also Diamond Gas Sakhalin B.V.
Mitsui Mining Company, Japan, 93, 251
Mitsui Sakhalin Holdings (Japan), 399, 413
MMM (oil consortium), 399
Mnogovershinnoe mine, 86, 147
Mochalivy Island oil concession, 305
Moiseev, Robert, contributions by, 319–22, 363–64, 364–66
Molikpaq oil-drilling platform (Sakhalin), 394, 399, 400, 408, 412, 413, 414
monitoring
 ecological, 51–52, 107, 307–08
 environmental, 38, 79, 337–38, 363, 367, 382
Moroshechnaya River
 as Ramsar site, 34 *(table)*, 321
 see also Zakaznik, Reka Moroshechnaya (Cloudberry River)
Moscow State University, 187, 325
Mukhinka forest area, as hotspot, 42, 208
Multilateral Investment Guarantee Agency (MIGA), 92, 280
Murashko, Olga, contribution by, 338–39
Muravyov, Nikolai, 100, 163
Mutnovsky geothermal power plant, 67, *90* (table), 92, 344, 362–63
MVD. *See* Ministry of Internal Affairs

Nabilsky Ridge, as hotspot, 388–89
Nakhodka, 113, 115
Naletov, Innokenty, 56, 58
Namibia, Sakha diamond interests in, 244
Nanai (indigenous peoples), 40, 100, *101* (table), 113, 140, 147, 159, 172, 173, 408–09
Natalka (Matrosov) gold project, 281
National Administration of Fishery Enforcement, Resources Restoration, and Fishing Regulation (Glavrybvod), xviii, 52
National Park (proposed)
 Central Koryakia, 324
 Kema-Amginsky, 123
 Sredne-Ussuriisky (Middle Ussuri), 38, 123, 127–28
 Susunaisky, 390, 391
 Verkhne-Ussuriisky (Upper Ussuri), 40, 123, 129
national parks, 35, 36
 defined, xx
 in Amur Oblast, 211
 in Chukotsky Autonomous Okrug, 292–93
 in Khabarovsk Krai, 158–59
 in Koryak Autonomous Okrug, 324
 in Primorsky Krai, 123
 in Sakhalin Oblast, 390

Natural Monument
 Anna River, 391
 Kedrovniki (Korean Pine Forests), 123
 Lunsky Zaliv (Lunsky Bay), 288
 Talan Island, 267
 Telekaiskaya Roscha (Telekai Grove) (botanical), 299–300
 Tnekveemskaya Roscha (Tnekveem Grove) (botanical), 299
 Vaida Mountain, 288, 405
 as hotspot, 393
natural monuments, 35, 36
 botanical, as hotspot, 43, 299–300
 defined, xx
 in Amur Oblast, 205, 207, 209, 210
 in Chukotsky Autonomous Okrug, 295, 299–300
 in the JAO, 184, 186, *186* (table)
 in Kamchatka Oblast, 350
 in Koryak Autonomous Okrug, 321
 in Magadan Oblast, 265, 267
 in Primorsky Krai, 123
 in Sakha, 235, 237
 in Sakhalin Oblast, 385, 388
natural resources. *See* resources, natural
Nature Chronicle (program), 268
Nature Park
 Bystrinsky, 83, 342, 350, 353, 361, 366, 370, 371
 as hotspot, 44, 351–52
 Khasansky, 123, 128
 Klyuchevskoi, 371
 see also Klyuchevskoi Volcano
 Kuldur, 185, 186, 193
 as hotspot, 41, 187–88
 Moneron Island, 387
 Mukhinka (proposed), 208
 Muravyovka (Muravyovsky), 36–37, 208, 219
 Nalychevsky, 350, 370, 371
 Vladivostoksky, 123
 Yuzhno-Kamchatsky (Southern Kamchatka), 350
 Yuzhno-Primorsky (Southern Primorsky), 123
nature parks, 36
 in Chukotsky Autonomous Okrug, 295
 in the JAO, 186
 in Kamchatka Oblast, 350
 in Primorsky Krai, 123
 in Sakha, 235, 237
 in Sakhalin Oblast, 385, 387
nature protection agencies, 246–47
Naukan (national cooperative), 310
Naumkin, Dmitry, contributions by, 290–95, 300–311
Naumkin, Sergei, 126
Navarro, Richard, 89
Nazarov, Alexander, 292
Nazdratenko, Evgeny, 7, 47, 49, 55, 58, 59, 60, 113–14, 120, 142, 143
Nechitailov, Yuri, 370
Nedoluzhko, V. A., 187, 189
Nedr, as abbreviation, xx
Negidal (indigenous peoples), *101* (table), 147, 154, 173

quotas
 auction of, 49, 51, 60
 crab, 318
 fishing, 46, 49–52, *52 (map)*, 54, 59, 140,
 276, 278, 337, 395, 409–10
 corruption and, 46, 50, 134, 350, 367
 resale of, 286, 287, 306
 seal hunting, 320

railroads, 9, 61
 Chinese Eastern, 74
 Hunchun, China–Kraskino, Russia, 115
 in Khabarovsk Krai, 149, 163–64
 in Primorsky Krai, 115
 in Sakha, 231
 in Sakhalin Oblast, 381
 see also Baikal-Amur Mainline;
 Trans-Siberian Railroad
raion, defined, xvi
RAIPON. *See* Russian Association of
 Indigenous Peoples of the North
Ramsar Convention List of Wetlands of
 International Importance, 122, 207, 208
 site(s): defined, xx
 in the RFE, 33, *34* (table), 37, 118,
 122, 128, 209, 321, 324, 386, 389
Rare Birds Reintroduction Station, 207
RAS. *See* Russian Academy of Sciences
Rassokha gold project, 281
recreation, sustainable development and, 140
Red Data Book, 41, 44, 45, 81, 160, 169, 177,
 194, 204, 225, 295, 296, 335, 337, 389
 described, xx
 IUCN, 39, 119, 155, 162
 Japanese
 Russian, xx, 39, 127, 155, 162
 Sakha, 229, 235, 240
 South Korean
 USSR, 39, 155, 162
redkolesie, 265, 270, 274
referendum, on environmental issues, 104
Regional Venture Fund for the Far East and
 Siberia (EBRD), 96
regions, biological, described, xix
reindeer herding
 in Amur Oblast, 224
 in Chukotsky Autonomous Okrug, *26,*
 286, 288, *290,* 299, 300, 306, 307,
 308, 310
 in Kamchatka Oblast, 359, 362, 366
 in Koryak Autonomous Okrug, 313, 315,
 326, 327, *327,* 331, 332, 336
 in Magadan Oblast, 274, 277
 in Sakha, 131, 238, 255
 in Sakhalin Oblast, 45, 383, 394, 408,
 410
republic. *See* Russia, administrative regions of
reserves, national resource, 235, 237, 240
Reshetenko, T., contribution by, 326–31
"resource curse," 89

resources, natural
 and the Asian market, 47
 control of, 4
 extraction of, 92–93
 illegal harvesting, 12
 marine, 34–35
 trade in, 10–11
 in Amur Oblast, 199–200
 in Chukotsky Autonomous Okrug,
 285–86
 in the JAO, 180–81
 in Kamchatka Oblast, 343
 in Khabarovsk Krai, 148
 in Koryak Autonomous Okrug, 315–16
 in Magadan Oblast, 261
 in Primorsky Krai, 114
 in the RFE, 8
 in Sakha, 228, 229–30, 407
 in Sakhalin Oblast, 379
Rezvanov, Vladimir, 369
RFE. *See* Russian Far East
RFE Biodiversity Hotspot Study (1994), 39
RH. *See* Rimbunan Hijau
Rich, Bruce, contribution by, 369–70
Rimbunan Hijau (RH; Malaysian logging
 corp.), *70* (table), 87, *91* (table), 93, 95
 in Khabarovsk Krai, 69–70, 78, 146,
 175–77
 in Primorsky Krai, 124
RITEG. *See* generator, radioisotopic
 thermoelectric
rivers, transport along, 9, 186, 201, 231, 287,
 317
Rivkin, V., contribution by, 356–58
roads, 9, 11, *22,* 92
 in Amur Oblast, 200, 210
 in Chukotsky Autonomous Okrug, 287,
 293, 298, 307
 in the JAO, 181
 in Kamchatka Oblast, 344
 in Khabarovsk Krai, 146, 169
 in Koryak Autonomous Okrug, 43, 317
 in Magadan Oblast, 262, *262,* 270–71
 in Primorsky Krai, 115, 124, 127, 132
 in Sakha, 231
 in Sakhalin Oblast, 390
Rockefeller Brothers Fund, 97
Rosgydromet. *See* Authority on
 Hydrometeorology and Monitoring of the
 Environment
Roskomcadaster. *See* Land Cadastre Service
 of Russia
Roskomdragmet, 244
Ross, Michael, 89
Rostomov, S., contribution by, 325–26
Royal Dutch Shell, 94, 412, 413
Russgold X. Investment Ltd. (Cyprus), 281
Russia
 administrative regions of, xv-xvi
 government of, xv
Russian Academy of Sciences (RAS), xix, 35,
 36, 38, 120, 121, 208
 Botanical Gardens, 39
 Comprehensive Analysis Institute for
 Regional Problems, 184–85
 Far Eastern Branch (FEBRAS), xix, 139,
 159, 276

Institute of Marine Biology, 162, 163
Kamchatka Institute for Environment
 and Nature, Laboratory of
 Ornithology, 324
Northeast Comprehensive Scientific
 Research Institute, 276
Yakut Science Center, 246
Russian Association of Indigenous Peoples
 of the North (RAIPON), 101, 173, 279,
 333, 334, 339, 366
 Khabarovsk Krai, 174
Russian Central Bank. *See* Central Bank of
 the Russian Federation
Russian Exclusive Economic Zone (EEZ),
 115, 134, 367
Russian Far East (RFE)
 cities of, 6
 climate of, 3
 described, xv
 development policies in, 89
 economic importance of, 11
 ecosystems of, *14* (map)
 energy infrastructure of, *63* (map)
 environmental issues in, *30* (table)
 fauna of, 5–6, 31, 33, 41–44
 fishing, 9
 flora of, 4–6, 12, 31, 39, 42, 45
 foreign investment in, 9–10, 12, 87–92,
 90–91 (table)
 forests of, *14–15* (maps)
 geography of, 3–4, *13* (map)
 industry, *8* (chart), 9
 infrastructure of, 9–10
 key issues and projects in, 4
 maps, *2, 13, 14–15, 63, 65, 82*
 minerals in, *82* (map)
 natural resources of, 8
 outlook for, 11
 politics, 7
 population of, 6–7, *7 (table)*
 size of, 3
 social change in, 12
 sustainable development in, 11–12
 trade, *8* (charts)
Russian Far East Sustainable Natural
 Resources Project (Environmental Policy
 and Technology Project) (EPT), 97
Russian Far East Update, 223
Russian Federation
 forests of, *14–15* (maps)
 geographic regions, *13* (map)
Ryabov, Andrei, 143
Ryb, as abbreviation, xx

Sabirova, N., contributions by, 388–89,
 390–91, 391
Sabirov, R., contributions by, 388–89,
 390–91, 391
Sachs, Jeffrey, 89

tin
 in Chukotsky Autonomous Okrug, 285,
 286, 300, 302
 in the JAO, 180, 182, 193
 in Khabarovsk Krai, 148, 165, 168
 in Primorsky Krai, 114, 136
 in Sakha, 228, 229–30, 239
TINRO. *See* Pacific Institute of Fisheries and
 Oceanography
Tkhsanom (Territory of Traditional Nature
 Use), in Koryakia, 325, 326, 336, 338–39
toad, Eastern firebelly (*Bombina orientalis*),
 24
Tolmachev, A. I., 384
TOO, defined, xxi
tourism, 372–73
 in Amur Oblast, 208
 in Chukotsky Autonomous Okrug, 288,
 297, 307
 in Kamchatka Oblast, 342, 345, *345*,
 348, 350, 351, 352, 354, 363, 368,
 370–73
 in Khabarovsk Krai, 163
 in Koryak Autonomous Okrug, 316, 317
 in Primorsky Krai, 115, 140
 in Sakha, 240
 in Sakhalin Oblast, 386
 see also ecotourism
trade
 foreign, *8* (charts), 10–11
 in Amur Oblast, 201
 in Chukotsky Autonomous Okrug,
 287
 in the JAO, 181–82
 in Kamchatka Oblast, 344
 in Khabarovsk Krai, 150, *150* (chart)
 in Koryak Autonomous Okrug, 317,
 327
 in Magadan Oblast, 262–63
 in Primorsky Krai, 115–16, *115*
 (chart)
 in Sakha, 231–32, 253–54
 in Sakhalin Oblast, 381
 illegal, 4, 10, 12, 297
 unofficial, 115, 134, 287
Trade and Development Agency (TDA), 92
traditional nature use
 in Kamchatka Oblast, 351, 352, 356, 362
 in Koryak Autonomous Okrug, 320, 323,
 331
 in Sakhalin Oblast, 383, 407
Transneft (pipeline company), 62
Transparency International, 99
transportation, as industry, in Primorsky
 Krai, 115
Trans-Siberian Highway. *See* Chita-
 Nakhodka road
Trans-Siberian Railroad, 9, 231
 in Amur Oblast, 48, 198, 199, 200, 206,
 210, 214
 in Khabarovsk Krai, 149, 164, 170, 176
 in the JAO, 181, 191, 193
 in Primorsky Krai, 113, 115, 130

Troika (trading company), 124
Trumbull, Nathaniel, contribution by,
 101–06
TTPs. *See* Territories of Traditional Nature
 Use
Tuimaada Diamond company, 244
Tuimaada Valley, as hotspot, 42, 241
Tumangan Project, 128
Tumen River Delta, 40, 93, 112, 123, 128
Tumninsky Zakaznik, 157
tundra, 4–5, 31, 119, 153
 in Sakha, as hotspot, 33, 42, 239, *239*
Tunguska River, 179
TUSRIF. *See* U.S. Russia Investment Fund
TVX Gold Inc. (Canada), 85
Tyndales (timber company), 70 (table), 200,
 213

Uchur River, protection for (as hotspot), 42,
 240
Udege (indigenous peoples), 100
 in Khabarovsk Krai, 98, *101* (table), 159,
 173, *174*, 177
 in Primorsky Krai, *23*, *24*, 40, 98, *101*
 (table), 113, 117, 124, 126, 127, 132,
 133, *133*, 140–41, *142*
 see also Iman Udege
Udyl Lake, as Ramsar site, *34* (table)
Uilta (indigenous people), 45, 100, 378, 394,
 410
Ulchi (indigenous people), *101* (table), 147,
 154, 173
Umara Island, 269–70
UNDAC. *See* United Nations Disaster and
 Assessment Coordination
UNDP. *See* United Nations Development
 Programme
UNEP. *See* United Nations Environment
 Programme
UNESCO World Heritage site, 37, 127, 128,
 296, 342, 350, 351, 355, 366, 369–70,
 372, 376
 defined, xx
 see also United Nations Educational,
 Scientific, and Cultural Organization
UNIDO. *See* United Nations Industrial
 Development Organization
Union of Marine Mammal Hunters of
 Chukotka, 310
Unique Premium Metals (U.S.A.), 256
United Energy System of Russia, 221
United Kingdom, investment in the RFE by,
 48, 217, 280, 414
United Nations
 Agenda 21, 235
 Summit (2002), 95
 United Nations Development Programme
 (UNDP), 89, 97, 128, 331
 see also Global Environment Facility
 United Nations Disaster and Assessment
 Coordination (UNDAC), 81
 United Nations Educational, Scientific, and
 Cultural Organization (UNESCO), 361
 United Nations Environment Programme
 (UNEP), 97, 104
 United Nations Food and Agricultural
 Organization (FAO), 31

United Nations Industrial Development
 Organization (UNIDO), 89
United States
 fishing in RFE waters by, 53, 58
 as investor in the RFE, 48, 85, 87, 92, 93,
 171, 217, 279, 280, 281, 329, 413, 414
 trade with, 10, *115* (chart), 116, 150, *150*
 (chart), 231, 262–63, 287, 317, 327,
 344, 381
United States Agency for International
 Development (USAID), 88, 89, 97–98,
 171
 Forest Resources and Technologies
 Project, 146, 172
University of Washington (U.S.A.), Fishery
 Department, 325
uranium ore, in Chukotsky Autonomous
 Okrug, 304–05
USAID. *See* United States Agency for
 International Development
U.S. Energy Information Agency, 62
U.S. Export-Import (Ex-Im) Bank, 89, 92,
 95, 244, 254
U.S. Geological Survey, 253
U.S. Russia Investment Fund (TUSRIF),
 86, 96
Ussuriisk, 113
Ussuri River, 4, 96, 111, 112, 146
 basin as hotspot, 40–41, 129
Ussuri Taiga, 5, 32, 67, 69, 112, 117, 146
Ust-Kuyga gold deposit, 249
Ust Srednekanskaya hydropower plant, 267
U.S. West Coast–Russian Far East Ad Hoc
 Working Group, 86
Utkholok, Cape
 as Ramsar site, *34 (table)*, 321
 see also Zakaznik, Utkholok, Cape
Uzon Caldera, 34, 44, 354, 373

Vaida Mountain, as hotspot, 45, 388, 393
Vakhrin, S., contribution by, 359
Valley of Death, 44, 354
Valley of the Geysers, 44, 341, 342, *348*,
 353–54, 368, 372
Vanino, 146, 147, 149
Vaskovsky, A. P., 300
Vassilyev, Boris, 195
Vengeri River, basin as hotspot, 45, 388–89
Vereinsbank (Germany), 280
Verkhoyansk, 227, 233
Vetrensky gold project, 281
Vilyui Committee, 238, 246
Vilyui River basin as hotspot, 42, 238, 242,
 246
Vilyuiskaya hydroelectric power station
 (Kaskad Station), 238, 252
Vinogradov, M. E., 400
Vinson, Ted, 29
Vladimir Semyonov Ecological Center, 350
Vladivostok, *21*, 113, 115
Vladivostok Conference. *See* Hotspots
 Conference, 1995
VNIRO. *See* Federal Research Institute of
 Fisheries and Oceanography

About the author

Josh Newell was born in Boston, Massachusetts, in 1969 and grew up in London, The Hague, and southern California. After graduating from Brown University in 1991 with a degree in history, he moved to Japan and began working for Friends of the Earth–Japan (FoE–J), organizing adventure tours to some of Asia's wildest places, including trips in Russia to Lake Baikal, the forests of the Bikin River, and the country's only marine reserve, Morskoi Zapovednik.

In 1994, he moved to Vladivostok to work for FoE–J on the Russian Far East Biodiversity Hotspot Study—a project that involved extensive data gathering throughout the region and close coordination with scientists, government officials, and emerging post-Soviet nongovernmental organizations. *The Russian Far East: Forests, Biodiversity Hotspots, and Industrial Developments*, co-authored with Emma Wilson and published in 1996, was a major outcome of the project.

From 1996 to 2000, Josh divided his time between Vladivostok and Tokyo. Reports on corruption and illegality in the Russian timber trade; a rock concert—VladiROCKstok—to raise funds for charitable causes; consultancy work for various U.N. agencies, private foundations, and Japanese government agencies; projects to create new protected areas in the southern RFE; and a campaign to improve the environmental performance of the Sakhalin oil and gas projects were some areas of focus. His involvement with the World Conservation Union (IUCN) helped to develop the template for this book. He also represented Russian and Japanese environmental concerns at the 1997 Kyoto Climate Change Conference, the 1999 World Trade Organization Ministerial in Seattle, the annual Group of Eight (G-8) meetings, and other forums.

In the fall of 2002, he received a master's degree in geography from the University of Washington.